NEW WORLDS

NEW WORLDS
GERMAN AND AUSTRIAN ART
1890–1940

Edited by Renée Price
with the assistance of Pamela Kort and Leslie Topp

With contributions by:

Vivian Endicott Barnett	Jane Kallir	Karin Orchard
Tayfun Belgin	Pamela Kort	Olaf Peters
Marian Bisanz-Prakken	Markus Krause	Anne-Katrin Rossberg
Matthias Boeckl	Markus Kristan	Burkhardt Rukschcio
Magdalena Droste	Rudolf Leopold	Serge Sabarsky
Wolfgang Georg Fischer	Beth Irwin Lewis	Andreas Schalhorn
Gerbert Frodl	Jill Lloyd	Elisabeth Schmuttermeier
Siegfried Gohr	Rose-Carol Washton Long	Franz Schulze
Reinhold Heller	Manfred Ludewig	Peter Selz
Annegret Hoberg	Maria Makela	Laurie A. Stein
Antonia Hoerschelmann	Karin von Maur	Leslie Topp
Keith Holz	Barbara McCloskey	Patrick Werkner
Christine Hopfengart	Peter Nisbet	Johann Winkler
	Osamu Okuda	Christian Witt-Dörring

NEUE GALERIE
MUSEUM FOR GERMAN
AND AUSTRIAN ART
NEW YORK

TABLE OF CONTENTS

This catalogue has been published in conjunction with the inaugural exhibition

NEW WORLDS: GERMAN AND AUSTRIAN ART, 1890–1940

Neue Galerie New York
16 November 2001–18 February 2002

Catalogue Editor
Renée Price
with the assistance of
Pamela Kort and Leslie Topp

Copy Editing
Diana Stoll, Philomena Mariani,
Karin Thomas, Alex Zucker

Research and Documentation
Claire Deroy and Janis Staggs-Flinchum

Translations
Elizabeth Clegg, Fiona Elliott, Bernhard Geyer,
Wolfgang Himmelberg, Michael Huey,
Esther Kinsky, Bram Opstelten,
Nicholas T. Parsons, Leslie Topp

Design
Pandiscio Co.
Birgit Haermeyer

Photography of Decorative Art
David Schlegel, New York

Production
Peter Dreesen, Marcus Muraro
DuMont Buchverlag, Cologne

Color Separations
Litho Köcher, Cologne
Pixelstorm, Vienna

Setting and Printing
Rasch, Bramsche

Binding
Bramscher Buchbinder Betriebe

Printed in Germany
ISBN 1-931794-01-4

All Rights Reserved
Copyright © Neue Galerie New York, 2001

Front cover: Gustav Klimt, *Die Tänzerin
(The Dancer)*, ca. 1916–18 (cat. no. I.15)

Back cover: Josef Hoffmann, *Brooch*, 1904
(cat. no. III.21)

Endpapers: 1048 Fifth Avenue, New York City.
This landmark building houses Neue Galerie
New York. Photo courtesy the Museum of the
City of New York

Frontispiece: Neue Galerie grand staircase,
photographed by David Schlegel, New York

ACKNOWLEDGEMENTS

The following people have contributed to making this a successful project:

Alice Adam, Chicago
Pierre Adler, New York
Jane Adlin, New York
Stefan and Paul Asenbaum, Vienna
Hildegard Bachert, New York
Patricia Bakunas, Chicago
Elisabeth R. Baldwin, New York
Stephanie Barron, Los Angeles
Selina Bartlett, Worcester
Marc Bascou, Paris
Tawney Becker, Cambridge, MA
Jörg Bertz, Düsseldorf
Kraig Binkowski, Detroit
Jennifer Black, Minneapolis
Mimi Braun, New York
Catherine Bruck, Chicago
Ann Butler, New York
Mikki Carpenter, New York
Kate Carr, New York
Andrea Clark, Pasadena
Donna Corbin, Philadelphia
Bonnie Cullen, Seattle
Katherine B. Crum, Oakland
Magdalena Dabrowski, New York
Betty Davis, Detroit
Gertrude Denis, New York
Claudine R. Dixon, Los Angeles
Nora Donnelly, Boston
Marcie Dreggers, Ft. Worth
Stephanie Dubsky, New York
Lydia Dufour, New York
Janis Ekdahl and the staff of the Museum
 of Modern Art Library, New York
Michelle Elligott, New York
Ines Engelhorn, Leipzig
Peter Eltz, Salzburg
Marcia Erickson, Raleigh
Ulrich Fiedler, Cologne

Allan Frumkin, New York
Eugene R. Gaddis, Hartford
Casey George, Chicago
Siegfried Gohr, Cologne
Scott Gutterman, New York
Jeffrey Haber, New York
Christa E. Hartmann, New York
Jean-Noël Herlin, New York
Michael Huey, Vienna
Milan Hughston, New York
Nicole Hungerford, Pasadena
Anthony K. Jahn, Chicago
Jane Kallir, New York
Greg Kelly, San Diego
Karen Kelly, New York
Ilse Maria Vogel Knotts, Bangall
Walther König and Jutta Linte, Cologne
Markus Krause, Berlin
Elizabeth Kujawski, New York
George Lang, New York
Jennifer Lawyer, New Haven
Michael Lesh, New York
Sophie Lillie, Vienna
Keith Lokovitz, Oakland
Maureen Mahoney, Cambridge, MA
Kirstin E. Martin, Cleveland
Laura Maurer, Philadelphia
Peter Mayer, New York
Jennifer McKenna, Oakland
Kynaston McShine, New York
Irene Mees, New York
Thomas M. Messer, New York
Amy Miller, Cincinnati
Hattula Moholy-Nagy, Ann Arbor
Peter Nelson, New York
Peter G. Neumann, Palo Alto
Peter Nisbet, Cambridge, MA
Peter Noever, Vienna
Vlasta O'Dell, New York
Todd Olson, New York
Susanne Orlando, Zurich
Susan L. Palamara, New York

Richard Pandiscio and Takaya Goto,
 New York
William A. Peniston, Newark
Allison Pennell, San Francisco
Carina Plath, New York, Cologne
Ernst Ploil, Vienna
Lars Rachen, New York
Tara K. Reddi, New York
Stephanie Revak, Baltimore
Barbara Paul Robinson, New York
Sandra Römermann, Berlin
Grant Rusk, Los Angeles
Edward G. Russo, Hartford
L. Elizabeth Schmoeger, Milwaukee
Margarethe Schultz, Great Neck
Jacob Z. Schuster, New York
Suzanne Schwarz, New York
Linda Seckelson and the staff of the
 Watson Library, Metropolitan Museum
 of Art, New York
Abigail G. Smith, Cambridge, MA
Anne Smith, Los Angeles
Cassandra Smith, San Francisco
Cristin Tierney, New York
Susan Turbeville, Richmond
Sarah H. Turner, Washington, D.C.
Wilfried Utermann, Dortmund
Stephen van Dyk and the staff of the
 Cooper-Hewitt Library, New York
Gordon VeneKlasen, New York
Caroline Weaver, Washington D.C.
Deborah S. Webb, Chicago
Wolfgang Wittrock, Düsseldorf
Catherine Wolcott, Cambridge, MA
Deborah Wythe, Brooklyn
Frederike Zeitelhofer, New York

Many thanks to all of them.

PREFACE

A museum for German and Austrian art has been a dream that I shared for many years with my friend, Serge Sabarsky. I first met Serge in the spring of 1967. My brother, Leonard, had purchased an Egon Schiele drawing at auction. Somebody whispered to him that what he had purchased was a fake, but that if he wanted to be sure, he should see an expert by the name of Serge Sabarsky.

Several days later I accompanied my brother to meet Serge. I was already very interested in the art of Egon Schiele and Gustav Klimt, and had purchased one work by each artist several years earlier. I will never forget entering Serge's apartment just off Riverside Drive that spring afternoon, and seeing in the hallway twelve Schiele drawings and watercolors. It was only after several minutes that I realized that Serge was talking to me. "You are reacting the same way I did when I saw my first Schieles," he said. Thus began a friendship that would last almost thirty years. We spoke for several hours that day and he told me he was going to open an art gallery the following year.

About six months later I received an invitation to the opening of the Serge Sabarsky Gallery at 987 Madison Avenue, just opposite two of my favorite institutions: Parke Bernet and Schrafft's Restaurant. The night of the opening I arrived early, filled with a great deal of excitement. Not only was I going to see several Schieles and Klimts for sale, but also a half dozen German Expressionist paintings Serge just purchased. I found myself standing in a corner of the gallery, looking at a self-portrait by Schiele. I asked Serge if there were any Schiele collectors in America. He said he knew of two. With that I answered, "You should also count me and my brother." He looked at me, smiled, and said, "I already counted both of you."

The Serge Sabarsky Gallery became my post-graduate course in Austrian and German Expressionism. I would call Serge nearly every day, and the conversations always included my asking him "Was gibt's Neues?" (What's new?) or Serge telling me about a new piece of art that he was offered or had just bought. On Sunday afternoons, when we both were in New York, we would spend hours reviewing all the work he had received the previous week. We would argue about the quality, and about what pieces he should sell and what should go into his collection or mine—and about whose collection was more important. Also, on those Sundays, I would listen as he told stories about Vienna in the 1930s and New York in the 1940s and '50s, and about the various people in the art world he knew.

We often discussed the dealers and collectors who figured prominently in this world, such as Roman Norbert Ketterer. I purchased my first Kandinsky watercolor from Roman in 1967. I remember how, several weeks after I had purchased the piece, my father received in a large manila envelope a sheet of paper with a lot of bright colored blotches and black lines all over it. I realized that this was my Kandinsky, and had I not been there when it was received, I don't know what would have happened to it. My father asked me what it cost, and I was embarrassed to tell him it cost $25,000. Or the gallery owner Leonard Hutton: Serge liked him, but always complained when Leonard got something that Serge felt he should have been offered. I purchased several great paintings from Leonard Hutton, especially Kandinsky's 1908 painting *Murnau—Street with Women* and Kirchner's wonderful *The Russian Dancer Mela*. There seemed to be no subject more fascinating to Serge than the continual disagreements between Otto Kallir of Galerie St. Etienne and

the collector Dr. Rudolf Leopold. I would listen and be transported to Vienna, with its particular mixture of intrigue and culture.

By the 1980s, the Serge Sabarsky Gallery had become extremely successful. Serge was at all the major art fairs and was constantly buying and selling art as he traveled through Europe. It was in 1981 that Renée Price joined the gallery. Her ability to organize the gallery's activities, as well as her great eye, allowed Serge to travel more and become even more successful. Although Serge did not trust many people, he trusted Renée and knew his gallery was in good hands with her.

In 1986, after spending three and a half years at the Pentagon, I became the United States Ambassador to Austria. During the time I was in Vienna, Serge and I spent a lot of time together looking at Austrian Expressionism. It was also during this time that I met Paul and Stefan Asenbaum, perhaps the greatest dealers in Austrian furniture and silver, and Christian Witt-Dörring, Curator of Decorative Arts at the Museum für angewandte Kunst. They have remained close friends and advisors. Perhaps the most poignant memory of my time in Vienna with Serge was when we celebrated his seventy-fifth birthday at the ambassador's residence. Many friends that Serge knew from the old days were there. At the end of the evening, all of them sang songs that had been popular in Vienna before the war. It was as if time had stood still.

When I returned from Vienna, Serge was starting to spend more time collecting, as well as putting on museum exhibitions of German and Austrian art. These exhibitions became his passion and his life's work. In 1990 we started talking about a home for his collection, as well as a place for him to put on exhibitions.

Everything we did together from that point on was always done with this in mind.

In November of 1993 we found the perfect building. It belonged to YIVO, an organization devoted to the study of Yiddish culture. As we walked through it, we both became almost giddy with excitement. On returning to his gallery he took out a pad of paper and started to lay out the spaces in the museum. Today, many of Serge's ideas have become central to the plans for the Neue Galerie.

On February 19, 1996, just a few days before he passed away, I had my last conversation with Serge in his hospital room. We had just purchased a Schiele self-portrait watercolor and were discussing where it would go in the museum. In the end he said simply, "That will have to be your decision. *Servus*."

This museum is about Serge's vision, about his love of art, and about our friendship.

Ronald S. Lauder
President, Neue Galerie New York
New York City
July 1, 2001

FOREWORD

We are frequently asked about the origin of the name of our newly opened museum. One can trace this name (which means "new gallery") to several nineteenth-century German institutions, among them the Neue Galerie Kassel, which opened in 1877. It has another important antecedent in Siegfried Bing's gallery founded in Paris in 1885, L' Art Nouveau. Neue Galerie New York, however, is closest in spirit to the Central European cultural milieu at the turn of the twentieth century. In this setting, the emphasis was everywhere on the new. In 1909, Egon Schiele and several colleagues banded together to form the Neukunstgruppe (New Art Group). Schiele also drafted an essay entitled "Neukünstler" (New Artist). That same year in Munich, Vasily Kandinsky, Alfred Kubin, and Alexej Jawlensky left the Munich Secession and formed the Neue Künstlervereinigung (New Artists Association).

Commercial art gallery names also reflected this tendency. Neue Kunst (New Art) was the name of Schiele's Munich gallery, opened by Hans Goltz. In 1923 Otto Kallir founded the Neue Galerie in Vienna, which held the first important posthumous Schiele exhibition. Kallir's gallery—the most similar to our museum among the Neue Galerie namesakes in terms of programming—also represented Oskar Kokoschka and Alfred Kubin, and showed the work of Gustav Klimt regularly. (Kallir later emigrated to New York, where he founded the Galerie St. Etienne, maintaining a lifelong commitment to the artists he had promoted in Vienna. His legacy has been continued superbly by his granddaughter Jane Kallir and his former associate Hildegard Bachert.) To round out the list of Neue Galeries, one should mention two Austrian museums established the following decade: the Neue Galerie Graz, which was founded in 1941, and the Neue Galerie der Stadt Linz, which opened in 1947 with a major exhibition of works by Kubin.

The name of our museum, then, indicates its dual allegiances: its embrace of both the city in which it is located and the Central European culture upon which its exhibitions and collections are based. In order to bring these two parts together, our inaugural catalogue traces the American reception of Austrian and German art in the twentieth century. Scholarship in this area has never before been so broadly undertaken, and I wish to acknowledge here the many distinguished authors for their invaluable contributions. I also extend a heartfelt thanks to our editors, Diana C. Stoll and Philomena Mariani.

Tracing the relationship between American and Germanic culture in the century just past is an important scholarly endeavor, one that is worthy of considerable further effort. One should note that, although some Americans maintained a strong interest in Germanic culture after the 1920s, the political events of the century's middle decades have, on the whole, seriously diminished that interest. It is one of the goals of Neue Galerie New York to bring a sense of perspective back to this area, and to make the best of this work available to American and other audiences for both scholarly and aesthetic inquiry.

With this in view, our catalogue includes biographies of twenty-six fine artists and eighteen decorative artists; each biography is headed with a reproduction of the invitation card to that artist's first solo exhibition in the United States (or, if no such show has taken place, the first group show to include the artist's work in the U.S.). We begin with a selection of fine arts from Austria, which is placed in historical context by Patrick Werkner's essay on the social and artistic climate of Vienna

circa 1900. We go on to include selected artist biographies, commencing with the Belgian artist George Minne, who exhibited at the Vienna Secession early on and exerted an undeniably strong influence on Oskar Kokoschka and Egon Schiele, among others. The first section concludes with Kokoschka, who can be considered a link to Germany and the subsequent artistic developments there. (Although Austrian by birth, Kokoschka first exhibited in Berlin in 1910, and frequently returned to that city and, later, to Dresden.) The German fine-art section begins with Wilhelm Lehmbruck and Lovis Corinth and continues with biographies of artists associated with the Brücke, the Blaue Reiter, the Neue Sachlichkeit, and the Bauhaus. The second part of the catalogue is dedicated to decorative arts from Austria and Germany. The Austrian section concentrates on the Viennese decorative arts from 1900, including Otto Wagner and Adolf Loos and artists working with the Wiener Werkstätte. The German chapter emphasizes the importance of Peter Behrens and the Bauhaus to twentieth-century design.

It should be noted that the selection of artists in this catalogue is based on those whose work is represented in the Neue Galerie collection, and is therefore not encyclopedic in scope. Although we recognize the importance of artists such as Otto Mueller, Alexej Jawlensky, Paula Modersohn-Becker, Käthe Kollwitz, and Ernst Barlach, they are not presented here. These and other artists may well be seen in future Neue Galerie catalogues, as the museum's collection continues to grow.

My own interest in this area began in earnest through my association with Serge Sabarsky. I first met Serge in 1977 when I was a student at Barnard College, having recently transferred from the University of Vienna. I was instantly disarmed by his mischievous sense of humor and his old-world Viennese charm. In the course of the seven years that I worked with Serge, I grew to admire his more serious character traits, especially his strong commitment to the art of early-twentieth-century Germany and Austria. Serge made this art come alive for me.

For the last fifteen years of his life, Serge worked to realize a small museum in New York devoted to the art he loved most. It has been an honor to participate in the creation of such an ambitious project. Gerwald Sonnberger, my esteemed, dear colleague from Austria, has accompanied me valiantly at every stage of the museum's development. I would like to express my personal thanks to him and to the many supportive friends and colleagues who have so generously shared their time and expertise. Most of all I am deeply indebted to the boundless trust, encouragement, and support of our co-founder and president, Ronald S. Lauder.

Renée Price
Director, Neue Galerie New York
New York City
June 8, 2001

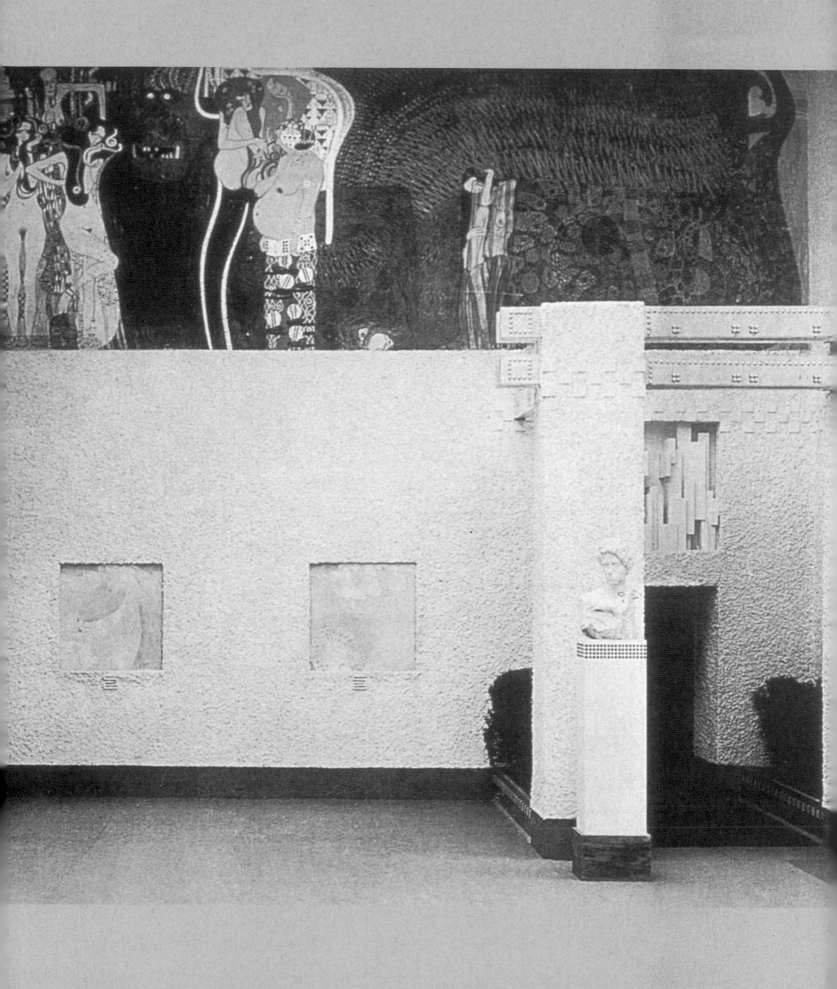

VIENNA CIRCA 1900

- GEORGE MINNE

- GUSTAV KLIMT

- ALFRED KUBIN

- RICHARD GERSTL

- EGON SCHIELE

- OSKAR KOKOSCHKA

Fourteenth exhibition of the Vienna Secession, 1902

MODERNISM IN VIENNA

PATRICK WERKNER

THE CULTURAL ENVIRONMENT OF VIENNA IN 1900

At the turn of the century Vienna was the capital of a great European empire, the historic territory of which lay in Central Europe, and whose crown lands reached far into the east and southeast of Europe. In addition, it had for centuries profited from cultural exchange with countries as diverse as Italy, the Netherlands, and Spain and its American colonies. Through a complex network of marriages motivated by political or diplomatic advantage, the Hapsburgs, whose own line could be traced back to the twelfth century, were by this time connected with all the European dynasties. From the fifteenth to the nineteenth century, they had regularly been elected to the office of Emperor of the Holy Roman Empire, a title that implied a claim to be the protectors and nominal rulers of Catholic Christendom, as well as the heirs of the Western Roman Empire. Only with the establishment of a new order in Europe by Napoleon were the Hapsburgs forced to restyle themselves more modestly as "Emperors of Austria."

Vienna was the metropolis of this empire, a city that had experienced rapid population growth for decades. It was the historical, political, economic, and cultural capital, the center of power, of the media (in 1900, no fewer than fifty newspapers were published in Vienna), and of fashion. Emperor Franz Joseph ruled from the vast complex of the Hofburg, the fortified imperial residence that had been extended and enlarged over the course of six centuries. He had come to the throne at the age of eighteen in the wake of the failed bourgeois revolution of 1848; by the end of the nineteenth century, he had become the aged embodiment of the Catholic Empire, both a symbolic figurehead and an obsessively bureaucratic ruler, who guided the destiny of the dual monarchy of Austria-Hungary up to his death during World War I. It was in the cultural context of Franz Joseph's imperial Vienna that modernism developed; without such a context, its distinctively Austrian features would have been impossible.

In 1857, the emperor had decided to have the ramparts of Vienna demolished. The ring road constructed in place of the city walls and the *Glacis* (military exercise grounds) was to become a magnificent boulevard along which administrative and cultural institutions were successively erected—among them the parliament, the city hall, the university, the opera, the court theater, and two massive museums for art history and natural history, which faced each other across a square laid out in the formal tradition of Baroque. Thus began the so-called Ringstrassen era.

The founding of the Kunstgewerbeschule (then known as the Imperial and Royal School of Applied Arts) took place by imperial decree in 1867, shortly after that of the Museum für Kunst und Industrie (the Museum of Art and Industry, today's Museum für angewandte Kunst, or MAK). The latter was a conscious reaction to recent developments in European applied art, above all to those in England. Both institutions, whose buildings arose on the Ringstrasse, prepared the way for modern applied arts in Vienna. The Kunstgewerbeschule (today's University of Applied Arts) became the cradle of Viennese Jugendstil: it was here that Gustav Klimt was trained, and the founders of the Wiener Werkstätte, Josef Hoffmann and Koloman Moser, taught at the turn of the century. Here also polymaths like Bertold Löffler were subsequently to inspire the young Oskar Kokoschka. It was a focal point for aspiring artists and succeeded in creating a con-

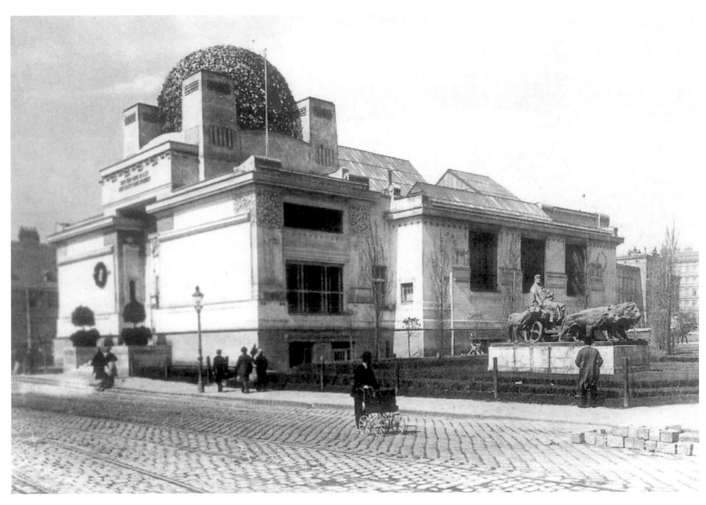

The Vienna Secession, built by Joseph Maria Olbrich in 1898, ca. 1901–02

siderable pool of talent. At the same time, the symbolic and ritualistic elements in which the Hapsburg Empire was so rich also had a pronounced effect on Viennese modernism. As far as cultural institutions were concerned, modernism was by no means opposed to the monarchy in its aesthetic character. This was evident both from the public spaces and the private sphere in which the spirit of modernism became manifest, for instance, along the Ringstrasse or in the fashionable cafés. Indeed, the Secession building itself was located only a stone's throw from the Akademie der bildenden Künste (Academy of Fine Arts). The most dramatic breakthrough for architectural modernism in Vienna's public space may be dated to 1894, when construction began on an entire network of stations, bridges, viaducts,

and ancillary buildings of the Stadtbahn. The artistic director of the Stadtbahn project, Otto Wagner, took care to make them as aesthetically pleasing as they were functionally appropriate.

From all the Austrian provinces and crown lands with their fifty-four million inhabitants, immigrants streamed to Vienna throughout the Ringstrassen era. Anyone aiming at economic or social advancement, or who wanted to make a significant contribution to culture, was attracted to Vienna. The cultural diversity of the city at this time was not only apparent from the multitude of languages of the monarchy—German, Czech, Slovak, Slovene, Polish, Italian, Romanian—but also from the ethnic peculiarities, regional cuisine, and social nuances that the immigrants brought with them. Without this cultural multifariousness,

the Vienna of Viennese modernism is unthinkable. A high percentage of immigrants were of Jewish origin, and many of these chose the path of assimilation. The liberal upper class of Vienna, with its many prominent Jewish families, provided one of the prerequisites for aesthetic renewal, since it supplied the economic base for artistic patronage. The most celebrated

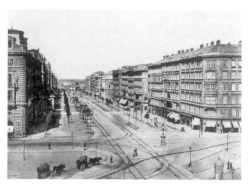

View of Schottenring, Vienna, ca. 1900

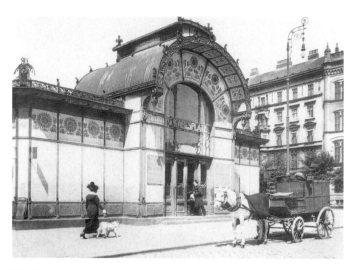

Otto Wagner, Karlsplatz subway station, Vienna, 1898

example of such patronage is the donation by the industrialist Karl Wittgenstein (father of the philosopher Ludwig), which made possible the building of the Secession in 1898. The emperor was pledged to uphold the legal and social equality of Jews, which his great-great-granduncle, Joseph II, had introduced with his Tolerance Patent of 1781–82. Franz Joseph, whose many titles included that of "Apostolic Majesty, the King of Jerusalem," was a firm protector of the Jews. By the same token, the Jews considered themselves loyal subjects of the emperor and Austrian patriots. In contrast, the populist mayor of Vienna, Karl Lueger, was notorious for his anti-Semitic statements and policies. It is one of the ironies of Vienna at that time that Georg Ritter von Schönerer propagated his deluded racial doctrines in the same city where Theodor Herzl was to develop his vision of a Jewish nation-state.

With the founding of the Secession and the close of the era of Historicism, which had offered the imperial family an ideal artistic ambience in which to propagate their dynastic vision of history, the Hapsburgs ceased to play a significant role in the patronage of the arts. The emperor had anyway always been extremely cautious in his pronouncements on art, but the same could not be said of his nephew and heir apparent, the reac-

tionary Archduke Franz Ferdinand, who was notorious for his sarcastic observations. Characteristically, it was he who managed to prevent Gustav Klimt from being appointed professor at the Akademie. Nevertheless, although Viennese modernism developed in the context of the institutional structures of the old monarchy, it soon managed to escape their confining embrace.

A TYPOLOGY OF VIENNESE MODERNISM

"Modern" and "modernism" are complex labels that are hard to encapsulate in concise definitions. For that reason, it is worth highlighting certain specific features of Viennese culture at this time. What unites the representatives of modernism in Vienna in art, music, and literature is their self-conscious distancing of themselves from the representational art of the nineteenth century. In place of an art oriented to historical styles and their refinement or imitation, these figures offered new forms and new content, which are nevertheless too heterogeneous to be subsumed under one descriptive formula. For example, in the field of architecture, there are strongly defined differences in the approach of an Adolf Loos or a Josef Hoffmann—that is, between the protagonist of a purist aesthetic regarding materials and function on the one hand, and, on the other, an artist who liked to fill out the available artistic field with luxuriant decoration. When Loos linked "ornament" to "crime" in what was to become a celebrated essay of 1908–10, he surely had in mind his rival Hoffmann, who came (like Loos) from Moravia and was born in the same year (there were only five days between them), and more especially had achieved much greater success in Vienna than Loos. Hoffmann was a professor at the Kunstgewerbeschule, co-founder of the Wiener Werkstätte, a sought-after architect for the noble villas of the bourgeoisie, the instigator of major exhibitions, and much more.

The Secession was founded in 1897; its first elected executive president was Klimt. It was clear from the very name chosen for

this association of artists that it was concerned with the abandonment of an old form of art as well as with "secession" from an anachronistic organization. The term *Secessionskunst* (Secession art) is normally a synonym for Wiener Jugendstil (although the organization itself, having long outlived Jugendstil, is still in existence today). The label "Wiener Werkstätte" signified the creation of the "Production Association of Applied Artists in Vienna" founded in 1903, which operated according to a system worked out by Hoffmann and Moser. Jugendstil, Secession, and Wiener Werkstätte are therefore concepts that partly overlap.

The thread that unites the artists of these various ilks is generally their rejection of the Ringstrassen era's pretentious art of historical display (known as "Historicism"), which was discarded on the grounds of its sometimes slavish imitation of the styles of earlier epochs and increasing lack of individual flair. The preference for new forms of expression, even when these were not yet clearly defined, represented a conscious attempt to offer an alternative to this form of art. As far as painting was concerned, the main foundation for the Secession was supplied by the achievements of the Post-Impressionists, whose works had created a stir at the Secession exhibitions and had been ecstatically received by influential critics such as Ludwig Hevesi. The work of Giovanni Segantini, Vincent van Gogh, and Paul Gauguin, the monumental paintings of Ferdinand Hodler, the sculptures of Max Klinger and Auguste Rodin were thus the important reference points for Viennese modernism. In addition, there was a particularly strong association with European fin-de-siècle Symbolism, specifically with Jan Toorop and Fernand Khnopff, the sculptures of George Minne (which were influential for Viennese painters), and generally with the symbolic painting of the late nineteenth century. It may, however, reasonably be objected that Richard Gerstl does not fit into this picture, a reminder of how precarious are all generalizations about an art that was so often sui generis.

The enthusiasm for "idea painting," laden with symbolic content, was particularly marked in Vienna. Introspective subjectivity is characteristic of many works of around 1900 and remained a dominant element in the later Expressionist works. In this respect, the Vienna schools are to be distinguished from those with an orientation toward technical modernity and an enthusiasm for the dynamism of big cities—found, for example, in Italian Futurism, or in French Fauvism with its ecstatic reveling in color. In the work of Klimt, Schiele, and Kokoschka, there is a tendency toward mysticism that should not, however, be interpreted in strictly religious terms, but more as a revelation of the immanent in the context of personal experience or psychological distress.

As far as aesthetic refinement is concerned, the painters of Viennese modernism remained in close contact with the applied arts of the city, which had reached a high point in 1900. The

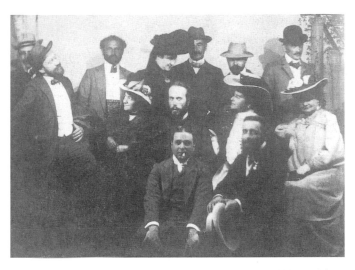

Group portrait taken at the time of the Secession's founding, ca. 1898. At left (in hat and carrying walking stick), Carl Moll; at far left (behind Moll) Josef Hoffmann; third from left (standing, without hat) Gustav Klimt; center (standing, in dark hat) Alfred Roller; center (seated, with beard) Fritz Waerndorfer; at far right (standing, in bowler hat) Koloman Moser

painterly refinement of Klimt is the corollary of the extremely cultivated production of the Wiener Werkstätte. Kokoschka and Schiele are also rooted in the applied arts, so characteristic of the aestheticism of Vienna in 1900. Even after their breakthrough into Expressionism, they are not cut off from this culture and remain in thrall to the beauty of ornament, despite the very different type of *sujet* now treated.

Characteristic for Vienna also are the interdisciplinary connections between the arts. Traditionally, music and musical theater had occupied pride of place in the arts in the city ever since the Baroque era; in the art of the Secession, however, the idea of the *Gesamtkunstwerk* (unified or total work of art) was the new ideal. *Gesamtkunstwerk* may be understood as the application of all the arts to a common aim, as for example in the 1906 Palais Stoclet in Brussels. Here, the Secessionists worked together with artists of the Wiener Werkstätte in order to ensure that even the smallest detail of the decoration was aesthetically refined and harmonious with the whole.

Even before this, the Secession had set itself the task of creating its own *Gesamtkunstwerk* when it organized the *Beethoven*

exhibition in 1902 in the Secession building. Music (in a piece by Beethoven arranged by Mahler for the opening ceremony), sculpture (Max Klinger's Beethoven monument), painting (Klimt's no less monumental *Beethovenfries [Beethoven Frieze]*), and the applied arts were all combined to honor the great composer in particular and the spirit of artistic genius in

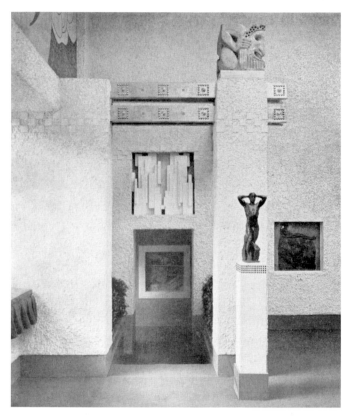

Installation view of the *Beethoven* exhibition, fourteenth exhibition of the Vienna Secession, 1902, showing side room with Josef Hoffmann's relief over the entryway

general. This celebration of creative genius was thus organized as a quasi-religious festival, and the Secession building was transformed into a kind of sanctuary. Its focus, as it were, the cult object, was Klinger's monument to the composer, while the two flanking spaces recalled the side-aisles of a basilica. The thirty-three-meter-long *Beethovenfries* represented the idea of salvation through art, influenced by a Wagnerian interpretation of Beethoven's contribution to the arts and to humanity. The fundamental message of Klimt's frieze is that the suffering of man will be healed through the power of poetry and art.

The supraportal relief that Hoffmann contributed to the exhibition is one of the earliest examples of abstraction in Austrian art. The show thus united an avant-garde aesthetic based on

form with one that was still indebted to Symbolism. At the same time, this Beethoven *Gesamtkunstwerk* displayed much of the wealth of ritualistic and religious symbolism drawn from the culturally rich Hapsburg Empire. It may not even be exaggerated to see in the *Beethoven* exhibition a secularized Catholic rite: Klinger and Klimt as the high priests, supported by Mahler and Secession artists who celebrated the cult of the titanic and solitary artistic genius. This genius sacrificed himself for his art: by bestowing his work on mankind, he cleared the way for reconciliation and enlightenment (the last scene of Klimt's frieze represents the heavenly chorus of Beethoven's Ninth Symphony). The other line of spiritual and intellectual inspiration that plays a role here recalls the sacral elements of a Greek temple, overlaid by German Romanticism and the nineteenth-century reception of antiquity by way of Friedrich Nietzsche and Hugo von Hofmannsthal. That the Secession itself should be a temple of art was a metaphor already current at the time it was built. The (no longer surviving) bearers of wreaths depicted by Moser in a frieze on the building's facade may be interpreted as the temple acolytes.

Nevertheless, many among the public were dismayed by the form of this secular celebration, and especially by Klimt's frieze. Its middle section representing the "evil powers" was the main focus of criticism. Klimt's depiction of "Sickness, Madness, Death, Lust, Promiscuousness, and Excess" (this was the catalogue description of the frieze), in the extraordinarily realistic form chosen by the painter, broke with all the conventions of beauty and harmony. The introduction of ugliness and sickness, the uncosmeticized presentation of the dark and threatening side of life, caused such a critical uproar that the writer Hermann Bahr was able to collect an entire anthology on the controversy, published in 1903 under the title *Gegen Klimt* (Against Klimt). But Klimt was not the only artist in the *Beethoven* exhibition to be attacked: Klinger's sculpture was lampooned in the press—indeed, the exaggerated pathos of his work was an easy target for ironic mockery. And Mahler himself was caricatured, Beethoven's ghost shown returning to protest at Mahler's wind(y) adaptation of the "Ode to Joy" and abusing him as a "desecrator of the Ninth Symphony." Of course, parody and satire were deeply embedded in Viennese culture, which had developed a philosophy of life based on an acute sense of moral ambivalence. From the gentle irony of Peter Altenberg to the biting satire of Karl Kraus, Vienna ran the whole gamut of ironic dissidence. Both writers belonged to the inner circles of intellectuals and artists who regarded themselves as "modern."

The anecdotes that Loos related of his friend Altenberg were legion. When Gustav Jagerspacher made a caricature of the poet, Altenberg wrote an epigram under it, in his inimitable English: "Are we not all Karikatures from the truly and ideal wishes which god and nature hade [sic] with our souls and bodies?"

In such an environment, anything presented with pathos or with pretentiousness was bound to attract the antidote of irony. In the case of an all-rounder in the field of applied arts like Bertold Löffler, irony became a recurrent stylistic device. Likewise, satire had a place of honor in the world of Viennese modernism. The most prominent establishment, Cabaret Fledermaus, was conceived in the Wiener Werkstätte (by Hoffmann and others) as a kind of *Gesamtkunstwerk*. It did indeed represent an opposite pole to the sacred aura of the *Beethoven* exhibition. Subsequently the exaggeration of character features became a stylistic device adopted by Expressionism, albeit without its comic elements. To that extent, at least, there is a continuing line of association between the caricatures of Jugendstil and the grimacing features painted by Egon Schiele.

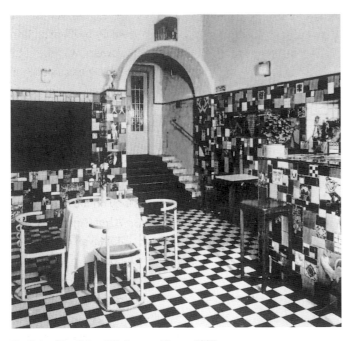

Vestibule of the Cabaret Fledermaus, Vienna, 1907

Polarity and ambivalence are integral to Viennese modernism. The combination effects of different art disciplines, whether programmatic in *Gesamtkunstwerk* projects, or simply in the free exercise of diverse talents, encouraged a blurring of the boundaries between artistic fields.

PAINTING AND GRAPHIC ART

Gustav Klimt was a key figure in the renewal of Austrian painting around 1900, both as an artist and through his personal influence as president of the Secession. His work is today regarded as representing the high point of Viennese Jugendstil, although its significance extends far beyond the artistic parameters of Jugendstil itself. It was Klimt who first successfully made the transition from the representative art of Historicism to one based on Symbolism and Post-Impressionism, in which the crisis of the individual was manifest. The heavily "psychological" portraits and physical features of the works created by the generation that succeeded Klimt would have been impossible without his work. His early supporters in the 1880s and the early 1890s saw in him a painter who brought the pompous Ringstrassen art of Hans Makart to the highest pitch of refinement and sensitivity. These admirers could still follow Klimt into the world of Jugendstil; however, as he began to combine dark and pessimistic symbolism with Jugendstil elements, the links to the positivistic Historicism in which he had been schooled disappeared entirely from his work.

Even before the founding of the Secession, Klimt accepted a commission for painting the ceilings of the aula of the newly built university on the Ringstrasse. The public and the university professors both expected him to produce a bravura celebration of science and knowledge, not least because he had already painted appropriately celebratory works to decorate the Burgtheater and the Kunsthistorisches Museum. However, *Philosophie (Philosophy;* 1900), the first work of this commission to be completed, provoked a vicious press campaign against the artist, as well as being the object of professorial protests, ministerial intervention, and ultimately questions in parliament. Klimt had dared to represent Philosophy as a mystical and pessimistic form of consciousness. The second picture, *Medizin (Medicine;* 1901), similarly rejected a positivist allegorical approach and met with equal disapproval from the university's faculty. Klimt's commission was finally withdrawn and the pictures were never erected in the university; they subsequently perished by fire during World War II.

Klimt's 1901 painting *Judith I* is a major work of Viennese Jugendstil, and a fine example of his erotic art. It shows a young, extravagantly made-up woman. Her seminudity is handled with great sophistication, and she is placed frontally to the viewer, whom she seems to regard through half-open lids. She is absently stroking the head of a man who appears in the lower part of the picture. Although the title and inscription on the gold

frame identify the figures as Judith and Holofernes, this dangerous beauty is quite evidently a lady of contemporary Vienna, recalling other elegant portraits of the Viennese upper class. Indeed, the picture bears no historical or thematic relationship to the biblical event. The background is flat, and Judith is elevated plastically in front of it; her jewelry is archaic in style, but obviously of modern production, while her dress recalls the fine material later to be the hallmark of the Wiener Werkstätte. Her hairstyle reflects the Japanese fashion popular in Vienna around 1900.

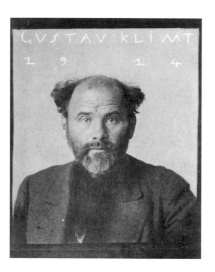

Gustav Klimt, 1914 (photograph by Anton Josef Trčka)

Klimt's *Judith* is a true femme fatale, a theme that was greatly in vogue at the turn of the century. The desired and desirable man-killing female (in the case of Judith, this is more than a mere pictorial conceit) evoked both lust and fear. Nevertheless, the murder of Holofernes could hardly be presented in more sublimated form than this, for there is no trace in the picture of blood or of violence. Judith has been disarmed, as it were, for although she certainly murders, it is only a symbolic murder. The equation of death and sexuality, which provided an agreeable frisson for a whole generation of readers of fin-de-siècle literature, is here fixed in a manner that was ideally suited to the "liberal" taste around 1900.

The current popularity of the picture, which is one of the most reproduced icons of Viennese Jugendstil, also demonstrates the strength of the Klimtian affinity with contemporary images. Indeed, its manner of presentation anticipates a certain soft-porn aesthetic of today, in which translucent, gold-ornamented material and glimmering jewelry accentuate areas of bare flesh. The preciousness of the materials exalts the exquisiteness of the body, whose ornamentation in turn melts sensuously into

decorative flesh. The veiled and unveiled areas seem at first sight to be randomly distributed and mingled; but on closer inspection they are revealed as creating a carefully calculated tension.

Klimt's pictorial world unfolds between a sensual celebration of life on the one hand, and a profound melancholy on the other. As we shall explore further, his impact on Kokoschka and

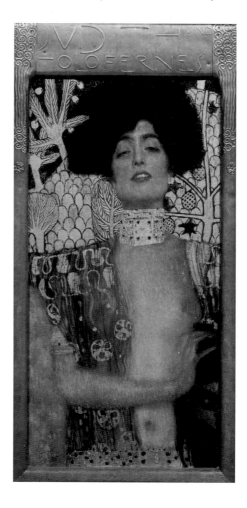

Gustav Klimt, *Judith I*, 1901. Österreichische Galerie Belvedere, Vienna

Schiele demonstrates a remarkable continuity in Viennese modernism. However, in any discussion of the post-Historicist generation, priority must be given to another artist, the reception of whose works appears all the more bizarre, insofar as he remained completely unknown during the lifetimes of Klimt and Schiele.

The tragedy of Richard Gerstl was made complete when, at the age of twenty-five, filled with despair at his artistic isolation and failure in love with Mathilde Schönberg (wife of Arnold Schönberg), he committed suicide. In this short life, he had never had an exhibition of his works. His pictures, some of which were

born out of the turmoil he was experiencing before his death in 1908, were first rescued from oblivion in 1931 when they were retrieved from a warehouse, only to be banned from exhibition in Austria and Germany shortly thereafter, at the time when modern art was being denounced as "degenerate." Although hardly more than seventy oil paintings and seven drawings have survived, these are sufficient to earn him a place with Klimt, Schiele, and Kokoschka among the most important exponents of early modernism in Austrian painting.

As an artist, Gerstl went his own way, although he certainly learned from Edvard Munch and van Gogh, while the Impressionists' handling of light and color also made a great impact on him. At the international art exhibitions staged by the Secession in their gallery, he first encountered Impressionist and Post-Impressionist paintings. His early pictures reveal an artist grappling with the technique of Pointillism, which had been introduced to Vienna via the "Divisionism" of Giovanni Segantini. The latter's work was well-received: a fine painting by Segantini, *Die bösen Mütter (The Evil Mothers;* 1894), was acquired at the instigation of the Secession for the state's Neue Galerie. This, it is worth noting, occurred at a time when Paul Signac was being stigmatized by Hevesi as "talentless." Gerstl practiced the technique of dissecting color on canvas, but broke out of a constraining artistic methodology to achieve a more lively formal approach. In his work, beside the dotted painting and more surface-oriented pictures (recalling the work of Edouard Vuillard and Pierre Bonnard), there is also a clear tendency to naturalism. The majority of Gerstl's work was created between 1904 and 1908 and was ignored, basically on account of its eschewing the decorative elements that were dominant in turn-of-the-century Viennese art. The playful and rather self-conscious elements that were so typical of Viennese Jugendstil were relegated to the background of Gerstl's work. What was important for him was the artist's subjective perception, and he adopted a highly suggestive use of color to achieve this. His work is distinguished from that of many Secession artists, but also from that of Schiele and Kokoschka, in that symbolism and literary reference are entirely absent. Portraits, landscapes, and town scenes were his preferred subject matter, and he heightened the optical experience of Impressionism to produce paintings filled with light and emotion. Gerstl developed this approach even more strongly in the form of stylized gesture, which was more and more distanced from the object being painted, and within a few years he had taken the process to the very border of autonomous painting. The energy radiated by these pictures recalls the art of Abstract Expressionism, and when Gerstl's work was rediscovered in the 1950s, it was precisely this element that seemed so sensational.

A painting such as Gerstl's *Selbstbildnis, lachend (Self-Portrait, Laughing;* 1908) may be seen as the painter's cynical settling of accounts with himself and the world. His head, with its cropped hair and sparse beard, appears ghostly, as if lit from below. The bitter laugh, with the wrenched-open mouth, twists his features into a grimace. The long neck emerges from a collarless, open-necked shirt, encompassed by a jacket hanging from the shoulders. When we think of the aesthetic portraits of Klimt, which were painted during Gerstl's lifetime, the latter's self-portrait seems to be a statement of rejection, extremely radical in its uncosmeticized presentation of the self. It is an antithesis of the beautification of the world that lay at the heart of the Vienna Secession's program.

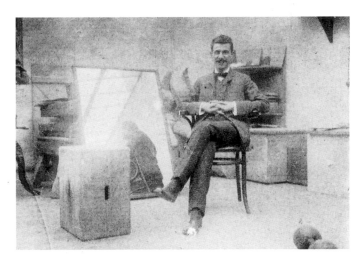

Richard Gerstl in his studio, ca. 1907–08

The only painter upon whom Gerstl may be said to have had some influence in his lifetime was just as unsuccessful as he was—his paintings, like Gerstl's, were esteemed widely only much later. Arnold Schönberg had begun painting in 1906 and taken instruction from Gerstl; despite this, there is hardly any evidence of Gerstl's stylistic influence on the work of the composer, who was nine years his senior. (In any case, after Gerstl's affair with Schönberg's first wife, the composer denied any influence from the younger painter on his work.)

Among Schönberg's paintings are somewhat clumsy portraits and occasional landscapes that fail to live up to their obviously naturalistic aspirations. What is fundamental to his œuvre are his highly expressive visionary figures. Schönberg himself char-

acterized them as *Blicke (Looks)*, and indeed, they are faces that have nothing to do with portraits. Their emphasis is on the eyes, which are accentuated in a ghostly way, suggesting that several of these paintings are the expression of extreme spiritual passion.

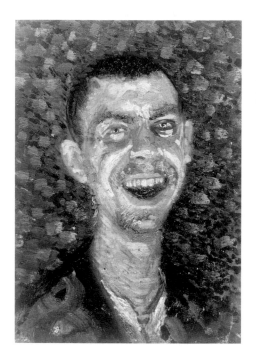

Richard Gerstl, *Selbstbildnis, lachend (Self-Portrait, Laughing)*, 1908. Österreichische Galerie Belvedere, Vienna

In 1910, Schönberg's paintings were exhibited for the first time in Vienna, where they met with the same contemptuous reaction that his music had already encountered. Of the exhibition opening, which was accompanied by some of Schönberg's chamber music, a newspaper critic wrote: "This music suits the pictures wonderfully: yesterday, both were truly repellent, the music to the ears and the pictures to the eyes." A portrait such as that of his wife Mathilde could only excite mockery in the Vienna of Klimt's elegant celebrations of the female of the species. It offered none of the prized refinement of Klimt's painting, his sensitive handling of paint, and the charm of a still flattering approach to womankind. In the following year, Schönberg's friendship with Vasily Kandinsky enabled him to take part in the Blaue Reiter exhibition in Munich. But among this German group of artists, too (with the exception of Kandinsky), the reaction to his work was once again extremely negative. In 1912, Schönberg largely abandoned painting, except for occasional subsequent works.

At the same time that Schönberg was beginning work on his musical drama *Die glückliche Hand (The Lucky Hand,* op. 18),

which combined music, drama, and creative lighting effects, Oskar Kokoschka's drama *Mörder, Hoffnung der Frauen (Murderer, Hope of Women)* premiered in Vienna. Unlike Gerstl and Schönberg, Kokoschka enjoyed success while still a young artist, at a time when he was regarded as a very promising protagonist of the Jugendstil aesthetic. His series of lithographs *Die träumenden Knaben (The Dreaming Youths),* which he published in 1908 and dedicated "with reverence" to Klimt, is a fine example of his pictorial dreamscapes at that time. Naked boys and girls, presented in crouching poses and with idiosyncratic configurations of limbs, bear witness to a naturalism that is already in command of gesture and movement. The influence of the gaunt sculptures of youths by Minne, and of the statuelike compositions by Hodler, is unmistakable. Above all, however, the impact of Klimt's work is evident, particularly in the treatment of nudity. At the same time, in one of Kokoschka's finest early works—a poster he designed in honor of Emperor Franz Joseph's sixtieth jubilee—it is clear that the artist was already distancing himself from the decorative flatness of Jugendstil and introducing a new form of stylization. Unfortunately,

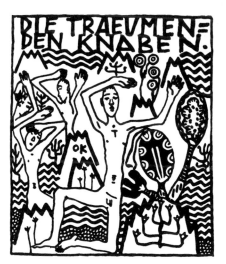

Oskar Kokoschka, title-page vignette of *Die träumenden Knaben (The Dreaming Youths),* Vienna, 1908

because of the subjective nature of his poster's symbolism, there was no chance of it being accepted for the ceremonies. Kokoschka's portraits of 1909 are among the most powerful works of Austrian twentieth-century art. In rapid succession, he created a series of portraits for members of Vienna's circle of artists, literati, and intellectuals, and also for the Viennese bourgeoisie, and continued the series soon thereafter in Berlin. Kokoschka himself wrote of his intention to "create a portrait of nerves out of control." His paintings in this vein are marked by

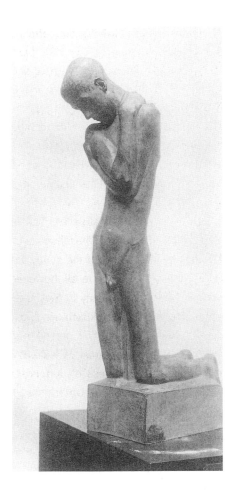

George Minne,
Kneeling Youth, 1898.
Museum voor Schone
Kunsten, Ghent

where he made a major contribution to Expressionism—and later in Prague, London, and Switzerland.

In the so-called opaque phase of Kokoschka's painting, around 1911–12, the subjects appear to be seen through mottled glass. It is in these examples of his early work that certain affinities with Cubism and Futurism may be discerned in the treatment of space and form. These are most apparent in the netlike structure that permeates some pictures, and in the light, which appears as skeins of color. However, the fundamental changes in Kokoschka's work at this point are most apparent in his choice of subject matter. He now began to be drawn to religious motifs, with an increasing dependence on the traditions of Christian iconography.

By 1913, the treatment of the human body in his portraits was already much more plastic than it had been; likewise, in his

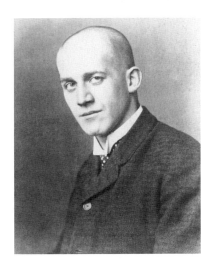

Oskar Kokoschka, 1909

broken colors and forms, which show actual nerves on the exterior of the sitters' skin. Kokoschka thus makes the face and hands into a mirror of the spiritual and emotional life of his subject. Most of the subjects are depicted as considerably older than they actually were, and often with wounds that (at least externally and visibly) they did not possess. As a result, several of his sitters were so outraged that they refused to accept their pictures. A number of commissions were obtained with the help of Loos, who was Kokoschka's protector and mentor around 1910, and who introduced him to his own clients. Loos (who was himself one of Kokoschka's subjects) offered himself as purchaser of last resort in the event that a portrait was unacceptable—with the result that he soon accumulated a substantial collection of Kokoschka's portraits!

Kokoschka left Vienna quite early on, a city to which he was to remain long bound by ambivalent feelings of love and hatred; he settled in Germany and became one of the most important artists of the Sturm circle in Berlin, which centered on the journal of the same name edited by Herwarth Walden. Kokoschka's further artistic development took place mostly in Germany—

landscapes the massively powerful Alpine scenery began to exercise a bulky presence. The psyche of his models was still the prime focus of Kokoschka's interest, but the fragility, brittleness, and decadence that had characterized the first phase of his portraiture now gave way to a new sense of structure; his sitters now seem to be less anxious, no longer in a state of crisis. This progression in his portraits reveals a transformation from the horror of mankind on the brink to a humanistic worldview, which nonetheless continues to feature the lineaments of tragedy. Among many journeys undertaken by the artist around this time, a trip to Italy brought him into contact with Venetian painting, in particular with Tintoretto, an encounter that was to have a visible effect on his subsequent works.

In 1916, following the end of a dramatic love affair with Gustav Mahler's widow Alma, and in the wake of traumatic experiences

in World War I (in which he was wounded), Kokoschka went to Dresden to convalesce. There, he painted important portraits and symbolic works (for example *Die Freunde [The Friends; 1917–18]*), enjoyed a degree of critical recognition, and generally consolidated his reputation. When he was appointed pro-

Oskar Kokoschka, *Die Freunde (The Friends),* 1917–18. Galerie der Stadt Linz

fessor at the respected Dresden art academy in 1919, his future career seemed destined to follow a more tranquil path. Tranquility, however, was not in his character: Kokoschka soon became restless and opted for the demanding life of the wandering artist. The fruits of these journeying years, which took him through the whole of Europe and to the Mediterranean, are a panorama of landscapes, cityscapes, and depictions of humanity. Kokoschka became a cosmopolitan; more importantly, as a consequence of the fatal political developments of the time, he became an artist who, in word and image, was committed to the defense of humanism.

Like Kokoschka, Egon Schiele was a child of Jugendstil who abandoned its cult of fragile beauty in 1909. Nevertheless, this transformation was, in Schiele's case, initially somewhat restrained. His flowers and trees, nudes and portraits were conceived in angular contours—as if they would no longer feel at ease in the beauteous wavelike ambience of the earlier works. In place of the representative elegance, which his original depictions of humanity had manifested under the influence of Klimt, a new and more raw characterization entered into the work. Schiele now became principally concerned with evoking his sitters through the devices of mimetic art and gesture. Drawing, a medium that he had made his own, formed the controlling basis of his painting. Schiele's watercolors and paintings

are indeed considerably less *painterly* in execution than is Kokoschka's work, and far less so than Gerstl's. In Schiele's painting, the figure is no longer primarily brought to life by means of color, but by exploitation of pose, contours, and a painstakingly achieved configuration.

Schiele's preferred subject matter was himself. In an almost manic way, he explored and exploited possible variations in self-depiction. In the course of this voyage of self-discovery, he visited all the ugly and "pathological" aspects of humanity, and (particularly in his graphic works) revisited every personal ordeal. More often than not, a crouching, tensed, or springing body in a picture would form the counterpart to a grimace, a cry of anguish, a distorted visage. The occasionally heightened coloring emphasized the distension or foreshortening of a body. Of course, Schiele's self-depictions were an unrepentant reflection of his considerable narcissism. However, especially after his arrest and persecution in 1912 for "outraging public decency" with his erotic drawings, this innate narcissism became allied to a sense of his own martyrdom. The latter pose took its most public and provocative form when he advertised his exhibition at the Arnot Gallery in Vienna with a poster representing himself as Saint Sebastian.

At a time when Schiele was rediscovering bodily gesture as an atavistic form of communication, Vienna was in the thrall of the modern dance of Ruth Saint Denis, Mata Hari, and Grete

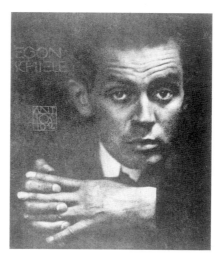

Egon Schiele, 1914 (photograph by Anton Josef Trčka)

Wiesenthal, who performed before an enthusiastic public in the Secession building and elsewhere. Indeed, the expressive power of the human body, which lies at the heart of Schiele's art, is especially relevant today in view of the importance that it also holds for contemporary artists. Its manifestation in

Schiele's work to some extent anticipates questions that would come to be explored later: of personal identity, of the role of the sexes, and of "pathological" behavior. The series of posed photographs that Schiele made with his friend Josef Trčka bear an obvious relation to today's self-depiction by artists using the medium of photography. Schiele's capacity for self-expression even extended to poetry, and some of his poems appeared between 1914 and 1916 in the Berlin Expressionist journal *Die Aktion*, edited by Franz Pfemfert.

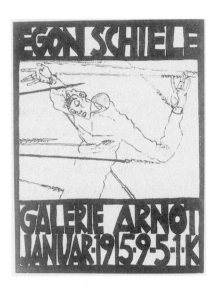

Egon Schiele, poster for his exhibition at the Galerie Arnot, 1915

Schiele's Expressionist art inhabits a world of tension dominated by Eros and Thanatos, while his motto, "Try to experience everything," frequently led him into taboo areas. As with Klimt, there is an abundance of drawings and watercolors with erotic themes in his œuvre. Schiele's interpretations of these themes, however, are mostly quite different from the generally soft, sensual, and introspectively posed nudity of Klimt's models. The gaunt, bony, and long-limbed girls of Schiele's nudes and half-nudes are unpredictable, demonic beings, but also suffering and abused creatures. Schiele's treatment of the nude and of sexuality is far removed from the vital and primitive nakedness that may be encountered, for instance, in the paintings of the Brücke group in Dresden. Indeed the Brücke artists strove to represent a pristine notion of natural sex that stands in sharp contrast to the problematic and tragic concept of sexuality manifest in Schiele's work.

Around 1912, the eruptive first phase of Schiele's artistic vision was transmuted into a more soothing presentation of man and the world. The paintings are no longer as threatening and nightmarish as his earlier work, and the symbolically laden pictures no longer appear as a terrible expression of despair. In the course of this development, Schiele softens the demonization of the nude and the former harshness in the presentation of nudity. *Die Umarmung (The Embrace)*, painted in 1917, shows a pair of lovers in an exalted, timeless scene. This embrace is not presented in the context of darkness and threatened death, as might have been the case in one of Schiele's paintings of a few years earlier. This work, which may be seen as an Expressionist pendant to Klimt's *Der Kuss (The Kiss)*, painted nine years earlier, is one of the most beautiful visual representations of love in Austrian painting.

Schiele's portraits, too, now began to exhibit a lyrical tendency. At the same time, his graphic works became more naturalistic, the portraits particularly showing a more pronounced preoccu-

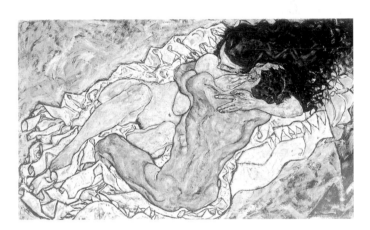

Egon Schiele, *Dic Umarmung (The Embrace)*, 1917. Österreichische Galerie Belvedere, Vienna

pation with the external physiognomy of the sitter. In general, Schiele's development in his last years leads to an art that places much more emphasis on the reproduction of the world as it is. Furthermore, the pictures of this last phase show every nuance of color and tone—nowhere to be found in German Expressionism with any degree of comparable refinement. When the pictures of this last period were shown at the Secession in 1918, they brought immediate recognition to the twenty-eight-year-old artist. A few months later, Schiele was dead, a victim of the Spanish flu that raged through Vienna at the end of World War I.

One artist who made an impressive portrait of Schiele was Max Oppenheimer. "MOPP," as the artist signed himself, was frequently accused in the early years of being a mere imitator of Kokoschka—an accusation fueled by Kokoschka himself, who

used his contacts among the critics and gallery owners to publicly discredit Oppenheimer. Nevertheless, his early portraits show an extraordinary artistic talent, even if the works clearly *are* influenced strongly by Kokoschka. Group portraits, religious scenes, nudes, and figurative works are the main ingredients of his œuvre, often painted in dispersed, blurred colors, sometimes very opaque and with considerable expressive freedom in the representation of physiognomy.

The influence of Cubism is apparent in Oppenheimer's work after 1912, which displays a tendency toward analytical form. However, he is generally more closely allied to Futurism in his fascination with movement and his attempts to depict dynamic processes. For example, he repeatedly chose to capture musicians in the act of playing, a theme that he returned to constantly in his graphics. Another recurring feature of Oppenheimer's work was that he often combined borrowed elements from Old Masters—such as El Greco—with idiosyncratic forms. This led to interesting and unconventional results, as for example in his religious paintings, which sometimes evoke a hothouse atmosphere saturated with eroticism. By the end of 1911, Oppenheimer had settled in Germany, and later moved to Switzerland; however, he returned to Vienna in the 1920s, before leaving the city forever after the *Anschluss* of 1938.

In contrast with the artists discussed up to this point, Alfred Kubin's work cannot be understood in the context of Viennese modernism, but in that of Munich. It is grounded in Symbolism, which was to find multifarious expression in literature and philosophy at the turn of the century. Death and destruction, sexuality and dream-worlds, cults and bizarre features of the human face are the subjects to which Kubin returned again and again. Only to a limited extent are these pictures an expression or resolution of Kubin's own psychological conflicts and extreme spiritual experiences. More often, they represent the elements of a consciously pessimistic worldview, which he had imbibed from his reading of Arthur Schopenhauer. Indeed, attempts to unravel Kubin's work in terms of psychoanalysis tend to lead to mistaken interpretations, which rest on a misleading identification in his work of iconography with pathological symptoms.

For several years, up to about 1908, Kubin painted in pastels and often produced pictures that would nowadays be regarded as Surrealist. He was, however, a natural draftsman, and for a long time remained true to the graphic arts and to his personal vision of the fantastic. Within this genre, he combined the multiple influences of Brueghel, Bosch, Goya, Munch, Redon, Klinger, and in particular James Ensor and Félicien Rops.

Notwithstanding his early enthusiasm for graphic prints, Kubin ultimately preferred pure drawing. However, even here he aimed to reproduce the effects of aquatint and etching by using a technique involving harshly drawn lines and hatching that gave a powdery, spraylike appearance. From about 1908 Kubin's work loosened up; for decades thereafter he adhered to his fantastic themes, but used faster and more scratchy drawing, with the result that the absurd was transmuted into the bizarre, existential anxiety into wonder, and cynicism into irony. Kubin's skill as an illustrator of literary works (often with grotesque themes) led to numerous editions of books illustrated by him. The best known is his own novel, entitled *Die andere Seite* (*The Other Side*), written in 1908, apparently in a

Alfred Kubin, "Mock-image with big fig leaf taken by my brother-in-law Richard Ferdinand Schmitz," Munich, 1904

state of high emotional excitement. Kubin worked on into old age, producing a graphic œuvre of several thousand sheets. However, his strongest period encompassed the first and second decades of the twentieth century, many of his later drawings achieving little more than the cheap frisson of harmless ghost stories.

Kubin's work may be placed somewhere between Symbolism and Expressionism—again, a closeness to Symbolism may be observed, as was also the case among the Expressionists in Vienna. But one cannot speak of a "school" of Viennese Expressionism, as the Austrian painters all adopted different artistic approaches; this absence of a collaborative movement distinguishes the Austrian from the German Expressionists. In the case of the latter and of the Fauves, one thinks of a group that

Alfred Kubin, *Der Aristokrat (The Aristocrat)*, ca. 1903

at least temporarily followed a common program, as did the Blaue Reiter in Munich, or Die Brücke in Dresden. The Austrian painters who can be termed Expressionist each followed his own path. There were no studio associations and individualism ruled, although there were of course points in common among the painters concerned.

Furthermore, the freedom that the German painters and the Fauves achieved in the realm of abstraction, as well as their elemental perception of color, are much less evident among the Expressionists in Vienna. A sophisticated use of color, which had its roots in the formal refinement of Jugendstil, was never entirely abandoned by the Viennese artists of this generation.

CAESURAS: 1918, 1938, AND AFTER 1945

Austrian art of the period between the two world wars was long judged by the standards of aesthetic quality of turn-of-the-century art. The result was that its reception has been a fragmentary affair, and only in the last fifteen years have serious efforts been made to assess its true value. A large number of biographical and critical works on the art of this era are now available. This period, though not the principle crux of discussion here, must be mentioned, even if briefly.

With the œuvre of Kubin we departed from Vienna as the focal point of Austrian modernism. However, it is a legitimate question to ask: What remained, in the Vienna of 1918, of the modernism that began with the founding of the Secession? That eventful year saw not only the collapse of the Hapsburg monar-

chy, but also the death of Gustav Klimt, Egon Schiele, Otto Wagner, and Koloman Moser. Gerstl remained undiscovered and Kokoschka had long since left Vienna. In November 1918, the Austrian Republic was proclaimed and Franz Joseph's successor, the young Emperor Karl, went into exile. The Danubian monarchy broke up into a number of small independent states. Cosmopolitan Vienna suddenly found itself off in the east of a small, German-speaking country, whose existence as a republic began with a major crisis of identity. Cut off from its former hinterland and economically shattered, Vienna was now a city with completely different, and mostly adverse, conditions for art and artists. During this period of "Red Vienna"—a time during which at least architects were kept employed in the field of social housing—the practitioners of the fine arts were almost entirely deprived of their traditional sources of patronage.

That 1918 represented a drastic caesura in the practice of the arts is clear. Artists of Schiele's generation had to find a new orientation. For painters such as Anton Kolig, Fritz Wiegele, Herbert Boeckl, and Carry Hauser, there remained an expressive form of art concentrating on figure, landscape, and symbolic representation. Jean Egger, who died young, carried his

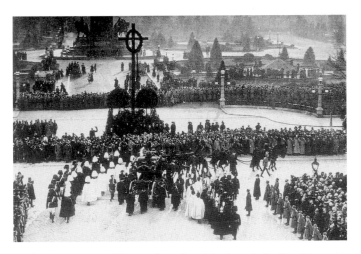

The funeral procession of Emperor Franz Joseph turning onto the Ringstrasse, November 1916

dissolution of form so far that his pictures are often compared with those of Chaim Soutine. On the other hand, a painter like Albert Paris Gütersloh adopted a stance of artistic eclecticism, with evident influence of Cézanne and Cubism, as well as the painting of the Neue Sachlichkeit.

Between the two world wars, abstraction was present in Austrian painting to quite a marked degree, but as far as public

taste was concerned, figurative painting remained dominant. Elements of Expressionism, Cubism, Futurism, and Constructivism were combined in the work of Franz Cizek, who was teaching at the Kunstgewerbeschule, and this laid the foundations for Viennese Kineticism, which produced a considerable array of talent. Erika Giovanna Klien was among the increasing number of prominent female artists, and was one of the most important representatives of Kineticism, which focused on, among other things, the depiction of complex processes of movement. The experiments with space of Frederick Kiesler were part of the Constructivist tendencies in Vienna in the 1920s, in which Hungarian Constructivists also took part.

Whereas the innovation in Austrian art at the turn of the century had been concentrated in Vienna, the important centers of painting were now scattered regionally. In Carinthia, the so-called Nötscher Kreis (named for their gathering place) was established, while in Tirol, Albin Egger-Lienz's highly expressive form of late Symbolism also dealt with matters of regional identity. More and more, however, the artists of the 1920s and '30s were confronted with the intellectual and economic obstacles that were thrown up by the political climate of the interwar period.

In 1934, the Austrian *Ständestaat* (corporative state) was established, which drastically reduced freedom in the cultural sphere. This, however, proved to be merely the overture to the horrors of the Third Reich, which began for Austria with the *Anschluss* of 1938. Kokoschka, who had been in Vienna for an extended period in 1934, went to Prague following the political upheaval that year in Austria (the short civil war), and in 1938 fled to London. More than four hundred of his works were removed from German museums and several of them displayed in the National Socialists' propaganda exhibition *Entartete Kunst* (Degenerate Art). Literature, music, and all the arts were now "brought into line" by the National Socialists. As Carry Hauser put it, Vienna was degraded to an "insignificant provincial town of the Third Reich." Viennese modernism, which had long since come to a halt, was eradicated from the cultural map.

With the emigration from the Reich of collectors, art dealers, gallery owners, and art historians, the reception of Viennese modernism began in the United States. The prelude to the wide recognition it enjoys today is of particular interest here. Above all, it is revealing to follow the history of the reception of works by Kokoschka and Schiele in America. As was the case with many of these artists, while recognition was at first hesitant, their later acceptance seemed to be all the more enthusiastic.

Kokoschka, whose painting had achieved prominence in Germany after World War I, had since the mid 1920s regularly exhibited individual works in American international shows. He already had an assured place as a "German Expressionist" in German and English art literature. In 1937, the year his works were defamed by the National Socialists as "degenerate," he was honored by the Carnegie Institute in Pittsburgh. From 1938, Curt Valentin repeatedly staged personal exhibitions of the artist at his Buchholz Gallery in New York. Kokoschka himself first came to the United States in 1949 to attend a solo exhibition of his work at the Institute of Contemporary Art (ICA) in Boston. The comprehensive show of 125 works was a major success for the painter; it subsequently traveled to five U.S. cities, finishing its run with a triumphant showing at New York's Museum of Modern Art. Since that time, Kokoschka has been recognized in the U.S. as one of the protagonists of European modernism, and his works have been acquired by many American public and private collections.

In the case of Schiele, it was principally the New York art dealer Otto Kallir who championed his work. Kallir originally founded the Neue Galerie in Vienna in 1923, where he had regularly shown works by Klimt, Kokoschka, and Schiele. It was he who first exhibited Gerstl to an astonished public in 1931. After emigrating, he regularly held one-man shows of Schiele at his Galerie St. Etienne. From Kallir's 1957 exhibition, the Museum of Modern Art purchased their first Schiele drawings. In 1960, Thomas M. Messer—who himself came from the old Hapsburg Empire—organized a Schiele exhibition that opened at Boston's ICA, where he was director; the show subsequently traveled to New York, Louisville, Pittsburgh, and Minneapolis. After Messer became the director of the Guggenheim Museum in New York, he curated a great Klimt and Schiele retrospective there in 1965, which included more than 120 works by Schiele, of which 53 were paintings. In the subsequent years, Schiele's work has been acquired by a new generation of museum curators and a great deal has been written about him in America.

One of the most important of this new generation of proponents was Serge Sabarsky, whose New York gallery consistently advanced the cause of Austrian and German painting in the U.S. from the late 1960s onward, and who later attracted a mass public to these works with touring exhibitions shown in many parts of the world. The unflagging efforts of these advocates helped to bring the names of Austrian and German modernists to their current level of familiarity and popularity—to say nothing of their strength on the international art market.

THE ART OF VIENNESE MODERNISM TODAY

After World War II, the art of fin-de-siècle Vienna was for a long period regarded as a belated and peripheral aspect of European modernism. Art historians, fixated on events in Paris (and thereafter in New York), paid scant attention to the art of Vienna. However, from the 1950s onward (although slowly at first), international recognition of Viennese art increased. Pioneering work was done by Werner Hofmann, who staged exhibitions first in Vienna and then in Hamburg, among them the

Cover of the exhibition catalogue *Experiment Weltuntergang*, Hamburger Kunsthalle, 1981

1981 *Experiment Weltuntergang* ("Experiment in the End of the World"—the title based on an aphorism by Karl Kraus) in Hamburg. The 1980s also brought the great exhibitions of Viennese turn-of-the-century art. In the course of the last two decades of the millennium, Viennese modernism became something of a cult, as evocatively glamorous as it is vaguely defined, occupying an increasingly important position in the history of art and cultural history. A mass of publications, both academic and popular, as well as exhibitions, symposia, events, and media presentations have recently examined the era of Viennese modernism at length.

It was at the 1984 Venice Biennale that this process of rehabilitation began. The exhibition *Vienna in 1900*, presented at the Palazzo Grassi, was at that time given the subtitle *The Arts of Vienna from the Secession to the Fall of the Hapsburg Empire*. A similar exhibition was shown in Vienna the following year under the title *Traum und Wirklichkeit* (Dream and Reality), and the period reviewed by this show was expanded to cover 1870

to 1930. Thus it was possible to show the art of the Ringstrassen era, and also (in a presentation organized by the City of Vienna) the cultural achievements of "Red Vienna" and of the city administration in the years following the end of the monarchy. In 1986, the organizers of the great *Vienna* exhibition in Paris altered the chronological parameters of the show yet again: at the Centre Georges Pompidou, curator Jean Clair assessed the end of Viennese modernism not as coinciding with the end of the monarchy, but with the *Anschluss* of 1938 and the start of the National Socialist regime.

Subsequent exhibitions and their catalogues, which sold in large numbers, also varied their chronological span according to their respective perceptions of the theme. In 1986, Kirk Varnedoe curated a major show at the Museum of Modern Art in New York entitled *Vienna 1900: Art, Architecture, and Design*, which followed Viennese modernism up to 1918. The exhibition made an indelible impression on the American public; the aureole that Vienna suddenly acquired as a result of the show was primarily due to the aesthetic side of Viennese modernism, albeit denounced by many critics as the expression of the narcissism of its day. *Vienna 1900* was nevertheless a huge success for the museum. Reviews, studies, and reports devoted to it ran to

Cover of the exhibition catalogue *Traum und Wirklichkeit*, Künstlerhaus, Vienna, 1985

hundreds of pages. *Art in America* published a twelve-page, richly illustrated review by Donald Kuspit. In *The Nation*, Arthur C. Danto used the exhibition as the basis for a philosophical discussion of the decorative in art, drawing parallels between turn-of-the-century Vienna and the present. The *New York Times* carried several reports on the show, together with coverage of the intellectual and stylistic issues to which it had drawn atten-

tion, under such elegiac headings as "The Brilliant Sunset of Vienna in Its Final Glory."

The Sezon Museum of Art in Tokyo called its 1989 exhibition *Vienna in 1900: Klimt, Schiele, and Their Age*, a title that shrewdly threw the spotlight on the two most popular artists of Viennese modernism. This identification of modernism with the two great names had already in fact taken place, since the cover of the Venice Biennale exhibition catalogue showed a cut-out of Klimt's *Beethovenfries*, while Vienna's *Traum und Wirklichkeit* catalogue had shown a detail from his portrait of Adele Bloch-Bauer, painted in 1907. *L'Apocalypse Joyeuse* (The Joyful Apocalypse), as the Paris show was subtitled, put Klimt's *Hoffnung I (Hope I;* 1903) on the catalogue cover (in New York, however, his 1905 portrait of Margarethe Stonborough-Wittgenstein was used); and in Tokyo the era of modernism was identified by Klimt's painting *Der Kuss (The Kiss;* 1907–08). When the Museo Nacional Centro de Arte Reina Sofia in Madrid put on its show *Vienna 1900* in 1993, Klimt's 1907–08 *Danae* supplied the image for the catalogue cover. And as a result of the popularization of Viennese modernism, individual exhibitions dedicated to Kokoschka and Schiele became magnets for a new and relatively young public.

The Viennese Expressionists thus made the transition in the public's perception from *enfants terribles* (as they were still regarded in the 1960s) to representative national artists, which they became as a result of international exposure. Austria exploits them today in its cultural diplomacy and they have also become marketable items for the tourist industry. In advertising prospectuses over the last ten years, at least one representative of Viennese modernist painting has almost invariably appeared, taking its place alongside more traditional icons such as Lipizzaners, Sachertorte, and the Vienna Boys Choir. If it is not the portrait of a fashionable woman by Klimt, then it is almost as likely to be a grimacing Schiele portrait, or the *Stilleben mit Hammel und Hyazinthe (Still Life with Wether and Hyacinth;* 1910) by Kokoschka, that adorns the tourist brochure.

Perhaps the clearest sign of the willingness of official Austria to identify itself today with the highlights of turn-of-the-century Vienna is the purchase by the Austrian Republic of the superb Leopold Collection (for more than two billion schillings or ca. $130 million), for which a dedicated museum is currently being built. The core of this collection, apart from items by Klimt, Gerstl, and Kokoschka, is a selection of many of the best works by Schiele.

The art market does its bit to raise the esteem in which the products of the voluptuous Viennese Jugendstil are held, to establish them in the artistic canon, and to place an economic value upon them. The exquisitely refined applied art of the Wiener Werkstätte—especially its furniture, ceramics, and graphics—have likewise found a prominent place in the international auction market as a result of their exposure in the great exhibitions. In 1997, Klimt's painting *Schloss Kammer am Attersee II (Schloss Kammer on the Attersee II;* 1909) was auctioned at Christie's for a record price of £14.5 million (ca. $23,490,000) in London. Klimt thus is in third place in the competition for the highest price fetched by a picture auctioned in London, after van Gogh and Picasso. In the fall of 2000, a record price was paid for Schiele's portrait of the art dealer Guido Arnot, when it was auctioned at Sotheby's in London for £7.15 million (ca. $10,380,930). While Kokoschka has long been a popular seller, in the cases of Gerstl and Schönberg there is too little material to stimulate a market for their works. The latest aspect of Viennese modernism to have attracted attention, and which increasingly made headlines from the second half of the 1990s onward, was the identification of modernist paintings as booty from the National Socialist era. This affected not only works from the collections that the National Socialists had "aryanized," but also those sold or donated under duress to the Austrian state by many owners *after* the war, in exchange for a general permission to export their other goods.

While the National Socialists included works of all periods in their plunder, their behavior with regard to works of Viennese modernism was particularly unscrupulous. It is likely that in the future the provenance of many artifacts of Viennese modernism will have to be reconstructed and rewritten.

The media's tendency to hyperbolize values in every field is one of the most far-reaching phenomena of the recent past and has obvious implications for art history. Something from the canon of classical modernism has long been one of the choices for the decorative background screens of PC monitors. More or less enjoyably, more or less deadened and dulled, we plunge daily into the flood of images in which everything that was successful in Viennese modernism has found its place. It is therefore impossible to see the astonishing popularity of this particular chapter in the story of art in isolation from factors such as the market's insatiable demand for images, together with its constant exploitation and evaluation of them.

We have now seen a century's response to these works—ranging from damnation to glorification. The new millennium will doubtless bring into focus fresh problems with regard to Viennese modernism. In what ways is this process likely to expand or at least change our perception of modernism? Although this is an open question, it is indisputable that the aesthetic and intellectual potentials of Viennese modernism will continue to have an impact on how modernity will be defined in years to come.

Translated from the German by Nicholas T. Parsons.

GEORGE MINNE

*** AUGUST 30, 1866, GHENT**
† FEBRUARY 20, 1941, LAETHEM-SAINT-MARTIN

Invitation to the exhibition
*Contemporary Belgian
Painting, Graphic Arts and
Sculpture*, Pennsylvania
Museum of Art (second
venue), opened December
10, 1929

George Minne was born in Ghent, Belgium, in 1866. He initially studied with Jean Delvin, but in 1879, at the age of thirteen, he entered the Ghent Koninklijke Academie voor Schone Kunsten (Royal Academy of Fine Arts), and was formally attached to this institution until 1886. There he studied painting under Théodore Canneel and Louis van Biesbroeck (who was himself a sculptor). Minne spent the academic year 1885–86 at the Academie voor Schone Kunsten in Brussels; he would remain in that city, working independently, until 1889. He made his first visit to Paris in 1886, and in the same year met the Belgian writers Maurice Maeterlinck and Grégoire Le Roy, who introduced him to the French Symbolists.

Minne joined the Belgian artists' association Les XX (The Twenty) and began to exhibit his work with them in 1890. This activity ensured his close ties with the Belgian capital. Belgium's most renowned artists were associated with Les XX, including James Ensor, Fernand Khnopff, and the architect-designer Henry van de Velde. Minne traveled again to Paris in 1890. He asked Auguste Rodin for permission to work in his studio, but was refused. Minne married Joséphine Destanberg, the daughter of a Ghent poet, in 1892; he then devoted himself principally to drawing, book illustration, and sculpture.

In the mid 1890s, Minne and van de Velde became closer friends; through the architect's mediation, Minne made a series of acquaintances abroad. Just before the end of the century, around 1898, Minne moved to Laethem-Saint-Martin, a village near Ghent that in the following years became the site of a small artists' colony. In 1898, Minne produced a work soon recognized as his masterpiece: the design for a marble fountain with five kneeling youths, which was installed in 1905–06 at Karl Ernst Osthaus's museum in Hagen. Over the subsequent two decades, Minne almost completely abandoned sculpture for drawing, although in 1910–14 he established his own bronze foundry in Ghent (his son managed the venture).

Minne taught drawing at the Koninklijke Academie in Ghent from 1912 to 1914. He fled to Wales to avoid the ordeal of World War I; while in Great Britain, he produced a great many striking charcoal drawings. After the war, he returned to Belgium and resumed his teaching activities. In the 1930s, his work began to gain attention in America. By this time, he had long been recognized as one of Europe's most important avant-garde artists. He died in 1941 at Laethem-Saint-Martin.

PUBLIC RECOGNITION

George Minne's work was integral to the development of modern art in Austria and Germany. One of the earliest and most significant presentations of Minne's work was at the eighth exhibition of the Secession, which ran from November 3 to December 27, 1900, at the group's recently constructed building. Its main focus was on European applied arts, but Minne was nonetheless generously represented with a total of thirteen sculptures.[1] His impact in Vienna was formidable, as was soon to be evinced in the work of Gustav Klimt. Initially interested in Minne's compatriot, the Symbolist painter and draftsman Fernand Khnopff, Klimt soon began

to lose his fascination with the latter's stylistic over-refinements. Minne's attenuated figures, on the other hand, assumed a significant role, above all in connection with Klimt's allegorical groups, as for example those in his celebrated *Beethovenfries* (*Beethoven Frieze;* 1902).[2]

Minne's chief artistic accomplishment was twofold: first, his distinctive elongation of figures, a style frequently referred to as "Gothic,"[3] which he developed in reaction to the formal canon of Jugendstil; and second, his exploration and use of religious symbolism, which derived partly from the Symbolist art he had encountered in his youth. These two innovative approaches helped to ensure his place as one of the leading artists in Europe and to establish him as a major exponent of Expressionism. The well-known Viennese critic Berta Zuckerkandl recognized this at an early stage, commenting about Minne's work in the eighth Secessionist exhibition: "At first glance one imagines one is seeing old Gothic monuments, so ascetic, so emaciated are his figures, which seem only to be kept alive by their sheer depth of feeling."[4]

Minne's work did not always meet with the approval of critics who were otherwise sympathetic to the Secession. For example, Viennese art critic Ludwig Hevesi vacillated between ridicule and esteem. "George Minne wins first prize for sheer oddness," he wrote. "Since the Middle Ages, no one has produced sculpture so gaunt, so bony, so angular, and so ascetic as his. These are figures that must have been suckled, as infants, on the milk of the seven lean cows; they consist of almost nothing but long bones and muscular atrophy. ... We find here a scorching spiritual fire, coupled with devotion, theology, and osteology."[5] Julius Meier-Graefe, the German art critic and propagandist for French painting, felt compelled to write a defense of the artist in the Secession's journal *Ver Sacrum*.[6] Twenty-five years later, art historian Ernst Michalski summarized the importance of the artist's achievement thus: "It was [Minne's] calling to lead the art of the Northern lands from Impressionism to Expressionism."[7]

The legendary fourteenth exhibition at the Secession, held April 15 to June 27, 1902, centered on Max Klinger's recently completed polychrome marble figure of Beethoven, but was above all significant as an exercise in making the installation a "total work of art." The show included four sculptural works by Minne, which were placed in the so-called

Ver Sacrum room to the right of the main entryway. Here, Minne's *Orator* (1901) was shown alongside his *Youth* (1902) and a study for a third figure, as well as a plaster version of his *The Bather* (1899). Fritz Waerndorfer, industrialist and co-founder of the Wiener Werkstätte, had been largely responsible for introducing the Belgian artist to the Viennese art world and to members of the Secession. Waerndorfer, one of Minne's chief supporters, owned several sculptures by the artist, including a marble version of the *The Bather* (cat. no. I.1) and a number of his sketchbooks.

Minne's sculptural work had a particular resonance in the context of the tension between aestheticism and industry in the Westphalian city of Hagen. There, Karl Ernst Osthaus, who came from a wealthy banking family, realized his aim of bringing art and culture to the hard-working inhabitants of a city defined almost entirely by its economic role.[8] In

George Minne, ca. 1910

Josef Hoffmann, view of the dining room of Ludwig Knips, 1909. Featured: George Minne's *The Bather*. MAK – Österr. Museum für angewandte Kunst; Wiener Werkstätte Archiv

1902, Osthaus opened his museum in Hagen (the collection was acquired by the Museum Folkwang in Essen in 1922). Soon thereafter, the institution gained a reputation as one of the leading centers of modern art in Germany.[9] Minne was among the artists whose works were collected and supported by Osthaus from the outset. Indeed, Osthaus had

MUSEUM FOLKWANG HAGEN:W

GEMÄLDE SKULPTUREN KUNSTGEWERBE
WECHSELNDE AUSSTELLUNGEN

Walter Bötticher, poster for the Museum Folkwang in Hagen, prior to 1914

installed several of his sculptures in the museum as early as 1903.[10] He particularly appreciated the artist's "lines and symbolic form," and detected in his work a "mood of mysterious celebration."[11] It is clear that, for Osthaus, art played an important, compensatory role in this city otherwise dominated by work and commerce.[12]

By 1912, Osthaus had acquired more than ten sculptures by Minne, and had commissioned three tombs by him for a cemetery in the Buschey district of Hagen. Osthaus even kept a small version of Minne's figure of a standing youth on his office desk. He also commissioned Minne to execute a marble work, from a scheme that the sculptor had devised years earlier; this was *Knabenbrunnen, Fountain with Five Kneeling Youths* (1898–1905), a serialization of an earlier figure of a kneeling youth from 1898.[13] Installed in 1905–06 in the entrance hall of Osthaus's museum, Minne's fountain replaced a work by his compatriot, the sculptor Constantin Meunier, and achieved a striking correspondence with the building and interior designed by his friend van de Velde. Arranged in a circle, the figures kneel on the rim of the fountain's basin, seemingly staring into it. Hugging themselves in a gesture of introversion, they turn away from the external world, as if shuddering at the brink of the

Karl Ernst Osthaus
(undated photograph)

numinous depths of the abyss. The unstable posture of the group stands in a tense relationship to the almost entirely abstract effect of the white marble. They express feelings that range from the obscure to the contradictory: narcissism, spiritual suffering, and an introspective melancholy. Notwithstanding the aesthetic power of the work, it has been justly observed that it highlights a general problem of the over-refined Jugendstil around 1900, which had become vacuous and consciously self-referential.

As Jugendstil ceded to Expressionism during the early decades of the twentieth century, Minne's work was effectively sidelined. Indeed, after extolling the artist in 1900 in *Ver Sacrum*, Meier-Graefe decided to omit his long chapter on Minne from the 1914 edition of his *Entwicklungsgeschichte der modernen Kunst* (originally published in 1904).[14] Fortunately for American readers, the book was translated into English in 1908 with the Minne chapter intact.[15] This text by Meier-Graefe is one of the only early sources of information on Minne in the English-speaking world.

Three years later, the first monograph on Minne was published in Brussels.[16] In response to the solo exhibition of Minne's work held at the Galerie Giroux in Brussels in October 1929, the critic Georges Marlier, writing in the English edition of the journal *Formes*, observed: "It looks as though Belgium had at last decided to give ... due recognition to the exceptional quality of George Minne's work. A few days before his retrospective exhibition was opened, a room specially devoted to the work of our greatest living sculptor was inaugurated at the Brussels Musée Moderne."[17]

Parallel to this honoring of Minne in his homeland, the artist also began to receive recognition in the United States. In 1927, several of his works were illustrated in *The Dial*.[18] In 1929–30, three works by Minne—*Bust of a Laborer* (1911), *Kneeling Youth* (1898), and *Kneeling Youth with a Shell* (1923)—were included in the touring exhibition *Contemporary Belgian Painting, Graphic Art and Sculpture*. The show was conceived in Belgium and organized under the auspices of the European and American Art Committee.[19] It opened at the Corcoran Gallery of Art in Washington, D. C., on October 24, 1929, then traveled to the Pennsylvania Museum of Art, where it opened December 10, and afterwards to the Brooklyn Museum, where it ran from January 24 through February 24, 1930. In late 1934, a

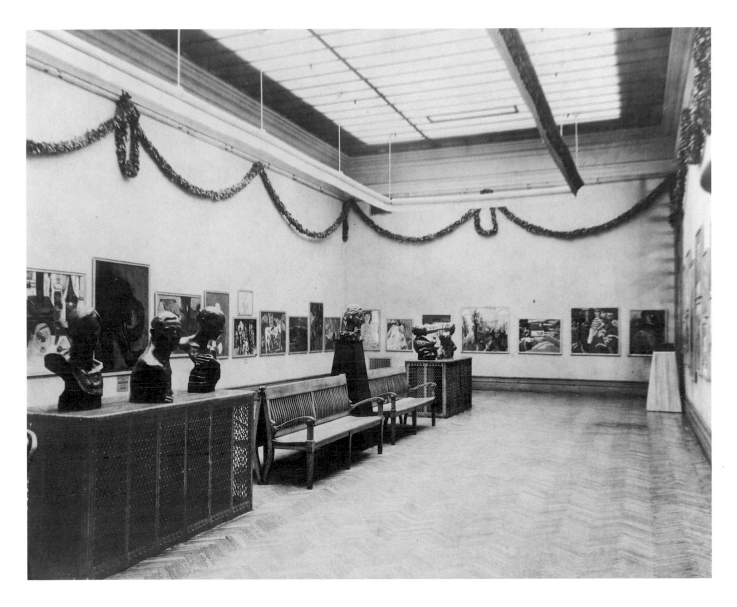

bronze cast of *Kneeling Youth with a Shell* was acquired by the Germanic Museum (now the Busch-Reisinger Museum in Cambridge, Massachusetts), and the figure was featured on the cover of the museum's bulletin.[20] By the end of the twentieth century, several works by Minne had entered museum collections in the United States. These include *Kneeling Youth,* which was donated in a plaster version by Mr. and Mrs. Josefowitz to New York's Metropolitan Museum of Art in 1962, and *Solitary* (ca. 1900) now in the Cleveland Museum of Art.[21]

During the late 1950s and early '60s, when the "rediscovery" of turn-of-the-century art was underway in Europe, art historian Kurt Bauch—who characterized Minne as "the greatest, the true sculptor

of Jugendstil"—had this to say of *Kneeling Youth:* "In barely intimated turns and inclinations, the slender body raises itself to an almost vertical position, then shrinks back, formally united with its tender crests and pointed contours, expanding in its upper portion, rising, exalted, and yet again meekly bowed. Without any element of imitation, there is in this figure something of the character of Gothic art."[22] This take reveals a new interest in the connection between Jugendstil and the Gothic. Bauch and other critics aligned the fin-de-siècle quest for a coherent idiom that could overcome the stylistic eclecticism of Historicism with the desire to incorporate an ahistorical notion of the medieval. It was this achievement that they viewed as characterizing the total work of art.

Installation view of *Contemporary Belgian Painting, Graphic Arts and Sculpture* at the Corcoran Gallery of Art, Washington D.C., October 24 –November 30, 1929. Featured: Minne's *Bust of a Laborer,* 1911 (second sculpture from left)

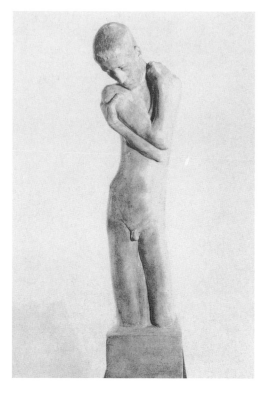

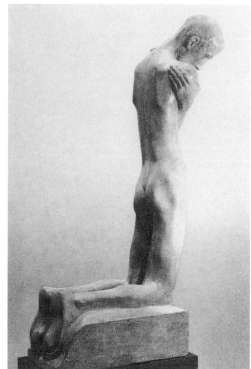

George Minne, *Kneeling Youth* (1898), as featured in the *Bulletin of The Museum of Modern Art*, New York, 1962

View of the Minne exhibition at the Galerie Giroux, Brussels, 1929

Minne's expressive figural style (which was to become even more marked in his later, religious subjects) profoundly influenced Austrian Expressionist painting.[23] In his memoirs (first published in 1971),

Kokoschka wrote that, in 1909, Minne's works had impressed him more even than those of van Gogh or the Fauves: "In the brittle forms, in the spirituality of his sculptures, I thought I could detect a break with the two-dimensionality of Jugendstil."[24] Egon Schiele also seems to have studied his work closely. His exhibitionistic self-portraits can be interpreted as a "radical continuation" of the narcissism of Minne's kneeling youths.[25]

Although Minne's name has yet to achieve the level of familiarity in the United States that others of his era have reached, he was one of the most important and catalytic influences on Austrian and German art in turn-of-the-century German-speaking Europe.

Olaf Peters
Translated from the German by Elizabeth Clegg, with Nicholas T. Parsons.
I would like to thank Claire Deroy for her valuable help in researching information for this essay.

1 For more on the points that follow, see in particular Ilse Dolinschek, *Die Bildhauerwerke in den Ausstellungen der Wiener Sezession von 1898–1910,* Munich: Scaneg, 1989, passim, and esp. pp. 52–59.

2 See Marian Bisanz-Prakken, "Khnopff, Toorop, Minne und die Wiener 'Moderne,'" in: *Sehnsucht nach Glück. Wiens Aufbruch in die Moderne: Klimt, Kokoschka, Schiele,* ed. by Sabine Schulze, exhibition cat., Frankfurt am Main, Schirn Kunsthalle, 1995, pp. 172–178.

3 See Magdalena Bushart, *Der Geist der Gotik und die expressionistische Kunst. Kunstgeschichte und Kunsttheorie 1911–1925,* Munich: Schreiber, 1990, pp. 81ff.

4 Berta Zuckerkandl, "Die VIII. Ausstellung der Wiener Secession" (1900–1901), cited in: Dolinschek, *Die Bildhauerwerke* (as note 1), p. 54.

5 Ludwig Hevesi, "Aus der Sezession" (1900), in: Ludwig Hevesi, *Acht Jahre Sezession (März 1897–Juni 1905). Kritik—Polemik—Chronik,* Vienna: Konegen, 1906, cited from reprint, ed. by Otto Breicha, Klagenfurt: Ritter, 1984, pp. 293–294.

6 See Julius Meier-Graefe, "Aus der VIII. Ausstellung der Vereinigung bildender Künstler Österreichs: George Minne," in: *Ver Sacrum,* vol. 3 (1900), pp. 27–46.

7 Ernst Michalski, "Die entwicklungsgeschichtliche Bedeutung des Jugendstils," in: *Repertorium für Kunst-wissenschaft,* vol. 46 (1925), p. 149.

8 For an introduction to this subject, see the outline provided in Monika Lahme-Schlenger, "Karl Ernst Osthaus und die Folkwang-Idee," in: *Avantgarde und Publikum. Zur Rezeption avantgardistischer Kunst in Deutschland 1905–1933,* ed. Henrike Junge, Cologne: Böhlau, 1992, pp. 225–233; and, in more detail, Herta Hesse-Frielinghaus et al., *Karl Ernst Osthaus. Leben und Werk,* Recklinghausen: Bongers, 1971, and Carmen Luise Stonge, *Karl Ernst Osthaus: The Folkwang Museum and the Dissemination of International Modernism,* Ann Arbor, Mich.: UMI, 1994.

9 On this point, see Henry van de Velde. *Ein europäischer Künstler seiner Zeit,* ed. by Klaus-Jürgen Sembach and Birgit Schulze, exhibition cat., Hagen, Karl Ernst Osthaus Museum, and other venues, 1992–94. See also Hans Curjel, ed., *Henry van de Velde: Geschichte meines Lebens,* Munich: Piper, 1962, pp. 217ff.

10 See the information published in Hesse-Frielinghaus et al., *Karl Ernst Osthaus* (as note 8), p. 511.

11 Karl Ernst Osthaus, in: *Hagener Zeitung* (June 19, 1903), cited in: Walter Erben, "Karl Ernst Osthaus. Lebensweg und Gedankengut," in: Hesse-Frielinghaus et al., *Karl Ernst Osthaus* (as note 8), p. 47.

12 On the Osthaus collection, which after his death was sold to the city of Essen, see Paul Vogt, *Museum Folkwang Essen. Die Geschichte einer Sammlung junger Kunst im Ruhrgebiet,* Cologne: DuMont, 1983.

13 On this work, see also Udo Kultermann, "The Fountain of Youth: The Folkwang Fountain by George Minne," in: *Konsthistorisk Tidskrift,* vol. 46, no. 2 (1977), pp. 144–152.

14 Julius Meier-Graefe, *Entwicklungsgeschichte der modernen Kunst. Vergleichende Betrachtung der bildenden Künste, als Beitrag zu einer neuen Ästhetik,* 3 vols., Stuttgart: Hoffmann, 1904, vol. 2, pp. 539–550. The second, revised edition appeared between 1914 and 1924.

15 See Julius Meier-Graefe, *Modern Art: Being a Contribution to a New System of Aesthetics,* transl. by Florence Simmonds and G. W. Chrystal, London: Heinemann, 1908, vol. 2, pp. 79–86.

16 Leo van Puyvelde, *George Minne,* Brussels: Editions des Cahiers de Belgique, 1930.

17 Georges Marlier, "Chronicle: Belgium Letter," in: *Formes* (English ed.), vol. 1 (December 1929), p. 22.

18 See *The Dial,* vol. 83 (July–December 1927). Illustrated here were works captioned as *Bathing Woman, Woman's Bust,* and *Wounded Boy.*

19 *Exhibition of Contemporary Belgian Painting, Graphic Art and Sculpture,* intr. by Christian Brinton and Louis Piérard, exhibition cat., New York, Brooklyn Museum, 1930. See also Christian Brinton, "Contemporary Belgian Art in America" and "Critics' Comments on Exhibitions," in: *The Brooklyn Quarterly,* vol. 17 (April 1931), pp. 48–52, 58–64.

20 See *Deutsche Kunst des 20. Jahrhunderts aus dem Busch-Reisinger Museum, Harvard University, Cambridge, USA,* ed. by Klaus Gallwitz et al., exhibition cat., Frankfurt am Main, Städtische Galerie im Städelschen Kunstinstitut, and other venues, 1982–83, p. 27; and *Germanic Museum Bulletin,* vol. 1 (November 1935), ill. on cover.

21 *The Museum of Modern Art: Painting and Sculpture Acquisitions 1962,* New York: Museum of Modern Art, 1962, pp. 4, 37; and *Bulletin of the Cleveland Museum of Art* (January 1969), p. 45.

22 Kurt Bauch, "Jugendstil," in: *Jugendstil. Der Weg ins 20. Jahrhundert,* ed. by Helmut Seling, Heidelberg: Keyser, 1959, pp. 9–35, reprinted in: *Jugendstil,* 3d ed., ed. by Jost Hermand, Darmstadt: Wissenschaftliche Buchgesellschaft, 1992, pp. 273–274.

23 See Patrick Werkner, *Physis und Psyche, Der österreichische Frühexpressionismus,* Vienna: Herold, 1986, transl. by Nicholas T. Parsons as: *Austrian Expressionism: The Formative Years,* Palo Alto, Calif.: Society for the Promotion of Science and Scholarship, 1993.

24 Oskar Kokoschka, *Mein Leben,* Munich: Bruckmann, 1971, p. 56.

25 Bisanz-Prakken, "Khnopff, Toorop, Minne" (as note 2), p. 178.

The Bather, ca. 1899 cat. I.1

ALFRED KUBIN

* APRIL 10, 1877, LEITMERITZ
† AUGUST 20, 1959, WERNSTEIN

Invitation to the exhibition *Alfred Kubin, Master of Drawing* at the Galerie St. Etienne, New York, opened December 4, 1941

Like many Austrian modernists, Alfred Kubin is a paradoxical figure. He participated in the birth of Expressionism in Munich, and some consider his early work a precursor to Surrealism. However, by 1910 the artist's style had changed decisively, and the nervously inked lines that characterize his mature work have little in common with any mainstream modernist movement. From 1906 on, Kubin lived a monklike existence in the remote West Austrian town of Wernstein, yet he was also in constant touch with the leading artistic and literary figures of his day. A prolific illustrator of the works of authors from Dostoevsky to Edgar Allan Poe, he reached countless readers outside the limited circumference of the Central European art scene. Indeed, Kubin was a surprisingly well-connected hermit.

Kubin's life may be divided into three phases, the durations of which are inversely proportional to the importance that his later biographers and other observers have attached to them. First came a troubled youth and adolescence, punctuated by his mother's death when the artist was ten, his suicide attempt at nineteen, and, in 1897, a complete mental and physical collapse during a brief period of military service. Following a yearlong convalescence, Kubin entered the second and pivotal phase of his life. Seemingly unfit for practical employment, he was sent in 1898 to Munich to study art, a longtime avocation for which he had shown some talent.

In Munich's hothouse of creative ferment, Kubin blossomed like some rare orchid. Influenced by the German Symbolist Max Klinger and stimulated by the urban environment, he drew as if in a fever dream: nightmares made palpable, fantastical creatures inhabiting shadowy imaginary kingdoms. His rise on the German art scene was rapid. By 1902, Kubin was exhibiting at the prestigious Cassirer gallery in Berlin. The following year, he exhibited at the Vienna and Berlin Secessions, and a portfolio reproducing fifteen of his eerie drawings was issued by the collector and publisher Hans von Weber. In 1904, Kubin joined the Phalanx group, beginning a long-term association with Vasily Kandinsky's Expressionist circle. Kubin remained allied with the core Munich avant-garde as it reconfigured itself over the ensuing years, joining the Neue Künstlervereinigung (New Artists Association) in 1909 and the seminal Blaue Reiter group in 1911.

Yet even during this period of artistic achievement and professional success, Kubin remained troubled and dogged by a seemingly tragic destiny. In 1903, his fiancée Emmy Bayer contracted typhus and quickly died. Less than a year later, Kubin married Hedwig Schmitz, whose chronic subsequent illnesses left her addicted to morphine. And in 1907, the artist's father died. Thrust into another spiritual and emotional crisis, Kubin turned to writing, producing an allegorical Expressionistic novel, *Die andere Seite* (*The Other Side*), in a mere twelve weeks in 1908. In illustrating the book, he forged the style that would, with minor modifications, characterize his work for the remainder of his lengthy career. The hallucinatory dream-world of his prior drawings was superceded by images that appeared more firmly grounded in reality. Scratchy pen strokes, often enlivened with touches of wa-

tercolor, replaced the misty "spray technique" and painterly experiments of former years. As Kubin phrased it, he had learned that "It is not only in the bizarre, exalted or comic moments of our existence that the highest values lie, but that the painful, the indifferent and the incidental commonplace contain these same mysteries."[1]

The most active stage in Kubin's development had ended by World War I. Already at the time of his marriage, he felt the fantastic visions that fueled his art ebbing. Travel did not have the desired effect of revitalizing his imagination, but rather produced a surfeit of confusing sensations. Kubin began to withdraw from new artistic contacts, and the war further disrupted his ties to the avant-garde, scattering the Blaue Reiter group and killing several of its key members. The artist's autobiography, first written as an addendum to the 1911 edition of *Die andere Seite* and updated periodically thereafter, focuses chiefly on his youth and early adulthood. Though he lived on for nearly half a century more, the third and final phase of Kubin's biography is in most accounts short on personal detail.

By the 1920s, Kubin was well established professionally. In Germany, he showed with such major dealers as Hans Goltz, Fritz Gurlitt, and J. B. Neumann, and in Vienna he was represented by Otto Kallir's Neue Galerie. In 1927, the Staatliche Graphische Sammlung in Munich mounted a fiftieth-birthday exhibition, and a group of prominent Austrian artists and writers published a commemorative festschrift. Kubin was also enjoying a lucrative career as a printmaker and book illustrator. In addition to occasional portfolios accompanying his own writings, Kubin illustrated more than 140 books by other authors. He still traveled periodically, if reluctantly, principally to attend exhibitions of his work, and he was enough of a personage to command audiences at his rural retreat, "Zwickledt," in Wernstein. He was also a prolific correspondent, maintaining relationships by mail with numerous far-flung friends. Nevertheless, Kubin led an essentially reclusive existence, his contact with outsiders suiting his own agenda. When the Nazis marched into Austria in 1938, Kubin was taken completely by surprise, for he neither owned a radio nor read newspapers.

Kubin lived out the years under the Nazis relatively undisturbed at Zwickledt. Unlike some banned German and Austrian colleagues, he did not have to go into "inner exile," because he was already

there. And in fact, Kubin was not banned; he was allowed to exhibit, so long as the works were judiciously edited. Still, he refused to do propaganda and found that there was little demand for his quirky drawings in Hitler's Reich. Following World War II, however, Austria attempted to reclaim her prewar heritage and hailed Kubin as a national treasure. In 1947, on the occasion of his seventieth birthday, he was lauded with a retrospective at the Graphische Sammlung Albertina in Vienna and the establishment of a "Kubin Kabinett" at the Neue Galerie in Linz. Similar accolades attended the artist's seventy-fifth and eightieth birthdays. A life-long hypochondriac, Kubin died at the venerable age of eighty-two, in 1959.

PUBLIC RECOGNITION

Alfred Kubin cannot be readily pigeonholed by the rigid categories that have traditionally been used to demarcate modern art. Those who rate artists strictly according to their position in major movements, such as Expressionism or Surrealism, tend to focus on Kubin's early work and largely ignore the remainder of his achievement, which comprises the bulk of his ultimate œuvre. Certainly, Kubin's attempts to visualize the unconscious in his early work anticipated a number of key Surrealist concerns, and his efforts to expose the mysteries underlying visible reality are consistent with the stated goals of Kandinsky and other Expressionists. However, Kubin was alienated by the formalist experimentation that increasingly preoccupied the European avant-garde. By the second decade of the twentieth century, he had resolutely decided to go his own way.

Portrait of Alfred Kubin, 1930s

Kubin's studio in Zwickledt (undated photograph)

Alfred Kubin, *Der Bräutigam (The Bridegroom),* 1929, as featured in *The Dial,* March 1929

At heart, Kubin was a profoundly literary—and literate—artist. He read widely; not just fiction, but philosophical treatises, books on Eastern religion, psychology, astrology, and the occult. Modern life and its technological marvels, however, held no appeal. Kubin was interested in primordial and timeless truths, which he felt could readily be found in rural Wernstein, or in folklore or childhood memories. Like many Austrians of his generation, he harbored a lingering affection for the recently deposed Hapsburg monarchy, even as he acknowledged that it could not and should not have endured. In this sense, Kubin was very much of his time and place: nostalgically seeking out surviving shards of the past in the present, believing that he could forestall a grim future by denying the inevitability of change. If Kubin's early drawings tap into the collective unconscious, his mature work reflects the unconscious of Austria's First Republic, in the period between the two world wars.

The extreme specificity of Kubin's sensibilities has hampered a proper international appreciation of his œuvre. His early, mystical drawings are easy enough for present-day audiences to comprehend, although the artist himself largely disowned them. But many observers have failed to properly read the subtext in his later drawings, seeing them merely as amusing or quaint genre scenes. The bifurcation of Kubin's œuvre—between his early and mature styles—caused a similar bifurcation in his reception. And as contemporary tastes changed, interpretations of Kubin's achievements shifted accordingly.

Unlike Klimt and Schiele, Kubin was still alive when, in 1941, he had his first one-man exhibition in the United States, at Otto Kallir's Galerie St. Etienne.[2] Kallir, who had previously represented Kubin in Vienna, shared the artist's preference for his mature style. As is routinely the case with contemporary artists, Kallir's Kubin exhibitions, both in Vienna and in New York, tended to favor current material. The only American collector to show a significant interest in Austrian modernism in the 1920s, Scofield Thayer, had likewise gravitated to Kubin's recent work.[3] The early Kubin did not come to the fore in the United States until much later.

The initial American response to Kubin may best be described as favorable, if underwhelming. The reviews of the 1941 St. Etienne exhibition were uniformly positive. The *New York Times* called Kubin "one of the outstanding European masters of [drawing]," and compared him to Daumier, van Gogh, and Rembrandt.[4] It may be inferred that Kubin's mature drawings had an easygoing, non-confrontational appeal that suited the comparatively conservative tastes of the period. Beyond this, however, New York critics in the 1940s savored the expressive power of Kubin's draftsmanship, which they rightly perceived to be on a par with that of the artist's greatest colleagues. Still, Kubin *was* a draftsman, and thus was denied the reach and gravitas accorded painters. Although Kallir regularly included Kubin in group exhibitions throughout the 1940s and '50s, and mounted a second one-man show in 1957,[5] the Galerie St. Etienne was unable to sell much of the artist's work until the 1960s, when he was caught up in a groundswell of appreciation for fin-de-siècle Austrian art.

The 1960s and '70s also witnessed the shift toward Kubin's early, Surrealistic style that continues to dominate assessments of the artist's accomplishments. Kubin had been included in the Museum of Modern Art's landmark 1936 survey *Fantastic Art, Dada, Surrealism.* However, it is unlikely that, among 694 exhibited items, the single Kubin lithograph on view had much impact. For all intents and purposes, the "Surrealist" Kubin first emerged in New York at a 1970 exhibition at the Serge Sabarsky Gallery.[6] Following close on the heels of the 1967 publication of an English-language edition of *The Other Side*[7] (which occa-

sioned another St. Etienne showing[8]), the Sabarsky exhibition capped a resurgence of interest in the idiosyncratic artist.

Kubin's ascension to a new level of prominence in the early 1970s was heralded by a lengthy article in the *New York Times*, in which the lead critic, Hilton Kramer, anointed him "one of the most interesting [artist-poets] in the history of modern art."[9] Kramer did not mince words when it came to his preference for Kubin's proto-Surrealist work. "I think Kubin was at his strongest in the earlier phases of his career," the critic wrote. "It is the drawings dating from 1899 to 1904 that are the real masterpieces. Subsequently, the draftsmanship became looser and more frenetic, no doubt in response to the Expressionist movement. He continued to produce fine work, but there is nothing quite as strong and personal in the later drawings." It was the "Surrealist" Kubin who was subsequently showcased in the big museum explorations of fin-de-siècle Vienna that took place in the 1980s in Venice, Vienna, Paris, and New York.[10] Like his compatriot Kokoschka, Kubin during this period suffered from the good fortune of a long life. Both artists saw their achievements truncated by late twentieth-century art historians, pared down to the few brief years that coincided with the fin-de-siècle cultural boom. While the *Vienna 1900* craze granted both Kubin and Kokoschka a new audience and an arguably broader renown than Kubin, at least, had previously enjoyed, the concentration on turn-of-the-century phenomena impeded study of the totality of their careers. The Galerie St. Etienne's 1983 Kubin exhibition, drawn extensively from the collection of the Städtische Galerie im Lenbachhaus in Munich, bowed to this trend by focusing on pieces done prior to publication of *The Other Side*.[11]

Today, Kubin's reputation remains in flux. The early work, which satisfies a contemporary predilection for edgy, iconoclastic material, is more popular than ever, but this popularity has only served to further eclipse the artist's mature style. On the other hand, however, the modernist orthodoxies that once caused critics to sideline Kubin's later work no longer exert their former pull. While there is still a tendency to privilege formalist concerns over literary ones, the former rigid, linear reading of modern art history has given way to a greater tolerance for idiosyncratic creations beyond the mainstream. It is too soon to tell whether these changes will eventually lead to a reassessment of Kubin's entire œuvre. Perhaps his mature works will always be seen as provincial curiosities. But it is to be hoped that future viewers will come to recognize that for Kubin, Zwickledt *was* the world. His seemingly innocuous rural scenes and quirky illustrations encompass the entire range of human foibles, fantasies, and desires: a universe no less profound and moving than that found in the more sensationalistic early pieces.

Jane Kallir

[1] Alfred Kubin, "Alfred Kubin's Autobiography," in: *The Other Side*, transl. by Denver Lindley, New York: Penguin Books, 1983, p. 268.
[2] *Alfred Kubin: Master of Drawing*, Galerie St. Etienne, New York, December 4, 1941–March 1942.
[3] Scofield Thayer owned three Kubin drawings, *Man from Lower Bavaria* (1925), *The Schnapps Distiller* (1928), and *The Bridegroom* (1929), the first and last of which were reproduced in his magazine, *The Dial*. All three works, quite possibly purchased from the Neue Galerie in Vienna, are today in the collection of the Metropolitan Museum of Art, New York.
[4] Howard Devree, "A Reviewer's Notebook," in: *New York Times* (December 7, 1941).
[5] *Alfred Kubin*, Galerie St. Etienne, New York, April 1957.
[6] *Alfred Kubin: An Exhibition of Drawings and Watercolors*, Serge Sabarsky Gallery, New York, December 1970–January 1971.
[7] Kubin, *The Other Side*, transl. by Denver Lindley, New York: Crown, 1967.
[8] *Alfred Kubin*, Galerie St. Etienne, New York, January 30–February 24, 1968.
[9] Hilton Kramer, "Kubin: Exorcising Demons", in: *New York Times* (January 17, 1971).
[10] *Le Arti a Vienna*, Palazzo Grassi, Venice, 1984; *Traum und Wirklichkeit: Wien 1870–1930*, Künstlerhaus, Vienna, 1985; *Vienne 1880–1938: L'Apocalypse Joyeuse*, Centre Georges Pompidou, Paris, 1986; *Vienna 1900*, Museum of Modern Art, New York, 1986.
[11] *Alfred Kubin: Visions from the Other Side*, Galerie St. Etienne, New York, March 22–May 7, 1983.

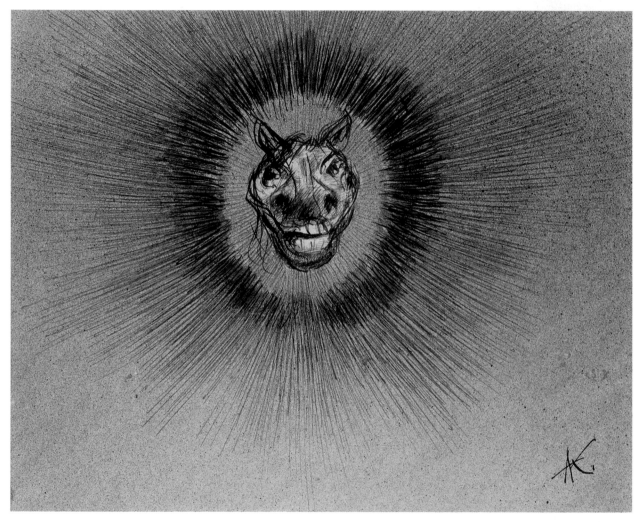

Stallion, ca. 1899 cat. I.2

Der Schlemmer

The Glutton, 1904 cat. I.5

Charon, ca. 1902 cat. I.3

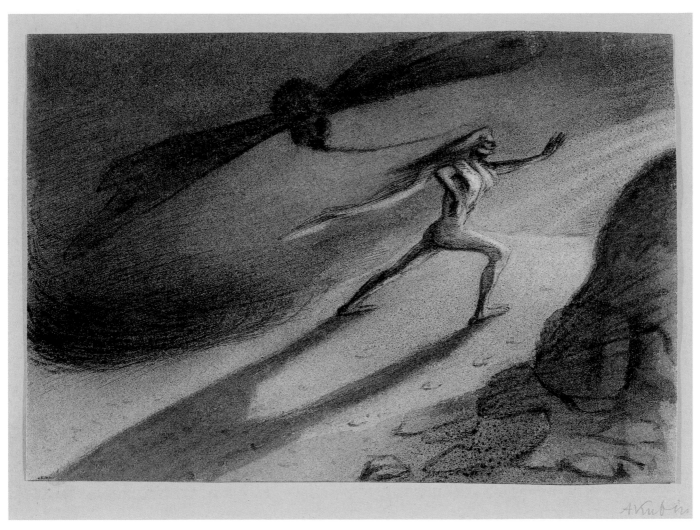

Man in a Storm, ca. 1903 cat. I.4

GUSTAV KLIMT

* JULY 14, 1862, BAUMGARTEN
† FEBRUARY 6, 1918, VIENNA

Invitation to the exhibition
*Oil Paintings and Drawings
by Gustav Klimt*, Galerie
St. Etienne, New York,
April 1–30, 1959

During the twentieth century, there were few artists whose reception and evaluation outside the borders of their native land varied as dramatically as Gustav Klimt's. Though in his lifetime he was idolized at home by the members of a small circle, and enjoyed an international reputation as the most important Austrian artist, there was on the whole very little real understanding of his work.[1] After his death, Klimt's name fell into oblivion for a period, until a revival of interest in the 1960s swiftly brought about a veritable Klimt "cult," which continues to this day.

It was apparent even to many of Klimt's contemporaries that the evolution of his style depended to a large degree on the stimulus provided by his familiarity with art from abroad. His work may indeed be seen partly as a seismographic reaction to the ever-varying range of exhibitions organized by the Vienna Secession, where he was given his first retrospective in 1903. While Klimt did little to stimulate and maintain international contacts, he was, of all the Viennese artists in his circle, the most fully engaged with a spectrum of non-Austrian art, both contemporary and from the past. It was, however, his practical friends within the Secession who kept up a vigorous international correspondence and who traveled throughout Europe to encourage international participation in the association's shows.[2]

A survey of the international reception of Klimt's work country by country reveals that he never exhibited in England during his lifetime. Yet reviews of the Secession exhibitions (and other mention of his work) were regularly published in the London art monthly *The Studio.* It was, however, some time before the Viennese correspondents of this publication recognized Klimt's genius for what it was. Wilhelm Schölermann, in his review of the second Secession presentation that opened in the fall of 1898, mentioned Klimt only in passing. And, although the review included a reproduction of his recently completed portrait of Sonja Knips (1898), there is no commentary at all on this painting.[3]

By 1906, Klimt's reputation in Britain had gained more terrain, and *The Art-Revival in Austria*, a special issue of *The Studio*, paid particular attention to him. Its survey article on "Modern Painting in Austria," by the Vienna-based Hungarian critic Ludwig Hevesi, focused largely on Klimt's work.[4] By this time, the regular *Studio* reviews from Vienna had begun to speak favorably of the artist; and at the high point of his career—his appearance as the main attraction at the *Kunstschau* of 1908—*The Studio*'s critic observed: "Klimt's is essentially an art for the few: the many cannot appreciate its subtle qualities, but how great is the enjoyment it gives to those who understand it!"[5]

On the Continent, Klimt's reputation had been growing since 1900. In Paris, his work was the principal draw in the Austrian pavilion at the Exposition Universelle of 1900, where he was represented by his 1898 portrait of Sonja Knips; his allegorical manifesto of the same year, *Pallas Athene*; and most notably, his controversial *Philosophie (Philosophy;* 1900). This latter was the first of a trio of paintings Klimt was commissioned to create for the ceiling of the Wiener Universität's Great Hall, representing the "University Faculties":

Philosophie, Medizin (Medicine; 1901), and *Jurisprudenz (Jurisprudence;* 1903). The three paintings caused an uproar every time they were exhibited—ultimately, they were rejected by the university both for their purported pessimism and for their formal qualities. Nonetheless, they constitute a key phase in Klimt's artistic development. At the 1900 Paris exhibition, *Philosophie* was awarded a *grand prix,* a considerable triumph in view of the scandal that the picture had only recently provoked when exhibited at the Secession in Vienna. French commentary on this painting was, however, not without its skeptical voices, particular objections being made to the unusual stylistic eclecticism of Klimt's work. One Paris critic characterized Klimt's style as "a curious mixture of classical memories and impressionistic disorder."[6] It was perhaps inevitable that in France, the birthplace of Impressionism, Klimt's own belated and highly individual accommodation of elements of this movement should provoke such a reaction. In any event, Klimt never again exhibited in France.

In Belgium, Klimt participated in the *Wereldtentoonstelling* (World Exhibition) held in Antwerp in 1894—where his Auditorium of the theater at Schloss Eszterhazy in Totis won him an honorary diploma.[7] But his relationship to the Belgian art scene was truly established through his contribution to the decorative scheme at the Palais Stoclet in Brussels. This was a project on which Josef Hoffmann and many members of the Wiener Werkstätte collaborated. Between 1905 and 1911, Klimt worked intermittently on his design for the mozaic-frieze in the dining room.

It was, however, in Italy that Klimt's work received the most positive critical reception during his lifetime. The artist himself felt a particular affinity with Italy's early cultural history, especially with the Byzantine mosaics of Ravenna, which he visited in 1903. Although his work was exhibited relatively rarely in Italy, two key paintings were acquired by Italian public collections. During the Venice Biennale of 1910, in which enormous critical attention was paid to Klimt's nineteen exhibited pictures, the Venetian Galleria d'Arte Moderna acquired the painting of 1909 shown as *Judith II* (now better known as *Salome*). And in 1912, the Galleria Nazionale d'Arte Moderna in Rome bought the *Drei Lebensalter (Three Ages of Woman;* 1905), which had been awarded a gold medal at the large international exhibition held in the Italian capital in

1911 to mark the fiftieth anniversary of the unification of Italy.

In Germany, Klimt had an intense, and complex, relationship with critics. In leading journals such as *Deutsche Kunst und Dekoration* or *Die Kunst für Alle,* Austrian artists were generally regarded as belonging to the wider Germanic cultural sphere. From the founding of the Secession in Vienna, the development of art life in that city was followed with great interest in these publications, with commentary by Austrians as well as by Germans.

One of the most highly regarded German critics was the art historian Richard Muther, who had reservations about Klimt: "I always find that I favor artists with a strong tendency toward the natural, such as [Gustave] Courbet, [Wilhelm] Leibl, and

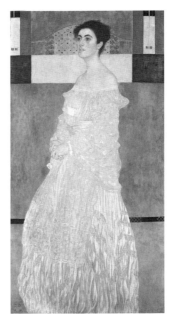

[Wilhelm] Trübner; whereas I become irritated by the 'high flavor' and over-refinement that one finds in most of Klimt's works. ..." Muther was further irritated by Klimt's preference for an "anti-German" type of woman: "Klimt prefers a type of femininity that shows an almost youthlike slenderness and a 'high flavor' redolent of the Old Testament—and this, admittedly, does not appeal to everyone." In spite of these reservations, Muther conceded that Klimt "has an incomparable greatness. For, within the European art of our day, he has not a single equal in terms of quality."[8]

Muther's younger German colleague Julius Meier-Graefe—equally internationalist but more emphati-

Cover of *The Art-Revival in Austria* (special issue of *The Studio*), 1906 (reprinted 1971), with a reproduction of Gustav Klimt's *Portrait of Margarethe Stonborough-Wittgenstein,* 1905

cally modernist—also had varied connections with the Secession in Vienna. The chapter on "The New Vienna" in his highly influential three-volume study of 1904, *Entwicklungsgeschichte der modernen Kunst* (published in English in 1908 as *Modern Art: Being a Contribution to a New System of Aes-*

thetics), had little to say in favor of the Viennese association or of Klimt himself. "It was a question," Meier-Graefe asserted, "as to whether too few or too many [examples of contemporary foreign art] were being absorbed [in Vienna]. Klimt, with his enormous enthusiasm, struggled in vain for a technique [of painting] that would be capable of giving enduring value to the great urge to expression." Ultimately, Meier-Graefe found Klimt's allegories too complex, and felt that his motifs failed to achieve the requisite degree of "formal unity."[9]

A decidedly positive view of Klimt's "Viennese" quality, on the other hand, was adopted by the Dresden critic Joseph August Lux, who was a keen champion of Viennese *Stilkunst* (stylizing art), and thus took a pro-Secessionist line. Writing in

Deutsche Kunst und Dekoration in 1902 of Klimt's *Beethovenfries (Beethoven Frieze)*—the mural created by the artist as part of the elaborate installation at the fourteenth Secession exhibition that year—he observed: "[Klimt] emerges from our entire modern culture as one of its finest flowers. He is … Viennese through and through. This is a quality that has been characterized as a mixture of lightheartedness and melancholy, of a sensual joy in life and a super-sensual longing for whatever is most distant, most profound, and most wondrous."[10]

Further enthusiastic commentary on Klimt came from the pen of Franz Servaes, a critic originally based in Berlin, who was in Vienna during the early years of the Secession and was a regular contributor to the leading Viennese daily *Neue Freie Presse.* Servaes disagreed with Muther's negative assessment of the character and quality of Klimt's paintings for the university. In rebuttal to Muther's comments that the allegorical works were "a hazy chaos made up of the subtle tones of gleaming bodies,"[11] Servaes wrote: "In the … German-speaking countries, I know of scarcely any other artist who would have been as capable as Klimt has proved to be at combining audacity and truth with the magic and seductive sweetness of an entirely personal charm. … What a stream of melody in his treatment of line is here, united with the sure rhythm of composition!"[12]

While Klimt's central presence at the *Kunstschau* of 1908 was also recognized internationally as a triumph, his one-man presentation of 1910 at the Viennese Galerie Miethke was received very negatively by the majority of critics. On this occasion, Klimt showed not only several new paintings but also a large number of drawn studies, which many critics found to be offensive on account of their erotic character. There was much talk of "obscenity" and "pornography," just as there had been eight years earlier when the *Beethovenfries* was first unveiled. Servaes insisted that Klimt's art was rooted in Vienna and was only comprehensible in terms of that city.[13] Indeed, it was as if Klimt himself wanted to remain in Vienna, but nonetheless sought, through his art, to escape its constrictions, as the pugnacious Viennese critic Berta Zuckerkandl observed in 1911.[14] Zuckerkandl penned an embittered assessment of the antimodernist intellectual climate that prevailed in the imperial capital—a climate that had also succeeded in "freezing out"

the composer and conductor Gustav Mahler. The increasingly negative reaction to Klimt's work in Vienna further encouraged him to concentrate on exhibiting abroad, above all in Germany. The commentary published there conveys the impression that Klimt's work was not entirely welcomed by the German public, and that, above all in the northern region, there was a certain skepticism toward his work. And, indeed, measured in terms of the frequency with which he exhibited in cities within the German empire, the number of paintings Klimt sold in that country was astonishingly low. Only two of his pictures were acquired by public collections. In 1901, the Neue Pinakothek in Munich acquired *Musik I (Music I;* 1895) when it was shown at the city's *Achte Internationale Kunstausstellung* (Eighth International Art Exhibition); and in 1912, at the large *Grosse Kunstausstellung* held in Dresden, the local Gemäldegalerie Neue Meister purchased the landscape *Buchenwald (Beech Forest;* 1902). Klimt's drawings did, however, find buyers in Germany starting at a relatively early date. Beginning in 1905, they entered public collections in Dresden, Leipzig, Berlin, Bremen, Hamburg, Karlsruhe, Munich, Stuttgart, and Wuppertal.[15]

In 1905, the year Klimt and his closest colleagues left the Viennese Secession, he achieved his first substantial impact in Berlin when six of his paintings, including his recently completed *Drei Lebensalter*, formed part of the second large exhibition mounted by the Deutscher Künstlerbund (German Artists' Union), which had elected Klimt to its board in 1903. A Viennese friend of Klimt, the painter Carl Moll, reported that special rooms within the exhibition had been reserved for the work of Klimt and that of the Swiss painter Ferdinand Hodler. Klimt himself was present at the opening. According to Moll: "The character of Klimt's work did not suit Berlin. But it could not help recognizing his technical and stylistic mastery."[16]

Julius Norden, for example, characterized Klimt's work as "a synthesis of the most diverse elements, [in which] the naive and the perverse, refinement and frugality are to be found in the most intimate embrace." He concluded with the observation that "Klimt will have no followers, as Hodler no doubt will; his art is too personal for that; it achieves, moreover, a combination of tastefulness and ingenuity that one would be hard pressed to find elsewhere."[17] The important Berlin magazine *Kunst und Künstler* emphasized Klimt's proximity to the

Studio-Talk

KLIMT ROOM AT THE "KUNSTSCHAU" EXHIBITION, VIENNA ARRANGED BY PROF. KOLO MOSER

View of the Klimt room in the *Kunstschau*, Vienna, in the *International Studio*, 1908

applied arts, referring specifically to his exhibited paintings: "Klimt's works have such refinement, maintaining such high levels of production … and achieving such a charming idleness, that even when a knight with a sword is depicted, a similarity to the appearance of Viennese applied art is particularly evident."[18] Indeed, it is in the Northern/German reception of this picture of a knight, titled *Das Leben ein Kampf (Life is a Struggle;* 1903), that the differences between the German and the Austrian points of view reach their focus. While in nationalistic German art of the early twentieth century Nietzschean heroism is embodied in Teutonic, muscular male nudes, or knights ready for battle, in Klimt's painting this idealism is instead evoked by a gold-gleaming fairy-tale figure who shows little or no drive to act.

Klimt's next startling appearance in Berlin took place in 1907, when his *Philosophie, Medizin,* and *Jurisprudenz* were exhibited as a "sensation" at the gallery of Keller & Reiner. Since their unveiling, these paintings had prompted intense debate both in Austria and elsewhere on the very contemporary question of the role of monumental decorative painting. Reporting on this Berlin exhibition, Zuckerkandl (who had vigorously defended Klimt's university paintings in various Viennese publications), wrote enthusiastically in *Deutsche Kunst und Dekoration*: "At a moment when the great art of decorative painting in Austria or Germany had not yet found a home … [Klimt's] genius was prompted by an internal demand to develop a monumental, planar style of painting, achieving something that we have never before encountered in a work of art; and, with the decorative vision of a colorist who

Gustav Klimt, *Das Leben ein Kampf* (*Life is a Struggle,* also known as *Der Goldene Ritter,* or *The Golden Knight),* 1903. Aichi Prefectural Museum of Art, Nagoya

models forms with the merest touch of tone, he has invented accents that are all but unknown in the images that we have become used to seeing."[19] The majority of German commentators, however, took a rather different view of this matter, above all with regard to the question of monumentality. On seeing Klimt's university paintings, Emil Heilbutt, a Northern German critic, rhetorically asked: "Are they so very different in Vienna than we are?"[20] Here again, a German critic was irked by Klimt's perceived "affectation," his way of borrowing different styles and yet having his works deemed "original." Another critic, Arthur Neisser, wrote of the three paintings: "Here we find an aesthetically all too refined painter of women, wrestling with his material; and, although he endeavors to sketch it in a painterly fashion in accordance with his imagination, he does not succeed in perfectly mastering it in intellectual terms."[21]

After 1910, Klimt exhibited more frequently in Germany; and it was around this time that he became increasingly appreciated as a draftsman. In 1911, the critic for *Kunstchronik* extolled his drawings in the Galerie Miethke show as revealing "Klimt as one of the most exquisite artists of our time, one who has mastered form and the expression of form down to the finest and subtlest nuance."[22]

During the last few years of Klimt's life, the reaction of German critics to his work swung between admiration and rejection. The landscapes and portraits that he showed at the large exhibition held in Dresden in 1912 were hailed by one critic as "the most outstanding achievements."[23] Still, the majority were annoyed and disapproving, above all with regard to the paintings that treated the great questions of life and death in an allegorical fashion. Significantly, it was not in Germany but in Prague that one of Klimt's monumental allegorical works was acquired. There, the Moderne Galerie purchased his key 1913 work *Die Jungfrau (The Maiden),* when it was included in the exhibition of the Deutsch-Österreichischer Künstlerbund (German-Austrian artists' union) presented at the Rudolfinum in 1914.

A particularly important moment during this last phase of Klimt's career with regard to his reception in Germany was the inclusion of his work—alongside that of many younger Viennese artists (Egon Schiele, Oskar Kokoschka, and Anton Faistauer, among others)—at the *Wiener Kunstschau* presented at the Berliner Secession in 1916. Writing of this event in *Deutsche Kunst und Dekoration,* Servaes now assumed a more distanced position in relation to the Viennese: although "Klimt and his people" were by no means unknown in Berlin, he argued, "they nonetheless still appear to have an alien quality. They seem to have something of the hothouse about them, something that brings out countless artistic flowers, yet that is in many cases already ailing in its over-refined sophistication." Servaes chose Klimt and Lovis Corinth as examples to demonstrate the antagonism between Vienna and Berlin. In Berlin, he believed, "We are much more naïve, more robust, more eager to grasp hold of life. … Take Corinth, for instance; he's nearing sixty, yet it's as if he still has his artistic development all ahead of him. In the case of Klimt, there is a finality about everything. He creates art only out of art, and himself transforms each painting into a jewel." Nonetheless, he felt that Klimt was "Vienna's most characteristic and congenial master of painting," one who stood "head and shoulders above any artist of his generation"; this was also true, he thought, of Klimt's work as a draftsman.[24]

Writing in *Kunst und Künstler,* Karl Scheffler went even further than Servaes in emphasizing the marked difference between the German and Austrian approaches to painting, which in his view was a distinction indisputably in favor of the artistic superiority of the North (Berlin) over the South (Vienna). Commenting on the Berlin exhibition of 1916, Scheffler noted: "Viennese painting lacked the spirit of Protestantism. That is to say: the readiness to go into depth." Where Viennese painting had an essentially decorative purpose, that of Berlin had a revelatory character; north German painting was masculine, Viennese painting "utterly feminine, it is charming but not creative."[25]

In the winter of 1917–18, Klimt's picture *Tod und Leben (Death and Life;* 1916) was exhibited in Stockholm. The artist died in February 1918; he thus did not live to see the exhibition *Ein Jahrhundert Wiener Malerei* (A Hundred Years of Viennese Painting), presented in Zürich later that year, which included fourteen of his images.

The repeatedly voiced reproach in the German-speaking countries that Klimt's work was too decorative, too "feminine," too eclectic, was to cling for some time to his posthumous reputation. One of very few critics to offer an objective and balanced assessment of Klimt's work was the versatile Vien-

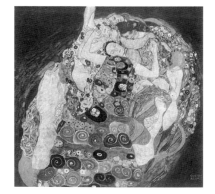

Gustav Klimt, *Die Jungfrau (The Maiden),* 1913. Narodni Gallery, Prague

nese art historian Hans Tietze. In 1918, in his obituary for Klimt in *Kunstchronik*, Tietze sought to define the artist's international significance: "Klimt, who like no other individual embodied both the strengths and the weaknesses of Viennese painting, led it out of the isolation in which it had been vegetating, and brought it back into the great world; he taught it how to become once again militantly conscious of its own vitality, and he won a place for it that clearly distinguished it from German and other national categories of contemporary art."[26]

The first serious posthumous appraisal of Klimt's entire œuvre was achieved in the monograph published in 1920 by the art historian Max Eisler, who had known Klimt, although he was twenty years the artist's junior. While he felt that Klimt's achievement constituted a "bridge of historical necessity and significance,"[27] other authors writing in the 1920s tended to distance themselves from his œuvre. The painter Anton Faistauer (a friend of Schiele), writing in 1921, said that Klimt was an "outsider … among European artists." He maintained that Klimt's art was "incomprehensible from the Western, the German, and the French points of view," and that this inability to understand accounted for the "unconditional rejection that his art had so far encountered."[28] In an essay published in 1924, "Die Stellung Wiens in der internationalen Kunst" (The place of Vienna in international art), the critic Heinrich Glück wrote that Klimt had "become a martyr to a certain conception of the quality of Vienna," for it was "not generally recognized that his achievement had been to translate the international into the Viennese. …"[29]

In Italy, however, Klimt was and continued to be extremely well received. As the critic A. Moraini reported in the *Bollettino d'Arte* of 1921–22, an entire group of artists was still working in a decorative manner derived from that of Klimt.[30] In this, Italy remained something of an exception within Europe.

During the National Socialist era in Germany and later in Austria, Klimt was not branded "degenerate." In fact, in 1934 the Austrian Federal Ministry of Trade arranged an exhibition in London, with the title *Austria in London*, in which four landscapes and a portrait (of Adele Bloch Bauer) by Klimt were featured, along with one of his drawings.[31] In the 1941 publication *Stilwende* (Turning Points in Style), a retrospective account of the years around 1900, the assessment of Klimt offered by Friedrich Ahlers-Hestermann is, unsurprisingly, imbued with a familiar sense of the German-Austrian polarity. In contrast to the "powerful and masculine gestures" found in the work of Hodler, the relationship between the human body and elements of ornamentation in the paintings of Klimt was, according to Ahlers-Hestermann, "only a richly nuanced, albeit also unresolved, mixture."[32]

The much-maligned university paintings, *Philosophie*, *Medizin*, and *Jurisprudenz*, were nonetheless included in an exhibition mounted in Vienna in 1943—a large survey of Klimt's œuvre presented in the building formerly owned by the Vienna Secession (which had been disbanded by the National Socialists after the *Anschluss* of 1938). Curated by Fritz Novotny, this show was effectively the first step toward a new, positive approach to Klimt's work, even though its location and timing meant that it had virtually no international resonance.[33] This would also be the last opportunity to study so much of Klimt's work in one location; shortly before the end of World War II, a total of nine major paintings—including all of those made for the Wiener Universität—were destroyed in a fire at Schloss Immendorf.

The history of the reception of Klimt's work after 1945 is packed with incident and so can only be outlined here. The first exhibitions to be devoted to Klimt in the immediate postwar period (all of them relatively small in scale) took place in Austria, Italy, and Switzerland. In Vienna, Rudolf Leopold established the beginnings of his later internationally renowned collection of work by Austrian artists of the nineteenth and twentieth centuries, among whom Klimt was particularly well represented. Of great art historical significance was *Um 1900* (Around 1900), presented in Zürich in 1952, the first show to offer a comprehensive overview of all the principal European centers of art at the turn of the century. According to the curator of this exhibition, Hans Curjel, Klimt was "the great force behind the Viennese group."[34]

In 1958, to mark the fortieth anniversary of Klimt's death, the thirty-ninth Venice Biennale mounted a wide-ranging Klimt retrospective. The show contributed significantly to a new and broader appreciation of his work. The first doctoral dissertations on Klimt were completed in 1955 and 1958, at the universities of Graz and Vienna, respectively.[35] As international interest in Symbolism, decadence,

Cover of the exhibition catalogue
Gustav Klimt, Vienna, 1943

and the fin de siècle in art and literature grew during the course of the 1960s, Klimt too began to appear in a new light. Within the wider context of an intensifying pan-European engagement with the turn of the century, the phenomenon of "Vienna 1900" began to take on a life of its own. In 1964, several museums in Vienna collaborated in mounting an exhibition with this title. This offered the first integrated overview of the achievement of artists in many fields—painting, printmaking, book and poster design, and other categories of applied art—and Klimt shone as the first among equals.[36]

Three publications of the late 1960s soon became established as standard reference points: the Klimt monograph written by Fritz Novotny and Johannes Dobai, which was accompanied by a catalogue raisonné of his paintings (1967); the publication *Gustav Klimt. Dokumentation* by Christian M. Nebehay (1969); and Werner Hofmann's cultural-historical study *Gustav Klimt und die Wiener Jahrhundertwende* (1970).[37] Important exhibitions also took place in these years: *Gustav Klimt—Paintings and Drawings* at Marlborough Fine Art in London in 1965; a 1968 exhibition of the work of Klimt and Schiele, commemorating the fiftieth anniversary of both their deaths, held at the Österreichische Galerie Belvedere and the Albertina in Vienna; and the comprehensive survey of the drawings of Klimt and Henri Matisse, which formed part of the third *Internationale der Zeichnung* (International Exhibition of Drawings) in Darmstadt (1970), which received euphoric critical reception. During the 1970s, Klimt emerged as the epitome of the stylizing fin-de-siècle artist, and he effectively became an international commodity. Sale prices for his relatively few paintings and his numerous drawings rose dramatically. Meanwhile, the critical and art historical reception of his work was divided. On one hand, critical assessment gave way entirely to a mystifying nostalgia and a longing to luxuriate in line, color, and erotic subtlety—a tendency of which the art market was only too happy to take advantage. On the other hand, there was increasing scholarly engagement with Klimt's work, but also a growing concentration on very specific issues.[38] A milestone in Klimt research was the publication between 1980 and 1989 of the four-volume catalogue raisonné of his drawings, the painstaking work of Alice Strobl.[39]

The 1980s saw the beginning of what would be a long, international series of ambitious exhibitions

Josef Hoffmann, proposed design for the Klimt room, Louisiana Purchase International Exposition, Saint Louis, 1904

devoted to the theme of Vienna in 1900, a series initiated by the *Experiment Weltuntergang* (Experiment in the End of the World) at the Hamburger Kunsthalle in 1981. The exhibition held at the Künstlerhaus in Vienna in 1985, *Traum und Wirklichkeit* (Dream and Reality), served as the principal model for these shows, which were presented in Venice, Paris, New York, Madrid, Moscow, Stockholm, Tokyo, Frankfurt, Copenhagen, Amsterdam, and other cities. On each occasion, Klimt was celebrated as the pioneer of modernism and the precursor of Austrian Expressionism, very often forming a triumvirate with Schiele and Kokoschka. The most comprehensive one-man show to be devoted to Klimt was presented at the Kunsthaus Zürich in 1992. As in the past, shows of, or centered on, Klimt's work could guarantee record attendance figures, as demonstrated in the case of the exhibition *Klimt und die Frauen* (Klimt and Women) at the Österreichische Galerie Belvedere in Vienna, which closed in January 2001.[40]

KLIMT AND THE UNITED STATES

The history of Klimt's reception in the United States begins with a show that in fact never took place, although it was planned for inclusion in the 1904 Saint Louis World's Fair in Missouri. The Secession avant-garde group known as the Stilisten (or "stylizing artists"), which centered around Klimt, submitted a highly unconventional scheme to the exhibition's jury: their proposal comprised an austere setting designed by Josef Hoffmann, which was to contain Klimt's *Philosophie* and *Jurisprudenz*, alongside two of his landscape paintings, two pieces by the young sculptor Franz Metzner, and a few small works of applied art by three other members of the Secession. This proposal was rejected on the grounds that it accommodated too few works of art and represented too few artists. Hoffmann and his colleagues, however, remained committed to their quest for an imposing and unified effect, and they refused to compromise; ultimately, they withdrew altogether from participation in the fair (which was later known officially as the Louisiana Purchase International Exposition).

This "Saint Louis crisis," which was widely and ardently discussed in Vienna, further aggravated differences between the Stilisten and their adversaries within the Secession, the so-called Naturalisten (or "naturalists"). This was one of the chief

factors that led to the departure of the "Klimt Group" from the association in 1905.[41] What remained of the project was a "virtual" exhibition in the form of a publication (it was, in fact, the final issue of the Secession magazine *Ver Sacrum*) illustrating Hoffmann's room design and some of the works that had been intended for exhibition. Also included in the issue was a statement on the crisis, written by the Stilisten.[42]

Throughout the entire first half of the twentieth century, there was no significant American interest in the work of Klimt. This indifference finds a reflection in the words of Fritz Waerndorfer, a co-founder in 1903 of the Wiener Werkstätte, who had moved to the United States for financial reasons in 1914 (and remained there until his death in 1939). On October 24, 1924 he wrote to the architect Eduard Wimmer, who was then in Vienna: "Undertake NOTHING regarding the sale of paintings by Klimt in Chicago. You will have endless trouble and inconvenience, and you will sell NO Klimts in Chicago, and then in Vienna they will say that you failed to sell anything by Klimt simply because you were unable to get enough money by this means. Whatever you do, wait until Chicago of its own accord declares that it dearly desires to have a picture by Klimt."[43] This statement, from the pen of a once very wealthy man who had done so much to foster the development of Viennese modernism around 1900, starkly reveals how little regard there was for Klimt in America in the 1920s.

This situation changed as a result of the emigration from Europe to America of numerous Jews—among them many art historians, art collectors, and art dealers—with the advent of the National Socialist regime in Germany and Austria, and in 1939 the start of World War II. One of these émigrés was Otto Kallir, the former director of the Neue Galerie in Vienna. In the exhibition *Saved from Europe*, mounted at Kallir's Galerie St. Etienne in New York in 1940, a portrait and a landscape by Klimt were shown alongside works by Egon Schiele, Käthe Kollwitz, Max Liebermann, Pablo Picasso, Henri de Toulouse-Lautrec, and other masters of classical modernism.[44] Commentary on Klimt's pictures at the Galerie St. Etienne in the *New York World Telegram* reveals to what extent the American point of view was primarily oriented toward the art of France: "Klimt is a kind of German Seurat, his work being thickly veiled with the pointillism of the

Frenchman, but lacking its essential architectural structure."[45]

A reflection of the gradual growth of American interest in Klimt after the end of World War II was the 1950 exhibition *Austrian Art of the Nineteenth Century*, also at the Galerie St. Etienne, which included no fewer than six of the artist's paintings. Of these, two were portraits (one of them, of Friederike Beer-Monti, was lent by the sitter, who was by this time a resident in America) and the other four were landscapes. As had been the case a decade earlier, American reviewers of this exhibition emphasized Klimt's apparent proximity to the work of the French Impressionists. As Stuart Preston wrote in the *New York Times*: "Vienna was no Paris and neither individually nor collectively can these Austrians stand up to their French contemporaries. But their art has high moments as well as a strong national character. ..."[46]

A moment of some significance in the evolution of American attitudes toward the work of Klimt occurred in 1959, when Kallir mounted the first one-man show of the artist's work (drawings as well as paintings) to take place in the United States. Some of the loans came from important public collections (the Fogg Art Museum in Cambridge, Massachusetts, and the Museum of Modern Art in New York). However, the majority were provided by private collectors, among them Friederike Beer-Monti, as well as Alma Mahler-Werfel and Mary Urban, the widow of the Austro-American architect and designer Joseph Urban. In his catalogue text, Kallir emphasized Klimt's uniqueness as a portraitist while seeking to distinguish his work from that of the Expressionists: "His portraits are full of sharp characterization and psychological insight which is, however, never carried to the analytical extreme of expressionism."[47] In the published reviews of this exhibition, the tendency to focus on the "impressionistic" element in Klimt's work had now been supplemented by an engagement with its Symbolist aspect.

The New York one-man show of 1959 was followed by an almost continuous series of exhibitions mounted in museums and galleries across America. These have variously focused on Klimt in his own right, considered him in association or comparison with other artists, or presented him as the key to understanding an entire historical period. Along with Kallir, the Viennese-born Serge Sabarsky played an important role in building the

Gustav Klimt and Friederike Beer-Monti in Weissenbach on the Attersee, 1916

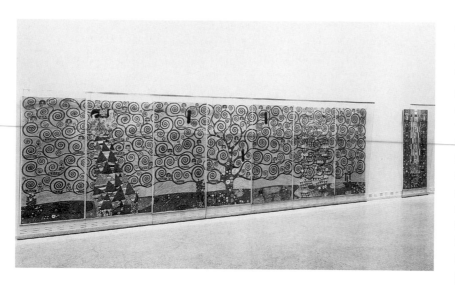

Installation view of *Gustav Klimt and Egon Schiele* at the Solomon R. Guggenheim Museum, New York, February 5–April 25, 1965. Photograph © The Solomon R. Guggenheim Foundation, New York

reputation of Klimt, both in the United States and abroad. Sabarsky emigrated to America in 1938, and in 1950 began to collect German and Austrian art of the early twentieth century. The hundreds of exhibitions he organized internationally contributed to the worldwide awareness of the work of Klimt. Once established, the American reception of Klimt's work is not easy to characterize in its entirety. In general, however, its evolution may be said to reflect that of its European counterpart. In 1965, inspired by Fritz Novotny (in Vienna) and supported by Kallir (in New York), Thomas M. Messer organized the first large American exhibition to be devoted exclusively to Gustav Klimt and Egon Schiele, at the Solomon R. Guggenheim Museum in New York. Included in this comprehensive and sensational show were not only paintings and drawings from American collections, but also, for the first time, loans from Vienna—from the Galerie Belvedere and the Albertina, among other sources. The doyen of Klimt studies at the time, Johannes Dobai, contributed a seminal essay on the artist to the show's catalogue. In the catalogue's general introduction, Messer wrote: "Klimt stood outside our field of vision apparently because we failed to look, or at least because we were incapable of seeing while our attention was focused in other directions. During the first half of the century, when Klimt went largely unnoticed, we were situated within a range of glaring lights that delighted and totally absorbed our vision. Thus it is not surprising that our averted faces could not be mirrored in the faintly shimmering surfaces of Klimt's subtle art."[48] In the commentary on this exhibition, there first

emerged a tendency in America, as in Europe, to see Klimt and Schiele as inextricable from the era in which they lived.

There is no doubt that this exhibition did a great deal to encourage scholarly fascination with the literature, the psychoanalysis, the music, the architecture, and the applied and fine arts of Vienna around 1900. There was now increased contact between American and European scholars, while academic conferences and publications sought to establish interdisciplinary connections. The achievements of Carl Schorske, Allan Janik and Stephen Toulmin, James Shedel, and Alessandra Comini are outstanding. Meanwhile, on the popular level, this rediscovery of the "world of yesterday" provided a context in which Klimt attained the status of a veritable cult figure, in America no less than in Europe.

In 1986, two decades after the Klimt show was mounted at the Guggenheim, the Museum of Modern Art in New York organized the exhibition *Vienna 1900* on the model of shows presented in Vienna (1985) and Paris (1986). In his introduction to the catalogue, curator Kirk Varnedoe proposed that "Vienna around 1900" appeared to many as the "modern archetype of a doomed society, in which brilliant achievements glowed in the gathering twilight and music covered distant thunder," as the breeding ground of "genius and neurosis."[49] And he noted that this "constellation of ideas" had been steadily gaining currency in the United States since the 1960s.

The latest research on Klimt has succeeded in overcoming the negative influence of the flood of superficial and popularizing writing and the general kitschifying of Klimt's achievement. As such, it has demonstrated considerable advances, evident most recently in the catalogue of a comprehensive exhibition, *Gustav Klimt—Modernism in the Making*, presented at the National Gallery of Canada in Ottawa beginning in June 2001. Nonetheless, the last word has yet to be spoken on Klimt's status and significance to artistic developments of his time, from a truly international perspective. There also remains the question of the complex and contradictory personality of this rather secretive artist, who still holds many mysteries for scholars the world over.

Marian Bisanz-Prakken
Translated from the German by Elizabeth Clegg.

1 The question as to how Klimt's work was received abroad during his lifetime has been answered most thoroughly by the scholar Alice Strobl in her four-volume catalogue raisonné of the artist's drawings. Considerable attention is paid in this publication to commentary appearing in the press, in specialized art journals, and elsewhere both within and outside Austria-Hungary. The observations that follow are principally drawn from this source, but they are also derived from my own research. See Strobl, *Gustav Klimt, die Zeichnungen,* 4 vols., Salzburg: Galerie Welz, 1980–89. On Klimt's participation in exhibitions outside Vienna, see Christian M. Nebehay, *Gustav Klimt. Dokumentation,* Vienna: Verlag der Galerie Christian M. Nebehay, 1969, pp. 516–520. For further discussion of Klimt's international reception, particularly in France and Italy, see Emily Braun, "Klimtomania/Klimtophobia," in: *Gustav Klimt: Modernism in the Making,* ed. by Colin Bailey, exhibition cat., Ottawa, National Gallery, 2001, pp. 41–53.

2 This aspect of Klimt's career is discussed in Marian Bisanz-Prakken, "Gustav Klimt und die frühe Secession," in: *Heiliger Frühling. Gustav Klimt und die Anfänge der Wiener Secession,* ed. by Bisanz-Prakken, exhibition cat., Vienna, Graphische Sammlung Albertina, 1998–99, pp. 73–79.

3 W.S. [Wilhelm Schölermann], "Art in Vienna," in: *The Studio,* vol. 16 (1899), p. 36.

4 Ludwig Hevesi, "Modern Painting in Austria," in: *The Art-Revival in Austria,* *(The Studio* Special Issue) ed. by Charles Holmer, London, 1906, pp. A v–vi.

5 A.S. L. [A. S. Levetus], "Studio-Talk: Vienna," in: *The Studio,* vol. 44, no. 186 (September 1908), p. 314.

6 Georges Lafenestre, "L'Exposition Universelle. La peinture, II: 'Les écoles étrangères,'" in: *Revue de l'Art Ancien et Moderne,* vol. 8, no. 2 (1900), p. 292.

7 On Klimt's success at Antwerp, see Nebehay, *Gustav Klimt* (as note 1), p. 510.

8 Richard Muther, *Geschichte der Malerei,* vol. 3, Leipzig: Konrad Grethlein's Verlag, 1909, pp. 583–585.

9 Julius Meier-Graefe, *Entwicklungsgeschichte der modernen Kunst,* Stuttgart: Verlag Julius Hoffmann, vol. 2, 1904, pp. 694–695.

10 Joseph August Lux, "Klinger's Beethoven und die Moderne Raum-Kunst," in: *Deutsche Kunst und Dekoration,* vol. 5 (1902), pp. 479–480.

11 Richard Muther, *Geschichte der Malerei* (as note 8).

12 Franz Servaes, "Gustav Klimts Monumentalmalereien (Ausstellung der Wiener Secession)," in: *Hamburgischer Correspondent* (December 1, 1903, evening ed.), p. 3.

13 Franz Servaes, "Ein Streifzug durch die Wiener Malerei," in: *Kunst und Künstler,* vol. 8 (1909–10), p. 588.

14 Berta Zuckerkandl, "Der Klimt-Fries," in: *Wiener Allgemeine Zeitung* (October 23, 1911), p. 3.

15 See Alice Strobl, "Eine Privatsammlung von Zeichnungen Gustav Klimts (1862–1918)," in: *Gustav Klimt—Zeichnungen aus Privatbesitz,* Düsseldorf: Boerner, 1987, p. 4; this volume of essays was published to accompany an exhibition mounted at C. G. Boerner, Düsseldorf. Among other issues, Strobl's essay discusses German perceptions of the significance of Klimt's drawings.

16 Carl Moll, cited in Nebehay, *Gustav Klimt* (as note 1), p. 496.

17 Julius Norden, "Der deutsche Künstlerbund in Berlin, II," in: *Die Gegenwart,* vol. 34 (1905), p. 29.

18 Emil Heilbutt, "Die zweite Ausstellung des deutschen Künstlerbundes," in: *Kunst und Künstler,* vol. 3 (1905), p. 428.

19 Berta Zuckerkandl, "Gustav Klimts Decken-Gemälde," in: *Deutsche Kunst und Dekoration,* vol. 11 (1908), p. 69.

20 Emil Heilbutt, "Klimts Deckenbilder für die Wiener Universität," in: *Die Nation,* vol. 14 (1906–07), p. 344.

21 Arthur Neisser, "Die Klimt-Ausstellung bei Keller und Reiner," in: *Die Gegenwart,* vol. 36, no. 9 (1907), p. 140.

22 O.P. [unidentified], "Ausstellungen," in: *Kunstchronik,* n.s., vol. 22 (1911), p. 214.

23 Pauls Schumann, "Die grosse Kunstausstellung Dresden 1. Allgemeine Ausstellung," in: *Die Kunst,* vol. 13, no. 25 (1912), p. 517.

24 Franz Servaes, "Wiener Kunstschau in Berlin," in: *Deutsche Kunst und Dekoration,* vol. 19, no. 38 (1916), pp. 41–42, 50.

25 Karl Scheffler, "Kunstausstellungen. Berlin," in: *Kunst und Künstler,* vol. 14, no. 21 (1917–18), pp. 311–312. The Berlin-Vienna controversy as it manifested in literature, theater, and journalism has been thoroughly researched in Peter Sprengel and George Stein, with a contribution from Barbara Noth, *Berliner und Wiener Moderne, Vermittlungen und Abgrenzungen in Literatur, Theater, Publizistik,* Vienna: Böhlau, 1998.

26 Hans Tietze, "Gustav Klimt †," in: *Kunstchronik,* n.s., vol. 29, no. 21 (1917–18), p. 219.

27 Max Eisler, *Gustav Klimt,* Vienna: Druck und Verlag der österreichischen Staatsdruckerei, 1920, p. 2.

28 Anton Faistauer, *Neue Malerei in Österreich,* Zürich: Amalthea, 1923, p. 11.

29 Heinrich Glück, "Die Stellung Wiens in der internationalen Kunst," in: *Der Cicerone,* vol. 16 (1924), p. 220.

30 A. Moraini, "Influenze straniere nell'arte italiana d'oggi," in: *Bollettino d'Arte,* vol. 1 (1921–22), p. 519.

31 The exhibition *Austria in London: Austrian National Exhibition of Industry, Art, Travel, Sport* was presented at Dorland Hall, Piccadilly Circus, London, April 16–May 12, 1934. As far as can be ascertained, the catalogue for this show has been hitherto overlooked by Klimt researchers. The patron of the exhibition was the Austrian Chancellor Englebert Dollfuss, who was assassinated on July 25 of the same year.

32 Friedrich Ahlers-Hestermann, *Stilwende,* Berlin: Gebr. Mann, 1941, Quotation taken from 1956 revised edition, p. 106.

33 *Gustav Klimt,* ed. by Fritz Novotny, exhibition cat., Vienna, Ausstellungshaus Friedrichstrasse (the former Secession building), 1943.

34 Hans Curjel, "Vom neunzehnten zum zwanzigsten Jahrhundert," in: *Um 1900, Art Nouveau und Jugendstil,* ed. by Curjel, exhibition cat., Zürich, Kunstgewerbemuseum, 1952, p. 16.

35 Ingomar Hatle, *Gustav Klimt, ein Wiener Maler des Jugendstils,* Ph.D. dissertation, Karl-Franzens-Universität Graz, 1955; Johannes Dobai, *Das Frühwerk Gustav Klimts,* Ph.D. dissertation, Universität Wien, 1958.

36 *Wien um 1900,* exhibition cat., Vienna, Secession, Graphische Sammlung Albertina, Künstlerhaus, and Österreichisches Museum für angewandte Kunst, 1964.

37 Fritz Novotny and Johannes Dobai, *Gustav Klimt,* Salzburg: Galerie Welz, 1967; 2d ed., 1975; Nebehay, *Gustav Klimt* (as note 1); and Werner Hofmann, *Gustav Klimt und die Wiener Jahrhundertwende,* Salzburg: Galerie Welz, 1970.

38 Notable among scholarly publications focusing on such specific issues are: Marian Bisanz-Prakken, *Gustav Klimt, der Beethovenfries: Geschichte, Funktion, Bedeutung,* Salzburg: Residenz, 1977; the essays by Gerbert Frodl, Wilhelm Mrazek, Herbert Giese, Peter Vergo, Christian M. Nebehay, Alice Strobl, Marian Bisanz-Prakken, Manfred Koller, and Johannes Dobai in: *Mitteilungen der Österreichischen Galerie,* nos. 66–77 (1978–79), as issue 22–23 of its series "Klimt Studien"; Thomas Zaunschirm, *Gustav Klimt, Margarethe Stonborough-Wittgenstein, Ein Österreichisches Schicksal,* Frankfurt am Main: Fischer Taschenbuch, 1987; Wolfgang Georg Fischer, *Gustav Klimt und Emilie Flöge. Genie und Talent,* Vienna: Brandstätter, 1987; Gottfried Fliedl, *Gustav Klimt (1862–1918). Die Welt in weiblicher Gestalt,* Cologne: Taschen, 1989; and Alfred Weidinger, "Natursehen am Attersee: Aspekte der Landschaftsmalerei Gustav Klimts," in: *Parnass,* vol. 17 (2000), pp. 56–71, special issue devoted to Gustav Klimt, including a bibliography of this author's earlier publications on Klimt's treatment of landscape.

The following exhibitions and their accompanying catalogues have also focused on specific themes in Klimt's work: *Inselräume—Teschner, Klimt und Flöge am Attersee,* exhibition cat., Vereinigung Junge Ausstellung—Secession, Seewalchen am Attersee Vienna, Secession, 1988–89; *Emilie Flöge und Gustav Klimt. Doppelporträt in Ideallandschaft,* ed. by Hans Bisanz, exhibition cat., Vienna, Hermesvilla (Historisches Museum der Stadt Wien), 1988; *Gustav Klimt und die Anfänge der Wiener Secession* (as note 2); *Gustav Klimt und die Frauen,* ed. by Tobias Natter and Gerbert Frodl, exhibition cat., Vienna, Österreichische Galerie Belvedere, 2000–01.

39 Strobl, *Gustav Klimt, die Zeichnungen* (as note 1).

40 *Gustav Klimt,* ed. by Toni Stooss and Christoph Doswald, exhibition cat., Kunsthaus Zürich, 1992; *Klimt und die Frauen* (as note 38). This last was an exhibition centered on a representative selection of female portraits by Klimt, and it supplied new biographical information on their subjects; the essays in the accompanying catalogue approached, from diverse viewpoints, the issue of Klimt's artistic rendering of women.

41 *Official Catalogue of Exhibits, Department of Art, Preliminary Edition, Universal Exposition, Saint Louis 1904, Austria:* pp. 80–86, cat. nos. 1–333.

42 *Die Wiener Secession und die Ausstellung [in] St. Louis,* special issue of *Ver Sacrum* (February 1904).

43 Fritz Waerndorfer, letter to Eduard Wimmer, October 4, 1924, in the Archives of the Universität für Angewandte Kunst, Vienna, inv. no. 11.214. I am grateful to Christian Witt-Dörring for drawing my attention to this document, which was discovered by Elisabeth Schmuttermeier.

44 *Saved from Europe,* ed. by Otto Kallir, exhibition cat., New York, Galerie St. Etienne, 1940.

45 "New Show at St. Etienne Galleries," in: *New York World Telegram* (June 26, 1940), clipping from Galerie St. Etienne archives.

46 Stuart Preston, "By Group and Singly, Last Century's Austrians—Tanguy and Others," in: *New York Times* (April 11, 1950), clipping from Galerie St. Etienne archives.

47 Otto Kallir, in: *Gustav Klimt,* exhibition cat., ed. by Kallir, New York, Galerie St. Etienne, 1959.

48 Thomas M. Messer, Introduction, in: *Gustav Klimt and Egon Schiele,* ed. by Messer, exhibition cat., New York, Solomon R. Guggenheim Museum Foundation, 1965, p. 10.

49 Kirk Varnedoe, Introduction, in: *Vienna 1900: Art, Architecture, and Design,* ed. by Varnedoe, exhibition cat., New York, Museum of Modern Art, 1986, pp. 17–20.

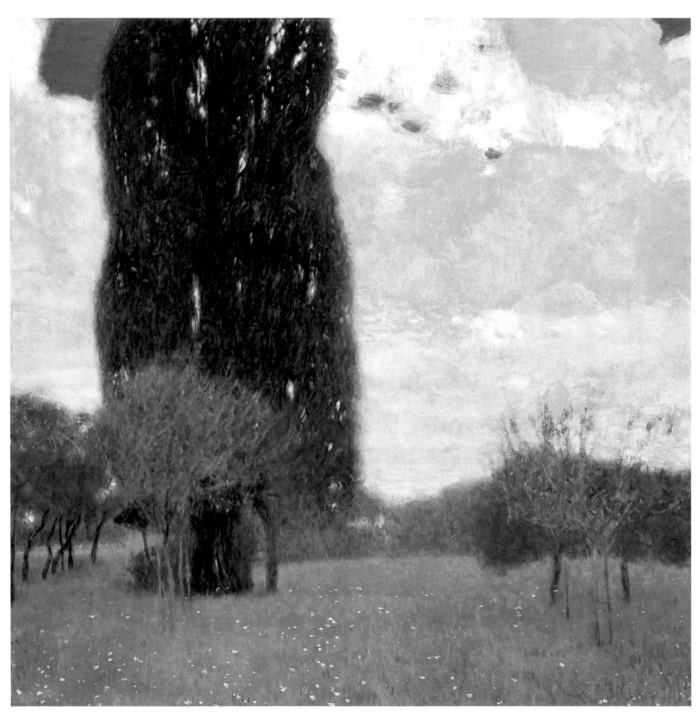

The Tall Poplar Tree I, 1900 cat. I.6

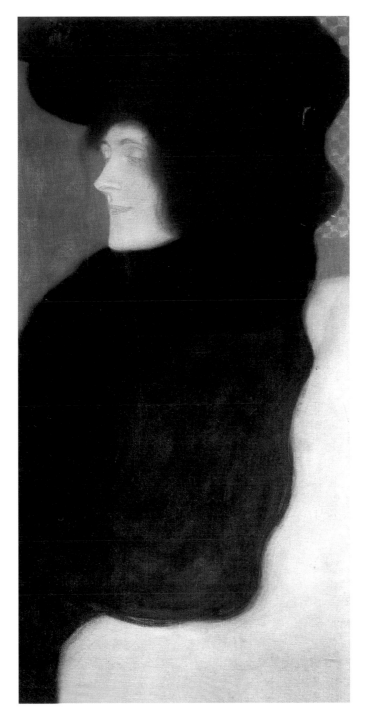

Pale Face, 1907–08 cat. I.9

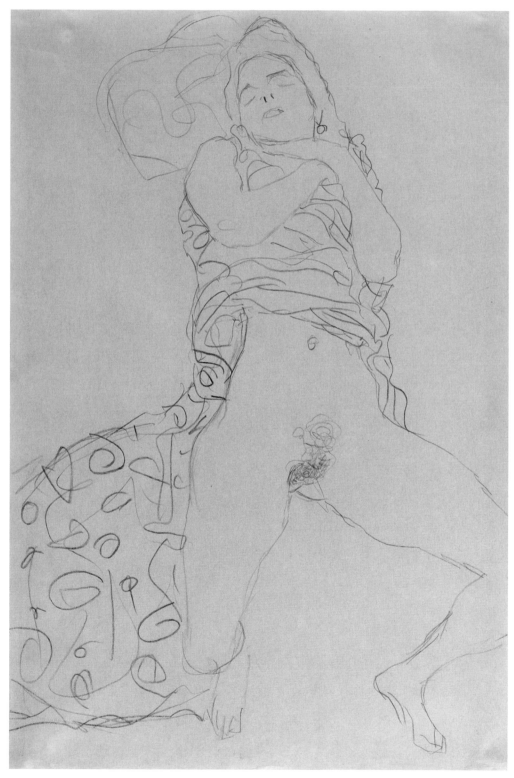

Seminude, 1913 cat. I.12

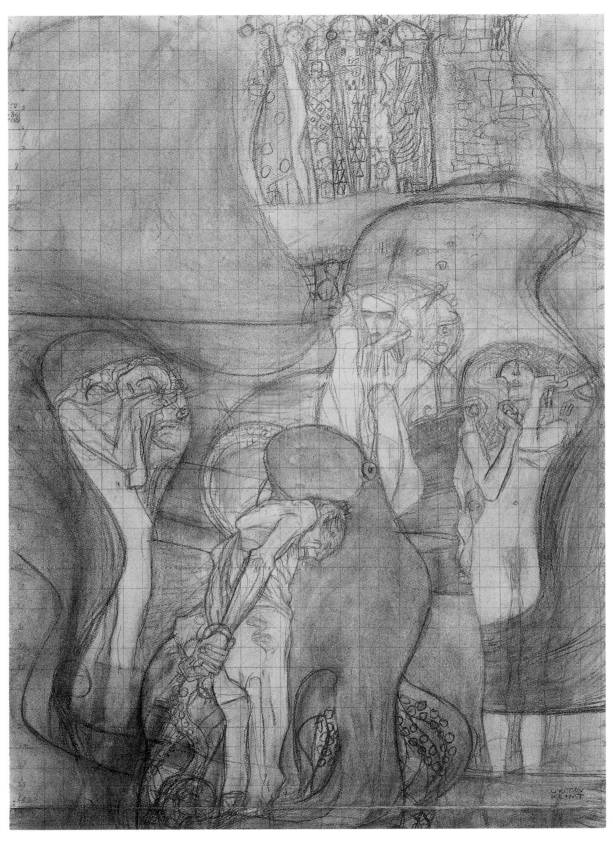

Transfer Drawing for *Jurisprudence*, 1902–03 cat. I.7

Pond of Schloss Kammer on the Attersee, before 1910 cat. l.10

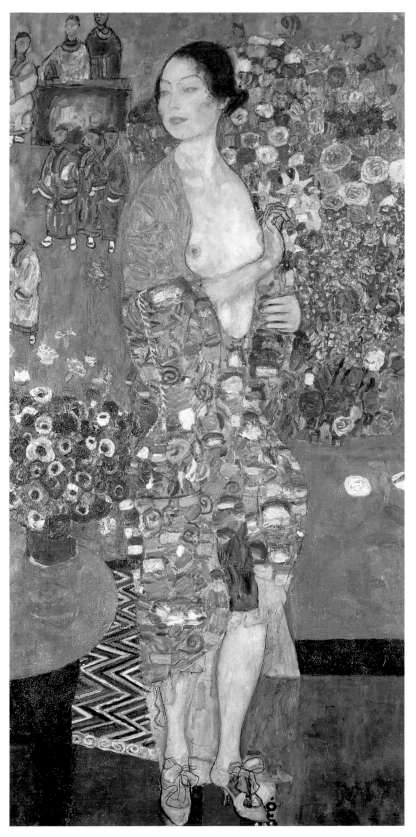

The Dancer, ca. 1916–18 cat. I.15

RICHARD GERSTL

*** SEPTEMBER 14, 1883, VIENNA**
† NOVEMBER 4–5, 1908 (DATE UNCERTAIN), VIENNA

Invitation to the exhibition *Paintings by Expressionists*, Galerie St. Etienne, New York, January 27–February 21, 1962

Richard Gerstl is one of the most important, and also most enigmatic, artists of turn-of-the-century Vienna. Fewer than one hundred canvases and drawings survived his suicide in 1908, at the age of twenty-five.[1] Yet these works were decades ahead of their time. Painted with a vibrant, expressive impasto that in many respects anticipates the work of the American Abstract Expressionists, Gerstl's paintings contrast sharply with the more decorative work of Gustav Klimt, then at the peak of his career. Egon Schiele and Oskar Kokoschka were both still in school in 1908, and even at maturity their work could not compete with Gerstl's when it came to abstract intensity.

The facts of Gerstl's brief life are few, but they resonate with the emotional turmoil that ultimately drove him to kill himself. A problem student, Gerstl flitted from one classroom to another. His well-to-do parents engaged private tutors when he dropped out of high school. After falling out with Christian Griepenkerl, his notoriously strict and reactionary professor at the Vienna Akademie der bildenden Künste (Academy of Fine Arts), the young artist spent two years studying independently and then returned to the Vienna Akademie, where he found refuge in the more liberal class of Professor Heinrich Lefler. Soon, however, the student was sparring with his new teacher and, in 1908, he walked out of the Akademie for good.

Gerstl felt far more comfortable with musicians than with his fellow artists. His attempts to curry favor with the controversial composer Gustav Mahler were rebuffed, but around 1905, Gerstl began associating with an even more radical composer, Arnold Schönberg. The artist grew so close to Schönberg's circle that in 1907 and 1908 he was invited to accompany the group to Gmunden for their annual summer holiday. Schönberg, who later had a short but impressive career as a painter, is said to have studied art with Gerstl.[2] And Gerstl painted a series of stunning portraits of the composer's family and friends. But eventually, the relationship grew too close: Gerstl ran off with Schönberg's wife Mathilde. The affair was short-lived, for Mathilde was soon persuaded to return to her husband and children. However, Gerstl was devastated, having lost not just his lover, but his most significant community of friends. Not long after Arnold and Mathilde reconciled, Gerstl chose to end his life.

PUBLIC RECOGNITION

Gerstl's hostility to the contemporary art scene completely prevented him from exhibiting during his lifetime. He snarled when the director of the Kunsthistorisches Museum offered advice, and he canceled his participation in a group exhibition at the prestigious Galerie Miethke after he was told that Klimt's work would be shown at the same time. For unknown reasons, Gerstl also canceled a showing (possibly arranged through Schönberg's contacts) sponsored by the Ansorge Verein, a musical performance group. Help or praise from any source that Gerstl judged unworthy only roused his ire. He once even slashed one of his own paintings, because it had been admired by someone whose taste he found abhorrent.

After Gerstl's suicide, recognition was further hampered by the paucity of surviving works. His family,

perhaps embarrassed by the circumstances of the artist's death, kept his paintings hidden in a warehouse for over two decades. However, in 1931, Alois Gerstl, Richard's brother, paid a visit to Otto Kallir (-Nirenstein), owner of the Neue Galerie in Vienna. Though the canvases in the warehouse had been rolled up and were dirty, Kallir immediately recognized that this was a major artistic find. Gerstl's first exhibition ever, subtitled *Ein Malerschicksal* (A Painter's Fate), opened at the Neue Galerie on September 28, 1931. The show created an instant sensation. Gerstl was hailed as "the Austrian van Gogh"[3] and garnered numerous favorable notices not just in the Viennese press, but in Salzburg, Frankfurt, Berlin, Prague, and even the Netherlands. In 1932, Kallir sent the exhibition on tour to venues in Munich, Berlin, Cologne, Aachen, and Salzburg.[4] A significant number of Gerstl paintings were acquired by Austrian public and private collections during this period.

Not the least of Kallir's accomplishments with regard to Gerstl was the physical rescue of the œuvre. The canvases were cleaned, mounted on new stretchers, and meticulously documented. Kallir acquired almost the entire estate from the artist's family, had an estate stamp made, and assigned each surviving work a record number. This information, along with all the firsthand source material Kallir had been able to gather through Alois Gerstl and others who had known the artist, was published in the *Mitteilungen der Österreichischen Galerie* in 1974.[5] Although a few additional works and a small amount of new biographical information have since come to light, most of what we know about Gerstl derives from Kallir's work on his behalf.

By 1933, Hitler had seized power in Germany, and five years later he would march into Austria. There would be no exhibitions of Gerstl in the Third Reich—indeed, the artist's wild, nearly abstract style of Expressionism epitomized Hitler's idea of *entartete Kunst* (degenerate art). Kallir, a Jew, began preparing to emigrate the day after the *Anschluss* in 1938. He sold the Neue Galerie to his secretary, Vita Maria Künstler, who made every effort to preserve the inventory and returned it to Kallir more or less intact after World War II. The Gerstl collection lay hidden in the Neue Galerie's storerooms throughout this period.

Meanwhile, Kallir had founded the Galerie St. Etienne in New York and was struggling to intro-

duce such Austrian masters as Oskar Kokoschka, Gustav Klimt, and Egon Schiele to America. This proved such a daunting challenge that Kallir held out little hope for Gerstl, who after all had just barely begun to be known in Europe before the war. Kallir had taken a few of Gerstl's smaller works with him when he left Vienna, but he dared not risk the expense of shipping the artist's larger canvases to the U.S. In the late 1940s, Künstler mounted a couple of Gerstl shows at Kallir's recently recovered Neue Galerie. However, Kallir himself was not in a position to actively promote Gerstl in Austria, and finally he decided that the artist's reputation would fare better if someone else took over the task. So, in 1954, the Neue Galerie's Gerstl inventory was sold to the Galerie Würthle, a prominent Viennese gallery then run by the sculptor Fritz Wotruba.

Kallir was determined to get maximum exposure for the few small Gerstl pictures that he had brought to New York. The Galerie St. Etienne routinely included Gerstl in group shows of Austrian Expressionism, and as that movement began to

Richard Gerstl, ca. 1905

Entrance to the original Neue Galerie, Vienna, ca.1923

Richard Gerstl, *Mathilde Schönberg in the Garden*, 1908. Leopold Museum, Vienna

for inclusion in the exhibition *20th Century Master Drawings*, which opened at the Guggenheim in New York and then traveled to the University of Minnesota in Minneapolis and the Fogg Art Museum in Cambridge, Massachusetts. In 1969, Kallir made sure that Gerstl was featured prominently in the exhibition *Creative Austria* at the Philadelphia Civic Center. In each case, the press singled out the artist for special mention.

By the late 1970s, fin-de-siècle Vienna was enjoying a new vogue in the United States and elsewhere. Both scholarly and popular books on the subject were proliferating, and in the 1980s a series of anthology exhibitions reached out to broad new international audiences, in Hamburg (1981), Edinburgh (1983), Venice (1984), Vienna (1985), Paris (1986), and finally at the Museum of Modern Art in New York (1986).[6] Gerstl's place in all of these exhibitions was unquestioned. He was finally approaching parity with his more prominent compatriots, Klimt, Kokoschka, and Schiele.

Still, Gerstl had not yet had a one-person American exhibition. When Kallir sold the remainder of the Gerstl estate to the Galerie Würthle, he extracted a promise that the collection would be made available for exhibition in the United States. However, that promise was never fully honored. Many of the major paintings were gradually dispersed, and in

gain in stature, Gerstl too received more attention. In 1964, Kallir chose a Gerstl self-portrait for the cover of the catalogue for *Austrian Expressionists*, an exhibition that was sent to the Sarasota Art Association in Florida and the Fort Worth Art Center in Texas after opening at the Galerie St. Etienne. That same year, a Gerstl self-portrait was selected

Richard Gerstl, *Self-Portrait* (ca. 1908), as featured on the cover of the exhibition catalogue *Austrian Expressionists: Watercolors, Drawings, Prints*, Galerie St. Etienne, New York, 1964

AUSTRIAN EXPRESSIONISTS

1954 Wotruba's backers, the Kamm family, sold the Galerie Würthle and took some of the best remaining Gerstls home to their native Switzerland.[7] In the ensuing decades, Gerstl's work was presented in several one-person shows in Austria: at the Vienna Secession in 1966,[8] at the Historisches Museum der Stadt Wien in 1983–84, and at the Vienna Kunstforum in 1994. While this last show did travel to the Kunsthaus Zürich, for the most part the difficulty of assembling a critical mass of works has made comprehensive presentations of Gerstl's work impossible outside of Austria. Following the death of Otto Kallir in 1978, the Galerie St. Etienne continued its commitment to his mission, periodically mounting museum-scale loan exhibitions. Thus over the years, a number of Gerstl's major masterpieces were brought from Europe to the United States. In 1981, several key works were borrowed from Austria (including the striking group portrait of the *Gruppe Schönberg (Schönberg Group)*, from the Museum des 20. Jahrhunderts in Vienna) for the exhibition *Austria's Expressionism*. In 1984, a selection of Gerstl's works was included in the gallery's exhibition *Arnold Schönberg's Vienna* (the first American presentation of the composer's paintings). These shows had a substantial impact, but while Gerstl's work was highlighted in each of them, they could not possibly do justice to the full scope of Gerstl's achievement.

By the early 1990s, it was clear to the Galerie St. Etienne's directors (Hildegard Bachert and myself) that the time had come to mount a full-fledged exhibition of Gerstl's work in New York. Nonetheless, even calling into play every possible international lender, there could never be enough paintings by

Otto Kallir (-Nirenstein) and Vita Maria Künstler, Kärntnerstrasse, Vienna, June 1938

him to fill the gallery: of the small quantity of extant works, a number were unavailable for loan. The decision was made to pair Gerstl's work with that of Kokoschka—an artist with whom he has much in common.

With twenty-six loans from the Historisches Museum der Stadt Wien and the Österreichische Galerie in Vienna, the Tiroler Landesmuseum Ferdinandeum in Innsbruck, the Kamm family in Switzerland, and numerous Austrian and American private collectors, *Richard Gerstl—Oskar Kokoschka* opened at the Galerie St. Etienne on March 17, 1992. It is, to date, the closest thing to a one-person show that has been bestowed upon Gerstl in the United States.

Jane Kallir

[1] Otto Kallir, who compiled the first catalogue raisonné of Gerstl's œuvre in 1974, counted sixty-three surviving works; see Kallir, "Richard Gerstl—Beiträge zur Dokumentation seines Lebens und Werkes," in: *Mitteilungen der Österreichischen Galerie*, vol. 17 (1974), p. 64. By 1994, Klaus Schröder had identified a total of eighty pieces, including ten whose whereabouts have been unknown since World War II (Klaus Albrecht Schröder, *Richard Gerstl, 1883–1908*, Vienna and Zürich: Kunstforum der Bank Austria and Kunsthaus Zürich, 1994). It has been said that, prior to taking his life, Gerstl destroyed the contents of his studio, but one suspects that,

were this truly the case, even fewer paintings would survive. However, the small number of extant drawings suggests that Gerstl may indeed have burned most of his works on paper.
[2] See Jane Kallir, *Arnold Schoenberg's Vienna*, New York: Galerie St. Etienne/Rizzoli, 1984.
[3] Wolfgang Born, "Ein österreichischer van Gogh," in: *Neues Wiener Journal* (September 27, 1931).
[4] Galerie Caspari, Munich; Galerie Gurlitt, Berlin; Kölnischer Kunstverein, Cologne; Städtisches Suermondt-Museum, Aachen; Galerie Welz, Salzburg.
[5] Otto Kallir, *Mitteilungen* (as note 1).

[6] *Experiment Weltuntergang: Wien um 1900*, Hamburger Kunsthalle, 1981; *Vienna 1900*, National Museum of Antiquities of Scotland, Edinburgh, 1983; *Le Arti a Vienna*, Palazzo Grassi, Venice, 1984; *Traum und Wirklichkeit: Wien 1870–1930*, Künstlerhaus, Vienna, 1985; *Vienne 1880–1938: L'Apocalypse Joyeuse*, Centre Georges Pompidou, Paris, 1986; *Vienna 1900*, Museum of Modern Art, New York, 1986.
[7] The bulk of the Kamm collection was donated to the Kunsthaus Zug, Switzerland.
[8] This exhibition subsequently traveled to the Tiroler Kunstpavillon in Innsbruck.

Self-Portrait, 1907 cat. I.16

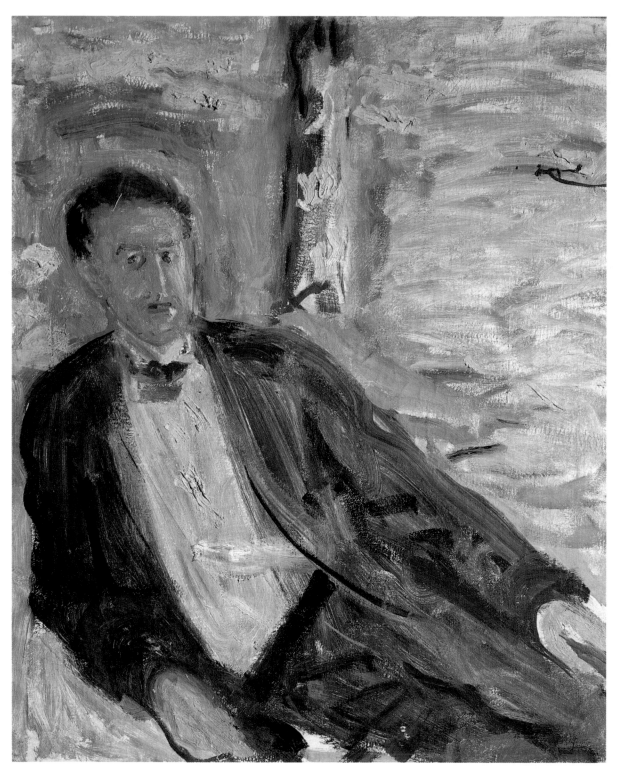

Portrait of a Man on the Lawn, 1907 cat. I.18

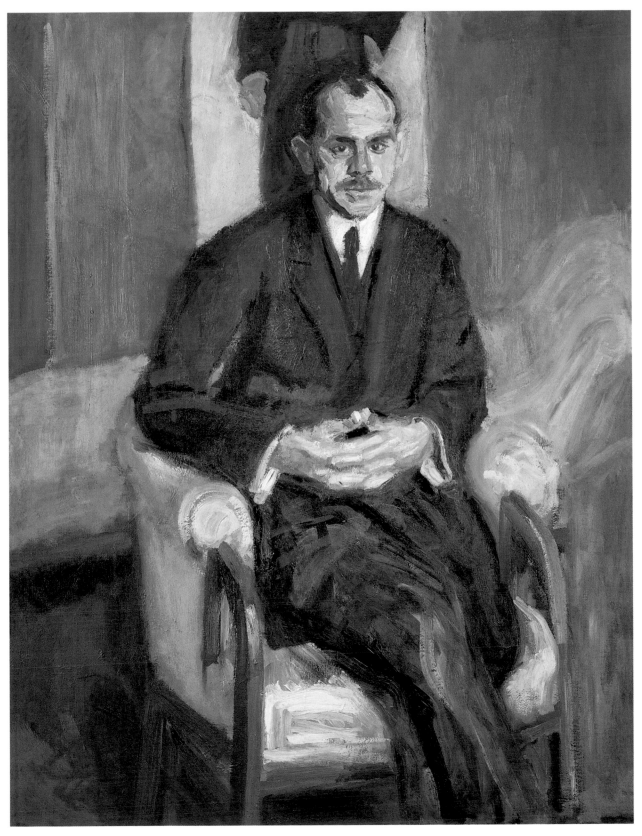

Portrait of a Seated Man in the Studio, 1907 cat. I.17

EGON SCHIELE

*** JUNE 12, 1890, TULLN**
† OCTOBER 31, 1918, VIENNA

Invitation to the exhibition *Egon Schiele*, Galerie St. Etienne, New York, November 7–December 5, 1941

Egon Schiele is an anomaly within the broader history of modernism. Like his compatriots Oskar Kokoschka and Richard Gerstl, Schiele can be loosely tied to German Expressionism, but he is essentially a loner. No group aesthetic molded his development, and while Gustav Klimt was an undeniable influence, Schiele vehemently rejected the decorative horror vacui that was intrinsic to his mentor's style. Schiele's distinctive brand of Expressionism entailed a melding of tight, Art Nouveau draftsmanship with intense personal emotion. Perhaps as a result, his art retains a timeless freshness. It has been received and interpreted anew by each successive generation since the artist's death in 1918.

Schiele's beginnings were hardly auspicious. The son of the stationmaster in the provincial Austrian town of Tulln, he was expected to follow his father, uncle, and grandfather into the railroad service. Young Egon, however, rebelled against the academic requirements of that trade. Instead, three years after his father's death and after near expulsion from secondary school, he gained admittance to the prestigious Vienna Akademie der bildenden Künste (Academy of Fine Arts). Here, too, however, he soon rejected the strict discipline and artistic conservatism of his teachers. In 1909, he and a like-minded group of classmates dropped out. Dubbing themselves the Neukunstgruppe, Schiele and his friends set about establishing their own professional reputations.

Schiele exhibited at the Gustav Pisko Galerie with the Neukunstgruppe in 1909, and was also included that year in the *Kunstschau,* a roundup of major international talent. From the outset, critical ire—both a nuisance and a badge of honor for fledgling modernists—was coupled with support from genuinely helpful mentors and patrons. Still, Schiele's sporadic experiences with commercial galleries were not particularly remunerative, and private patrons could prove fickle. For much of his brief life, he led a hand-to-mouth existence.

Disgusted by the competitive, back-stabbing atmosphere of the Viennese art scene, Schiele in 1911 moved to Krumau (now Český Krumlov in the Czech Republic), the extraordinarily beautiful medieval town where his mother had been born. However, his bohemian ways antagonized the conservative natives, and within months of his arrival, Schiele was forced to retreat. He ended up relocating to the Austrian village of Neulengbach, where, however, he fared even worse. In the spring of 1912, Schiele was jailed for twenty-four days on charges that he had corrupted the morals of minors by exposing them to "obscene" drawings in his studio. Though vehemently disputing the charges, the artist thereafter all but abandoned his practice of drawing children and adolescents.[1]

From being an unwitting rebel, Schiele gradually reverted to the bourgeois values that were, after all, his birthright. In 1915, he broke with his longtime lover and model, Valerie Neuzil (Wally), and instead married Edith Harms, the staid, rather conventional daughter of a railroad machinist. A few days after the wedding, he had to report for duty in the Austro-Hungarian army. Like many Austrian artists, Schiele found ways to pursue his true vocation while still serving in the military, though his output

was drastically reduced in the second half of 1915 and in 1916, the period of his most active service. In 1917, after serving for roughly a year at a prisoner-of-war camp in the rural village of Mühling, Schiele was reassigned to Vienna. Here, he resumed his artistic career at full throttle. For the first time, he seemed truly successful: prominent patrons were virtually lining up to have their portraits done, and he could finally afford a substantial cohort of professional models. After a sell-out exhibition at the Vienna Secession in March 1918, Schiele was widely hailed as the leading artist of his generation. Tragically, both he and his wife Edith succumbed to the deadly Spanish flu epidemic in October of that same year. The artist was twenty-eight years old.

PUBLIC RECOGNITION

From the time of the founding of the Neukunstgruppe in 1909 to the 1918 Secession exhibition, Schiele was a natural leader. And like just about every other member of the Viennese avant-garde, he was an unrepentant elitist. Art was decidedly not a democratic enterprise; the masses had no taste but rather had to be led by a more rarified minority.[2] Likewise, dealers were seen as intrinsically corrupt mercenaries. Lacking access to a strong network of commercial galleries, Viennese artists had long been accustomed to taking the marketing of their work in hand—first at the conservative Künstlerhaus, and then with the more progressive Secession and Wiener Werkstätte. Schiele, at the time of his death, was plotting a similar enterprise, the "Kunsthalle." It was extremely important to Schiele that his Kunsthalle, which he envisioned as "a spiritual gathering place" for artists of all sorts, function as "its own art dealer and publisher."[3]

The backward nature of the Viennese art market, as well as his own personal proclivities, prompted Schiele to forge strong direct ties with patrons early on. Many of these patrons were older men, who may well have sought a vicarious second youth through Schiele's postadolescent struggles. (Sexuality, an often over-emphasized aspect of Schiele's art, was only a part of his youthful appeal.) After the artist's death in 1918, his work rapidly developed an almost cultlike following. Those who had known him considered their acquaintance a rare privilege, and by 1922, no fewer than five memoirs had appeared.[4] Foremost among Schiele's immediate posthumous biographers was Arthur Roessler, art

critic for the socialist *Arbeiter-Zeitung*, as well as a close friend and patron of the artist. Heinrich Benesch, a devoted collector who perennially felt outclassed by Schiele's wealthier patrons, would eventually bequeath much of his collection to the Graphische Sammlung Albertina, of which his son Otto was for many years director. Another important Schiele acolyte in the years between the two world wars was Max Wagner, who amassed a huge file of autograph letters and documents (also today housed at the Albertina), comprising most of the extant primary source material.

Despite Schiele's ambivalence toward art dealers, there is no question that they played a key role in furthering his reputation. Guido Arnot was the last Viennese dealer to represent the artist during his lifetime, and Richard Lányi, who was also a bookseller, published the first portfolio of Schiele reproductions, as well as a series of postcards, in 1917. The honor of mounting the first posthumous Schiele exhibition went to the dealer Gustav Nebehay, who arranged an exhibition of drawings from the artist's estate in 1919. However, the first major posthumous showing to include oil paintings was that assembled by Otto Kallir (-Nirenstein) to inaugurate his Neue Galerie in 1923. The Galerie Würthle, also in Vienna, held two Schiele shows in the 1920s, but without a doubt, Kallir was Schiele's most active champion before, during, and immediately after World War II.

In addition to the shows that he mounted at the Neue Galerie, Kallir curated a double show with the Hagenbund in 1928, on the occasion of the tenth anniversary of Schiele's death. Most important, in 1930 he authored the first catalogue raisonné of Schiele's oil paintings (updated in 1966).[5] Had he not compiled this document before Schiele's paintings were dispersed by the vicissitudes of World

Egon Schiele, 1915

Arthur Roessler and Egon Schiele in Altmünster, 1913

Otto Kallir (-Nirenstein), ca. 1923

War II, the œuvre would today be extremely difficult to reconstruct (and prewar ownership, now a major issue in Holocaust-related claims, would be far harder to prove).

In 1939, Kallir, who had been forced to flee Austria following the *Anschluss*, established the Galerie St. Etienne in New York. Because Schiele's work had been judged "degenerate," Kallir was not prevented from taking much of his inventory with him. Other refugees did likewise, and the works that they brought to the New World formed the basis for establishing Schiele's international reputation. However, in 1939, the artist was completely unknown in the United States. When Kallir, in 1940, included him in *Saved from Europe*, a group show of works salvaged from the menace of the Nazis, the *New York Herald Tribune* commented: "A good many of these canvases by reputable Europeans are definitely worth saving from Europe. … We are not so sure, however, that the reception here to the paintings of Schiele and Klimt will be all that may be expected for them. It is difficult to awaken enthusiasm at this time for artists so little known and appreciated here and for many years passed from the contemporary scene in Europe."[6]

The outlook was not promising when, in 1941, the Galerie St. Etienne opened Schiele's first American one-man show. Only one work sold: an oil painting, priced at $250, which was paid off in monthly installments of $13 over a year-and-a-half period. Nevertheless, Kallir persevered. Throughout the 1940s and '50s, he repeatedly included Schiele in group exhibitions and periodically mounted one-person presentations. By the mid 1950s, he began to have some significant successes. He sold the first Schiele oil, the portrait of Albert Paris Gütersloh, to the Minneapolis Institute of Arts—in 1954.[7] And, in 1957, the Galerie St. Etienne hosted its first truly successful Schiele exhibition. At long last, American collectors began purchasing the artist's work, as did the Museum of Modern Art. Still, when Kallir offered the museum's director, Alfred H. Barr, Jr., his choice of any oil in the St. Etienne inventory as a gift, Barr turned him down.

The tide really turned for Schiele in the 1960s. Kallir had established a close working relationship with Thomas M. Messer, the director of the Institute of Contemporary Art in Boston, and together they curated the first American museum exhibition of Schiele's work, seen at five institutions in 1960–61.[8] When, several years later, Messer was appointed director of the Solomon R. Guggenheim Museum in New York, Kallir immediately prodded him into arranging a Schiele show, which opened there in 1965.[9] By this time, interest in the artist was so keen that the University Art Gallery at Berkeley actually jumped the gun by featuring him in the 1963 exhibition *Viennese Expressionism*. "We scooped the Guggenheim!" crowed one California newspaper.[10] In 1968, Serge Sabarsky established his eponymous gallery in New York City. Like Kallir, he was passionately committed to Schiele.

Schiele was accumulating a substantial international exhibition history and English-language bibliography. In 1963, Herschel B. Chipp, curator of the Berkeley exhibition, wrote a cover story for *Artforum* magazine.[11] Two young art historians who had contributed to the catalogue of the Guggenheim show, Alessandra Comini (a student of Chipp) and James Demetrion, also made decisive contributions to Schiele scholarship. In 1971, Demetrion, then director of the Des Moines Art Center, mounted a major exhibition, *Egon Schiele and the Human Form*. And Comini's 1974 book, *Egon Schiele's Portraits*, remains one of the definitive biographies in English.[12] By the 1980s, both Europe and the United States were in the throes of a full-fledged Vienna "boom." Schiele figured prominently in a number of landmark exhibitions exploring fin-de-siècle Austrian culture, in Hamburg (1981), Edinburgh (1983), Venice (1984), Vienna (1985), Paris (1986), and New York (1986).[13]

Installation view of the inaugural exhibition *Egon Schiele* at Neue Galerie, Vienna, November 20–December 1923

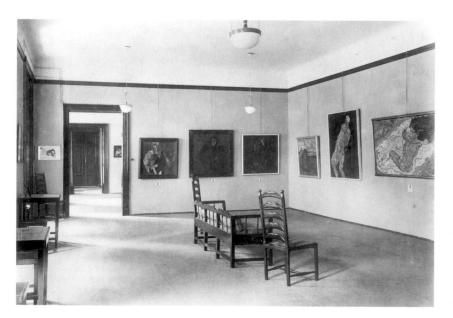

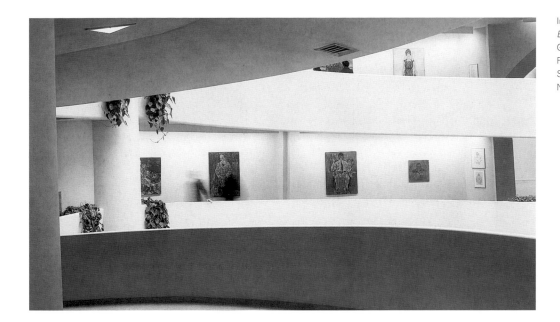

Schiele's reputation continued to grow through the 1990s, with the publication of the first comprehensive catalogue raisonné (1990; revised 1998),[14] and exhibitions at the National Gallery of Art in Washington, D.C. (1994)[15] and the Museum of Modern Art in New York (1997). His cult following, too, has continued. Schiele is still the quintessential artist of adolescence, beloved especially by teen-agers and young adults, who empathize with his existential angst and sexual experimentation. And Schiele remains controversial. His forthright depictions of the human condition still strike a nerve, both with his detractors, but, more importantly, with his legion of ardent admirers.

Jane Kallir

1 Prior to his arrest, Schiele had been in the habit of asking schoolchildren to pose for him—in part because they were cheaper than professional models, and in part because he personally identified with them. Apparently, one of these girls developed a crush on the artist and tried to run away from home with him. Though she was returned to her family unharmed within a few days, the incident prompted the police to launch a full-fledged investigation, which led to the subsequent charges.

2 This was the guiding principle behind the Secession and the Wiener Werkstätte. Elitist—not to say proto-aristocratic—attitudes toward culture were shared by Gustav Klimt, Adolf Loos, and Arnold Schönberg, among others. Invited to contribute to a periodical entitled *Die Kunst für Alle* (Art for Everyone), Schiele commented, "The 'Kunst' without the 'Alle' would suit me much better." (See Christian M. Nebehay,

Egon Schiele—Leben, Briefe, Gedichte [Salzburg: Residenz, 1979], no. 723.)

3 Ibid., no. 1182.

4 Fritz Karpfen, ed., *Das Egon Schiele Buch*, Vienna: Verlag der Wiener Graphischen Werkstätte, 1921; Arthur Roessler, ed., *Briefe und Prosa von Egon Schiele*, Vienna: Verlag der Buchhandlung Richard Lányi, 1921; idem, ed., *In Memoriam Egon Schiele*, Vienna: Verlag der Buchhandlung Richard Lányi, 1921; idem, *Erinnerungen an Egon Schiele*, Vienna: Konegen, 1922; and idem, ed., *Egon Schiele im Gefängnis*, Vienna: Konegen, 1922.

5 Otto Nirenstein (-Kallir), *Egon Schiele: Persönlichkeit und Werk*, Vienna: Paul Zsolnay, 1930; Otto Kallir (-Nirenstein), *Egon Schiele: Œuvre Catalogue of the Paintings*, New York and Vienna: Crown and Paul Zsolnay, 1966.

6 "Saved from Europe," in: *New York Herald Tribune* (July 4, 1940).

7 The sale initially took place in 1951, to the McMillan Land Company, with the understanding that the painting would be donated to the museum later. The donation became effective in 1954.

8 The Institute of Contemporary Art, Boston; Galerie St. Etienne, New York; J. B. Speed Art Museum, Louisville; Carnegie Institute, Pittsburgh; Minneapolis Institute of Arts.

9 Schiele was paired with Klimt at the Guggenheim; this double show included fifty-three paintings and sixty-five works on paper by Schiele, and forty-eight paintings and twenty-six drawings by his mentor.

10 "Expressionist Exhibition to Open," in: *Daily Californian* (February 4, 1963). The Berkeley show subsequently traveled to the Pasadena Art Museum.

11 Herschel B. Chipp, "A Neglected Expressionist Movement," in: *Artforum*

(March 1963), pp. 21–27.

12 Alessandra Comini, *Egon Schiele's Portraits*, Berkeley: University of California Press, 1974.

13 *Experiment Weltuntergang: Wien um 1900*, Hamburger Kunsthalle, 1981; *Vienna 1900*, National Museum of Antiquities of Scotland, Edinburgh, 1983; *Le Arti a Vienna*, Palazzo Grassi, Venice, 1984; *Traum und Wirklichkeit: Wien 1870–1930*, Künstlerhaus, Vienna, 1985; *Vienne 1880–1938: L'Apocalypse Joyeuse*, Centre Georges Pompidou, Paris, 1986; *Vienna 1900*, Museum of Modern Art, New York, 1986.

14 Jane Kallir, *Egon Schiele: The Complete Works*, New York: Abrams, 1990; rev. ed., 1998.

15 The National Gallery exhibition subsequently traveled to the Indianapolis Museum of Art and the San Diego Museum of Art.

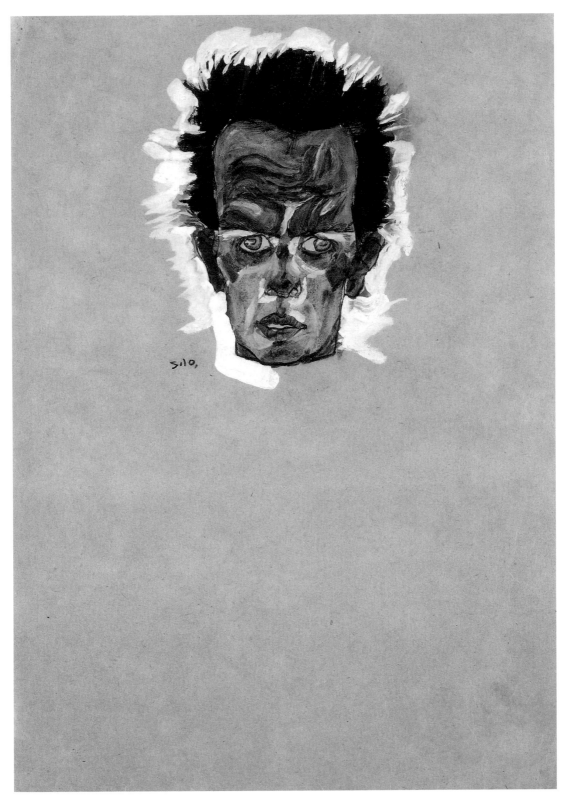

Self-Portrait: Head, 1910 cat. I.23

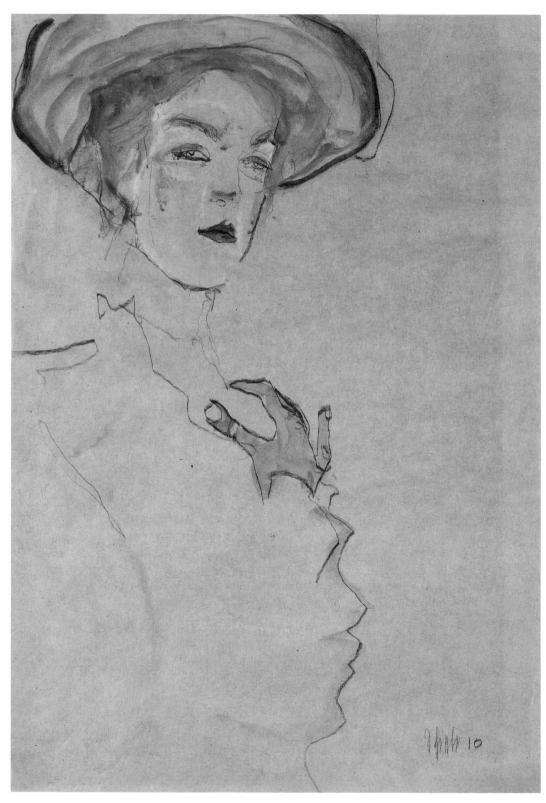

Portrait of a Woman with Orange Hat, 1910 cat. I.19

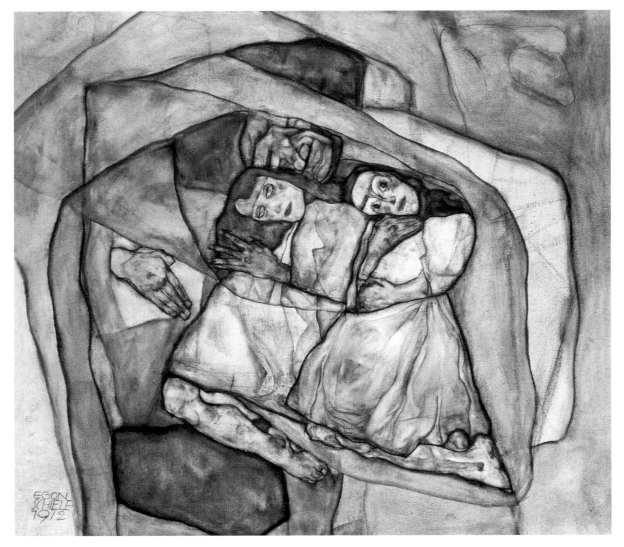

Conversion, 1912 cat. I.30

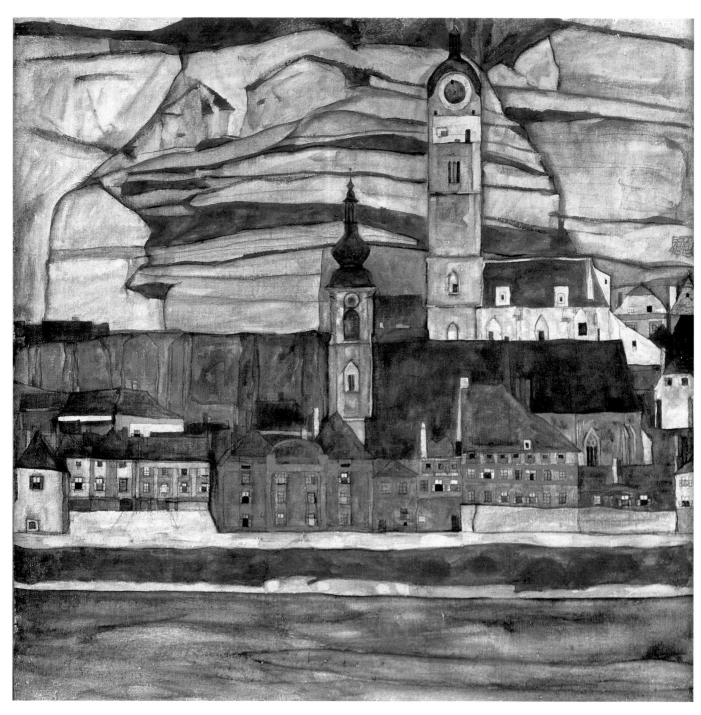

Stein on the Danube, Seen from the South (Large), 1913 cat. I.32

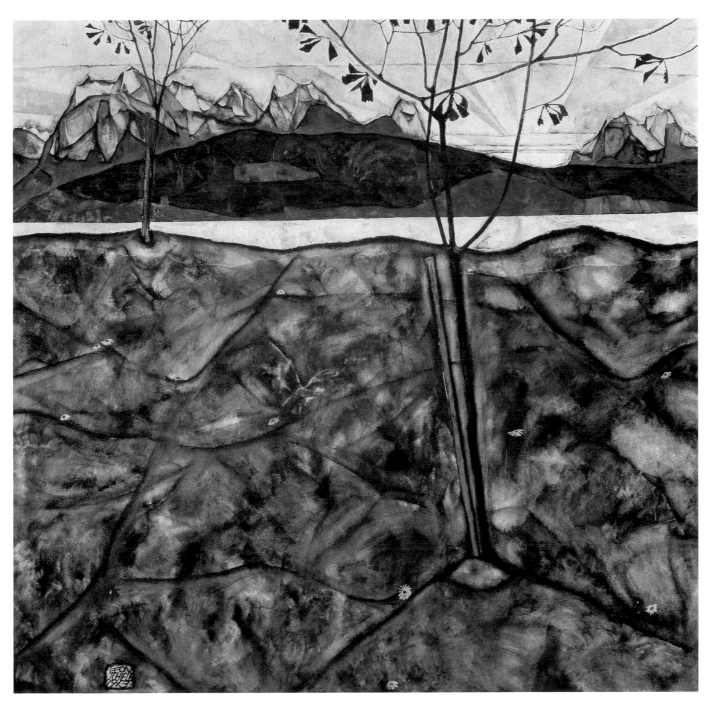

River Landscape with Two Trees, 1913 cat. I.34

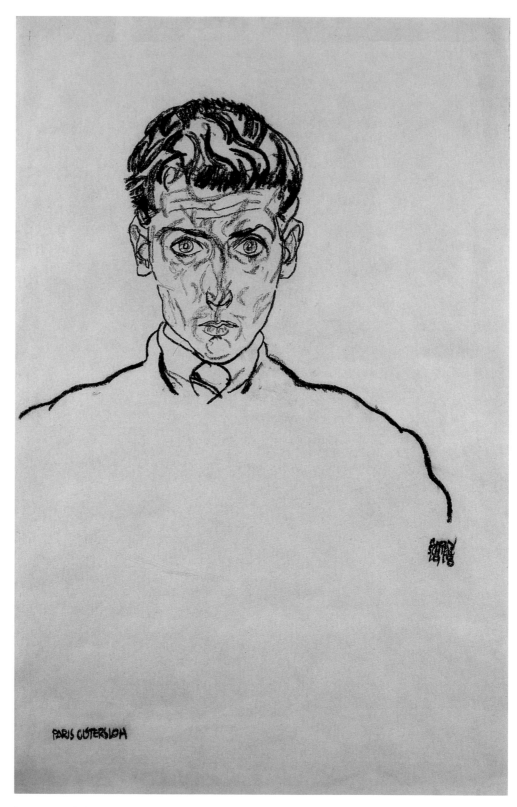

Portrait of the Painter Paris von Gütersloh, 1918 cat. I.41

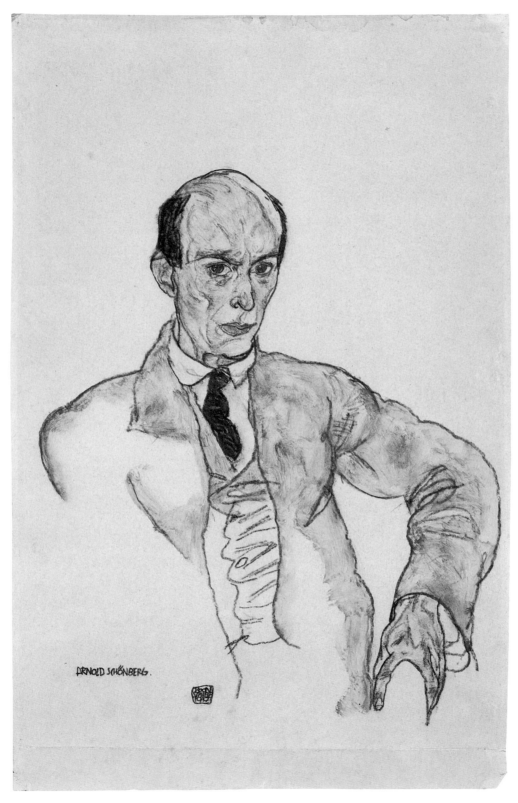

Portrait of the Composer Arnold Schönberg, 1917 cat. I.40

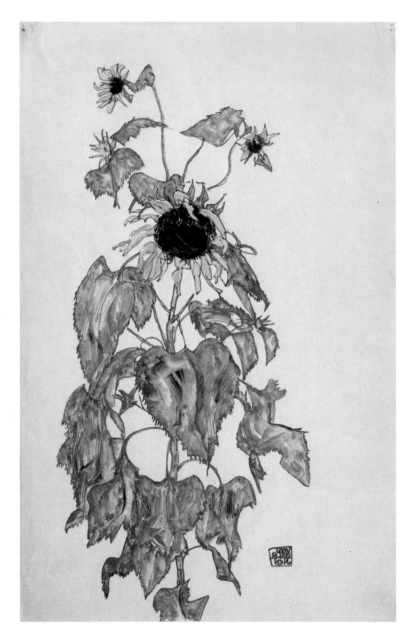

Sunflower, 1916 cat. I.37

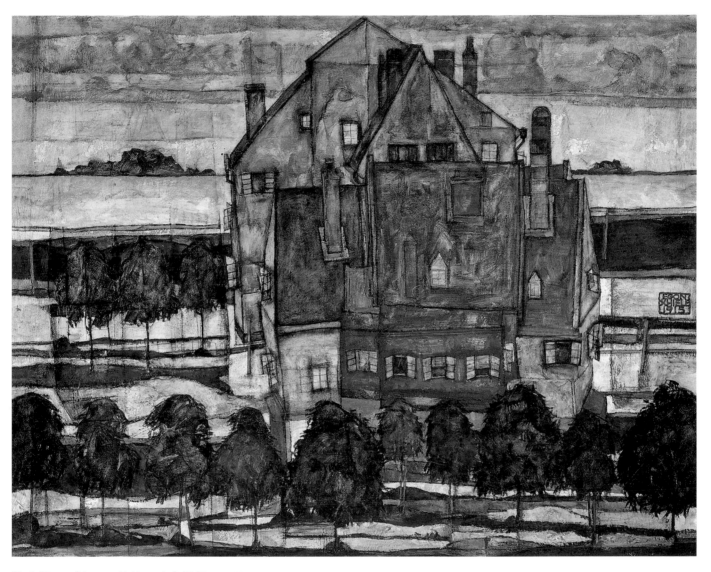

Single Houses (Houses with Mountains), 1915 cat. I.36

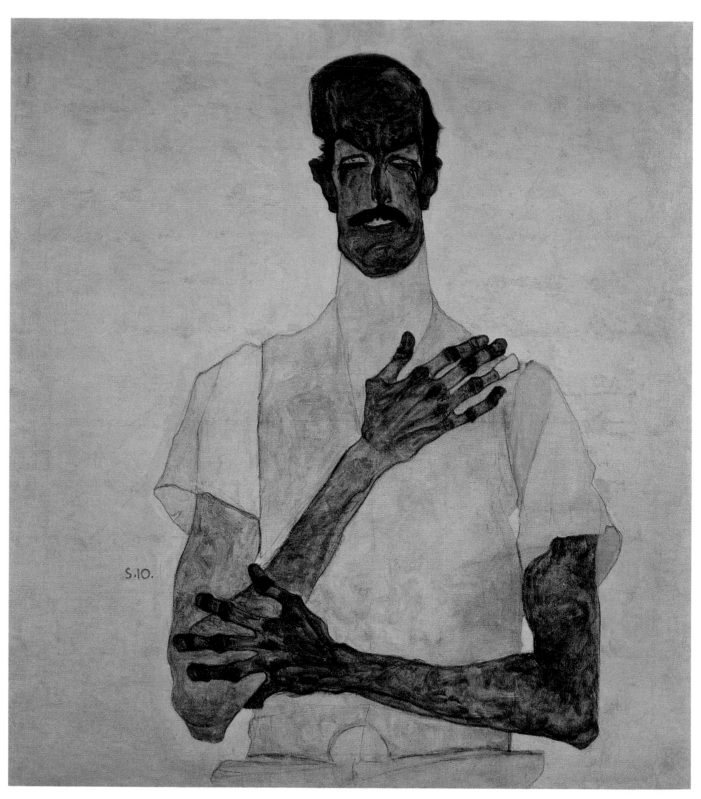

Portrait of Dr. Erwin von Graff, 1910 cat. I.24

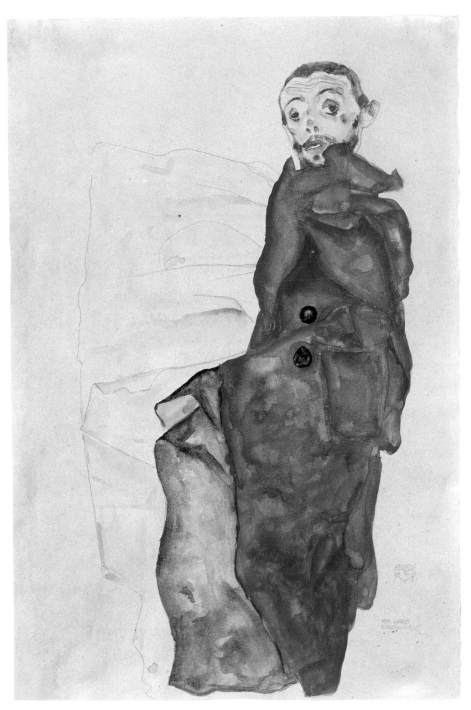

I Love Antitheses, 1912 cat. I.29

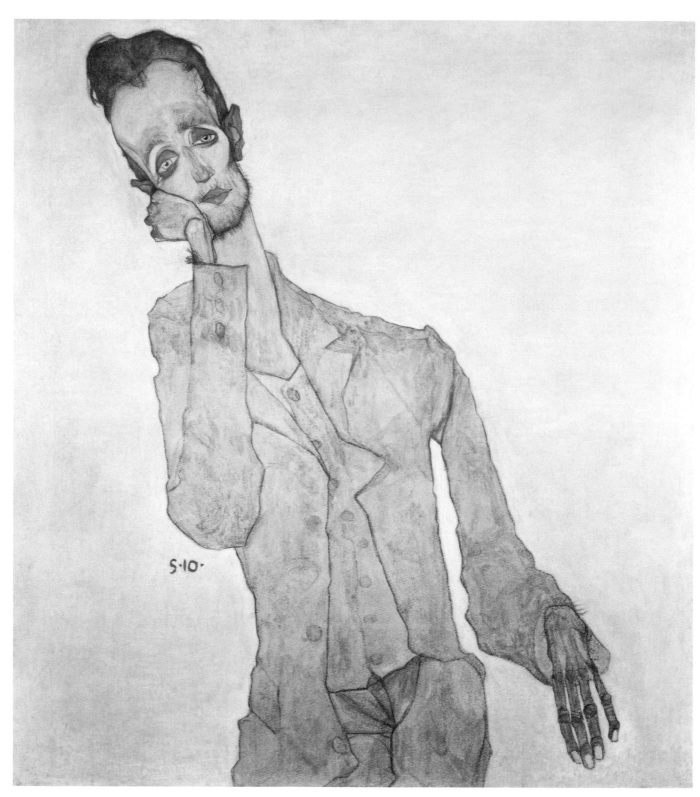

Portrait of the Painter Karl Zakovsek, 1910 cat. I.21

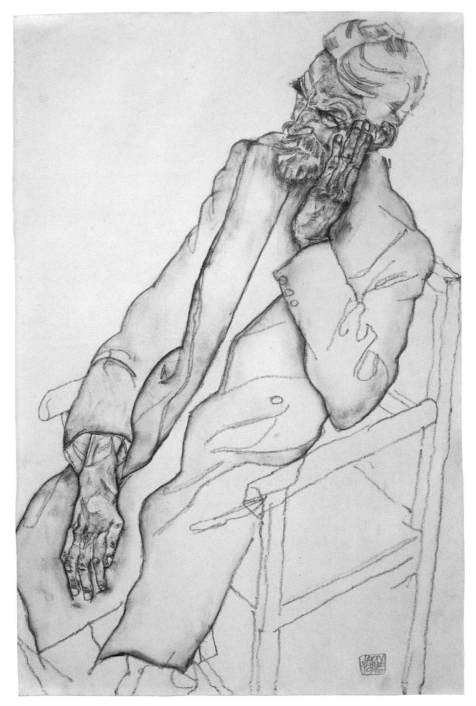

Portrait of Johann Harms, 1916 cat. I.38

OSKAR KOKOSCHKA

*** MARCH 1, 1886, PÖCHLARN (MORAVIA)**
† FEBRUARY 22, 1980, MONTREUX

Invitation to the exhibition
Oskar Kokoschka,
Buchholz Gallery, New York,
September 22–October 12,
1938

The artistic contributions Oskar Kokoschka made to twentieth-century art have been divided into many phases. These phases usually correspond to places he visited or lived in during his long itinerant life: Pöchlarn, Vienna, Switzerland, Berlin, Dresden, London, North Africa, Paris, Prague, Salzburg, or Villeneuve. To identify Kokoschka with Vienna only—or with any other place, European or American—is to misunderstand him. As variegated as the roster of cities where he resided, Kokoschka—painter, printmaker, writer of dramas and political essays, and artist in exile—confounds easy categorization. Art history is still in search of the terms to measure Kokoschka's myriad achievements. This essay revisits Kokoschka's path from youthful, restive avant-garde heroics toward a position of increased acceptance of social and political responsibility. In retracing that path, emphasis is placed here upon the mirror that America offered the artist throughout his career.

Kokoschka's life began in rural Moravia—Pöchlarn was a small town near the monastery of Melk on the Danube. He was the son of a downwardly mobile goldsmith from Prague, and a devoted mother. He gained admission to Vienna's Kunstgewerbeschule (School of Applied Arts), where he studied under the progressive professor of graphic arts and printmaking Carl Czeschka, and his successor Bertold Löffler. Kokoschka shared other young and restless artists' admiration of Gustav Klimt, the reigning patriarch of Vienna's Secession. Early on, he created an exquisite set of eight lithographs, *Die träumenden Knaben* (*The Dreaming Youths;* 1908), casting an adolescent fairy tale that he had

written into flat patterns of line and color. When he was twenty-two, his name first spilled beyond Vienna's studio and coffeehouse cultures when he joined other avant-garde artists led by Klimt in an exhibition to feature the newest in contemporary art, the *Wiener Kunstschau* of 1908. Kokoschka's tapestry designs, lithographs, and drawings met with hostile criticism in the local press. Nonetheless, other artists were quick to purchase his art, and the Wiener Werkstätte purchased his designs. Following another, equally controversial showing at the 1909 *Internationale Kunstschau* where his drama *Mörder, Hoffnung der Frauen (Murderer, Hope of Women)* also premiered, commissions from the Wiener Werkstätte ensued, and Kokoschka's art attracted the interest of modernist architect Adolf Loos. Loos became a father figure and patron to the young artist. He also nudged Kokoschka away from decorative arts and toward painting by arranging numerous portrait sittings for Kokoschka. Although flagrantly transgressive of contemporary tastes, these early Vienna portraits have since come to be considered the finest paintings of his long career. They include the portraits of Polish aristocrat Ludwig Ritter von Janikowsky, poet Peter Altenberg, Swiss scientist Auguste Forel, and the double portrait of art historians Hans and Erika Tietze. Painted in thin, iridescent colors, often with scraped surfaces or nervous scratched lines, they display Kokoschka's uncanny ability to register the inner character of sitters, rather than merely describe outward appearances.

Kokoschka's talents were soon recognized by Berlin impresario, publisher, and art dealer for the

avant-garde, Herwarth Walden. In 1910, Kokoschka installed himself in Berlin as an editor for Walden's art periodical *Der Sturm*, to which he continued to contribute drawings and essays after returning to Vienna in 1911. Through Walden's help, and following a joint exhibition with abstract painter Max Hoffmann at the Salon Paul Cassirer in June 1910, Kokoschka realized his first solo exhibition in Germany at Karl Ernst Osthaus's museum in Hagen that August. With strong support from Berlin, and a solo exhibition at one of Germany's premier venues for new art, Kokoschka was on his way to renown in the German art world. Upon his return to Vienna, he exhibited twenty-five canvases in an exhibition of contemporary art at the city's art association Hagenbund—his last Vienna exhibition until 1924. Although Europe was lunging toward war, Kokoschka's thoughts were seldom captivated by politics or military developments. In 1912, he fell deeply in love with the recently widowed Alma Mahler: this relationship would consume him for the next decade, although they separated in 1915. Apart from the dozens of letters to Alma, the most enduring testament to this intense relationship is his large canvas *Die Windsbraut* (known in English as *The Tempest*; 1914), showing the two intertwined lovers borne aloft within a feathery, boatlike surround. But as with many other artists and intellectuals, Kokoschka's progressive aesthetics did not inure him to the war enthusiasm that swept through Central Europe in 1914. The war's outbreak led to his enlistment in the elite Imperial-Royal Regiment of Dragoons, and his service at the Eastern front, where he incurred severe head and chest wounds.

After World War I, at the outset of the Weimar Republic, Kokoschka moved to Dresden, where he would remain until 1927. Together with other leading members of the prewar Expressionist avant-garde, he joined the ranks of Germany's artist professoriat at Dresden's Kunstakademie, where he taught from 1919 to 1924. The year 1918 also saw the publication of the first monograph on Kokoschka, by *Das Kunstblatt* editor Paul Westheim. After a series of increasingly favorable dealer contracts, 1925 brought a lucrative contract with Germany's leading gallery for modern art, Paul Cassirer Berlin.

Dominant among Kokoschka's paintings from the 1920s are the scores of landscapes and cityscapes executed across Europe, North Africa, and the Middle East—in London, Marseilles, Monte Carlo, Tunisia, Scotland, Italy, Palestine, Paris—leading detractors to call him the "Cook Tour painter."[1] Until his Cassirer contract was terminated in 1930, Kokoschka generated a stream of paintings that record his nearly perpetual travels. But no matter how Kokoschka reinvented himself as the cosmo-

Oskar Kokoschka and Herwarth Walden, Berlin, 1916

politan artist-traveler nonpareil, family matters kept him tied to Vienna, where he returned in 1933. Kokoschka's mother died the following year, effectively breaking this modern knight errant's attachment to Vienna; her death presaged his final days there. He left Vienna and Austria's deteriorating political environment—marked by the assassination of Chancellor Engelbert Dollfuss—and set out for

Oskar Kokoschka, *Die Windsbraut (The Tempest)*, 1914. Öffentliche Kunstsammlung Basel. Kunstmuseum

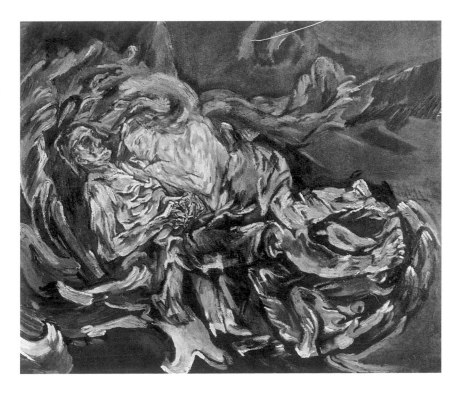

Prague, where the artist would make his home for the next four years. Art dealer Hugo Feigl helped to establish Kokoschka, with introductions to the city's art-loving property owners—properties where he erected his easel and painted his many views of that city nestled in the Moldau (Vlatva) River basin. In these years, he also met Olda Palkovska, a young law student whom he would marry in 1941, and with whom he lived for the rest of his life.

Also in Prague, Kokoschka weathered the National Socialists' first widely publicized attacks on modern art: the series of traveling *Entartete Kunst* exhibitions. No fewer than 417 of Kokoschka's paintings were confiscated from German public collections. But by the autumn of 1938, after the annexation of Austria in March, the German government's draconian art policies were less ominous than its territorial ambitions to the east; National Socialist motorcades rolled into the largely ethnic German Sudetenland, and Prague fell in March 1939. Oskar and Olda had already escaped on a plane to London in October 1938. While there, he painted a series of antifascist works, including the renowned 1939 canvas *Das rote Ei (The Red Egg).* Kokoschka remained in Great Britain through the war and was active in exiled cultural associations (the Free League of German Culture and the Free Austria Movement), often speaking out for justice and human-rights issues related to the war. Their extended stays in the countryside (Polperro in Cornwall in 1939–40, and Scotland in 1941, 1944, and 1945) yielded numerous landscape paintings, watercolors, and colored-pencil drawings. The Czech citizenship he had been granted in 1935 by President Tomáš G. Masaryk spared him internment and the hardship of changing residency regulations imposed upon his fellow Austrian and German exiles. Paradigmatic of the respect Kokoschka commanded among his peers was that the groups of exiled artists founded in Prague, Paris, and London each elected Kokoschka to serve as their president or honorary figurehead in their public opposition to the National Socialists. In no case, it seems, did he refuse.[2]

After the war, Kokoschka remained in England and acquired British citizenship in 1947. During the following decades, his frequent travels took him to Italy, the United States, Ireland, Germany, Austria, Libya, Tunisia, Turkey, Greece, and Israel; and he purchased a home in Villeneuve, Switzerland. Often he directed his energies into teaching the next generation, attaining notoriety for his School of Seeing, the classes he taught each summer between 1953 and 1963 at the Internationale Sommerakademie für Bildende Kunst in Salzburg. Along with the regular outpouring of landscape paintings he created up until the final year of his life, he produced a stream of portraits of heads of state and other politicians, and also tackled large-scale history paintings. At his death in 1980, he was survived by Olda, who served as the first administrator of his estate.

PUBLIC RECOGNITION

Although efforts were undertaken to bring Kokoschka to the United States as the Wehrmacht overran the continent and the Luftwaffe threatened England,[3] the artist preferred to remain in England. After he became a British citizen in 1947, he resided in London until 1953. From at least the early 1920s, Kokoschka's reputation was keyed to his mobility and transience—an itinerant identity that signaled a modernist detachment, if not genuine freedom. But while Kokoschka's entrance into the English-language discourse came through England rather than America,[4] his involvements in America were manifold.

As was the case with many Central European Expressionists, Kokoschka's renown in the United States was established during the 1920s, only to swell in the next decade as cultural institutions in Allied countries rushed to embrace modern art in response to the National Socialists' assault on modern culture. Regular inclusion in Pittsburgh's Carnegie International, where he exhibited between 1925 and 1964, was key to that ascendancy.[5] In February 1927, Kokoschka's *Biarritz, Strand (Beach at Biarritz;* 1925) was featured in color as the frontispiece of *The Dial* magazine.

After the National Socialist party assumed power in 1933, the aesthetically conservative director of the Carnegie International, Harvard-educated Homer Saint-Gaudens, began to admit official National Socialist artists into the prestigious exhibition. Assisting Saint-Gaudens in Germany was his agent Charlotte Weidler, who would emigrate to the United States in 1939. In 1937, the year of the *Entartete Kunst* exhibition in Munich, Saint-Gaudens even conceded to exhibit a group of thirty canvases by official National Socialist painters. Yet in each Carnegie International from 1933 to 1939, Saint-Gaudens also offset the participation of the

National Socialist artists with the inclusion of Jewish artists. In 1936, for example, the year that Kokoschka's portrait of Tomáš Masaryk (1935–36) premiered, the show's first prize was awarded to a Jewish-American artist, Leon Kroll, which prompted the German government to label the Carnegie a "Jewish propaganda show."[6]

The Carnegie's support of Kokoschka did little to allay American critics' resistance to his work. For example, in early 1928, when a selection of works from the twenty-sixth Carnegie International traveled to the Brooklyn Museum, journalist Helen Appleton Read wrote that many visitors were disturbed by the psychological intensity of Kokoschka's

oning of two New York galleries—Curt Valentin's Buchholz Gallery and Otto Kallir's Galerie St. Etienne—interest in Kokoschka grew. Valentin, who had only arrived in the U.S. himself in 1937, held Kokoschka's first solo exhibition—featuring twenty-five oils—at the Buchholz Gallery in 1938, and a second in 1941. Austrian exile Kallir made concurrent efforts at his Galerie St. Etienne—which would continue for decades—keeping Kokoschka's name, art, and ideas before the American public. Between 1939 and 1949, Kallir hosted no fewer than five solo Kokoschka shows; these stood apart from most exhibitions realized by exiled dealers, as Kallir's own anti–National Socialist position was

Oskar Kokoschka, *Biarritz, Strand (Beach at Biarritz)* 1925, color frontispiece of *The Dial*, February 1927

(and Dix's) works, while the *New York Times* noted that Kokoschka portrayed his figures with "abnormal appearances," which they deemed "as childish as the medieval stress upon deformity."[7]

Four oils by Kokoschka were also included in Alfred H. Barr's 1931 *German Painting and Sculpture* exhibition at New York's Museum of Modern Art, but the show's catalogue offered only the scantest praise for his art. This exhibition marked both a short-lived thaw in U.S.–German cultural relations and Barr's effort to broaden Americans' pictorial tastes beyond the reigning values of the School of Paris. But with the persistent champi-

utterly undisguised. To demonstrate the National Socialists' violence against art, in April 1943, Kallir exhibited Kokoschka's portrait of Robert Freund (ca. 1908–09 or 1914), a canvas that had been slashed into quarters in a Gestapo house search in Vienna in May 1938.[8]

Valentin and Kallir's commercial endeavors paved the way for Kokoschka's first full-scale solo museum exhibition in the United States, in 1948–49, organized by James S. Plaut for Boston's Institute of Contemporary Art. The accompanying catalogue (prepared by Plaut) emphasized Kokoschka's humanitarianism. This exhibition traveled to the

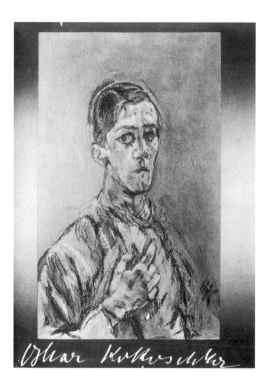

Phillips Memorial Gallery in Washington, D.C.; the City Art Museum in Saint Louis; and the M. H. de Young Memorial Museum in San Francisco, before its final appearance at New York's Museum of Modern Art.[9] The national art press devoted considerable attention to the exhibition, and the Galerie St. Etienne and Kokoschka's old friend from Prague, Hugo Feigl, organized smaller exhibitions of his work to coincide with that at the Museum of Modern Art. Evaluating this first retrospective exhibition of Kokoschka's paintings and prints in the United States, critics generally hailed the greatness of the man and favorably reviewed the successive periods in his life and work. The exception within his career, according to critics, were the years 1931 to 1946, which they deemed a low point, his painting going into a decline, and his work verging on propaganda as the artist became concerned with political ideology. But most critics were pleased to discover a return to pictorial vibrancy and spatial openness in his most recent landscapes of Switzerland (1947–49).[10]

It may be instructive at this juncture to consider the America that Kokoschka had imagined from very early in his career, as well as the America he visited in the 1950s—an America far from the New York art world he would ultimately encounter. Additionally, an early event in Kokoschka's American exposure must be addressed: namely, the comprehensive exhibition of his paintings at the International Pavilion of the Panama-Pacific exhibition at the 1915 World's Fair, held in San Francisco during the course of World War I.

As early as 1913, Kokoschka had written to Herwarth Walden regarding his prospects in America. Discussing *Die Windsbraut*—the painting that had been inspired by Alma Mahler—he wrote: "The picture must go to America where my name is slowly filtering through."[11] But the large canvas had just been sold to Vienna collector Otto Winter. Shortly after the sale, Kokoschka wrote to Winter imploring him to loan it for the San Francisco show: "This exhibition enables my long-held wish to find a foothold in America through the assistance of new friends whom I shall win there through my work."[12] And the following week: "I ask you to help me through the loan of the picture to San Francisco, so that in America I may find recognition and later patrons, to which this major work shall contribute everything!"[13] The artist's desire to gain recognition in America continued through the 1920s.

Winter did not part from his newly acquired *Windsbraut*, but thanks to the ever-generous help of Adolf Loos, Kokoschka was represented splendidly in San Francisco. The fifteen paintings presented to fair-goers in San Francisco were all from Loos's own collection. They included portraits of the archi-

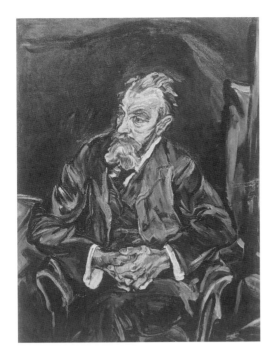

Oskar Kokoschka ... who packs more of virile organization and rugged form into a canvas than any other follower of van Gogh and Cézanne. There is a quality of ruthlessness in the way in which Kokoschka, [Emil] Nolde, and [Karl] Schmidt-Rottluff have sought form—at the expense of natural aspect and finished technique."[16] But such isolated praise was the exception. Kokoschka could hardly count on America's art critics to strengthen his reputation.

As with so many other Central European artists, a key break for Kokoschka came in the aftermath of *Entartete Kunst* in 1937. From 1938 through the

Oskar Kokoschka, *Carl Moll*, 1913. Österreichische Galerie Belvedere, Vienna

tect and his wife, the writer of utopian fiction Paul Scheerbart, Peter Altenberg, Dr. Egon Wellesz, composer Anton von Webern, Emma Veronica Sanders, and a 1913–14 self-portrait. But nothing suggests that San Francisco was better prepared for Kokoschka's probing psychological portraits than Vienna had been seven years earlier. Scores of medals were awarded to other artists, but Kokoschka received none. The exposition jury even gave a gold medal for a self-portrait by the Munich painter Heinrich Knirr, who today is perhaps best remembered for his 1930s official portraits of Hitler.[14] But as American art lovers encountered Kokoschka's work,[15] the twenty-nine-year-old artist was in no position to enjoy his newfound notoriety, as he was confronting the traumas of modern trench warfare on Europe's Eastern front.

With few exceptions, the American art press paid scant attention to Kokoschka during the 1910s and '20s. While expanding recognition and increasing security defined Kokoschka's professional position in 1920s Germany, his prospects in America remained an uphill struggle, a matter of incremental visibility in a society far less concerned with modernist art. One art historian to take up the cause of Expressionism was Sheldon Cheney. Writing in his *World History of Art* (1937), Cheney positioned Kokoschka and several German Expressionist painters as the stylistic heirs to van Gogh and Cézanne, writing, "The outstanding figure is

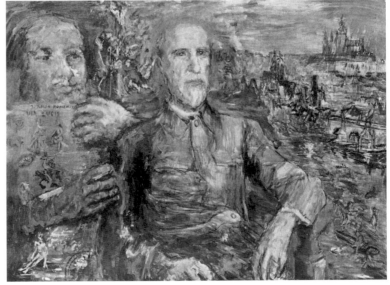

war, the aforementioned efforts of Valentin and Kallir's New York galleries provided the most constant representation of his art in the United States. It is important to realize, however, that the promotion of European modern art in the U.S. during the 1930s was never free of opposition. Intolerant, philistine antimodernism, very like what Kokoschka had once met in Vienna, was not absent in 1930s America. Kokoschka's first biographer, German critic Paul Westheim, warned German exiles in 1938 of the damning reception modern art was encountering in Chicago through the efforts of Josephine Hancock Logan's Society for Sanity in Art. In 1938, this group promoted "rationally beautiful" and sanitized art that compared, according to Westheim, with the official art of National Socialist Germany.[17] Similarly, receptivity to modernism was less than warm on the occasion of émigré dealer

Oskar Kokoschka, *Tomáš G. Masaryk*, 1935–36. Carnegie Institute, Pittsburgh

Title page of the exhibition catalogue *Oskar Kokoschka, Die frühen Jahre, 1906–1926*, edited by Serge Sabarsky, Munich, 1986

J. B. Neumann's lecture at the City Art Museum of Saint Louis on October 5, 1942. Speaking in conjunction with the museum's exhibition of Kokoschka oils and watercolors, Neumann's lecture title acknowledged the resistance to modern art he anticipated in the Midwest: "Why Do We Hate Modern Art?"[18] There is little to suggest that Kokoschka thought much about these pockets of intolerance, but their relationship to the Central European context he had just left behind could not have been lost upon him.

By the time Valentin and Kallir came to promote Kokoschka through solo exhibitions in New York City, a number of the artist's paintings were already part of the collections of American museums and private collectors. Many had been placed by the efforts of the director of the Detroit Institute of Arts, German émigré Wilhelm R. Valentiner. In addition to hosting exhibitions in their own galleries, Valentin and Kallir facilitated further shows and provided the loans for solo Kokoschka exhibitions at Mills College, Oakland (1937), and the Arts Club of Chicago (1941). In response to these and the New York exhibitions, the U.S. art press gave increasing attention to Kokoschka.

Among Kokoschka's works of the late 1930s, one painting stood out for American critics as summarizing the artist's "humanitarianism" or "humanism." It was his 1936 portrait of Tomáš Masaryk.[19] It depicted the aged patriarch and founder of Czechoslovakia, with the sixteenth-century humanist Johann Amos Comenius (1592–1670) at his side within the cradling space of the Vlatva (Moldau) River valley. In pairing Masaryk with Comenius, Kokoschka foregrounded his own commitment to strengthening democracy with mass educational reform, through a system of *Volkshochschule* (People's Colleges), an idea the outgoing Czech president had discussed with the artist during their many portrait sittings. The painting took a medal at the 1936 Carnegie International; Valentin exhibited it in 1938; and it was featured in the Mills College exhibition as well. In 1945, Alfred Neumeyer of Mills College would discuss it in a particularly astute and comprehensive article on Kokoschka and his art.[20]

The Masaryk portrait epitomized an approach Kokoschka continued during his later years, as he sought out portrait opportunities with leading heads of state. One could argue that Kokoschka's efforts to effect social and political change depended upon the rapport he established with leading politicians during portrait sittings. Unlike his early, notorious portraits (ca. 1907–13) of Viennese, Berlin, and Dresden intellectuals and cultural figures—generally, peers from his own bohemian artistic milieu, or with whom he experienced some kind of artistic communion—his sitters from the 1930s and later mark his dealings with political figures from the larger stage of national and international political life. These included Michael Croft (1939), Ivan Maisky (1942–43), Theodor Körner (1949), Theodor Heuss (1950), Ludwig Erhard (1959), Konrad Adenauer (1966), and Golda Meir (1973).

By the end of World War II, Kokoschka's paintings had found their way into major U.S. museums, including the Museum of Modern Art, the Detroit Institute of Arts, the Art Institute of Chicago, the City Art Museum of Saint Louis, the Albright Art Gallery, and the Phillips Memorial Gallery. Apart from his rising reputation within the U.S. museum world, the 1950s saw significant advances in American scholarship on Kokoschka and other Expressionists. New postwar histories of art positioned Kokoschka within the Expressionist movements and struck a balance between his institutional affiliations with Vienna and Berlin art associations and dealers and the stylistic qualities of his painting and drawing.[21] A 1954 Kokoschka exhibition opened at the Santa Barbara Museum of Art and traveled to the California Palace of the Legion of Honor in San Francisco. Ada Story, the

director of the Santa Barbara museum, characterized Kokoschka as "a strong individualist—convincing as a painter, a draftsman, a thinker, a speaker, a writer, a humanitarian—a great artist and a great personality." This was a far cry from the public figure Kokoschka had cut in prewar Vienna.

In 1949, with renown growing due to the Institute of Contemporary Art's traveling exhibition, the painter taught summer school at Tanglewood, near Boston, and visited New York. He also accepted an invitation from the Minneapolis Institute of Arts to visit Minnesota. Within the decade, Kokoschka would spend a surprising total of five months in Minnesota—more time than he would stay anywhere else in America. He made three extended visits to Minnesota (1949, 1952, and 1957), and painted several portraits of some of the region's most socially prominent personalities. On his second and third visits, he was also guest professor at the Minneapolis School of Art. According to Kokoschka, the portrait commissions on these trips earned him enough to build a house in Villeneuve, Switzerland.[22]

As much as we may chronicle Kokoschka's public venues and indigenous opinions about his art, there is one important fact that must be reckoned with if the U.S. reception of Kokoschka—and so many other crucial European Expressionists—is to be understood. From the 1950s to the 1970s, the dean of American art criticism, Clement Greenberg, never once offered his opinion in print on Kokoschka's art, despite the artist's soaring international reputation and increasing prestige in the United States. In fact, Kokoschka's postwar reputation in America had come to rest upon his humanism and the panoply of humanitarian causes he championed. Such qualities—beyond the paintings' frames—did not register, it seems, on Greenberg's radar screen. And indeed, from the late 1930s, Kokoschka's life as well as his art were swamped by matters of social conscience.

It is therefore unsurprising that evaluations of Kokoschka's work are often split over the quality of his art and the fact of his ideological and political commitment. Such assumptions and judgments repeatedly surface in the writings of those faced

Kokoschka in his painting class at the Minneapolis School of Art, December 1957 (photograph by Earl Schubert of the *Minneapolis Star Tribune*)

with making sense of Kokoschka's diverse selves and art. Grace Glueck, in her 1980 *New York Times* obituary for the ninety-three-year-old artist, summarized the range of opinion that had coursed through the previous forty-odd years of American art writing on Kokoschka. The positive and negative criteria commonly applied to Kokoschka's paintings were identified. His best paintings, according to Glueck, featured "the penetrating portraits of his early years, in which he achieved psychological and emotional depth by means of a nervous, tense line and an 'expressive' use of distortion, and for his later paintings of cities, done in a mystical, imaginative vein that expressed the largeness of the metropolis and its power." And less favorably: "1931 … began the long years of ideological involvement during which his art was put to the service of his humanist ideas."[23]

By the time of the centennial exhibition of his work at the Serge Sabarsky Gallery in 1985–86, which focused on the artist's early portraits, critics were noting a related shift in Kokoschka's art and career. Namely, how did the young man with a reputation as the "horror of the middle-class" (*Bürgerschreck*) mature into a leading spokesman for international humanism and human rights?[24] Having shocked the bourgeoisie of Vienna in his youth, by the 1930s, Kokoschka had become one of the grander old men of European painting, busy promulgating his particular brand of humanitarianism. But even as critical consensus has it that the quality of Kokoschka's work slipped—according to many critics, as early as 1925—most concur that this turn was not for naught. Kokoschka in the 1930s shifted into a life engaged, putting his painting and writing talents toward a host of humanitarian ends. The edgy, nervously rendered paintings and drawings—based in lived experience of young bodies, of visages individualized—gave way to a broader pictorial articulation of the painted surface depicting the wider landscape, the kingpins of public life, of international affairs and history past and history made over into myth, while the painter focused his commitments upon teaching the next generation.

Keith Holz

1 Susanne Keegan, *The Eye of God: A Life of Oskar Kokoschka,* London: Bloomsbury, 1999, p. xv.

2 Keith Holz, "Scenes from Exile in Western Europe: The Politics of Individual and Collective Endeavor Among German Artists," in: *Exiles and Émigrés: The Flight of European Artists from Hitler,* ed. by Stephanie Barron and Sabine Eckmann, exhibition cat., Los Angeles County Museum of Art; and Berlin, Neue Nationalgalerie, Staatliche Museen, 1997–98, pp. 42–56; and idem, *Modern German Art for Thirties Prague, Paris, and London: Resistance and Acquiescence in a Democratic Public Sphere* [working title], "Social History, Popular Culture and Politics in Germany," series ed. Geoff Eley, Ann Arbor: University of Michigan Press, forthcoming 2002.

3 See "Oakland: Painting: Exhibition of Kokoschka," in: *Art News,* vol. 35, no. 20 (April 17, 1937): "Kokoschka will come to California this summer to join the faculty [at Mills College] for the Summer Session in Art, June 27 to August 1, 1937."

4 While Kokoschka's American admirers were many, it is striking that his English-language biographers are all British, not American: Edith Hoffmann (1947), Josef Paul Hodin (1966), Frank Whitford (1986), Richard Calvocoressi (1991), and Susanne Keegan (1999).

5 Kokoschka was included in the following Carnegie International exhibitions with a single painting, except where otherwise noted: 1925, 1927 (2), 1929, 1930 (3), 1933 (2), 1935, 1936, 1937 (2), 1938, 1939, 1950, 1952, 1955, 1958, 1964.

6 Susan Platt, "Gambling, Fencing, and Camouflage: Homer Saint-Gaudens and the Carnegie International, 1922–1950," in: *International Encounters: The Carnegie International and Contemporary Art, 1896–1996,* ed. by Vicky A. Clark, Pittsburgh: Carnegie Museum of Art, 1996, p. 85. Citing Saint-Gaudens to O'Connor, April 13, 1937.

7 Helen Appleton Read, "Carnegie International Comes to Brooklyn Museum for First Time in History," in: *Brooklyn Daily Eagle* (January 8, 1928), p. 5; and idem, "National Characteristics in Art Are Em-

phasized at Carnegie International," in: *Brooklyn Daily Eagle* (January 15, 1928), p. 6. Also Elisabeth L. Cary, "Carnegie International Shown at Brooklyn Museum," in: *New York Times* (January 15, 1928), p. 12; cited in Penny Joy Bealle, *Obstacles and Advocates: Factors Influencing the Introduction of Modern Art from Germany to New York City, 1912–1933: Major Promoters and Exhibitions,* Ann Arbor, Mich.: UMI, 1990, p. 218, n. 95.

8 Maude Riley, "Verboten Kokoschka," in: *Art Digest* (April 15, 1943).

9 *Oskar Kokoschka: A Retrospective Exhibition,* with Introduction by James S. Plaut and a letter from the artist, exhibition cat., Boston, Institute of Contemporary Art, 1948.

10 See for example Lawrence Dame, "Boston Institute Reviews Life of Kokoschka," in: *Art Digest,* vol. 23, no. 2 (October 15, 1948), p. 13; James S. Plaut, "Oskar Kokoschka," in: *Art News,* vol. 47 (October 1948), pp. 38–40, 55–56; and J.K.R., "Oskar Kokoschka," in: *Art Digest,* vol. 23, no. 19 (August 1, 1949), p. 9.

11 Oskar Kokoschka, letter to Herwarth Walden, December 1913. "Das Bild müsste nach Amerika, wo mein Name langsam durchsickert!" in: *Oskar Kokoschka, Briefe,* 4 vols., ed. by Olda Kokoschka and Heinz Spielmann, Düsseldorf: Claassen, 1984–88.

12 "Diese Ausstellung ermöglicht meinen langen Wunsch, in Amerika einmal Fuss fassen zu können, mit Hilfe der neuen Freunde, die ich mir dort durch meiner Arbeit erwerben werde." Oskar Kokoschka, letter to Otto Winter, December 25/27, 1914.

13 "Wenn es mit Ihrem Naturell halbwegs vereinbar ist, so bitte ich Sie, mir durch Verleihung des Bildes nach San Franzisco zu verhelfen, dass ich in Amerika Anerkennung und später Gönner finde, wozu dies Hauptstück alles beitragen wird!" Oskar Kokoschka, letter to Otto Winter, January 3, 1915.

14 *Official Catalogue of the Department of Fine Arts, San Francisco,* Panama-Pacific International Exposition San Francisco, 1915, "International Section," p. 102.

15 Kokoschka's paintings were apparently

being exhibited on both U.S. coasts: from October 9 to 23, 1915, a show of "original art" by Kokoschka is reported to have been presented at a little-known address— "Bruno's Garret," on Washington Square in New York's Greenwich Village. One report claims that the director of this space, Guido Bruno, was exhibiting Kokoschka together with another key artist of Walden's stable, Jacoba van Heemskerck. Announced in *Guido Bruno's Greenwich Village 2,* no. 5 (1915), p. 171; cited in: *German and Austrian Expressionism in the United States, 1900–1939, Chronology and Bibliography,* comp. by E. R. Hagemann, Westport, Conn.: Greenwood, 1985, pp. 17–18.

16 Sheldon Cheney, *A World History of Art,* New York: Viking, 1937, p. 885.

17 Paul Westheim, "Sanity in Art," in: *Die Neue Weltbühne,* vol. 34, no. 50 (December 15, 1938), pp. 158–160.

18 *Saint Louis Star* (October 3, 1942), Saint Louis Art Museum Library, clipping notebooks on exhibitions.

19 See, for example, M.G., "Drawings and a Great Portrait in a Rare Kokoschka Show," in: *Art News,* vol. 37, no. 1 (October 1, 1938), p. 13.

20 Alfred Neumeyer, "Oskar Kokoschka," in: *Magazine of Art,* vol. 38, no. 7 (November 1945), pp. 261–266.

21 Peter Selz, *German Expressionist Painting,* Berkeley: University of California Press, 1956, pp. 161–160, 251–254, 309–311; see also Bernard S. Myers, *The German Expressionists: A Generation in Revolt,* New York: Praeger, 1957, pp. 58–70.

22 Beth Petheo, *Oskar Kokoschka in Minnesota 1949–1957: Mission and Commission,* Collegeville, Minn.: Saint John's University, 1991.

23 Grace Glueck, "Oskar Kokoschka, Painter, Dead; A Major Figure in Expressionism," in: *New York Times* (February 23, 1980).

24 Kokoschka himself discussed the term *Bürgerschreck* in an interview titled "Der Bürgerschreck Kokoschka," in: *Die Neue Weltbühne,* vol. 32, no. 10 (March 5, 1936), pp. 335–339.

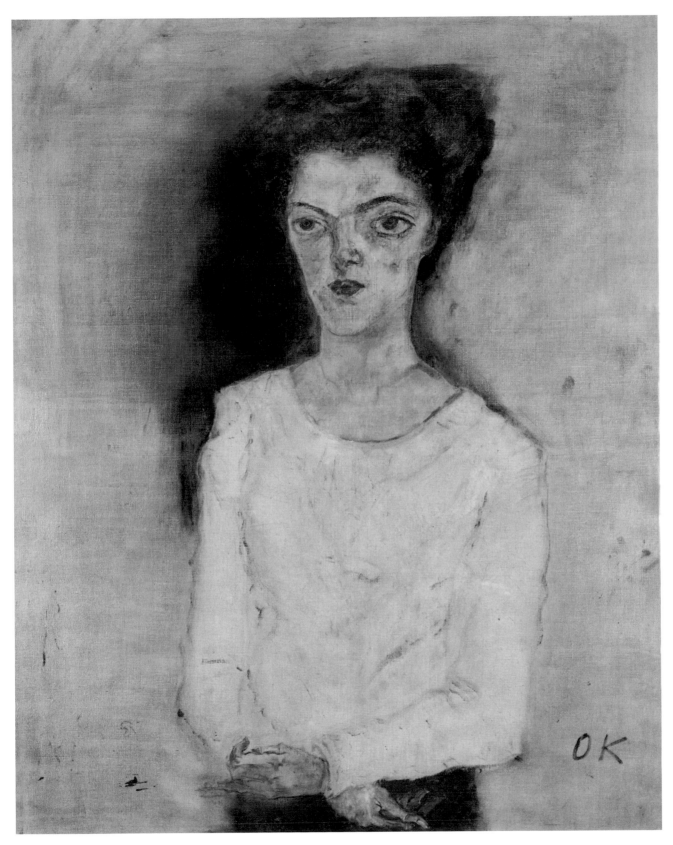

Martha Hirsch, 1909 cat. I.45

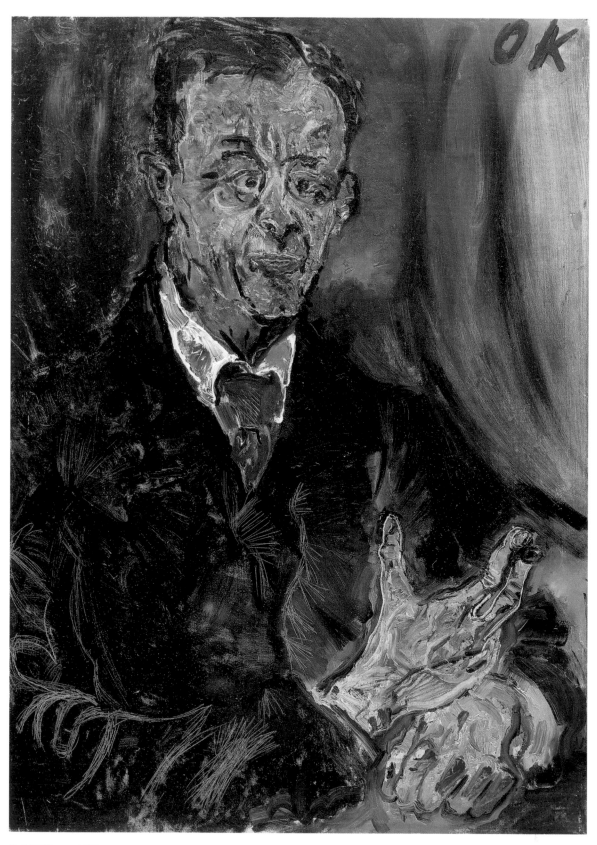

Rudolf Blümner, 1910 cat. I.48

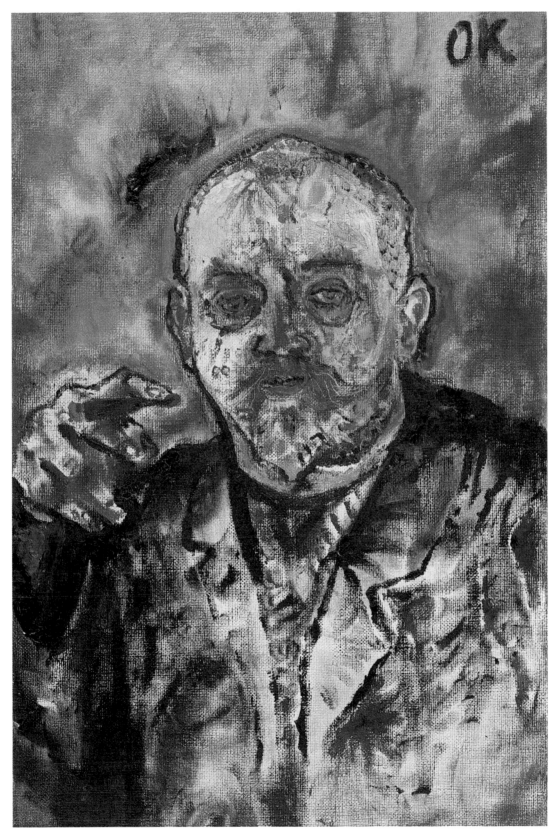

Paul Scheerbart, 1910 cat. l.47

Wilhelm Köhler, 1912 cat. I.49

Girl With Turban, early 1920s cat. I.50

Emil Löwenbach, 1914 cat. I.51

Herr Bauer, 1914 cat. I.52

CHECKLIST: VIENNA CIRCA 1900

Please see Bibliography for cited literature.

GEORGE MINNE

I.1

The Bather (Die Badende) ca. 1899
marble
H. 39.5 cm (15 1/2 in.)
Ill. p. 39

Provenance:
Fritz Waerndorfer, Vienna
Knips family, Vienna
Private collection, New York

Literature:
Deutsche Kunst und Dekoration, vol. 4,
no. 2 (1910), p. 240.
Leo van Puyvelde, *George Minne,* Brussels: Editions des Cahiers de Belgique,
1930, no. 31.
Eduard F. Sekler, *Josef Hoffmann, das architektonische Werk,* Salzburg: Residenz, 1981, pp. 278–279.

This sculpture is a typical example of George Minne's work around 1900. The figure, standing up to its knees in water, seems to be twisting upward; the deliberately distorted pose anticipates Expressionism's treatment of the human form. Such features as the subject's boyish look, and the way the right arm is bent sharply backward, were to have considerable influence on the Austrian Expressionists, specifically Egon Schiele and Oskar Kokoschka. Another obvious allusion to Minne may be seen in Klimt's painting *Wasserschlangen (Freundinnen)* (*Water Serpents [Female Friends];* 1904–07), although in the case of the Klimt, the erotic stylization of the women and their subsumption in ornament goes far beyond what is attempted in the Minne sculpture. Minne was considered an important name among the protagonists of Viennese modernism. His works were shown at the Secession and received critical attention that was generally favorable, although sometimes mixed with reservations. Nevertheless, his highly idiosyncratic work exercised a strong influence over the art of his day. Here, Minne's female figure is portrayed as distracted, totally absorbed by her own sensuality. As a result, the viewer is almost perforce transformed into voyeur, like the elders in the Old Testament story who spied on Susanna bathing. The introspection of the girl, her nudity, and the fixed, transient moment of her posture, all emphasize the erotic nature of the representation. By using marble, and exploiting its distanc-

ing coolness, the moment remains almost uninterrupted.
The version of *The Bather* seen here (bronze and plaster versions also exist) comes from the collection of the wealthy Viennese industrialist and patron of the Secession, Fritz Waerndorfer, who also possessed one of Minne's sketchbooks. Waerndorfer kept this figure standing on his desk. Interestingly, the collector Karl Ernst Osthaus also had a Minne figure on his work table; and the Secession painter Carl Moll even painted a self-portrait with one of Minne's works. In Moll's work, a mirror was cunningly used to display the figure from several angles, and this artistic strategy served once again to underline the voyeuristic moment as a key element in the work.
Olaf Peters
Translated from the German by Nicholas T. Parsons.

ALFRED KUBIN

I.2

Stallion (Hengst) ca. 1899
India ink, wash and spray on paper
13.2 × 16.6 cm (5 3/16 × 6 1/2 in.)
Initialed l. r.: AK
Ill. p. 44

Provenance:
Galerie Altnöder, Salzburg
Private collection, New York

I.3

Charon ca. 1902
India ink, wash, spray, and charcoal on paper
17.15 × 26 cm (6 3/4 × 10 1/4 in.)
Signed l. r.: Kubin
Ill. p. 46

Provenance:
Sotheby's, London
Private collection, New York

I.4

Man in a Storm (Mann im Sturm) ca. 1903
India ink, wash, charcoal, and spray on paper
16.5 × 24.15 cm (6 1/2 × 9 1/2 in.)
Signed l. r.: A. Kubin
Ill. p. 47

Provenance:
Albert Grokoest, New York
Galerie St. Etienne, New York
Private collection, New York

On his deathbed, Kubin pleaded with his doctor: "Don't take away my fear, it is my only asset!"[1] Fear was indeed something that accompanied Kubin throughout his life. From his early years in Munich, an atmosphere of menace and of persecution, a feeling of impotence in the face of violence and horror, are the dominant features of his work. The "cry of anguish," which has been characterized as "the motif of an age," is particularly identified with Kubin. It is a motif he shares with painters such as Edvard Munch and Egon Schiele, as well as with later artists such as Francis Bacon. In the extreme states of feeling portrayed in such works, human beings mutate into hermaphrodites. In this respect, the running figure here is related to that in Munch's painting *The Scream.* Both figures, depicted in extreme emotional states, appear to be sexless, or at any rate of indefinable sex. For this reason the title of the drawing would seem to be problematic. The depersonalized nature of the work underlines the overriding intention of the artist: namely, to represent an existential feeling.[2]
This is a drawing that evokes a nightmare, moving between dream and a constructed, surreal appearance of reality. The shadow itself is transformed into a ghostly doppelgänger. A flying animal, already encountered in other drawings such as *Die Verfolgung (The Pursuit),* swoops down on the running figure. The diagonal thrust serves to increase the tempo of movement in the picture, at the same time emphasizing its sense of claustrophobia. The whole recalls works by Kubin's artistic heroes—the etchings of Max Klinger or Felicien Rops for instance; through this recollection, we become vividly aware of the tradition from which the artist drew inspiration, both for his themes and for their manner of composition.
Antonia Hoerschelmann
Translated from the German by Nicholas T. Parsons.

[1] Günter Rombold, "Die Angst im Werk von Alfred Kubin," in: *Alfred Kubin 1877–1959,* ed. by Peter Assmann, Linz: Residenz,1995, p. 83.
[2] Hilde Zaloscer, *Der Schrei, Signum einer Epoche. Das expressionistische Jahrhundert,* Vienna: Brandstätter, 1985, pp. 101ff.

I.5

The Glutton (Der Schlemmer) 1904
India ink, wash, spray, and charcoal on paper

29.8 × 30.2 cm (11 3/4 × 11 7/8 in.)
Signed l. r.: AKubin
Inscribed l. l.: Der Schlemmer
Ill. p. 45

Provenance:
Serge Sabarsky Gallery, New York
Private collection, Salzburg
Galerie Wienerreuther & Kohlbacher, Vienna
Private collection, New York

GUSTAV KLIMT

I.6

The Tall Poplar Tree I
(Die Grosse Pappel I) 1900
oil on canvas
80 × 80 cm (31 1/2 × 31 1/2 in.)
Ill. p. 58

Provenance:
Magda Mautner Markhof, Vienna
Sotheby's, London
Private collection, New York

Literature:
Eisler, 1920, p. 21.
Novotny and Dobai, no. 111.
Fritz von Ostini, in: *Die Kunst,* vol. 3 (Kunst für alle, no. 16), p. 387.
Ver Sacrum, vol. 4 (1901), p. 209 (list of works sold).

The particular effects of this picture are achieved by the contrast between two opposing motifs. In the foreground is the flowery meadow, spotted with white blooms and a filigree of apple trees, where red points serve as the visual abstraction of fruit. Contrasted to this scene is the monumental, soaring poplar, cut off at the upper edge of the picture. A third element is the cloud formation in the sky, made more dramatic by a break in the cloud ceiling through which dazzles the blue of the sky, a focal point of both color and light.
In 1899, in the year in which *The Tall Poplar Tree I* was created, Klimt's landscape painting was still embedded in the tradition of late Romanticism and Impressionism. In 1902, two years after the picture was completed, Klimt again chose the motif of the poplar, but this time he dissolved the body of the tree in a whirl of Pointillist-style brushwork, and set the main subject against the dark blue and white of dramatic clouds above a low horizon. Klimt is here exploiting in an assured manner the stylistic experiences and discoveries made in

the generation that preceded him—Impressionism, German late Romanticism, and Pointillism. Nature was dramatically invested with wild vitality, in the manner of van Gogh, in order to achieve the results he wanted.

One thing is common to all of Klimt's landscapes: without exception, they lack any ancillary features. Human figures, animals, and objects do not distract from the sectioned scene of pure landscape. The square format favored by the Secession underpins this strong focus on subject matter. The result is that "mood" becomes the real motif, as the art historian Alois Riegl pointed out in his essay "Mood as Content in Modern Art" (1899), and as indeed was the prevalent understanding of nature at the turn of the century. What was looked for, and discovered, in nature was the triumph of harmony over dissonance, tranquility over turmoil.

In his *Tall Poplar Tree I*, Klimt once again summed up the stylistic experience of the nineteenth century, but he did so with an individuality that stamped his personal artistic character on the work, and placed it sublimely beyond and above any suspicion of academic epigonism.

Wolfgang Georg Fischer
Translated from the German by
Nicholas T. Parsons.

I.7

Transfer Drawing for *Jurisprudence* (Übertragungsskizze für die *Jurisprudenz*) 1902–03
black chalk and pencil on paper
84 × 61.4 cm (32 1/2 × 23 3/4 in.)
Signed l. r.: GUSTAV / KLIMT
Ill. p. 61

Provenance:
Fritz Waerndorfer, Vienna
Galerie Arnot, Vienna
August Lederer, Vienna
Erich Lederer, Geneva
Klipstein & Kornfeld, Bern
Wolfgang Wittrock, Düsseldorf
The Woodbridge Company, Toronto
Serge Sabarsky Gallery, New York
Private collection, New York

Literature:
Novotny and Dobai, p. 329.
Pirchan, 1942, fig. 77.
Pirchan, 1956, fig. 68.
Strobl, vol. 1, no. 942.
Ver Sacrum, special issue (1903), p. 21 (reproduction).

I.8

Two Reclining Women (Freundinnen nach rechts liegend) 1905–06
pencil on paper
35.3 × 55.6 cm (13 7/8 × 21 7/8 in.)
Signed l. r.: GUSTAV / KLIMT
Ill. p. 66

Provenance:
Private collection, United Kingdom
Marianne Feilchenfeldt, Zürich
Private collection, New York

Literature:
Strobl, vol. 4, no. 3572 (Study for *Wasserschlangen II [Water Serpents II],* second version, 1904–07).

I.9

Pale Face (Bleiches Gesicht)
1907–08
oil on canvas
80 × 40 cm (31 1/2 × 15 3/4 in.)
Ill. p. 59

Provenance:
Galerie Neumann, Vienna
Bruce Goff, Kansas City, Missouri
Galerie St. Etienne, New York
Private collection, New York

Literature:
Novotny and Dobai, no. 156.

I.10

Pond of Schloss Kammer on the Attersee (Schlossteich in Kammer am Attersee) before 1910
oil on canvas
110 × 110 cm (43 1/4 × 43 1/4 in.)
Ill. p. 62

Provenance:
Galerie Miethke, Vienna
Heinrich Böhler, Vienna
Galerie Welz, Salzburg
Galerie Neumann, Vienna
Bruce Goff, Kansas City, Missouri
Galerie St. Etienne, New York
Private collection, New York

Literature:
Novotny and Dobai, no. 167.

I.11

Forester House in Weissenbach on the Attersee (Forsthaus in Weissenbach am Attersee) 1912
oil on canvas
110 × 110 cm (43 1/4 × 43 1/4 in.)
Signed l. l.: GUSTAV / KLIMT
Ill. p. 63

Provenance:
Viktor Zuckerkandl, Vienna
Hans Böhler, Vienna
Serge Sabarsky Gallery, New York
Private collection, New York

Literature:
Deutsche Kunst und Dekoration, vol. 38 (1916), p. 58.
Eisler, 1931, pl. 9.
Novotny and Dobai, no. 182.

I.12

Seminude (Halbakt) 1913
blue pencil on paper

56.2 × 36.9 cm (22 1/4 × 14 1/2 in.)
Ill. p. 60

Provenance:
Köchert Family, Vienna
Irene Ginsberg, Vienna
Private collection, New York

Literature:
Strobl, vol. 3, no. 2283.

I.13

Reclining Seminude (Liegender Halbakt nach rechts) ca. 1914
pencil and red and blue colored pencil
37.1 × 56 cm (14 5/8 × 22 1/16 in.)
Signed l. r.: GUSTAV / KLIMT
Ill. p. 64

Provenance:
Erich Lederer, Geneva
Elisabeth Lederer, Geneva
Estate of Erich and Elisabeth Lederer
de Pury & Luxembourg Art, Geneva
Private collection, New York

Literature:
Hofstätter, no. 20.
Strobl, vol. 2, no. 2319.

I.14

Portrait of Baroness Elisabeth Bachofen-Echt (Bildnis Baronin Elisabeth Bachofen-Echt) ca. 1914
oil on canvas
180 × 128 cm (70 7/8 × 50 3/8 in.)
Signed l. r.: GUSTAV / KLIMT
Ill. p. 65

Provenance:
August Lederer, Vienna
Erich Lederer, Geneva
Serge Sabarsky Gallery, New York
Private collection

Literature:
Eisler, 1920, p. 46.
Eisler, 1931, pl. 22.
Ingomar Hatle, *Gustav Klimt, ein Wiener Maler des Jugendstils,* Ph.D. dissertation, Universität Graz, 1955.
Novotny and Dobai, no. 188.
Pirchan, 1956, no. 100.

The young woman in this picture is the daughter (1894–1944) of August and Serena Lederer, the two greatest patrons of Gustav Klimt. In 1899, some fifteen years before he began this work, Klimt had painted a full-length portrait of Elisabeth's mother.

From the last years of the nineteenth century onward, Klimt had—in the realm of portraits—been occupied exclusively with representations of women. Even when ornament seemed to predominate as compositional element, the model herself was still of utterly compelling interest to the painter, as may be seen from his constant striving to

achieve a perfect likeness. That indeed is true of Klimt in all periods of his creative activity. The close likeness was something he achieved by means of a subtle painterly technique, which celebrated specific physical features (face, neck, hands, etc.) as if they were precious jewels. The contrast with the stylized background, comprised of a complex mass of ornament, served to heighten the effect of the portrait element. The combination of naturalism and extremely abstract settings, together with an almost complete absence of pictorial space, is strongly evident in this portrait of the baroness. Different areas of the picture surface show various styles of ornamentation, which are indeed contrasted with one another. The sitter's fashionable robe made by an English couturier, is set against a triangular patch of ornamented material, which has been identified as a section of a Chinese dragon patterned robe. The symbols for good fortune that appear on it are a reference to the typical hopes and dreams of a young woman, which the painter attributes to her. This section of robe, which Klimt may have seen in Vienna's Museum für angewandte Kunst (Museum of Applied Art), is situated in front of a section of wallpaper, which itself is decorated with motifs taken from Chinese porcelain. The only suggestion of space is supplied by the carpet on which the woman is standing, with its static geometrical pattern.

Gerbert Frodl
Translated from the German by
Nicholas T. Parsons.

I.15

The Dancer (Die Tänzerin)
ca. 1916–18
oil on canvas
180 × 90 cm (71 1/16 × 35 3/8 in.)
Ill. p. 67

Provenance:
Richard Lányi, Vienna
Galerie Gustav Nebehay, Vienna
Joseph Urban, Vienna and New York
Private collection, Paris
Private collection, New York

Literature:
Bulletin of the Art Institute of Chicago (October 1922), ill. p. 67.
Kunst und Kunsthandwerk, vol. 23 (1920), p. 189.
Novotny and Dobai, no. 208.

Klimt is considered one of the greatest painters of women; indeed, there is scarcely any other artist of the period around 1900 who was as intensely concerned with representing the feminine and the female. Thousands of drawings, redolent of eroticism and

showing great calligraphic sophistication, bear witness to this fascination. In addition, Klimt's easel portraits of women have a particularly important place in his œuvre.

This brilliantly colored portrait of *The Dancer* was one of the first Klimt pictures to reach the United States, having originally been in the possession of the Viennese architect Joseph Urban. When Urban decided to pursue his career in the United States, he soon made a name as an idiosyncratic designer in theater and film. In June 1922, he founded a New York branch of the Wiener Werkstätte. The highlight at the opening of the Fifth Avenue gallery was Klimt's *Dancer,* which was being exhibited for the first time in America.

The picture belongs to the late phase of Klimt's work and should be considered in association with his posthumous portrait of Ria Munk. Munk, a cousin of Elisabeth Lederer (who became Baroness Bachofen-Echt), committed suicide in December 1911. Some time in 1914, a second portrait of her was created, although we do not know exactly how it looked. When this work failed to gain the approval of the commissioner, Klimt reworked it as the picture of *The Dancer.* However, the main concept of the original work—with its extremely flat composition, and where the surroundings of the sitter are presented as layered foil, rather than as pictorial space—had not altered since the first two large-format pictures painted around 1900, although the relationship between background and sitter now took on an altogether different and more significant aspect. As before, there is an effective contrast between the delicately traced and refined surface of the living being and the other parts of the painting. However, unlike in earlier works, Klimt conceals the painterly aspects of these areas, and to this extent we clearly see him coming to terms with the developments of Expressionism in Paris and Berlin. The rich and colorful garment of the dancer, which delicately reveals the breast of the young woman, hardly contrasts with the background at all. The latter consists of Japanese motifs and a dense arrangement of flowers. Next to the woman is a small, round table with a bunch of flowers, while on the floor in the flat picture surface may be seen a carpet with a geometric pattern on a red background. The simple, strongly colored marks with geometric and floral patterns—which so often occur in Klimt's work—achieve a heightened complexity in this piece. It is clear from individual details that the full composition and exact distribution of the color fields in the lower third of the picture were never brought to completion.

Gerbert Frodl
Translated from the German by Nicholas T. Parsons.

RICHARD GERSTL

I.16

Self-Portrait (Selbstbildnis) 1907
pen and ink on paper
46 × 31.5 cm (13 5/8 × 10 1/4 in.)
Estate stamp on verso
Ill. p. 73

Provenance:
Estate of Richard Gerstl
Neue Galerie, Vienna
Galerie St. Etienne, New York
Private collection, New York

Literature:
Otto Breicha, "Gerstl, der Zeichner," in: *Albertina-Studien,* vol. 3, no. 2 (1965), p. 93 (fig. 1).
Cornelia Ellersdorfer, *Das verkannte Genie Richard Gerstl: Analyse einer Sonderstellung im österreichischen Frühexpressionismus anhand seiner bekannteren Porträts,* Master's thesis, Universität Graz, 1991, p. 51.
Niels Ewerbeck, *Richard Gerstl: Studien zum Werk des Künstlers,* Master's thesis, Cologne, 1989, pp. 72ff.
O. Kallir, no. 61.
Kollektivausstellung der Neuen Galerie Wien, exhibition cat., Berlin, Galerie Gurlitt, 1932.
Schröder, pp. 74ff.
Patrick Werkner, "Richard Gerstl," in: *Physis und Psyche: Der österreichische Frühexpressionismus,* Vienna: Herold, 1986, p. 66.

I.17

Portrait of a Seated Man in the Studio (Bildnis eines sitzenden Mannes im Atelier) 1907
oil on canvas
130 × 100 cm (51 1/2 × 39 in.)
Estate stamp on verso
Ill. p. 75

Provenance:
Estate of Richard Gerstl
Neue Galerie, Vienna
Galerie Würthle, Vienna
Private collection, Vienna
Serge Sabarsky Collection

Literature:
Werner Hofmann, "L'Espressionismo in Austria," in: *L'Arte Moderna,* vol. 3, no. 20 (1967), ill. p. 47, pp. 41–53.
O. Kallir, no. 32.
Schröder, p. 134.

Richard Gerstl's small, intense oeuvre defies ready analysis, and it can be argued that this enigmatic quality is part of the artist's charm. Only a few tangi-

ble facts provide guidelines for dating his paintings. Almost none of the surviving works were dated by the artist, so clues must be sought in style and subject matter. The handful of identifiable portrait sitters provides at least a partial time frame (as the works in question could not have been executed prior to Gerstl's acquaintance with the subjects). However, the ultimate goal of extrapolating a comprehensive chronological development from such fragmentary associations remains elusive. Otto Kallir, who first catalogued Gerstl's estate after rescuing it in the early 1930s, declined to assign dates to the paintings, believing that this would entail an untenable degree of speculation.[1] However, Klaus Albrecht Schröder, who prepared the most complete recent documentation of the œuvre, decided to accept the challenge of imposing order on the artist's unwieldy output.[2] From Schröder's work, a rough trajectory in Gerstl's development can be discerned. As might be expected, the artist's earliest pictures (through ca. 1905) are the most academic, and their palette is comparatively muted. According to Schröder's chronology, Gerstl developed his idiosyncratic version of Pointillism around 1906, and over the remaining two years of his life his brushwork grew increasingly expressive, his colors ever more exuberant. Though accurate, this analysis does not necessarily make it easy to place specific paintings within the overall chronological framework, particularly in the critical period from 1906 through 1908. Unanswered—perhaps unanswerable—is the question of whether Gerstl was progressing systematically toward expressive abstraction, or whether his ecstatic jags in that direction were partly the result of the extreme fluctuations in mood from which he evidently suffered.

Schröder dates *Portrait of a Seated Man in the Studio* to 1907. The sitter has so far not been identified, but an intriguing bit of information is provided by Gerstl's portrait of Ernst Dietz, recognizable in the background of the composition. Dietz, an art historian, was a cousin of the composer Anton von Webern, and Gerstl presumably met him through the Schönberg circle, with which he was first associated in 1906. Since Gerstl's work in 1906 is still relatively Pointillistic, the 1907 dating for this work, as well as for the related Dietz painting, is plausible.

Portrait of a Seated Man in the Studio is a curious amalgam of academic portrait conventions and stylistic flourishes that serve to undermine, if not deliberately flout, those traditions. The subject is presented frontally, seated in an armchair with folded hands, just as sitters

have been portrayed in countless paintings through the ages. But here, the area occupied by the sitter is distinctly unnerving. Foreground and background seem to collapse in on one another, trapping the man in an airless, essentially two-dimensional space. The heavy use of acid green (a favorite color of Gerstl's) accentuates this aura of discomfort. Finally, there is the strange positioning of the Dietz portrait, directly behind the sitter's head. The headless figure of Dietz hovers over this man like a ghost, covertly challenging the primacy of the painting's ostensible subject. The meaning of all this, however, remains obscure. Here, Gerstl left traces to follow, but then, through his suicide, obliterated the crucial last steps.
Jane Kallir

[1] Otto Kallir, "Richard Gerstl—Beiträge zur Dokumentation seines Lebens und Werkes," in: *Mitteilungen der Österreichischen Galerie,* vol. 17, no. 64 (1974).
[2] Klaus Albrecht Schröder, *Richard Gerstl, 1883–1908,* exhibition cat., Vienna, Kunstforum der Bank Austria; and Kunsthaus Zürich, 1993–94.

I.18

Portrait of a Man on the Lawn (Bildnis eines Mannes in der Wiese) 1907
oil on canvas
109.5 × 90.2 cm (43 1/8 × 35 1/2 in.)
Estate stamp on verso
Ill. p. 74

Provenance:
Estate of Richard Gerstl
Neue Galerie, Vienna
Galerie Würthle, Vienna
Private collection, Vienna
Serge Sabarsky Gallery, New York
Private collection, New York

Literature:
Otto Breicha, *Richard Gerstl: Bilder zur Person,* Salzburg: Verlag Galerie Welz, 1991, p. 20.
Cornelia Ellersdorfer, *Das verkannte Genie Richard Gerstl: Analyse einer Sonderstellung im österreichischen Frühexpressionismus anhand seiner bekannteren Porträts,* Master's thesis, Graz, 1991, p. 82.
O. Kallir, no. 38.
Schröder, p. 92.

EGON SCHIELE

I.19

Portrait of a Woman with Orange Hat (Bildnis einer Frau mit oragnefarbenem Hut) 1910
watercolor and black crayon on paper
44.5 × 30.5 cm (17 1/2 × 12 in.)
Signed and dated l. r.: Schiele 10
Ill. p. 82

Provenance:
Marlborough Fine Art, London
Serge Sabarsky Collection

Literature:
J. Kallir, D 499.

I.20
Self-Portrait with Arm Twisting Above Head (Selbstportrait mit Arm über Kopf gezogen) 1910
watercolor and charcoal on paper
45.1 × 31.7 cm (17 3/4 × 12 1/2 in.)
Initialed l. r.: S
Ill. p. 85

Provenance:
Eugene V. Thaw and Co., New York
Private collection, New York

Literature:
J. Kallir, D 688.
Vienna 1900: Art, Architecture and Design, ed. by Kirk Varnedoe, exhibition cat., New York, Museum of Modern Art, 1986, p. 212.

It has been said that, among artists known for their self-portraits, Schiele was the most prolific, producing more works of this sort than even Rembrandt, Corinth, or Beckmann. Scarcely twenty years old when he emerged as an Expressionist of major talent, Schiele was also the quintessential adolescent artist. His self-searching as he struggled to assume an adult identity provided a powerful impetus for the creation of self-portraits. And the self-portraits themselves provide an almost diaristic glimpse into the artist's changing sense of self.
While it is tempting to try to tie Schiele's self-portraits into specific details of his biography, it is clear that, especially in 1910, these works involved a strong element of role playing. The Schiele whom we see—happy, sad, belligerent, or shy—is not the real Schiele, or at least not the *complete* Schiele. Rather, the artist chose to highlight and exaggerate specific aspects of his personality as a way of questioning and defining his identity. This self-portrait presents Schiele at his fiercest. The furrowed brow, piercing stare, and thrust-out ribcage all suggest a highly confrontational mien. His nudity is both a challenge and a come-on.
But was Schiele really such a tough character in 1910? On one level, yes: Schiele, who believed above all in the sanctity of his mission as an artist, was unwilling to make any sort of concession to those who failed to share his views. He was prepared, if necessary, to take on the world. And yet, on another level, the young artist was very vulnerable. After years of squabbling with his conservative uncle, Leopold Czihaczek,

Schiele in 1910 had finally been cut off financially by his family. He had acquired a small group of patrons, but most people were outraged by his art and his unconventional behavior. The bravado expressed in this self-portrait is thus more a matter of wishful thinking on the artist's part than a reflection of his true position.
Jane Kallir

I.21
Portrait of the Painter Karl Zakovsek (Bildnis des Malers Karl Zakovsek) 1910
oil, gouache, and charcoal on canvas
100 × 89.9 cm (39 3/8 × 35 3/8 in.)
Initialed and dated l. l.: S. 10
Ill. p. 102

Provenance:
Carl von Reininghaus, Vienna
Auktionshaus Glückselig, Vienna
Rolf Stenersen
Albert Grokoest, New York
Sotheby's, New York
Serge Sabarsky, New York
The Woodbridge Company, Toronto
Private collection, New York

Literature:
Comini, pl. 25.
J. Kallir, P 160.
O. Kallir(-Nirenstein), 1966, no. 102.
Leopold, 1972, no. 148.
Nebehay, 1979, fig. 281.
Nirenstein(-Kallir), no. 68.

The painter Karl Zakovsek (born 1888) was two years older than Egon Schiele, and was a fellow student at the Viennese Kunstakademie. From 1911 he was a teacher of drawing, latterly at the Bundesrealgymnasium in Vienna's seventeenth district. He was also a founding member of the Neukunstgruppe, initiated by Schiele with some colleagues who left the Akademie with him in April 1909. In December of that year they held their first exhibition at Vienna's Kunstsalon Pisko; Anton Faistauer designed a poster for the show, and Schiele composed its manifesto. This he subsequently altered and published in 1914, in volume 20 of the journal *Die Aktion* under the title "Art—The New Artists."
In his portrait of Zakovsek, Schiele captures the poverty and harshness of the life of a poor painter. The depiction is merciless, with the bones of the hands and face showing through the subject's taut skin, while the meager beard seems in contradiction to the bushy hair of his arms. Equally grotesque is the effect of the seemingly distended neck; here, Schiele consciously employs an artistic strategy: the shirtless upper body is so intersected by the jacket and waistcoat that part of the

bare breast appears as a continuation of the neck's elongation.
These effects are intensified by the lack of any depiction of the chair on which the subject is presumably sitting; at the same time his arm, which seems somehow invisibly supported in a void, adds significantly to the alienating atmosphere of the whole. The detachment and independence of the subject is emphasized even more by the way it is set against a bright background. In the well-balanced composition of the figure, the diagonal plays a dominant role, leading from the slanting head resting on the right hand to the listlessly hanging left hand.
Rudolf Leopold
Translated from the German by Nicholas T. Parsons

I.22
Mother and Child (Mutter und Kind) 1910
watercolor, gouache, and pencil on paper
55.6 × 36.5 cm (22 × 14 1/2 in.)
Initialed and dated l. r.: S. 10
Ill. p. 84

Provenance:
Auktionshaus Lempertz, Cologne
Serge Sabarsky, New York
Private collection, New York

Literature:
Egon Schiele: Aquarelle und Zeichnungen, ed. by Walter Koschatzky, Salzburg: Verlag Galerie Welz, 1968, pl. 5.
"Egon Schiele," in: *Mizue,* no. 870 (September 1977), p. 10.
J. Kallir, D 396.
Vienne 1880–1938: L'apocalypse joyeuse, ed. by Jean Clair, exhibition cat., Paris, Centre Georges Pompidou, 1986, p. 423.

I.23
Self-Portrait: Head (Selbstbildnis, Kopf) 1910
gouache, watercolor, charcoal, and pencil on paper
42.5 × 29.5 cm (16 7/8 × 11 3/4 in.)
Initialed and dated l. l.: S. 10
Ill. p. 81

Provenance:
Stuttgarter Kunstkabinett
Viktor Fogarassy, Graz
Serge Sabarsky, New York
Private collection, New York

Literature:
Comini, fig. 65.
J. Kallir, D 714.
Christian M. Nebehay, *Egon Schiele: Von der Skizze zum Bild,* Vienna: Brandstätter, 1989, fig. 1.
Simon Wilson, *Egon Schiele,* Ithaca, N.Y.: Cornell University Press, 1980,

pl. 19.

I.24
Portrait of Dr. Erwin von Graff (Bildnis Dr. Erwin von Graff) 1910
oil, gouache, and charcoal on canvas
100 × 90 cm (39 3/8 × 35 3/8 in.)
Initialed and dated l. l.: S. 10
Ill. p. 100

Provenance:
Erwin von Graff, Vienna
Galerie St. Etienne, New York
Private collection, New York

Literature:
Das Egon-Schiele-Buch, ed. by Fritz Karpfen, Vienna: Verlag der Wiener Graphischen Werkstätten, 1921, pl. 6.
J. Kallir, P 161.
O. Kallir(-Nirenstein), 1966, no. 101.
Fritz Karpfen, *Österreichische Kunst,* Vienna: Literaria, 1923, pl. 114.
Leopold, 1972, no. 147.
Nirenstein(-Kallir), no. 67.
Peter Selz, "Egon Schiele," in: *Art International,* vol. 4, no. 10 (December 1960), p. 39.

I.25
Seated Pregnant Nude (Sitzende Schwangere) 1910
watercolor, gouache, and charcoal on paper
45.1 × 31.1 cm (17 3/4 × 12 1/4 in.)
Initialed l. l.: S
Ill. p. 90

Provenance:
Private collection, Germany
Christie's, London
Private collection, New York

Literature:
J. Kallir, D 533a.

I.26
Portrait of the Painter Max Oppenheimer (Bildnis des Malers Max Oppenheimer) 1910
watercolor, gouache, ink, and black crayon on paper
45.1 × 31.7 cm (17 7/8 × 12 5/8 in.)
Signed l. r.: S. 1910
Ill. p. 91

Provenance:
Oskar Reichel, Vienna
Heinrich Benesch, Vienna
Otto Benesch, Vienna
Serge Sabarsky, New York
Private collection, New York

Literature:
J. Kallir, D 588.
Leopold, 1972, pl. 39.

I.27
Self-Portrait in Brown Coat (Selbstbildnis in braunem Mantel)

1910
gouache, watercolor, and black crayon
on paper
45.6 × 32.2 cm (18 × 12 5/8 in.)
Initialed and dated l. r.: S. 10
Ill. p. 83

Provenance:
Harry Fuld
Serge Sabarsky, New York
Private collection, New York

Literature:
"Egon Schiele," in: *Mizue,* no. 870 (September 1977), p. 12.
J. Kallir, D 698.
Alfred Werner, "The Passion of Egon Schiele," in: *American Artist,* vol. 36, no. 355 (February 1972), p. 30.

I.28
Seated Nude, Three-Quarter-Length (Moa) (Sitzender Akt in halber Figur [Moa]) 1911
gouache, watercolor, pen and ink, and pencil
48.2 × 32.1 cm (19 × 12 5/8 in.)
Signed and dated u. r.: EGON / SCHIELE / 1911
Inscribed c. r.: MOA
Ill. p. 88

Provenance:
Klipstein & Kornfeld, Bern
Rudolf Leopold, Vienna
Serge Sabarsky, New York
Private collection, New York

Literature:
J. Kallir, D 910.

I.29
I Love Antitheses (Ich liebe Gegensätze) 1912
watercolor and pencil on paper
48.1 × 31.4 cm (18 7/8 × 12 3/8 in.)
Signed and dated l. r.:
EGON/SCHIELE/24.4.12/M
Inscribed l. r.: ICH LIEBE / GEGENSÄTZE
Ill. p. 101

Provenance:
Collection Lucacs
Gutekunst & Klipstein, Bern
Erich Lederer, Geneva
Galerie Kornfeld
The Woodbridge Company, Toronto
Private collection, New York

Literature:
Alessandra Comini, "Egon Schiele in Prison," in: *Albertina-Studien,* vol. 2, no. 4 (1964), p. 131.
Comini, *Schiele in Prison,* Greenwich, Conn.: New York Graphic Society, 1973, pl. VIII, fig. 35.
Comini, fig. 90.
J. Kallir, D 1187.
Nebehay, 1979, fig. 89.

I.30
Conversion (Bekehrung) 1912
oil and charcoal on canvas
69.9 × 80 cm (27 1/2 × 31 1/2 in.)
Signed and dated l. l.: EGON / SCHIELE / 1912
Ill. p. 93

Provenance:
Franz Hauer, Vienna
Guido Arnot, Vienna
Neue Galerie, Vienna
Wolfgang Gurlitt, Berlin
Serge Sabarsky, New York
Sotheby's, New York
Private collection, New York

Literature:
J. Kallir, P 231.
O. Kallir(-Nirenstein), 1966, no. 158.
Leopold, 1972, no. 219.
Nirenstein(-Kallir), no. 109.

I.31
Elisabeth Lederer, Seated with Hands Folded (Elisabeth Lederer, sitzend mit gefalteten Händen) 1913
gouache and pencil on paper
48.2 × 32.4 cm (19 × 12 3/4 in.)
Signed and dated l. r.: EGON / SCHIELE / 1913
Ill. p. 89

Provenance:
Richard Davis
Galerie St. Etienne, New York
Richard Sterba
Serge Sabarsky, New York
Private collection, New York

Literature:
Comini, pl. 107a.
J. Kallir, D 1232.
Nebehay, 1979, fig. 112.
Nebehay, 1980, ill. 115.

I.32
Stein on the Danube, Seen from the South (Large) (Stein an der Donau, von Süden gesehen (gross) 1913
oil on canvas
89.8 × 89.6 cm (35 3/8 × 35 1/4 in.)
Signed and dated c. r.: EGON / SCHIELE / 1913
Ill. p. 94

Provenance:
Franz Hauer, Vienna
Guido Arnot, Vienna
Neue Galerie, Vienna
Otto Kallir, New York
Samuel Maslon
Galerie St. Etienne, New York
Private collection, New York

Literature:
J. Kallir, P 268.
O. Kallir(-Nirenstein), 1966, no. 187.
G. Knuttel, "Oostenrijksche Kunst," in:

Wendingen, vol. 8, nos. 9–10 (1927), p. 7.
Leopold, 1972, no. 239.
Nirenstein(-Kallir), no. 126.
Arthur Roessler, "Zu den Gedächtnisausstellungen im Hagenbund und in der Neuen Galerie," in: *Bühne, Welt und Mode,* no. 158 (November 4, 1928), pp. 546–550.
Arthur Roessler, *Erinnerungen an Egon Schiele: Marginalien zur Geschichte des Menschentums eines Künstlers, erweiterte Auflage,* Vienna: Wiener Volksbuchverlag, 1948.

I.33
Friendship (Freundschaft) 1913
gouache, watercolor, and pencil on paper
48.2 × 32 cm (19 × 12 5/8 in.)
Signed and dated l. r.: EGON / SCHIELE / 1913
Inscribed l. l.: FREUNDSCHAFT
Ill. p. 86

Provenance:
Albert von Keller, Vienna
B. F. Dolbin, New York
Serge Sabarsky, New York
Private collection, New York

Literature:
"Egon Schiele," in: *Mizue,* no. 776 (September 1969), p. 3.
"Egon Schiele," in: *Mizue,* no. 870 (September 1977), p. 5.
J. Kallir, D 1355.
Nebehay, 1979, fig. 198.
Serge Sabarsky, *Egon Schiele: Disegni Erotici,* Milan: Mazzotta, 1981, pl. 17.
Peter Selz, "Egon Schiele," in: *Art International,* vol. 4, no. 10 (December 1960), p. 41.

Schiele rarely titled his drawings and watercolors; most of the titles by which they have subsequently become known were invented by the dealers and collectors through whose hands the works passed. However, in the latter part of 1913, Schiele inscribed a number of watercolors, including *Friendship* with brief titles. It is not clear exactly why he did this, or what, if anything, the titles signify. Given that many of the inscribed drawings were exhibited at the Munich Secession in the winter of 1913 or the spring of 1914, it is possible that the artist wanted them to appear as a series. Alternatively, he may merely have appended the titles as a way of keeping track of the works, since retrieving loaned pieces had often been a problem in the past.
During 1913, Schiele (who was still recovering from the shock of his 1912 imprisonment) was determined to make his mark as a painter of monumental allegorical canvases. However, his reach far exceeded his grasp, and the canvases yielded disappointing results,

several have vanished, and the largest was cut up by the artist in frustration. What we know of these abortive works suggests that they were figural compositions depicting totemic themes. Schiele would carry forth this approach in his last allegorical canvases of 1917–18, which were probably intended to function as a sequence depicting aspects of earthly existence. It is possible that, in the inscribed drawings of 1913, Schiele was already looking to develop a repertoire of figure types representing iconic subjects. This would provide an explanation, not just for *Friendship* but for others in the group, such as *Kämpfer (Fighter), Tänzer (Dancer), Andacht (Devotion), Erlösung (Redemption),* and, most portentously, *Die Wahrheit wurde enthüllt (The Truth Unveiled).* On the other hand, many of the 1913 inscriptions are merely descriptive: "torso," "foreshortened figure," "green girl," "the folded hands," and so on.
Additional interpretive possibilities are suggested by the specific title—and subject—of *Friendship.* One is reminded of the tongue-in-cheek titles (such as *Water Serpents* and *Female Friends*) that Klimt used for his paintings of lesbian couplings. Veiling such a taboo subject with a seemingly innocuous name fooled no one, of course. Schiele depicted lesbian couples repeatedly throughout his career, and most of these works imply that the women in question had a genuine relationship, were in fact truly friends, if not in reality lovers. It was his interest in all aspects of female sexuality—and probably also the precedent set by Klimt—that prompted Schiele to explore a subject that had seldom before figured so overtly in "high" art.
Jane Kallir

I.34
River Landscape with Two Trees (Flusslandschaft mit zwei Bäumen) 1913
oil on canvas
88.9 × 89.7 cm (35 × 35 3/8 in.)
Signed and dated l. l.: EGON / SCHIELE / 1913
Ill. p. 95

Provenance:
Ferdinand Eckhardt, Winnipeg
Serge Sabarsky, New York
Private collection, New York

Literature:
J. Kallir, P 264.
O. Kallir(Nirenstein), 1966, no. 187.
Leopold, 1972, no. 239.
Gianfranco Malafarina, *L'opera di Egon Schiele,* Milan: Rizzoli, 1982, p. 248.
Christian M. Nebehay, *Egon Schiele 1890–1918: Die Gedichte,* Vienna:

Wiener Bibliophilen-Gesellschaft, 1977, p. 46.
Nirenstein(-Kallir), no. 126.
Peter Selz, "Egon Schiele," in: Art International, vol. 4, no. 10 (December 1960), p. 40.

I.35
Man and Woman I (Lovers I) (Mann und Frau I [Liebespaar I]) 1914
oil on canvas
119 × 138 cm (46 7/8 × 54 3/8 in.)
Signed and dated l. c.: EGON / SCHIELE / 1914
Ill. p. 92

Provenance:
Arthur Stemmer, Vienna
Fritz Lang, Berlin
Marlborough Gallery, Zürich
Sotheby's, London
Anonymous Collection
Sotheby's, New York
Private collection, New York

Literature:
J. Kallir, P 275.
O. Kallir(-Nirenstein), 1966, no. 203.
Leopold, 1972, no. 254.
Gianfranco Malafarina, L'opera di Egon Schiele, Milan: Rizzoli, 1982, no. 277.
Christian M. Nebehay, Gustav Klimt, Egon Schiele und die Familie Lederer, Bern: Verlag Galerie Kornfeld, 1987, p. 102.
Nirenstein(-Kallir), no. 141a.
Bonnie Barrett Stretch, "Egon Schiele," in: Art and Auction, vol. 7, no. 9 (April 1985), p. 118.

I.36
Single Houses (Houses with Mountains) Einzelne Häuser [Häuser mit Bergen]) 1915
oil on canvas
109.2 × 140.2 cm (43 × 55 1/4 in.)
Signed and dated c. r.: EGON / SCHIELE / 1915
Ill. p. 99

Provenance:
Felix Albrecht Harta, Vienna
Hugo and Broncia Koller, Vienna
Rupert and Silvia Koller, Vienna
Bruno Grimschitz, Vienna
Viktor Fogarassy, Graz
Aberbach Gallery, New York
Private collection, New York

Literature:
Das Egon-Schiele-Buch, ed. by Fritz Karpfen, Vienna: Verlag der Wiener Graphischen Werkstätten, 1921, pl. 26.
J. Kallir, P 292.
O. Kallir(-Nirenstein), 1966, no. 208, XLV.
G. Knuttel, "Oostenrijksche Kunst," in: Wendingen, vol. 8, nos. 9–10 (1927), p. 9.
Leopold, 1972, no. 259.

Nebehay, 1979, fig. 123.
Nirenstein(-Kallir), no. 148, XLI.
Arthur Roessler, "Zu Egon Schieles Städtebildern," in: Österreichs Bau- und Werkkunst, vol. 2 (October 1925), p. 11.

I.37
Sunflower (Sonnenblume) 1916
gouache and black crayon on paper
46 × 29.2 cm (17 7/8 × 11 1/4 in.)
Signed and dated l. r.: EGON / SCHIELE / 1916
Ill. p. 98

Provenance:
Serge Sabarsky Gallery, New York
Private collection, New York

Literature:
J. Kallir, D 1868.

I.38
Portrait of Johann Harms
(Bildnis Johann Harms) 1916
gouache, watercolor, and pencil on paper
48.2 × 36.4 cm (19 × 14 3/8 in.)
Signed and dated l. r.: EGON / SCHIELE / 1916
[Study for the painting Portrait of an Old Man (Johann Harms), 1916; Nirenstein(-Kallir), no. 153; O. Kallir(-Nirenstein), 1966, no. 213; Leopold, 1972, no. 270; J. Kallir, P 300]
Ill. p. 103

Provenance:
Heinrich Benesch, Vienna
Betty Parsons Gallery, New York
Margaret Sargent McKean, Massachusetts
Sotheby's, New York
The Woodbridge Company, Toronto
Private collection, New York

Literature:
J. Kallir, D 1844.
Arthur Roessler, "Zu den Gedächtnisausstellungen im Hagenbund und in der Neuen Galerie," in: Bühne, Welt und Mode, no. 158 (November 4, 1928), p. 547.

I.39
Kneeling Seminude
(Kniender Halbakt) 1917
gouache and pencil on paper
45 × 28 cm (17 3/4 × 11 in.)
Signed and dated l. l.: EGON / SCHIELE / 1917
Ill. p. 87

Provenance:
Clara Mertens, New York
Serge Sabarsky, New York
Private collection, New York

Literature:
c. 34 Postkarten, Vienna: Buchhand-

lung Richard Lányi, ca. 1917–20.
J. Kallir, D 1953.
Leopold, 1972, p. 503.
Serge Sabarsky, Egon Schiele: Disegni Erotici, Milan: Mazzotta, 1981, p. 35.

I.40
Portrait of the Composer Arnold Schönberg (Bildnis des Komponisten Arnold Schönberg) 1917
gouache, watercolor, and black crayon on paper
45.7 × 29.2 cm (18 × 11 1/2 in.)
Signed and dated l. l.: EGON / SCHIELE / 1917
Inscribed l. l.: ARNOLD SCHÖNBERG
Ill. p. 97

Provenance:
Karl Grünwald, Vienna
Johann Piering, Jr.
Marlborough Fine Art, London
Serge Sabarsky, New York
Private collection, New York

Literature:
c. 34 Postkarten, Vienna: Buchhandlung Richard Lányi, ca. 1917–20.
Egon Schiele: Aquarelle und Zeichnungen, ed. by Walter Koschatzky, Salzburg: Verlag Galerie Welz, 1968, pl. 52.
J. Kallir, D 2085.
Christian M. Nebehay, Egon Schiele: Von der Skizze zum Bild, Vienna: Brandstätter, 1989, fig. 228.

I.41
Portrait of the Painter Paris von Gütersloh (Bildnis des Malers Paris von Gütersloh) 1918
black crayon on paper
46.8 × 30 cm (18 1/2 × 11 3/4 in.)
Signed and dated c. r.: EGON / SCHIELE / 1918
Inscribed l. l.: Paris Gütersloh
[Study for the untinished painting Bildnis des Malers Paris von Gütersloh, 1918; Nirenstein(-Kallir), no. 177; O. Kallir(-Nirenstein), 1966, no. 234; Leopold, 1972, no. 294; J. Kallir, P 322]
Ill. p. 96

Provenance:
Arthur Stemmer, Vienna
Rudolf Leopold, Vienna
Galerie St. Etienne, New York
Thomas Bergen, New York
Christie's, London
Galerie St. Etienne, New York
Private collection, New York

Literature :
J. Kallir, D 2448.
O. Kallir(-Nirenstein), 1970, pl. 16.
Frank Whitford, Egon Schiele, London: Thames & Hudson, 1981, fig. 148.

OSKAR KOKOSCHKA

I.42
Dancing Young Girl in a Blue Dress, Right Hand at the Skirt's Hem (Tanzendes Mädchen in blauem Kleid, die rechte Hand am Rocksaum) 1908
watercolor, tempera, and pencil on paper
44.8 × 31.5 cm (17 5/8 × 12 3/8 in.)
Initialed l. r.: OK
Ill. p. 116

Provenance:
Ernest Rathenau, Berlin
Estate of Ernest Rathenau
Sotheby's, Munich
Wolfgang Wittrock, Düsseldorf
David Thomson, Toronto
Serge Sabarsky Collection

Literature:
Rathenau, vol. 1, no. 8.

I.43
Seated Nude Girl, Left Hand Resting on Hip (Sitzender Mädchenakt, die linke Hand an der Hüfte gestützt) 1908
watercolor, gouache, and pencil on paper
43.3 × 30.5 cm (17 × 12 in.)
Initialed l. r.: OK
Ill. p. 117

Provenance:
Serge Sabarsky Collection

Literature:
Serge Sabarsky, Die Malerei des deutschen Expressionismus, Stuttgart: Jentsch, 1987, p. 128.
Sabarsky, Zeichnungen und Aquarelle des deutschen Expressionismus, Stuttgart: Cantz, 1990, plates.
Strobl and Weidinger, p. 18.

I.44
Reclining Seminude Woman
(Liegender Halbakt) 1908–09
watercolor, gouache, and pencil on paper
30.8 × 45 cm (12 1/8 × 17 3/4 in.)
Initialed l. r.: OK
Ill. p. 118

Provenance:
Private collection, New York
Serge Sabarsky Collection

Literature:
Serge Sabarsky, Oskar Kokoschka: Drawings and Watercolors 1906–1924, New York: Rizzoli, 1986, no. 15.

I.45
Martha Hirsch 1909
oil on canvas
90 × 71 cm (35 3/8 × 28 in.)

Initialed l. r.: OK
Ill. p. 119

Provenance:
Adolf Loos, Vienna
Neue Galerie, Vienna
Fritz Wolff, Vienna and New York
Annie Knize, New York
Serge Sabarsky, New York
Wendell Cherry, Louisville, Kentucky
Serge Sabarsky Collection

Literature:
Kurt Hiller, "Oskar Kokoschka," in: *Der Sturm*, vol. 1 (July 7, 1910), no. 150.
Paul Westheim, "Oskar Kokoschka," in: *Das Kunstblatt*, vol. 1 (1917), no. 319. (*Frau mit großen Augen [Woman with Large Eyes]*).
Westheim, no. 52.
Winkler and Erling, no. 23.

During the second half of 1909, Martha Hirsch and her husband Wilhelm Hirsch had their portraits painted by Kokoschka, having been introduced to the artist by architect-designer Adolf Loos. Wilhelm Hirsch was an industrial manufacturer living in Pilsen, and in 1907 he had commissioned Loos to design the interior of his Pilsen apartment. When this painting was first exhibited in the summer of 1910 at Paul Cassirer's Berlin gallery, it was referred to as *Die verträumte Frau (Dreaming Woman)*. Like the title Cassirer used for it in 1927—*Frau mit den grossen Augen* (Woman with Large Eyes)—this suggests Kokoschka's sensitivity toward the psychic state of his subjects, and his ability to portray their inner emotions through his representation of their external appearance.
Loos had known Kokoschka since the artist's work had been presented at the *Kunstschau* in Vienna in 1908; there, his *Traumtragende* tapestry designs had elicited a storm of public indignation. The piece had also attracted the attention of connoisseurs and critics who were open to new ideas. Loos was one of these: he recognized Kokoschka's unusual talent, assured him of his support, and thus became one of the mainstays of the young artist's career. The portraits that Kokoschka produced between 1909 and 1914 came about mainly as a result of Loos's efforts to encourage his friends and clients to have their portraits painted by the young artist. Yet few of the sitters Kokoschka portrayed were prepared to buy or to keep the pictures. Consequently, Loos—having promised to take the portraits himself if the sitter did not like them or could not afford them—involuntarily became the "administrator" of the largest collection of early masterworks by Kokoschka. Between 1909 and 1925, this amounted to a total of

twenty-nine oil paintings, including twenty-six portraits. Without loans from the collection Loos amassed, it would not have been possible to mount the exhibitions of Kokoschka's oil paintings that took place before World War I, and the painter would no doubt have remained unknown to the wider public. Kokoschka's portraits of Wilhelm Hirsch and of Adolf Loos, also painted in 1909, are today in the Neue Nationalgalerie in Berlin. In 1935, in Prague, Martha Hirsch sat a second time for a portrait by Kokoschka.
Johann Winkler
Translated from the German by Fiona Elliott.

I.46
Peter Altenberg 1909
oil on canvas
76 × 71 cm (30 × 28 in.)
Initialed and dated l. l.: OK/09
Ill. p. 115

Provenance:
Peter Altenberg, Vienna
Fritz Wolff, Vienna and New York
Annie Knize, New York
Peter Knize, Newtown, Connecticut
Serge Sabarsky Collection
Private collection, New York

Literature:
Paul Fechter, *Der Expressionismus*, Munich: Piper, 1914, ill.
Kurt Hiller, "Oskar Kokoschka," in: *Der Sturm*, vol. 1 (July 7, 1910), no. 150.
Oskar Kokoschka, *Dramen und Bilder*, Leipzig: Wolff, 1913, ill.
Paul Stefan, "Oskar Kokoschka," in: Kokoschka, *Dramen und Bilder*, Leipzig: Wolff, 1913, p. 5.
Paul Westheim, "Oskar Kokoschka," in: *Das Kunstblatt*, vol. 1 (1917), no. 319.
Winkler and Erling, no. 31.

This portrait occupies a special position in the oeuvre of Oskar Kokoschka. Of the 112 paintings he made between 1905 and 1914, there are 82 portraits and self-portraits—an extraordinary and unique portrait gallery in its self-containment and in the radicalism of its striving for the truth. As early as 1921, Emil Waldmann remarked that Kokoschka "must be the most outstanding depictor of people we have today. In his portraits … you can read the history of the person he is painting, not piecemeal … but in its entirety; suddenly it is all there for the viewer." Peter Altenberg (1859–1919), the great master of poetry and prose, was close to fifty years old when Kokoschka painted him sitting with his friends at a table in a coffeehouse. In the ambience of that coffeehouse, filled with "prismatic light," the friends are spellbound by the poet's evocative words. But any

sign of good cheer or high spirits is entirely absent from the picture. Kokoschka's interest is focused exclusively on the poet, who emerges from the indeterminate picture ground and enters the viewer's field of vision with extraordinary vitality. Altenberg was understood as "living fantasy" and "writing reality"; these characterizations seem to be anticipated in Kokoschka's portrait. The subject's lips are closed. What speaks to us are his eyes (following his inner thoughts to distant places) and hands (preempting the still unspoken words). At the same time, they hint of the sense of loss and loneliness in this deeply vulnerable, oversensitive soul. Kokoschka paints an octopus with blood-red tentacles in the twilight of the background, symbolizing the poet with his abrupt mood-swings. At the end of his "Erinnerung," (from the collection *Neues Altes*, which first appeared in 1911), Altenberg wrote: "We lived 'romantic idylls,' which later made it so hard to do justice to real life. …"
Johann Winkler
Translated from the German by Fiona Elliott.

I.47
Paul Scheerbart 1910
oil on canvas
70 × 47.5 cm (27 1/2 × 18 3/4 in.)
Initialed u. r.: OK
Inscribed across verso: Paul Scheerbart
Ill. p. 121

Provenance:
Adolf Loos, Vienna
Neue Galerie, Vienna
Fritz Wolff, Vienna and New York
Annie Knize, New York
Serge Sabarsky Collection

Literature:
Oskar Kokoschka, *Dramen und Bilder*, Leipzig: Wolff, 1913, ill.
Westheim, no. 52.
Paul Westheim, *Künstlerbekenntnisse. Briefe/Tagebuchblätter/Betrachtungen heutiger Künstler*, Berlin: Propyläen, 1925, ill. 59.
Winkler and Erling, no. 52.

I.48
Rudolf Blümner 1910
oil on canvas
80 × 75 cm (31 1/2 × 22 1/2 in.)
Initialed u. r.: OK
Ill. p. 120

Provenance:
Herwarth Walden, Berlin
Nell Walden, Bad Schinznach
Stuttgarter Kunstkabinett
Paul Hänggi, Basel
Christie's, London
Private collection, New York

Literature:
Hermann Bahr, *Expressionismus*, Munich: Delphin, 1919, ill. opposite p. 136.
Fritz Burger, *Cézanne und Hodler*, Munich: Delphin, 1918, ill. 178.
Sammlung Walden: Gemälde, Zeichnungen, Plastiken, 5. Verzeichnis, April 1917, Berlin: Hause, 1917, no. 131.
Sammlung Walden: Gemälde, Zeichnungen, Plastiken, 6. Verzeichnis, Mai 1917, Berlin: Hause, 1917, no. 154.
Paul Westheim, "Oskar Kokoschka," in: *Das Kunstblatt*, vol. 1 (1917), no. 319.
Westheim, no. 52.
Winkler and Erling, no. 51.

I.49
Wilhelm Köhler 1912
black crayon and ink on paper
34.5 × 24.5 cm (13 1/2 × 9 5/8 in.)
Initialed l. r.: OK
Ill. p. 122

Provenance:
Hans Tietze, Vienna
Private collection, New York
Galerie St. Etienne, New York
Private collection, New York

Literature:
Rathenau, vol. 1, no. 46.

I.50
Girl with Turban (Mädchen mit Turban) early 1920s
watercolor on paper
69.8 × 52.1 cm (27 1/2 × 20 1/2 in.)
Signed l. r.: OKokoschka
Ill. p. 123

Provenance:
Villa Grisebach, Berlin
Private collection, New York

I.51
Emil Löwenbach 1914
oil on canvas
125 × 79 cm (49 1/4 × 31 1/8 in.)
Initialed u. l.: OK
Ill. p. 124

Provenance:
Barbette Löwenbach, Vienna
Francis M. Pick, Vienna
Steven Kay, Vienna
Marlborough Fine Art, London
Ralph Jentsch, Esslingen
Kunsthaus Lempertz, Cologne
Sotheby's, London
Robert Gore Rifkind, Los Angeles
Neue Galerie New York

Literature:
Alte und Moderne Kunst, no. 90 (1967), ill. p. 47.
Kunsthaus Lempertz, Cologne, auction no. 482, May 20–21, 1965, no. 483.
Winkler and Erling, no. 108.

Emil Löwenbach was Adolf Loos's landlord as well as his patron; in the summer of 1913, Loos redesigned and refurnished the dining room and study of Löwenbach's Vienna apartment. The designer persuaded his patron (as he had persuaded many others) to have his portrait painted by Kokoschka, Loos's protégé.

Up to the 1960s, this painting was known as *E. Ludwig (The Blind Man);* only in 1967 did a letter from Löwenbach's nephew in New York reveal the true identity of the sitter. Emil Löwenbach had lost his eyesight in an accident in Switzerland in 1908, which seriously damaged the optic nerves of both his eyes. Kokoschka's portrait makes reference to this loss of sight in a way that is both subtle and insistent. The subject's empty stare into an undefined distance immediately catches the attention of the viewer. It is the expression of an inwardly concentrated gaze determined by blindness, a darkling animation that suggests a high degree of inner tension, precisely through the absence of external movement in the model, who sits quietly in an armchair. For Kokoschka, the expressive potential of the hands for suggesting the temperament of the sitter is always of major importance (as for example in the portraits of Rudolf Blümner or Peter Altenberg). Here, the hands are depicted as composed and controlled, one resting gently in the other.

As in most of Kokoschka's portraits from 1913 and 1914 (for example, that of the painter Carl Moll, or of the artist's friend the poet Albert Ehrenstein), the figure of Löwenbach is striated with energetic brushstrokes. The sitter is brought vividly to life against an undefined background through a coordination of color values that produces a single overall tone, relieved only by a few lines of light.
Johann Winkler
Translated from the German by Nicholas T. Parsons.

I.52
Herr Bauer 1914
oil on canvas
69 × 56 cm (27 1/8 × 22 in.)
Initialed u. r.: OK
Ill. p. 125

Provenance:
Viktor Bauer, Vienna
Gustav Nebehay, Vienna
Galerie Paul Cassirer, Berlin
Private collection, Berlin
Gottschalk collection, Düsseldorf-Oberkassel
Galerie Meier Hahn, Düsseldorf
Galerie Roswitha Haftmann, Zürich
Thomas T. Solley, Bloomington, Indiana
Galerie Wolfdietrich Hassfurther, Vienna
Serge Sabarsky Collection

Literature:
Winkler and Erling, no. 110.

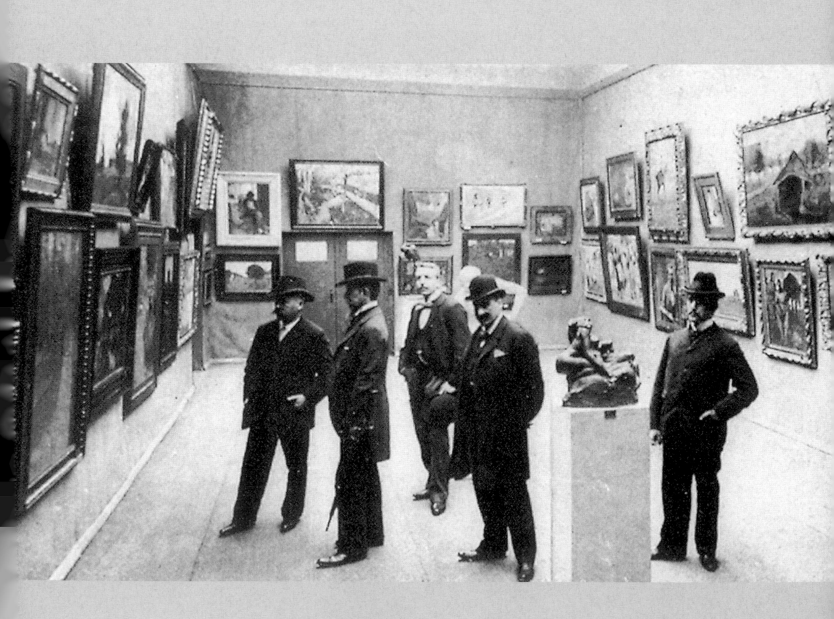

GERMANY AFTER 1900

Members of the Berliner Secession before the opening of the second exhibition, spring of 1900.
At right: Max Liebermann (wearing a bowler hat) and Bruno Cassirer

THE EXPRESSIONIST IMPULSE IN GERMAN PAINTING

PETER SELZ

The term "Expressionism" was first used by German critics in reference to the paintings of violently contrasting colors by the Fauves, the French "wild beasts" surrounding Henri Matisse and André Derain, when they exhibited at the Berliner Secession in 1911. Then almost immediately it was applied to the revolutionary new developments in Germany first proclaimed by the artists of the Brücke group in Dresden. In 1906, Ernst Ludwig Kirchner announced the group ideology in a woodcut that stated: "With faith in evolution, in a new generation of creators and appreciators, we call together all youth. And as youths who embody the future, we want to free ourselves from the long-established older powers. Anyone who renders his creative drive directly and genuinely is one of us."

The name "Expressionism" was coined to differentiate it from Impressionism, which the young revolutionary artists viewed as a transcription of external natural appearances rather than the projection and communication of emotional experience driven by what Vasily Kandinsky called "inner necessity." In their appeal to other innovative artists, the German painters responded to their turn-of-the-century predecessors, whose paintings were known in Germany by this time. They admired Vincent van Gogh and Edvard Munch, Paul Gauguin and Odilon Redon, Paul Cézanne and Ferdinand Hodler, artists who each in his individual way stressed the symbolic, emotional, and spiritual meaning of art. Expressionism was a state of mind. It was and is not a style. It included a great variety of stylistic forms and orientations. A comparison between Erich Heckel's erotic and pubescent *Mädchen mit Puppe (Fränzi) (Girl with Doll [Fränzi]*; 1910; cat. no. II.13) and Franz Marc's arcadian, lyrical vision of *Die ersten Tiere (The First Animals*; 1913; cat. no. II.31) clearly demon-strates this diversity in form, construction, and expression. Expressionism must be seen as an art opposing authority, proclaiming its conflict with received forms and standards. Following the principles annunciated by Friedrich Nietzsche as well as the philosopher's visionary and rhetorical language, Expressionism postulated the "transvaluation of values." An interactive and subjective view of a world in flux took the place of a faith in an eternal deity and the concomitant belief in objective universal values. This was also the period when the certainty of Newtonian physics began to be questioned by concepts of relativity. Expressionists sensed the far-reaching congeries of an old world passing and they responded with a sentiment that Herbert Marcuse many years later called a "flight into inwardness." The Expressionist artist demanded freedom from the constraints of rules and codes in art.

In a broader sense, Expressionism was also directed against conventional morality as well as the effects of the rise of industrial capitalism with the consequent mechanization of labor in most aspects of life. The proponents were distressed by the developing market economy, the accompanying commodification of art, and the alienation of the artist from a more cohesive society. This is true not only of the visual arts, but also of the theater, music, dance, and poetry. The Expressionist poet Georg Heym, a close friend of Kirchner's, expressed the ugliness of the city and the hope for "the dream of light" in "Berlin II."

> *. . . Die Omnibusse, . . . Rauch und Huppenklänge.*
> *Dem Riesensteinmeer zu. Doch westlich sahn*
> *Wir an der langen Strasse Baum an Baum,*
> *Der blätterlosen Kronen Filigran.*

Ernst Ludwig Kirchner with Erna Schilling in his atelier in Berlin-Wilmersdorf, ca. 1912–13

Der Sonnenball hing gross am Himmelssaum.
Und rote Strahlen schoss des Abends Bahn.
Auf allen Köpfen lag des Lichtes Traum.

. . . Buses, . . . smoke and car horns.
Towards the sea of stone. But to the west
We saw along the street of trees
The leafless filigree crowns.
The ball of the sun hung low at the edge of the sky.
And rays of red stopped the evening's passage.
The dream of light touched every head.

Heym's later poem "Umbra Vitae" was illustrated by Kirchner in 1912 when the painter and his Brücke associates had left Dresden for Berlin, where they painted the modern metropolis with all its double-edged aspects: the sophisticated café life of the cultural metropolis as well as the vice and prostitution prevalent all over the city. The nervous excitement and the decadence of big city life found visual response in their drawings and paintings. Kirchner painted dancers and tightrope walkers or various scenes from the dance hall, the circus, and the cabaret. The exoticism of the cabaret with its pointed castigation of middle-class values provided aspects of bohemian life

to the Brücke artists that were comparable to their own existence. The Brücke had been founded in Dresden by architectural students still in their twenties when Kirchner, Heckel, and Karl Schmidt-Rottluff formed a cohesive community of artists, soon to be joined by Max Pechstein and the older, more established Emil Nolde. They were impressed by the elemental form they saw in the ethnic art of Oceania and Africa, which they dis-

Ernst Ludwig Kirchner, frontispiece of the portfolio *Chronik KG Brücke*, color woodcut, 1913

Ernst Ludwig Kirchner, woodcut for the cover of Georg Heym's *Umbra Vitae*, 1919–23

covered in Dresden's ethnographic museum. They found affirmation in German medieval art and were well informed in the recent trends in European art.

In their search for direct and immediate expression the Brücke painters rejected professionally posed nudes, and instead found models in their own neighborhoods. They painted them lying or sitting in erotic poses on couches and chairs. Or they would take them as companions to the lakes in the nearby countryside and depict their bodies moving freely in natural surroundings, as in Heckel's *Badende im Teich (Bathers in a Pond;* 1908; cat. no. II.10). These paintings reflected the artists' response to a new form of nature worship that was gaining popularity in Germany early in the century. They also echoed a Nietzschean vision of a Dionysian world.

The admiration of natural forces is exemplified in the landscape painting of the Brücke artists. Nolde, born at the edge of the North Sea, painted *Sonnenuntergang (Sunset;* 1909; cat. no. II.19) with the water in multiple colors, reflecting the burst of the setting sun with a small boat tossed in the waves and no safe

shore in sight. The sea for Nolde was the embodiment of a regenerative primordial force, always changing and never tame—an element of ominous power. Schmidt-Rottluff, influenced by Nolde early in his career, painted a stormy landscape with a palette of deeply contrasting colors, achieving an intense and terrifying beauty in *Landschaft mit Haus und Bäumen (Dangast vor dem Gewitter) (Landscape with House and Trees [Dangast Before the Storm];* 1910; cat. no. II.15).

Schmidt-Rottluff was still living in Dresden when he painted this canvas, but he soon joined his associates in Berlin, which was in the process of becoming an important cultural metropolis early

View of Dresden showing the old market with Kreuzkirche, city hall tower, and R. Henze's *Germania* in the center of the square, ca. 1930

in the century. Germany, however, lacked the tradition of a cultural capital comparable to Paris or London. In fact, Germany as a united nation-state was only about thirty-five years old when the Brücke was founded in Dresden. It was in the provincial capitals of the kingdoms of Saxony and Bavaria, rather than in Berlin, that Expressionism had its origins.

The Bavarian capital was a much more important center than Dresden. A vital locus of Jugendstil, it was a city where more international exhibitions took place; and it was in Munich that practitioners and theorists such as Theodor Lipps and August Endell proposed an art that no longer depended on representational subject matter. It was here that the innovative and influential group Der Blaue Reiter was launched.

Munich attracted artists from many countries, and the founders of the Neue Künstlervereinigung München (New Artists Association of Munich; NKVM), the precursor to the Blaue Reiter, were two Russian painters who had come to Munich to study painting. Alexej Jawlensky, the oldest member of the NKVM, had traveled in France and by 1912 painted portraits such as *Infantin (Infanta;* 1912), in which the influence of Matisse was

Vasily Kandinsky, final design of the dust jacket of the almanac *Der Blaue Reiter*, color woodcut, 1911. Städtische Galerie im Lenbachhaus, Munich

fused with the strong color and formal structure of Russo-Byzantine art. At this juncture the Russian painter's portrait is also related in its arbitrary sensuous color to portraits such as *Rotblondes Mädchen (Strawberry-Blonde Girl;* 1919) by the Nordic Nolde (cat. no. II.20). Jawlensky's later paintings were surreal images of abstracted heads of mystic spiritualism; he painted them in Wiesbaden until his death in 1941.

View of the Marienplatz and Frauenkirche in Munich, ca. 1910

Vasily Kandinsky, having studied jurisprudence and political economy in Moscow, decided to become a painter and went to Munich, studied with Franz von Stuck, and soon assumed leadership of the progressive trend of art of that city. Together with Franz Marc, Gabriele Münter, and Alfred Kubin, he resigned from the NKVM and founded the Blaue Reiter in 1911, and with Marc published the almanac of the same name. As Marc remarked, they went "with a divining rod through the art of the past and present." For the first time works that seemed totally unrelated were placed together with no hierarchical distinction in this pluralist collection: Bavarian glass paintings and Egyptian shadow puppets, Russian folk prints and Chinese paintings, African and Pacific sculptures, children's drawings, paintings by Baldung Grien and El Greco as well as Picasso, Matisse, Robert Delaunay, Kandinsky, and Marc, musical scores by Arnold Schönberg, Anton von Webern, and Alban Berg. Schönberg's innovations in music constituted a historic breakthrough parallel to Kandinsky's in art. In their search for the basic organic rhythms underlying human artistic, religious, and philosophical expression, they strove to bring about a *Gesamtkunstwerk*, a synthesis of all the arts.

Kandinsky classified his paintings as "Improvisations," which, he wrote, were direct responses to external nature; "Impressions" (largely visual responses to internal nature); and the more ambitious and carefully considered "Compositions." Only ten of his canvases, completed between 1910 and 1939, merited this latter nomenclature. Complying with his "inner necessity," he searched for an art that would express the affirmation of the spirit, an art in which content is embodied in nonobjective form.

He proposed to find "pure painting"—an art that no longer resorted to subject matter and that would speak directly to the viewer on a preverbal level. When he painted *Komposition V (Composition V;* cat. no. II.26) in 1911, a painting that at first view appears to be totally abstract, he still relied to a certain extent on representational motifs from earlier paintings. A careful perusal of the picture reveals angels blowing trumpets, the towers of a small city on a hill, a boat with oars, and burning candles. The great black whiplash line, however, is the dominant feature of this thundering composition. The colors in Kandinsky's painting are meant to symbolize specific feelings and emotions, and also to elicit transcendental sensations.

Kandinsky's "Compositions," created during the years prior to World War I, were the first consistent series of abstract painting and stand forth as landmarks of the art of the twentieth century. The term "Abstract Expressionism" was originally applied to these paintings by German critics. Through the teachings of Kandinsky's follower Hans Hofmann, Kandinsky's paintings as well as his theories had a direct effect on the Abstract Expressionists who flourished in America more than a generation later. Gabriele Münter, Kandinsky's student and his companion until the outbreak of World War I, lived with him in Murnau, near Munich at the foot of the Alps. She seems to have been the first artist to discover the unique quality of children's drawing as well as the naive nature of Bavarian glass painting. But she also created astonishing semiabstract landscapes with tremendous emotional impact, such as *Weisse Mauer (White Wall;* ca. 1915), in which stark, contrasting colors build powerful geometric shapes. (A second version of this painting, from ca. 1930, is cat. no. II.23.)

The painters of the Blaue Reiter were aware of the independent expressive and spiritual strength of color to penetrate beyond the appearance of visual perception. Influenced by the brilliant spectral color composition of Robert and Sonia Delaunay, and at the same time imbued by the Romantic attitude of empathy into the lives of animals, Marc would paint a blue deer and red horses in a gouache like the 1913 *Die ersten Tiere.* He attempted to transport his imagination into understanding how the animals perceive the world, and then to communicate the feeling that "each animal is the embodiment of a cosmic rhythm." Marc later painted visions of apocalyptic catastrophes, almost predicting the immolation to come, before losing his life at Verdun in the war in 1916.

Marc's friend August Macke, also killed in the war, was the artist in the group most closely related to the developments of modern art in Paris, above all to Delaunay's Orphic paintings. Macke's pictures of men and women on walks in the Rhenish cities where he lived are joyful fusions of civilization and nature, rendered in clear light and luminous color. In 1914 Macke and Paul Klee set off together for a trip to Tunisia, where Kandinsky had been earlier. Macke's *Eselreiter (Donkey Rider;* 1914; cat. no. II.34) conveys the transparent quality of Tunisian light in the springtime.

It was in North Africa that Klee, who had been working primarily as an incisive draftsman, handling delicate lines with tremulous strokes, became a painter. Overwhelmed by the color of the landscape, he wrote in his diary: "Color has claimed me....This is the meaning of this happiest hour, I and color are one." A watercolor such as the radiant hues in the beautifully structured *Gelbes Haus (Yellow House;* 1915; cat. no. II.58) indicates the master's new understanding of color as form. In his later paintings, Klee gives complete freedom to an unfettered fantasy, based on long years of self-reflection. There are wondrous paintings combining a gentle humor with great depth of psychic insight and playful imagination, as seen in a watercolor such as *Auf der Wiese (On the Lawn;* 1923; cat. no. II.59). In his mature years, he would make pictures like *bunte Mahlzeit (Gay Repast/ Colorful Meal;* 1928; cat. no. II.61), in which he formulated a veritable new language of symbols. Art, to Klee, was an act of creation similar to nature, and as an artist he invented new forms of life that he combined at random with human artifacts—a fork, a house, a telephone, and so on. He presented these items with a visual script, transporting the viewer into a world of magic. Klee and Kandinsky were appointed by the architect Walter Gropius to the faculty of the Staatliche Bauhaus in Weimar, a

"Hinterglas" paintings in the summerhouse of Gabriele Münter and Vasily Kandinsky, Murnau, ca. 1913

school that combined the arts and crafts (and, later, technology) into an all-encompassing educational experience with the goal of creating a new and engaged community of artist-designers to be brought about by the exploration of creative form. The first programmatic manifesto of the new school had as its cover a woodcut, often referred to as the "Cathedral of Socialism," by Lyonel Feininger.

Feininger, born in New York in 1871, but living in Germany from 1887, was the first artist to join the Bauhaus staff in 1919 as "form master" and head of the graphic workshop. He had been enchanted by the simple Thuringian villages and their churches, and made eleven paintings of the church at Gelmeroda between 1913 and 1936, the year he left the Germany of the National Socialists to return to New York. The Bauhaus, which was to embrace the modern world of technology, adapted its name from the medieval "*Bauhütte*," the workshops that built the cathedrals. Similarly, in these Gelmeroda paintings, Feininger transformed the little Gothic church into an impressive cathedral, using the syntactic Cubist breakup of forms into interlocking facets as well as the dynamic simultaneity derived from Futurism and culminating in crystalline visions such as *Gelmeroda II* (1913; cat. no. II.55). The precision and transparent structure of modernist architecture is also apparent in the prismatic towering cloud shapes in *Die blaue Wolke (The Blue Cloud;* 1925; cat. no. II.56). It responds to the sublimity of awe in Romanticism and recalls Caspar David Friedrich's renowned *Mönch am Meer (Monk by the Sea)* of 1809–10. Like the master of German Romantic painting, Feininger placed a small solitary figure standing at the edge of the sea in silent contemplation of a vast universe.

Oskar Schlemmer—painter, sculptor, dancer, choreographer—was the paradigmatic Bauhaus master. He devised ideal human figures of geometric order as humanist symbols of a rational world. These universal supra-individual and nongendered figures create their own space in a work like *Fünf Akte (Five Nudes;* 1929; cat. no. II.62).

During the years preceding World War I, German Expressionists had painted cosmic dreams or ecstatic works predicting the coming devastation either quite graphically (as in Ludwig Meidner's apocalyptic cityscapes of 1913), or abstractly, as did Kandinsky and Marc. After the war many artists worked in a very different manner, creating a genre that in 1925 was dubbed "post-Expressionism" by the art critic Franz Roh. The four years of trench warfare, followed by an abortive revolution in Germany and a period of starvation, rioting, assassinations,

and devastating inflation, brought an end to an art that had been preoccupied with inner reflection. Artists now were likely to work in a clear, normative style like Feininger and Schlemmer, or they chose to become politically engaged and/or brutally realistic like George Grosz and Otto Dix. Grosz, after a brief digression under the influence of Giorgio de Chirico and the

Teachers and students at Bauhaus party, ca. 1921–23

Italian Pittura Metafisica movement, used a subdued palette to paint human beings as puppets or robots, commenting on the depersonalization of the time. But soon a violent expressionistic mood took over in an explosive painting titled *Panorama (Nieder mit Liebknecht) (Panorama [Down with Liebknecht];* 1919; cat. no. II.49). Grosz presents a pandemonium of agitation, frenzy, sex, and greed in this picture of rage, protesting the brutal murders in Berlin of Karl Liebknecht and Rosa Luxemburg, who had been leaders of the Socialist Party's Spartakus Bund, by the counterrevolutionary German Free Corps. To the earlier idealist Expressionist message "Der Mensch ist gut"

Soldiers demonstrating in favor of immediate demobilization. Karl Liebknecht speaks in front of the Ministry of the Interior, Berlin, January 4, 1919 (photograph by Willy Römer)

(People are good) Grosz countered "Der Mensch ist ein Vieh" (People are animals).

After having served in the trenches for four years, and having recorded the horrors of war in a number of devastating paintings and a series of etchings, Dix turned to depictions of individuals with cool detachment and penetrating observation of character and personality, sometimes coming close to caricature, as in the direct boldness of the *Bildnis Rechtsanwalt Dr. Fritz Glaser (Portrait of the Lawyer Dr. Fritz Glaser;* 1921; cat. no. II.41). His paintings of female nudes show the reality of their flesh, with sagging breasts, painted faces, and wrinkled skins.

In 1925, when the Kunsthalle in Mannheim announced the apparent end of Expressionism by mounting the exhibition *Die Neue Sachlichkeit,* Max Beckmann was featured along with Grosz and Dix among the exhibitors. A giant in the art of the twentieth century, Beckmann undertook a quest for the identity of the artist that caused him to produce more than eighty self-portraits in various guises and in many media. In his *Selbstbildnis vor rotem Vorhang (Self-Portrait in Front of Red Curtain;* 1923; cat. no. II.36) he poses before a heavy red velvet curtain, the traditional backdrop for ruling aristocrats in European painting. The painter himself, recently recovered from the trauma of his war experiences, dressed in tuxedo and bowler hat, is the artist as man of the world. But his facial expression, with contemplative solemn eyes, shows a man of sober vulnerability. Two years later, on a honeymoon trip to Italy, he conceived a visionary painting. Upon his return from Naples to Frankfurt he painted *Galleria Umberto* (1925; cat. no. II.37), referring to the nineteenth-century mall in that city. The figures in this emphatically vertical painting are crowded together as in a Mannerist canvas, and are painted in bright polychrome colors. A naked body is hanging from the ceiling—almost as though predicting

the display of the dead Mussolini, who would be hanged by his feet twenty years after this painting was completed. Indeed, in the center, right above the drowning person with the Napoleonic hat, is a bloody head that seems to resemble Mussolini. As if aware of the prophesy in the painting, Beckmann placed a large crystal ball next to the hanging body. (Twenty years later, on April 30, 1945, living in self-imposed exile in Amsterdam, the painter noted in his diary: "Mussolini tot": "Mussolini is dead.")

Beckmann, who often referred to himself as a "realist of inner visions," stands alone among twentieth-century German painters. He used his great skill and craftsmanship as a painter to analyze appearances and then "to find the bridge," as he said, "from the visible to the invisible." The resultant multifaceted work is often not meant to be understood in a literal sense. It depends, rather, on the eye, the mind, and the intuitive sensibility of the viewer, whose response completes the cycle initiated by the artist.

Poster for the exhibition *Die Neue Sachlichkeit–Deutsche Malerei seit dem Expressionismus* at the Städtische Kunsthalle Mannheim, 1925

■ **WILHELM LEHMBRUCK**

■ **LOVIS CORINTH**

BRÜCKE

■ **ERNST LUDWIG KIRCHNER**

■ **ERICH HECKEL**

■ **KARL SCHMIDT-ROTTLUFF**

■ **MAX PECHSTEIN**

■ **EMIL NOLDE**

Exhibition of the Künstlergruppe Brücke at the Galerie Arnold, Dresden, 1910

WILHELM LEHMBRUCK

* JANUARY 4, 1881, MEIDERICH (DUISBURG)
† MARCH 25, 1919, BERLIN

Announcement for the exhibition *The Standing Youth: A Figure in Artificial Stone* at the Museum of Modern Art, New York, November 16–December 7, 1933. The Museum of Modern Art Archives, New York: The Abby Aldrich Rockefeller Scrapbooks, v. 2. Photograph © 2000 The Museum of Modern Art, New York

Wilhelm Lehmbruck was born in 1881, in the small town of Meiderich, on the outskirts of Duisburg in Germany's industrial Ruhr region. He was the fourth of eight children born to the miner Wilhelm Lehmbruck and his wife Margaretha.

Early evidence of Lehmbruck's sculptural talents gained him a stipend from the municipal authorities. This enabled him to study from 1895 through 1899 at the Kunstgewerbeschule (School of Applied Arts) in Düsseldorf. After his father's death in 1899, he earned a living by preparing anatomical and botanical drawings for scientific publications. From 1901 through 1906, he trained under Carl Janssen at the Düsseldorf Kunstakademie.

Lehmbruck was deeply impressed by the works of Auguste Rodin, which he saw at the *Internationale Ausstellung* in Düsseldorf in 1904. In the same year, he made study trips to England and the Netherlands, and in 1905 he traveled to Italy. The year 1906 brought the *Deutsche Kunstausstellung Köln* (German Exhibition of Art in Cologne), where Lehmbruck was represented with his *Badende (Woman Bathing;* 1902). In 1906, he made his first visit to Paris, and in the following year he married Anita Kaufmann. The couple gave birth to a son, Gustav Wilhelm, in March 1909 in Düsseldorf. From 1910 to 1914, Lehmbruck lived with his family in Paris. In the artists' quarter of Montparnasse he became part of the international art world, of which the French capital was the hub. It was here that Lehmbruck first began to work with printmaking and also to expand his sculptural repertoire by producing works in cast stone and cast cement. In 1912, he made a second trip to

Italy; during his stay, he declined the offer of a teaching post in Weimar. In 1913, Lehmbruck's second son, Manfred, was born. In the same year, two of his sculptures were exhibited at the legendary Armory Show in New York. He had his first solo exhibition the following year, 1914, at the Galerie Levesque in Paris.

Upon the outbreak of World War I, Lehmbruck returned to Germany, traveling via Cologne and Düsseldorf to Berlin. He worked as a medical orderly in a Berlin military hospital until 1915, and was subsequently employed as a war artist in Strasbourg. In 1916, he encountered Julius Meier-Graefe, who would later become one of the principal champions of his work. Thanks to the intervention of the well-connected Berlin artist Max Liebermann, Lehmbruck was able to move to Zürich, in neutral Switzerland, where he remained until early 1919. During this time, he endeavored to encourage a greater appreciation of modern German art in Switzerland. While in Zürich, the artist's third son, Guido, was born. Lehmbruck was elected to the Preussische Akademie der Künste (Prussian Academy of Arts) in Berlin in early 1919. Several months later, following an extended period of depression, he committed suicide.

RECEPTION IN THE UNITED STATES

In December 1911, the Association of American Painters and Sculptors was founded by the Realist painter Walt Kuhn and the New York Symbolist Arthur B. Davies. The aim of this group was to exhibit the work of a number of invited artists, including many from Europe. One of the most impor-

tant results of their efforts was the 1913 *International Exhibition of Modern Art*. Initially intended for New York's Madison Square Garden, the show was eventually mounted in a drill hall, the Sixty-fifth Regiment Armory—which provided the name under which the event has passed into history: the Armory Show. Taking full advantage of the building's enormous interior, the exhibition organizers were able to show some 1,300 works—about a third of them by European artists. It was the Armory Show, along with the activities of photographer Alfred Stieglitz (a German émigré) at his 291 Gallery in New York, that introduced the American public to artistic modernism and its aesthetic criteria.[1]

As is evident from a well-known photograph of the Armory Show's installation, Lehmbruck's *Kniende (Kneeling Woman;* 1911) occupied a prominent position. This sculpture, of enormous significance in the evolution of Lehmbruck's work, represents the definitive break with the sculptural conventions of the nineteenth century. Nearby was his *Stehende weibliche Figur (Standing Woman;* 1910), exhibited alongside Aristide Maillol's *La Femme au bain (Woman Bathing)* and Brancusi's *Mlle. Pogany*—in other words, with works that spanned the range of French (or at least Parisian) sculpture in the early twentieth century. Just before the

show's closing in Chicago in March 1913, Stephen C. Clark purchased the *Stehende weibliche Figur*, which was donated to the Museum of Modern Art in 1930. Through his inclusion in the Armory Show, Lehmbruck achieved international recognition as a leading sculptor in Europe and America. The *Kniende* was chosen as one of the works to be reproduced as a picture postcard, for sale to exhibition visitors.[2] In later years, casts of this work would be acquired by both the Albright-Knox Art Gallery in Buffalo (in 1938) and the Museum of Modern Art in New York (in 1939).

Although it has generally been forgotten, six works on paper by Lehmbruck were also exhibited in the Armory Show. Indeed, Lehmbruck's reputation in both Europe and the United States was not based exclusively on his small but powerful output as a sculptor. The artist was also active as a painter, draftsman, and printmaker. The important German art critic Carl Einstein was one of the first to remark upon the multiplicity of Lehmbruck's talents, in speaking of his "return to elemental sensations," and in his appreciation for Lehmbruck's high degree of awareness of what is possible in any given medium.[3]

By the 1930s, Lehmbruck's work had become widely visible in the United States. Of particular

Wilhelm Lehmbruck, 1916

Installation view of the *International Exhibition of Modern Art* (Armory Show), New York, 1913, showing two sculptures by Wilhelm Lehmbruck

significance was the joint exhibition *Wilhelm Lehmbruck/Aristide Maillol*, held at New York's Museum of Modern Art in the spring of 1930. Works by the two artists were exhibited together in one room, while works by Max Weber and Paul Klee were shown in neighboring rooms. According to the catalogue, eight pieces by Lehmbruck were shown, all of them loaned by American collectors.[4] At this relatively early date, however, the American response to Lehmbruck was not unreservedly positive. The critic for the *Chicago Evening Post Magazine of the Art World*, for example, remarked that "Lehmbruck seems an authentic but very limited talent."[5]

Three years later, in 1933, Lehmbruck had his first one-man show in America. This exhibition, held

November 16 to December 7 at the Museum of Modern Art, featured only a single work of art: his *Emporsteigender Jüngling (Standing Youth;* 1913), made of artificial stone. According to the *New York Times* (November 26, 1933), the sculpture was lent by the Flechtheim Gallery in Berlin, in cooperation with the Weyhe Gallery in New York City. In his review of the show for the *Times*, Edward Alden Jewell was also not especially enthusiastic: "Familiarity with Lehmbruck's work in general cannot be said adequately to prepare us for the 'Standing Youth.' ... The piece now on view is being shown, we learn, for the first time in America. ... This stone youth ... is agitated, ugly, and, to a grotesque degree, emaciated ... unimpressive in design, meaningless in emotional and intellectual content."[6]

In March 1937, Curt Valentin, a former colleague of the dealer Karl Buchholz, organized the inaugural exhibition of the Buchholz Gallery in New York. The show included sculptures by Ernst Barlach, Georg Kolbe, Gerhard Marcks, Richard Scheibe, Renée Sintenis, and a few works by Lehmbruck.[7] The inclusion of Lehmbruck in this group show served to affirm his significance as a leading German modernist sculptor. In response to this exhibition, the American critic Margaret Breuning asserted that Lehmbruck's name, in spite of the relatively small size of his œuvre, was emerging as a synonym for modern German sculpture in its entirety.[8] Lehmbruck had his first large solo show in America in the spring of 1939, when seventeen of his sculptural works were exhibited at the Marie Harriman Gallery in New York. Valentin published a catalogue with thirty-five entries to accompany the show.[9] This exhibition received outstandingly favorable reviews: Lehmbruck was heralded as a "pioneer of modern art," and his work was noted in *Art News* magazine as "foreshadowing Picasso's brilliant arabesques of the early 'thirties."[10]

Valentin continued to show work by Lehmbruck in his gallery: his *Kopf eines Denkers (Head of a Thinker;* 1918; cat. no. II.1) was included in an exhibition of sculpture mounted in 1939, *Contemporary European Painters and Sculptors*.[11] This year proved exceptionally important for Lehmbruck's reception in America and marked its first high point. Writing about Lehmbruck's work in the 1939 exhibition *Contemporary German Art* at the Institute of Modern Art in Boston, James S. Plaut stated: "Until 1930, when the Museum of Modern Art in New York presented a rather thorough exhibition of his work, [Lehmbruck] had been known in America through a few scattered examples. ... American collectors have become increasingly interested in him. ... He began under the influence of the eminent sculptor Maillol, doing roundly contoured figures. Then his own nature asserted itself, and the attenuated style by which he is best known set in. A poetry of the soul pervades every line of these later works; stately rhythms co-ordinate the abstract forms which place him among the Expressionists. No modern sculptor has equalled Lehmbruck's capacity for expressing profound emotion by means of superb technical gifts."[12]

Plaut's growing appreciation of Lehmbruck's work in America came at a point when his sculptures were being removed from public collections in Germany, to be banished to storerooms or sold. Indeed, by the beginning of World War II, Lehmbruck's work might be said to have symbolized the "other" Germany, the Germany that was not aligned with the National Socialists.[13] Lehmbruck's *Emporsteigender Jüngling* and *Kniende* were both shown

in 1939 in the seminal exhibition *Art in Our Time*, held at the Museum of Modern Art in New York. The latter piece was described in the show's catalogue as "Lehmbruck's finest work and one of the masterpieces of Modern sculpture," and the artist was hailed as "one of the greatest of 20th Century Sculptors, much of his art now officially repudiated in his own country."[14]

The warm critical response to Lehmbruck, now aesthetically "ennobled" and henceforth accepted as belonging to the canon of modernist sculpture, was further articulated in a review of the same year in *Art News*. The article included a full-page illustration of the *Kniende*, which was now widely perceived as an incontrovertible "model for sculpture in our time" and as an "established milestone of the modern age"—and as superior to the superficially comparable (but in fact merely derivative) work of the now largely unknown sculptors Robert Laurent

and William Zorach.[15] The *Kniende* was again reproduced in the October–November 1942 issue of the *Bulletin of the Museum of Modern Art*. Here, it served as an example of the works "outlawed" by Adolf Hitler and banned from public display at the Nationalgalerie in Berlin. For Americans in the 1940s, it rapidly became an icon that evoked the fate of art at the hands of the National Socialists and their allies across much of Europe. The qualities that Hitler is thought to have detested in Lehmbruck's figure were the very ones for which it was admired in America: its expressive power, its modernity, its internationalism, and its embodiment of artistic autonomy.

While the invocation of German censorship by the Americans must be situated in the political context of the late 1930s and early '40s, it is nonetheless misleading in its polarizing simplicity. This becomes evident if we consider the markedly nationalistic,

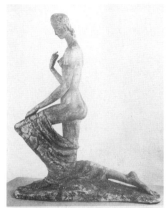

Wilhelm Lehmbruck's *Kniende (Kneeling Woman)*, 1911, as featured in the *Art News* (May 20, 1939) on the occasion of the exhibition *Art in Our Time*

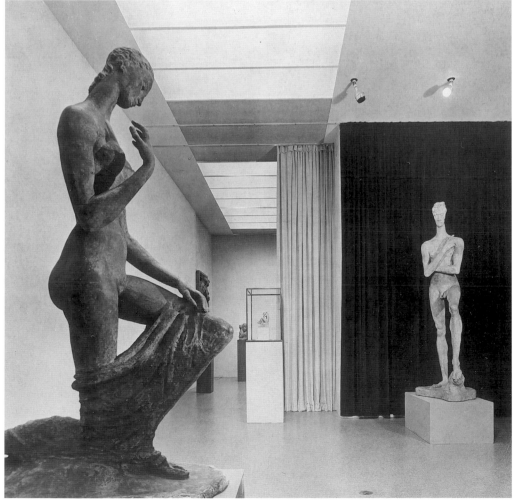

Installation view of *Art in Our Time* at the Museum of Modern Art, New York, May 10–September 24, 1939, showing Wilhelm Lehmbruck's *Emporsteigender Jüngling (Standing Youth)*, 1913, and *Kneeling Woman*, 1911. Photograph © 2001 The Museum of Modern Art, New York

even racist, character of critical discourse prevailing at the time Lehmbruck's *Kniende* was created. Almost immediately after Lehmbruck completed the sculpture, it was associated with the so-called "German Gothic."[16] During World War I, the concept of the Gothic (as applied to contemporary art) underwent a transformation in its meaning and associations, increasingly taking on positive modernistic connotations. In fact, "Gothic" became part of the clichéd language used to describe the presumed Expressionist leaning toward the spiritual, and a disdain for the merely material, the merely sensual. In so doing, the term came to imply something both timeless yet endemic to a particular nation and race: in this case Germany. However, less than two decades later, the term had begun to take on a negative connotation, as for example

when Julius Meier-Graefe, who described the *Kniende* as "Gothic" in an outburst of uncomprehending ire sparked by the "disappointment" (his term) he first felt toward this revolutionary work.

One indication of a latent tendency toward a national/racial reception of Lehmbruck's work in the U.S. was the response to the above-mentioned joint show of Lehmbruck and Maillol at the Museum of Modern Art in 1930. Here, the museum's associate director, Jere Abbott, observed in his catalogue essay: "The difference [between the two artists], in part, is racial, but it is more fundamentally allied to the traditional juxtaposition of north and south—of the gothic to the classical."[17] Thus, Abbott set up a fundamental aesthetic antagonism between the German artist and his French counterpart, with the "French" (read: Southern) attentiveness to physical movement set against a "German" (read: Nordic) drive toward spirituality. This simplification recapitulates arguments developed by German critics writing in the 1910s and '20s—such as Wilhelm Worringer, Max Osborn, and Wilhelm Hausenstein—in response to Lehmbruck's sculpture. And it thus reveals the dependence of certain American commentators on preestablished European critical topoi.

The status of the *Kniende* in general was initially founded on its ostensible embodiment of a new image of humanity, an image attaining its paradigmatic expression in this work. The elongated body forms of the larger-than-life female figure, its relative "disproportion," and its resulting expressive capacity prompted the poet Theodor Däubler to speak, in 1916, of a "preface to Expressionism in sculpture."[18]

Lehmbruck himself firmly rejected a historicizing adaptation of past styles, and embraced the notion of a spiritual identity that exists outside of history. "I believe," he said, "that we are once again moving toward a great art, and that we will soon find the expression of our age in a monumental, truly contemporary style. This must be of its time, and not the return to an older style ... it must be monumental and heroic, like the spirit of our age."[19] His *Emporsteigender Jüngling* achieves an admittedly restrained version of this heroic quality, and may perhaps be regarded as his true sculptural masterpiece.[20] Gustav Friedrich Hartlaub, an art historian and later director of the Kunsthalle in Mannheim, described the evident ambivalence of this figure in his book *Kunst und Religion*, published shortly

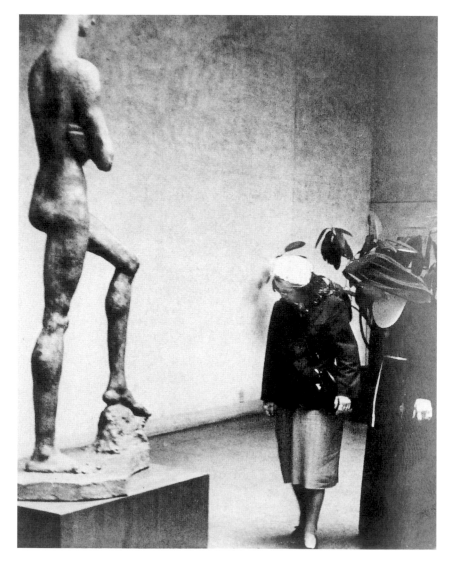

Wilhelm Lehmbruck's *Emporsteigender Jüngling (Standing Youth)*, 1913, on view at the Museum of Modern Art, New York

after the end of World War I, in the following terms: "It is again worth having the courage to lift up our gaze to the sea of stars above us. Lehmbruck's [*Emporsteigender Jüngling*] … only cautiously and tentatively bears upward his ghostly, slender, but noble body; the shadows playing around his high browed head, raised up on his long, high neck, bestow on him the appearance of one who ponders even more deeply on his forgotten purpose, while his arms arrange themselves into a gesture that suggests a need for self-persuasion, as much as an attempt to persuade his listeners."[21]

Despite the imposing size of the *Emporsteigender Jüngling* (at 228 centimeters high, it is larger than life), and its intrinsic monumentality, the piece is imbued with a deep sense of humanity. As in all of his sculptural works, Lehmbruck here emphasized the image of the human figure as the "bearer of symbols."[22] What symbolic content his works actually possess remains obscured by the abstract vocabulary of forms employed by the artist.

The ability to create works of aesthetic complexity and richness exposed Lehmbruck's work to a considerable diversity of opinion, as concerns its critical reception. This, indeed, is demonstrated by the widely divergent (and superficially contradictory) resonances of his work in America between 1930 and 1942. Yet, despite his acclaim as one of the central proponents of German modernist art, Lehmbruck's last retrospective in a U.S. museum was held nearly three decades ago, in 1972–73, at the National Gallery of Art in Washington, D.C. It would seem that the time is ripe for Lehmbruck to be rediscovered by an American public.

Olaf Peters
Translated from the German by Elizabeth Clegg, with Nicholas T. Parsons.
I would like to thank Claire Deroy for her valuable help in researching information for this essay.

Wilhelm Lehmbruck's *Torso*, 1913–14, as featured on the cover of the *Art Digest* (November 15, 1942)

[1] On this point, see Milton W. Brown, *The Story of the Armory Show*, New York: Abbeville Press, 1988; on the New York context, see William B. Scott and Peter M. Rutkoff, *New York Modern: The Arts and the City*, Baltimore: Johns Hopkins University Press, 1999, pp. 44–72.

[2] I am most grateful to Naomi Sawelson-Gorse of Pasadena, California for informing me that one such postcard is to be found in the Arensberg Archive at the Philadelphia Museum of Art.

[3] See Carl Einstein, *Wilhelm Lehmbrucks Graphisches Werk*, Berlin: Paul Cassirer, 1913, reprinted in Carl Einstein: *Werke*, vol. 1, 1908–1918, ed. by Rolf-Peter Baacke and Jens Kwasny, Berlin: Fannei & Walz, 1980, pp. 207–210.

[4] The exhibition ran from March 13 through April 2. See *Wilhelm Lehmbruck/Aristide Maillol: Exhibition of Sculpture*, exhibition cat., New York, Museum of Modern Art, 1930.

[5] Anon., *Chicago Evening Post Magazine of the Art World* (March 18, 1930), p. 7.

[6] Edward Alden Jewell, "Realm of Art: A Richly Diversified Week, Sculptors Issue: Their Modern Challenge," in: *New York Times* (November 26, 1933), sec. 9, 12, p. 1.

[7] *Opening Exhibition*, exhibition cat., New York, Buchholz Gallery, 1937. See also *Wilhelm Lehmbruck*, exhibition cat., New York, Marie Harriman Gallery, 1939, cat. nos. 23–29.

[8] See Margaret Breuning, "Art in New York," in: *Parnassus* (November 9, 1937), pp. 37ff.

[9] *Wilhelm Lehmbruck*, exhibition cat. (as note 7). The exhibition ran from February 20 through March 11, 1939, and comprised seventeen sculptures and a total of eighteen drawings and prints.

[10] Anon., in: *Art News*, vol. 37, no. 2 (February 25, 1939), p. 15.

[11] See *Sculpture*, exhibition cat., New York, Buchholz Gallery, 1930, cat. nos. 29–35. The *Kopf eines Denkers* was here shown as cat. no. 32, in the form of the bronze cast confiscated from the museum in Duisburg.

[12] *Contemporary German Art*, exhibition cat., Boston, Institute of Modern Art, 1939, p. 38.

[13] For the parallel reception of Lehmbruck during the Third Reich, see August Hoff, *Wilhelm Lehmbruck*, Berlin: Klinkhardt & Biermann, 1933; also idem, *Wilhelm Lehmbruck. Seine Sendung und sein Werk*, Berlin: Rembrandt, 1936.

[14] *Art in Our Time: 10th Anniversary Exhibition*, exhibition cat., New York, Museum of Modern Art, 1939, pp. 270, 268.

[15] See Doris Brian, "Art in the Modern Museum's Time: Glamour Opening of Its New Building on Its Tenth Birthday," in: *Art News* (May 20, 1939), pp. 6ff., 19ff., these statements on p. 6. The author describes this work as "one of the high spots of the exhibition" (p. 20).

[16] For a comprehensive discussion of this point, see Magdalena Bushart, *Der Geist der Gotik und die expressionistische Kunst, Kunstgeschichte und Kunsttheorie 1911–1925*, Munich: Silke Schreiber, 1990.

[17] Jere Abbott, in: *Wilhelm Lehmbruck/Aristide Maillol* (as note 4), pp. 5ff., this passage on p. 5.

[18] Theodor Däubler, *Der neue Standpunkt*, Dresden: Hellerauer, 1916, cited in: Dietrich Schubert, *Die Kunst Lehmbrucks*, 2d ed., Worms and Dresden: Wernersche Verlagsgesellschaft und Verlag der Kunst, 1990, p. 157.

[19] Lehmbrucks's comments on sculpture, as reported by Paul Westheim, cited in: Hoff, *Wilhelm Lehmbruck* (as note 13), p. 20.

[20] This important work was donated to the Museum of Modern Art by Abby Aldrich Rockefeller in 1936, three years after Lehmbruck's first one-man show there. In the American mind, Lehmbruck's name is inseparably linked not only with this work, but also with the *Kniende*, which was donated by the West German government in 1966 to New York's Metropolitan Opera House.

[21] Gustav Friedrich Hartlaub, *Kunst und Religion. Ein Versuch über die Möglichkeit neuer religiöser Kunst*, Leipzig: Wolff, 1919, p. 100.

[22] See Schubert, *Die Kunst Lehmbrucks* (as note 18), p. 135.

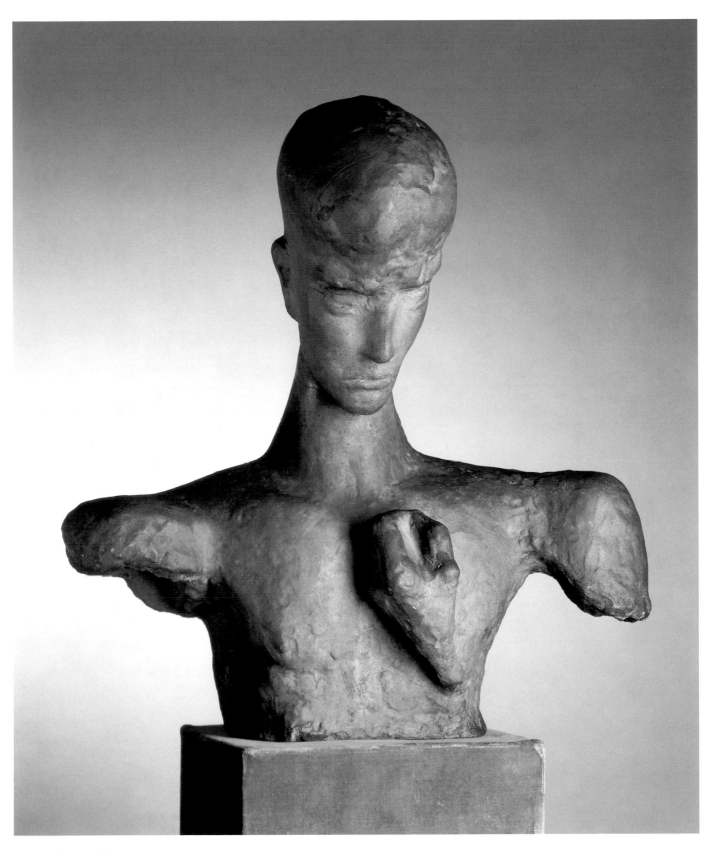

Head of a Thinker, 1918 cat. II.1

LOVIS CORINTH

*** JULY 21, 1858, TAPIAU (EAST PRUSSIA)**
† JULY 17, 1925, ZANDVOORT (NETHERLANDS)

The work of Lovis Corinth defies easy categorization. This is perhaps not surprising, since his relatively long and productive career spanned radically different social and political milieus that informed his art, from Catholic Munich to Protestant Berlin, from the Wilhelminian Empire and World War I to the tumultuous first half of the Weimar Republic. And, because Corinth was as much a graphic artist as a painter, working in all two-dimensional media with equal facility, his œuvre is extraordinarily wide-ranging, including etchings, engravings, lithographs, paintings, and drawings. Nor did he specialize in a particular genre, producing instead a broad range of landscapes, portraits, still lifes, and figure paintings with widely varying themes. Furthermore, although it is possible to speak generally of a stylistic progression in Corinth's work from a sober naturalism to a liberated Expressionism, he shifted easily between these and other aesthetic idioms. The artist was also an author, who wrote at least nine periodical articles on topics as diverse as German painting, religion in the arts, etching, and freemasonry; a handbook on painting (1908); and an autobiography, published posthumously by his wife in 1926. Perhaps it is for this reason that today, in our postmodern era that tends to spurn cohesive style and one-dimensional careers, Corinth and his work seem particularly compelling. The artist was born in 1858 in Tapiau, a village in East Prussia (now Gvardeisk, in the Russian Federation). His parents owned a tannery and small farm, and it was here that the young Corinth spent his early childhood, in a rough-and-tumble rural environment isolated from the cultural refinements

of Munich, Berlin, or Hamburg. By his own account, his closest companions at the time were farmhands, but he also spent time with a local carpenter who entertained the boy by drawing farm animals and then letting Corinth use the sketches as patterns for paper cutouts. Later, when attending school in Königsberg (now Kaliningrad, in the Russian Federation), Corinth himself began to draw in earnest, developing a reputation among his classmates for his trenchant caricatures of the school's faculty. Corinth received his lower school certificate, and then chose to pursue his interest in art by enrolling at the Königsberger Kunstakademie in 1876.

This was the beginning of an exceptionally long training period of nearly eleven years: in Königsberg (1876–1880), primarily with the genre painter Otto Günther; in Munich (1880–84), first at the private atelier of Franz von Defregger and subsequently at the Akademie der bildenden Künste under Ludwig Löfftz; and in Paris (1884–87) at the Académie Julian, with Adolphe William Bouguereau and Tony Robert-Fleury.

It was in Paris that Corinth had his first major successes. Two of his large-scale oil paintings were accepted to the Salon—the *Pietà* (1889), which was exhibited in 1890 and awarded an honorable mention, and *Susanna im Bade* (*Susanna and the Elders;* 1890), which was shown in 1891. Despite their religious subject matter, both paintings were essentially naturalist studies of the nude; the figures of Christ and Susanna were not only devoid of conventional attributes, they were so unidealized that one writer even suggested that the title of the

Pietà be changed to remove the allusion to Christ.[1] Yet however inappropriate some critics found Corinth's use of naturalism in paintings of religious themes, both these and other early works are characterized by an emotional sobriety that is not at odds with their subjects. This would change decisively when Corinth finally returned to Munich in 1891, settling there after brief stays in Berlin and Königsberg.

Munich at the end of the century was one of Central Europe's preeminent art centers, and Corinth—who referred to the city as a "swarming beehive" in the memoirs he began to write while he was there[2]—arrived just before the Munich Secession was established in 1892. A founding member of that association, Corinth was initially invigorated by its forward-looking program, but for reasons that are unclear he joined in 1893 a dissident group of artists who formed an unsuccessful rump Secession called the Freie Vereinigung (Free Association). Both splinter groups were comprised of stylistically diverse artists, many of whom were just beginning to abandon naturalist modes of representation for more abstract idioms. Corinth—known throughout his life for his coarse, even somewhat vulgar behavior and humor—was drawn less to the lofty tone and elegant, finely crafted forms of Jugendstil than he was to the work of Munich's irreverent caricaturists, including Thomas Theodor Heine, Eduard Thöny, Olaf Gulbransson, and Rudolf Wilke. All working for the satirical journal *Simplicissimus*, they mercilessly parodied the stuffy bourgeois culture of Wilhelminian Germany, in particular the culturally conservative Bavarian Catholics, who just then were increasingly using their considerable political influence to censor writers and artists of Munich's avant-garde. Corinth's association with the virulently anticlerical literary circle surrounding Josef Ruederer (one of Munich's best satirical writers, who lived directly above Corinth's studio and who remained a lifelong friend of the artist) brought him into close contact with equally irreverent writers. Thus, though he continued to produce landscapes and portraits informed by the naturalist tradition, Corinth not only began again to caricature himself and his friends in witty drawings and watercolors, he also introduced an element of persiflage into many of his figure paintings, particularly those having to do with Christian themes. Part career strategy (Corinth himself admitted that he wanted to impress the public and his colleagues with his "eccentric originality"[3]), part impatience with established traditions of art-making, and part rebellion against the Catholic religious authorities who strove to muzzle the artistic and literary avant-garde,[4] he began in Munich to produce what would ultimately become a large body of historical, mythological, and religious compositions that speak in a broadly comic tone.

PUBLIC RECOGNITION

In 1900 Corinth completed a large painting, *Salome*, that would have a decisive impact on his career. As with other of his large-scale figure paintings of this time, he disregarded traditional conventions in this work, transposing the familiar subject into a milieu that is both modern and commonplace.[5] Corinth submitted the work to the Munich Secession, hoping to present it in their annual exhibition, only to have it rejected. The painter Walter Leistikow assured the artist that the painting would be enthusiastically received in Berlin, where indeed it was when it was shown at the second exhibition of the newly created Berliner Secession in July 1900. The episode confirmed Corinth's suspicions that it was not in provincial Munich but in cosmopolitan Berlin where his talents would be most appreciated, and, thus, in 1901 he moved to the Reich capital.

Lovis Corinth, Paris, 1887

Lovis Corinth, *Salome*, 1900. Museum der bildenden Künste, Leipzig

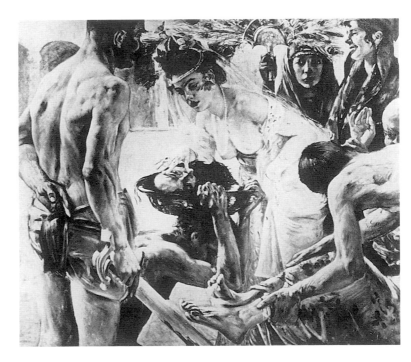

In Berlin, Corinth's rise to fame began. His connections to the Berliner Secession, of which he became a member of the executive committee in 1902 and president in 1915, and to the wealthy art impressarios Bruno and Paul Cassirer—who between them owned an art gallery that represented Corinth, two publishing companies that produced books he wrote, and a fine-arts press that published a number of the artist's illustrated books and print portfolios—brought him into contact with Berlin's cultural elite. He began to receive commissions for portraits and, now, still lifes, which became an important part of his output. Equally lucrative was the private painting school for women that Corinth opened in 1901; his first student was the twenty-one-year-old Charlotte Berend, who became his wife in 1903 as well as his favorite model. Together they had two children: Thomas, born in 1904, and Wilhelmine, born in 1909. Not surprisingly, Corinth now began to devote considerable energy to representing his new home and family in paintings, drawings, and prints (the latter was a medium that he had largely abandoned since he had first experimented with reproductive processes in the early 1890s). Turning his gaze

onto himself, he began to make self-portraits in earnest, evidencing more and more frequently a fascination with his own image that exceeded that of almost any artist, except perhaps Rembrandt, Max Beckmann, and Egon Schiele. Corinth also maintained his commitment to the production of large-scale multifigure compositions with mythological or religious subject matter. As a result of his growing familiarity with French Impressionism, featured both in the Secession as well as the Cassirer gallery exhibitions, the artist's brushwork in all these genres became looser, his colors lighter and more vibrant. Yet it was still primarily descriptive, and for all its expressiveness remained basically tied to the tradition of naturalism.

Then, in December 1911, Corinth suffered a stroke that would change the course of his life and art. Although he lived until 1925, his remaining years were fraught with physical hardship, including the partial paralysis of his left hand and tremors in his right. Renowned in his youth for his great physical strength—and married to a woman twenty-two years his junior—Corinth found it difficult to adjust. To be sure, by all acccounts not only did his shaking hand steady as soon as he took hold of a

Lovis Corinth's studio on Klopstockstrasse, Berlin, 1911

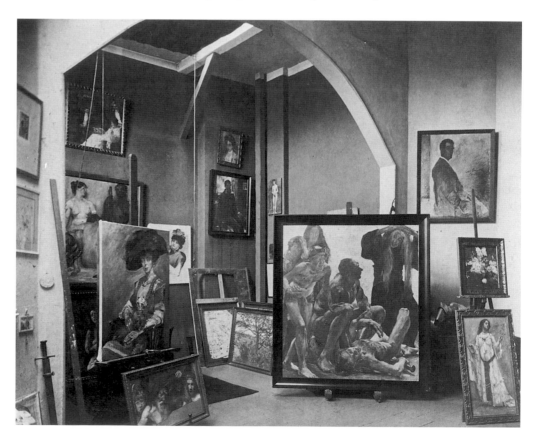

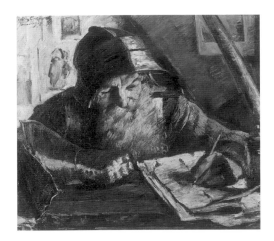

pen, brush, or etching stylus, his whole demeanor changed the moment he began to work, from that of a tired old man to an energetic, vital artist in full command of himself and his output. But Corinth's health and its real or imagined impact on his work was nevertheless often the source of bouts of deep depression, which were intensified after 1918 by his sadness about Germany's military and moral defeat in World War I and its aftermath. Like most other Europeans, Corinth had welcomed the war as a means of sweeping away the problems that had developed during the early years of the century. He was also a true patriot, believing in Germany's moral right in the conflict and stubbornly retaining his faith in the country's military leaders long after most others had abandoned theirs. He was thus ill-prepared for Germany's capitulation in September 1918, and for the social, economic, and political events that would shake the nation to its very foundations during the subsequent five years. Above all, Corinth could not accept the fall of his beloved Hohenzollern dynasty, nor did he trust the democratic republic led by the majority socialists, which replaced the empire.

It was the narrative graphic cycle that Corinth used above all to articulate his feelings on these issues, and his output of book illustrations and print portfolios increased exponentially after World War I. In part this was due to Germany's postwar inflation. As the value of the mark spiraled downward between 1919 and 1923, the number of potential collectors of Corinth's expensive oil paintings diminished, as the cost of materials skyrocketed. Because canvas was very expensive (and useable only once) while a copper plate or lithographic stone could be ground down at little cost and used

repeatedly, Corinth could both maximize the market for his work and minimize his own expenses by publishing moderately priced prints. Notably, the artist often chose narratives with which he could identify on both a personal and political level. The story of Götz von Berlichingen, for example, so appealed to Corinth that he made it the subject of two lengthy graphic cycles, each of which tells the tale of this medieval knight who lost his hand in battle but carried on against all odds with an iron replacement.[6] Corinth, hampered by his own physical handicaps, sympathized with Götz as much because of this as because of the knight's conservative politics. Known as the true-hearted champion of the lost cause of feudalism, Götz, like Corinth, was gradually forced against his will to accept a new system where power was no longer held by the nobility but increasingly in the hands of the urban middle class.

Corinth continued to paint as well. As before, he worked in all genres, but while earlier he had used color and form in the service of description, now he did so more toward suggestion. In Corinth's work of this period, paint itself becomes the trace of the artist's hand, a cipher of expressive movement that merely adumbrates a ghost of an image. The mood of his work changed, too, perhaps most apparently in the pictures he made of himself. Corinth's pre-1911 self-portraits invariably depict a strong, even cockily defiant man, but those he made after his stroke, and especially after 1918, usually highlight

Lovis Corinth, *Götz von Berlichingen*, 1917. Museum am Ostwall, Dortmund

Installation view of *Lovis Corinth, Ausstellung von Gemälden und Aquarellen zu seinem Gedächtnis* at the Nationalgalerie, Berlin, 1926

the artist's psychological and physical frailty. The most poignant of these portray a gaunt, haggard shell of a man, fearfully confronting the world beyond his studio. Corinth's figure paintings also underwent a perceptible change. Devoid of the element of burlesque that was ever present in his prewar treatments of mythological and, especially, religious themes, his works of these years are deadly serious metaphors of both the man who painted them and the defeated country he loved. Rather more upbeat are Corinth's paintings of the spectacularly beautiful Walchensee in the Bavarian Alps, which the artist visited in 1918. Recognizing how the extraordinary beauty of the setting affected Corinth, his wife insisted that they build a house overlooking the lake, which was completed in October 1919. The area subsequently became one of Corinth's favorite subjects, but unlike Cézanne's analytical paintings of Mont Saint Victoire, the approximately eighty Walchensee pictures Corinth made before his death in 1925 are highly expressive.

The Walchensee paintings were very popular with collectors, museums, and galleries, which acquired the works as soon as they were complete and provided the artist with a source of income even at the height of Germany's postwar inflation. But Corinth's

success was not only financial; his critical reputation continued to grow as well during the war and after. In 1917 Karl Schwarz's catalogue raisonné of Corinth's graphic work was published, as was the first biography of the artist, Herbert Eulenberg's *Lovis Corinth: Ein Maler unserer Zeit* (Lovis Corinth: A Painter of Our Time). He had major exhibitions of his work at the Städtische Kunsthalle in Mannheim and at the Kestner-Gesellschaft in Hannover, and was made an honorary citizen by the city magistrates of Tapiau. In 1918, the Berliner Secession celebrated his sixtieth birthday with a large retrospective, and the Prussian Ministry of Culture awarded him the title of Professor. In 1921 the Albertus-Universität in Königsberg conferred upon Corinth an honorary doctorate, and in 1923 the Nationalgalerie in Berlin marked the artist's sixty-fifth birthday with an exhibition of 170 paintings from private collections. The year 1924 saw another one-man exhibition of the artist's work at the Kunsthaus in Zürich and at the museum in Königsberg, and after Corinth died in 1925 on a trip to Holland from an infection in the lungs, memorial exhibitions were mounted throughout Germany. The most notable took place in Berlin in January 1926, when the Nationalgalerie featured more than five hundred paintings and watercolors while the Berliner Secession exhibited his drawings and the Berlin Akademie der Künste his prints. In short, Corinth's work, especially his late work, was highly lauded in Germany at the time of his death. But merely a decade later, in 1937, he was featured with seven paintings in the Munich exhibition *Entartete Kunst* organized by the National Socialists. Several of his confiscated works were then sold at auction in Lucerne, while others were exported by dealers. That same year, the artist's son, who had settled in New York, organized Corinth's first gallery show in the United States at New York's Westermann Gallery. The selection of this exhibition, which contained twenty-five paintings in addition to watercolors and drawings, privileged the artist's landscapes, portraits, and still lifes over religious, mythological, or historical compositions. Consequently, the author of the catalogue essay— *Art News* critic Martha Davidson—praised the artist for "freeing Germany from its Classical-Romantic spirituality and concern with remote subject matter." Singling out the Walchensee pictures as Corinth's "master works," Davidson lauded both the "sensuous eloquence" of the artist's brush and his

Review by Martha Davidson of the Lovis Corinth exhibition at the Westermann Gallery, in the *Art News* (May 8, 1937), showing a Walchensee landscape

"boldly expressive" line.[7] Perhaps it was these qualities that led Wilhelm R. Valentiner, then director of the Detroit Institute of Arts, to arrange for the Westermann exhibition to be shown in Michigan at the Alger House in Grosse Point Farms, a branch of the Detroit museum.[8] This—Corinth's first museum show in the United States—took place in the summer of 1937, just as the *Entartete Kunst* show was on view in Munich. Three other exhibitions were mounted in the United States before the onset of World War II, one at the Rochester Memorial Art Gallery (November 1937), one at the Milwaukee Art Institute (February 1938), and one at the Westermann Gallery (April and May 1939). But though critics praised Corinth as "one of the most passionately emotional artists of his period in Germany,"[9] ultimately Americans did not wholly embrace his work, accustomed as they were to the more analytical solutions of the French avant-garde. World War II and the Holocaust did little to foster sympathy toward the German aesthetic in general, and, despite the continued efforts of individuals such as the dealers Curt Valentin and Allan Frumkin, Corinth's reputation more or less languished in both the United States and Germany until the 1980s advent of neo-Expressionism renewed interest in his work. Since that time he has been prominently featured in both group exhibitions of modern German art and in solo shows in Germany and the United States. Corinth is now widely acknowledged as one of the great German painters of the twentieth century.

Maria Makela

[1] Fragment of a review appearing in July 1890 in the *Allgemeine Zeitung*, Criticism Scrapbook, Lovis Corinth Estate, Archiv für bildende Kunst am Germanischen Nationalmuseum.

[2] Lovis Corinth, *Selbstbiographie,* Leipzig: Verlag von S. Hirzel, 1926, p. 108.

[3] Corinth, "Wie ich das Radieren lernte," in: *Gesammelte Schriften,* ed. by Kerstin Englert, Berlin: Gebr. Mann, 1995, p. 45. When Corinth used these words, he was referring specifically to his *Tragikomödien,* a series of nine etchings that he made in 1893 and 1894 that are characterized by the same comic tone as his large-scale figure paintings of the 1890s.

[4] On this, see Maria Makela, "The Politics of Parody: Some Thoughts on the 'Modern' in Turn-of-the-Century German Culture," in: *Imagining Modern German Culture, 1889–1910,* ed. by Françoise Forster

Hahn, Washington D.C.: National Gallery of Art, 1996, pp. 185–207.

[5] Art historian Horst Uhr has written that "the makeshift robes and vulgar figure types give the scene the character of a *tableau vivant* staged by studio models at a costume ball," an impression reinforced "by the nonchalant detachment with which the gruesome episode is reenacted." Horst Uhr, *Lovis Corinth,* Berkeley: University of California Press, 1990, p. 119.

[6] The first, "Das Leben des Götz von Berlichingen, von ihm selbst erzählt," is a cycle of fifteen lithographs illustrating the 1731 edition of Götz's biography. Published by the Gurlitt Press in 1920, this version was followed in 1922 by a suite of twenty-seven etchings illustrating Goethe's *Geschichte Gottfriedens von Berlichingen mit der eisernen Hand,* produced by Erich Steinthal in Berlin.

[7] *Oil Paintings, Watercolors, Drawings,* exhibition cat., New York, the Westermann Gallery, April 22–May 21, 1937. The text that Davidson wrote for this exhibition catalogue appeared almost verbatim as an exhibition review in *Art News* vol. 35 (May 8, 1937), p. 16. I am extremely grateful to Claire Deroy for her invaluable assistance in locating the catalogue from the Westermann show, as well as other important information regarding Corinth's first exhibitions in the United States.

[8] See the letter from Herbert Bittner of the Westermann Gallery to Perry Rathbone of the Alger House, May 1937, Archives of the Detroit Institute of Arts, which intimates that it was Valentiner who suggested the show be sent to Michigan.

[9] Review by D[oris] B[rian], in: *Art News,* vol. 37 (May 6, 1939), pp. 13–14.

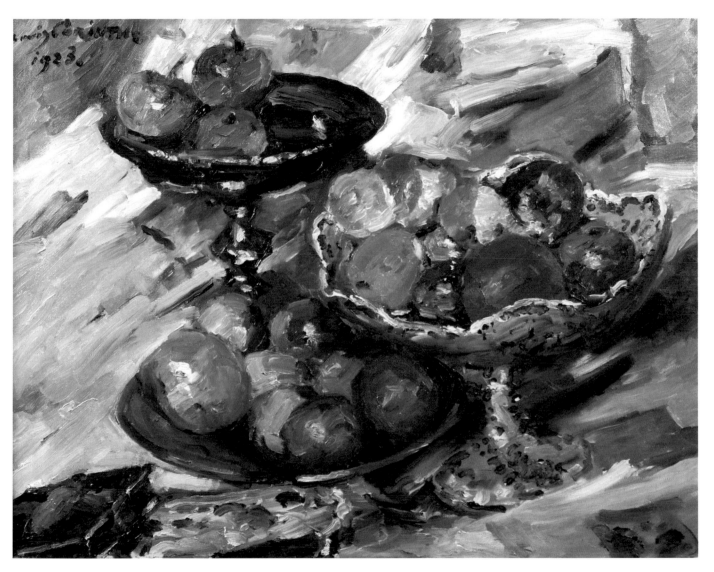

Fruit Bowls, 1923 cat. II.4

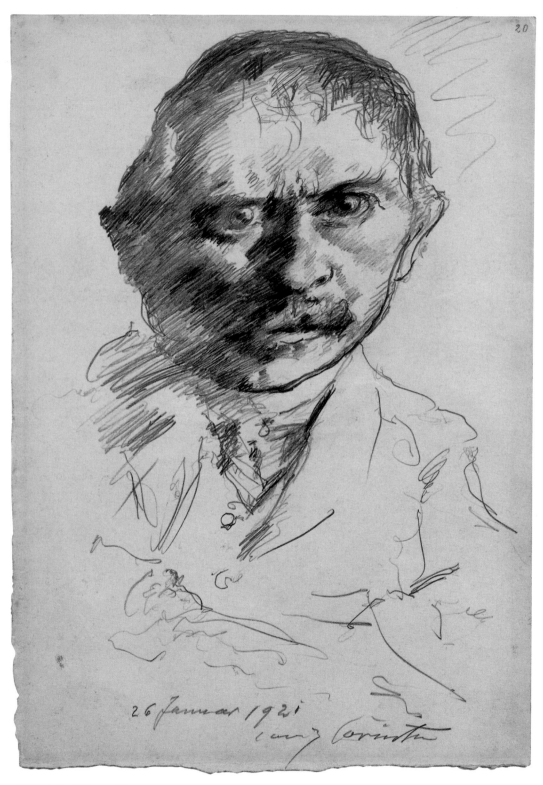

Self-Portrait, 1921 cat. II.3

values of Wilhelminian German society. The artists' concept of their personal bohemia, and their art, was an eclectic synthesis derived from the writings of various nineteenth-century European authors, including Friedrich Nietzsche, Oscar Wilde, Arno Holz, and—though probably indirectly—the French utopian socialist Charles Fourier. But perhaps the major guide for Brücke artists, through their enthused explorations of personal, sensual, and sexual freedom, was the American poet Walt Whitman.

As Curt Valentin was making plans for an exhibition of Kirchner's work in New York in 1937, the artist wrote a letter to the dealer, contending: "[In my art] I wanted to express the richness and the joy of living, to paint humanity at work and at play in its reactions and interactions and to express love as well as hatred. … The great poet Walt Whitman was responsible for my outlook on life. During my dismal days of want and hunger in Dresden, his *Leaves of Grass* was and still is my comfort and encouragement."[3]

While Kirchner's statement is clearly addressed to an audience in America, and thus may have represented an attempt to render his art more accessible to such an audience, the vehemence of the claim is remarkable. There was no other writer, not even Nietzsche, to whom Kirchner ever expressed such indebtedness for his own thoughts and ambitions. Indeed, in 1929, he planned to create a series of woodcuts for an edition of Whitman's *Leaves of Grass;* the project seems, however, not to have come to fruition.[4]

Kirchner was not the only one among Expressionist artists and writers to admire Whitman so intensely as to recognize him alongside Charles Baudelaire and Nietzsche as a primary literary influence. *Leaves of Grass* appeared in German as *Grashalme,* translated by the German poet Johannes Schlaf, in 1907, but individual poems from the collection had been known in translation at least since the 1890s. What drew Kirchner and other German Expressionists to Whitman were above all the poet's sense of a pantheistic vitalism, his celebrations of individual freedom, and his praise of erotic sensualism and unhampered sexuality; and there was certainly also the sense of the exotic that clung to German perceptions of America. Whitman's exclamation-mark-studded verses clearly proved to be a foretaste of Expressionism's own ethos:

One hour of madness and joy! O furious! O confine me not!
(What is this that frees me so in storms?
What do my shouts amid lightnings and raging winds mean?)

.

O something unprov'd! Something in a trance!
To escape utterly from others' anchors and holds!
To drive free! To love free! To dash reckless and dangerous!
To court destruction with taunts, with invitations!
To ascend, to leap to the heavens of the love indicated to me!
To rise thither with my inebriate soul!
To be lost if it must be so!
To feed the remainder of life with one hour of fulness and freedom!
With one brief hour of madness and joy.[5]

Whitman's poetry served as a virtual credo for Kirchner.[6] The American poet spoke fervently against established bourgeois values and social institutions: he celebrated youth and the present moment without reserve, adulated nature but also valued modernity's "populous city." Whitman positioned himself in a space of ecstasy and delirium that could flirt with madness and self-destruction. It was as if *Leaves of Grass* were an extended commentary on Kirchner's own *Programm der Künstlergruppe Brücke* (Program of the Brücke Artists' Group).

Brücke, with its utopian experiments, collapsed in 1913, slightly over a year after the group moved from Dresden to Berlin. Their final period had been fraught: they had accepted Otto Mueller as an additional member and expelled Pechstein for having broken the group's pledge not to exhibit separately. Kirchner had attempted to write the group's "chronicle." Later in 1913, he had his first one-man exhibition in Hagen and also Berlin. In this period, he continued to develop an increasingly personal painting style, tied closely to the look of his woodcuts and wood sculptures in its sharp, splintery accents; this new style differed significantly from the works of his former Brücke colleagues. His work was seen for the first time in the United States in the 1913 Armory Show: the painting exhibited was *Wirtsgarten in Steglitz (Garden of an Inn in Steglitz;* 1911), which did not sell.

Just as Kirchner's reputation and exposure were on the rise, both his career and his personal life

Ernst Ludwig Kirchner, ca. 1919

Ernst Ludwig Kirchner, *Der Neue Kunstsalon*, poster design, 1913.

were interrupted by the outbreak of World War I. As an "involuntary volunteer"—he joined up to avoid being drafted—Kirchner became a driver with a field artillery regiment in Halle. Soon, however, he was furloughed because of his deteriorating physical and mental health, a demise brought on, in large part, by military service and his resistance to it. To overcome his "weak nerves" and his increasing dependence on a variety of drugs, Kirchner entered the sanatorium in Königstein in 1916. He managed to escape German military demands when, now partially paralyzed, he moved to Davos, Switzerland, where he received further treatment and then entered another sanatorium. Finally, in Frauenkirch, a small farming community near Davos, Kirchner settled into an old peasant cottage, where he spent the remainder of his life, suffering from continued illnesses and bouts of depression, working and orchestrating his exhibition activities in Germany, Switzerland, and elsewhere in Europe. In an explication of his work, he noted in 1919: "My work is derived from the longing of loneliness. I have always been alone. The more I was among other people, the more I felt my loneliness, felt rejected, although no one rejected me. That results in profound sadness and it retreated and disappeared before my work and my will."[7]

KIRCHNER AND THE UNITED STATES

In the United States, Kirchner's work was little seen during his lifetime. The German émigré dealer J. B. Neumann included his prints in an inventory for his New York gallery, but seems to have sold few, if any, of them. Kirchner participated in the twenty-fourth *International Exhibition of Paintings* at the Philadelphia Arts Club in 1926, and also in the Carnegie International exhibition that same year; however, it was not until 1931, when Alfred H. Barr, Jr. included four Kirchner paintings in his epochal exhibition *German Painting and Sculpture* at New York's Museum of Modern Art that a significant selection of his paintings would be seen in the United States. There was, interestingly, no major public or critical response to the Kirchner paintings in the show.

Ironically, it was Adolf Hitler's rise to power in 1933 that finally ended Kirchner's neglect in the United States. Important works came to this country, as Jewish and other refugees were able to save portions of their collections when they fled Germany.

The director of the Detroit Institute of Arts, Wilhelm R. Valentiner, who had been in America since shortly after World War I, arranged the first exhibition devoted to Kirchner in the United States. The show opened at the Detroit museum in January 1937. Valentiner had sought out Kirchner during a visit to Switzerland in August 1936, and the artist agreed to a small American exhibition of recent paintings, watercolors, and prints. As Valentiner later recalled: "That day we also made plans for a small exhibition of Kirchner's work in Detroit; I did not dare suggest sending more than ten paintings and twenty-five water colors, because the shipping costs would have to be paid by the exhibitor out of possible sales and there would not be a great deal of interest in an unknown name. The artist insisted

that the works chosen be sent directly to Detroit, although it would have been less expensive to have a New York dealer act as a forwarding agent—Kirchner was too distrustful of dealers. The exhibition … unfortunately, was not at all successful. A few water colors were sold, but no oil paintings, so I finally bought one myself—though I was rather hard up at the time—without telling the painter, for he would have been too disappointed."[8]

The possibility of gaining an American audience greatly interested Kirchner. His German market had effectively disappeared and his work was being publicly reviled in Germany after the confiscation of his paintings from museums and the 1937 exhibition *Entartete Kunst*, which included

Ernst Ludwig Kirchner, letter to Wilhelm R. Valentiner, 1936. Photograph © 2001 The Detroit Institute of Arts

Wilhelm R. Valentiner, New York, ca. 1936

thirty-two of his works.[9] In Europe, the only country where his art continued to sell was Switzerland; the helpful hand Valentiner offered him from America was much needed. Valentiner's plan to show Kirchner's work in conjunction with Detroit's first exhibition of paintings by Paul Cézanne surely appealed to Kirchner as well. The juxtaposition with one of the pioneers of modernism attested to Valentiner's high estimation of Kirchner's work, its intrinsic value, and its historical significance. The show consisted of six oil paintings and fifteen watercolors by Kirchner, as well as a selection of recent woodcuts. According to a review in the *Detroit News* that also quoted Valentiner's evaluation of Kirchner's recent work: "His paintings are of an extraordinary vividness and clarity of color, showing the influence of the high mountain air of his environment. They are built up in large planes and usually show a fine sense for linear pattern. They express at the same time a very personal and intense approach to nature, as would be expected from a man who has lived isolated from the world in a mountain hut for twenty years."[10] Accenting the personal and biographic dimensions of Kirchner's art, with hints of eccentricity but also an emphasis on an Impressionistic concern for light, Valentiner sought to generate an audience for Kirchner in Detroit and beyond.

To garner wider American attention for Kirchner, Valentiner also insisted on the importance of his having an exhibition in New York. Through Valentiner as well as directly, the artist contacted Barr at the Museum of Modern Art. Though Barr had included his work in the museum's 1931 survey of modern German art, Kirchner apparently received no response to his letter: "Mr. Alfred Barr at the Museum of Modern art has not answered my request for an exhibition as yet," he wrote to Valentiner.[11] More successful were negotiations with Curt Valentin, who was preparing to open his new Buchholz Gallery in New York. Kirchner was initially skeptical of Valentin (noting, for example, his lack of officially imprinted stationery), and needed reassurances from Valentiner of the New York dealer's reliability. Slowly, however, the artist came to trust him: "I am not now clear how it stands with that Mr. Valentin, but he [sounds from his note] more human, free, and more warm. It seems the air in the United States has done him good. In any case, I will be glad to be friendly with him and if he should succeed in creating interest for my paintings in

New York hope to work with him. We are after all both expulsed persons, although for different reasons."[12]

The Buchholz Gallery's opening exhibition took place from September 29 to October 27, 1937, and included thirty-two recent works by Kirchner—twelve paintings, eight watercolors, and twelve prints—apparently, many of the same works that Kirchner had originally sent to his Detroit exhibition, but with the addition of a number of paintings. The cover of the catalogue presented one of Kirchner's newest woodcuts; the introduction reproduced part of Barr's essay from his 1931 *German Painting and Sculpture* exhibition. Unfortunately, as Valentiner reported: "In New York, also, there was no success, so I again had to buy a painting."[13] Kirchner likewise was not happy with the exhibition and its presentation, and complained to Valentiner: "The exhibition in New York opened with a strange preface written by Barr; 'irascible' and 'distorted drawing' was no recommendation. Why Valentin did

Curt Valentin, as featured in *Art Digest* (June 1, 1954)

Cover of the exhibition folder *Ernst Ludwig Kirchner*, Buchholz Gallery, New York, 1937. The Jean-Noël Herlin Archive Project, New York

THE BUCHHOLZ GALLERY
CURT VALENTIN

ERNST L. KIRCHNER
September 29 - October 27

3 WEST FORTY-SIX STREET
NEW YORK BRyant 9-8522

that to me, I do not understand. I received some ironical letters. My bad luck seemed to pile up in 1937, but it will not deprive me of my pleasure in working. ..." But he concluded with gratitude to Valentiner for his efforts and a statement of hope in America: "I wish you a very pleasant 1938. Do come again to Europe. ... America has a direct relationship to art and therefore a clearer vision of the modern development [than Europe]. It is our land of hope. Many thanks again."[14]

Kirchner wrote once more to Valentiner, on March 15, 1938, to express his thanks yet again: "There are only a very few who can understand anything of those new paintings of mine. As a German painter, one is looked at now as something not very pleasant. Thus my position after the 'defamation' has become very difficult, and during the past few months after one unfortunate thing after another has happened I have had to fight against melancholy which otherwise is foreign to me. Not that I have despaired of my work; I still can see my way clearly and shall go on as until now, but from a human point of view I have become very lonesome, and this one discovers when he becomes old."[15]

Despite his hopes for American acceptance, despairing of the European political and artistic situation as well as of his own physical and psychological health, Kirchner committed suicide exactly three months after he wrote those words, on June 15, 1938. Valentiner was en route to Europe to pay another visit to Kirchner when he received news of the artist's death, but nonetheless visited Kirchner's home in Davos after being invited by Erna Schilling, Kirchner's companion since 1911. He later described the visit: "It was a dismal day of steady rain when I started up the little valley behind Frauenkirch; the mountains were buried in clouds and an empty streambed of the year before was full of turbulent, muddy water. The zig-zag road to Kirchner's house was slippery, and no one was there to take my hand and help me up [as Kirchner had done previously]. Mrs. Kirchner received me in mourning. Within the house little had changed, except that in the living room there was now a full-

length self-portrait of the artist with a background of colorful textiles that suited the bright surroundings. … The last weeks of Kirchner's life had been terrible for his wife. Everything seemed to have worked against him."[16]

In the United States, Kirchner's art slowly began to gain an audience, largely due to the efforts of Curt Valentin. Working with German dealers, he brought to America a significant number of major paintings, many of them confiscated from German museums and collectors. In his gallery, for the first time since the Armory Show, the United States was introduced to Kirchner's earlier Expressionist works. Among the first purchasers was the Museum of Modern Art, which in 1939 acquired Kirchner's monumental *Die Strasse, Berlin (Street, Berlin;* 1913), which had once hung in a prominent position in the Nationalgalerie in Berlin. World War II interrupted Valentin's efforts on Kirchner's behalf, but after its end he immediately resumed his promotion of the artist's paintings. He established contacts with the Kirchner estate, enabling him to bring additional paintings into the country; he showed Kirchner's works in his gallery, and fostered museum exhibitions, most notably one organized by Charles L. Kuhn at Harvard University's Busch-Reisinger Museum in 1950.

This steady exposure and promotion gave Kirchner a primacy of position within the American understanding of German Expressionism that exceeded his prior reputation in Germany—where he had often been regarded as less significant than Max Pechstein or Karl Schmidt-Rottluff among the Brücke artists. None of the other Brücke painters, however, gained the recognition now accorded to Kirchner in America. None but Kirchner has had a major museum retrospective exhibition; indeed, none of them has been quantitatively or qualitatively so well represented in American museum collections.[17] In 1958, when Valentiner organized another Kirchner exhibition, at the North Carolina Museum of Art in Raleigh, he was able to bring together a collection of ninety-six works—forty-three of them paintings—and in the catalogue reproduced others, every one derived from American collections. Only twenty years earlier, for the show Valentiner had organized in Detroit, all of the works had come from Kirchner himself.

His work was championed yet again in a large retrospective exhibition at the Seattle Art Museum, the Pasadena Art Museum, and the Boston

Installation view of the exhibition *E. L. Kirchner, German Expressionist*, North Carolina Museum of Art, Raleigh, January 10–February 9, 1958. Photograph courtesy of the North Carolina Museum of Art, Raleigh

Installation view of the exhibition *E. L. Kirchner: A Retrospective Exhibition by Donald E. Gordon*, Seattle Art Museum, November 23, 1968– January 5, 1969. Photograph courtesy of the Seattle Art Museum

Museum of Fine Arts in 1968. For this show, the 148 works were selected by Donald E. Gordon. In 1959, Gordon had written the first American dissertation on Kirchner and, with the publication of his catalogue raisonné of the artist's paintings in 1968, he became the premier Kirchner scholar—his work setting the standard for the slowly emerging Kirchner research in Germany.[18] For Kirchner, although posthumously, America had at last become the longed-for place that he had described only months before his death: a "land of hope."

Reinhold Heller

[1] "Ich zeichnete … alles was mir neu und rätselhaft war… Mein Vater sammelte die Blätter, bezeichnete und datierte sie, und alle meinten, ich müsse einmal ein Maler werden… ." Ernst Ludwig Kirchner, *Anfänge und Ziel* (1935), as cited in *Ernst Ludwig Kirchner 1880–1938*, exhibition cat., (West) Berlin, Nationalgalerie Berlin, Staatliche Museen Preussischer Kulturbesitz, 1979–1980, p. 47.

[2] Kirchner, letter to Curt Valentin, April 17, 1937, as cited and transl. in: *Ernst Ludwig Kirchner*, exhibition cat., New York, Curt Valentin Gallery, 1952, n.p.

[3] Ibid. The letter goes on to identify the German Expressionist poet Georg Heym, for whose posthumous poetry collection *Umbra vitae* Kirchner provided forty-seven woodcuts (Munich: Kurt Wolff, 1924), as "a Whitman transposed into the German psyche who saw and wrote prophetically about the recent decades of our era."

[4] Kirchner, letter to Gustav Schiefler, dated September 26, 1929, in: *Ernst Ludwig Kirchner/Gustav Schiefler, Brief-wechsel 1910–1935/1938*, Stuttgart and Zürich: Belser, 1990, #532, p. 622. A German edition of *Leaves of Grass* appeared in 1920, accompanied by thirteen arguably Expressionist lithographs by Willy Jaeckel: Walt Whitman, *Grashalme*, Prospero Druck, no. 9, Berlin: Erich Reiss, 1920. Cf. Lothar Lang, *Expressionist Book Illustration in Germany 1907–1927*, Boston: New York Graphic Society, 1976, pp. 42 and 221.

[5] Walt Whitman, "One Hour of Madness and Joy," from *Leaves of Grass* (1891–1892), in: *Walt Whitman, Complete Poetry and Collected Prose*, New York: The Library of America, 1982, pp. 262–263.

[6] For a specific discussion of Whitman's eroticism and its reflection in Kirchner's art, cf. Donald E. Gordon, *Expressionism: Art and Idea*, New Haven: Yale University Press, 1987, p. 29.

[7] "Meine Arbeit kommt aus der Sehnsucht der Einsamkeit. Ich war immer allein, je mehr ich unter Menschen kam, fühlte ich meine Einsamkeit, ausgestossen, trotzdem mich niemand ausstiess. Das macht tiefe Traurigkeit und diese wich durch die Arbeit und das Wollen zu verschwinden." Kirchner, "4 Texte," in: *Bilder von E. L. Kirchner*, exhibition cat., Frankfurt am Main, Galerie Ludwig Schames, February–March 1919, as reprinted in: *Ernst Ludwig Kirchner*, exhibition cat. (as note 1), p. 79.

[8] Wilhelm R. Valentiner, "Notes" (1940), in: *E. L. Kirchner, German Expressionist*, exhibition cat., Raleigh, North Carolina Museum of Art, 1958, p. 34.

[9] For further discussion of the *Entartete Kunst* exhibition, see particularly *"Degenerate Art": The Fate of the Avant-Garde in Nazi Germany*, exhibition cat., ed. by Stephanie Barron, Los Angeles County Museum of Art, 1991.

[10] The simultaneity of the Cézanne and Kirchner exhibitions is noted by Florence Davis, "Back to Beginnings," in: *Detroit News* (January 3, 1937). A copy of this review was kindly provided to me by Claire Deroy.

[11] Kirchner, letter to Valentiner, February 27, 1937, as transl. in: *E. L. Kirchner: German Expressionist* (as note 8), p. 41.

[12] Kirchner, letter to Valentiner, March 18, 1937, as transl. in: *E. L. Kirchner: German Expressionist* (as note 8), p. 42.

[13] Valentiner, "Notes" (as note 8), p. 35.

[14] Kirchner, letter to Valentiner, January 24, 1938, as transl. in: *E. L. Kirchner: German Expressionist* (as note 8), pp. 47–48.

[15] Kirchner, letter to Valentiner, March 15, 1938, as transl. in: *E. L. Kirchner: German Expressionist* (as note 8), p. 48.

[16] Valentiner, "Notes" (as note 8), pp. 35–36.

[17] Emil Nolde, who however was only briefly a Brücke member, is the exception to this and competes with Kirchner.

[18] Donald E. Gordon, *Ernst Ludwig Kirchner: A Retrospective Exhibition*, exhibition cat., Greenwich, Conn.: New York Graphics Society, 1968; Donald E. Gordon, *Ernst Ludwig Kirchner*, Cambridge, Mass.: Harvard University Press and Munich: Prestel-Verlag, 1968.

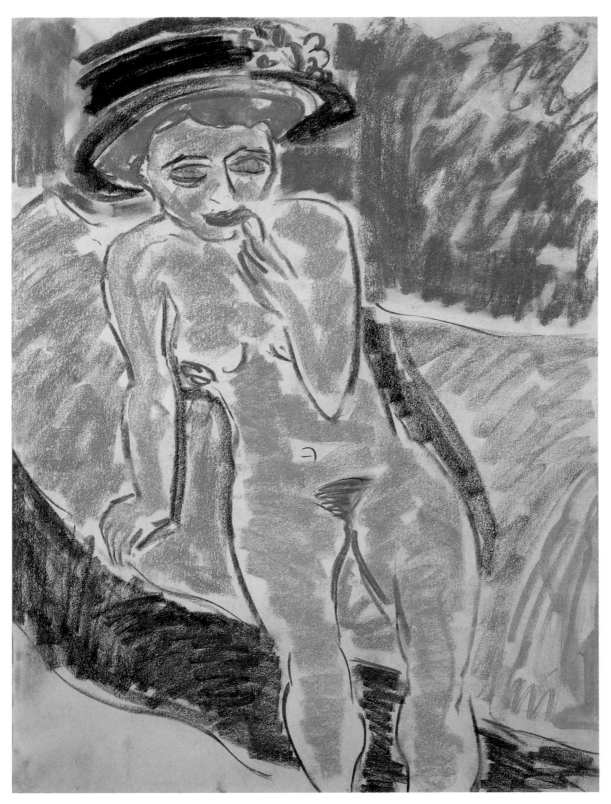

Seated Female Nude, 1907–08 cat. II.5

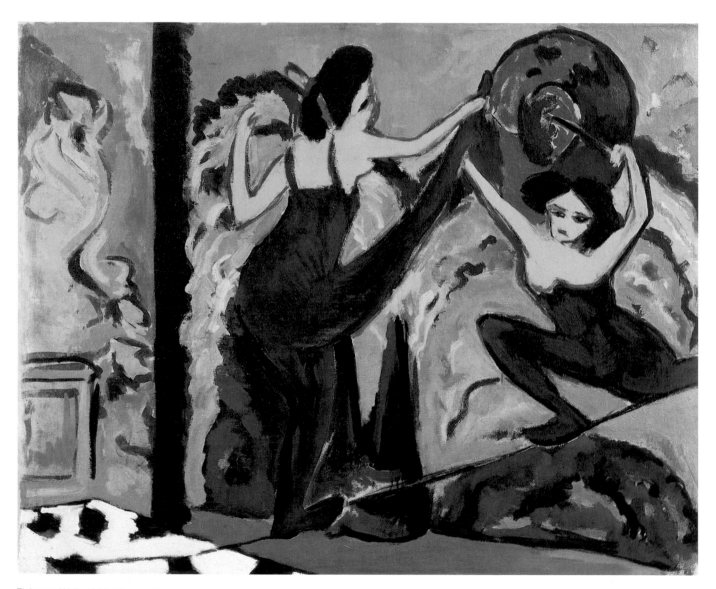

Tightrope Walk, 1908–10 cat. II.6

painterly effects."[2] Yet only a year later, in response to the Brücke exhibition mounted at the showrooms of the Seifert lamp factory, Stiller wrote in a more conciliatory (and informative) manner in the *Dresdner Anzeiger*. "The new artists' group seeks to place itself in direct contact with the buying public and will once a year present those friends who have become members [of the association] with original prints (etchings, woodcuts, lithographs)… If one regards the more or less robust application of the Pointillist principles of color to be 'modern,' then these oils are, with a few exceptions, 'modern.'"[3]

It was not long before Heckel managed to establish contact with one of the great German supporters of international artistic modernism, Karl Ernst Osthaus, founding director (in 1902) of the Museum Folkwang in Hagen. Heckel wrote to Osthaus on December 3, 1906: "On behalf of the artists' group Brücke, may I be so bold as to put respectfully to you the following request: the modern and, in our eyes, exemplary installation of the Museum Folkwang, and the truly artistic spirit in which it operates, has inspired in us the wish to mount an exhibition of our works there."[4] Osthaus responded positively, and the Brücke artists exhibited in Hagen in June–July 1907. Surviving documentation indicates that four paintings were shown by the Swiss artist Cuno Amiet (who had joined Brücke in 1906, along with Emil Nolde and Max Pechstein); Kirchner showed six, Schmidt-Rottluff eleven, Nolde five, Pechstein one, and Heckel eight. The exhibition also included a total of twenty-eight prints, by Heckel, Pechstein, and Schmidt-Rottluff.[5]

Osthaus subsequently helped the Brücke artists by enabling them to exhibit at the shows mounted by the Sonderbund Westdeutscher Kunstfreunde und Künstler (Union of Western German Art Lovers and Artists) in 1910 and 1912. He was also the first museum director to acquire paintings by Brücke artists for his institution.[6] It was through Osthaus that Heckel came to know the Hamburg lawyer and collector Gustav Schiefler, who was to emerge as a true champion of German Expressionism. In 1918, Schiefler wrote with admiration of Heckel's work as a printmaker in the Leipzig journal edited by Paul Westheim, *Das Kunstblatt*. Over time, Heckel developed his role as the principal organizer of Brücke. He was an unparalleled master of good public relations. An increasing

number of collectors and enthusiasts recognized that it was to Heckel, the group's "manager," that they could turn for advice and information. The regular production of Brücke print portfolios—Heckel's idea—proved to be an extremely shrewd move. Heckel was in every sense an "activist" on behalf of Brücke; although his emphasis on the "revolutionary" element in their work may have been merely a part of Heckel's inventive campaign to rouse interest in the group and their activities.

A high point in the history of Brücke achievements was the exhibition mounted at the Galerie Arnold, September 1–30, 1910.[7] This show was accompanied by a thirty-eight-page catalogue, which contained twenty original woodcuts by the Brücke artists. Eighty-seven exhibited works were listed in this publication (paintings, watercolors, drawings, woodcuts, lithographs, and etchings), representing the contribution of six artists (Amiet, Heckel, Kirchner, Pechstein, Schmidt-Rottluff, and, as a guest, Otto Mueller). Simultaneously, there appeared a second catalogue, produced by the artists themselves: this contained fourteen full-page woodcuts, in addition to a list of the names of "passive members" of the association (friends, sponsors, and collectors)—also in the form of a woodcut, made by Kirchner. Heckel designed the publication's title page. An unusual and interesting feature of this catalogue was that most of the woodcuts were executed by one artist, from the original subject of another artist. That is, Pechstein contributed a *Sitzender Mann (Seated Man;* 1919), which he had derived from a painting by Heckel, and reworked

Erich Heckel (undated photograph)

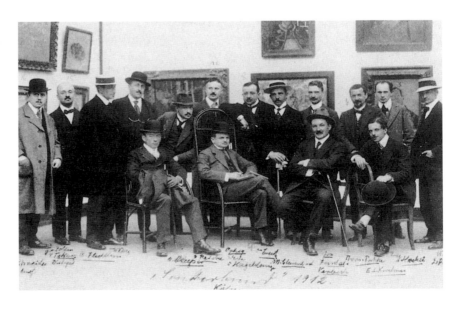

Jury of the *Sonderbund* exhibition, Cologne, 1928. Right: Erich Heckel, Ernst Ludwig Kirchner, and Wilhelm Lehmbruck

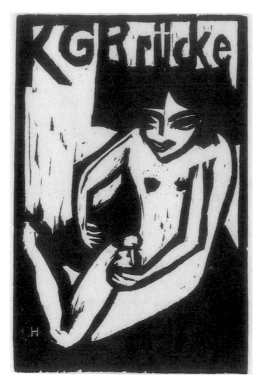

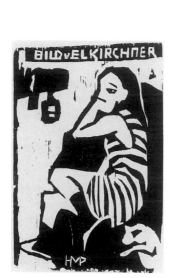

Max Pechstein, woodcut after E. L. Kirchner's painting *Artistin; Marcella (Artist; Marcella)*, 1910, in the exhibition catalogue *Erster Ausstellungskatalog der Künstlergruppe Brücke*, Galerie Arnold, Dresden, 1910

the theme of a painting by Kirchner, *Artistin; Marcella (Artist; Marcella)* 1910.

This collaborative work also served to acquaint a broader public with the new Brücke mode, their so-called planar style (*Flächenstil*). Soon, however, the group's fruitful collaborative phase was to come to an end. They moved to Berlin in the fall of 1911 and, although Heckel's studio would serve until 1913 as the group's informal "business center," the era of their communal creativity had now passed.

Heckel's first one-man show took place at Fritz Gurlitt's Berlin gallery in 1913, the year in which Brücke was formally dissolved. In a sense, this testifies to Heckel's loyalty to the group: for him, it went without saying that those who were active Brücke members should not exhibit individually. In addition to his show at Gurlitt, Heckel also exhibited in 1913 alongside the French artist Maurice Vlaminck, at the Berlin gallery of J. B. Neumann. Shortly before the outbreak of World War I in 1914, Heckel again showed at Gurlitt, in an exhibition titled *Einzelausstellung mit Erbslöh, Wettner, Helberger, Lindau, and Langer*.

Heckel volunteered for military service, and spent the duration of the war in a Belgian medical unit, run by art historian Walter Kaesbach, where many other artists served, including Max Beckmann. In 1915, he married Milda Frieda Georgi (known as Siddi Reha), a dancer with whom he had lived for some time.

J. B. Neumann organized the first large important exhibition of Heckel's graphic work in 1923. But it was not until 1948 that the first monographs on Heckel's work appeared, written by Paul Ortwin Rave in Leipzig and Heinz Köhn in Berlin. A year later, Heckel accepted a teaching position at the Karlsruhe Akademie der bildenden Künste (Academy of Fine Arts), which he retained until 1955. Fifteen years later, in 1970, he died in Radolfzell am Bodensee, a region he first moved to in 1944 after his atelier in Berlin had been destroyed in a bombing raid.

RECEPTION IN THE UNITED STATES

Heckel's work was first seen in the United States in 1923, when Wilhelm R. Valentiner included five of his oil paintings and nine works on paper in the show *A Collection of Modern German Art* at the Anderson Galleries in New York City. Two years earlier, Valentiner had already acquired two paintings by Heckel for the Detroit Institute of Arts: *Frau (Woman*—or alternately, *Portrait of the Artist's Wife)* and *Sonnenblumen (Sunflowers)*, both from 1920. Between 1925 and 1939, Heckel's work was regularly included in the yearly Carnegie International exhibitions. In 1927 he was represented in the *Multinational Exhibition of Works by American, British, French, German, Swiss and Mexican Artists*, organized by Mrs. Edward Henry Harriman. The show was held at the Grand Central Art Galleries in New York—a stop on its international tour (it had already appeared at the Nationalgalerie in Berlin and the Kunsthalle Berne, as well as at venues in London, Paris, and elsewhere). Works by Heckel were presented in 1928 at the *Exhibition of Paintings, Drawings, and Prints by Thirty European Modernists*, arranged by Galka Scheyer at the Art Gallery in Oakland, California.

In April–May 1930, the exhibition *Modern German Art* was presented at the Harvard Society for Contemporary Art in Cambridge, Massachusetts. For this show, Valentiner lent Heckel's painting *Boats*, and two watercolors, *Study of a Woman* and *Portrait Study*, from his own collection. Also presented was Heckel's watercolor *Landscape*, on loan from the collection of Mrs. John D. Rockefeller, Jr. With Valentiner, J. B. Neumann was a principal lender to the Harvard Society exhibition.

Neumann opened Heckel's first American one-man show, *Water Colors*, at his New Art Circle gallery in New York; it ran from November 24–December 13, 1930. A write-up in the *Art News* stated: "The large group of watercolors at the New Art Circle show [Heckel] to be an artist of considerable inventive power, both in the handling of the figure and in landscape. There is a pleasant freshness running through all his work, and an easy handling of form without too great stress on detail. He is fortunate in escaping something of the heaviness and obvious self-determination that tinctures so much of the modern German school, and obviously responds simply and naturally to the beauty of the world about him."[8]

After the major exhibition *German Painting and Sculpture* at New York's Museum of Modern Art in 1931 (in which five of Heckel's works were presented), Abby Aldrich Rockefeller purchased his *Löwenmäulchen (Snapdragons)* and *Bootshafen (Harbor for Little Boats;* 1929) from Neumann; and two watercolors were sold: one to Jere Abbott, and the other to Franz Hirschland.[9]

Heckel's most devoted champion in the United States was unquestionably Valentiner. Although the artist's works would be included in several group exhibitions of modern German art during the 1930s and '40s in America, it was not until the 1950s that there was a general revival of interest in his work. The Busch-Reisinger Museum in Cambridge acquired his painting *Landschaft mit Badender (Landscape with Bathers,* 1910), and the extraordinary triptych *Genesende (The Convalescent Woman;* 1913) in 1950. In March 1955—some twenty-five years after his first U.S. solo show—his second one-man exhibition, *Erich Heckel: Watercolors*, appeared at New York's Galerie St. Etienne. Several exhibitions of Heckel's prints were presented between 1969 and 1984;[10] there has yet, however, to be a comprehensive show of his paintings in the United States.

As was the case with so many important artists, Heckel saw a great deal of his output seized and destroyed during the National Socialist regime. In connection with preparations for the touring exhibition *Entartete Kunst,* first presented in Munich in 1937, 729 works by Heckel were confiscated from their owners. Like many of his artist colleagues in Germany, Heckel was forbidden to exhibit; he nonetheless decided not to leave the country, opting instead to become an "émigré" at home.

Today, in both Germany and the United States, Heckel is best known and celebrated as a printmaker—the 1984 exhibition *The Prints of Erich Heckel: From the Los Angeles County Museum of Art, the Robert Gore Rifkind Center for German Expressionist Studies* at the Marriner S. Eccles Federal Reserve Board Building in Washington, D.C celebrated his printworks. The sheer scale of his graphic output (466 woodcuts, 401 lithographs, and 197 etchings) attests to his deep love of and devotion to the print media. However, a large number of his paintings (as many as half of them) were lost or destroyed in World War II; thus the picture that remains of his artistic œuvre is unfortunately incomplete.

Tayfun Belgin
Translated from the German
by Elizabeth Clegg.

[1] Erich Heckel, in conversation with Hans Kinkel in 1958, published as "Erich Heckel—75 Jahre alt," in: *Das Kunstwerk,* vol. 12, no. 3 (September 1958), pp. 24 and 35, this passage on p. 24.

[2] Richard Stiller, in: Leipziger Volkszeitung (November 16, 1905), cited in: Karlheinz Gabler, ed., *Erich Heckel, Zeichnungen, Aquarelle, Dokumente,* Zürich: Belser, 1983, p. 40.

[3] Stiller, in: *Dresdner Anzeiger,* no. 275 (October 6, 1906), p. 4, cited in: *Erich Heckel und sein Kreis, Dokumente, Fotos, Briefe, Schriften,* Stuttgart and Zürich: Belser, 1983, p. 44.

[4] Ibid., p. 50.

[5] Ibid., p. 50.

[6] Ibid., p. 50.

[7] See the attempt to reconstruct the exhibition of the *K.G. Brücke* at the Galerie Arnold in Mario-Andreas von Lüttichau, "Künstlergruppe Brücke," in: *Stationen der Moderne: Die bedeutenden Kunstausstellungen des 20. Jahrhunderts in Deutschland,* ed. by Eberhard Roters and Bernd Schulz, exhibition cat., West Berlin, Berlinische Galerie, 1988–89, pp. 88–107.

[8] *The Art News,* vol. 29, no. 9 (November 29, 1930), p. 12.

[9] Penny Joy Bealle, *Obstacles and Advocates: Factors Influencing the Introduction of Modern Art from Germany to New York City, 1912–1933: Major Promoters and Exhibitions,* Ph.D. dissertation, Ann Arbor, Mich.: U.M.I. 1990, p. 335.

[10] *The Graphic Work of Erich Heckel: Woodcuts, Lithographs, Etchings, from 1907 to 1968* was presented in April 1969 at the Gropper Art Gallery in Cambridge, Massachusetts; the 1971–72 exhibition *Erich Heckel: Paintings, Watercolors, Drawings, Graphics* traveled to the Busch-Reisinger Museum in Cambridge, after appearing first at the National Gallery of Canada in Ottawa and the Winnipeg Art Gallery. In 1984, *The Prints of Erich Heckel: From the Los Angeles County Museum of Art, the Robert Gore Rifkind Center for German Expressionist Studies* was presented at the Marriner S. Eccles Federal Reserve Board Building Gallery in Washington, D.C.

Bathers in a Pond, 1908 cat. II.10

Seated Man, 1909 cat. II.11

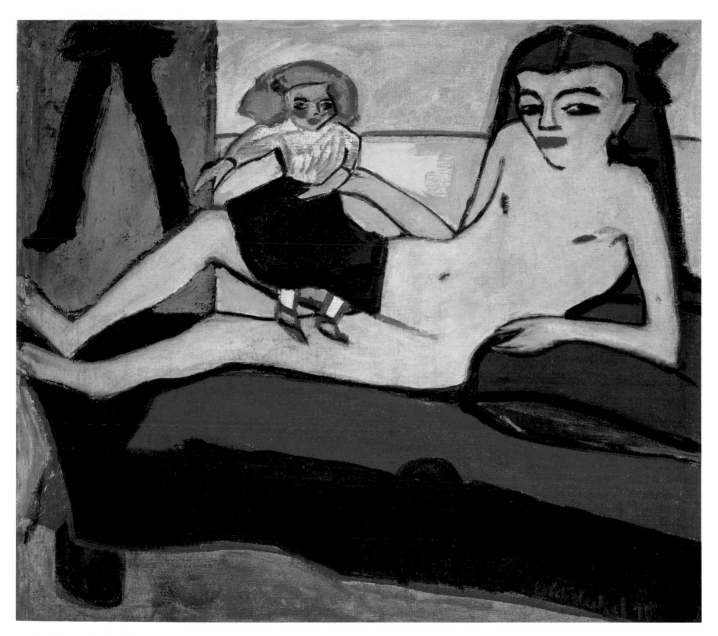

Girl with Doll (Fränzi), 1910 cat. II.13

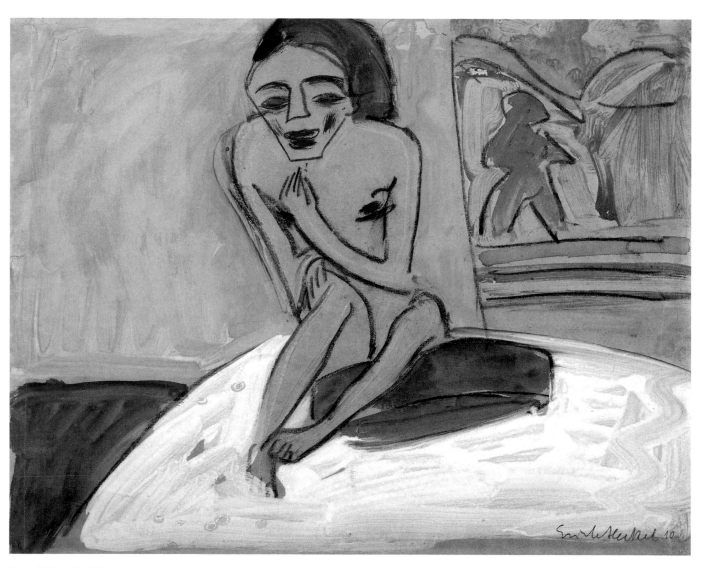

Seated Girl on Red Pillow, 1910 cat. II.12

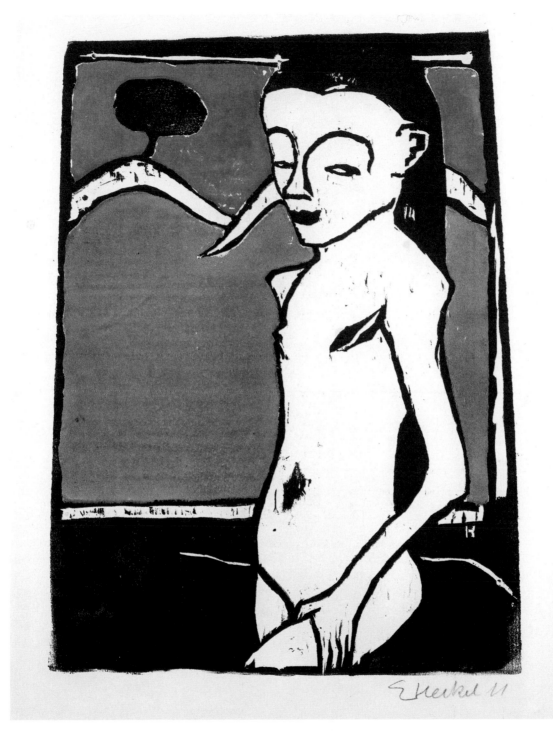

Standing Child, 1910 cat. II.14

KARL SCHMIDT-ROTTLUFF

*** DECEMBER 1, 1884, ROTTLUFF BEI CHEMNITZ**
† AUGUST 10, 1976, BERLIN

FOURTH EXHIBITION, FROM OCTOBER 3 TO OCTOBER 24, 1936

KARL SCHMIDT-ROTTLUFF
OIL PAINTINGS AND WATER-COLORS

"And as with all great works of art, content and form appear in most perfect harmony with greatest simplicity of construction."
(W. R. Valentiner in his monograph on Schmidt-Rottluff)

"Schmidt-Rottluff's personal style, founded first on Hodler, Munch and Van Gogh, later was modified by elements from stained glass windows of German medieval cathedrals and by Fifteenth Century woodcuts."
(C. J. Bulliet in "The Significant Moderns")

THE WESTERMANN GALLERY, NEW YORK
24 West 48th Street Facing Rockefeller Center
Tel. BRyant 9-5633

Invitation to the exhibition *Karl Schmidt-Rottluff, Oil Paintings and Water-Colors*, Westermann Gallery, New York, October 3–24, 1936. The Museum of Modern Art Library, New York. Photograph © 2000 The Museum of Modern Art, New York

Karl Schmidt-Rottluff is best known for his connection with the German Expressionist group Brücke, which he helped to found in 1905 along with Ernst Ludwig Kirchner, Erich Heckel, and Fritz Bleyl.[1] The oils and graphics that he produced and exhibited during his association with the group, which dissolved in 1913, reflect their belief that artistic innovations could bring about moral and ethical change. His involvement in World War I and the revolutionary activity at the beginning of the Weimar Republic further intensified his utopian hopes for the transformative power of art. Schmidt-Rottluff's woodcuts, which he had started making during the war, began to be discussed as powerful distillations of Expressionism. Several patrons—among them the art historian Rosa Schapire, who published the first study of his graphic works in 1924, and Wilhelm R. Valentiner, who arranged his first solo exhibition in New York in 1936—helped to make the artist's works more widely known in Germany, England, and the United States.

Born Karl Schmidt in 1884, the son of a miller, he would later combine his family name with that of his birthplace, Rottluff, to create his hyphenated signature. By 1902 he had become friends with Heckel, who was a student at the same school in Chemnitz, an industrial town near Rottluff. Both went on in 1905 to study architecture at the Dresden Technische Hochschule (Technical College), where they met Kirchner, and together the three of them developed the concept of forming a communal working and exhibition society. Calling themselves "Brücke" (bridge) to emphasize their goal of being a link to the future as the "new generation of

creators and appreciators,"[2] they worked in oils as well as graphics, and published a series of print portfolios that were given to sustaining members, such as Schapire. The fourth of these portfolios, the cover of which featured a depiction of Schmidt-Rottluff by Kirchner, included two of Schmidt-Rottluff's lithographs as well as an etching.[3] In 1911 he moved to Berlin with the other Brücke artists; the city would remain his primary home for the remainder of his life.

In World War I, Schmidt-Rottluff served on the Eastern front. During those years, he produced several wood sculptures and reliefs. His war experiences had a dramatic effect on him, and led to the creation of a series of religious woodcuts, which were widely written about by critics and collectors after the war. He also contributed woodcuts to the proliferation of journals and magazines that emerged with the beginning of the Weimar Republic. By the 1920s, Schmidt-Rottluff's works—particularly his prints—were viewed throughout Germany as vital examples of Expressionism. However, when the National Socialists came to power in 1933, he was expelled from the Preussische Akademie der Künste (Prussian Academy of Art), to which he had been appointed in 1931, and in 1937 his paintings and prints, along with those of former members of the Brücke group, were displayed as examples of the decadence of modern art in the infamous *Entartete Kunst* exhibition. By 1941, the National Socialist government had prohibited him from painting or exhibiting.

After World War II, Schmidt-Rottluff was appointed professor at the West-Berliner Hochschule für

Bildende Künste (School of Fine Arts), was given numerous retrospectives in Germany, and was included in the many exhibitions devoted to Expressionism in Germany, England, and the United States. He assisted with the founding in 1967 of the Brücke Museum in Berlin-Dahlem, which was the recipient of Schmidt-Rottluff's artistic estate after his death in 1976.

PUBLIC RECOGNITION

The prolific art critic Rosa Schapire was a fervent advocate of the Brücke artists and of German modernism.[4] In addition to writing about Schmidt-Rottluff, she also published essays on Kirchner, Emil Nolde, Cuno Amiet, Paula Modersohn-Becker, and Franz Radziwill, among others. Schapire fled Germany for England in 1939, at the age of sixty-five, one of many Jewish intellectuals to escape the National Socialists. Her entire library was lost, along with a number of works she owned by Heckel and Emil Nolde, many Brücke prints, and most of her personal belongings, including furnishings designed for her by Schmidt-Rottluff. She managed to save her collection of Schmidt-Rottluff's works, and it was these that later enabled her to play an important role in bringing the names of Schmidt-Rottluff and the Brücke to the English public. Despite her forced departure from Germany, where she had spent more than half her life, Schapire was determined to speak out about the humanistic power of German modern art, and wanted examples of her collection to be known to an international audience.[5] She organized an exhibition of Schmidt-Rottluff's graphic and sculptural production in 1952–53 at the Leicester Museum and Art Gallery and, shortly before her death in 1954, offered her Schmidt-Rottluff collection to several museums in Britain. Although the British Museum rejected her offer of Schmidt-Rottluff's graphics, the Tate received three of his oils, and the Leicester Museum and the Victoria and Albert Museum in London each accepted several of his prints from Schapire's collection.[6]

Born into an upper-middle-class Jewish family and trained as an art historian at the university in Zürich, Schapire had played a dual role as friend and promoter of Schmidt-Rottluff's work since 1907 when they first met.[7] He in turn depicted her in numerous oil paintings and prints and in 1921, using vivid colors, textures, and shapes appropriated from African and Oceanic art, he redecorated her

Hamburg residence, where she had lived since 1908.[8] An important portrait of her from 1911, now in the Brücke Museum, Berlin, captures the essence of Schapire's unusual persona rather than serving as a physiognomic likeness.[9] Through jagged brushstrokes of contrasting colors and simplified forms, the portrait exudes a feeling of vitality and daring. Placing Schapire at the center of the canvas in a three-quarter view, Schmidt-Rottluff frames her face—painted in reddish and orange hues, her eyes suggested by a few green and black brushstrokes—with an enormous, semicircular black arc of a hat. Writing about his approach, Schmidt-Rottluff explained that he wanted to abandon conventional colors and proportions, and that he "exaggerated heads monstrously, compared to other body forms, as the nexus of the whole psyche."[10] A few years after he had completed the Schapire portrait, in answer to a questionnaire about his goals, the artist wrote about his "inexplicable desire to shape what [he saw and felt] in order to find the purest, clearest expression."[11]

Although his prints were published in the few periodicals featuring Expressionist works before and during World War I, such as *Der Sturm* and *Die Aktion*, by the early years of the Weimar Republic, essays that included reproductions of his work began to appear in a variety of journals. In the pages of the radical and short-lived *Menschen* and *Das Tribunal* to the more established *Der Cicerone*, artists such as Conrad Felixmüller and writers

Karl Schmidt-Rottluff, ca. 1908–10

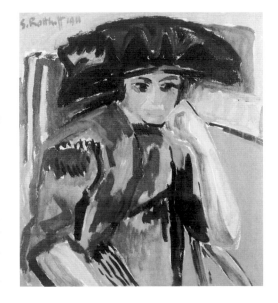

Karl Schmidt-Rottluff, *Portrait of Rosa Schapire*, 1911. Brücke-Museum, Berlin

Karl Schmidt-Rottluff, title page for portfolio *9 Holzschnitte* (Nine woodcuts), 1918

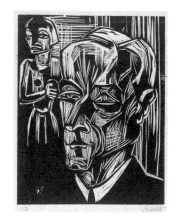

Karl Schmidt-Rottluff, *Portrait of W. R. Valentiner I*, 1923

(among them Schapire and Valentiner) helped to publicize Schmidt-Rottluff's work.[12] His portfolios, which were being produced by publishers such as Kurt Wolff and dealers such as J. B. Neumann, were of particular interest during this time. In Schapire's 1919 article on Schmidt-Rottluff's religious woodcuts, she wrote about finding "new aspects in the age-old materials." She explained that artists of Schmidt-Rottluff's generation were "tired of that wave of naturalism that impoverished the world" and were "risking new solutions" in their quest to rise above the provincial and to communicate something "transcendental."[13] For Schapire, Schmidt-Rottluff gave redemptive images from the past, such as stories from the life of Jesus, the power to affect the morale of the new Weimar Republic by simplifying them into stark black-and-white forms.

During World War I, Schmidt-Rottluff's longing for the transformation of German society intensified. In 1918, together with two former members of the Brücke (Heckel and Max Pechstein), he joined the radical Arbeitsrat für Kunst (Workers' Art Council) in Berlin. This group called for all creative people to work together under the founders—architects Bruno Taut and Walter Gropius—to shape the artistic values and fabric of the new republic. During his affiliation with the Arbeitsrat, Schmidt-Rottluff designed a sculptural relief to crown one of Taut's buildings; he also produced covers for other utopian journals such as *Die Kündung* and *Die Rote Erde*. The latter was, not incidentally, under the editorship of Schapire in Hamburg, and it was through her that Schmidt-Rottluff was asked to design for the magazine.[14] Although neither he nor Schapire was directly involved in party politics, both of them held a belief in the potential of art to change humanity.

Another member of the Arbeitsrat für Kunst, Wilhelm R. Valentiner, also discussed Schmidt-Rottluff's religious woodcuts in a 1920 article about his graphic output.[15] Valentiner, who had just begun to collect Expressionist works, saw reflected in the religious woodcuts the artist's despair in response to the war, as well as his idealized hopes for the republic. Before the war, Valentiner had worked at the Metropolitan Museum of Art in New York, and he returned to the United States in 1921; two years later he was appointed director of the Detroit Institute of Arts. It was Valentiner who arranged one of the earliest group exhibitions of German Ex-

pressionist artists, at the Anderson Galleries in New York, shortly before he left for Detroit.[16] Schmidt-Rottluff was well represented in the show, with five oil paintings and nineteen works on paper. Besides Schmidt-Rottluff, Heckel, and Pechstein, Valentiner included in the show other modern German artists such as Christian Rohlfs, Wilhelm Lehmbruck, and Lyonel Feininger.

Schmidt-Rottluff considered Valentiner to be responsible for introducing American art collectors to the significance of German Expressionism,[17] and represented him in a 1923 woodcut as a thoughtful, vigorous figure.[18] In this portrait, a three-quarter view of Valentiner's head, the artist includes a glimpse of neck and shoulder: the suit, tie, and white shirt accentuate his facial features, but also his aura of respectability. A representation of an African or Oceanic tribal sculpture occupies the upper-left corner, a sign of both Valentiner's and the artist's interest in the visual manifestations of other cultures—which many felt to be more forceful and compelling than the long-established artistic conventions of the imperial past. From his Brücke years onward, Schmidt-Rottluff had sought to appropriate the proportions and angularity of tribal sculptures, often giving figures in his works the stylized faces and elongated characteristics of these non-Western works. Although here Valentiner's head gives the illusion of greater solidity than the more stylized heads from Schmidt-Rottluff's earlier period, the deeply triangulated eyes and the protruding cheeks and forehead, racked with irregular parallel and crisscrossed lines, recall the powerful and monumental masks of an African religious figure.

Schmidt-Rottluff viewed Valentiner as a contemporary activist-prophet, who brought his work and those of other similarly inclined artists to international attention. In 1936 (a few years after Valentiner arranged for the Mexican Communist artist Diego Rivera to construct a mural for the Detroit Institute of Art) he was responsible for bringing Schmidt-Rottluff's first one-man exhibition to the Westermann Gallery in New York. In a review of this show for the *New York Times*, critic Howard Devree described Schmidt-Rottluff as a "striking colorist" and related his work to that of Munch, Hodler, Cézanne, and van Gogh.[19] After World War II, Valentiner became a consultant director of the Los Angeles County Museum of Art and gave the museum many of the prints that formed the cor-

nerstone of its large German Expressionist collection. Valentiner was also instrumental in introducing many people in Hollywood (among them playwright Clifford Odets) to the significance of Schmidt-Rottluff and other Expressionists, making Los Angeles along with New York and a few key Midwestern cities the major repositories for German Expressionism in the United States.

When Valentiner first introduced Schmidt-Rottluff to the United States, the artist was presented as an example of modernism in Germany. After World War II, art historians such as Peter Selz and Bernard S. Myers, in their 1957 books on German Expressionism, stressed the works Schmidt-Rottluff created during the Brücke years (1905–13). Starting in the late 1950s, many exhibitions of Expressionist art also focused on the period before World War I, and gave the greatest attention to Kirchner in their display of the Brücke group. By the mid 1980s, exhibitions such as Ida Rigby's 1983 *An alle Künstler! War–Revolution–Weimar* at the art gallery at San Diego State University, and Stephanie Barron's 1989 *German Expressionism, 1915–1925: The Second Generation* at the Los

Angeles County Museum of Art, began to reconsider the works of Schmidt-Rottluff and others produced after World War I and at the beginning of the Weimar Republic in connection with their earlier development in the prewar years.[20] The greater political involvement of Schmidt-Rottluff and other Expressionist artists began to be viewed as a noteworthy act as well as an extension of the utopian yearnings of the earlier years. In the same period, Schmidt-Rottluff's sculptural output also began to be presented. The 1983 *German Expressionist Sculpture* exhibition at the Los Angeles County Museum of Art was among the first in the United States to show Schmidt-Rottluff's sculpture: he was featured in the show with seven works in wood. Although fewer exhibitions have explored his late years, after he stopped producing prints, the works of Schmidt-Rottluff, along with his colleagues Heckel and Pechstein, have taken their rightful place in the pantheon of German Expressionist artists.

Rose-Carol Washton Long

[1] By late fall of 1911, groups such as the Brücke were beginning to be referred to as "Expressionist" in Germany. For a discussion of the term, see Rose-Carol Washton Long, "First Identifiers: Introduction," in: *German Expressionism: Documents from the End of the Wilhelmine Empire to the Rise of National Socialism,* ed. by Long, Berkeley: University of California Press, 1995, pp. 3–5.

[2] [Ernst Ludwig Kirchner, et al.], *Brücke Program* (1906), as reprinted in ibid., p. 23.

[3] Hans Bolliger and E. W. Kornfeld, eds., *Ausstellung Künstlergruppe Brücke: Jahresmappen 1906–1912,* Bern: Klipstein & Kornfeld, 1958.

[4] For a list and discussion of Schapire's numerous publications, see Gerhard Wietek, "Dr. Phil. Rosa Schapire," in: *Jahrbuch der Hamburger Kunstsammlung,* vol. 9 (1964), pp. 150–160.

[5] For a discussion of the interest of German-Jewish collectors in disseminating information about German Expressionism, see Robin Reisenfeld, "Collecting and Collective Memory, German Expressionist Art and Modern Jewish Identity," in: *Jewish Identity in Modern Art History,* ed. by Catherine M. Soussloff, Berkeley: University of California Press, 1999, pp. 122–124.

[6] See Frances Carey and Antony Griffiths, *The Print in Germany 1880–1933: The Age of Expressionism,* New York: Harper and Row, Icon Editions, 1984, p. 7; and Dennis Farr, "J. B. Manson and the Stoop Bequest," in: *Burlington Magazine,* 125 (November 1983), p. 690.

[7] Schapire was born in 1874 to Jewish parents in the town of Brody, then on the eastern border of the Austro-Hungarian Empire. She thus knew Polish as well as German and supplemented her income for many years by doing translation. Through the Hamburg collector Gustav Schiefler, she met Schmidt-Rottluff in 1907; see Wietek "Rosa Schapire" (as note 4), pp. 117–118.

[8] For a photograph of the room and its furnishings, see fig. 39 in *Karl Schmidt-Rottluff: Retrospektive,* ed. by Gunther Thiem and Armin Zweite, exhibition cat., Munich: Prestel-Verlag, 1989; and also Wietek "Rosa Schapire" (as note 4), figs. 3 and 4, and for the reactions of contemporaneous artists and collectors, pp. 129–135.

[9] Wietek "Rosa Schapire" (as note 4) discusses additional portraits of Schapire, done by Schmidt-Rottluff, Nolde, and other German modernists, pp. 143–149. For a examination of Schapire's organization of a women's group to support German art, see Maike Bruhns, "Rosa Schapire und der Frauenbund zur Förderung deutscher bildenden Kunst," in: *Avantgarde und Publikum, zur Rezeption avantgardistischer Kunst in Deutschland 1905–1933,* ed. by Henrike Junge, Cologne: Böhlau Verlag, 1992.

[10] Karl Schmidt-Rottluff, letter to Gustav Schiefler, ca. 1913; as reprinted in Long, ed., *German Expressionism: Documents* (as note 1), pp. 28–29.

[11] "Das neue Programm," in: *Kunst und Künstler,* 12 (1914), p. 308.

[12] See for example, Conrad Felixmüller, "Schmidt-Rottluff," in: *Menschen, vol. 2* (July 1919), pp. 10–11.

[13] Rosa Schapire, "Schmidt-Rottluff's Religious Woodcuts," in: *Die Rote Erde* (1919); as reprinted in Long, *German Expressionism: Documents* (as note 1), p. 150.

[14] For illustrations of Schmidt-Rottluff's design for Taut and the covers of Die Kündung and Die Rote Erde, see *Karl Schmidt-Rottluff: Retrospektive* (as note 8), figs. 38, 214, and 36.

[15] Wilhelm R. Valentiner, "Karl Schmidt-Rottluff," in: *Der Cicerone,* vol. 12 (1920), pp. 455–476.

[16] For a discussion of this exhibition, see Stephanie Barron, "The Embrace of Expressionism: The Vagaries of Its Reception in America," in: *German Expressionist Prints and Drawings: The Robert Gore Rifkind Center for German Expressionist Studies,* vol. 1, Los Angeles and Munich: Los Angeles County Museum of Art and Prestel, 1989, pp. 135–136.

[17] Margaret Heiden Sterne, *The Passionate Eye,* Detroit: Wayne State University Press, 1980, p. 149.

[18] Schmidt-Rottluff produced portraits of a few collectors who were important to him. He did self-portraits as well, but most of his œuvre, with the exception of the religious works, focused on landscapes, seascapes, and rural village scenes.

[19] Howard Devree, "A Score of Shows Open in the Local Galleries," in: *New York Times* (October 11, 1936), section X, p. 9:3.

[20] See Ida Katherine Rigby, *An alle Künstler! War–Revolution–Weimar: German Expressionist Prints, Drawings, Posters and Periodicals from the Robert Gore Rifkind Foundation,* San Diego: San Diego State University Press, 1983; and Stephanie Barron, ed., *German Expressionism, 1915–1925: The Second Generation,* Los Angeles and Munich: The Los Angeles County Museum of Art and Prestel, 1989. For a historiographic discussion of the varying approaches in the art historical literature on Expressionism, see Long, "Scholarship; Past, Present, and Future Directions," in: *German Expressionist Prints and Drawings: The Robert Gore Rifkind Center* (as note 16), pp. 183–205.

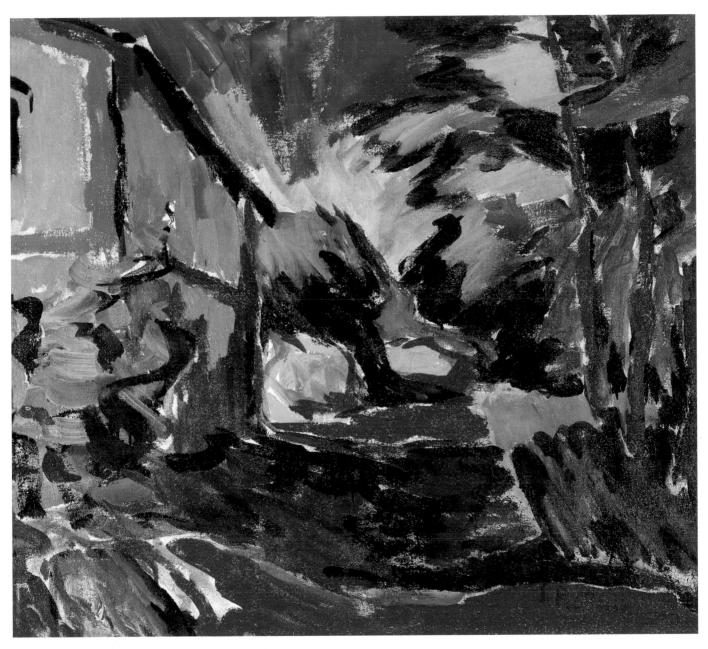

Landscape with House and Trees (Dangast Before the Storm), 1910 cat. II.15

HERMANN MAX PECHSTEIN

*** DECEMBER 31, 1881, ECKERSBACH (SAXONY)**
† JUNE 29, 1955, BERLIN (WEST)

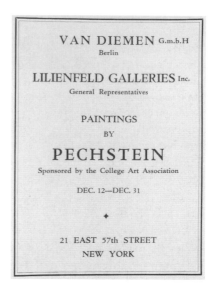

Advertisement for the exhibition *Paintings by Pechstein*, Lilienfeld Galleries, New York, December 12–31, 1932

Max Pechstein came to painting, graphics, and sculpture by way of a journeyman's education in the applied arts. The son of a textile worker, he made a living as a decorative painter in Zwickau from 1896 to 1900. From 1900 to 1902 he studied at the Dresden Kunstgewerbeschule (School of Applied Arts), and from 1902 at Dresden's Akademie der bildenden Künste (Academy of Fine Arts). His decorative-arts training reemerged throughout his career, both in the many commissioned works he undertook in mosaic and stained glass, as well as in the flat, decorative designs integral to many of his paintings.

In 1906, he joined Ernst Ludwig Kirchner, Erich Heckel, Karl Schmidt-Rottluff, and Fritz Bleyl in the small Expressionist artists' collective, Brücke. Inspired by Nietzsche, the group aimed to shake off repressive Wilhelminian social strictures by pursuing unconventional, communal lifestyles and an art full of bold, clashing colors and forms that were defiantly antinaturalistic. But in contrast to his comrades, Pechstein's Brücke-period works adhered more closely to observed reality, and were less aggressive in their distortion of figures and objects. His preferred motifs were the human figure and landscapes; circus scenes, maritime landscapes, and still lifes rounded out his œuvre. Of the Brücke artists, he was also the first to enjoy public success, which did not bode well for his solidarity with fellow artists in the group.

In late 1907 Pechstein traveled to Paris and encountered the Fauves and their brazen new canvases firsthand. His commercial breakthrough came in 1909 through an exhibition with the Berliner Secession; the following year, however, his work was rejected by the same institution, and he became instrumental in the founding of a splinter group, the Neue Secession. Together with Kirchner, he exhibited in 1912 at Herwarth Walden's Der Sturm gallery in Berlin. Pechstein broke from the Brücke group in May 1912, with his decision not to go along with their collective withdrawal from the Neue Secession. That summer, he executed four wall paintings for the dining room of the Villa Hugo Perls, Berlin-Zehlendorf, a house built by Mies van der Rohe.

Inspired by the work of Paul Gauguin and Emil Nolde, Pechstein took a keen interest in painting nude figures in exotic landscapes. With financing from the dealer Wolfgang Gurlitt, he embarked in 1914 on an expedition to the Micronesian island of Palau (at the time a German colony). The two years he had planned to spend in his sought-after arcadia ended abruptly, however, as Japanese forces occupied the island at the outbreak of World War I. Pechstein's possessions were stolen and he and his wife Lotte were sent by troop transport to Nagasaki. From there he traveled, first on the consular steamer the *United States* and then on the *Mongolia*, to Manila. In early 1915 he secured passage via Honolulu to California. Pechstein's first encounter with the United States was grim. After arriving in San Francisco, he was transferred across the country by train to New York City. Penniless, and subjected to anti-German wartime sentiment, he worked odd jobs to save money for the passage back to Germany. His break came when he was offered a position as a stoker on a Dutch

freighter. Work in the overheated engine rooms was oppressive and grimy (however, it made for an experience that Pechstein relished recounting in a Berlin newspaper after his return, and again decades later in his autobiography, which was published posthumously).[1]

Upon his return to Berlin, Pechstein was dismayed to find that his studio had been plundered. Soon thereafter, he enlisted in the German military. He first saw battle on the Western front against England, and subsequently fought in the trenches in the Battle of the Somme. He escaped further combat by being assigned a desk job, drawing strategic military maps during the year before his discharge in 1917. After his military duty was over, he created many romanticized paintings of Palau. In Germany, by the summer of 1916, the war economy had rekindled the market for contemporary German art, and Expressionism had a surge in popularity. Between 1916 and 1922, no fewer than four books were published on Pechstein, by important critics (Walther Heymann, Georg Biermann, Paul Fechter, and Max Osborn).[2] His primary commercial representation during these years was with the Salon Fritz Gurlitt in Berlin, directed by the founder's son Wolfgang Gurlitt.

During Germany's November Revolution of 1918–1919, Pechstein actively supported the Sozialdemokratische Partei (Social Democratic Party; SPD) with a stream of graphics for the party's publicity office. Many of these posters and pamphlet covers were aimed at inciting fear of potential terrorism or anarchy from the far left. Active in both the radical Arbeitsrat für Kunst (Workers' Art Council) and the Novembergruppe, Pechstein used his art to support the SPD's advocacy of social reconciliation rather than political revolution. His work found a secure niche in the reemergent art market, as Expressionism was officially embraced by the new SPD government and German museum world of the Weimar Republic.[3] In 1922, he was appointed professor at the Hochschule für Bildende Künste (School of Fine Arts) in Berlin, and also became a member of the Preussische Akademie der Künste (Prussian Academy of Arts). He received a government commission in 1927 to design a large-scale stained-glass window for the Internationales Arbeitsamt (International Labor Office) in Geneva.

After 1933, Pechstein's socialist orientation and modernist art made him a ready target of the National Socialists. More than three hundred of his works would be confiscated from German public collections. Reproductions of his paintings were great favorites with National Socialist art writers, who would sometimes accompany their antimodernist diatribes with derogatory collages and pictorial layouts. Although Pechstein received offers of help with immigrating to the United States, he felt such a strong attachment to the East Prussian landscape that he declined them. During the Third Reich he most often wintered in Berlin and summered in the small villages of Leba or Nidden on the Baltic Sea (now in Poland and Lithuania, respectively).

Pechstein was conscripted into the Heimwehr, or local military labor force, in 1944, and during that year and the following, his Berlin studio was bombed by Allied planes, destroying all of the artwork inside. In 1945, Pechstein again assumed the post of professor at the Hochschule für Bildende Künste in West Berlin, at the invitation of Karl Hofer. Pechstein spent his final decade with his wife in Berlin, and scouted out new lake- and seaside resorts as the Soviet occupation of Eastern Europe had made his beloved Baltic fishing villages inaccessible. In 1947, his hometown of Zwickau created the "Max-Pechstein-Preis für Malerei" in his honor, and he was awarded the esteemed Verdienstkreuz der Bundesrepublik Deutschland in 1952. He died in Berlin on June 29, 1955.[4]

Max Pechstein, ca. 1909 (photograph by Hugo Erfurth)

Dining room of the Hugo Perls villa in Berlin with murals by Max Pechstein, 1912 (photograph by Ute Frank)

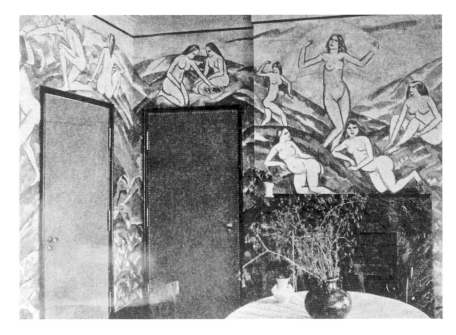

PECHSTEIN AND AMERICA

The acclaim Pechstein received in the United States frequently hinged on his position within the Brücke group. American art history has also inscribed him into other German artists' groups in which he actively participated, e.g. the Berliner Secession, the Neue Secession, the Arbeitsrat für Kunst, and the Novembergruppe.[5] Pechstein was first represented in an exhibition in the United States with four graphic works at the Berlin Photographic Company on East 23rd Street in New York City. The exhibition, titled *Contemporary German Graphic Art,* was held from December 1912 to January 1913—just weeks before the notorious Armory Show, and two years prior to his own cross-country rail voyage. Pechstein was one among eighty artists in the show, which included work by Ernst Barlach, Lyonel Feininger, Vasily Kandinsky, Max Liebermann, and Franz Marc. Of Pechstein, the author of the exhibition's thirty-five-page catalogue, Martin Birnbaum, had little to say: "Pechstein's *'Somalitanz' [Somali Dance],* to single out an example, seems to us peculiarly felicitous and amusing." Speaking of the modernist tendencies of all the works in the show, Birnbaum wrote, "Violent agitation and conflict with tradition cannot in the end result in much harm, and may do good. To make critics and public rail like madmen is in itself an achievement."[6]

Nearly a decade later, in 1922, in an article in the journal *International Studio* on the revival of woodblock printing in Germany, Sheldon Cheney (one of America's first advocates of European Expressionism in the visual arts) mentioned Pechstein among the "seething, searching, powerfully creative, but often wild group of 'Junge Kunst' painters." "Junge Kunst" was a reference to the title of a series of small monographs published by Klinkhardt & Biermann, Leipzig. The 1920 volume on Pechstein was the first in this popular series.[7] In October 1923, Pechstein was represented with twelve works in *A Collection of Modern German Art* at the Anderson Galleries, New York, an exhibition organized by one of Expressionism's earliest champions in America, Wilhelm R. Valentiner. This exhibition generated little attention or sales for Pechstein, but *International Studio* did reproduce his 1922 *Brücke (Bridge),* a South Seas landscape painting. In the same issue, Pechstein's landscape *Früher Morgen (Early Morning;* 1921) was singled out to enlighten skeptical American readers about the operative premises of Expressionist picture making: "Pechstein's *Early Morning* is the early morning as it lived in his imagination. Out of his imagination he created the scene: the primordial colors (to call them thus) red and green, which are in constant contrast with each other and yet, in complementing each other, make for harmony, as the morning is the promise of the day to come—these colors pervade the canvas to meet the wondering eye of the awakening spirit."[8]

The war had taken a toll on U.S.–German relations, not only politically, but culturally and in terms of public opinion. It was not until 1925 that German artists were welcomed back to Pittsburgh's Carnegie International show under the directorship of the aesthetically conservative Homer Saint-Gaudens. Despite his own personal tastes, however, Saint-Gaudens was committed to providing a balanced overview of contemporary international art. For the German sections in the mid and late 1920s, the result was a roster of works by conservative artists alongside a few (relatively tame) pieces by Germany's more radical but better-known artists, such as former members of the Brücke and Blaue Reiter groups. Pechstein's less adventurous paintings, with their plainly rendered forms and decorative patterns, fit perfectly into this conciliatory agenda.[9] Writing home from Germany to the Carnegie's acting director, Saint-Gaudens reported that Pechstein "does charming things of yellow high lit blue-shadowed doctors, listening through stethoscopes to tubercular nude young ladies' lungs, so we are going to try to escape with a landscape that represents the Tyrolean Alps anyway you look at it. You can hang it upside down, if breakfast doesn't agree with you if you see it right side up."[10] Saint-Gaudens's choice to avoid figure painting in favor of landscapes (in which distortions were less offensive to traditional audiences) also served Pechstein well in the local press. His painting *Sonnenuntergang (Sunset;* ca. 1921) was deemed "as rough as peasant bread—rough in mood, in form, in color," but nonetheless "compelling."[11] The ongoing representation of the German Expressionists at the Carnegie was largely due to the efforts of Charlotte Weidler, a Berlin-based art critic and champion of German Expressionism, who assisted Saint-Gaudens in representing the Carnegie International in Germany between 1924 and 1939.[12] In 1927, Pechstein exhibited *Calla-Stilleben (Calla Lilies;* 1917), and was

awarded best flower painting in the show by the Allegheny Garden Club—the first time a German had ever won a prize at the Carnegie. And yet the fact that the award was granted for a flower painting spoke worlds of the backwater in which American art-appreciation outside of New York remained mired. The following year, a selection from this twenty-sixth Carnegie International traveled to the Brooklyn Museum. Pechstein continued to be presented among the regular German exhibitors at the Carnegie each year up until the outbreak of World War II, and once again after the war.[13] During his regular visits to Germany from the late 1920s well into the National Socialist period, Saint-Gaudens visited Pechstein in Berlin to select pictures for exhibition in Pittsburgh.[14]

A turning point in Pechstein's U.S. reputation—as with so many of the German moderns—came with the Museum of Modern Art's 1931 exhibition *German Painting and Sculpture*. Three paintings by Pechstein were included: *Fischerboot (Lifeboat;* 1913), from the National Gallery, Berlin; *Doppelbildnis (Double Portrait;* a 1919 watercolor) from the collection of J. B. Neumann, New York; and *Landschaft (Landscape;* 1921) from the collection of Ralph Booth, Detroit. The show's curator, Alfred H. Barr, Jr. characterized Pechstein thus: "Bold, eclectic, clever, he did much to popularize the ideas of his more reticent and uncompromising companions. To-day his reputation has become somewhat deflated so that there is now a tendency to underrate his art."[15]

Pechstein's first solo show in the United States seems to have been calculated to build upon the interest in German art stirred up by the Museum of Modern Art exhibition. It was held from December 12 to 31, 1932, at New York's newly opened Lilienfeld Galleries, the U.S. branch of Van Diemen Galleries, Berlin. Located in the heart of Manhattan's gallery district at 21 East 57th Street, the venue was directed by the well-connected dealer Karl Lilienfeld, and benefited from the sponsorship of the College Art Association. The paintings in the show were from Lilienfeld's own collection, which included twenty-two choice Pechstein canvases executed between 1909 and 1916—paintings the dealer had purchased from the Kunstverein Leipzig in 1916.[16] Among the exhibited works were many Brücke-period canvases, including *Die gelbe Maske (The Yellow Mask;* 1910), as well as a number of more recent paintings.[17] New York reviewers of the

exhibition were not always kind. Royal Cortissoz, an archconservative critic and defender of craftsmanship and morality in art, wrote in the *Herald Tribune*: "In the main this artist seems to have looked at Cézanne and then to have proceeded, without any disciplinary experience, to paint rather crude compositions." Cortissoz also deemed the paintings "bravely unconventional" but "ugly." The critic for the *New York Times*, however, regarded Pechstein more favorably (indeed, he waxed poetic): "Reds and greens sing … with the deep-lunged fervor of German youths roaming the Schwarzwald."[18] *Art News* assessed the paintings in terms of the influence of Cézanne, van Gogh, and Beckmann. Here, the anonymous reviewer singled out the paintings *Stilleben (Still Life with Fruit and Flowers;* 1913), *Fischer im Boot (Mending Nets;* 1927), and *Der*

Review of the Max Pechstein exhibition at the Lilienfeld Galleries, New York, in *Parnassus* (December 1932), showing Pechstein's *Bridge*

Sohn des Künstlers auf dem Sofa (Interior; 1917). For this last work, terms were marshaled that would later haunt Pechstein's reputation: "The *Interior* with a boy on a sofa … strikes me as being a decidedly tricky and meretricious performance." Whereas Barr had simply dubbed Pechstein a "popularizer," now his work was considered "tricky and meretricious."[19]

After the New York presentation, Lilienfeld reportedly toured variants of this Pechstein exhibition to

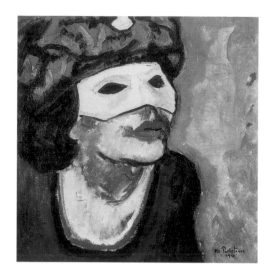

Max Pechstein, *Die gelbe Maske II (The Yellow Mask II)*, 1910, inscribed on the verso: *Frau mit grossem Federhut*, 1909

numerous cities around the United States until 1935.[20] While Pechstein appreciated the publicity, he reaped no financial benefits, as the works belonged to Lilienfeld. This lack of proceeds was particularly difficult for Pechstein after 1933, as his career in Germany had come to a near standstill: he had been designated a "degenerate" artist by the National Socialists, and was forbidden to exhibit. It would seem that Lilienfeld was not greatly profiting from Pechstein sales during the 1930s and '40s either: the dealer's first truly major U.S. sale of the artist's work only transpired in 1951, when Pechstein's 1910 *Inder und Weib (Indian and Woman)* was bought by Morton D. May in Saint Louis.[21]

Five years would pass before Pechstein again exhibited in New York. Eighteen oils and watercolors were presented from October 17 to November 30, 1938, at Lilienfeld's gallery. *Art News* editor Alfred M. Frankfurter pointed to the contemporary difficulty of discerning the value of Pechstein (and other German moderns), what with the "outlawing of most of the prominent artists of pre–National Socialist Germany" and the consequent welcome these artists' works were receiving in democratic lands. Frankfurter also noted that Lilienfeld had wisely opted "to eliminate the controversial 'middle' period of the artist from the works shown, thus concentrating on the paintings up to 1914, exemplary of Pechstein's first maturity and his outgrowth from the early violence of Brücke and the watercolors since 1933, which marks the beginning of a new and poetic style expressed largely in terms of the aquarelle medium." Frankfurter praised Pech-

stein's late watercolors as "sensitive records, couched in the smooth, experienced technique of the accomplished artist, ... extremely attractive for their independence of literary content." Here Frankfurter's formalist criteria applied to Pechstein's paintings clearly anticipate the dogma of modernist, Greenbergian criticism, which would be the reigning critical stance during the 1950s and '60s in America. The elimination of "the controversial 'middle' period," however, positions this exhibition, and Frankfurter's views, in line with the overwhelming tendency to depoliticize the œuvre of the German artists (a tendency supported by dealers such as Curt Valentin at the Buchholz Gallery, but resisted by Otto Kallir at the Galerie St. Etienne). In the case of Pechstein, this meant that none of his art or activities referencing the war or the November Revolution appeared at Lilienfeld's gallery. But in retrospect, Frankfurter's eloquent review and Lilienfeld's exhibition may be seen as a kind of high-wire act, distracting art lovers from the anti-modernist, anti-Bolshevik opinions that aligned a disturbing number of Americans with the aesthetic and political views of Adolf Hitler.[22]

The year 1938 also brought the exhibition *Modern German Painting* in March at the Columbus Gallery of Fine Arts. Pechstein was represented in this exhibition with three paintings—more than any other artist in the show—all of which were loaned by Lilienfeld. This was one of a number of American shows to emphasize the persecution of German Expressionist art by the National Socialists in Germany. As the gallery's *Bulletin* put it: "Most of the painters represented served in the war and are now exiles or forbidden to exhibit their work in Germany. In the eyes of the present regime they are too individual and too undisciplined to speak for the totalitarian state."[23]

Pechstein's solo show at Lilienfeld's gallery did raise awareness of the artist's work at a particularly bleak moment in his career. Unfortunately for both Lilienfeld and Pechstein, the American art press often only parroted Barr's less-than-glowing assessment of 1931. As another writer expressed it in *Art Digest* (plagiarizing Barr almost word for word): "His art, bold, eclectic and clever, ... did much to popularize the contemporary German school, though in recent years Pechstein's reputation has become somewhat atrophied."[24]

From November 1947 to January 1948, the Baltimore Museum of Art hosted the exhibition *German*

Expressionism from the Collection of Ralph and Mary Booth, which featured Pechstein's *Meereslandschaft mit Sonnenuntergang (Seascape with Sunset;* n.d.) on the catalogue's cover. Ralph Booth, a former president of the Detroit Institute of Arts, was one of the first major collectors of Expressionist art in the U.S. The Baltimore show included a total of seven works by Pechstein.

Pechstein's "first West Coast exhibition" was held from March 5 to 31, 1959 at Los Angeles's Ambassador Hotel, sponsored by the city's Dalzell Hatfield Galleries. Limited to works from 1911–1921, it was one of four exhibitions held to commemorate the artist's death in 1955. Lilienfeld was apparently behind the exhibition, as he also hosted a show of Pechstein's 1911–1921 paintings at his New York gallery from May 2 to June 3, 1959. The brochure prepared for the Los Angeles venue reprinted several excerpts from classic and recent German and American publications on Pechstein and modern German art. In contrast to the prewar U.S. criticism, a more favorable and subtly differentiated evaluation of Pechstein and his achievement was now available to American audiences, thanks in part to a new and better-educated generation of art historians. Quotations in the Hatfield leaflet, such as this one by Peter Selz, mark the turn to a critical assessment of both Pechstein's drawings and the highly charged claims the artist made for them: "Drawing to Pechstein was not an expression of the intellect. Rather, it meant a physical expression of his visual and motor senses. He made an analogy between his early drawing and previous fistfights. 'Now I draw as wildly during my tramps as I fought before.' ..."[25] The anonymously penned two-page introductory essay in the exhibition's catalogue hailed the artist as "one of the intelligent, imaginative and searching young men in revolt who developed Die Brücke." According to the author, the group "seemed to adopt Nietzsche's statement—'Who wishes to be creative ... must first destroy and smash accepted values.'" He also claimed that "Pechstein's work, radiating a robust strength and joyous attitude, provided the transitional means toward this new way of seeing the whole group. ..." But all in all, the introduction and the excerpts from contemporary scholarship offered a picture of the recently deceased artist as a rebellious, radical youth who had settled into a more tranquil maturity. The reviews of the New York venue of this exhibi-

tion resuscitated the usual platitudes in the face of Pechstein's pre-1914 canvases. One critic claimed that the artist "painted his alienated condition," "painted with the fervor of a revolutionary," and also found evidence of his "life-affirming attitude," an attitude that set him apart from the other "more pessimistic and frenetic German Expressionists."[26] Other reviewers noted the use of "color for expressive purposes," and an "intensity of emotion" evident in canvases such as *Stilleben mit Akt (Still Life with Nude,* 1913), and the scenes of fishing boats and fishermen from the Baltic.[27]

Cover of the *Columbus Gallery of Fine Arts Monthly Bulletin,* featuring *The Indian* by Max Pechstein, March 1938

In 1957, the curator of prints at the Philadelphia Museum of Art, Carl Zigrosser, published one of the more comprehensive surveys of the graphic arts of the Expressionists. Pechstein was represented with only two prints, a woodcut titled *Krankes Mädchen (The Convalescent;* 1918) and a drypoint, *Der Kritiker (Portrait of Dr. Paul Fechter,* 1921). While lacking originality, the judgments Zigrosser penned on behalf of the postwar generation seem significant: "[Pechstein's] restless search for what was new and useful and *à la mode* drove him as far afield as Paris and the South Seas Islands. A facile artist, albeit eclectic and superficial, he had the qualities and drive that made for

Cover of the catalogue *Max Pechstein, First West Coast Exhibition*, Dalzell Hatfield Galleries, Los Angeles, 1959, showing Pechstein's *Stilleben mit Akt, Kachel und Früchten (Still Life with Nude, Tile and Fruit),* 1913. The Museum of Modern Art Library, New York. Photograph © 2001 The Museum of Modern Art, New York

quick success. With it all, there was a certain robustness in his nature, an extrovert joy of life. His forms were full, not niggardly, even if a bit vulgar. ..." Zigrosser had little to add to the lackluster reputation Pechstein had accrued over the past three decades in the United States. Indeed, it is striking how many of the disparaging estimations of Pechstein and his work came to be recycled.[28]

That Pechstein did not live beyond the mid 1950s, when American interest in Expressionist art was rejuvenated, also did nothing to consolidate a favorable image of his work in the United States. Up to that time, criticism of his work had ranged from the indecisive to the damning. Perhaps that first cross-country rail journey under dire circumstances was a bad omen of what the U.S. had in store for him.

Twenty years after Pechstein's death, Expressionism underwent a revival in America. One of the first exhibitions to be mounted in this period was *German and Austrian Expressionism* at the New Orleans Museum of Art (November 22, 1975 to January 18, 1976). The cover image of the exhibition catalogue was Pechstein's *Zirkus mit Dromedäre (Circus with Dromedaries;* ca. 1910). This show marked the initial stages of a reappraisal of Pechstein's work and of Expressionism in general. It is not entirely surprising that Pechstein's personal affiliations throughout his life remained elsewhere: in Germany, in Berlin or the small fishing villages along the Baltic. Although Germany had disparaged his work during the war years, it was the country where he felt most at home. As was the case with many of the Expressionists, his work would not find a warm welcome in America until it was too late for him to witness it.

Keith Holz

[1] Jill Lloyd, *German Expressionism: Primitivism and Modernity,* New Haven: Yale University Press, 1991, p. 211, n. 84; Max Pechstein, *Erinnerungen. Mit 105 Zeichnungen des Künstlers.* Herausgegeben von L. Reidemeister, Wiesbaden: Limes Verlag, 1960, pp. 96–100.

[2] Walther Heymann, *Max Pechstein,* Munich: R. Piper & Co., 1916; Georg Biermann, *Max Pechstein, Junge Kunst,* vol. 1, Leipzig: Klinkhardt & Biermann, 1920; Paul Fechter, *Das Graphische Werk Max Pechsteins,* Berlin: Fritz Gurlitt, 1921; Max Osborn, *Max Pechstein,* Berlin: Propyläen, 1922.

[3] Joan Weinstein, *The End of Expressionism: Art and the November Revolution in Germany, 1918–19,* Chicago: University of Chicago Press, 1990, pp. 50–56.

[4] Leonie von Rüxleben, "Lebensdaten 1881–1955," in: *Max Pechstein: Sein malerisches Werk,* ed. by Magdalena M. Moeller, exhibition cat. Berlin, Brücke Museum, Munich: Hirmer, 1996, pp. 31–39.

[5] Peter Selz, *German Expressionist Painting,* Berkeley: University of California Press, 1956, pp. 89–90, 131–135, 312–313; Bernard S. Myers, *The German Expressionists: A Generation in Revolt,* New York: Frederick A. Praeger, 1957, pp. 167–172; Peter Paret, *The Berlin Secession: Art and its Enemies in Imperial Germany,* Cambridge, Mass.: Harvard University Press, 1980, pp. 190, 208, 219; and Weinstein (as note 3), pp. 50–56.

[6] Martin Birnbaum, Introduction, in: *Contemporary German Graphic Art,* exhibition cat., New York, Berlin Photographic Company, 1912–13, p. 18.

[7] S. C. [Sheldon Cheney], "German Expressionism in Wood," in: *International Studio,* vol. 75 (June 1922), pp. 249–254; Georg Bierman, "Max Pechstein," in: *Junge*

Kunst, vol. 1, Leipzig: Klinkhardt & Biermann, 1920.

[8] F. E. Washburn Freund, "Modern Art in Germany," in: *International Studio,* vol. 78 (October 1923), pp. 41, 44.

[9] On German participation at the Carnegie in 1925 and 1927, see Penny Joy Bealle, *Obstacles and Advocates: Factors Influencing the Introduction of Modern Art From Germany to New York City, 1912–1933: Major Promoters and Exhibitions,* Ph.D. dissertation, Ann Arbor, Mich.: UMI, 1990, pp. 151–222.

[10] Saint-Gaudens, letter to Edward Duff Balken, June 15, 1925, Carnegie Papers, Archives of American Art; cited in Bealle, *Obstacles and Advocates* (as note 9), p. 184, n. 50.

[11] Penelope Redd Jones, "Student Groups Reveal Interest in International," and "International Most Stimulating to be Exhibited Here," in: *Pittsburgh Post* (November 1 and 29, 1925), "1925 International Scrapbook," Carnegie Papers: Pittsburgh; cited in Bealle, *Obstacles and Advocates* (as note 9), p. 190.

[12] Susan Platt, "Gambling, Fencing, and Camouflage: Homer Saint-Gaudens and the Carnegie International, 1922–1950," in: *International Encounters: The Carnegie International and Contemporary Art, 1896–1996,* Pittsburgh: Carnegie Museum of Art, 1996, pp. 76, 85–86.

[13] Pechstein was represented in the Carnegie International exhibitions in 1925, 1926, 1927, 1931, 1933, 1935, 1936, 1937, 1938, and 1939; and once after World War II in 1950. Peter Hastings Falk, *Record of the Carnegie Institute's International Exhibitions 1896–1996,* Madison, Conn.: Sound View Press, 1998, p. 260.

[14] Rüxleben, *Lebensdaten* (as note 4), p. 34.

[15] Alfred H. Barr, Jr., *German Painting and Sculpture,* exhibition cat., New York,

Museum of Modern Art, 1931, pp. 7, 33.

[16] Anon., "A Trio of Exhibitions," in: *Parnassus,* vol. 4, no. 7 (December 1932), p. 17; and Rüxleben, *Lebensdaten* (as note 4), p. 34.

[17] Ibid., p. 17.

[18] Cited in *Art Digest,* vol. 17, no. 7 (January 1, 1933), p. 14.

[19] Anon., "Max Pechstein Lilienfeld Galleries," in: *Art News,* vol. 31, no. 12 (December 17, 1932), p. 6. The exhibition's catalogue noted another Pechstein exhibition being planned to focus on his more recent work.

[20] Rüxleben, *Lebensdaten* (as note 4), pp. 34–35.

[21] Rüxleben, *Lebensdaten* (as note 4), p. 35.

[22] A similar editing of the politically leftist periods of recent German art history transpired that very year in the Museum of Modern Art's presentation of the *Bauhaus 1919–1928* exhibition, which did not include this progressive design school's most politically left, Communist-oriented late period under the direction of Hannes Meyer.

[23] *Columbus Gallery of Fine Arts Monthly Bulletin,* vol. 8, no. 5 (March 1938), n.p.

[24] *Art Digest,* vol. 13, no. 2 (October 15, 1938), p. 18.

[25] Selz, *German Expressionist Painting* (as note 5), p. 90; as cited in brochure for Dalzell Hatfield Galleries, *Max Pechstein,* 1959, n.p.

[26] H. C. [Hubert Crehan], "Max Pechstein," in: *Art News,* vol. 58, no. 3 (May 1959), p. 13.

[27] H. M. [Hugo Munsterberg], "Max Pechstein," in: *Arts Magazine,* vol. 33, no. 9 (June 1959), pp. 63, 66.

[28] Carl Zigrosser, *The Expressionists: A Survey of Their Graphic Art,* New York: Braziller, Inc., 1957, pp. 18, 33–34, ns. 57, 58.

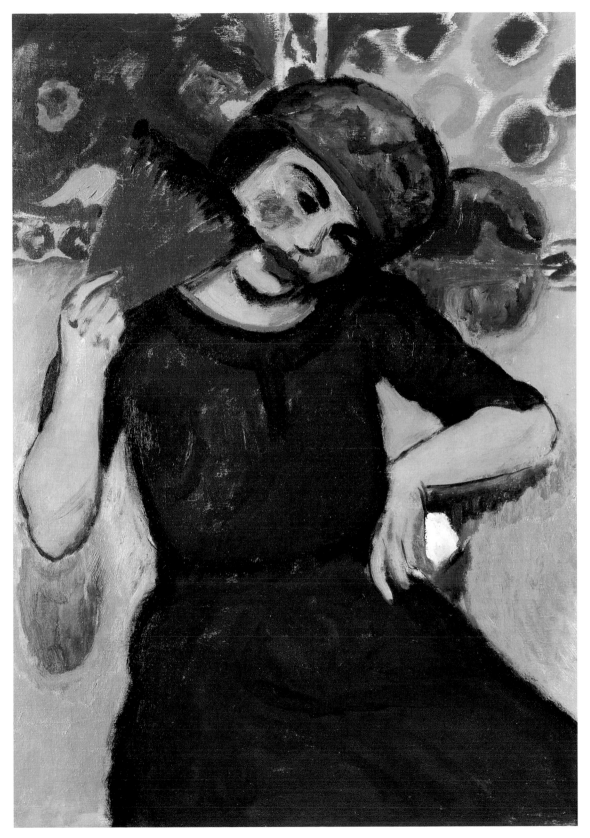

Young Woman with Red Fan, ca. 1910 cat. II.18

EMIL NOLDE

*** AUGUST 7, 1867, NOLDE (NORTHERN SCHLESWIG)**
† APRIL 13, 1956, SEEBÜLL

Emil Nolde was born Emil Hansen in 1867 in the town of Nolde, near Tønder in northern Schleswig. He was the fourth son of the farmer Niels Hansen. From 1884 through 1888, he trained as a wood-carver at a furniture factory and its associated school in Flensburg; he subsequently worked in furniture factories in Munich, Berlin, and Karlsruhe. In 1889, he enrolled at the Kunstgewerbeschule (School of Applied Arts) in Karlsruhe, and shortly thereafter, in 1890, took a job as draftsman and model maker for a furniture factory in the same city. From 1892 through 1898, Nolde taught drawing at the Kunstgewerbeschule in Sankt Gallen, Switzerland. He finally left his post to become an independent artist when his painted picture post-cards—with motifs he initially copied from the Munich weekly magazine *Jugend*—began to sell.

In 1898, after being rejected for study at the Munich Akademie der bildenden Künste (Academy of Fine Arts), Nolde determined nonetheless to become an artist, and began to take classes at the private painting school in Munich run by Friedrich Fehr. In 1899, he attended the art school that had been established by Adolf Hölzel in the nearby village of Dachau. Nolde made a prolonged visit in 1899–1900 to Paris, where he became acquainted with the work of Paul Cézanne and Vincent van Gogh. During this period, he painted and sketched from live models at the Académie Julian. In 1901–02, Nolde lived in Copenhagen and Lildstrand (in Jutland), before moving to Berlin. It was during this period that he formally adopted the name Emil Nolde, taken from the name of his birthplace. In 1902, he married the Danish actress Ada Vilstrup,

and the couple moved into a studio in the Grunewald district of Berlin. Beginning in 1903 and continuing through 1913, Nolde spent every summer on the Baltic island of Alsen, and wintered in Berlin. In 1906, Nolde encountered two people who would later become important advocates of his work, the collector Gustav Schiefler and the painter Karl Schmidt-Rottluff. For a brief period, during 1906–07, he was a member of the Dresden artists' group Brücke. Around this time, he also met Karl Ernst Osthaus in Hagen, and the artist Christian Rohlfs in Soest. In 1907, he came into contact with Edvard Munch. He became a member of the Berliner Secession in 1908; within a year, however, he was at odds with several of the group's other members and began to consider founding a new, international artists' society. In 1910, he was expelled from the Secession.

In 1912, Nolde showed work in the second exhibition mounted by the artists of Der Blaue Reiter, and also at the large *Sonderbund* show in Cologne (*Internationale Kunstausstellung des Sonderbundes Westdeutscher Kunstfreunde und Künstler*). Nolde and his wife participated in an expedition to the South Seas in 1913–14, sponsored by the German Reichskolonialamt (Office of Colonial Affairs). Two years later, the couple moved to Utenwarf in northern Schleswig. In 1919, Nolde was elected a member of the Arbeitsrat für Kunst (Workers' Art Council). During the 1920s, he visited France, England, Spain, and Switzerland. In 1927, he moved to Seebüll, on the southern side of the relocated German-Danish border, though he retained his studio in Berlin.

Nolde was appointed a member of the Preussische Akademie der Künste (Prussian Academy of Arts) in 1931. In 1933 or 1934, now a Danish citizen, he became a member of the Danish section of the National Socialist party (NSDAP)—at this point, Germany's ruling political party. Nonetheless, in 1936 he was among the first artists to be banned from exhibiting in Germany, and in 1941, after his exclusion from the Reichskulturkammer, the Nazis prohibited him from working altogether. Beginning in 1938, Nolde surreptitiously worked on "unpainted pictures," small watercolors with which he responded to the repressive aesthetic politics of the regime. In 1944, during a bombing raid on the city, his Berlin studio was destroyed.

Nolde died twelve years later at Seebüll on April 13, 1956. Earlier that year, his Seebüll home had been formally established as a foundation, the Stiftung Seebüll Ada and Emil Nolde, and today it still houses the largest collection of the artist's work.

PUBLIC RECOGNITION

What his monographer in 1929 called "the spiteful ridicule and abuse of a hostile environment"[1] is now a thing of the past, and Emil Nolde is today one of the best known and most well-received of the German Expressionists. He is an artist who is understood to have created a comprehensive œuvre, which (despite some painful losses during the years of the Third Reich) still testifies to the considerable achievement of a life devoted to art. The catalogue raisonné of Nolde's oil paintings contains more than 1,300 items. In addition, there are more than 500 graphic works that reveal the wealth of the artist's productivity. In America, it is above all his numerous watercolors that enjoy exceptional popularity. In 1995, Clifford S. Ackley, writing about the show *Nolde: Watercolors in America*, observed that he "is, in fact, better known in America for his watercolors than for his paintings or his prints."[2]

Nolde's use of color has played an important part in his reception in America since 1930. That year, the *Art News* critic Flora Turkel-Deri described his works in a one-man exhibition then being held at the gallery of Ferdinand Möller in Berlin in these terms: "The eloquence of his painting lies in the suggestive quality of his color, which is built up on contrasting elements to convey awe, tragedy, horror and mystery."[3] For Nolde, painting signified an intense exploration of all that color in itself could achieve—this regardless of whether the work was deemed Expressionist and thus sometimes criticized as deeply subjectivist. His work systemically addresses the multifunctionality of color, the underlying reality of its expressive value, and the degree to which it was capable of departing from mere objective depiction—in the context of the representational image.[4]

In 1931, the Museum of Modern Art in New York showed six pictures by Nolde—three of them oils—in its important survey exhibition *German Painting and Sculpture*. Writing of the Nolde watercolors in the show, Alfred H. Barr, Jr. was frank in his praise: "Nolde is one of the foremost masters of watercolor in Germany; in the three examples included in the exhibition he attains remarkable vibrancy and lushness."[5] Barr made two other observations that would prove to be deeply resonant to German art's American reception in general. "German Art," he asserted, "is as a rule not pure art"; and "They [German artists] frequently confuse art and life."[6] In the light of Nolde's differentiated and purely painterly approach to color alluded to above, such comments may be seen as part and parcel of the ideological preconceptions of a modernism strongly oriented toward French art.

Nolde's first one-man show to have a significant impact on his reception in America took place eight years later, from April 18 through May 6, 1939 at the Buchholz Gallery in New York. The show subsequently traveled to the San Francisco Museum of Art. Devoted exclusively to watercolors, this exhibition featured work from the period 1910–34 and consisted of twenty-nine pieces.

Emil Nolde during his time as a drawing teacher at the Kunstgewerbeschule, Sankt Gallen, Switzerland, 1896

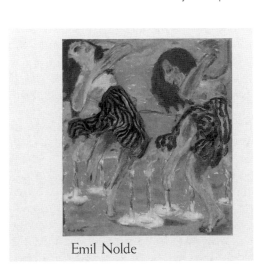

Emil Nolde

Cover of the catalogue *Emil Nolde*, The Museum of Modern Art, New York, 1963

The catalogue essay had this to say: "With their fluidity of stroke his portrayals of people are almost barbaric in color. Seldom does watercolor attain such richness of effect."[7] The following year, the Katharine Kuh Gallery in Chicago also mounted a show of watercolors, which however attracted little press.

Nolde's work garnered increasing attention in America following his death in 1956. The next year, from September 25 to October 26, *Emil Nolde: Memorial Exhibition* was held at the New Gallery in New York.[8] A retrospective opened in 1963 in New York at the Museum of Modern Art and traveled to venues on the West Coast, marking a high point in his reception by the American public.[9] From January 10 to February 19, 1967, fifty-four of his so-called "unpainted pictures" were shown at the Museum of Fine Arts in Boston, then toured the country.[10] One year later, the Fitzwilliam Museum in Cambridge, England staged an exhibition of watercolors from the Seebüll collection that had previously been at the Hayward Gallery; critical response in the English-speaking press was generally positive. Reviewer Keith Roberts of the *Burlington Magazine* observed, however, that Nolde's work was "dangerously close to the edge of decadence" insofar as it exhibited a combination of "extreme Romanticism, and harsh Fauvist colours, but at the same time a rather saccharine quality."[11] The most recent extensive exhibition of Nolde's work, a highly focused show titled *Nolde:*

Emil Nolde, *Pfingsten (Pentecost)*, 1909. Neue Nationalgalerie, Staatliche Museen zu Berlin, Preussischer Kulturbesitz

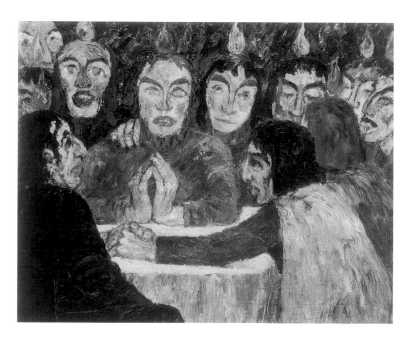

The Painter's Prints, was held at Boston's Museum of Fine Arts and the Los Angeles County Museum of Art in 1995.[12]

Nolde was nevertheless a figure who elicited contradictory responses, both because of the specific character of his work and because of his intermittent sympathy for National Socialism. As early as 1929, Paul Ferdinand Schmidt, director of the Dresden Städtisches Museum described his reception as one of "spiteful ridicule" and "abuse by a hostile environment."[13] Neither the issues nor the prevailing prejudices have yet been sufficiently clarified; record auction prices for his work, combined with ill-informed press commentary and public reaction, continue to fuel the controversy. In 1995, the *London Student* advised visitors to the Nolde exhibition at Whitechapel Gallery to wear sunglasses and referred to Nolde as "a northern Monet with dirty fingernails."[14] In another newspaper, his work was defamed with the slogan "dancing to fascism's tune."[15] The reasons for this situation are complex and can be discussed only briefly here. To understand it better requires an exploration of the context in which Nolde's art developed.

Nolde's long artistic career took a decisive turn in 1908, when he joined the Berliner Secession, and two leading German galleries—Paul Cassirer in Berlin and Galerie Commeter in Hamburg—began to exhibit his work.[16] Within two years, however, in the wake of a dispute over his painting *Pfingsten (Pentecost;* 1909), Nolde left the Secession when the work was rejected by the selection jury, headed by the painter Max Liebermann (who was also the Secession's president). Although eighty-nine paintings were rejected by twenty-six other artists, it was Nolde who made the event into a real generational quarrel.[17] His discomfort mounted when Karl Scheffler subsequently wrote a review in *Kunst und Künstler* of an exhibition of graphics organized by the Neue Secession that included several Nolde drawings. Scheffler illustrated the review with two of these works and assessed Nolde's achievement in these terms: "It is still not possible to say anything definitive about Nolde … [he] has some insight into the magical formula of art but still does not know how to use the formula like a true master."[18] In response to both these critical judgments, Nolde penned a letter to Scheffler on December 10, 1910. In it he expressed his thanks for Scheffler's decision to reproduce two of

his drawings. He then went on to attack Liebermann for clinging to power despite his now advanced age, for the stagnation in his development as a painter, and for the "weak and kitschy" character of his recent work. Nolde concluded his diatribe with the prediction that Liebermann's "house of art," built on "insecure foundations," would soon collapse.[19] Nolde was so angry that he sent a copy of the letter to Liebermann. As a result, the board of the Berliner Secession felt compelled to formally expel Nolde from the association on December 19 in view of his "loathsome attitude."[20]

Two aspects of this episode are of particular significance in the context of this period. First, it soon became clear that the Berliner Secession was no longer able to accommodate the more "radical" aesthetic positions now assumed by the younger exponents of Expressionism (albeit by this time Nolde was already forty-three years old). Second, a number of fundamental ideological differences began to emerge as artists addressed the question of what constituted the essential character of German art.

The "quest for a German art" was, in a sense, a compensatory response to a perceived state of crisis in the identity of a nation and its art.[21] The concept of a national identity based on and created by

a national culture played an integral role in this response, a role that of course was not without its chimerical aspects. On occasion it seemed that German art could only achieve a distinct profile if placed in sharp contrast to French art—or, more specifically, to a tendency of French art toward abstraction. In this respect, an unbroken continuity may be observed between a nationalist attitude that led to a partial rejection of French modernism around 1910 and positions that were renewed during the Third Reich. The result was that aesthetically radical artists like Nolde unexpectedly aligned themselves with more artistically traditional, but ideologically similar, figures such as the Worpsweder painter Carl Vinnen. As is well known, Vinnen was the man behind the 1911 publication *Protest deutscher Künstler* (German Artists' Protest), a conservative tract that polemicized against Expressionism and the excessively "French-oriented" acquisitions policy of the museums.[22] Nolde's own writings also provide an example of this perspective, particularly his autobiography *Jahre der Kämpfe*, published in 1934 in National Socialist Germany. In this account, he resorted to the stereotype of the deracinated Jewish intellectual with an open-mindedness toward abstraction and French art: "Herwarth Walden sided with them [the Futurists], this remarkable man with his great hank of hair and his grayish smoker's face, who applied his Jewish intellectual sensibility to "discover" so many artists (showing their work at his gallery, Der Sturm) whose art historical significance was only fully grasped by scholars many years later. … He [Walden] championed one wing of a swiftly evolving movement that was essentially heading toward abstract form; Constructivist, often pointless art was his especial joy; what was sensual, innate, and spiritually deeply rooted in the homeland was foreign to him … He thought us Germans to be worthless. It was the same story at [Paul] Cassirer's gallery, where only the work of French artists and their German imitators was exhibited. Among the German people there was not a soul who spoke out about this. Nor any [German] artists, except in as far as they complained about the extraordinary prices paid for French pictures."[23]

The passage reveals that like Vinnen, Nolde was an ardent nationalist. Nevertheless, he never took Vinnen seriously as an artist. The citation also suggests Nolde's somewhat tardy recognition of his

Sheldon Cheney's article "German Expressionism in Wood," in the *International Studio* (June 1922), showing Emil Nolde's *Prophet*, 1912

Cover of Carl Vinnen's *Ein Protest deutscher Künstler*, Verlag Eugen Diederichs, Jena, 1911

own path to a Post-Impressionist, Expressionist art that departs from the purely external (and to that extent, "materialist") French art and its reception in Germany. Finally, and most tellingly, it makes clear just how problematic the racial, anti-intellectual slant of Nolde's thinking actually was. Interestingly, it was precisely the German Jewish emigrants who began to acquire Expressionist art and works by Nolde for their collections in the 1930s. Evidently, this was partly because they saw in the marginalization of modern art a parallel to their own fate. The fundamental problem, namely, to what extent Nolde's art represents a projection of his ideological preoccupations, and how these are grounded in reality, remains an open question that requires future research and discussion.

Nolde was already perceived by critics in the 1920s as an extreme example of an artist representing a Nordic racial sensibility that was sometimes associated with emergent German modernist art. The Bauhaus master Paul Klee defined himself—in contrast to the "earthy-demonic" Nolde—as "an artist drawn toward abstraction, far from the earth and fleeing the earth."[24] A different take is found in Paul Ferdinand Schmidt's 1929 Nolde monograph, in which he characterized the artist's aesthetic in these terms: "That all stems from a magnificent and strange sensuality that is derived from the ardor of his genuinely Nordic nature … He is obsessed by color as if it were his

demon; and, depending on the mood of this demon, the painter can be tremendous, truly great, overpowering, and sometimes alienating and difficult. Nolde is a sorcerer of the North: possessed of inexhaustible powers, he produces figures and mythical images of enormous resonance. And he is an extremely German barbarian who clothes his Viking figures in sumptuous brocades and jewels. He arouses panic in the heart of every merely cultivated Formalist, but he is a true model of Germanic greatness in search of an as yet unidentified god. And who, among today's artists, has more to say to us with the dangerous and as if newly discovered painters' weapon—color—than Nolde does!"[25]

The "dangerous weapon" of color was indeed one aspect of Nolde's work that the National Socialists (with their restricted aesthetic criteria, generally derived from nineteenth-century art) ultimately found unacceptable. Nevertheless, for a short time Nolde's rather extreme form of nationalism (as manifest in his thought and the reception of his art) made his person and art appealing to segments of the National Socialist movement, particularly younger members of the party, such as the Nationalsozialistischer Deutscher Studentenbund (National Socialist League of German Students).

The chaotic and contradictory cultural politics of the National Socialists provided no clear guidelines for those concerned with the future of art or for German artists; and even after the opening of the *Entartete Kunst* exhibition in 1937,[26] there was in fact far more leeway for artistic expression—and exhibition and discussion in publications—than is usually assumed today. This explains what now may appear to be the paradoxical reception of Nolde in the Third Reich. The ideological vacuum resulting from the specific structure of the NSDAP, founded as a protest party and reliant on propaganda at the expense of concrete programmatic content, was tackled unsystematically. Thus, on the one hand there were initiatives at the local level in individual cities such as Mannheim, Karlsruhe, and Dresden that launched campaigns of defamation against Expressionism and Weimar modernism. Initially, such uncoordinated efforts were sharply condemned by Joseph Goebbels, minister of propaganda, who nevertheless requested the loan of several Nolde paintings from the Nationalgalerie in Berlin in 1933, for installation in his private apartment. On the other hand, there was an interest in

postulating a distinct tradition within German art. A painter such as Nolde was seen by some members of the party as potentially capable of playing an important role as a contemporary embodiment of that tradition within the Third Reich.[27]

In Nolde's case, the latter alternative was negated no later than July 1937 when the *Entartete Kunst* exhibition opened in Munich with no less than thirty-six works by the artist. By then some 1,052 of the artist's works also had been confiscated from public institutions. Perhaps the time has now

come for a critical (and no doubt painful) analysis of the concept of the "German" element in German Expressionism, a movement that drew strength from its polemical contempt for French painting, from which it was in no sense inferior. Ultimately, Nolde's "problematic" art could prove to be particularly useful in conducting such an analysis.

Olaf Peters
Translated from the German by Elizabeth Clegg, with Nicholas T. Parsons.

1 Paul Ferdinand Schmidt, *Emil Nolde,* Leipzig: Klinkhardt & Biermann, 1929, pp. 5–6.
2 *Nolde: Watercolors in America,* ed. by Clifford S. Ackley with the assistance of Anne E. Haringa, exhibition cat., Boston, Museum of Fine Arts, 1995, n.p.
3 Flora Turkel-Deri, "Berlin Letter," in: *Art News,* vol. 28 (March 8, 1930), p. 14. On this exhibition, which presented twenty paintings, forty-four watercolors, and thirteen lithographs, see Will Grohmann, "Emil Nolde," in: *Blätter der Galerie Ferdinand Möller,* vol. 6 (February 1930), pp. 1–8.
4 On this point, see the result of the research carried out by Martina Sprotte, *Bund oder Kunst? Die Farbe im Werk Emil Noldes,* Berlin: Gebr. Mann, 1999.
5 *German Painting and Sculpture,* ed. by Alfred H. Barr, exhibition cat., New York, Museum of Modern Art, 1931, p. 32.
6 Alfred H. Barr, Introduction, in: *German Painting and Sculpture* (as note 5), p. 7.
7 See the leaflet published to accompany the exhibition *Emil Nolde: Water Colors 1910–1934,* New York, Buchholz Gallery, 1939.
8 *Emil Nolde: Memorial Exhibition,* ed. by Eugene Victor Thaw, exhibition cat., New York, New Gallery, 1957.
9 *Emil Nolde,* ed. by Peter Selz, exhibition cat., New York, Museum of Modern Art; San Francisco Museum of Art; and Pasadena Museum of Art, 1963.
10 *"Unpainted Pictures": Emil Nolde, 1867–1956,* exhibition cat., Boston, Museum of Fine Arts, 1967.
11 Keith Roberts, in: *Burlington Magazine,* vol. 110, no. 788 (November 1968), p. 642.
12 *Nolde: The Painter's Prints,* ed. by Clif-

ford S. Ackley et al., exhibition cat., Boston, Museum of Fine Arts; and Los Angeles County Museum of Art, 1995.
13 Paul Ferdinand Schmidt, *Emil Nolde* (as note 1), pp. 5–6.
14 Clara Farmer, in: *London Student* (January 18–February 1, 1996), quoted in: Sprotte, *Bund oder Kunst?* (as note 4), p. 10.
15 Tim Hilton, in: *The Independent on Sunday* (December 17, 1995), p. 24, quoted in: Sprotte, *Bund oder Kunst?* (as note 4), p. 10.
16 On the Berliner Secession, see Werner Doede, *Die Berliner Secession. Berlin als Zentrum der deutschen Kunst von der Jahrhundertwende bis zum Ersten Weltkrieg,* Berlin: Propyläen, 1977; and, of fundamental importance, Peter Paret, *The Berlin Secession: Modernism and Its Enemies in Imperial Germany,* Cambridge, Mass.: Belknap Press, 1980.
17 For a thorough discussion of the conflict, see Paret, *The Berlin Secession* (as note 16), pp. 210–216.
18 Scheffler, cited in: Donald Gordon, *Expressionism: Art and Idea,* New Haven: Yale University Press, 1987, p. 92.
19 The letter is published in Doede, *Berliner Secession* (as note 16), pp. 63–64, n. 106. On Liebermann's cultural-political role at this time, see Klaus Teeuwisse, "Berliner Kunstleben zur Zeit Max Liebermanns," in: *Max Liebermann in seiner Zeit,* ed. by Sigrid Achenbach and Matthias Eberle, exhibition cat., Munich, Haus der Kunst; and Berlin, Neue Nationalgalerie, 1979–80, pp. 72–87; also Andrea Bärnreuther, "Im Spannungsfeld von künstlerischem Selbstverständnis und öffentlicher Verantwortung. Anmerkungen zu Liebermanns Kulturpolitik," in: *Max Lieber-*

mann. Jahrhundertwende, ed. by Angelika Wesenberg, exhibition cat., Berlin, Alte Nationalgalerie, 1997, pp. 259–266. On the "Jewish" aspect of Liebermann, see "Immo Wagner-Douglas, Realist, Secessionist, Jude und Partriarch—Liebermann in der Karikatur," in: *Max Liebermann. Jahrhundertwende,* pp. 267–276; and Chana C. Schütz, "Max Liebermann as a 'Jewish' Painter: The Artist's Reception in His Time," in: *Berlin Metropolis: Jews and the New Culture, 1880–1918,* ed. by Emily D. Bilski, exhibition cat., New York, The Jewish Museum, 1999–2000, pp. 147–163.
20 *Einladung des Vorstandes der Berliner Sezession zur ausserordentlichen Generalversammlung am 17. Dezember 1910,* quoted in: Doede, *Berliner Secession* (as note 16), p. 64, n. 106.
21 On the general intellectual background, see Georg Bollenbeck, *Tradition, Avantgarde, Reaktion. Deutsche Kontroversen um die kulturelle Moderne 1880–1945,* Frankfurt am Main: Fischer, 1999.
22 See Wulf Herzogenrath, "Ein Schaukelpferd von einem Berserker geritten.' Gustav Pauli, Carl Vinnen und der 'Protest deutscher Künstler,'" in: *Manet bis Van Gogh. Hugo von Tschudi und der Kampf um die Moderne,* ed. by Johann Georg Prinz von Hohenzollern and Peter-Klaus Schuster, exhibition cat., Berlin, Alte Nationalgalerie; and Munich, Neue Pinakothek, 1996–97, pp. 264–273; and Barbara Paul, *Hugo von Tschudi und der Kampf um die moderne französische Kunst im Deutschen Kaiserreich,* Mainz: von Zabern, 1993, pp. 319–327.
23 Emil Nolde, *Jahre der Kämpfe,* Berlin: Rembrandt, 1934, pp. 121–122.

24 See the text by Paul Klee, in: *Festschrift für Emil Nolde anlässlich seines 60. Geburtstages,* Dresden: Neue Kunst Fides, 1927, p. 26.
25 Schmidt, *Emil Nolde* (as note 1), pp. 10–11. See also Max Sauerlandt, *Emil Nolde,* Munich: K. Wolff, 1921, who likewise employs the nationalist/racist terminology characteristic of this period.
26 See *"Degenerate Art": The Fate of the Avant-Garde in Nazi Germany,* ed. by Stephanie Barron, exhibition cat., Los Angeles County Museum of Art; Art Institute of Chicago; and Berlin, Deutsches Historisches Museum, 1991–92, passim and, in particular, Mario-Andreas von Lüttichau, *Entartete Kunst, Munich 1937: A Reconstruction,* pp. 45–81; also Katharina Hoffmann-Curtius, "Die Inszenierung 'Entartete' Kunst," in: *Überbrückt. Ästhetische Moderne und Nationalsozialismus. Künstler und Kunsthistoriker 1925–1937,* ed. by Eugen Blume and Dieter Schulz, Cologne: Walther König, 1999, pp. 237–246.
27 See Christoph Zuschlag, *"Entartete Kunst." Ausstellungsstrategien im Nazi-Deutschland,* Worms: Wernersche Verlagsgesellschaft, 1995; see also the documentation assembled in *Kunst in Deutschland 1907–1937. Die verlorene Sammlung der Nationalgalerie,* ed. by Annegret Janda and Jörn Grabowski, Berlin: Staatliche Museen, 1992, passim, on the well-known efforts of Alois J. Schardt at the Kronprinzenpalais in Berlin, and Annegret Janda, "The Fight for Modern Art: The Berlin Nationalgalerie after 1933," in: *"Degenerate Art"* (as note 26), pp. 107–119.

Strawberry-Blonde Girl, 1919 cat. II.20

Sunset, 1909 cat. II.19

BLAUE REITER

- **GABRIELE MÜNTER**
- **VASILY KANDINSKY**
- **FRANZ MARC**
- **AUGUST MACKE**

Second exhibition of *Der Blaue Reiter* in the gallery of bookseller Hans Goltz, Munich, 1912

MODERNISM'S GERMAN ROOTS: THE BIRTH AND SURVIVAL OF EXPRESSIONISM

SERGE SABARSKY

Fifty years after Vincent van Gogh painted his *Starry Night* and more than a quarter-century after the German Expressionist artists established themselves, the National Socialist government in Germany started what was to become the most infamous cultural "revision" ever orchestrated in the Western world.

As a teenager, Adolf Hitler went to Vienna to fulfill his dream of becoming an artist, but failed the entrance examinations for the Vienna Kunstakademie in 1906 and again in 1907. Just over twenty-five years later, after the frustrated painter became chancellor of Germany in 1933, agencies of the state officially sanctioned vandalism and the persecution of established artists, beginning an unparalleled campaign of defamation and destruction. Artists were forbidden to paint; museum directors and academy teachers were hounded from their posts.

Finally, in 1937, Hitler ordered the staging of the exhibition *Entartete Kunst*, in which the Expressionist artists were slandered, ridiculed, and stigmatized. The show opened on July 19 in Munich, then traveled to several German cities and set a record for the number of visitors to an art exhibition—3.2 million. Many of the visitors were schoolchildren, or shifts of factory workers who had been commandeered. Some of the people who stood before pictures by Emil Nolde, Max Beckmann, Otto Dix, Vasily Kandinsky, and the others had never been in a museum. But admirers of the outlawed art came too, even if they did not dare to express their admiration aloud. They saw what was labeled "degenerate," but was in reality surely the most magnificent survey ever of the art of this century—works by 120 artists who today are crucial to our understanding of modern painting. At the beginning of the twentieth century, the German Expressionists created a furor in the art world when they rebelled against all aesthetic traditions. The contribution of these artists was not only the development of new stylistic principles, but also a total break with the past and the expression of a radically new attitude toward life. Painters and sculptors shared this revolutionary search for revision with Expressionist authors, poets, and composers.

What is generally referred to as German Expressionism is the art created by the painters of two groups: Die Brücke and Der Blaue Reiter. Among the unaffiliated artists who are also labeled German Expressionist, the most prominent are Max Beckmann, Otto Dix, Lyonel Feininger, and Oskar Kokoschka. Rarely, however, is an artistic movement confined within national borders. The Norwegian painter Edvard Munch had lived and worked in Berlin before the turn of the century, and he influenced young German artists greatly. His dramatic brushwork and his ability to express emotions with color were an early version of what the Brücke painters would later do.

At an age when others had nearly completed their academic studies, four architecture students joined together to found the Brücke group on June 7, 1905 in Dresden. They were: Ludwig Kirchner, Erich Heckel, Karl Schmidt-Rottluff, and Fritz Bleyl. Their agenda was to overcome the need to copy nature, to paint as their feelings inspired them to; emotion was to dictate what they did. Their so-called Dresden Manifesto, which was carved in wood by Kirchner in 1906, said: "Anyone who renders his creative drive directly and genuinely is one of us."

The young artists of the Brücke were autodidacts—they learned as they painted. Still, these zealots probably worked harder than many students at the academies, drawing and painting as if possessed. Among their idols were van Gogh, Munch, and

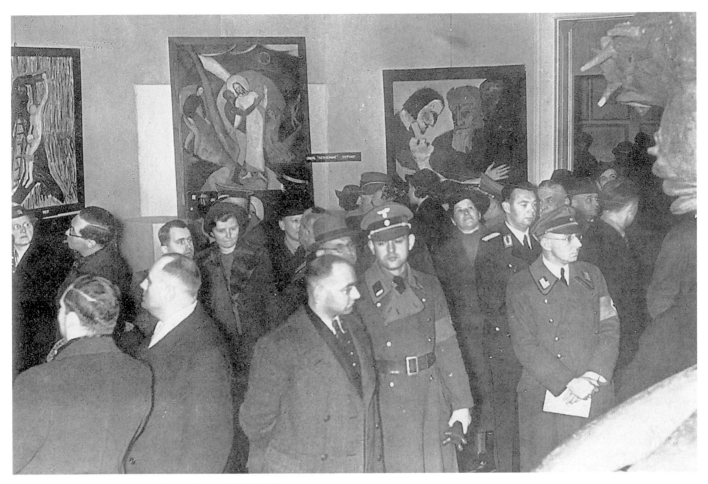

Opening of the exhibition *Entartete Kunst* in Munich, July 19, 1937

Gauguin. It was not until 1908 that they learned that the art that had the most in common with theirs—the paintings of the Fauvists—was developing simultaneously in France. The Brücke was a close-knit group; the members often worked together in the studio and traveled together. They held lively discussions that stimulated their creativity, but they hardly ever formulated a comprehensive theory.

The opposite was true of the Blaue Reiter, which was formed in December 1911 in Munich. Two Russians, Vasily Kandinsky and Alexej Jawlensky, along with Franz Marc and August Macke, formed a more loosely knit group, giving impetus to the new movement through intellectual discussions. In 1912, Kandinsky published his essay "On the Spiritual in Art." If the watchphrase in Dresden and Berlin (where the Brücke group moved in 1911) was "Emotion, not construction," the artists of Munich

inverted this dictate. Their innovations, which were accompanied by the publication of their almanac *Der Blaue Reiter*, would eventually lead to abstract painting, wherein some of them saw the highest spiritualization of art.

One of the most important contributions of German Expressionism was made in the graphic arts. The Germanic graphic tradition extends even further back than the time of Albrecht Dürer and Martin Schongauer, and has a distinctly national character. Many of the techniques of the graphic arts, too, have their European origins in Germany. Although the woodcut was an art form in China as early as the second century A.D., in the Western world it was first practiced in the fifteenth century by Bavarian and Austrian craftsmen. The golden age of the woodcut unquestionably found its greatest exponent in Dürer.

Ernst Ludwig Kirchner, invitation to the exhibition of the Künstlergruppe Brücke, woodcut, 1906

Around the same time, the first engravings were created, also in southern Germany. Along with Schongauer, it was again Dürer who transformed this craft into a prominent art form. Only much later, at the end of the eighteenth century, was stone printing invented: Alois Senefelder, a Bavarian, perfected the process that we know today as lithography. These discoveries, along with Johannes Gutenberg's invention of book printing, demonstrate Germany's groundbreaking role in the graphic arts.

At the beginning of the twentieth century, a cultural mood of restlessness and sense of awakening demanded more spontaneity and directness in art. The Expressionists believed that these qualities could be found in a new primitivism; this paved the way for a rediscovery of graphic techniques. In the ecstatic, almost barbaric forms of the woodcut, the German artists, primarily the Brücke members, encountered a style that intensified the expressiveness of art through rough, simplified, strongly sensual forms. German-language periodicals, manifestos, and books in the first quarter of the twentieth century were often illustrated with graphic works. The illustrations were almost exclusively woodcut prints, as were posters of the period. Many of these works are as artistically convincing and modern today as they were when they were created. Yet the graphic works of the Expressionists have long been neglected. Of course, the years during which they were labeled "degenerate" contributed to this neglect.

The German Expressionists revolutionized art, but the subjects of their paintings remained classic: landscapes, still lifes, portraits, nudes. True, they debated their country's ills heatedly in their studios and in coffeehouses, but for the most part, their works show little or no determination to bring about social and political changes.

This absence of chronicling and criticism was most notable when World War I erupted and threw the lives of most of these artists into turmoil. When Macke was killed in September 1914 in France, Marc said of his friend, "The insatiable war won another hero, but the world lost an irreplaceable artist." A year and a half later, on March 4, 1916, Marc was killed near Verdun. Macke was twenty-seven years old when he died, Marc thirty-six.

Yet war hardly appears as a subject in the paintings of the important Expressionists. These artists, like the Impressionists, Post-Impressionists, and Fauves in France, did not react to their era as socially or politically engaged observers. Otto Dix was the great exception. The only German artist of the early twentieth century with whom Dix might be compared in this respect is George Grosz. What connects these two painters is their dissatisfaction and the passion with which they expressed it in their work. But Dix and Grosz reacted to events and experiences in different ways. Grosz was a partisan artist through and through: he parades abuses before the viewer's eyes, attacking the military, the judiciary, the church, racketeers, and war profiteers, and he seems to demand that the viewer become a revo-

Max Pechstein, poster for the *Kunstausstellung Zurückgewiesener der Secession Berlin*, color lithograph, 1910. (Günter Krüger, *Das Druckgraphische Werk Max Pechsteins,* L 110)

lutionary too. Dix, on the other hand, simply shows things as he sees them: the horror of war, the ugliness and banality of the everyday. He is a chronicler and leaves it to the viewer to respond in his own way.

NACH ZEHN KAMPFJAHREN FÜR

DieAktion

VON GENOSSEN / FREUNDEN / MITARBEITERN

Conrad Felixmüller, *Widmungsblatt für Franz Pfemfert*, reproduced on the cover of the periodical *Die Aktion*, 1921

Unlike so many who lived through the squalor without reacting to it, or who retained memories only of the glories, Dix was still haunted by the unspeakable reality of war many years later. In an interview with the *Thüringer Nachtrichten* in Gera, East Germany, in November 1966, Dix said: "I have studied war carefully. One has to show it realistically, so that its nature can be understood. The artist wants to work so that others can see what things were like. ... I believe no one else saw the reality of this war the way I did, the deprivation and the gruesomeness. I chose to report war factually: the destroyed earth, the sorrows, the wounds."

It is not surprising that Dix became a thorn in the side of fanatic supporters of the many political movements that flourished after the war. Nor is it surprising that his dismissal in 1933 from his teaching post at the Dresden Kunstakademie was based in part on the charges that he could not guarantee "his unstinting support for the national state," and that his works "offend moral sensibilities in the gravest fashion, jeopardizing the moral framework and the will to carry arms of the German people." This declaration is contained in a memorandum of the Ministry of the Interior of Saxony, dated April 13, 1933—in the first days of the Third Reich—and in retrospect can be seen as an honor for Dix.

This is not to say that the other Expressionists lacked idealism. Just as the Wiener Werkstätte mass-produced fine design and

applied arts, to try to educate the masses aesthetically (and failed), the Brücke artists wanted to create art for the people. But like reading and writing, art appreciation must be learned, and the German people proved themselves nearly illiterate when faced with the art of the Expressionists. This obdurate ignorance reached its apex after Hitler seized power in 1933. But even earlier, the Expressionists were not popular; the public's reaction was often one of contempt. So-called polite society just ignored the movement, which was perhaps worse than contempt.

The Expressionist artists were supported by only a small circle of patrons. Their most important sponsors—apart from a few enlightened museum directors, collectors, and dealers—were individuals such as Franz Pfemfert, publisher of the magazine *Die Aktion*, and Herwarth Walden with his magazine and gallery, both called *Der Sturm*.

The travesty of the *Entartete Kunst* show of 1937 was followed by an auction of confiscated art in Lucerne, Switzerland, in May 1939. Germany, hungry for foreign exchange, hoped for huge prices in foreign currencies but was disappointed. Most of the treasures were sold for bargain prices. A few of the works were bought back after the war by museums, in some cases the same museums from which they had been confiscated. But many pictures have never been found. Even worse, the National Socialists burned about a thousand paintings and nearly four thousand works on paper—watercolors, drawings, and prints—in March 1939, in the courtyard of Berlin's central fire station. Thus the painters fared as the authors had a few years earlier at the infamous book burning, though with irrevocable consequences: burned books can at least be reprinted; burned art is gone forever.

After 1945, when the darkest chapter of German history was closed, a period of recognition of the German Expressionists began. It was as if the movement had just sprung into existence with all the exhilaration of a new discovery. Today, there is hardly an important museum that does not proudly display works of German Expressionism or try to acquire examples when they become available.

More than three-quarters of a century after its inception, this art and its artists are understood as central facets of modernism.

This essay was originally published as the Introduction to the catalogue for the exhibition From Kandinsky to Dix, *curated by Serge Sabarsky, at the Nassau County Museum of Art, 1989. Translated from the German by Bernhard Geyer.*

GABRIELE MÜNTER

* FEBRUARY 19, 1877, BERLIN
† MAY 19, 1962, MURNAU

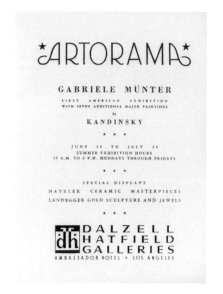

Gabriele Münter was one of the central, founding members of the Neue Künstlervereinigung München (New Artists Association of Munich), as well as of the key avant-garde group Der Blaue Reiter. Although major works by her can be found in American museums and private collections, until only recently she has been a much-ignored contributor to German Expressionism. It is therefore ironic that no progressive German-born artist of the early twentieth century was as profoundly linked to America as was Münter in her personal life, her attitudes, and her public reception. Inquiring about exhibition possibilities in a 1950 letter to museum-curator Katharine Kuh, she summarized: "I already have various connections over there, not only through my family (since I have American cousins in many states) but also because one of the first significant collectors who paid attention to me (likewise also the first to write dispassionately about the beginnings of modern art), A. J. Eddy, was from Chicago."[1]

Münter was born in Berlin in 1877, the youngest of four children.[2] Her parents, although native Germans, had both emigrated to the United States, where they met and married; they then returned to Germany in 1864 to escape the American Civil War. The family settled first in Berlin, then moved to her father's hometown of Herford shortly after Gabriele's birth, and finally to the Rhenish city of Koblenz, where her father practiced dentistry.

In the Münter home, awareness of America was part of everyday family life. The Münters maintained close contacts with the United States through the mother's parents, who remained in Tennessee (where Frau Münter visited them), along with numerous cousins clustered around Saint Louis and the Texas-Arkansas region, as well as in New York City. Münter's two brothers spent time in the United States engaged in business, and the eldest later married an American singer. While it was far from unusual for German families, especially after the massive emigrations of the middle and later nineteenth century, to have links to America, the Münter family was unusual for both the degree and constancy of its association with America. Münter's later companion and biographer, Johannes Eichner, noted that, according to her recollections, American influence was largely responsible for the lack of rigidity that characterized the family's life. "There was no use of force, and little discipline," Eichner wrote. "Social formalities, habitual niceties, superficial appearances, drawing attention to oneself: these were things the child and young girl was not taught."[3] Unlike most German middle-class daughters, therefore, the Münter girls enjoyed unusual freedoms: they rode bicycles, smoked, and read controversial contemporary literature, and they were not forced into early marriages. Subtly, along with American words and songs, objects and sayings, American attitudes infiltrated the daily life of the family in the Prussian city of Koblenz.

The major formative American experience for Gabriele Münter herself, however, was the extended trip she took with her sister Emmy, from 1898 to 1900, shortly after their mother died. The two arrived in New York on the S.S. *Statendam* on October 9, 1898, then left by train on October 20

for Saint Louis to stay with the family of their mother's sister, Albertine Happel. While there, they visited the Saint Louis Exposition, where predominantly local artists exhibited. In New York, Gabriele admired the plaster casts at the Metropolitan Museum, but otherwise art was notably absent in Münter's America.

The sisters traveled for two years, visiting more relatives in Arkansas and Texas, before returning to Saint Louis and from there journeying to New York. They sailed for Hamburg on the S.S. *Pennsylvania* on October 6, 1900. But even if she saw no significant art during her American journey, Münter gained confidence in her own artistic abilities. She filled sketchbooks with portraits of her American relatives, with views of her relatives' properties and the landscapes of Texas and Arkansas, and with precise renditions of native flowers and plants. The sketched record she supplemented with photographs, using the camera given to her shortly after she arrived in the United States.[4] Many of the sketches reveal an aesthetic rooted in German Jugendstil, with its stylized simplifications and linear emphasis, which Münter applied with a certain hesitancy, but remarkable skill, producing simple, increasingly sophisticated images. Indeed, the motifs that would preoccupy her in later work were all treated in the American sketches, and the preference for simple, easily legible compositions that likewise characterize her mature work is also manifest in them. Sketching alone, displaced from the European context and artistic support, in isolation and with absolute self-reliance, Münter remarkably laid the basis for her later Expressionist art in the plains of the American Southwest, among her German-American relatives.

Nonetheless, it was only after her return to Germany that Münter finally determined that she would become an artist and seek professional training. Since the German art academies remained closed to women, she was forced to turn to private schools where women were trained, although their ambitions were considered fundamentally dilettantish, if not actually damaging to their womanhood.[5] After brief studies in Düsseldorf, she enrolled in 1901 in the Damen Akademie in Munich, but, as she later recalled, "Soon I began to attend the Phalanx School and ... the evening class for drawing after the nude with [Vasily] Kandinsky. There I had a new artistic experience, how—unlike other teachers—Kandinsky explained

things in detail clearly, and treated me as though I were a consciously striving person who can set herself problems and goals. That was something new for me and impressed me."[6] As she joined Kandinsky's landscape class in the Bavarian Alpine town of Kochel, the relationship between teacher and pupil quickly became a romantic one as well: although Kandinsky was married, the two celebrated their "secret engagement" while he led a landscape class in Kallmünz in 1903, and for the next two years they traveled together in Europe and North Africa before settling in Sèvres, outside of Paris, in 1906. Kandinsky and Münter shared of working techniques to a degree that often makes it difficult to distinguish the work of one from that of the other, experimenting in a variety of styles rooted loosely in Impressionism and neo-Impressionism as well as aspects of Jugendstil. By the time they returned to Munich in 1908, neither had settled firmly on an approach to their painting, both seemingly seeking a new painting vocabulary, now with a new awareness of the work of Henri Matisse—whom Münter sought out shortly before she left France—and other Fauve artists in Paris.

WORK AND RECOGNITION

The breakthrough to an Expressionist vocabulary for Münter, as for Kandinsky, came not in Paris, however, but in the Alpine market town of Murnau on Lake Staffel, approximately a half-hour's train ride from Munich. They discovered the town early in the summer of 1908, and immediately commu-

Gabriele Münter with an American relative, Marshall, Texas, March 1900

Kandinsky with his Phalanx painting class in Kochel, summer 1902

nicated their enthusiasm for it to artists Marianne von Werefkin and Alexej Jawlensky. In early August, all four were there painting together. Seeking to provide a historical record of the group's activities, Münter wrote in 1911: "After a brief time of experimentation, I took a major leap there—from painting after nature, more or less impressionistically, to the feeling of a content to abstracting to the presentation of an extract. ... We all tried hard and each one of us matured [in our art]. I made a mass of studies. There were days when I made five studies ... and many when there were three, and a few when I did not paint at all. We all worked hard."[7] The Expressionist style the artists evolved communally represented a radical break, with no true transition, from their prior work. It was personally eclectic, with elements derived from their previous painting but now fused with lessons learned from Paul Gauguin and his followers' Synthetist practice of flattening colored planes and surrounding them with accented dark outlines, from Matisse's Fauvism with its coloristic intensity and willingness to simplify and distort spatial relationships, and from the apparent naiveté of Bavarian folk art, most notably the reverse glass paintings they discovered in a Murnau collection. Especially for Münter, it was a vocabulary that fused visual experience with personal subjective formulation. With some variation and intermittent interruptions as she experimented with alternatives, this vocabulary sustained her art throughout her entire career.

Upon their return to Munich early in 1909, the four Murnau colleagues founded the Neue Künstler-

vereinigung München, to foster their newly shaped Expressionist work, and to bring together other progressive Munich artists seeking exhibition opportunities and the support of collectors. "Kandinsky resolved to become its head since no one else could do it," Münter observed in her recollections.[8] She handled most of the Neue Künstlervereinigung's correspondence as the first exhibition was organized for December in Munich at Heinrich Thannhauser's Moderne Galerie; it would travel subsequently to eight other German cities.[9] As a preface to their exhibition, the artists offered a brief programmatic statement: "We proceed from the thought that the artist gathers experiences in an inner world in addition to the impressions that he receives from the external world, from nature; and the search for artistic forms which should give expression to the mutual interaction of all experiences—for forms that must be freed of all that is accidental in order to bring only the necessary to strong expression—in short the striving for artistic Synthesis, this appears to us to be a solution which is uniting ever more artists at this very moment."[10] With ten paintings and eleven prints, Münter's work represented the largest collection by a single artist in the exhibition; only Kandinsky offered as many paintings.

The second Neue Künstlervereinigung exhibition likewise accented Münter's contributions, but internal conflicts in the association led, in 1911, to her joining Kandinsky, Franz Marc, and several others in resigning and founding the alternate, more radical and international exhibition society, sponsored through the *Blaue Reiter* almanac. When the first Blaue Reiter exhibition opened in December 1911 with some thirty-eight paintings by fourteen artists, six of the works were Münter's, hung in featured locations throughout the four exhibition rooms. She participated in the traveling Blaue Reiter exhibition that Herwarth Walden's Galerie Der Sturm sent throughout Germany and to Scandinavia. Walden likewise brought a large collection of Münter's paintings to his Berlin gallery, featured her woodcuts in his periodical *Der Sturm*, and included her in his momentous *Erster Deutscher Herbstsalon* (First German Autumn Salon) of 1913, in which he presented Europe's most innovative artists, defining the moment of radical modernist artistic developments. In the years immediately before 1914, when Expressionism gained ascendancy as Germany's major contribution to classical modernism,

Erste Ausstellung der Redaktion Der Blaue Reiter at the Moderne Galerie Thannhauser, Munich, December 18, 1911–January 1, 1912 (photograph by Gabriele Münter)

Münter's paintings and prints were an indispensable and conspicuous component of the movement. Within an artistic tendency dominated almost totally by male artists, Münter was virtually the sole woman participating as an essential, although often controversial, equal. In the Blaue Reiter group, she alternated between being a presence who brought the artists together, and one causing bitter accusations of gendered inferiority as the male artists defended their own positions within the group and among Germany's avant-garde against her often sharp-tongued comments and criticism. On a more practical level, with her ability to speak and write English (acquired during her stay in America), she acted as intermediary between the Munich artists and two American painters who were associated with them, Albert Bloch and Marsden Hartley, as well as with American collectors.

If Münter's skills in English allowed her to act as translator and expeditor for American artists in Germany, they also served her—and Kandinsky—in interactions with American collectors, most notably the Chicagoan Arthur Jerome Eddy, who first came to Munich late in the summer of 1913. Münter was away at the time, visiting her family in Bonn, and Kandinsky was in Moscow, leaving their housekeeper to show their works to the American. As Kandinsky observed: "A Mr. Eddy from Chicago visited me in Munich. … He wants to buy small things for 1000 M[arks] immediately and in general to put together a small collection 'from all times' for himself. Wonderful!"[11]

Kandinsky also wrote directly to Eddy, encouraging him to buy his paintings but also others by Marc and, above all, Münter: "You will surely believe me when I tell you that I do not mention her because she is my wife. By her nature, she is endowed with a personal, refined vision through which she views the world in a remarkable strongly national manner.

She was also granted a hand that allows her to pour this vision into form."[12]

The perception of Münter's style as uniquely German (although not parochially nationalistic) echoed the stance in Kandinsky's still-unpublished essay written on the occasion of her retrospective exhibition at Walden's Der Sturm gallery in Berlin and Max Dietzel's Neuer Kunstsalon in Munich earlier in the same year, 1913. Münter took over negotiations with Eddy and accompanied the collector on visits to the Blaue Reiter artists' studios, including her own. Sales were not finalized, however, until more than a year later, after the outbreak of World War I and Münter's and Kandinsky's separation when he returned to Russia. From Moscow, he wrote to Münter, whom he had left in Zürich, briefly but with urgency due to major financial sacrifices the war had imposed on him: "Do not hesitate to sell my paintings to Eddy and to anyone who will pay for them. I need money."[13]

Eddy purchased a total of sixteen Kandinsky paintings for a thousand marks, a currency already beginning to suffer devaluation as an effect of the war. From Münter he bought six works—still lifes and landscapes—at an unrecorded price. These were the first works by her—other than drawings and paintings she gave her American relatives—to

Gabriele Münter, *Landstrasse im Winter (Country Road in Winter)*, 1911, shown at the *Erste Ausstellung der Redaktion Der Blaue Reiter* at the Moderne Galerie Thannhauser, Munich, December 18, 1911– January 1, 1912

enter an American collection.[14] Eddy thus amassed the most significant private collection of her work then in existence, a unique note among American collections of European modernist paintings. Significantly, it was also the largest single sale Münter (who never sold large quantities of her work during her lifetime) made to a collector up to that time, and would remain so until well after World War II.

Gabriele Münter, *Kahnpartie (Boating)*, 1910, as featured in *Cubists and Post-Impressionism* by Arthur Jerome Eddy, 1914. Milwaukee Art Museum, Milwaukee

Eddy died in 1920; his collection was dispersed in the years thereafter, most notably through the auction of his remaining estate in 1937. This unique, historically important body of work by Münter was thus lost from view, her contributions to the pre-1914 avant-garde were largely forgotten, and her name was excluded from the annals of modern art in America. Her work was scarcely exhibited in the United States from that point until 1960. It was, however, included at the Société Anonyme's *International Exhibition of Modern Art*, organized by Marcel Duchamp and Katherine Dreier at the Brooklyn Museum in 1926–27. There, she was represented with two paintings; the catalogue listing identified her as "Gabriel [*sic*] Kandinsky-Münter," ironically denying her gender even as it seemingly legitimized her long "marriage of conscience" with Kandinsky.

When Kandinsky returned to Russia in 1914 after the German and Russian empires declared war on one another, Münter went to Denmark, then Sweden, expecting him to join her in one of the neutral Scandinavian countries. He failed to come, however, except for a brief visit to Stockholm from December 1915 to March 1916 on the occasion of an exhibition of his work, arranged by Münter. Within a year, he was married to a young Russian woman, Nina Andreevskaia; he did not inform Münter of his marriage, broke off all communication with her, did not respond to her letters or telegrams—was, in short, determined never to see her again.

Alone in Sweden, believing Kandinsky to have been killed in the October Revolution (the Bolshevik/Communist uprising of 1917), a German national in a nervously neutral country, Münter entered a life of relative isolation. Although she retained friendships with Swedish artists who had exhibited with Walden, and was able to arrange exhibitions of her work, she lost virtually all links with German art developments and exhibition venues. When she finally returned to Germany in 1920, critics and artists were proclaiming the death of Expressionism. Her own painting now appeared to be out of context and dated, initiating a severe crisis of artistic identity—which she shared with many of the Expressionists in Germany who had survived the war. For more than a decade, Münter vacillated between a classicizing realism akin to Neue Sachlichkeit and more experimental, expressively subjective modes of painting. This

indecision was resolved only after she returned to Murnau in the 1930s to live in the house she had bought in 1909 at Kandinsky's urging. He had, meantime, also returned to Germany with Nina in 1921, and he and Münter agreed in 1926 on a division of their property that left most of it—including a large body of his own paintings and other works—to her. In later recollections about the Blaue Reiter in prewar Munich, however, Kandinsky never mentioned her name, thereby depriving her of due recognition, as had the histories of modern art written in Germany during the 1920s.

Largely forgotten by the German art establishment, Münter retreated to Murnau, the environment that had seen the development of her individual modernist vocabulary in 1908. There she resurrected with some variation the style of her prewar paintings. In an attempt to revitalize her reputation, she had a collection of her work travel to several German cities, but the increasingly vehement National Socialist attacks on modern art brought the effort to an end. With no works in the collections of German museums, Münter escaped having her work pilloried in the *Entartete Kunst* exhibition of 1937—but any significant market for her art was destroyed. Quiet, withdrawn, unknown, she lived through the remaining years of the Third Reich in Murnau without being vilified by the regime, as other Expressionists were, and was able to preserve her collection of paintings by herself, Kandinsky, and other Blaue Reiter artists from destruction by secreting them in a hidden basement room. Ironically, it was the very fact that she had been written out of modern art's history that protected her from persecution under the National Socialist regime.

American troops entered Murnau on April 29, 1945, and after her house had been searched several times, Münter was granted immunity from further inspections and possible confiscation of her collection by the military governor. Her knowledge of English stood her in good stead once again. Slowly she regained contact with her American cousins, most of whom had been children when she first met them.[15] Several sought her out in Murnau in the postwar years. She now regularly received from them packages of food and other goods not obtainable in Germany and carefully recorded each arrival—in all, seventy packages between 1946 and 1950—with gratitude in her daybooks.

As the defeated nation slowly began its recovery and attempted to revive its art as well, Münter started to receive attention as one of the last survivors of the Blaue Reiter group. Ludwig Grote of the Bayerische Staatsgemäldesammlung (Bavarian State Painting Collection), in conjunction with the American military government's Central Collection Point for Art, organized a first retrospective exhibition of the Blaue Reiter in Munich in 1949. Münter was named to the exhibition's honorary advisory committee, but the catalogue devoted but two brief, dismissive sentences jointly to her and to Marianne von Werefkin: "They set themselves no problems; their painting remains simple and close to nature." Nonetheless, haltingly after the Blaue Reiter exhibition, her work began to be included in German shows; she was featured with three paintings at the 1950 Venice Biennale; another large traveling exhibition of her work was organized; and several critics and historians began to write about her. The process of rehabilitation and discovery culminated in 1957 with the publication of the monograph *Kandinsky and Gabriele Münter: Concerning the Origins of Modern Art*, written by Münter's companion Eichner. Making use of the extensive documentation she had preserved, Eichner thereby was able to contribute significantly to the historical record of Munich's Expressionist years. Significantly, however—despite his emotional ties to her—he did not devote the book to Münter alone, but placed her in a subordinate position to Kandinsky. As he had in life, Kandinsky continued to overshadow her.

Throughout the 1950s, as Münter's reputation in Germany slowly grew, she also attempted to find American venues for her work. But her efforts were unsuccessful. Nonetheless, American scholars began to encourage her, among the first being Kenneth Lindsay, who started to correspond with her in 1950 as he researched his dissertation on Kandinsky and the beginnings of abstraction. She patiently answered Lindsay's long lists of questions, then repeatedly sought to bring attention to her own work and the possibilities of exhibiting it in America: "Recently we had a very pleasant visit from your colleague, Joyce Fritters. … She felt that I should send my collection to the U.S.A., and if I recall correctly, she also said you expressed the same wish. Now I have written to Dr. Cath. Kuh [sic] at the Art Institute of Chicago in order to orient myself concerning the possibilities and potential gen-

erally. … Perhaps you too would have an idea of how I can realize such a plan for a tour in the U.S.A. It seemed better to us not to attempt it with art galleries, but with museums. Certainly one should start out in New York. What do you think? Would there be an interest in my paintings over there? It is not sensationalistic."[16]

Lindsay underlined the last sentence, and in the margin noted the name of dealer Sidney Janis as a possible contact, but nothing came of this. Münter persisted, however. In 1954, she proudly informed Lindsay that one of her paintings, *Stilleben, rot (Still Life, Red;* 1909) would be in a first American exhibition devoted to the Blaue Reiter, to take place at Curt Valentin's gallery in New York. "I do not know what works have been brought together there. One painting by me, *Still Life, Red* (1909) will hang there. I thought it would be sellable. It would be interesting to hear something of your impressions!"[17] The painting, which featured an American flag that Münter had brought back to Germany from her U.S. trip (and which surely was her reason for considering it particularly suitable to the American market), did not sell. Two years later, she again approached Lindsay about exhibitions, providing a list of eight paintings—including the *Stilleben, rot*—that he had volunteered to offer to New York's Museum of Modern Art. She set prices at 2,000–4,000 marks, which Lindsay figured to be the equivalent of $476.76 to $953.52.[18] The Museum of Modern Art showed no interest. When the museum organized its extensive 1957 exhibition *German Art of the Twentieth Century*, the first such exhibition in the United States since 1931, Münter's work was not in it. Only in a small exhibition of works from private collections in 1956, which Lindsay organized and in which he included several small sketches she had given him as gifts, did he manage to exhibit Münter's work in the United States.[19]

However, another American scholar, Peter Selz, had included Münter in his pioneering book *German Expressionist Painting* (1957), granting her a presence no prior study of the movement had done. "I am delighted that Peter Selz is writing so seriously about me," she wrote enthusiastically to Lindsay.[20] And finally she was sought out by American gallery owners, notably Dalzell Hatfield of Los Angeles and Leonard Hutton of New York, both of whom began to feature her work in exhibitions, attracted in part by the publicity she received when

she donated much of her collection of Kandinsky paintings to the municipal gallery of Munich. In July 1958, Münter could report with pride to Lindsay, "Now I am writing to you hurriedly. Dalzell Hatfield Galleries in Los Angeles has sold my painting *Kandinsky at the Tea Table* of 1910 for netto 6,000 dollars. So I have money left over and now your trip [to Europe] is not a 'question of money.' I can finance your so necessary European trip. ..."[21] Lindsay visited her in Murnau, and also arranged for the American collector Norbert Adler to visit her and purchase his first Münter painting directly. On June 20, 1960, Hatfield finally opened the first American exhibition devoted to Münter's work in Los Angeles; this exhibition traveled to the California Palace of the Legion of Honor in San Francisco. On November 22, 1961, Hutton offered the first show in New York. These exhibitions attracted significant attention and appreciation, especially among relatively younger collectors interested in purchasing modern art, who discovered in her works not only a style and motifs to which they could relate, but also prices far lower than for comparable works by other major pioneers of modernism. Accordingly, they often obtained not just one painting, but several by Münter. Mr. and Mrs. Harry Lynde Bradley of Milwaukee, for example, amassed eleven paintings, which today at the Milwaukee Museum of Art form the largest public collection of her art outside of Germany. A similar fascination with Münter caused Mr. and Mrs. Frank Taplin, Jr. in Princeton also to form a collection focused predominantly on her paintings.

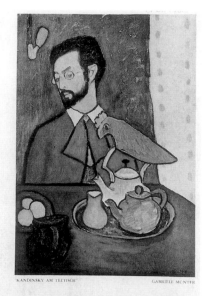

"KANDINSKY AM TEETISCH" GABRIELE MÜNTER

münter

Münter enjoyed this unprecedented American success only very briefly, however: she died in Murnau in 1962 at the age of eighty-five. Her work continued to sell well in the United States, although by the mid 1960s, as the German "economic miracle" took hold, German collectors increasingly became the dominant buyers. Regular American gallery exhibitions of the early 1960s slowly tapered off, and she was largely forgotten. Exhibitions of German Expressionist painting failed to include her. A major show of her work was organized in 1980 at the Busch-Reisinger Museum (accompanied by a small but significant catalogue by Anne Mochon) and traveled to the Princeton University Art Museum. Not until 1997, however, when the Milwaukee Art Museum organized the exhibition *Gabriele Münter: The Years of Expressionism, 1905–1920* did a major public institution in America devote an exhibition to her. In the wake of that show, the Marion Koogler McNay Museum in San Antonio became the first American museum to purchase a Münter painting, although Milwaukee and several others owned works that had been donated by museum patrons. The painting purchased was *Stilleben, rot*, the work identified by Münter in 1955 as particularly apt for a United States collection.

Reinhold Heller

GABRIELE MÜNTER

1 "Ich habe dorthin schon einige Beziehungen, nicht nur familiäre, (da ich in vielen Staaten amerikanische Cousins habe), sondern auch, weil einer der ersten bedeutenden Sammler, der mich beachtete, (zugleich der Erste, der sehr sachlich über die Anfänge der modernen Kunst geschrieben hat), A. J. Eddy in Chicago war." Gabriele Münter, letter to Katharine Kuh, March 26, 1950, archives of the Art Institute of Chicago. I wish to thank Sabine Wieber for bringing this letter to my attention.

2 For the fundamental biographic information concerning Münter, see Reinhold Heller, Gabriele Münter: The Years of Expressionism 1903–1920, Munich: Prestel, 1997, and Annegret Hoberg and Helmut Friedel, eds., Gabriele Münter 1877–1962: Retrospektive, Munich: Prestel, 1992.

3 Johannes Eichner, Kandinsky und Gabriele Münter: Von Ursprüngen moderner Kunst, Munich: Bruckmann, 1957, p. 27.

4 For a sampling of Münter's American sketches and photographs, see Heller, Gabriele Münter (as note 2), pp. 31–36.

5 See ibid., pp. 44–50. For an extensive consideration of the status of women artists in nineteenth- and early twentieth-century Germany, see Renate Berger, Malerinnen auf dem Weg ins 20. Jahrhundert: Kunstgeschichte als Sozialgeschichte, Cologne: DuMont, 1982.

6 Münter, undated recollection written for Johannes Eichner, mid 1950s. Gabriele Münter- und Johannes Eichner-Stiftung, Munich, as cited and transl. in: Heller, Gabriele Münter (as note 2), p. 12.

7 Münter, diary entry of May 17, 1911,

cited and transl. in: Heller, Gabriele Münter (as note 2), p. 16. Also compare the citation provided by Annegret Hoberg, Wassily Kandinsky und Gabriele Münter: Letters and Reminiscences 1902–1914, Munich: Prestel, 1994, pp. 45–46.

8 Münter, diary entry of May 17, 1911, in: Heller, Gabriele Münter (as note 2), p. 17; and Hoberg, Wassily Kandinsky and Gabriele Münter (as note 7), pp. 46–47.

9 For an extensive discussion of the Neue Künstlervereinigung München, including documentation and reconstructions of the exhibitions, see Der Blaue Reiter und das Neue Bild 1909–1912: Von der "Neuen Künstlervereinigung München" zum "Blauen Reiter," ed. by Annegret Hoberg and Helmut Friedel, exhibition cat., Munich, Städtische Galerie im Lenbachhaus, 1999. Unless otherwise indicated, my information concerning the histories of the Neue Künstlervereinigung and the Blaue Reiter exhibitions derives from this source.

10 Gründungszirkular (Neue Künstlervereinigung München, 1909), transl. in: Heller, Gabriele Münter (as note 2), p. 80.

11 "Ein Mr. Eddy aus Chicago war bei mir in München. … Er will für 1000 M kleine Sachen sofort kaufen u. überhaupt eine kleine Collektion m. Sachen 'aus allen Zeiten' sich anlegen. Fein!" Vasily Kandinsky, letter to Münter, August 21, 1913. Archives of the Gabriele Münter- und Johannes Eichner-Stiftung, Munich.

12 Kandinsky, letter to Arthur Jerome Eddy, October 17, 1913, cited in: Gisela Kleine, Gabriele Münter und Wassily Kandinsky: Biographie eines Paares, Frankfurt am Main: Insel, 1990, p. 434.

13 Kandinsky, letter to Münter, December 15, 1914. Archives of the Gabriele

Münter- und Johannes Eichner-Stiftung, Munich.

14 The locations of only two Münter paintings from Eddy's collection are currently known: Stilleben mit Königin (Still Life with Queen; 1912) (Art Institute of Chicago) and Stilleben Im Kreis (Still Life in Circle; 1911) (private collection). Compare the sales listing, Art Auction by Order of Jerome O. Eddy, Son of late Arthur J. Eddy, Chicago, Williams, Barker & Severn Co. Auctioneers, January 20, 1937.

15 Among her papers, Münter preserved a list of relatives she identified in 1945–46: Louise Mahan, Fairfax, Oklahoma; Lena and Helen Ware; Mrs. E. (Millie) Moore, Little Rock, Arkansas; Jennie C. Scheuber, Shreveport, Louisiana; Annie Scheuber Smith, Brownsville, Louisiana; Hall Hamilton. Archives of the Gabriele Münter- und Johannes Eichner-Stiftung, Munich.

16 Münter, letter to Lindsay, September 9, 1950, private collection.

17 Münter, letter to Lindsay, November 12, 1954, private collection.

18 Münter, letter to Lindsay, January 19, 1956, private collection.

19 Exhibition at Harpur College, State University of New York, Endicott.

20 Münter, letter to Lindsay, September 3, 1956, private collection.

21 Münter, letter to Lindsay, July 3, 1958, private collection. The painting was purchased by Billy Wilder, and later formed part of his donation to the Israel Museum, Jerusalem. Before sending the painting to Los Angeles, Münter restored or repainted portions, notably the area of the nose.

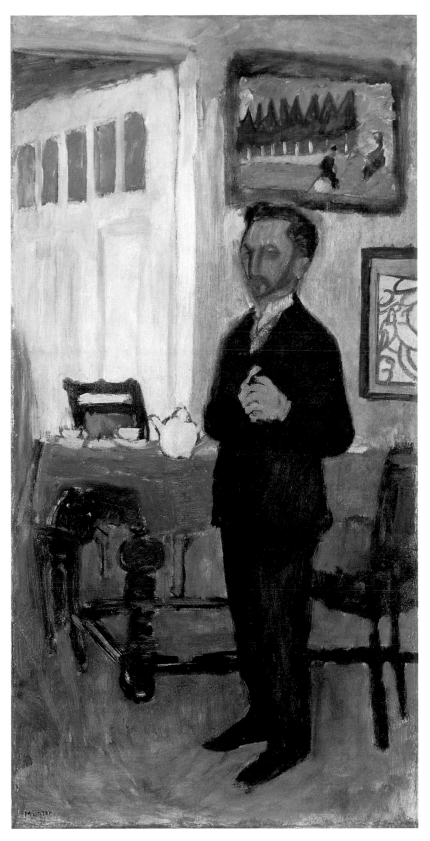

Kandinsky in Interior, ca. 1912 cat. II.22

VASILY KANDINSKY

* DECEMBER 4, 1866, MOSCOW
† DECEMBER 13, 1944, NEUILLY-SUR-SEINE

Cover designed by Katherine S. Dreier for the brochure *Kandinsky*, Société Anonyme, New York, March 1923. Yale Collection of American Literature, Beinecke Rare Book and Manuscript Library

Born in Moscow, Vasily Kandinsky grew up in Odessa and, from 1886 to 1892, studied law, economics, and ethnography at the University of Moscow. At the age of thirty, he decided to become an artist and went to Munich to study with Anton Azbè (1897–1898) and with Franz von Stuck (1900). From 1901 to 1903, Kandinsky taught at the art school of the Phalanx, an exhibiting society that he had co-founded in Munich. One of his students was Gabriele Münter, who became his companion. In 1902, Kandinsky began to exhibit with the Berliner Secession as well as the Association of South-Russian Artists in Odessa and the Phalanx in Munich. From 1903 to 1908, Kandinsky traveled extensively with Münter in the Netherlands, Tunisia, Italy, Germany, and France, where they resided for a year in Paris (1906–07).

In 1908, Kandinsky returned to Munich; that summer he and Münter stayed with Alexej Jawlensky and Marianne von Werefkin in the nearby village of Murnau. In 1909, the four were founding members of the Neue Künstlervereinigung München (New Artists Association of Munich) and presented two shows before Kandinsky, Münter, Franz Marc, and Alfred Kubin withdrew from the group in December 1911, after the jury rejected Kandinsky's large canvas *Komposition V (Composition V;* cat. no. II.26). Kandinsky and Marc organized *Die erste Ausstellung der Redaktion "Der Blaue Reiter"* (First Exhibition of the Editorial Board of the Blue Rider), which opened at Heinrich Thannhauser's Moderne Galerie in Munich later that month. Kandinsky and Marc were co-editors of the almanac *Der Blaue Reiter*, which appeared in May 1912. Late in 1911,

Kandinsky published *Über das Geistige in der Kunst* (On the Spiritual in Art) and *Klänge* (Sounds). Kandinsky had an important one-man exhibition at Herwarth Walden's Galerie Der Sturm in Berlin in 1912, and his art was shown internationally in 1913–14.

From the end of 1914 until late 1921, Kandinsky lived primarily in Moscow, except for a visit to see Münter in Stockholm in 1916. In 1917, he married Nina Andreevskaia in Moscow. Kandinsky joined the department of visual arts of Narkompros (People's Commissariat for Enlightenment) in 1918, taught at the Svomas (Free State Art Studios), and was appointed first director of the Muzei zhivopisnoi kul'tury (Museums of Painterly Culture) in 1919. In 1922, Kandinsky accepted a teaching position at the Bauhaus in Weimar. He and Nina moved with the Bauhaus to Dessau in 1925, and became German citizens in 1928. His book *Punkt und Linie zu Fläche* (Point and Line to Plane) was published in 1926. He continued to teach at the Bauhaus in Dessau until 1932 and then briefly in Berlin. After the Bauhaus closed in 1933, the Kandinskys relocated to Paris, settling in Neuilly-sur-Seine. During the Paris years, he wrote numerous essays and executed more than 350 works of art. He obtained French citizenship in 1939. Kandinsky died at the age of seventy-eight in 1944.

PUBLIC RECOGNITION

Throughout his career, Kandinsky was acutely aware of where his works of art were exhibited and how they were received. He understood the art market and played an active role in promoting his

art through exhibition associations, art dealers, museums, and private collectors. His point of view was international and encompassed a broad spectrum: Kandinsky stayed in contact with artists' groups in Odessa, Moscow, and Saint Petersburg when he lived in Munich. From 1901 to 1905, he kept a notebook with lists of the works lent to shows traveling in Germany. As early as 1904, his art was exhibited regularly in the Salon d'Automne in Paris and, from 1909, with the Allied Artists' Association at the Royal Albert Hall in London. Kandinsky recorded the exhibitions in which his works were shown as well as names of those who acquired them in handlists (*Hauskataloge*) or inventories of paintings, colored drawings, woodcuts, and later also of watercolors.

Not only German collectors—such as Bernhard Koehler and Karl Ernst Osthaus—but also the English educator Michael Ernest Sadler and the Chicago lawyer Arthur Jerome Eddy sought out Kandinsky. Eddy had seen Kandinsky's painting *Improvisation 27 (Liebesgarten) (Improvisation 27 [Garden of Love];* 1912) in 1913 at the Armory Show in New York, where it was acquired by the photographer Alfred Stieglitz. That summer Eddy purchased the three Kandinsky canvases shown with the Allied Artists' Association in London and went to Murnau to meet the artist, who was unfortunately not at home. Eddy acquired numerous works and, in 1914, arranged for the commission of four panels intended for the entrance hall of Edwin R. Campbell's New York apartment. He published excerpts from Kandinsky's letters and reproductions of his paintings in his book *Cubists and Post-Impressionism* (1914). Sadler's son, Michael T. H. Sadleir, translated *Über das Geistige in der Kunst* into English and wrote an introduction for it in 1914, thus making Kandinsky's theoretical and philosophical ideas accessible to a wider audience. Through his association with Walden's Galerie Der Sturm in Berlin, Kandinsky's work was presented in traveling exhibitions in Germany, the Netherlands, Scandinavia, and even Japan. Moreover, Walden published an album, *Kandinsky 1901–1913*, containing many illustrations and the artist's autobiographical text "Rückblicke" (Reminiscences).

Thus, during the Munich years, Kandinsky became a well-known artist throughout Europe. However, with the outbreak of World War I, he had to leave Germany quickly on August 3, 1914 as he was a Russian citizen. By 1917, he had little contact with colleagues in Germany. Although his involvement with Russian museums, art schools, and scientific academies was significant, the years in Russia marked a hiatus in his relations with Europe. His decision to return to Germany in 1921 was definitive: he could not go back to Russia. Kandinsky quickly reestablished contact with friends such as Paul Klee. He initiated legal action to recover the paintings left with Galerie Der Sturm and, through intermediaries, negotiated the return of some of the works that had remained with Münter during the war. Kandinsky resumed an ambitious exhibition schedule with the Galerie Goldschmidt-Wallerstein and Galerie Twardy in Berlin, Galerie Nierendorf in Cologne and Berlin, Moderne Galerie Thannhauser in Munich, and Galerie Neue Kunst Fides (Rudolf Probst) in Dresden. He participated in the Bauhaus exhibitions in Weimar as well as the *Erste russische Kunstausstellung* (First Russian Art Exhibition) in Berlin in 1922, and a show of Russian art organized by Otto Kallir and the Gesellschaft zur Förderung moderner Kunst in Vienna in 1924.

During the autumn of 1922, soon after he moved to Weimar, Kandinsky met numerous artists, collectors, critics, and art historians. The American collector and educator Katherine S. Dreier, who had

Vasily Kandinsky, ca. 1912 (photograph by Gabriele Münter)

Vasily Kandinsky, *Improvisation 27 (Liebesgarten) (Improvisation 27 [Garden of Love]),* 1912

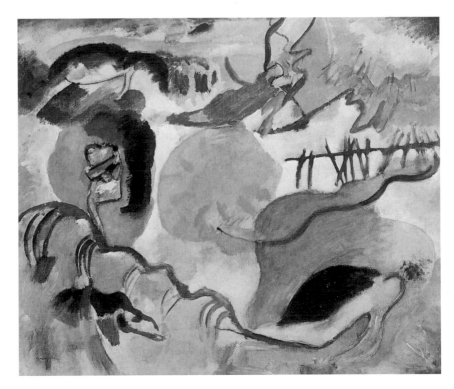

heard about Kandinsky when she studied art in Munich in 1912 and had purchased one of his paintings at the Galerie Der Sturm in 1920, came to visit the Bauhaus in October and met Kandinsky and Klee. Together with Marcel Duchamp, Dreier had founded the Société Anonyme in New York in 1920 and had already included Kandinsky's art in numerous group exhibitions organized by the Société. Dreier acquired several of Kandinsky's works in Weimar, she arranged for his first one-man show in America to be held at the galleries of the Société Anonyme in the spring of 1923, and she appointed him first honorary vice-president of the association. At the time of the Kandinsky exhibition in March–May 1923, New York critics noted the extreme degree of abstraction in Kandinsky's recent paintings and watercolors on view at the galleries of the Société Anonyme; they thus knew of his art. In the introductory text, Dreier quoted ex-

Marcel Duchamp, Katherine S. Dreier, and Vasily Kandinsky at the Dessau train station, 1929

tensively from the artist's essay "Rückblicke," and emphasized the clarity that Kandinsky achieved in his paintings from 1921–22, which she attributed to his belief that art has much in common with religion. Of the works included in the exhibition, Dreier acquired three paintings from 1921–22 for her own collection: *Bunter Kreis (Multicolored circle)*, *Kreise auf Schwarz (Circles on Black)*, and *Blauer Kreis (Blue Circle)*. Her preference for works from the Russian period is evident from the illustrations and text in the Société Anonyme catalogue and in her book *Western Art and the New Era: An Introduction to Modern Art* (1923). Dreier had also purchased works by El Lissitzky, Kasimir Malevich, Liubov Popova, and Nadezhda Udaltsova from the *Erste russische Kunstausstellung* in Berlin. In May 1926, Dreier visited Kandinsky again at the

Bauhaus and received two recent pictures. For several years, Dreier worked on an English translation of *Punkt und Linie zu Fläche*, which Kandinsky gave her permission to publish; however, she did not complete the project.

Kandinsky also met Emmy (Galka) Scheyer in 1922, probably when she came to visit Klee in Weimar. She had grown up in Braunschweig, where she studied music and painting: since 1917, she had dedicated her efforts to promoting the art of Jawlensky by organizing exhibitions, giving lectures, and writing. Because of her adventurous spirit and probably because of the terrible inflation in Germany, Scheyer founded the Blue Four group (comprised of Kandinsky, Klee, Jawlensky, and Lyonel Feininger) on March 31, 1924. A few weeks later, Scheyer left for the United States, where she would represent the four artists and promote their work; she brought with her two paintings and five Kandinsky watercolors on consignment. Soon after arriving in New York, she met with Dreier, but they did not collaborate on exhibitions. During the autumn of 1924, Scheyer worked for a few weeks for art dealer J. B. Neumann, who had emigrated from Berlin a year earlier, at his New York gallery (he did not, however, show the Blue Four). The first Blue Four exhibition opened at the Daniel Gallery in New York on February 20, 1925. Although the reviews were favorable and the show well attended, no works were purchased from the exhibition. However, in January, Scheyer sent Kandinsky thirteen dollars for two lithographs of 1923, *Orange* and *Violett*, which she had sold in New York.

At the end of May 1925 Scheyer traveled with Angelica Archipenko to California, and by late August, Scheyer had decided to settle in San Francisco. The artist Maynard Dixon introduced her to many influential people in the Bay area. During the first year in California, she gave lectures and organized Blue Four exhibitions at Stanford University, Mills College, the Oakland Art Gallery, and the Los Angeles Museum. William Clapp appointed Scheyer the European representative of the Oakland Art Gallery in 1926, and arranged for her shows to travel to institutions affiliated with the Western Association of Museum Directors. Scheyer sold several Kandinsky lithographs in 1926 and the photographer Edward Weston bought one in 1927. The San Francisco artist and professor Evelyn Mayer traveled with Scheyer to Europe during the summer of 1928: Mayer purchased Kan-

dinsky's recent painting *Bestimmend (Determining)* and later that year received a watercolor as a gift from the artist. In April 1929, the Oakland Art Gallery presented a one-man show of works by Kandinsky that Scheyer had obtained the previous summer from the artist himself and from the Galerie Neue Kunst Fides in Dresden. Scheyer organized another Kandinsky exhibition at the Braxton Gallery in Los Angeles in the following year. In April 1931, the California Palace of the Legion of Honor in San Francisco presented a Blue Four exhibition. The catalogue included a text by Diego Rivera and listed Kandinsky's *Kreise im Kreis (Circles Within a Circle;* 1923), lent by Mr. and Mrs. Walter Arensberg, and *Launischer Strich (Capricious Line;* 1924), lent by Rivera, as well as loans from the artist and collector Marjorie Eaton, Mayer, and Scheyer herself.

The German artist Hilla Rebay came to New York in 1927, where she met Solomon R. Guggenheim and persuaded him to collect nonobjective paintings rather than the Old Masters. Rebay was familiar with Kandinsky's art from her friend Hans Arp and from her contact with Galerie Der Sturm in Berlin before the war. In 1929, Guggenheim purchased three masterpieces from 1913: *Bild mit weissem Rand (Painting with White Border)*, *Helles Bild (Light Picture)*, and *Schwarze Linien (Black Lines)* (all of which belonged to the artist Georg Muche), through the dealer and artist Rudolf Bauer in Berlin for 15,000 marks. Early in 1930, Bauer bought for Guggenheim works from the 1920s, primarily from the artist himself and from the Galerie Ferdinand Möller in Berlin. On July 7, 1930, Mr. and Mrs. Guggenheim, accompanied by Rebay, visited Kandinsky in Dessau, where Guggenheim purchased *Composition VIII* of 1923 and Rebay acquired *Schweigsam (Taciturn)* of 1929. Rebay favored Kandinsky's recent geometric works rather than paintings from the Munich period, and she viewed his art within the context of nonobjective painting. By 1931, her admiration for Bauer and his art and her criticism of Kandinsky resulted in tension between Kandinsky and Rebay. Both Scheyer and Rebay were born in Germany, whereas Dreier was an American of German descent. All three women were artists themselves, and all believed in the spiritual meaning of abstract art. Although they did not work together, their collective efforts and individual eccentricities had an enormous impact on the presentation and interpre-

tation of Kandinsky's art in this country. All of them gave lectures and organized traveling exhibitions that toured different regions of the United States. All three women collected works of art, although Scheyer is the only one who can be considered an art dealer.

By 1931, the economic situation in Europe—especially in Germany—became much worse. Kandinsky hoped that he would be able to have a large exhibition in New York and sell more pictures in the United States. Dreier acquired her last two Kandinskys in 1929–30 and Guggenheim apparently did not purchase works in the years 1931–33. In December 1932, Valentine Dudensing presented an exhibition of twenty-seven paintings by Kandinsky at his gallery in New York, although he appears not to have sold works at that time. Earlier that year, the Art Institute of Chicago included several Kandinsky paintings in the exhibition of the Arthur Jerome Eddy Collection, which had entered the museum. In addition, in 1932, Scheyer organized a Blue Four exhibition for the Arts Club of Chicago, where she sold a few Kandinsky lithographs. Scheyer purchased watercolors for her own collection from the artist between 1930 and 1932; however, she found it increasingly difficult to sell works of art in the U.S. during the 1930s and she did not travel to Europe after 1933.

By 1933, when the National Socialists came to power, Kandinsky could no longer exhibit in Germany and, consequently, he turned his attention to France, Italy, England, and the United States. Even before he moved to Paris, he was in contact with the Galerie "Cahiers d'Art," and he arranged for numerous exhibitions in Paris from 1934 to 1944. In 1935, J. B. Neumann became Kandinsky's representative in the eastern United States, although Scheyer continued to represent him on the West Coast. Neumann organized a one-person show for January 1936 at his New Art Circle in New York. In

Irene Guggenheim, Vasily Kandinsky, Hilla Rebay, and Solomon R. Guggenheim in front of the Bauhaus in Dessau, 1930

Galka Scheyer and Vasily Kandinsky on the balcony of his house, Dessau, 1928

1937, Karl Nierendorf opened a gallery in New York and presented *Kandinsky: A Retrospective View*, which he organized with the College Art Association and circulated to the Cleveland Museum of Art and the Germanic Museum at Harvard University. Nierendorf showed works by Kandinsky as well as those of Klee and Feininger in December 1937; in subsequent years he played an important role in representing all three artists. Although Nierendorf collaborated on occasion with Scheyer, their relationship became competitive and acrimonious. Like Scheyer, Neumann and Nierendorf had known Kandinsky when they worked together in Berlin in the 1920s.

When Alfred H. Barr, Jr. organized the exhibition *Cubism and Abstract Art* in 1936 for the Museum of Modern Art in New York, he borrowed Kandinsky's works from the Art Institute of Chicago, Katherine Dreier, and J. B. Neumann, as the museum owned only one Kandinsky watercolor, a recent gift from Abby Aldrich Rockefeller. Barr placed little emphasis on Kandinsky in the catalogue, focusing instead on the significance of Cubism and merely relating Kandinsky to Fauvism. Likewise, in 1938, Kandinsky's work was not well represented in the exhibition *Bauhaus 1919–1928* at the Museum of Modern Art. At that time, Barr borrowed pictures by Kandinsky from Neumann and Nierendorf, and did not acquire any of his Bauhaus work for the museum. Kandinsky's hopes for a major one-man show in a New York museum were not to be fulfilled during his lifetime.

In contrast, Grace McCann Morley, the director of the San Francisco Museum of Art, presented various exhibitions of German art and showed *Kandinsky Abstractions* in May 1935 as well as a one-person show in 1939 surveying his work from 1923 to the present. In 1935, Howard Putzel arranged a Kandinsky watercolor show at his gallery in San Francisco, with Duchamp's assistance and the artist's approval, which infuriated Scheyer. Scheyer, who had settled in Los Angeles in late 1933, organized a Kandinsky show, which opened at the Stendahl Art Galleries there in February 1936 and then traveled to the San Francisco Museum of Art. Later, in 1940, Scheyer signed an agreement with Earl Stendahl and presented a Kandinsky exhibition at his gallery.

During the summer of 1935 and again in July 1936, Rebay and Guggenheim visited Kandinsky, who lived in Neuilly-sur-Seine near Paris at that time, and purchased numerous recent canvases from him directly. After the National Socialists confiscated works from German museums in 1937, the Swiss artist Otto Nebel contacted Rebay, who had become the curator of the Solomon R. Guggenheim Foundation, to propose that Guggenheim acquire pictures condemned as *entartete Kunst*. Consequently, Guggenheim purchased from Gutekunst & Klipstein in Bern major paintings by Kandinsky that had belonged to the Anhältische Gemäldegalerie in Dessau, the Staatliche Gemäldegalerie in Dresden, the Angermuseum in Erfurt, the Städtische Landesmuseum in Hannover, and the Kunstsammlungen zu Weimar. Guggenheim and Rebay also bought works that had belonged to private collectors in Germany primarily through Bauer and Nierendorf. By 1937, they no longer acquired works directly from the artist, and Kandinsky broke off contact with Rebay that year because she preferred Bauer's paintings to his.

Although Kandinsky was invited to teach at the Art Students' League in New York in 1931 and to be an artist in residence at Black Mountain College in North Carolina in 1935, he declined the offers. He never traveled to the United States and did not express great enthusiasm for Americans in general. He found it difficult to understand why "rich Americans" did not buy his pictures for what he considered to be low prices. On numerous occasions, Scheyer tried to persuade Kandinsky to visit her in Hollywood. The artist, however, focused his attention on Europe, where his work was more favorably received and where he felt at home. When Varian Fry, who worked closely with Barr, contacted Kandinsky on behalf of the Emergency Rescue Committee in 1941 and offered him and his wife visas to emigrate to the United States, the Kandinskys refused the offer, as they did not want to leave France. At that time, Kandinsky was seventy-four years old and had already relocated several times. Certainly the preference for Cubism and Surrealism and the resistance to abstract art in America were deterring factors. After the artist's death in 1944, a large memorial exhibition was presented at Guggenheim's Museum of Non-Objective Painting in New York and subsequently traveled to Chicago, Milwaukee, and Pittsburgh in 1945–46. Among the collectors who lent to the exhibition were Walter Arensberg, William Dieterle, and Leslie Maitland from California; Ludwig Mies van der Rohe and Katharine Kuh from Chicago; Wilhelm R.

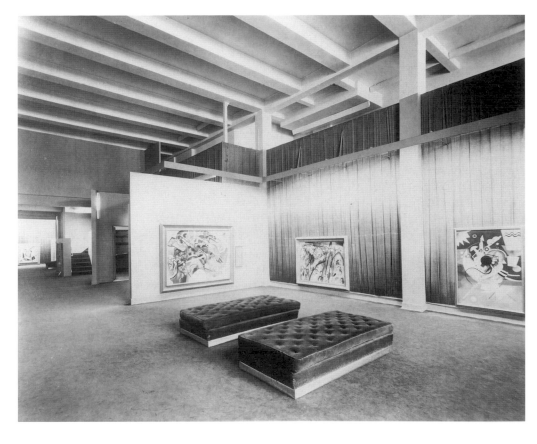

Installation view of *In Memory of Wassily Kandinsky* at the Museum of Non-Objective Painting, Solomon R. Guggenheim Foundation, New York, March 15–April 29, 1945 (extended through summer). Photograph © Solomon R. Guggenheim Foundation, New York

Valentiner, and Lydia and Harry Winston from Michigan; Helen Resor, Evangeline Zalstem-Zalessky, as well as Dreier and Rebay, who lived in Connecticut. The following year, Rebay published an English edition of *Point and Line to Plane*. After Nierendorf died in 1947, the contents of his gallery were purchased by the Museum of Non-Objective Painting. Dreier, who had given most of the Société Anonyme collection to Yale University in 1940, bequeathed the rest of her Kandinskys to the Museum of Modern Art, the Museum of Non-Objective Painting, and the Phillips Collection in Washington D.C. upon her death in 1952.

The largest collections of Kandinsky's work belong to the Solomon R. Guggenheim Museum in New York; the Städtische Galerie im Lenbachhaus in Munich (which received a large gift from Gabriele Münter in 1957); and the Musée National d'Art Moderne, Centre Georges Pompidou in Paris, to which Nina Kandinsky bequeathed all the artworks and archives from the artist's estate. In addition, the state museums in Moscow and Saint Petersburg as well as regional museums that acquired pictures through the Museums of Painterly Culture possess Kandinsky works from 1902–21. In the United States, the concentrations of Kandinsky's art are primarily due to the extraordinary efforts of three women, Katherine Dreier, Galka Scheyer, and Hilla Rebay, who were passionately committed to modern art.

Vivian Endicott Barnett

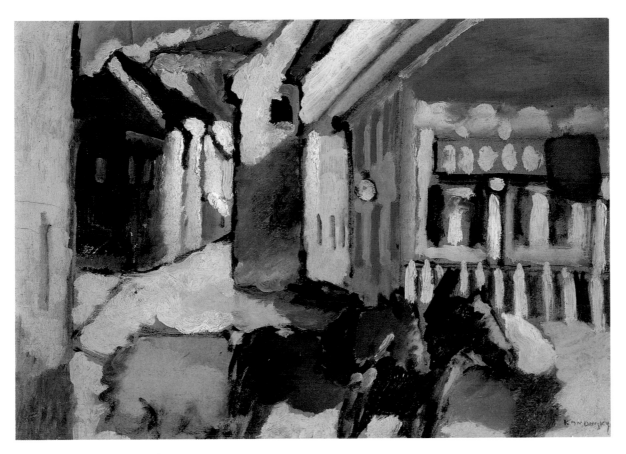

Murnau: Street with Horse-Drawn Carriage, 1909 cat. II.25

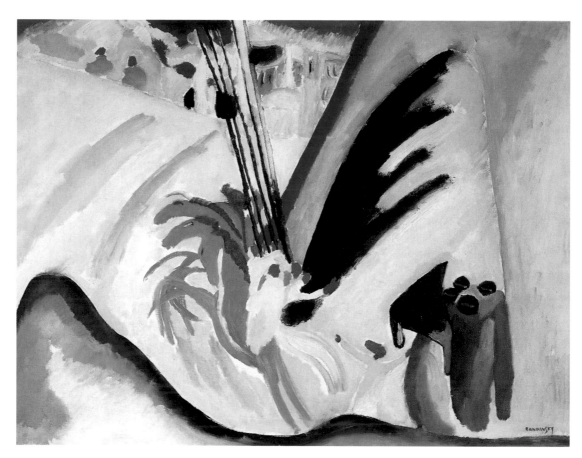

Arabs II, 1911 cat. II.27

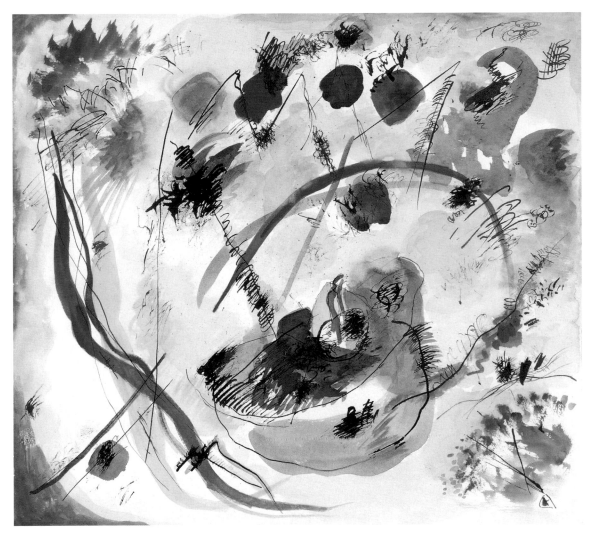

Red and Blue, 1913 cat. II.28

FRANZ MARC

* FEBRUARY 8, 1880, MUNICH
† MARCH 4, 1916, VERDUN

Review of the exhibition of woodblock prints by Franz Marc at the Paul Elder Gallery, as featured in the *Wasp*, San Francisco (January 1927)

Franz Marc was born in 1880, the second son of the painter Wilhelm Marc and his wife Sophie. In 1899, Franz took up studies of theosophy and philology at the Ludwig-Maximilians-Universität in Munich, with the intention of pursuing a career in the church; however, within a year he had enrolled at the Münchner Kunstakademie (Art Academy). There he studied under Wilhelm von Diez and Gabriel von Hackl, former pupils of the history painter Karl Piloty. In 1901, Marc visited Italy, and spent the summer of 1902 sketching at a cottage in the village of Kochel am See in Bavaria. In 1903, he accompanied a fellow student, Friedrich Lauer, on a trip to Paris. In France, he first encountered the work of the French Impressionists, which had a profound impact on him.

In 1905, Marc met the artist Marie Schnürr and her student Maria Franck; he spent the summer of the following year painting with them at Kochel am See. In the spring of 1907, Marc married Marie Schnürr. In the same year, he made a second trip to Paris, where he was particularly struck by the work of Vincent van Gogh and Paul Gauguin. Upon his return to Munich, Marc devoted himself to *plein air* painting and gave private lessons in anatomical drawing in order to earn a living. In 1909, Marc made his first sales of artwork, to the Munich dealers Franz Joseph Brakl and Heinrich Thannhauser. In 1910, Marc met the brothers Helmuth and August Macke, as well as the affluent industrialist and art collector Bernhard Koehler, Jr. Marc began to study the painting of Henri Matisse and had his first one-man show at the Brakl Gallery in Munich. In the same year, he divorced Marie Schnürr and in 1911 married Maria Franck. His friendship with Vasily Kandinsky began in 1911, as did his short-lived membership in the Neue Künstlervereinigung München (New Artists Association of Munich); Marc had seen the group's exhibition in 1910 at the Moderne Galerie Thannhauser and had defended their work against critical attacks at that time. Plans arose for the almanac *Der Blaue Reiter* (which appeared in May 1912). Meanwhile, by the summer of 1911, disagreements within the Neue Künstlervereinigung prompted Marc, Kandinsky, Gabriele Münter, and Alfred Kubin to leave the group.

During 1912, Marc traveled to Berlin and Paris, meeting Brücke artists Ernst Ludwig Kirchner and Max Pechstein, composer Arnold Schönberg, poets Guillaume Apollinaire and Else Lasker-Schüler, and painters Robert Delaunay and Henri Le Fauconnier. It was around this period that he also had his first encounter with Futurism. In the same year, Marc was invited onto the committee of the Cologne *Sonderbund* exhibition. It was also during this year that he engaged in a dispute over aesthetic matters with the painter Max Beckmann, published in the pages of *Pan*. In 1913, he was in Tyrol; in 1914, he settled in Ried. After the outbreak of war, he was conscripted and served on the Western Front. In March 1916, he was fatally wounded by a grenade at Gussainville, near Verdun.

PUBLIC RECOGNITION

Marc's status in Germany around 1913–14 as a (tentative) pioneer of abstraction was largely due to his friendship with Kandinsky, and must be seen

in the context of their collaboration in the Blaue Reiter project. Virtually all the activities of the Blaue Reiter were the result of the ideas and efforts of this pair. As Kandinsky wrote: "The Blaue Reiter consisted of two people: Franc Marz and myself. … In reality there was no association called the Blaue Reiter, also no group. … Marc and I took up what seemed to us to be important, freely chosen, without worrying about anybody else's opinions or wishes. …"[1] Kandinsky and Marc's collaboration

Franz Marc, ca. 1913

generated two exhibitions and the publication of the almanac *Der Blaue Reiter,* the latter financially supported by Koehler.[2]

The catalogue of the first Blaue Reiter exhibition listed forty-three works, shown at Thannhauser's Moderne Galerie in December 1911.[3] It was met with almost universal incomprehension; the only surviving review, which appeared in the *Augsburger Postzeitung* (December 22), was devastating. It spoke of "shouting madness" and an "infantile and color-mad pollution of canvases." Such comments paved the way for the later defamation strategies of the National Socialists.

The second and last Blaue Reiter exhibition, devoted to works on paper, was presented by the Munich bookseller and art dealer Hans Goltz, from February through April 1912. The organizers included international artists as well as various German Expressionist graphics and woodcuts, which were slowly

becoming recognized as having reached a point of refinement not seen since the Renaissance.[4]

As a protagonist of a modern art that was distinctly and indisputably German, Marc became familiar to critics, collectors, and museum directors in the United States at a fairly early date. In fact, he was one of the first of these German artists to have a one-man show in America. It was presented at the Paul Elder Gallery in San Francisco in 1927 and subsequently traveled to the Fine Arts Gallery in San Diego; the exhibition focused on Marc's graphic works. Writing for *The Argonaut,* Junius Craven noted, in particular, Marc's colored woodcuts: "In the wood block prints of Franz Marc one recognizes a master mind and hand. He has the intellect of a Dürer simplified and uncluttered with extraneous symbolism. … His composition is almost perfect, and the rhythm and balance of color distribution is extraordinary."[5]

The presentation of Marc's work at the San Francisco gallery was largely due to the concerted

Cover of the exhibition catalogue *Franz Marc,* Buchholz Gallery, November 11–December 7, 1940. The Museum of Modern Art Library, New York. Photograph © 2000 The Museum of Modern Art, New York

efforts of German émigré Galka Scheyer. In the spring of the previous year, Scheyer had already succeeded in mounting two exhibitions of what she termed her "Blue Four"—Lyonel Feininger, Alexej Jawlensky, Vasily Kandinsky, and Paul Klee—at Elder's space. It was Scheyer's efforts in California to promote those particular four artists

Three Red Horses, 1911: Franz Marc

Marc Found in Animals What Humans Lack

Franz Marc, one of the best known of the European modernists in color reproductions and one of the least known in original works, is being accorded his first large one-man show in this country at the Buchholz Gallery, New York, until Dec. 7. The German artist, who died in 1916 when only 36 years old, painted the famous swirling studies of *Blue Horses* and *Red Horses*.

The Buchholz show, comprising 25 oils and watercolors, features the large *Red Horses* in which pigment is carried to full, bursting strength to depict three animals arranged in pin-wheel design in a landscape. The show also includes numerous studies of cows, deer, other horses, and several landscapes, all of them ranging from semi- to complete abstraction.

Why Marc painted animals so frequently is explained by Robert Goldwater in the exhibition catalogue: "He wished especially to interpret the animal world because it was above all in beasts that he found those qualities he felt lacking in men and in himself: harmony within their own beings, a group cooperation unquestionably accepted and harmoniously carried out, and a successful sub-

mission and adaptation to the laws of nature. Because man struggled (with himself, with others, with the world), with the beasts did not, he was 'ugly' and they were 'pure.' This harmony Marc expresses in his pictures by means of a continuity of design that spreads from animal to animal until all are united in a common movement and a common mood."

Marc's highly emotional color and his abstract design are characteristics of the Blue Rider group of German modernists, which he helped found with Klee and Kandinsky. Like these two, he came out of the 19th century Munich naturalism which the three jettisoned after their contact with Paris. In many of the later paintings design grows more complex and abstract under the impetus of Picasso, Braque, and, apparently, Duchamp, for the *Bewitched Mill*, lent by the Chicago Art Institute, has violent planular movement as in cubism.

In his more restrained moods Marc achieved some of his most effective compositions, such as the relatively quiet, rather pathetic *Yellow Horse* of 1913, the sombre *Three Horses* of 1911, and the finely composed *Good Shepherd* of 1912.

that would result in Marc's initial posthumous recognition in the United States.

Not until 1940, however, did a genuine interest in Marc's work develop on the East Coast. That year, between November 11 and December 7, the Buchholz Gallery in New York presented a Marc exhibition, providing the first opportunity on the East Coast to study firsthand an artist whose work was hitherto known principally from color reproductions.[6] This remarkable show presented a relatively comprehensive view of Marc's output, just a year before America entered into war with Germany. Accompanied by an equally remarkable catalogue, it included ten oil paintings and twenty works on paper (five prints and a total of fifteen gouaches, watercolors, and drawings). Press coverage included a large-format illustration of Marc's *Drei rote Pferde (Three Red Horses;* 1911) in the *New York Times* (November 17, 1940). Among the private lenders were the artist and former Bauhaus teacher Feininger (who had recently emigrated from Germany to America) and Willem Beffie of Brooklyn, New York (a steadfast collector of Marc's work), who loaned three paintings to the show. Though small, the catalogue of the show also contained a three-page essay by art historian Robert J. Goldwater, who just two years before had published the widely read book *Primitivism in Modern*

Painting.[7] In that text, Goldwater briefly sketched the essential characteristics of Marc's work and the influences on his ultimate turn toward abstraction, citing the interest among modernist artists in "primitive" art, children's drawings, folk art, and the work of Matisse and Picasso. He nonetheless concluded that Marc, while responding eagerly to such sources, had succeeded in producing an "œuvre unique in style and personality."[8] Goldwater's comments indicate the level of esteem in which Marc's work was held at this relatively early date in America. A decisive step forward for Marc's reputation had already been taken in 1931, when Alfred H. Barr, Jr. decided to include six of his works in the groundbreaking exhibition *German Painting and Sculpture* at the Museum of Modern Art in New York. Barr's unqualified respect for Marc's work was evident: he reproduced the artist's 1913 painting *Der Mandrill* on the catalogue cover and described Marc within its pages as "perhaps the most brilliant of the 20th century German painters." About *Der Mandrill* he observed that Marc "submerges the grotesque color scheme of the animal itself in a kaleidoscopic pattern of line and color."[9] This latter statement is perhaps the earliest indication of an American tendency to value Marc's work primarily for its decorative qualities. A similar take can be seen in a 1939 *Art News* review of an exhibition of German Expressionist works at Karl Nierendorf's gallery in New York. Describing Marc's painting *Stallungen (Stables;* 1913), the critic emphasized the propensity toward "rectangularity" in his work: "In the Cubist technique and biting color familiar in other of his paintings of that year, he has created a frenzied abstraction the swirling facets of which, upon examination, resolve themselves into an assemblage of lively equine shapes. The strong sharp diagonals are interrupted by what becomes the active movement of a twisted neck, a whirling tail, or a twitch of rump."[10] Marc's Buchholz show of the following year was discussed in similar terms in *Art Digest*, where reference was made to the artist's "highly emotional color and his abstract designs," which were slowly becoming regarded as characteristic of the work of all the artists associated with the Blaue Reiter.[11]

In America, then, the recognition of Marc's work was a milestone connected with a growing interest in abstract art. Unfortunately this meant that to a certain degree an appreciation of his art was reduced to an appreciation of merely its formal

aesthetic aspects. Be that as it may, during the 1940s the Museum of Non-Objective Painting (now the Guggenheim) in New York acquired several important paintings by Marc, including *Knabe mit Lamm* (*Young Boy with a Lamb*; 1911) and *Stallungen*.

In Germany, meanwhile, Marc's work had been received quite differently. The incisive and uncompromising art critic Carl Einstein, in his 1926 book *Die Kunst des 20. Jahrhunderts*, offered the following observations on the artists associated with the *Blaue Reiter* almanac: "This group … seems to me to have been at the heart of new developments in German art. They were concerned with experimenting and inventing something far more than yet another variant of painterly technique … namely, a transformation of the spiritual state [of modern cultural life]. The movement they represented was in every respect part of a larger pan-European development. Artists in Germany were at last beginning to confront the issue of the autonomy of painting and of the freely evolving processes of visionary seeing."[12]

Einstein was speaking of a newly evolving concept of the painted image that had the capacity to bring about cultural renewal. Gustav Pauli, director of the Hamburger Kunsthalle, had already voiced a similar position in his small 1922 monograph on the

Gustav Pauli, 1914

Mandrill, about which he observed: "Animals are loved and respected [by Marc] because he believes that the will to life is more purely embodied in them than it is in human beings. [Humans] are preoccupied above all with submitting the natural world to their own will, to which end they are easily capable of ravishing its face almost without noticing and, in the process, becoming slaves to their own inventions."[13]

Pauli's comments point to Marc's harsh critique of civilization and materialism. Like Kandinsky, Marc repudiated nineteenth-century faith in science and early twentieth-century rationalism, materialism, and agnosticism as symptoms of humanity's alienation. His response to this bleak cultural situation was to adopt a unifying, Romantic paradigm that was fundamentally at odds with an essentially critical modernist position. It was precisely this aspect of Marc's work that Alois J. Schardt highlighted in his 1936 monograph on the artist, which was published to commemorate the twentieth anniversary of the artist's death. Schardt had been hired by the National Socialists to direct the Berlin Nationalgalerie, after the dismissal of Ludwig Justi, who had held the post since 1909. Schardt's deftly phrased argument was a calculated attempt to rehabilitate Marc's work by aligning it with nineteenth-century German Romantic painting, increasingly embraced

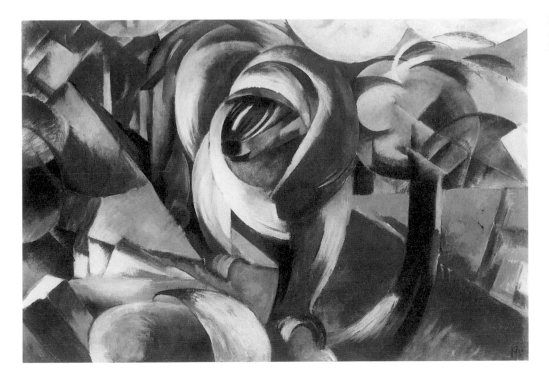

Franz Marc, *Der Mandrill* (*The Mandrill*), 1913. Hamburger Kunsthalle

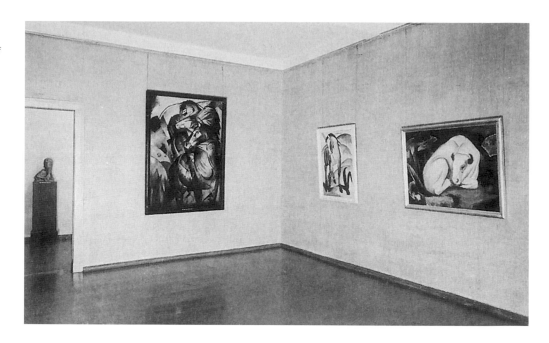

Installation of Franz Marc's paintings (arranged by Alois J. Schardt), including *Turm der blauen Pferde (Tower of the Blue Horses),* 1912–13, in the new section of the Nationalgalerie Berlin, Kronprinzenpalais, 1933

by National Socialist cultural officials: "These pictures by Franz Marc—images intended to liberate us from ever-increasing individualism and intellectualism, seeking to reintegrate us within the great continuum of nature and other living beings, and so successful in their search for a symbolic form that subsumes the individual object—take up the program of a movement that first emerged a hundred years ago as Romanticism, and that set itself similar challenges. … The Romantic program was the renewal of a Nordic-oriented will to life and, ultimately, a renunciation of the exaggerated sense of individual identity."[14]

Apart from the attempt to legitimize the artist's work, Schardt's thesis also struck at the heart of its most problematic aspect: its "objective" core. Behind the painter's culturally defined rejection of "exaggerated individualism" lies a thinly veiled nihilism. The age of the "great spirits" promulgated by the Blaue Reiter admitted no compromise. The rolling back of the materialist Wilhelminian age was a process that would lead to decidedly doctrinaire features in the context of Marc's art and thought.[15] Largely unaware of this, an American public continues to view Marc's work as an exercise in formal aesthetics.

Olaf Peters
Translated from the German by Elizabeth Clegg, with Nicholas T. Parsons.

1 Cited in Klaus Lankheit, *Franz Marc. Sein Leben und seine Kunst*, Cologne: DuMont, 1976, p. 93.

2 On Koehler's role, see Silvia Verena Schmidt-Bauer, "Bernhard Koehler als Mäzen und Sammler des Blauen Reiters," in: *Der Blaue Reiter und seine Künstler*, ed. by Magdalena M. Moeller et al., exhibition cat., Berlin, Brücke-Museum; and Kunsthalle Tübingen, 1998–99, pp. 117–125. See also Katharine Erling, "Der Almanach der Blaue Reiter," in: *Der Blaue Reiter*, ed. by Christine Hopfengart, exhibition cat., Kunsthalle Bremen, 2000, pp. 188–239.

3 On the exhibition, see Mario-Andreas von Lüttichau, "Der 'Blaue Reiter' in der Modernen Galerie Heinrich Thannhauser," in: *Der Blaue Reiter und das neue Bild. Von der "Neuen Künstlervereinigung München" zum "Blauen Reiter,"* ed. by Annegret Hoberg and Helmut Friedel, exhibition cat., Munich, Städtische Galerie in Lenbachhaus, 1999, pp. 315–320.

4 On this point, see Ida Katherine Rigby, "The Revival of Printmaking in Germany," in: *German Expressionist Prints and Drawings: The Robert Gore Rifkind Center for German Expressionist Studies*, vol. 1, ed. by Stephanie Barron, Munich: Prestel, 1989, pp. 39–65.

5 Junius Craven, "Art Notes," in: *The Argonaut* (January 22, 1927).

6 *Franz Marc*, exhibition cat., New York, Buchholz Gallery, 1940.

7 Robert J. Goldwater, *Primitivism in Modern Painting*, New York: Harper & Brothers, 1938.

8 Goldwater, in: *Franz Marc* (as note 6).

9 Alfred H. Barr, in: *German Painting and Sculpture*, ed. by Barr, exhibition cat., New York, Museum of Modern Art, 1931, p. 29.

10 D. B., "Marc and a Small But Important Group of German Expressionists," in: *Art News* (May 6, 1939), p. 15.

11 *Art Digest* (November 15, 1940), p. 20.

12 Carl Einstein, *Die Kunst des 20. Jahrhunderts*, 3d ed., Berlin: Propyläen, 1931, cited in: *Einstein: Werke—Berliner Ausgabe*, vol. 5, ed. by Uwe Fleckner and Thomas W. Gachtgens, Berlin: Fannai & Walz, 1996, p. 241.

13 Gustav Pauli, *Franz Marc. Der Mandrill*, Hamburg: N.p, 1922, p. 5. See also the many anatomical studies of animals made by Marc in 1907–10, a striking example being the *Panther, einen Ochsen angreifend* (*Panther Attacking an Ox;* 1907) reproduced in the monograph by Alois J. Schardt cited in note 14.

14 Alois J. Schardt, *Franz Marc*, Berlin: Rembrandt, 1936, p. 100.

15 This aspect of Marc's later work has recently encouraged the implicit, if rather contrived, accusation that his thinking embraces elements that might be construed as proto-fascist. On this point, see Peter Ulrich Hein, *Die Brücke ins Geisterreich. Künstlerische Avantgarde zwischen Kulturkritik und Faschismus*, Reinbek bei Hamburg: Rowohlt, 1992, passim; and Beat Wyss, *Der Wille zur Kunst. Zur ästhetischen Mentalität der Moderne*, Cologne: DuMont, 1996, pp. 172–179. On the intellectual historical basis of Marc's views, see Cornelia Klinger, *Flucht Trost Revolte. Die Moderne und ihre ästhetischen Gegenwelten*, Munich: Hanser, 1995.

expression of a widely different temperament—the one Northern, the other Latin. Whereas French art is largely concerned with subtly calculated formal relationships, German art is impulsive and based upon emotional values, expressed in terms of line and bold pattern and an uninhibited use of color."[1] The distinction between French and German art posited by Rathbone is contradicted in the person and the work of August Macke. The artist, who by the time of this show had been dead for more than twenty-five years, was represented in it with his *Frau vor einem Hutladen (Woman in Front of a Hat Shop;* 1913), which had been confiscated from the Museum Folkwang in Essen during the 1930s by the National Socialists. While his early work and his intellectual interests were marked by his knowledge of the art of the Italian Renaissance and of the established masters of the nineteenth century,[2] Macke had been quicker than many of his German colleagues to engage with the work of French contemporaries and to adapt their stylistic principles. As early as June 1907, he expressed enthusiasm for their work: "When I was in the Louvre and saw everything there and finally even Rembrandt in all his somber greatness, and then afterwards came to the [Musée du] Luxembourg with its [pictures by] Manet, Degas, Pissarro, Monet, then I really felt as if I had just emerged from a crater into the sunlight."[3]

With his ordinary motifs of strolling couples and women gazing into shop windows, Macke turned to a contemporary iconography that Charles Baudelaire, writing in the second half of the nineteenth century, had already insisted was required to interpret the modern world. The melancholy mood of the *flâneuses*, together with his apparent allusion to the "commodity aesthetic," might be taken as symptomatic of the social alienation (or even isolation) in the world Macke was depicting.[4] However, his light-flooded and strongly colored vocabulary of forms seems to counter this pessimistic reading. In fact, Macke's principal interest was in the formal, or decorative, aspect of his treatment of subjects. The anonymity of Macke's figures in such works does not represent a critique of modern civilization; only recently has this viewpoint informed the critical reception of his œuvre.[5]

It was not only as an artist that Macke helped to establish modernism in Germany; his contribution also had a decisive cultural-political component. One of the central publications of the avant-garde,

the almanac *Der Blaue Reiter*, appeared in May 1912. It was produced by Reinhard Piper of Munich, with substantial financial support from Koehler.[6] Although Macke was at a remove from the core group of contributors, his commitment to the project is nonetheless evident: the almanac reproduced his painting *Der Sturm (The Storm;* 1911) and included his essay "Die Masken" (Masks), in which he argued that content should determine artistic form.[7] Macke was talented at conceptualizing and promoting exhibitions.[8] He persuaded the Gereonsklub in Cologne (which had opened with a show of work by Vincent van Gogh, André Derain, Pablo Picasso, and others) to take an interest in the Rheinland Expressionists.[9] He then introduced the club to the artists associated with the Blaue Reiter's almanac. In 1913, he was the moving force behind the important *Ausstellung Rheinischer Expressionisten* (Exhibition of the Rheinland Expressionists), mounted at the Bonn art gallery and bookshop Kunstsalon Friedrich Cohen, run by the brothers Fritz and Heinrich Cohen. This exhibition was subsequently shown at Herwarth Walden's Galerie Der Sturm in Berlin as the *Erster Deutscher Herbstsalon* (First German Autumn Salon).[10] Macke was also a member of the committee formed to select and prepare the large international *Sonderbund* exhibition, mounted in Cologne in 1912 by the Sonderbund Westdeutscher Kunstfreunde und Künstler (Union of

August Macke, ca. 1904–05

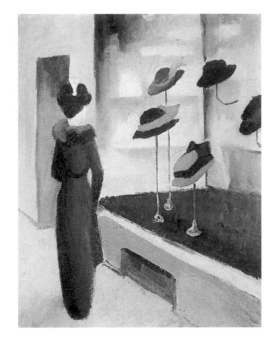

August Macke, *Hutladen (Hat Shop)*, 1913. Städtische Galerie im Lenbachhaus, Munich

Western German Art Lovers and Artists). This was an event of enormous significance throughout Europe.[11] It also had a direct influence on the reception of the European artistic avant-garde in America, and provided the most significant model for those who planned and organized the seminal Armory Show, which took place in New York in 1913.[12]

Macke's own aesthetic position was best voiced by Gustav Vriesen, the author of a 1953 biography of the artist.[13] Vriesen also penned a text for the catalogue accompanying his first one-man exhibition in the United States. The show, held at the Fine Arts Associates gallery in New York from March 24 to April 17, 1952, was organized by art dealer Otto M. Gerson and included twenty-four oils and eighteen watercolors.[14] In his essay, Vriesen alluded to Macke's "special role among the Germans," thereby implicitly contradicting Rathbone's above-cited argument, while nevertheless reiterating the notion of an elemental distinction between German and French art: "Among the German painters before 1914 Macke's work rings an especially clear and pure note. There is nothing heavy and problematic in his paintings—as we so often find in German art. His paintings are not an intellectual experiment—they have their origin in an abundance of the joy of being alive, they breathe grace and harmony. They have sensuality and highly developed feeling for color and form. These characteristics and the qual-

Poster design for the *Ausstellung Rheinischer Expressionisten*, Kunstsalon Friedrich Cohen, Bonn, 1913

Art gallery and bookstore
Friedrich Cohen, Bonn

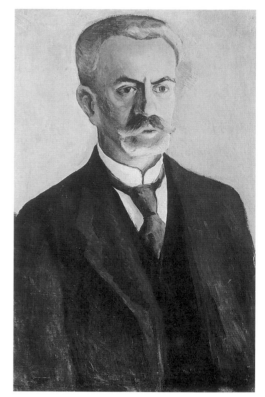

August Macke, *Portrait of Bernhard Koehler*, 1910

ity of his paintings establish the esthetic niveau of Macke's work. … His artistic development goes hand in hand with his close relationship to French art."[15]

A few years after World War II, Macke's affinities with French art, both aesthetically and philosophically, had begun to be stressed. From a German perspective, the promotion of Macke's art as full of lightness and joy was a welcome balm for the privations of the postwar period. The oversimplified characterization of Macke's work—as indebted to developments in French modernist painting—by his early American interpreters was an obvious marketing strategy. Nevertheless, despite a preference for French rather than German art, Macke's œuvre still remains largely unknown to a broad American public.

Olaf Peters
Translated from the German by Elizabeth Clegg, with Nicholas T. Parsons.

1 Perry T. Rathbone, in: *Landmarks in Modern German Art,* exhibition cat., New York, Buchholz Gallery, 1940.

2 See Ernst-Gerhard Güse et al., eds., *Macke und die Tradition. Zeichnungen aus den Skizzenbüchern von 1904 bis 1914,* 2d ed., Münster: Landschaftsverband Westfalen-Lippe, 1986.

3 August Macke, letter to Elisabeth Gerhardt, June 25, 1907, cited in: Irene Kleinschmidt-Altpeter, "August Macke—Aspekte des Frühwerks. Der Beginn—die Skizzenbücher—erste Porträts," in: *August Macke. Gemälde, Aquarelle, Zeichnungen,* ed. by Ernst-Gerhard Güse, exhibition cat., Münster, Westfälisches Landesmuseum für Kunst und Kulturgeschichte; Bonn, Städtisches Kunstmuseum; and Munich, Städtische Galerie im Lenbachhaus, 1986–87, p. 18.

4 See Sherwin Simmons, "August Macke's Shoppers: Commodity Aesthetics, Modernist Autonomy, and the Inexhaustible Will of Kitsch," in: *Zeitschrift für Kunstgeschichte,* vol. 63, no. 1 (Spring 2000), pp. 47–88.

5 For a different reading of the situation, see Jutta Hülsewig-Johnen, "Gesichter der Stadt. Überlegungen zur Menschendarstellung in den Grossstadtbildern des Expressionismus," in: *Die Grossstadt als "Text,"* ed. by Manfred Smuda, Munich: Fink, 1992, pp. 239–263, esp. pp. 253–257.

6 On Koehler's role, see Silvia Verena Schmidt-Bauer, "Bernhard Koehler als Mäzen und Sammler des Blauen Reiters," in: *Der Blaue Reiter und seine Künstler,* ed. by Magdalena M. Moeller et al., exhibition cat., Berlin, Brücke-Museum; and Kunsthalle Tübingen, 1998–99, pp. 117–125.

7 August Macke, "Die Masken," in: *Der Blaue Reiter,* Munich: Piper, 1912, pp. 21–26; see also Rosel Gollek, "Indianer, Sturm und Masken. August Mackes Beitrag zum Blauen Reiter," in: *August Macke. Gemälde, Aquarelle, Zeichnungen* (as note 3), pp. 39–48; and Ursula Heiderich, "'Der Leib ist die Seele.' August Mackes Beitrag zum Almanach Der Blaue Reiter," in: *Der Blaue Reiter,* ed. by Christine Hopfengart, exhibition cat., Kunsthalle Bremen, 2000, pp. 248–254.

8 See Katharina Schmidt, "August Macke in Bonn—1910 bis 1913. Kulturpolitische Aktivitäten und Aspekte seiner Malerei," in: *August Macke. Gemälde, Aquarelle, Zeichnungen* (as note 3), pp. 49–74.

9 See *Der Gereonsklub 1912–1913. Europas Avantgarde im Rheinland,* Bonn: Verein August-Macke-Haus, 1993, passim; *Die Rheinischen Expressionisten. August Macke und seine Malerfreunde,* exhibition cat., Bonn, Städtisches Kunstmuseum; Krefeld, Kaiser Wilhelm-Museum; and Wuppertal, Von der Heydt-Museum, 1979; and Peter Dering, "Die 'Rheinischen Expressionisten.' August Macke und sein Kreis," in: *Die Expressionisten. Vom Aufbruch bis zur Verfemung,* ed. by Gerhard Kolberg, exhibition cat., Cologne, Museum Ludwig, 1996, pp. 119–128.

10 See Georg Brühl, *Herwarth Walden und "Der Sturm,"* Leipzig: Edition Leipzig, 1983, passim; M. S. Jones, *Der Sturm: A Focus of Expressionism,* Columbia, S.C.: Camden House, 1984; and Volker Pirsich, *Der Sturm. Eine Monographie,* Herzberg: Bautz, 1985, passim.

11 On the early stages of this association, see Magdalena M. Moeller, *Der Sonderbund. Seine Voraussetzungen und Anfänge in Düsseldorf,* Cologne: Rheinland-Verlag, 1984, passim. On the exhibition of 1912 and its reception, see Wulf Herzogenrath, ed., *Frühe Kölner Kunstausstellungen. Sonderbund 1912, Werkbund 1914, Pressa USSR 1928,* Cologne: Wienand, 1981, which serves as a companion volume to the reprint of the exhibition catalogues; see also Wulf Herzogenrath, "Internationale Kunstausstellung des Sonderbundes Westdeutscher Kunstfreunde und Künstler zu Köln 1912," in: *Die Kunst der Ausstellung. Eine Dokumentation dreissig exemplarischer Kunstausstellungen dieses Jahrhunderts,* ed. by Bernd Klüser and Katharina Hegewisch, Frankfurt am Main: Insel, 1991, pp. 40–47.

12 See Milton W. Brown, *The Story of the Armory Show,* 2d ed., New York: Abbeville Press, 1988; and Bruce Altshuler, *The Avant-Garde in Exhibition: New Art in the 20th Century,* New York: Abrams, 1994, pp. 60–77.

13 Gustav Friesen, *August Macke,* Stuttgart: Kohlhammer, 1953; 2d ed., 1957.

14 *August Macke,* exhibition cat., New York, Fine Arts Associates/Otto M. Gerson, 1952.

15 Gustav Vriesen, in: *August Macke* (as note 14), p. 6.

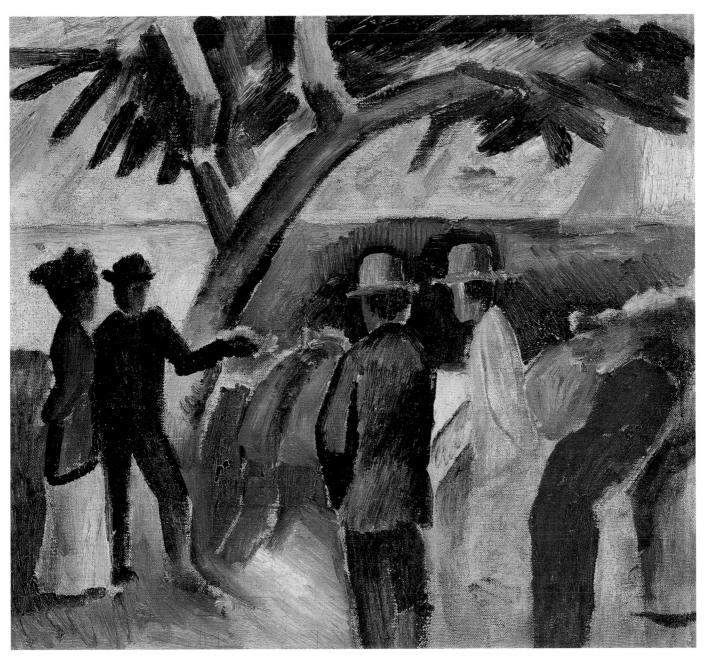

Strollers at the Lake II, 1912 cat. II.32

THE MYTHS OF EXPRESSIONISM IN AMERICA

PAMELA KORT

The question that concerns us is this: in a modern civilization, which prides itself on ever-transcendent progress, just how could any cultural phenomenon (whether style or attitudinal complex) endure and deepen over a span of decades and continents? More simply, why does expressionism seem to possess a broader public acceptance than such synchronous styles as cubism (historically more significant) or abstraction (today, generally thought synonymous with modern art)?[1]

In 1975, when art historian Donald E. Gordon wrote those words, German Expressionist art was indeed well on its way to attaining a new and unexpected level of popularity in America that was not easy to explain. In the following decade, enthusiasm would also mount around the so-called neo-Expressionist work of younger German artists born during or immediately after World War II. By the end of the 1980s, American interest in this art reached its twentieth-century apogee. What was it about Expressionism that was so captivating to the American eye?

Yes, the growing number of publications and exhibitions devoted to Expressionism since 1970 helped focus public attention upon it. True, the heightened emotionalism and agitated brushwork of neo-Expressionist art was refreshing to an American public growing weary of the prosaic severity of Conceptual and Minimalist art. And certainly, both generations of artists were increasingly appreciated during the 1980s for their role in the revival of American figurative painting. But none of this fully explains why such a broad public should find Expressionism so deeply appealing as the twentieth century approached its end.

In the earliest collection of essays devoted to modern German art to appear in the United States—*The New Vision in the German Arts* (1924)—American writer Herman George Scheffauer described the "essence of Expressionism" in terms that would

be reiterated time and time again in America through the course of the century: "The true expressionist not only realizes and expresses the real world—that is, its veritable soul as he declares, but he is as pitiless toward his own feelings as toward those of his fellow men. The inherent, the arcane truth is what he seeks and this explains the hideousness, the inhuman, other-worldly terror and strangeness that dwell in much expressionist art."[2]

Ultimately, it seems to be precisely these purported qualities—its ghastliness, ruthlessness, and eerie otherness—oversimplifications though they are, that lie at the core of Americans' continuing fascination with Expressionism. No matter that many Expressionist paintings are landscapes, genre scenes, and portraits. Throughout the twentieth century, their paint strokes have been pejoratively characterized as fierce, their intense colors as clashing, and their handling of form unbridled to the point of crudeness. All of this indicates the extent to which Expressionism has remained linked with *human behavior* rather than aesthetics, a mode of behavior that was (and to a large extent still is) understood as distinctly and endemically German.

Ironically, the American reception of Expressionism as an exclusively German version of modernism stands in diametric opposition to the objectives of early proponents of the style in Germany. Those cultural critics hoped that by appropriating a

"Electro-diagnosis" of the character with Byssky diagnoscopy, from Robert W. Schulte, "Über Elektrodiagnose seelischer Eigenschaften" in *Psychologie und Medizin*, 1925

designation, originally associated with emerging French painting, they could establish the *internationalism* of new trends in early twentieth-century German art. Another, equally trenchant element that drew Americans to Expressionism seems to have been the early equation of the style with the temperament of the "depraved" artist. The first book translated into English about Expressionism—*Expressionism in Art: Its Psychological and Biological Basis* (1922)—was written not by an art historian, but by Oskar Pfister, a psychologist close to Freud, who asked: "Is Expressionism only an expression of the pseudo-anarchistic tendency among us at the present time, which by means of Bolshevistic radicalism is shattering the old table of the law? Is it a question of oddity and desire for originality? Of degeneration and decadence? Of paranoia and hebephrenia? ... Are we facing, not a fettered negativism? [*sic*] A new inward compulsion ...?"[3]

By the time Pfister wrote his book, the association of artistic genius with degeneracy and anarchism had been in place in Europe for thirty years.[4] Not surprisingly, Pfister's queries also fell on receptive ears in America, where the book was reissued

in 1923: this was a decade when many influential theories about human nature were conceptualized. Though the theoretical viewpoints came from various branches of the humanities, most of them agreed: only through the exercise of intellect and restraint, efficiency, progress, and science could the imperiled condition of divided modern man be salvaged.[5] With regard to German Expressionism, the result was a subtle shifting from an analysis of the style to an investigation of the *allegedly psychotic disposition of its makers*. Although it took longer to fully manifest itself, this trend too played a decisive role in bringing Expressionism to the attention of a broad-based American public.

Finally, there can be no question that American interest in Expressionist art intensified *because that art was denounced and suppressed* in National Socialist Germany. Never really accepted abroad as a vanguard genre, but, rather, sensationalized as the "art that Hitler hates," Expressionist art was newly intriguing to Americans precisely because the National Socialists victimized it. This perception effectively extricated Expressionism from its sociohistorical context. By the late 1950s (and culminating in the 1990s), Expressionism was primarily valued

in America as a testament of the power of art to survive. Not only had it borne witness to and lived through a devastating period in history but, in the wake of World War II, it also was credited as having prophesized this very era. Perhaps more than any other factor, its ability to endure the attacks leveled against it seem to have been responsible for bringing about Expressionism's legitimization as an important movement in twentieth-century art. How such myths gained currency in the United States—through the popularity of three decisive American museum exhibitions—and why they prevailed—the political and cultural context that allowed their success—these are the subjects of this essay.

DECISIVE DELAYS

Few of the artists known today as Expressionists referred to themselves as such. For lack of a better rubric, the term "Expressionism" was coined not by artists but by their chroniclers, to encompass the multifaceted, often only tangentially related works of artists active in at least six German regions: the Brücke artists who emerged in 1905 in Dresden (including Erich Heckel, Ernst Ludwig Kirchner, and Karl Schmidt-Rottluff); painters first associated in 1909 with the Neue Künstlervereinigung (New Artists Association) and then from 1911 with the Blaue Reiter in Munich (including Vasily Kandinsky, Alexej Jawlensky, Paul Klee, Franz Marc, and Gabriele Münter); artists associated around 1910 with the Neue Secession in Berlin (Käthe Kollwitz, Ludwig Meidner, and Max Pechstein); painters active in northern Germany (Paula Modersohn-Becker and Emil Nolde); artists working around the same time in the Rheinland region (Ernst Barlach and Wilhelm Lehmbruck among them); and finally, painters living in and around Frankfurt, such as Max Beckmann.

Though not politically radical, pre–World War I Expressionists were united by their disdain for the bourgeois culture and imperial politics of Wilhelminian Germany. Following World War I, many Expressionist artists not only affiliated themselves with the politically progressive aims of the November Revolution, but also felt their art had anticipated its goals. Few of these artists were actual anarchists, although they may have been advocates of a "revolutionary," sometimes "spiritualist" counterculture.

The history of the exhibition of German art in America during the twentieth century began in 1903. That year saw the founding of the Germanic Museum in Cambridge, Massachusetts. And yet, despite the aim of its first curator, German-born Kuno Francke—"to illustrate by reproductions … the development of

German culture from the first contact of Germanic tribes with the civilization of the Roman Empire to the present day"—it was not until 1931, when Charles Kuhn became his successor, that the museum began to acquire and exhibit Expressionist art.[6]

The first showing in America of actual works by German painters and sculptors took place in 1904 in the Palace of Fine Arts at the Louisiana Purchase International Exposition in Saint Louis. Though the cultural officials who organized the fair were interested in modern German art, the works chosen by their counterparts in Germany for the exposition were not by avant-garde artists.

Contemporary German Art—the next important exhibition of German art in the United States—appeared in 1909 at the Metropolitan Museum of Art, the Art Institute of Chicago, and the Copley Society of Boston. Despite the show's title, its 130 paintings and 30 sculptures were anything but contemporary. It seems that the German government's meddling thwarted the intentions of its American organizer and co-sponsor—German émigré Hugo Reisinger—"to give an impression of the accomplishment of German painting of the last thirty years."[7] The two academic painters (Arthur Kampf and Carl Marr) chosen by German officials to curate the show omitted younger artists and ignored work by more established avant-garde painters such as Lovis Corinth and Max Slevogt. Unfortunately, far from being an isolated case, this practice came to characterize officially sponsored exhibitions of modern German art during the ensuing years.

In his review of the 1909 exhibition, published in the well-known German arts periodical *Kunst und Künstler*, art historian Wilhelm R. Valentiner criticized the clumsiness of German cultural officials, accusing them of failing to assure the quality of the exhibition—just as they had with the world's fairs at Chicago in 1893 and Saint Louis in 1904.[8] Valentiner (who had just taken a curatorial post at the Metropolitan Museum) recognized that it was an important, missed opportunity to present the work of emerging artists within the context of achievements by the older vanguard painters who had partly inspired them.

In 1912, Martin Birnbaum, an émigré Hungarian lawyer and aficionado of modern art, traveled with the American art critic Christian Brinton to Europe to organize what Birnbaum proposed would be "the finest exhibition of modern German graphic art ever shown in this country."[9] In many respects, Birnbaum accomplished his aim, although the majority of the three hundred works in his exhibition were by conservative rather than progressive artists.[10] Nevertheless, *Contemporary German*

Installation view of *Exhibition of Contemporary German Art* at the Metropolitan Museum of Art, New York, January–February 1909. Metropolitan Museum of Art, New York

Installation view of *Contemporary German Graphic Art* at the Worcester Art Museum, March 9–30, 1913. Courtesy Worcester Art Museum, Worcester, Massachusetts

Graphic Art provided an American public with an unprecedented viewing opportunity. After the show's presentation in December 1912, at the Berlin Photographic Company (a publishing house based in Germany), Birnbaum arranged for it to travel during 1913 to several museums in the United States, including the Art Institute of Chicago, the Buffalo Fine Arts Academy, the Worcester Art Museum, and the City Art Museum in Saint Louis.[11] These comments from a 1913 review of the exhibition in *Studio International* by W. H. de B. Nelson indicate that the reception of this art as *modern* was at best lukewarm. "The marvelous locomotives of Lyonel Feininger, the horses of Franz Marc, the Somali dance of Pechstein give a note of comic relief to the Russian peasants of Barlach, and it is a long cry from Kandinsky, with *Composition No. 4*, to the work of Max

Slevogt. Let us not jeer. They are in earnest and theirs may be the art of tomorrow."[12]

In 1913, Americans should have had a chance to view many Expressionist paintings firsthand. For it was then that the groundbreaking Armory Show—the first large exhibition to present international trends in modern art in America—opened in New York and then traveled to Chicago and Boston. However, although the exhibition was modeled on the 1912 Cologne *Sonderbund* exhibition—the most important presentation of Expressionism as an international movement—the Armory Show's organizers included only a few Expressionist works: *Improvisation (no. 27)* from 1912 by Kandinsky; *Wirtsgarten in Steglitz (Garden of an Inn in Steglitz;* 1911) by Kirchner; and two sculptures by Lehmbruck: *Stehende weibliche Figur (Standing Woman;* 1910) and *Die Kniende (Woman Kneeling;* 1911), as well as six of his works on paper.[13] Only one critic even commented upon the inadequate presence of contemporary German art in the exhibition.[14] Shortly after the exhibition closed, World War I broke out, effectively bringing the development of Expressionist art in Germany to a stop, and chilling American curiosity concerning cultural developments there.

Expressionism's rather late introduction in America, then, had at least three causes. First, during the period of the style's emergence, it found no official support and as a result was excluded from exhibitions sanctioned by the German government that were to be presented abroad. Further, in the first decades of the twentieth century, though both public officials and private patrons frequently traveled from America to Europe, with few exceptions they paid little attention to developments in German art, focusing instead on modern French art. Finally, the outbreak of World War I not only put a halt to American-German cultural relations, but also resulted in anti-German sentiments that tainted the perception of this art for more than a decade afterward. Fully aware of this, only a few plucky individuals tried to advance the cause of German art in the United States immediately after the war. Among these were: Katherine S. Dreier, J. B. Neumann, Hilla Rebay, Galka Scheyer, and Wilhelm Valentiner, all of whom (apart from Dreier) emigrated to the United States from Germany during the 1920s.

TELLING FIRST VOICES

There was at least one purely practical reason why many individuals connected with the promotion of modern art in Germany came to the United States during the early 1920s. By 1923, the German mark had become so devalued that the art market (like the rest of the German economy) virtually collapsed. In contrast, the strength of the American dollar held out the promise of a comparatively wealthy buying public. As it turned out, these hopeful émigrés would, at least at first, be disappointed: Americans were still not particularly eager to acquire modern German art. This reluctance can be attributed in part to political tensions that did not begin to ease until 1924, when the Dawes Plan was initiated by the American government to help Germany recover economic stability.

Nevertheless, an optimistic Valentiner—who had returned from war service in Germany to become an adviser to the Detroit Institute of Arts—opened *A Collection of Modern German Art* during October 1923 in the temporary exhibition rooms of the Anderson Galleries, a New York auction house. The show, organized with the assistance of Berlin art dealer Ferdinand Möller, was comprised of 274 works by thirty living artists. A

Wilhelm R. Valentiner, undated photograph.
Photograph © 2001 The Detroit Institute of Arts

scholar of Dutch art, Valentiner became a deep admirer of Expressionism under the influence of Marc, whom Valentiner met while training as a military officer.[15]

Aware that Americans would probably find the work of more socially conscious postwar artists offensive because of its pessimist tone, Valentiner excluded from the show such artists as Otto Dix. He did, however, include two George Grosz drawings, which were described in the *New York Times* as "vulgar" and

Exterior of the Anderson Galleries, Park Avenue and 59th Street, New York, 1924.
Mitchell Kennerley Papers, Manuscripts and Archives Division, The New York
Public Library, Astor, Lenox and Tilden Foundations

casting aside the picture many Americans had formed of Germany as a militaristic, indeed barbarous country, early critics of modern German art managed, if anything, to reinforce these engrained prejudices.[20]

The idea of the "terrible earnestness" of this art was not an American invention. It can be traced to one of the earliest books published on Expressionism, Hermann Bahr's 1916 *Expres-*

Preview of the exhibition *Modern German Art* at the Anderson Galleries, New York, in the *International Studio* (October 1923)

"an unpleasant surprise."[16] The agenda of Valentiner's catalogue essay was to present Expressionist art as a product of a "country that has been cut off from the world for years and has developed an art more indigenous than almost ever before in its history."[17] He underscored the *authenticity* of modern German painting by insisting that it had been influenced only negligibly by French art. Anything but a dilettante, Valentiner seems to have chosen to distort the facts in order to capitalize on the attraction of these works as *Echt Deutsch*. Nonetheless, as a kind of counterbalance, Valentiner included fifty-two works by Feininger, an expatriate American artist. Celebrated as one of Germany's best painters, but virtually forgotten at home, he was perhaps a more palatable representative.

Despite these strategies and a lengthy advance article in the *International Studio*, this dynamic, pioneering exhibition was not well attended.[18] Not only did it come too soon after the carnage of World War I, but the economic and political chaos of the Weimar Republic was regarded with reserve and even suspicion in America. A review in the *New York Tribune* certainly did not help: its conservative author Royal Cortissoz criticized the tastelessness of German artists who "rejected technical discipline altogether, cultivating instead that crude, fumbling mode of expression which seems to be the special sign of the modernist."[19] Although several reviewers were more sympathetic, any admiration was hesitant. An October 1923 article in *Art News* had a telling subtitle: "A Kind of Terrible Earnestness. Even in Landscapes at Times an Intentional Brutality." Far from

sionismus. For Bahr, Expressionism was a cultural spirit with the power to help man regain his very soul, which had been stolen from him by the machine. He wrote: "Never yet has any period been so shaken by horror, by such a fear of death. Never has the world been so silent, silent as the grave. ... Distress cries aloud: man cries out for his soul; this whole pregnant time is one great cry of anguish. Art too joins in, into the great darkness she too calls for help, she cries to the spirit: this is Expressionism."[21]

Cover of the book *Expressionismus* by Hermann Bahr, Munich, 1918 (second edition)

Cover of the book *Western Art and the New Era* by Katherine S. Dreier, New York, 1923. The Museum of Modern Art Library, New York. Photograph © 2000 The Museum of Modern Art, New York

Hermann Bahr's study, designed by Joseph Maria Olbrich (Gustav Klimt's *Nuda Veritas* was built into the wood paneling). Photograph ca. 1905

Katherine S. Dreier, ca. 1930–35

Bahr's book was widely read in German-speaking Europe and was republished there in 1918 and 1920 (although it would not be translated into English until 1925). The book also attracted the attention of Katherine Dreier, who kept it in the reference library of America's first museum of modernist art, the Société Anonyme, which she founded in 1920. Dreier, who spoke German fluently, quoted a passage from it dealing with the value of artistic "inner vision" in her 1923 book *Western Art and the New Era: An Introduction to Modern Art,* in the chapter entitled "What Is Modern Art?"[22]

The popularity of Bahr's book is also evidenced by Valentiner's obvious debt to it in his 1923 catalogue essay. There, Valentiner described modern German art as being like "life itself that rises out of the depths like a cry, and in this cry carries the deepest expression of true humanity."[23] Valentiner seems to have understood that such language was more likely to win Americans over to the cause of German art than an intellectual argument for its modernity. The identification of Expressionism with an "anguished cry" eventually became one of the more treacherous clichés associated with this art.

Here it should be recalled that the first book on the style in English, Pfister's 1922 *Expressionism in Art: Its Psychological and Biological Basis*, was so popular that Dutton Books in New York reissued it in 1923, in the same year that Valentiner opened his show. Pfister, who had also carefully read Bahr, disagreed with him, arguing: "The expressionist artist cannot be

merely deduced out of a protest against the artistic or cultural milieu … Expressionism is a 'cry of distress', like a stream of lava forcing itself forward prompted by the soul's misery and a ravenous hunger for life." Indeed, it is with Pfister that the equation of Expressionism with idiosyncratic behavior really begins. Arguing that all Expressionist works are essentially portraits of their makers (who to his mind were regressively autistic), Pfister concluded: "The chaos of the picture betrays the confusion of the expressionist himself, the brutal color and outlines the brutality of his character."[24]

Well aware of the dangers of such judgments, Sheldon Cheney denounced Pfister's "malicious definition of Expressionism" in his *Primer of Modern Art*, which appeared the following year. One of the most popular and respected accounts of modernism in America, it had two chapters devoted to Expressionism. Pfis-

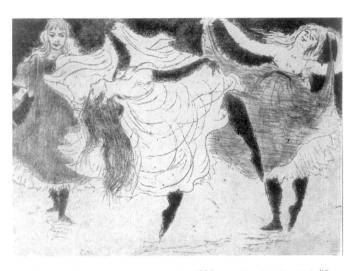

Lovis Corinth, *Dancers*, etching and aquatint, 1895, reproduced in the article "German Art After The War" by Julius Meier-Graefe, in the *Dial*, July 1923

particular—and their unnaturalistic images. According to him, they renounced realism because they now saw the world with a vision that was *psychologically* super-charged. Herein lay the modernity of German Expressionism, which Cheney proclaimed "the most vigorous art development anywhere in the world."[27]

GERMAN ART AFTER THE WAR

BY JULIUS MEIER-GRAEFE

Translated from the German by Kenneth Burke

SUPERFICIAL examination fails to reveal with us the influence of the war on the artists. And not only with us. Neither have the victors gained any jubilating fresco by their triumph. Painting goes on, and sculpture, it seems, as though nothing had happened. This phenomenon is taken for granted, and is explained in accordance with the individual temperament and manner of thinking. Sceptics fall back on a precarious Platonism: according to them, art spends its shadowy life so far from all reality that even the decay of the world could not disturb it. The socialist finds a confirmation for his legend of the time-wasting of a privileged class, and he compares the Muse to an all-night restaurant in Berlin which is never empty even in the worst periods of destitution. Idealists harp on the nonsense of the catastrophe. For them the war is simply the hypertrophy of a dirty *fait divers* which pure art has nothing to do with.

In reality, nothing stands out so prominently in the art of the present as the world war; and unfortunately the impossibility of determining the duration of the catastrophe makes it more difficult to uncover the correlated facts. No one knows yet when the war is over, even if he does imagine himself capable of fixing its start. For art, it did not begin on the day when some potentate or other gave the order to mobilize and the first grenade shook the air, but long before. It was not the military incidents which affected the creative faculties, nor the verdict of victory or defeat; but it was the

ter's disclaimer of "any but a biological and psychological intent" angered Cheney, who attempted to refocus attention upon Bahr's idea of Expressionism as the antithesis of Impressionist art.[25] Given Cheney's scant knowledge of German, his discussion and development of Bahr's theories were most likely indebted to conversations with Dreier. Soon after joining the Société Anonyme in 1920, Cheney became a member of its library committee. Recent scholarship has suggested that his position as such had the important effect of drawing Cheney's attention to the art of German-speaking Europe, an area in which Dreier was particularly interested.[26] Ultimately, but under the influence of Bahr, Cheney also emphasized the connection between the *psychic state* of modern artists—Expressionists in

Another important work published in 1924 (likewise influenced by Bahr) was Scheffauer's *The New Vision in the German Arts*. Scheffauer was a poet whose work was frequently reviewed, including by the cultural journal *The Dial*. Beginning in 1921 and continuing until 1929, under the editorship of Scofield Thayer and later Marianne Moore, *The Dial*'s pages regularly contained reproductions of Expressionist works and a "German Letter." Paul Westheim, an established art critic in Germany, devoted the magazine's very first "German Letter" to a discussion of Expressionist art. Thayer also asked the well-known art historian Julius Meier-Graefe to contribute an article, titled "German Art After the War," which appeared in *The Dial* in July 1923. Although Meier-Graefe had admired the work of Beck-

mann, Lehmbruck, and Marc, after 1911 he turned his back on even these modern German painters, whose work he decried as becoming too "decorative" for his taste. The pessimistic tone of Meier-Graefe's 1923 essay is therefore not surprising. Indeed, it harkened back to this very change of attitude, first articulated in his 1912 lecture "Wohin treiben wir?" (Where are we heading?). A passage from his *Dial* text sheds light on the double bind into which Expressionist art had been forced by 1923: "It was not the military incidents [leading to World War I], which affected the creative faculties ..., but it was the root of the evil, the spiritual and moral confusion of Europe. In art there was nothing but the defeated. ... Every development after the mighty rise of the nineteenth century ... pointed to the coming catastrophe. ... The *rôle* of German art corresponds to the role of Germany. There, culture has already been for a long time the matter of a few personalities: peaks with slight connection to one another."[28]

With such words, Meier-Graefe intended not only to discredit the achievements of the few Expressionist artists he had once briefly supported, but also to imply that, far from transcending the depravities of pre–World War I Europe, their art was hopelessly mired in them. His statement also makes reference to the disconnected condition of modern German culture, which was racked by infighting among its critics and its artists. In the early 1920s, his words rang particularly true vis-à-vis Expressionism. By then, its early proponents had abandoned the style, less than a decade after they had embraced it. Even Wilhelm Worringer, who was one of Expressionism's first and most persistent advocates, jumped ship, writing in 1921 that the genre seemed to be "a last-ditch effort of art despairing about itself."[29]

These harsh (and enduring) reactions in Germany had a significant impact on the reception of German Expressionism in the United States. For the time being, they meant the end of further studies about the style, which had yet to be thoroughly analyzed by those German critics who were in a position to do so. Bahr's histrionic book on Expressionism, which appeared in English in 1925, remains the only early German discussion of the style in art historical terms ever to appear in America. By then it was all but out of date in Germany, where Expressionism had been rejected by the political left as not sufficiently revolutionary, by the right as too radical, and by the Dadaists as a component of an escapist bourgeois society partly accountable for the war.[30] This no-win situation spelled the end of Expressionism as truly vanguard art in Weimar Germany, but as yet did not prevent it from becoming further institutionalized there.

ISOLATIONIST AMERICA AND THE YARN OF GERMAN ART AS "INDIGENOUS"

Curiously enough, it was neither a scholar nor an institution that organized the first mildly successful museum show of Expressionism in America, but three bright undergraduate students at Harvard University: Lincoln Kirstein, Edward M. M. Warburg, and John Walker III. *Modern German Art* was the sixteenth exhibition mounted by the Harvard Society for Contemporary Art, founded by them on December 12, 1928. Almost completely forgotten today, the show ran April 18–May 10, 1930 at the university's "Coop" in Harvard Square. Kirstein's ties with the newly appointed director of the Wadsworth Atheneum, A. Everett Austin, resulted in the show traveling to this Hartford,

John Walker III, Lincoln Kirstein, and Edward M. M. Warburg

Connecticut museum, where it was on view from May 19 until June 2 of the same year. According to the Wadsworth Atheneum's 1930 Annual Report, the exhibition "drew a good attendance, particularly at the evening openings." Austin clearly regarded this art as vanguard, as revealed in this statement: "It seems very important that a museum should exhibit as much contemporary art as possible if it is to be of real educational value; and a fair estimate of modern forms much [*sic*] include progressive as well as academic art."[31] By this time, German-

American relations were so improved that "it could be safely said that no two major powers had fewer difficulties and worked better with each other than the United States and Germany."[32] The Harvard Society's focus on recent art was quite unique for its time in America. With the support of Edward Forbes, the director of Boston's Museum of Fine Arts, and the museum's associate director Paul Sachs, the organization quickly gained a reputation for assembling excellent shows that featured the newest trends in art, architecture, and design. A small catalogue

Cover of the exhibition catalogue *Modern German Art*, Harvard Society for Contemporary Art, Cambridge, 1930. The Museum of Modern Art Library, New York. Photograph © 2001 The Museum of Modern Art, New York

Alfred H. Barr, Jr., New York, 1931–33 (photograph by Jay Leyda)

with a fine, though brief preface (probably penned by Kirstein) accompanied *Modern German Art*. Its checklist records twenty-two paintings, twelve sculptures, and twenty-five works on paper, by almost all of Germany's leading artists, including Beckmann, Grosz, Kirchner, Nolde, Pechstein, and Schmidt-Rottluff. Valentiner, who was now serving as the director of the Detroit Institute of Arts, lent the majority of the works, while a number of others came from New York art dealer J. B. Neumann. The exhibition also included more than a hundred prints lent by the Galerie Arnold in Dresden. These were exhibited in both Cambridge and Hartford, and later at the California Legion of Honor in San Francisco.

Neumann again played a key role in the next museum exhibition of contemporary German art in America, organized in 1931 by Alfred H. Barr, Jr., a brilliant young art historian, who in 1929

had become the first director of the newly founded Museum of Modern Art. Barr had initially met Neumann at his gallery in July of 1926, and by October of that year was corresponding with him frequently. The seriousness of Barr's growing interest in developments in German art is indicated by the comprehensive list of German publishers Barr sent to Neumann, with a request for his assistance in importing the books at dealer prices. Quite proficient in German, Barr also wanted to make reproductions from the books to be used in classes he was then teaching at Wellesley. Partly financed by a scholarship, he spent most of November 1927 in Germany, visiting with many of the Bauhaus masters in Dessau before leaving for Berlin, where he remained until December 24. After four months in Russia, Poland, Austria, and Czechoslovakia, Barr returned to Germany on the way back to America. After calling upon museum officials, dealers, and collectors, he wrote to Neumann to say that he was "still very much interested in modern German art. I hope to write several short articles, one on Dix, Grosz, Schrimpf, etc.—the *sogenannte Neue Sachlichkeit* [the so-called New Objectivity]—one on Feininger, one on Schmidt-Rottluff (as typical of the *'Brücke'*), … We must talk about these things."[33]

Barr was not unaware of the activities of the Harvard Society. In fact, the following year he reviewed their first show, *Americans*, for the April 1929 issue of *Arts* magazine. Two months later, he drafted an article on Dix for the same journal. Passionate about Dix's work, Barr could scarcely disguise his contempt for the

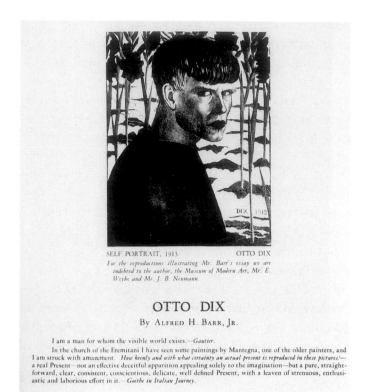

SELF PORTRAIT, 1913 OTTO DIX
For the reproductions illustrating Mr. Barr's essay we are indebted to the author, the Museum of Modern Art, Mr. E. Weyhe and Mr. J. B. Neumann.

OTTO DIX
By Alfred H. Barr, Jr.

I am a man for whom the visible world exists.—*Gautier*.

In the church of the Eremitani I have seen some paintings by Mantegna, one of the older painters, and I am struck with amazement. *How keenly and with what certainty an actual present is reproduced in these pictures!*—a real Present—not an effective deceitful apparition appealing solely to the imagination—but a pure, straightforward, clear, consistent, conscientious, delicate, well defined Present, with a leaven of strenuous, enthusiastic and laborious effort in it.—*Goethe in Italian Journey*.

"Otto Dix" by Alfred H. Barr, Jr. in the *Arts* (January 1931), showing Dix's *Self-Portrait*, 1913

limitations of American taste: "Those who are devoted to contemporary French painting or its American imitation will feel their prejudice against German painting strengthened by the work of Otto Dix. It seems so coarse and ruthless, so filled with 'extra pictorial' elements, so 'realistic.'"[34] Barr was referring to the American preference for art faithful to natural appearance and devoid of overt social commentary.

Immediately after being appointed director of the Museum of Modern Art in the summer of 1929, Barr decided to withhold publication of his Dix article. Later he was straightforward about his reasons: "I did not want to be identified immediately with a stand that would have seemed to the Museum supporters a very reactionary one."[35] By this Barr meant that he felt his superiors would find many of these blatantly realistic pictures, which were often openly critical of German society, disturbing both aesthetically and politically. Barr's decision not to publish his Dix article in 1929 may also have been influenced by Gustav Hartlaub, the art historian who first coined the term *Neue Sachlichkeit* in 1924. Barr apparently contacted him while writing his article, as indicated by a letter he received from Hartlaub dated July 8, 1929: "The expression [*Neue Sachlichkeit*] ought really to apply as a label to the new realism bearing a socialistic flavor.

It was related to the general contemporary feeling in Germany of resignation and cynicism after a period of exuberant hopes (which had found an outlet in expressionism) … In the last analysis this battle cry is today much misused and it is high time to withdraw it from currency."[36]

It is against this background that Barr's decision to mount an exhibition titled *German Painting and Sculpture* in March 1931 that featured primarily Expressionist works of art should be viewed. In the midst of Depression-era America, it was undoubtedly politically safer to present Expressionist rather than Neue Sachlichkeit art. In his catalogue, Barr emphasized Expressionism as a visionary, if idealistic, style; he knew only too well that the glumness of many Neue Sachlichkeit canvases could not be so easily theorized away.

Cover of the exhibition catalogue *German Painting and Sculpture*, Museum of Modern Art, New York, 1931

That Barr was able to mount *German Painting and Sculpture* at all was quite remarkable. Within a year and a half of the museum's opening, he had succeeded in convincing rather reluctant trustees (who were primarily interested in French art) of the importance of such a show, and had hired Neumann as the museum's agent for it. Shortly thereafter, Barr left for Europe to begin organizing the loans.[37] This was during a time of severe economic depression and an increasing trend toward isolationist practice. Given these factors, the organization of a

show of modern German art was no small undertaking. Though Barr could not have known it, within three years the majority of the museum directors and dealers he contacted in Germany would no longer be secure in their jobs.

A review of Barr's correspondence with the lenders reveals that he viewed the exhibition as an opportunity not merely of presenting vanguard modern German art, but also of garnering institutional support in the United States for the work of living American artists. On September 22, 1930 he wrote Ernst Büchner of the Wallraf-Richartz-Museum in Cologne: "We are especially eager to borrow paintings from German museums not only because it would be excellent 'Reklame' for the progressiveness and foresight of German museums but would also help us a great deal in proving to the American public how very far behind the Germans are our museums."[38]

Barr's essay in the catalogue for German Painting and Sculpture drove home this point on its very first page. Wasting no words, he stated: "[German] museum directors have the courage, foresight, and knowledge to buy works by the most advanced artists long before public opinion forces them to do so." Barr also congratulated German scholars, critics, and publishers for producing high-quality monographic studies on contemporary artists. He noted that not only was there a large buying public for these books in Germany, but the German state gave support to living artists, who, "despite the unacademic character of their work," were employed as professors in municipal art schools.[39] Barr's argument was plain enough: one of the reasons contemporary art was flourishing in Germany (to the point that it warranted exhibition in America) was that there was widespread backing for the arts there. In other words, it was high time that Americans began to provide the same for its artists. This was the real rallying call of the show.

There can be no question as to Barr's concern with awakening interest in modern German art, so long neglected by American critics and curators. This had already led him to give Paul Klee a one-man show in 1930 and to feature Lehmbruck in a two-

Installation view of German Painting and Sculpture at the Museum of Modern Art, New York, March 13–April 26, 1931. Photograph © 2001 The Museum of Modern Art, New York

man show with Aristide Maillol the same year. However, Barr wanted *German Painting and Sculpture* not only to showcase Expressionism, but also to *look* unmistakably German, hence the show's straightforward title. *German Painting and Sculpture* was the eleventh exhibition to be mounted at the Museum of Modern Art. With 123 works by twenty-one painters and seven sculptors, the show was a huge success, attracting some 26,044 visitors.[40] Another gauge of its impact was W. W. Norton's decision to reissue its catalogue as a book later the same year. Interestingly, this seems to have been the first and just about the last occasion upon which Expressionist art was really appreciated as vanguard in America, as indicated by a number of its reviews in the press. Several critics urged audiences not to leave the exhibition too hastily, but to "forbear" the works' initial repugnance and linger a while. Nevertheless, the title of one article in the *New York Sun*—"Present Day Teutonic Ideals Are Intelligently Presented"—by art critic Henry McBride, hints that certain long-engrained prejudices against German art persisted.[41] In fact, more than a few reviewers explicitly linked the work with German military maneuvers: "There is very little … that is just plain unforgettable among the canvases that fill the various galleries with such a disturbing sequence of slashing patterns and rather unconsidered chromatics. It is all very virile, this German modernism, rather obviously on parade, and with a certain strutting forwardness not a little suggestive of the famous goose-step of yesteryear."[42]

More forthright praise appeared in the *Cleveland News*: "The Museum of Modern Art of New York has apparently scored the greatest art "scoop" in recent years with its big show of contemporary German painting and sculpture. The Germans might almost as well have been painting in an airtight box up in the attic for all we Americans have been able to see of it in this country."[43]

The enormous popularity of *German Painting and Sculpture* is somewhat ironic given that it contained many of the same artists—and even some of the same works—as Valentiner's 1923 exhibition at the Anderson Galleries. This fact did not escape the attention of several reviewers, who felt that its curator had not paid sufficient attention to present-day German art. Writing for *Arts* magazine, Lloyd Goodrich also took Barr to task for focusing on Expressionism: "German expressionism has not proved such a lasting influence nor left behind works of such permanent interest as the corresponding French movement."[44] Margaret Breuning, his colleague from the *New York Evening Post*, complained that Expressionism is, as far as "contemporary German art goes, 'old hat.'" Essentially, this statement was quite true. Bruening's subsequent assessment of why an American public might find this art appealing was also dead-on: "It is a showing that should be vastly popular with those Americans, who like … color that hits you hard between the eyes and violent, vehement expression rather than subtlety."[45] Such forceful language underscored this art as unequivocally German—meaning it was nothing if not ruthless. In fact, the connection of German art with *fierce behavior* was so prevalent during the 1920s as to find its way into the 1929 edition of the *Encyclopaedia Britannica*. There, in the article on "Post-Impressionism" this downright vituperative phrase was to be read: "[For German Post-Impressionist activities] the term 'expressionism' serves the purpose as well as any other, unless one were found which denotes a combination of truth, bestiality, creation and destruction—all expressed in a manner in which a snarling brutality obscures many finer feelings."[46] Such jargon fueled the American conception of these artists as stalwart characters themselves—they had, after all, continued to paint despite the devastations of World War I, and the national humiliation brought about by the Treaty of Versailles—and had managed to resist capitulating to an international market dominated by modernist French aesthetics.

These features seem to be what most interested a number of critics. Urging the public to study this art "open-mindedly," McBride wrote in the *New York Sun*: "You will for one thing, almost instantly discover that this new effort of the Germans to secure a place in the sun is only our own problem all over again, for we too, have been barred from world recognition of the congress of arts and any effort of another nation to seek a new path up Parnassus is bound to be interesting to us—is bound to suggest ideas to us."[47] This had of course been Barr's hope—as he clearly articulated in an article that appeared shortly after the exhibition closed. In a German periodical for museum professionals, he wrote: "Here as in Germany, indigenous art has all too often been stifled by French painting. The German exhibition has finally yielded proof to an American public that there also exists in Europe art that expresses an individualistic nationalism that knows nothing of Paris."[48] Thus, it was the adamant national quality of this art, tainted or not, that critics felt could be of most interest to Americans, still uncertain about the quality of their own endemic art. In short, not only did the exhibition present them with an alternative to French painting, it provided a measure of reassurance, even of hope for the future of American painting.

EARLY REACTIONS TO THE DENOUNCEMENT OF EXPRESSIONISM IN NATIONAL SOCIALIST GERMANY

Immediately after the show's closing, Barr proudly wrote to his colleagues in Germany that the exhibition had brought in "more than 27,000 visitors during six weeks … many more than came to an exhibition of Toulouse-Lautrec and Odilon Redon."[49] These facts most likely confounded more than a few of his correspondents. For by then, Expressionism had long since seen its heyday in Germany and unfortunately attacks against this art were already beginning. Indeed, just the year before, in 1931, Paul Schultze-Naumburg, a National Socialist theorist and official, had removed works by Barlach, Kandinsky, and Klee from the walls of the Schlossmuseum in Weimar and ordered the effacement of Oskar Schlemmer's murals in the Weimar Bauhaus. It is difficult to assess the degree to which the American audience's interest in German art may have been affected by this radical act. Three months before the exhibition opened at the Museum of Modern Art, the German correspondent for *Art News*, Flora Turkel-Deri, had reported on these events in an article titled "Weimar Museum Shelves Moderns."[50]

Whatever its shortcomings, the 1931 *German Painting and Sculpture* show took place just in the nick of time. Within two years, Hitler's campaign against modern art began in earnest. In short order, he turned Barr's case for governmental support of modern art in Germany on its head. In 1932, the Dessau town council forced the Bauhaus to shut down. It subsequently became a private school in Berlin, only to be closed the following year by the police. Among the artists whose work Barr had exhibited, Baumeister, Beckmann, Dix, Hofer, Klee, Pechstein, and Schlemmer were all dismissed from their teaching positions. Moreover, two of the museum directors that had been critical to the establishment of modern art in Germany (and who had also loaned works to Barr's show)—Gustav Pauli of the Hamburger Kunsthalle and Ludwig Justi of the Nationalgalerie Berlin—were removed from their posts. It was not until 1934, however, that the National Socialists took a firm stance against Expressionist art, which initially had been supported by Germany's propaganda minister Joseph Goebbels. Indeed, the hero of Goebbels's 1929 novel *Michael* had declared: "We are all Expressionists today. … The Expressionist builds in himself a new world. His secret and his power is this ardor."[51] Nevertheless, by 1934, the National Socialist regime began to denounce Expressionist art as "degenerate" and, by 1937, to systematically purge it and other modern art from German museums. By late summer 1937, more than 16,000 works by some 1,400

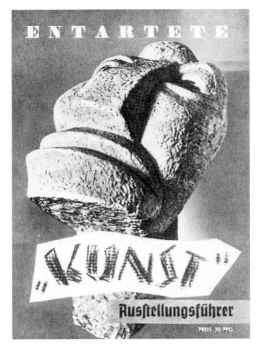

Guide to the *Entartete Kunst* exhibition in 1937

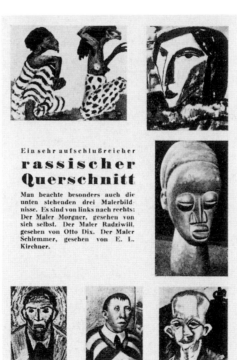

A page from the Guide to the exhibition of *Entartete Kunst*

artists had been removed from thirty-two public art collections throughout the country.[52] On July 19, 1937, the *Entartete Kunst* exhibition opened in Munich at the former institute of archaeology. The show was comprised of more than 650 works, of which the vast majority were Expressionist. Seen by nearly three million people by the time it finished touring twelve addi-

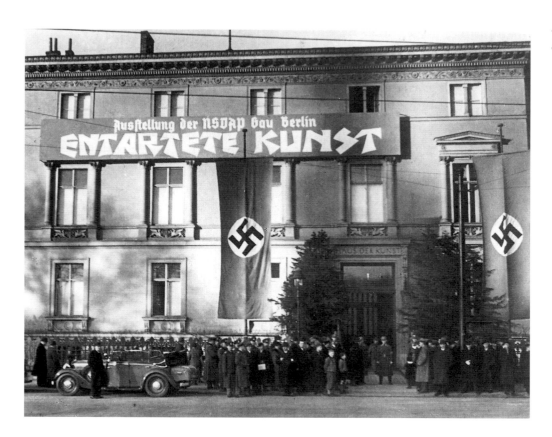

tional cities in Germany and Austria, this was the first true blockbuster exhibition of Expressionist art anywhere. Just the day before its debut in Munich, Hitler had opened an exhibition of officially sponsored art—*Grosse Deutsche Kunstausstellung* (Great German Art Exhibition)—with much ceremony at the Haus der Kunst in the same city. This show was meant to prove just how "degenerate" the art on view in the nearby institute

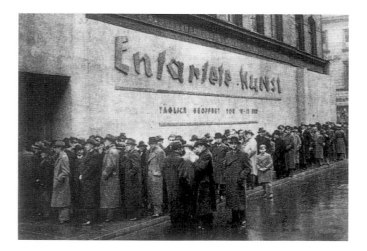

Line of visitors in front of the entrance to the exhibition *Entartete Kunst*, Hamburg, 1938

was, by presenting a new mainstream art understandable to everyone and purportedly morally uplifting. The day after the *Entartete Kunst* exhibition's opening, an article appeared in the *New York Times* titled "'Degenerate Art' Displayed in the Reich: Exhibition Opened in Munich to Show Contrast Between the 'Healthy' and "Filthy'" that left no doubt about the vehemence of the attack: "Professor Adolf Ziegler, who made the opening address at the exhibition … said that this 'incomprehensible and often disgusting art' had been bought with the German workmen's savings … All that is decent in Germany has been dragged in filth by such alleged artists. … This is only a little of what we have been suffering through Jewish-Marxist dealers and critics. They have had their years of glory. They will disappear from our art institutions forever."[53]

In a move to raise funds, the German government authorized the Galerie Fischer in Lucerne to auction off 125 "degenerate" works of art, several of which had been in the *Entartete Kunst* exhibition. Only 60 percent were sold (at half their estimated prices), and another 10 percent at prices slightly above their estimates. The rest of the works, the majority of which were Expressionist and of varying quality, were returned to the German government, which tried to dispose of them by contacting such art dealers as Bernard A. Böhmer, Karl Buchholz, Hilde-

brand Gurlitt, and Ferdinand Möller.[54] More than a few of these sold and unsold works eventually made their way into American collections.

Paradoxically, as the campaign against modern German art began to escalate in Germany, an American, Sheldon Cheney, published the first book on the subject in 1934. *Expressionism in Art* soon found a wide readership. In it, Cheney argued that while modern art "tends *toward* Abstraction," the object nevertheless survives in it "even though its natural aspect is subordinated, at times distorted."[55] This point of view soon came into direct conflict with the ideas of both Barr and later the critic Clement Greenberg. Indeed, by 1936, Barr seems to have undergone a partial turnabout—possibly due to American isolationist politics making wholehearted affirmation of artistic achievements based in Germany untenable—and now asserted that abstract French art was after all the guiding light of modernism. Barr set forth these ideas in *Cubism and Abstract Art*, which opened in the spring of 1936 at the Museum of Modern Art and traveled to six cities. The exhibition's catalogue and its dustcover, which was made into a poster, was prominently displayed in several rooms of the exhibition. It made clear that the only German art that Barr now acknowledged as modern was that produced by several "Abstract Expressionist" painters grouped around Kandinsky in Munich in 1911. Shortly after *Cubism and Abstract Art* opened, Kandinsky wrote Barr several letters objecting to the simplification of his art to a mere formalist impulse and Barr's seeming disinterest in the fact that Kandinsky had continued to paint realistic canvases. As Kandinsky was undoubtedly aware, Barr's reductionism meant the removal of figurative German painting from the canon of modern art.[56]

For some time, this theoretical infighting was of little concern to the general American public, although thereafter work done in an abstract rather than figurative mode became gradually equated with modernism. This trend received an unexpected boost in 1937 when the Solomon R. Guggenheim Foundation was endowed to operate the Museum of Non-Objective Painting, with Hilla Rebay as its curator. Two years later, the museum opened to the public and featured the work of Vasily Kandinsky, Rudolf Bauer, Paul Klee, and Franz Marc, as well as "nonobjective" works by Cubist, Orphic, and Futurist artists.

Beginning around 1938, the censorship of modern art in Germany, besides being covered in the press, was increasingly brought to the attention of Americans via a number of museum exhibitions featuring the modern art now labeled "degenerate"

"Forbidden and Approved Art" in the *New York Times* (July 25, 1937), a few days after the opening of the exhibition *Entartete Kunst* in Munich

in Germany.[57] *Modern German Painting* at the Columbus Gallery of Fine Arts held in the spring of 1938 was one of the earliest of these shows. That museum's monthly bulletin made clear that the exhibition's aim was simply to present publicly works now being suppressed in Germany.

Modern German Art, the first English-language book to focus on this topic, was also published in 1938, in connection with an exhibition at the New Burlington Art Galleries in London. The exhibition was one of very few shows organized in Europe that overtly reacted against the 1937 *Entartete Kunst* show then still touring Germany. Written by Peter Thoene (a pseudonym for Otto Bihalji-Merin), a Yugoslav émigré active in Berlin and later in Paris, the passage with which the book concluded is worth noting: "In what an age of darkness we must live ... when art, the great protectress of the living, has to be protected; art, that creative force which expands the prison house of our being and allows a vision of eternity to be glimpsed beyond the brief span of our existence. But art, if it is to live, needs freedom. Its dreams with their abundance of solace cannot flourish in the arid atmosphere of duress."[58]

Although the statement is accurate, by 1938, it was human life in National Socialist Europe that really needed protecting, as everyone knew. Nonetheless, modern German art was now being presented in America as "the latest refugees ransomed from Nazi Germany and from annihilation." One of the clearest

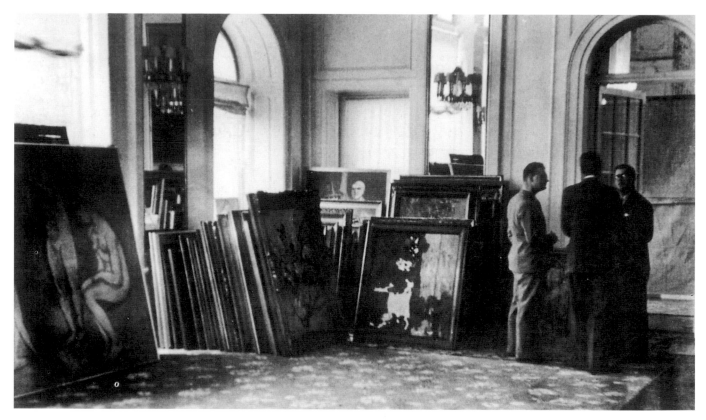

Theodor Fischer and colleagues in a salon of the Grand Hôtel National, Lucerne, before the auction of "degenerate" works of art on June 30, 1939

indications of this was the catalogue that accompanied the exhibition *Contemporary German Art* held at the Institute of Modern Art in Boston in 1939. Its author, art historian James S. Plaut, who had recently become director of the institute, carefully and prominently listed the "lender" of each work, which quite frequently was a museum in Germany from which the work had been removed.[59]

In his foreword to the book, Plaut outlined in detail the measures the National Socialists had taken to purge Germany of modern art. In contrast to the Columbus exhibition, the Boston show was an outright denunciation of cultural politics in National Socialist Germany, a point not missed by the press. One short review in *Art News* ran under the title "German Museums' Nazi-Verboten Art Exhibited in Boston." Though that review's author did not even touch upon the quality of the art in the show, the writer for the *Boston Globe* indicated that many Americans might view the persecution of this art by the National Socialists as not entirely unwarranted: "There are probably many people—art lovers—in Boston, who will side with Hitler in this particular purge ... So it is that the war of opinions has come to Boston—the judgment seat of the United States in

art matters—with the emphasis slightly on the side of traditions, which Hitler seems to respect."[60]

At least one reason why Hitler's denunciation of this art as the product of morally "depraved" "cruel dabblers" found more than a few sympathizers in puritanical America was that during the 1930s, the discourse around the nature of modern man continued to accelerate.[61] However, by then authors such as John Dewey emphasized that there had been a loss of "confidence in reason because we have learned that man is chiefly a creature of habit and emotion." This pessimistic turn was further attested by a series of essays titled "Is Man Improving?" published in *Scribner's* magazine in 1935. The series concluded with an article that contained the following sentence, which seems to have cut to the heart of the matter: "The enemy, in fact, is not now without, but within; it is no longer Nature, but *human nature*" (italics added).[62] In other words, the accusation that modern artists were morally corrupt psychotics was now seen to have a relevance to the endangered temperament of middle-class Americans.

The upshot was that for the next two decades in America, all the stereotypical attributes associated with the artist as mad

genius—irrationality, excessive emotionalism, and lack of self-control—were downplayed to counteract a growing concern with the allegedly unstable psyche of twentieth-century man. Hence the uneasy embrace of Expressionism by Americans was much more than a matter of aesthetic preferences. Instead, it echoed a widespread preoccupation with the disquieting findings of psychologists, anthropologists, and behavioral scientists, which intensified suspicions about this purportedly "degenerate" art and its impact upon man's "precarious" mental balance.

THE ALLURE OF "FORBIDDEN" GERMAN ART

The year 1939 also saw the *Exhibition of Twentieth Century German Art* at the Milwaukee Art Institute—a smaller version of a show that had originated at the New Burlington Galleries in London. Ironically, although perhaps predictably, the American press made frequent use of the very term it should have been contesting in its coverage of the Milwaukee exhibition. A short review in *Art News* began: "The famous collection of German 'degenerate' art which last July aroused so much interest during its London exhibition … constitutes the June attraction at the Milwaukee Art Institute."[63] One of the reasons for the attention this exhibition garnered in London—where it was intensely debated and at times vigorously denounced—seems also to have applied in America: "it has a political significance that has nothing to do with its artistic value." This compelling declaration appeared in the *London Times* July 10, 1938 review of the Burlington Galleries show and was reprinted in the June–August 1939 *Bulletin of the Milwaukee Art Institute* without comment.[64]

The popularization of Expressionism during the 1940s was bolstered by its identification as "free" art that had found a safe harbor in democratic America. A *New York Times* article of June 1942 bears this out. Edward Alden Jewell wrote the article in connection with the presentation of several Expressionist works by Beckmann, Barlach, Nolde, and Kollwitz that had been recently acquired by the Museum of Modern Art, and were being exhibited under the slogan "Free German Art." Most likely conscious that the term *Freie deutsche Kunst* had originally been the title of an exhibition held in November 1938 at the Paris Maison de la Culture in reaction to the *Entartete Kunst* show, Barr was quoted in the *Times* piece: "Among the Freedoms, which the Nazis have destroyed, none has been more cynically perverted, more brutally stamped upon, than the Freedom of Art. … But in free countries, [their works] can still be seen, can still bear witness to the survival of a free German culture. …"[65]

In 1942, the year after the United States had entered into war with Germany, Americans finally began to rally in support of freedom of artistic expression at home. Exhibitions such as the Museum of Modern Art's *Road to Victory* played an important role by demonstrating the degree to which the war effort relied upon whole-hearted civilian engagement. The upshot was that an appreciation and market for modern American art began gradually to develop in the United States. It is not entirely surprising that by mid 1944, the kind of work Americans were looking for was expressionistic, in other words, "art that was at once abstract and emotive."[66]

Fully aware both of this and of the magnetism that a prohibited art style such as Expressionism held out to an American audience, Karl Nierendorf presented *Forbidden Art in the Third Reich* at his New York gallery in October 1945; the show traveled to the Boston Institute of Modern Art the following month. Rather than waste words discussing the different styles of the artists, the brief catalogue focused upon the general details of their persecution.

In sum, by 1945, three factors had converged that would determine the future reception of Expressionist art in America: a

"Exiled Reich Art Put on View Here" in the *New York Times* (August 8, 1939), showing Wilhelm Lehmbruck's *Kniende (Kneeling Woman)*, 1911

continuing tendency to present Expressionism as parochially German (and hence a phenomenon separate from the mainstream of modernist art); political events in Germany that caused this art to become identified with the National Socialist attack against the Jews; and the subsequent promotion of Expressionism as an exiled art, protected by democratic America.

To be sure, as World War II had been heating up in Europe, Americans had begun to focus increasingly on militaristic Germany and the specter of fascism. Partly out of sympathy for the plight of modern German artists, which by then had been internationally recognized, and partly because the prices of their paintings had become so low, American museums and private collectors began to purchase these works, thus encouraging the organization of exhibitions around them.

Immediately following World War II, America began to make efforts to stabilize the German economy, just as it had in the wake of World War I. This time, however, the desire to restore democracy and to encourage a capitalist economy in Germany were prompted by the American fear of a possible communist victory in war-ravaged Germany. To defuse this threat, the Marshall Plan was implemented between 1948 and 1951, bringing an unprecedented degree of economic aid to Germany from the United States. The flourishing of West German industry and the influx of American goods soon negated any opportunity for Soviet expansion there.

The identification of the rescue of modern German art with the preservation of democratic values was, of course, part and parcel of Cold War politics. In the interest of transforming America's former enemies into its new allies, the atrocities committed against humankind in National Socialist Germany became, in a sense, marginalized. Evidence of this trend emerged as early as June 1945, when a piece titled "The End of Belsen?" appeared in *Time* magazine, arguing that the evils of concentration camps "lay deeper than any tendency to scientific brutality on the part of the German people. They lay in the political philosophy of totalitarianism, which is not the exclusive property of any people."[67] It was not long before Americans' preoccupation with Soviet totalitarianism overrode any concern with former fascist Germany, in part redirecting a loathing of Germany onto the Russians. These circumstances, compounded by the alliance many Americans drew between victimized German art and democratic values, helped to generate a new level of sympathy for Expressionism. Evidence of this can be found in the introduction to the catalogue of one of the first postwar exhibitions to take place in America: *German Expressionism in Art*, which

Sheldon Cheney, ca. 1941

opened during 1951 at the University of Minnesota. After noting that the exhibition was the first in a series intended to commemorate the hundredth anniversary of the university, the organizers stated: "Its occurrence at a time when a free university in a democracy celebrates its centennial is a happily symbolic coincidence. The works of art in the exhibition and their creators would find no favor in recent and current totalitarian countries."[68]

It was in this climate that Cheney's *Expressionism in Art* was reissued, a book that was unique in its argument that the modernism of Expressionist art also had a social dimension. Keeping in mind the risks of such a stance in Cold War America, he concluded his "Note to the Revised Edition, 1948": "Nor have I trimmed my original chapter on socially conscious art, chiefly about Communism, though the word 'Communism' has come to have sinister connotation not felt fifteen years ago. My broad, even idealistic use of the word was perhaps sufficiently guarded even then, through disavowal of political or party attachment. 'Expressionism,' as a name identifying the main current of creative art in the 20th century has steadily gained adherents among artists, writers, and museum people."[69]

Paradoxically, another key reason Expressionism grew so rapidly in popularity during the 1940s and '50s was that it was stripped of any social meaning and touted as a naïve style, born of the anguished temperament of its makers. This superficial

understanding of Expressionism was reinforced by the almost categorical exclusion of works with overt political content in the exhibitions of "banned" German art presented during these decades. The result was a further loosening of this art from the cultural and political climate in which it had actually emerged. The same tendency occurred in Germany. There, however, among artists Expressionism remained a "painful and political issue" that "smacked of the failure of Germany, of Weimar, and the two World Wars."[70] Nevertheless, the market for Expressionist art once again began to thrive in Germany, both because work was readily available and its acquisition was viewed as an antifascist gesture. Post–World War II German artists that during the 1950s aligned themselves with Expressionism—Karl Otto Götz, Otto Greis, Heinz Kreutz, and Bernard Schultze—seem to have done so not out of a desire to identify with the beleaguered German style, but because of the favorable reception of Abstract Expressionist painting during these years in America. Revealingly, soon after the opening of their first exhibition, *neo-Expressionism*, in December 1952 at the Zimmergalerie Klaus Franck in Frankfurt, these German artists dropped the name *Neuexpressionisten* (neo-Expressionists) in favor of the designation "Quadriga."[71]

THE FABLE OF GERMAN EXPRESSIONISM AS THE FORERUNNER OF AMERICAN ABSTRACT EXPRESSIONISM

In contrast to Germany, in the United States Expressionist art steadily grew in popularity during the 1950s because of its tainted legacy. Moreover, certain critics attempted to link it with new developments in American painting. Such a connection was not unforeseen; as early as 1924 Scheffauer had proposed the idea that Expressionism could be a catalyst for American artists: "Expressionism as a means to an end can serve our ends … the intellectual fanaticism ready to go to ruin for the sake of an idea or an ideal, which characterizes the German soul, can only be of inestimable service to those forces full of promise which are struggling for artistic liberty and recognition in America of to-day."[72]

This view, combined with the increasingly energetic promotion during the 1940s of Expressionism as an emotionally charged

Installation view of *German Art of the Twentieth Century* at the Museum of Modern Art, New York, October 1–December 8, 1957. Photograph © 2001 The Museum of Modern Art, New York

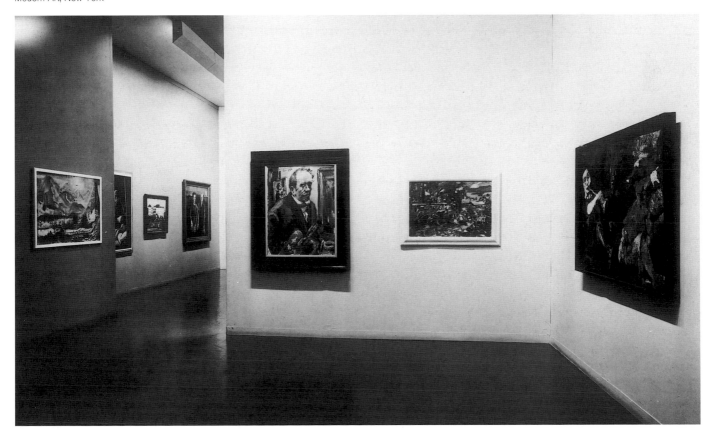

imperiled "free" art virtually assured the success of the fabricated alliance between Expressionism and Abstract Expressionism. Here it should be recalled that ever since Barr's 1936 *Cubism and Abstract Art* show, the term "Abstract Expressionism" had been vaguely linked in the American mind with German art. Interestingly, it was not Barr, but the critic Oswald Herzog, who first coined the idiom "Abstract Expressionism" in the title of a 1919 article that appeared in Herwarth Walden's magazine *Der Sturm*.[73] The following year, art historian Eckart von Sydow used the phrase in his book *Die deutsche expressionistische Kultur und Malerei* to designate one of the four currents of Expressionist art. It was left to the critic Robert Coates to bring the term "Abstract Expressionism" back into parlance in 1946 with the new aim of characterizing the work of Willem de Kooning and Jackson Pollock.

It was not until 1951 that the achievement of American Abstract Expressionists was recognized on a large scale by an American museum, when *Abstract Painting and Sculpture in America* opened at the Museum of Modern Art. The following year, the Albright Art Gallery in Buffalo mounted the exhibition *Expressionism in American Painting*, which not only showcased recent figurative "Expressionist" artists, but also included the early work of Kandinsky, Kirchner, Marc, Nolde, and even contemporary paintings by Beckmann. The gamut of "Expressionist" works featured in the Albright exhibition did not escape critical comment. Writing for *Art News* in 1952, Henry McBride protested: "What bothers me about the collection [of works] is not the collection itself but the name that has been given to it— Expressionism—and the willingness of so many diverse painters to be called Expressionists."[74]

Not surprisingly, American-German relationships continued to improve during these same years, as every reader of *Life* and *Time* must have known. The July 9, 1952 issue of *Life* contained a feature article titled "The Germans on Our Side," which presented postwar Germany as "a businessman's country." In the same year, *Time* hailed Konrad Adenauer's reelection as chancellor of West Germany, crediting him with making his homeland "the most stable country in Europe." In January 1954, Adenauer appeared on the cover of *Time* as "Man of the Year." In 1954, *Life* also published a special issue titled "Germany: A Giant Awakening."[75]

By 1957, Expressionism, in all its permutations, was reaching a first real apogee in America. In January of that year, a number of New York galleries exhibited Expressionist art. By October, *German Art of the Twentieth Century* had opened at the

Museum of Modern Art, where it remained on view from October 1 to December 8, before traveling to Saint Louis's City Art Museum where it was shown in 1958. While the show included several Neue Sachlichkeit paintings and a handful of emergent post–World War II German artists, it was an unmistakably Expressionist show. More or less concurrent with the Museum of Modern Art's exhibition were the Boston Museum of Fine Arts' *European Masters of Our Time* (with nearly fifty works by modern German artists), and *German Expressionist Painting, 1900–1950* at the Pomona College Galleries, in Claremont, California, with a total of forty-six works by Expressionist artists. At the same time, a landslide of publications on the subject came onto the American market. Along with the catalogue for the Museum of Modern Art's *German Art of the Twentieth Century*, there appeared in 1957 *Modern German Painting* by Hans Konrad Roethel, *German Expressionism and Abstract Art: The Harvard Collections* by Charles L. Kuhn, *German Expressionist Painting* by Peter Selz, and *The German Expressionists: A Generation in Revolt* by Bernard S. Myers.

The American press hailed the 178 paintings, drawings, sculptures, and prints that comprised the Museum of Modern Art exhibition as the largest showing of Expressionist art in America since Barr's *German Painting and Sculpture*. Unlike the 1931 exhibition, however, *German Art of the Twentieth Century* received major sponsorship from the government of the German Federal Republic. The show's organizer, Andrew C. Ritchie, was advised by art historian Werner Haftmann, professor at the Hochschule für bildende Kunst in Hamburg, Alfred Hentzen, director of the Hamburger Kunsthalle, and Kurt Martin. Haftmann had not only published the much-heralded *Malerei im 20. Jahrhundert* in 1954 (the book did not appear in English until 1960), but had also collaborated with Hentzen and Martin on the working committee of the first large international exhibition of art presented in Germany since the 1912 *Sonderbund* show: the 1955 *documenta* at Kassel. One of its principal aims was to respond to the *Entartete Kunst* show, by presenting these artists as heroic, if bourgeois, individualists, whom it was now time not to rehabilitate, but to finally enthrone.[76]

Just a few months before Ritchie's exhibition opened, a special supplement of the *Atlantic* magazine on "The New Germany" appeared that included a long article titled "German Character and History." Authored by Theodor Heuss, president of the Federal Republic of Germany, it contained a passage that is as disturbing as it is revealing: "The result of his [Hitler's] evil intentions was a curious good: he opened the world's doors to

Cover of the special issue of the *Atlantic*, "Perspective of Germany,
An Atlantic Supplement" (March 1957)

modern German art. … Modern German painting is now much
more fully represented in foreign museums than ever before.
And judging by the interest aroused by various retrospective
shows in the United States and England, it seems to me that
curiosity about Germany's special achievements in this field,
and a readiness to be moved by them, is beginning to extend to
works of the past."[77]

The American vogue for modern German art also caught the
attention of the German press. The title of an October 1957
article in the weekly paper *Die Zeit* asked incredulously, "Sieg
deutscher Kunst in Amerika?" (Triumph of German art in Amer-
ica?). An astonishing 35,000 catalogues had been printed to
meet the needs of a curious public visiting *German Art of the
Twentieth Century*; the reviewer observed that such a large edi-
tion of an exhibition catalogue was simply unimaginable in
Europe. He was further amazed by the fact that the exhibition's
organizers were so proud of the show and its catalogue that
they were distributing 20,000 copies gratis to the museum's
members.[78]

In fact, several critics were caught off-guard by the Museum of
Modern Art's interest in such a show. While Sidney Geist, writ-
ing for *Arts*, claimed that the museum "had to exhaust its Fran-

cophilia before mounting the present exhibition," the editor of
Art News, Alfred Frankenstein, denounced the growing interest
in Expressionist art as a marketing strategy masterminded by a
conspiracy of dealers.[79] Nevertheless, there were others who
questioned why it had taken so long for the museum to organ-
ize such an obviously important exhibition of artists critical to
the development of American art: "Paul Klee and Wassily
Kandinsky have exercised an extensive influence upon Ameri-
can artists … German influences have been more penetrating
than French in various art centers of the United States. Max
Beckmann was a source of inspiration to many young painters
and Soutine and Kokoschka have been favorites particularly
with our painters of romantic or mystical inclination. Albers is at
this moment a greatly admired teacher and the winds of the
influence of Bauhaus teaching blow to all four corners."[80]

In the same year during which *German Art of the Twentieth
Century* closed, the Museum of Modern Art organized two exhi-
bitions—*The New American Painting* and *Jackson Pollock:
1912–1956*—that were crucial to establishing the primacy of
American Abstract Expressionism in cities throughout Europe,
including Berlin. The presentation of American art in Germany
reached a high point in 1959, with the installation *Art Since
1945* at *documenta 2,* which included more than 140 works by
over forty painters.[81] The first and only non-German to be asked
to join the working committee of this documenta was Porter A.
McCray, then director of the Museum of Modern Art's Interna-
tional Program.

Thus it would seem that the museum's decision to organize
German Art of the Twentieth Century in 1957—in consultation
with the very experts who had helped Germany attain interna-
tional recognition at *documenta I* in 1955—was informed by a
desire to promote the cultural contribution not only of Germany,
but of America as well. And the timing could not have been bet-
ter. By this point, purported affinities between German Expres-
sionism and American Abstract Expressionist painting had had
more than a decade to mature and take hold, inspiring a new
appreciation of the older genre.

Nevertheless, terms used by many critics to "praise" the Ger-
man work retained a rather negative tone: "The works are per-
vaded by a spirit of rebellion, restlessness, aggressiveness, and
by unorthodox and often violent color. Primarily the Expression-
ists reduce each form to its essential rudiments, developing a
new pictorial language that is a forceful and sometimes brutal
expression of relationships between the ego, nature, and soci-
ety."[82] Such language is also strangely reminiscent of the jargon

Two-page spread of the *Life* magazine article "Violent Images of Emotion: Expressionist Art Has a Big Revival" (May 1958)

that Ernst Kretschmer, an internationally respected psychologist, had employed to criticize Expressionism in his 1921 book *Körperbau und Charakter*. There, Kretschmer singled out Expressionism for special mention because of its relevance to psychology, taking care to enumerate its alleged links with the art of "highly-gifted, mentally-diseased schizophrenes": "A tendency to pathos, to extreme exploitation of the expressive powers of color and gesture; even with the risk of caricature … a tendentious turning away from real forms, a refusal to draw things as they really are … a pronounced tendency toward displacement, condensation, and symbolism."[83] Kretschmer's book was hugely successful, and apparently not merely among scientists interested in the investigation of constitutional typologies. Translated into English in 1925 as *Physique and Character: An Investigation of the Nature of Constitution and the Theory of Temperament,* by 1951 it was already in its fourth English edition.

Further evidence of the American fascination with the link between Expressionism and the suffering, even possessed nature of the artist can be found in the enormous popularity of the exhibition *Van Gogh and Expressionism* held at the Solomon R. Guggenheim Museum in 1964. While it may not have been the intent of the organizers to suggest that Expressionist artists were mentally unbalanced, the inclusion of thirty-three paintings by van Gogh—the quintessential exemplar of the anguished genius, and broadly admired as the precursor of Expressionist art—not only guaranteed the show's success, but capitalized on the notion of excessive emotionalism by now

firmly associated in America with Expressionist art. Max Kozloff wrote in *Artforum*: "The psychology of Expressionism—how its pictures were created and what they were supposed to do—is a very fragile and faulty thing." Though in principle he admired the show, Kozloff defended the difference between German Expressionism and Abstract Expressionism in these telling terms: "Where the Expressionists presumed to find content in the confession of their various psychological states, their successors could only commit themselves to seek the means of painting a picture—an altogether more desperate undertaking."[84] The vitality, inventiveness, confrontationalism, and ugly beauty of German Expressionist paintings make them inarguably some of the most profound achievements of twentieth-century art. Significantly, few American Abstract Expressionist painters ever paraphrased the older idiom.[85] Indeed, only one American pop artist, Roy Lichtenstein, thoroughly engaged himself with German Expressionist themes, albeit not until 1977, when the star of Expressionism was once again on the rise.[86]

BLOOD, SOIL, AND SCREAMS: THE INVENTION OF THE MYTH OF AN INSTINCTIVE EXPRESSIONISM

The degree to which Expressionist art had, by this time, come to be associated in America with the idea of anguish is attested by the first painting of Lichtenstein's Expressionist series. Not incidentally, he chose to title it and the earliest work in the Expressionist suite (its study) *Despair*.[87] While the drawing is from 1977, the related painting was executed in 1979—a year of great consequence to the future reception of Expressionist art in America. As is generally known, the painting that Edvard Munch (who, like van Gogh, has long been considered a forerunner of Expressionism) designated "his first scream" bears the title *Fortvilelse (Despair;* 1892). A depiction of a man isolated from two distant conversing figures, the work is an unequivocal expression of loneliness. What seems to have caught and held Lichtenstein's imagination was the parallel between this condition of gloomy alienation and the enunciation of distress embodied by Munch's *Shrik (The Scream;* 1893). Both images had become ciphers, not only for German Expressionist art, but also for the apprehensive mood of late 1970s America.

If the "collective anguish" deemed typical of German Expressionist art can be reduced to one operative sign, that sign would have to be the figurative Expressive shriek. While Hermann Bahr may have been the first to associate German Expressionism with this "cry," it seems not to have been until 1957 that

Edvard Munch, *Fotografisches Selbstporträt in einem Zimmer auf dem Kontinent I (Photographic Self-Portrait in a Room on the Continent I)*, ca. 1906

Bernard S. Myers articulated it in connection with the Munch painting in his book *The German Expressionists: A Generation in Revolt*: "The frontalized figure of [*The Scream*] ... its horror-evoking shriek coming from a dematerialized face, blends with tortured nature as it gives forth the *geballter Schrei*, the spasmodic clenched cry of Expressionism."[88]

While 1960s America was unquestionably an optimistic era, it was also marked by a fascination with death. Urging the establishment to "make love not war," many young Americans were entranced by figures whose lives were cut short by drugs and violence. During the 1970s, the climate of a hopeful, forward-looking America could no longer be sustained. In the wake of the social upheaval and chaos of the 1960s, the '70s were characterized by a widespread feeling of alarm and even despair. Additional pessimism was engendered by the 1973 Arab-Israeli Yom Kippur War, which set off a worldwide oil shortage that within a few years created a state of emergency within America. The Watergate crisis further undermined the confidence of Americans in the morality of their leaders. Finally, at the end of the decade, *The Global 2000 Report to the President* unleashed a wave of pessimism surrounding the earth's resources and environment.[89]

It was in this climate of anxiety, perhaps not surprisingly, that Expressionism once again came into fashion. During the 1970s,

a number of new books on German Expressionist art were published, and several large museum shows with substantial catalogues were presented, including *German Expressionist Art: The Robert Gore Rifkind Collection*, which opened in 1977 at the Frederick S. Wight Art Gallery at UCLA and then traveled to three American cities, ending its tour at the Busch-Reisinger Museum at Harvard (formerly the Germanic Museum). The following year, *German and Austrian Expressionism: Art in a Turbulent Era* was organized by the Museum of Contemporary Art in Chicago. The decade closed with the Guggenheim Museum's presentation of *Expressionism: A German Intuition* in 1980, a show that traveled the following year to the San Francisco Museum of Modern Art.

Expressionism: A German Intuition was the last major American exhibition devoted exclusively to German Expressionist art. The show was comprised of 140 paintings, 70 watercolors, and 120 prints and was supplemented by a program of Expressionist films, concerts, and lectures. The mammoth proportions of the accompanying program in San Francisco (largely underwritten by the Goethe Institute) indicate just how captivating Americans once again found the genre.[90] Although the exact attendance figures for the show are unavailable, less than a month after its opening in New York, Germany's *Neue Ruhr-Zeitung* reported, "About a thousand visitors are counted daily. And last

Cover of the exhibition catalogue *Expressionism: A German Intuition*, Solomon R. Guggenheim Museum, New York, 1980

Saturday not less than four thousand viewers wanted to see these paintings made between 1905 and 1920. There are days when some 100 copies of the richly illustrated comprehensive catalogue are sold."[91] In the catalogue's introduction, Paul Vogt (director of the Museum Folkwang in Essen) emphasized the uniqueness of Northern German art (that is, that of both Munch and van Gogh) with its "old landscape ties. ... Their art comes from an unsophisticated instinct. ... It contains visionary apparitions."[92]

Visitors flocked to this show despite a critical response that was not all positive. The title of a *Newsweek* article—"The Fine Art of German Angst"—says much about the prevailing attitude responsible for the drawing power of the show: "As if we didn't have troubles of our own, Germany has chosen this moment to bombard us with some of the most *Angst*-inducing art of this

1930s and '40s in the United States. Similarly, during the 1970s and early '80s, there developed a deep insecurity, an almost tragic sense of man's imperiled selfhood. The hard sciences could not, it was felt, be relied upon to dispel the sense of looming danger, and the concomitant social malaise. Instead, society gradually turned toward therapeutic remedies with an emphasis on self-awareness.[94]

Prevailing aesthetic leanings also played a part in the success of the 1980 Guggenheim show. Americans were ready for a visual change from the reductionist, abstract, Conceptual art that had dominated the 1970s art scene. Moreover, a new version of American Expressionism, now in a predominantly figurative idiom, was becoming increasingly popular. As Kim Levin, writing for the *Village Voice*, put it: "Raw feelings are emerging in angry art that tries to reinvent crude, crazy naiveté, with

Installation view of *Expressionism: A German Intuition*, Solomon R. Guggenheim Museum, New York, 1980. Photograph © Solomon R. Guggenheim Foundation, New York

century. Highest on the emotional Richter scale is the Guggenheim Museum's show of German Expressionist art, one of the largest ever mounted in this country. ... Warning: twentieth century German art may be hazardous to your mental health. The show has been financed by Philip Morris, the National Endowment for the Arts and the Federal Republic of Germany ... all of which have given pause to that bunch of would-be anarchist weirdoes."[93]

The reactionary tone of this review recalls the conservatism of the discourse around the nature of modern man during the

energy from new sources. We're ready to see an earlier, uncooked art of violent passions and excessive expressionism that's as deliberately inedible and clumsy as our own."[95] Be that as it may, the pejorative tone of this passage hints that the American embrace of Expressionism was still reluctant.

There were other, more important factors in the exhibition's success. One was the shift in the American perception of Germany, which had already begun late in 1961 in the wake of extensive media coverage of Adolf Eichmann's trial in Jerusalem. The term "Holocaust" has today become so current, so familiar a

part of our historical vocabulary as almost to have lost all mean-
ing. Nevertheless, one important result of Eichmann's trial was
the presentation of the Holocaust as a distinct event, which
could be considered separately from World War II. At that time,
the press referred to the calamity not as the "Holocaust," but
more commonly as "man's inhumanity to man."[96] This was sig-
nificant: rather than emphasizing the Holocaust as a primarily
Jewish experience, it helped to allow the tragedy and its mem-
ory to become the shared property of the public at large. The
turmoil of the 1970s contributed to a further universalizing of
the Holocaust in America. In other words, the term became
more than merely a reminder of historical evil: as it gained par-
lance, it came to be used as a symbol of contemporary chaos.
Eerily, the same jargon and terminology that during the war
years had been utilized to describe the Holocaust was being
used by 1970 to describe current events. As Elie Wiesel wrote
that year: "I remain convinced that the current wave of protest
calls into question much more than the present. Its vocabulary
takes one back a quarter of a century. Factories and university
buildings are 'occupied.' The Blacks rise up in the 'ghettos.' …
The police use 'gas' to disperse demonstrations. … The Watts
and Harlem riots are compared to the Warsaw Ghetto uprising.
… Political analysts talk of nuclear 'holocausts.'"[97]

The single most significant media event that enabled the Holo-
caust of World War II Germany to become part and parcel of the
general American consciousness was the April 1978 NBC
broadcast of a four-part, eight-and-a-half-hour Hollywood tele-
vision movie, *The Holocaust.* The series attracted close to 100
million viewers. Although several people (among them Wiesel)
protested that the film trivialized the catastrophe, the general
consensus was that "more information about the Holocaust
was imparted to more Americans over those four nights than
over all the preceding thirty years."[98] The NBC miniseries was
rebroadcast in the United States in the fall of 1979. That year
also brought the publication of George Steiner's *The Portage to
San Cristobal of A.H.* over several issues of the *Kenyon Review*,
a fictional account of the discovery of Hitler, alive, in the 1970s
in South America.

JOSEPH BEUYS ON THE STATE OF EMERGENCY OF MODERN MAN

Coincidentally, in October of 1979, shortly after the *Holocaust*
miniseries aired, the first large museum show in America
devoted to a post–World War II German artist opened at the
Guggenheim Museum.[99] The exhibition *Joseph Beuys* was not

View from the top of the ramp of the Solomon R. Guggenheim Museum, New York,
during the opening of *Joseph Beuys*, November 2, 1979. Photograph by Mary
Donlon © Solomon R. Guggenheim Foundation, New York

only one of the largest yet to be held at the Guggenheim, but
prompted a succès de scandale.[100] Still a highly controversial
artist in Germany, within one week of his retrospective's open-
ing at the Guggenheim, Beuys was featured on the cover of *Der
Spiegel* under the heading "Der Grösste Weltruhm für einen
Scharlatan?" (The Greatest World Acclaim for a Charlatan?). In
New York, however, Beuys's achievement was better received, if
not hotly debated. Writing for *Time* magazine, Robert Hughes
went so far as to assert that Beuys was an artist without Euro-
pean rivals.[101]

The museum itself was permeated by the smell of fat, and filled
with stacks of felt, crosses, flashlights, and emergency sleds. It
was impossible, in other words, for visitors to escape the
impression that Beuys's art was about the deepest, most deter-
minedly disavowed or suppressed thoughts and feelings asso-
ciated with both those who survived the war, as he did, and
those who perished in battle, or worse, in concentration camps.
Moreover, his decision to arrange his sculpture into twenty-four
"stations," staggered along the Guggenheim's ramp, seemed a

very deliberate conflation of "Christianity, the Holocaust, and art." As a whole, the installation "emphatically recalled both the 'Stations of the Cross' in the Christian Church and the movement of the Jews to concentration camps on railroads throughout Nazi-occupied Europe."[102]

Whether this was Beuys's actual intention is, in a sense, immaterial. Beuys had served in Hitler's Luftwaffe, and was thus widely associated with National Socialist Germany. Tellingly, he managed to focus critical attention not on the fact of his having participated in gunning, but on his near-death and miraculous survival after the last of a series of plane crashes—as illustrated in the Guggenheim catalogue. At the time, Beuys's fabrication of some of the circumstances surrounding the crash, his rescue, and subsequent convalescence puzzled and irritated critics, leading many of them to denounce him as a sham. Today, however, it seems that the explanation for this obvious mythmaking is tied to his interest in aligning not only his art, but also his person with the idea of "emergency" and the need for a "recuperation," an image that in 1970s therapy-oriented America had great drawing power.

What this "emergency" might be was indicated in the words of Beuys himself, printed in the first few pages of the exhibition's catalogue: "The human condition is Auschwitz, and the principle of Auschwitz finds its perpetuation in … the silence of intellectuals and artists. I have found myself in permanent struggle with this condition and its roots … I find for instance that we are now experiencing Auschwitz in its contemporary character … Ability and creativity are burnt out: a form of spiritual execution, the creation of a climate of fear perhaps even more dangerous because it is so refined."[103]

Without question, Beuys's œuvre is to a certain extent about the need of the German nation to "show its wound"—the title of an environment (*zeige deine Wunde*, 1974–75) featured prominently in the Guggenheim catalogue—and to mourn. But in 1979 art critics were not yet willing to posit such an interpretation. Instead, in America they either criticized Beuys for constructing an "ahistoric mythology of fascism," or were captivated by his art for precisely the same reason.[104] Writing for *Arts* magazine in early 1980, Kim Levin assessed the exhibition thus: "Beuys and his art were nothing if not 'quintessentially Germanic' … His art wallows in morbidity. It resonates with … the agonized torments of German Expressionism … It is powerful, personal, and painful—an exorcism of secret horrors, a therapeutic act—and it exudes a Teutonic cruelty."[105] Indeed, reviewing the exhibition for *Art in America,* Donald Kuspit was perplexed at "why Beuys wants to keep the Expressionist option alive in contemporary Germany, particularly when that option has been associated, however tenuously, with Nazi ideology?"[106] This was the last thing Beuys wanted to do in Germany, where the style was laden with just such fraught baggage. Indeed, it was American art historians, and not Germans, who tended to associate his art with Expressionism. And in fact, they were not really wrong in making this connection. Beuys was indeed a second-generation Expressionist whose early work was indebted to the aesthetics of Franz Marc and Ewald Mataré, who was his teacher at the Düsseldorf Kunstakademie. Nevertheless, after becoming a professor at the Kunstakademie himself in 1961, Beuys stopped making Expressionist-looking work, and began to affiliate his art with the international Fluxus movement. This, because Beuys sought above all to develop an art form that opposed the very notion of "style" and any attendant ideologies—such as those associated with Expressionism. Beuys seems to have understood by the time of his Guggenheim show in 1979 that a large section of the American public would find a distinctively Germanic-looking art intriguing. Furthermore, ironically, that American public would also readily associate its themes—death and survival, suffering and anguish, divination and transformation—with Expressionism, which was the only modern German art they had ever really known. As Mark Stevens put it in a *Newsweek* article about the show entitled "Art's Medicine Man": "Part of [Beuys's] power derives from the expressionist anger of the art, its very 'nowness.'"[107] (Of course, by 1979, Beuys had been making such art for more than thirty years.) By "nowness," Stevens undoubtedly meant the atmosphere of distress prevalent in 1970s America, which within a year had become keynotes of the critical reception of *Expressionism: A German Intuition* at the Guggenheim. Writing for the *New York Times* about this later exhibition, John Russell asserted: "It [Expressionism] was an art of emergency. Something had to be done about the alienation of the individual from himself, from other people and from society as a whole. People had to be not so much 'shocked' in an everyday sense, as challenged, jarred, disoriented and made to share in the collective anguish of the times."[108]

Just a week earlier, Hilton Kramer had penned an article for the same newspaper with a title—"Expressionism Means Revolt"—that referenced the subtitle of Myers's 1957 book *The German Expressionists: A Generation in Revolt.* Unfortunately, instead of fading away, this misleading cliché regained currency in 1980, not the least because it was one of the catchwords of Paul

Poster for Hans-Jürgen Syberberg's *Our Hitler—A Film from Germany*, 1977

Vogt's introductory essay in the catalogue for the Guggenheim show.[109] One German reviewer, Jürgen Kramer of the *Stuttgarter Zeitung*, cogently observed that, just when the United States was taking a pronounced turn toward conservatism, when there seemed not a trace left of revolutionary spirit, critics had chosen to praise Expressionism as though it were the first counterculture of Germany.[110] Conscious of the outmoded language used by Vogt and irritated at the show's "lack of a coherent and convincing rationale," Donald Gordon published an article in 1981 in *Art in America* protesting: "I do not believe in a 'Nordic' or 'Germanic' artist, nor in his being 'deeply entangled in the mysterious and tension-ridden creative process,' nor at all in his having a national heritage 'in the blood.'"[111]

The questionable association of Expressionist art with the idea of upheaval also reiterated another early cliché associated with the style, as voiced by Scheffauer in his 1924 book *The New Vision in the German Arts* (which had been reissued in 1971): "Much ecstatic violence was apparent in the prophets of the new movement. ... Much that was extravagant, bizarre, and even monstrous was born of these convulsions. Then out of the chaos ... the creed, or the emotion, or even the instinct of Expressionism was born."[112] These same notions were referenced in the subtitle—*A German Intuition*—of the 1980 show, and in its specious thesis—that Expressionism was a distinctively German sensibility. Needless to say, in an increasingly inauthentic era, the more deeply parochial German art appeared

to be, the more firmly anchored in German soil, the more appealing it became to Americans looking for their own roots. Certainly, the word *intuition* in the show's subtitle referenced yet another long-standing cliché associated with the idiom: the purported ability of Expressionist artists to divine catastrophe. Historically, if the Expressionists had really "intuited" any calamity, then it could only have been World War I. Nonetheless, for a generation of Americans born in the teens and 1920s—and even more for the following generation, born during or after the 1940s—the tragedies of World War I were utterly eclipsed by the crimes against humanity committed during World War II in Germany. Thus, for the majority of Americans, the apocalypse these artists purportedly "intuited" was a war that wouldn't even begin for another twenty years.

Immediately after the Beuys show closed in 1980 at the Guggenheim, Hans-Jürgen Syberberg's seven-hour film *Hitler—A Film from Germany* was screened at Avery Fisher Hall in New York City. A press release issued in connection with this event stated: "Within hours after tickets ... went on sale, the box-office was completely sold out. ... [The film is] distributed by Francis Ford Coppola ... such intellectual luminaries as Michel Foucault and Susan Sontag have called it 'one of the great works of art of the twentieth century.'"[113] The film's American distributors retitled it *Our Hitler*, capitalizing not only on a widespread feeling during the 1970s that the Holocaust could happen again, but also upon increased American interest in fascist Germany. What particularly interested Sontag was the film's contemporary relevance. As she put it: "By Hitler, Syberberg does not mean only the early historical monster, responsible for the deaths of tens of millions. He evokes a kind of Hitler-substance that outlives Hitler, a phantom presence in modern culture, a protean principle of evil that saturates the present and remakes the past."[114] Sontag was right: the success in America of the film—which had been banned in Germany—seems to have been due not just to a curiosity to understand Hitler, but to anxieties and existential questions that plagued American culture of the time. It was also this mindset that fueled the popularity of the Beuys exhibition and the Guggenheim show of Expressionist art. These were seen as both symptoms and emblems of an enduring "state of emergency," with particular relevance to "*our*" own condition.

THE LORE OF NEO-EXPRESSIONISM

Only months after *Expressionism: A German Intuition* closed in San Francisco, American interest in Expressionist art took yet

another new direction: a younger generation of so-called neo-Expressionists became the rage in New York during the 1980s. Active in several German cities, of two generations, and with widely differing aesthetic aims, these painters—Georg Baselitz, Rainer Fetting, K. H. Hödicke, Jörg Immendorff, Anselm Kiefer, Bernd Koberling, Markus Lüpertz, and A. R. Penck, among them—were presented to an American audience as though they comprised a unified school. Without question, the success of Beuys's debut at the Guggenheim was a key factor in drawing attention to these younger artists (although of them, only Immendorff and Kiefer had been his students in Düsseldorf). Equally important was the growing number of young American painters—Eric Fischl, David Salle, Julian Schnabel, and others—who also were perceived by critics as working in a figurative Expressionist idiom.

In January 1981, the exhibition *A New Spirit in Painting* opened at the Royal Academy of Arts in London—showcasing work by all these artists as well as those considered to be their Italian and British counterparts—that had an immediate impact on the United States' side of the Atlantic. "Expressionism Returns to Painting" proclaimed Hilton Kramer in a *New York Times* article of July 12, 1981. Later that year, Roberta Smith discussed the British show at length in *Art in America*. As she observed, "The exhibition's main goal seemed to have been to increase the visibility and appreciation of the northern Expressionist tradition in current painting, and to unseat American painting's hegemony."[115] Her statement suggests that *Expressionism: A German Intuition*—which had promoted Expressionism as an essentially Northern art form—assisted, albeit inadvertently, in paving the way for an appreciation of these younger German artists in America. By the end of 1981, five of these new painters were showing at seven New York galleries.[116] Given the history of America's uneasy admiration of Expressionism, it is perhaps not surprising that the new trend soon became fraught with thorns. In November 1981, an article titled "The New [?] Expressionism: Art as Damaged Goods" by Donald Kuspit appeared in *Artforum* making this case: "This so-called 'new' Expressionism currently being heralded by old media trumpets is a false Expressionism ... Neo-expressionism is like Abstract Expressionism ... like every significant new art, whose claim to importance at least in part rests on the importance of the past art that it is dependent on. This is just where the trouble lies in this false Expressionism. ... Revival in the name of new interests is always botched because new interests mean discarding the foundations of the old interests."[117]

The problem was that the "foundations of the old interests"—that is, of German Expressionist art—were so amorphous that their actual significance did not begin to be assessed until the late 1950s and then primarily among academics. It was not until 1987 that what may be the best book on the subject came into print: Donald Gordon's *Expressionism: Art and Idea*. And by that time, the public had long since formed its own (rather simplistic) opinions about Expressionism—opinions that persisted to the point of cliché.

One of the most disruptive early critiques on the new art from Germany had been published in *October* magazine in spring 1981. In an article with a line of argument not so different from strategies used by earlier twentieth-century art historians to criticize "modern" German art, Benjamin H. D. Buchloh inadvertently revealed just how plagued the reception of Expressionist art in America had become. Buchloh wrote: "Historical continuity had to be established in order to legitimize the neo-expressionists as heirs to the German cultural heritage. ... When art emphasizing national identity attempts to enter the international distribution system, the most worn-out historical and geo-political clichés have to be employed. And thus we now see the resurrection of such notions as the Nordic versus the Mediterranean, the Teutonic versus the Latin. ... The lack of formal and historical complexity in the painters' works and the attendant avoidance of genuine critical analysis of their contrived 'visions' result inevitably in a stereotypical critical language."[118]

Still, it is true that the new German painting suffered from the apparent inability of critics on both sides of the Atlantic to get down in words what it was about this art that made it highly significant, Expressionist or not: there seemed to be no appropriate vocabulary for what needed to be said; art critics resorted all too often to the hackneyed lexicon that had already done so much to trivialize Expressionist painting in America. Presumably aware of this, Buchloh used the most pedestrian categorizations—"Nordic versus Mediterranean" and "Teutonic versus the Latin"—that had been resurrected in the introductory essay to the 1980 Expressionism show at the Guggenheim.

Unfortunately, Buchloh seems to have missed the point: it was precisely because several of these new German artists dared to use taboo images associated with fascism, and remained indifferent to cultivating a style that could be construed as reminiscent of Expressionism, that their work was deemed exceptional. This had been part of Beuys's strategy in America as well, although he never risked making an overt reference to the Expressionist tradition, as Baselitz did in his *Nachtessen in*

Art in America

JANUARY 1983/$3.50
Outside North America/$5.00

THE EXPRESSIONISM QUESTION, II

Kirchner's Berlin Scenes/Expressionist Architecture/More on New German Painting
Critical Takes on Neo-Expressionism/"Expressionist" Lichtensteins

Cover of *Art in America* (January 1983), showing Anselm Kiefer's *Innenraum (Interior)*, 1981

Dresden (Supper in Dresden; 1983). In this work, the masked faces of Kirchner, Heckel, and Otto Mueller arranged around a table paraphrase those in Emil Nolde's *Pfingsten (Pentecost;* 1909). The central figure with a wide-open mouth is not only a portrait of Schmidt-Rottluff, but it is also an unmistakable evocation of the legacy of the "Expressionist shriek" inspired by Munch's *Shrik.*

Despite this overt paraphrase, and its quasi-Expressionist style, Baselitz and many of his painter friends never considered themselves "neo-Expressionists."[119] Their primarily figurative paintings were attacked as regressive and complacent, because they seemed to make deliberate references to Expressionism, and by extension, to the nonabstract style sanctioned by East German Communist officials. Also, like "modern" German art, neo-Expressionist art was occasionally denounced as "visions" manufactured ultimately for the bourgeois.

What had begun as a hesitant acknowledgment of this art by Americans nonetheless blossomed during the 1980s into an almost full-hearted embrace of Expressionism, albeit for senti-

mental reasons. It was almost predictable, then, that by 1982, when documenta 7 took place in Kassel, the new German painting would be characterized by one critic as "*Traumkitsch* (dream kitsch) … the rhetoric of redemption that surrounds these painters' works ultimately boils down to their attempted resurrection and revalorization of cultural traditions discredited by their association with fascism."[120] Indeed, such a statement is strangely reminiscent of the 1930s "Expressionist debate" provoked by Georg Lukacs's allegation that the road to fascism had been paved by the popularity of Expressionist literature. However, in 1980s America this critic was referring not to the alleged affinity of these painters to Expressionism, but to the much more problematic quagmire of German Romantic painting. In 1983, two major exhibitions of the "new art" from Germany were presented: *New Figuration: Contemporary Art from Germany*, which appeared at the Frederick S. Wight Art Gallery in Los Angeles in January and February of 1983, and *Expressions: New Art from Germany*, which opened at the Saint Louis Art Museum, where it remained on view from June to August of that year and then traveled to seven other American cities.

The vogue for neo-Expressionism served to reactivate an interest in Expressionism itself and its relationship to the revival of painting in America during the 1980s. Two special issues of *Art in America* devoted to "The Expressionism Question," in December 1982 and January 1983, attest to this. While the December issue examined the ties between Expressionism and figurative painting in America since the 1940s, the January edition focused on the work of both German and American so-called neo-Expressionists. The cover of the latter issue featured Kiefer's *Innenraum (Interior;* 1981), a replica of Albert Speer's fascist neoclassical reconstruction of the Neue Berliner Reichskanzlei (New Reich Chancellery) in Berlin. The Kiefer image emphasized long-simmering connections between the Expressionist mode and the idea of the moral bankruptcy of Germany, which resulted in the extermination of Jewish and non-Jewish Europeans under Hitler's regime. Significantly Kiefer, like post-1960s Beuys in Germany, continues to avoid any direct allusion to the Expressionist tradition. Instead, since the early 1980s, he has increasingly made work that explores Germany's fascist past and the history and religion of the Jewish faith.

THE LOOKING GLASS OF EXPRESSIONISM

By the 1990s, the perplexing identification of Expressionism with fascism—which dates back to the 1930s—had become more prevalent than ever. The best-attended exhibition of

Expressionist work ever presented in America opened in 1991 at the Los Angeles County Museum of Art. A reconstruction of the infamous 1937 *Entartete Kunst* show, this exhibition was not really about Expressionist art itself, but about Germany's attempt to obliterate it. *"Degenerate Art": The Fate of the Avant-Garde in Nazi Germany* was a veritable blockbuster, attracting 147,760 visitors during its Los Angeles stint alone. By the time *"Degenerate Art"* closed at the Smithsonian Institute in Washington D.C. in January of 1992 (after having also been presented at the Art Institute of Chicago), another 300,000 people had attended.[121]

In a rather surprising twist, the exhibition's popularity was partly due to the uproar surrounding accusations of censorship by the National Endowment for the Arts in the months immediately prior to the show's opening. Certain that Americans would draw parallels between Hitler's cultural politics and the conservative policies that had recently been introduced by the National Endowment for the Arts, Stephanie Barron included this note in the catalogue: "At this moment the arts in America are the subject of much discussion and controversy, and the issue of government support for the arts has been questioned for the first time since the founding of the National Endowment for the Arts more than twenty-five years ago. An exhibition that reflects on a dark moment in cultural history but focuses on those works of art and creative geniuses that survived is a celebration of the power of art to transcend the most daunting circumstances."[122] Now it was not German art, but American art that was perceived as in need of protection. One critic, Emily Braun, writing about the 1991 exhibition for *Art in America*, concluded a thorough discussion of the historical conditions that had led to the 1937 *Entartete Kunst* show with this warning note: "The differences between the events documented in 'Degenerate Art' and those surrounding the NEA censorship battle are, of course, enormous. But these differences should not obscure one fundamental fact: incomprehension of transgressive art and hostility to it are not historical relics, but continue to thrive."[123]

Though the press generally applauded both the exhibition and the catalogue for furthering knowledge of this decisive event in modern history, Hilton Kramer, writing for the *New Criterion*, felt he was probably not "alone in finding the documentary sections of the current survey more compelling than the galleries devoted to the art itself. This is an exhibition about an historic attempt to destroy art."[124] This was indeed part of Barron's aim. She felt strongly that in order to communicate to the public the extent of the National Socialists' attack on this art, the exhibi-

"A Millennium Worthy of the Angst Is Dawning," in the *New York Times* (January 7, 2001), showing Edvard Munch's *Shrik (The Scream),* 1893

tion must "be presented in a way to convey the original spirit— the works will be installed with some of the same methodology, including commentaries about the works that appeared at the first exhibition."[125] The show was championed in *Time* magazine as a "brave and necessary effort," but its reviewer, Robert Hughes, didn't doubt that "some folks will get more thrills from the show's documents of Nazi kitsch than from the once 'shocking' works of Kokoschka and Kirchner."[126]

Here it is worth noting that almost a decade earlier, Saul Friedländer had pinpointed a growing preoccupation with kitsch and death that since the end of the 1960s had brought about a change in the Western image of fascist Germany: "Nazism has disappeared, but the obsession it represents for the contemporary imagination ... necessarily confronts us with this ultimate question: Is such attention fixed on the past only a gratuitous reverie, the attraction of spectacle, exorcism, or the result of the need to understand; or is it, again and still, an expression of profound fears and, on the part of some, mute yearnings as well?"[127] It is not entirely surprising, then, that more than one reviewer admired the restaged *"Degenerate Art"* exhibition for its pres-

entation of a "morality tale that can never be told too often."[128] Others were more struck by the phantasmagoric effect of the show—which, despite all its didactic material, was, "like staring into the eyes of a cobra—mesmerizing and frightful. The exhibition … is one of the most remarkable—and troubling—seen in a lifetime of looking."[129]

Perhaps in the end, what is most important in an overview of the history of twentieth-century American reception of German Expressionism is what it reveals about this audience, its psyche, and its attitude toward specific cultural, political, and aesthetic milieux. We discover a public deeply involved in a complex maze of identity, repression, and dejection; a public struggling to come to terms with the contradiction between an appetite for morbid themes and a desire for upright morality; a public faced with growing evidence that its ideals and dreams have become near impossibilities. Unwilling to give up, this society looks time and again to the crystal ball of Expressionism for a new means to grapple with its own fascination with terror, decay, and death. These questions, which had no place in the aesthetics of Cubist or abstract art, are what have made Expressionist art "modern" and pertinent to an American audience. It is time to debunk these simplistic myths and look deeper. There is still much to be uncovered.

The writing of this essay has been greatly facilitated by the research assistance of Claire Deroy. I also wish to thank Barbara McCloskey, Diana Stoll, and Joan Weinstein for their insightful comments.

[1] Donald E. Gordon, "Expressionism and Its Publics," in: *Beiträge zur Rezeption der Kunst des 19. und 20. Jahrhunderts*, ed. by Wulf Schadendorf, Munich: Prestel, 1975, p. 85.

[2] Herman George Scheffauer, *The New Vision in the German Arts* (1924), Port Washington, N.Y.: Kennikat, 1971, p. 16.

[3] Oskar Pfister, *Expressionism in Art: Its Psychological and Biological Basis* (1920), transl. by B. Lowe and M. A. Müggc, London: Kegan Paul, Trench, Trubner, 1922, p. 3.

[4] See Max Nordau, *Entartung*, Berlin: Duncker, 1892–93.

[5] See Michael Leja, *Reframing Abstract Expressionism: Subjectivity and Painting in the 1940s*, New Haven: Yale University Press 1993, pp. 203–211.

[6] Peter Nisbet and Emile Norris, *The Busch-Reisinger Museum: History and Holdings*, Cambridge, Mass.: Harvard University Art Museums, 1991, pp. 30, 55.

[7] Paul Clemen, "Contemporary German Art," in: *Exhibition of Contemporary German Art*, transl. by G. E. Maberly-Oppler, exhibition cat., New York, Metropolitan Museum of Art, 1908. Though all the works were shown in New York and Chicago, a reduced number were shown in Boston. See the twelve-page supplement inserted at the end of the catalogue for the Boston venue.

[8] Wilhelm R. Valentiner, "Die Deutsche Ausstellung in New York," in: *Kunst und Künstler*, vol. 7 (1909), p. 374.

[9] Martin Birnbaum, letter to Cornelia B. Sage, June 4, 1912, Albright-Knox Art Gallery Archives, cited in: Penny Joy Bealle, *Obstacles and Advocates: Factors Influencing the Introduction of Modern Art from Germany to New York City, 1912–1933: Major Promoters and Exhibitions*, Ann Arbor, Mich.: UMI, 1990, p. 57.

[10] Birnbaum, Introduction, in: *Catalogue of an Exhibition of Contemporary German Graphic Art*, exhibition cat, New York, Berlin Photographic Company, 1912–13.

[11] Anon., "Contemporary German Graphic Art," in: *American Art News*, vol. 11, no. 8 (November 30, 1912), p. 2.

[12] W. H. de B. Nelson, "German Art: Berlin Photographic Company," in: *International Studio* (March 1913), pp. xix–xx.

[13] Stephanie Barron, "The Embrace of Expressionism: The Vagaries of Its Reception in America," in: *German Expressionist Prints and Drawings: The Robert Gore Rifkind Center for German Expressionist Studies*, Los Angeles and Munich: Los Angeles County Museum of Art and Prestel, 1989, pp. 131–149.

[14] Christian Brinton, "Evolution not Revolution in Art," in: *International Studio*, vol. 49 (April 1913), pp. xvii–xx.

[15] Margaret Sterne, *The Passionate Eye: The Life of William R. Valentiner*, Detroit: Wayne State University Press 1980, p. 113–115.

[16] Anon., "Art Exhibitions of the Week: Modern German Art," in: *New York Times* (October 7, 1923), p. 12.

[17] Valentiner, in: *A Collection of Modern German Art*, exhibition cat., New York, Anderson Galleries, 1923, p. 2.

[18] F. E. Washburn Freund, "Modern Art in Germany: Representative Work Selected by Dr. W. R. Valentiner for Exhibition in New York Shows National Spirit," in: *International Studio*, vol. 78 (October 1923), pp. 41–46.

[19] Royal Cortissoz, "Modern German Art in Exhibit Here Is Crude. Works Shown at Anderson Galleries, Supposed to Usher in new Era, Indicate Germany Is Badly Off. Delicacy of Form Lacking. One Contributor Seems Like Man Exploring Fairyland in Hobnail Boots," in: *New York Tribune* (March 15, 1931), p. 15.

[20] Anon., "Modern German Art Speaks by Its Art. A Kind of Terrible Earnestness. Even in Landscapes at Times an Intentional Brutality," in: *Art News*, vol. 22 (October 13, 1923) pp. 1–2.

[21] Hermann Bahr, *Expressionism* (1916), transl. by R. T. Gribble, London: Henderson, 1925, p. 84.

[22] Katherine S. Dreier, *Western Art and the New Era: An Introduction to Modern Art*, New York: Brentano's, 1922, p. 75.

[23] Valentiner, *A Collection of Modern German Art* (as note 17), p. 2.

[24] Pfister, *Expressionism in Art* (as note 3), pp. 208, 198.

[25] Sheldon Cheney, *A Primer of Modern Art*, New York: Boni and Liveright, 1924, p. 195. By 1932, the book was in its seventh printing.

[26] Gregory Wallace, *Sheldon Cheney and the Historiography of Modern Art in America*, Ann Arbor, Mich.: UMI, 1996, pp. 85–87.

[27] Cheney, *A Primer of Modern Art* (as note 25), p. 222.

[28] Julius Meier-Graefe, "German Art After the War," transl. by Kenneth Burke, in: *The Dial* (July 1923), pp. 1–2.

[29] Wilhelm Worringer, *Künstlerische Zeitfragen*, Munich: Bruckmann, 1921, pp. 9–10, cited in: *German Expressionism: Documents from the End of the Wilhelmine Empire to the Rise of National Socialism*, ed. by Rose-Carol Washton Long, Berkeley: University of California Press, 1995, p. 285.

[30] Joan Weinstein, *The End of Expressionism: Art and the November Revolution in Germany, 1918–19*, Chicago: University of Chicago Press, 1990, pp. 219–244.

[31] A. Everett Austin, "Report of the Director for the Year 1930," in: *Wadsworth Atheneum Annual Report*, 1930, p. 5.

[32] Gerhard L. Weinberg, "From Confrontation to Cooperation: Germany and the United States, 1933–1949," in: *America and the Germans: An Assessment of a Three-Hundred-Year History*, ed. by Frank Trommler and Joseph McVeigh, Philadelphia: University of Pennsylvania Press, 1985, p. 45.

33 Rona Roob, "Alfred H. Barr, Jr.: A Chronicle of the Years 1902–1929," in: *New Criterion* (Summer 1987), pp. 11, 16.

34 Alfred H. Barr, Jr., "Otto Dix," in: *Arts*, vol. 17, no. 4 (January 1931), pp. 250–251.

35 Barr, letter to James Thrall Soby, November 1948, cited in: Bealle, *Obstacles and Advocates* (as note 9), p. 297.

36 Gustav F. Hartlaub, letter to Barr, July 8, 1929, cited in Barr, "Otto Dix" (as note 34), p. 237.

37 Bealle, *Obstacles and Advocates* (as note 9), p. 303.

38 Barr, letter to Ernst Büchner, September 22, 1930. Archives of Museum of Modern Art, New York.

39 Barr, in: *German Painting and Sculpture*, exhibition cat., New York, Museum of Modern Art, 1931, pp. 7–8.

40 Only four other shows had been more popular with the public: the inaugural exhibition *Cézanne, Gauguin, Seurat, van Gogh* (47,293 visitors); the second show, *Nineteen American Painters* (27,924 visitors); the third, *Painting in Paris* (58,575); and the eighth, *Corot and Daumier* (29,349), which closed four months before the German show opened. Figures courtesy Museum of Modern Art, New York.

41 Henry McBride, "Present-Day Teutonic Ideals Are Intelligently Presented," in: *New York Sun* (March 14, 1931), p. 8.

42 Ralph Flint, "German Art Shown at Modern Museum," in: *Art News*, vol. 29, no. 25 (March 21, 1931), p. 5.

43 Milton S. Fox, "German Painting Stirs Great Controversy in American Art Circles," in: *Cleveland News* (April 5, 1931). Page 110 of the scrapbook for *German Painting and Sculpture*, in the Archives of Museum of Modern Art, New York.

44 Lloyd Goodrich, "German Painting at the Museum of Modern Art," in: *Arts*, vol. 17 (April 1931), p. 503.

45 Margaret Breuning, "The Modern Museum Presents a Group of German Artists," in: *New York Evening Post* (March 21, 1931), p. 5.

46 *Encyclopaedia Britannica*, 14th ed., 1929, s.v. "Post-Impressionism." I am grateful for Diana Stoll's assistance in locating this passage.

47 McBride, "Present-Day Teutonic Ideals" (as note 41), p. 8.

48 Barr, "Die Wirkung der Deutschen Ausstellung in New York," in: *Museum der Gegenwart, Zeitschrift der Deutschen Museen für Neuere Kunst*, vol. 2 (1931), p. 58.

49 Ibid.

50 Flora Turkel-Deri, "Weimar Museum Shelves Moderns," in: *Art News*, vol. 29 (January 17, 1931), p. 6.

51 Joseph Goebbels, cited in: Jean Clair, *Die Verantwortung des Künstlers: Avantgarde zwischen Terror und Vernunft*, Cologne: DuMont, 1998, p. 41.

52 Stephanie Barron, "1937: Modern Art and Politics in Prewar Germany," in:

"Degenerate Art": The Fate of the Avant-Garde in Nazi Germany, ed. by Barron, exhibition cat., Los Angeles County Museum of Art; Art Institute of Chicago; and Berlin, Deutsches Historisches Museum, 1991–92, p. 19.

53 Anon., "'Degenerate Art' Displayed in Reich: Exhibition Opened in Munich to Show Contrast Between the 'Healthy' and 'Filthy,'" in: *New York Times* (July 20, 1937), p. 15.

54 Stefan Frey, "Die Auktion in der Galerie Fischer in Luzern am 30. Juni 1939—ein Ausverkauf der Moderne aus Deutschland?" in: *Überbrückt: Ästhetische Moderne und Nationalsozialismus Kunsthistoriker und Künstler 1925–1937*, ed. by Eugen Blume and Dieter Scholz, Cologne: Walther König, 1999, pp. 275–289.

55 Sheldon Cheney, *Expressionism in Art* (1934), New York: Liveright, 1948, p. 81.

56 Susan Noyes Platt, "Modernism, Formalism, and Politics: The Cubism and Abstract Art Exhibition of 1936 at the Museum of Modern Art," in: *Art Journal*, vol. 47, no. 8 (Winter 1988), pp. 284–295.

57 See Vivian Endicott Barnett, "Banned German Art: Reception and Institutional Support of Modern German Art in the United States, 1933–1945," in: *Exiles and Émigrés: The Flight of European Artists from Hitler*, ed. by Stephanie Barron and Sabine Eckmann, exhibition cat., Los Angeles County Museum of Art; and Berlin, Neue Nationalgalerie, Staatliche Museen, 1997–98, pp. 273–284.

58 Peter Thoene, *Modern German Art*, transl. by Charles Fullman, Harmondsworth: Penguin, 1938, p. 108. I am grateful to Keith Holz for information on Thoene.

59 Reinhold Heller, "The Expressionist Challenge: James Plaut and the Institute of Contemporary Art," in: *Dissent: The Issue of Modern Art in Boston*, exhibition cat., Boston, Institute of Contemporary Art, 1985, p. 31.

60 Cited in: ibid., p. 32.

61 *Reich Propaganda Directorate Culture Office, Entartete Kunst Ausstellungsführer*, Munich: Fritz Kaiser, 1937, cited in: facsimile of the *Entartete Kunst* exhibition brochure, transl. by David Britt, in: *"Degenerate Art"* (as note 52), pp. 372–374.

62 John Dewey, "What I Believe," in: *Forum* (March 1930), and C.E.M. Joad, "Is Man Improving?" in: *Scribner's* (August 1935), both cited in: Leja, *Reframing Abstract Expressionism* (as note 5), pp. 221, 233.

63 Anon., "Art Throughout America," in: *Art News*, vol. 37 (June 10, 1939), p. 18. The show, organized by Blanche A. Byerley in America, may have also traveled to Saint Louis, Kansas City, Portland, Ore. and San Francisco. See, "Nazi-Banned Art Comes to American Shores," in: *Art Digest* (May 15, 1939), p. 19.

64 Anon., "Twentieth Century German Art," in: *Bulletin of the Milwaukee Art Institute*,

vol. 13, no. 10 (June–August 1939), p. 3.

65 Barr, cited in: Cécile Whiting, "Regenerate Art: The Reception of German Expressionism in the United States, 1900–1945," in: *Art Criticism*, vol. 9, no. 1 (1994), p. 84.

66 Serge Guilbaut, *How New York Stole the Idea of Modern Art: Abstract Expressionism, Freedom, and the Cold War*, transl. by Arthur Goldhammer, Chicago: University of Chicago Press, 1983, p. 93.

67 Anon., "The End of Belsen?" in: *Time* (June 11, 1945), p. 36.

68 Anon., Introduction, in: *German Expressionism in Art: 1905–1935*, exhibition cat., Minneapolis, University Gallery, n.p.

69 Cheney, *Expressionism in Art* (as note 55), p. xii.

70 Yule F. Heibel, *Reconstructing the Subject: Modernist Painting in Western Germany, 1945–1950*, Princeton: Princeton University Press, 1995, p. 107.

71 Kurt Winkler, "Neuexpressionisten (Quadriga), Frankfurt 1952," in: *Stationen der Moderne: Die bedeutenden Kunstausstellungen des 20. Jahrhunderts in Deutschland*, exhibition cat., Berlinische Galerie 1988, p. 418.

72 Scheffauer, *The New Vision in the German Arts* (as note 2), p. 39.

73 Oswald Herzog, "Der Abstrakte Expressionismus," in: *Der Sturm*, vol. 10, no. 2 (May 1919), p. 29, cited in: *German Expressionism: Documents* (as note 29), pp. 117–119. I am grateful to Vivian Endicott Barnett for drawing my attention to this article.

74 Henry McBride, "It's Called Expressionism," in: *Art News*, vol. 51, no. 3 (May 1952), p. 27.

75 Jost Hermand, "From Nazism to NATOism: The West German Miracle According to Henry Luce," in: *America and the Germans* (as note 32), pp. 84–85.

76 Walter Grasskamp, *Die unbewältigte Moderne: Kunst und Öffentlichkeit*, Munich: Beck, 1989, pp. 76–100.

77 Theodor Heuss, "German Character and History," in: *Atlantic*, vol. 3 (March 1957), p. 108.

78 Carl Georg Heise, "Sieg deutscher Kunst in Amerika?" in: *Die Zeit* (October 10, 1957).

79 Sidney Geist, "Month in Review," in: *Arts*, vol. 32, no. 2 (November 1957), pp. 46–49; Alfred Frankenstein, "Editorial: Expressionism—A Dissenting Opinion," in: *Art News*, vol. 56, no. 7 (1957) p. 23.

80 Dorothy Adlow, "German Art of the Twentieth Century in New York," in: *Christian Science Monitor* (October 12, 1957).

81 In comparison, the 1955 *documenta* featured only three "American" artists—Josef Albers, Alexander Calder, and Kurt Roesch; of them, only Calder was born in America.

82 George McCue, "German Art Revival: It Is Acknowledged in Coming Art Museum Show," in: *St. Louis Dispatch* (December 29, 1957).

83 Ernst Kretschmer, *Physique and Character: An Investigation of the Nature of Constitution and of the Theory of Temperament* (1921), transl. by W.J.H. Sprott, New York: Paul, Trench, Trubner, 1925, pp. 233–234.

84 Max Kozloff, "The Dilemma of Expressionism," in: *Artforum*, vol. 3, no. 2 (November 1964), pp. 32, 35.

85 Of notable exception were the so-called Figurative Expressionists active in Boston, including Hyman Bloom and Jack Levine. See Judith A. Bookbinder, *Figurative Expressionism in Boston and Its Germanic Cultural Affinities: An Alternative Modernist Discourse on Art and Identity*, Ann Arbor, Mich.: UMI, 1998.

86 Between 1977 and 1984, Lichtenstein made a series of thirty paintings and drawings that are paraphrases of Expressionist artworks. I am grateful to Jack Cowart, Roy Lichtenstein Foundation, New York for providing this information.

87 Lichtenstein's *Despair* closely resembles a 1921 woodcut by Franz Radziwill entitled *Abkehr (Alienation)*, reproduced in the catalogue for the 1977 exhibition of works from the Robert Gore Rifkind collection. Lichtenstein's interest in Expressionist art was encouraged by discussions with Rifkind, whom he met for the first time in 1978. See Stephanie Barron, "Painless Expressionism," in: *Art News*, vol. 81, no. 7 (September 1982), pp. 64–65.

88 Bernard S. Myers, *The German Expressionist: A Generation in Revolt*, New York: Praeger, 1957, p. 32.

89 Philip M. Boffey, "Will the Next 20 Years Bring Prosperity or Decline?" in: *New York Times* (January 12, 1982), pp. C1–2.

90 German Expressionist music and theater performances, films, and art were presented in San Francisco for two and a half months during the run of the show. See Michael Gallantz, "The German Cultural Invasion," in: *ArtBeat* (March 1981), pp 8–11. In the press-clipping file of *Expressionism: A German Intuition*, courtesy Solomon R. Guggenheim Museum Archives. I am grateful to Ann E. Butler, Archivist at the Solomon R. Guggenheim Museum, for her helpful assistance with the numerous documents in the Guggenheim Museum Archives.

91 "Emil Nolde ist der Star," in: *Neue Ruhr-Zeitung* (December 19, 1980), n.p. In the press-clipping file of *Expressionism: A German Intuition*, courtesy Solomon R. Guggenheim Museum Archives.

92 Paul Vogt, Introduction, in: *Expressionism: A German Intuition*, 1905–1920, exhibition cat., New York, Solomon R. Guggenheim Museum, 1980, p. 22.

93 John Ashbery, "The Fine Art of German Angst," in: *Newsweek* (December 1, 1980), p. 114.

94 See Christopher Lasch, *The Culture of Narcissism: American Life in An Age of*

Diminishing Expectations, New York: W. W. Norton, 1979.

95 Kim Levin, "Life Is Just a Scream," in: *Village Voice* (November 26–December 2, 1980), p. 80.

96 See Peter Novick, *The Holocaust in American Life,* Boston: Houghton Mifflin, 1999, pp. 207, 127–134.

97 Elie Wiesel, *One Generation After,* New York: Random House, 1970, p. 172.

98 Novick, *The Holocaust in American Life* (as note 96), pp. 209.

99 Correspondence in the archives of the Guggenheim Museum indicates that Thomas Messer, the museum's director, had been interested in mounting a Beuys show since at least 1976, well before he began working with German cultural officials on the exhibition *Expressionism: A German Intuition.*

100 Thomas Messer, conversation with the author, New York, December 1, 2000.

101 Robert Hughes, "The Noise of Beuys," in: *Time* (November 12, 1979), p. 90.

102 Clare Bell, "The Institution as Frame: Installation at the Guggenheim," in: *Art of this Century: The Guggenheim Museum and Its Collection,* New York: Guggenheim Museum Publications, 1993, p. 297.

103 Joseph Beuys, in: Caroline Tisdall, *Joseph Beuys,* exhibition cat., New York, Solomon R. Guggenheim Museum, 1979, p. 22.

104 Benjamin H. D. Buchloh, "Beuys: The Twilight of the Idol: Preliminary Notes for a Critique," in: *Artforum,* vol. 18, no. 5 (January 1980), p. 35.

105 Levin, "Joseph Beuys: The New Order," in: *Arts,* vol. 54, no. 8 (April 1980), p. 154.

106 Donald Kuspit, "Beuys: Fat, Felt and Alchemy," in: *Art in America,* vol. 68, no. 5 (May 1980), p. 82.

107 Mark Stevens, "Art's Medicine Man," in: *Newsweek* (November 12, 1979), p. 77. In the press-clipping file of *Joseph Beuys,* courtesy Solomon R. Guggenheim Museum Archives.

108 John Russell, "German Loans Make Expressionist Show a Landmark," in: *New York Times* (November 14, 1980). In the press-clipping file of *Expressionism: A German Intuition,* courtesy Solomon R. Guggenheim Museum Archives.

109 Hilton Kramer, "Expressionism Means Revolt," in: *New York Times* (November 9, 1980). In the press-clipping file of *Expressionism: A German Intuition,* courtesy Solomon R. Guggenheim Museum Archives.

110 Jürgen Kramer, in: Stuttgarter Zeitung, p. 125. In the press-clipping file of *Expressionism: A German Intuition,* courtesy Solomon R. Guggenheim Museum Archives.

111 Gordon, "Expressionism: Art by Antithesis," in: *Art in America,* vol. 69, no. 3 (March 1981), pp. 99, 103.

112 Scheffauer, *The New Vision in the German Arts* (as note 2), p. ix.

113 Renee Furst, "Immediate Sellout at Avery Fischer Hall for January 13th Performance of Hans-Jürgen Syberberg's 7 Hour Film Cycle," press release, January 3, 1980. The Celeste Bartos Film Study Center, Department of Film and Media, Museum of Modern Art, New York.

114 Susan Sontag, *Under the Sign of Saturn,* New York: Anchor, 1980, pp. 150–151.

115 Roberta Smith, "Fresh Paint?" in: *Art in America,* vol. 69, no. 6 (Summer 1981), p. 71.

116 They included Georg Baselitz, Markus Lüpertz, A. R. Penck, Rainer Fetting, and Salomé. See Donald Kuspit, "Flak from the 'Radicals': The American Case Against German Painting," in: *Expressions: New Art from Germany,* exhibition cat., Saint Louis Art Museum, 1983, p. 43.

117 Kuspit, "The New [?] Expressionism: Art as Damaged Goods," in: *Artforum,* vol. 20, no. 3 (November 1981), p. 47.

110 Benjamin H. D. Buchloh, "Figures of Authority, Ciphers of Regression: Notes on the Return of Representation in European

Painting," in: *October,* no. 16 (Spring 1981), pp. 63–65.

119 Georg Baselitz (1988), cited in: Diane Waldman, *Georg Baselitz,* exhibition cat., New York, Solomon R. Guggenheim Museum, 1995, p. 149.

120 Craig Owens, "Bayreuth '82," in: *Art in America,* vol. 70, no. 8 (September 1982), p. 134.

121 Zahava D. Doering, Andrew J. Perarik, and Audrey E. Kindlon, "Different Sites, Different Views: A Study of the Exhibition 'Degenerate Art': The Fate of the Avant-Garde in Nazi Germany," Institutional Studies Office, Smithsonian Institute, Washington D.C., Report 95-2, April 1995, n.p. In the files of *"Degenerate Art": The Fate of the Avant-Garde in Nazi Germany,* at the Los Angeles County Museum of Art. I am grateful to Stephanie Barron for allowing me access to these files.

122 Barron, Acknowledgments, in: *"Degenerate Art"* (as note 52), p. 415.

123 Emily Braun, "Return of the Repressed," in: *Art in America,* vol. 79, no. 10 (October 1991), p. 123.

124 Kramer, "'Degenerate Art' and the War against Modernism," in: *New Criterion,* vol. 10, no. 2 (October 1991), p. 8.

125 Barron, in the curatorial files for the exhibition *"Degenerate Art": The Fate of the Avant-Garde in Nazi Germany,* at the Los Angeles County Museum of Art.

126 Hughes, "Culture on the Nazi Pillory," in: *Time* (March 4, 1991), p. 87.

127 Saul Friedländer, *Reflections of Nazism: An Essay on Kitsch and Death* (1982), transl. by Thomas Weyr, New York: Harper & Row, 1984, p. 19.

128 Michael Kimmelman, "Examining Works by Artists the Nazis Hounded and Scorned," in: *New York Times* (February 25, 1991), p. C11.

129 William Wilson, "Nazi Germany's 'Degenerate Art' Show at LACMA," in: *Los Angeles Times* (February 15, 1991), p. F1.

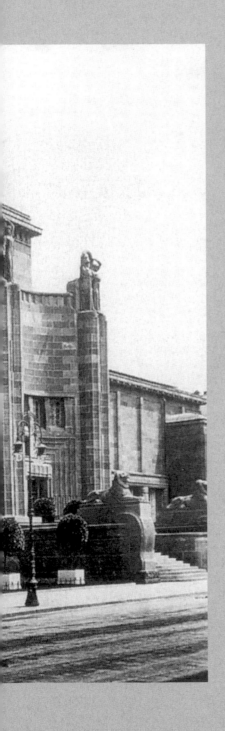

DADA AND
NEUE SACHLICHKEIT

- **MAX BECKMANN**
- **OTTO DIX**
- **CHRISTIAN SCHAD**
- **GEORGE GROSZ**
- **KURT SCHWITTERS**

Kunsthalle Mannheim, built by Hermann Billig, 1907

MAX BECKMANN

*** FEBRUARY 12, 1884, LEIPZIG**
† DECEMBER 27, 1950, NEW YORK CITY

Invitation to the exhibition *Paintings by Max Beckmann*, New Art Circle (J. B. Neumann), New York, April 12–May 7, 1927. The Museum of Modern Art Library, New York. Photograph © 2001 The Museum of Modern Art, New York

Max Beckmann was born in Leipzig in 1884, the third child of Carl Heinrich Christian Beckmann, a real-estate agent and flour merchant, and his wife Antoinette Bertha. Beckmann attended a school in Falkenburg in Pomerania from 1892 to 1894, when his father died. The family then moved to Braunschweig, where Beckmann continued his schooling.

Beckmann's application to the Dresden Kunstakademie in 1899 was denied; the following year, however, he enrolled at the Kunstschule in Weimar. In 1902, he met Minna Tube, who was also studying art in Weimar; the couple married four years later in 1906.

In 1903, Beckmann left the Kunstschule and traveled to Paris, where he rented a studio. During his time there, he was particularly drawn to the paintings of Paul Cézanne. Beckmann left France in 1904, and moved to Berlin to begin in earnest a career as a painter. In 1905, his painting *Junge Männer am Meer (Young Men by the Sea;* 1905) won him a stipend, enabling him to live and study at the Villa Romana in Florence. With Minna, he traveled again to Italy in the fall of 1906. Upon their return to Berlin the following year, the pair moved into a new studio and apartment in the city's Hermsdorf district. Their son Peter was born in 1908.

After the outbreak of war in the summer of 1914, Beckmann served as a volunteer medical orderly with the German army in East Prussia. He suffered a nervous breakdown in the summer of 1915, and was granted leave to return to Germany. He moved to Frankfurt, which would remain his base until 1933.

In 1919, Beckmann declined the offer of a job as supervisor of the class for nude drawing at the Weimarer Kunstschule, which later became the state-supported Bauhaus. Instead, he signed a contract in 1920 with Berlin dealer J. B. Neumann. In 1924 (after Neumann's move to New York), Beckmann signed contracts with Paul Cassirer in Berlin and Peter Zingler in Zürich. In the same year, he met the singer Mathilde von Kaulbach, known as "Quappi," who would become Beckmann's second wife after his divorce from Minna in 1925.

Beckmann took a teaching post at the Städelschule in Frankfurt in 1925, and began what would be his most successful period in Germany. Between 1929 and 1932, the artist spent most of the year in Paris, traveling once a month to Frankfurt to teach at the Städelschule, where he was now a full professor. With the rise to power of the National Socialists in 1933, his teaching contract at the school was prematurely terminated, and Beckmann moved to Berlin.

The following year, he began to explore the possibility of emigrating from Germany. In 1937, more than six hundred of his works were confiscated from German museums. No less than ten paintings and twelve prints by Beckmann were included in the *Entartete Kunst* exhibition, which opened in Munich on July 19, 1937. One day before this exhibition opened, Adolf Hitler inaugurated the *Grosse Deutsche Kunstausstellung* (Great German Art Exhibition) at Munich's Haus der Kunst. Immediately following this, the Beckmanns left Germany forever, moving first to Amsterdam, which would be their home until 1947.

Several important pieces by Beckmann were included in the 1938 *Exhibition of Twentieth Century German Art* in London. At the opening of that show, Beckmann delivered his now-famous speech, "On My Painting."

With the German occupation of Holland, beginning in May 1940, the Beckmanns' lives were increasingly imperiled. In 1947, Beckmann accepted a temporary professorship at the Art School of Washington University in Saint Louis. He applied for American citizenship in 1948. In June 1949, he left Saint Louis, teaching that summer at the University of Colorado at Boulder and then, beginning in September, at the Brooklyn Museum Art School in New York. In December 1950, Beckmann died in New York.

PUBLIC RECOGNITION

Max Beckmann's career as a painter began in 1906, with the stipend he was awarded for his *Junge Männer am Meer*.[1] With this work, Beckmann declared his artistic ambitions in a form of "monumental Impressionism," that is, a style both indebted to *plein air* painting and yet clearly possessed of a genuine respect for tradition.[2] His aim was to apply lessons derived from the Old Masters to subjects that were in fact emphatically modern.

J. B. Neumann played a critical role in establishing Beckmann's reputation in Germany.[3] In 1911, the dealer had established a gallery, the Graphisches Kabinett, in Berlin, and in the very next year prints by Beckmann were among the works exhibited. In 1917, Neumann mounted a show of Beckmann's work, and in 1920 signed his first contract with the artist. In 1921, Neumann held two exhibitions of Beckmann's paintings. Around this time, the dealer was frequently depicted by Beckmann in the artist's larger figural compositions (see, for example, *Fastnacht [Carnival;* 1920]). In 1923, Neumann left Berlin and moved to New York.

And so it was that on the eve of World War I, Beckmann appeared on the scene as a successor to the Impressionist Max Liebermann. At this time, he reached a first peak in his career. In 1913, gallery-owner Paul Cassirer organized a one-man show for him in Berlin, which helped to consolidate his reputation in the art circles of Wilhelminian Germany. In the first monograph on the twenty-nine-year-old painter, the critic Hans Kaiser asserted: "What is lacking in our age, and that from which it recoils, is exactly what Beckmann's painting, pas-

sion, and heroic romanticism supplies."[4] Kaiser's still indispensable monograph thus presents the first provisional stocktaking of Beckmann's work and, in retrospect, also marks a fundamental shift in the artist's career. As a result of the conflict between his Impressionist style and the influence of contemporary tendencies, Beckmann was obliged to rethink and reformulate his position.[5]

The change was heralded in 1912 when a controversy erupted between Beckmann and Franz Marc, co-founder of the Blaue Reiter, in the art journal *Pan*.[6] There, Beckmann spoke in favor of objectivity (*Sachlichkeit*), taking a stand against Expressionism and the emerging tendency toward nonobjective painting. Throughout the artist's life, his attitude toward the avant-garde would be ironic, critical, and sometimes implacable.

Beckmann sought to characterize the evolution of his own painting by invoking the seemingly paradoxical concept of a "transcendental objectivity." In his *Bekenntnis* (Confession), written in 1918 and published two years later, he deplored the pointlessness of Impressionism, of the abstract art promoted by the activities of artists associated with the Blaue Reiter, and of the late, increasingly shallow manifestations of Expressionism.[7]

By the mid 1920s, Beckmann had emerged as one of the leading representatives of the artistic current known as Neue Sachlichkeit (New objectivity).[8] In 1925, Gustav Friedrich Hartlaub, director of the Städtische Kunsthalle in Mannheim and one of the most progressive and influential figures in the German museum world at the time, mounted

Beckmann at Stephen's College, Columbia, Missouri, 1948

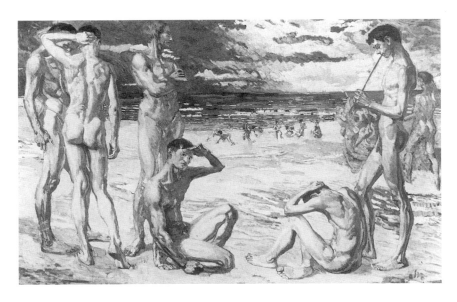

Max Beckmann, *Junge Männer am Meer* (*Young Men by the Sea*), 1905. Kunstsammlungen zu Weimar, Schlossmuseum

Gustav Friedrich Hartlaub
in front of the Kunsthalle
Mannheim, autumn 1926

KUNSTHALLE MANNHEIM

VOM 19. FEBRUAR

BIS 1. APRIL 1928

GEMÄLDE **MAX** GRAPHIK
BECKMANN
DAS GESAMMELTE WERK
AUS DEN JAHREN 1905-27

Poster of the exhibition *Max Beck-
mann: Gemälde, Graphik, das gesam-
melte Werk aus den Jahren 1905–27*,
Kunsthalle Mannheim, February 19–
April 1, 1927

View of the Max Beckmann room
(arranged by Ludwig Justi) in the new
section of the Nationalgalerie Berlin,
Kronprinzenpalais, Berlin, 1933

the exhibition that was to give this movement its name: *Die Neue Sachlichkeit. Deutsche Malerei seit dem Expressionismus* (The New Objectivity: German Painting Since Expressionism). Beckmann's work was central to this undertaking. In Hartlaub's view, he was the perfect representative of Neue Sachlichkeit, in that his work achieved a synthesis of the two "wings" of the movement: the veristic and the classicizing. Three years later, Hartlaub organized the first Beckmann retrospective, held at the Kunsthalle Mannheim from February 19 through April 10, 1928.[9]

From 1926, Beckmann began to distance himself from Neue Sachlichkeit, and to formulate—in both pictures and written statements—the notion of a deliberate estrangement from the "style of the era."[10] An important embodiment of this change is the celebrated *Selbstbildnis im Smoking (Self-Portrait in Tuxedo;* 1927), in which the painter faces the viewer in an aggressively frontal pose. A year after it was painted, this picture entered the collection of the Nationalgalerie in Berlin and was subsequently given a prominent position in a room devoted entirely to Beckmann's work. This room—the Beckmann-Saal—was closed in 1933 when the museum's director, Ludwig Justi, was dismissed from his position. In 1937, the work was confiscated by the National Socialists, from whom

it was acquired for the sum of $150 by the art dealer Karl Buchholz. Within a year it was sold, through Beckmann's dealer Curt Valentin, to Charles Kuhn for the Germanic Museum (today the Busch-Reisinger Museum) in Cambridge, Massachusetts.[11]

Beckmann's writings and notes of the late 1920s appear to reflect a markedly conservative way of thinking, not far removed from the mindset of the so-called conservative revolution (an aspect of his development still largely ignored—or suppressed—in Beckmann scholarship). Beckmann voiced his belief in the artist as a superior authority within modern society in a 1927 article in the *Europäische Revue* titled "Der Künstler im Staat" (The Artist in the State): "The artist in the contemporary sense is the conscious shaper of the transcendent idea. He is at one and the same time the shaper and the vessel. His activity is of vital significance to the state, since it is he who establishes the boundaries of a new culture."[12] Implicit in such statements is an anti-egalitarianism directed against collectivist and democratic ideals.[13]

Unlike many other proponents of Neue Sachlichkeit, Beckmann sought a productive engagement with the French avant-garde of the 1920s and '30s. The evident connection between Beckmann's *Die Loge I (Loge I;* 1928) and Renoir's

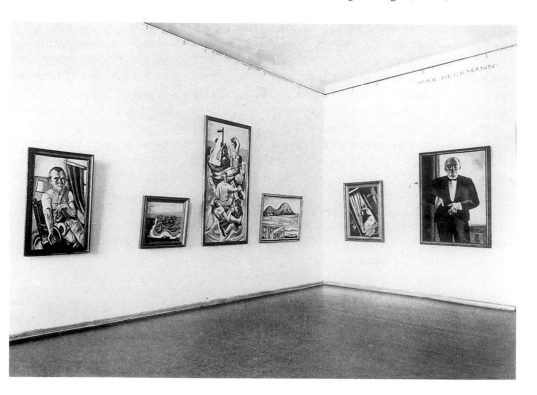

composition *La Loge* from 1874 is just one example of this influence.[14] *Die Loge I* received an honorable mention at the 1929 Carnegie International in Pittsburgh; the nomination was the first high point in the American reception of Beckmann's work. Writing of *Die Loge I*, one American critic even referred to "the dynamic of a brushstroke that Picasso himself might have envied,"[15] thereby capturing the sense of international artistic competition that Beckmann must have felt at this time. Neumann did much to encourage the increasingly enthusiastic reception of Beckmann's work in America through his journal *Artlover*, published in New York at irregular intervals between 1926 and 1945. In 1927, he mounted Beckmann's first one-man show in the United States.[16] The dealer summed up his aims that same year as follows: "It is now three years since I have been in your midst. When I first arrived in New York I intended to exhibit the work of the man I am just now presenting [to] you. ... My wish is that the response to this exhibition may be great enough to encourage the Neue Kunstgemeinschaft [New Art Society] in its aim, which is to establish a friendly exchange of art between America and Germany."[17] Yet, despite this declaration of intent and Neumann's evident devotion to the cause of German art, it appears that Beckmann was not especially pleased with the dealer's work on his behalf. In all probability, this dissatisfaction was linked to the artist's own success in positioning himself within the international art world.

Indeed, Beckmann was deeply concerned with making his name in Paris, which by this time was the art world's true capital. He therefore arranged for his contract with German art dealer Alfred Flechtheim (who had excellent Parisian connections) to be acknowledged in a new agreement drawn up with Neumann in 1930. It was only later, and at a time when contact between Beckmann and Neumann was strained (not least because of contemporary political developments), that the artist would recognize that Neumann's pioneering work in the United States had truly served his interests and prepared fertile ground for him there. Neumann's achievements provided the basis on which Curt Valentin was later able to build when he too embarked on promoting Beckmann in America, both during and after World War II. Valentin had initially met Beckmann and Quappi when Valentin was an employee of Flechtheim. One of the earli-

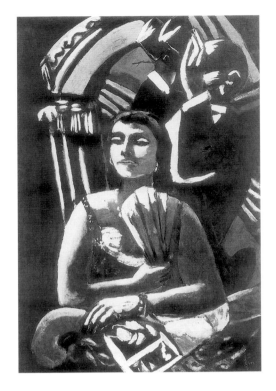

est exhibitions at the Buchholz Gallery in New York was a solo show of Beckmann's work; it ran from January 11 through February 8, 1938, and subsequently traveled to several venues, including the Saint Louis Art Museum. From then on, Valentin continually staged shows of Beckmann's latest works, as for example the striking triptych *Akrobaten (Acrobats;* 1939), which now hangs at the Saint Louis Art Museum. It would be difficult to overstate the significance of Valentin's role in supporting Beckmann's work in America. At the same time, it would be incorrect to assume that the artist's success there was simply a matter of course.

A revealing example of American enthusiasm for Beckmann's work—and of the difficulty inherent in achieving an adequate appreciation of his complex and hermetic œuvre—is seen in the response of museum director Alfred H. Barr, Jr. In the catalogue for the seminal exhibition *German Painting and Sculpture* held at the Museum of Modern Art in 1931, Barr praised Beckmann as "one of the most important living European artists," and included eight of his works in the show. On the other hand, in the same publication Barr revealed an ambivalence about Beckmann's future status: "Whether the genuine greatness of [his] personality will be realized in his paintings so that he will take his place among the half dozen foremost modern

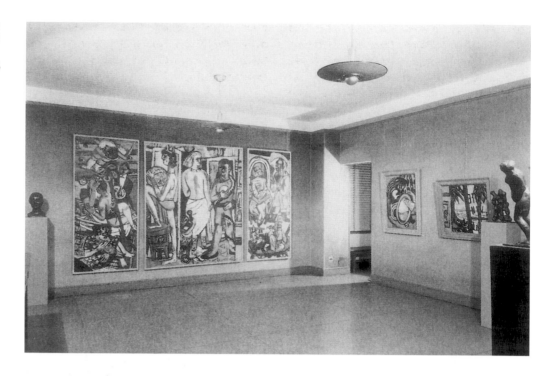

artists is a question which the next few years should answer."[18]

Barr was nonetheless able to persuade the collector Abby Aldrich Rockefeller to purchase Beckmann's early *Familienbild* (*Family Portrait;* 1920) and to bequeath it to the Museum of Modern Art in 1935.[19] Over the following years, an increasing number of museum directors and curators began to champion Beckmann, effectively supplying a positive answer to Barr's question and establishing the artist as a real presence in the awareness of the American public. In this, key roles were played by Wilhelm R. Valentiner, an émigré from Germany who in 1924 had become the director of the Detroit Institute of Arts, and by Perry T. Rathbone, a curator at the same museum.[20] (Later, Rathbone not only arranged for Beckmann's initial teaching post at Washington University in Saint Louis, but also organized the first American Beckmann retrospective in 1948.[21] It is, moreover, to Rathbone that we are indebted for a wealth of personal reminiscences by the artist.)

Before World War II, however, Beckmann's work was given greater attention in France and Switzerland than it had achieved thus far in America. Among the most important events were his 1930 solo exhibition at the Kunsthalle in Basel (a gathering of some one hundred paintings), and the 1931 solo show at the Galerie de la Renaissance

in Paris (where thirty-six canvases were shown). The latter exhibition was honored with a visit from the French foreign minister.[22]

The seizure of power in Germany by the National Socialists in early 1933 precipitated a sharp turn in Beckmann's personal and artistic fortunes. Not only did he lose his teaching post at the Städelschule in Frankfurt, but there was also a noticeable decline in international contacts, within a short space of time. However, Beckmann received help from an unexpected source: his friend Stephan Lackner, a writer who demonstrated a remarkable commitment to Beckmann's work throughout his career. In 1933, Lackner bought Beckmann's striking and mysterious picture *Adam und Eva (Mann und Frau)* (*Adam and Eve [Man and Woman]*; 1932), which was to have been included in an exhibition in Erfurt that was banned by the National Socialists. In his text of 1938, *Das Welttheater des Malers Max Beckmann* (The World Theater of the Painter Max Beckmann), Lackner proposed a compelling though brief interpretation of Beckmann's work. He and his wife assembled one of the world's largest Beckmann collections (along with that of Morton D. May), and made this work widely accessible to the public through exhibitions in Santa Barbara (in 1951, 1955, and 1960), and through his own publications.[23] The moral and financial support that Lackner's coura-

geous advocacy provided Beckmann, at a time when the artist's work had been banned in Germany, and when it was underappreciated in America, was crucial.[24] Lackner's contribution was deservedly the focus of an exhibition, titled *Stephan Lackner—der Freund Max Beckmanns* (Stephan Lackner: Max Beckmann's Friend), mounted at the Bayerische Staatsgemäldesammlungen in Munich in 2000.[25]

The deliberately shocking iconography of violence evolved by Beckmann in response to his experiences during World War I took on a horrendous literalism in the work he created under the Nazi dictatorship. This became especially clear in the first of ten triptychs, *Abfahrt (Departure;* 1932, 1933–35), which in 1942 was acquired by the Museum of Modern Art in New York. In the same year, it was exhibited—alongside the works of Emil Nolde—as an example of "free German art," in a small *New Acquisitions* show organized by Barr. In adopting the medieval format of the triptych, with its ecclesiastical associations, Beckmann was also creating some of the most complex arrangements in twentieth-century painting, an aspect of his work that American commentators would later observe.[26] In 1939, Beckmann's triptych *Versuchung (Temptation;* 1936–37) won first prize in the contemporary European art section of the Golden Gate Exhibition held in San Francisco.[27] Today, seven of Beckmann's ten triptychs are in American collections.

The advent of war in 1939 precluded Beckmann's plans to emigrate to France or to the United States. (In 1936, he had traveled to Paris to meet Lackner and to explore the possibility of moving.) His time in Amsterdam—several years of which were under German Occupation—was marked both by an acute sense of oppression (as reflected in his personal notebook entries) and, somewhat paradoxically, by his extraordinary productivity. In this perilous situation, Beckmann received support from various quarters, including many American friends and colleagues who attempted to help him obtain permission to leave Europe.[28]

In 1940, Beckmann was formally invited to teach at the Art Institute in Chicago, an offer he was unable to accept because he was denied a visa. In 1947, the Art School at Indiana University offered him a teaching post, but by this time he had decided to accept an invitation to teach at Washington University in Saint Louis. Beckmann was in fact taken on as a temporary replacement for the painter Philip Guston, who was away on sabbatical. Guston's unexpectedly prolonged absence (ultimately, he did not return to the school) permitted Beckmann to stay longer than planned.

In 1948, a year after Beckmann's arrival in Saint Louis, the city hosted the first large retrospective of his work to be presented in America, and this later toured to Baltimore, Cambridge, Detroit, Los Angeles, San Francisco, Boulder, and Minneapolis. According to the show's catalogue, the exhibition contained forty-seven oil paintings, more than half of which were loaned by American collectors.[29]

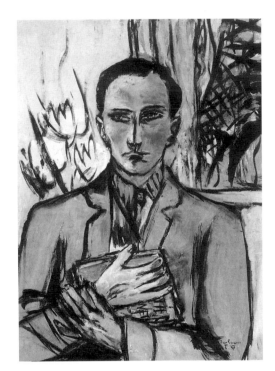

Max Beckmann, *Portrait of Stephan Lackner*, 1939. Lackner Collection, Santa Barbara

Late in 1949, after Beckmann had already left Saint Louis, Morton D. May, the owner of a department-store chain, was introduced to Beckmann's work by Valentin. May commissioned Beckmann to do a portrait, and over the following years acquired more than fifty paintings by the artist—one of the largest collections of Beckmann's works in the world.[30]

Beckmann himself embarked on a long American lecture tour, as reported in his speech "Drei Briefe an eine Malerin" (Three Letters to a Woman Painter).[31] The text of this lecture also provides a starting point for a reappraisal of the late work and the character of Beckmann's years in America. It

Max Beckmann and Morton D. May in front of Beckmann's portrait of May, Saint Louis, 1949

Max Beckmann, *Selbstbildnis auf gelbem Grund mit Zigarette* (*Self-Portrait with a Cigarette Against a Yellow Background*), 1923, on the cover of *Artlover*, 1927. The Museum of Modern Art Archives, New York: The J. B. Neumann Papers, III.B.1. Photograph © 2001 The Museum of Modern Art, New York

reveals, in fact, that this seemingly "happy" ending contained an element of tragedy. Having survived the confusion and disruption of war in Europe, he was at last free to experience firsthand the wide recognition that his work now received. But with the emergence of Abstract Expressionist painting in the United States, his work began to be perceived as "anachronistic." American interest in Beckmann entered a relative slump during the 1950s, before it revived and stabilized in the 1960s with a retrospective at the Museum of Modern Art in 1964–65.[32] The show combined seventy-three paintings, five triptychs, and about ninety works on paper, and constituted a milestone in the American reception of Beckmann after 1945. This was true as well of the great Beckmann exhibition of 1984 mounted in Saint Louis and Los Ange-les.[33] In America today, Beckmann is one of the most exhibited and most esteemed German painters of the twentieth century. Two aspects of his life and work have gained increasing significance and relevance: first, his paradigmatic role as the artist in exile, and second, his status as a painter comparable to Picasso and Matisse. These were highlighted in recent shows at the Guggenheim Museum and the Saint Louis Art Museum entitled, respectively, *Max Beckmann in Exile* and *Max Beckmann and Paris*,[34] both of which contributed new perspectives and gave new impetus to Beckmann studies.

Olaf Peters
Translated from the German by Elizabeth Clegg, with Nicholas T. Parsons.

[1] See Barbara C. Buenger, "Beckmann's Beginnings: 'Junge Männer am Meer,'" in: *Pantheon*, vol. 41, no. 2 (1983), pp. 134–144.
[2] On this point, see Christian Lenz, *Max Beckmann und die Alten Meister. "Eine ganz nette Reihe von Freunden,"* Heidelberg: Edition Braus, 2000.
[3] On Neumann, see the concise introduction by Karl-Heinz Meissner, "Israel Ber Neumann. Kunsthändler, Verleger," in: *Avantgarde und Publikum. Zur Rezeption avantgardistischer Kunst in Deutschland 1905–1933*, ed. by Henrike Junge, Cologne: Böhlau, 1992, pp. 215–224.
[4] Hans Kaiser, *Max Beckmann*, Berlin: Paul Cassirer, 1913, p. 45. On Beckmann's early work, in addition to Kaiser,

see Ernst-Gerhard Güse, *Das Frühwerk Max Beckmanns. Zur Thematik seiner Bilder aus den Jahren 1904–1914,* Frankfurt am Main: Lang, 1977, and *Max Beckmann. Die frühen Bilder,* exhibition cat., Kunsthalle Bielefeld; and Frankfurt am Main, Städtische Galerie im Städelschen Kunstinstitut, 1982–83.

5 On the combined influence of Cubism and the reception of the art of the late Middle Ages, see Manfred Brunner, "Beckmann und der Kubismus. Ursachen des grossen Stilumbruchs oder der Anteil der Kunsterfahrung am Werden einer modernen Malerei," in: *Max Beckmann,* ed. by Siegfried Gohr, exhibition cat., Cologne, Josef-Haubrich Kunsthalle, 1984, pp. 11–40; and Günther Aust, "Max Beckmann und die Spätgotik," in: *Ikonographia. Anleitung zum Lesen von Bildern: Festschrift für Donat de Chapeaurouge,* ed. by Bazon Brock and Achim Preiss, Munich: Klinkhardt & Biermann, 1990, pp. 249–280.

6 See Franz Marc, "Die Neue Malerei," in: *Pan,* vol. 2 (1913), pp. 468–471; Max Beckmann, "Gedanken über zeitgemässe und unzeitgemässe Kunst. Eine Erwiderung von Max Beckmann," in: *Pan,* vol. 2 (1913), pp. 499–502; and Franz Marc, "Anti-Beckmann," in: *Pan,* vol. 2 (1913), pp. 555–556. For a detailed account of the dispute between Marc and Beckmann, see Dietrich Schubert, "Die Beckmann-Marc Kontroverse von 1912: 'Sachlichkeit' versus 'Innerer Klang,'" in: *Max Beckmann. Die frühen Bilder* (as note 4), pp. 175–187, also the documentation provided on pp. 28–35.

7 Max Beckmann, *Ein Bekenntnis* (written in 1918, first published in 1920), cited in: *Max Beckmann: Self-Portrait in Words. Collected Writings and Statements, 1903–1950,* ed. by Barbara C. Buenger, Chicago: University of Chicago Press, 1997, p. 185.

8 See Olaf Peters, "Max Beckmann, die Neue Sachlichkeit und der Werterelativismus in der Weimarer Republik," in: *Wallraf-Richartz-Jahrbuch,* vol. 41 (2000), pp. 237–261.

9 See *Neue Sachlichkeit. Deutsche Malerei seit dem Expressionismus,* ed. by Gustav Friedrich Hartlaub, exhibition cat., Mannheim, Städtische Kunsthalle, 1925; and *Max Beckmann. Das gesammelte Werk, Gemälde, Graphik, Handzeichnungen aus den Jahren 1905–1927,* ed. by Hartlaub, exhibition cat., Mannheim, Städtische Kunsthalle, 1928. On the arrangement of the exhibition, see Karoline Hille, "'Neue Sachlichkeit': Deutsche Malerei seit dem Expressionismus," in: idem., *Spuren der Moderne. Die Mannheimer Kunsthalle von 1918 bis 1938,* Berlin: Akademie Verlag, 1994, pp. 82–155.

10 Beckmann, letter to Wilhelm Hausenstein, March 12, 1926, in: *Max Beckmann Briefe,* vol. 2, 1925–1937, ed. by Klaus

Gallwitz et al., Munich: Piper, 1994, pp. 33ff. For a discussion of this letter and Beckmann's position in relation to Neue Sachlichkeit, see Peters, "Max Beckmann" (as note 8).

11 See Charles W. Haxthausen, "'Deutsche Kunst in Amerika': Zur Geschichte des Busch-Reisinger Museum," in: *Deutsche Kunst des 20. Jahrhunderts aus dem Busch-Reisinger Museum, Harvard University, Cambridge, Mass.,* exhibition cat., Frankfurt am Main, Städtische Galerie im Städelschen Kunstinstitut; Berlin, Bauhaus-Archiv; and Kunstmuseum Düsseldorf, 1982–83, pp. 14–31, esp. p. 28.

12 Beckmann, "Der Künstler im Staat" (1927), cited in: *Max Beckmann: Self-Portrait in Words* (as note 7), p. 287. On this issue, see also Buenger, "Max Beckmann, 'Der Künstler im Staat,'" in: *Überbrückt. Ästhetische Moderne und Nationalsozialismus. Kunsthistoriker und Künstler 1925–1937,* ed. by Eugen Blume and Dieter Scholz, Cologne: Walther König, 1999, pp. 191–200.

13 See also Beckmann, "Notizen 1925–1930," cited in: *Die Realität der Träume in den Bildern. Schriften und Gespräche 1911 bis 1950,* ed. by Rudolf Pillep, Munich: Piper, 1990, p. 45.

14 On this point, see Westheider, *Die Farbe Schwarz in der Malerei Max Beckmanns,* Berlin: Reimer, 1995.

15 Henry McBride, "The Pittsburgh International," in: *Creative Art,* vol. 5, no. 5 (1929), pp. xiv–xvi, cited in: Peter Selz, "Die Jahre in Amerika," in: *Max Beckmann Retrospektive/Retrospective,* ed. by Carla Schulz-Hoffmann and Judith C. Weiss, exhibition cat., Munich, Haus der Kunst; Berlin, Neue Nationalgalerie; Saint Louis Art Museum; and Los Angeles County Museum of Art, 1984–85, p. 159.

16 For many years, scholars have incorrectly assumed that Beckmann's first show at Neumann's gallery took place in 1926. In fact, it was in 1927, as indicated not only by Neumann's comments in his short introduction to the special Beckmann issue of his widely read journal *Artlover* (published in 1927), but also in the fact that no one-man Beckmann show for 1926 is mentioned in the documentation that Neumann published in the 1930s relating to his gallery. (See *Artlover, J. B. Neumanns Bilderhefte, Anthologie d'un Marchand d'Art,* vol. 3 [1937], pp. viii, ix. This documentation is also discussed in Penny Joy Bealle, *Obstacles and Advocates. Factors Influencing the Introduction of Modern Art from Germany to New York City, 1912–33: Major Promoters and Exhibitions,* Ann Arbor, Mich.: UMI, 1990, p. 266 and n. 62.) This April 1927 show, the thirtieth exhibition to be held at Neumann's New York premises, is here cited as being the gallery's first one-man event. American commentators at the time, moreover, clearly regarded this as Beckmann's

exhibiting debut in New York. (See the extensive commentary published by Henry McBride in *The Dial,* vol. 83 [July–December 1927], pp. 85ff.) Another clue is the fact that on page 88 of the issue of *Artlover* that appeared in the summer of 1936 (vol. 3, no. 6), Neumann comments as follows on the Beckmann exhibition of 1927: "The current and last [i.e., latest] show is of Max Beckmann, an artist that Neumann accepted some sixteen years ago. He asserts that this show is the realization of a lifetime dream—a show of Max Beckmann in New York." This strongly suggests that no earlier Beckmann exhibitions had taken place in that city. The only source for an assumption to the contrary (though a source to which commentators repeatedly resort) is the evidently imprecise recollection of Neumann himself. His memoirs are preserved in the archives of the Museum of Modern Art, New York, under the title "Confessions of an Art Dealer." The chapter devoted to Beckmann is called "Sorrow and Champagne."

17 Jsrael Bar Neumann, "Max Beckmann," in: *Artlover, J. B. Neumanns Bilderhefte, Anthologie d'un Marchand d'Art* (1927), p. 16. Reproduced on the title page was Beckmann's well-known *Selbstbildnis auf gelbem Grund mit Zigarette* (*Self-Portrait with a Cigarette Against a Yellow Background;* 1923), acquired by the Museum of Modern Art, New York, in 1956 from the Hirschland Collection.

18 See *German Painting and Sculpture,* ed. by Alfred H. Barr, Jr., exhibition cat., New York, Museum of Modern Art, 1931, quotes on pp. 20, 12; see also Barr, "Die Wirkung der deutschen Ausstellung in New York," in: *Museum der Gegenwart,* vol. 2, no. 2 (1931), pp. 58–75.

19 See Alice Goldfarb Marquis, *Alfred H. Barr, Jr., Missionary for the Modern,* Chicago and New York: Contemporary Books, 1989, p. 118.

20 On this point, see Pamela Kort's essay in this volume; see also Stephanie Barron, "The Embrace of Expressionism: The Vagaries of Its Reception in America," in: *German Expressionist Prints and Drawings. The Robert Gore Rifkind Center for German Expressionist Studies,* Munich: Prestel, 1989, vol. 1, pp. 131–149, 143–145.

21 See *Max Beckmann,* ed. by Perry T. Rathbone, exhibition cat., City Museum of Saint Louis and venues in Baltimore, Cambridge, Detroit, Los Angeles, San Francisco, Minneapolis, and Boulder, 1948–49.

22 See *Max Beckmann and Paris: Matisse, Picasso, Braque, Léger, Rouault,* ed. by Tobia Bezzola and Cornelia Homburg, exhibition cat., Kunsthaus Zürich and Saint Louis Museum of Art, 1998–99.

23 All the exhibitions were held at the Santa Barbara Museum of Art: *Max Beckmann Memorial Exhibition* (1951), *Max Beckmann* (1955), and *Max Beckmann: Lackner Collection* (1960–61). See also

Stephan Lackner, *Max Beckmann: Memories of a Friendship,* Coral Gables, Fla.: University of Miami Press, 1969; idem, *Max Beckmann,* New York: Abrams, 1991.

24 For example, in 1938, Beckmann signed a contract with Lackner stipulating that, in return for a regular stipend, Beckmann would produce two paintings a month.

25 See the comprehensive tribute and documentation provided in *Stephan Lackner—der Freund Max Beckmanns,* ed. by Christian Lenz, exhibition cat., Munich, Bayerische Staatsgemäldesammlungen, 2000.

26 The importance of the triptych in Beckmann's œuvre was soon recognized by American art historians. See Charles S. Kessler, *Max Beckmann's Triptychs,* Cambridge, Mass.: Belknap Press, 1970. For more recent commentary, see Peter J. Gärtner, *Der Traum von der Imagination des Raumes. Zu dem Raumvorstellungen auf einigen ausgewählten Triptychen Max Beckmanns,* Weimar: VDG, 1996, and Reinhard Spieler, *Max Beckmann. Bildwelt und Weltbild in den Triptychen Max Beckmanns,* Cologne: DuMont, 1998.

27 See Vivian Endicott Barnett, "Banned German Art: Reception and Institutional Support of Modern German Art in the United States, 1933–45," in: *Exiles and Émigrés: The Flight of European Artists from Hitler,* ed. by Stephanie Barron and Sabine Eckmann, exhibition cat., Los Angeles County Museum of Art; and Berlin, Neue Nationalgalerie, Staatliche Museen, 1997–98, pp. 273–284, esp. p. 278.

28 See *Max Beckmann in Exile,* exhibition cat., New York, Guggenheim SoHo, 1996–97; and Barbara C. Buenger, "Max Beckmann in Paris, Amsterdam, and the United States, 1937–50," in: *Exiles and Émigrés* (as note 27), pp. 58–67.

29 See *The Morton D. May Collection of 20th Century German Masters,* exhibition cat., New York, Marlborough-Gerson Gallery; and City Art Museum of Saint Louis, 1970; Charles Werner Haxthausen, "Modern German Masterpieces," in: *Saint Louis Art Museum Winter Bulletin* (1985).

30 *The Morton D. May Collection* (as note 29).

31 The lecture was presented at various venues, including Columbia University in New York and the Art School in Boston, and published in *College Art Journal,* vol. 9 (Autumn 1949), pp. 39–43; reprinted in: *Max Beckmann, Sichtbares und Unsichtbares,* ed. by Peter Beckmann, Stuttgart: Belser, 1965.

32 *Max Beckmann,* ed. by Peter Selz, exhibition cat., New York, Museum of Modern Art, 1964–65.

33 *Max Beckmann Retrospektive/Retrospective* (as note 15).

34 *Max Beckmann in Exile* (as note 28); *Max Beckmann and Paris* (as note 22).

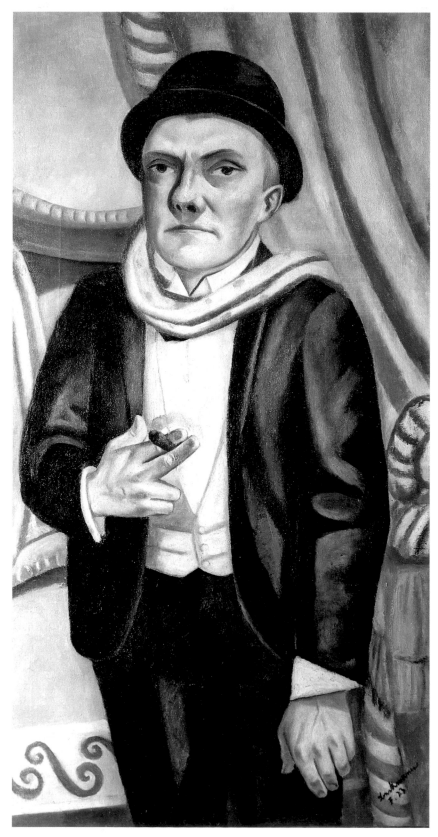

Self-Portrait in Front of Red Curtain, 1923 cat. II.36

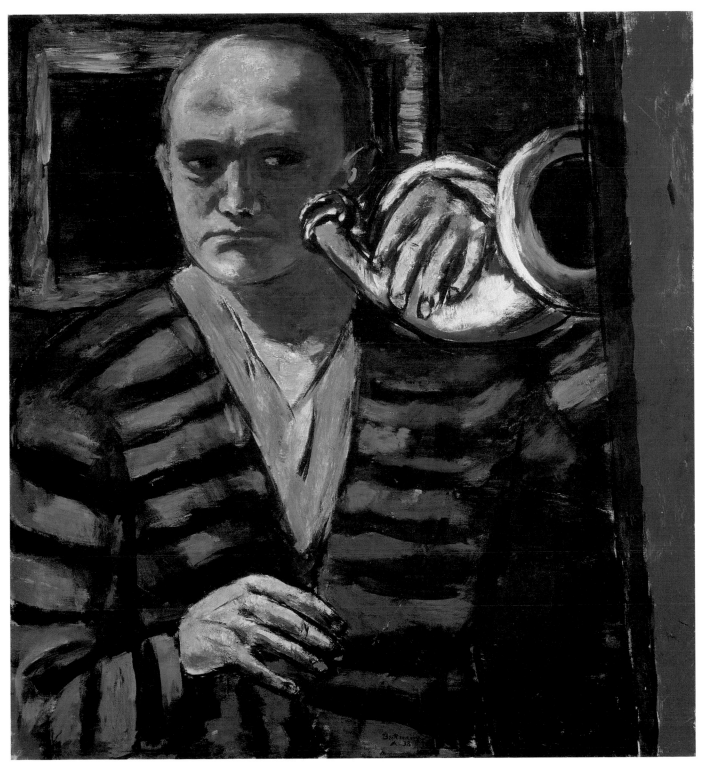

Self-Portrait with Horn, 1938 cat. II.40

The Ideologues, 1919 cat. II.35

Galleria Umberto, 1925 cat. II.37

Field Workers, 1928 cat. II.38

the two sides of the now divided Germany. He died in Singen in 1969.

PUBLIC RECEPTION

Otto Dix, one of the most important German painters of the interwar period, has yet to be given a comprehensive retrospective in the United States. However, his work was familiar to American audiences from a relatively early date. In 1926, three of his paintings were shown in the twenty-fifth annual International Exhibition of Painting held at the Carnegie Institute in Pittsburgh. In the spring of 1931, Alfred H. Barr, Jr. included five Dix works in his seminal exhibition *German Painting and Sculpture* at New York's Museum of Modern Art.[2] In the accompanying catalogue, Barr focused on the historical precedents of the artist's painting: "Dix's art is not merely a reaction to the abstract, cubist or expressionist denial of natural appearances. It is,

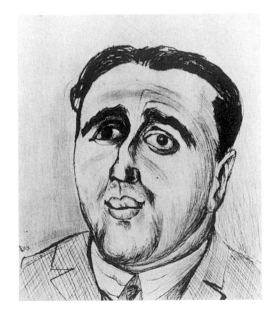

rather, a deep-seated passion for the appearance of the real world which he shares with his artistic ancestors of the early nineteenth century and his greater forebears of four centuries ago—Dürer, Holbein and Grünewald."[3] Avoiding the brutal scenes of war or prostitution (which may have disturbed an American audience), Barr selected figurative works demonstrating Dix's awareness of the long tradition of German painting since the Renaissance.

In the following year, 1932, one of these works, Dix's *Bildnis des Laryngologen Dr. Mayer-Herrmann (Portrait of the Laryngologist Dr. Mayer-Herrmann;* 1926), was donated to the Museum of Modern Art by Philip Johnson, then head of the museum's architecture department. A press release issued in connection with the gift described it as the museum's "first important modern German painting."[4] That same year, art dealer J. B. Neumann organized the artist's first one-man show in the United States, at his New Art Circle in New York. This exhibition, comprised solely of watercolors and drawings, was largely ignored by the press.[5]

Like Nierendorf, Dix's Cologne-based business partner Neumann (who had worked out of Berlin) had an enormous influence in the early 1920s on the course of his career in Europe.[6] As early as 1923, the year Dix was forced to go to court in defense of his allegedly "obscene" representations of women,[7] Neumann organized the earliest significant Dix exhibition in Berlin at his gallery. In the same year, he published the first monograph on Dix, a small volume written (at Neumann's urging) by the critic Paul Ferdinand Schmidt.[8] Dix met his other dealer, Nierendorf, in 1922, when the artist moved to Düsseldorf. Nierendorf was especially interested in Dix's prints, which he felt would sell well given the strong market at the time for works on paper (high inflation had slowed the market for painting). In 1924, Nierendorf published a portfolio of fifty Dix etchings, inspired by the work of Goya and known collectively as *Der Krieg (The War).*[9]

Otto Dix

Otto Dix, *Portrait of the Laryngologist Dr. Mayer-Herrmann*, 1926, in *Art Digest* (October 1, 1932)

Otto Dix, *Portrait of the Art Dealer J. B. Neumann*, 1938

Dix's work around 1920 reveals a multitude of stylistic allegiances: Cubo-Futurism, Expressionism, Dada, and Verism.[10] The adaptations of past styles in Dix's work are not, however, simply the expression of a "passion for the real" (*pace* Barr). Dix selected a particular style to appropriately characterize and interpret a particular sitter or thematic/narrative content. This point is illustrated in one of his most famous portraits, *Bildnis des Kunsthändlers Alfred Flechtheim (Portrait of the Art Dealer Alfred Flechtheim;* 1926), which today belongs to the Nationalgalerie in Berlin. The picture is a masterpiece of Neue Sachlichkeit, although Dix also combines different styles (German Old Masters, Expressionism, Cubism) and reflects on different techniques (e.g., photography and collage), which he transfers to the medium of painting and in so doing reveals their full potential as a means of expression. Like his 1921 portrait of the lawyer Fritz Glaser (cat. no. II.41), this work failed to meet with the approval of its sitter. Although Flechtheim frequently attested to his interest in Dix's work, neither was he the artist's dealer nor had he commissioned the portrait. In the painting, Dix depicted the dealer surrounded by Cubist paintings in his gallery, looking almost like a wild beast in a cage. The cool, distanced gaze on Flechtheim's caricaturish face contrasts with his expressive gestures: the hands seem to extend out of the canvas from his sleeves. These elements combine to provide a view of the art dealer that vacillates between sympathy and ironic critique. The picture is not simply a hostile representation of the Jewish dealer surrounded by French works of art, but an assertion by Dix that he was just as much a master of the Cubist style as were the Cubists themselves.[11]

A year after completing the picture, Dix formulated his aesthetic position in a short programmatic text, "Das Objekt ist das Primäre" (My Principal Concern is the Object), which was published in the *Berliner Nachtausgabe* on December 3, 1927. "To my mind," he wrote, "what is new in painting is to be found in the extension of the thematic field, in the intensification of the forms of expression already available, in embryo, to the Old Masters. For me anyway, the object remains fundamental, and the form is determined by the object. I have always found it of the greatest importance to ask myself whether I am getting as close as possible to the thing that I am observing, for the 'what' is more important to me

than the 'how'! It is only out of 'what' that 'how' emerges."[12]

This passage reveals that the influence of the German Old Masters, with which Dix has frequently been associated, by no means implies a mere continuation of the Old Master tradition. The painter engages with tradition, but also with the artistic challenges of the here and now. From this perspective, the modernism of Dix's work is actually

underlined by its apparently anachronistic elements; his work possesses a contemporary relevance that has yet to be sufficiently assessed. Nevertheless, Dix's ability to make use of opposing art historical traditions was appreciated by several of his contemporaries. In 1926, on the occasion of the large Dix retrospective in Berlin at Galerie Neumann-Nierendorf, Paul Ferdinand Schmidt (at this point director of the Städtisches Museum in Dresden) observed of Dix that he "arrives on the scene like an elemental event, monstrous, inexplicable, dreadful, just like a volcanic eruption. One never knows what to expect from this wild lad. Again and again he suddenly changes course and heads off for new shores, transforms his own abilities, as if he were himself Proteus, just as he transforms his

Otto Dix, *Portrait of the Art Dealer Alfred Flechtheim*, 1926

Alfred Flechtheim, Berlin, 1928

subjects, his points of view, and the techniques he employs."[13]

The stylistic pluralism and astonishing capacity for transformation described by Schmidt were to become crucial to Dix's artistic strategy during the early years of the Third Reich. They enabled him to criticize the excesses of the National Socialist regime while remaining in Germany, as part of the so-called inner emigration.[14] Dix made use of allegory—as in the striking *Sieben Todsünden (Seven Deadly Sins;* 1933), which presents Adolf Hitler as the personification of Envy, or the *Judenfriedhof in Randegg (The Jewish Cemetery in Randegg;* 1935)—to present a masked critique of those in power.

By the mid 1930s, 260 of Dix's works had been purged from public collections in Germany; twenty-six of these were shown in the *Entartete Kunst* exhibition. In 1937, when the Nazis hastily organized this loudly trumpeted show, Dix became the focus of their attacks on modern art. His uncompromisingly provocative realism, which dealt with topics such as prostitution, sexual murder (*lustmord*), and war, and which had been such a feature of his Weimar period, were denounced in the show's catalogue. Two of Dix's paintings on the theme of war—*Der Kriegskrüppel (War Cripples;* 1920) and *Der Schützengraben (The Trench;* 1920–23)—were reproduced on a page with the heading "Gemalte Wehrsabotage des Malers Otto Dix" (The Army Sabotaged by the Painter Otto Dix). The National Socialists viewed these works as having a "marked *political tendency.* … The intention is manifest; the viewer is meant to see the soldier either as a murderer or victim, senselessly immolated for something known to the Bolshevik class struggle as 'the capitalist world order.' Above all, the deeply embedded respect of the people for the military virtues, for boldness, courage, and commitment, is to be driven out."[15]

One of the many paradoxes of this period is that such works, though lauded in America and elsewhere as "antiwar pictures," were in all probability neither intended nor initially understood as such. It is true that the works were exploited in pacifist circles, for example, by Franz Leschnitzer, who wrote about *Der Schützengraben* in the *Weltbühne*, and above all by Nierendorf, who released the 1924 *Krieg* cycle amidst enormous publicity. At the same time, right-wing circles—for example, the periodical *Germania*—also saw in his work a realistic description of the horrors they themselves had experienced in war.[16] But these readings missed (or ignored) the evident ambivalence in Dix's representation of war, noted in 1927 by the art critic Ernst Kallai in his important and still instructive essay "Dämonie der Satire" (The Demonic Element in Satire): "The recoil from the horrors of war is

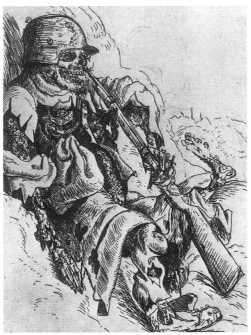

Cover of the portfolio *Der Krieg (The War)* by Otto Dix, edited by Karl Nierendorf, Berlin, 1924

Otto Dix, *Sturmtrupp geht unter Gas vor*, 1924. Page from the portfolio *Der Krieg*

demonstrated with a ceremonial pathos in the conjuring of precisely those horrors that in the end leaves the question fully open, namely as to whether we are concerned here with a rejection or a fetishization."[17] Dix's own intentions are embodied in the descriptions of war that he interpreted in a Nietzschean way as a "happening of nature," the product of the need to work through a traumatic experience. There was also the desire to create a scandal by challenging aesthetic preconceptions; indeed this was just what *Der Schützengraben* subsequently provoked.

It is important to stress that the "antiwar pictures," and particularly the *Krieg* cycle, definitively shaped

memorating the twentieth anniversary of the start of World War I. Three years later, just before the outbreak of World War II, the museum once again exhibited thirty-four of the etchings. A reviewer for *Art News* described them thus: "In these [etchings], Dix, as the leading realist in his country, has relentlessly and with a haunting, ineradicable effect, reproduced the terrifying scenes, that, during the four years of his service at the Western Front penetrated first his vision and then his horrorstricken compassion."[19]

Similarly symptomatic in its identification of Dix as an antiwar artist are the comments made by curator James S. Plaut. In 1939, just months before the U.S. entered World War II, Plaut appraised Dix's work in the catalogue for the exhibition *Contemporary German Art* at Boston's Institute of Modern Art: "Early in his career Otto Dix painted classical idylls, remote from this world. Then the War placed in his hands a scalpel, with which he has ruthlessly probed the vicissitudes of modern civilization. ... A profound, emotional realist, Dix joins George Grosz in a sweeping pictorial indictment of the evils of war and its aftermath."[20] Not only has the artist's ambivalent position with respect to war been obscured by these words, but the statement marks the beginning of an American predilection to associate the sharp social criticism of Dix's art with that of his contemporary George Grosz.

Following the close of World War II—as attention shifted from Nazi Germany to the threat of Communist Russia—Dix's popularity began to wane in America. Although he was included in numerous group shows of modern German art, he has never been given a one-man show at any American museum. In Germany, however, a large retrospective was mounted by the Galerie der Stadt Stuttgart (which traveled to the Nationalgalerie in Berlin and the Tate Gallery in London) in 1991 to celebrate the hundredth anniversary of the artist's birth. This notwithstanding, the disconcerting complexity and polyvalency of his work are yet to be sufficiently explored and appreciated by both an American and a German public.

Olaf Peters
Translated from the German by Elizabeth Clegg, with Nicholas T. Parsons.

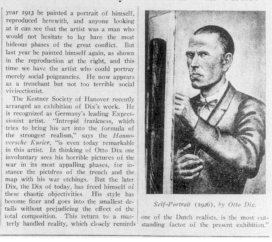

"The Years Have Toned Down Germany's Terrible War Artist," in *Art Digest* (March 15, 1927), showing two self-portraits by Otto Dix

the American reception of Dix after the National Socialists came to power. Far from being viewed as a realistic painter influenced by the Old Masters, he became recognized in America as an overtly political painter. The fact that the political content of Dix's art constituted his drawing power for an American public demonstrates the degree to which the reception of German art in America was influenced by contemporary political events. Deemed the "leading German realist,"[18] not surprisingly American interest in Dix grew as the National Socialist attack on modern German art escalated. In 1934, the Museum of Modern Art in New York purchased a set of the *Krieg* prints and exhibited them from July 30 to September 13 in a show com-

1 On the "joint exhibition" with Franz Lenk, see also *Franz Lenk 1898–1968. Retrospektive und Dokumentation,* exhibition cat., Cologne, Galerie von Abercron, 1976.
2 See Alice Goldfarb Marquis, *Alfred H. Barr, Jr.: Missionary of the Modern,* Chicago and New York: Contemporary Books, 1989, p. 118; and *German Painting and Sculpture,* exhibition cat., New York, Museum of Modern Art, 1931, cat. nos. 13–17. The five works shown were *Bildnis der Eltern I (Portrait of the Artist's Parents;* 1921), *Die Witwe (The Widow;* 1925), *Bildnis des Larynologen Dr. Mayer-Herrmann (Portrait of The Laryngologist Dr. Mayer-Herrmann;* 1926), *Das Baby (The Baby;* 1928), and *Kind mit Puppe (Child with Doll;* 1930).
3 *German Painting and Sculpture* (as note 2), p. 22. See also Birgit Schwarz, "'Kunsthistoriker sagen Grünewald': Das Altdeutsche bei Otto Dix in den zwanziger Jahren," in: *Jahrbuch der Staatlichen Kunstsammlungen in Baden-Wurttemberg,* vol. 28 (1991), pp. 141–163; and *Otto Dix et les Maîtres Anciens,* exhibition cat., Colmar, Musée d'Unterlinden, 1996.
4 Press release issued by the Museum of Modern Art on September 17–18, 1932. Museum of Modern Art Library, Press Releases 1929–1940, MFILM 0095.
5 See *Artlover. J. B. Neumann's Bilderhefte. Anthologie d'un Marchand d'Art,* vol. 3 (1037), p. 80. The exhibition was shown in February 1932 as the eightieth to be mounted by Neumann.
6 On this point, see the detailed study by Andreas Strobl, *Otto Dix. Eine Malerkarriere der zwanziger Jahre,* Berlin: Reimer, 1996, passim. Dix's estate, which contains much of his copious correspondence with Nierendorf, is now in the Archiv für bildende Kunst of the Germanische-Nationalmuseum, Nuremberg.
7 See Maria Tatar, *Lustmord: Sexual Murder in Weimar Germany,* Princeton: Princeton University Press, 1995, pp. 68–97; Rita E. Täuber, *Der hässliche Eros. Darstellungen zur Prostitution in der Malerei und Grafik 1855–1930,* Berlin:

Mann, 1997, pp. 105–137; and Beth Irwin Lewis, "Lustmord: Inside the Windows of the Metropolis," in: *Women in the Metropolis: Gender and Modernity in Weimar Culture,* ed. by Katharina von Ankum, Berkeley: University of California Press, 1997, pp. 202–232.
8 Paul Ferdinand Schmidt, *Otto Dix,* Cologne: Nierendorf/Neue Kunst, 1923.
9 See *Der Krieg. 24 Offsetdrucke nach Originalen aus dem Radierwerk von Otto Dix,* Berlin: Karl Nierendorf, 1924. See also Wulf Herzogenrath, "Die Mappe Der Krieg 1923/24," in: *Otto Dix. Zum 100. Geburtstag 1891–1991,* ed. by Wulf Herzogenrath and Johann-Karl Schmidt, exhibition cat., Galerie der Stadt Stuttgart; Berlin, Neue Nationalgalerie, 1991–92, pp. 167–175.
10 For earlier commentary on this subject, see Dietrich Schubert, "Rezeptions- und Stilpluralismus in den frühen Selbstbildnissen des Otto Dix," in: *Beiträge zum Problem des Stilpluralismus,* ed. by Werner Hager and Norbert Knopp, Munich: Prestel, 1977, pp. 203–244.
11 See Dieter Schmidt, "Das gute Jahr in Berlin," in: *Otto Dix. Zum 100. Geburtstag 1891–1991* (as note 9), pp. 193–198, 196; and Scarlett Pfau, "Der Kunsthändler als Höfling, Gelehrter, Torero und Stratege," in: *Alfred Flechtheim. Sammler, Kunsthändler, Verleger,* exhibition cat., Kunstmuseum Düsseldorf, 1987, pp. 107–114, esp. pp. 113ff.
12 Otto Dix, "Das Objekt ist das Primäre," in: *Berliner Nachtausgabe* (December 3, 1927), reprinted in *Künstlerschriften der 20er Jahre. Manifeste und Dokumente aus der Weimarer Republik,* 3d ed., ed. by Uwe M. Schneede, Cologne: DuMont, 1986, p. 166.
13 Paul Ferdinand Schmidt, "Otto Dix," one of three introductory texts in: *Otto Dix. Gesamtausstellung,* exhibition cat., Berlin, Galerie Neumann-Nierendorf, 1926, pp. 6ff.
14 See Heidrun Ehrke-Rotermund, "Camoufliertes Malen im 'Dritten Reich.' Otto Dix zwischen Widerstand und Innerer Emi-

gration," in: *Exilforschung. Ein internationales Jahrbuch,* vol. 12 (1994), *Aspekte der künstlerischen Inneren Emigration 1933–1945,* pp. 126–155; and Olaf Peters, *Neue Sachlichkeit und Nationalsozialismus. Affirmation und Kritik 1931–1947,* Berlin: Reimer, 1998, pp. 119–144.
15 *Führer durch die Ausstellung Entartete Kunst,* Berlin: Verlag für Kultur und Wirtschaftswerbung, 1937, p. 12. See facsimile of the *Entartete Kunst* exhibition brochure, transl. by David Britt, in: *"Degenerate Art": The Fate of the Avant-Garde in Nazi Germany,* ed. by Stephanie Barron, exhibition cat., Los Angeles County Museum of Art, 1991, p. 350.
16 See Wolfgang Schröck-Schmidt, "Der Schicksalsweg des Schützengraben," in: *Otto Dix. Zum 100. Geburtstag 1891–1991* (as note 9), pp. 159–164; and Jörg Martin Merz, "Otto Dix' Kriegsbilder. Motivationen—Intentionen—Rezeptionen," in: *Marburger Jahrbuch für Kunstwissenschaft,* vol. 26 (1999), pp. 189–226. See also Dennis Charles Crockett, "The Most Famous Painting of the 'Golden Twenties'? Otto Dix and the Trench Affair," in: *Art Journal,* vol. 51, no. 1 (1992), pp. 72–80.
17 Ernst Kallai, "Dämonie der Satire," in: *Das Kunstblatt,* vol. 11 (1927), pp. 97–104.
18 M.D., "The War Etchings by Otto Dix," in: *Art News* (October 2, 1937), p. 15.
19 Ibid., pp. 15–16. This account is remarkable because it draws a distinction between Dix and the contemporaneously exhibited "abstract" works of the Italian Gino Severini, yet without denigrating the latter for his Futurist glorification of war.
20 *Contemporary German Art,* exhibition cat., Boston, Institute of Modern Art, 1939, p. 13. According to this catalogue, the show included three works by Dix: the painting *Kind mit Puppe (Child with Doll;* 1928) from the collection of the Museum of Modern Art, and two watercolors, *Mr. Bitterman* and *Mutter mit Kind (Mother with Child),* no dates given.

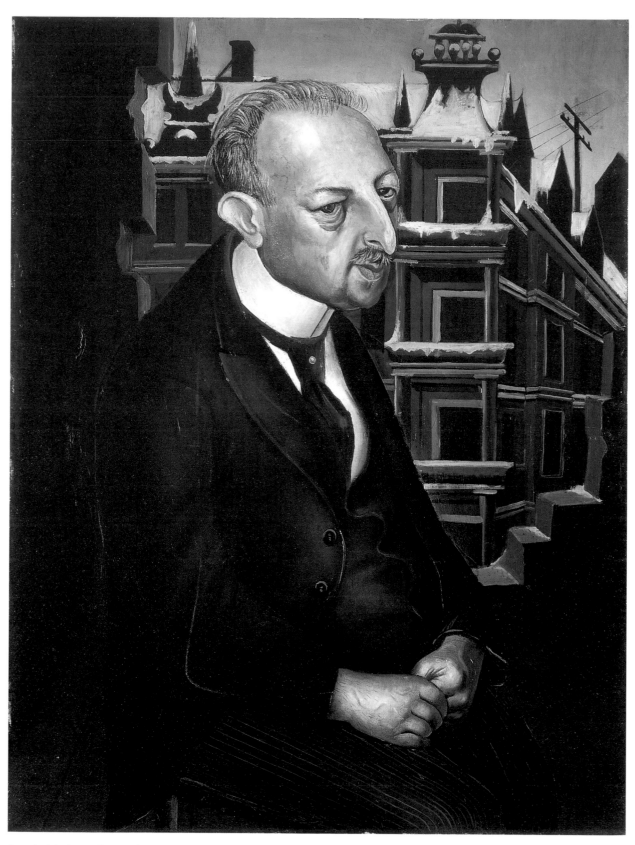

Portrait of the Lawyer Dr. Fritz Glaser, 1921 cat. II.41

Self-Portrait, 1922 cat. II.42

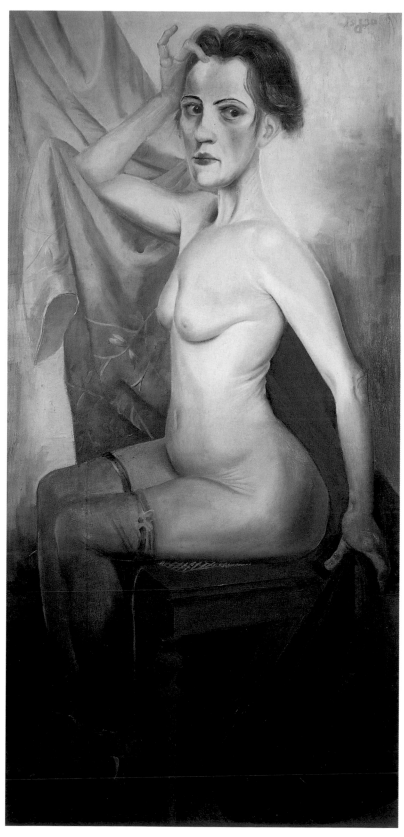

Seated Female Nude with Red Hair and Stockings in Front of Pink Cloth, 1930 cat. II. 44

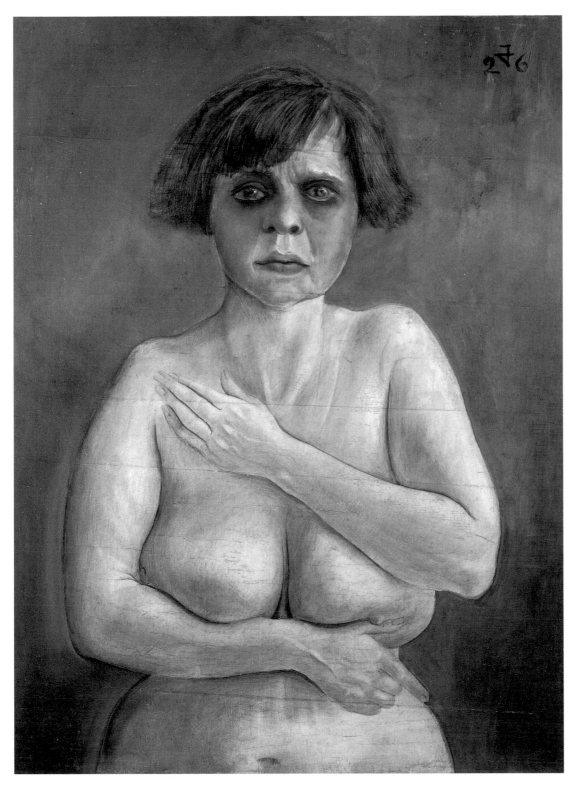

Seminude, 1926 cat. II.43

CHRISTIAN SCHAD

*** AUGUST 21, 1894, MIESBACH (UPPER BAVARIA)**
† FEBRUARY 25, 1982, STUTTGART

Christian Schad was born in 1894 in Miesbach in Upper Bavaria, into the family of a well-to-do attorney, Carl Schad, and his wife Marie. He grew up in Munich but left high school before taking his final examinations; he then studied for one semester at the Munich Akademie der bildenden Künste (Academy of Fine Arts), where he was the pupil of the well-known animal painter Heinrich von Zügel. Schad stayed on in Munich and immersed himself in the artistic and intellectual bohemia of the city's Schwabing district. After the outbreak of World War I in the summer of 1914, he avoided being drafted into the German army by feigning the symptoms of a weak heart. In 1915, he was sent to "recuperate" in a sanatorium in Switzerland.

In the summer of 1915, Schad was in Zürich, where he made contact with the emerging circle of Dadaists and befriended the writer Walter Serner. In the fall of 1916, Serner and Schad moved to Geneva, where they established their own circle of Dadaists. In 1919, this group organized the first World Congress of Dadaists. Around this time, Schad experimented with found objects and devised a type of photogram (camera-free photographs produced by placing objects directly onto light-sensitive paper) that Tristan Tzara subsequently termed "schadographs."

In 1920, Schad returned briefly to Munich; within a year, he moved to Italy, living first in Rome and then in Naples, where he settled in 1923 upon his marriage to Marcella Arcangeli. Their son, Nikolaus, was born in 1924. That year, Schad received a commission from the Vatican to paint a portrait of Pope Pius XI. In 1925, he moved to Vienna. Two years later, Schad separated from Marcella and moved the following year to Berlin.

Around 1930, Schad began to take an interest in Eastern philosophy and the occult. In 1935, he also became a businessman, assuming the management of a Berlin brewery. In the following year, he joined the Verein Berliner Künstler (Association of Berlin Artists), which had openly declared its support for the National Socialist regime; this affiliation enabled Schad to continue regularly exhibiting until 1942: his work was even included in the *Grosse Deutsche Kunstausstellung* (Great German Art Exhibition), the first large-scale exhibiton of officially sanctioned National Socialist art that opened in 1937 at the Haus der Kunst in Munich. In 1943, his Berlin studio was destroyed during an air raid on the city; afterwards Schad moved to the northern Bavarian city of Aschaffenburg and was commissioned to make a copy of Grünewald's *Stuppacher Madonna*. In 1947, he was remarried, to the actress Bettina Mittelstädt. During the 1960s, Schad's work began to be more widely exhibited in Europe. The largest restrospective of his work to be organized during his lifetime took place in 1980 at the Staatliche Kunsthalle in Berlin. Schad died in Stuttgart in 1982, at the age of eighty-seven.

PUBLIC RECOGNITION

More than any other works produced in Germany in the 1920s and early '30s, the sharp-focused, dispassionate portraits painted by Christian Schad epitomize the fragile glamour of the Weimar era. Interestingly, Schad's artistry has its origins in a medium other than painting.

Schad first came to the attention of the German public in the mid and later 1910s, as a contributor of illustrations to Franz Pfemfert's political and cultural Berlin journal *Die Aktion*, and to *Sirius*, a journal for literature and art edited by Walter Serner. These graphic works were both religious and autobiographical comments on his own status as an emerging artist. He also produced scenes of Indians in the Wild West, comparable to similar work by George Grosz or Rudolf Schlichter. The early phase of Schad's career is usually identified with the wartime Dada movements, in which he participated initially in Zürich and, from 1919, in Geneva. Following his beginnings with expressively Cubistic and brightly colored woodcuts, he created his renowned photograms, or "schadographs," his key contribution to Dadaist aesthetics. Created in Geneva in 1919, Schad said of them: "It was at this time that I had a particular fondness for small things, either carelessly discarded in the street or for some reason just lying around. I was fascinated by their patina and the charm of uselessness that clung to them."[1]

Schad's method with these photograms reflects both the dilettantism of his early, somewhat dandyish period in Munich, and his fascination with the enigma of the everyday object. Significantly, Schad himself did not recognize the art historical importance of his experiments and their results. It was his friend Serner, whose identity as a writer is acknowledged in the artist's *Schreibmaschinenbild (Typewritten Picture;* 1920), who encouraged Schad to take his own work more seriously. Serner saw in his photograms a crucial innovation: "the irruption of technology into art."[2] Schad had in fact narrowly anticipated the production of photograms by both the American Man Ray and the expatriate Hungarian László Moholy-Nagy.

Nonetheless, until the late 1920s, Schad's original (though rather haphazardly developed) contribution to the history of photography was known only to experts and fellow photographers. The celebrity he later acquired as a painter, and as one of the leading representatives of Neue Sachlichkeit, overshadowed his early photographic experiments. Moreover, only around thirty examples of Schad's photograms from this period are now known and evidently only seven woodcuts can be dated to the early and decisive aesthetic experiments he conducted in Geneva. Schad's work from the time of the Weimar Republic can be seen as paradigmatic

Neue Sachlichkeit works.[3] Their cold, smooth surfaces seem almost to be frozen, an effect intensified by the rapid ductus of his paint strokes. In the foreword to the catalogue for *Die Neue Sachlichkeit*, an exhibition held between March and April 1927 in the Galerie Neumann-Nierendorf, the Munich art critic Franz Roh commented about the exhibited Schad works: "What a crystalline self-definition does the world of objects here assume! How blank, cool, and metallic has the color become."[4] A few months later, at the turn of 1927–28, Schad was represented in the *Neue Sachlichkeit* exhibition at the Stedelijk Museum in Amsterdam with two works *Frau mit Blumen (Woman with Flowers;* a.k.a. *Triglion;* 1926) and the famous *Graf* [Count] *St. Genois d'Anneaucourt* (1927).[5]

Schad deliberately turned away from Expressionism and Dadaism, as well as an incipient Abstractionism, and chose instead to develop a deliberately realistic style. Far from satisfied with merely replicating scenes from everyday life, Schad transformed these into mysterious and fragile settings. The ambivalence of these works oscillates between the ever-active chameleon of "cold persona,"[6] and its inherent melancholy brokenness. Such cramped, artistically manipulated pictorial paraphrases reveal Schad's knowledge of a portrait tradition that dates back to the Renaissance, and his familiarity with advances in contemporary photography.

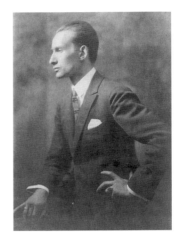

Christian Schad, Munich, 1912

Christian Schad, *Isabella*, 1934

In spite of its revolutionary and experimental beginnings, the importance of Schad's work for the development of modern German art has typically been viewed as lying in the paintings he produced in the 1920s. In those works, he explicitly addressed the problem of alienation so central to the age, most shockingly, perhaps, in *Zwei Mädchen*

Christian Schad, *Schadographie Nr. 4 (Amourette) (Schadograph Nr. 4 [Amourette])*, 1919. The Museum of Modern Art, New York

(Two Girls; cat. no. II.45). In this 1928 painting, Schad endowed the two girls with a level of psychopathological sophistication uniquely in tune with contemporaneous investigations into the subject and sources of melancholy.[7]

In the 1930s, Schad's painting became increasingly conservative and the artist aligned himself more closely to National Socialism. The former Dadaist was represented at the 1936 exhibition *Lob der Arbeit* (In Praise of Work), organized by the NS-Kulturgemeinde (Cultural Society) in Berlin, and in 1937 at the *Grosse deutsche Kunstausstellung* with two works, *Pariser Landschaft (Paris Landscape;* ca. 1929) and *Isabella* (1934).[8] The painter also submitted a number of works to National Socialist cultural officials for inclusion in these and other officially sanctioned exhibitions. Schad's obvious political opportunism and moral indifference worked well with the uncoordinated cultural policies of the National Socialists; the upshot of

these policies, curiously enough, was the affording of safe niches to several former Dadaists and Neue Sachlichkeit protagonists.

Precisely at the time he was ingratiating himself with the Third Reich, Schad's experimental photograms began to determine his image in America as a representative of the German avant-garde. In 1936, the Museum of Modern Art in New York mounted the panoramic exhibition *Fantastic Art, Dada, Surrealism*, which included four schadographs and two woodcuts by Schad.[9] Alfred Barr, who organized this show, hailed these three movements as the second "mainstream" of modern art after Cubism and Abstraction. In the show's catalogue, the photograms are erroneously dated to 1918. The works numbered 2, 3, and 4 are today in the possession of the Museum of Modern Art. The works were all from the collection of Tristan Tzara. Schad was honored in the catalogue as the pioneer of the lighting technique associated with his name and one of his schadographs was illustrated alongside Kurt Schwitter's *Strahlen Welt: Merzbild 31B (Glowing World: Merz 31B;* 1920) from the collection of Katherine S. Dreier. In this important exhibition, only minor (in view of the neoromantic portraits and landscapes) and somewhat "anachronistic" aspects of Schad's œuvre were conveyed, aspects which by then were almost irrelevant to the German reception of his work.

Apparently with an eye to commercial success, Schad took up his schadographs again in the 1960s. By this time, he had established a reputation in America as an avant-garde experimental photographer. His inclusion in *Avant-Garde Photography in Germany, 1919–1939* at the San Francisco Museum of Modern Art in 1980–81, and *Experimental Photography: The Painter-Photographer* at the J. Paul Getty Museum in Malibu, California in 1989, only reinforced this association. Schad has never had a one-man show in America. Moreover, his Neue Sachlichkeit paintings have featured in only two of the eighteen group exhibitions presented between 1936 and 1994 in which his work was included.[10] The perception of Schad in America continues to be dominated by a focus on his photographic work, which cannot be viewed as other than marginal.

Olaf Peters
Translated from the German by Elizabeth Clegg, with Nicholas T. Parsons.

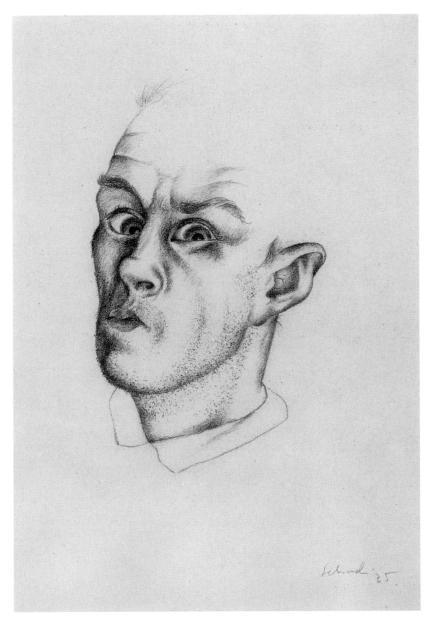

Zacharias I (Grotesque), 1935 cat. II.46

GEORGE GROSZ

*** JULY 26, 1893, BERLIN**
† JULY 6, 1959, BERLIN

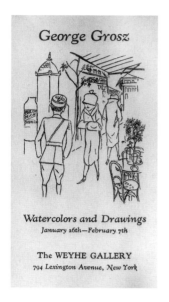

Invitation to the exhibition
*George Grosz, Watercolors
and Drawings*, Weyhe
Gallery, New York, January
26–February 7, 1931.
Courtesy Weyhe Gallery,
New York

George Grosz's artistic fantasies of "America" long predated his first visit to the United States in 1932. Born in Berlin in 1893, he belonged to a generation of German artists for whom the U.S. served as an imaginary and ever-changing standpoint from which to assess their own culture. As a leading member of the avant-garde and German Communist Party during the Weimar Republic, Grosz, like many of his artistic circle, incorporated visions of "America" into his paintings, collages, and drawings. For Grosz, such visions often became a vehicle for registering his contempt for Germany's prevailing social, political, and economic order. He became internationally famous in the 1920s for his bitterly satiric illustrations, which landed him in court on three separate occasions. Under increasing attack by German nationalists in the waning years of the republic, Grosz accepted an invitation to teach at the Art Students' League in New York. Arriving on U.S. shores in 1932, he faced for the first time the contradiction between his imaginings of America and its reality for him as a notorious émigré from Hitler's Germany.

Grosz's artistic career began with formal training at the Akademie der Künste in Dresden from 1909 to 1911. Eager to establish himself in the avant-garde, he returned in 1912 to Berlin. He enrolled in Berlin's Kunstgewerbeschule (School of Applied Arts), where he studied under Emil Orlik, an instructor known for his open attitude toward current art world tendencies. At the Kunstgewerbeschule, Grosz met Eva Peter, another art school student, who would marry Grosz in 1920. On the eve of World War I, Berlin became recog-

nized as one of Europe's newest, most vibrant artistic centers and host to the burgeoning Expressionist movement. Before Grosz could fully establish himself in his new milieu, however, Germany declared war on Russia in August 1914. Though he claimed years later to have opposed the war, Grosz nonetheless enlisted for a tour of military service beginning in November 1914. He was discharged seven months later after a period of illness that rendered him unfit to serve.[1]

Upon his return to Berlin, Grosz's work began to attract attention in the established art world for the first time. In 1915, Franz Pfemfert published some of his poems and drawings in his Expressionist journal *Die Aktion*. Grosz also came in contact during this period with the Expressionist poet and critic Theodor Däubler. Däubler wrote some of the earliest critical essays on Grosz's art, including a celebratory 1916 essay in the journal *Die Weissen Blätter* that solidified the artist's reputation in the Expressionist avant-garde. Däubler also introduced Grosz to major artists, critics, and dealers in Berlin's wartime art world.[2]

Most consequential, however, was Grosz's increasing involvement with the dissident circle of Expressionist artists and writers that congregated regularly at Ludwig Meidner's studio. Here he encountered the young poet Wieland Herzfelde, who became Grosz's lifelong friend and an ardent promoter of his art among radical circles. In July 1916, Herzfelde began publishing his antiwar journal, *Neue Jugend*, expressly for the purpose of disseminating Grosz's drawings and graphic portfolios. Many of Grosz's earliest published works

reflected his reading of James Fenimore Cooper and Karl May's stories of the American Wild West.[3] Using a crude, graffiti-like style, Grosz rendered his "America" during this period as a land of unbridled adventure and frontier freedom populated by cowboys, Indians, prostitutes, and missionary priests. Deployed in the context of *Neue Jugend*'s oppositional program, such imagery served as an implicit indictment of what Grosz, Herzfelde, and others of their circle had come to regard as the rigidity of wartime Wilhelminian society, its despised social mores, and tradition-bound culture. Grosz's *Neue Jugend* images continued to promote the journal's critical stance with caustic, childlike scrawlings that became more and more pointed in their attack on institutions of authority as the war progressed.

On January 4, 1917, Grosz was inducted into military service once again. The next day he entered a military hospital for a sinus infection and from there was put under psychiatric observation until his discharge in the spring of 1917. Grosz returned to Berlin radicalized by his experience.[4] He became at this time—along with Herzfelde, Herzfelde's brother John Heartfield, Raoul Hausmann, and Richard Huelsenbeck—a leading figure of the nascent Berlin Dada movement.

George Grosz and John Heartfield, *dada-merika*, 1919

In their manifesto of April 1918, the Berlin Dadaists declared their rejection of Expressionism as escapist and part and parcel of a bourgeois cultural order they now held in contempt. They announced their commitment instead to a radical form of creative practice expressly engaged with the calamitous events of the day.[5] A new vision of "America" began to emerge in their paintings, collages, and performances as part of Dada's dissident "anti-art" program. In *dada-merika*, a cut-and-paste collage by Grosz and Heartfield, the brash kitschiness of American-style mass advertising replaces the cowboys and Indians of Grosz's earlier U.S. imaginings. Through works such as these, the Dadaists solidified German perceptions of the U.S. as a "mass culture" lacking the social and cultural hierarchies associated, by contrast, with German culture. Dada collage dispensed with high-art notions of artistic genius and originality in favor of works that could be created collaboratively, at times anonymously, and, indeed, by anybody with the ability to "take scissors and cut out for [them]selves" whatever source materials they might desire.[6] In the volatile context of national defeat, Grosz and his fellow Dadaists indulged their vision of American mass culture as a thoroughgoing rejection of Germany's high-cultural tradition and the political, social, and economic system that sustained it.

George Grosz and John Heartfield demonstrate in favor of Tatlin's "new machine art" at the *Erste Internationale Dada-Messe*, Berlin, 1920

With the collapse of the German Imperial government and in the shadow of the November Revolution of 1918, Grosz, along with Herzfelde and Heartfield, sought to realize Dada's claim to cultural revolution in concrete political terms. The three joined the German Communist Party (Kommunistische Partei Deutschlands; KPD) shortly after its founding congress in December 1918. Their intention to link artistic and political revolt guided their staging of the *Erste Internationale Dada-Messe* (First International Dada Fair) held in Berlin in 1920. Placards affixed to the gallery walls amidst a jumbled array of collages, paintings, drawings, and sculptures announced Dada's ambition to align itself with Soviet Russia and to stand "on the side of the revolutionary proletariat."[7]

Alongside their attack on accepted notions of art, works included in the Dada fair also openly condemned the continuation of German militarism under the newly founded Weimar government. Grosz's antimilitarist portfolio, *Gott mit uns (God with Us),* drew particular fire from German authorities. Published by Herzfelde, the portfolio contained drawings that exposed the government's brutal armed suppression of the November Revolution. The group was tried in 1921 on charges of insulting the military. Grosz and Herzfelde were fined and the plates of the *Gott mit uns* portfolio were destroyed.[8] Grosz entered into negotiations sometime during this period to bring his own Dada troupe on a yearlong tour of the U.S., though the project was never realized.[9] He and others of his radicalized artistic circle soon abandoned Dada after the trial, however, partly in response to its negative reception by the KPD. The party rejected Dada's anarchistic nihilism on the grounds that it was an inadequate expression of the constructive and forward-looking nature of the revolutionary workers' movement the Dadaists claimed to serve.[10]

Beginning in 1921, Grosz became the leading artist of the KPD. His illustrations, which took aim at capitalist exploitation, government authority, militarism, and the rise of fascism became a regular feature in leftist publications, including the KPD newspaper *Die Rote Fahne* (The Red Flag).[11] Also in 1921, Grosz became a founding member of Willi Münzenberg's International Arbeiter-Hilfe (International Workers Aid; IAH), a relief organization connected to the Comintern's Western Propaganda Bureau. As part of IAH's efforts to alleviate the plight of the starving in Soviet Russia, Münzenberg enlisted Grosz to tour and illustrate a text about some of the country's most devastated areas for five months in 1922.

In his 1955 autobiography, Grosz claimed that this trip marked the turning point in his allegiance to Communism. Dispirited by what he described as the grinding poverty of the region and the bureaucratic attitudes of party functionaries, Grosz allegedly found himself unable from that point on to identify with Soviet Russia's revolutionary experiment.[12] Though scholars have disputed this retrospective claim, letters recently deposited in the Grosz Archive in Berlin reveal that he was once again making arrangements during his Russian trip to come to the United States in the spring of 1923.[13] To what extent such plans may have concerned his political outlook at the time remain uncertain. What was sure, however, was Grosz's dismay over what greeted him on his return to Berlin. Before currency stabilization and the introduction of the Dawes Plan in 1924, Germany's future looked bleak in the face of a hyperinflated economy and a political landscape made increasingly treacherous by rising fascism and militarism.[14]

Instead of traveling to the U.S. in 1923, Grosz remained in Berlin and prepared for his second trial, this time on charges of distributing obscene materials in his 1922 portfolio *Ecce Homo.* Of the eighty-four drawings and sixteen watercolors in *Ecce Homo*, the majority depicted fleshy bourgeois figures engaged in a variety of explicit sexual acts. The trial took place in 1924 and concluded with a fine and the imposition of a ban on several of the portfolio's images.

The *Ecce Homo* trial coincided in time with Grosz's by then apparent and growing disillusionment with the KPD. The party became more sectarian in its political tactics during this period and attempted to dictate the form and content of the art produced by its adherents, Grosz included. Though he continued to be associated in various ways with the radical left throughout the remainder of his years in Germany, he now turned his attention away from politically engaged work and toward securing his reputation in the established art world.

In 1923, Grosz ended his contract with Hans Goltz, the Munich dealer who had represented the artist since 1918 and had staged his first solo show in 1920. Grosz signed on instead with Alfred

Flechtheim, who also handled the promotion of Paul Klee's and Otto Dix's work. Until 1932, Flechtheim staged regular and critically acclaimed shows of the accomplished landscape studies and portraits that Grosz now began to produce. His stature as a leading contemporary artist was confirmed in 1925 when his paintings, including his recent portrait of the writer Max Herrmann-Neisse, were included in Gustav Hartlaub's celebrated Neue Sachlichkeit exhibition in Mannheim.

Grosz became embroiled in legal controversy for the third and last time when he agreed to provide a series of drawings as stage backdrops for Erwin Piscator's antimilitarist play, *Die Abenteuer des braven Soldaten Schwejk* (The Adventures of the Good Soldier Schwejk). Several images indicted the church for its role in Germany's resurgent militarism. One in particular, Grosz's depiction of Christ on the cross wearing combat boots and a gas mask, stood at the center of a rancorous and internationally publicized blasphemy trial that began in 1928 and dragged on for three years.

GROSZ AND AMERICA

In 1930, during the final phases of Grosz's trial, the U.S. artist Adolf Dehn contacted Grosz to arrange for an exhibition of his work at the Weyhe Gallery in New York. Founded in 1918, the gallery was devoted to the display of avant-garde prints, with special emphasis on critical and controversial artists. Early exhibitions featured works by Daumier, Gavarni, and Hogarth. In 1928, the gallery hosted Diego Rivera's first solo show in New York, followed by graphics exhibitions of the other Mexican muralists José Clemente Orozco and David Alfaro Siqueiros.[15] A left-wing caricaturist and long-time admirer of Grosz, Dehn enjoyed a close relationship to Weyhe Gallery's director, Carl Zigrosser, who featured Dehn's work regularly at the gallery throughout the 1920s. Dehn made Grosz's acquaintance during his years of work and travel that brought him to Berlin for extended stays several times in the 1920s. Dehn's and Zigrosser's planning for the Grosz exhibition coincided with some of the most heated international press coverage of Grosz's ongoing blasphemy trial.

Grosz attempted to have one of his trial dates rescheduled in order to accommodate an exhibition planning meeting in New York between August and October 1930. He never made the trip, however, due to his worsening health brought on

by the stress of the trial.[16] The Weyhe Gallery show nonetheless went forward and opened on January 26, 1931, shortly after Grosz's acquittal. Twelve of his works were on view, including drawings and watercolors of workers, street scenes, bourgeois types, and portraits. Reviewing the show for the *New York Times*, Edward Alden Jewell cautioned the faint of heart concerning Grosz's "ferocious" use of satire. His drawings, according to Jewell, were unsparing; even the deceptively gentle "surface allure" of his watercolor washes did little to mask the lacerating quality of line beneath the satirically dissected social types captured in

Grosz's imagery. "He sweeps before him into a kaleidoscopic gallery of horrors all that comes his way. No one need hope to be spared," Jewell warned. "The only recourse you would have would be to refuse to recognize the image flashed back at you from the grotesque mirror."[17] The Weyhe Gallery show remained on view until February 7, 1931, thus formally introducing this infamous satirist to the mainstream American art world for the first time.

The Weyhe bookstore and gallery, 794 Lexington Avenue, New York, 1924

Facing a collapsing art market as the Depression began to take its toll, and increasingly shrill attacks as Germany's "Cultural Bolshevist #1" from the nationalist right, Grosz readily accepted an offer from John Sloan, president of the Art Students' League board in New York, to teach at the school in the summer 1932 session. Grosz's appointment touched off a firestorm of controversy at the League. Conservative factions objected strenuously to Grosz's hiring because of his foreign national status and notorious political past.[18] Opposition was quelled, however, and he was offered a permanent position to begin the following year.

Grosz returned to Germany in October 1932 in order to make arrangements for relocating himself, his wife Eva, and their two sons, Peter (born 1926) and Martin (born 1930), to the U.S. Grosz's timely return to New York on January 23, 1933, just days before Hitler was appointed chancellor, spared him certain persecution under the National Socialist regime. On March 8, 1933, he was deprived of his German citizenship. Letters from his former artistic circle kept him abreast of the scattering of his friends into exile. For Grosz, the task now became one of establishing himself under completely changed circumstances in America.

Teaching at the Art Students' League and doing illustrations for *Esquire* and other American magazines provided Grosz with a living during his first years in the U.S. In letters to Herzfelde, who was then doing antifascist work from exile in Prague, Grosz expressed relief that he had arrived, at last, in the relatively democratic environs of the U.S., freed from Germany's political strife and able to pursue his career on entirely new terms.[19]

Indeed, his first impressions of the U.S. promised to conform to the positive fantasies of America that he had cultivated during his years in Germany. Grosz immersed himself in his new surroundings, walking the streets of New York with sketchbook in hand, studying lexicons of American slang, and avoiding contact with the growing German exile community. Unlike many of his compatriots who held out hope of an eventual return home, Grosz considered himself an immigrant and set about the task of integrating into his new environment. He produced a number of drawings and watercolors during his first years in New York that furthered this aim by taking their cue from the American Scene imagery of Sloan, Dehn, Reginald Marsh, and others. He abandoned the satirical edge of his Weimar work in favor of gentle caricatures of New York City types and the urban environment.

Works by George Grosz, as featured in *Esquire* magazine (September 1936)

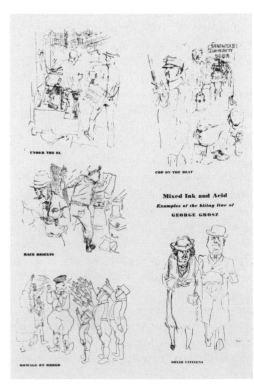

Grosz's dream of assimilation began to change, however, prompted by developments in the reception of his work in the U.S. art press as more became known about atrocities being committed in Germany under the National Socialists. It was in this climate that Alfred Stieglitz's American Place Gallery staged the first major show of Grosz's U.S. work. The exhibition, held in March and April of 1935, featured some forty watercolors and drawings from 1933–34 devoted to New York's urban scene. Marsden Hartley, who wrote the text for the exhibition catalogue, directed his comments at Grosz's German production, however, with only passing commentary for the works currently on display.[20] More important for Hartley was Grosz's art of the 1920s for which, Hartley insisted, Grosz would have assuredly been executed had he remained in Germany after 1933. As to the pictures on display, their largely uncritical character revealed, in Hartley's view, little more than Grosz's positive response to his new environment. He affirmed Grosz's desire to become an "American" artist. Like other critics of the time, however, he placed greatest importance on Grosz's identity as an exile whose authenticity of expression derived not from his current situation, but rather from those circumstances that he had left behind. In 1935, Grosz sent a rueful appeal to Herzfelde, asking him for copies of his graphic portfolios of the 1920s, which were now much in demand.[21] The German caricaturist and political polemicist of the past was what Grosz's new American audience wanted, not the American artist he was now struggling to become. After the display of twenty of his works in the *Entartete Kunst* exhibition of 1937, his reputation as a notorious German exile became only more entrenched.

From 1937 until the end of World War II, Grosz produced a series of prize-winning, large-scale oil paintings. He was awarded two Guggenheim fellowships, one in 1937 and the other in 1938, in support of his recent work. Grosz's art during this period adopted the trembling line and gloomy palette of the Northern Renaissance tradition he had begun to explore in detail in the late 1920s. Several of these works, including *Kain (Cain; 1944–45)*, dealt in allegorical terms with the experience of exile, war, and the horrors of National Socialist evil. *Kain* takes up the biblical story of fratricide and depicts Hitler crouching in a war-torn landscape as his skeletal victims rise up from the

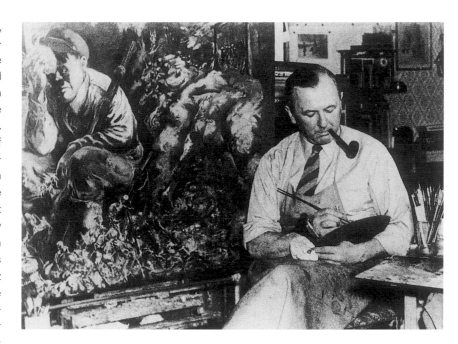

George Grosz in his studio, Douglaston, Long Island (photograph by Arnold Newman)

mud and clamor up his legs. *Kain*, along with Grosz's many self-portraits, landscape studies, and nudes produced at this time, consistently garnered critical acclaim. Given the current ascendancy of Surrealism and Abstract Expressionism in the U.S. art scene, however, his allegiance to figurative art made it increasingly difficult to find buyers for his work. The growing precariousness of his financial situation doubtlessly helped to erode his earlier positive vision of the U.S. as a land of opportunity. His diaries and letters of this period registered instead embitterment and disgust at what he now saw as a U.S. art world overrun by rampant success-oriented commercialism.

Grosz remained in the United States after World War II, pursuing his figurative paintings and witnessing from the sidelines the heyday of American Abstract Expressionism. The postwar art establishment not only maintained its high regard for Grosz's achievement, but also now readily claimed him as one of America's own. In 1948, *Look* magazine published a survey of museum directors and art critics that voted him one of the ten best living American painters.[22] But such accolades did nothing to improve his poor sales.

By the early 1950s, Grosz saw the arrival on U.S. shores of the German vision of Americanness that he and his fellow Dadaists had developed during World War I. In 1951, Robert Motherwell published *Dada Painters and Poets*, a volume that marked the American domestication of Berlin Dada's anti-

Postcard sent by George Grosz to Mark Neven DuMont on October 3, 1946

art radicalism. The volume recast Dada's critical embrace of U.S. mass culture into a codified style and coherent artistic movement ready for emulation in the mainstream U.S. art world. It was under these circumstances that Grosz launched with enthusiasm into what was to be his latest and, indeed, last artistic imagining of "America." In 1958,

he produced a series of collage works that, unlike his American fantasies of the Wilhelminian and Weimar years, now took satirical aim not at the shortcomings of his native Germany, but rather at the standardized, pre-processed, and pre-packaged realities of U.S. postwar consumerism. Finished the year before his death, Grosz's collages anticipated 1960s Pop art. Through Pop, Grosz's latest vision of "America" not only endured. As the U.S. art scene, including Pop and its successors, began its historic rise to a position of international cultural leadership, Grosz's artistic imaginings also helped to define the very nature of the "America" that the world would come to know in the postwar years.

Shortly before his death, Grosz was embraced again by his homeland: in 1958, he was elected *ausserordentliches Mitglied* (Extraordinary Member) of West Berlin's Akademie der Künste. The following year, he and Eva returned to Berlin, where he died at the age of sixty-five.

Barbara McCloskey

1 George Grosz, *Ein kleines Ja und ein grosses Nein: Sein Leben von ihm selbst erzählt,* Reinbek bei Hamburg: Rowohlt, 1986 (original German edition 1955), p. 101. His enlistment in an infantry guard regiment may well have been an attempt to avoid a more undesirable form of military service.

2 Beth Irwin Lewis, *George Grosz: Art and Politics in the Weimar Republic,* Princeton: Princeton University Press, 1991, pp. 25–39. See Lewis in general for the most comprehensive account of Grosz's activities and reception in both established and left-wing art worlds during the Wilhelminian and Weimar years.

3 For more on Grosz's American fantasies, see Beeke Sell Tower, Envisioning America: Prints, Drawings, and Photographs by George Grosz and his Contemporaries, 1915–1933, exhibition cat., Cambridge, Mass., Busch-Reisinger Museum, 1990.

4 For more on the relationship between Grosz's mental disturbance, his political radicalization, and his art at this time, see Barbara McCloskey, *George Grosz and the Communist Party: Art and Radicalism in Crisis, 1918 to 1936,* Princeton: Princeton University Press, 1997, pp. 32–46.

5 *Dadaistisches Manifest,* 1918, reprinted in *Die Zwanziger Jahre: Manifeste und Dokumente deutscher Künstler,* ed. by Uwe M. Schmeede, Cologne: DuMont, 1979, pp. 20–22.

6 Wieland Herzfelde, "Zur Einführung," flier for the *Erste Internationale Dada Messe,* Berliner Galerie, Dr. Otto Burchard, 1920.

7 Text from wall placard at the *Erste Internationale Dada-Messe,* Berlin, 1920. For a comprehensive summary of the exhibition, see Helen Adkins, "Erste Internationale Dada-Messe," in: *Stationen der Moderne,* exhibition cat., Berlinische Galerie, 1988, pp. 156–183.

8 For a thorough account of this and Grosz's other trials during the Weimar Republic, see Rosamunde Neugebauer, *George Grosz, Macht und Ohnmacht satirischer Kunst: Die Graphikfolgen "Gott*

mit Uns," Ecce homo, und Hintergrund, Berlin: Gebr. Mann, 1993.

9 Grosz was solicited by Herman Sachs, director of the Dayton Museum of the Arts, to create his own Dada troupe for a twelve-month U.S. tour. An undated contract recently deposited in the Grosz Archives at the Akademie der Künste in Berlin spells out the terms of the agreement. Referring to Grosz by his Dada nickname ("Herr Marschall G. Grosz"), the contract gave Grosz total control over selecting anywhere between four and fourteen of the most talented artists for the troupe, to be named the "Internationale Dadakompany." Grosz was to arrange the program, produce twelve posters for each month of the tour, and handle all advertising. Sachs, in return for 20 percent of the profits, was to cover all travel, advertising costs, and related expenses. The project was never realized. See "Vertrag zwischen Herr Hermann Sachs, Chicago, und Herrn George Grosz" in the Grosz Archive, Akademie der Künste, Berlin. In the first U.S. monograph on Grosz's art, the author acknowledges Sachs as Grosz's personal representative in the U.S. See Hi Simon, *George Grosz: Twelve Reproductions from his Original Lithographs with an Introduction by Hi Simon,* Chicago: Musterbookhouse, 1921. Sachs gave Simon permission to reproduce the twelve Grosz lithographs in this volume.

10 For the KPD response to Dada, see McCloskey, *George Grosz and the Communist Party* (as note 4), pp. 80–84.

11 Grosz's first illustration for *Die Rote Fahne* appeared in the May 1, 1921 issue of the paper. See letter dated February 10, 1921 to Grosz from R. Franz of *Die Rote Fahne* soliciting Grosz's collaboration, Grosz Archive, Akademie der Künste, Berlin.

12 Grosz, *Ein kleines Ja und ein grosses Nein* (as note 1), pp. 153–176.

13 See Grosz's letters to Mont Schuyler, January 5, 1923; to Claude McKay, December 8, 1922; and to Max Eastman, December 8, 1922 in the Grosz Archive, Akademie der Künste, Berlin, for Grosz's

requests for assistance concerning this unrealized trip.

14 Among other things, Grosz became concerned for his own safety during this period. See his application for a permit to carry a gun, "Grosz an das Polizei Revier, Berlin-Wilmersdorf, May 31, 1923," in the Grosz Archive, Akademie der Künste, Berlin.

15 German-born Erhard Weyhe emigrated to New York in 1914 and opened his fine-art bookstore and gallery in New York in 1918. For a history of the Weyhe Gallery and a comprehensive list of its exhibitions during these years, see Reba White Williams, *The Weyhe Gallery Between the Wars, 1919–1940,* Ph.D. dissertation, City University of New York, 1996.

16 McCloskey, *George Grosz and the Communist Party* (as note 4), p. 140.

17 Edward A. Jewell, "A Satirical Exhibition," in: *New York Times* (January 27, 1931), p. 20.

18 M. Kay Flavell, *George Grosz: A Biography,* New Haven: Yale University Press, 1988, pp. 69–71. See Flavell and Birgit Möckel, *George Grosz in Amerika, 1932–1959,* Frankfurt am Main: Lang, 1997, for the most thorough accounts of Grosz's career in the United States.

19 See, for example, Grosz's letter from New York to Wieland Herzfelde, August 23, 1932, in: George Grosz, *Briefe, 1913–1959,* Reinbek bei Hamburg: Rowohlt, 1979, pp. 157–160.

20 Marsden Hartley, in: *George Grosz at An American Place,* exhibition cat., New York, An American Place Gallery, 1935.

21 For more on the contradiction between Grosz's desire to assimilate and his reception as a German artist during this period, see Barbara McCloskey, "Hitler and Me: George Grosz and the Experience of German Exile," in: Exil: *Transhistorische und transnationale Perspektiven,* Augsburg: Stauffenberg (forthcoming).

22 *Look* (February 3, 1948), p. 44. Cited in Möckel, *George Grosz in Amerika* (as note 18), p. 163.

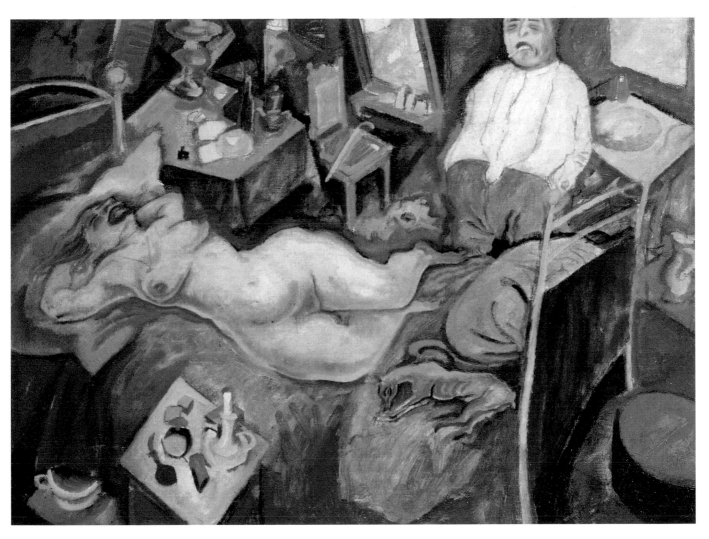

Couple in Interior, 1915 cat. II.47

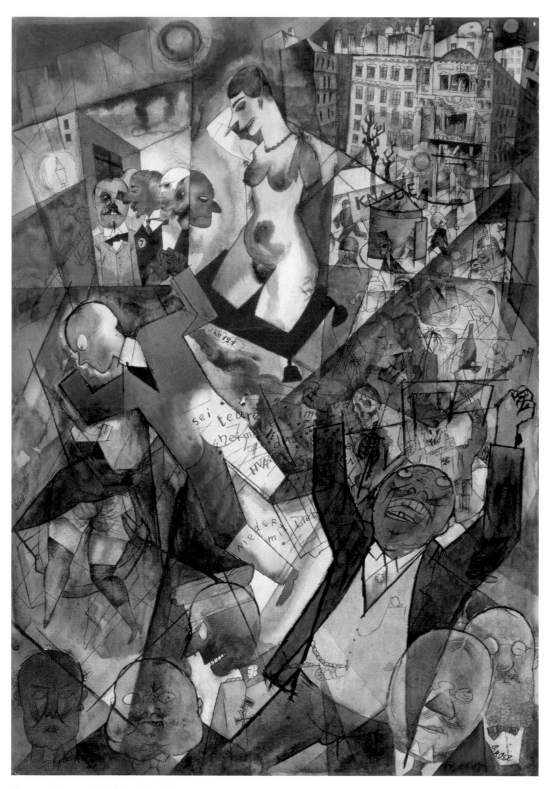

Panorama (Down with Liebknecht), 1919 cat. II.49

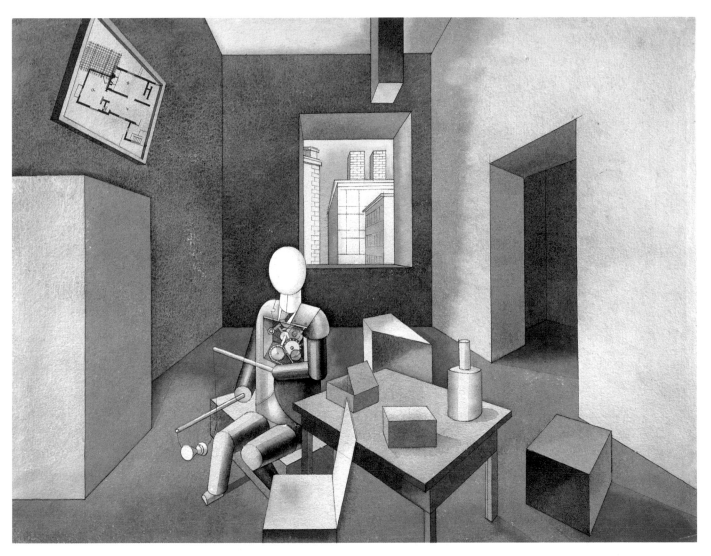

Diabolo Player, 1920 cat. II.50

Night, 1917 cat. II.48

was intially placed in a series of internment camps, then relocated to Douglas on the Isle of Man, where he remained for seventeen months. After being released, he moved to London to be with his son.

In London, Schwitters felt isolated and misunderstood. Only a few critics—among them, Herbert Read, Roland Penrose, and E.L.T. (Éduard Léon Théodore) Mesens—evinced any interest in the abstract work that he continued to produce. Their support, however, enabled Schwitters to mount a one-man show in London in 1944, the only such event to take place within his lifetime. Schwitters showed paintings, collages, and sculptural works at Jack Bilbo's Modern Art Gallery; yet there were virtually no sales and very few critical responses of any sort.

The most important person in Schwitters's life during his final, British years was Edith Thomas, known as Wantee. In 1944, Schwitters learned of the death of his wife Helma, and in the summer of 1945 he moved with Wantee to Ambleside in the Lake District. Here, in the midst of the highly romantic landscape, he was to spend what remained of his life. Schwitters died on January 8, 1948 in the hospital in Kendal.

RECEPTION IN AMERICA

I think I could do well in the USA.

—Kurt Schwitters, in a letter to Helma Schwitters, June 11, 1941

In the May 2000 issue of the American magazine *Art News*, when the journal's editors, along with critics and curators, listed "the century's twenty-five most influential artists," Kurt Schwitters was not among those chosen. Instead, the list named artists such as Max Ernst, Henri Cartier-Bresson, Walker Evans, Robert Rauschenberg, Mark Rothko, and Marcel Duchamp. Despite this "relative absence of Kurt Schwitters"[1] in the late twentieth century, in the 1950s and '60s he was hailed—with Duchamp—as a hero of modernism and as a role model for avant-garde artists in the postwar period. In order to analyze the response among American artists to Schwitters's work, and its influence on the next generation, it is necessary to establish what artists, critics, and curators living in the United States could have known of his work. We have to ask which works from which periods of his career could be seen in the original; which of his theoretical and literary texts were available in English

translation; how he was presented in publications and exhibition catalogues; in which contexts, in what kind of galleries, museums, and exhibitions he was present. Since Schwitters, to his regret, never visited the United States, he did not have the opportunity to promote his work there personally, nor to captivate audiences with his skills as a speaker and performer. If he had been able to fulfill his plans to visit the United States (or even to emigrate there), his impact would no doubt have been that much greater, for he generally made a memorable impression with his pleasing, humorous, yet eccentric personality.

Schwitters's contacts with the U.S. began in 1920, the year after he had begun work on his so-called *Merz* collage technique. The initiative came from the American collector Katherine S. Dreier, who was looking for new artists and ideas for the Société Anonyme, which she had recently founded with Duchamp and Man Ray in New York. In her search she traveled through Europe, making new contacts.[2] It was in Herwarth Walden's Der Sturm gallery in Berlin that Dreier first encountered the nailed and glued pictures by Schwitters that were causing a scandal at the time. Convinced of their quality, from then on she showed Schwitters's work almost every year in the exhibitions of the Société

Kurt Schwitters, portrait on an invitation to one of his Dada lectures

Kurt Schwitters, *Merzbild 31*, 1920. Sprengel Museum, Hannover

Anonyme—and many of these shows toured throughout the United States. The most important of these was certainly the *International Exhibition of Modern Art* at the Brooklyn Museum in New York in 1926–27.[3] Since the legendary Armory Show in New York in 1913, there had been no comparable major exhibition of international contemporary art in the United States. Dreier had asked Schwitters and his wife Helma to assist in the selection process, particularly for the Constructivist section. They both enthusiastically took to the task and acted as European agents for the Société Anonyme. (In 1931, Schwitters was appointed an honorary president of the society.) In the Brooklyn exhibition, there was a total of eleven works by Schwitters on show.

Over the years, Dreier purchased a large number of works by Schwitters from all the different stages in his career, both for her private collection and for the collection of the Société Anonyme. This became partly accessible to the general public when Dreier gave it to the Yale University Art Museum in 1941. After her death in 1952, Duchamp was named the administrator of the private collection left in her estate. He donated nineteen works by Schwitters to the Museum of Modern Art in New York; another eleven went to the Yale University Art Museum; three to the Solomon R. Guggenheim Museum in New York; one *Merz* picture and one collage to the Phillips Collection;

and two works to the American University in Washington, D.C.

Dreier's support for Schwitters did not stop at the purchase of works of art for her collection; she also paved the way for acquisitions by other leading private American collections and assisted the artist and his family financially during the difficult years of his exile. She did not meet Schwitters in person until 1926, when she visited him in Hannover. There was a second meeting in 1929—again in Hannover, this time with Duchamp as well. There is no detailed record of this meeting, and we can only speculate as to how this single encounter between these two protagonists of modernism may have gone. Schwitters was greatly flattered by Dreier's interest in him, particularly since this committed collector offered him a good chance of becoming better known in the United States. Yet Dreier found it difficult to interest a wider public in Schwitters's art, a problem she frankly acknowledged in a speech delivered at his first one-man show in New York at the Pinacotheca Gallery in 1948: "It has taken a long time for the American public to respond to the Schwitters [works] though we had shown them already in 1920. I had thought that the response would come as quickly as did that of Klee, not realizing that Schwitters was far more difficult for the average person to understand because he was purely the painter and there was no approach through the intellect which Klee

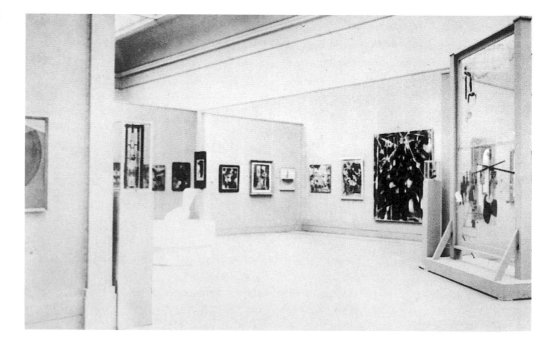

Installation view of *International Exhibition of Modern Art* at the Brooklyn Museum, November 19, 1926–January 9, 1927. On the far left: Kurt Schwitters's *Merz 1003. Pfauenrad*, 1924

reached through his whimsical delineation of ideas. This all happened twenty-seven years ago and except for a few lovers of the rare quality of Schwitters's 'Merz' collages, he remained almost unknown in this country."[4]

Again through Dreier, in 1935 contact was made with the newly founded Museum of Modern Art in New York, which was—alongside the Société Anonyme—the most important institution for modern art in America. On Dreier's suggestion, the museum's director Alfred H. Barr, Jr. visited Schwitters in Hannover; he bought one picture that year and two the following for the museum's collection.[5] Included in the extremely influential exhibitions put on by the Museum of Modern Art in 1936, *Cubism and Abstract Art* and *Fantastic Art, Dada, Surrealism*, were collages by Schwitters and *Merz* pictures, as well as photographs of his *Merzbau* (a full-scale collage environment) both on display and illustrated in the catalogue.[6] The catalogue essay for the latter show (an "introduction to Dada" by Georges Hugnet) devoted a whole section to Schwitters.

The regard that those responsible at the Museum of Modern Art had for Schwitters and his work is attested by a fellowship they awarded him to work on a third *Merzbau*. Since 1946, Schwitters with Barr and curator Margaret Miller—had been working on plans to complete earlier *Merzbaus*. Initially the idea was to rebuild and restore the *Merzbau* in Hannover that had been destroyed in 1943 during the war; later discussions turned to the question of completing the Haus am Bakken, the Norwegian *Merzbau* in Lysaker, near Oslo, which Schwitters was forced to abandon when he fled the country. However, the wholesale destruction of the Hannover *Merzbau* and Schwitters's precarious state of health meant that neither of these was a viable possibility. By this time, the artist was already living in England's Lake District, which led him to consider undertaking a new *Merz* project in a barn in Elterwater near Ambleside. The first installment of the Museum of Modern Art fellowship—one thousand dollars—arrived punctually in June 1947 on Schwitters's sixtieth birthday, and he started immediately on his *Merzbarn*. Yet this project, too, was never to be finished, as Schwitters died early the following year.

In 1946, Schwitters had also discussed other projects besides the *Merzbau* with the Museum of Modern Art—including a one-man show. Another planned project was his participation in an international group show focusing on collage, which was initially intended for summer 1947. However, both shows were repeatedly postponed—and in the end, Schwitters's first solo show at the New York museum did not take place until 1985. During the earlier period of negotiation with the museum, Schwitters had selected thirty-nine recent collages and sent them to New York in four groups.[7] Some of these were shown in the major exhibition *Collage*, held September 21 to December 5, 1948, after Schwitters's death (in this show nineteen of his collages were shown, eight of them from 1946–47). Along with Picasso and Max Ernst, Schwitters was one of the few artists in this influential exhibition whose work was shown in any great numbers.[8] This in itself is evidence of the recognition he enjoyed at the Museum of Modern Art as a pioneer of collage. In the short introduction to the exhibition list, his *Merz* art is described as being "distinct from the anti-aesthetic and political directness of the Dada movement in Germany"—a distinction that was to be very important for the subsequent reception of his work. Although Schwitters's œuvre has frequently been labeled Dada, the qualities of his more aesthetic approach had in fact been recognized early on.

Marcel Duchamp and Katherine S. Dreier, spring 1929

The exhibition was very positively received and reviewed. Clement Greenberg, the most influential critic and promoter of the emergent Abstract Expressionism, wrote that Schwitters and Hans Arp—even if at a "certain distance"—could be seen to be following in the footsteps of Picasso and Braque, the "great masters of collage."[9] Greenberg's estimation of the significance of collage resulted in a far-reaching reassessment of this technique: "The medium of collage has played a crucial role in the painting and sculpture of the twentieth century, and it is the most trenchant and direct key to the aesthetics of genuine modern art."[10]

As the originally planned one-man show of Schwitters's work at the Museum of Modern Art did not come to fruition, credit for putting on the first solo presentation of his work in the U.S. goes to a commercial space, the Pinacotheca Gallery in New York. Although this exhibition had been planned during Schwitters's lifetime, and he had selected some of the works himself, by force of circumstance, it turned out to be a memorial exhibition. The show opened on January 19, 1948, shortly after the artist's death.

Once again, it was Dreier who was responsible for the connection: she had introduced the gallerist Rose Fried to the work of the German Dadaist, and had also supported the exhibition by lending works. Schwitters and Fried had enjoyed a lively correspondence beginning in late 1946, and were both enthused by their shared plans for an exhibition. In order to set this show apart from the *Collage* exhibition—which was scheduled to take place at the same time at the Museum of Modern Art—Schwitters suggested presenting *Merz* pictures and sculptures as well as collages.[11] In the end, the exhibition contained collages and constructions, mainly from 1946–47; there were twenty-six entries in the catalogue.

Even before the exhibition had opened, Fried had sold some of Schwitters's works, and asked both the artist and Dreier for more.[12] From a commercial point of view, however, the show turned out to be a disaster: only two works sold during its run. But it was not long before the situation improved: in October 1948 Fried wrote to the artist's son, Ernst Schwitters, requesting more works, as "there is growing interest in them and I would like to put on an exhibition again this year, if possible."[13] The opening of a second one-man show, titled *Small Group of Collages by Kurt Schwitters*, was, however, delayed until 1953. In 1954 and 1956, Fried presented his work in group shows, including the important *International Collage Exhibition*, held in the spring of 1956. Through eighty-five selected artworks, this exhibition traced the development of collage from the beginnings of modernism right up to contemporary works by American artists such as Robert Motherwell, Lee Krasner, and Anne Ryan.

During World War II and in the immediate postwar period, the reception of Schwitters's art had reached one of its early high points. At the same time, New York became a focal point for the avant-garde, and the *Merz* artist played a crucial part in this as an inspiration and role model. His increasing renown coincided with the emergence of an independent art scene and new artistic tendencies in the United States—the so-called New York School, Abstract Expressionism, and neo-Dada (there was even a suggestion that the new movement should be called "neo-*Merz*" instead of neo-Dada).[14]

Motherwell was not only recognized as an emerging Abstract Expressionist, but also made a name for himself as a leading critic and art historian. His *Dada Painters and Poets: An Anthology* is still the standard work in English on the Dada movement.[15] It first appeared in 1951, and quickly became a kind of bible for all those who were interested in Dada at the time—it might even be said that it inspired a renewed enthusiasm among artists and critics for Dada.[16] It was Motherwell who first introduced Schwitters's work and theories to a wider English-speaking public, and to a large number of artists and critics. In his introduction to the anthology (and in the book's annotated bibliography by Bernard Karpel, librarian at the Museum of Modern Art), Schwitters occupies more space than any other artist. A whole chapter is given over to an English translation of Schwitters's programmatic 1920 text "Merz," in which he formulated his *Merz* theory for the first time. Another chapter of the book contains Schwitters's text, "Theo van Doesburg and Dada," and in Georges Hugnet's essay on the history of the Dada movement, Schwitters again occupies a prominent position: "It was Schwitters who gave Dada its final impetus."[17] The basic artistic approach that Hugnet identified in Schwitters struck a nerve among the younger generation of American artists: "Walking along the street, he would pick up a piece of string, a frag-

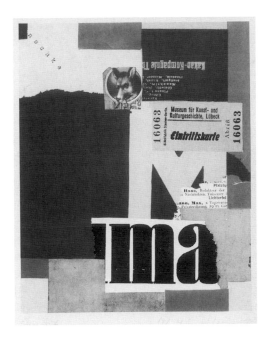

disturbing products of his time. To the principle of the object, he added a respect for life in the form of dirt and putrefaction. … Schwitters suggested the irrational tastes that we know from our dreams: spontaneity and the acceptance of chance without choice."[18]

Apart from Motherwell's anthology, at that time there were scarcely any English-language publications on Schwitters or translations of his texts. Carola Giedion-Welcker's essay on Schwitters, which first appeared in *Weltwoche* in 1947, was published in the *Magazine of Art* as the artist's obituary in October 1948 with the title "Schwitters, or The Allusions of the Imagination." This was the first extended, copiously illustrated text on Schwitters available in English. In addition, there was also the small pamphlet-catalogue produced for the 1948 Pinacotheca Gallery show, with texts by Dreier, Naum Gabo, and Charmion Wiegand.

In September 1948, Sidney Janis opened his gallery space on East 57th Street (directly opposite the legendary Betty Parsons Gallery).[19] Thanks to the triumphant progress of Abstract Expressionism, Janis established himself as an extremely successful gallerist and art dealer, as early on he had managed to entice the most promising young artists away from Parsons, including Jackson Pollock in 1952; Franz Kline and Mark

Cover of the exhibition catalogue *Collage, Painting, Relief & Sculpture by Schwitters*, Sidney Janis Gallery, New York, 1952, showing the Merzbild *Eintrittskarte*, 1922

Installation view of *Collage, Painting, Relief & Sculpture by Schwitters* at the Sidney Janis Gallery, New York, October 13–November 8, 1952

Rothko in 1953; and Motherwell in 1954. Janis's practice was to show these younger artists together with established exponents of classical modernism—such as Fernand Léger or Piet Mondrian—in order to break down the wider public's resistance to new art forms.

One of these modernists, whose work Janis exhibited very frequently over the years, was Schwitters. Shortly after Schwitters's death, Janis made contact with Edith Thomas, the artist's companion during the last years of his life in England, and acquired a large number of works from her. These were predominantly collages from Schwitters's late period in England, since the artist had been forced to leave his early works and his large *Merz* pictures behind in Lysaker and Hannover when he fled to England. Thus the American public was much more familiar than Europeans with the late collages from the ensembles on loan to the Museum of Modern Art, from Fried and from Edith Thomas.[20] In contrast to the rediscovery of the artist in postwar Europe, which—largely due to the preferences of Werner Schmalenbach and of Ernst Schwitters—concentrated on the early *Merz* drawings and pictures, there had been a steady interest in Schwitters's works in the United States since the early 1920s; in the 1950s, this was directed above all to his late works.

By mid century, there was in America an independent, self-confident art market for classical modernist objects. The extensive one-man shows of Schwitters's work at the Sidney Janis Gallery in 1952 (with a catalogue that listed seventy works), 1956 (fifty-seven works), 1959 (seventy-five), and 1962 (fifty-four) were therefore the first exhibitions of his work to be commercially successful. Whereas Fried had still been asking seventy-five dollars for a collage in 1947 (and had passed fifty dollars of that on to the artist),[21] by 1954, Janis's price for a late collage had risen to three hundred dollars. Schwitters's work, just like the abstract American art of the time, had meanwhile become so popular that it even found its way into lifestyle magazines such as *Vogue*.[22] In the 1950s, Janis became the most important dealer for Schwitters's work in the United States; his works were now being bought by major private collections such as those owned by the Rothschilds and the Rockefellers. In the early 1960s, however, Janis yielded his dominant position to the Marlborough Fine Arts Gallery, which had signed an exclusive contract

Cover of the exhibition folder
57 Collages Kurt Schwitters, Sidney Janis Gallery, New York, 1956

with the administrator of Schwitters's estate. From that point on, working with the artist's son Ernst, Marlborough coordinated all of Schwitters's exhibitions and sales—thereby contributing to his growing fame both in and beyond the United States.

Sidney Janis may be credited with more than establishing Schwitters in the American art market; he also nurtured the popularity of Dada in general in the United States. One of the most influential exhibitions of this movement was *Dada 1916–1923*, presented at his gallery in April and May 1953. None other than Marcel Duchamp was in charge of the hanging, and he also designed the catalogue: a poster-sized sheet of silk paper, printed and crumpled into a ball, which then had to be retrieved from a trash can. Schwitters's art was on prominent display in this exhibition: the catalogue lists six of his works, which were shown along with publications and his *Merz* magazines.

One of the visitors to this exhibition was Robert Rauschenberg—this is his earliest recorded encounter with Schwitters's œuvre. He, too, was one of Betty Parsons's artists and had had his first one-man show in her gallery in 1951. Rauschenberg is often hailed as Schwitters's greatest successor (and is sometimes even accused of being an imitator). In an interview in 1965, he recalled that on a visit to a Schwitters exhibition, he had felt "as if the whole exhibition had been made just for me."[23] Later he stated that he had "found out about collages because everyone was talking about Schwitters and I wanted to know more about him."[24] Rauschenberg bought some of Schwitters's late collages (as did Jasper Johns and Cy Twombly).

"The waste of the world becomes my art"—this quote from Schwitters served as the motto for the first comprehensive book on collage, published by Harriet Janis (wife of Sidney Janis) and Rudi Blesh in 1962. This publication marked the apex of Schwitters's reception in the 1950s and '60s in the United States: it contains numerous illustrations of his work, and his writings are cited to explain his theories—indeed, his name appears on practically every page. The authors draw their critical investigation of collage to a close with the following statement: "Schwitters moved from dada to a prophecy of this generation's leap from anti-art's social and aesthetic protest to the calm acceptance of our harvest of junk as material for a truly contemporary art—and let the chips of meaning fall

where they may. They use junk as an act of moral and aesthetic integrity, as the only realistic course. Their intellectual god is Marcel Duchamp who preceded dada, then transcended its negative limitations; their guide is Schwitters who heard the mute eloquence of our waste."[25]

Due respect is paid to the inventors of modern collage—Picasso, Braque, and Arp—but Schwitters takes precedence as the true master of collage using found objects.

In the critical assessment in the 1950s and '60s of the precursors and the progress of postwar art, Schwitters was seen as the equal of Duchamp. Often the two were named in the same breath when it came to identifying the most important influences on art until well into the 1960s and '70s—not to mention literature, poetry, and music. American artists and critics recognized Schwitters's achievements even if his unwieldy, scarcely narrative abstraction meant that he never attained the wide public acclaim of a Picasso or a Klee. He is often described as an "artist's artist," whose real impact came when those pursuing new directions—in Abstract Expressionism, neo-Dada, Pop art—were searching for role models and inspiration, and discovered a rich seam in Schwitters's late work.

Karin Orchard
Translated from the German by Fiona Elliott.

[1] Rudi Fuchs, *Conflicts with Modernism, or The Absence of Kurt Schwitters/Konflikte mit dem Modernismus, oder Die Abwesenheit von Kurt Schwitters,* Bern: Gachnang & Springer, 1991.

[2] See Gwendolen Webster, "Kurt Schwitters and Katherine Dreier," in: *German Life and Letters,* vol. 52, no. 4 (1999), pp. 443–456.

[3] See Ruth L. Bohan, *The Société Anonyme's Brooklyn Exhibition: Katherine Dreier and Modernism in America,* Ann Arbor, Mich.: UMI, 1982, pp. 47ff., 55.

[4] Katherine S. Dreier, unpublished manuscript (carbon copy), Kurt Schwitters Archive in the Sprengel Museum, Hannover.

[5] These were: *Reichardt-Schwertschlag Der Weihnachtsmann* (1922), collage; *Mz. 379. Potsdamer* (1922), collage; *Zeichnung A 2 Haus. (Hansi)* (1918), collage.

[6] Schwitters's works exhibited in *Cubism and Abstract Art* were: *Strahlen Welt: Merzbild 31B* (1920), and *Merzkonstruktion (Merzconstruction;* 1921), as well as four collages from 1921 to 1926. Both assemblages were illustrated in the catalogue. The *Fantastic Art, Dada, Surrealism* exhibition included *Strahlen Welt: Merzbild 31B* (1920); three collages from 1920 to 1922; and nine photographs of the *Merzbau.* The *Merz* picture and two photographs of the *Merzbau* were illustrated in the catalogue.

[7] These lists from the estate are in the Schwitters Archive in the Sprengel Museum, Hannover.

[8] According to the exhibition list, 102 works were shown. There was no catalogue, although there was evidently a plan to publish one (see Margaret Miller, letter to Schwitters, November 29, 1946, copy in the Kurt Schwitters Archive in the Sprengel Museum, Hannover).

[9] Clement Greenberg, the "Art" column, in: *The Nation,* vol. 167, no. 21 (November 27, 1948), pp. 612ff., reprinted in: Greenberg, *The Collected Essays and Criticism,* ed. by John O'Brian, Chicago: University of Chicago Press, 1986, p. 262.

[10] Ibid., p. 259.

[11] Schwitters, letter to Rose Fried, January 25, 1947, Archives of American Art, Rose Fried Gallery Papers, microfilm no. 2206.

[12] Rose Fried, letter to Schwitters, May 27, 1947, Kurt Schwitters Archive in the Sprengel Museum, Hannover. Among other things, Fried sold a collage to a "young artist"; see Fried, letter to Katherine S. Dreier, March 25, 1947, Yale University, The Beinicke Rare Book and Manuscript Library, New Haven, Box 29, Folder 838. Unfortunately, it is not possible to say who this artist might have been.

[13] Fried, letter to Ernst Schwitters, October 31, 1948, Kurt Schwitters Archive in the Sprengel Museum, Hannover.

[14] Irving Sandler, "Ash Can Revisited," in: *Art International,* vol. 4, no. 8 (1960), p. 29, as quoted in: Maria Müller, *Aspekte der Dada-Rezeption, 1950–1966,* Essen: Die Blaue Eule, 1987, p. 86.

[15] Robert Motherwell, *Dada Painters and Poets: An Anthology,* New York: Wittenborn, 1951.

[16] Barbara Rose, "Dada Then and Now," in: *Art International,* vol. 7, no. 1 (1963), p. 28.

[17] Georges Hugnet, "The Dada Spirit in Painting," in: *Motherwell, Dada Painters and Poets* (as note 15), p. 162. The text had been previously published in a slightly different version in the Museum of Modern Art exhibition catalogue *Fantastic Art, Dada, Surrealism* in 1936.

[18] Ibid., pp. 163ff.

[19] On the history of the gallery, see: *Three Generations of Twentieth-Century Art: The Sidney and Harriet Janis Collection of the Museum of Modern Art,* New York: Museum of Modern Art, 1972, pp. 210–230.

[20] For further detail, see Karin Orchard, "'Meine Zeit wird kommen.' Voraussetzungen der Rezeption von Kurt Schwitters in Europa und den USA," in: *Entdeckungen in der Hamburger Kunsthalle. Essays zu Ehren von Helmut R. Leppien,* ed. by Uwe M. Schneede, Hamburger Kunsthalle, 1999, pp. 65–69.

[21] Fried, letter to Schwitters, May 27, 1947, Kurt Schwitters Archive in the Sprengel Museum, Hannover.

[22] Illustration of the collage *PA CO* (1947) and a picture caption including the price in the December 1954 issue of *Vogue.*

[23] As quoted in Roni Feinstein, *Random Order: The First Fifteen Years of Robert Rauschenberg's Art, 1949–1964,* Ph.D. dissertation, New York University, 1990, p. 158.

[24] Robert Rauschenberg, in conversation with Barbara Rose, in: Rauschenberg et al., *Kunst heute,* no. 3, Cologne: Kiepenheuer & Witsch, 1989, p. 59.

[25] Harriet Janis and Rudi Blesh, *Collage: Personalities, Concepts, Techniques,* Philadelphia: Chilton, 1962, p. 255.

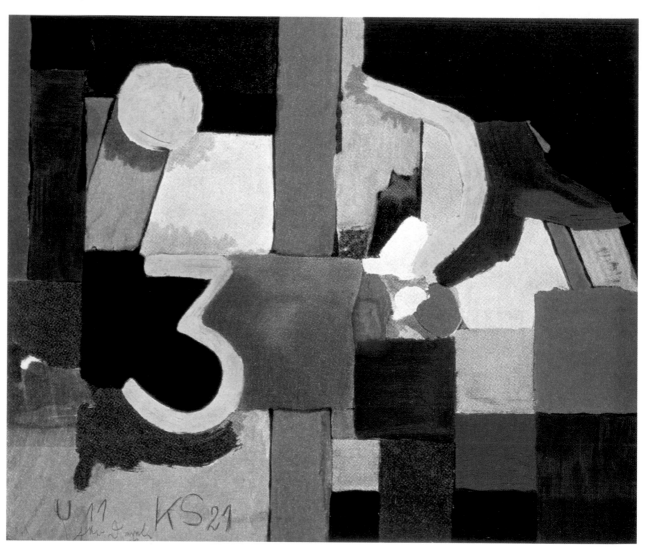

U 11 for Dexel, 1921 cat. II.52

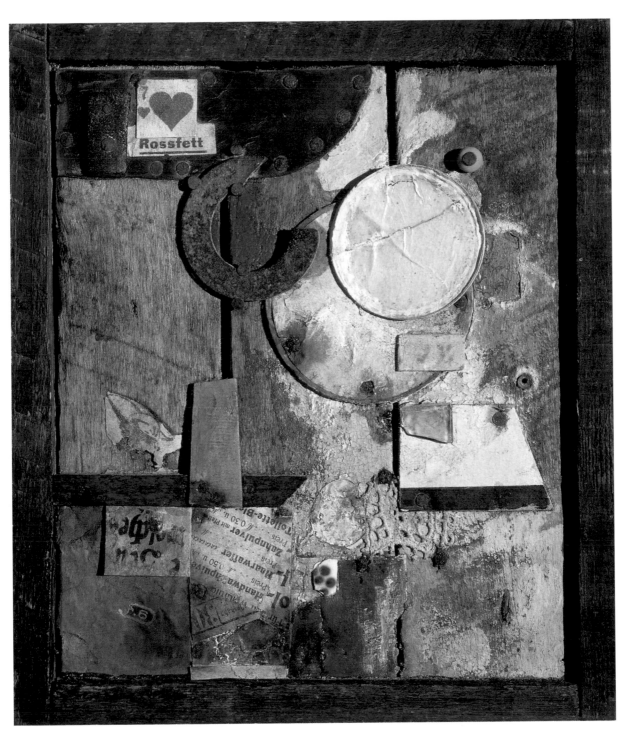

Untitled (Merz Picture Horse Fat), ca. 1920 cat. II.53

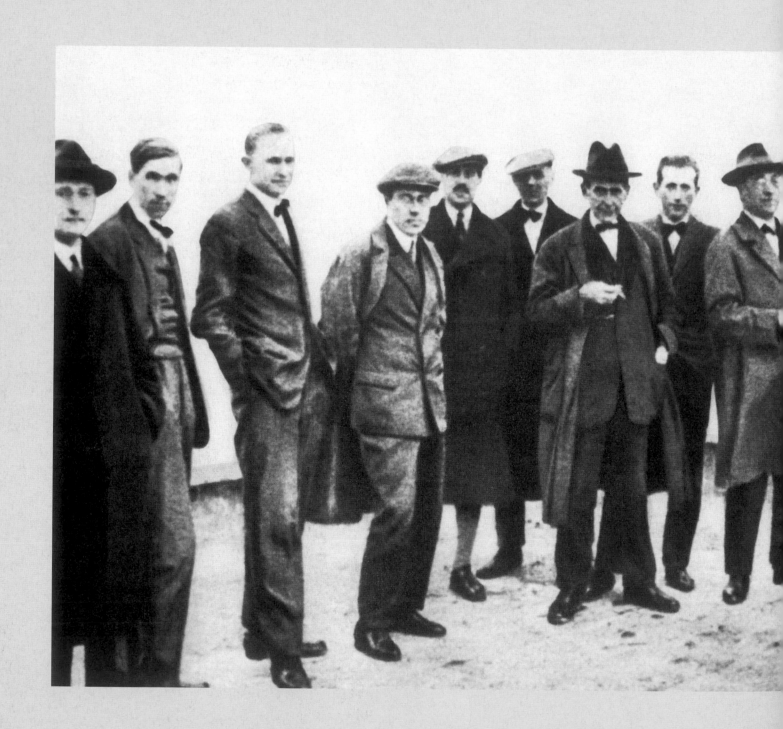

BAUHAUS

- **LÁSZLÓ MOHOLY-NAGY**
- **LYONEL FEININGER**
- **PAUL KLEE**
- **OSKAR SCHLEMMER**
- **VASILY KANDINSKY** *

The Bauhaus masters photographed on the roof of their new building in Dessau, after their move from Weimar in 1925. From left to right: Josef Albers, Hinnerk Scheper, Georg Muche, László Moholy-Nagy, Herbert Bayer, Joost Schmidt, Walter Gropius, Marcel Breuer, Vasily Kandinsky, Paul Klee, Lyonel Feininger, Gunta Stölzl, and Oskar Schlemmer

* Information on VASILY KANDINSKY, a teacher at the Bauhaus in Dessau, may be found in the "Blaue Reiter" chapter, pp. 230–243.

LÁSZLÓ MOHOLY-NAGY

*** JULY 20, 1895, BÁCSBORSÓD (NOW HUNGARY)**
† NOVEMBER 24, 1946, CHICAGO

Invitation to the exhibition *Paintings, Fotograms, Sculpture by Moholy-Nagy*, Fine Arts Society of Jacksonville, opened June 8, 1938. Robert Delson Design Collection [RD neg. 1], Special Collections, The University Library, University of Illinois at Chicago

László Moholy-Nagy was born László Weisz in 1895 in the village of Bácsborsód, in the extreme south of present-day Hungary. His father emigrated to America in 1897. Thereafter, László lived with his mother and two brothers at the home of an uncle, the lawyer Gusztav Nagy (whose name they assumed), in Mohol (now Mol, Serbia). After graduating from high school in 1913, Moholy-Nagy moved to Budapest, to study law at the university. He enlisted in the Austro-Hungarian army in the spring of 1915; from early the next year, he served as an officer in the artillery, until the summer of 1917 when he was severely wounded in action.

During his convalescence, Moholy-Nagy discovered his artistic proclivity, as he chronicled his army experiences in small, naturalistic sketches, which he often sent to friends in the form of postcards. Beginning in 1919, he took evening classes in life drawing from the nude. His paintings were seen in the fall of that year in a two-man show along with work of the Hungarian sculptor Sándor Gergely, at Gergely's studio in Szeged.

Late in 1919, as the Counterrevolution in Budapest became increasingly active, Moholy-Nagy left Szeged and (after a brief stay in Vienna) moved to Berlin. There he came into contact with the Dadaists and the avant-garde circle around Herwarth Walden's gallery and journal *Der Sturm*. Once established in the city, Moholy-Nagy embarked on a busy program of exhibiting, publishing, and traveling.

He married Lucia Schulz on January 18, 1921. The following year, Moholy-Nagy started to make photograms (camera-free photographs produced by placing objects directly onto light-sensitive paper)—around the same time that Christian Schad and Man Ray were experimenting with the same technique. Throughout his career, Moholy-Nagy would continue to produce photo-based works, and in recent years his photograms have come to be regarded as some of his most original contributions to the art of the twentieth century.[1]

In March 1923, Walter Gropius invited him to join the Bauhaus teaching staff. Moholy-Nagy became head of the school's metal workshop; he also occasionally taught the preliminary core class taken by all Bauhaus students. In the school's environment, he was able to broaden his already wide artistic range, and when the Bauhaus was forced to relocate from Weimar to Dessau in 1925, Moholy-Nagy decided to go with it.

In Dessau, the artist lived in one of the new apartments provided for the school's staff, and furnished his rooms with Bauhaus furniture. It was around this time that Moholy-Nagy acquired his first camera, a Leica, and started producing photographs and *Fotoplastiken* (photographic sculptures)—the term he used for his collages. At the school, differences of opinion regarding the organization of the metal workshop arose between Moholy-Nagy and Hannes Meyer, then head of the new architecture department. In 1928, Moholy-Nagy joined Gropius in leaving the Bauhaus (where Meyer succeeded Gropius as director).

Moholy-Nagy returned to Berlin where, without a regular income from teaching, he began to accept numerous commissions. He designed stage sets (and occasionally costumes) for productions at the

Kroll-Oper and Erwin Piscator's theater; in 1929–33, he regularly designed the covers of the progressive, illustrated journal *Die neue Linie*; and he designed and curated the exhibition *Film und Foto* (Film and Photography), mounted in Stuttgart in 1929 by the Deutscher Werkbund.

In 1929, Moholy-Nagy separated from his wife Lucia (although they did not officially divorce until 1934). He subsequently traveled extensively with the actress Ellen Frank (the sister of Gropius's wife Ise), whom he frequently used as a model in his photographic work.

Moholy-Nagy produced his kinetic sculpture *Licht-requisit einer elektrischen Bühne (Light Machine of an Electric Stage)* in 1930; this was the fruit of research and experiments in which he had been engaged since 1922. It was exhibited as part of the Deutscher Werkbund exhibition at the Paris Salon des Artistes Décorateurs Français (Salon of Decorative Artists). In the following year, he completed his first film, and the only one that was entirely abstract: *Ein Lichtspiel schwarz-weiss-grau (Light Prop: Black and White and Gray)*. He would make eleven more films over the next five years, some of them commissioned. In 1934, he married Sibyl Pietzsch, head of the script department at the Tobias film company (the couple had already had a daughter, Hattula, the previous year; a second, Claudia, was born in 1936).

The increasing difficulty of functioning as a progressivist artist in Germany under the National Socialist regime in 1934 prompted Moholy-Nagy to leave Berlin for Amsterdam. There, he remained active as a graphic and set designer and also pursued his interests in color film and color photography. In the following year, 1935, he moved on again, to London, which was already home to numerous former Bauhaus colleagues, among them Gropius and Marcel Breuer. Here, too, Moholy-Nagy worked as a graphic designer. But he also designed exhibition installations, made documentary films (*Lobsters* and *The New Architecture at the London Zoo*), and published three volumes of photographs (*Street Markets of London*, *Eton Portrait*, and *An Oxford University Chest*).

Moholy-Nagy left Europe in 1937 for the United States, where he settled in Chicago. In October of that year, he became the director of the New Bauhaus–American School of Design, a new institution for training in design initiated by the American Association of Arts and Industries. After only a year, however, the school was closed due to unforeseen financial difficulties. Moholy-Nagy immediately turned his attention to founding another institution to carry on the Bauhaus ideals, and managed to do it in a relatively short time: on February 22, 1939, the School of Design opened in Chicago. Over the following years this institution was expanded and reorganized, and in 1944 it was relaunched as the Institute of Design.

Moholy-Nagy's publication work focused increasingly on design and photography. As an artist, he was largely engaged with color photography and with sculpture made of heat-pliable Plexiglas. From 1945, however, his life was suddenly overshadowed by a diagnosis of leukemia. He then focused his energies on the publication of the book *Vision in Motion*, intended as a review of his life's work. Moholy-Nagy died in Chicago in November of 1946. *Vision in Motion* appeared the following year.

László Moholy-Nagy, undated portrait

RECEPTION IN EUROPE

Moholy-Nagy's perception of himself as an artist was crucially influenced by his early contact with Aktivizmus—the Hungarian Activists. This was a revolutionary movement that had emerged in the political context of Budapest during and immediately after World War I; their aims were pacifist and internationalist, and they sought an art that would function, and be recognized, as an integral part of life. In the view of Aktivizmus, art should achieve

László Moholy-Nagy, *Fotogram*, 1925–27. Bauhaus-Archiv, Berlin

Cover of the exhibition catalogue
*Moholy-Nagy, Peri: Gesamtschau des
Sturm*, published by *Der Sturm*
(February 1922)

Installation view of the exhi-
bition *Staatliches Bauhaus,
Weimar, 1919–1923* at the
Bauhaus, Weimar, August
15–September 30, 1923

the liberation (even in a political sense) of both the inner and the outer individual.[2] Art, they felt, should not be tied to expression in a specific range of media, for it is a part of everyday life. Upon his 1919 move to Berlin—a city that at first overwhelmed him with its metropolitan scale, pace, and complexity—Moholy-Nagy began to integrate the principles of Activism with a new regard for technology and the machine. Thereafter, he viewed this combination as both the starting point and the vehicle for his own contribution to contemporary art. Moholy-Nagy based his approach not on a style but on a particular intellectual position. According to recent scholarship, he "thought that the numerous unused skills possessed by everyone must lead, if tapped by means of the carefully calculated exploitation of the possibilities of technology, to the creation of a better way of life that would accommodate all of humanity's needs."[3] The optimism and ambition of this outlook are reflected in the breadth of Moholy-Nagy's artistic interests.

The several features that remained constants in Moholy-Nagy's œuvre and life were offset by several surprising changes of direction. He had little difficulty adapting, in turn, to the distinct artistic mentalities prevailing in Hungary, Germany, and the United States. Nonetheless, he never aligned himself fully with any one artists' group or association. The most important factor in Moholy-Nagy's outlook remained the utopian orientation of his art: his concern for the needs of humanity, his readiness to embrace the era of technology and industry, and

his efforts to reconcile the physiological with the technological.

Moholy-Nagy, unlike the majority of avant-garde artists, was not involved in a long and self-tormenting search for his "own style." As early as 1921, in Berlin, he abandoned the naturalistic and expressionistic modes he had deployed as a draftsman and as a painter, to engage briefly with Dadaism, then Russian Constructivism, ultimately evolving a style of his own based upon the ideas of transparency and the creation and organization of light. By this means, he sought to activate the perceptual potential of the spectator.

Among Moholy-Nagy's most significant artistic innovations were the *Telefonbilder (Telephone Pictures)* of 1923. For these, the enamel-paint factory of Stark & Riese of Tannroda (near Weimar) followed the artist's instructions (ostensibly provided over the telephone) to produce five paintings, identical in content but of varying size—all created by a "mechanical process."[4] With this anticipation of Conceptual art, Moholy-Nagy questioned the notion of "originality" in painting, and at the same time redefined himself as an artist-engineer. In this, he was undoubtedly influenced by the model of Aleksandr Rodchenko, a leading exponent of Russian Constructivism with its indifference to "the original" in art. Nonetheless, although this gesture implied an end to painting, Moholy-Nagy himself continued to be active as a painter. In fact, he never abandoned painting entirely, although his focus was often elsewhere—from 1925 in photography, in the 1930s in film, and thereafter in design. Moreover, contradictions between theory and practice within his own activities continued to characterize Moholy-Nagy's artistic personality. He also appears as an artist-engineer in the frequently reproduced portrait photographs taken by his first wife Lucia in 1925, in which he is seen wearing a mechanic's overalls.

Public awareness of Moholy-Nagy during his lifetime was focused upon three main areas of his artistic activity: painting, photography, and graphic design.[5] Of all the exhibiting venues in Germany, the most significant for Moholy-Nagy before 1925 was Herwarth Walden's Berlin gallery, Der Sturm. The artist showed his work (mostly paintings) there in 1922, 1924, and 1925. He also managed to gain a foothold wherever in Germany the Constructivists had shown their work: for example, in 1922 at the *Erste Internationale Kunstausstellung*

Düsseldorf. In Berlin, he also exhibited regularly with the Novembergruppe, which was an important rallying entity for progressivist German artists. Moholy-Nagy's most significant one-man show was organized in 1926 by the Dresden gallery of Rudolf Probst and presented at the Galerie Fides; the show subsequently toured to Wiesbaden's Kunstverein and to the Kunsthalle Mannheim. Probst had already organized exhibitions for Vasily Kandinsky and Lyonel Feininger, and his own exhibiting spaces were furnished with items from the Bauhaus workshops. This, however, appears to have been the only collaboration between Probst and Moholy-Nagy.[6]

Moholy-Nagy had very little interest in the art market. This indifference was fundamentally related both to his idealism and to his passionate commitment to teaching. While many artists of the day adopted shrewd "strategies" in their relations with art dealers, Moholy-Nagy's contacts of this sort were rare; he also doesn't seem to have favored any particular dealer. This may be due in part to the sheer range of Moholy-Nagy's activities as an artist, and the fact that his painting was repeatedly sidelined by other preoccupations. Furthermore, in Germany at that time there was no established network of exhibiting institutions for photography, nor for graphic design.

More important, though, than contacts with individual gallery owners were Moholy-Nagy's friendships with certain critics and cultural commentators—among them, Sigfried Giedion and Franz Roh. In Giedion (already established as a sympathetic commentator on the work of Gropius) the artist found an eloquent intellectual ready to support his cause. He was among the few to recognize the significance of Moholy-Nagy's commitment to synthesis in the arts, and to testify to his belief in the artist's potential. Giedion was also one of several important contributors to the special Moholy-Nagy issue of the Czech journal *Telehor*, published in Brno in 1936.

Roh, a critic based in Munich, was apparently the first to express enthusiasm for Moholy-Nagy's photographs, photograms, and paintings, in his response to the 1926 show at the gallery of Hans Goltz in Munich. In the same year, Goltz exhibited work by El Lissitzky, Piet Mondrian, and Man Ray. In 1930, Roh published the first monograph on Moholy-Nagy as a photographer, *Sechzig Fotos* (Sixty Photographs).

Dust jacket of the publication *Bauhausbuch Nr. 8, Malerei, Photographie, Film* by László Moholy-Nagy, 1925

Walter Gropius, 1920

Of particular importance among the numerous critical opponents of Moholy-Nagy as an artist were the art historians Will Grohmann and Carl Einstein. Grohmann, who contributed significantly to Klee and Kandinsky's reputations in the Weimar Republic, perceived Moholy-Nagy's abstractions as mere "mathematical formulae." Einstein, author of a highly regarded and widely read art historical survey (published by Propyläen-Verlag), basically rejected Constructivism and dismissed Moholy-Nagy as "petit bourgeois." Both Grohmann and Einstein considered Moholy-Nagy as exclusively a painter, and as such, a mere plagiarist of El Lissitzky's work. Almost inevitably, comparison with El Lissitzky also arose among reactions to a commission that Moholy-Nagy received from the Provinzialmuseum in Hannover. In 1927, El Lissitzky had completed the installation there of his *Abstraktes Kabinett (Abstract Cabinet)*. The museum's director, Alexander Dorner, subsequently discussed with Moholy-Nagy the creation of a "contemporary space" within the institution. Moholy-Nagy intended this to be a site—both an exhibition area and an installation in its own right—in which all the optical and technological possibilities of the present age would be demonstrated. This scheme was, however, never realized because of a combination of financial and political difficulties.[7]

Moholy-Nagy's reputation today, as during his lifetime, owes more to his achievements as a theorist—his teachings and his publications on art—than to his work as an artist.[8] He published in a wide

Alexander Dorner, director of the Provinzialmuseum in Hannover, ca. 1926

László Moholy-Nagy, title page of the *New Bauhaus*, 1937. Bauhaus-Archiv Berlin

Installation view of *László Moholy-Nagy* at the Museum of Non-Objective Painting, New York, May 15–July 10, 1947. Photograph © Solomon R. Guggenheim Foundation, New York

range of avant-garde journals in Germany, Switzerland, France, Holland, Hungary, Czechoslovakia, Poland, and England. The three American avant-garde periodicals in which his work appeared between 1923 and 1929 (*Broom*, *Transition*, and *The Little Review*) were to some extent also available in Europe. His energetic publishing activities testify both to a missionary zeal to promote his own ideas, and also to his endeavor to establish and maintain a network of international connections. Throughout his career, Moholy-Nagy remained receptive to the latest ideas of the European avant-garde, an interest and openness reflected in his series of *Bauhausbücher* (Bauhaus Books), fourteen of which were produced between 1925 and 1930. These were edited with Gropius, but largely the fruit of his own intellectual initiative. Moholy-Nagy was himself responsible for two books in this series: the eighth (published in 1925), *Malerei, Photographie, Film*, and the fourteenth (published in 1929), *Von Material zu Architektur*, a compilation of explanations and arguments used in his classes at the Bauhaus.

RECEPTION IN THE UNITED STATES

When Moholy-Nagy began his teaching career in the United States in 1937, the principal focus of his concerns shifted yet again. Establishing and then heading his own school, which he intended as a successor to the Bauhaus, consumed all his energy, particularly as it received no financial support.

Moholy-Nagy repeatedly modified his plans in order to accommodate the prevailing economic, political, and financial conditions.[9] His principal aim was to establish a training method for designers that would unite "art, science, and technology."[10] Moholy-Nagy nonetheless continued to resist succumbing to the forces of commercialization, even though he wished to enrich the industry through his own artistic convictions. Shortly after Moholy-Nagy's death, the principles governing the school he founded were altered. In the long term, it would seem that only his approach to teaching photography retained its influence—an influence that can still be seen in the programs and methods of many American centers for training designers and photographers to this day.[11]

In Moholy-Nagy's last book, *Vision in Motion*, he focused his attention on design, finding in it all the possibilities for the "organization of life" that he had earlier seen in painting, photography, and other disciplines. Thus "updating" his utopian concepts, he was able to reformulate his aspirations and requirements. He demanded that the training of designers be wide-ranging, and—rather than limited to the study of texts—thoroughly visual at every level. As in his earlier Bauhaus books, his argument was not presented in words alone, but also through images, typography, and page layout. For Moholy-Nagy, the intellectual content of the text and the overall appearance of the page were equal in value and significance; each, moreover, gained through its juxtaposition and interaction with the other.

In America as in Europe, it appears that Moholy-Nagy did not evolve any systematic scheme for establishing himself as an artist. He collaborated on exhibitions with a number of gallery owners, but seems to have had little commercial success. His first one-man show in the United States ran from March 30 to April 10, 1938 at the Bryan Lounge in the Florida Union, part of the University of Florida. It consisted of thirteen paintings, ten photograms, and four sculptural pieces; the show was organized by Robert Delson, who was based in Jacksonville, Florida as the local head of the Works Progress Administration (renamed the Work Projects Administration in 1939, a program initiated by the U.S. government in 1935, and responsible for commissioning work from numerous artists).[12] Delson, who had studied at the Art Institute of Chicago and was himself an artist, aimed to make art accessible

to a broad cross-section of the public. Seeing Moholy-Nagy's school as exemplary in this respect, he organized an exhibition to promote the institution and toured it around to educational establishments in Florida, also delivering lectures at each venue. Here, clearly, the goals were didactic rather than commercial.

Recent research suggests that, as "an exponent of the 'total work of art' and as a designer," Moholy-Nagy "was less successful in the United States than in Europe."[13] It would seem that he had no decisive impact on the American art world during the 1930s and '40s, but that a great many of his ideas have since taken hold there, principally as a result of the 1947 book *Vision in Motion*, which was reprinted in 1956.

Soon after Moholy-Nagy's death, his widow Sibyl sold a sculptural work, four paintings, and two works on paper to the Solomon R. Guggenheim Museum in New York; with that, the museum became the owner of the world's largest collection of his work, as it had already acquired six oils and a watercolor.[14] The 1947 exhibition at the Guggen-

heim, *In Memoriam: László Moholy-Nagy*, was in all probability prompted by this acquisition, and it marked the beginning of his widow's endeavors to make his work more widely known. It was at that date the largest and most comprehensive exhibition to have been devoted to Moholy-Nagy.

Today, work by Moholy-Nagy is in many European and American collections. As yet, there exists no catalogue raisonné of the paintings. The largest collection of these is at the Guggenheim Museum. The finest gatherings of photograms by Moholy-Nagy are in the Museum Folkwang in Essen and the Centre Georges Pompidou in Paris. Substantial and representative collections of photography, photographic sculpture, and photograms are in the Museum of Modern Art in New York; the Getty Museum in Malibu; the International Museum of Photography at George Eastman House in Rochester, New York; the Art Institute of Chicago; and the Bauhaus-Archiv in Berlin.

Magdalena Droste
Translated from the German by Elizabeth Clegg.

[1] Herbert Molderings, "Lichtjahre eines Lebens," in: *László Moholy-Nagy. Fotogramme 1922–1943,* exhibition cat., Essen, Museum Folkwang, 1996, pp. 8–17.
[2] See Krisztina Passuth, *Moholy-Nagy,* Budapest: Corvina, 1982; English transl. by Éva Grusz et al.: *Moholy-Nagy,* London: Thames & Hudson, 1985, pp. 10–13.
[3] Floris M. Neusüss and Renate Heyne, "Von Berlin nach Chicago. Historische und technische Betrachtungen zu den Fotogrammen von László Moholy-Nagy," in: *László Moholy-Nagy: Fotogramme* (as note 1), p. 140.
[4] The catalogue of the 128th exhibition to be mounted at the Berlin gallery Der Sturm, *Moholy-Nagy, Hugo Scheiber …,* which opened in February 1924, lists five constructions in enamel.
[5] On Moholy-Nagy's exhibitions, see Magdalena Droste, "László Moholy-Nagy—Zur Rezeption seiner Kunst in der Weimarer Republik," in: *Über Moholy-Nagy. Ergebnisse aus dem Internationalen László Moholy-Nagy-Symposium, Bielefeld 1995, zum 100. Geburtstag des Künstlers und Bauhauslehrers,* ed. by Gottfried Jäger and

Gudrun Wessing, Bielefeld: Kerber, 1997, pp. 23–36. The most extensive bibliography and list of exhibitions is in Renate Heyne, *László Moholy-Nagy,* exhibition cat., Valencia, IVAM Centre Julio González; Marseilles, Musée Cantini; and Kassel, Museum Fridericianum, 1991, pp. 318ff.
[6] Research has not yet revealed whether a catalogue was published to accompany this show.
[7] See Sabine Lange, "Der Raum der Gegenwart von László Moholy-Nagy," in: *Museum der Gegenwart—Kunst in öffentlichen Sammlungen bis 1937,* exhibition cat., Düsseldorf, Kunstsammlung Nordrhein-Westfalen, 1987–88, pp. 59–69.
[8] See Andreas Haus, *Moholy-Nagy. Fotos und Fotogramme,* Munich: Schirmer-Mosel, 1978; English transl. by Frederic Samson: *Moholy-Nagy: Photographs and Photograms,* New York: Pantheon, 1980, p. 15.
[9] See Sheri Bernstein, "László Moholy-Nagy in Chicago, 1937–45," in: *Exiles and Émigrés: The Flight of European Artists from Hitler,* ed. by Stephanie Barron and Sabine Eckmann, exhibition cat., Los

Angeles County Museum of Art; and Berlin, Neue Nationalgalerie, Staatliche Museen, 1997–98, pp. 262–269.
[10] Alain Findeli, "Die pädogogische Ästhetik von Moholy-Nagy," in: *50 Jahre New Bauhaus. Bauhausnachfolge in Chicago,* ed. by Peter Hahn and Lloyd C. Engelhart, Berlin: Bauhaus-Archiv, 1987, p. 46.
[11] See Victor Margolin, "László Moholy-Nagys Odyssee. Von Ungarn nach Chicago," in: *Bauhaus: Dessau, Chicago, New York,* exhibition cat., Essen, Museum Folkwang, 2000, pp. 198–207.
[12] I am grateful to Claire Deroy for providing the materials from which I drew this information from the archives of the University of Chicago: a newspaper article of April 1, 1938 in the *Florida Alligator,* and the manuscript of Sydney L. Delson, "Robert Delson: An Anecdotal Biography."
[13] Margolin, "László Moholy-Nagys Odyssee" (as note 11), pp. 206–207.
[14] See Angelica Zander Rudenstine, *The Guggenheim Museum Collection: Paintings 1880–1945,* New York: Solomon R. Guggenheim Foundation, 1976.

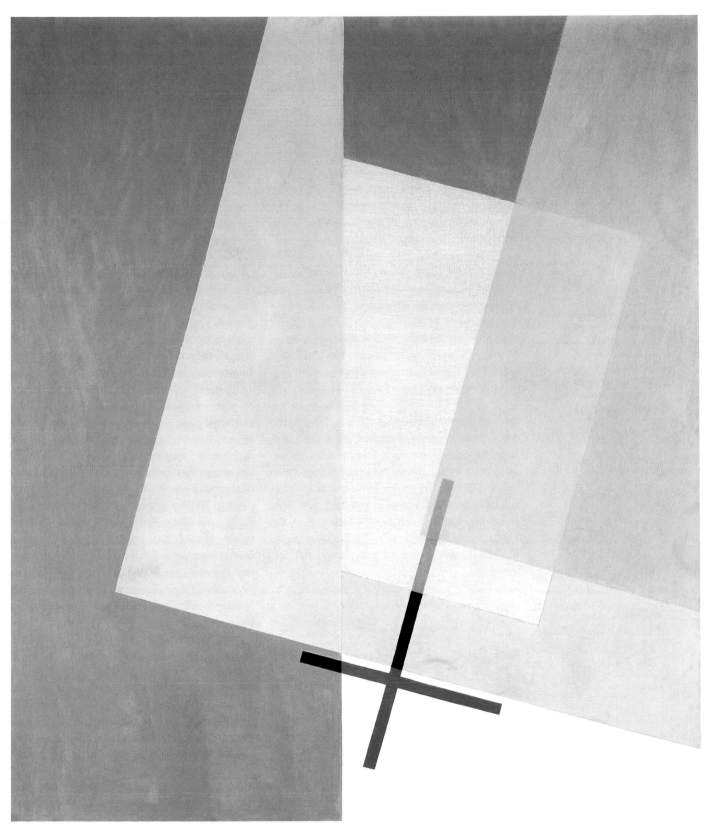

A XI, 1923 cat. II.54

American public as an artist whose work revealed a no-nonsense, pragmatic approach to design that went beyond the aesthetic purism of the Bauhaus and was more consonant with American traditions. The exhibition traveled to ten U.S. cities and was accompanied by a well-illustrated catalogue. Critical response was favorable, and Feininger continued to be celebrated with exhibitions and honors up until his death in 1956. His most lasting legacy, however, was the role his biography and art played in Barr's successful campaign to install the latest tendencies of European modernism in the mainstream U.S. art world. Feininger's work served the purpose of jettisoning not only the Bauhaus's political identity, but its foreign character as well. In an artful inversion of historical events, Feininger was no longer the exile forcibly driven out of Germany. On the contrary, in Barr's narrative of homegrown modernism, Feininger, like modernism itself, had returned from its state of exile in Europe to assume its rightful place in the vanguard of American culture.

Barbara McCloskey
I thank María Carolina Carrasco and Claire Deroy for their research assistance on this essay.

1 Lyonel Feininger quoted by Alfred H. Barr, Jr., in: *Lyonel Feininger—Marsden Hartley,* exhibition cat., New York, Museum of Modern Art, 1944, p. 13.

2 Georg Hermann, *Die Karikatur im 19. Jahrhundert,* Bielefeld 1901, p. 127. Cited in Ulrich Luckhardt, "Vom populären Karikaturisten zum unbekannten Maler—Lyonel Feiningers Weg zum unabhängigen Künstler," in: *Lyonel Feininger: Von Gelmeroda nach Manhattan: Retrospektive der Gemälde,* exhibition cat. Neue Nationalgalerie Staatliche Museen zu Berlin, 1998, p. 226.

3 Ernst Scheyer, *Lyonel Feininger: Caricature and Fantasy,* Detroit: Wayne State University Press, 1964, pp. 67–96.

4 For Feininger's reflections on art and mass culture see his letter to Alfred Kubin, December 11, 1912, in: June Ness, ed., *Lyonel Feininger,* New York: Praeger, 1974, pp. 34–35.

5 Feininger, letter to Alfred Kubin, January 5, 1919, in: ibid, p. 53.

6 For a thorough account of these artists' groups during the November Revolution, see Joan Weinstein, *The End of Expressionism: Art and the November Revolution in Germany,* Chicago: University of Chicago Press, 1990.

7 Walter Gropius, *Programm des Staatlichen Bauhauses in Weimar,* Weimar: Staatliche Bauhaus, 1919. Reprinted and transl. in: Hans M. Wingler, *The Bauhaus,* Cambridge, Mass.: MIT Press, 1978, pp. 31–33.

8 Feininger, letter to Julia Feininger, May 21, 1919, in: Ness, *Lyonel Feininger* (as note 4), p. 98.

9 Feininger, letter to Julia Feininger, March 29, 1935, in: Ness, *Lyonel Feininger* (as note 4), p. 238

10 For an account of Feininger's experiences under the National Socialist regime, see Mario-Andreas von Lüttichau, "'Wartesaal' Berlin—Die Jahre 1933 bis 1937," in: *Lyonel Feininger. Von Gelmeroda nach Manhattan* (as note 2), pp. 337–345.

11 See Feininger's letters to Julia Feininger on this subject from September 11, 1922 and January 23, 1924 in: Ness, *Lyonel Feininger* (as note 4), pp. 124, 130–31.

12 Feininger, letter to Galka Scheyer, May 3, 1924. Transl. in Christina Houstian, "Minister, Kindermädchen, Little Friend: Galka Scheyer and 'The Blue Four,'" in: *The Blue Four: Feininger, Jawlensky, Kandinsky, and Klee in the New World,* exhibition cat., Kunstmuseum Bern und Kunstsammlung Nordrhein-Westfalen 1997, p. 32.

13 Quoted in Sabine Eckmann, "Lyonel Feininger in New York," 1937–1945, in: *Exiles and Émigrés: The Flight of European Artists from Hitler,* exhibition cat., Los Angeles County Museum of Art, 1997, p. 296.

14 Houstian "Minister, Kindermädchen" (as note 12), p. 42.

15 Anon., "Art: The Clivette Invasion," in: *The Argonaut* (January 19, 1929), p. 6.

16 Florence "Wieben Lehre, Feininger, Clivette and Others," in: *The Argus* (January 1929), p. 10.

17 Among them were Alfred Neumeyer, Alois J. Schardt, Wilhelm R. Valentiner, and Curt Valentin. In 1941, Valentin and Marian Willard signed a contract with Feininger guaranteeing him $200 per month financial support. See Eckmann, "Feininger in New York" (as note 13), p. 297.

18 Included among them was Feininger's 1913 painting *Sidewheeler,* on loan from the Detroit Institute of Arts. Purchased by Wilhelm R. Valentiner in 1921 for the Institute, *Sidewheeler* was the first of Feininger's paintings to be included in a major U.S. public collection. See Alfred H. Barr, *Paintings by Nineteen Living Americans,* exhibition cat., New York, Museum of Modern Art, 1929.

19 For a discussion of the critical response see Barr, *Lyonel Feininger—Marsden Hartley* (as note 1), pp. 12–13.

20 Herbert Bayer, Walter Gropius, and Ise Gropius, eds., *Bauhaus 1919–1928,* exhibition cat., New York, Museum of Modern Art, 1938.

21 See Feininger's letters to Dorothy Cahill Miller, August 22, 1944 and September 13, 1944, in: Ness, *Lyonel Feininger* (as note 4), pp. 62–63. See also Eckmann, pp. 296–303 for a thorough discussion of Feininger's U.S. reception as well as political considerations that informed Barr's 1944 retrospective.

22 Barr, *Lyonel Feininger—Marsden Hartley* (as note 1), p. 7.

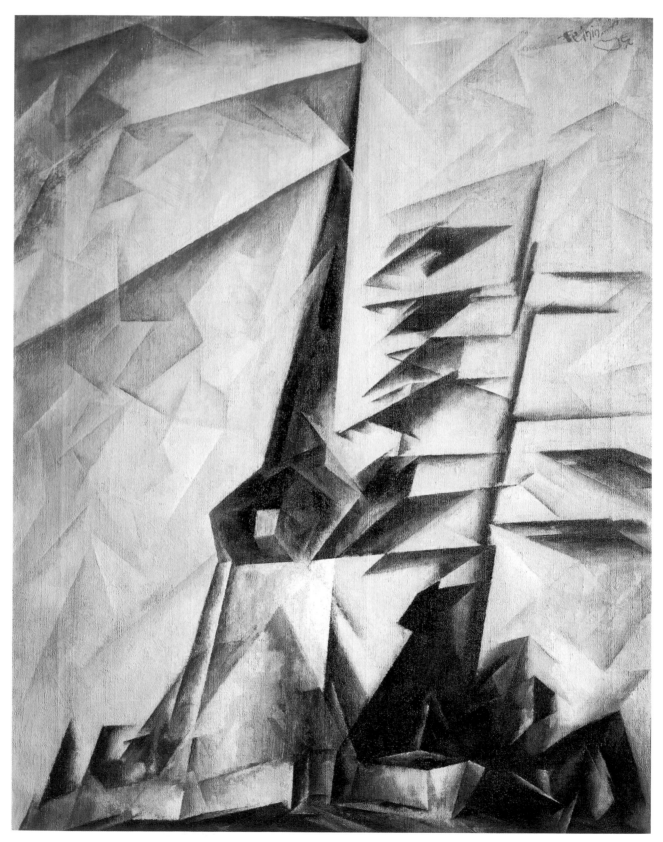

Gelmeroda II, 1913 cat. II.55

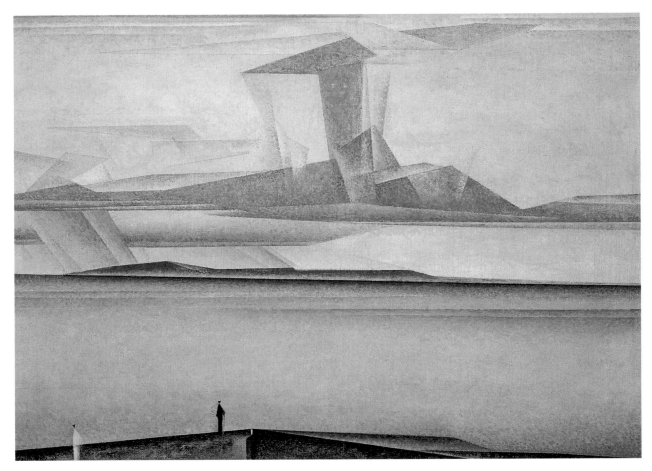

The Blue Cloud, 1925 cat. II.56

PAUL KLEE

*** DECEMBER 18, 1879, MÜNCHENBUCHSEE (NEAR BERN)**
† JUNE 29, 1940, MURALTO (NEAR LOCARNO)

Folder for the exhibition
Paul Klee at the Société
Anonyme, New York,
January 7–February 7,
1924

Paul Klee was born in Münchenbuchsee, near Bern, in 1879. His father taught music and his mother had trained as a singer. Klee spent his childhood in Bern, where both his artistic and his musical talents were encouraged, leaving him undecided, by the time he left high school, as to which direction to follow. He eventually decided on art, which he studied for three years in Munich, from 1898 at the private school of Heinrich Knirr, and subsequently under Franz von Stuck at the Munich Akademie, which he left in 1901. In that year he became engaged to the pianist Lily Stumpf, whom he would marry in 1906. After completing his studies, he traveled for several months in Italy, an experience that brought him to the sobering realization that the contemporary era was, in artistic terms, an "age of imitators."[1]

Between 1903 and 1906, Klee produced a series of satirical etchings that he was to term his *Opus I,* their marked literary character clearly indebted to the recent and contemporary Symbolist and Jugendstil currents in German art. In 1905, however, following Klee's visit to Paris and his first direct encounter with the work of the French Impressionists, his attention turned to the technical and compositional problems associated with rendering the observed, and he began to explore in particular the nature of light and the phenomenon of illumination. Thereafter, Klee spent many years slowly and systematically evolving his own form of expression, which mediated between objective record and subjective invention. In 1911–12, he first came into contact with the Munich artists who were to become his close colleagues—Alfred Kubin, Vasily

Kandinsky, Franz Marc, and August Macke—and he particapated in some of their joint projects, notably the publication of the almanac *Der Blaue Reiter,* and the second of two exhibitions mounted in association with it. In 1914, having worked almost exclusively as a draftsman, Klee suddenly expanded his repertoire through the production of a series of watercolors, painted during and after his two-week trip to Tunisia in the company of Macke and the Swiss artist Louis Moilliet. This experience enabled Klee to overcome his previous reluctance to work in color.

In 1916, two years after the outbreak of World War I, Klee was called up to fight in the German army. He came through the conflict without being wounded, and was discharged after the Armistice at the end of 1918. During the war years, Klee painted numerous intensely hued watercolors, but after the war he turned to painting in oils.

In 1920, he took a post at the newly founded art school in Weimar, the Bauhaus, where he remained for ten years, teaching a variety of classes (in accordance with the school's system), initially heading the studio for bookbinding, and later that for glass painting. His most significant contribution lay in the lectures he gave on the theory of form and design. For these he developed his own teaching system, the outlines of which he published in 1925 as the *Pädagogisches Skizzenbuch* (Pedagogical Sketchbook). His strong sense of a need for theoretical reflection and exposition found an equivalent in his commitment to achieving even greater precision in his own visual language. Discussion with his students and with the other

Bauhaus teachers—Kandinsky, Lyonel Feininger, Johannes Itten, Oskar Schlemmer, László Moholy-Nagy, among others—resulted in a fruitful exchange of ideas and influences. However, toward the end of the 1920s, as the emphasis at the Bauhaus (by now relocated to Dessau) shifted increasingly to the artist's contribution to industry and technology, and as Klee began to feel that his teaching duties were taking up too much of the time he might otherwise devote to his own work, he began to think of leaving the school.

In 1931, Klee left the Bauhaus and moved to Düsseldorf to take a post at the Kunstakademie, a far more conventional institution. He taught there until 1933 and the advent of the National Socialist regime in Germany. After his house had been searched and his teaching contract prematurely terminated, he left Germany and returned to his native Bern. In 1935, he began to suffer from the first signs of the skin disease (soon to be diagnosed as incurable scleroderma) that would intermittently influence his ability to work for the rest of his life. The year 1936 was his least productive, his output dropping to only 25 works, but during 1937 it increased dramatically, reaching a peak in 1939 of 1,253 pieces. Although Klee would return to many of his early subjects during the 1930s, he also evolved his own "late style," distinguished by the use of a visual "script" consisting of simple, linear constructions resembling pictograms. Klee died in June 1940 near Locarno.

PUBLIC RECOGNITION

It was only gradually that Klee achieved wide public recognition, his "breakthrough" occurring during World War I, when he had already been an artist for some fifteen years.[2] His work at this time took the form of small, glowing watercolors depicting a poetic, imaginary world of mysterious symbols (eyes, stars, hearts, arrows), to set against the events of the war.[3] The first key player in promoting Klee's reputation was the Berlin art dealer Herwarth Walden, who in 1910 had founded a journal, *Der Sturm*, and in 1912 a gallery of the same name. While Klee remained skeptical concerning Walden's approach to his own activities—"He doesn't even *like* the pictures! He just has a nose for them …"[4]—he was nonetheless happy to profit from Walden's aggressive marketing strategy, and he made available to him a constant supply of his latest work. Between 1912 and 1921, Klee was

included in no less than twelve of the exhibitions organized by Walden, making him one of the artists best represented at Der Sturm. Although his work sold there with varying degrees of success, it attracted increasing attention from reviewers in the German art press, and by 1919–20, Klee had effectively become something of a cult figure of the avant-garde.

The pioneer among Klee's German art critics at this time was Theodor Däubler (also prominent as an Expressionist poet), who lauded Klee, in ecstatically enthusiastic language and cosmic metaphors, as a self-absorbed dreamer with his gaze fixed on an otherworldly landscape of the soul. This view of Klee would set the tone for future commentators on the artist's work. In Däubler's footsteps, noted critics and art historians such as Adolf Behne, Eckart von Sydow, and Gustav Friedrich Hartlaub declared Klee to be an exception who could not be classified within the traditional categories of art and could only be understood by those "in the know."

By 1920, Klee was among the most prominent of relative newcomers to the contemporary German art world, and his situation stabilized. In joining the Bauhaus in Weimar, he achieved his ambition to teach at an art school, and he was promoted to the rank of professor. Within a short space of time, no fewer than three monographs on Klee appeared, and he was able to reposition himself in relation to the art market. He distanced himself from Walden and signed a general contract with the Munich gallery-owner Hans Goltz.[5] In 1920, Goltz mounted a large Klee retrospective and published one of the three above-mentioned monographs. In hindsight, this volume was particularly significant as the first publication to include Klee's frequently cited artistic creed—"I am not at all to be understood in worldly terms. For I dwell just as much among the dead as do those do who have not yet been born. …" Indeed, it would seem that Klee may have devised this exceptionally resonant statement precisely for publication in this form. For reviewers, Klee's early celebrity nonetheless also aroused increasing resistance. Conservative observers dismissed his work as a manifestation of the "defeat of the intellect," or mocked it as nothing more than handicraft in doubtful taste or "larking about with a pencil."[6]

The year 1923 was particularly important for Klee's evolving reputation. In February, he had his first exhibition in a museum, and at no less an

Hans Goltz, undated photograph

Page from *Der Ararat,* second special issue, Paul Klee, catalogue for the sixtieth exhibition at the Galerie Neue Kunst Hans Goltz, Munich, May–June, 1920

institution than the revered Nationalgalerie in Berlin.[7] Klee himself assembled the artworks (there was a total of 270 in the show), and he took advantage of this opportunity to provide a comprehensive overview of his work to date. It is interesting to note that he selected only a few of his poetic images from the war years, the work that had first brought him to public attention, preferring to emphasize the output of his first two years at the Bauhaus, 1921 and 1922, work notable for its more rigorous pictorial construction and its systematic use of color. Evidently, Klee sought by this means to divorce himself from his image as romantic dreamer. After the exhibition had closed, Ludwig Justi, director of the Nationalgalerie, acquired four works for the museum's permanent collection. It is significant that Klee agreed to this sale only on condition that the new acquisitions be on permanent public display. It was at this point that other public collections and art societies in Germany began to pay attention to Klee and to acquire his work—for example, in Weimar, Erfurt, Hellerau, Halle, and Dessau. At some of these institutions a separate, small "Klee gallery" was created within the existing public spaces to display works held on loan.

It was also at this time that Klee became acquainted with the young art critic Will Grohmann, who was to contribute more than any other commentator to publicizing the artist's work. For many years Grohmann would write prolifically about the work of Klee and Kandinsky—these writings were published both during the artists' lives and continued long after their deaths; by this means Grohmann significantly influenced the retrospective perception of their achievement. His first essay on Klee appeared in 1924 in the journal *Cicerone*; in it, he sought (as Klee himself had done with his show at the Nationalgalerie) to "correct" the public perception of the artist and in particular to strengthen Klee's reputation as a member of the Bauhaus. According to Grohmann, "Nowadays, Klee is neither … a mystic nor something entirely exotic … Rather, his work constitutes one of the most illuminating answers that we possess to the question of what painting can achieve."[8] Grohmann soon published more essays, in both German and French journals, in every case endeavoring to present Klee's achievement as a draftsman as equal in significance with his work as a painter. By 1925, Klee had attained sufficient status, both financially

and artistically, to be able to end his commercial arrangement with Goltz and to resume control of the business side of his own affairs.

Nonetheless, in light of the ongoing economic crisis in Germany, he sought to assure himself of a second regular income in addition to his Bauhaus salary. To this end, he joined forces with the Braunschweig collector Otto Ralfs (a great admirer of the artist) to found the Klee-Gesellschaft (Klee Society).[9] For this private association of supporters (to which members committed themselves by paying monthly dues), Klee offered his works at favorable prices. In addition, once a year he donated a print or drawing to each member of the society.

Among German art dealers it was above all the Berlin- and Düsseldorf-based gallery owner Alfred Flechtheim who, over the following years, did the most for Klee. Like Walden, Flechtheim was a strategist, keen to initiate and then steer developments, a dealer who not only organized exhibitions but also did much more to promote the reputation of "his" artists. Particularly notable among the shows presented by Flechtheim was the one mounted in 1929 to mark Klee's fiftieth birthday, a presentation that succeeded in confirming beyond any doubt his status as a "master of contemporary art." Thanks to Flechtheim's good international contacts, many of Klee's shows subsequently toured, in particular to Brussels and Paris. Flechtheim also made a point of featuring Klee in

the journals published by his gallery, *Der Querschnitt* and *Omnibus*. In addition to collaborating on shows with Flechtheim, Klee granted several other art dealers the right to offer a limited number of his works for sale. Among these, Klee had a particularly good working relationship with Rudolf Probst, owner of the Neue Galerie Fides in Dresden.

Will Grohman, 1923

Portrait of artist and artwork, "Paul Klee" in the periodical *Der Querschnitt*, edited by Alfred Flechtheim, 1928

In the second half of the 1920s, the critical discussion of Klee increasingly alluded to the work of the Parisian Surrealists. In 1925 these had invited Klee to take part in their first group exhibition, at the Galerie Pierre, and had reproduced a number of his works in their journal *La Révolution Surréaliste*, thereby staking a claim to Klee as a contributor to their movement. Moreover, Klee's work was also taken up by the circle associated with the leading French journal of the mainstream avant-garde, *Cahiers d'Art*, where it was to appear regularly until the early 1930s. Recognition in France improved Klee's standing in Germany, where this achievement was understood not only as the personal success of one artist but as proof of an increase in the prestige of German art as a whole. Consequently, Klee began to find himself informally assuming the task of representing German art in the international arena. In art historical writing, too, Klee was now perceived as one of the central figures of contemporary art. In 1931, he was described by Carl Einstein in his volume *Kunst des 20. Jahrhunderts* (Art of the Twentieth Century) as "the most important of the German artists."[10] Such plaudits, however, would have hardly any impact on the evolution of public opinion in Germany. Only two years later, in March 1933, the National Socialists seized power, and with this, discussion of the art of modernism would be interrupted for many years, to be resumed only after 1945 by a younger generation of German art critics.

Klee, like all modernist artists, became the victim of the aggressively antimodernist cultural politics of the new regime. At the end of 1933, he was dismissed from his professorial post at the Düsseldorf Kunstakademie. Those of his works that were found in public collections, or that had been placed there on long-term loan by their owners, were for the most part confiscated, and sixteen of them were displayed in 1937 in the initial Munich presentation of the touring *Entartete Kunst* exhibition. In 1933, Klee had already taken back the works that he himself had loaned to public museums, and had set up business arrangements with art dealers outside Germany. Daniel-Henry Kahnweiler in Paris now assumed responsibility for Klee's international sales. In Switzerland, where Klee returned after leaving Germany, his work would never again during his lifetime reach a broad public. While it is true that he was given a number of comprehensive exhibitions in important institutions in Bern, Basel, and Zürich, he had no success on the Swiss art market; and Swiss commentary on his work alluded dismissively to the "*schizophreneli's gärtli*" ("little schizophrenic's odd garden").

On a happier note, however, it was during his late, Swiss period, that Klee saw a decisive improvement in his reputation in the United States. While by no means unknown in America before this period, his work only entered the country in substantial quantities with the arrival of art dealers emigrating from Germany in the 1930s. These ensured that Klee's art appeared in exhibitions and that it was reproduced in periodicals and other publications. In the past, it had been principally Katherine S. Dreier, Galka Scheyer, J. B. Neumann, and the Museum of Modern Art in New York that had tried to draw attention to Klee's work.

Klee's first one-man show in America took place in New York between January 7 and February 7, 1924 under the auspices of the Société Anonyme, which had been founded in 1920 by Dreier and the artist Marcel Duchamp. Eight oils and nineteen watercolors were presented here, in an event that inaugurated the association's new exhibition galleries in the Heckscher Building on 57th Street.[11] In 1921, work by Klee had already been included in a group exhibition organized by the Société Anonyme. It was at this show that the American painter Charles Demuth had discovered Klee and had declared an interest in purchasing some of his pictures.

Dreier's first encounter with Klee's work took place in the fall of 1920, during a trip to Europe, when she saw it in an exhibition at Walden's Berlin gallery. But it was only in October 1922, during further travels in Europe, that she met the artist in person in Weimar. It would seem that it was on this occasion that she not only discussed with Klee the possibility of mounting a one-man show of his work in America, but also collaborated with him in selecting the items that might be included in such a show. In the summer of 1923, Klee contacted Dreier on his own initiative in order to confirm a proposed opening date of January 1924. For Klee, who remained rather cautiously noncommittal in his dealings with art dealers and museum directors, this move is outstanding, and may be seen as a measure of his great interest in the possibility of exhibiting in New York.

Dreier's Klee exhibition, opening in January 1924, took place at a time when interest in contemporary

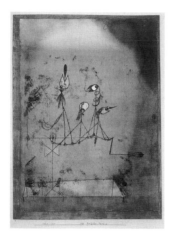

Paul Klee, *Die Zwitschermaschine* (*The Twittering Machine*), 1922. The watercolor was shown at the 1931 *German Painting and Sculpture* exhibition at the Museum of Modern Art, New York, and later purchased by the museum. The work, originally in the collection of the Berlin Nationalgalerie and confiscated by the National Socialists, was purchased through art dealer Curt Valentin

Installation view of *German Art of the Twentieth Century* at the Museum of Modern Art, New York, October 1–December 8, 1957. Photograph © 2001 The Museum of Modern Art, New York

German art was beginning to emerge in New York. *A Collection of Modern German Art,* organized by Wilhelm R. Valentiner at New York's Anderson Galleries in 1923 (and including work by Klee), appeared to have placed a question mark over the enduring monopoly of French art as uniquely representative of European modernism, and had for the first time provided Americans with an overview of contemporary art in Germany.[12]

It was also in 1924 that the artist, collector, and art dealer Galka Scheyer, a native of Braunschweig, set off for America, where she tried to draw attention to the work of Alexej Jawlensky, Klee, Kandinsky, and Lyonel Feininger, whom she grouped together as "The Blue Four."[13] After an unsuccessful start in New York, Scheyer moved in 1925 to the West Coast, and there committed herself, with an almost missionary zeal, to promoting the reputation of what she called her "blue kings," through exhibitions and lectures. It was principally as a result of Scheyer's efforts on his behalf that Klee saw his work enter the collection of Louise and Walter Arensberg. For Klee, the exhibition organized by Dreier clearly offered a timely chance for him to gain access to a new market. With the soaring inflation in Germany, the years 1923 and 1924 were extremely difficult for German artists hoping to sell their work on the home market, hence the clear advantage of establishing new, international business relationships.

In the later 1920s the increasing familiarity of Klee's work in America was due above all to three factors: the *Sesqui-Centennial International Exposition* held in Philadelphia in 1926 to mark the 150th anniversary of the Declaration of Independence (for this show, Dreier selected and organized the modern German section); the *International Exhibition of Modern Art* mounted in the same year at the Brooklyn Museum (also organized by Dreier); and the opening of Albert E. Gallatin's Gallery of Living Art in exhibition spaces provided by New York University, in which Klee would for many years be the only German artist represented. Klee's true recognition as part of the officially sanctioned world of art in America took place in 1930 with his one-man show at the Museum of Modern Art in New York. However, although the museum's director, Alfred H. Barr, Jr., had taken a great interest in Klee since his own visit to Weimar in 1927, this was not an exhibition initiated and conceived by the museum. It was, rather, an adaptation of the Berlin show that Alfred Flechtheim had mounted in his own gallery in the late fall of 1929 to mark Klee's fiftieth birthday, and which he had endeavored to tour abroad. Initially, J. B. Neumann had wanted to present the exhibition in his New York gallery, but he then succeeded in persuading Barr to show a reduced version at the Museum of Modern Art. The works made available by Flechtheim were supplemented by items loaned by private collectors in America, including Jere Abbott, Gallatin, Eduard Weyhe, and Philip Johnson. Barr presented the Klee exhibition as a parallel with three other one-man shows, devoted to Wilhelm Lehmbruck, Aristide Maillol, and Max Weber.[14]

After making his U.S. museum debut at such an eminent institution as the Museum of Modern Art, Klee was accorded much more attention than he had previously been given by the American press. However, while now taken seriously by American critics, his work provoked negative as well as positive commentary. It is evident that it caused reviewers a fair amount of difficulty in their attempts to place it among the categories of art then commonly employed in critical discourse—Abstraction, Objectivity, Cubism and so on—or, indeed, to grasp in what sense it could be understood as "painting," in the conventional meaning of that term.

In the following year, 1931, work by Klee was again to be seen at the Museum of Modern Art, when two watercolors from the collection of the Berlin Nationalgalerie, *Die Zwitschermaschine* (*The Twittering Machine;* 1922) and *Der Angler* (*The Angler;* 1921), were included in the exhibition *German Painting and Sculpture*. Ludwig Justi had been keen to lend the paintings for this event—both in a move to strengthen the international reputation of German art, and because he respected

Barr as a museum man who "bought not only modern French art—nowadays that can hardly be regarded as heroic—but even dared to exhibit Lehmbruck and Klee."[15]

It was on such promising beginnings for Klee's reception in America that the German art dealers Karl Nierendorf and Curt Valentin were able to build when they emigrated to New York (in 1936 and 1937 respectively). They effectively competed with each other, and with Neumann, in presenting Klee's work to the American public in a virtually continuous series of exhibitions, and in numerous publications. Nierendorf became Klee's principal dealer in America as the result of a not entirely advantageous contractual agreement drawn up with the artist.[16] Valentin, meanwhile, acquired a great many of the works by Klee that had been confiscated in Germany by the National Socialists, so that he could sell these in America. It was through Valentin that works such as *Um den Fisch (Around the Fish;* 1926) from the Gemäldegalerie in Dresden, or *Die Zwitschermaschine* from the Berlin Nationalgalerie entered the collection of the Museum of Modern Art.[17]

Moreover, these art dealers did not limit their activities to America. After World War II, and thus after the National Socialist regime, Klee's work—much

Cover of the exhibition catalogue *Paul Klee: An Exhibition in Honor of the Sixtieth Birthday of the Artist*, Nierendorf Gallery, New York, 1940

Cover of the exhibition catalogue *Paul Klee*, Buchholz Gallery, New York, 1938

more highly valued now, with his success in America—was "reimported" into Germany as that of an internationally significant German representative of modernism. At this point, moreover, it was to be promoted among, and in due course appreciated by, a much broader public. But that is another chapter in the story of Klee's reception, a phase during which the complexity of his work was to be reduced, in popular perception, to the more easily comprehended qualities of poetry and humor.

Christine Hopfengart
Translated from the German by Elizabeth Clegg.

[1] "Fast unerträglich ist der Gedanke in einer epigonischen Zeit leben zu müssen. In Italien war ich fast wehrlos diesem Gedanken ergeben," in: Paul Klee, "Tagebuchblätter" (for the Zahn monograph), Verlag Kiepenheuer, in: Paul Klee, *Tagebücher 1898–1918*, with the assistance of Wolfgang Kersten, Stuttgart: Hatje Cantz 1988, p. 521.
[2] On the history of the reception of Klee's work, see Christine Hopfengart, *Klee. Vom Sonderfall zum Publikumsliebling*, Mainz: Verlag Philipp von Zabern, 1989.
[3] On Klee's "breakthrough" during World War I, see Otto Karl Werckmeister, "Klee im Ersten Weltkrieg," in Christine Hopfengart, *Versuche über Paul Klee*, Frankfurt am Main: Syndikat, 1981, p. 9ff.
[4] Paul Klee, *Tagebücher* (as note 1), Diary no. 914.
[5] Cf. Christian Rümelin, "Klee und der Kunsthandel," in: *Paul Klee. Kunst und Karriere. Beiträge des Internationalen Symposiums in Bern*, ed. by Oskar Bätschmann and Josef Helfenstein, Bern: Stämpfli, 2000, pp. 28–29.
[6] Cited in Hopfengart, *Klee* (as note 2), pp. 46–47.
[7] See Hopfengart, "Klee an den deutschen 'Museen der Gegenwart' 1916–1933," in: *Paul Klee*. ed. by Bätschmann and Heltenstein (as note 5), p. 74ff.
[8] Will Grohmann, "Paul Klee 1923/24," in: *Der Cicerone*, vol. 16, no. 17 (1924), p. 787.
[9] Stefan Frey and Wolfgang Kersten, "Paul Klees geschäftliche Verbindung zur Galerie Alfred Flechtheim," in: *Alfred Flechtheim—Sammler, Kunsthändler, Verleger, 1937: Europa vor dem 2. Weltkrieg*, exhibition cat., Kunstmuseum Düsseldorf and Munster, Westfälisches Landesmuseum für Kunst und Kulturgeschichte, 1987–88, p. 75. Stefan Frey, "Hanni Bürgi-Bigler: Sammlerin und Mäzenin Paul Klees. Zur Geschichte ihrer Sammlung," in: *Paul Klee. Die Sammlung Bürgi*, ed. by Frey and Josef Helfenstein, Kunstmuseum Bern; Hamburger Kunsthalle; and Edinburgh, Scottish National Gallery of Modern Art, 2000, pp. 19–20.
[10] Einstein's book had appeared in first and second editions in, respectively, 1926 and 1928, but was fundamentally reworked by its author for the third edition, published in Berlin in 1931. Klee's assessment of the work thereafter altered considerably.
[11] On the American reception of Klee's work, see Carolyn Lanchner, "Klee in America," in: *Paul Klee*, ed. by Lanchner, exhibition cat., New York, Museum of Modern Art; Cleveland Museum of Art; and Bern, Kunstmuseum, 1987, p. 83ff. On Klee at the Société Anonyme, see Robert L. Herbert, Eleanor S. Apter, and Elise K. Kenney, eds., *The Société Anonyme and the Dreier Bequest at Yale University: A Catalogue Raisonné*, New Haven and London: Yale University Press, 1984, p. 375ff.
[12] Lanchner, "Klee in Amerika" (as note 11), p. 86. On the exhibition at the Anderson Galleries, see also Eberhard Roters, *Galerie Ferdinand Möller. Die Geschichte einer Galerie für Moderne Kunst in Deutschland, 1917–1956*, (West) Berlin: Gebr. Mann, 1984, pp. 56–58.
[13] See *Die Blaue Vier. Feininger, Jawlensky, Kandinsky, Klee in der Neuen Welt*, ed. by Vivian Endicott Barnett and Josef Helfenstein, exhibition cat., Kunstmuseum Bern; Düsseldorf Kunstsammlung Nordrhein-Westfalen, 1997–98, Cologne: DuMont, 1997.
[14] On the Klee exhibition, see also Penny Joy Bealle, *Obstacles and Advocates: Factors Influencing the Introduction of Modern Art from Germany to New York City, 1912–33: Major Promoters and Exhibitions*, Ph.D. dissertation, Ann Arbor, Mich.: UMI, 1990, pp. 298–302.
[15] Justi, letter to Barr, April 26, 1930, in the Zentralarchiv der Staatlichen Museen zu Berlin, Preussischer Kulturbesitz, I/NG, Gen. 19, Bd. 15, Beiheft 4.
[16] On this point, see Anja Walter, *Die Geschichte der Galerie Nierendorf 1920–1995*, Ph.D. dissertation, Berlin: Freie Universität, 1999, p. 220ff.
[17] On *Die Zwitschermaschine*, see Andreas Hüneke, "On the Trail of Missing Masterpieces. Modern Art from German Galleries," in: *"Degenerate Art": The Fate of the Avant-Garde in Nazi Germany*, ed. by Stephanie Barron, exhibition cat., Los Angeles County Museum of Art; Art Institute of Chicago; and Berlin, Deutsches Historisches Museum, 1991–92, pp. 130 and 133.

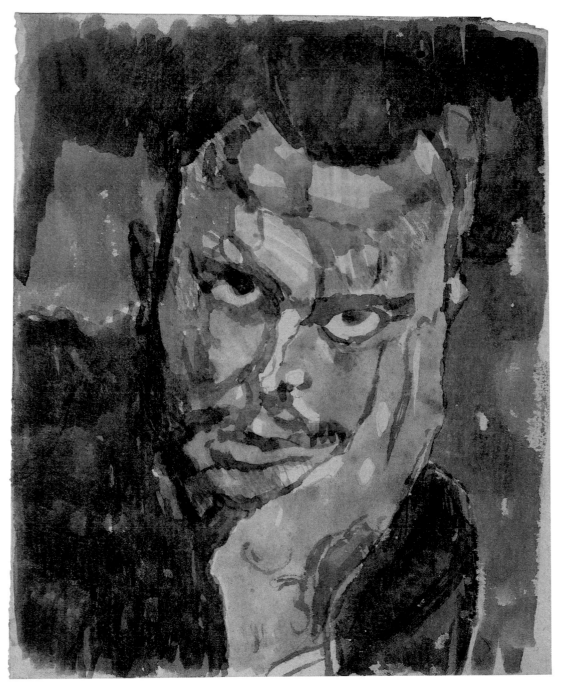

Self-Portrait Full Face, Resting Head in Hand, 1909, 32 cat. II.57

Mystical Ceramic (In the Manner of a Still Life), 1925, 118 (B8) cat. II.60

On the Lawn, 1923, 93 cat. II.59

Yellow House, 1915 cat. II.58

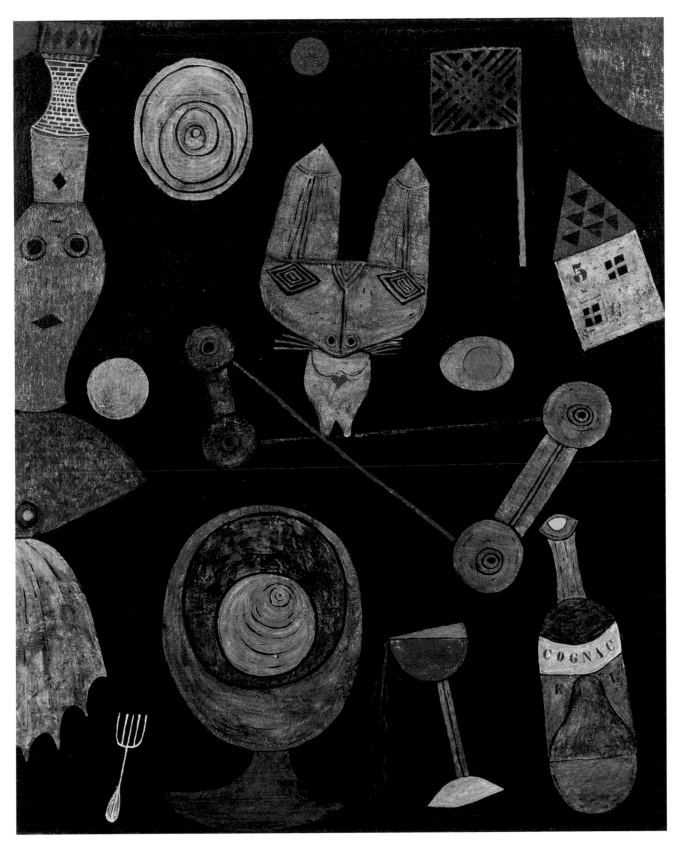

Gay Repast / Colorful Meal, 1928, 29 (L 9) cat. II.61

OSKAR SCHLEMMER

* SEPTEMBER 4, 1888, STUTTGART
† APRIL 13, 1943, BADEN-BADEN

Over the fifty-five years of Oskar Schlemmer's life, his native Germany underwent a number of radical transformations, politically, socially, and culturally. In the year of his birth, 1888, Emperor Wilhelm II came to the throne. Thirty years later, at the end of 1918, Schlemmer found himself in Berlin, when the emperor abdicated. And after a further fifteen years, in March 1933, the artist was again in the capital city at another turning point in German history: the collapse of the Weimar Republic with the seizure of power by the National Socialists under the leadership of Adolf Hitler.

Schlemmer attended school, first at the city's Kunstgewerbeschule (School of Applied Arts), and then, from 1906, at the Akademie der bildenden Künste (Academy of Fine Arts). In 1910, Schlemmer traveled to Berlin for some weeks, and in the following year returned for a longer stay. There he established contact with Herwarth Walden and some of the artists associated with his journal *Der Sturm*, and the gallery of the same name. Upon Schlemmer's return in 1912 to the Stuttgart Akademie as a senior student, he was inspired by the tenets of his professor Adolf Hölzel, a pioneer of abstract art. Through his interest in the work of Cézanne, Braque, and Derain, whose paintings he had seen in Berlin, Schlemmer was inspired, by 1912–13, to paint landscapes, portraits, and self-portraits in a style reminiscent of early Cubism.

Even at this early date, Schlemmer's artistic stance was not aligned with the Expressionism that the Brücke artists were propagating. Later, he would write of his struggle toward "discipline, form, and plainness," and assert that "the magnificence of any idea depends on the clarity with which it is perceived."[1] Among the artists in Hölzel's circle, Schlemmer met several contemporaries who would remain his close friends: among them his fellow student Willi Baumeister, and the Swiss artists Otto Meyer-Amden and Johannes Itten (who, like Schlemmer, would later teach at the Bauhaus in Weimar).

During World War I, Schlemmer served in the German army on both the Western and Eastern fronts, and was eventually wounded in action. In 1915–16, during a period of home leave, he returned to painting, and produced his first abstract compositions. After the war, and the months of the November Revolution in Berlin in 1918, Schlemmer was elected to serve as one of two student representatives on the academic council of the Stuttgart Akademie. In this role, he fought in vain to have Paul Klee appointed as Hölzel's successor in the post of professor. In connection with this student initiative—which was turned down by the senate committee—Schlemmer wrote an article titled "Paul Klee und die Stuttgarter Akademie," which was published in 1920 in Paul Westheim's journal *Das Kunstblatt*.[2]

Around this time, Schlemmer produced his series of "figural planes" and sculpted reliefs: in these he developed a unique style of anthropomorphic Constructivism—with the human figure reduced to a conical silhouette, or a modular "automaton." The years 1920–21 brought Schlemmer both personal and professional happiness: he married Helena Tutein ("Tut"), and had his first shows (along with Baumeister) in Stuttgart, Berlin, and Dresden. Paul

Ferdinand Schmidt, director of the Städtisches Museum in Dresden, published in the *Jahrbuch der jungen Kunst* the first article to be devoted entirely to the artist's œuvre.

Early in 1921, Schlemmer moved to Weimar, upon Walter Gropius's invitation to him to teach at the Bauhaus. Here, Schlemmer took over several workshops (for stone carving, mural painting, and metalwork), and later taught classes in life drawing from the nude. In Weimar, he associated with fellow teachers Klee, Itten, Lyonel Feininger, and Vasily Kandinsky. At the Bauhaus, Schlemmer emerged as a talented and radically innovative stage designer and choreographer. In September 1922, the complete version of his *Triadische Ballett (Triadic Ballet)* was performed at the Landestheater in Stuttgart; it was presented again the following year in Weimar. According to Schlemmer, this symphonically constructed dance—based on the number three, or the Greek *trias*—was "the first consistent demonstration of sculptural costume,"[3] a form of choreographic Constructivism far removed from traditional ballet.

The Bauhaus exhibition of 1923 left no doubt as to the range of Schlemmer's talents: he was featured as a painter, sculptor, mural designer, and choreographer. It was also Schlemmer who authored the text that advertised the exhibition, as well as an essay on the Bauhaus mural (the latter appeared in *Das Kunstblatt* in 1923).[4]

In 1925, just before the Bauhaus was forced to move from Weimar to Dessau, Schlemmer produced what would be some of his most celebrated paintings of the 1920s, such as *Römisches, Figuren Im Raum (Roman, Figures in a Room)* and *Konzentrische Gruppe (Concentric Group)*. In these works, he made visual links between the structure of the human body and architectonic elements. In a sharp turn from the planimetric compositions of his early, Stuttgart period, Schlemmer now began to outline metaphysical spatial perspectives that reveal an affinity with Italian Pittura Metafisica.

The move to Dessau offered an expanded scope for Schlemmer, now director of the Bauhaus stage workshop. He designed an experimental stage, which was constructed in the school's new building. With the collaboration of his students, Schlemmer conceived the *Bauhaus-Tänze (Bauhaus Dances)*. These pieces usually comprised the simplest props and only three dancers, dressed in one-piece primary-colored costumes that were padded

so as to render variously simplified shapes. Schlemmer was also the guiding spirit of the Bauhaus's numerous costumed festivities. After Hannes Meyer succeeded Walter Gropius as director of the school in 1928, Schlemmer was asked to teach an ambitious course on *Der Mensch* (Man), which was intended to impart a comprehensive knowledge of biology and anatomy; a survey of social theory, psychology, and philosophy; and some study of the theory of proportion and the nude.

In addition to his work at the Bauhaus, Schlemmer was active as a professional theater designer. He designed sets and costumes for ballets and operas (as he had earlier for two pieces by Paul Hindemith, performed 1921 in Stuttgart), as well as for plays presented at the Volksbühne in Berlin and at the Nationaltheater in Weimar. Later, he created the sets for productions at the Stadttheater in Breslau (now Wroclaw, Poland)—including a piece by Stravinsky performed in 1929–30, and for Arnold Schönberg's *Die glückliche Hand (The Lucky Hand)*, performed in 1931 at the Kroll-Oper in Berlin.

Schlemmer's name thus became increasingly linked with theater, through his many production designs, and through his 1925 book *Die Bühne im Bauhaus* (later published in English as *The Theater of the Bauhaus*). Schlemmer's work was first exhibited in America (in early 1926) at the *International Theater Exhibition* mounted at the Steinway Building in New York, where he was represented with six set designs. From 1930 on, he contributed to numerous exhibitions of theater design, both in Germany and abroad, in most cases as a representative of the Bauhaus.

Oskar Schlemmer during his time at the Bauhaus, 1925 (photograph by Hugo Erfurth)

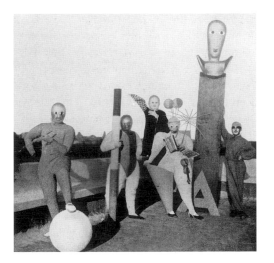

Members of the Bauhaus drama workshop wearing masks and costumes (for Schlemmer's pantomime *Treppenwitz*), on the roof of the studio in Dessau (photograph by T. Lux Feininger, 1926 or 1927)

In June 1929, Schlemmer accepted an offer of a professorship at the Schlesische Akademie für Kunst und Kunstgewerbe (Silesian Academy for Fine and Applied Arts) in Breslau. Here, he continued teaching in the style he had evolved at the Bauhaus—including courses in theater design—and even introduced his own class titled *Mensch und Raum* (Man and Space).

In the same period, Schlemmer received an important commission from Ernst Gosebruch, director of

Oskar Schlemmer, *Bauhaustreppe* (*Bauhaus Staircase*), 1932, in the *Magazine of Art* (October 1945)

the Museum Folkwang in Essen: a series of murals for the museum's circular hall gallery, designed by Henry van de Velde. The centerpiece of the gallery, *the Knabenbrunnen (Fountain with Five Kneeling Youths)*, was a sculpture by George Minne: a fountain with a circle of five naked kneeling youths depicted along the border of its basin. For the surrounding circular walls, Schlemmer conceived a cycle of nine paintings, showing figure groups and monumental single nudes in gymnastic positions. In 1930–31, Schlemmer created a large relief mural in the villa of the Leipzig physician Erich Rabe. This work was among the most innovative achievements of his career, using various metal elements and wire to form a transparent but shadow-throwing form, mounted at some distance from the wall.

At this point, Schlemmer was one of the most sought-after artists in the Weimar Republic, and was represented in virtually every important exhibition of contemporary art, both in Germany and abroad. Between 1929 and 1933, he participated in a total of forty-four shows, of which eight were one-man exhibitions. These included the first show in America to feature Schlemmer's work as a painter: *German Painting and Sculpture,* at the Museum of Modern Art, which was presented in March–April 1931.

The economic and political situation in Germany was already grave by the early 1930s. Schlemmer accepted a post at the Vereinigte Staatsschulen für Kunst und Kunstgewerbe (United State Schools for the Fine and Applied Arts) in Berlin, where he moved with his wife and three children in October of that year. In November he gave his inaugural lecture, titled "Perspektiven" (Perspectives). In early 1933, there were increasing attacks from students who sided with the National Socialists, accusing several professors (including Schlemmer) of being "destructive, Marxist-Judaic elements."[5] After Hitler had seized power and appointed Joseph Goebbels his minister for public education and propaganda, Schlemmer's fate as a teacher was sealed. On May 17, 1933 he was dismissed without notice from the Berlin post in which he had served for only one semester.

The year 1933 brought Schlemmer further reversals of fortune. In January came the death of his best friend, the Swiss painter Otto Meyer-Amden. On March 1, a large Schlemmer retrospective opened in his hometown, but only twelve days later the show was closed—"to ensure the protection of the works"—because of threats made in the National Socialist press. Around the same time, two Schlemmer paintings in the Stuttgart museum collection were removed from public display and placed in storage.

A witness to these events was Alfred H. Barr, Jr., who visited Stuttgart at this time and wished to see the exhibition of Schlemmer's work. Barr was outraged at these moves against the painter, whom he counted among the twenty best artists then at work in Germany. In 1945, Barr recounted these events in a comprehensive article titled "Art in the Third Reich," published in the *Magazine of Art.*[6] While in Stuttgart, Barr managed to visit the Schlemmer exhibition at the local Kunstverein (Art Union)—though it had already been closed to the public—and to see there his *Bauhaustreppe (Bauhaus Staircase),* painted the previous fall. Barr immediately grasped its artistic and programmatic significance, and sent a telegram to Philip Johnson (who had been responsible for establishing the architecture department of the Museum of Modern Art), asking him to make funds available for the acquisition and eventual donation of the painting to the museum. This was the artist's first work to enter a museum outside of Germany, and his last sale to a museum during his lifetime. While he

agreed to a price that was considerably below what would have been its market value, Schlemmer was nonetheless delighted that the picture he regarded as "perhaps his best" was to be assured of a home in a prestigious museum.[7]

In June 1933, Schlemmer was informed that his recently completed cycle of nine murals in the Museum Folkwang in Essen would be removed from public display. Shortly before this, the artist had refused the museum director's suggestion that he remove the works "voluntarily." Gosebruch was subsequently dismissed from his post, to be replaced by a confirmed National Socialist, Klaus Graf Baudissin. With this, both Schlemmer and his Essen patron, one of the most prominent art historians in Germany, were effectively excluded from the nation's art life.

Schlemmer and his family were now without an income; the artist was therefore pleased when Paul Meyer, the brother of Otto Meyer-Amden, asked him to oversee his deceased friend's estate and to prepare a memorial exhibition in his honor. The show was presented in 1933–34 in Zürich, Basel, and Bern. At the same time, Schlemmer produced the first monograph on Meyer-Amden, a volume written with great feeling and based on the extensive correspondence between the two friends. This book was published in 1934 in a collectors' edition of 250 copies, incorporating facsimile reproductions.

In 1935, Schlemmer rented a farmhouse in a village in southern Baden, near Lake Constance. He embarked on a new life as a farmer, but soon found that he was unable to support himself and his family. He returned to painting, focusing mostly on innocuous subjects—landscapes or portraits of his children or friends—but also producing a number of freer compositions (these he made in pastels or oils on oil paper, so that the work could easily be hidden away from unwelcome visitors). He was preoccupied for some time with the possibility, raised by Hans Curjel, of staging his *Triadische Ballett* in a new production using only nine costumes, at the Corso-Theater in Zürich; this project was eventually abandoned because of insufficient funds.

In 1936, the year of the Olympic Games in Berlin, the cultural policy of the National Socialist regime became for a short time more liberal; a number of German gallery owners—among them Ferdinand Möller in Berlin and F. C. Valentien in Stuttgart—dared to exhibit new works by Schlemmer. Among these was a series of figurative pastels, and even a group of *Abstraktionen (Abstractions)* painted in oils on oil paper. In the same year, Berlin landscape architect Hermann Mattern commissioned Schlemmer to create a mural in the house that architect Hans Scharoun had built for him near Potsdam.

In July 1937, the London Gallery presented the first one-man exhibition of Schlemmer's work in England. This event was, however, to have tragic repercussions: after the exhibition closed, Schlemmer decided to leave his work in London out of fear that it might otherwise be seized by the National Socialists. Ironically, after war was declared between Germany and Great Britain, these pieces were confiscated on the grounds that they were enemy property. (Although Schlemmer's widow was partially successful after the war in her struggle to have these works returned, some of the large watercolors produced in Breslau have never been recovered.)

When Schlemmer was given notice to leave the farmhouse, the couple were able to build a house of their own with funds recently inherited by his wife. They found an affordable plot of land at Badenweiler, not far from the Swiss border, and one of Schlemmer's former students at the Bauhaus, Hans Fischli, designed a simple house for them. It was ready for habitation by the fall of 1937. Shortly thereafter, Schlemmer learned that five of his paintings were to be included in the traveling exhibition *Entartete Kunst*, which opened in Munich; and that moreover many of his works had been confiscated from German museums. With this news, Schlemmer's last hope of regaining recognition as an artist in Germany evaporated. He wrote in his diary: "What a summer! Devoted to building a house! … A fine, big studio—now useless and pointless."[8]

Through the help of his friend Baumeister, Schlemmer took a job at Albrecht Kämmerer's housepainting firm in Stuttgart. For Kämmerer, he painted countless facades and murals; he earned a good wage, but working on scaffolding, at the mercy of the elements, was a perpetual physical strain—and the artistic compromises to which he had to submit under the National Socialists were a psychological torment. He began to consider emigrating—and eventually received a few opportunities to do so: he was invited to teach at the Art Center of the University of Louisville, Kentucky (through the mediation of Justus Bier), and was

also contacted by Josef Albers, who offered to help find him a post in the United States.[9] In the end, Schlemmer rejected these possibilities because of the low pay and his concern for the welfare of his family.

In 1938, the English art critic Herbert Read organized the exhibition *Twentieth-Century German Art* at the Burlington Galleries in London, as a deliberate counter to the defamatory *Entartete Kunst* show, which was at the start of its long German and Austrian tour. Works loaned to the London exhibition were obtained from collections outside Germany in order not to endanger the represented artists. Schlemmer was represented at this show with three paintings, among them *Zwei Freunde (Two Friends;* 1936).

At the end of that year, paintings and sculptures by Schlemmer, and figurines for his *Triadische Ballett,* were included in the exhibition *Bauhaus 1919–1928,* organized by Walter and Ise Gropius and Herbert Bayer for New York's Museum of Modern Art. At the same time, a selection of set designs by Schlemmer was presented at New York's East River Gallery. These shows offered the American public a compelling sampling of Schlemmer's work. American commentators were particularly appreciative of the designs for the *Triadische Ballett,* which one critic described as a "pantomime of rotating fantastic automata in a mechanized drama."[10]

The monotony of Schlemmer's house-painting work was occasionally broken by commissions (obtained through friends) for murals of a more intellectually stimulating kind in and around Stuttgart. But the irregularity and insecurity of his life was wearing, both psychologically and physically. Relief of a sort came in 1940, when the owner of a Wuppertal paint factory, Kurt Herberts, invited Schlemmer to help set up a laboratory for experiments relating to the technical properties of varieties of varnish, lacquer, and enamel paint. Here, Schlemmer devised a technique for painting cupboards and decorative chests, and created a series of forty abstract experimental panels on the theme of "Modulation and Patina."[11]

In 1941, Schlemmer choreographed the *Lackballett (Lacquer Ballet),* to commemorate the seventy-fifth anniversary of the Wuppertal firm's founding. Performed by dancers (employees of the firm) wearing brightly painted segmented forms in an entirely black stage set, this short ballet received a very warm public response.

The following year, Schlemmer began a series of small *Fensterbilder (Window Pictures):* these recorded curiously touching views into the lit windows of the houses opposite his own, where the inhabitants, moving randomly in and out of the "frame," could be observed eating or talking or engaged in other activities, such as sewing or playing the piano. Schlemmer also produced a number of painted plaster reliefs, which he termed his *Hausgötter (Home Gods).* His works of this period took a new approach to artistic creation—an intimate and meditative one—incorporating accidental effects, with the result, as Schlemmer himself noted, that each of the objects produced looked "as if it came 'from somewhere' and not from the hand of man."[12]

In the autumn of 1942, Schlemmer once again traveled to Stuttgart, where Kämmerer had commissioned him to devise painted camouflage for structures such as gasworks and factories. Shortly after completing this work, the artist became very ill with diabetes and jaundice, and was hospitalized. He was released after three weeks and returned to Wuppertal in order to complete his contribution to a book on painting techniques that Herberts planned to publish. Schlemmer spent the Christmas and New Year holidays of 1942–43 with his family in Badenweiler; but in early January he again fell ill. He died on April 13, while taking a cure at Baden-Baden.

Installation view of *Bauhaus 1919–1928* at the Museum of Modern Art, New York, December 7, 1938–January 30, 1939. Photograph © 2001 The Museum of Modern Art, New York

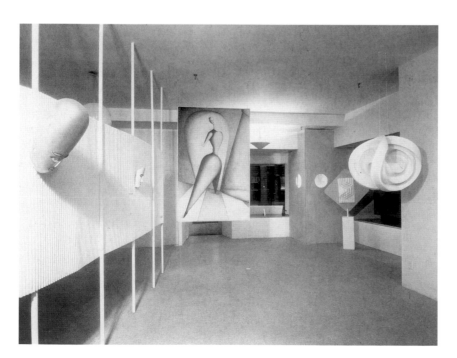

After 1945, many exhibitions of Schlemmer's work were held in Germany and Switzerland, but it was not until 1969, twenty-six years after the artist's death, that his first one-man show in America was presented, at the gallery of Spencer A. Samuels in New York. A further seventeen years would pass before the Baltimore Museum of Art organized the first comprehensive exhibition of Schlemmer's work, a gathering of more than 200 items (paintings, sculptures, drawings, and designs for sets and costumes). This show opened in 1986 and subsequently toured, until spring 1987, to New York (IBM Gallery of Science and Art), San Francisco (Museum of Modern Art), San Diego (Museum of Art), and Amsterdam (Stedelijk Museum). It was accompanied by a generously illustrated catalogue containing numerous scholarly essays.[13] This show attracted considerable media attention; but, as in the case of earlier Schlemmer exhibitions, his work for the stage (a particular focus of this presentation) received greater acclaim than his œuvre as a painter and sculptor.

Though Schlemmer's name was thus rather late in gaining currency with American audiences, his work is now seen in the U.S. as emblematic of his era, in particular of the Bauhaus aesthetic. As his varied artistic activities—painting, drawing, sculpture, murals, stage design, and choreography—are increasingly recognized, and his contribution as a teacher in Weimar, Breslau, and Berlin is acknowledged, Schlemmer's position in the history of art continues to gain in complexity and significance.

Karin von Maur
Translated from the German by Elizabeth Clegg.

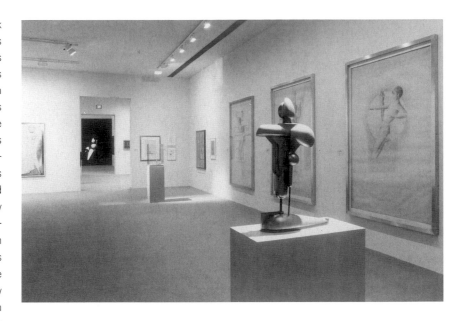

Installation view of *Oskar Schlemmer* at the Baltimore Museum of Art, February 9–April 6, 1986. Photograph © The Baltimore Museum of Art

[1] Oskar Schlemmer, diary entries for March 1916 and September 2, 1915, in: *Oskar Schlemmer: Briefe und Tagebücher,* ed. by Tut Schlemmer, Munich: Albert Langen, Georg Müller, 1958; published in English as *Oskar Schlemmer: Letters and Diaries,* transl. by Krishna Winston, Middletown, Conn.: Wesleyan University Press, 1972, pp. 45, 40 (German), 34, 29 (English). Translation cited here with slight adaptations.
[2] Schlemmer, "Paul Klee und die Stuttgarter Akademie," in: *Das Kunstblatt,* vol. 4, no. 4 (April 1920), pp. 123–124.
[3] Schlemmer, "Bühnenelemente" (1931), reprinted in: *Oskar Schlemmer und die abstrakte Bühne,* ed. by Willy Rotzler; exhibition cat., Zürich, Kunstgewerbemuseum; and Munich, Neue Sammluung, Bayerisches Nationalmuseum, 1961–62.

[4] Schlemmer, *Das Staatliche Bauhaus,* Stuttgart: Gustav Christmann, 1922; see p. 2 of the announcement for the *Erste Bauhaus-Ausstellung in Weimar 1923* (this page was not published, as it contained the politically inopportune notion of the "Kathedrale des Sozialismus"). See also Schlemmer, "Gestaltungsprinzipien bei der malerisch-plastischen Ausgestaltung des Werkstattgebäudebau des Staatl. Bauhauses," in: *Das Kunstblatt,* vol. 7, nos. 11–12 (November–December 1923), pp. 340–343.
[5] Schlemmer, letter to Willi Baumeister, April 2, 1933, in: *Oskar Schlemmer: Briefe / Letters* (as note 1), p. 308 (German), 309 (English).
[6] Alfred H. Barr, "Art in the Third Reich," in: *Magazine of Art,* vol. 38, no. 6 (October 1945), pp. 211–222; on Schlemmer see p. 214.

[7] Schlemmer, letter to Philip Johnson, April 4, 1933, cited in: Karin von Maur, *Oskar Schlemmer, Monographie und Œuvrekatalog,* vol. 2, Munich: Prestel, 1979, p. 106.
[8] Schlemmer, diary entry of November 27, 1937, in: *Oskar Schlemmer: Briefe / Letters* (as note 1), p. 365 (German), 367 (English). Translation cited here with adaptations.
[9] Justus Bier, letters to Schlemmer, May 14 and June 21, 1938 (unpublished). We know of Albers's activities only through a letter from Schlemmer to Carl Nierendorf, March 4, 1937 (unpublished), Oskar Schlemmer Archives, Staatsgalerie Stuttgart.
[10] Martha Davidson, "Epitaph Exhibition of the Bauhaus," in: *Art News,* vol. 37, no. 11 (December 1938), p. 14.

[11] See the posthumous publication (expanding on the original project) Kurt Herberts, ed., *Modulation und Patina: Ein Dokument aus dem Wuppertaler Arbeitskreis um Willi Baumeister, Oskar Schlemmer, Franz Krause, 1937–1944,* Stuttgart: Hatje Cantz, 1989.
[12] Schlemmer, diary entry of July 8, 1941, in: *Oskar Schlemmer: Briefe / Letters* (as note 1), p. 386 (German), pp. 388–390 (English).
[13] *Oskar Schlemmer,* ed. by Arnold L. Lehmann and Brenda Richardson, with texts by Vernon L. Lidtke, Karin von Maur, Nancy J. Troy, Debra McCall, exhibition cat., Baltimore Museum of Art, 1986. The Walker Art Center in Minneapolis, which had planned to present the exhibition from November 1986 to January 1987, canceled the show for financial reasons.

Five Nudes, 1929 cat. II.62

Pointing Man, 1931 cat. II.63

Figures Climbing Stairs, 1932 cat. II.64

CHECKLIST: GERMANY AFTER 1900

Please see Bibliography for cited literature.

WILHELM LEHMBRUCK

II.1
Head of a Thinker (Kopf eines
Denkers) 1918
cast stone
62.90 × 57.80 × 34.30 cm
(24 3/4 × 22 3/4 × 13 1/2 in.)
Stamped lower edge: Lehmbruck
Ill. p. 153

Provenance:
Rudolf and Clara Kreutzer, Nuremberg
Michael Werner Gallery, New York and
Cologne
Private collection, New York

Literature:
Schubert, 1990, no. 100, cast stone
5/8.

LOVIS CORINTH

II.2
Eduard Krüger 1912
oil on canvas
50 × 40 cm (19 5/8 × 15 7/8 in.)
Signed and dated c. r.: Lovis
Corinth/1912
Inscribed u. l.: 1912/E. Krüger
Ill. p. 163

Provenance:
Eduard Krüger, Berlin
Private collection, New York
Galerie G. Paffrath, Düsseldorf
Phillips, New York
Private collection, New York

Literature:
Berend-Corinth, no. 536.

II.3
Self-Portrait (Selbstbildnis) 1921
pencil on gray paper
6.8 × 26.7 cm (14 1/2 × 10 1/2 in.)
Signed l. r.: Lovis Corinth
Dated l. c.: 26 Januar 1921
Ill. p. 162

Provenance:
Minne Klopfer-Corinth, New York
Private collection, New York

Literature:
Lovis Corinth, *Selbstbiographie,* Leipzig:
Herzel, 1926, p. 132 (ill.).

II.4
Fruit Bowls (Fruchtschalen) 1923
oil on canvas
70 × 90 cm (27 9/16 × 35 7/16 in.)

Signed and dated u. l.: Lovis
Corinth/1923
Ill. p. 161

Provenance:
Galerie Ernst Arnold, Dresden
Bayerische Staatsgemäldesammlung,
Munich
Galerie Fischer, Lucerne
Kofler, Lucerne
Private collection, Switzerland
Private collection, Dortmund
Galerie Arnoldi-Livie, Munich
Private collection, New York

Literature:
Berend-Corinth, no. 898.
*"Degenerate Art": The Fate of the
Avant-Garde in Nazi Germany,* exhibition cat., Los Angeles County Museum
of Art, 1991, p. 152.
Lovis Corinth, eine Dokumentation,
comp. by Thomas Corinth, Tübingen:
Wasmuth, 1979, p. 317.
Weltkunst, no. 12 (1988), p. 1739.

Corinth painted very few still lifes early
in his career, but his output in this
genre increased considerably after he
moved to Berlin in 1901 and subsequently opened an art school for
women. Initially, it was probably in his
role as teacher that he learned to appreciate the still life; in the teaching
manual he wrote in 1908, he advocated
still-life painting as a useful exercise in
learning to represent a variety of
shapes and textures, from delicate,
subtle flowers and soft, juicy fruit to
transparent glass vases, paper, and envelopes with postage stamps.[1] But as
the artist became increasingly well-
known, his interest in the genre assumed a rather different form. As a favorite of collectors, the commissioned
still life became very profitable for
Corinth. At the same time, it is clear
that the artist genuinely relished the
work, particularly as his brushwork became looser and less descriptive in the
postwar period. Still life, perhaps more
than any other genre except landscape,
allowed Corinth to unleash his passion
for painterly, sensuous surfaces. In the
last seven years of his life, the artist
produced more than seventy still lifes,
most of them flower paintings; he expended such effort on no other genre.
Corinth's late still lifes, like his late portraits, are usually painted close-up, with
details of the surrounding environment
largely suppressed. This painting is no
exception. Three bowls of fruit—careful-

ly chosen for their contrasting shapes,
textures, and colors—are massed together on a table covered by a white
cloth. With its diagonal thrust from left
front to right back, the arrangement recalls Cézanne's late still lifes, although
the French artist's coolly deliberated
style is nowhere in evidence here. On
the contrary, Corinth clearly painted this
work quickly and with relative abandon,
especially when applying the cascading
series of brushstrokes that delineate
the background of white cloth. More
suggestive than descriptive, they set an
emotional tone that is repeatedly struck
throughout the whole of Corinth's late
work. The subject suggests an interest
in the exotic that is apparent in a number of Corinth's still lifes.[2] When he
painted *Fruit Bowls* in 1923, at the
height of Germany's legendary hyperinflation, the apples and plums in the picture would have been readily available
at the market, but even in Berlin a kiwi
would have been rare in the extreme.
Maria Makela

[1] Lovis Corinth, *Das Erlernen der Malerei*
(1920), Hildesheim: Gerstenberg, 1979,
pp. 85–87.
[2] Horst Uhr, *Lovis Corinth,* Berkeley: University of California Press, 1990, p. 179. If, in fact,
the fuzzy brown fruit on the left side of the
porcelain bowl is a kiwi, as it appears to be,
this would be in keeping with Corinth's
predilection (as noted by Uhr) for the unusual
in his still lifes.

ERNST LUDWIG
KIRCHNER

II.5
Seated Female Nude (Sitzender
weiblicher Akt) 1907–08
colored crayon and charcoal on paper
90.2 × 69.2 cm (36 1/4 × 27 1/4 in.)
Estate stamp (L 157/b); numbered FS
Drc/Bg-58c and K419 (verso)
Ill. p. 171

Provenance:
Estate of Ernst Ludwig Kirchner, Davos
Private collection, Switzerland
Galerie Art Focus, Zürich
Neue Galerie New York

Literature:
Registered at the Kirchner Archive,
Wichtrach/Bern.

II.6
Tightrope Walk (Drahtseiltanz)

1908–10
oil on canvas
120 × 149 cm (49 1/4 × 58 3/4 in.)
Signed and dated on verso: E.L. Kirchner 08
Ill. p. 172

Provenance:
Estate of Ernst Ludwig Kirchner, Davos
Curt Valentin Gallery, New York
Fine Arts Associates, New York
Robert Blaffer, Houston
Joan Blaffer, Houston
Private collection, Switzerland
Galerie Art Focus, Zürich
Neue Galerie New York

Literature:
Gordon, no. 114.

When he included this painting in his
retrospective exhibition in Bern in
1933, Kirchner described it as "Two
women tightrope walkers in green tricot, the one with a Japanese umbrella,
on a stage on a rope. To the right on
the rose-colored background, the shadow of a stage flat." The description is
rather dry, without any indication of the
emotive and spatial tension in the work.
The acrobats' stage-lit bodies are colored in such a way that their tenuous
balance on the rope extends across the
entire composition. The excited character of the composition is further intensified by the agitated, zigzagging strokes
of blue-black and gold that disrupt the
background, and by the red-blue echo
of the parasol (left), and a portion of the
stage decor at the painting's lower
center.
Without regard for such subjective
qualities, Kirchner's description—which
seems to function merely to provide
identification—focused only on the motif
of the two tightrope walkers. This was a
theme he treated repeatedly, especially
during the years 1908–14, in paintings,
sketches, and prints; in this period, he
frequented music halls and circuses
that featured *Seiltänzer* and other acrobats. It was a subject matter, however,
that many German artists (and writers)
turned to in this period, responding to
an apparent public demand. If such
marketing concerns were part of Kirchner's motivations in painting such
scenes, the images also resonate with
echoes of Friedrich Nietzsche's *Thus
Spake Zarathustra.* The opening scenes
of Nietzsche's text relate the prophet's
descent from his mountain to a crowd
collected to watch a tightrope walker

perform. When the performer loses his footing after being harassed by the crowd, and falls at Zarathustra's feet, the prophet addresses him: "You made danger your occupation, and in that there is nothing to decry. Now your occupation destroys you: and for that I will bury you with my own hands." For Kirchner and other artists of the German Expressionist avant-garde, the tightrope walker became a paradigm of their own defiance of tradition, established aesthetic, and social mores. These modern artists "walked a rope" over a chasm, defying the very real danger of failure, while public opinion mocked and denigrated them. In their very act, however, they were engendering the new art that would offer a bridge to the future—just as Nietzsche's Zarathustra had proclaimed. This painting, while remaining fundamentally a genre scene depicting popular entertainment, thus becomes an unstable amalgam of personal predilection, public taste, contemporary artistic practice, and philosophical rumination—all activated through Kirchner's Expressionist vocabulary.

The dating of the painting has varied between 1907 and 1910. Kirchner provided a date of 1908 on the verso of the canvas, but his propensity for dating his works early makes this year suspect—as does his apparent reworking (to what degree is not clear) of sections of the painting after 1919 in Davos. Further clouding the issue, the artist dated the painting 1907 in the photographic documentation of his work (a kind of preliminary oeuvre catalogue), and in 1916 he exhibited it at his first one-man show in Frankfurt with the date of 1910. Stylistically, *Tightrope Walk* reveals the intense influence of French Fauvist painting on Kirchner's work late in 1908, but does not evince the impact of primitive art, which shaped his work before early 1910. The theme likewise parallels other paintings of this late 1908–early 1910 period.
Reinhold Heller

II.7
The Russian Dancer Mela
(Die Russische Tänzerin Mela) 1911
oil on canvas
100 × 79.4 cm (39 3/8 × 29 1/2 in.)
Signed l. l.: Kirchner
Ill. p. 173

Provenance:
Estate of Ernst Ludwig Kirchner, Davos
Max Zurier, Beverly Hills, California
Parke-Bernet Galleries, New York
Private collection, New York

Literature:
Gordon, no. 222.

II.8
Gentleman with Lapdog at the Café (Herr mit Schosshündchen) 1911
colored woodcut
18 × 23.5 cm (7 1/8 × 9 1/4 in.)
Signed u. r.: Kirchner
Ill. p. 174

Provenance:
Estate of Ernst Ludwig Kirchner, Davos
Stefan Lennert, Munich
Serge Sabarsky Collection

Literature:
Dube-Heynig and Dube, H 171.

II.9
Female Nude at the Stove
(Mädchenakt am Ofen) 1914
watercolor and black crayon
37.9 × 45.1 cm (14 7/8 × 17 3/4 in.)
Signed and dated l. r.: E L Kirchner 12
Estate stamp; numbered on verso "A Be / Bg 1."
Ill. p. 175

Provenance:
Estate of Ernst Ludwig Kirchner, Davos
Walter Bareiss, Connecticut
Villa Grisebach, Berlin
Private collection, New York

Literature:
Registered at the Kirchner Archive, Wichtrach/Bern.

ERICH HECKEL

II.10
Bathers in a Pond
(Badende im Teich) 1908
oil on canvas
75 × 95 cm (29 1/2 × 37 3/8 in.)
Initialed and dated l. r.: EH 08
Signed, titled, and dated on stretcher:
Heckel: Badende im Teiche, 1908
Ill. p. 181

Provenance:
Roman Norbert Ketterer, Campione
Leonard Hutton Galleries, New York
Private collection, New York

Literature:
Serge Sabarsky, *Die Malerei des deutschen Expressionismus,* Stuttgart: Jentsch, 1987, pp. 248ff.
Vogt, no. 1908/4.

II.11
Seated Man (Sitzender Mann) 1909
oil on canvas
70.5 × 60 cm (27 3/4 × 23 5/8 in.)
Dated and monogrammed l. r.: 09 / EH; inscribed on verso: EHeckel 1909; inscribed on stretcher: Heckel Sitzender Mann
Ill. p. 182

Provenance:
G. David Thompson
Museum of Modern Art, New York
Serge Sabarsky Collection

Literature:
Serge Sabarsky, *Die Malerei des deutschen Expressionismus,* Stuttgart: Jentsch, 1987, pp. 248ff.
Vogt, no. 1909/3.

II.12
Seated Girl on Red Pillow (Sitzendes Mädchen auf rotem Kissen) 1910
black crayon, tempera, and watercolor on paper
34 × 43.5 cm (13 3/8 × 17 1/8 in.)
Signed and dated l. r.: Erich Heckel 10
Ill. p. 184

Provenance:
Felix Landau, Los Angeles
Private collection, New York

Literature:
Serge Sabarsky, *Die Malerei des deutschen Expressionismus,* Stuttgart: Jentsch, 1987, p. 91.
Sabarsky, *Erich Heckel: Die frühen Jahre,* Bietigheim-Bissingen: Die Galerie, 1995, p. 87 (ill.).

II.13
Girl with Doll (Fränzi)
(Mädchen mit Puppe [Fränzi]) 1910
oil on canvas
65 × 70 cm (25 5/8 × 27 1/2 in.)
Signed and dated l. r.: Erich Heckel 10
Ill. p. 183

Provenance:
Roman Norbert Ketterer
Serge Sabarsky Collection

Literature:
Serge Sabarsky, *Die Malerei des deutschen Expressionismus,* Stuttgart: Jentsch, 1987, pp. 254ff.
Sabarsky, *Erich Heckel: Die frühen Jahre,* Bietigheim-Bissingen: Die Galerie, 1995, p. 11 (ill.).
Vogt, no. 1910/16.

Heckel's portrait depicts a young girl, Fränzi, reclining nude on a studio couch, holding her doll. The composition is constructed in bold bands of black, red, green, blue, and gold. In the background Heckel features the lower half of a male portrait, in fact a detail from Ernst Ludwig Kirchner's portrait of Heckel, also painted in 1910. Kirchner's painting suggests that the setting for the scene is the Brücke artists' communal studio at Berliner Strasse 80, in the working-class district of Dresden-Friedrichstadt, where Kirchner moved in November 1909. Kirchner's new studio became the focus for the bohemian lifestyle of the young

Brücke group; it was the period of their closest collaboration, and they decorated the two small rooms with colorful wall-hangings and curtains depicting nude bathers from their summer trips to the Moritzburg lakes outside Dresden, and couples making love. It was an exotic space, inspired by illustrations of Buddhist cave temples at Ajanta, and by decorated wooden beams from the South Seas island of Palau, which they discovered in the Dresden Ethnographic museum. Numerous sketches, prints, and paintings by Heckel and Kirchner show the artists and their girlfriends, sometimes joined by black models they met at local cabaret and circus acts, moving freely around the studio, chatting, sketching, and making love.
Two young sisters, Fränzi and Marcella, who were daughters of a local artist's widow, joined the studio entourage in early 1910. Heckel's first mention of them is in a postcard decorated with a colored sketch of two young nudes holding bows and arrows. Immediately, the sisters began to play an important role in the primitivist iconography of Heckel's and Kirchner's studio scenes. In *Girl with Doll (Fränzi)*, the girl's angular body is outlined by spiky black contours derived from the Palau carvings. The composition is a self-conscious construction, which plays on the ambivalent naïveté and seductiveness of the girl, whose nudity is juxtaposed to the clothed doll on her knee. Heckel "signs" the painting with his legs from Kirchner's portrait, thereby introducing a lurking male presence, which intensifies the ambiguous sexuality of the scene. The Brücke artists' liberated attitude toward sexuality, their enthusiasm for child art, exotic art, and popular entertainment, were all aspects of their drive to challenge and renew bourgeois art and society. Heckel's *Girl with Doll (Fränzi)* is a superb example of the environmental portraiture he and Kirchner evolved in 1910, where style and subject were fused into a new expressive synthesis.
Jill Lloyd

II.14
Standing Child (Stehendes Kind) 1910
colored woodcut
37.5 × 27.8 cm (14 3/4 × 11 in.)
Signed and dated l. r.: EHeckel 11
Monogrammed in block l. r.: H
Ill. p. 185

Provenance:
Serge Sabarsky Collection

Literature:
Dube, H 204 B II (from the portfolio VI. *Jahresmappe der Künstlergruppe Brücke,* 1911).

KARL SCHMIDT-ROTTLUFF

II.15
Landscape with House and Trees
(Dangast Before the Storm)
(Landschaft mit Haus und Bäumen
[Dangast vor dem Gewitter]) 1910
oil on canvas
74.3 × 82.6 cm (29 1/4 × 32 1/2 in.)
Signed and dated l. r.: S. Rottluff 1910
Ill. p. 193

Provenance:
Eckart von Sydow
Leonard Hutton Galleries, New York
Private collection, New York

Literature:
Wietek, pp. 390, 588.

II.16
Houses in Dangast
(Häuser in Dangast) 1911
watercolor, gouache, and pencil on
paper
38.5 × 48.3 cm (15 1/8 × 19 in.)
Signed and dated l. r.: S. Rottluff 1911
Ill. p. 192

Provenance:
Roman Norbert Ketterer, Campione
Maria Möller-Garny, Cologne
Serge Sabarsky Collection

Literature:
Serge Sabarsky, *Zeichnungen und
Aquarelle des deutschen Expressionis-
mus,* Stuttgart: Cantz, 1990, color ills.
Wietek, pp. 486, 598.

II.17
Nude (Akt) 1914
oil on canvas
90.5 × 76 cm (35 5/8 × 29 7/8 in.)
Signed and dated u. r.: S. Rottluff 1914
Ill. p. 191

Provenance:
Alfred Hess, Erfurt
Peter Herkenrath, Cologne
Private collection, Germany
Villa Grisebach, Berlin
Private collection, New York

Literature:
Grohmann, p. 260 (ill.).
Moeller, 1997, p. 40.

MAX PECHSTEIN

II.18
Young Woman with Red Fan
(Mädchen mit rotem Fächer)
ca. 1910
oil on canvas
100 × 71 cm (39 3/8 × 27 5/16 in.)
Ill. p. 203

Provenance:
Roman Norbert Ketterer, Campione
Private collection, New York

Literature:
Moderne Kunst VI, exhibition cat., Cam-
pione, Roman Norbert Ketterer, 1969,
no. 97, p. 159.

Young Woman with Red Fan was paint-
ed at a particularly confident moment in
Pechstein's life. After responding posi-
tively to the Brücke artists' invitation to
join their group in 1906, Pechstein had
continued to pursue a successful and
relatively independent career. First he
traveled to Italy and Paris on the pro-
ceeds of an award from the Dresden
Kunstakademie. But instead of return-
ing to Dresden in 1908, he decided to
accept a commission in Berlin to deco-
rate one of the fashionable apartment
blocks that were springing up in the
west end of the city.
Pechstein's move to Berlin established
a base for the other Brücke artists in
the German capital. He reaffirmed his
solidarity with the group by joining their
nudist bathing trip to the Moritzburg
lakes near Dresden in the summer of
1910. Pechstein was also propelled
into the forefront of art politics in Berlin
that year when he became a founding
member of the Neue Secession, a
splinter group of progressive artists
whose works had been rejected by the
old Berliner Secession.
On a personal level, Pechstein had
found a new companion and model
who personified his ideal of female
beauty. Lotte (whom Pechstein married
in the spring of 1911) posed nude or
dressed in the fashions of the day for
many of Pechstein's works, and she
was almost certainly the model for
Young Woman with Red Fan. The
painting—like many classic Expression-
ist works—is a study in complementary
colors, based in this case on the domi-
nant red hue. The bright red of the
woman's fan is repeated in her dress
and hands. The color recurs in the pat-
terned textile behind her head, contrast-
ing with the complementary greens
Pechstein uses to define his shadows.
The other dominant color, yellow, is cor-
respondingly paired with the blues that
feature in the shadows and contours,
and in the blue-green hat that perches
on the model's head.
Pechstein's glowing colors are partly
derived from the stained-glass windows
he was then designing for various ar-
chitectural projects in Berlin. He was
also the Brücke artist most strongly in-
fluenced by the French Fauves. The
bright non-naturalistic colors and the
patterned textile in this painting recall
Matisse's portraits of his wife, or por-
traits of women by Kees van Dongen,

with whom Pechstein made contact
during his Parisian stay. Nevertheless,
the combination of singing colors with
the slightly melancholy, pensive tilt of
the model's head is highly individual and
distinct from precedents in French art.
Jill Lloyd

EMIL NOLDE

II.19
Sunset (Sonnenuntergang) 1909
oil on canvas
73 × 88 cm (28 1/4 × 34 5/8 in.)
Signed l. l.: Emil Nolde
Dated l. r.: 1909
Signed and titled on stretcher: Emil
Nolde "Sonnenuntergang"
Ill. p. 211

Provenance:
Carl Steinbart, Berlin
Bender Family, Berlin
Auktionshaus Lempertz, Cologne,
1966, sale no. 1966
Walter Franz, Cologne
Charles Tabachnick, Toronto
Christie's, London
Private collection, New York

Literature:
Urban, vol. 1, no. 285.

II.20
Strawberry-Blonde Girl
(Rotblondes Mädchen) 1919
oil on panel
46.4 × 49.6 cm (18 1/4 × 19 1/2 in.)
Signed u. r.: Emil / Nolde
Signed and titled on verso: Emil Nolde:
"Rotblondes Mädchen"
Ill. p. 210

Provenance:
Jakob Paulson, Niebuell
Private collection, Singen
Villa Grisebach, Berlin
Private collection, New York

Literature:
Urban, vol. 2, no. 864.

GABRIELE MÜNTER

II.21
Woman in Garden (Frau im Garten)
1912
oil on canvas
48.25 × 66 cm (19 × 26 in.)
Initialed l. l.: M / ü
Ill. p. 228

Provenance:
Leonard Hutton Galleries, New York
Private collection, New York

II.22
Kandinsky in Interior (Kandinsky im

Innenraum) ca. 1912
oil on canvas on panel
84.5 × 43.2 cm (33 1/4 × 17 in.)
Signed l. l.: Münter
Ill. p. 229

Provenance:
Hirschl and Adler Galleries, New York
Serge Sabarsky Gallery, New York
Private collection, New York

In early April 1912, Münter worked as-
siduously on an ambitious composition
set in the living room of the home she
shared with Vasily Kandinsky. She and
Kandinsky were visited by another cou-
ple, apparently the Munich art dealer
Hans Goltz with his wife, and Münter
determined to paint a portrait of the
four of them. For the group portrait, she
selected the genre scene of the visit,
showing Kandinsky and Goltz deep in
conversation, Frau Goltz listening, and
Münter herself at the image's extreme
left, turned away from the others but si-
multaneously looking back at them.
With the space and furnishings of the
interior itemized, and the psychological
tension inherent in the group relation-
ship, the painting was complex both in
composition and content. It also proved
to be an impossible pictorial problem
for Münter to resolve to her satisfaction.
She varied the image in ten uncharac-
teristically large drawings (now in the
Gabriele Münter and Johannes Eich-
ner-Stiftung, Munich), two painted stud-
ies, and one large-scale composition.
Judging from the sketches, the large
painting must have been on a canvas
measuring some 95 by 125 cm, a size
she used several months later for other
similarly large paintings. The multiple
studies and the grand scale, which con-
trast notably to her prior practice of
working in moderate and sometimes
even intimate scale, indicate the impor-
tance she gave the composition and
her hopes that it would mark a new di-
rection for her art.
The portrait of Kandinsky, however,
represents only about one-third of such
a grand canvas and composition. Un-
able to resolve the group image to her
satisfaction, Münter reverted to two
procedures. She translated the formal
organization of her painting into her
first abstract composition—significantly
titled by means of its date, *Abstraktion
25. 4. 1912.* This deprived the scene of
all reference beyond its own inherent
pictorial logic, but also acknowledged
the frustrated termination of the large
portrait project. Secondly, she cut the
canvas down and discarded all but the
figure of Kandinsky standing near a
table set for afternoon tea at their Ain-
millerstrasse apartment. The remnants
of the figure of Goltz, which leaned
slightly into the scene, she painted out

at the left-hand edge of the newly formed portrait. From the complex genre scene she thus retrieved a simple representation of Kandinsky alone, standing as if engaged in a dialogue, but now incongruously deprived of his conversation partners. On the wall behind him hang two paintings; one a Münter still life, the other a landscape whose proportions and multifigured scene suggest it is one of Kandinsky's. Münter seems to have initially intended the large composition to function as a kind of homage to the interaction of artists and Goltz—whose Munich gallery had hosted the second Blaue Reiter exhibition—the artists as creators, and the dealer as publicist. The final painting fragment significantly restored the artist to isolated independence, as hoped-for further collaboration with Goltz did not materialize. Kandinsky alone remains, framed by the two paintings that testify to the interaction—personal as well as artistic—between Münter and himself. This was a relationship that reached its apogee in 1912, and then slowly unraveled internally until it was severed outright by the intervention of war in 1914, when Kandinsky returned to Russia.
Reinhold Heller

II.23
White Wall (Weisse Mauer) ca. 1930
oil on canvas
48.3 × 63.5 cm (19 × 25 in.)
Signed l. l.: Münter
Ill. p. 227

Provenance:
Private collection, New York
Leonard Hutton Galleries, New York

Literature:
Gabriele Münter, exhibition cat., 1966, ill.
Gabriele Münter, exhibition cat., 1992, p. 268.

VASILY KANDINSKY

II.24
Murnau: Street with Women
(Murnau: Strasse mit Frauen) 1908
oil on cardboard
71 × 97 cm (27 1/2 × 37 3/4 in.)
Signed and dated l. l.: KANDINSKY/908
Ill. p. 238

Provenance:
Nina Kandinsky, Paris
Leonard Hutton Galleries, New York
Private collection, New York

Literature:
Röthel and Benjamin, vol. 1, no. 207.
Serge Sabarsky, *Die Malerei des deutschen Expressionismus,* Stuttgart: Jentsch, 1987, p. 91.

Sabarsky, *Erich Heckel: Die frühen Jahre,* Bietigheim-Bissingen: Die Galerie, 1995, ill. p. 87

II.25
Murnau: Street with Horse-Drawn Carriage (Murnau: Strasse mit Gespann) 1909
oil on cardboard
34 × 46 cm (13 × 17 3/4 in.)
Signed l. r.: KANDINSKY
Ill. p. 239

Provenance:
Gabriele Münter
Private collection, Munich
Leonard Hutton Galleries, New York
Private collection, New York

Literature:
Grohmann, p. 344.
Röthel and Benjamin, vol. 1, no. 314.

Soon after their first stay at Murnau in 1908, and early in the following year, Kandinsky and Gabriele Münter settled for a longer period in the village with their fellow artists and friends Alexej Jawlensky and Marianne von Werefkin. In the summer of 1909, Münter, with Kandinsky's encouragement, bought a small villa on the outskirts of Murnau, where they would spend many weeks together up until the start of World War I. In the Munich and Murnau years from 1909 to 1914, Kandinsky experienced a period of exceptional creativity, moving toward abstraction with large-scale "Impressions," "Improvisations," and "Compositions." Until about 1913, he maintained a close correspondence to nature, rendering views of Murnau's streets in numerous oil paintings of smaller or middle size. These scenes were often depicted from his own house across the garden, with the Schlosshügel and church beyond; or he painted the view of the mountains, as in the now almost completely abstract colored mountain chain in *Landschaft mit rotem Fleck* (*Landscape with Red Spot;* 1913).
In *Murnau: Street with Horse–Drawn Carriage,* the subjects—such as the slightly rising village street with colorfully painted houses on both sides, and the horse-drawn carriage in the foreground—are dissolved almost to the point of indecipherability in the colored surfaces. In the midst of diffuse, partly floating and loosely applied color, the artist's use of narrow, dark contours is remarkable, and marks a contrast with the earlier Murnau pictures by Kandinsky. This "cloisonné" technique—the concentration on a few principal elements in the picture emphasized by black contours—was something he had learned from Jawlensky, who thus passed on his experience of two stays

in Paris, and the inspiration he had received from the works of the Nabis and Gauguin. While this "synthesis" had the revolutionary function in French modernism of developing a picture in the context of flatness, through a coordinating linear structure, and of treating individual elements as equal in value, Kandinsky and the like-minded artists of the Blaue Reiter took this process a stage further. For Kandinsky, the dark contours employed in *Murnau: Street with Horse–Drawn Carriage* become the principal reductive element in an almost geometric scaffolding, while at the same time they represent the ultimate sundering of color from the description of objects. These objects themselves are increasingly described in terms of the graphic black lines, which disintegrate into the puzzling cypher of his symbol-laden, half-abstract pictures. On the other hand, as Kandinsky wrote in his book *On the Spiritual in Art,* color, "if correctly used, can move forwards or backwards, and strive forwards or backwards, thus making the picture into a sort of floating presence in the air, which is the same effect as the pictorial extension of the space."
Annegret Hoberg
Translated from the German by Nicholas T. Parsons.

II.26
Composition V (Komposition V) 1911
oil on canvas
190 × 275 cm (6 ft. 3 7/8 in. × 9 ft. 1/4 in.)
Signed and dated l. l.: KANDINSKY 1911
Ill. p. 241

Provenance:
Josef Müller, Solothurn
Private collection, Switzerland
Private collection, New York

Literature:
Johannes Eichner, *Kandinsky und Gabriele Münter: Von Ursprüngen moderner Kunst,* Munich: Bruckmann, 1957, pp. 114, 133.
Grohmann, p. 332.
Röthel and Benjamin, vol. 1, no. 400, p. 385.

II.27
Arabs II (Araber II) 1911
oil on canvas
70.2 × 93.6 cm (27 5/8 × 36 3/8 in.)
Signed u. l.: KANDINSKY
Ill. p. 240

Provenance:
Sold December 1911, Cologne
Horst Gottschalk, Düsseldorf
Galerie Beyeler, Basel
Harold Diamond, New York

J. Seward Johnson, Princeton, New Jersey
Rosenberg and Stiebel, Inc., New York
Private collection, New York

Literature:
Grohmann, pp. 54 (ill.), 331, 353 (ill.).
Röthel and Benjamin, vol. 1, no. 379.

II.28
Red and Blue (Rot und Blau) 1913
watercolor, India ink, and pencil on paper
36 × 40 cm (14 1/8 × 15 3/4 in.)
Monogrammed l. r.: K
Ill. p. 243

Provenance:
Nina Kandinsky, Paris
Galerie Beyeler, Basel
Private collection, New York

Literature:
Barnett, 1992, vol. 1, no. 375, p. 337.
Will Grohmann, *Wassily Kandinsky: Farben und Klänge,* Baden-Baden: Klein, 1955, pl. I.
Grohmann, pp. 132, 347.
Röthel and Benjamin, vol. 1, no. 375.

II.29
With Green Rider
(Mit grünem Reiter) 1918
oil on glass
25 × 31 cm (9 3/4 × 12 1/2 in.)
Monogrammed l. l.: K
Ill. p. 237

Provenance:
O. A. Andreevskaia
Nina Kandinsky, Paris
Private collection, New York

Literature:
Hans K. Röthel, *Kandinsky: Painting on Glass,* New York: Solomon R. Guggenheim Foundation, 1966, no. 44.
Röthel and Benjamin, vol. 2, no. 648.

II.30
Black Form (Schwarze Form) 1923
oil on canvas
110 × 97 cm (43 5/16 × 38 3/16 in.)
Monogrammed and dated l. l.: K 23
Ill. p. 242

Provenance:
Hjalmar Gabrielson, Göteborg and Berlin
Moderne Galerie Thannhauser, Munich
Galerie Beyeler, Basel
Sidney Janis Gallery, New York
Arnold Maremont, Chicago
Eugene V. Thaw and Co., New York
Private collection, New York

Literature:
Grohmann, no. 334, ill. 142.
Röthel and Benjamin, vol. 2, no. 692.

FRANZ MARC

II.31
The First Animals (Die ersten Tiere)
1913
watercolor and gouache on paper
38.7 × 46.4 cm (15 1/4 × 18 1/4 in.)
Initialed l. r.: M
Ill. p. 251

Provenance:
Städtische Galerie Moritzburg, Halle
Solomon R. Guggenheim Museum,
New York
Private collection, New York

Literature:
Franz Marc 1880–1916, exhibition cat.,
1980, no. 129.
Klaus Lankheit, *Franz Marc, Unteilbares
Sein: Aquarelle und Zeichnungen,*
Cologne: DuMont Schauberg, 1959, ill.
p. 40.
Lankheit, 1970, no. 464.

In 1927, Marc's *The First Animals* was
acquired for 20,000 marks by the Halle
Museum in Saxony, along with his
Hirsche im Walde (Deer in the Woods).
In 1937, it was confiscated by the National
Socialists. After the rejection of
Ferdinand Möller's offer to buy it in
February 1939, *The First Animals* was
sold to America for 600 dollars by Karl
Buchholz in March 1939.[1]
The First Animals[2] was an extended
study for an oil composition of the
same title, on which Marc worked during
March 1913; the oil painting was
finished in May of the same year. In
1917 in Berlin, the painting was burned
while in a storehouse where it was being
held before being sent to an exhibition
in Wiesbaden. At that time it belonged
to Marc's heir in Ried, Maria
Marc.[3]
This work shows four horses in a landscape.
Two small animals, to the left in
the foreground, and two large animals
in the background, are ordered in pairs
beside one another. Since they are located
to the right, and parallel to the
picture surface, the two groups overlap
to some extent. The large horses in the
background dominate the composition.
A blue horse, its head turned toward
the back, is placed before a violet one.
The latter is shown with its head
lowered, as if it were contemplating
the two small red horses, which would
seem to be the foals of the large ones.
These horses have an elemental and
aboriginal look, which no doubt inspired
the title by which the work has sometimes
been known, *Die beiden Urtiere
(Two Aboriginal Animals).*[4]
The abstract landscape in which the
animals are situated is arranged in angular
fields of crisscrossing color.
Marc's interest in contemporary French

painting, particularly the Orphism of
Robert Delaunay, is evident here.
Greens, yellows, and orange dominate
the composition. In the upper-left corner,
the sun is indicated with a brilliant
red circle. Landscape and sky are
closely integrated through green lines
of color, which intersect the picture
space by means of a cone of light, and
pierce the hindquarters of the large
blue horse as if it were made of glass.
The blue horse that is shown most
clearly became a kind of trademark for
the artist. Marc had developed his own
theory of color in 1910, and had designated
the primary color blue as the
"male" color—that is, as having the
properties of dry intellectualism. Complementary
to blue was a warm yellow,
which he designated the "feminine"
color.
The title of *The First Animals* recalls a
project to make an illustrated Bible,
which occupied Marc intensely in 1913.
For this project, which was interrupted
by the outbreak of World War I, graphics
were to have been contributed by
Klee, Heckel, Kokoschka, and Kubin.
Marc chose for his illustrations the
theme of Genesis, and produced a
number of woodcuts in this and subsequent
years, including a work entitled
*Geburt der Pferde (The Birth of
Horses).* It was significant that none of
the works produced for the Genesis
series was concerned with the creation
of man, the central focus of the biblical
story of the Creation. This was, of
course, quite intentional. According to
Marc, civilized man did not represent
the ideal of creation—but animals did,
because the latter exist in a paradisiac
world, in complete harmony with the
forces of nature. Marc's project of inventing
a new kind of art was to be reflected
in a new cosmos of color and
form. *The First Animals* is a painting
that bears witness to the painter's ambitions
in this respect.
Andreas Schalhorn
*Translated from the German by
Nicholas T. Parsons.*

[1] Andreas Hüneke, *Die faschistische Aktion
"Entartete Kunst" 1937 in Halle* (Schriftenreihe
zur Geschichte der Staatlichen Galerie
Moritzburg Halle, Heft 1), Halle: Staatliche
Galerie Moritzburg, 1987, p. 70, n. 159.
[2] Klaus Lankheit, *Franz Marc: Katalog der
Werke,* Cologne: DuMont Schauberg, 1970;
Magdalena M. Moeller, ed., *Franz Marc. Zeichnungen
und Aquarelle,* exhibition cat., Berlin,
Brücke-Museum; Essen, Museum Folkwang;
and Kunsthalle Tübingen, 1989–90, cat.
no. 156; Marc Rosenthal, *Franz Marc, 2d ed.,*
Munich: Prestel, 1992, pl. 54.
[3] On the painting (though its exact size is unknown,
the horses in the background were,
according to Klaus Lankheit, rendered lifesize),
see Alois Schardt, *Franz Marc,* Berlin:

Rembrandt, 1936, p. 167, ill. p. 126; Lankheit,
Franz Marc: Katalog der Werke (as note 2),
no. 207; Hajo Düchting, *Franz Marc,* Cologne:
DuMont, 1991, p. 102; *Franz Marc. Kräfte der
Natur. Werke 1912–1915.,* ed. by Erich Franz,
exhibition cat., Munich, Staatsgalerie Moderner
Kunst; Westphalian Landesmuseum Münster,
1993, cat. no. 25, p. 317, ill. p. 59; Christian
von Holst, "… der Hufschlag meiner Pferde,"
in: von Holst, *Franz Marc—Pferde,* exhibition
cat., Staatsgalerie Stuttgart, 2000, p. 169,
ill. 155.
[4] See Hüneke, *Die faschistische Aktion "Entartete
Kunst"* (as note 1), p. 70.

AUGUST MACKE

II.32
Strollers at the Lake II
(Spaziergänger am See II) 1912
oil on canvas
48.5 × 51.5 cm (19 1/8 × 20 1/4 in.)
Signed on stretcher: August Macke; inscribed
on verso: August Macke "I. Fassung
der Spaziergänger" entstanden
Sommer 1912 Tegernsee
Ill. p. 259

Provenance:
Max Leon Flemming, Berlin
Johannes Schuerer, Muelheim a.d. Ruhr
Galerie Vömel, Düsseldorf
Roman Norbert Ketterer, Munich
Serge Sabarsky Gallery, New York
Private collection, New York

Literature:
Vriesen, no. 547.

II.33
Two Figures at the River
(Zwei Figuren am Fluss) 1913
watercolor, gouache, and charcoal on
paper
24.1 × 16.5 cm (9 1/2 × 6 1/2 in.)
Signed l. r.: Aug. Macke
Ill. p. 258

Provenance:
Estate of Franz Marc
Galerie Stangl, Munich
Serge Sabarsky Gallery, New York
Private collection, New York

Literature:
August Macke, exhibition cat.,
1986–87, p. 122, fig. 15.
Heiderich, no. 390.
Vriesen, no. 382a, ill. p. 294.

II.34
Donkey Rider (Eselreiter) 1914
watercolor on paper
24.5 × 30.5 cm (9 5/8 × 12 in.)
Ill. p. 257

Provenance:
von Kielmannsegg, Essen
Galerie Vömel, Düsseldorf

Private collection, Germany
Christie's, London
Private collection, New York

Literature:
Ernst-Gerhard Güse, "Raum und Fläche
—Europa und der Orient: Zu August
Mackes Tunis-Aquarellen," in: *Die
Tunisreise: Klee, Macke, Moilliet,* ed. by
Güse, exhibition cat., Münster, Westfälisches
Landesmuseum für Kunst und
Kulturgeschichte; and Bonn, Städtisches
Kunstmuseum, 1982–83, p. 130.
Heiderich, no. 511.
Uta Laxner, *Stilanalytische Untersuchungen
zu den Aquarellen der
Tunisreise 1914: Macke, Klee, Moilliet,*
Ph.D. dissertation, Universität Bonn,
1967, pp. 98–101, 102, 105, 112.
Janice Mary McCullagh, *August Macke
and the Vision of Paradise: An Iconographic
Analysis,* Ph.D. dissertation,
University of Texas, Austin, 1980, p. 98.
Moeller, pp. 19, 84.
*Die Tunisreise: Aquarelle und Zeichnungen
von August Macke,* ed. by
Günter Busch, Cologne: DuMont, 1958,
fig. 54.
Vriesen, p. 487.

MAX BECKMANN

II.35
The Ideologues (Die Ideologen)
1919
black crayon on transfer paper
84.5 × 60.7 cm (31 1/8 × 21 5/8 in.)
Signed and dated l. r.: Beckmann 1919
Inscribed l. l.: Originalzeichnung zu
"Ideologen"
Ill. p. 306

Provenance:
Catherine Viviano, New York
Martin Gallery, New York
Edinburgh Collection
Galerie Jan Krugier, Geneva
Private collection, New York

Literature:
Barbara C. Buenger, "Max Beckmann's
'Ideologues': Some Forgotten Faces,"
in: *Art Bulletin,* vol. 71, no. 3 (1989), pp.
453–479.
Max Beckmann Retrospective, exhibition
cat., 1984–85, pp. 343, 402–405.
Wiese, no. 413 (drawing for pl. 6 of the
portfolio *Die Hölle [Hell],* containing
eleven lithographs and title page).

II.36
**Self-Portrait in Front of Red
Curtain** (Selbsbildnis vor rotem
Vorhang) 1923
oil on canvas
122.9 × 59.2 cm (43 3/8 ×
23 5/16 in.)
Signed and dated l. r.: Beckmann/F.23
Ill. p. 304

Provenance:
Reinhard Piper, Munich
Klaus Piper, Munich
Bayerische Staatsgemäldesamm-
lungen, Munich (loan)
Eugene V. Thaw and Co., New York
Private collection, New York

Literature:
Glaser, pl. 52.
C. Adolph Glassgold, "Max Beckmann,"
in: The Arts II (1927), ill. p. 201
Göpel, no. 218.
Der kleine Brockhaus, Leipzig: Brock-
haus, 1925.
Kunst und Künstler, vol. 3, no. 21
(1923), p. 314.
Julius Meier-Graefe, Entwicklungs-
geschichte der modernen Kunst, vol. 3,
2d ed., Munich: Piper, 1924, pl. 572.
Neues Tageblatt Stuttgart (November
1928).
Der Querschnitt, no. 4 (1924), ill. after
p. 56.

II.37
Galleria Umberto 1925
oil on canvas
113 × 50 cm (44 5/8 × 19 3/4 in.)
Signed and dated l. r.: Beckmann /
F.25
Ill. p. 307

Provenance:
Harry Spiro, New Orleans, New York
Richard W. Levi, New York
Richard L. Feigen and Co., New York
Siegfried Adler, Montagnola
Private collection, Turin
Private collection, New York

Literature:
Göpel, no. 247.
Wilhelm Hausenstein, in: exhibition cat.,
Munich, Galerie Günther Franke, 1928,
pp. 5, 8, 10.
Max Beckmann, exhibition cat.,
1948–49, pp. 28–29.
Neues Tageblatt Stuttgart (November
1928).
Benno Reifenberg, Max Beckmann,
Munich: Piper, 1949, p. 70.

II.38
Field Workers (Feldarbeiter) 1928
gouache on red paper
90.1 × 59.6 cm (35 1/2 × 23 1/2 in.)
Signed and dated l. r.: Beckmann /
F 28
Ill. p. 308

Provenance:
Galerie Günther Franke, Munich
Private collection, New York
Alice Adam Ltd., Chicago
Private collection, New York

Literature:
Gallwitz et al., eds., vol. 2, p. 416.

II.39
Sunrise (Sonnenaufgang) 1929
oil on canvas

The year 1928 marked a breakthrough
for Beckmann in Germany. It was in this
year that a retrospective staged by Gustav
Hartlaub at the Kunsthalle Mannheim
provoked the widespread discussion of
his work; part of the show went on be
presented in Berlin and Munich.
One year earlier, Beckmann had paint-
ed his Selbstbildnis im Smoking (Self-
Portrait in Tuxedo), which ultimately
ended up in the Berlin Nationalgalerie;
it was a work that revealed the artist at
the peak of his self-conscious phase.
During this period, he produced a se-
ries of large works on paper, in pastel
or gouache, that assumed a position
somewhere between drawing and
painting. He often made use of white
highlights, a technique developed by
German Old Masters such as Dürer and
Baldung. And like them, Beckmann
tended to use colored papers as a
background: thus a solid, continuous
color was present even before the artist
made the first line of his composition.
The pink paper used for the field-
worker image provides a rather bizarre
sense of light on the figures of the man
and woman, bent over their hard work.
In addition to the strong foreshorten-
ing—something Beckmann particularly
admired in the work of Tintoretto and
other artists—the division of the page
on a diagonal is remarkable: it cuts off
the feet of the woman, who is seen
from the back. The foreground and
middle distance of the composition are
starkly separated from each other
through this device, which Beckmann
later used in a similar manner in his
large 1932 painting Adam und Eva
(Mann und Frau) (Adam and Eve [Man
and Woman]). Indeed, the scene of this
couple working in the field recalls the
biblical passage in which Adam and
Eve are told that after being driven from
paradise they will have to work by the
sweat of their brow.
Beckmann takes this simple motif
(which he would have encountered of-
ten in his frequent travels to Bavaria
and elsewhere) and renders it a monu-
mental iconography, capable of being
interpreted at many levels. The man
and the woman are turned away from
each other. They belong together and
yet are disconnected as they go about
their daily work. Such a sense of dis-
connection is characteristic of Beck-
mann's art: he repeatedly used the
strained or foundering relationship of
the sexes as a symbol of human alien-
ation in the world.
Siegfried Gohr
Translated from the German by
Nicholas T. Parsons.

60 × 81 cm (24 × 32 in.)
Signed and dated u. l.:
Beckmann/F.29
Ill. p. 309

Provenance:
Heinrich Fromm, Munich
Galerie Günther Franke, Munich
Franz Hart, Munich
Sotheby's, London
Private collection, New York

Literature:
American Magazine of Art, no. 23
(1931), ill. p. 479.
The Artlover Library, no. 5 (1931), ill.
p. 32.
Aussaat I (1946), no. 5.
Göpel, no. 303.

II.40
Self-Portrait with Horn (Selbstbild-
nis mit Horn) 1938
oil on canvas
110 × 101 cm (43 1/4 × 39 3/4 in.)
Signed and dated l. c.: Beckmann/A. 38
Ill. p. 305

Provenance:
Gretl and Stephan Lackner, Santa
Barbara
Sotheby's, New York
Neue Galerie New York and Private
collection

Literature:
Max Beckmann, Handliste, 1938.
Buchalter, The Magazine of Art (No-
vember 1939), p. 633 (ill.).
Lothar Buchheim, Max Beckmann,
Feldafing: Buchheim, 1959, no. 69, p.
138 (ill.).
Howard Devree, "A Reviewer's Note-
book," in: New York Times (January 7,
1940), sec. 9, p. 10 (ill.).
Göpel, no. 489, ill. on dust jacket.
Dorothy Grafly, in: American Magazine
of Art, vol. 3 (1939), p. 481.
Stephan Lackner, Max Beckmann,
Berlin: Safari, 1962, pl. 6.
Lackner, Max Beckmann, New York:
Abrams, 1977, no. 34, p. 139 (ill.).
Max Beckmann, exhibition cat.
1964–65, p. 64 (ill.).
Kaspar Niehaus, "Beckmann's expres-
sionisme: Expositie bij van Lier van
nieuwe werken," in: Telegraaf (Amster-
dam) (June 22, 1938).
Benno Reifenberg, Max Beckmann,
Munich: Piper, 1949, no. 395, p. 75.
Peter Selz, Max Beckmann: The Self-Por-
traits, New York: Rizzoli, 1992, p. 72 (ill.).

Beckmann painted this self-portrait in
1938 in Amsterdam, one year after he
had left his homeland of Germany for-
ever. The picture offers an aesthetically
intense and powerful evocation of exile.
Like few other works of its time, it cap-
tures the fate of the political marginal-

ization of the modernist-oriented artist
at the hands of the Third Reich, a fate
that had already been sealed by the
National Socialists' notorious show of
"degenerate" art. In 1937, the year of
that exhibition, Beckmann's initial reac-
tion to his enforced departure had been
to show himself as a liberated artist, in-
sofar as he had managed to evade the
tentacles of the now fully established
despotism.
By contrast, in this picture, he confronts
the viewer with a melancholy, tension-
filled passivity. His thin mouth and
shadowed eyes suggest both an inner
anxiety and outward watchfulness. The
limited spatial dimensions and the
gloomy, indeed anxiety-inducing color-
ing of the portrait oppress and threaten
its subject all the more. The artist
seems to be caught at a crucial junc-
ture in time, between a possible blast
on the horn and the wait for an expect-
ed signal, an answer. This anxious wait-
ing shows the sitter to be at the mercy
of circumstance, whose prisoner and
plaything he has become.
Certainly Beckmann was himself
caught unawares by the political events
of the 1930s, as he admitted in his fa-
mous London speech of 1938. There,
on the occasion of a major exhibition
(at the New Burlington Galleries) of
modernist art, by then officially con-
demned and abused in Germany, he in-
sisted on his opposition to contempo-
rary developments: "The greatest
danger that threatens all of us as hu-
man beings is collectivism. Everywhere
attempts are being made to reduce the
possibilities of people in life, their po-
tential for happiness, to the level of ter-
mites. Against this tendency I am com-
mitted with the entire strength of my
spirit." His self-portrait appears today as
the expression of this determination to
preserve the individuality of the artist,
transmitted through his pictures by
means of a hermetic metaphysical
code. It is precisely in their almost im-
penetrable symbolism that Beckmann's
works offer a specific form of artistic
resistance to the antidemocratic ten-
dencies of his day.
Olaf Peters
Translated from the German by
Fiona Elliott.

OTTO DIX

II.41
**Portrait of the Lawyer Dr. Fritz
Glaser** (Bildnis Rechtsanwalt Dr. Fritz
Glaser) 1921
oil on canvas
105 × 80.5 cm (41 3/8 × 31 in.)
Signed and dated l. r.: Dix 1921
Ill. p. 316
Provenance:

Provenance:
Fritz Glaser, Dresden
Volkmar Glaser, Dresden
Gemäldegalerie Neuer Meister,
Dresden
Volkmar Glaser, Dresden
Rolf Deyle, Stuttgart
Sotheby's, London
Private collection, New York

Literature:
Strobl, pp. 53, 113, 245.

This veristic portrait conveys an interpretation of the Dresden attorney that is at once sensitive and alarming. Fritz Glaser is brought close to the viewers and helplessly placed at the mercy of their scrutiny. The atmosphere of interrogation evoked here questions the role of the lawyer. His hands are the powerless little fists of a child. The terrible passivity of the potential "victim" is cruelly underscored by the social status communicated by his clothing. The subject's positioning in space is startling; the room is so bare that it seems almost as if Glaser is sitting outside. An opening in the broken exterior wall of the house reveals a snow-covered Baroque-style structure jutting in from the background and constricting the sitter. Dix devises a forbidding architectural form, with empty window frames devoid of life. It exemplifies the destitute existence of a person who has lost his home. Dix uses this consciously constructed spatial situation to focus on Glaser's Jewish destiny and to articulate the unfathomable nature of life. Produced in the early days of the Weimar Republic, the painting bears urgent witness to the danger facing the assimilated German Jews. Glaser's existence here seems precarious; perhaps this is the reason why he never liked the portrait. And indeed, it is a troubling painting—not least because of the stereotyped "Jewish physiognomy" that the artist has projected onto his subject. Despite the fact that Glaser was well-established, it suggests an uncertain social status. With this portrait, the painter created a warning sign that today reflects a historic experience that could hardly have been anticipated at the time. Nor is the painting alone in its statement; as early as 1920, in his famous *Prager Strasse (Prague Street),* Dix had depicted the rampant postwar anti-Semitism, and after 1933 he produced one of his most remarkable social commentaries of the time, *Judenfriedhof in Randegg (Jewish Cemetery in Randegg).* In light of the anti-Jewish persecution of the time, this was a taboo subject that, as a kind of subversive affirmation, the artist realized in the stylistic idiom of old German and Romantic art. For many years, Dix con-

sciously examined the Jewish destiny in Germany with a critical eye.
Olaf Peters
Translated from the German by Fiona Elliott.

II.42
Self-Portrait (Selbstbildnis) 1922
watercolor and pen and ink
47.4 × 30.9 cm (18 3/4 × 12 1/4 in.)
Ill. p. 317

Provenance:
Kurt Günther, Dresden
Hildegard Fritz-Denneville, London
Private collection, New York

Literature:
Pfäffle, no. A 1922/210.

II.43
Seminude (Halbakt) 1926
tempera and oil on panel
79 × 55 cm (31 1/8 × 21 5/8 in.)
Monogrammed and dated u. r.: OD/26
Ill. p. 319

Provenance:
Martha Dix
Private collection, Stuttgart
Museum Folkwang, Essen (loan)
Galerie der Stadt Stuttgart (loan)
Luc Bellier, Paris
Private collection, New York

Literature:
Eva Karcher, *Otto Dix, 1881–1969: Leben und Werk,* Cologne: Taschen, 1988, p. 149 (ill.).
Otto Dix Bestandskatalog, Galerie der Stadt Stuttgart, no. LG-98, p. 111 (ill.).

II.44
Seated Female Nude with Red Hair and Stockings in Front of Pink Cloth (Sitzender weiblicher rothaariger Akt mit Strümpfen vor rosa Tuch) 1930
mixed media on panel
134 × 65 cm (52 3/4 × 25 5/8 in.)
Monogrammed and dated u. r.: 19 / O D / 30
Ill. p. 318

Provenance:
Otto Dix Estate, Vaduz
Serge Sabarsky Collection

Literature:
Heinz-Egon Kleine-Natrop and Fritz Löffler, "Die Medizin im Werk von Otto Dix," in: *Personal- und Vorlesungsverzeichnis der Medizinischen Akademie Carl Gustav Carus,* Dresden: Medizinische Akademie, 1968, pp. 15.

CHRISTIAN SCHAD

II.45
Two Girls (Zwei Mädchen) 1928
oil on canvas
109.5 × 80 cm (43 1/2 × 32 3/16 in.)
Signed and dated l. r.: SCHAD / 28
Ill. p. 324

Provenance:
Private collection, Italy
Wolf Uecker, Hamburg
Barry Humphries, Sydney
Richard Nagy, Sydney and London
Private collection, New York

Literature:
Heesemann-Wilson, no. 109.
Bettina Schad, "Christian Schad: Werkverzeichnis Bilder 1920–1930," in: *Christian Schad,* exhibition cat., Milan, Galleria del Levante, 1970, no. 53.

Schad was a Dadaist, dandy, and salon lion, who in the early 1920s discovered an Old Master–like technique through the example of Raphael. He was an individualist who did not seek to belong to a group. At the same time, however, his cool, distant portraits from the late 1920s are considered the quintessence of Neue Sachlichkeit. They represent the physiognomy of life in the big city, its pleasures, shortcomings, and scintillating extravagance. Initially in Vienna, and from 1928 in Berlin, he created paintings that present the unusual, eccentric qualities of the protagonists in an irritatingly tasteful and cultivated style. *Two Girls,* produced during Schad's first year in Berlin, is exemplary of this phase—and yet, it is an absolute exception. In no other painting did the artist reveal the sexual preferences of his subjects with such outspoken candor.
In Berlin, Schad lived on Hardenbergstrasse, near Bahnhof zoo, very close to the Kunstakademie. This is where he encountered the central figure. Schad related that her frail appearance gave him the idea to paint her masturbating. He then added the second, reclining woman, without working from a live model. Despite all of the permissiveness in describing the scene, this painting defies licentious observation: the two young women signal anything but availability. They are not posing for the viewer; each remains separate, her gaze turned away. What is conveyed is a sense of alienation and isolation; there is no relationship between these "girlfriends," and any feeling of closeness and affection seems utterly impossible. With this presentation of lesbian love, Schad broke a taboo that persisted for a long time. This painting, undoubtedly one of the artist's most important, was not shown

in public until fifty years after it was created.
Markus Krause
Translated from the German by Fiona Elliott.

II.46
Zacharias I (Grotesque) (Zacharias I [Groteske]) 1935
colored pencil on cardboard
19.8 × 11.8 cm (26 1/8 × 19 1/4 in.)
Signed and dated l. r.: Schad/35
Ill. p. 325

Provenance:
Lafayette Parke Gallery, New York
Sammlung G. A. Richter, Rottach-Egern
Villa Grisebach, Berlin, 1988
Private collection, New York

Literature:
Heesemann-Wilson, no. 257 *(Groteske).*

GEORGE GROSZ

II.47
Couple in Interior (Paar im Zimmer) 1915
oil on canvas
38.3 × 50.5 cm (15 1/8 × 19 7/8 in.)
Ill. p. 335

Provenance:
Richard Feigen Gallery, Chicago
Morton D. May, Saint Louis
Richard Feigen Gallery, New York
HRN Primitives, New York
Serge Sabarsky Collection

Literature:
Kathrin Hoffmann-Curtius, *"Im Blickfeld": George Grosz, "John, der Frauenmörder,"* Stuttgart: Hatje, 1993, pp. 43.
Serge Sabarsky, *George Grosz: The Berlin Years,* New York: Rizzoli, 1985, no. 2.

II.48
Night (Nachts) 1917
brush and pen and ink on paper
50.8 × 36.2 cm (20 × 14 1/2 in.)
Signed l. r.: Grosz
Ill. p. 338

Provenance:
Richard Cohn, New York
Private collection, New York

Literature:
Uwe Schneede, *George Grosz: Leben und Werk,* Stuttgart: Hatje, 1975, no. 60.

II.49
Panorama (Down with Liebknecht) (Panorama [Nieder mit Liebknecht]) 1919
pen and ink and watercolor on paper
48.9 × 34.6 cm (19 3/16 × 13 5/8 in.)

Signed l. r.: Grosz
Ill. p. 336

Provenance:
Richard L. Feigen and Co., New York
Private collection, New York

Literature:
George Grosz: Berlin–New York, exhibition cat., 1994–95, pp. 332 (ill.), 412.
Serge Sabarsky, *George Grosz: The Berlin Years,* New York: Rizzoli, 1985, no. 67.

In 1918–19, after surviving military service in a mental asylum for deranged soldiers, an angry Grosz channeled his aggression into remarkable paintings of protest against the incompetent leaders, the military, and the German middle classes who not only had promoted the war, but also supported the army in its bloody suppression of a radical left-wing uprising in January 1919. Working with a complex futuristic style to capture those chaotic days, Grosz insistently juxtaposed the voluptuous naked female body—whole or truncated or dismembered—against the self-righteous, narrow-minded men whom he held responsible for the stupidity of German society. In so doing, he transformed the earlier motif of the sexual murder into scathing indictments of contemporary German society and politics.
Preceded by his great *Deutschland, ein Wintermärchen (Germany, a Winter's Tale)* of 1918 (now lost), in which Grosz identified the pillars of society—priest, general, teacher, and solid citizen—this watercolor is one of the many variations of drawings and paintings that depicted the intersection of sexuality with politics. That image of a legless, one-armed female, who evokes the bloodstained, blooming, dismembered bodies in his *Lustmord* series, is presented to the gaze of respectable German men as a seductive object on a red velvet pillow. One of the men agitatedly rails against the murdered leader of the Communist party, Karl Liebknecht, even as two figures of Death behind him echo his gesture. In a café, above the skulls, a profile of Grosz appears with his friend Otto Schmalhausen, who reappears in the center, dancing to a popular song; below Schmalhausen, a man gropes a pair of female buttocks and above him a seriously maimed war veteran confronts a supercilious bureaucrat in a blood-red room. On the upper right, citizens busily pass through an urban center. This cross-section of German society, with its intersecting, penetrating spheres, centers upon a dark profile—Grosz perhaps—who leers at the truncated female.
Beth Irwin Lewis

II.50
Diabolo Player (Der Diabolospieler)
1920
pen and ink and watercolor on paper
42.9 × 55.7 cm (16 7/8 × 21 7/8 in.)
Ill. p. 337

Provenance:
M. H. Franke, Murhardt
Eugene V. Thaw and Co., New York
Private collection, New York

Literature:
Envisioning America, exhibition cat., 1990, no. 60, p. 73 (ill.).
George Grosz: Berlin–New York, exhibition cat., 1994–95, p. 152 (ill.).

II.51
Portrait of John Förste, Man with Glass Eye (Portrait John Förste, Mann mit Glasauge) 1926
oil on canvas
102.9 × 73 cm (40 1/2 × 28 3/4 in.)
Signed and dated on verso: Grosz 1926; inscribed on stretcher: angefangen 24.Sept.26
Ill. p. 339

Provenance:
Galerie Alfred Flechtheim, Berlin
Erich Cohn, New York
Raphael Soyer, New York
Lafayette Parke Gallery, New York
Fred Elghanayan, New York
Christie's, London
Private collection, New York

Literature:
Grosz, 1979, pp. 105, 107ff.
Wieland Herzfelde, *John Heartfield: Leben und Werk,* Dresden: Verlag der Kunst, 1962, p. 6.
Paul Raabe, *Die Autoren und Bücher des literarischen Expressionismus: Ein bibliographisches Handbuch,* Stuttgart: Metzler, 1985, p. 146.
Kurt Tucholsky, *Briefe: Auswahl 1913 bis 1935,* Berlin: Verlag Volk und Welt, 1983, p. 149.

KURT SCHWITTERS

II.52
U 11 for Dexel (U 11 für Dexel)
1921
oil, glass, and fabric on glass
22.4 × 27.1 cm (9 3/8 × 11 1/8 in.)
Inscribed l. l.: U 11 KS 21 für Dexel
Ill. p. 348

Provenance:
Estate of Walter Dexel
Ubu Gallery, New York
Private collection, New York

Literature:
Ernst Nündel, "Kurt Schwitters: Merz

oder die Verfremdung," in: *Bildnerische Erziehung,* no. 1 (1968), pp. 17–26, ill. p. 26.
Orchard and Schulz, vol. 1, no. 786.

At a time of intense involvement with the radical procedures of collage and assemblage in his art-making, Schwitters produced the glass painting *U 11.* Alongside his *Merz* works—combining scraps of modern detritus (tram tickets, cigarette and chocolate packaging, printed matter, and the like)—*U 11* shows the artist turning to a venerable medium: deploying oil paint behind a sheet of glass. This is the largest of three such works made by Schwitters in 1921. The impulse behind this detour into a "folkloristic" technique probably came from Schwitters's friend and fellow avant-garde artist, a practicing enthusiast for the medium, Walter Dexel (1890–1973), to whom this picture is dedicated. Schwitters, however, approached underglass painting in his own idiosyncratic fashion.
U 11 offers the eye a dense patchwork of colored areas, which seems to resolve itself into four contrasting quarters arranged on either side of two central turquoise lines. To the right, a stable grid of rectilinear blocks is surmounted by a random assortment of angular, irregular, and shapeless forms tumbling off toward the edge. On the picture's left side, this compositional contrast of order and chaos is mirrored in a juxtaposition of symbols: an abstracted numerical cipher (the yellow "3" in the lower quadrant) and an allusion to nature (the sunlike disk above). This array of pictorial possibilities is rendered neutrally, in oil paint applied over the back of the entire glass pane. Nowhere does the artist exploit the support to achieve effects of actual or implied transparency. Even the heightened luminosity that glass might grant to the colors seems contradicted by the predominantly dark hues and extensive blacks. *U 11* refuses to traffic in any of the spiritual or transcendent associations of stained glass.
At the heart of this sobriety, however, there lies a witty surprise. Close to the center of this painted inventory of artistic languages, Schwitters has planted a subversive twist: two small pieces of fabric, one blue and one pink. These are poignant reminders both of the canvas fabric that might have been the support for a painting of this kind, and of the artist's own dedication to his *Merz* technique. It is tempting to see *U 11* as an unresolved moment, playing out a hesitation between geometric nonobjectivity and turgid late Expressionism, between *Merz* collage and oil painting, between technical experimentation and a traditional medium. Signifi-

cantly, the artist seems to have exhibited this and his other two "underglass" paintings just once (in the year of their creation), if at all. Only one was offered for sale; the other two entered Dexel's collection. Nevertheless, *U 11* is a telling reminder that Schwitters—though rightly celebrated as the master of collage—never abandoned his interest in the potential of oil paint. It was, for him, a medium for landscapes and portraiture, for constructivist abstractions, or, as here, for dialogue with fellow artists searching for media and techniques best suited to the confusions and upheavals in art and society in the aftermath of a devastating war.
Peter Nisbet

II.53
Untitled (Merz Picture Horse Fat)
(Ohne Titel [Merzbild Rossfett])
ca. 1920
assemblage and oil on wood
20.4 × 17.4 cm (8 × 6 7/8 in.)
Ill. p. 349

Provenance:
Estate of Kurt Schwitters
Marlborough Fine Art, London
Bruno Lassato, Paris
Private collection, Switzerland
Private collection, New York

Literature:
John Elderfield, *Kurt Schwitters,* Düsseldorf: Claassen, 1987, fig. 5.
Elderfield, fig. III.
Orchard and Schulz, vol. 1, no. 610.
Dian Pouw, "Kurt Schwitters in Hannover," in: *Vrij Nederland* (February 22, 1986), pp. 20–27, 23 (ill.).
Kurt Schwitters 1887–1948, exhibition cat., Hannover, Sprengel Museum, 1986, no. 8, p. 13 (ill.).

LÁSZLÓ MOHOLY-NAGY

II.54
A X1 1923
oil on canvas
132.5 × 115 cm (52 1/8 × 45 1/4 in.)
Stenciled on verso: L MOHOLY-NAGY AX1 1923
Ill. p. 359

Provenance:
Galerie Neue Kunst, Munich
Sybil Moholy-Nagy, New York
Sotheby's, London
Neue Galerie New York

Literature:
Kostelanetz, no. 5.
László Moholy-Nagy, ed. by Renate Rüdiger et al., exhibition cat., Kassel, Museum Fridericianum, 1991, p. 77.
László Moholy-Nagy, ed. by Catherine David and Corinne Diserens, exhibition

Réunion des Musées Nationaux, 1991, p. 111.

LYONEL FEININGER

II.55
Gelmeroda II 1913
oil on canvas
100 × 80 cm (39 3/8 × 31 1/2 in.)
Signed u. r.: Feininger
Ill. p. 368

Provenance:
Stadtmuseum, Dresden
Adolphe J. Warner, New York
William Mayer, New York
Serge Sabarsky Gallery, New York
Private collection, New York

Literature:
"Degenerate Art": The Fate of the Avant-Garde in Nazi Germany, ed. by Stephanie Barron, exhibition cat., Los Angeles County Museum of Art, 1991, ill. p. 234, fig. 205 (incorrectly identified as *Gelmeroda III).*
Hess, no. 102.

II.56
The Blue Cloud (Die blaue Wolke) 1925
oil on canvas
48.3 × 67.3 cm (19 × 26 1/2 in.)
Signed and dated l. l.: Feininger 25
Ill. p. 369

Provenance:
Estate of Julia Feininger, New York
Andreas Feininger Trust, New York
Ralph Colin, New York
Eugene V. Thaw and Co., New York
Private collection, New York

Literature:
Hess, no. 256.

PAUL KLEE

II.57
Self-Portrait Full Face, Resting Head in Hand (Selbstportrait en face, in die Hand gestützt) 1909, 32
watercolor on paper mounted on cardboard
16.5 × 13.5 cm (6 1/2 × 5 1/4 in.)
Ill. p. 377

Provenance:
Private collection, Switzerland
John and Paul Herring and Co., New York
Private collection, New York

Literature:
Jürgen Glaesemer, "Klee and German Romanticism," in: *Paul Klee,* ed. by Carolyn Lanchner, exhibition cat., New York, Museum of Modern Art; The

Cleveland Museum of Art; and Kunstmuseum Bern, 1987–88, p. 72.
Will Grohmann, *Paul Klee,* Geneva and Stuttgart: Edition des Trois Collines and Kohlhammer, 1954, ill.
Andrew Kagan, "Paul Klee's 'Ad Parnassum': The Theory and Practice of Eighteenth-Century Polyphony as Models for Klee's Art," in: *Arts Magazine,* vol. 52, no. 1 (September 1977), p. 95.
Paul Klee-Stiftung, vol. 1, no. 419.
Margaret Plant, *Paul Klee: Figures and Faces,* London: Thames & Hudson, 1978, p. 19.

II.58
Yellow House (Gelbes Haus) 1915
watercolor and gouache on paper
19.7 × 13.3 cm (7 3/4 × 5 1/4 in.)
Signed c. l.: Klee
Inscribed l. l.: 1915.55
Ill. p. 380

Provenance:
Galerie Neue Kunst (Hans Goltz), sold May/June 1921
Galerie Nierendorf (Florian Karsch), Berlin
Serge Sabarsky Gallery, New York
Private collection, New York

Literature:
Uta Gerlach-Laxner, "Paul Klee und der Orient: Die Auswirkung auf sein Werk unter besonderer Berücksichtigung seiner Tunesienreise 1914," in: *Die Tunisreise: Klee, Macke, Moilliet,* ed. by Ernst-Gerhard Güse, exhibition cat., Münster, Westfälisches Landesmuseum für Kunst und Kulturgeschichte; and Bonn, Städtisches Kunstmuseum, 1982–83, p. 65.
Paul Klee: Aquarelle aus der Berner Zeit, ed. by Tilman Osterwold und Thomas Knubben, exhibition cat., Ravensburg, Städtische Galerie Altes Theater, 1995, p. 24.
Paul-Klee-Stiftung, vol. 2, no. 1388.
Otto Karl Werckmeister, *The Making of Paul Klee's Career, 1914–1920,* Chicago: University of Chicago Press, 1989, p. 268, note 64.

II.59
On the Lawn (Auf der Wiese) 1923, 93
watercolor and gouache on paper mounted on board
22.9 × 30.5 cm (9 × 12 in.)
Signed l. r.: Klee
Dated, numbered, and titled center border: 1923 / 93 Auf der Wiese
Ill. p. 379

Provenance:
Herwarth Walden (Der Sturm), Berlin
Paul Eluard, Paris
Galerie Jeanne-Bucher, Paris
Willard Gallery, New York
Danna Dunning, Patterson

John and Paul Herring and Co., New York
The Woodbridge Company, Toronto
Private collection, New York

Literature:
René Crevel, *Paul Klee: Peintres nouveaux,* Paris: Gallimard, 1930, p. 25 (ill.).
Will Grohmann, *Paul Klee,* Paris: Editions Cahiers d'Art, 1929.
Grohmann, *Paul Klee,* New York: Abrams, 1954, p. 187.
Paul-Klee-Stiftung, vol. 4, no. 3186.
Anon., "Ideas and Illuminations," in: *Time,* vol. 41 (April 1938), p. 39 (ill.).

II.60
Mystical Ceramic (in the Manner of a Still Life) (Mystisch-Keramisch [i. d. Art eines Stilllebens]) 1925, 118 (B8)
oil on cardboard
33 × 47.5 cm (13 × 18 3/4 in.)
Signed, numbered, and dated l. l.: Klee B8 /1925
Label on verso in artist's handwriting: An Herrn Richard Doetsch-Benziger, Basel, Paulenstrasse 12
Ill. p. 378

Provenance:
Galerie Alfred Flechtheim, Düsseldorf, Berlin, Paris, London
Richard Doetsch-Benziger, Basel
Christie's, London
Private collection, New York

Literature:
Margrit Bosshard-Rebmann, *Paul Klee: Sammlung Richard Doetsch-Benziger,* Basel, 1953, no. 6.
Carola Giedion-Welcker, *Paul Klee,* London: Faber & Faber, 1952, p. 138.
Will Grohmann, *Paul Klee,* New York: Abrams, 1954, p. 62.
Paul-Klee-Stiftung, vol. 4, no. 3799.
Leopold von Zahn, Paul Klee: *Im Lande Edelstein,* Baden-Baden: Klein, 1952, ill.

II.61
Gay Repast/Colorful Meal (bunte Mahlzeit) 1928, 29 (L9)
oil and watercolor on cardboard
81 × 67 cm (31 7/8 × 26 3/8 in.)
Ill. p. 381

Provenance:
Galerie Alfred Flechtheim, Berlin
Erich Raemisch, Krefeld
Buchholz Gallery, New York
Stanley B. Resor, New York
Gabriel Hauge, Washington, D.C.
Jane P. and Stanley B. Resor, New Canaan, Connecticut
Private collection, New York

Literature:
Uta Gerlach-Laxner, "Paul Klee und der Orient: Die Auswirkung auf sein Werk

unter besonderer Berücksichtigung seiner Tunesienreise 1914," in: *Die Tunisreise: Klee, Macke, Moilliet,* ed. by Ernst-Gerhard Güse, exhibition cat., Münster, Westfälisches Landesmuseum für Kunst und Kulturgeschichte; and Bonn, Städtisches Kunstmuseum, 1982–83.
Paul Klee: Aquarelle aus der Berner Zeit, ed. by Tilman Osterwold and Thomas Knubben, exhibition cat., Ravensburg, Städtische Galerie Altes Theater, 1995, p. 23.
Paul-Klee-Stiftung, vol. 5 (in preparation).
Otto Karl Werckmeister, *The Making of Paul Klee's Career, 1914–1920,* Chicago: University of Chicago Press, 1989.

In the second half of the 1920s, it became increasingly common in Germany to regard Klee as a precursor to Surrealism, and thus an artist who demonstrated that German modernism preceded that of the French. The picture entitled *Gay Repast* was crucial to this claim. Almost immediately after completing it, Klee exhibited the picture in a one-man show at the Galerie Flechtheim in Berlin, from March 18 to Easter of 1928. The composition, on a black background, occupied a prominent position in the catalogue; in the accompanying text, Flechtheim proclaimed: "The real creator of Surrealism is Paul Klee. ..." *Gay Repast* was reproduced on the facing page. Hans Heilmaier also illustrated the painting in his essay on Surrealism, which appeared in volume 4 of the *Kunstblatt* in 1928. There, he described Klee's work as "one of the purest examples of 'Surreal' art."
In fact, the "Surrealist" Klee was then teaching at the Bauhaus in Dessau—where Constructivist-Functionalist tendencies were dominant—and developing his own pedagogic theories in light of Bauhaus principles. Klee situated his work somewhere between Surrealist and Constructivist art, where both tendencies existed in creative tension with each other. As such, the cat in the center of the picture may be read as a disguised portrait of the artist. Despite its awkward bodily construction, with a large head and small legs, the image is insouciantly balanced on a geometrical construction, which, like the other objects in this dark and mysterious picture space, seems to float in space. Klee's composition is indebted to the artistic notion of "tension," which he borrowed around 1925–26 from the Russian and Hungarian Constructivists and integrated into his own aesthetic theory.[1] To the right of the cat an egg is sliced in half, part of a repast including wine and cognac. Eggs were also favored motifs

for the Constructivists, as for example in the work of Klee's Bauhaus colleague Moholy-Nagy.

During the National Socialists' campaign against "degenerate" art, the painting found its way to the United States, when Helen Stanley Resor, a trustee of New York's Museum of Modern Art, apparently acquired it around 1937–38 through Curt Valentin in New York. When Mies van der Rohe, the last director of the Bauhaus (1930–33) received a commission from Resor (through the mediation of Mr. and Mrs. Philip Johnson) to design her summer house in Wyoming, he used as part of his project a color reproduction[2] of Klee's *Gay Repast* in the form of a collage.[3] In this collage, Klee's intimate composition stands in stark contrast to the wild, rocky landscape around Resor's house. The house itself, conceived in a strictly geometric modern style with large windows, underlines this disparity. This example does much to place Klee's picture in a wider cultural-historical context.

Osamu Okuda
Translated from the German by Nicholas T. Parsons.

[1] A similar construction is found, for example, in Klee's watercolor titled *Static-Dynamic Tension* (1927).
[2] The director of the Museum of Modern Art, Alfred H. Barr, Jr., was the first to publish the color reproduction of *Gay Repast*, on the occasion of the exhibition *Art in Our Time* (1939), at which the picture was also shown.
[3] Collection Museum of Modern Art, New York. Cf. Werner Blaser, *Mies van der Rohe: The Art of Structure*, New York: Praeger, 1965, pp. 214ff.

OSKAR SCHLEMMER

II.62
Five Nudes (Fünf Akte) 1929
oil on canvas
90.2 × 60.3 cm (35 1/2 × 23 3/4 in.)
Signed, dated, and inscribed on verso:
5 Mai 1929 '5 Akte' Osk Schlemmer
Ill. p. 389

Provenance:
Heinrich Lauterbach, Breslau
Galerie Alfred Flechtheim, Berlin
London Gallery, London
I. B. Neumann-Nierendorf, New York
Perlmann, New York
G. D. Thompson, Pittsburgh
Rose Fried Gallery, New York
New Gallery, New York
Galerie Stangl, Munich
Galerie Aenne Abels, Cologne
Roman Norbert Ketterer, Campione
Private collection, New York

Literature:

Hildebrandt, no. 164.
Heinrich Lauterbach, *Bauten von 1925–1965*, Berlin: Mann, 1972, p. 33 (ill.).
Moderne Kunst IV, exhibition cat., Campione, Roman Norbert Ketterer, 1969, no. 112.
Edith Nowak-Richowsky, "Ein Haus im Vorgebirge: Eine Arbeit von Architekt H. Lauterbach," in: *Innen-Dekoration*, vol. 43 (November 1932), p. 389 (ill.). von Maur, G194.

The painting was created in Dessau in May 1929, shortly before Schlemmer left the Bauhaus to accept a teaching post at the State Academy in the Silesian capital city of Breslau (today Wrocław, in Poland). He had just completed the first version of nine murals for the Museum Folkwang in Essen and installed them in the circular space with the fountain monument by George Minne. The completion of the mural project, which had been drawn out over many months, came as a great relief to the artist; it soon became apparent, however, that they competed too strongly with Minne's sculpture, and for this reason he continued work on a further version of the cycle until 1931. For a time, however, Schlemmer was able to freely devote himself to his own painting; *Five Nudes* belongs to the first body of work done directly after the trial hanging of the initial Folkwang panels and was thematically connected to it. He was now able to model his paintings in a more sculptural manner—in contrast to the strict flatness of the mural composition—and introduce an element of spatial chiaroscuro. After many years of instruction in "The Human Form," which included intense training in the drawing of live models, he had become so highly skilled in the depiction and stylization of the human body that he was able to work entirely without a model.

In the center of the vertical canvas is a group of three figures, painted in a tower-like arrangement; one is a profile head turned to the right with a shoulder turned toward the viewer. Above this rises a tall, curved nude seen from behind; beyond this, a frontal figure to the left faces the viewer and takes up eye contact. On the right edge, visible only in the silhouette of its outer body shape, is a standing youth who fills the entire height of the canvas and appears to have joined the group from a distance. On the left-hand side, in a diffuse background, a significantly smaller, thin figure in profile flanks the central group and forms a complement to the figure at the right-hand edge. The composition shows that Schlemmer not only conceives of the individual figures tectonically, but also that he creates with

them a kind of complex "human architecture," structuring the space on all sides through the interplay of symmetry and asymmetry, light and shadow, frontal, side, and back views and multidimensionally through the directions of their looks. It is likewise notable that the figures are now all unclothed—naked youths, related to Greek kouroi. Cut by the frame, they seem to continue further beyond the picture space in the viewer's imagination, thereby entering into a relationship with the greater wall surface and the real viewing space. The picture is a kind of ideal concentrate from a potential real scenario. At the same time, Schlemmer is now working to a greater degree with painterly effects, with highlights and dark shadows that dissolve the architecturally defined space in uncertainty and allow for an unlimited spatial quality. The colors here are largely warm, brownish skin tones and a deep blue that at times turns to violet. The changing light—the brightly lit back of the central figure contrasts with the shadowed silhouette figure on the righthand edge whose profile stands out against a light background—enlivens the statuesque group.

The carefully constructed play of lines between the rounded and sharp edges, and the horizontals and verticals that form the contours of the figures contributes much to the harmony and rhythm of the scene.

Karin von Maur
Translated from the German by Michael Huey.

II.63
Pointing Man (Deutender) 1931
watercolor, gouache, and pencil on paper
44.45 × 31.75 cm
(17 1/2 × 12 1/2 in.)
Inscribed, signed, and dated u. l.: Herrn / Fritz Mosert / freundlichst / zugeeignet / von O Schlemmer / 1931
Ill. p. 390

Provenance:
Fritz Mosert, Breslau and Berlin
Galerie Nierendorf, Berlin
Carus Gallery, New York
Private collection, New York

Literature:
Hildebrandt, no. 648.
von Maur, A454.

II.64
Figures Climbing Stairs (Treppensteigende) 1932
oil on canvas
99.06 × 87.95 cm (39 × 34 5/8 in.)
Ill. p. 391

Provenance:

Roman Norbert Ketterer, Campione (1969)
Serge Sabarsky Gallery
Private collection

Literature:
Hildebrandt, no. 236.
Moderne Kunst VI, exhibition cat., Campione, Roman Norbert Ketterer, 1969, no. 113, pl. 184.
von Maur, G263.

VIENNESE DECORATIVE ARTS AROUND 1900

- **OTTO WAGNER**

- **ADOLF LOOS**

- **JOSEF HOFFMANN**

- **EDUARD JOSEF WIMMER-WISGRILL**

- **KOLOMAN MOSER**

- **JUTTA SIKA**

- **THERESE TRETHAN**

- **OTTO PRUTSCHER**

- **HANS PRUTSCHER**

- **JOSEPH URBAN**

- **DAGOBERT PECHE**

Drawing Office of the Wiener Werkstätte ca. 1903
MAK – Österreichisches Museum für angewandte Kunst, Wiener Werkstätte Archiv

TOWARD AN AESTHETIC OF INDIVIDUALITY: VIENNESE DECORATIVE ARTS AROUND 1900

CHRISTIAN WITT-DÖRRING

In Vienna at the turn of the twentieth century, the decorative arts took on a leading role in the contentious process of creating a modern world of the senses. The new artistic ideas were first made manifest in the realm of objects for daily use, as opposed to the fine arts. Most of these ideas originated in the work of architects, who thus created much necessary theoretical groundwork for what was to follow, and led fruitful and controversial discussions. These discussions had a common premise: that the language of historical styles, dominant for the past seventy years, had nothing whatsoever to do with contemporary social, economic, or technical developments. In this call for a form of expression suited to the times, individual artistic expression was construed as a key source of renewal. The programmatic equal weight given the decorative and fine arts must be seen in this context. The autonomous ornament was now understood as an expression of individual artistic creativity. Separated in this way from its application to objects for daily use, the ornament becomes an expression of free, creative, artistic will and thus a driving force for the entire movement of artistic renewal around 1900.[1]

The idea—within the context of the artistic immersion of everyday life—that the new forms possessed universal application finds its particular medium in the *Gesamtkunstwerk* or "total work of art." New spatial concepts, formally conceived down to the smallest detail, were created under the leadership of architects and artists; more than a mere outward expression of the new values, they were thought to be the very *basis* of modern life itself, which took shape according to the needs of the individual. The ways in which such a universal artistic applicability might be turned into a material reality were outlined in Vienna chiefly by Otto Wagner and Josef Hoffmann. Adolf Loos, by contrast, took a different, independent route—a primarily cultural critical view, giving precedence to conceptual renewal over formal renewal. In the work of this trio of protagonists of the Viennese *Ver Sacrum* movement around 1900, individuality—as the expression of modern, conscious, democratically oriented mankind—is central. The following discussion explores the varying positions that brought about the achievement of this goal. As we shall see, while Wagner and Loos defined their positions partly through the vehicle of theoretical and cultural critical writings, Hoffmann's stance was established almost exclusively within the framework of his remarkable creativity at the Wiener Werkstätte.

The traditional image of turn-of-the-century decorative arts is generally based on a one-sided modernist view of the world, which is founded in turn upon the notion of a one-dimensional, linear development of forms toward the abstract.[2] Debate concerning this topic took place not within the context of a decorative arts museum, or even in a general history of the applied arts, but rather in the framework of the media, and of cultural institutions devoted to the modern movement itself. Beginning in the 1930s, the debate served basically to legitimize the formal and artistic achievements of the modern movement. Thus in 1933 Philip Johnson organized a small exhibition titled *Objects 1900 and Today*[3] at the Museum of Modern Art in New York, with the intention of demonstrating the superiority of contemporary designs over their Jugendstil predecessors. And Nikolaus Pevsner was the first to take on the topic as a distinct art historical stage of development in his book *Pioneers of Modern Design*, which appeared in London in 1936.

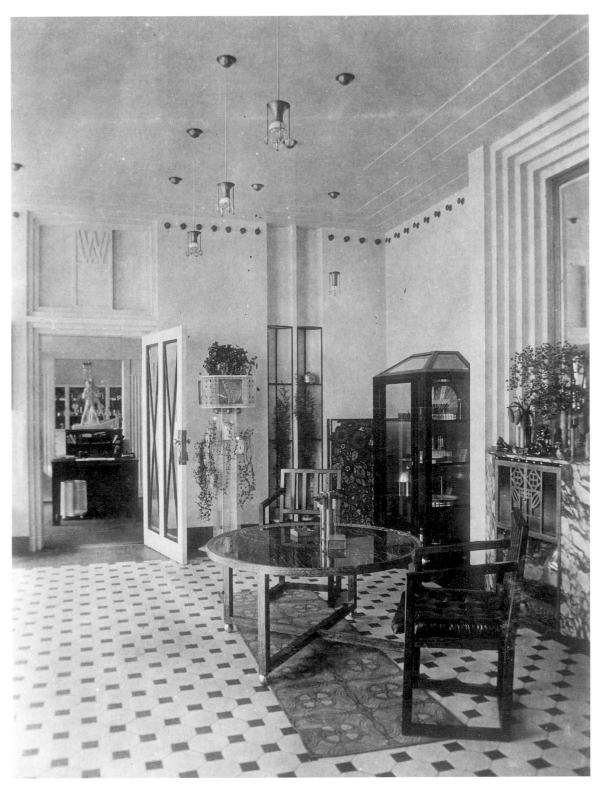

Wiener Werkstätte Salesroom, 1905. MAK – Österreichisches Museum für angewandte Kunst, Wiener Werkstätte Archiv

Beginning in the 1950s, art historians addressed the subject of turn-of-the-century decorative arts with increasing frequency—they did so, however, almost exclusively in the context of exploring the roots of the modern movement.[4] In 1952, the first exhibition devoted to the topic was mounted at the Zürich Kunstgewerbemuseum.[5] Johannes Itten, director of the museum (and a former teacher at the Bauhaus), placed this motivation clearly in the foreground in his introduction to the exhibition catalogue: "If we are to clarify the goals and primary roots of our present creativity in the applied arts—and this seems to us to have become an utmost necessity—we must look closely at the years before and after 1900." Itten declined to outline why this was necessary, or where the relevance of the period around 1900 might lie, but the objects selected for the show articulated his argument eloquently. Though they followed no single formal direction,[6] they had one thing in common: they all differed greatly from their predecessors, which were based on historical models. The seventy-year dominance of eclectic forms had been vehemently called into question in the 1890s, and these forms came to be replaced by a new formal language. The Zürich exhibition focused upon a rediscovery of that language and emphasized that important break with the past.

The positioning of the applied arts of the turn of the century as the cradle of modern form may thus be traced back to the 1930s. Such proponents as Pevsner and Johnson initiated the inquiry, and by mid century, the association between 1900 Viennese design principles and the innovations of modernism was an established issue among historians and cultural critics.

Within the modern movement, the turn-of-the-century decorative-arts object was understood as an isolated product, clearly demarcated from the values of the cultural eras that preceded it. Only when the object was seen in this manner—divorced from its history—could the dimensions that fulfill the functional criteria of modernism become apparent. These criteria include the rejection of hierarchic notions of "rank" inherent in the object, for a purely functional, democratic design directive: it was not the circumstances and motivating factors that led to the object's development that mattered (by 1910, these were already ten years out of date) but, rather, the object itself, the end result. This result managed to hold its own through decades of great societal flux, and broke ground for the next stage of artistic development. Therefore, by the 1950s, lack of ornamentation and simple stereometric form were perceived as essential sensibilities of modern design and as the highest achievements of the turn-of-the-century Viennese decorative-arts movement.

THE PROBLEM OF INDIVIDUALITY

Art historically, the stage was set by mid century for a convenient oversimplification of some important fin-de-siècle Viennese design concepts. Such central figures as Loos (1870–1933) and Hoffmann (1870–1956)—along with Wagner (1841–1918), essentially a mentor to both—were crucial figures in the rise of the independent Viennese formal design dialect. Interestingly, Loos (a proponent for reconsidering society's needs in terms of functionality) and Hoffmann (a staunch believer in the power of form as an expression of individuality), came to be pigeonholed by their own most basic philosophical tenets. Loos's 1908 essay "Ornament und Verbrechen" (Ornament and Crime)[7] was taken for his entire credo, while Hoffmann was associated with the square as a kind of "trademark."[8] This misguided perception was compounded by the cultural/historical reduction of the concept of the *Gesamtkunstwerk*, a notion that has become synonymous with the Wiener Werkstätte approach.[9] In a story published in 1900, "Von einem armen reichen Manne" (Poor Rich Man),[10] Loos impugned the idea of living spaces that were styled under the rule of a single, dogmatic design concept, down to the smallest detail.

Room in Italian Renaissance style, from Jakob von Falke's *Die Kunst im Hause*, 1882

Of course, the concept of "unified" artistic decor was not an innovation of the turn of the century: it had been revived some decades earlier in response to a long period of extreme eclecticism. Historicist theorists took up the issue and made it part of their larger discourse. As early as 1871, in his decorating primer *Die Kunst im Hause* (Art in the Home), Jakob von Falke had discussed the limitations that would arise for the consumer as a consequence of adhering to a strictly unified aesthetic.[11] But

what was for Falke a mere stylistic restriction[12] took on a deeper psychological dimension for Loos, who held that every single aspect of an architectural living space should reflect *its owner*'s individuality, and not an aesthetic proposed by another.[13] Subsequently, this idea came to be seen by many as the principle point of argument between Hoffmann and Loos, without taking historical context into consideration.

Adolf Loos, view of the bedroom of Loos's wife Lina, Vienna, in *Kunst* (1903)

Decorative initial for Otto Wagner's article "Die Kunst im Gewerbe" ("Art in Industry") in *Ver Sacrum*, vol. 3, Vienna (1900)

Thus by 1900, the artistic nature or value of the design object was no longer determined by its archaeological or historical status, but rather by its capacity for expressing *individuality*. For Loos's "poor rich man," this "individuality" was not his own, but was *imposed* on him (the consumer) by the artist.[14] Loos believed, in other words, that the consumer must take responsibility for deciding what would constitute his own individual expression. By contrast, Hoffmann believed that the artist had a comprehensive understanding of creative integrity that the average consumer did not possess, and was thus more qualified to decide what should determine individuality. Their debate provoked a question we may still ask today—is "individuality" an empirical potential, or an inherent given?

Loos and Hoffmann represent the two great antipodes in Viennese architecture and design at the turn of the century: Loos as proponent of modernity as a cultural phenomenon; Hoffmann viewing modernity as integrally connected to form. It is interesting to note the commonalities upon which their divergent views

were based. Both were born in Moravia in 1870. They were both confronted with the same artistically stagnant atmosphere of academic Historicism in Vienna in the late nineteenth century. This stagnation began to be alleviated through the efforts of Wagner, a generation older and, from 1894, the director of the department of architecture at Vienna's Akademie der bildenden Künste. His challenges to the artistic status quo formed the foundation upon which Loos and Hoffmann's opposing positions were both premised.[15] Wagner's central proposal was for an independent, contemporary formal "language of design"; this concept was based upon his high regard for artistic expression,

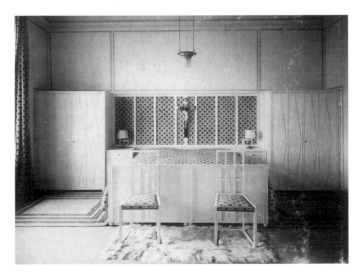

Josef Hoffmann, view of the bedroom in residence of K. (possibly Knips), Vienna, 1909. MAK – Österreichisches Museum für angewandte Kunst, Wiener Werkstätte Archiv

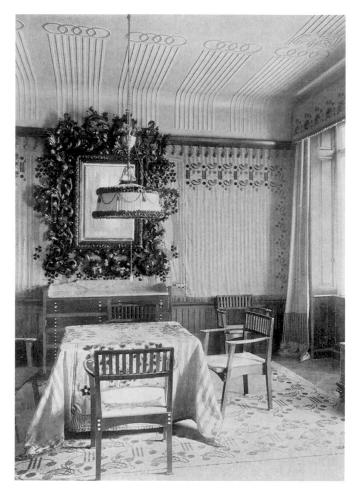
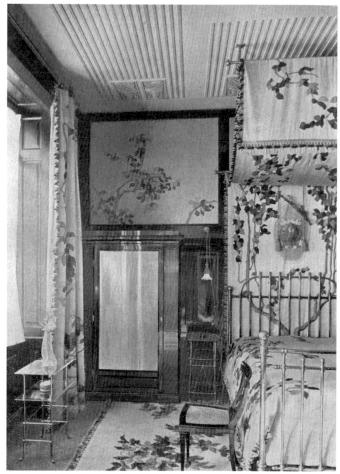

Otto Wagner, view of the dining room with buffet (cat. no. III.2) and the bedroom in his residence at Köstlergasse 3, Vienna, 1898–99, in *Ver Sacrum* (1900)

and his belief in art's potential to sustain a culture that was moving irrevocably into industrial dependence. He wrote: "Only through art—its cultivation and recognition—will it be possible to infuse industry with the saving breath of life and thereby elevate the nation through prosperity and creative potency."[16] To him, however, the creativity inherent generally in art was by itself not enough of a guarantee of the birth of the modern, functional object. He expanded his convictions on the *creative* dimension by adding to them the prerequisite of *practicality*.[17] (This ultimately led to Wagner's theory of "functional style"[18] and his notion that "something impractical can never be beautiful"[19]—an axiom that Loos would appropriate into his own line of argument shortly after Wagner proposed it.[20])

FORMULATING A NEW LANGUAGE

For Wagner, the creation of a new *style* per se was not the primary objective; instead, he was calling for a sharpened con-

sciousness, among artists and public alike, of a formal *language* of design and art, a language that would be appropriate and organic to the cultural Zeitgeist, to new technologies and inventions that had no precedents, such as telephones, electrical appliances, and trains. Once a full understanding of the requirements was in place, he believed, the fitting expressions of this new language would follow as logical extensions of thought. In this process of logical deduction, Wagner latched onto the idea of "construction" as his prerequisite: "It is," he wrote, "... always a constructive issue that influences form, and thus it certainly follows that new construction itself must give birth to new forms."[21] Wagner encouraged individual expression, but for him it was not the sole determinant of contemporary, modern forms: the artistic consciousness of the new formal language would also lead naturally to new forms.

Loos's critique of the "applied artist" was articulated in 1908 at the founding of the Deutscher Werkbund. "Modern man," he

Josef Hoffmann, view of the dining hall for Purkersdorf Sanatorium showing Hoffmann's dining chair (cat. no. III.16). Österreichisches Museum für angewandte Kunst, Wiener Werkstätte Archiv

said, "perceives the fusion of art and household utensils as the greatest debasement that can be wrought upon the former."[22] Essentially, this did not contradict Wagner's thesis. Wagner himself had stated in 1899 that the makers of decorative arts "have never admitted ... that everything really good that has happened in the decorative arts has been done and is being done by artists."[23] Wagner, a board member of the Österreichisches Museum für Kunst und Industrie (Austrian Museum of Art and Industry), had confidently offered his statement as the basis for the reform of that institution and its adjacent school—both of which had been founded on Historicist design precepts. For Loos, Wagner was unique in his ability to "slip out of his architect's skin" and into that of a random artisan. "When he makes a water glass—he thinks like a glassblower, like a glass-cutter. He makes a brass bed—and thinks, feels like a brass craftsman. He leaves everything else, all his profound architectural knowledge and capability, behind, in the old skin."[24] Nonetheless, it was architects—representative of a discipline that mediates between function and artistic expression—who, at the turn of the century, were cast as guarantors for the artistic and aesthetic reform of everyday life.

Loos, however, saw the purely superficial formal approach as a threat to this reform, and fought for his own fundamental ideal: to make Austria once again an important force in Western culture. The architect, he felt, would play a central part in this battle; he "must not only be familiar with the cultural needs of his age; he must also be himself standing at the pinnacle of that

culture."[25] This is also the reason behind Loos's rejection of Hoffmann's approach: "In order to be able to find the style of our age one must be a modern person. But people who attempt to alter those things that are already in today's style, or who wish to replace them with other forms—I need only mention the word *cutlery*—show, by so doing, that they fail to recognize the style of our time. Their search will be futile."[26] And further: "For me, tradition is everything; free reign for fantasy takes second place, in my view."[27]

DEFINING TRADITION

The definition of *tradition* is another central point of difference between the positions of Loos and Hoffmann—for Hoffmann too called for *tradition*, in the founding program of the Wiener Werkstätte.[28] While one of Loos's central tenets was a belief in the established division between art and handicrafts,[29] Hoffmann felt that the connection to a lost standard of quality would

Adolf Loos, view of the main room of the Café Museum with chair (cat. no. III.9), Vienna, 1899. Courtesy Burkhardt Rukschcio

be assured by the rejuvenation of the handicrafts tradition—through the leadership of an artist or an architect. Without such leadership, he believed, "We have lost the connection to our ancestors' culture and find ourselves tossed to and fro by thousands of desires and considerations."[30]

Not surprisingly, Loos saw a distinction between the purity of Wagner's teachings and the students who were trained by him: "Decorative art is so very much the domain of the Wagner School—[though] not of Wagner's own creed."[31] Hoffmann—who, unlike Loos, had been a pupil of Wagner's and had worked in his atelier—was championed by his former teacher, and was at least partially indebted to Wagner for his appointment as a

Josef Hoffmann, view of the dining room in Fritz Waerndorfer's residence (1902), with George Minne's sculpture *Die Badende (The Bather;* cat. no. I.1). Österreichisches Museum für angewandte Kunst, Wiener Werkstätte Archiv

professor at the Viennese Kunstgewerbeschule. Wagner described Hoffmann and his fellow candidates for teaching positions in positive terms in 1899: "They all possess a marked 'individuality,' a characteristic I cherish all the more because their work is thereby lent a local flavor rather than losing its way in foreign territory."[32] The word *individuality* as it is used here by Wagner indicates a kind of integrity—remaining true to oneself— essentially unrelated to the desire to be different or to set oneself apart. In a traditionally Catholic, authority-respecting culture like Austria's, which not only tends to discourage the latter type of individuality but, indeed, has been known to undermine it, this issue acquires primary significance where the origins of modernism are concerned.

Indeed, it is immaterial whether this integrity, or truth, takes a formal, aesthetic dimension (as with Wagner),[33] or manifests as the appurtenances of a particular class—"a king should live like a king, a townsman like a townsman, and a farmer like a farmer" (as Loos put it).[34] In both cases, the impulse is to liberate one-self from established norms and artificial dependencies, to become, in short, "mature," as citizens and thus as consumers. The then-current revivals of specific national forms—which is to say, *individual, subjective* forms of expression—thus reveal themselves to be merely aids in a process of development in which traditional values gave way to the fulfillment of desires in a democratic society. The ideas propagated by the Bauhaus, in turn, would eventually help bring about the great breakthrough of the International Style. As Frederick Kiesler summarized in 1930: "Happily for contemporary architecture, today it is no longer a conglomeration of all sorts of materials and styles, but a living expression of the spirit of a community, or of a person-ality. And so it is in the best way towards becoming an *interna-tional* architecture. *One style for all.* ... To build or decorate in a more or less indigenous style is an individual idiosyncrasy: The trend of the age is to break down insularity."[35]

Translated from the German by Michael Huey.

1 Dieter Bogner, "The Constructive Ornament—Vienna's Contribution on to Abstraction," in: *Ornament and Abstraction*, exhibition cat., Basel, Fondation Beyeler, 2001, pp. 36–43.

2 Markus Brüderlin, "Introduction: Ornament and Abstraction," in: *Ornament and Abstraction* (as note 1), pp. 16–27.

3 See Peter Selz and Mildred Constantine, eds., *Art Nouveau—Art and Design at the Turn of the Century*, exhibition cat., New York, The Museum of Modern Art, 1959, p. 6.

4 Stephan Tschudi Madsen, *Sources of Art Nouveau*, Oslo: Wittenborn, 1955, p. 410. "It can be shown that even before 1900 the road ahead had been mapped out in Austria, a road which … was to lead directly to the Modern Movement, and which, as far as applied art was concerned, resulted in entirely new stylistic ideals, which were to be spread across Austria and Europe through the Wiener Werkstätte."

5 The exhibition *Um 1900: Art Nouveau und Jugendstil—Kunst und Kunstgewerbe aus Europa und Amerika zur Zeit der Stilwende* (Around 1900: Art Nouveau and Jugendstil—Art and Decorative Arts from Europe and America at the Turning Point of Style) was presented at Zürich's Kunstgewerbemuseum from June 28 through September 28, 1952.

6 Apart from the dominant examples of floral Jugendstil, there were also a number of pieces that reflected its geometric style.

7 This essay, published in 1908, is often cited as "Ornament Is Crime"—perhaps an example of wishful thinking.

8 In her 1910 book, *Box Furniture: How to Make a Hundred Useful Articles for the Home* (New York: Century), Louise Brigham recommends the following decorating methods: "The simple motif shown in the several interiors are an adaptation of the 'Hoffmann method' of utilizing the square as the basic principle of decoration."

9 A small brochure published by the Wiener Werkstätte in 1907 for the opening of the Cabaret Fledermaus, built and decorated according to Josef Hoffmann's designs, describes the realization of certain artistic ambitions as follows: "We have set great store by fashioning every detail of the place with precision, in keeping with the honesty of an artistic exercise undertaken from an organic standpoint, and have devoted our attention to the least of these details with equal love as to the greatest: The furnishing of the interior, like the tableware and lighting, down to the smallest of objects, thus sprang from the basic unified idea of the room that was to be created. …"

10 Franz Glück, ed., *Collected Writings of Adolf Loos*, Vienna: Herold, 1962, pp. 201ff.

11 Eva Ottilinger, *Wiener Möbel des Historismus—Formgebungstheorie und Stiltendenzen*, Ph. D. diss., Universität Wien, 1985, p. 49.

12 Jakob von Falke, *Die Kunst im Hause*, Vienna: Carl Gerold's Sohn, 1871, p. 173: "But we admit that here, too, there can easily be too much of a good thing, that one must take this unity in a proper and comprehensible sense and not from the standpoint of an artistic or archaeological pedant. A home or apartment should be artistically decorated but hardly a work of art in the highest, monumental sense."

13 *Writings of Adolf Loos* (as note 10), p. 202: "But it wasn't your average architectural work; no, each ornament, every shape, every nail expressed the owner's individuality. (A psychological task whose difficulty will be readily apparent to all.)"

14 Adolf Loos, "Das Heim," in: *Das Andere*, no. 1, 1903, pp. 8f.: "The spokesmen of the modern artists tell you that they furnish each apartment solely according to your individuality. This is a lie. An artist is only capable of furnishing an apartment according to his own particular method."

15 In 1896, Otto Wagner published these ideas in his programmatic text *Moderne Architektur*. After a second (1898) and third edition (1902), it appeared in 1914 in a fourth printing under the title *Die Baukunst unserer Zeit*.

16 Otto Wagner, "Die Kunst im Gewerbe," in: *Ver Sacrum*, vol. 3 (1900), p. 29.

17 Otto Wagner, *Moderne Architektur*, Vienna: Schroll, 1896, p. 37: "All modern forms must conform with the new materials, the new requirements of our time, if they are to be suitable for modern humanity; they must display our own better, democratic, self-assured, ideal being and the colossal progress made by technology and science, in addition to bearing witness to the constant practical nature of man—but this is self-evident!"

18 Otto Wagner, *Einige Skizzen, Projecte u. ausgeführte Bauwerke*, Vienna: Schroll, 1890 (reprinted Tübingen, 1987), p. 17: "To see in this or that style a 'Eureka!'—or to adapt certain styles for special construction purposes—seems childish to me. The truly flourishing branch of art will certainly avoid such one-sidedness. Yet it seems to me unavoidable that this continuation of development and, indeed, redevelopment, along with the use of all motifs and materials, must necessarily push us toward a new style altogether, and even more definite that this future style will be the 'functional style' toward which we are steering with full sails even now."

19 Otto Wagner, *Moderne Architektur* (as note 17), p. 41.

20 Adolf Loos wrote: "The modern spirit demands above all that a product be practical. For it, beauty symbolizes the highest perfection. And since the impractical can never be perfect, neither can it ever be beautiful." *Writings of Adolf Loos* (as note 10), p. 152.

21 Otto Wagner, *Moderne Architektur* (as note 17), p. 57.

22 *Writings of Adolf Loos* (as note 10), p. 274: "Kulturentartung."

23 Minutes of a meeting on January 30, 1899, archives of Österreichisches Museum für angewandte Kunst, Zl. 259/1899, p. 4.

24 *Writings of Adolf Loos* (as note 10), p. 47.

25 Adolf Loos, "Die alte und die neue Richtung in der Baukunst," in: *Der Architekt* (1898), in: Adolf Opel, ed., *Die Potemkin'sche Stadt* (Potemkin's Village), Vienna: Prachner, 1983, p. 66.

26 Adolf Loos, "Kulturentartung" (1908), in: *Die Potemkin'sche Stadt* (as note 25), p. 274.

27 Adolf Loos, "Ein Wiener Architekt," in: *Dekorative Kunst*, vol. 11 (1898), in: *Die Potemkin'sche Stadt* (as note 25), p. 53.

28 Josef Hoffmann stated: "The boundless harm done to the decorative arts on the one hand by poor mass production and by the thoughtless imitation of old styles on the other hand is a current so large that it has inundated the world. We have lost the connection to our ancestors' culture and find ourselves tossed to and fro by thousands of desires and considerations." Wiener Werkstätte program, Vienna 1908, pp. 1ff.

29 Adolf Loos, "Über die Wiener Werkstätte" (1927), in: *Die Potemkin'sche Stadt* (as note 25), p. 221: "Of all the theories I have given the world the one that will rank foremost for those to follow will be the one that says that art and handicrafts share no connection of any kind."

30 Josef Hoffmann, Wiener Werkstätte program, 1908 (as note 28).

31 *Writings of Adolf Loos* (as note 10), p. 50.

32 Minutes of a meeting on January 1, 1899, archives of Österreichisches Museum für angewandte Kunst Zl. 259/1899, p. 6.

33 Otto Wagner, *Moderne Architektur* (as note 17), p. 39: "Such views prohibit the choice of a style from being the foundation of a modern architectural creation; instead, they require that the architect must see to the creation of new forms or to the adaptation of those forms that most readily suit our modern construction and needs, which is to say, already adhere best to the truth."

34 Adolf Loos wrote: "After all, the modern spirit demands absolute truth. … It demands individuality. This means that, in general, a king should live like a king, a townsman like a townsman, and a farmer like a farmer and that, in particular, every king, every townsman, and every farmer expresses his qualities of character in the decoration of his home." *Writings of Adolf Loos* (as note 10), p. 152.

35 Frederick Kiesler, *Contemporary Art Applied to the Store and Its Display*, London: Pitman & Sons, 1930, p. 39.

Vitrine for boudoir in the apartment of Otto Wagner in Vienna, 1892 cat. III.1

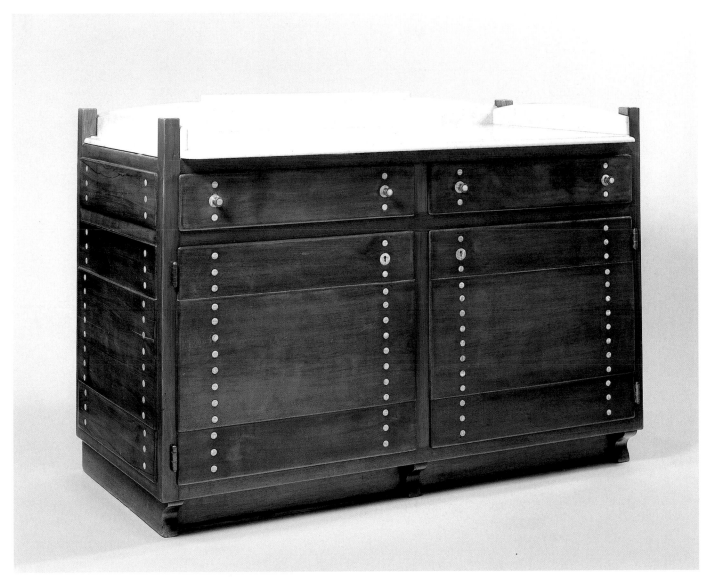

Buffet for the apartment of Otto Wagner in Vienna, 1898–99 cat. III.2

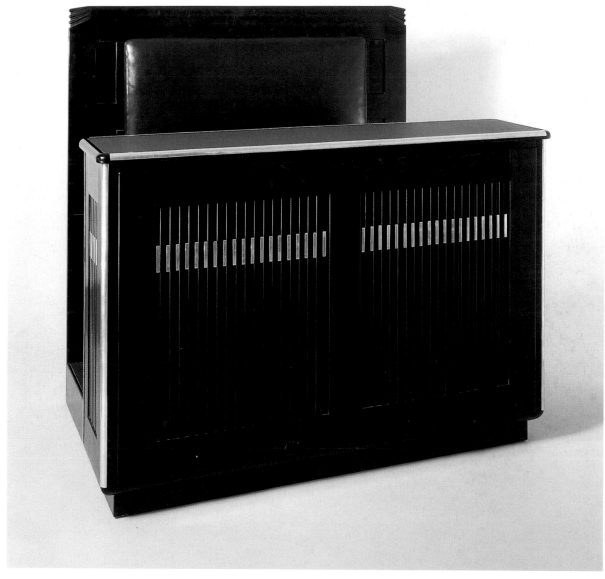

Reception desk for dispatch bureau of *Die Zeit*, 1902 cat. III.4

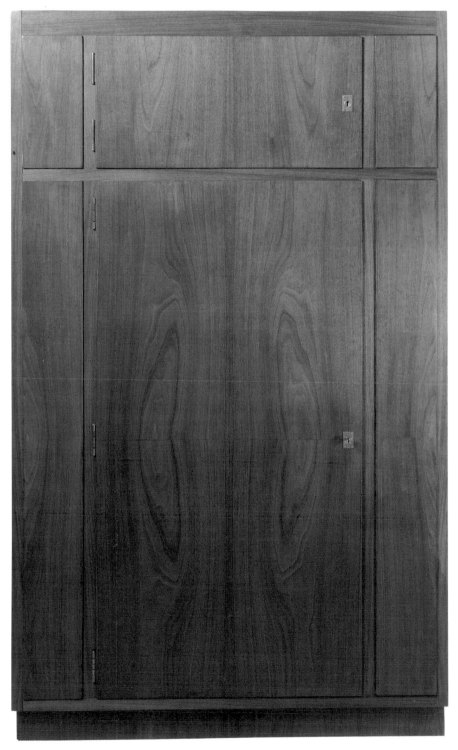

Cabinet for Österreichische Postsparkasse, 1912–13 cat. III.8

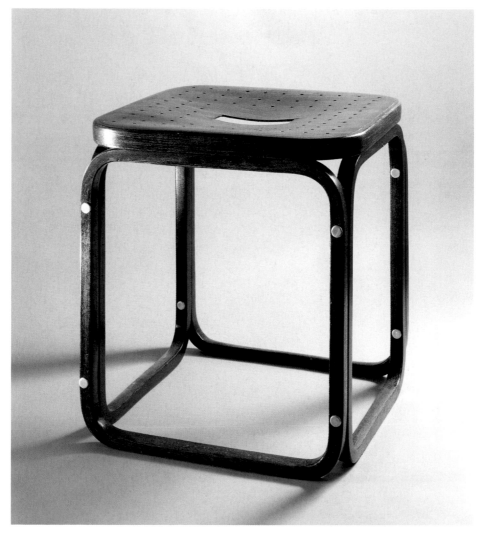

Stool for main hall of Österreichische Postsparkasse, 1906 cat. III.6

Armchair for dispatch bureau of *Die Zeit*, 1902 cat. III.3

Ceiling lamp for dispatch bureau of *Die Zeit*, 1902 cat. III.5

Ceiling lamp for office in Österreichische Postsparkasse, 1906 cat. III.7

Chair for Café Museum, 1899 cat. III.9

Knieschwimmer club chair, ca. 1930 cat. III.12

Mantelpiece clock, ca. 1902 cat. III.11

Sherry glass, 1931 cat. III.13

Table for dining/drawing room in the apartment of Dr. Hugo Haberfeld, 1899 cat. III.10

Armoire for little girl's room in the apartment of Max Biach, 1902 cat. III.14

Chair for dining room in Purkersdorf Sanatorium, 1904 cat. III.16

Chair for *Kunstschau Wien*, 1908 cat. III.36

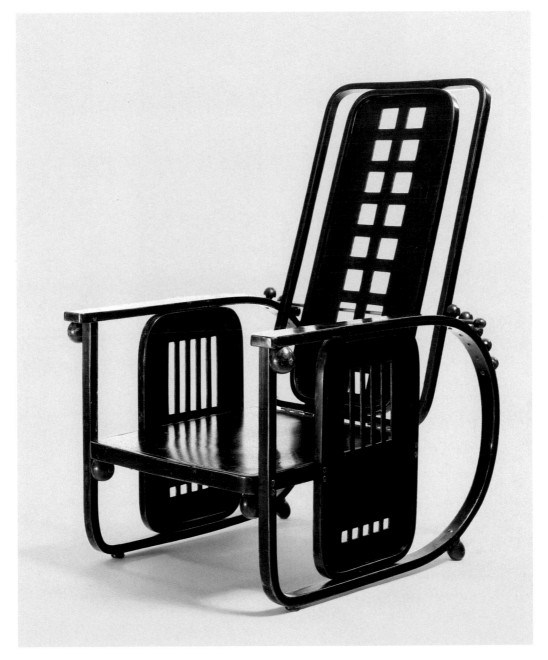

Sitzmaschine, 1908 cat. III.35

Hanging lamp for salon in the apartment of
Dr. Hermann Wittgenstein in Vienna, 1905 cat. III.28

Hanging lamp with eight bulbs for the home of Max Biach, 1902 cat. III.15

Candlestick, 1904 cat. III.18

Flower basket, 1905 cat. III.26

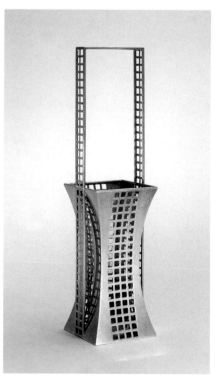

Flower basket, 1906 cat. III.31

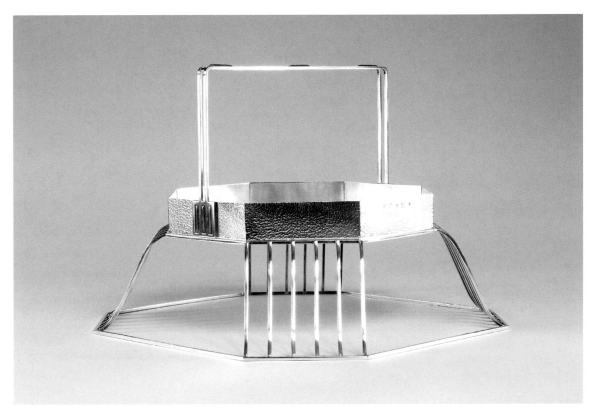

Centerpiece, 1904 cat. III.19

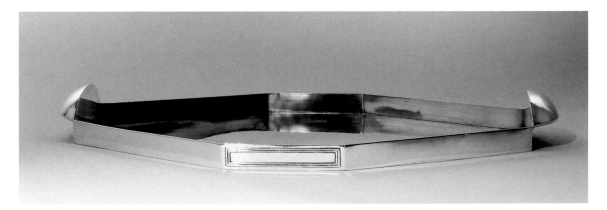

Tray for Samuel Waerndorfer, 1905 cat. III.24

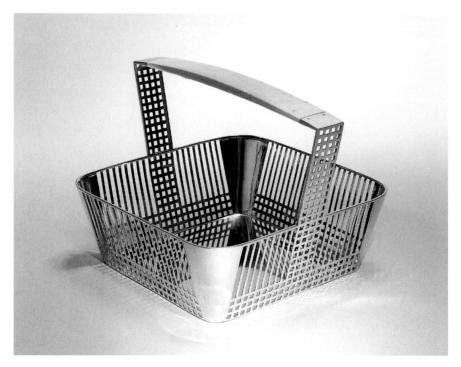

Basket, 1905 cat. III.25

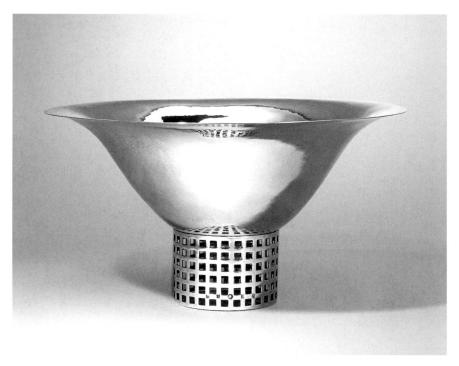

Sugar bowl, 1905 cat. III.23

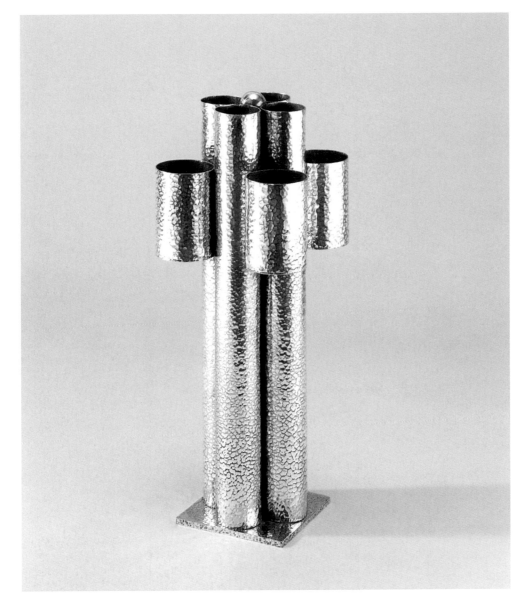

Vase, 1905 cat. III.27

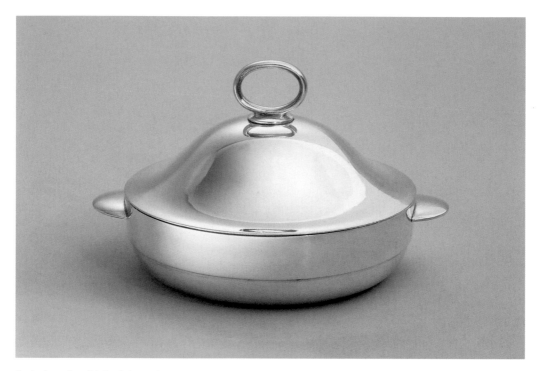

Goulash serving dish for Cabaret Fledermaus, 1907 cat. III.33

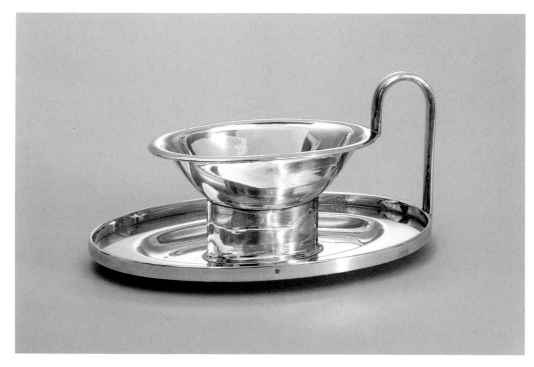

Gravy boat for Cabaret Fledermaus, 1907 cat. III.34

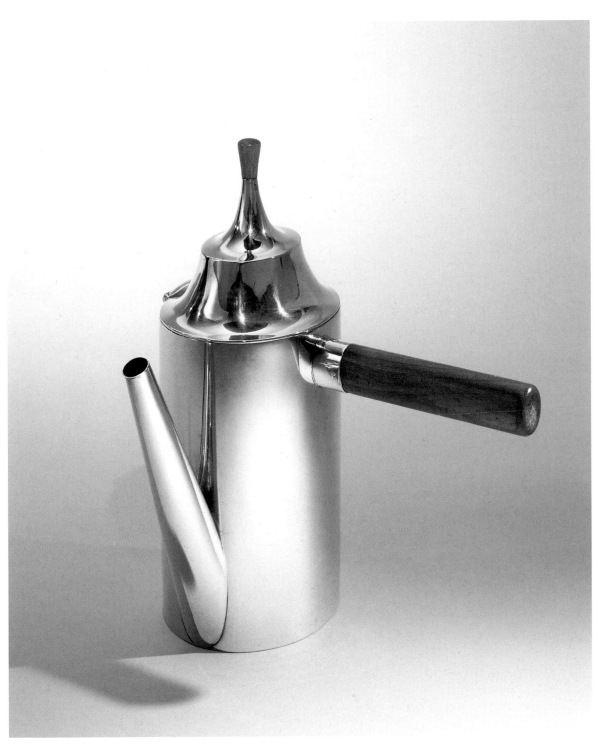

Coffeepot for Jenny Mautner, 1906 cat. III.30

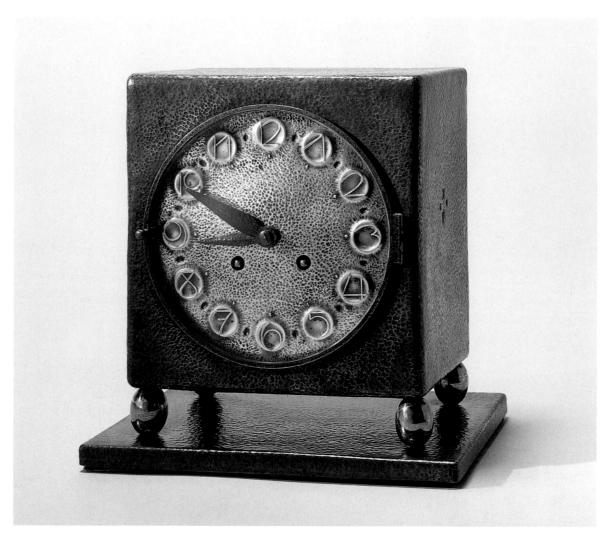

Table clock, 1904–12 cat. III.20

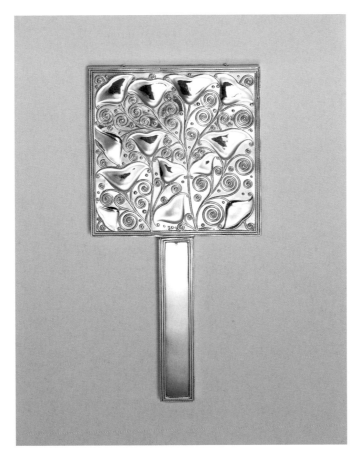

Hand mirror, 1909 cat. III.37

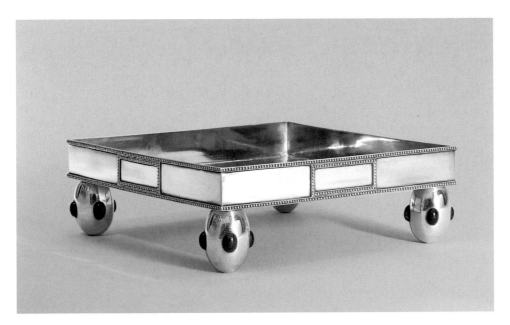

Candy tray, 1912 cat. III.39

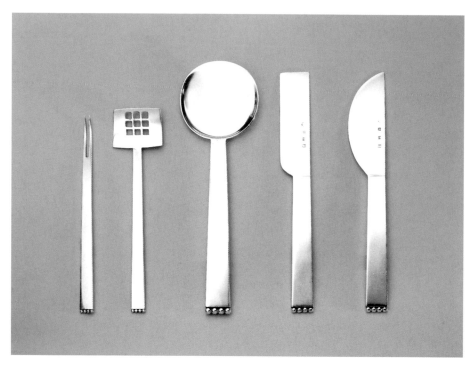

Five pieces from "Flat" serving set: crab fork, sardine fork, pastry serving spoon, cheese knife, and butter knife, 1904–07 cat. III.17

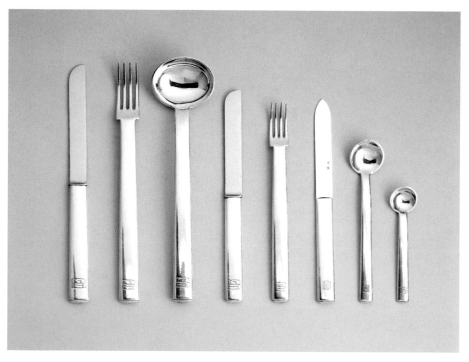

Eight pieces from "Round" flatware set, monogrammed EB and GHB: knife, fork, tablespoon, dessert knife, dessert fork, fruit knife, coffee spoon, mocha spoon, 1906 cat. III.29

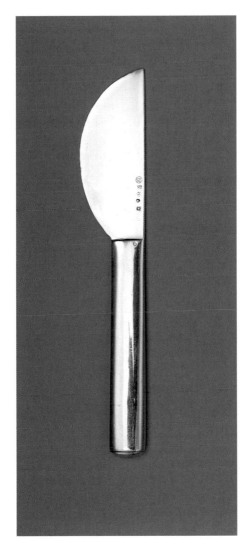

"Round" butter knife, 1907 cat. III.32

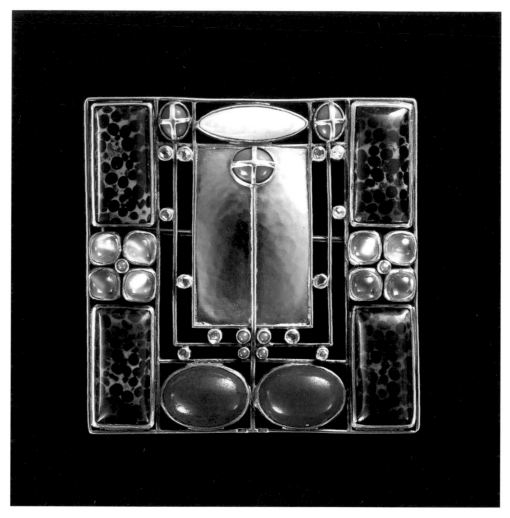

Brooch, 1904 cat. III.21

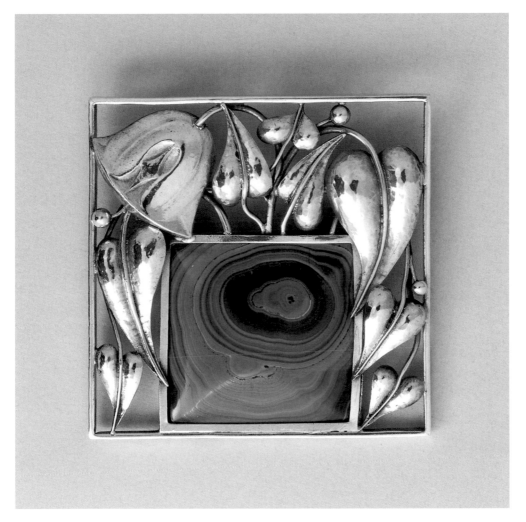

Brooch, 1912 cat. III.40

Necklace, 1905 cat. III.22

Silk belt with buckle for Emilie Flöge, 1910 cat. III.38

Display case for the Flöge sisters fashion house, 1904 cat. III.48

Vitrine, ca. 1902 cat. III.43

Combination collector's cabinet/library case for living room of Dr. Jerome Stonborough, 1905 cat. III.50

Vase, 1904 cat. III.49

Armchair, ca. 1903 cat. III.45

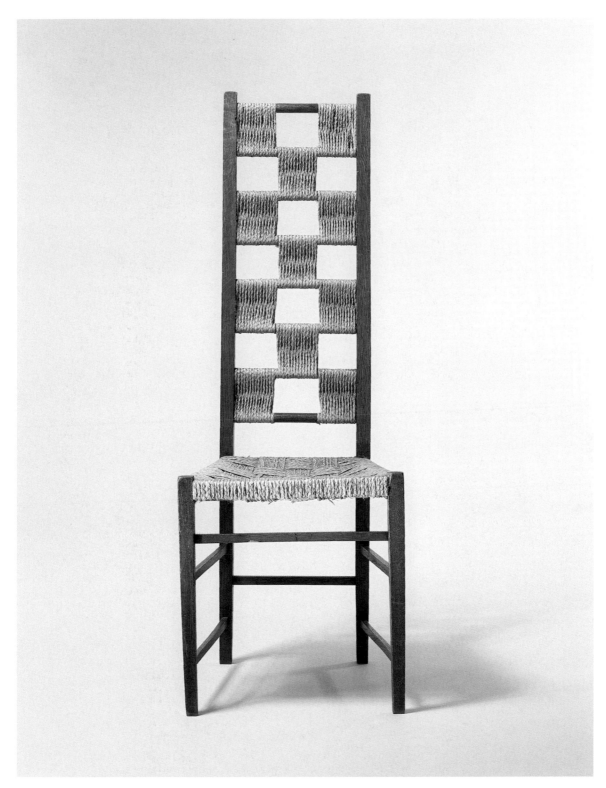

Chair, 1902 cat. III.44

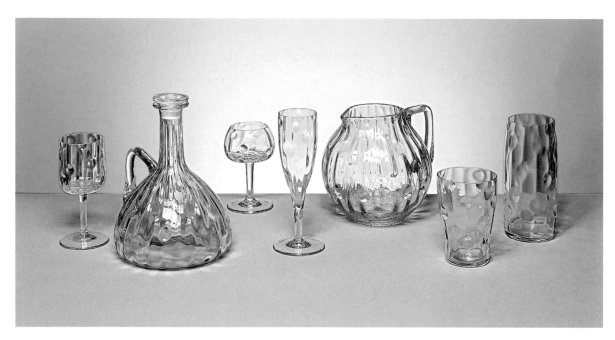

Glass service "For the Simple Household," 1899–1900 cat. III.41

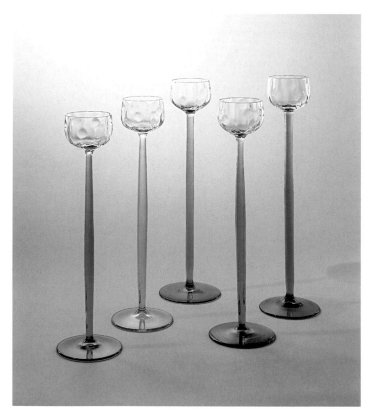

Five liqueur glasses, 1900 cat. III.42

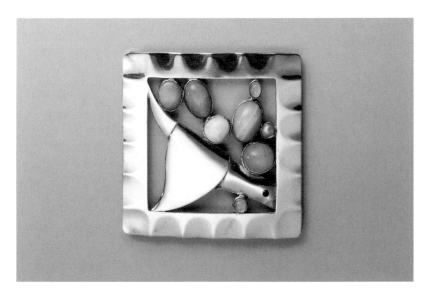

Belt buckle with original box, 1903 cat. III.47

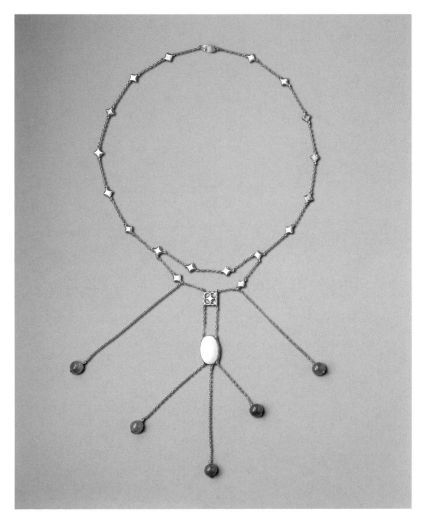

Necklace, 1903 cat. III.46

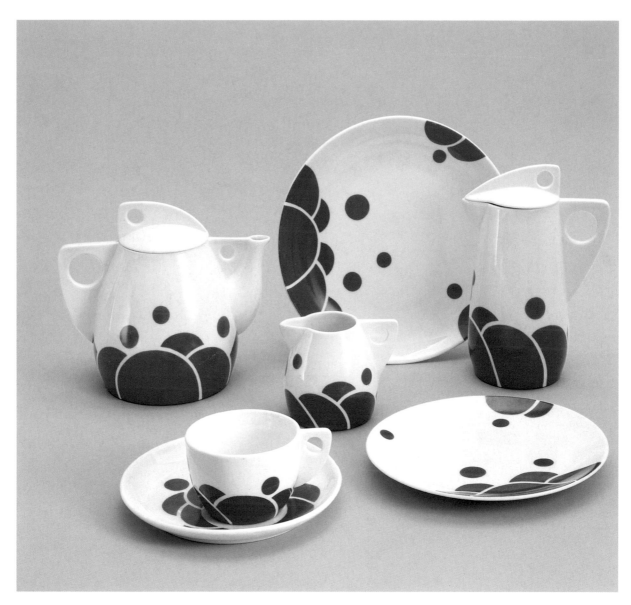

Tea and coffee service, 1901–02 cat. III.51

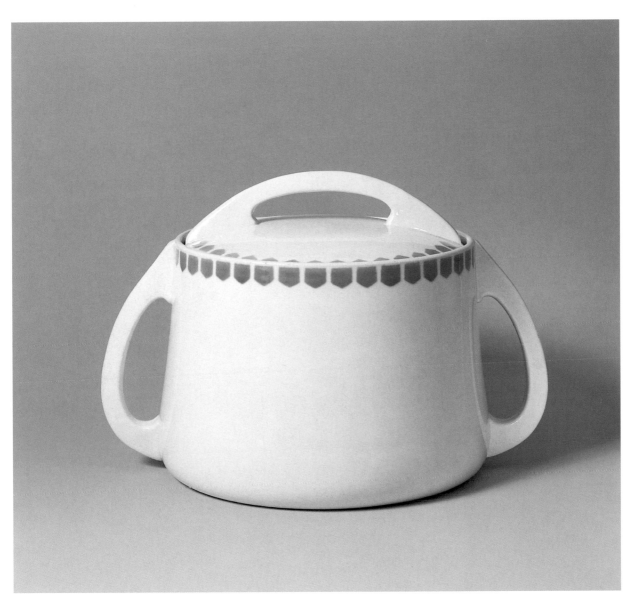

Tureen, 1901–02 cat. III.52

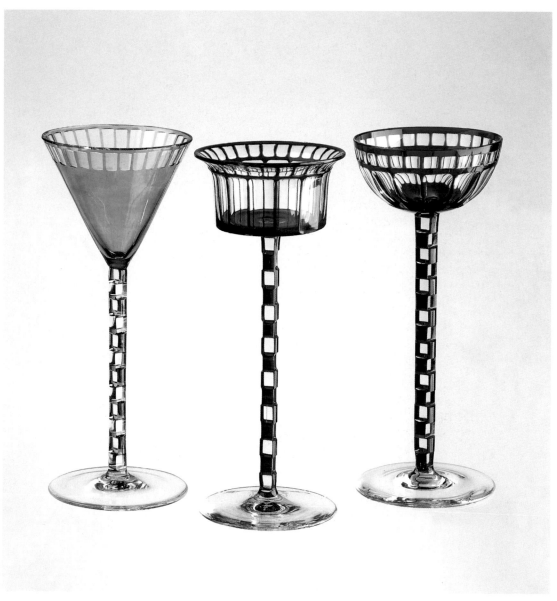

Three stemmed glasses, 1907 cat. III.53

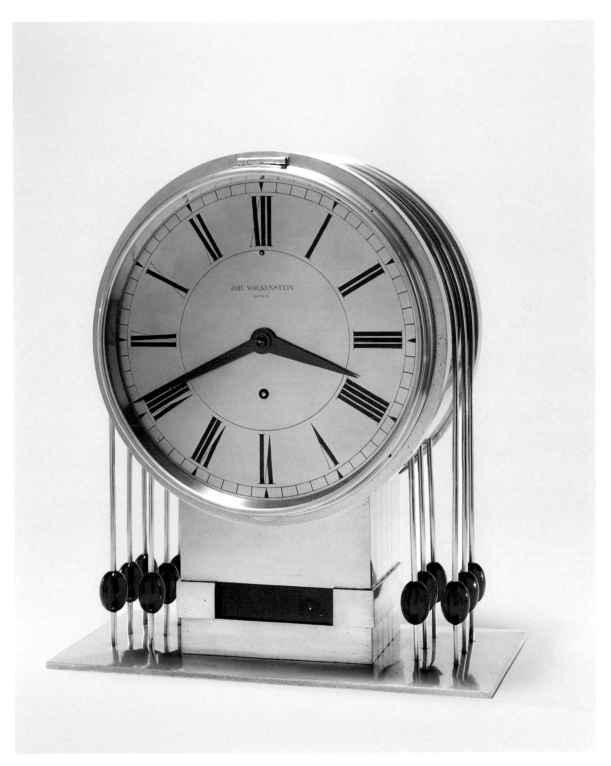

Mantelpiece clock for Milek tailor's shop, 1903 cat. III.54

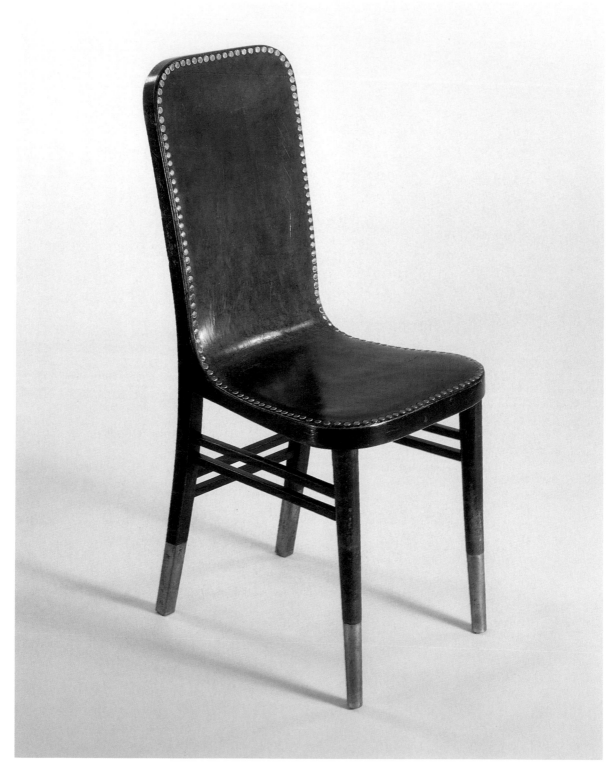

Chair, 1902 cat. III.55

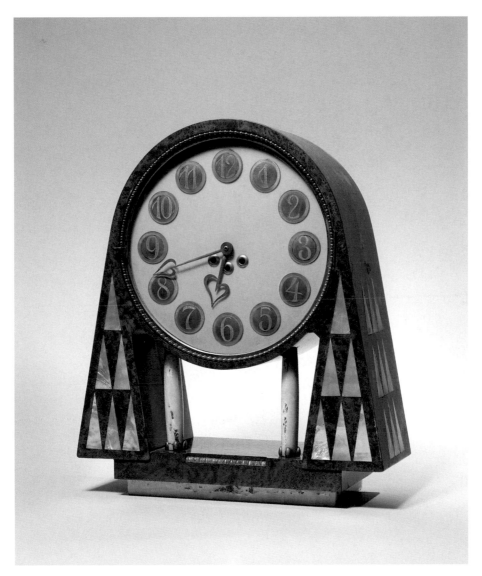

Mantelpiece clock for Paul Hopfner Restaurant, 1906 cat. III.56

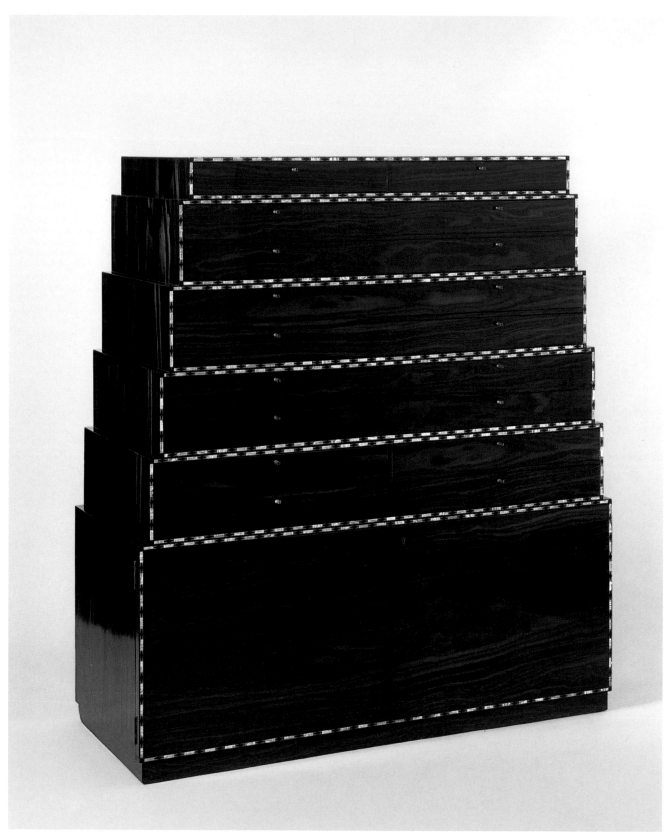

Drawing cabinet for *Kunstschau Wien*, 1908 cat. III.57

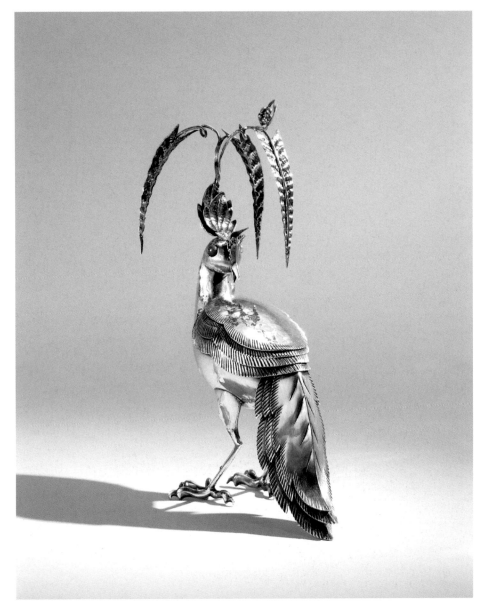

Bird-shaped candy box, 1920 cat. III.58

CHECKLIST: VIENNESE DECORATIVE ARTS AROUND 1900

Christian Witt-Dörring
Translated from the German by Michael Huey.

Please see Bibliography for cited literature.

Key:
AD = archival document
PD = preparatory drawing
MAK = Österreichisches Museum für angewandte Kunst (Austrian Museum of Applied Arts)

OTTO WAGNER

III.1
Vitrine for boudoir in the apartment of Otto Wagner (Vienna 3, Rennweg 3)
Design: Otto Wagner, 1892, Vienna
Execution: Alexander Albert
Walnut, gilt bronze mounts, nickel-plated brass, cut glass
H. 172 × W. 132 × D. 65 cm
(68.8 × 52.8 × 26 in.)
Marks: "Alex. Albert, Wien" stamped on locks
Ill. p. 412

Neue Galerie New York

Literature:
Asenbaum et al., p. 145, ill. pp. 126, 179, 180.

III.2
Buffet for the apartment of Otto Wagner (Vienna 6, Köstlergasse 3)
Design: Otto Wagner, 1898–99, Vienna
Execution: unknown
Solid walnut and walnut veneer, mother-of-pearl inlays, marble (replaced)
H. 107 × W. 150 × D. 71 cm
(42.8 × 60 × 28.4 in.)
Ill. p. 413

Private collection, New York

Literature:
PD: Historisches Museum der Stadt Wien, inv. no. 96005/17.
Asenbaum et al., pp. 83, 168ff.
Dekorative Kunst, vol. 7, no. 4 (1901), p. 95 (ill.).
Ver Sacrum, vol. 3, no. 19 (1900), pp. 295–298.

When Otto Wagner moved his primary residence to Hütteldorf, a village on the outskirts of Vienna, he decided he no longer needed such a spacious apartment in the city and instead took a small pied-à-terre (bedroom, dining room, bathroom) in the building designed by him at Köstlergasse 3. It was for this dining room that he designed the first "modern" Viennese furniture

(including this buffet) consistent with his maxim that, "Every architectural form has arisen in construction and successively become an art form."[1] The piece's outward appearance is based on the construction principle of "frame and panel," with the stone top resting between the vertical endposts. Together with the vertically oriented mother-of-pearl disks and the horizontally oriented panels, this produces a harmonious framework of crisscrossing lines. Wagner uses the decorative mother-of-pearl also as a structural element for psychological purposes: their rivetlike look is calculated to inspire confidence in the solidity of the piece.

These dining room furnishings occupy a special place in Wagner's oeuvre, signaling as they do a reorientation toward *Nutzstil* (functional style). The significance he accorded them may be deduced from the fact that he used the dining room armchair as an illuminated capital for his programmatic article "Die Kunst im Gewerbe" (Art in Industry), published in *Ver Sacrum.*[2] In terms of color, too, Wagner took a new approach to the decor of his dining room. In contrast to the dark, uniformly colored rooms of the Historicist period, he produced striking contrasts of light and dark by placing the furniture in proximity to a yellow silk wall covering with brown velvet appliqués, underneath a silver-colored plaster ceiling.

[1] Otto Wagner, *Modern Architecture,* intro. and trans. by Harry Frances Mallgrave, Santa Monica, Calif.: The Getty Center, 1988, p. 92.
[2] *Ver Sacrum,* vol. 3 (1900), p. 21.

III.3
Armchair for dispatch bureau of daily newspaper *Die Zeit*
Design: Otto Wagner, 1902, Vienna
Execution: J. & J. Kohn
Beechwood, stained dark brown, partly bent; nickel-plated metal, aluminum, new covering (formerly string webbing)
H. 78.5 × W. 56 × D. 55.7 cm
(31.4 × 22.4 × 22.3 in.)
Marks: stamped "J. & J. KOHN/Teschen.Austria"
Ill. p. 417

Private collection, New York

Literature:
Das Interieur, vol. 4 (1903), p. 77.

III.4
Reception desk for dispatch bureau of daily newspaper *Die Zeit*
Design: Otto Wagner, 1902, Vienna
Execution: unknown
Beechwood, stained gray-brown; aluminum
H. 137.3 × W. 132 × D. 91 cm
(54.9 × 52.8 × 36.4 in.)
Ill. p. 414

Private collection, New York

Literature:
Deutsche Kunst und Dekoration, vol. 11, no. 2 (December 1902), p. 118.

III.5
Ceiling lamp for dispatch bureau of daily newspaper *Die Zeit*
Design: Otto Wagner, 1902, Vienna
Execution: unknown
Nickel-plated white metal, porcelain sockets
H. 60.3 × W. 33.5 cm (24.1 × 13.4 in.)
Ill. p. 418

Private collection, New York

Literature:
Asenbaum et al., pp. 197ff.
Deutsche Kunst und Dekoration, vol. 11, no. 2 (December 1902), pp. 118ff.
Wiener Bauindustrie Zeitung, vol. 1 (1902–03), p. 137.

In 1902, Otto Wagner designed for the Viennese daily newspaper *Die Zeit* a street-level store, as well as a second-floor dispatch bureau on Kärntnerstrasse, one of the city's most popular shopping streets. In doing so, he formulated a completely new aesthetic for public space, based on the premise that "Something impractical cannot be beautiful."[1] The selection and use of materials played a crucial role in the commission, spawning a material language that demanded of the user a new kind of sensitivity, one irreconcilable with traditional ideas of ostentation.

As the most visible sign of his belief that new needs required new forms, Wagner designed the storefront out of aluminum, a material seldom used in Vienna at that time. For the interior he chose his materials based on durability, resistance to soiling, and ease of repair. The black/brown-stained bentwood furniture (see the reception desk [cat. no. III.4] and bentwood armchair [cat.

no. III.3]) stood out against a white wall protected up to roughly head level by gray-painted linoleum. For inlays and mounts on both furniture and plaster, aluminum—which, as Hevesi noted, does not oxidize[2]—was used. Similarly, the light fixtures for the dispatch bureau were not, as was common at the time, fashioned of brass, which involved complicated cleaning procedures, but of nickel-plated white metal. Together with the simple linear and geometric plasterwork, these formed the main decorative accent of the space. In between two broad, fluted plaster bands, the light fixtures, which each held two lightbulbs, were attached to the center of the ceiling in a single row down its length, one after another, visually not unlike track lighting. Their simple, stripped-down form, a radical break with traditional lighting fixtures of the pre-electric era, only revealed its full decorative and functional impact when viewed in the entirety of the space. The room's artificial lighting was installed parallel to the three large windows that took up one of the room's long sides. The intensity of the light was increased by mirrors attached to one of the room's small sides, above the wall vitrines and thus above eye level. Here one is instantly reminded of the lighting solution used by Adolf Loos five years later in his American Bar. The ultimate effect is to transform the lights into a single huge fixture in the shape of a long band of light that defines the space.

[1] Otto Wagner, *Modern Architecture,* intro. and transl. by Harry Frances Mallgrave, Santa Monica, Calif.: The Getty Center, 1988, p. 82.
[2] Ludwig Hevesi, "Der Neubau der Postsparkasse" (1907), in: Hevesi, *Altkunst–Neukunst: Wien 1894–1908,* Vienna: Konegen, 1909, p. 246.

III.6
Stool for main hall of Österreichische Postsparkasse
Design: Otto Wagner, 1906, Vienna
Execution: Gebrüder Thonet
Beechwood, stained gray-brown and bent; molded laminated wood; aluminum rivets
H. 47 × W. 42 × D. 42 cm
(18.8 × 16.8 × 16.8 in.)
Marks: Thonet trademark paper label; branded "THONET"
Ill. p. 416

Private collection, New York

Literature:
Asenbaum et al., pp. 207ff.
Ludwig Hevesi, "Der Neubau der Postsparkasse" (1907), in: Hevesi, *Altkunst–Neukunst: Wien 1894–1908,* Vienna: Konegen, 1909, pp. 245ff.

The philosophy behind the design of Wagner's bentwood furniture for the Österreichische Postsparkasse (Austrian Postal Savings Bank) and the dispatch bureau of the daily newspaper *Die Zeit* falls somewhere in between that of Adolf Loos and Josef Hoffmann. Like Loos's chair for the Café Museum (cat. no. III.9), they were not conceived as part of an ensemble but rather as light, mobile pieces that would stand in clear contrast to the rest of the room's furnishings. In this regard, the stool designed in 1906 for the Postsparkasse's main hall is a masterpiece.

By constructing the stool from five lengths of bentwood, screwed together, and a perforated plywood sheet, with a cut-out handle, for the seat, Wagner fully lives up to his tenets of design—tersely formulated in the fourth edition of his *Moderne Architektur* (retitled *Die Baukunst unserer Zeit* [Architecture in Our Time] in 1914) as follows: "I. Extremely precise grasp and complete fulfillment of the purpose (down to the smallest detail). II. Felicitous choice of materials (i.e. easily attainable, readily adaptable, lasting, economical). III. Simple and economic construction and, only after consideration of these three main points: IV. The form that evolves from these premises (which flows as though of its own volition from the pen and is always readily comprehensible)."[1] Aluminum disks are the sole decorative element here; serving as covers for the screws, they translate and reveal the manner of construction, expanding on an idea Wagner developed several years previously, using small mother-of pearl disks on the dining room furniture (cat. no. III.2) of his pied-à-terre on Köstlergasse.

[1] Otto Wagner, *Modern Architecture,* intro. and transl. by Harry Frances Malgrave. Santa Monica, Calif.: The Getty Center, 1988, p. 136.

III.7
Ceiling lamp for office in Österreichische Postsparkasse
Design: Otto Wagner, 1906, Vienna
Execution: unknown
Aluminum
H. 15.2 cm × Diam. 15.7 cm
(6.1 in. × 6.3 in.)
Ill. p. 419

Private collection, New York

III.8
Cabinet for Österreichische Postsparkasse
Design: Otto Wagner, 1912–13, Vienna
Execution: Bothe und Ehrmann, Vienna
Walnut veneer, interior oak veneer, nickel-plated brass mounts
H. 218 × W. 130.5 × D. 75.5 cm
(87.2 × 52.2 × 30.2 in.)
Ill. p. 415

Private collection, New York

Literature:
Asenbaum et al., pp. 275ff.

For the second phase of construction on the Postsparkasse, Wagner designed furnishings for the new administrative offices. Produced at the same time he was outfitting his second villa in Hütteldorf and his Vienna apartment at Döblergasse 4, these are the last furniture designs of his career. As such, the case furniture for these three interior sites represents the final stage of Wagner's evolution toward maximum simplicity of form. All share a clear emphasis on the panel as a constructive element and thus meet the criteria formulated by Wagner in 1914 in *Die Baukunst unserer Zeit*: "Even today our senses must already tell us that the lines of load and support, the panel-like treatment of surfaces, the greatest simplicity, and an energetic emphasis on construction and material will thoroughly dominate the newly emerging artform of the future."[1]
This maxim had been altered since its original publication in 1896. Together with panel-like structuring, which he had once felt would leave its imprint on modern architecture, Wagner now renounced "the horizontal line imitating the style of classical antiquity,"[2] and the formal aspects of his case pieces changed accordingly. Though he had used a prominent cornice to finish the top edge of his bedroom cabinet on Köstlergasse (1898–99), the Postsparkasse cabinets lack any horizontal articulation in the form of profile decorations. However, the top of the cabinet still has a clear horizontal conclusion due to the fact that the rail on top is nearly twice as wide as the rest of the frame. This creates an exciting emphasis on the flat surface of the cabinet sides, into which the doors appear to have been set as panels. By comparison, the man's wardrobe by Marcel Breuer (cat. no. IV.4), which postdates Wagner's Postsparkasse cabinet by fourteen years, gives an idea of the direction in which things were headed: increasingly, the cabinet assumes a subordinate role in the context of any given space. Pushed back into the wall, little remains of it but the pat-

tern of the veneer itself. Breuer takes Wagner's accentuation of flat surfaces a step further by actually leaving off the upper horizontal conclusion; the cabinet can no longer be defined as a self-contained space, instead becoming a single disposable surface. Wagner's cabinet therefore represents an important step in the genesis of modern case furniture.

[1] Otto Wagner, *Modern Architecture,* intro. and trans. by Harry Frances Mallgrave, Santa Monica, Calif.: The Getty Center , 1988, p. 124.
[2] Wagner, *Moderne Architektur,* Vienna: Schroll, 1896, p. 100.

ADOLF LOOS

III.9
Chair for Café Museum
Design: Adolf Loos, 1899, Vienna
Execution: J. & J. Kohn
Beechwood, stained red, partly bent; caning
H. 99.5 × W. 41 × D. 52 cm
(39.8 × 16.4 × 20.8 in.)
Marks: J. & J. Kohn trademark paper label; stamped "J. & J. KOHN/VSETIN.AUSTRIA"
Ill. p. 420

Private collection, New York

Literature:
Ludwig Hevesi, "Moderne Kaffeehäuser," in: *Kunst und Kunsthandwerk,* vol. 2 (1899), pp. 196–197.
Rukschcio and Schachel, pp. 418ff.

The Café Museum, situated diagonally across from the Secession, was one of Adolf Loos's earliest projects in Vienna. Dating from 1899, it housed one of the most radical modern Viennese interiors of its day. Owing to its unrelenting lack of ornamentation and strict functional furnishings, it was dubbed "Café Nihilism" by critics of the day.[1] The bentwood chair designed by Loos for this space has earned a unique place in the history of Viennese design; this particular piece is one of the few remaining chairs to have retained its original red surface.
Commenting on the café's reopening, Ludwig Hevesi, one of the most vehement defenders of Vienna's "Sacred Spring," emphasized the significance of the chairs' color. In a detailed description of the chairs' design process, he wrote: "The construction of the chairs merits particular notice. Loos designed and modeled them himself; the Kohn firm was responsible for their execution. Though they are of bentwood, this is no source of shame. On the contrary, they shun all that is reminiscent of cabinetmaking and joinery. They are meant to be—and seek only to be—bentwood.

Through functionally minded thickening and thinning of the wood in anticipation of distributing the load of the sitter's weight, and through the use of minutely calculated curves, the maker has created a chair that seems like a living functional being and meets with our general admiration. The chairs are of redstained and polished beechwood, creating a strong contrast to the mahogany all around them, as well as acting as a counterbalance to the green walls and velvet sofas. They cost ten florins apiece."[2]
The chair for the Café Museum illustrates Loos's attitude toward the question of to what extent architects should occupy themselves with designing furniture and objects for daily use. Displaying no signs of personal style whatsoever, its formal appearance owes entirely to the designer's concern with questions of function and production, all of which he seeks to answer in accordance with local tradition; thus his choice of bentwood. The production of this chair was also the first time an architect had worked in tandem with the Austrian bentwood industry and thus served as the starting point for a trend diametrically opposed to Loos's feelings about individuality being expressed through objects. For the bentwood industry, however, this was a crucial selling point, offering as it did an alternative to standardization and machine production, resulting in a product with individual character. In contrast to Hoffmann's designs for the bentwood industry, the Café Museum chair displayed no decorative unity with the interior's other furnishings, either in terms of color or in its formal appearance.

[1] Adolf Loos, *Sämtliche Schriften,* ed. by Franz Glück, Vienna: Herold, 1962, p. 309.
[2] Ludwig Hevesi, "Moderne Kaffeehäuser," in: *Kunst und Kunsthandwerk,* vol. 2 (1899), p. 197.

III.10
Table for dining/drawing room in the apartment of Dr. Hugo Haberfeld
Design: Adolf Loos, 1899, Vienna
Execution: Friedrich Otto Schmidt, Vienna
Wood, stained mahogany; copper; ceramic tiles (Minton), glazed yellow
H. 65.5 × Diam. 82.3 cm
(26.2 × 32.9 in.)
Ill. p. 424

Neue Galerie New York

Literature:
Das Interieur, vol. 4 (1903), pp. 14ff.
Adolf Loos, *Wohnungswanderungen,* Vienna, 1907, p. 11.
Rukschcio and Schachel, pp. 420ff.

III.11
Mantelpiece clock
Design: Adolf Loos, ca. 1902, Vienna
Execution: unknown
Brass, copper, cut glass
H. 48.2 × W. 42 × D. 25.5 cm
(19.3 × 16.8 × 10.2 in.)
Ill. p. 422

Private collection, New York

Literature:
Adolf Loos, exhibition cat., 1989,
p. 464.
Rukschcio and Schachel, pp. 44ff.

III.12
***"Knieschwimmer"* club chair**
Design: Adolf Loos, ca. 1930, Vienna
Execution: Vereinigte U.P. Werke, Brno,
Czechoslovakia
Walnut veneer, original velvet covering
H. 73 × W. 77 × D. 117 cm
(29.2 × 30.8 × 46.8 in.)
Ill. p. 464

Neue Galerie New York

Literature:
Acquisitions: 1977–1993, holdings cat.,
Brno, Uměleckoprůmyslové Museum,
1995, pp. 204ff., cat. no. 939.
Collection: 1900–1945, holdings cat.,
Brno, Muzeum města Brna–Špilberk,
1997, pp. 94ff.
Eva B. Ottillinger, *Adolf Loos: Wohn-konzepte und Möbelentwürfe,* Salzburg:
Residenz, 1994, pp. 148ff.
Rukschcio and Schachel, pp. 295ff.

In 1906, Adolf Loos first used the
"*Knieschwimmer*" in furnishing the
Vienna apartment of factory owner
Arthur Friedmann. Adapting a turn-of-the-century club chair from the London
firm Hampton & Sons, Loos had it pro-duced and modified to his specifications
by Friedrich Otto Schmidt in
Vienna (model no. 4306) and also put it
to use in a number of other interior
projects. The model shown here can
also be found in the Knize men's cloth-ing store in Paris, designed by Loos
(1927–28); in the great hall of the
Müller House in Prague (1928–30);
and in the Pilsen apartment of Dr. Josef
Vogl (1929). All of these models share
the same curved front and back legs; the
model in the Neue Galerie differs in
that its legs are abstracted into a wedge
shape similar to those used by Le Cor-busier, Pierre Jeanneret, and Charlotte
Perriand in their 1930 chaise longue.
Beginning in 1930, Loos had this ver-sion of the "*Knieschwimmer*" produced
in a small series by Vereinigte U.P.
Werke in Brno. In addition to serving as
its representative in Paris, Loos collabo-rated with VUPW on a regular basis,
conceiving of a number of furnishings

and household objects for the firm,
which had workshops in Prague, Brno,
and Bratislava, and beginning in 1924
put out its own magazine, *Woh-nungskultur* (Home Culture). For the
first issue, one of the editors, Bohuslav
Markalous, published an article titled
"Von der Sparsamkeit" (On Economy), a
series of discussions with Loos. The
designer's comments on the conse-quences of dressing up old functions in
new decorative clothing are of particu-lar relevance with respect to this
"*Knieschwimmer*" model, altered to his
specifications and available on the
open market: "I can invent something
new when I have a new task at hand;
for example, in architecture: a building
for turbines, hangars for airships. But a
chair, a table, a wardrobe? I will never
admit that we should alter forms tried
and true over centuries merely because
we have a yen for fantasy."
Among Loos's other projects with
VUPW was the furnishing of industrial-ist Dr. Victor Ritter von Bauer's classi-cist castle in Brno, which Loos renovat-ed in 1925. Also, thanks to Loos's
connections, VUPW was originally se-lected to furnish Le Corbusier's Pavilion
de l'Esprit Nouveau.

III.13
Sherry glass
Design: Adolf Loos, 1931, Vienna
Execution: J. & L. Lobmeyers Neffe,
Stefan Rath, ca. 1931–35, Steinschönau
Crystal glass with cut bottom
H. 5.5 × Diam. 3.8 cm (2.2 × 1.5 in.)
Ill. p. 423

Neue Galerie New York

Literature:
Vera Behalova, "Adolf Loos and Glass
Design: Loos's Correspondence with
Stephan Rath," in: *Journal of Glass
Studies*, vol. 16 (1974), pp. 120–124.
Rukschcio and Schachel, pp. 376ff.

JOSEF HOFFMANN

III.14
**Armoire for little girl's room in the
apartment of Max Biach**
Design: Josef Hoffmann, 1902, Vienna
Execution: unknown
Pine, painted white, blue, and black;
maple veneer with inlays of black-stained wood, white metal
H. 190 × W. 111 × D. 48 cm
(76 × 44.4 × 19.2 in.)
Ill. p. 425

Neue Galerie New York

Literature:
Innendekoration, vol. 16 (1905), p. 50 (ill.).
Sekler, p. 278.

In 1902, Josef Hoffmann designed an
apartment for Viennese industrialist
Max Biach and his wife Anna (née
Loew-Beer), in a late Eclectic town-house built by Ferdinand Fellner and
Hermann Helmer at Mayerhofgasse 20
in Vienna's fourth district. The armoire
pictured here is one of two from the
bedroom of their daughter Käthe, part
of a wall-unit setup that filled one of
the long sides of the room. The center
of this symmetrical arrangement was
accentuated by a washbasin topped by
a hanging cabinet and mirror, with an
armoire on either side. Bordering these
in turn were, to the left, an armoire-shaped, framed standing mirror and, to
the right, a curtain. Despite this con-sciously asymmetrical setup, the height
of the individual armoire elements cre-ates the feeling of a harmonious whole.
The single, unbroken horizontal line
found in so many of Hoffmann's interi-ors from this period—creating, in effect,
a room within a room—is absent here.
The armoire group stands as a separate
wall within the room, spatially distinct
from the other three walls. Similarly,
the stenciling on the wall is done with
no regard for the furniture in front
of it.
Aesthetically, the armoire comes to life
through the conscious use of contrast,
whether in terms of materials or in their
forms and shapes. Panels with maple
veneer are set into the white-painted
softwood of the doors, thus forming a
frame for the natural veneer pattern,
which in turn acts as the base for the
black-lined marquetry. The clean frame
construction, articulated by the blue-painted board, makes the doors seem
clamped flush to the top and bottom,
while the broad stripes on either side,
unlike the other constructive elements,
possess neither sharp corners nor a flat
surface but are instead slightly curved.
This adds to the otherwise vertical ori-entation a horizontal tension, echoed in
the drawer of the armoire's base and its
longish handles. To prevent these two
vertical white strips from overpowering
the broader verticals of the doors' white
framing elements, the doors themselves
are framed in a carved, semicircular
pattern of blue paint, again reinforcing
their verticality.

III.15
**Hanging lamp with eight bulbs for
the home of Max Biach**
Design: Josef Hoffmann, 1902, Vienna
Execution: Joh. Lötz Witwe (globes)
Nickel-plated white metal, iridescent
glass ("Papillon" style), fabric, wood
painted white and black
L. 216.6 cm (86.6 in.)
Ill. p. 429

Private collection, New York

Literature:
Innendekoration, vol. 16 (1905), p. 47 (ill.).

As the owner of the building at Mayer-hofgasse 20, Max Biach hired Josef
Hoffmann not only to redecorate his
apartment but also to redesign the
building's entrance and main stairway.
Hoffmann responded with plans for a
new wooden banister, painted white;
lead glass windows; and a hanging
lamp for the staircase. Just over two
meters long, the lamp illuminated the
entire staircase from the center of the
stairwell; its lower end reached a point
between the second and third floors.
While the long, drawn-out shape, with
each of the eight bulbs hanging from a
separate wire, give it a clear vertical
structure, the irregular groupings of
disk-shaped plates, each slightly raised
in the center, add a horizontal dimen-sion, culminating in the plate-shaped
cloth-skirted light fixture that encircles
four of the bulbs.
Integrating structure and materials into
a harmonious whole, Hoffmann fash-ioned an appropriate setting for electric
light, at that time still a novelty in Vien-na. The visible wires indicate the direc-tion of the light, while the silver, ham-mered surface of the disks and metal
mounts gives the light itself a strobe ef-fect, reflected also in the "Papillon"
style of the inset Lötz glass. This is no
longer a traditional chandelier; the ad-vent of electric light, as opposed to
candles or natural gas, enabled the use
of textiles as shades, as well as the
skirt mentioned above. This new setting
for a new kind of light was the logical
next step after Otto Wagner's combina-tion of flexible electric wiring and tradi-tional textile cords and trimmings for
the lighting above the chaise longue in
the boudoir of his Rennweg apartment
in 1892. In Wagner's design, lightbulbs
were screwed into glass globes hung
at varying heights to match the asym-metrical drapery of the canopy on the
bed, while the glass globes were sus-pended from drapery cords with large
tassels, concealing the electrical wires
within.

III.16
Chair for dining room in Purkers-dorf Sanatorium
Design: Josef Hoffmann, 1904, Vienna
Execution: J. & J. Kohn
Beechwood, stained brown, partly bent
and lathe-turned; laminated wood, red
leather covering (formerly red oilcloth)
H. 99 × W. 46 × D. 43 cm
(39.6 × 18.4 × 17.2 in.)
Marks: branded "J. & J.
KOHN/VSETIN.AUSTRIA"
Ill. p. 426

Neue Galerie New York

Literature:
AD: MAK-WWF 102, p. 87.
Bent Wood and Metal Furniture: 1850–1946, ed. by Derek Ostergard, New York: American Federation of Arts, 1987, p. 243.
Moderne Bauformen, vol. 7 (1908), p. 368.

In a 1905 article for the bimonthly *Hohe Warte*, cultural critic Joseph August Lux described a country's artistic vitality as that "invaluable economic commodity … known as TALENT."[1] In saying this, Lux, who was also the publisher of the journal, was merely confirming the guiding principle of the nineteenth-century decorative arts movement. Around 1900, however, this idea was imbued with a new meaning—unfettered by history; founded on subjectivity, individuality, and, often, nationalism. A number of Austrian companies saw the economic opportunity for industrial products inherent in this standpoint. Jakob and Josef Kohn, who in comparison to the Thonet Brothers were new to the field of bentwood furniture, were quicker than their competitors to realize the potential of homegrown creative capital, and in 1899 they began working with Vienna's finest designers (Adolf Loos, Otto Wagner, Josef Hoffmann, Koloman Moser, and others) to assemble a new product line. In the foreword to a revised version (undated, ca. 1910) of the 1906 Kohn sales catalogue for the U.S., the company's directors commented: "In fact, the adoption of the modern style by us at its early stages has opened up to our branch of manufacturing entirely new and wider fields until then undreamed of. To achieve this our firm had to invent a new method of bending stout pieces of wood almost to a right angle. This process allows of any, even the most acute, angle being produced without any glueing to a delicate permanent curved line."

Hoffmann's chairs for Purkersdorf Sanatorium and the 1908 Vienna *Kunstschau* (cat. no. III.36) are representative of this trend. While the first was designed for a very specific interior (the dining room of the Purkersdorf Sanatorium), the second was the result of J. & J. Kohn's desire to broaden its product line and was introduced to the public at the *Kunstschau* as veranda furniture for a small country house. The two chairs illustrate nicely the design's formal evolution, from the early emphasis on pure, simple shapes to the later, more decorative solutions after 1907. The structure of the pieces, with their simultaneously decorative and frame-reinforcing balls between the apron and the leg, is basically identical. In the backrest, however, one is witness to the completion

of an exciting process, a process that tests our traditional sense of tectonics. Instead of the closed structure of the Purkersdorf chair, we get an extremely fragile-looking structure that radiates a good deal more humor than stability. Apparently, after the turn of the century's ideological battles, enough energy and security had been built up to allow for this unbridled expression of subjectivity.

[1] *Hohe Warte*, vol. 1, no. 1 (1905), p. 73.

III.17
Five pieces from "Flat" serving set: crab fork, sardine fork, pastry serving spoon, cheese knife, and butter knife
Design: Josef Hoffmann, 1904–07, Vienna
Execution: Wiener Werkstätte, model nos. S 204, 231, 1009 (1907), 213, 214
Silver
Crab fork: L. 13.5 cm (5.4 in.)
Sardine fork: L. 14 cm (5.6 in.)
Pastry serving spoon: L. 17.3 cm (6.9 in.)
Cheese knife: L. 16.6 cm (6.6 in.)
Butter knife: L. 16.5 cm (6.6 in.)
Marks: WW, rose mark, JH, hallmark
Ill. p. 438

Private collection, New York

Literature:
AD: MAK-WWF 93, p. 5, and MAK-WWMB S5, p. 1041.
PD: MAK-K.I. 12086/10, 17, [unknown], 13.
American Modern, 1925–1940: Design for a New Age, exhibition cat., New York, American Federation of Arts, 2000, p. 97.
Deutsche Kunst und Dekoration, vol. 19 (1906–07), pp. 471ff. and 474ff. (ill.).
Hohe Warte, vol. 3, no. 2 (1906–07), pp. 29ff.
Innendekoration, vol. 20 (1909), pp. 46ff. (ill.).
Adolf Loos, *Sämtliche Schriften*, ed. by Franz Glück, Vienna: Herold, 1962, p. 274.
Waltraud Neuwirth, *Josef Hoffmann: Bestecke für die Wiener Werkstätte*, Vienna: Selbstverlag Dr. Waltraud Neuwirth, 1982.
New York Herald Tribune (March 3, 1929), ill.

Among the cutlery designed by Josef Hoffmann for the Wiener Werkstätte, the most well-known are the "Flat" and "Round" models (cat. no. III.29). The "Flat" model was produced from 1904 to 1910 for such clients as Fritz Waerndorfer (a co-founder of the Wiener Werkstätte), Dr. Hermann

Wittgenstein, and the Hohenzollern-Kunstgewerbehaus (Hohenzollern Decorative Arts House) in Berlin. The "Round" model, on the other hand, was produced not only by the Wiener Werkstätte but also, from 1906 to 1915, by Alpacca- und China-Silberwaren-Fabrik Bachmann & Co.—first for Cabaret Fledermaus, and then for Sonja Knips, Berthold Löffler, and Edward Titus, the husband of Helena Rubinstein. No other product from the Wiener Werkstätte elicited such vehement reactions as the "Flat" cutlery model. Whether enthusiastic or scathing, they left no room for consensus. The critic Ludwig Hevesi numbered among the most enraptured. After a private visit to the Waerndorfer home, he declared in 1905: "All the tableware was of Hoffmann's invention. Silverware of a distinctive, simple type proceeding straightaway from its purpose and from the character of the sheet metal, which is reinforced according to need, and bent and curved in places to fit the natural hand movements of the person eating. A sauce spoon could serve as the topic for a lecture on logic."[1] The first opportunity for public reaction came with *Der gedeckte Tisch* (The Set Table), an exhibition sponsored by the Wiener Werkstätte in its own showroom in October 1906 with both models of cutlery on view. This time Hevesi's words were those of a cultural critic: "It is said that one cannot eat properly with them; eat properly, to say nothing of eating 'English-style'! Mr. Waerndorfer has been the only one to purchase this cutlery service, and since that time I myself have eaten with it—as English as an Englishman—and found everything about it quite practical."[2] This passage calls to mind Russel Wright's flat cutlery model, designed around 1930, which seems to have found an enduring place in Anglo-Saxon culture.

The negative camp was divided into two main factions, one of which was repelled by the shape of the cutlery, and the other which deemed the artistic fuss over cutlery unnecessary in a modern culture. A critic from the *Hamburg Fremdenblatt* fell into the former camp, writing: "A new vision of a life lived in beauty appears before us. But then there's the cutlery. And the cutlery—whose least fault may be that it doesn't even appear to be cutlery—is very odd indeed. It truly reminds one of anatomical tools, and would surely spoil an appetite or two merely by virtue of its calling to mind the dissecting chamber. One might have broken with traditional forms without having had to create something unpleasant to the eye, the hand, and, in all likelihood, the mouth."[3] Adolf Loos was a protestor of the sec-

ond sort, a lone crier in the cultural desert. In a 1908 article, tellingly titled "Kulturentartung" (Cultural Degeneration), he used the Hoffmann cutlery as an example: "In order to find the style of our age, one must be a modern man. But those who seek to alter or replace with other forms things that are already in the style of our own age—I need merely mention the word *cutlery*—show by so doing that they have not recognized the style of our age. They will search for it in vain."[4]

[1] Ludwig Hevesi, "Das Haus Wärndorfer" (1905), in: *Altkunst–Neukunst: Wien 1894–1908*, Vienna: Konegen, 1909, p. 222.
[2] Hevesi, "Vom gedeckten Tisch" (1906), in: ibid., p. 229.
[3] *Hamburg Fremdenblatt* (October 17, 1906).
[4] Adolf Loos, *Sämtliche Schriften*, ed. by Franz Glück, Vienna: Herold, 1962, p. 274.

III.18
Candlestick
Design: Josef Hoffmann, 1904, Vienna
Execution: Wiener Werkstätte, model no. M 247
Iron, formerly painted white or black
H. 15.8 × Diam. 13.8 cm (6.3 × 5.5 in.)
Marks: WIENER/WERK/STÄTTE, rose mark, JH
Ill. p. 418

Private collection, New York

Literature:
PD: MAK-K.I. 12123/13.
Marian Bisanz-Prakken, "Das Quadrat in der Flächenkunst der Wiener Secession," in: *Alte und Moderne Kunst*, vol. 27, no. 180/181 (1982), pp. 40ff.
Josef Hoffmann, autobiographical essay, in: *Ver Sacrum: Neue Hefte für Kunst und Literatur*, vol. 4 (1972), pp. 105ff.

The square, today practically regarded as Josef Hoffmann's personal signature, was a decorative leitmotif of fin-de-siècle Vienna. Whether the inspiration for it came from Japan, Scotland (C. R. Mackintosh), or Holland (K.P.C. De Bazel) is no longer clear. But it is certain that it had to do with the newly awakened interest in two-dimensional artistic expression featuring graphic, linear composition, as opposed to a more painterly approach, and as a result it employed a new, contrast-rich palette. For the Wiener Werkstätte and Josef Hoffmann, this meant a concentration on the opposites black and white. It was this same impetus that led Hoffmann and Koloman Moser to develop a special product for the Wiener Werkstätte metal workshop, focusing on the structural and compositional qualities of the square and its potential for contrasting effects. In this process,

the square is no longer a mere decoration but rather a raw material; Hoffmann and Moser both used squares of stamped sheet metal—whether iron, nickel-plated or white-painted zinc, silver, or gold-plated silver—for a variety of objects. The resulting pieces, like much of Hoffmann's architecture, exist in a constant state of tension between two and three dimensions. Conceived by Hoffmann almost exclusively on graph paper, they serve as early testimony to the search for harmonious interplay between space and matter.

Hoffmann's candlestick was produced 75 times between 1904 and 1914: from zinc or sheet iron and either nickel-plated or painted white. Gustav Mahler was the first purchaser, taking home two in December 1904. Between 1904 and 1912, 171 specimens of Moser's vase (cat. no. III.49) were produced in silver with matte, polished, and gilt finishes. Again, Mahler was quick to purchase two, as did Helene Hochstetter, for whom Hoffmann furnished a city apartment in 1901–02 and built a home in the Hohe Warte settlement in 1906–07. Both the candlestick and the vase exhibit a clever balance between solid and transparent surfaces. In the candlestick, the closed socket is the logical extension of the candle's closed cylindrical body, while the thin yet solid stand is given volume subtly, through the use of pierced sheet metal. The vase's enclosed yet transparent glass body is surrounded by pierced silver sheet metal, with visual stability supplied by the solid, bowl-shaped base.

III.19
Centerpiece
Design: Josef Hoffmann, 1904, Vienna
Execution: Wiener Werkstätte (Josef Hossfeld), model no. S 267
Silver, malachite
H. 22.2 × L. 33.9 × W. 33.9 cm
(8.9 × 13.6 × 13.6 in.)
Marks: WW, rose mark, JH, jh, AA, hallmark
Ill. p. 431

Private collection, New York

Literature:
AD: MAK-WWF 93, p. 7.
Deutsche Kunst und Dekoration, vol. 15, no. 1 (October 1904), p. 26 (ill.).

This centerpiece was made in only one version in 1904 by the Wiener Werkstätte and was purchased by a Mr. Hirschwald for an exhibition of Wiener Werkstätte pieces organized the same year by the Hohenzollern-Kunstgewerbehaus in Berlin. This show, the Wiener Werkstätte's first presentation of its products outside of Austria, generated international media interest. Visitors

were struck by the utterly new look of the works, whose forms and shapes seemed consciously to defy standard notions of conspicuous display. In this respect, the centerpiece is typical of the early Wiener Werkstätte. Functionally, it is an upper-middle-class item for daily use. While its material language (silver and malachite) still clearly identifies it with this social milieu, its formal language takes it into new, unclassifiable territory. Contrasting with its formal modesty, however, is an individualistic artistry, backed by a powerful imagination. This renders the object a precious novelty, and therefore a desirable item. Hoffmann's design depends a great deal on its transparency and light structure, and yet also succeeds in conveying its basic "load and support" function. The thin silver bars of the base appear to sag under the weight of the centerpiece, which is made of hammered sheet silver. It is not physical pressure, however, that forces them into this shape, but the designer's creative will speaking through them.

III.20
Table clock
Design: Josef Hoffmann, 1904–12
Execution: 1912, Wiener Werkstätte (Karl Kallert), model no. M 127
Alpaca, brass, burnished copper, oxidized silver, all partly hand-hammered
H. 20.5 cm (8.2 in.)
Marks: WW, rose mark, JH, CK, 421890 stamped on back plate
Ill. p. 436

Private collection, New York

Literature:
AD: MAK-WWF 97, p. 5.
PD: MAK-K.I. 12161/5.
Deutsche Kunst und Dekoration, vol. 15, no. 1 (October 1904), p. 16 (ill. of 1904 model).

III.21
Brooch
Design: Josef Hoffmann, 1904, Vienna
Execution: Wiener Werkstätte (Karl Ponocny), model no. G 363
Silver, partly gilt; diamonds, moonstones, opal, lapis lazuli, coral, leopardite
H. 5.1 × W. 5.1 cm (2 × 2 in.)
Marks: WW, rose mark, JH, KP, hallmark
Ill. p. 440

Neue Galerie New York

Literature:
AD: MAK-WWMB 05 (GSM 5)/0967.
PD: MAK-K.I. 12144/46.
Die Wiener Werkstätte, exhibition cat., Vienna, Österreichisches Museum für angewandte Kunst, 1967, cat. no. 174, pl. 25.

"Only those who appreciate workmanship—that is, workmanship of a kind indistinguishable from love or art—are in a position to understand these accomplishments. This workmanship is the 'higher value' of the jewelry, in the face of which its mere material worth falls away; it follows that the degree of culture or barbarity in a man is expressed in the jewelry as well."[1] These thoughts, articulated by Joseph August Lux on the occasion of the reopening of the Galerie Miethke at Graben 17 in 1905, could be described as a credo of fin-de-siècle Viennese jewelry production. The Galerie Miethke presentation was the first by the Wiener Werkstätte outside its own premises. In the quotation above, Lux sought to contrast material value, divorced from human creativity, with the higher values of art and craft. This view paralleled that of the Viennese reform movement known as the "Sacred Spring," which attributed no less value to the creative powers of humans than to the value of the materials themselves. According to critic Hermann Bahr, the Viennese had plenty to learn from the Americans in this regard: "We learn from them to listen to the material. Every material has its own language; we must understand it and through it speak our thoughts and feelings. Just as there are the genres Drama, Lyric, and Epic, so wood, leather, and glass each occupy a separate realm. The Americans' cry can be expressed thus: let the artist become a craftsman."[2] Not coincidentally, the library of the Wiener Werkstätte contained, specially bound in bindings of its own design and execution, a run of the American journal *The Craftsman* (October 1901–September 1904).[3]

The brooch pictured here calls to mind the geometrically stylized ornamental inventions of Klimt. Whether it be the abstract ornamental square in the baseboard trim in the background and the ornament-filled arch behind the sitter's head in the portrait of Fritza Riedler (1904–06), or his signature square on the portraits of Emilie Flöge (1902) and Hermine Gallia (1903–04), Klimt's grouping and connection of the simplest elements and letters cause the viewer to see the pattern as a closed unity. Similarly, Hoffmann's brooch is an ornamental square assembled from a wide variety of materials and forms to create an almost Ravenna-like mosaic. Yet it is the stones' colors, rather than their shapes, that give the impression of variety; this precedence of color over shape was typical of the two-dimensional art of the day.

In the course of 1904, Hoffmann designed eight square brooches with various types of ornamentation and stone, each executed just once.[4] The first fin-

ished model (G 363) was purchased by Fritz Waerndorfer, patron of the arts and a financier of the Wiener Werkstätte, for 300 crowns on December 24, 1904, as a Christmas present for his wife Lilly. Three later models (G 366–368) were purchased for Emilie Flöge by Gustav Klimt between February and December 1905.

[1] Joseph August Lux, "Moderne Kunst," in: *Hohe Warte,* vol. 2, no. 4 (1905), p. 69.
[2] *Secession,* Vienna: Wiener Verlag, 1900, p. 36.
[3] Christie's, New York, *Vienna and Darmstadt: Design Circa 1900,* December 13, 1986, lot no. 473.
[4] *Deutsche Kunst und Dekoration,* vol. 17 (1905–06), pp. 186–187 (ill.).

III.22
Necklace
Design: Josef Hoffmann, 1905, Vienna
Execution: Wiener Werkstätte, model no. G 478
Silver, gold foil
L. 33.5 × W. 3.3 cm (13.4 × 1.3 in.)
Marks: WW, JH, hallmark
Ill. p. 442

Private collection, New York

Literature:
AD: MAK-WWF 91, p. 18.

III.23
Sugar bowl
Design: Josef Hoffmann, 1905, Vienna
Execution: Wiener Werkstätte (Adolf Wertnik), model no. S 609
Silver
H. 11 × Diam. 20.3 cm (4.4 × 8.1 in.)
Marks: WW, JH, hallmark
Ill. p. 432

Private collection, New York

Literature:
AD: MAK-WWF 93, p. 47.

III.24
Tray for Samuel Waerndorfer
Design: Josef Hoffmann, 1905, Vienna
Execution: Wiener Werkstätte (Konrad Schindel), model no. S 498
Silver-plated white metal
L. 54.5 × W. 34.5 cm (21.8 × 13.8 in.)
Marks: WW, rose mark, JH, KS
Ill. p. 431

Private collection, New York

Literature:
AD: MAK-WWF 93, p. 16.

III.25
Basket
Design: Josef Hoffmann, 1905, Vienna
Execution: Wiener Werkstätte (silversmith AB), model no. S 509

Silver, ivory
H. 16 × L. 26.3 × W. 21.9 cm
(6.4 × 10.5 × 8.8 in.)
Marks: WIENER/WERK/STÄTTE, WW,
rose mark, JH, AB, hallmark
Ill. p. 432

Private collection, New York

Literature:
AD: MAK-WWF 93, p. 18.
PD: MAK-K.I. 12033.

III.26
Flower basket
Design: Josef Hoffmann, 1905, Vienna
Execution: Wiener Werkstätte, model
no. M 508
Zinc-plated copper
H. 24 × L. 4.3 × W. 4.3 cm
(9.6 × 1.7 × 1.7 in.)
Marks: WIENER/WERK/STÄTTE, rose
mark, JH
Ill. p. 430

Private collection, New York

Literature:
AD: MAK-WWF 97, p. 25.

III.27
Vase
Design: Josef Hoffmann, 1905, Vienna
Execution: Wiener Werkstätte (Johann
Blaschek), model no. M 457
Hand-hammered alpaca, brass
H. 28.5 × L. 13.5 × W. 13.5 cm
(11.4 × 5.4 × 5.4 in.)
Marks: WW, rose mark, JH, JB
Ill. p. 433

Private collection, New York

Literature:
AD: MAK-WWF 97, p. 18.

The first article on the Wiener Werk-
stätte in a major decorative arts journal
outside of Austria was published in
Deutsche Kunst und Dekoration in
1904; the illustrations depicted only the
group's metalwork.[1] Similar in spirit to
the vase shown here, the pieces were
characterized by the individuality of
their design, demanding surroundings
of similar style—a demand that was in
fact met by the Wiener Werkstätte,
committed as it was to the idea of a
Gesamtkunstwerk.
Founded in 1903 as a firm for the pro-
duction of high-quality metal objects,
the Wiener Werkstätte was based on
the idea of the English Guild of Handi-
crafts. Charles Rennie Mackintosh, who
had participated in the eighth Seces-
sion exhibition together with Wiener
Werkstätte founders Josef Hoffmann,
Koloman Moser, and industrialist Fritz
Waerndorfer, offered the following ad-
vice in a letter to Hoffmann: "If one

wants to achieve artistic success with
your program (and artistic success
must be your first thought) every object
you pass from your hand must carry an
outspoken mark of individuality, beauty,
and the most exact execution."[2]
These three criteria, which were to be-
come the creed of the Wiener Werk-
stätte, are clearly at work in Hoffmann's
vase, originally dubbed a "flower stand."
Here the object's appearance is no
longer achieved by means of decora-
tion but instead through the composi-
tion itself. Even the original description
of its function as a flower stand, as op-
posed to the neutral *vase*, betrays a
conscious way of looking at the overall
form. Put together like a small, abstract
piece of architecture composed of
eight cylinders, it stands on its own
square base. The shiny silver surfaces
of the geometric shapes are decorated
with hand-hammering, allowing them to
meld again into a single, sensual, shim-
mering object. The nature of the flower
presents a contrast to the geometry of
the "vase" device, each opposite help-
ing to articulate the other, thereby
bringing to light their differing individu-
ality.

[1] Joseph August Lux, "Wiener Werkstätte," in:
Deutsche Kunst und Dekoration, vol. 15, no. 1
(October 1904), p. 7.
[2] Eduard F. Sekler, *Josef Hoffmann: The Ar-
chitectural Work*, Princeton: Princeton Univer-
sity Press, 1985, p. 65.

III.28
**Hanging lamp for salon in the
apartment of Dr. Hermann
Wittgenstein**
Design: Josef Hoffmann, 1905, Vienna
Execution: Wiener Werkstätte, model
no. M 451
Hand-hammered alpaca, glass
L. 120 cm (48 in.)
Ill. p. 428

Private collection, New York

Literature:
AD: MAK-WWF 97, p. 15.

III.29
**Eight pieces from "Round" flat-
ware set, monogrammed EB and
GHB: knife, fork, tablespoon,
dessert knife, dessert fork, fruit
knife, coffee spoon, mocha spoon**
Design: Josef Hoffmann, 1906, Vienna
Execution: k. k. priv. Alpacca- und
China-Silberwaren-Fabrik Bachmann &
Co. for Wiener Werkstätte, model nos.
M 848, 847, 852, 849, 850, 858, 851,
853
Silver-plated alpaca
Knife: L. 21.5 cm (8.6 in.)
Fork: L. 21.5 cm (8.6 in.)
Tablespoon: L. 21.8 cm (8.7 in.)

Dessert knife: L. 18.3 cm (7.3 in.)
Dessert fork: L. 18.2 cm (7.3 in.)
Fruit knife: L. 16.7 cm (6.7 in.)
Coffee spoon: L. 14.8 cm (5.9 in.)
Mocha spoon: L. 10.3 cm (4.1 in.)
Marks: WW, rose mark, JH
Ill. p. 438

Private collection, New York

Literature:
PD: MAK-K.I. 12086/23, 22, 27, 25,
40, 28, 29.
Deutsche Kunst und Dekoration, vol.
19, no. 6 (March 1907), p. 473 (ill.).
Hohe Warte, vol. 3, no. 2 (1906–07), p. 30.
Waltraud Neuwirth, *Josef Hoffmann:
Bestecke für die Wiener Werkstätte*,
Vienna: Selbstverlag Dr. Waltraud
Neuwirth, 1982.

III.30
Coffeepot for Jenny Mautner
Design: Josef Hoffmann, 1906, Vienna
Execution: Wiener Werkstätte (Josef
Wagner), model no. S 650
Silver, cherry wood
H. 23 × W. 15 cm (9.2 × 6 in.)
Marks: WW, rose mark, JH, JW,
hallmark
Ill. p. 435

Private collection, New York

Literature:
AD: MAK-WWF 93, p. 35.
Deutsche Kunst und Dekoration, vol.
22, no. 8 (May 1908), p. 90 (ill.).

This coffeepot, produced only once by
the Wiener Werkstätte, was originally
part of a coffee and tea service consist-
ing of a tray, coffee- and teapots,
creamer, water jug, sugar box, and
sugar tongs. It was purchased from the
Wiener Werkstätte in 1906 for the
wedding of Kathi Mautner and Dr. Hans
Breuer by Jenny Mautner and Moriz
Schur, the mother and uncle of the
bride, for 850 crowns. This connection
to the Viennese Jewish upper middle
class was typical for Vienna's new art
movements and, by extension, for the
clients of the Wiener Werkstätte. In her
marriage to Isidor Mautner, Jenny
Mautner wed one of the chief textile
manufacturers of the Austro-Hungarian
Empire; she herself was the aunt of the
Wiener Werkstätte's co-founder and
first financier, Fritz Waerndorfer.
Breuer, for his part, was the son of the
internist Dr. Josef Breuer, a mentor of
Sigmund Freud.
Culturally, the Mautners identified with
the Biedermeier tradition, rediscovered
in Vienna around 1900, while the
Waerndorfers were sympathetic to the
avant-garde art of the day. Thus when
Isidor and Jenny Mautner purchased
the Geymüller-Schlössel, an early nine-

teenth-century summer estate in Pöt-
zleinsdorf, an outlying district of Vienna,
they decorated it entirely in Bieder-
meier fashion. On the night before their
wedding, the young couple held a party
at their new home, with all of the
guests dressed in Biedermeier cos-
tume. Fritz Waerndorfer, on the other
hand, had his villa in Währing decorated
by Josef Hoffmann, Koloman Moser,
and Charles Rennie Mackintosh.
The Mautner coffeepot combines both
of these tendencies. Its basic form is
that of a simple, classicist, early nine-
teenth-century coffeepot, with a long
straight spout and a horizontally
attached handle. Its modernity derives
from the absence of any surface deco-
ration, though a decorative effect is
achieved through the pagoda-like
curves of the top.

III.31
Flower basket
Design: Josef Hoffmann, 1906, Vienna
Execution: Wiener Werkstätte, model
no. M 614/M 975
Nickel-plated brass, glass inset
H. 26.7 × W. 6.6 × D. 6.6 cm
(10.7 × 2.6 × 2.6 in.)
Marks: WW, rose mark
Ill. p. 430

Private collection, New York

Literature:
AD: MAK-WWF 97, pp. 29, 132.
PD: MAK-K.I. 12032/21, 22.

III.32
"Round" butter knife
Design: Josef Hoffmann, 1907, Vienna
Execution: Wiener Werkstätte (uniden-
tified silversmith FK), model no. S 893
Silver
L. 16.7 cm (6.7 in.)
Marks: WW, rose mark, JH, FK,
hallmark
Ill. p. 439

Private collection, New York

Literature:
AD: MAK-WWMB 09 (S05)/0893.

III.33
**Goulash serving dish for Cabaret
Fledermaus**
Design: Josef Hoffmann, 1907, Vienna
Execution: Wiener Werkstätte, model
no. M 832
Silver-plated alpaca
H. 11.3 × W. 19.2 cm (4.5 × 7.7 in.)
Marks: WW
Ill. p. 434

Private collection, New York

Literature:
AD: MAK-WWF 97, pp. 30, 32.

Deutsche Kunst und Dekoration, vol. 23 (1909), p. 183 (ill.).
Josef Hoffmann, autobiographical essay, in: *Ver Sacrum: Neue Hefte für Kunst und Literatur,* vol. 4 (1972), p. 118.

In 1907, Ludwig Hevesi described the cabaret as "a place where immaculately dressed muses in the latest cosmopolitan fashions have an artistically reliable place to go where no cultured person should feel bored, or at least should only feel bored in the manner of his own choosing. German cabaret, on the other hand, has become a rather heavy thing, in some ways difficult to distinguish from the good old '*Sauwirt.*'"[1] After members of the literary circle of Café Central saw their plans for a new cabaret fall by the wayside due to lack of finances, in October 1907 the Cabaret Fledermaus, funded by Fritz Waerndorfer and designed by Josef Hoffmann, opened at the corner of Kärntnerstrasse and Johannesgasse in the basement of a new building, eight meters below street level.
Besides a bar, a spectator gallery, a stage, and various service areas, there was also a kitchen headed by a Parisian chef. Hoffmann described his ambitions for the project, realized with the help of the Wiener Werkstätte and its artists, as follows: "We stressed the fact that every detail of the building was to be scrupulously done in an honest manner as an organic artistic exercise; our artistic sensibility was to be applied to the most insignificant-seeming object with the same care as to the most important: the interior decoration, the table settings, the light fixtures, and the smallest objects for everyday use were thus all created from the unified basic idea of the overall space."[2] Representing the fruition of this idea are the gravy boat (cat. no. III.34) and the goulash serving dish, captivating in their minimalist yet warm appearance.

[1] Ludwig Hevesi, "Kabaret Fledermaus" (1907), in: Hevesi, *Altkunst–Neukunst: Wien 1894–1908,* Vienna: Konegen, 1909, p. 240.
[2] Program brochure on the opening of the Cabaret Fledermaus, Vienna, n.d., pp. 9–10.

III.34
Gravy boat for *Cabaret Fledermaus*
Design: Josef Hoffmann, 1907, Vienna
Execution: Wiener Werkstätte, model no. M 825
Silver-plated alpaca
H. 8.5 × W. 17 cm (3.4 × 6.8 in.)
Marks: WW
Ill. p. 434

Private collection, New York

Literature:
AD: MAK-WWF 97, pp. 30, 31.

III.35
"Sitzmaschine"
Design: Josef Hoffmann, 1908, Vienna
Execution: J. & J. Kohn
Beechwood, stained brown, partly bent and lathe-turned; laminated wood
H. 110 × W. 62 × D. 83 cm (44 × 24.8 × 33.2 in.)
Marks: branded "J. & J. KOHN/Teschen.Austria"
Ill. p. 427

Private collection, New York

Literature:
Bent Wood and Metal Furniture: 1850–1946, ed. by Derek Ostergard, New York: American Federation of Arts, 1987, p. 257.
Carl Burchard, *Gutes und Böses in der Wohnung in Bild und Gegenbild (Grundlagen für neues Wohnen),* Leipzig: Beyer, 1934, p. 161.
Dekorative Kunst, vol. 16, no. 11 (September 1908), p. 542 (ill).
Moderne Bauformen, vol. 7 (1908), p. 370.
The Studio Year Book of Decorative Art (1910), p. 223.
Christian Witt-Dörring, "Bent Wood Production and the Viennese Avant-Garde: Thonet Brothers and J. and J. Kohn, 1899–1914," in: *Bent Wood and Metal Furniture: 1850–1946,* ed. by Derek Ostergard, New York: American Federation of Arts, 1987, pp. 95ff.

In the latter half of the twentieth century, Josef Hoffmann's "Sitzmaschine" became an icon of modern furniture design. It was during this period, too, that its metaphorical name was coined in an attempt to establish it as part of the same evolutionary line as the tubular-steel furniture of the Bauhaus. The tone of the name makes it seem borrowed from the combative vocabulary of the National Socialist movement. In a 1934 volume on the fundamentals of new living, Carl Burchard used Breuer's B3 tubular-steel chair (later known as the "Wassily Chair"; cat. no. IV.3) as a negative example, describing it as follows: "Seating as a sitting machine. The tubes and straps support [the sitter] well, but the shape is reminiscent of an electric chair."[1] Though still neutrally labeled model no. 670 in J. & J. Kohn's 1916 sales catalogue, Hoffmann's design, based on the Morris chair with adjustable backrest, was introduced at the 1908 *Wiener Kunstschau* in a traditional, bourgeois atmosphere still based on the status-conscious Biedermeier attitude. Hoffmann had a country house of his own design erected on the grounds,

and filled its eight rooms with bentwood furniture, also designed by him and executed by J. & J. Kohn. The "*Sitzmaschine*" stood at an angle in front of a fireplace niche and, together with the chair for the Cabaret Fledermaus and the Seven Balls Chair (cat. no. III.36), was among the more progressive of the house's furnishings.

[1] Carl Burchard, *Gutes und Böses in der Wohnung in Bild und Gegenbild (Grundlagen für neues Wohnen),* Leipzig: Beyer, 1934, p. 39.

III.36
Chair for *Kunstschau Wien,* 1908
Design: Josef Hoffmann, 1908, Vienna
Execution: J. & J. Kohn
Beechwood, stained brown, partly bent and lathe-turned; molded laminated wood
H. 109 × W. 45 × D. 44 cm (43.6 × 18 × 17.6 in.)
Marks: stamped "J. & J. KOHN/Teschen.Austria"
Ill. p. 426

Private collection, New York

Literature:
Bent Wood and Metal Furniture: 1850–1946, ed. by Derek Ostergard, New York: American Federation of Arts, 1987, pp. 255ff.
Deutsche Kunst und Dekoration, vol. 23, no. 1 (October 1908), p. 37 (ill.).

III.37
Hand mirror
Design: Josef Hoffmann, 1909, Vienna
Execution: Wiener Werkstätte, model no. S 1599
Silver
L. 24.4 × W. 12.2 cm (9.8 × 4.9 in.)
Marks: WW, hallmark
Ill. p. 437

Private collection, New York

Literature:
AD: MAK-WWF 94, p. 102.
PD: MAK-K.I. 12136/10.

III.38
Silk belt with buckle for Emilie Flöge
Design: Josef Hoffmann, 1910, Vienna
Execution: Josef Souval for Wiener Werkstätte, model no. M 107
White and black enamel on brass, white silk
H. 6 × W. 6 cm (2.4 × 2.4 in.)
Marks: WIENER/WERK/STÄTTE
Ill. p. 443

Private collection, New York

Literature:
AD: MAK-WWF 89, p. 20.
PD: MAK-K.I. 12158/15.

III.39
Candy tray
Design: Josef Hoffmann, 1912, Vienna
Execution: Wiener Werkstätte, model no. S 2610
Silver, lapis lazuli
H. 5.4 × L. 15.6 × W. 15.6 cm (2.2 × 6.2 × 6.2 in.)
Marks: WW, rose mark, JH, A, hallmark
Ill. p. 437

Private collection, New York

Literature:
AD: MAK-WWF 95, p. 150.
PD: MAK-K.I. 12006/30.

III.40
Brooch
Design: Josef Hoffmann, 1912, Vienna
Execution: Wiener Werkstätte, model no. S 2451
Silver, malachite
H. 5 × W. 5 cm (2 × 2 in.)
Marks: WW, JH, A, hallmark
Ill. p. 441

Private collection, New York

Literature:
AD: MAK-WWMB 14 (S10)/2451.
PD: MAK-K.I. 12146/44.

KOLOMAN MOSER

III.41
Glass service "For the Simple Household"
Design: Koloman Moser, 1899–1900, Vienna
Execution: for E. Bakalowits & Söhne, model no. 100A
Clear, mold-blown glass
Carafe: H. 19.5 cm (7.8 in.)
Water pitcher: H. 14.5 cm (5.8 in.)
Champagne flute: H. 16.9 cm (6.8 in.)
Beer glass: H. 15.2 cm (6.1 in.)
Red wine glass: H. 13.5 cm (5.4 in.)
White wine glass: H. 11.6 cm (4.6 in.)
Wine glass: H. 11.4 cm (4.6 in.)
Water glass: H. 10.5 cm (4.2 in.)
Ill. p. 450

Private collection, New York

Literature:
AD: MAK-K.I. 7393 (photo).
MAK-B.I. 32066A, p. 21v. (production drawing).
Dekorative Kunst, vol. 7, no. 4 (1901), p. 227 (ill.).
Kunst und Kunsthandwerk, vol. 3 (1900), p. 52 (ill.).
Gustav E. Pazaurek, *Kunstgläser der Gegenwart,* Leipzig: Klinkhardt & Biermann, 1924, p. 24 (ill.).

With this service, created for a contest sponsored by the Österreichisches Mu-

seum für Kunst und Industrie, Koloman Moser made his name as a designer for the glass industry. In the category of glass service "for the simple household," Moser won first prize. This category was the idea of the museum's new director, Arthur von Scala, who saw it as the museum's responsibility to ensure that the working and lower middle classes—the two groups most affected by the negative effects of the industrial revolution—were provided with "suitably tasteful" and affordable objects for everyday use. The simplest version of Moser's mold-blown glass service cost 73 crowns for twelve settings and included five different glasses per setting as well as two wine decanters and two pitchers. The more costly version, featuring the new "Meteor" decor, which is the type exhibited at the Neue Galerie, was available for 90.40 crowns.

III.42
Five liqueur glasses

Design: Koloman Moser, 1900, Vienna
Execution: for E. Bakalowits & Söhne
Clear, green, yellow, and violet glass
H. 30.7, 31.5, 32, 33, 34.2 cm
(12.3, 12.6, 12.8, 13.2, 13.7 in.)
Ill. p. 450

Private collection, New York

Literature:
MAK-B.I. 32066A, p. 30 (production drawing).
Dekorative Kunst, vol. 7, no. 4 (1901), pp. 184, 227 (ill.).
Ludwig Hevesi, "Aus der Sezession: Achte Ausstellung der 'Vereinigung,'" in: *Acht Jahre Secession,* Vienna: Konegen, 1906, p. 287.
Gustav E. Pazaurek, *Kunstgläser der Gegenwart,* Leipzig: Klinkhardt & Biermann, 1924, p. 23.
The Studio, vol. 24, no. 106 (January 1902), p. 248.

Kolo Moser's high-stemmed liqueur glasses were introduced at the eighth Secession exhibition, in November–December 1900. For the show, he had them set up on the sideboard "*Der reiche Fischzug*" (The Rich Catch; also designed by Moser) like an arrangement of exotic flowers. Although conceived as a set, each glass differs in height and color combination. As Ludwig Abels noted, this served to identify each drinker's glass. Due to their extreme proportions, moreover, the glasses take on an individual presence; because of this, they were often a topic of discussion in social settings, and soon came to be known simply as "the tall glasses." Thus the consumer's desire for individuality was met by the modern practice of identifying a product by name rather than number.

In 1924, Gustav Pazaurek, one of the period's great connoisseurs of historical and modern decorative arts, said he believed Moser's were the first tall-stemmed glasses with bulbous stems. However, in 1898—two years earlier than Moser—Peter Behrens conceived a set of drinking glasses with the same type of bulbous stem for the Benedikt von Poschinger crystal glass factory in Oberzwieselau.
Noteworthy is the fact that these examples of "the tall glasses" belonged to Berta Zuckerkandl, an ardent promoter of the ideas and values of the Vienna Secession and Wiener Werkstätte. She was the sister-in-law of Victor Zuckerkandl, director of Purkersdorf Sanatorium; he commissioned the Wiener Werkstätte to design and execute the building and interiors of the sanatorium, which was the Werkstätte's first *Gesamtkunstwerk.*

III.43
Vitrine

Design: Koloman Moser, ca. 1902, Vienna
Execution: J. & J. Kohn
Beechwood, stained mahogany, partly bent; laminated wood stained in dark and light mahogany, brass mounts
H. 188 × W. 66 × D. 58.4 cm
(75.2 × 26.4 × 23.4 in.)
Ill. p. 445

Neue Galerie New York

Literatur:
Dekorative Kunst, vol. 10, no. 5 (September 1902), p. 457.
Hohe Warte, vol. 2, no. 21/22 (1905–06), p. 2.
Kunst und Kunsthandwerk, vol. 5 (1902), p. 4.
Christian Witt-Dörring, "Bent Wood Production and the Viennese Avant-Garde: Thonet Brothers and J. and J. Kohn, 1899–1914," in: *Bent Wood and Metal Furniture: 1850–1946,* ed. by Derek Ostergard, New York: American Federation of Arts, 1987, pp. 95ff.

First exhibited at the 1901–02 *Winterausstellung* (Winter Exhibition) in the Österreichisches Museum für Kunst und Industrie, where the Kohn firm displayed three complete interiors (reception room, dining room, bedroom), this vitrine is attributed to Koloman Moser in the museum's own journal, *Kunst und Kunsthandwerk.*[1] But an advertisement by J. & J. Kohn in the 1905–06 issue of *Hohe Warte* shows the same vitrine with the caption "Salonecke: Installation und Möbel aus gebogenem Holze, scharfkantige Biegungen nach dem neuen System-Entwurf Professor Josef HOFFMANNS" (Salon corner: installation and furnishings of bentwood,

square-sectioned curves, with Professor Josef HOFFMANN'S new modular design).[2] Nor does the next illustration of the vitrine, set in a lady's boudoir at the 1902 *Esposizione Internazionale d'Arte Decorativa Moderna* (International Exhibition of Modern Decorative Arts) in Turin offer any help in determining its origin, as the exhibited pieces merely appear under the name of J. & J. Kohn. However, it is well known that Hoffmann and Moser collaborated on a number of projects, sometimes even signing them together. This was the case, for instance, in 1906 with the facade and interior design of the Kohn firm's Berlin showroom at Leipzigerstrasse 40.
This piece is one of the most felicitous products of the contemporary call for unity of form and function. Two bentwood frames form the structure housing the two container elements (vitrine above, cabinet below), also constructed of bentwood frame parts. The decorative rivets—similar to Wagner's mother-of-pearl disks for his Köstlergasse interior—lend visual stability, thereby encouraging confidence in the construction. This solution retained its validity well into the 1930s, with the tubular-steel furniture of the Thonet firm.

[1] *Kunst und Kunsthandwerk,* vol. 5 (1902), p. 4.
[2] *Hohe Warte,* vol. 2, no. 21/22 (1905–06), p. 2.

III.44
Chair

Design: Koloman Moser, 1902, Vienna
Execution: Prag-Rudniker Korbwaren Fabrication
Solid elm, rush webbing
H. 122 × W. 42.5 × D. 47.3 cm
(48.8 × 17 × 18.9 in.)
Ill. p. 449

Private collection, New York

Literature:
Deutsche Kunst und Dekoration, vol. 8 (1904), pp. 117ff., and vol. 12 (1908), p. 37.
Das Interieur, vol. 4 (1903), pp. 201, 204, and vol. 5 (1904), p. 26.
A. S. Levetus, "Modern Austrian Wicker Furniture," in: *The Studio,* vol. 30, no. 130 (January 1904), pp. 323–328.
Eva B. Ottillinger, *Korbmöbel,* Salzburg: Residenz, 1990, pp. 107, 110ff.

In 1907, *The Studio Year Book of Decorative Art* wrote of the latest development in Austrian applied arts: "Wickerwork furniture is becoming a necessity in every home, and real artistic work is produced by Prag-Rudniker."[1] This phenomenon was the result of a conscious

promotion of wicker furniture production by the Austro-Hungarian Empire. In 1899, Austria-Hungary had seven trade schools, and another ten educational institutions teaching wickerwork. Originally advocated in the 1880s as a way to stimulate the monarchy's poorer regions, these schools attained such a high standard of craftsmanship and artistic excellence that private entrepreneurs were encouraged to found wickerwork businesses. The firm with the greatest artistic ambitions was founded in 1880 in Rudnik (Galicia) as the Prag-Rudniker Korbwarenfabrikation (Prag-Rudniker Wickerwork Factory). Drawing on talent from the Wiener Kunstgewerbeschule (Vienna School of Applied Arts), by 1900 the firm and its products were attracting international attention. The driving force behind this success was Josef Hoffmann—described by *The Studio* in 1906 as having "… given much care to the solving of bentwood and wicker problems in furniture, in which task he has been ably supported by Messrs. J. and J. Kohn and the Prag-Rudniker Wickerwork Factory, Vienna"[2]—and Kolo Moser, whose students Wilhelm Schmidt and Hanns Vollmer in 1902 designed a new line of very successful pieces for Prag-Rudniker (Moser himself contributed a chair and an armchair model).
Given equal billing with works of fine art, Prag-Rudniker's seating and tables appeared as furnishings for the spaces in most of Vienna's major art shows. Moser, for instance, used the armchair version of the model shown here for his entry in the eighteenth Secession exhibition in November–December 1903, dedicated to Gustav Klimt. Clear, constructive wooden elements serve as the structural frame for this model. The pattern of the weaving not only ties together and encloses the structural elements, but also serves a decorative function.

[1] *The Studio Year Book of Decorative Art* (1907), p. 212.
[2] *The Art-Revival in Austria* (The Studio Special Issue), ed. by Charles Holme, London, 1906, p. DV.

III.45
Armchair

Design: Koloman Moser, ca. 1903, Vienna
Execution: Prag-Rudniker Korbwarenfabrikation
Beechwood, painted white; woven cane seat, painted black and white
H. 70 × W. 65 × D. 63.1 cm
(28 × 26 × 25.25 in.)
Ill. p. 448

Neue Galerie New York

Literature:
Dekorative Kunst, vol. 12, no. 7 (June 1904), pp. 355ff. (ill.).
Deutsche Kunst und Dekoration, vol. 18, no. 7 (April 1906), pp. 427ff. (ill.).
Sabine Forsthuber, *Moderne Raumkunst: Wiener Ausstellungsbauten von 1898 bis 1914,* Vienna: Picus, 1991, pp. 99ff.

This chair appeared in art magazines for the first time in November–December 1903, during the eighteenth Secession exhibition, Gustav Klimt's first one-man show. Attention to the design of its shows had been a key element of the Secession's program from the outset, and Moser's chair was created as part of his overall concept for the exhibition space. He framed the walls of the rooms with simple geometric borders so that they functioned simultaneously as space-creating and flat elements. This transformed them into empty mats, or "*passepartouts,*" for Klimt's paintings, depending on their position on the wall. A similar approach is evident in the tension between space and surface in the design of the armchair and its positioning in the exhibition space.
The chair is based on a simple frame construction that remains in the background, a mere structural necessity, its material substance made to "disappear" by formal/aesthetic means. The sides and back come to rest on the broad frame of the seat, while its narrow-ribbed flanks are turned to face the gallery, presenting minimal material resistance. The chair's stability derives from the use of sticks set into the frame at regular intervals; their narrow sides, too, face outward. At the chair's back corners, they meet at right angles, with the vertex aimed toward the frame's interior. As a result, the back corners seem weightless, floating in air. Similarly ingenious is Moser's solution for the incorporation of the solid horizontal seat into the transparent, vertical lattice structure of the sides and back. The small, concave wooden blocks, set vertically between the lattices, connect the horizontal seat to the lattice structure, giving the impression of continuous fluting. The interplay of light and shadow also helps re-create the transparency lost by the presence of the seat. (Originally the transparent effect was emphasized even further by placing the chair on four small wheels, which made it appear to float through the room on a pillow of air.)
Although Moser was not cited as the designer of this piece in period publications, we can assume it was his based on stylistic criteria. The pointed contrast between flat and spatial elements is typical of Moser's furniture from the years 1902 to 1904. Again and again—

as in the sliding table for the Hölzl apartment (1903) or the case pieces for patients' rooms at the Purkersdorf Sanatorium (1904)—he contrasts the flat board with a concave, spatial element in a manner similar to that of the wooden blocks in the latticework of our armchair.
In their view of the room, the photographs Moser selected for the publication of his exhibition design betray no preference for fine as opposed to applied arts. The angle is so carefully chosen that the chairs and the paintings appear as equals, encouraging the viewer to compare their proportions. Finally, all of the photographs are titled "Koloman Moser: Raumausstattung in der Wiener Secession" (Koloman Moser: Furnishings in the Vienna Secession), rather than merely giving him credit for designing the space.
As far as we know, Moser's chair, which never appeared in Prag-Rudniker sales catalogues, was made in an extremely limited number for the 1903 Klimt show at the Secession and again a year later for the entrance hall of the Purkersdorf Sanatorium. There are three known variations, each differing in the decorative pattern of its seat, as well as of its sides and back, and the type of woven material used (raffia cord or caning).

III.46
Necklace (gift from Gustav Klimt to Emilie Flöge)
Design: Koloman Moser, 1903, Vienna
Execution: Wiener Werkstätte, model no. G 23
Silver, carnelian, chalcedony
L. 47 cm (18.8 in.)
Marks: WW, hallmark
Ill. p. 451

Private collection, New York

Literature:
AD: MAK-WWMB 03 (GSM 3)/0187.
MAK-WWF 101, pp. 18–22.
Emilie Flöge und Gustav Klimt: Doppelporträt in Ideallandschaft, 112th Special Exhibition of the Historisches Museum der Stadt Wien, exhibition cat., 1989, cat. no. 4.2.1 and 4.1.2 (ill.).
Wolfgang Fischer, *Gustav Klimt und Emilie Flöge: Genie und Talent, Freundschaft und Besessenheit,* Vienna: Brandstätter, 1987.
Vienna 1900: Art, Architecture, Design, exhibition cat., New York, Museum of Modern Art, 1986, p. 141 (ill.).

In December 1903, the year the Wiener Werkstätte was founded, Gustav Klimt purchased this necklace for 100 crowns as a gift for Emilie Flöge. Together with Klimt's painting of her in 1902 and a number of photographed

portraits, some of which depict her wearing this piece of jewelry, it is a token of long-lasting friendship between the two. Emilie and her sister Helene, who was married to Gustav Klimt's brother Ernst, were the proprietors of a well-known fashion studio on the second floor of "Casa Piccola" (Mariahilferstrasse 1b). (The studio was designed by Josef Hoffmann and Kolo Moser and furnished by the Wiener Werkstätte in 1904. The Neue Galerie owns a display case [cat. no. III.48] designed by Moser for this space.)
This necklace, altered from its original state during Flöge's lifetime, is closely attuned to the idealistic principles of the Wiener Werkstätte founders. As Hoffmann put it: "In our jewelry department we tried above all not to produce jewelry of the type then current, with the value placed in the foreground and the carats left to glitter on their own with as little craftsmanship as possible. Because of the stones' great value, craftsmanship was applied only in order to ensure their security."[1]
The manifesto published in 1905 by the Wiener Werkstätte board (Hoffmann, Moser, and Fritz Waerndorfer) addressed the issue still more specifically: "We often use semiprecious stones, especially in our jewelry; for us, they replace the value of diamonds with the beauty of their colors and their endless, seldom-repeated variety. We love silver for silver's sake and gold for its golden shine; we regard copper as every bit as valuable, in an artistic sense, as these precious metals. We must own up to [our feeling] that a piece of jewelry in silver can be just as valuable as one in gold with precious stones."

[1] Josef Hoffmann, autobiographical essay, in: *Ver Sacrum: Neue Hefte für Kunst und Literatur* (1972), pp. 105ff.

III.47
Belt buckle with original box
Design: Koloman Moser, 1903, Vienna
Execution: Wiener Werkstätte (Adolf Erbrich), model no. S 59
Silver, opal, ruby
H. 6 × W. 6 cm (2.4 × 2.4 in.)
Marks on belt buckle: WW, KM, AE, AA, hallmark
Marks on leather box: WW, rose mark, KM, F (Ferdinand Heider)
Ill. p. 451

Private collection, New York

Literature:
AD: MAK-WWMB 03 (GSM 3)/0247.

III.48
Display case for the Flöge sisters fashion house

Design: Koloman Moser, 1904, Vienna
Execution: for Wiener Werkstätte
Maple, stained black; glass, white metal
H. 115 × W. 100 × D. 50 cm (46 × 40 × 20 in.)
Ill. p. 444

Neue Galerie New York

Literature:
AD: MAK-WWF 101, p. 20.
Hohe Warte, vol. 1 (1904–05), pp. 28ff.

III.49
Vase
Design: Koloman Moser, 1904, Vienna
Execution: Wiener Werkstätte, model no. S 356
Silver
H. 21 cm (8.4 in.)
Marks: WW, rose mark, KM, AA, hallmark
Ill. p. 447

Private collection, New York

Literature:
AD: MAK-WWF 94, p. 62.
PD: MAK-K.I. 12591.
The Studio, vol. 56, no. 233 (August 1912), p. 188 (ill.).

III.50
Combination collector's cabinet/library case for living room of Dr. Jerome Stonborough
Design: Koloman Moser, 1905, Vienna
Execution: for Wiener Werkstätte
Solid oak and oak veneer, stained black, pores chalked white; white metal mounts
H. 200 × W. 200 × D. 50 cm (80 × 80 × 20 in.)
Ill. p. 446

Private collection, New York

Literature:
Deutsche Kunst und Dekoration, vol. 17, no. 3 (December 1905), p. 156 (ill.).
Eduard F. Sekler, *Josef Hoffmann: The Architectural Work,* Princeton: Princeton University Press, 1985, p. 292.

In 1905, Margarethe Wittgenstein (sister of philosopher Ludwig Wittgenstein and daughter of industrialist and Secession patron Karl Wittgenstein) married the American chemist Dr. Jerome Stonborough and the couple moved to Berlin, where Josef Hoffmann and Koloman Moser decorated their new apartment. Moser was responsible for the living room, also to serve as Mrs. Stonborough-Wittgenstein's salon, while Hoffmann designed the room for her husband. The library case/collector's cabinet, for the salon, was conceived as a modular system, with two additional glass-front cases correspon-

ding to its two glass side elements. Upon closer inspection, the unit's simple building-block-like appearance gives way to that of a solid salon piece, an effect achieved by means of the pedestal's narrow profile, shaped like a semicircle with the smooth, sharp-edged body set atop it. The socle is actually little more than a shadow joint, which tells us this piece of furniture has a specific purpose and a fixed place in the room. This is a common characteristic of fin-de-siècle Viennese furniture: though edging toward modernity, at the last minute they opt for luxury instead; like a simple piece of Chinese porcelain outfitted with an eighteenth-century gilt-bronze mount.

JUTTA SIKA

III.51
Tea and coffee service

Design: Jutta Sika (school of Prof. Kolo Moser), 1901–02, Vienna
Execution: Josef Böck, Wiener Porzellanmanufaktur
Porcelain with stenciled design in red
Coffeepot: H. 19.8 cm (7.9 in.)
Teapot: H. 17 cm (6.8 in.)
Creamer: H. 8.5 cm (3.4 in.)
Cup: H. 6 cm (2.4 in.)
Saucer: Diam. 16.7 cm (6.7 in.)
Dessert plate: Diam. 22.9 cm (9.2 in.)
Dinner plate: Diam. 22.9 cm (9.2 in.)
Marks: SCHULE PRF. KOLO MOSER. (green stamp), PWM (red stamp, under glaze), D 501 (red, under glaze)
Ill. p. 452

Private collection, New York

Literature:
Kunst und Kunsthandwerk, vol. 5 (1902), p. 407.
Waltraud Neuwirth, Österreichische Keramik des Jugendstil, Munich: Prestel, 1974, p. 260, cat. no. 154.

This breakfast service, designed by Jutta Sika, a student of Kolo Moser at the Kunstgewerbeschule (School of Applied Arts), was one of the most provocative solutions for everyday tableware created during the "Sacred Spring." Taking up Moser's challenge to redesign every aspect of daily life, Sika carefully studied the functions of each individual piece. Her design of the cup and saucer was particularly radical, moving the cup—conventionally placed in the center of the saucer—off-center to make room for a roll. The distribution of the East Asian–inspired circular red decoration on the saucer and cup makes visual reference to this unusual new arrangement, giving it stability in the eyes of the beholder. The decoration, composed of overlapping circles,

calls to mind the porcelain service Frank Lloyd Wright designed between 1916 and 1922 for the Imperial Hotel in Tokyo. Wright, however, not only used the pattern asymmetrically, but negated the spatial boundaries of the cup and saucer by allowing the pattern to overlap their contours.
As early as 1914, Dagobert Peche had covered a dessert plate with a flower motif in such a way that the decoration seemed divorced from the object, as if the flowers had been strewn across it at random. By so doing, he allowed the decoration to transcend the function as circumscribed by the contours of the plate.
Also key to the realization of Sika's unorthodox pattern was Josef Böck's porcelain factory. Böck's firm, founded in 1898, leaving it unburdened by tradition, was one of the few firms in Vienna (along with Kohn, Backhausen, and Bakalowits) that understood how to exploit the creative potential of the city's young avant-garde for commercial purposes.

THERESE TRETHAN

III.52
Tureen

Design: Koloman Moser (design), Therese Trethan (decoration), 1901–02, Vienna
Execution: Josef Böck, Wiener Porzellanmanufaktur
Stoneware with gray-blue transfer-print design
H. 18.5 × Diam. 29.5 cm (7.4 × 11.8 in.)
Marks: SCHULE PRF. KOLO MOSER. (black, under glaze), N, 69 (stamped)
Ill. p. 453

Neue Galerie New York

Literature:
Koloman Moser, exhibition cat., Vienna, Hochschule für angewandte Kunst, 1979, p. 103.
The Studio Year Book of Decorative Art (1907), p. 222 (ill.).

OTTO PRUTSCHER

III.53
Three stemmed glasses

Design: Otto Prutscher, 1907, Vienna
Execution: Adolph Meyer's Neffe, Adolfshütte/Winterberg, for E. Bakalowits & Söhne
Clear glass with blue and yellow casing, cut decoration
H. 21 cm (8.4 in.)
Ill. p. 454

Private collection, New York

Literature:
AD: MAK-WWF 89, p. 15.
MAK-B.I. 32066C, p. 22 (production drawing).
Dekorative Kunst, vol. 16, no. 11 (September 1908), p. 542 (ill.).
Deutsche Kunst und Dekoration, vol. 20, no. 12 (September 1907), p. 340 (ill.), and vol. 25, no. 6 (March 1910), p. 376 (ill.).
Gabriele Koller, "Otto Prutscher und die Glaskunst," in: Otto Prutscher 1880–1949, exhibition cat., Vienna, Hochschule für angewandte Kunst, 1997, pp. 20ff., 62 (ill.).

Moser's pioneering "tall glasses" (cat. no. III.42) paved the way for glassware sets that employed a variety of designs. Otto Prutscher took up the idea seven years later, designing a tall-stemmed glass in six different models produced in various colors (four with overlay, two clear with colored dots). This highly idiosyncratic set—not meant for the table, where it would have to subordinate itself to a unified whole, but rather for use before or after a meal, or completely independent of it—was essentially an updated take on Biedermeier. Despite the pure geometrical approach, the design was still dominated by the language of nineteenth-century glass technique, producing an atmosphere less of renewal than refinement. The Wiener Werkstätte included Prutscher's set in its sales line, and some of the glasses were exhibited at the 1908 Wiener Kunstschau.

HANS PRUTSCHER

III.54
Mantelpiece clock for Milek tailor's shop

Design: Hans Prutscher, 1903, Vienna
Execution: Johann Wolkenstein (clockwork)
Aluminum, glass, enamel dial
H. 42 × W. 37.1 × D. 17.5 cm (16.8 × 14.8 × 7 in.)
Marks: "JOH. WOLKENSTEIN/WIEN" on the dial
Ill. p. 455

Private collection, New York

Literature:
Das Interieur, vol. 5 (1904), p. 34.

JOSEPH URBAN

III.55
Chair

Design: Joseph Urban, 1902, Vienna
Execution: Gebrüder Thonet
Beechwood, stained black; original leather covering, tacks, brass mounts

H. 98 × W. 40 × D. 52.5 cm (39.2 × 16 × 21 in.)
Ill. p. 456

Private collection, New York

Literature:
The Art-Revival in Austria (The Studio Special Issue), ed. by Charles Holme, London, 1906, p. 61 (ill.).
Kristan, p. 324.

III.56
Mantelpiece clock for Paul Hopfner Restaurant

Design: Joseph Urban, 1906, Vienna
Execution: unknown
Marquetry of thuja and mother-of-pearl, walnut (back), brass nickeled and brushed, onyx marble. Celluloid dial with numerals in enamel and silvered copper.
H. 59.8 × W. 51.2 × D. 18 cm (23.9 × 20.5 × 7.2 in.)
Ill. p. 457

Private collection, New York

Literature:
PD: Watercolor sketch in the collection of the Rare Book and Manuscript Library, Butler Library, Columbia University, New York City (Ref.: Joseph Urban Collection, Vienna Period, B1.12).
Kristan, p. 324, ill. pp. 120, 121/1, 121/2.

EDUARD JOSEF WIMMER-WISGRILL

III.57
Drawing cabinet for Kunstschau Wien, 1908

Design: Eduard Josef Wimmer-Wisgrill, 1908, Vienna
Execution: Wilhelm Niedermoser, Vienna
Macassar ebony veneer and ebony, boxwood, and mother-of-pearl marquetry, brass
H. 144 × L. 130 × W. 53 cm (57.6 × 52 × 21.2 in.)
Ill. p. 458

Neue Galerie New York

Literature:
Ausstellung der Österr. Tapeten-, Linkrusta- und Linoleum-Industrie, exhibition cat., Vienna, Österreichisches Museum für Kunst und Industrie, 1913, pp. 46, 67.
Vera Behal, Möbel des Jugendstils: Die Sammlung des Österreichischen Museums für angewandte Kunst, Munich: Prestel, 1988, p. 262.
Das Interieur, vol. 14 (1913), pl. 113.
Kunstschau Wien 1908, exhibition cat., Vienna, 1908, p. 12.

Verborgene Impressionen: Japonismus in Wien, 1870–1930, exhibition cat., Vienna, Österreichisches Museum für angewandte Kunst, 1990, p. 369 (ill.).

This cabinet was acquired by the Österreichisches Museum für angewandte Kunst in 1963, together with a companion piece thought to be the work of Josef Hoffmann. In the 1988 exhibition catalogue *Möbel des Jugendstils* (Jugendstil Furniture), Vera Behal corrected this error, which had been based on the faulty interpretation of a period caption, and rightfully identified Josef Wimmer as the designer of both pieces. The cabinets were displayed at the *Ausstellung der Österr. Tapeten-, Linkrusta- und Linoleum-Industrie* (Exhibition of the Austrian Wallpaper, Lincrusta, and Linoleum Industry) at the Österreichisches Museum für Kunst und Industrie in 1913. The one pictured here (acquired in 1990 in a trade with the Museum für angewandte Kunst) stood in Room 3 in front of a Lincrusta wallpaper designed by Josef Hoffmann (illustrated in a 1913 issue of *Das Interieur*).

Stylistic criteria—coupled with the fact that a "Cabinet for Drawings" by Wimmer appeared in the 1908 *Wiener Kunstschau*—enable us to identify the cabinet as Wimmer's work and assign it an earlier date than previously assumed. Unlike its counterpart, this piece has no small, deep drawers but only two wide, flat drawers, which take up its entire width, designating its function as a drawing cabinet. Its rigid, geometric design and clearly defined frontality indicate its origins prior to 1910. The emphasis on surface decor—with each of the six stairlike levels framed by a geometric strip of marquetry and the lively structure of the veneer put to use as a decorative motif on every level—fits with the aesthetic ideas of the early "Sacred Spring" movement. Along with varying drawer sizes as structural elements, these characteristics are clearly borrowed from Japanese culture; the ambivalent way in which they are employed, though, is wholly Viennese. The emphasis on the flatness of the cabinet front is juxta-

posed with the unexpected depth of the piece. This visual impression is reinforced by the sides, which have no decorative borders, but diminished by the vertical pattern of the veneer, making the piece appear as though it were merely one segment of a structure that once extended to infinite length. The definite cross-section here is at odds with the indefinite longitudinal section.

DAGOBERT PECHE

III.58
Bird-shaped candy box
Design: Dagobert Peche, 1920, Vienna
Execution: Wiener Werkstätte, model no. S 4881
Silver, coral
H. 21.7 cm (8.7 in.)
Marks: WW, MADE/IN/AUSTRIA, P, 900, hallmark
Ill. p. 459

Neue Galerie New York

Literature:
AD: MAK-WWF 96, p. 200.
PD: MAK-K.I. 12791/3.
Die Überwindung der Utilität, exhibition cat., 1998, p. 218, cat. no. 43.
Janis Staggs-Flinchum, "A Glimpse into the Showroom of the Wiener Werkstaette of America, 1922–23," in: *The International Twentieth-Century Arts Fair,* catalogue, New York, Haughton's, 1999, pp. 26–35.

When, toward the end of his life, Dagobert Peche declared the "overcoming of utilitarianism" as a precondition for the creation of art, he was adopting a position diametrically opposed both to contemporary, modernist trends and to the functional style propagated by Otto Wagner in the late nineteenth century. By the time Peche entered school, the issues that had occupied the members of the Secession movement—namely, the oppressiveness of historicizing styles and the artistic isolation of Vienna—were no longer current. What they had fought for so bitterly he was able to take for granted, which allowed him to reassess

the question of ornamentation with an open mind.

Peche criticized Wagner's creative process as a clumsy mixture of *Sachlichkeit* (functionalism) and artistic sensitivity that could have been avoided had Wagner not insisted on calling himself an artist. For Peche, there could be no unity between technical solutions and artistic expression; they were two distinct approaches—one the realm of the engineer, the other the realm of the artist.

In Peche's world, there was no intrinsic value either in being true to the materials or in emphasizing tectonic elements. He sought to force the raw material into silence, allowing it to speak only the language of the artist. This explains his often Baroque or Rococo-inspired creations, unlike the spare, simple forms of the early Wiener Werkstätte. His bird-shaped bonbonnière is a typical example of this, its function apparent only after careful inspection. The stylized feathers can be lifted from behind as a top, revealing a hollow space where the sweets are to be stored. The Wiener Werkstätte produced Peche's candy box five times between 1920 and 1924; the version in the Neue Galerie comes from the estate of Joseph Urban. In 1922, Peche had the candy box put on display at the opening of the Wiener Werkstätte's New York branch, where he served as both manager and decorator. Reporting on the event for the New York magazine *The International Studio,* F. E. W. Freund wrote: "Very characteristic is the almost instinctive way in which the artists combine style and realism. In the silver cock for instance, the natural form is only slightly conventionalized, just to give emphasis to certain points, and that is kept well within the medium of the metal used, which could only be 'forced' into imitating a 'real' bird. The artist's imagination, however, must have its fling, so he adds the fantastic 'head dress.' Yet how graceful and really natural is this bit of living ornament!"[1]

[1] F. E. W. Freund, "Vienna's Joy Seeks to Live," in: *The International Studio,* vol. 76, no. 306 (November 1922), p. 151.

OTTO WAGNER

* JULY 13, 1841, PENZING (NEAR VIENNA)
† APRIL 11, 1918, VIENNA

Invitation to the exhibition *Otto Wagner: Drawings*, at The Drawing Center, New York, November 13, 1987–January 16, 1988. Courtesy The Drawing Center, New York

In an autobiographical outline written six months before his death, Otto Wagner noted: "I was born in Penzing on July 13, and three months later my parents moved to the first district, to 1 Göttweihergasse." This district, as part of Vienna proper, was in those days still separated from the outskirts by the old city walls; after the uprisings of 1848, the fortifications were torn down and replaced by the Ringstrasse, the circling boulevard that would become the path of Wagner's destiny, his "*Schicksalsweg*."[1] Following his father's death in 1846, Wagner's mother, Susanne, had extensive renovations made to the house by the architects Ludwig Förster and Theophilus Hansen. Once Wagner completed his architectural studies, in 1863, he went to work with Förster, who was a major force in the planning of the Ringstrasse. Meanwhile, his colleague Hansen was busy designing several of the great public buildings that would eventually line the boulevard, and he entrusted the young Wagner with the execution of his design for the Palais Epstein near the parliament building (also on the Ringstrasse).

The Göttweihergasse house, a "simple, almost austere building,"[2] played a key role in Wagner's personal and artistic development. His biographer and contemporary Joseph August Lux saw in it the origins of the expansiveness in Wagner's own work, while Otto Antonia Graf, who was responsible for Wagner's "rediscovery" years later, added a more explicitly psychological dimension: "Up to 1917, Wagner repeatedly recast his mother's amazingly progressive house into a series of (as known so far) eighteen houses, villas, and projects he designed and built for himself: the fifteen houses he completed were one of the mainstays of his art of converting his strict mother into architecture, and sublimating her sternness."[3]

On moving to Berlin (probably at the end of 1859), Wagner found the same expansiveness and severity, underpinned with a strong rationality. Here, on Hansen's advice, he enrolled at the Königlich Preussischen Bauakademie (Royal Prussian Academy of Architecture), to continue the studies he had begun at Vienna's Technische Hochschule (Technical College). Founded by Karl Friedrich Schinkel (who died the year Wagner was born), the Bauakademie's curriculum was based on Schinkel's belief that there was a logical connection between the construction of a building and its external appearance. Al-

though in retrospect Wagner saw little significance in the time he spent in Berlin, the approach he learned at Schinkel's school left its mark on him. He himself realized this only after returning to Vienna in 1860 to enroll at the Akademie der bildenden Künste (Academy of Fine Arts). His studies there, under August Sicard von Siccardsburg ("[who] cultivated in me the principle of utility") and Eduard Van der Null (an "unparalleled talent for drawing"),[4] laid the groundwork for his path later in life.

In 1863, at the age of just twenty-two, Wagner won his first architectural competition, with his design of a *Kursalon* for Vienna's Stadtpark (City park). In the end, it was built from a design other than his, setting a pattern that was to plague Wagner for many years as he was repeatedly prevented from executing his prize-winning designs. But he had continued success in competitions (as with his Berliner Dom [Berlin cathedral] in 1867, Vienna's Justizpalast [Palace of justice] in 1874, Lemberg's Landtag [Parliament of the crown lands] in 1875). With these accolades, coupled with his ability to find buyers for the structures he erected at his own expense, he was soon held in high regard, at home and abroad alike. In 1876, he wrote of his "great success" in a contest for the design of a new town hall in Hamburg: "in the face of the most enormous competition there has ever been, I won second prize out of 136 architects from all over."[5]

Along with monumental architecture, Wagner had a lifelong interest in urban planning, dating back to his 1868 scheme for the redesign of a district in Budapest. Four years later, he submitted proposals for a diversion of the Wien River and a new metropolitan railway for Vienna (both implemented in the 1890s), and in 1910 he formulated his ideas on *Die Grossstadt* (the great city) for a congress at Columbia University in New York. His third enduring fixation was the urban apartment block, an architectural form that brought together the energies and abilities of Wagner the entrepreneur (who financed the construction and then sold the finished product), Wagner the artist (who used the occasion to implement and assess his evolving ideas), and Wagner the modern man (who wouldn't give up until he had achieved a style of living that suited his needs). In this case, Graf's argument about the importance of Wagner's mother is confirmed by the words of the son himself: "The true architect must be part idealist and

part realist. How many times did my adored and revered Mama tell me to strive always for independence: money and yet more money is the means to that goal … then you'll be able to live out your ideal in every particular."[6]

In November 1879, six months before the death of his mother, Wagner met a young woman named Louise Stiffel, who gave French lessons to his daughter, the offspring of an early and unsuccessful marriage. Meeting Stiffel launched the thirty-eight-year-old Wagner into a "frenzy of happiness," he said. In 1884 the two were wed, and throughout their decades of marriage Stiffel had an enormous impact on Wagner's artistic development—not least by rendering him psychologically immune to whatever setbacks he encountered. All of his most famous work he produced while married to her: his two villas in Hütteldorf (1886 and 1912); the apartment blocks in Wienzeile and Neustiftgasse (1898 and 1909); Vienna's Stadtbahn (metropolitan railway; 1894–1900) and the Nussdorf Lock in the Danube Canal (1894); his proposals for the Kaiser Franz Joseph Stadtmuseum (1900–1912); the building for the Anker insurance company and the dispatch bureau for the newspaper *Die Zeit* (1894 and 1902); the church Am Steinhof (1902–04); and the Postsparkasse (Postal savings bank) on the Stubenring (1903–10). In addition, there were his published works: *Einige Skizzen, Projekte und ausgeführte Bauwerke* (Some Sketches, Projects, and Executed Buildings; 4 vols., 1889–1922), and *Moderne Architektur* (1896–1902), which went through four editions, the last published in 1913 as *Die Baukunst unserer Zeit* (Architecture in Our Time).

In retrospect, many of Wagner's lesser-known projects paved the way for his more famous works. Some were early examples of the functional style (*Nutzstil*) he later went on to champion (the Länderbank offices and the Stadiongasse apartment block, both 1882); others paid tribute to older architectural styles, in line with the tenets of Historicism. And according to Lux, Wagner's ambitious "Artibus" project of 1880—an architectural declaration of love for art and for his second wife—was one of the reasons he was appointed to a position at the Akademie der bildenden Künste fourteen years later.

In fact, when the Akademie invited Wagner to join its faculty, it was expecting an architect who advocated established historical styles. After all, this was the man who in his foreword to the first volume of *Einige Skizzen* had supported a "free" version of the Renaissance style. But Wagner's inaugural lecture made it clear his approach was quite different. His ten years teaching at the academy gave him an influential position from which to pursue his modernist mission, as well as the chance to refresh his ideas through contact with his students. These included Josef Hoffmann, Jan Kotěra, Jože Plečnik, Marcel Kammerer, Ernst Lichtblau, Franz and Hubert Gessner, Emil Pirchan, and Rudolf Schindler. Also key was his collaboration with younger colleagues, in particular Joseph Maria Olbrich, who worked with Wagner on the Stadtbahn, and Koloman Moser, who provided designs for elements of the Steinhof church.

In 1915, Louise Wagner died. Wagner sought to come to terms with the loss by writing letters to his departed wife, telling her of his memories, his work, and a life stripped of hope by the continuing war in Europe. He sold his last houses and began work on a new one that would include an apartment for himself in "an entirely different style." Meanwhile, the Steyr arms factory had pledged to build "a car after my [Wagner's] own design." This project, in a sense, brought him full circle; for it was the experience of riding in a carriage owned by one of the architects who rebuilt the house in Göttweihergasse that had first encouraged Wagner to choose the career he did. Looking back on his life, he recalled: "I wanted to be an architect and to own my own carriage."[7]

In his account of Wagner, Lux divided his career into three phases: the early period, the years of struggle, and the time of maturity. Interestingly, he saw the first as not getting under way until Wagner was nearly forty; and strange as it seems, Wagner's work did undergo a noticeable change of direction in the years around 1880: his increasingly loose interpretation of historical styles was accompanied by a deeper involvement in the functional aspects of building. This led him to conclude, in the first volume of *Einige Skizzen* in 1889: "It seems to me immature to see a perfect solution, a sort of 'Eureka!' in this or that style, or to strive to make certain styles serve particular architectural ends. … But … there can be no doubt, in my view, that our use of every motif or material should drive us to evolve a new style, and I am still more convinced that this style of the future will be the '*Nutzstil*' toward which we are already heading full tilt."[8] This was Wagner's first use of the term that would later lead to so much misunderstanding and, worse, accusations that he was a slave to a banal, soulless utilitarianism.[9] For its champion, however, the notion of a functional style transcended mere pragmatism: "If we add to this [approach] the striving after inner truth, it will be justified in aesthetic terms as well."[10]

Wagner's "years of struggle" (Lux's *Kampfzeit*) included his tenure as a professor, his work on the Stadtbahn, and his design of the Nussdorf Lock (ten years later, in 1904, still deemed worthy of inclusion in the Louisiana Purchase International Exposition in Saint Louis).[11] Also during this period, *Moderne Architektur*, Wagner's theoretical legacy, went through three editions. Finally, it was around this time too that Wagner's faith in a style for the future became a true doctrine. He quit the conservative Künstlerhaus and joined the Secession, a move viewed by his former supporters as a slap in the face.

Wagner's new approach came to life in the celebrated Wienzeile apartment blocks and his spectacular bedroom and bathroom interiors for the 1898 *Jubiläumsausstellung* (Jubilee Exhibition), illustrated in the Secession journal *Ver Sacrum*.[12] These projects show a commitment to what Wagner saw as the practical tenor of modern life. His use of glass and metal, in the construction and the furnishings alike, as well as the glazed tiling on the facades and the terrycloth in the bathrooms, show Wagner aiming to satisfy both the new demand for hygiene and the desire for durability and affordability. The facades of the Wienzeile buildings, too, exhibit a new approach—he rejects the conventional emphasis on the *bel étage* in favor of a more democratic treatment of the various stories. The two figures decorating the cor-

nice of the apartment block at the corner of Wienzeile and Köstler-
gasse (which, incidentally, Otto Antonia Graf compares with Louis
Sullivan's department store for Carson-Pirie-Scott in Chicago) create
the impression that this is the home of modern man, who dwells in a
new type of street. Gleaming gold and white, Wagner's house seems
to embody truth itself.

In his "maturity" (Lux's *Reifezeit*, dating from around 1900), Wagner
returned to the use of decoration—now, though, in concentrated, geo-
metrical form, and more in harmony with the construction of the build-
ing. As Lux notes, almost with relief: "The extreme variant of the
Secession style, an element alien to Wagner's work, disappears from
his œuvre almost as soon as it occurs." The first clear evidence of this
new approach occurs in an interior: the dining room in Wagner's pied-
à-terre, designed in 1898–99 (see note 12), included furniture
graced by small circular panels inlaid with mother-of-pearl that not
only allude to the art of marquetry (constructive decoration) but also
emphasize the keyholes and handles (functional decoration); alter-
nately, they serve simply as decoration for its own sake.

Wagner used decoration in similar fashion for the facades of the
Steinhof church and the Postsparkasse. For both he employed the
"modern approach to building" as he described it in *Moderne Archi-
tektur*: instead of piling up vast blocks of stone, as in the Renais-
sance, the outer shell of a building should consist of panels, Wagner
wrote. This would mean substantial savings of time and expense, and
allow the builder to use more valuable materials, such as marble. Bolts
of copper (in the case of Steinhof) or of aluminum refer to the way in
which the cladding has been attached, making it look as if it has been
nailed on. There is a concentration of aluminum ornament on the cen-
tral bay of the Postsparkasse facade, drawing attention to the execu-
tive offices accommodated there. Wagner had originally intended that
this ornament be gilded, as a symbol of the wealth of the institution's
customers (and the virtues of saving). Here again, the decoration
serves three ends: constructive, semantic/functional, and symbolic.
This illustrates one of the principles central to Wagnerian theory: "The
architect will select that type of construction … which may the most
naturally be incorporated within the image that he is creating and is
best suited to the evolving artistic form."[13]

WAGNER AND AMERICA

Graf cites just one religious edifice of his day as truly comparable to
the Steinhof church: Frank Lloyd Wright's Unity Temple in Chicago. As
it happens, Wagner recommended Wright's *Ausgeführte Bauten und
Entwürfe*[14] to his students, telling them: "Gentlemen, this man is ca-
pable of more than I am." And it seems the admiration went both
ways: Wright's son John sent a letter to Wagner in 1913 applying for
a position with his firm.[15]

Apart from his ongoing interest in the evolution of architecture in the
United States, and the high regard in which his work was held there,
Wagner had three specific and important connections to America.
The first was through his magnum opus, *Moderne Architektur*. In the
summer of 1901, the Boston architectural journal *The Brickbuilder*

published N. Clifford Ricker's English translation of the second, 1898
edition of the work, and in 1902 it appeared in book form.[16] By and
large, the brief introduction to Wagner's text in *The Brickbuilder* took
a very positive view of "the Germans" (used here to include Austrians
as well)—their capacity for analysis and intellectual abstraction, and
their persuasiveness as theorists as a result. But the anonymous au-
thor also pointed out the risk (in particular when it came to Wagner)
of becoming too focused on abstract issues: "The discussion, truly, is
an academic one … and the essentials of good architecture, whether
retrospective or most thoroughly modern, are in reality quite in
accord."

Despite not being translated into English, the fourth edition of *Mo-
derne Architektur*, which appeared in German in 1914 as *Die Bau-
kunst unserer Zeit*, extensively revised and with two new chapters, was
widely discussed in the United States. Wagner himself took action to
ensure it would not be ignored by sending a signed copy to the Amer-
ican Institute of Architects, whose journal reciprocated by publishing
a review. The author of the piece, Robert D. Kohn, while admiring
Wagner's arguments and their relevance to architectural practice,
took the occasion to voice his criticism of the American architectural
community: "We, the artists who in the nature of our work come most
closely to actual life and modern conditions, ignore those conditions
and that life in our design." Kohn expressed regret for the fact that the
new edition of Wagner's work had not been translated, but added that
there would be little point in doing so as long as American architects
remained averse to theory: "I know that not one architect in fifty in this
country will read [these discourses]. We never read books on art, and
if we did we would not heed any that might disturb our serene com-
posure."[17]

It took decades before Americans began to explore Wagner's writ-
ings, spurred by their growing interest in architectural history. In 1988,
Harry Francis Mallgrave invited Wagner scholars from Europe and the
U.S. to attend "Otto Wagner and the Genesis of European Mod-
ernism," a symposium in Santa Monica organized by the Getty Center
for the History of Art and the Humanities. The same year, Mallgrave
published his translation of the third (1902) edition of *Moderne
Architektur*. It was only thanks to Mallgrave's efforts that the United
States audience—both general and specialized—was introduced to
this major figure in the history of architecture.[18]

Wagner's second concrete link with the United States was his treatise
Die Grossstadt, prompted by "a flattering invitation received by the
author of this text on March 18, 1910, from A. D. Hamlin, on behalf of
Columbia University, requesting that I give a talk in New York at the
international congress 'for the art of the city.'" Although the congress
itself did not take place, Wagner's text was published in German in
1911, and appeared in English translation the following year as "The
Development of a Great City" in the May issue of *Architectural
Record*.

Die Grossstadt draws on the knowledge Wagner gleaned from his in-
volvement in urban planning. Here again he upholds a rational, pur-
pose-minded approach as opposed to "sentiment in city planning."

Championing "sanitary and cheap apartments" behind uniform facades as an expression of democracy, Wagner rejects the "ungainly absurdities" of the stylistic revivalists. The approach outlined in his essay is embodied in the accompanying plan for a new, twenty-second district of Vienna. Based on a grid system derived from Baroque models, it effectively refuted the Romantic notion of "the will to art" (in this context, the idea that a painterly effect may be achieved by means of a consciously organic layout). On the other hand, Wagner was more insistent than ever about the need for an end to the "beauty-destroying influence of the engineer." It was time, he declared, for the artists to have their say.

Wagner's essay came with eight illustrations, to convey a more accurate visual impression of his concept of "beauty." And for his part, A. D. (actually Alfred Dwight Foster) Hamlin, the director of the architecture program at Columbia University, devoted considerable attention to explicating the concept in his introduction to the text. Hamlin met Wagner in Vienna in 1894, when Wagner was seemingly at the height of his career: recently appointed to the faculty of the Akademie der bildenden Künste, he had been granted the title of *k. k. Oberbaurat* (Senior Imperial and Royal Adviser on Architecture) and put in charge of drafting an ambitious transport scheme for Vienna—the Stadtbahn. Though impressed by the artistic quality of Wagner's architecture for his theoretical "great city," Hamlin recognized the impossibility of adapting his scheme to the American context. As he observed: "It is based on conditions which can only exist under a strongly centralized, not to say imperial, government." In Hamlin's view, Wagner's democratic but uncompromising grid would have to be imposed from above. Ignoring the authoritarian cast of his remarks, Hamlin wrote approvingly of the scheme that it offered "facilities which shall guide urban development into favorable conditions and not follow the haphazard growth of ragged and unrelated fringes of speculative suburbs."[19]

The third tangible connection between Wagner and the United States was his 1907 "House of Glory" design, contained in the last volume of *Einige Skizzen*. According to Lux, this work was "intended as a museum of American National Shrines, worthy of a place in Washington." Together with an American colleague, and with a pledge of backing from a wealthy American patron, Wagner devised a plan for a complex that was to include a pantheon, mausoleum, and exhibition halls; its exterior was a modernized version of his 1882 design for the Berlin Reichstag. It took eighty years for the "House of Glory" to get the attention of the nation it was designed for: in 1987, a drawing of it appeared on the cover of the catalogue for the first Wagner exhibition in the United States, heralding a new era in the U.S. reception of Wagner's work. Organized by the Wagner Archive at the Akademie der bildenden Künste, under the direction of Graf, the show opened at the Drawing Center in New York City, followed by stops in Portland, Minneapolis, and Los Angeles. The American response to Wagner was not entirely positive, and the negative remarks, though rare, were significant. One critic wrote that "Wagner disappoints, as he does in the 1911 Great City, his proposal for a new Vienna where an architectural determinism produces an oppressive monumentalism." Referring to another design by Wagner, for the Berlin cathedral in 1890, the same author declared, "the tension between convention and invention becomes a cacophonous battle of the Neo-Classical and Art Nouveau."[20] If not entirely unreasonable, comments such as these are as one-sided as their focus on external appearance. Invariably, too, they demonstrate that in Wagner's case, the individual work cannot be understood in isolation. Both the "House of Glory" design and the study *Die Grossstadt* possess a quality that epitomizes Wagner—call it linkage, the nearly unconscious achievement of continuity—and they do so in a variety of ways. Even when creating something entirely new, Wagner still drew on the "full treasury of tradition."[21] In doing so, he offered future modernists access to rudimentary architectural forms dating back, as Graf discovered, to the Neolithic era. Though it seems to fall neatly enough into Lux's tripartite chronological division, Wagner's work was in fact a continuous process of anticipation and reminiscence: there are already instances of innovation in the early work, just as there are recurrences in the late work of elements that were presumably outdated. And, ultimately, there is the physical continuity within the buildings themselves, arising from the way in which seemingly separate areas are connected (through the use of glass in walls, floors, and ceilings) and separate categories merged (outer/inner, public/private). This signals an unraveling of the very notion of separation itself, as one space literally flows into the next. Was this a great leap forward into modernism? Yes, but even more, it was an affirmation that art, love, and life are inseparable. As the inscription Wagner chose for his first villa reads, *Sine Arte Sine Amore Non Est Vita*: There is no life without art and love.

Anne-Katrin Rossberg
Translated from the German by Elizabeth Clegg.

As with all of my contributions to this catalogue, this text would not exist without the support of friends and colleagues. I would like to express special thanks for assistance regarding the reception of Wagner's work in the United States to Janis Staggs-Flinchum (who undertook research) and Leslie Topp (for her apposite comments on my text as it progressed). My greatest debt, however, is to the knowledge and constant support of Christian Witt-Dörring.

[1] Otto Antonia Graf, "Otto Wagner," in: *Otto Wagner: Das Werk des Architekten (1841–1918)*, exhibition cat., Vienna, Historisches Museum der Stadt Wien, 1963, p. 11.

[2] Joseph August Lux, *Otto Wagner*, Munich: Delphin, 1914, p. 20.

[3] Otto Antonia Graf, "Biographical Note," in: *Masterdrawings of Otto Wagner: An Exhibition of the Otto Wagner-Archiv*, ed. by Graf, exhibition cat., Vienna, Akademie der bildenden Künste; New York, The Drawing Center; and other venues, 1987–88, pp. 3–4.

[4] Otto Wagner, "Aus einer Autobiographie" (1917), in: Max Eisler, "Künstlerbriefe aus Österreich 1890–1930," in: *Österreichische Rundschau*, vol. 2 (1935–36), p. 301. According to the Akademie archives, Wagner studied from October 1860 to April 1863. This contradicts the account he himself gave in his "Promemoria" (see note 5), which suggests that he completed his studies in 1862.

[5] "Promemoria," 1876, in the Handschriftensammlung of the Wiener Stadt- und Landesbibliothek, inv. no. 188.352.

[6] Cited in Hans Ostwald, *Otto Wagner: Ein Beitrag zum Verständnis seines baukünstlerischen Schaffens*, Baden: Buchdruck, 1948, p. 24.

[7] Wagner, "Aus einer Autobiographie" (as note 4).

[8] Wagner, *Einige Skizzen, Projekte und ausgeführte Bauwerke*, vol. 1 (1889), in: Otto Antonia Graf, *Otto Wagner*, vol. 1: *Das Werk des Architekten 1860–1902*, Vienna: Böhlau, 1985, p. 72.

[9] See, for example, the obituary by Ferdinand von Feldegg in the supplement (*Der Bauinteressent*) to *Wiener Bauindustrie-Zeitung*, vol. 35, no. 29 (April 19, 1918), and Hans Tietze, *Otto Wagner*, Vienna: Rikola, 1922, p. 11.

[10] Wagner, *Einige Skizzen*, in: Graf, *Otto Wagner*, vol. 1 (as note 8), p. 73.

[11] See illustration in: *Wiener Bauindustrie-Zeitung*, vol. 22, no. 1 (1904–05), p. 35.

[12] This exhibition was held to mark the fiftieth year of Emperor Franz Joseph's reign. The October 1898 issue of *Ver Sacrum* contained illustrations of individual pieces of furniture from Wagner's interiors. In issue no. 3 of 1900, the rooms were pictured incorporated into Wagner's small apartment at Köstlergasse 3, extended by the addition of a dining room; the caption reads "Ein Absteigquartier" (pied-à-terre).

[13] Wagner, *Moderne Architektur*, in: Graf, *Otto Wagner*, vol. 1 (as note 8), p. 176.

[14] Frank Lloyd Wright, *Ausgeführte Bauten und Entwürfe*, Berlin: Wasmuth, 1910. The book was distributed in the United States with an inserted English translation of the text, titled "Studies and Executed Buildings."

[15] Archive of Paul Asenbaum, Vienna.

[16] Otto Wagner, "Modern Architecture," published over the course of three issues in: *The Brickbuilder*, vol. 10, no. 6 (June 1901), pp. 124–128; vol. 10, no. 7 (July 1901), pp. 143–147; vol. 10, no. 8 (August 1901), pp. 165–171. *Otto Wagner, Modern Architecture: A Guide for His Pupils in This Domain of Art*, transl. by N. Clifford Ricker, Boston: Rogers & Manson, 1902.

[17] Robert D. Kohn, Book Reviews: "'Die Baukunst Unserer Zeit' by Otto Wagner, Vienna 1914, Anton Schroll & Co.," in: *Journal of the American Institute of Architects*, vol. 3 (1915), p. 203.

[18] *Otto Wagner, Modern Architecture: A Guide for His Students to This Field of Art*, transl. and intr. by Harry Francis Mallgrave, Santa Monica, Calif.: Getty Center for the History of Art and the Humanities, 1988; *Otto Wagner: Reflections on the Raiment of Modernity*, ed. by Harry Francis Mallgrave, Santa Monica, Calif.: Getty Center for the History of Art and the Humanities, 1993.

[19] Otto Wagner, *Die Grossstadt: Eine Studie über diese*, Vienna: Schroll, 1911; Otto Wagner, "The Development of the Great City," transl. and intr. by A.D.F. Hamlin, in: *Architectural Record*, vol. 31, no. 5 (May 1912), pp. 485–500.

[20] Roy Strickland, "Exploring Wagner's Vision," in: *Progressive Architecture*, vol. 69, no. 4 (1988), p. 28.

[21] Wagner, *Moderne Architektur*, in: Graf, *Otto Wagner*, vol. 1 (as note 8), p. 272.

ADOLF LOOS

*** DECEMBER 10, 1870, BRNO**
† AUGUST 23, 1933, KALKSBURG (NEAR VIENNA)

THE IRWIN S. CHANIN
SCHOOL OF ARCHITECTURE
of
THE COOPER UNION
presents

An Exhibition of
THE ARCHITECTURE *of* ADOLF LOOS

Panel Discussion :
TUESDAY, 15 DECEMBER 1987
from 4 to 6 pm
THE GREAT HALL
The Cooper Union Foundation Building

Opening Reception :
TUESDAY, 15 DECEMBER 1987
from 6 to 8 pm
ARTHUR A. HOUGHTON, JR. GALLERY
The Cooper Union Foundation Building

THE COOPER UNION
Foundation Building
7th Street and Third Avenue
New York City
212·353·4220

Invitation to the exhibition *The Architecture of Adolf Loos* at Cooper Union, New York, December 16, 1987–January 13, 1988. Courtesy Cooper Union, New York

Writing of Europe in the years around 1890, cultural historians have long paid particular attention to the city of Vienna, capital of Austria-Hungary and site of the official residence of its penultimate emperor, Franz Joseph. The period of cultural change initiated in these years was in fact to prove the last "golden age" in the multicultural society of that venerable empire. Only three decades after 1890, the empire had ceased to exist.

The transformation of Vienna was set in motion by a project that initially seemed destructive but that actually prepared the ground for a new beginning. The major urban-planning project of the mid nineteenth century was supposed to allow the medieval city to enter the modern world and flourish there. Accordingly, the fortification walls were torn down and an unprecedented building boom got underway, soon transforming Vienna into a gigantic building site. The emperor, who had ordered the demolition, heeded those of his advisors who urged him to present the appearance of a forward-looking monarch supportive of trade and industry. A new social stratum emerged: the Viennese upper bourgeoisie. This group was sufficiently self-confident to use art and learning to its own advantage as contexts for self-representation, and sufficiently wealthy to be able to counter the previously unchallenged "official" taste of the conservative forces in society with their own understanding of art.

It was precisely in this period of social and cultural upheaval that Adolf Loos, born in 1870 in Brno, arrived in Vienna to embark on what would soon become a campaign of enlightenment. As a reformer, Loos achieved his first impact on Viennese society as a journalist, interior designer, and furniture maker, and it was only later that he was able to effect change through the medium in which he was to express himself most emphatically—architecture. But, as Loos himself would later insist, the architect is born only with the realization of his de-

signs, in their materialization in three dimensions. Loos first had to create an environment in which an architect such as he would become might receive commissions. Even while still at school, Loos had been attracted to the idea of being an architect (although he had first considered the study of electronics). In trade school, he entered the engineering department. As the son of a sculptor active largely as a stonemason, Loos grew up with a close familiarity both with three-dimensional art and with craft. His father made his living as a highly regarded supplier of tomb monuments, always ensuring that his team was responsible for every aspect of production. Thus, in his youth Loos came to understand the necessary interplay of art and craft, of the idea and its execution.

His father's business was based in Moravia, and it was only logical that, having completed his schooling with moderate success in Brno, it was to Vienna that Adolf Loos should go in order to obtain a solid training as an architect. First Loos was obliged to serve for one year in the Austro-Hungarian army. He then resumed his studies, not in Vienna, but at the Technische Hochschule (Technical College) in Dresden. He remained there for two years but obtained no qualification. It appears that he spent less time attending lectures than in touring the city and its environs, allowing the built environment to exert its influence on his imagination, much preferring to learn in this way than through the academic study of architectural theory.

A much more formative experience for Loos than the dry lectures at the Technische Hochschule were his years in the United States, to which he was initially attracted by the World's Columbian Exposition mounted in Chicago in 1893. Loos's visit to America, where he was eventually to spend three years, brought him into direct contact, for the first time, with Anglo-Saxon culture and lifestyle. He stopped in England both on his way to New York and on his way back to Vienna. In America, he initially stayed with relatives in Philadelphia, a bastion of the nineteenth-century Greek Revival. However, Loos was inspired less by American architecture itself than by another aspect of the American way of life. He returned to Vienna full of admiration for the way in which the virtues of economy, functionality, truth to materials, hygiene, and classlessness were reflected in the design of the most commonplace objects and utensils, but also in the essentially practical layout of cities, hotels, and apartment blocks.[1]

Arriving back in Vienna, Loos embarked on his career as an essayist—and it was primarily the bizarre and impractical design of commonplace objects and utensils encountered in Europe that prompted his harshest criticism in numerous articles for the press. It was not long, however, before he moved beyond his written campaign for more functional design and engaged in the battle with designs of his own, not least in order to give his arguments concrete support. Virtually every object that Loos designed during a period of more than thirty years, be it a piece of furniture or some other sort of household item, is notable for its practicality, the suitability and durability of its material(s), and the perfection, indeed sensuality, of its form.

Over the following years, his interiors were to incorporate copies of classical furniture as well as pieces he had himself created (some of

these also becoming "classics"). For the interior of the Viennese Café Museum, he designed extremely light-weight chairs (cat. no. III.9) to accommodate the need to move them from table to table. They were made, accordingly, in bentwood cut against the grain (for lightness) but broader at points of attachment (for strength). They were also stained bright red. Despite every precaution, however, this café furniture did not prove as robust as hoped and, years later, in designing seating for the Café Capua, also in Vienna, Loos would settle for heavy, "indestructible" armchairs. While these have remained collectors' items occasionally possible to find, an original and well-preserved chair from the Café Museum is an extreme rarity.

One of Loos's especially notable designs is the case clock, apparently first produced in 1897 as part of what may well have been his first executed domestic interior. This early version still has conventional features such as a brass housing, Roman numerals, and ornamental hands. Yet only a few years later, Loos used the design again in an adapted form that would be repeatedly incorporated into his interiors, one of a series of perpetually recurring objects. Another such was to be his tripod stool, a design based on a stool seen in the Liberty store in London (which was itself an adaptation of an ancient Egyptian design), or the armchair he termed the *Knieschwimmer* (knee-swimmer [cat. no. III.12]), which combined the utmost elegance with an extreme degree of comfort and, moreover, was derived—like much of Loos's seating furniture—from an English model.

Also of particular significance was the glass service designed in 1931 for the firm of Lobmeyr (cat. no. III.13), which is of interest in representing a period of Loos's career when he was active almost exclusively as an architect. A slightly adapted form of this design (altered in accordance with modernized production methods) is still made, along with other glass designs, by the same firm. Loos's glassware for Lobmeyr received more attention in the anglophone world than any of his other design work.[2]

Loos's visit to the 1893 exhibition in Chicago had enabled him, as a sharp-eyed observer and analyst, to assess the relative importance of the applied arts in the various countries of Europe, as demonstrated by the international range of products on display. And it was here that he laid the foundations for his new aesthetic of the true, the practical, and the enduring. He drew further encouragement for this way of thinking from the extensive displays representing the host country, America, but also from those of Japan and, indeed, many other distant parts of the world. The breadth of this material itself helped Loos toward a new perception of the situation in Europe, and this in turn to the elaboration of an ethical counterpart to his new aesthetic.

Loos, however, did not wish to become a pioneer of design and architectural reform in the United States, but to liberate Europeans from the mental and social cul-de-sac in which he perceived them to have become immobilized. He already had a clear idea of his program, which he would embody in presenting himself as *der mensch mit den modernen nerven* ("the man with modern nerves"). He lost no time in establishing his preferred methods for the introduction and dissemination of his ideas: his own appearance (dressed immaculately in tai-

lor-made clothes of English cloth and cut), the provocative impact he could achieve through aggressive and amusing publications, and vigorous support for every representative of the modern and the unconventional in any of the arts. Loos used his exhibition reviews to give voice to his own fundamental reflections, exploiting such texts, in the best possible sense, both to define and to promote himself. In no time at all, his witty articles were the preferred reading of an enlightened section of Viennese society, and this success in itself made Loos into a recognized exemplar of the most progressive elements in that society. It was Loos's own stylish tailors in Vienna, Goldman and Salatsch, who in 1898 first commissioned from him a commercial interior, for their shop in Graben in the Inner City. And, as even one of his sharpest critics, Ludwig Hevesi, was to concede, Loos did a brilliant job. For he was far from being merely a theorist. It was indeed in practice that he excelled. It was thus inevitable that architecture would in due course become the medium through which Loos would most effectively achieve the "introduction of Western civilization into Austria," the phrase he used as the subtitle of the journal he founded in 1903, *Das Andere* (The Other).

However, until Loos emerged as the most advanced architect of his generation (and this was not until around 1910), he had to pursue the verbal and written propagation of his notions of reform. This naturally brought him into contact with the various progressive circles to be found within Austria-Hungary. And, just as he committed himself to a contemporary and forward-looking architecture, and to the "liberation" of the applied arts, so Loos repeatedly demonstrated his material (often financial) support for members of these circles—be they the early Austrian representatives of the women's movement (for example, Rosa Mayreder) and the reform of children's education, in particular for girls (Eugenei Schwarzwald), or the most advanced composers of the day (Arnold Schönberg, Alban Berg, Anton von Webern, Josef M. Hauer) and their counterparts in painting (Oskar Kokoschka), literature (Karl Krauss, Peter Altenberg), and theater. Many of Loos's first published articles, which employ an engagingly dramatic narrative style, are not only programmatic in content but enlivened by accounts of personal experiences, for example, "Die Schumacher" (The Shoemaker; 1898).

Loos finally earned recognition as an architect with the commercial interiors designed in the late 1890s (for Goldman and Salatsch in 1898 and the Café Museum in 1899), and with the domestic interiors that he permitted a small circle of enlightened patrons to view through his "apartment tours." It was clear, even in this earliest work, that Loos had already established a distinct personal style, and one that was not the outcome of academic training but, rather, an "illustration" of the world as he conceived it, as a quintessentially "modern" man drawing on the impressions and experiences gathered during his travels. This was a store from which he was then able to select, adapt, and transform as appropriate to each commission. Fundamental to his treatment of architectural space, alongside the norms of style and proportion employed in Classical Greece, were a concern for the individual's experience of space, the placing of volumes in relation to

each other (always taking account of their purpose and the patterns of movement they imposed), and the incorporation of the built structure into its urban environment. Practicality was equally important to Loos, and wherever possible he aimed for unornamented, precise execution in economically deployed, naturally beautiful materials, such as he had discovered in the furniture and objects made by Shaker communities in America. There can be no doubt that the evolution of Loos's early work in Vienna (a context to which it might appear to owe nothing) had an enormous impact on a small circle of aesthetically and culturally oriented individuals and that, through their support, it influenced the development of the elegant and slender forms of Viennese Jugengstil, which were in turn to achieve a consummation of sorts in the products of the Wiener Werkstätte founded in 1903.

In 1902, Loos married Lina Obertimpfler, the exquisitely pretty daughter of a coffeehouse owner. After separating from Loos, she would have an acting career in the United States. All of Loos's later relationships, in each case with women much younger than himself, were of short duration. His first marriage did, however, prompt him to design a Viennese apartment for himself that he intended for long-term use. This was to be the "still point" in the "turning world" of Loos's often turbulent private and professional life for his remaining thirty years. At the end of each of his numerous journeys to the Mediterranean and around Europe, Loos always returned for a certain time to Vienna. (The dining room of this apartment has been preserved and can today be viewed at the Historisches Museum der Stadt Wien.)

The first high point in Loos's architectural career occurred in the years immediately preceding World War I. By this time, he was beginning to receive a fair number of commissions—notably for houses—and these permitted the beginnings of financial independence. Between 1910 and 1912, Loos built individual houses for a series of clients: Steiner, Stoessl, Goldman, König, and Scheu. At around the same time, he also carried out several important projects of interior decoration in central Vienna: for the American (or Kärntner) Bar, for the men's outfitters Knize, and for the Café Capua. But the outstanding Viennese architectural achievement of these years—before the outbreak of war and collapse of the Hapsburg Empire—was Loos's scheme for a commercial and residential block commissioned by Goldman and Salatsch in the city's center. This commission certainly earned Loos greater regard than he had so far achieved, but it also generated vehement attacks—at one point, the municipal council ordered that work be halted—to the extent that his health began to suffer. Even today, the Goldman and Salatsch building (restored in 1990) is capable of provoking heated arguments, although its architectural significance is undisputed. It was, indeed, the first of Loos's buildings to be listed (in 1947) as a protected monument.

The advent of war in the summer of 1914 brought building activity in Vienna to a virtual standstill. In due course, it also meant that Loos was called up for active service. However, even in this exceptional situation, he remained true to his own aesthetic and ethical convictions, turning up for work in the "reform uniform" he had invented for himself, despite its obvious derivation from the model provided by Eng-

land and America, the wartime enemies of the Central Powers. It was only with a great deal of effort that Loos escaped being tried by a military court for such outrageous individuality.

The end of the war brought with it unimaginably severe food and housing shortages to much of the new, postimperial Austria, and above all to Vienna. Loos now focused all his energy and resourcefulness on devising solutions to both problems. He assumed the (unsalaried) leadership of the project to establish new, low-cost housing estates in order to provide those most in need (who were often wounded war veterans) with their own home and attached vegetable plot. Loos distributed the schemes he had devised to those prepared to build their own homes. He also assisted in the technical planning and building of new districts on the outskirts of Vienna. It was only when appointed chief architect to the authorities overseeing this project that Loos began to receive any form of remuneration for his activity. However, even his undeniably successful contribution to the restoration of postwar Vienna issued at length in a new confrontation with the city council.

This ultimately persuaded Loos to leave Austria, and in the early 1920s he moved to France, where he had been invited in 1923 to exhibit at the Salon d'Automne, and where a collection of his early essays had been published in book form in 1921 as *Ins Leere gesprochen*. Before leaving Vienna, however, Loos returned to working for private clients, building the Strasser and Rufer houses and designing interiors for several Viennese retailers, in addition to one for the Berlin branch of the Knize firm.

While in France, Loos spent most of his time in Paris and on the Côte d'Azur. He established himself as an architect in the French capital and completed a number of projects, among them a house for the expatriate Romanian poet and leading Dadaist Tristan Tzara, and an interior for the Paris branch of Knize. In the south of France, however, he found it hard to attract commissions. But his design submitted to the 1922 competition for the Chicago Tribune Tower was the most talked about of all the entries.[3] Loos proposed a tower in the form of a gigantic Doric column, a form with the capacity to function at any scale, as a play on the English word *column* with its simultaneously journalistic and architectural connotations. Although Loos had always opposed architectural competitions, he made an exception in this case, partly because he had firsthand experience with Chicago, but also because he evidently trusted the Americans to appreciate the symbolic significance of his design.

From 1927 onward, ill health increasingly prompted Loos to make return visits to the reduced, postimperial Austria and the newly independent Republic of Czechoslovakia. During the last years of his life, periods devoted to work were to be interrupted by ever-longer stays in sanatoria. It was, nonetheless, in these years that Loos achieved three of his most mature and timeless designs: the Moller House in Vienna (1928), the Müller House in Prague (1928–30), and the Khuner House near Payerbach in Lower Austria (1930). In all three projects, he implemented to perfection the *Raumplan* (spatial plan), a concept first formulated in 1930 by Loos's pupil and collaborator

Heinrich Kulka. Loos made a point of designing not on paper but in his head, that is to say, in imagined three-dimensional space—as every architect should. Just as he once said that future generations would play chess in three (not two) dimensions, so he achieved dazzling sequences of interacting spaces in the interiors he designed. By this means, he not only obtained surprising views and exciting transitions from one space into another, he also succeeded in achieving the requisite spatial "economy" insofar as his scheme offered more usable surface than would be available in a house divided into conventional storeys.

The Moller, Müller, and Khuner houses were Loos's last great works, although he would remain engaged in contemporary debate through essays and lectures to the end. It is characteristic that this confirmed individualist of modern cultural history should never have any true pupils or followers, even though he remained committed throughout his life to the communication of ideas and to education, not least at the private architectural school he founded in Vienna in 1912. Here he sought to impart to his pupils what he himself had seen and experienced in the United States in the 1890s, his aim being to convey to them a strong sense of, and commitment to, whatever was genuinely new and forward-looking. Unsurprisingly, one result of this approach was that his two most gifted students—Rudolf M. Schindler and Richard Neutra—were persuaded to emigrate to America, where they both had successful architectural careers.[4] Although both continued to work in a style that reflected the influence of Loos, they were unable (and in fact did not wish) to effect a continuation of his approach to architecture.[5]

For Loos, architecture had always meant a great deal more than the creation of form. In effect, he used architecture to formulate ideas of how the world should be remade to accommodate the free and self-confident modern individual. Loos requested that his tombstone bear the inscription: "Here lies Adolf Loos, who freed humanity from superfluous labor." He intended the stone itself to be in the form of a cube of gray granite—a symbol of his creative engagement with three-dimensional space. Ironically, his Viennese pupils failed him even in this, being unable to provide a perfect cube for the grave.

In 1920, Loos's essay "Ornament und Verbrechen" (Ornament and Crime) appeared in the journal *L'Esprit Nouveau* with a foreword by Le Corbusier in which he claimed Loos as a forerunner of his own brand of modernism. The association with Le Corbusier would distort the international perception of Loos's work for decades. This began to change in the 1980s, when Loos's architecture, furniture, writings, and notions of spatial planning began to receive a great deal of attention in Vienna and the United States. The key year was 1982: the first comprehensive biography and catalogue raisonné was published in Austria, and his essays from *Ins Leere Gesprochen* were translated as *Spoken into the Void* in the U.S.[6] Both publications went beyond the superficial idea of Loos as a warrior against all ornament and a "pioneer" of the modern movement. The latter, with an introduction by contemporary Italian architect Aldo Rossi, provided an American readership direct access to Loos's writings and can be seen as part

of an effort to draw on early twentieth-century figures like Loos for support of a design approach that sought to be modern without rejecting the past.[7]

It was not until 1987 that an exhibition devoted to Loos was held in the United States, at the Cooper Union in New York.[8] The show featured scale models of his buildings and several examples of his furniture and glassware. In 1989, the largest Loos exhibition to date opened in Vienna in three locations: the Graphische Sammlung Albertina, the Historisches Museum der Stadt Wien, and the newly restored "Looshaus" on the Michaelerplatz.[9] Although Loos received relatively few architectural commissions, the private houses he executed have been preserved, and in most cases restored. Of the many shop interiors he designed, only a few have survived, and the same is true of his numerous apartment interiors. Most of his drawings and plans were acquired in 1966 by the Graphische Sammlung Albertina.

Burkhardt Rukschcio
Translated from the German by Elizabeth Clegg.

[1] For more on the influence of America and England on Loos, see Johannes Spalt, "Adolf Loos and the Anglo Saxons," in: *The Architecture of Adolf Loos,* exhibition cat., New York, Cooper Union, 1987, pp. 14–19.

[2] The service was featured in "Modern Glass Since 1880: Austria," in: *Industrial Arts,* vol. 1, no. 4 (Winter 1936), p. 277. It was through his glassware that Loos was present in two American exhibitions in the 1940s: *2500° F: The Art and Technology of Modern Glass,* New York, Cooper Union, 1948, and *Lobmeyr Glass,* New York, Museum of Modern Art, 1949 (for the latter, see "Marble, Shantung, and Glass," in: *Interiors,* vol. 108 [June 1949], p. 16). The first Loos designs to be collected by American museums were glassware, and these still dominate Loos collections in the United States. The first museum acquisition of a Loos object we have been able to find is a glass tumbler by the Indianapolis Museum of Art in 1933. Glassware by Loos was acquired in the 1950s by the Busch-Reisinger Museum and the Museum of Modern Art in the 1950s, and by the Corning Museum of Glass and the Philadelphia Museum of Art in the 1970s.

[3] The volume in which all the competition entries were published listed Loos as an architect based in Nice. For more on the competition and Loos's entry, see Stanley Tigerman and Stuart Cohen, *Chicago Tribune Tower Competition and Late Entries to the Chicago Tribune Tower Competition,* 2 vols., New York: Rizzoli, 1980; Stuart Cohen, "The Skyscraper as Symbolic Form," in: *Design Quarterly,* vol. 118–119 (1982), pp. 12–17; and Katherine Solomonson, *The Chicago Tribune Tower Competition: Skyscraper Design and Cultural Change in the 1920s,* New York: Cambridge University Press, 2000.

[4] See Otto Kapfinger and Adolf Stiller, "Neutra und Schindler: Zwei Europäer in Kalifornien," in: *Visionäre & Vertriebene. Österreichische Spuren in der modernen amerikanischen Architektur,* ed. by Matthias Boeckl, exhibition cat., Kunsthalle Vienna, 1995, pp. 117–137.

[5] Neutra did play a role in ensuring that Loos's memory was kept alive in the United States. For example, when the English translation of Ludwig Münz and Gustav Künstler's monograph on Loos was published in 1966 (*Adolf Loos: Pioneer of Modern Architecture,* New York: Praeger), Neutra wrote a review for *Architectural Forum* in which he argued for the continued relevance of his ideas. See Richard Neutra, in: *Architectural Forum,* vol. 125, no. 1 (July–August 1966), pp. 88–89, 116.

[6] Burkhardt Rukschcio and Roland Schachel, *Adolf Loos: Leben und Werk,* Salzburg: Residenz, 1982; Adolf Loos, *Spoken into the Void: Collected Essays, 1897–1900,* transl. by Jane O. Newman and John H. Smith, Cambridge, Mass.: MIT Press, 1982.

[7] Rossi also wrote the introduction to a monograph on Loos published in English in the same year: Benedetto Gravagnuolo, *Adolph Loos: Theory and Works,* transl. by C. H. Evans, New York: Rizzoli, 1982.

[8] *The Architecture of Adolf Loos* (as note 1). This exhibition originated at the Museum of Modern Art in Oxford in 1985.

[9] *Adolf Loos,* ed. by Burkhardt Rukschcio, exhibition cat., Vienna, Graphische Sammlung Albertina, with the Historisches Museum der Stadt Wien, 1989.

JOSEF HOFFMANN

*** DECEMBER 15, 1870, PIRNITZ/BRTNICE**
† MAY 15, 1956, VIENNA

Announcement for an exhibition of the work of Josef Hoffmann, "News and Events May 1975," Austrian Institute. Courtesy Austrian Cultural Institute, New York

The work of Josef Hoffmann embodies like no other the qualities of gentle modernism and simple glamour that have made Viennese design so compelling for American audiences. Born in 1870 in the Moravian village of Pirnitz (Brtnice, now Czech Republic), Hoffmann moved to Vienna to begin his architectural training in 1892 and remained there through two world wars and four regimes until his death in 1956. Throughout his career, he was active as both architect and designer; his work encompasses everything from sanatoria to wine

glasses, from public housing to exhibition design to leather handbags. Though Hoffmann himself never in fact set foot in the United States, his objects and interiors, and more generally his influence as a designer of total environments, have been traveling across the Atlantic since the beginning of the twentieth century.

As a young man, Hoffmann was at the very center of the reforms in art, architecture, and design that took place in Vienna around 1900.[1] One of Otto Wagner's first students, he worked closely with his progressive teacher (as both student and employee in Wagner's studio), while exchanging ideas with his fellow Wagner-*Schüler* and with nonarchitects such as Koloman Moser. In 1897, the group of young architect-designers around Hoffmann joined with the dissatisfied *Jungen* who, under Gustav Klimt's leadership, had decided to leave the dominant Viennese exhibiting society, the Künstlerhaus, to form the Vereinigung bildender Künstler Österreichs (Union of Austrian Artists), otherwise known as the Secession. Secessionists criticized the Künstlerhaus for a mundane commercial attitude, manifested in their jumbled exhibitions and slapdash publications; the Secessionists, in contrast, took presentation very seriously. Indeed, they saw exhibition design as artistically and ethically valuable in itself, and the design and illustration of their catalogues and their journal *Ver Sacrum* were equal to (if not more important than) the information conveyed.

Hoffmann was involved in all these aspects of the group's activities, designing and illustrating issues of *Ver Sacrum* and catalogues, and contributing fully furnished rooms to the first Secession exhibition in the spring of 1898 and to his friend Joseph Maria Olbrich's Secession building, which opened in November of that year. The innovative flexibility of the building's exhibition spaces meant that an entirely new interior could be designed for each show. The sequence of Hoffmann's Secession exhibition designs clearly demonstrates the shift in his formal vocabulary from Henry van de Velde–inspired organic curves in the late 1890s to a rectilinear control and emphasis on the square. The latter approach reached fruition in the celebrated fourteenth Secession exhibition of 1902 (known as the *Beethoven* exhibition), where Hoffmann also played with the tension between surface pattern and cubic volumes. This so-called *Flächenkunst* is a recurring theme in Hoffmann's designs.

Exhibition design would occupy Hoffmann throughout his career, as would the creation of domestic interiors, both in preexisting buildings and in buildings he designed himself. His first major architectural commissions were for the villas of the artists' colony on the Hohe Warte in Vienna. It was here, in an effort to create an environment for modern lifestyles—combining comfort with hygiene, order, light, and air—that Hoffmann first demonstrated the overall rectilinear simplicity and a kind of image of functionality that would characterize much of his design work. In 1901–02, Hoffmann, Moser, and Charles Rennie Mackintosh renovated and designed the interiors for the Viennese villa of businessman and patron Fritz Waerndorfer. This combination of British Arts and Crafts influence and enlightened patronage fed directly into the foundation in 1903 of the Wiener Werkstätte. Emulat-

ing Arts and Crafts cooperative workshops such as C. R. Ashbee's Guild of Handicraft, the Wiener Werkstätte had as a goal to bring design and manufacturing of objects, from metalwork to bookbinding to furniture, under one roof, thus gaining complete control over the quality of the end products. Theoretically, craftsmen would participate in business decisions and receive a share of the profits; in reality, the Wiener Werkstätte was run by the three founders (Hoffmann, Moser, and Waerndorfer), and was perpetually foundering. The emphasis was on handcrafting—machines were used sparingly.

In its first few years, the Wiener Werkstätte's main activities revolved around Hoffmann's architectural projects, including two that continue to define his legacy: the Sanatorium Purkersdorf (1904–05) outside of Vienna, and the Palais Stoclet (1905–11) in Brussels. These two buildings were completely furnished and outfitted by the Wiener Werkstätte, and some of Hoffmann's most well-known furniture was made for the spare and hygienic Purkersdorf project (cat. no. III.16). At the Palais Stoclet, Hoffmann combined art (including Klimt's mosaics for the dining room, as well as Stoclet's eclectic collection of medieval and non-Western sculpture), furniture, fittings, textiles, objects of use, garden design, sculpture, and architecture in an integrated modern whole, avoiding both excess and monotony.

In other projects, from 1905 on, Hoffmann began to incorporate forms from the past into his repertoire, though never by direct quotation. In 1908, his huge complex for the *Kunstschau* (the exhibition by the group surrounding Klimt which had seceded from the Secession) combined an abstracted classical vocabulary with original forms (Hoffmann's so-called *Sitzmaschine*, or reclining chair [cat. no. III.35] was first shown here). The Primavesi country house (1913–14) in Winkelsdorf (Kouty, now Czech Republic) drew on Moravian folk traditions in all aspects of its architecture and interior design to create a kind of colorful, patterned stage set for the rustic holidays of its wealthy owners. At the same time, the Villa Skywa-Primavesi in Vienna (1913–15) and the Austrian pavilion at the Werkbund exhibition in Cologne in 1914 combined an unorthodox but monumental classicism in the facades with an equally idiosyncratic version of the Biedermeier in the furniture and other interior features. The 1910s were, until the war, a busy time for Hoffmann, during which he received considerable international exposure, especially through his exhibition-design activities. It should be noted that, unlike many designers of the epoch, Hoffmann was not a theorist—he tended to let his work speak for itself, and even Adolf Loos's frequent attacks rarely provoked a written defense. His influence spread through the German-speaking realm and into France via frequent publications of photographs of his work in journals, via his students, and via the web of personal connections among designers and patrons throughout Europe.

In the restricted economic situation of 1920s and '30s Austria, commissions for grand houses were not as forthcoming as they had been. Hoffmann did design and furnish a series of houses in the more prosperous Czechoslovakia from 1919 on, and he received the commission for one more grand suburban Viennese villa, for Sonia Knips (1924–25). Continuing exhibition designs found their climax in Hoff-

mann's Austrian pavilion for the 1925 *Exposition Internationale des Arts Décoratifs et Industriels Modernes* (International Exhibition of Modern Decorative and Industrial Arts) in Paris. In the pavilion, Hoffmann and the Wiener Werkstätte, at the height of their international influence at this point, displayed objects of great playfulness, delicacy, and historical resonance, at a far remove from the contemporary designs of the Bauhaus. But it would be a mistake to assume that Hoffmann was completely divorced from the modern movement and the social concerns of architecture and design in the "Red Vienna" of the interwar period. Between 1923 and 1929, he designed three pared-down municipal apartment blocks and, in 1927, equally simple furnishings for an exhibition of model interiors for working-class housing. Hoffmann was very much aware of the international modern movement, and experimented in a rather eclectic fashion with its forms, while having little sympathy for or understanding of its ideas.

Hoffmann's career extended into Austria's National Socialist period, when he continued to be active after many of his clients and collaborators had been murdered or forced into exile. His only monumental public building dates from this period: the 1940 remodeling of the German embassy into the Wehrmacht officers' club.[2] Hoffmann was far from an enthusiastic National Socialist, but he did enjoy a privileged position in social and design circles after the *Anschluss*. He would continue to fill the role of the venerated elder statesman of modern Austrian architecture for the rest of his life.

Hoffmann also played an important role as a teacher. From 1899, when, just four years out of school, he was appointed professor at Vienna's Kunstgewerbeschule (School of Applied Arts), to his retirement in 1936, he presided over a design course through which more than 400 Austrian and foreign students passed.[3] Officially, it was a special class for architecture, but in reality all aspects of design (including fashion) were included, and there was a strong emphasis on independent work and individual development. Students of Hoffmann who went on to become well-known designers included Maria Likarz, Eduard Wimmer, Vally Wieselthier, Otto Prutscher, and Franz Lebisch. Another student who should be mentioned is Leopold Kleiner, who later made great efforts on behalf of his teacher's reputation both in Europe and the United States. Kleiner not only published the first monograph on Hoffmann in 1927, but after his emigration to New York in the 1930s, he continued as a loyal publicist for Hoffmann and for modern Austrian design in general.[4]

HOFFMANN AND THE UNITED STATES: ANOTHER KIND OF MODERNISM

The history of Hoffmann's American reception and influence reaches back to the beginning of the twentieth century and the early stages of his career. It is a history that winds its way through turn-of-the-century avant-garde design, to the 1920s *moderne*, through the polarizations of the International Style, to the revisions of postmodernism, all the while urging the redefinition of our assumptions about the European influence on modern American design. Hoffmann's first exposure to American audiences came at the 1904 World's Fair in Saint Louis, Missouri, known as the Louisiana Purchase International Exposition, to which he contributed a small room exhibiting applied arts and sculpture produced in the Vienna Kunstgewerbeschule.[5] White walls, black-and-white striped and gridded carpets, black wood pedestals, lecterns, and display cases were combined to create a self-conscious rationality and simplicity. Americans interested in modern developments in design would have also encountered the work of Hoffmann through articles and illustrations that had been appearing since the late 1890s in German art journals such as *Dekorative Kunst* and *Deutsche Kunst und Dekoration*, both of which were read in the United States, and in the British art magazine *The Studio* and its American version, *The International Studio*.[6] A prominent example is Frank Lloyd Wright, whose deep engagement with early twentieth-century German and Austrian design has only recently been recognized.[7]

On a more prosaic level, a booklet by Louise Brigham, titled *Box Furniture: How to Make a Hundred Useful Articles for the Home*, published in New York in 1910, shows Hoffmann's designs already being applied to do-it-yourself home decoration. Brigham explained to her readers that "the 'Hoffmann method' of utilizing the square as the basic principle in decoration … makes it possible to have attractive rooms decorated in a simple manner without any especial art training."[8] Hoffmann's work was first exhibited in a museum setting in 1912, as part of an exhibition organized by Karl Ernst Osthaus in Germany in collaboration with John Cotton Dana of the Newark Museum.[9] This exhibition, which traveled to six American cities after leaving Newark, presented Hoffmann working in a range of media. Hoffmann's "incomparable art of surfaces and proportions" (Osthaus's phrase) was represented in a series of architectural photographs, with exterior and interior views of the Wiener Werkstätte premises of 1903, and of the Palais Stoclet, among other buildings.[10] A section devoted to "Reklamekunst"/"The Advertising Art" included Wiener Werkstätte postcards, brochures, and wrapping paper; and other sections on "Buchgewerbe und Leder"/"Book Industries and Leather," "Tapeten, Linoleum und Linkrusta"/"Wallpapers, Linoleum and Lincrusta," "Textilien"/"Textile Fabrics," and the "Metallarbeiten"/"Metal Work" included marbled paper, leather accessories, wallpaper and linoleum designs, decorative fabrics, vases and other pieces in silver, a gold necklace, and two of the now-famous white-lacquered latticework pieces by Hoffmann.[11]

The exhibition benefited from a certain prewar American enthusiasm for things Germanic (especially considering the cities included on the tour all had large German populations) and friendly relations with the German government authorities.[12] The hostile environment directly after World War I and (in Dana's words) the "persistence of Anti-German prejudice" into the 1920s, stood in the way of the Newark Museum director's desire to continue to present the example of Hoffmann and his fellow designers across the country through museum exhibitions.[13] Newark did host *Applied Arts of Germany*, an exhibition organized by the Deutscher Werkbund in 1922, which included works designed by Hoffmann for the glass manufacturers J. & L. Lobmeyr.[14]

It was well attended, although a planned tour of American cities never came about.[15]

On the other hand, personal and commercial connections between Hoffmann and the United States grew in the 1920s. There was considerable Hoffmann-related traffic across the Atlantic, with aspiring American designers traveling to Vienna to study under the now internationally famous teacher, and Hoffmann students emigrating to the United States to work. Lillian Langseth-Christensen's memoirs provide a vivid account of the appeal of Hoffmann's elegant modernism to a sophisticated young New Yorker, and of the experience of an American woman in the Hoffmann school in the mid 1920s.[16] Scholars have traced many of these Hoffmann students and their travels. One intriguing early example is Edward Ascherman, who came from Milwaukee, studied with Hoffmann in Vienna, and by 1907 had established a design studio in New York, working in Hoffmann's early style.[17] Hoffmann's only child, Wolfgang, also a designer, emigrated to the United States in 1925; he was married to Pola Weinbach, another Hoffmann student, who worked for many years for the Botany Woolen Mills in Passaic, New Jersey, designing textiles in the spirit of the Wiener Werkstätte.[18] The Wiener Werkstätte ceramicist Vally Wieselthier moved to the U.S. in 1929, and worked in the same circles in New York.[19] The attraction of America, and specifically of New York, for these designers should be seen in the context of the strong representation of Germans and Austrians in the design scene in New York in the 1920s.

The Austrian architect and designer Joseph Urban had known Hoffmann in Vienna, and remained in close touch with him after moving to New York in 1911. Urban became one of the most important conduits of Hoffmann and Wiener Werkstätte influence in the United States, both through his own work and through the connections he provided to Hoffmann students in New York, as well as his encouragement of Americans wanting to study design in Vienna.[20] Most significantly, it was Urban who was behind the first Wiener Werkstätte retail branch outside of Europe, the Wiener Werkstätte of America, which opened in 1922 in New York.[21] It seems that no inventory lists have survived for the shop, but from the photographs of the original displays and from the reviews, it is clear that Hoffmann was well represented, above all with works in silver (vases, tea sets, etc.). This was a different Hoffmann from that of Newark: the postwar Hoffmann, under the influence of Dagobert Peche (a major force at the Wiener Werkstätte from 1915), and producing precious objects, still simple, but of playful, elongated proportions, and consistently in expensive materials.

It is clear from the many newspaper commentaries published about the Wiener Werkstätte of America that the readers of the general-interest press in 1922 did not need to be told who Hoffmann was. He emerges as a celebrated architect and designer, the "most significant art personality of the young Vienna," whose influence "in all the decorative and domestic arts … has been conspicuous and pervasive."[22] Long articles on Hoffmann appeared in major American architectural journals in 1924 and 1928.[23] Through a clutch of connections in the American design world (notably Rena Rosenthal, who ran an applied arts business called, for a time, the Austrian Workshop; her brother Ely Jacques Kahn, the Art Deco architect and designer; and her husband Rudolf Rosenthal), Hoffmann was almost brought to New York to run an "American arts and crafts academy."[24] Hoffmannesque forms appeared in the interwar work of American architects and designers such as Kahn, Eugene Schoen, and Rosario Candela in New York, Bruce Goff in Oklahoma, and David Adler in Illinois, all of whom were working in a modernist idiom that had little or nothing to do with the modern movement.[25] "America is beginning to feel the modern spirit," wrote Shepard Vogelgesang at the end of a 1928 article on Hoffmann.[26] The original combination of function and aesthetics, of tradition and abstraction in Hoffmann's work of the 1920s represented an acceptable way forward.

Hoffmann's architecture, in drawings, plans, and photographs, was shown in May 1927, again in New York, but in a very different kind of setting. The Machine-Age Exposition was organized by Jane Heap, co-editor of the Little Review (one of the intellectual "little magazines" of the interwar period); the show took place on West 57th Street, amid "unpainted white plaster finish of walls, columns, beams, girders and floor slabs of a common type of building erected for commercial renting."[27] The objects displayed were not vases and silverware, but "radio sets, valves, gears, propellers … aeroplanes … machine guns … motor car designs and electric light bulbs," alongside examples of photography, painting, sculpture, and architecture that, according to the curators, demonstrated a "machine age" tendency.[28] In the section devoted to Austrian architecture, Hoffmann was represented alongside his younger colleagues Josef Frank, Oswald Haerdtl, and Oscar Wlach, all of whom tended in the 1920s toward simple, cubic volumes in their architecture.[29] The selection of Hoffmann's architecture included in the exhibition, inasmuch as it can be reconstructed, consisted primarily of works demonstrating such simple, cubic volumes.[30] Works by younger, more radical architects such as Walter Gropius and the Russian Constructivists were also included; the show is seen by historians as the first American exhibition to fully embrace the machine aesthetic.[31] It is of particular interest that Hoffmann was included at all in such a show—while some examples of his work were undoubtedly simple and devoid of references to tradition, he himself never saw the machine as an inspiration. One wonders whether the organizers hoped that his status as a respected, senior architect in the late 1920s might give this innovative exhibition a certain gravity.

Hoffmann's design work was back in New York a year later as part of the International Exposition of Art in Industry at Macy's department store, in May 1928.[32] In addition to contributing a display room containing, among works by other Austrian artists, about fifty of his own brass, silver, and glass objects, Hoffmann caused a sensation with a boudoir and powder room.[33] These were two complete adjoining interiors, the former with walls covered in large square panels of burnished walnut, the latter lined with mirrors on walls, floor, and ceiling. The boudoir, which had already been included in exhibitions in Vienna in 1923 and in Paris in 1925, included a deep, stagelike upholstered

niche in one wall, really a large bed, with, in the words of the *New York Times*, "a host of drawers and shelves, some of them secret, for the intimate belongings of the occupant."[34] The mirrored powder room contained only a table and stool, and, ideally, a "modern woman," admiring her own multiple reflections.[35] "Concealed lights throw a soft glow over the lovely little occupant," imagined one reviewer, "and she can sit in there and powder herself until the cows come home—or whoever she may be waiting for."[36] Hoffmann's rooms seem to have evoked a powerful combination of modernity, eroticism, and a consumerist narcissism appropriate to their setting in Macy's and fascinating to New York audiences. "Constantly crowded with spectators," they were the stars of a show that attracted some 250,000 visitors in two weeks.[37] A catalogue was published to accompany the exposition; Hoffmann penned a short essay for it. With his Austrian patronage having shrunk drastically in the previous decade, and the Wiener Werkstätte on its last legs, he was acutely aware of American audiences for such exhibitions as a potential source of wealthy clients. His appeal at the end of his essay is poignant in view of what was about to happen to the American economy: "We know that America, which is not only a country of immense wealth, but of rapid development, of fresh and supreme receptivity, will know how to appreciate our endeavors and raise them to higher levels."[38]

Meanwhile, American architectural writers were starting to produce histories of modern architecture with a view to providing a pedigree for the so-called International Style of Le Corbusier and the Bauhaus. The sheer number of words devoted to Hoffmann and his work in some of the early histories is a testament to the fact that in the United States he was seen as a force to be reckoned with. But Hoffmann's role in these authors' narratives is that of a foil for the "true" modernists, and it is the central position of decorative arts in his work that helps to put him on the wrong side of the fence. For Sheldon Cheney in 1930, Hoffmann's designs have the modernity of high fashion: "They are smartly simple, alluringly enriched with color and pattern, chic, modish."[39] This in contrast to the earnest social commitment of, for example, the Bauhaus architects. A year earlier, Henry-Russell Hitchcock discussed Hoffmann as a leader of a kind of false modernism, using ornament, handcraftsmanship, and "the past in a reduced eclectic form."[40] Hoffmann's "close relationship to the minor arts," as Hitchcock put it, was suspiciously frivolous. While the Purkersdorf Sanatorium was admirable for its simplicity, the Palais Stoclet was already a "decorator's architecture."[41] The selection of Purkersdorf (or of a particular view of Purkersdorf, emphasizing its facade and ignoring its plan) as the one monument with which Hoffmann contributed to the history of the "true" modern architecture would be made again and again. Hoffmann was present in what became the canonical version of modern architecture, but only as a precursor, and only with one or two early buildings.[42]

During the two decades after World War II, Hoffmann's reputation in the United States was at a low ebb. It was not until the second half of the 1960s, when rigid definitions of architectural modernism were loosening, that the American design world began gradually to be aware of the entirety of Josef Hoffmann's œuvre. Beginning in the mid 1960s, Eduard Sekler at Harvard produced a series of articles and eventually a monograph that presented Hoffmann in all his phases and in the context of the Austrian art world and society.[43] An exhibition of Wiener Werkstätte objects and paintings by Klimt, Oskar Kokoschka, and Egon Schiele at the Galerie St. Etienne in New York in 1966 sought "to convey the fascinating artistic atmosphere pervading many areas of creative endeavor in Vienna during the last years of the Austro-Hungarian monarchy."[44] A series of publications on turn-of-the-century Vienna, beginning in the 1970s, fed a growing international fascination with this period, its art, design, and architecture.[45] It was in this context that the first American exhibition devoted solely to Hoffmann's work was presented, at the Austrian Institute in New York in 1975.[46] Not surprisingly, the show focused on Hoffmann as a decorative artist; objects mentioned in the *New York Times* review were: a Purkersdorf chair, wine glasses, an ashtray, a hammered brass server, and a *Gitterwerk* vase.[47] An exhibition text published by the Austrian Institute declared that "Hoffmann loved the ornament"; according to a review by architecture critic Paul Goldberger in the *New York Times*, "Hoffmann is probably correctly remembered more today as a decorator and maker of objects than as an architect."[48]

Meanwhile, both original Hoffmann designs and Hoffmannesque impulses were cropping up in some of the earliest postmodern architectural contexts. In 1975, the International Contract Furnishings (ICF) firm announced that it was distributing a range of reproduction furniture, accessories, and textiles in the U.S., designed by "Josef Hoffmann, rediscovered genius."[49] Hoffmann furniture can be seen in photographs of the home that Michael Graves designed for himself in Princeton in 1977, and of the 1979 De Menil residence in East Hampton, designed by Gwathmey Siegel.[50] It also appears in Graves's Humana Building in Louisville, Kentucky in 1982.[51] Charles Gwathmey, Richard Meier, and Michael Graves all designed Hoffmann-inspired furniture in the late 1970s and early '80s.[52]

Two larger exhibitions devoted to Hoffmann took place in 1981 and 1982–83 respectively, and differed in interesting ways. The first, organized by the private Vienna and New York–based Galerie Metropol and displayed at the Austrian Institute in New York, focused on Hoffmann's early furniture and metalwork.[53] The interpretive framework was derived from the canonical narrative of modern design, with Hoffmann positioned as a proto-Bauhaus functionalist. By contrast, the Hoffmann exhibition that opened at the Fort Worth Art Museum in 1982 included a great deal of the later work, and took on board a new, more inclusive approach to the history of twentieth-century design and Hoffmann's place in it.[54] The director David Ryan, in his foreword to the catalogue, put his finger on the reasons for Hoffmann's growing popularity: "The revival of interest in Josef Hoffmann's architecture and design coincides with a widespread return to more romantic styles and attitudes. In sculpture, crafts, and interior design, there is a pronounced re-emergence of handcrafted objects; organic materials, particularly wood, have become favorite media after many years dominated by industrial materials. New architecture and interior

design abound with art-historical quotations; references to earlier styles are now familiar throughout the arts."[55]

Half a century earlier, another American museum director, C. R. Richards of the Metropolitan Museum of Art in New York, had offered a similar evaluation of Hoffmann's significance. In "interior design and arts and crafts," Richards wrote, "[Hoffmann's] creations are not only outstanding examples of the contemporary spirit, but they served also as a bulwark against tendencies of extreme radicalism. He has never been content to interpret the 'Moderne' as a potential expression of rigid Functionalism, but he possessed the gift to unite charm with the utmost simplicity."[56] Throughout the twentieth century, Hoffmann's work inspired and attracted Americans who, like Richards, sought design that engaged with modern life while making it somehow more human, and easier to bear.

Leslie Topp
I would like to thank Eduard Sekler, Christian Witt-Dörring, Laurie Stein, Johannes Spalt, Jane Kallir, Franz Schulze, and above all Janis Staggs-Flinchum for their kind assistance during the preparation of this essay.

[1] Except where otherwise indicated, I have drawn my information on Hoffmann's life and career from Eduard Sekler, *Josef Hoffmann: The Architectural Work*, Princeton: Princeton University Press, 1985.

[2] See Jan Tabor, "The Strange Objectivity of a Mythical Artist's Hand," in: *Josef Hoffmann Designs*, exhibition cat., Vienna, Museum für angewandte Kunst, 1992, pp. 282–290.

[3] Sekler, *Josef Hoffmann* (as note 1), pp. 34, 240–242.

[4] Leopold Kleiner, *Josef Hoffmann*, Vienna: Hubsch, 1927. For a short biography of Kleiner, see Matthias Boeckl, in: *Visionäre & Vertriebene. Österreichische Spuren in der modernen amerikanischen Architektur*, ed. by Boeckl, exhibition cat., Kunsthalle Vienna, 1995, p. 336.

[5] Sekler, *Josef Hoffmann* (as note 1), p. 289. Hermann Muthesius, "Die Wohnungskunst auf der Weltausstellung in St. Louis," in: *Deutsche Kunst und Dekoration*, vol. 15 (1904–05), p. 221. Max Creutz, "Die Weltausstellung in St. Louis 1904: Der Österreichische Pavillon," in: *Dekorative Kunst*, vol. 13 (1905), p. 126, ill. p. 125.

[6] An article devoted to Hoffmann appeared in *The International Studio* as early as 1901, written by Belgian painter Fernand Khnopff ("Josef Hoffmann—Architect and Decorator," in: *The International Studio*, vol. 13 [June 1901], pp. 261–267). Hoffmann was well represented in *The Studio*'s 1906 special summer issue, devoted to art, architecture, and design in Vienna (Charles Holme, ed., *The Art-Revival in Austria*). The articles on Hoffmann and illustrations of his work in *Deutsche Kunst und Dekoration* and *Dekorative Kunst* are too numerous to mention here.

[7] Anthony Alofsin, *Frank Lloyd Wright: The Lost Years, 1910–1922: A Study of Influence*, Chicago: University of Chicago Press, 1993, pp. 12–16.

[8] Louise Brigham, with illustrations by Edward Ascherman, *Box Furniture: How to Make a Hundred Useful Articles for the Home*, New York: Century, 1910, p. 6.

[9] For discussions of this exhibition, see the essays by Leslie Topp and Laurie A. Stein in this catalogue.

[10] Karl Ernst Osthaus, "Architecture," in: *Touring Exhibition of the Deutsches Museum für Kunst in Handel und Gewerbe, Hagen I. W. with the Co-operation of the Oesterreichisches Museum für Kunst und Industrie in Wien*, exhibition cat., Newark, Chicago, Indianapolis, Pittsburgh, Cincinnati, Saint Louis, 1912–13, p. 11. For the photographs of Hoffmann buildings, see *Moderne Baukunst 1900–1914. Die Photosammlung des Deutschen Museums für Kunst in Handel und Gewerbe*, exhibition cat., Krefeld, Kaiser Wilhelm Museum; Hagen, Karl Ernst Osthaus-Museum; and Berlin, Werkbund-Archiv, 1993, pp. 209–210.

[11] *Touring Exhibition* (as note 10), pp. 38, 43, 49, 51, 52, 57, 82, 86, 88. Barry Shifman, "Design für die Industrie: Die Ausstellung 'German Applied Arts' in den Vereinigten Staaten, 1912–13," in: *Deutsches Museum für Kunst in Handel und Gewerbe 1909–1919*, exhibition cat., Krefeld, Kaiser Wilhelm Museum; and Hagen, Karl Ernst Osthaus-Museum, 1997, p. 383.

[12] Osthaus obtained assistance from the German foreign office, and officials from the German consulates in the host cities were invited to the exhibition openings (Shifman, "Design für die Industrie" [as note 11], p. 379, n. 14).

[13] John Cotton Dana, letter to Arthur Wiener, May 12, 1921, in Newark Museum Archive (cited in Shifman, "Design für die Industrie" [as note 11], p. 388).

[14] *The Applied Arts: Objects in Wood, Metal and Glass, Textiles, Embroideries, Laces, Books, Engravings, Etc.*, exhibition cat., Newark Museum, 1922, p. 22.

[15] Shifman, "Design für die Industrie" [as note 11], p. 388.

[16] Lillian Langseth-Christensen, *A Design for Living*, New York: Viking, 1987.

[17] A 1913 article by Ascherman himself on German and Austrian design, illustrated with his own photographs of interiors by Hoffmann and others, encourages American designers to emulate Hoffmann (Ascherman, "Some Foreign Styles in Decoration and Furniture," in: *House and Garden*, vol. 24, no. 1 [July 1913], pp. 32–34, 56). See also Sekler, *Josef Hoffmann* (as note 1), pp. 189, 514, n. 42.

[18] Boeckl, *Visionäre* (as note 4), pp. 333–334, and Langseth-Christensen, *Design for Living* (as note 16).

[19] Sekler, *Josef Hoffmann* (as note 1), p. 514, n. 46.

[20] For example, Urban helped Wolfgang Hoffmann find work when he arrived in New York (Sekler, *Josef Hoffmann* [as note 1], p. 189), and advised Langseth-Christensen on her Vienna studies (Langseth-Christensen, *Design for Living* [as note 16]).

[21] Janis Staggs-Flinchum, "A Glimpse into the Showroom of the Wiener Werkstaette of America, 1922–23," in: *The International 20th Century Arts Fair*, catalogue, New York, Haughton's, 1999, pp. 26–35.

[22] "Exhibition," in: *New York Times* (June 25, 1922); "A Workshop Background," in: *New York Evening Post* (June 17, 1922).

[23] Peter Behrens, "The Work of Josef Hoffmann," in: *Journal of the American Institute of Architects*, vol. 12 (1924), pp. 421–426; Shepard Vogelgesang, "The Work of Josef Hoffmann," in: *Architectural Forum*, vol. 49 (1928), pp. 697–712.

[24] Sekler, *Josef Hoffmann* (as note 1), p. 188. Rena Rosenthal's shop on Madison Avenue sold work by Hoffmann (see *Arts and Decoration*, vol. 13, no. 4 [1920], p. 266). An article of 1928 describes "the decorations of the shop itself" as having been designed by "Hoffmann of Vienna," although whether this was Hoffmann himself or his son Wolfgang is uncertain (Elizabeth Lounsbery, "From the Smart Shops," in: *Arts and Decoration*, vol. 29 [June 1928], p. 22).

[25] For Hoffmann's probable influence on Kahn, Schoen, Candela, and Goff, see Sekler, *Josef Hoffmann* [as note 1], pp. 111, 186–189. David Adler's Clow House (1927, Lake Forest, Illinois) adopts motifs from the facade and garden architecture of the Villa Skywa-Primavesi, photographs of which were in Adler's collection (Stephen Salny, *The Country Houses of David Adler*, New York: Norton, 2001, pp. 96–97).

[26] Vogelgesang, "The Work of Josef Hoffmann" (as note 23), p. 712.

[27] Herbert Lippmann, "The Machine-Age Exposition," in: *The Arts*, vol. 11 (1927), p. 325. See also *Machine-Age Exposition: Catalogue*, New York, 1927. On Jane Heap, see Robert A. M. Stern et al., *New York 1930: Architecture and Urbanism Between the Two World Wars*, New York: Rizzoli, 1987, p. 264.

[28] Lippmann, "Machine-Age Exposition" (as note 27), p. 325.

[29] *Machine-Age Exposition: Catalogue* (as note 27), cat. nos. 52–98.

[30] Three of the four works by Hoffmann displayed were named: the project for the so-called Beethoven Music Hall (presumably the World Concert Hall of 1927; Sekler, *Josef Hoffmann* [as note 1], cat. no. 279); the pavilion for the 1925 Paris exhibition of decorative arts; and the Summer House for Eduard Ast at Aue near Velden, Carinthia, 1923–24 (Sekler, cat. no. 254). (*Machine-Age Exposition: Catalogue* [as note 27], cat. nos. 66–74.)

[31] Stern et al., *New York 1930* (as note 27), p. 336; Margret Kentgens-Craig, *The Bauhaus and America: First Contacts 1919–1936*, Cambridge, Mass.: MIT Press, 1999, pp. 71–72.

[32] This was an elaborate event, claiming to offer "the most complete picture of modern art in industrial design ever presented" in the United States (C. Adolph Glassgold, "Art in Industry," in: *The Arts*, vol. 13 [1928], p. 375). A catalogue was published, with a short essay by Hoffmann: "Austrian Contribution to Modern Art," in: *An International Exposition of Art in Industry*, exhibition cat., New York, Macy's, 1928, pp. 8–9.

[33] *International Exposition* (as note 32), pp. 10–11. The boudoir and powder room feature in several reviews and photo spreads of the exhibition, copies of which are in the Macy's archive. They include: Walter Rendell Storey, "The Latest Art-in-Industry Exhibit," in: *New York Times Magazine* (May 27, 1928), pp. 18–19; "Modern Interiors from the Exposition of Art in Industry," in: *New York Times* (June 9, 1928); Nunnally Johnson, "Macy's Modern

Exposition Limns the Art of Comfort," in: *New York Evening Post* (May 1928), from Macy's archive; "Boudoir, Powder Room and Butcher Shop Features of Macy's Exhibit," source and date unknown, from Macy's archive; "Art in Industry at Macy's," in: *Dry Goods Economist* (June 2, 1928), pp. 74–75, 89, 94. See also Glassgold, "Art in Industry" (as note 32), and Helen Appleton Read, "Twentieth-Century Decoration," in: *Vogue*, vol. 72, no. 2 (July 15, 1928), pp. 74–75, 100, 102.

34 "Modern Interiors," in: *New York Times* (June 9, 1928). For the prehistory of Hoffmann's boudoir, see Sekler, *Josef Hoffmann* (as note 1), pp. 180–181, 389–390, 404, 410.

35 Hoffmann's interiors are described in two reviews (though not in the catalogue) as being intended "for the modern woman" (Storey, "The Latest"; and "Boudoir" [both as note 33]).

36 Johnson, "Macy's Modern Exposition" (as note 33).

37 "Macy's Art Exposition to Close," source and date unknown, from Macy's archive. Another department store that displayed contemporary design, including objects by Hoffmann, in the late 1920s was Chicago's Marshall Field & Co. See "Contemporary Art in Current Exhibitions," in: *Good Furniture Magazine*, vol. 32, no. 5 (May 1929), pp. 241, 245–247.

38 Hoffmann, "Austrian Contribution to Modern Art" (as note 32), p. 9.

39 Sheldon Cheney, *The New World Architecture,* London: Longmans, Green,

1930, p. 185.

40 Henry-Russell Hitchcock, *Modern Architecture: Romanticism and Reintegration,* New York: Payson & Clarke, 1929, p. 133.

41 Ibid., pp. 131, 132.

42 For a discussion of the treatment of Hoffmann in histories of modern architecture, see the essay by David Gebhard in: *Josef Hoffmann: Design Classics,* exhibition cat., Fort Worth Art Museum, 1982, pp. 26–30.

43 Sekler, *Josef Hoffmann, das architektonische Werk,* Salzburg: Residenz, 1982; published in English in 1985 (as note 1), 2d rev. ed., 1986.

44 *Wiener Werkstätte,* exhibition cat., New York, Galerie St. Etienne, 1966, p. 3. Six Hoffmann metalwork objects were displayed in this exhibition, which consisted of pieces from the Joseph Urban family collection.

45 For example, Alan Janik and Stephen Toulmin, *Wittgenstein's Vienna,* New York: Simon & Schuster, 1972; Nicholas Powell, *The Sacred Spring: The Arts in Vienna 1898–1918,* London: Studio Vista, 1974; Peter Vergo, *Art in Vienna, 1898–1918: Klimt, Kokoschka, Schiele and Their Contemporaries,* London: Phaidon, 1975. In 1979, Carl Schorske's influential *Fin-de-siècle Vienna: Politics and Culture* (New York: Knopf) was published; many of its chapters were based on articles Schorske had published in academic journals in the 1960s and '70s.

46 See *Austrian Institute: News and Events* (May 1975), n.p.

47 Rita Reif, "In Design: A Glance Back at Two Who Made the Present," in: *New York Times* (May 13, 1975), p. 40.

48 Paul Goldberger, "Their Vision Was New and Personal," in: *New York Times* (May 13, 1975), p. 40. Hoffmann's furniture, metalwork, glass, and textiles dominated two U.S. exhibitions of Viennese design in the 1970s. See: *Art & Design in Vienna: 1900–1930,* exhibition cat., New York, La Boetie, in association with Robert K. Brown, 1972; and Jan Ernst Adlmann, *Vienna Moderne, 1898–1918: An Early Encounter Between Taste and Utility,* exhibition cat., Sarah Campbell Blaffer Gallery, University of Houston, 1978–79. This latter show began at the Cooper-Hewitt Museum in New York in late 1978, before traveling to the Blaffer Gallery in Houston, the Portland Art Museum, and the Art Institute of Chicago in 1979.

49 "Josef Hoffmann, Rediscovered Genius: ICF Introduces a Collection of Furniture, Fabrics and Accessories," in: *Interior Design,* vol. 46, no. 5 (May 1975), pp. 186–189. There was a special exhibition of the reproduced Hoffmann furniture, along with some drawings and photographs, in the ICF showrooms in New York in 1975 (ibid., p. 189, and Rita Reif, "From Vienna, With Comfort," in: *New York Times Magazine* [April 6, 1975], pp. 74–75). The furniture distributed by ICF was produced by the Austrian furniture manufacturer Wittmann from 1973 on, according to drawings by the prominent Vienna architect Johannes Spalt after photographs of

Hoffmann's originals (see Spalt, "Josef Hoffmann—Recreation: Wittmann präsentiert Josef Hoffmann—Möbel und Gegenstände," in: *Bauforum,* vol. 42 [1974]).

50 *Michael Graves: Buildings and Projects, 1966–1981,* New York: Rizzoli, 1982, p. 103; Jane Kallir, *Viennese Design and the Wiener Werkstätte,* New York: Braziller, 1986, p. 12.

51 See *Michael Graves: Buildings and Projects, 1982–1989,* New York: Princeton Architectural Press, 1990, p. 43.

52 Kallir, *Viennese Design* (as note 50), pp. 12–13; *Michael Graves, 1966–1981* (as note 50), pp. 174–175.

53 *Josef Hoffmann, Architect and Designer, 1870–1956,* exhibition cat., Vienna and New York, Galerie Metropol, 1981, with an essay by Christian Meyer. Reviews included: Rita Reif, "A Viennese Master's Furniture," in: *New York Times* (February 19, 1981), pp. C1, C12; John Pile, "Hoffmann Exhibit Shows 'Sezession' Geometry," in: *Industrial Design,* vol. 28 (May–June 1981), p. 55; and Kim Levin, "A Chair Is a Chair," in: *Village Voice* (March 8, 1983).

54 *Josef Hoffmann: Design Classics* (as note 42).

55 David Ryan, foreword, *Josef Hoffmann: Design Classics* (as note 42), p. 6. The essay in this catalogue by David Gebhard explores themes of historicism, classicism, and decoration in Hoffmann's work.

56 C. R. Richards, in: *Josef Hoffmann zum sechzigsten Geburtstag,* Vienna: Almanach der Dame, 1930, reprinted in: Sekler, *Josef Hoffmann* (as note 1), p. 497.

EDUARD JOSEF WIMMER-WISGRILL

*** APRIL 2, 1882, VIENNA**
† DECEMBER 25, 1961, VIENNA

Title page of catalogue for *German Applied Arts (Touring Exhibition of the Deutsches Museum für Kunst in Handel und Gewerbe, Hagen),* 1912–13

Eduard Josef Wimmer-Wisgrill dedicated his creative skill to aspects of life that are, in essence, "trivial": he designed fashion, theatrical costumes and sets, and domestic interiors. The expectation that these "trivial" areas should maintain a high artistic standard owes much to the notion of the "total work of art" prevalent among Wimmer-Wisgrill's contemporaries.

Wimmer-Wisgrill, also frequently known as Wimmer,[1] was born in Vienna on April 2, 1882. In 1901, after completing studies at the Handels-

akademie (Commercial Academy), he joined the Viennese Kunst-gewerbeschule (School of Applied Arts), studying under set designer Alfred Roller and architect/designer Josef Hoffmann. According to Wimmer's own account, he was a member of the Wiener Werkstätte from 1907 to 1922, appointed by Hoffmann virtually as a successor to Koloman Moser.[2] Here, Wimmer produced designs for textiles, furniture, jewelry, and household utensils which, in form and decoration, were clearly influenced by Hoffmann. However, Wimmer's designs are more regular and less idiosyncratic than Hoffmann's, and they lack the spontaneity and wealth of ideas that distinguished his teacher's work. While clearly imbued with the Wiener Werkstätte spirit, Wimmer's designs cannot be described as inspired.

The decision of a trained architect to become a fashion designer can only be explained by reference to the artistic cult of *totality* that prevailed in Vienna around 1900. The goal that art be omnipresent in the human-made environment required the artist to master as many media and disciplines as possible.

From 1910, Wimmer directed the Wiener Werkstätte fashion department. The group's first fashion show was held April 26–27, 1911, and included items credited to Hoffmann as well as Wimmer. According to one scholar, Hoffmann at this time "was evolving artistic forms of dress and taking no account of the latest developments in fashion. In the spirit of artistic planarity, he decorated the model as if she were an object of applied art."[3] While Hoffmann designed dresses using the same principles applied to the rest of his work, Wimmer's creations were more *au courant* and closer to the contemporary work of celebrated French designer Paul Poiret (1879–1944). At the Wiener Werkstätte, Wimmer was involved not only in designing clothes, but also in the operation of the fashion department. Indeed, his surviving letters[4] contain repeated suggestions as to how the Wiener Werkstätte as a whole might be made a more efficient—and thus more profitable—concern. But they also attest to his admiration for and unconditional loyalty to his teacher Josef Hoffmann.

Wimmer was publicly identified as a member of the Wiener Werkstätte for the first time in May 1907, when he became set and costume designer for the Viennese Cabaret Fledermaus.[5] In 1908, he designed and painted the coffeehouse terrace for the *Wiener Kunstschau* of that year. The exhibition included Wimmer's "cabinet for prints and drawings" (cat. no. III. 57). Wimmer also designed costumes for performances staged at the exhibition's outdoor theater.[6] This was not his first experience in theater design: he had provided the set for a 1906 production of Leonid Andreyev's Symbolist drama *To the Stars* presented by the Freie Volksbühne at the Theater in der Josefstadt.[7]

It is apparent that Wimmer's talents and interests lay in the fashionably decorative, a tendency that became increasingly characteristic of Wiener Werkstätte products from 1907 onward. Motifs were often derived from vernacular traditions (which the Viennese critic Berta Zuckerkandl was later to term "Austria's fountain of youth for every sort of artistic and decorative renewal"[8]), and included stylized flowers and leaves typically found in the embroidery on costumes reserved

for traditional holidays and festivals. These motifs were used as readily on utensils and jewelry as in textile patterns. Many artists—among them, Gustav Klimt and Josef Hoffmann, but also Paul Poiret[9]—collected examples of traditional embroidery from Bohemia, Moravia, and other parts of the Austro-Hungarian Empire. This floral inspiration is also reflected in Wimmer's work. In 1911, in the sitting room designed for the *Frühjahrsausstellung österreichischen Kunstgewerbes* (Spring Exhibition of Austrian Applied Art) at the Österreichisches Museum in Vienna, Wimmer used plant motifs not only for wall coverings but also for the armchairs' tapestry covers.[10] Wiener Werkstätte customers, having had enough of the frugality of earlier designs by Hoffmann and Moser, reacted positively to the new motifs. And the increase in the use of decorative patterns—for instance, bluebell-shaped flowers, heart-shaped leaves, or trellis effects with ivy or roses—even on household utensils was to have a beneficial effect on sales.

In addition to clothing design, Wimmer worked as an interior designer, sometimes collaborating with Hoffmann, as in the case of the apartment for the *diseuse* of the Cabaret Fledermaus, Mimi Marlow,[11] where Wimmer was responsible for the murals as well as proposals for the choice of decorative textiles. In other apartment interiors, published in 1911 in the journal *Das Interieur*, Wimmer found new solutions for what were, in his own words, "unpromising spaces, with scant resources, and once good but long outdated furniture and carpets that in any case had to be incorporated."[12] In these situations, he added new decoration for walls and windows. He adopted this approach in an apartment for the Flöge sisters,[13] where he used a textile of his own design (already employed in Mimi Marlow's bedroom) for the walls and for the curtains around the bed.[14] A rather different sort of commission, embracing both new furniture and interior design, was that for the consulting and waiting rooms in the apartment of Dr. Benjamin Gomperz in the Inner City.[15] The geometric simplicity and strong coloring of the pieces designed for Gomperz again testify to Hoffmann's influence.

In 1912–13, Wimmer returned to his alma mater, the Kunstgewerbeschule, where he became an assistant in the class taught by Koloman Moser, also serving as artistic director in the textile workshop. After a short break in his teaching career, during which he worked exclusively for the Wiener Werkstätte, Wimmer was back at the school in 1918–21, now with the title of professor, to head the newly established workshop for fashion. By this time, along with many other artists and industrialists, Wimmer had become a founding member of the Österreichischer Werkbund, established in 1913[16] to foster the "improvement of commercial work through the collaboration of artists, industry, and craftspeople."

Hoffmann's high regard for Wimmer was evident in the commission the latter received in connection with the Deutscher Werkbund exhibition mounted in Cologne in 1914: he was asked to design the Wiener Werkstätte room in the Austrian pavilion (this last designed by Hoffmann himself). The success of Wimmer's scheme was confirmed in the extremely positive critical reaction: Zuckerkandl described the

room as a place of "the cultivated enjoyment of life's delicacies, and the most refined culture."[17] Wimmer's position within the Wiener Werkstätte was also strengthened when, in March 1914, it became a limited company following a change of financial director when industrialist Otto Primavesi replaced Fritz Waerndorfer. Like Josef Hoffmann and Otto Prutscher, Wimmer was able, at relatively little expense, to become a Wiener Werkstätte stockholder.[18]

During World War I, from 1914 to 1918, Wimmer served in the Austro-Hungarian army as an engineer in the reserves. Stationed at the Viennese Arsenal, he was able to continue his work at the Wiener Werkstätte.[19] He contributed, as a designer, to the twelve-volume portfolio publication *Wiener Mode 1914/15*, published at the instigation of the Kunstgewerbeschule. In 1916, in collaboration with Hoffmann, Wimmer designed new showrooms for the Wiener Werkstätte fashion department at 41 Kärntnerstrasse in the Inner City, taking responsibility for the decoration of walls and ceilings. He had his own studio at this time in the former Palais Eszterhazy.

On July 4, 1918, Wimmer married the *directrice* of the fashion department, Clara Solm (1895–1981). Growing tensions in his personal and professional life probably fueled his decision to leave Vienna in 1922.[20] After a short stay in Paris, he traveled to New York, where he lived for a year and a half. And when he arrived in the U.S. in 1922 for an extended stay, at least part of his mission was to view and evaluate the new Wiener Werkstätte of America, founded by Joseph Urban in New York. The details of what turned out to be a varied and inspiring period for Wimmer are recounted in his letters to Hoffmann, beginning with his initial impressions of New York: "Even the very first thing that you see of America is good: country houses in the Colonial style, entirely built of wood. Then you enter the harbor [of New York]. A stupendous, unforgettable impression. The city of skyscrapers is suddenly there in front of you, like a *Fata Morgana*, rising up out of the mist. ... Then there's the exciting impression made by the underground train (the "tube") under the Hudson, you go up some steps and you're suddenly and unexpectedly confronted by a sort of heavenly fortress of crazily imposing scale, and you're right in the thick of it. And yet it isn't at all oppressive, for in between you can always catch glimpses of the clear American sky, and you feel quite at ease there, as you would in a room with a high ceiling."[21]

Wimmer immediately visited the New York branch of the Wiener Werkstätte and reported his observations to Hoffmann: "Already on my first day I took a look at the W.W. on Fifth Avenue, from the outside. It makes a good impression, with its golden man by Lurie [Viktor Lurje] and the rest. The next day I called in and went up to the showrooms: really well decorated, so much better than it looks in the photographs, perhaps Urban's best work, full of clever effects and cleverly organized into distinct areas. What isn't so good about the arrangement is that objects such as lamps can easily be overlooked. ... In any case I also learnt, to my regret, that the whole thing was going rather badly. Virtually nothing has been sold, even now in the time just before Christmas. ... I'm writing to tell you about this so that you'll know what the situation is here. It would, of course, be very expedient

if you, through the sort of personal influence you wield, could intervene in some way to save what there still is to be saved. This is the center of the world, New York, *the* metropolis. And the W.W. must establish itself here, otherwise it will die a slow death."[22]

It appears that, thanks to Urban, "who provided the kindest possible introduction into New York society,"[23] Wimmer was commissioned to design costumes for the opera singer Maria Jeritza for her performance in the title role in *Tosca* at the Metropolitan Opera. According to Wimmer's own later account, he worked in New York between November 1922 and September 1923 as an independent fashion and textile designer.[24] But as early as January 1923, he had revised his previously positive opinion of Urban and the New York branch of the Wiener Werkstätte, as revealed in a letter sent to Hoffmann, in which he suggests how and by whom this concern should be run in future: "We really have to adapt ourselves to America. As a result of its wealth, it has a high level of civilization (the most emphatically conspicuous culture!) and this means that we need make no concessions in that respect. ... On the other hand, the branch here would effectively have to be kept in business by an Interior Decorating Department. As they build very well here, very much in our style, both in the city and in the countryside, it will not be difficult to establish our sort of interior decorating. There are a lot of skyscrapers here, each full of middle-class apartments that are usually entirely furnished by the architect and only then rented out. There would be rich pickings here for us."[25]

A special showing of the Wiener Werkstätte of America material—including textile designs and silver objects by Wimmer—was installed by Urban at the Art Institute of Chicago in 1922. Impressed by his work, the school attached to the Art Institute offered Wimmer the position of head instructor in the department of design and interior decoration.[26] He did in fact teach a course there in late 1923,[27] and also organized a number of modest exhibitions of applied art, in which he showed his "small W.W. treasures."[28] By May 1924, Wimmer was considering a possible return to Vienna. But as soon as his desire to leave Chicago became known around town, he began to receive offers "from the opposition," including *the* Chicago art patron, an enormously rich bachelor who, as Wimmer reported to Hoffmann, "wants to keep me here. In addition, Filene [the Boston department store] claims to have found just the thing for me. What's more, the city of Denver, which only recently sprang up in the mountains, wants to have me as its architect (!) and as the founder of some sort of school. Here in Chicago they are talking about establishing a Chicago Workshop and a small group of my younger colleagues would be very interested in such a scheme."[29] In the summer of 1924 he returned to Vienna via Paris, where he exhibited a number of textile designs.

Back in Vienna by summer 1925, he rejoined the staff of the Kunstgewerbeschule, now teaching the master class in fashion and heading the textiles workshop. Over the following years, Wimmer participated in a number of exhibitions. In 1929, for example, at the *Weihnachtsausstellung* (Christmas exhibition) at the Österreichisches Museum für Kunst und Industrie (Austrian Museum for Art and

Industry), under the slogan "Room for Two," he presented a dining and sitting room.[30] The style of these rooms has been described as "mixing Parisian flair with the rich fund of *Wiener Werkstätte* forms."[31] A laid table from the dining room was shown again in the exhibition *Wiener Raumkünstler* (Viennese Interior Designers), also mounted at the Österreichisches Museum für Kunst und Industrie.[32] In 1932, he designed a "bridge room"[33] for the exhibition *Raum und Mode* (Space and Fashion) staged by the same institution.[34]

While serving from 1928 to 1938 as head of the Kunstgewerbeschule's fashion department, Wimmer was also active as a designer of interiors, completing a dozen such commissions for apartments in Vienna.[35] In 1937, he designed the interior of the Austrian Pavilion at the Exposition Internationale in Paris. He continued to teach in the 1940s but was also involved in set and costume design for the cinema. After serving for two years in an emeritus capacity at the Kunstgewerbeschule, Wimmer formally retired on September 30, 1955. During the last years of his life, he devoted himself to painting, producing some sixty-four oils and thirty watercolors, including portraits in an Expressionist style, in addition to landscapes and flower pieces. Eduard Josef Wimmer-Wisgrill died in Vienna on December 25, 1961. A memorial exhibition, *Eduard Josef Wimmer-Wisgrill und die Wiener Werkstätte*, organized by pupils and friends, was presented at the Österreichisches Museum für Kunst und Industrie in 1962. In 1983, the Hochschule für angewandte Kunst (College of Applied Arts, the former Kunstgewerbeschule) mounted the exhibition *Eduard Josef Wimmer-Wisgrill. Modeentwürfe 1912–1927* (Eduard Josef Wimmer-Wisgrill: Fashion Designs 1912–1927), in honor of its former teacher. This, Wimmer's last place of work and influence, houses in its archive fashion designs produced by him between 1911 and 1927 and the aforementioned portraits and watercolors, in addition to documentation on Wimmer's life. The Österreichisches Museum für angewandte Kunst (Austrian Museum of Applied Arts) in Vienna owns the Wiener Werkstätte archives, and hence a great deal of documentation relating to Wimmer; its library and collection of prints and drawings contain designs by Wimmer for fashion, household utensils, and jewelry dating from 1907 to 1922, in addition to later works shown in the exhibition of 1962. The museum also possesses furniture, textiles, jewelry, and tableware in silver. Several American museums have Wimmer designs in their collections, including the Art Institute of Chicago, the Busch-Reisinger Museum in Cambridge, Massachusetts, the Cooper-Hewitt National Design Museum and the Metropolitan Museum of Art in New York, the Minneapolis Museum of Arts, the Museum of Fine Arts in Boston, and the Wolfsonian in Miami. But the majority of objects designed by Wimmer are still in private hands.

WIMMER AND AMERICA

The years during which Wimmer gained a position of prominence within the Wiener Werkstätte were also the years in which the group became known in the United States. In 1912, an exhibition of German-Austrian applied arts opened at the Newark Museum and traveled through the Midwest, ending its tour in New York in 1913.[36] It featured a broad selection of Wiener Werkstätte products from the collection of the Österreichisches Museum für Kunst und Industrie. Wimmer was well represented in his area of strength: textiles. A section containing squares of fabric in various patterns included examples by Wimmer in silk and linen, alongside patterns by Peter Behrens, Henry van de Velde, and others.[37] That same year, 1912, marks Wimmer's first appearance in the influential British-American publication, *The Studio Year Book of Decorative Art*. Photographs of a textile pattern and two examples of metalwork, all bearing Wimmer's characteristic pattern of stylized flowers and leaves, were included among other Wiener Werkstätte items.[38] And in a 1913 *House and Garden* article by former Hoffmann student Edward Ascherman, Wimmer's *Ameise* pattern of 1910–11 dominates the accompanying illustration of a Wiener Werkstätte interior. Without naming Wimmer, Ascherman comments on the "delightful hand block printed linen, the design of which is most unusual, strongly suggesting a Japanese stencil…"[39]

It is intriguing to imagine what would have become of Wimmer had he taken up any of the opportunities offered to him in the United States. He does seem to have remained in touch with contacts in America after his return to Vienna. We catch glimpses of him in the late 1920s and '30s—no longer in the context of the Wiener Werkstätte but, rather, in association with various other efforts to unite "art and industry." He contributed a brass bowl to the *International Exposition of Art in Industry* presented by Macy's department store in New York in 1928.[40] In 1932, "Professor Wimmer" is listed among the contributors to *Design for the Machine*, an exhibition at the Pennsylvania Museum of Art (later the Philadelphia Museum of Art).[41] Here, Wimmer's textiles were shown as exemplars of "design that is at once appropriate to the machine and agreeable to the eye."[42] Also in 1932, Wimmer collaborated with Everfast Fabrics through his association with a new group of designers called Contempora, founded in 1929 and based in New York, Paris, Berlin, and Vienna. Wimmer was apparently in charge of Contempora's "Vienna Studio."[43]

Elisabeth Schmuttermeier
Translated from the German by Elizabeth Clegg.

[1] The name Wimmer-Wisgrill was derived by combining the family names of the artist's parents, Josef Lorenz Wimmer and Charlotte Wisgrill. As Wimmer-Wisgrill himself frequently used only the first half of this combination, I shall (with a few exceptions) do likewise.

[2] The information provided here on Wimmer's life and career is found in his personal file in the archives of the Universität für angewandte Kunst, Vienna. Wimmer himself gave various dates for when he joined the Wiener Werkstätte: 1906, 1907, and 1909. Based on available evidence, the most likely date is 1907.

[3] Jeanne Ligthart, *Eduard Josef Wimmer-Wisgrill, seine Bedeutung für die Modeabteilung der Wiener Werkstätte 1910–1922*, Master's thesis, Universität Wien, 1997, p. 33.

[4] See, e.g., Wimmer-Wisgrill (writing from Karlsbad), letter to Josef Hoffmann, July 23, 1910.

[5] Gertrud Pott, *Die Spiegelung des Sezessionismus im österreichischen Theater*, Vienna: Braumüller, 1975, pp. 148–151.

[6] Josef August Lux, "Kunstschau Wien 1908. VII. Theater," in: *Deutsche Kunst und Dekoration*, vol. 23 (1908–09), pp. 58–65.

[7] Pott, *Die Spiegelung* (as note 5), p. 114.
[8] Berta Zuckerkandl, "Paul Poiret und die Klimt Gruppe," in: *Neues Wiener Journal* (November 25, 1923), p. 5.
[9] Ibid.
[10] *Das Interieur*, vol. 13 (1912), pp. 57–59.
[11] Eduard F. Sekler, *Josef Hoffmann, das architektonische Werk*, Salzburg: Residenz, 1982, p. 111.
[12] E. J. Wimmer, "Bemerkungen zu meinen Wohnungen," in: *Das Interieur*, vol. 12 (1911), pp. 74–75, ills. pp. 73–81.
[13] Ibid., pp. 74–76.
[14] See Angela Völker, *Die Stoffe der Wiener Werkstätte 1910–1932*, Vienna: Brandstätter, 1990, p. 265, cat. no. 1234.
[15] Photographs of the work for Gomperz appeared in *Das Interieur*, vol. 12 (1911), pp. 78–79.
[16] See Astrid Gmeiner and Gottfried Pirhofer, *Der Österreichische Werkbund. Alternative zur klassischen Moderne in Architektur, Raum- und Produktgestaltung*, Salzburg: Residenz, 1985, p. 13.
[17] Zuckerkandl, "Das Österreichische Haus auf der deutschen Werkbund-Ausstellung, Köln 1914," in: *Deutsche Kunst und Dekoration*, vol. 34 (1914), pp. 363–364, ill. p. 369.
[18] Handelsregister Wien (March 23, 1914), Register C 17/7, no. 10.
[19] Traude Hansen, *Wiener Werkstätte: Mode, Stoffe, Schmuck*, Vienna: Brandstätter, 1984, p. 66.

[20] Ibid., p. 76.
[21] Wimmer-Wisgrill, letter to Hoffmann, December 13, 1922, in the Handschriftensammlung, Wiener Stadt- and Landesbibliothek, Vienna, inv. no. 162.134.
[22] Ibid.
[23] Ibid.
[24] The library and the collection of prints and drawings of the Museum für angewandte Kunst has a number of textile designs produced by Wimmer in New York in 1923, cat. no. 13715/2–6.
[25] Wimmer-Wisgrill, letter to Hoffmann, January 10, 1923, in the Handschriftensammlung, Wiener Stadt- und Landesbibliothek, Vienna, inv. no. 162.135.
[26] *Bulletin of the Art Institute of Chicago*, vol. 17, no. 8 (November 1923), p. 85.
[27] In the archives of the Art Institute of Chicago is a contract relating to the period 1923–24, effective October 1. Thanks to Deborah S. Webb, Archives Assistant in Charge of Records Management for this information. In Wimmer's personal file in the archives of the Universität für angewandte Kunst, Vienna, information on the contract for a teaching post in Chicago refers to a period beginning October 1, 1923 and running to June 30, 1925. According to information supplied by Gino Wimmer, his father gave a lecture in Chicago in 1925, but by that time was no longer under contract to the Art Institute school.

[28] For the Applied Arts Exhibition 22nd Annual, held May–June 1924, Wimmer lent two glass flower vases from the Wiener Werkstätte, which were subsequently acquired by the museum as "purchase prizes." Information from the archives of the Art Institute of Chicago.
[29] Wimmer-Wisgrill, letter to Hoffmann, May 15, 1924, in the Handschriftensammlung, Wiener Stadt- und Landesbibliothek, Vienna, inv. no. 151.380.
[30] Designs and blueprint in the library and the prints and drawings collection of the Museum für angewandte Kunst, Vienna, cat. nos. 13701/4, 13756/128.
[31] Christian Witt-Dörring, "Wiener Innenraumgestaltung 1918–1938," in: *Neues Wohnen, Wiener Innenraumgestaltung 1918–1938*, exhibition cat., Vienna, Österreichisches Museum für angewandte Kunst, 1980, p. 47.
[32] The glass service was manufactured by the firm of Lobmeyr, and the furniture by August Ungethüm; see *Die Form*, vol. 5 (1930), p. 131.
[33] Wimmer-Wisgrill [introduction], in: *Raum und Mode*, exhibition cat., Vienna, Österreichisches Museum für angewandte Kunst, 1932.
[34] *Österreichische Kunst*, vol. 3, no. 12 (December 1932), pp. 32–34.
[35] Hansen, *Wiener Werkstätte* (as note19), p. 86.
[36] See Leslie Topp's essay in this volume.

[37] *Touring Exhibition of the Deutsches Museum für Kunst in Handel und Gewerbe, Hagen*, exhibition cat., Newark Museum and other venues, 1912–13, pp. 58–59.
[38] *Studio Year Book of Decorative Art* (1912), pp. 221, 224.
[39] Edward Ascherman, "Some Foreign Styles in Decoration and Furniture," in: *House and Garden*, vol. 24, no. 1 (July 1913), p. 32. For more on Ascherman, see the biography of Josef Hoffmann in this volume.
[40] *An International Exposition of Art in Industry*, exhibition cat., New York, Macy's, 1928, p. 12.
[41] *Design for the Machine*, exhibition cat., Philadelphia, Pennsylvania Museum of Art, 1932, n.p. The American Union of Decorative Artists and Craftsmen (AUDAC) was very involved in this exhibition; Urban and Hoffmann's son Wolfgang were both AUDAC members, and perhaps it was through these connections that Wimmer was invited to participate.
[42] C. R. Richards, introduction, in: ibid.
[43] Everfast Fabrics were marketed by N. Erlanger Blumgart and Company, based in New York City. See Everfast/Contempora, Pamphlet, undated (ca. 1931–32), in the Cipe Pineles Archives (Box #46), housed at Rochester Institute of Technology. Thanks to Martha Scotford for bringing this to our attention.

KOLOMAN MOSER

*** MARCH 30, 1868, VIENNA**
† OCTOBER 18, 1918, VIENNA

Invitation to the exhibition *Kolo Moser: Painter and Designer, 1868–1918*, Austrian Institute and Galerie Metropol, New York, February 15–April 15, 1983. The Museum of Modern Art Library, New York

As a central figure in the Vienna Secession and co-founder of the Wiener Werkstätte, graphic artist and designer Koloman (Kolo) Moser played a critical role in the artistic awakening that occurred in fin-de-siècle Vienna. It was above all through the geometric forms and sparing ornamentation of the products designed by Moser and Josef Hoffmann for the Wiener Werkstätte that this "designers' workshop" achieved international renown.

Born on March 30, 1868, in Vienna, Moser gained insight into the forming of objects and the various production processes involved in a wide range of applied arts at a young age. As the son of a There-

sianum steward who supervised the commercial side of craft training, he was allowed free access to the school and thus was able to observe the craftsmen at work.[1] After a training in the applied arts and a parallel course in drawing, Moser studied painting from 1885 at the Akademie der bildenden Künste (Academy of Fine Arts) in Vienna. In 1892, he transferred to the Viennese Kunstgewerbeschule (School of Applied Arts) for further study in drawing and painting. After his father's death in 1888, Moser financed his studies by working as a graphic artist. His early efforts—illustrations for various publications—were conventionally naturalistic. A change is first detectable in the early 1890s, when he began to simplify figures to the point of stylization and to treat their setting and framing more expansively, for example, placing several square or rectangular outlines in a clear relation to each other.

Moser's talent for decorative planarity made a strong impression on architect and designer Josef Hoffmann, whom he met in 1895. This acquaintance—and soon friendship—would prove significant for each of them. Together with other budding artists with a commitment to the contemporary, Moser and Hoffmann voiced their aesthetic views, first as members, from 1895, of the Siebener Club and then, from 1897, as founding members of the progressive modernist artists' association formally called Vereinigung bildender Künstler Österreichs, Secession (Union of Austrian Artists, Secession)—more commonly known simply as the Secession.

When the Secession held its first general assembly on June 21, 1897, there was unanimous agreement that it should publish its own journal, for which the name Ver Sacrum (Sacred Spring) was chosen. Moser's notable contributions throughout the journal's life (it survived until 1903) allow us to trace precisely his development as a graphic artist over these six years. He also designed postcards and exhibition posters for the Secession, and both their motifs and striking use of planarity were immensely influential on other artists.

While the Secession building was designed by Olbrich in 1897, Moser contributed significantly to both its exterior and interior, providing figural decoration for the facade and an image in stained glass representing Art for the entrance hall. At the Secession, an effort was made not only to "offer the public elite exhibitions of specifically modern works of art," but also "to have an innovative impact on the arrangement"[2] of exhibited objects, which in the view of leading Secession members, including Moser, demanded as much artistic care as the design of exhibition props such as pedestals and glass cases. Alongside Hoffmann, who evinced a particular talent for exhibition installation, Moser made a valuable contribution in this area. It was to this end that, in 1900, he traveled to Paris to help install the Secession's entry in the Austrian Pavilion at the Exposition Universelle. For the eighteenth show at the Secession, November 1903–January 1904, intended as an homage to Gustav Klimt, Moser devised an extremely plain setting in order to distract as little attention as possible from the paintings and drawings. He emphasized each wall by "framing" it in dark borders, which also had the effect of establishing a visual link between all the images placed together on any given plane.

A crucial development for Moser's future career was his appointment in 1899 to the Kunstgewerbeschule in Vienna. At this time, Moser was particularly inspired by Japanese art, which had fascinated artists in Europe and America since the 1870s. Viennese artists were especially receptive to the two-dimensional decorative patterns found in Japanese art. They learned, for example, how to layer and stagger planes in order to achieve novel ornamental effects, and how to incorporate line as a pictorial element in its own right. Through such means, they acquired a new language of forms that permitted the "invisible" itself to serve as a compositional element.

The combination of Moser's talents and training ensured that he soon emerged as an innovative designer of two-dimensional patterns, such as those devised in 1898 for textiles produced by the firm of Johann Backhausen & Söhne. Despite the often biomorphic character of these masterful patterns, his work of this period also attests to a preference for regular geometric forms. Hence the choice of a square format for Ver Sacrum and for most of the decoration and illustration that Moser submitted to this and other publications. After 1900, most of Ver Sacrum's contributors tended to favor typography combined with decoration, but here too Moser maintained an "uncompromising purism"[3] in using squares alone as decoration for the text of a play by Arno Holz, Die Blechschmiede (The Tin Smithy).[4] The square was ultimately to become a trademark for the Wiener Werkstätte, whether used in a latticework pattern of metalwork (cat. no. III. 49) or as a frame around designers' and makers' marks and seals. The majority of monograms used by artists,[5] designers, and craftsmen associated with the Wiener Werkstätte appear to have been derived from designs by Moser.

The Viennese artists in the circle of Klimt, united in their commitment to innovation, were convinced that they "should not limit their joint activity to the occasional mounting of exhibitions, but that they should also, and above all, strive to achieve an ever greater influence on the various aspects of modern life."[6] According to Moser's recollection of the Secession's early years, it was at its fourth exhibition, in 1899, that the Viennese public realized that even the most commonplace objects might be infused with art: "For the first time they saw modern interiors decorated in accordance with a new Viennese taste: there was furniture by Olbrich and Hoffmann, furnishing textiles that I had designed for a Viennese retailer, objects made of utterly unfamiliar types of wood and metal. And, to top it all, the objects we exhibited were not Belgian, or English, or Japanese, but Viennese—a point noted by almost all those who commented on this exhibition. And the demand for such objects in Vienna grew and grew. ..."[7]

These comments clarify why the "painter" Koloman Moser, while serving as professor of drawing and painting at the Kunstgewerbeschule, would urge his students to become involved in designing furniture, ceramic and glass objects, textiles, and bookbindings. The designs produced were realized by a wide range of manufacturing specialists: porcelain manufacturer Josef Böck (cat. nos. III. 51–52), textile firm Johann Backhausen & Söhne,[8] glassmaker E. Bakalowits & Söhne (cat. nos. III. 41–42), and furniture makers Portois & Fix, Jakob &

Josef Kohn (cat. no. III. 43), and Prag-Rudniker (cat. nos. III. 44–45). As Hoffmann acknowledged, "many of our aims could not be realized on account of our having no workshops of our own. Understandably, therefore, we turned our attention to founding one. But to begin we lacked the capital or a generous patron."[9] A patron was, however, soon found in the person of industrialist Fritz Waerndorfer, who (according to his own later account) first met Hoffmann and Moser on the scaffolding of the Secession building during its construction. While in London, Waerndorfer had learned of the workshop ideal that had emerged from the English Arts and Crafts movement, and he was keen to be involved in a similar undertaking in Vienna.

In 1903, fired with enthusiasm, Hoffmann, Moser, and Waerndorfer founded the Wiener Werkstätte. In a statement published two years later, the members discussed their goals: "We wanted to establish close contact between the public, the designer, and the craftsman, and to produce household objects of good, simple design. As we saw it, our products had, above all, to serve their intended purpose, while their aesthetic strength was to reside in good proportion and in an appropriate use of materials."[10] Initially, the designs for all the "good, simple" household objects produced by the Wiener Werkstätte were provided by Moser and Hoffmann. Their range embraced furniture and objects made of wood, metal utensils, bookbindings, marbled paper, toys, jewelry, and fashionable garments.[11] Hoffmann was also very active as an architect.

The intellectual affinity between Hoffmann and Moser is attested in the character of their designs at this time, which were often markedly similar in terms of form, and to such an extent that, without reference to the designer's monogram, it would be impossible to decide which of the two was responsible in any given case. Approached intuitively, however, their work can usually be distinguished, for the designs by the painter and draftsman Moser have a softer, more painterly, and more organic character than those of the architect Hoffmann, whose pieces are usually more tectonic and geometric, and sometimes more radical in construction. It would appear that Moser was able to act more freely as a designer because he was not constrained by an awareness of architectonic norms. Klimt was to say of this difference between the two: "If you want immediately to know what has been designed by Hoffmann and what by Moser, all you have to do is observe who is looking at what. Women always flock to Moser's work, while men are drawn to Hoffmann."[12]

In addition to producing hundreds of designs for a variety of objects and utensils, Moser also contributed to the interior design and furnishing of a number of galleries—notably the private picture gallery in Waerndorfer's house (1902), and the display galleries at the principal Wiener Werkstätte premises at 32–34 Neustiftgasse (1903). He also devised schemes for the interior of the sanatorium that Hoffmann built at Purkersdorf outside Vienna (1904), the fashion house on Mariahilferstrasse owned by the Flöge sisters (1904; cat. no. III. 48), the Stoneborough apartment in Berlin (1905; cat. no. III. 50), and the Palais Stoclet in Brussels (1905–11). In each case, Moser and Hoffmann enjoyed a congenial working relationship. But in two other proj-

ects—the interior decoration for the apartment of Dr. Hölzl (1903) and for Margarethe Hellmann (1904)[13]—Moser worked alone.

In 1904, Moser was commissioned to design the stained-glass windows and the main altar decoration for Otto Wagner's church at the Lower Austrian Provincial Psychiatric Hospital "Am Steinhof." But only the stained-glass windows were executed. He formally left the Secession in 1905, along with other members of a faction known as the "Klimt group," whose views and aims had come to differ irreconcilably from those of others in the association. Then, two years later, disagreements with Waerndorfer concerning the organization and financing of the Wiener Werkstätte prompted Moser to end his association with it.[14] After the break, Moser devoted most of his time to painting, thus returning to the skill in which he had been trained, producing primarily landscapes and portraits. From around 1913, his work as a painter is characterized by a marked increase in scale and by rather stiff, hieratic figures. The style, color, and subject matter of Moser's paintings were clearly influenced by the Swiss painter Ferdinand Hodler (Moser had curated an exhibition devoted to Hodler's work at the Secession in 1904). In contrast to the emphatic variety of form and the independence of expression found in his work as a graphic artist or designer of applied art objects, Moser's output as a painter is very uniform in character. It is difficult to avoid the impression that he had exhausted his inherent creativity in the sheer range of his designs.

RECEPTION

Because of the international interest in the Vienna Secession and the circulation of its work and ideas in the journal *Ver Sacrum*, Moser's extraordinary production as a graphic artist was soon well known to a broad public and range of artists. His influence was undisputed. Nor was Moser's work as a member of the Wiener Werkstätte forgotten, for widely read periodicals such as *Deutsche Kunst und Dekoration* or *The Studio* continued to feature it. Moser was also able to disseminate his ideas through his activities as a teacher and his innovative contributions to exhibition installation both at home and abroad. Recalling the beginnings of the Wiener Werkstätte, Moser observed that "it was not in Vienna that we had our first success, but abroad—in Berlin. [In 1904] a branch of our workshop was established at the Hohenzollern Kaufhaus [a Berlin department store]. ... And we had even greater success in London [in 1906] and in Dresden."[15]

Moser received considerable exposure in the English-speaking world via *The Studio* and its sister magazine, *The International Studio*, from 1902 onward.[16] He was the major Austrian participant in an international exhibition held in London in 1902 under the auspices of *The Studio*, in which he showed several pieces of glassware. The magazine's reviewer was impressed: "contemporary handicraft has given us nothing more exquisite of their kind than these vases and drinking vessels…"[17] Amelie Levetus, whose reports on Austrian decorative arts regularly appeared in both publications, was a passionate supporter of Moser. In 1904, she wrote a seven-page illustrated article on the designer for *The International Studio*, stressing his wide-rang-

ing production—encompassing textiles, furniture, graphic design, whole interiors—and his deep involvement in the Viennese art world, as an influential and progressive teacher and as a member of the Secession.[18] When in 1906 *The Studio* published a special issue entitled *The Art-Revival in Austria*, its title page mimicked a Moser design. Levetus again promoted Moser, this time discussing his collaboration with Hoffmann, crediting both with creating "a new style in decorative and applied art, a style which is essentially Viennese." Compared with Hoffmann's more severe, structural approach, Moser's "mind is a fertile one, filled with rich stores of fancy; his colouring is warm but well modulated, and his taste perfect." His designs "possess a charm and beauty revealing not only the true artist but the true Viennese." Photographs of Moser's metalwork, jewelry, bookbinding, glasswork, and interiors were reproduced in the volume.[19]

Moser's pedagogy was introduced to the American public at the 1904 Louisiana Purchase International Exposition in Saint Louis. The context was a display of student work from the Kunstgewerbeschule in a section of the Austrian pavilion devoted to applied-arts education.[20] Although none of Moser's own designs were shown, the work of thirteen of his students was featured, including Jutta Sika and Therese Trethan, described in the official catalogue as representing their teacher's approach.[21] Hoffmann designed the Kunstgewerbeschule section of the pavilion, incorporating windows and two mosaic panels "executed in Prof. Kolo Moser's studio."[22] Along with the other instructors at the school, Moser won a gold medal at Saint Louis, and several of his students received bronze medals.[23]

Moser's early influence on American design can, perhaps, be seen in a hanging lamp (ca. 1906–08) by Dard Hunter, a member of the Roycroft community of craftspeople in East Aurora, New York, where German and especially Austrian design had a strong impact. The lamp combines metal, colored glass, and a motif of small squares very reminiscent of Moser's work.[24] Wiener Werkstätte designs were also disseminated through commercial publications and, thus, to a wider American purchasing public. *The House Beautiful*, for instance, devoted a page of its annual gardening number in March 1907 to Moser and Hoffmann's white metal *Gitterwerk* vases and planters.[25] A 1913 advertisement in *House and Garden* for Joseph P. McHugh & Son of New York boasted of a wide range of "Weiner Werkstaette" [*sic*] silks and linens, and illustrated this with a striking image of Moseresque textiles.[26]

In 1908, Moser participated in the *Wiener Kunstschau* organized by artists of the Klimt group, where he exhibited objects designed for the Wiener Werkstätte.[27] By contrast, a combined German-Austrian exhibition of applied art that in 1912–13 toured several U.S. cities contained only a few objects designed by Moser.

The first exhibition of Moser's paintings was held in 1911 at the Viennese Galerie Miethke. In 1927, the Österreichisches Museum für Kunst und Industrie (Austrian Museum for Art and Industry) mounted a memorial exhibition, but did not publish an accompanying catalogue. In the United States during the 1920s and early '30s, while Hoffmann had a high profile, Moser was only occasionally mentioned

in the art magazines as a precursor to current trends. When Joseph Urban opened the Wiener Werkstätte of America showroom in New York in 1922, only current members of the group such as Hoffmann and Dagobert Peche were exhibited (although Moser was represented, alongside Hoffmann, with glassware in the second Newark Museum show of German-Austrian applied arts in 1922).[28]

Retrospective assessments of the Wiener Werkstätte began in the 1960s. The exhibition *Art Nouveau* began an American tour in 1960, visiting New York, Pittsburgh, Los Angeles, and Baltimore. The show included examples of Moser's work from 1898 to 1903 as a graphic artist and designer of glasswork and textiles. The first exhibition devoted exclusively to the Wiener Werkstätte after its closure in 1932 was organized in 1967 by the Österreichisches Museum für angewandte Kunst (Austrian Museum of Applied Arts) in Vienna. Here Moser was rightly presented as an individual of enormous significance. In 1969, an exhibition embracing Moser's work as draftsman and painter was held at the Neue Galerie am Landesmuseum Joanneum, Graz, an event issuing, seven years later, in the publication of the first monograph on Moser. In 1979, the Hochschule der angewandte Kunst (College of Applied Art) in Vienna organized *Koloman Moser 1868–1918*, but the show included a number of items that proved not to have been made or designed by him.

Meanwhile, in the United States, the "rediscovery" of turn-of-the-century Vienna continued apace, with Moser's design work strongly featured. Nine entries by Moser were included in an early exhibition of Viennese fin-de-siècle design at the La Boetie gallery in New York in 1972.[29] In 1978, *Vienna Moderne, 1898–1918* opened at the Cooper-Hewitt Museum in New York and then traveled to the Sarah Campbell Blaffer Gallery (University of Houston). A 1905 chest by Moser in silver, enamel, and semiprecious stones was a main attraction of the show.[30]

When a record price for a piece of twentieth-century furniture was attained at auction in 1982—a desk designed by Moser in 1902[31]—the time was evidently ripe for the first solo exhibition of his work in the United States. *Kolo Moser: Painter and Designer, 1868–1918* was organized by the Galerie Metropol and presented at the Austrian Institute in New York in 1983.[32] The show consisted of fifteen pieces of furniture, including tables, chairs, desks, settees, and cabinets; thirty smaller objects in glass and metal; and fifteen drawings and paintings.[33] The catalogue introduction invoked the Hoffmann-Moser dichotomy seen in the 1906 article by Levetus. Hoffmann's work is described as "the more astringent, the less ornamented," while Moser "enriches his relatively spare, rather sharp-edged forms through a sensual profusion which is expressed in ornament, the choice of rich materials and aggressive colorism."[34]

According to one critic, writing in the *New York Times* on the occasion of the exhibition, Moser was "virtually unknown outside Austria to all save specialists and collectors of the style," despite the now "decade-long revival of the Wiener Werkstätte," which had been dominated by Josef Hoffmann.[35] Thus the show coincided with the reattribution of several designs from Hoffmann to Moser. Articles pub-

lished during and directly after the exhibition commented on the rapidly growing demand for Moser's work and the rise in prices: "Hoffmann is the artist most in demand, although Moser is running a close second, partly because of a recent show of his work at the Austrian Institute," wrote the *Daily News* reviewer. "In fact, the Museum of Modern Art purchased a Moser vase for $5000 following the exhibit."[36] *New York* magazine's writer commented on the extent to which contemporary American designers—especially those associated with postmodernism—were influenced not only by Hoffmann's work but also by Moser's. Juxtaposing photographs of furniture by Moser, Michael Graves, and Richard Meier, the critic saw not only formal ties but a similarity of approach: "As Hoffmann, Moser, and Loos sought to cleanse the excesses of the nineteenth century, so Graves, Meier, and their colleagues now seem determined to revitalize an era of design deadened by modernism."[37]

It nonetheless remains the case that Moser's contribution is overshadowed by the (much longer) life, achievement, and powerful artistic personality of Josef Hoffmann.

The work of Koloman Moser, as painter, graphic artist, and designer of objects, is to be found in many public and private collections. The most extensive is held in Vienna's Museum für angewandte Kunst. This includes works from the Wiener Werkstätte archives, now housed in this institution, and designs and drawings still in Moser's possession at the time of his death and subsequently acquired from relatives. Smaller Moser collections are located in the archives of the Viennese Universität für angewandte Kunst (University for applied art) and the Historisches Museum der Stadt Wien (Historical museum of the city of Vienna). There are paintings by Moser in the Galerie Belvedere, Vienna. Outside Austria, important works are held by the Badisches Landesmuseum, Karlsruhe, and the Musée d'Orsay, Paris. American collections containing work by Moser include the Museum of Modern Art and the Metropolitan Museum of Art in New York, the Art Institute of Chicago, the Wolfsonian in Miami, and the Virginia Museum of Fine Arts in Richmond.

Elisabeth Schmuttermeier
Translated from the German by Elizabeth Clegg.

[1] See Kolo Moser, "Vom Schreibtisch und aus dem Atelier. Mein Werdegang," in: *Velhagen und Klasings Monatshefte,* vol. 10 (1916), pp. 9–13.

[2] Preface, catalogue of the first exhibition, Vereinigung bildender Künstler Österreichs, Vienna, 1898.

[3] See Marian Bisanz-Prakken, "Das Quadrat in der Flächenkunst der Wiener Secession," in: *Alte und Moderne Kunst,* vol. 27, no. 180–181 (1982), p. 42.

[4] *Ver Sacrum,* nos. 18–19 (September–October 1901).

[5] It is safe to assume that Moser also designed most of the artists' monograms for members of the Secession. On this point, see Bisanz-Prakken, "Das Quadrat in der Flächenkunst" (as note 3), pp. 45–46.

[6] *Neue Freie Presse,* vol. 146 (June 18, 1905), p. 11.

[7] Moser, "Vom Schreibtisch und aus dem Atelier" (as note 1).

[8] Moser worked for the firm of Backhausen, designing textiles and carpets, from 1898 to 1904. On this subject, see Angela Völker, *Die Stoffe der Wiener Werkstätte 1910–1932,* Vienna: Brandstätter, 1990, pp. 21–30.

[9] See Eduard F. Sekler, *Josef Hoffmann, das architektonische Werk,* Salzburg: Residenz, 1982, p. 490.

[10] *Arbeitsprogramm der Wiener Werkstätte,* Vienna, 1905.

[11] See Moser, "Vom Schreibtisch und aus dem Atelier" (as note 1): "In my view, our activity was too varied and far too dependent on the tastes of our clients. And, what's more, the public on the whole had no precise idea of what it really wanted.

The impossible requests we received from our customers, and other differences of opinion, prompted me, quite a few years ago, to leave the Wiener Werkstätte."

[12] See Ludwig Hevesi, "Der gedeckte Tisch" (1906), in: *Altkunst-Neukunst. Wien 1894–1908,* Vienna: Konegen, 1909, p. 227.

[13] Werner J. Schweiger, "Saloneinrichtung von Kolo Moser," in: *Moderne Vergangenheit 1800–1900,* ed. by Peter Wawerka et al., exhibition cat., Vienna, Künstlerhaus, 1981, pp. 290–293. A number of photographs of furniture designed for the Hellmann apartment are included in an album deriving from the Wiener Werkstätte archives, now in the collection of the Museum für angewandte Kunst (inv. no. WWF 101, pp. 22–25, 55).

[14] Moser, letter to Josef Hoffmann, February 3, 1907, in the Handschriftensammlung, Wiener Stadt- und Landesbibliothek, inv. no. 172.579.

[15] Moser, "Vom Schreibtisch und aus dem Atelier" (as note 1).

[16] For examples, see A. S. Levetus, "The Exhibition of the Vienna Secession," in: *The Studio,* vol. 25 (1902), pp. 267–275, in which several views of Moser's design for the twentieth Secession exhibition are reproduced. See also Levetus's column in *The Studio,* vol. 29 (1903), pp. 135–141.

[17] "First International 'Studio' Exhibition, Part II," in: *The Studio,* vol. 24 (December 1901), p. 256, ill. pp. 247–249.

[18] A. S. Levetus, "An Austrian Decorative Artist: Koloman Moser," in: *The International Studio,* vol. 24 (December 1904), pp. 111–117.

[19] A. S. Levetus, "Modern Decorative Art in Austria," in: *The Art-Revival in Austria* (The Studio Special Issue), ed. by Charles Holme, London, 1906, p. D vi. See also the entry on Moser in the guide to "Leading European Craftsmen and Designers," in: *Studio Year Book of Decorative Art* (1909), pp. 59–60.

[20] See Leslie Topp's essay in this volume.

[21] *Official Catalogue of Exhibitors, Universal Exhibition St. Louis USA, Saint Louis, 1904,* pp. 102–105.

[22] *Imperial Royal Ministry for Public Instruction, Universal Exhibition St. Louis, Exhibition of Professional Schools for Arts and Crafts,* exhibition cat., Vienna, 1904, p. 57.

[23] Emil Fischer, *Rückblick auf die Beteiligung der österreichischen Regierung an der Louisiana Purchase Exposition World's Fair St. Louis 1904,* Vienna: Niederösterreichischer Gewerbeverein, 1906, pp. 25, 27, 31.

[24] Hunter visited Vienna in 1908; see *"The Art That Is Life": The Arts & Crafts Movement in America, 1875–1920,* ed. by Wendy Kaplan et al., exhibition cat., Boston, Museum of Fine Arts, 1987, pp. 168–169.

[25] "A Page of German Flower Holders," in: *The House Beautiful,* vol. 21, no. 4 (March 1907), p. 17.

[26] *House and Garden,* vol. 24, no. 5 (November 1913), p. 329.

[27] See Josef August Lux, "Kunstschau Wien 1908," in: *Deutsche Kunst und Dekoration,* vol. 23 (1908–09), p. 57.

[28] *The Applied Arts: Objects in Wood, Metal and Glass, Textiles, Embroideries, Laces, Books, Engravings, Etc.,* exhibition cat., Newark Museum, 1922, p. 13.

[29] *Art and Design in Vienna: 1900–1930,* exhibition cat., New York, La Boetie, 1972.

[30] See John Loring, "America Rediscovers Vienna Moderne," in: *Art in America,* vol. 67, no. 3 (May–June 1979), pp. 106–108.

[31] Sold at Sotheby's Monaco on April 19, 1982, as lot no. 144, for US$ 266,702.

[32] *Kolo Moser: Painter and Designer, 1868–1918,* exhibition cat., New York, Galerie Metropol, 1982, p. 26. The Galerie Metropol, owned by Wolfgang Ritschka and Georg Kargl, opened in Vienna in 1973 and on Madison Avenue in New York in 1981, following the success of a Josef Hoffmann exhibition at the Austrian Institute; it carried furniture by Hoffmann and Otto Wagner as well as by Moser. See Tracey Harden, "Antiquers Vie for Viennese Furnishings," in: *Daily News* (May 5, 1983), p. 51.

[33] Rita Reif, "Shedding Light on a Viennese Designer," in: *New York Times* (March 13, 1983).

[34] Christian Meyer, introduction, in: *Kolo Moser* (as note 32), p. 26.

[35] Reif, "Shedding Light" (as note 33).

[36] Harden, "Antiquers Vie for Viennese Furnishings" (as note 32). See also Andrew MacNair, "Inspired Collection," in: *New York Post* (February 10, 1983), Home sec., p. 6, and Reif, "Shedding Light" (as note 33).

[37] Carter Wiseman, "Tales of the Vienna Woods," in: *New York* (February 14, 1983).

JUTTA SIKA

* SEPTEMBER 17, 1877, LINZ
† JANUARY 2, 1964, VIENNA

Cover of exhibition catalogue *Universal Exhibition St. Louis 1904, Austria Imperial Royal Ministry for Public Instruction Exhibition of Professional Schools for Arts and Crafts*, Louisiana Purchase International Exposition, Saint Louis, 1904. Collection Österreichische Nationalbibliothek

In 1905, the work by Jutta Sika at the Brno exhibition *Der gedeckte Tisch* (The Set Table) prompted critics to single her out as one of the most promising talents of the Vienna school, yet today little is known about her. Sika herself has provided us with an outline of her career in the form of a list of dates relating to her studies and exhibitions.[1] But her personality as an individual and an artist is as scantily documented as her private life. The examination of previously unexplored sources has made it possible to provide a more complete biography of this artist.

Jutta Josefa Sika was the daughter of Alfred Sika, an inspector for the Austrian state railways, based in Pilsen (now Plzeò, Czech Republic), and his wife Ida.[2] In 1887, she moved with her parents to Vienna. Eight years later, she embarked on her artistic career, enrolling at the Graphische Lehr- und Versuchsanstalt, an institution described in the catalogue of the 1904 Louisiana Purchase International Exposition in Saint Louis, Missouri, as follows: "The 'School and Experimental Laboratory for Graphic Art' in Vienna teaches the best methods used in photography and graphic reproductions, and facilitates their application to art, industry and science, whilst purely artistic, technical, physical and chemical subjects are attended to with equal zeal. This institution has, no doubt, added much to the great development of graphic art in Austria, and served … as a model for similar educational establishments in other countries."[3] Along with the other subjects Sika studied at the school, she took courses in drawing and painting in watercolor—two artistic forms she would return to in the latter decades of her career.

In 1897, Sika entered the Kunstgewerbeschule (School of Applied Arts; attached to the Österreichisches Museum für Kunst und Industrie in Vienna) to study in the department of ornamental, animal, and flower painting under Rudolf Ribarz. Therese Trethan meanwhile had enrolled in Oscar Beyer's department of architecture. After a year of attending the same lectures as Sika, in 1899 Trethan joined her class (now, under Koloman Moser, called the department of decorative drawing and painting), and the two students soon became fast friends. From the outset, it was clear that Sika was more gifted; not only did she receive better marks in nearly every subject, but her work was shown in more exhibitions and mentioned more frequently in reviews. And even if the difference was often merely one of nuance—for example, when Moser assessed Trethan's work as "very good" but Sika's as "excellent"—it confirms the impression one has today from her surviving work: Sika appears to have been the more varied, the more imaginative, the more innovative of the two.

For both Sika and Trethan, the years immediately following their time at the Kunstgewerbeschule were the most fruitful of their careers. Already in 1900, Sika had contributed to the Exposition Universelle in Paris, for which Moser selected work by his students (male and female alike) to represent the school.[4] But her first major success came with the exhibition mounted by the school in 1901 at the Österreichisches Museum für Kunst und Industrie (Austrian Museum of Art and Industry). The show's catalogue included the names of all the participants and a brief statement for each class supplied by the professor. According to Moser, the works "were intended to show how the design is always considered in relation to the method of production."[5] This practical approach to objects (also apparent in their functionality), combined with a refined artistic flair, was what made the work of Moser's pupils so distinctive.

Encouraged by the response to the show, that same year, ten of Moser and Josef Hoffmann's students, among them Sika and Trethan, founded the group Wiener Kunst im Hause (Viennese Art in the Home). Wasting no time, in December 1901 they presented three attention-getting interiors (bedroom, dining room, and music room) at the Vienna Kunstgewerbeverein (Union of Applied Art). In their commitment to the notion of the *Gesamtkunstwerk* (total work of art) and their promotion of a style based on Viennese Biedermeier and English models, Wiener Kunst im Hause in fact was a forerunner of Hoffmann and Moser's Wiener Werkstätte, founded in 1903. When it came to marketing, it seems, it was the teachers who learned from their students.

Writing in the influential German journal *Dekorative Kunst*, Josef Folnesics declared: "What the ten graduates ... have achieved is in every respect interesting. Even if there is an air of immaturity about much of it, it has something that is fresh and immediate." Turning his attention to Sika, he wrote: "The washing set designed by Jutta Sika has turned out somewhat ungainly, but the flattened front of the basin is a rational innovation. On the other hand, her fire screen in brass and colored glass, executed by Bakalowits, merits ... unqualified praise." Folnesics also singled out Sika's coffee and tea service, executed by Josef Böck, noting the "ease and lightness of the form and its ornamentation."[6]

A year later, in the winter of 1902, Wiener Kunst im Hause participated in the fifteenth exhibition at the Secession, home of the Viennese avant-garde. According to the catalogue, Sika showed textiles, ceramics, glass services, and bookbindings.[7] Following its high-profile appearance at the Secession, the group's reputation was further boosted when it was selected as the subject of a special issue of the Secession journal *Ver Sacrum*. Shortly thereafter, the Ministerium für Kultus und Unterricht (Ministry of Religion and Education) offered Wiener Kunst im Hause a set of studios. The group's next exhibition, in 1903–04, was held there. Sika used the occasion to display her versatility, contributing not only tableware and a toiletry set, but two woodcuts—*Wirbelwind (Whirlwind)* and *Schnee (Snow)*, her first efforts as a printmaker—and a candelabra of her own design and execution.

A critic for *Das Interieur* wrote approvingly of the show: "There is work in every medium: wood, metal, glass, leather, paper, and linen. And the results are tasteful and, on the whole, inexpensive."[8] It was this combination of discerning design and economic accessibility that made the group's work as much at home in the commercial setting of Vienna's 1905 Christkindlmarkt as in the grand and serious *Erste Internationale Jagdausstellung* (First International Hunting Exhibition) of 1910, where Wiener Kunst im Hause came away with a silver medal.[9] In 1922, twenty-one years after its founding, the group adopted the less evocative name Wiener Arbeitsbund (Vienna Labor Union). When Sika and Trethan took part in the 1925 *Exposition Internationale des Arts Décoratifs et Industriels Modernes* (International Exhibition of Modern Decorative and Industrial Arts) in Paris, it was as representatives of this body.

Though committed to the group, neither artist worked and exhibited with it exclusively. As designers for the Viennese porcelain manufacturer Josef Böck and the E. Bakalowits Söhne glassware firm,[10] both Sika and Trethan had their work shown constantly in Vienna. Besides the winter exhibitions of 1901–02, 1902–03, and 1903–04 at the Österreichisches Museum für Kunst und Industrie, Sika also took part in the exhibitions of Austrian applied art at the same venue in 1909–10 and 1910–11 (to the latter contributing metalwork executed by the Argentor factory), and the celebrated 1908 *Wiener Kunstschau*, where she was represented with decorative textiles, embroideries, and a mosaic image of Saint Leonard.[11]

At the same time, Sika and Trethan were becoming known internationally. In 1902, Sika showed her work at the first *Esposizione Internazionale d'Arte Decorativa Moderna* (International Exhibition of Modern Decorative Arts) in Turin. Together with Trethan, that same year she also participated in the *Deutsch-Nationale Kunst-Ausstellung* (German National Art Exhibition) in Düsseldorf and the *Exhibition of Fine Art and Decorative Furnishings* in London.

Two years later, the American public was introduced to the two artists' work at the 1904 Louisiana Purchase International Exposition in Saint Louis. The catalogue lists six items under Sika's name: three different types of jug, two crystal glasses, and a tea service were displayed in the applied arts section designed by Josef Hoffmann. Both Sika and Trethan won bronze medals at the show, with Sika's glass items attracting "well-deserved attention."[12] Though not included in the catalogue, a ceramic vase with a green and reddish-brown glaze is known to have been shown in the fair. Upon its return from the United States, this was purchased by the Österreichisches Museum für Kunst und Industrie; to this day, it bears the traces of a U.S. customs sticker.[13]

The year 1905 saw the two women again showing work in the same exhibition, this time for *Der gedeckte Tisch* in Brno. The German journal *Kunstgewerbeblatt* ran illustrations of not only the more widely known items—Sika's coffee service (with the cup shifted to one side of the saucer and the beaklike handle) and Trethan's tea service (with the "hinged" polka dots)—but also a Sika-designed table lamp in glass and metal, its struts supported on three spheres that doubled as vases.

In the wake of the Brno show, the two artists' work began to appear in the English-language press. In 1906, a special issue of *The Studio* titled *The Art-Revival in Austria* included Sika's beautiful glass vases and elegant hanging lamps; over the next four years, Sika's name cropped up time and again in *The Studio Year Book of Decorative Art*. Amelie S. Levetus, *The Studio*'s British-born correspondent in Austria, repeatedly referred to the role of women in the development of modern applied art. Writing in 1906, she said: "Many women, too, are to the fore in the applied arts. Before the modern movement they were chiefly interested in the old methods of coloured embroidery in silks, flowers and other designs. ... Now they are taught on nature's system, and at the Imperial Kunstgewerbe-Schule they learn all branches of applied art, and by turning their thoughts to the simplest articles of every-day life are opening up a new field in art. The women can turn their hands to most things, as can the men." And in 1910: "The women-artists are also doing their share in helping to introduce the spirit of art into everyday life. Fraulein Juta Sika and Fraulein Theresa Trethahn [*sic*] are designing delightful dinner, tea and coffee services; Frau Poller-Hollmann is producing admirable book bindings, and Fraulein Marietta Peyfuss excellent bed-linen and leather-work. These artists all belong to a group known as the 'Wiener Kunst im Hause'..."[14]

Levetus thus drew attention to a fact barely noticed decades later during the rediscovery of Viennese modernism. In 1978, the catalogue for a traveling U.S. exhibition, organized by the Sarah Campbell Blaffer Gallery in Houston, contained illustrations of pieces by Sika and Trethan, but effectively stripped the artists of their gender by fail-

ing to give their first names. Furthermore, the appendix provides biographies for the male artists only.[15] It was not until the 1980s that more thorough research was done, rescuing the two from a state of quasi-anonymity.[16]

Apart from her work for Bakalowits and Böck, Sika—a founding member of the Deutscher Werkbund and, from 1913, a member of the Österreichischer Werkbund—joined forces with a variety of individuals and institutions over the years. From 1905 to 1910, she designed accessories for the Flöge sisters' fashion house and made costumed dolls and postcards for the Wiener Werkstätte. From 1906 to 1912, she worked for the Wiener Stickerei (Viennese embroidery) group, creating women's suits, tapestries, and panels for fire screens. For ten years beginning in 1914, she collaborated with the Salon Hilda Kulmer (evening gowns, murals, curtains, and shawls), while also designing tea packaging for Komansky of Danzig and cardboard packaging for W. Spitzer and Löwit & Co. And in the 1930s, she worked for the renowned confectioner Demel, creating Christmas tree decorations and packaging for chocolates. On the educational front, from 1911 to 1933, Sika taught drawing to underwear manufacturers and embroiderers, and during World War II she taught in various girls' high schools. Seeking to broaden her own knowledge, in 1913–14 Sika returned to the Kunstgewerbeschule for a course in costume design taught by Alfred Roller. In 1921, she completed a course in fashion drawing, and four years after that a course in etching for artists.

After joining the Vereinigung bildender Künstlerinnen Österreichs (Union of Austrian women artists) in 1920, Sika's interest turned away from applied arts to painting. Despite receiving an honorary diploma for achievements in the applied arts at the 1925 *Exposition Internationale des Arts Décoratifs et Industriels Modernes* in Paris, she only exhibited in the field sporadically after that, her last appearance being at the Österreichisches Museum für Kunst und Industrie, in a show called *Das befreite Handwerk* (The Liberated Crafts) in 1935. Her primary concern now became the truthful rendering of nature: she is reported to have produced some 800 flower paintings, in addition to views of Innsbruck and pictures painted during her vacations in Sweden. Between 1930 and 1954, Sika showed her works in gouache and pastel in at least twelve exhibitions.[17] Her paintings of sunflowers, poppies, and begonias reveal an artist who strives for the utmost verisimilitude in her treatment of the observable world, but without the artistic ambition noticeable, for example, in her image of two birds reproduced in *Ver Sacrum* in 1903.

In abandoning the applied arts for painting, Sika followed in the footsteps of her teacher Koloman Moser. And, like Moser, she too turned out to be more accomplished in her original vocation. Sika's spirited breakfast service, with its beaklike handles and the brilliant extension of the saucer to accommodate a pastry, became famous in her lifetime. While this design still guarantees her a place in museums, her innocuous flower paintings, acceptable to followers of any ideology,[18] suggest that this once-promising talent retired in order to indulge a passion for triviality.

Anne-Katrin Rossberg
Translated from the German by Elizabeth Clegg.

[1] Typed curriculum vitae in the Handschriftensammlung of the Wiener Stadt- und Landesbibliothek, Vienna, inv. no. 161.934.

[2] In 1932, Sika's mother was still listed in the Viennese directory *Lehmann's Wohnungsanzeiger*, as the widow of Oberinspektor Sika, living with her two daughters, Jutta and Friedrike, at 27 Ungargasse in the third district of Vienna. Sika mentions her sister in her surviving correspondence; she also, on one occasion, speaks of two brothers (letters in the Handschriftensammlung of the Wiener Stadt- und Landesbibliothek and the archives of the Universität für angewandte Kunst, Vienna). Information on Sika's father was found in Nationale zur Aufnahme in die k.k. Kunstgewerbeschule des k.k. Oesterr. Museums für Kunst und Industrie 1901, in the archives of the Universität für angewandte Kunst, Vienna.

[3] *Universal Exhibition, St. Louis, 1904, Austria: Exhibition of Professional Schools for Arts and Crafts*, exhibition cat. (English ed.), Vienna: k. k. Ministerium für Kultus und Unterricht, 1904, pp. 13–14.

[4] Sika's curriculum vitae mentions an enamel vase, but there is no documentation to confirm that this was the piece she entered in the show.

[5] *Führer durch die Ausstellung der Arbeiten der Wiener Kunstgewerbeschule, Österreichisches Museum für Kunst und Industrie*, Vienna: Holzhausen, 1901.

[6] Josef Folnesics, "Wiener Kunstgewerbeverein," in: *Dekorative Kunst*, vol. 9 (1902), pp. 136, 138.

[7] There is no mention of the fire screen praised by Folnesics and illustrated in a review of the exhibition in *Das Interieur* (Anon., "Wiener Kunst im Hause," in: *Das Interieur*, vol. 4 [1903], p. 213). This review calls it a "Paravent"—in other words, a windbreak rather than a fire screen. Another illustration, shows the screen placed in front of a window, suggesting the same conclusion (Folnesics, "Wiener Kunstgewerbeverein" [as note 6], p. 133).

[8] Anon., "Wiener Kunst im Hause," in: *Das Interieur*, vol. 4 (1903), p. 29.

[9] "'Kunst im Hause'—Am Wiener Christkindlmarkt," in: *Hohe Warte*, vol. 2 (1905–06), p. 63; *Die Erste Internationale Jagd-Ausstellung Wien 1910: Ein monumentales Gedenkbuch*, Vienna: Frick, 1912, p. 208. Though it cannot be confirmed, Sika also mentions a bronze medal. It is possible she received it in a personal capacity for the panels she contributed to an interior by Josef Hoffmann (on this, see Sabine Forsthuber, *Moderne Raumkunst: Wiener Ausstellungsbauten von 1898 bis 1914*, Vienna: Picus, 1991, p. 145).

[10] Bakalowits was not itself a manufacturer, but rather marketed the glassware after commissioning the design (for example, from Sika) and production (for example, from Lötz Witwe)—this explains the common assumption that Sika worked for Lötz. The surviving pieces from the Lötz workshop in Klostermühle were designed by Sika for Bakalowits and sold under the firm's name. See Helmut Ricke et al., *Böhmisches Glas 1880–1940*, vol. 1, Werkmonographie, Munich: Prestel, 1989, pp. 105–107, 188–190.

[11] The mosaic was executed in the workshop headed by Leopold Forstner and was later installed above the business premises of a property in Bohemia. See the documents in the estate of Hans Ankwicz-Kleehoven (Jutta Sika file), in the archives of the Österreichische Galerie Belvedere, and Forsthuber, *Moderne Raumkunst* (as note 9), p. 125.

[12] *Official Catalogue of Exhibitors. Universal Exposition St. Louis: Department B "Art," USA, 1904*, exhibition cat.: published for the committee on press and publicity by the Official Catalogue Company (Inc.), p. 105, cat. nos. 444–449 (as note 3), p. 104. Klara Ruge, "Kunst und Kunstgewerbe auf der Weltausstellung zu St. Louis, I," in: *Kunst und Kunsthandwerk*, vol. 7 (1904), p. 538.

[13] Österreichisches Museum für angewandte Kunst, Vienna, inv. no. W.I. 569. See Waltraud Neuwirth, *Österreichische Keramik des Jugendstils*, Munich: Prestel, 1974, p. 172.

[14] A. S. Levetus, "Modern Decorative Art in Austria," in: *The Art-Revival in Austria* (The Studio Special Issue), ed. by Charles Holme, 1906, p. D 9; idem, "Austrian Architecture and Decoration," in: *Studio Year Book of Decorative Art* (1910), p. 220.

[15] Jan Ernst Adlmann, *Vienna Moderne 1898–1918: An Early Encounter Between Taste and Utility,* exhibition cat., Sarah Campbell Blaffer Gallery (University of Houston); New York, Cooper-Hewitt Museum; Portland Art Museum; and Art Institute of Chicago, 1978–79, n.p. This was one of the first exhibitions in the United States to focus on Viennese modernism.

[16] See Werner J. Schweiger, *Wiener Werkstätte: Kunst und Handwerk*

1903–1932, Vienna: Brandstätter, 1982; Isabelle Anscombe, *A Woman's Touch: Women in Design from 1860 to the Present Day,* London: Virago, 1984; and *Frauen in Design: Berufsbilder und Lebenswege seit 1900 / Women in Design: Careers and Life Histories since 1900,* exhibition cat., Stuttgart, Design Center, 1989. The first book to engage this subject comprehensively and critically was Sabine Plakolm-Forsthuber, *Künstlerinnen in Österreich 1897–1938: Malerei, Plastik, Architektur,*

Vienna: Picus, 1994.

[17] For information on Sika's work as a painter, see the documentation in the estate of Hans Ankwicz-Kleehoven (Jutta Sika file) in the archives of the Österreichische Galerie Belvedere, and also the archives of the Vereinigung bildender Künstlerinnen Österreichs. I am grateful to Rudolfine Lackner and to Lydia Lorenzova at the Vereiningung for their dedicated research into this matter.

[18] Although in the 1930s the Vereinigung

bildender Künstlerinnen Österreichs was committed to the promotion of Austrian female artists, in the 1940s it embraced National Socialist ideology, changing its title to Vereiniging bildender Künstlerinnen der Reichsgaue der Ostmark im Grossdeutschen Reich. In the 1950s, it displayed a new, modern openness to the world and a readiness to exhibit "alongside its foreign guests." Sika's flower pieces and landscapes were shown during all of these phases.

THERESE TRETHAN

*** JULY 17, 1879, VIENNA**
† JUNE 22, 1957, VIENNA

Cover of exhibition catalogue *Universal Exhibition St. Louis 1904, Austria Imperial Royal Ministry for Public Instruction Exhibition of Professional Schools for Arts and Crafts,* Louisiana Purchase International Exposition, Saint Louis, 1904. Collection Österreichische Nationalbibliothek

At some point or other the error crept in, and Therese Trethan was suddenly twenty years older. According to some of the literature,[1] she was born in 1859, though she did not enter Vienna's Kunstgewerbeschule (School of Applied Arts) until nearly four decades later, just before the turn of the century. Isabelle Anscombe refers to this anomaly in writing of Trethan and Jutta Sika as Kolo Moser's "most successful students": "Jutta was then in her early twenties, but Therese was already in her forties when she graduated."[2] In reality, Trethan was two years *younger* than Sika, having been born in 1879, the daughter of Ferdinand Trethan, an upholsterer, and his wife, also Therese.[3] Little information survives on Trethan's life or work; no letters—not even a single photograph—offer us closer access to her as a person. After careful study, at least the date of her death has now been discovered, along with some other basic facts of her life and career.

For almost forty years, beginning in 1907, Trethan lived at Landstrasser Hauptstrasse 12, in the third district of Vienna, not far from Jutta Sika. In 1945, she was registered as living in the town of Klosterneuburg, close to Vienna, but two years later she was back in the city and living with another former student of the Kunstgewerbeschule, sculptor Emil Meier (b. 1877), whom Trethan married on May 28, 1947. She died ten years later, in Vienna, shortly before her seventy-eighth birthday. Beyond these bare facts, however, the

only insight we have into Trethan's personal life is an enigmatic comment from Sika in a letter dated October 10, 1957: "I could … tell you something of our dear friend Trethan, who had such a sad end …"[4]

In 1897, when Trethan enrolled in the department of architecture at the Kunstgewerbeschule, architecture was still considered a subject unfit for women. But unlike the Technische Hochschule (Technical College), where women were not accepted to the architecture program until 1919, the Kunstgewerbeschule's curriculum focused on the applied arts—in particular the design and furnishing of domestic interiors, an area viewed as appropriate for students of "the weaker sex." Textiles, of course, were an important component of domestic interior design, and moreover a domain traditionally viewed as feminine. So it was that when Trethan graduated in 1899, she received a certificate testifying to her proficiency as a "draftswoman of embroidery patterns."

Among the observations on Trethan's report card for the 1898–99 academic year we read: "On May 1, 99 transferred to the class of Prof. [Rudolf] Ribarz; wanted to transfer to [Josef] Hoffmann's class but was not accepted!" The ambitious student was lucky, though: after receiving her certificate, she transferred to the department of decorative drawing and painting, in which that year Ribarz was replaced by Koloman Moser. Like Hoffmann, Moser was a major proponent of

modernist design and, along with his students, was soon to attract international attention.

It was in the classes of Moser's department that Trethan first met Jutta Sika. Both of them were completing a course in ceramics taught by Friedrich Linke in 1900–01. In the following academic year 1901–02, both were registered as "guest students" of Moser's, suggesting that they were already employed in some capacity. Following the success of an exhibition presented in 1901 by the Kunstgewerbeschule at the Österreichisches Museum für Kunst und Industrie (Austrian Museum of Art and Industry), some of Hoffmann and Moser's students, among them Sika and Trethan, founded the applied arts group Wiener Kunst im Hause (Viennese Art in the Home). In December 1901, the group held its first exhibition, in Vienna. The next year it was invited to stage a show in Düsseldorf, and in late 1902 it appeared as part of the fifteenth exhibition at the Secession; to this last show Trethan contributed several ceramic decorative objects, along with a set of curtains that she both designed and made. Meanwhile, Trethan and Sika were showing work independently as well. In the spring of 1902, they participated in a Secession show; influenced, perhaps, by their recent training with Linke, both artists chose ceramics to represent them. The next appearance of their work was at the Exhibition of Fine Art and Decorative Furnishings in London, and at the end of the year they exhibited pieces at the Museum für Kunst und Industrie. Including the Wiener Kunst im Hause shows, then, Trethan and Sika contributed to a total of six exhibitions in the space of a year—it is hardly surprising their studies suffered as a result.

During this same period, Trethan was also working with the porcelain manufacturer Josef Böck, for whom she designed her Johannisbeeren (Black currants) coffee service, presented at the Winterausstellung. Already at the 1903 London show, Trethan had been listed as a designer for the firm. Not long after, Böck launched a successful advertising campaign aimed at the Russian market: in late 1903, instead of taking part in the first Wiener Kunst im Hause presentation, held at the studios of the artists, Trethan opted to accompany her work to Saint Petersburg, where it appeared as part of the exhibition Die Kinderwelt (The World of the Child). She came away with an honorable mention for a ceramic cicada, a tea service made by Böck, and a toiletry set she designed for the Bakalowits glassware firm.[5] Further recognition came soon after, in the form of a bronze medal from the 1904 Louisiana Purchase International Exposition in Saint Louis, where Trethan again showed the cicada.[6] The following year, a tea service (possibly the same one that had been exhibited in Saint Petersburg) attracted the attention of commentators during the spring exhibition at the Mährisches Gewerbemuseum (Moravian Museum of Applied Arts) in Brno.

That 1905 exhibition, titled Der gedeckte Tisch (The Set Table), featured "several extremely original coffee services designed by Miss Jutta Sika" and "a beautiful tea service by Miss Trethan," according to the review by Julius Leisching.[7] The photograph that ran with Leisching's article showed two of the tea service items, notable for their decoration: cut into the porcelain's white surface is a pattern of small dots and, when colored (for example, in red), the combination of chromatic brightness and physical depth creates the effect of hinged, movable flaps. This design was a sophisticated alternative to the usual monotony of such patterns, adding energy and wit to the pieces' formal elegance.

This tea service, along with a kindred version for coffee (illustrated in the 1907 Studio Year Book of Decorative Art) and two other similar tableware items (decorated with a frieze of triangles and pentagons in yellow or blue), are the best-known examples of Trethan's work in this area—known as much through publication as through pieces in museum collections. The Österreichisches Museum für angewandte Kunst (Austrian Museum of Applied Arts), for example, has parts of these services in its permanent collection, as well as eight of Trethan's designs for Böck, including the drawing for the shape of the polka-dot service. Common to all of these pieces is the fact that, despite the conventionality of their decoration, they are clearly the work of an original thinker. Other examples of Trethan's inventive designs are her tea and coffee services executed by Ernst Wahliss and illustrated in The Studio: one decorated with a flower pattern (anticipating a look of the 1960s), and the other with an austerely delicate Jugendstil motif.

Apart from her work as a decorative painter with the Wiener Werkstätte from 1905 to 1910,[8] Trethan began to devote time to easel painting, as well as trying her hand at fashion design. She also began to teach drawing and the history of theatrical costume design at a number of Viennese vocational schools. At the 1908 Wiener Kunstschau, she exhibited a stage costume and four dolls; and a painting by her, titled Dekorativer Fleck (Decorative Patch), appeared in the Internationale Kunstschau of 1909. The Ausstellung österreichischer Kunstgewerbe (Exhibition of Austrian Applied Arts) of 1909–10 included a miniature painted by Trethan on parchment. In the following year, she exhibited various hats of her own design. After the 1925 Exposition Internationale des Arts Décoratifs et Industriels Modernes (International Exhibition of Modern Decorative and Industrial Arts) in Paris, where her work was again singled out for mention honorable, the last show we know she participated in was a special exhibition mounted in 1930 by the Vereinigung bildender Künstlerinnen Österreichs (Union of Austrian Women Artists). Titled Zwei Jahrhunderte Kunst der Frau in Österreich (200 Years of Art by Women in Austria), this show commemorated the twentieth anniversary of the group, and made a point of placing applied arts on an equal footing with fine arts. Sika, who belonged to the union for ten years, served on the selection jury for the applied arts, and it was probably she who ensured the inclusion of Trethan's work in the show—here again, the tea service, which had already attained near-classic status by that time. At this point, Trethan's focus shifted entirely away from ceramics. It seems fitting that her last exhibition should have been a personal retrospective of sorts, featuring this work for which she was most celebrated.

Anne-Katrin Rossberg
Translated from the German by Elizabeth Clegg.

1 Werner J. Schweiger, *Wiener Werk-stätte: Kunst und Handwerk 1903–1932*, Vienna: Brandstätter, 1982, p. 268. See also *Wien um 1900. Kunst und Kultur*, Vienna: Brandstätter, 1985, p. 547; and Dieter Zühlsdorff, *Markenlexikon*, vol. 1, *Porzellan und Keramik Report 1885–1935*, Stuttgart: Arnold'sche Verlagsanstalt, 1988, p. 448.

2 Isabelle Anscombe, *A Woman's Touch: Women in Design from 1860 to the Present Day*, London: Virago, 1984, p. 101.

3 The correct date of Trethan's birth, given in the Thieme-Becker artists' index of 1939, is confirmed by preserved documents. Thieme-Becker, *Allgemeines Lexikon der bildenden Künstler: Von der Antike bis zur Gegenwart*, ed. by Hans Vollmer, Leipzig: Seemann, 1939, vol. 33, p. 383.

4 Jutta Sika, letter to Alexandra Ankwicz, October 10, 1957, in the Handschriften-sammlung of the Wiener Stadt- und Lan-desbibliothek, Vienna, inv. no. 161.932.

5 While this suggests Trethan may have designed for Bakalowits on a regular basis, it is the only known instance of her collaborating with the firm (on Bakalowits, see also the Jutta Sika biography in this catalogue).

6 *Official Catalogue of Exhibitors. Universal Exposition St. Louis: Department B "Art," U.S.A., 1904*, p. 105, cat. no. 457. While the cicada is here referred to as a "cricket" and the material is described as porcelain, it can be assumed that this is the same piece.

7 Julius Leisching, "Der gedeckte Tisch," in: *Kunstgewerbeblatt*, vol. 16 (1905), p. 15.

8 The collection at the Österreichisches Museum für angewandte Kunst includes a screen designed by Koloman Moser and executed by Karl Beitl and Therese Trethan at the Wiener Werkstätte. To date, however, this is the only evidence of Trethan's involvement with the Wiener Werkstätte.

OTTO PRUTSCHER

*** APRIL 7, 1880, VIENNA**
† FEBRUARY 15, 1949, VIENNA

Title page of catalogue for *German Applied Arts (Touring Exhibition of the Deutsches Museum für Kunst in Handel und Gewerbe, Hagen)*, 1912–13

In a manner equaled by few architect-designers, Otto Prutscher embodied the collectivist tendencies in the circle around the Vienna Secession both before and after World War I. Prutscher belonged to the first generation of universalist designers to be trained, from 1899, under Josef Hoffmann at the Viennese Kunstgewerbeschule (School of Applied Arts), entirely in the spirit of William Morris and the English Arts and Crafts movement. Beginning around 1900, Prutscher designed numerous buildings, interiors, and luxury versions of household requisites. And it was, indeed, as a favored student of the *Gesamtkunstwerk* ("total work of art"), a concept so dear to the Secessionists, that Prutscher was perceived by contemporary commentators. Even then, his work was difficult to distinguish from that of other prototypical products of the *Wiener Moderne*, for example, the work of Hoffmann, Joseph Maria Olbrich, or Koloman Moser.

It is true that in 1906, when Prutscher was only twenty-six years old, A. S. Levetus devoted an entire article in *The Studio* to his work, in which she addressed this very issue and concluded that Prutscher was "no mere copyist."[1] Nonetheless, if one considers his stylistic development in isolation from the context in which he was working, one is less aware of a distinctive personal style than of a persistent capacity for adaptation. Before 1914, Prutscher's work is notable for its light and elegant forms. That of the 1920s achieves a distinct style that might well be termed "Viennese Art Deco." In the 1930s, his work is marked by an often oppressive material heaviness. Compared to Viennese designers who were able to retain and evolve the urbane and fragile elegance of the Wiener Werkstätte even into the 1930s and '40s—Oswald Haerdtl, for example—Prutscher had by that time partially adapted his work to the intervening antimodernist tendencies in design.

Prutscher's career is notable for the qualities that Joseph August Lux characterized in 1906 as "instinct" and "an affectionate determination." As the son of a cabinetmaker who had moved to Vienna from Bohemia, he initially took a course in carpentry. But from 1897, he studied in the drawing and painting class at the Kunstgewerbeschule. The true starting point in his training occurred, however, in 1898, when he transferred to the architecture class taught by Josef Hoffmann. Here, in the company of other enthusiastic students of Hoffmann—who was then taking the art of exhibiting exemplary interiors

to a refined high point, and using it as an autonomous medium for the propagation of modern ideas[2]—Prutscher fully assimilated Secessionist ideals. While still a student, his work was included in the Austrian Pavilion at the Paris Exposition Universelle in 1900, where Hoffmann had designed the installation for both the Secession and the Kunstgewerbeschule, employing the curvilinear style of early Jugendstil.[3]

From this point on, Prutscher showed his notably wide-ranging work at virtually every exhibition of contemporary Austrian applied art, and he soon assumed responsibility for the design of exhibition installations. During the period up to World War I, Prutscher emerged, alongside Hoffmann, as a key figure in the modern design movement in Vienna, occupying a series of influential posts. He became, for example, a professor at the Kunstgewerbeschule, a founding member of the Österreichischer Werkbund, and an advisor to the Österreichisches Museum für Kunst und Industrie (Austrian Museum for Art and Industry). His designs for furniture, textiles, objects in glass, ceramics, and metal, and a wide range of decorative items may be counted among the choicest examples of the applied art production of that era. In 1901, just after completing his studies, he collaborated with Erwin Puchinger on the design for a lady's bedroom, which was presented at the winter exhibition of the Österreichisches Museum für Kunst und Industrie.

Prutscher's work attracted the attention of most of the leading Viennese commentators on art and applied art, including Joseph A. Lux (who in 1914 published the first monograph on Otto Wagner), Max Eisler, Ludwig Hevesi, Egon Schiele's mentor Arthur Rössler, and Armand Weiser, who wrote about his work in such respected journals as Das Interieur. In 1902, Prutscher was first introduced to an English-speaking public when the London journal The Studio carried illustrations of a jewelry collection made to his design, and in the following years A. S. Levetus repeatedly wrote about the work of this prolific designer.

Also in 1902, Prutscher was among those representing Austria at the legendary Esposizione Internazionale d'Arte Decorativa Moderna (International Exhibition of Modern Decorative Arts) in Turin, and in the same year he participated in the thirteenth exhibition to be presented at the Vienna Secession. Other important episodes in his exhibiting career in the prewar years include: the installation designed for the Möbel Ausstellung (Furniture Exhibition) at the Gartenbaugesellschaft (Horticultural Society) in Vienna in 1905; his participation in the Jubiläumsausstellung (Jubilee Exhibition) presented in Mannheim in 1907 (this brought him further international acclaim); his collaboration with Gustav Klimt and others in planning and organizing the legendary Kunstschau for Vienna in 1908; his installation design for the Austrian section of the 1909 Internationale Photo-Ausstellung (International Photography Exhibition) held in Dresden; his design of the Lower Austrian pavilion for the Internationale Jagdausstellung (International Hunting Exhibition) held on the Prater in Vienna in 1910; his design of the Austrian contribution to the 1911 Reise- und Fremdenverkehrausstellung (Travel and Tourism Exhibition) in Berlin, and to the Internationale Baufach-Ausstellung (International Architectural Exhibition) mounted in Leipzig in the same year; and finally, his Raum für eine Kunstsammlung (Room for an art collection) presented at the Deutscher Werkbund exhibition in Cologne in 1914. Even while employed during the war at the K.k. Kriegspressequartier, the chief Austro-Hungarian wartime information and propaganda service, Prutscher organized exhibitions of applied art in Bucharest, Odessa, and Sofia.

Prutscher was equally active as an architect before the war. Here too his work was extremely close in many respects to that of Olbrich and Hoffmann, whose villas on the Hohe Warte (in the suburban nineteenth district of Vienna) clearly provided the model that he strove to emulate. While initially active as a designer of interiors (for which he would invariably also supply furniture of his own design), by 1904, Prutscher had begun to receive architectural commissions, building in that year a large house in the western Viennese suburb of Penzing. In 1905, he designed salesrooms for the Trier department store in Darmstadt and later built shops for a wide range of specialist suppliers of applied art objects: Habig (hats), Böck (bed linen), Munk (leather and bronzes), and Rothberger (textiles). Around 1911, he provided designs for numerous coffeehouse interiors, and also one (still extant) for a pharmacy.

Between 1912 and 1915, Prutscher finally had the chance to demonstrate more fully his understanding of the modern style of living in his designs for a series of villas: the Villa Moriz Rothberger in Baden, near Vienna (1912), the Villa Bienenfeld, also in Baden (1912–13), the Flemmich House in Jägerndorf, northern Moravia (now Krnov, Czech Republic; 1914–15), and the Benesch residence in the Meidling district of Vienna (1914–15). In 1913–14, he also collaborated with the ceramicist Michael Powolny on a design for two rooms at the Viennese Dianabad.

As a very typical representative of the Viennese artistic community serving a primarily bourgeois—and often wealthy Jewish—clientele, Prutscher was badly affected by the impact of both world wars on Viennese society and culture. And his suffering was ultimately to be as much personal as professional. While the disintegration of Austria-Hungary at the end of 1918 incurred the loss of virtually all his previous clientele and a more or less definitive end to the aestheticization of life that had persisted in prewar Vienna, the advent of National Socialism in Austria, with the Anschluss of 1938, proved little short of catastrophic. Because his wife was Jewish, Prutscher was dismissed without notice from his professorship at the Kunstgewerbeschule and forced into long-term unemployment.

In the intervening period of two decades, Prutscher, like other Viennese designers, engaged in the attempt to adapt the pre-1914 ideal of noble craftsmanship to the less opulent circumstances of postwar, postimperial Austria. Prutscher continued to design for the leading Viennese producers of interior decoration: he produced glassware for Johann Lötz Witwe, vases for the Augarten porcelain factory, and works in silver for the Wiener Werkstätte. However, both in design and in architecture, there emerged a tendency to much heavier forms,

with an emphasis on materials. The formal playfulness of the Secession's heyday now gave way to a gravity of expression, although the results did not thereby lose their intensity or the sense of pleasure in formal exploration and inventiveness.

The attempt to adapt to changing times was more successful than might have been expected. In 1925–29, for example, Prutscher designed four large apartment blocks for "Red Vienna," which, with their expressive sculptural decoration, perfectly satisfied the expectations of their occupants as well as those of the commissioning city authorities. Indeed, Prutscher's work of the interwar years is excellent evidence in support of the argument that, although the social modernization of Austria after 1918 did occur, it was effectively masked by the rather heavier forms of the late Secession and a rustic "Expressionism." A clear example of this development is to be found in the villa that Prutscher built for Marie Knopf in 1919 in the northwestern Viennese suburb of Hernals, which seemed to hark back to the prewar period. This phenomenon is even more apparent in the country houses built in the 1930s for industrialists and physicians in the area around the pilgrimage site of Mariazell, on the border between Lower Austria and Styria, an area that became fashionable at this time thanks to the combination of a Catholic revival and a cult of life in the mountains.

Prutscher's career in the 1920s and '30s also included a fair amount of exhibition and interior design. The Austrian contributions to the *Internationale Hygiene Ausstellung* (International Hygiene Exhibition) in Dresden in 1925, to the *Pressa* show in Cologne in 1928, and to the municipal *Ausstellung Gas und Wasser* (Gas and Water Exhibition) in Berlin in 1929 testify to a spirit of measured optimism among designers now working with a repertoire of clearer but also more compact forms. In 1934, Prutscher designed a shop for the Viennese delicatessen Piccini, a culinary landmark in the city.

From 1938 to 1945, Prutscher remained with his wife in Vienna, but his two daughters were able to escape to Como, Italy. Shortly after the war, he was reinstated as a professor at the Kunstgewerbeschule and participated in the legendary antifascist exhibition *Niemals vergessen!* (Never Forget) at the Viennese Künstlerhaus. Between his retirement in 1946 and his death in 1949, Prutscher designed installations for further exhibitions and devoted himself to a few unrealized architectural projects.

Virtually throughout his prolific career, Prutscher's work was perceived by commentators in relation to the leading figures of the Secession and the Wiener Werkstätte: Hoffmann, Olbrich, and Moser. In his own right, Prutscher was generally noted for his evident pleasure in opulent forms of ornamentation. In 1906, for example, Joseph August Lux observed that Prutscher's work was "not especially remarkable by the standards of the model provided by the Wiener Werkstätte, and yet not quite true to this model in as far as it [the model] exemplified severe sobriety and restraint from a playful ornamentation."[4] A decade later, Lux would recapitulate this view: "In terms

of taste, Prutscher hits the Viennese note so very felicitously that he manages to retain his personal identity even within the group of artists from which he derives his character as a designer … but he is not the great conductor of this orchestra … in the manner of Otto Wagner or [Joseph Maria] Olbrich. Compared to these, Otto Prutscher produces art that is merely amateur Viennese music-making."[5] A more recent analysis of Prutscher's contribution refers to a "bewildering experience of 'collective artistic individuality,' an almost paradoxical identity between artistic originality and the spirit of the age, which appears to correspond less to our own concern with the contribution of the individual than to the rules and production methods of the old guild system."[6]

Otto Prutscher's estate is largely held by the families of his daughters, who remained in Como after the end of World War II, although a few items have entered the Museum für angewandte Kunst (Museum of Applied Arts) and the Universität für angewandte Kunst, both in Vienna. Within Prutscher's lifetime, his work was little known outside Austria, except insofar as it was, on occasion, discussed in German and English journals. He did participate, in a minor way, in two exhibitions in the United States. The 1912 touring exhibition of *German Applied Arts*, which originated in Newark, contained a piece of glassware by Prutscher. Another American traveling exhibition, in 1929, dedicated to "glass and rugs," presented a variety of his glass vessels.[7]

The only monograph on Otto Prutscher to be published appeared in 1925, at a time when he was much in evidence as a leading collaborator with the Wiener Werkstätte in its later years. This was written by Max Eisler, one of the most knowledgeable commentators on modern Austrian design.[8]

Since 1945, with the increasing interest in Jugendstil, leading private collectors have tended to acquire designs by Prutscher dating from the period before 1914. In particular, his ceramics and glassware have attracted the interest of the most important Austrian collectors of applied art (Ernst Ploil, Rudolf Schmutz), with the result that such items have come to be seen as epitomizing the high-water mark of Viennese modernism. A number of U.S. institutions have work by Prutscher, including the Carnegie Museum of Art in Pittsburgh; the Chrysler Museum of Art in Norfolk, Virginia; the Cooper-Hewitt National Design Museum, Metropolitan Museum of Art, and Museum of Modern Art in New York; the Detroit Institute of Arts; the Indianapolis Museum of Art; Los Angeles County Museum of Art; Minneapolis Institute of Art; Museum of Fine Arts in Boston; and the Saint Louis Art Museum. The first retrospective survey of Prutscher's entire œuvre was published in Italy in 1994, at the instigation of his descendants.[9] In 1997, the Universität für angewandte Kunst organized a retrospective accompanied by a comprehensive catalogue.[10]

Matthias Boeckl
Translated from the German by Elizabeth Clegg.

[1] A. S. Levetus, "Otto Prutscher: A Young Viennese Designer of Interiors," in: *The Studio*, vol. 37 (February 1906), pp. 33–41.
[2] On this theme, see Sabine Forsthuber, *Moderne Raumkunst. Wiener Ausstellungsbauten von 1898 bis 1914*, Vienna: Picus, 1991, passim.
[3] Eduard Sekler, *Josef Hoffmann, das architektonische Werk*, Salzburg: Residenz,

1982, p. 261, cat. nos. 38, 39.
[4] Joseph August Lux, "Architekt Otto Prutscher—Wien," in: *Innendekoration*, vol. 17 (April 1906), p. 93.
[5] Lux, "Professor Otto Prutscher—Wien," in: *Innendekoration*, vol. 28 (June 1917), pp. 212, 218.
[6] Friedrich Achleitner, introduction, in: *Otto Prutscher, 1880–1949*, ed. by

Matthias Boeckl et al., exhibition cat., Vienna, Universität für angewandte Kunst, 1997, p. 4.
[7] *Touring Exhibition of the Deutsches Museum für Kunst in Handel und Gewerbe, Hagen*, exhibition cat., Newark Museum and other venues, 1912–13, p. 76; *International Exhibition of Contemporary Glass and Rugs*, exhibition cat., American

Federation of Arts, 1929. My thanks to Janis Staggs-Flinchum for locating this information.
[8] Max Eisler, *Otto Prutscher*, Vienna: Hubsch, 1925.
[9] Gabriele De Giorgi et al., eds., *Otto Prutscher, 1880–1949, Metamorfosi*, vols. 22–23, Rome: Uniénone Stampa Periodical Italiana, 1994.
[10] *Otto Prutscher, 1880–1949* (as note 6).

HANS PRUTSCHER

*** DECEMBER 5, 1873, VIENNA**
† JANUARY 25, 1959, VIENNA

In 1928, Hans Prutscher (the older brother of Otto Prutscher) published "a sort of account of my thirty-year career," which he dedicated, in gratitude, to those who had commissioned designs from him. This reference to his patrons offers an explanation for the otherwise bewildering diversity of Prutscher's work. For though at least partially due to the self-taught artist's constant search for "direction," more than anything else this diversity reflected the differing needs and desires of his various employers over the years. As Prutscher wrote in 1928: "If my work has brought me success, it was due not least to the fact that those who commissioned me to design buildings or interiors were usually in a position to tell me what they wanted, while I was adept at obtaining such advice from them."[1] Prutscher's survey of his career reveals an early involvement in architecture. But until around 1910, this son of a long-established Viennese family of cabinetmakers was engaged primarily in the design of shop and department-store interiors. As a writer for the Viennese journal *Das Interieur* claimed (somewhat prematurely, given Prutscher's later residential and religious designs): "Hans Prutscher has done his best work on commercial buildings. He has the good fortune to possess a clear, practical understanding, coupled with a solid education and, above all, a rare level of craftsmanship. He has trained as a carpenter and a mason, and he has always been remarkably quick to grasp the essence of the tasks assigned to him and to carry them out to the satisfaction of his patrons. It goes without saying that he is not an artist much given to sentiment; but then this is not really possible in the realm of the strictly functional applied arts."[2] The article's emphasis on function and rationality, like so much of the period commentary on Prutscher, is surprising in view of the illustrations that accompany it. Of these, the only design that might be properly termed

"neutral" is the one for the main entrance of the Frick bookstore. And as for Prutscher's "rococo-classical" interior for the Pollak department store, it is difficult to see it as anything but a sentimental tribute to the golden age of the Habsburg Empire.

Was it at all possible to *avoid* sentimentality in Vienna? A concern with functionality, in the Viennese context, necessarily entailed the creation of an illusion in the service of self-representation, the creation of *Gemütlichkeit* (comfort)—a solace for body and soul. Here, as opposed to in Germany, mere functionality was not enough: in designed objects, it was necessary that *meaning* must also be present. But this creation of illusion (through the imitation of historical styles) and *Gemütlichkeit* were broadly defined and emotionally inflected concepts that were open to interpretation, including Prutscher's own. In 1911, he wrote: "The imitation of historical styles and *Gemütlichkeit* are both the result of a kind of tolerated laziness, and the sort of thing requested by people who, incapable of drawing inspiration from within, want to be superficially reminded of something. ... All sorts of messiness is called *gemütlich*, and there is enormous danger in this, because this messiness is an affront to both the passage of time and the sense of morality."[3] Here, Prutscher sought to resist the force of the *genius loci*, a force that nonetheless exerted its pull on him again and again. Otto Wagner too had issued a call for order: architecture, he believed, should be based on reason, not romanticism or feeling. But from this point on, feeling could not be avoided by any architect who sought to provide for human needs. Wagner was able to probe feeling and intensify it; his own treatment of historical modes of expression enriched those who understood him with new ideas.

Hans Prutscher's solution, though, was limited to the surface. The imitative approach he had so roundly criticized was in fact the dominant

quality of his own interiors well into the 1920s. At first this imitation consisted of quoting the language of forms devised by such eminent contemporaries as Josef Hoffmann, Koloman Moser, Joseph Maria Olbrich, and Adolf Loos. Moreover, Prutscher would happily combine biomorphic and geometric Jugendstil (as in his *Entwurf für eine Halle* [Design for a hall], 1902); Wiener Secession style with the creations of Adolf Loos (Schneidersalon Milek [Milek tailor's shop], 1903); medieval with Oriental (Nebenraum der Wildprethandlung Zitterbart [Office of the Zitterbart game storeroom], 1904); or Historicist set pieces alongside products of the Biedermeier revival in a Jugendstil approximation of a "farmhouse" (*Sitzzimmer* [Conference room], 1905). He was even successful at integrating such diverse elements into a semblance of the "order" for which he strove. But he was still unable to hide the fact that his was an essentially additive approach. Prutscher's failure to grasp the significance and implications of his method is evident in the piece he showed at the *Imperial and Royal Austrian Exhibition* in London in 1906. His glass and metal fish tank at first sight recalls the designs of Wagner, and critics reacted accordingly. One, alluding to Prutscher's use of rivets as both decorative and constructive elements, acclaimed the work as "exceptionally satisfying on account of the fact that its form is determined by necessity."[4] Wagner had in fact employed a similar scheme, arranged in groups of three, in the dining room of his apartment in Köstlergasse (where mother-of-pearl inlays functioned as allusions to marquetry), as well as in his metal furniture, where intersecting supports form "nodes." But Prutscher took it further. In the supporting structure for his fish tank he included a relief of a heron, while the container's upper corners take the form of fish heads. Here, yet again, there is always something to add. The horror vacui, the dread of the clarity of the functional, was thus transported from the era of Historicism into the new century.

From 1907 to 1913, Prutscher worked mostly in the resurgent revival styles, characterized by the simplification and/or monumentalization of eighteenth- and early nineteenth-century models. For instance, in his design for the workshop of the court tailor Heinrich Grünbaum, Prutscher created a sumptuous setting combining late Rococo and Empire style (an achievement *Das Interieur* saw fit to honor with eight illustrations). His design for the Pollak department store was a blend of Neoclassicism and Rococo. And for the game room of his Dom Café, he concocted an adaptation of Biedermeier.[5] Even as late as 1928, we find Prutscher's design for the cashiers' hall of the Städtische Elektrizitätswerke (Vienna Electric Works) embellished with Corinthian pilasters and a projecting cornice.

Contemporary with these were such bizarre designs as Prutscher's *Keramik* pavilion for the *Erste Internationale Jagdausstellung* (First International Hunting Exhibition) in Vienna in 1910—entirely covered in the material it was intended to showcase, the exterior came across as curiously Eastern. The interior was calmer, and this in particular provoked a positive response from the critics. Amelie S. Levetus, in the 1911 *Studio Year Book of Decorative Art*, wrote: "Hans Prutscher has been turning his attention to the manipulation of tiles for decora-

tive purposes, and with excellent results."[6]

Ludwig Hevesi wrote equally approvingly of a similar room shown at the *Ausstellung österreichischer Kunstgewerbe* (Exhibition of Austrian Applied Arts) at the Österreichisches Museum für Kunst und Industrie in the winter of 1909–10: "I shall conclude … by mentioning a highly accomplished work by Hans Prutscher, a 'butcher's shop.' It is entirely covered in glazed tiles, their coloring a pale, aqueous, almost 'washed-out' green, the rounded corners of the walls a darker tone, and with bright-colored medallions. … As a form of pictorial decoration, the walls have large majolica inlays showing pigs, sheep, and oxen—literally, 'scenes of slaughter.' … The entire wall is also enlivened by a fountain, again all in glazed tile. This is one of the best rooms in the show."[7] In this relatively modern design, Prutscher for once took his cue from more contemporary models: delicate striped borders outlined separate sections of wall, recalling designs produced by Hoffmann around 1904, or Wagner in 1909.[8] At the same exhibition, however, Prutscher also showed one of his historicizing interiors, the fitting room for a women's boutique—an approximation of Rococo that moved Hevesi to speak of "a thoroughly delicious design imbued with the spirit of the dressing table."[9]

The same ambivalence that typifies Prutscher's interiors is also present in his work as an architect, which began in earnest with his entryway designs, beginning in 1910. Here, despite the uneven results, it is clear that Prutscher was gradually finding his own voice. Next to the entrance to the Frick bookstore, the one he designed for Stalzer is something of a surprise, its convex and concave parts braced against one another in perfect harmony. In fact, the plasticity and dynamism of this design were to become hallmarks of Prutscher's facades. With the combined residential/commercial block commissioned by the printer Fromme in Lerchenfelderstrasse, and the apartment block in Danhausergasse, Prutscher introduced a new architectural phenomenon to Vienna: the undulating facade. Windows swell into bays, integrated into the wall so that a wave appears to be sweeping through the surface. With his pulsating facades, Prutscher offered his own original alternative to the city's traditional emphasis on the plane, even if graphic elements (strips and lines) continue to provide structure.

He achieves a different sort of sculptural effect in his 1911 treatment of the Elsa Hof, a two-bay residential and commercial block in Neubaugasse. Here, walls appear hollowed out or puffed up, balconies are "liberated," bay windows shrink back into the walls or, alternately, jut outward into space. With the Elsa Hof, Prutscher ceased to be a mere imitator; indeed, he approached the ranks of the avant-garde. Working on a relatively narrow site, he anticipated the expansive facades of Vienna's communal housing blocks of some ten years later. His continuous balconies, bay windows, and the decorative motif of the stilted column all reappeared in the 1923 Metzleinsthaler Hof design, by Wagner's pupils Franz and Hubert Gessner.

Ultimately, Prutscher's architectural career was limited to facade designs: his innovations extended to the surfaces of his buildings, but not to the architectural space itself. Still, his contribution to architectural history was substantial—if brief, and made without the benefit of

any professional training, solely through drawing on years of experience with a particular range of materials. This alone should allow him to emerge from the shadow of his younger brother Otto, who has routinely attracted more attention.

"Forward, upward, toward our goal"—this is the motto inscribed on the window of the staircase at the Paula Hof in Westbahnstrasse (1912), a design by Hans Prutscher with an inner courtyard where bay windows in a glass and iron construction are primarily functional but also of a remarkable beauty. The motto could well have been Prutscher's own: the forward-looking architect is always present in his apartment facades. On the other hand, the same architect was responsible for Schloss Heroldegg (1913) in the Carinthian countryside, a miniature version of the Bavarian castle of Neuschwanstein.

Prutscher's œuvre is well documented. A good deal is known about all of his ecclesiastical projects of the 1920s and '30s. His last commission, in 1948, was to rework the facade of the Wiener Tischler-Innungshaus (Vienna Carpentry Guild). But there is almost no information on Hans Prutscher the man.[10] Highly disciplined and industrious, he more or less lived for his work and was something of an outsider. His influence on other designers and architects seems to have been limited to Austria. And with the exception of three mentions in *The Studio Year Book of Decorative Art* between 1910 and 1912, his contribution to the 1906 exhibition in London is the only evidence of any exposure abroad, during his lifetime or since. Now, with his aluminum clock in the Neue Galerie (cat. no. III.54), a striking example of Prutscher at his most modern, perhaps he will at last receive the recognition he deserves.

Anne-Katrin Rossberg
Translated from the German by Elizabeth Clegg.

[1] Hans Prutscher, *Auslese meiner Arbeiten 1898–1928*, Vienna: Selbstverlag, 1928, n.p.
[2] Anon., "Geschäfts- und Warenhauseinrichtung," in: *Das Interieur*, vol. 12 (1911), p. 66.
[3] Hans Prutscher, "Betrachtungen," in: *Das Interieur*, vol. 12 (1911), p. 66.
[4] A. Schestag, "Arbeiten von Hans Prutscher und Hubert von Zwickle," in: *Kunst und Kunsthandwerk*, vol. 9 (1906), p. 440.
[5] In Prutscher's own account of his work, he dates the Dom Café to 1919, but in fact it was published as his design in

1913. His text contains other errors as well: a view of the interior of the ceramic pavilion shown at the *Erste Internationale Jagdausstellung* in 1910 is captioned "Hubertuskamin 1909"; this incorrect date is given again in one other place.
[6] A. S. Levetus, "Austrian Architecture and Decoration," in: *Studio Year Book of Decorative Art* (1911), pp. 213–214, ill. pp. 236–239. The pavilion was built by the Wienberg brickworks, with which Prutscher collaborated from at least 1908. That year he designed and furnished an exhibition stand for the firm (including a "deluxe bathroom," a coffeehouse kitchen,

and a retail outlet, among other features) as part of an exhibition of furniture at the Gartenbaugesellschaft in Vienna. The exhibition was written up in the 1908–09 *Wiener Bauindustrie-Zeitung*.
[7] Ludwig Hevesi, "Ausstellung österreichischer Kunstgewerbe im Österreichischen Museum," in: *Kunst und Kunsthandwerk*, vol. 9 (1910), p. 14.
[8] The catalogue for this show included Jakob and Josef Kohn in the list of contributing firms. Kohn had provided fittings for the butcher's shop (unfortunately not visible in the illustrations). This has led scholars to assume that Prutscher provid-

ed designs for Kohn. The catalogue also gave the designer's name for every item displayed, however, and since Prutscher was not credited as the creator of the Kohn pieces, it is more likely that he merely selected the items for the show; just as in his 1913 interior for the Dom Café, he used armchairs by Thonet that had appeared in its catalogue in 1906.
[9] Hevesi, "Ausstellung" (as note 7), p. 13.
[10] The December 5, 1953 edition of *Wiener Zeitung* ran a photograph of Prutscher (p. 4) with an article marking his eightieth birthday.

JOSEPH URBAN

*** MAY 26, 1872, VIENNA**
† JULY 10, 1933, NEW YORK

Installation view of Joseph Urban's one-man exhibition held at the Architectural League of New York, February 1932, in *Architecture* (April 1932)

As a result of a series of major exhibitions on turn-of-the-century Vienna presented during the 1980s, Viennese architecture of that period has come to be associated with four individuals almost to the exclusion of all others: Otto Wagner, Joseph Maria Olbrich, Josef Hoffmann, and Adolf Loos. The fact, however, that their achievements could only have come about because of the sheer mass of high-quality building activity, most of it based on the designs of less well-known architects, is all too often overlooked. One of these figures, who is

nowadays far less appreciated in his native Austria than in his adopted homeland of America, is Joseph Urban.

Urban was born in Hernals—in those days, a suburb of Vienna—in 1872. In 1911, he left Vienna for Paris, subsequently moving to the United States, where he first lived in Boston and later in New York. He died in New York, of cancer, on July 10, 1933. He thus spent the first half of his professional career in Austria, primarily in Vienna. The second half was spent entirely in America, above all on the East Coast—in Boston, New York, and Palm Beach.

Urban's Austrian career really got underway around 1895. Between that date and his departure for America, he was enormously productive and his output astonishingly diverse in character, embracing important contributions to architecture, exhibition and set design, book illustration, graphic design, interior decoration, and other categories of the applied arts. Sharing in the period's commitment to the *Gesamtkunstwerk* (total work of art), Urban succeeded in realizing this ideal in numerous ways. For the villas he designed, he would invariably also devise the interior decoration; for the exhibitions he organized, he would provide the installation; for the books he illustrated, he would be responsible for the layout.

The principal events in the first, Austrian half of Urban's career may be summarized as follows. In 1890, he embarked on the study of architecture at the Viennese Akademie der bildenden Künste (Academy of Fine Arts), in the class taught by Karl von Hasenauer. In 1896, Urban became a member of the Künstlergenossenschaft (Association of Viennese Artists). In 1897, he married Marie Lefler, and began collaborating—particularly on book illustration—with her brother Heinrich. In 1898, he first attracted attention and praise for his contribution to the Jubilee Celebrations marking the fiftieth year of Emperor Franz Joseph's reign. In 1900, Urban became a founding member of the artists' association Hagenbund.

As an architect, Urban's stylistic development was much the same as that of virtually every young open-minded member of the profession in Vienna at that time: from the neo-Renaissance and neo-Baroque of late Historicism, to vegetal Jugendstil, via the geometric rigor of the Vienna Secession, to the Biedermeier revival. During his training under Hasenauer, he acquired an extensive knowledge of the decorative patterns favored in Renaissance and Baroque architecture and an abiding awareness of the desirability of a sense of structural "mass." Through close collaboration with his brother-in-law, who was an early exponent of Jugendstil stylization, or *Stilkunst*,[1] Urban became deeply familiar with this trend, which was "modern" in relation to late Historicism but less radical than the Secession. More of an eclectic than a modernist,[2] Urban was naturally also ready to adopt elements from the architecture of Otto Wagner and the Vienna Secession. All this was paired with Urban's insatiable lust for life, which ensured that he pursued every aspect of his activities, personal and professional, "to the full."

Although Urban embarked on his career as an exhibition organizer and designer only some time after he had begun to establish himself as an architect, he remained active in this field until the end of his life.

Here too he can be seen moving from the sweeping curves of Jugendstil to the straight lines and geometric forms of the Vienna Secession.

An instance of Urban's activity in this area that would prove important to his emerging reputation both at home and abroad was his contribution, as organizer and designer, to the Hagenbund room at the 1904 Louisiana Purchase International Exposition in Saint Louis. Although no photograph survives, we know that—like other entries in the Austrian pavilion—the Hagenbund room was designed "in a modern style" and furnished by Urban with armchairs, a table, and mahogany corner cupboards inlaid with mother-of-pearl.[3] Unlike figures such as Hoffmann, Plečnik, Kotěra, and Leopold Bauer, who also designed interiors for the pavilion, Urban traveled to America to oversee the installation "down to the last detail … with great conscientiousness and skill."[4] Not only did this event bring Urban to the United States for the first time, it also constituted the first instance of his own response to architecture encountered in America: decorative elements of the Saint Louis railroad station are echoed in the vaulted ceiling of the Viennese restaurant that Urban would design in 1906 for Paul Hopfner. Urban was also an exhibitor in the Hagenbund room, showing a series of fairy-tale illustrations made with Lefler.[5]

For some time, members of the Hagenbund were generally regarded as the second Viennese representatives of modernism after the Secession. Even the most advanced Hagenbund members did not evince the same radicalism in their modernity as did the figures who dominated the Secession, often retaining elements of Historicism. Until the Secession was markedly weakened with the departure, in 1905, of the "Klimt group," the Hagenbund thus remained in its shadow. Thereafter, however, it steadily gained in importance, and its status in Vienna reached a high point in 1908—yet again a jubilee year, in this case marking Franz Joseph's sixtieth year as emperor.

As an established authority on exhibition organization and installation, Urban assumed this role in the vast majority of shows presented by the Hagenbund between 1900 and 1908, justifiably taking credit for the positive reviews received in the Viennese press. In contrast, however, to the practices of Hoffmann, Moser, and others who organized and installed exhibitions at the Secession, Urban always used Hagenbund funds to pay for his often elaborate schemes, and this practice soon began to attract criticism. Urban was also able to make his mark on the Hagenbund in his role as an architect when he was given the opportunity to adapt part of a market hall in Zedlitzgasse, donated by the Vienna city council, for use as an exhibition hall. The result, one of Urban's principal contributions to architecture in Vienna, was notable for its curious and elaborate facade: this attested to the influence of both the Vienna and Munich Secessions but it also had a marked orientalizing quality.

Urban's role as the chief influence on design at the Hagenbund extended beyond exhibition installation, for he also produced the accompanying catalogues and posters. His most popular work in this area, however, was the design—with Lefler—for a new thousand-crown banknote in 1900. For most of the illustration projects on

which Urban and Lefler collaborated, it is usually impossible to distinguish their separate contributions. In general, however, it can be said that Urban tended to contribute the more emphatic, ornamental frames and was responsible for the overall arrangement and placement of the drawings, while Lefler provided the more painterly and scenic elements. It was through Lefler that Urban also began to design for the stage. Sadly, the early projects can no longer be reconstructed in detail, although it is reasonable to assume, in view of his academic training as an architect, that Urban was principally engaged in the structural aspects of set design. In addition to sets and costumes created for Vienna's principal theaters (the Burgtheater, the Hofoper, and the Volksoper), Urban and Lefler worked for other leading European opera houses (notably the Budapest Opera, Berlin's Komische Oper, and Covent Garden in London).

The year 1908 proved to be a turning point for Urban, both professionally and personally. In addition to numerous small commissions (most of them connected with the jubilee celebrations), he was asked to design the temporary architectural structures for the Festplatz on the Viennese Ringstrasse near the Burgtor—that is, the site from which the emperor and his court would watch the ceremonial procession along this circular boulevard.[6]

Working very rapidly, within a few days Urban devised a scheme with a gateway comprising a pair of huge wooden pylons, each bearing a tall wooden figure. Beyond this, a section of the Ringstrasse was flanked by two sets of bleachers. At the center of those on the Hofburg side of the street, he placed an "imperial pavilion." From its circular wooden base, it narrowed as it rose through a series of stepped ledges, and was topped by a giant imperial crown, gleaming in its metallic finish. A tautly suspended canopy was to extend from the base of the crown toward the Ringstrasse.

This scheme, however, issued in disaster: the canopy proved too short to protect the emperor from the sun and the elderly Franz Joseph was forced to stand in the heat and glare of a June day during the entire procession. Urban's contribution to the jubilee celebrations also came under criticism for other reasons. The occasion developed into a financial scandal, and led in 1909 to the resignation of Lefler and Urban from the Hagenbund. In the same year, the Jubilee Procession Committee was taken to court by the Social Democratic parliamentarian Franz Schuhmeier over financial irregularities, and it lost the case. During the hearing, Urban was charged with having accepted a bribe from a group of craftsmen engaged on the project. This accusation dogged Urban's career in Vienna, and it soon became apparent that he would receive no further important official commissions. His departure from the Hagenbund was also to prove a professional disadvantage and, as he felt quite unable to adopt a less extravagant lifestyle, he found himself in financial straits.

In 1911, Urban went to Paris to discuss a production of the opera Pelléas et Mélisande with its composer Claude Debussy. While there, Urban met Henry Russell, impresario for the Boston Opera, who offered him the post of art director. Urban accepted. Meanwhile, he was receiving some attention in the American press.[7] In 1912, by which

time he was living with his family in Boston, corruption charges against him were still being pursued in Vienna. In 1917, he divorced his wife, then married Mary Porter Beegle in 1919.[8]

Urban worked on over thirty productions mounted by the Boston Opera. When it went bankrupt in 1914, he moved to New York to work on a Broadway show. This production attracted the attention of Florenz Ziegfeld, who engaged Urban as artistic designer for his celebrated revues (the "Follies," the "Midnight Frolics," and the "Musicals"). The success of the Ziegfeld Follies prompted Urban to settle in New York. Here, in addition to some three dozen stage sets devised for Ziegfeld, he also worked on more than fifty musicals and plays. In addition, from 1917—when he became an American citizen—until his death in 1933, he created the sets for most of the productions of the Metropolitan Opera,[9] where he was appointed head of design.

Urban was responsible for a great many innovations in American set design. The very first set devised for the Boston Opera had been conceived as a Gesamtkunstwerk, in which all the visual aspects of the production were considered interrelated parts of a continuous whole—an approach virtually unknown in the United States. He also worked on dozens of movies in his capacity as art director at Cosmopolitan Productions, a studio owned by media tycoon William Randolph Hearst. Although these were filmed in black and white, Urban nonetheless created sets that capitalized on the interaction of color and lighting, his principal aim being to achieve a strong contrast of light and shadow.

Despite the haste and disgrace in which he had left Europe, Urban had not entirely broken off contact with Vienna. In the summer of 1922, following a brief visit to the city (now quite a different place in the misery of the first postwar years), he opened at his own expense a New York branch of the Wiener Werkstätte. Here, in specially fitted-out rooms, he introduced the American public to the designs of Hoffmann and Dagobert Peche, and to the paintings of Gustav Klimt and Egon Schiele. For the second exhibition of the Art-in-Trades Club held in the fall of 1923, Urban organized a dining room in the "modernistic manner," outfitted with many items borrowed from the so-called Wiener Werkstätte of America. Urban's skill in the installation of such exhibitions, and his facility as a designer of applied art objects, would have a significant impact on the evolution of "American Art Deco."

It is necessary to consider his relationship to this style in more detail. Until the mid 1920s, Art Deco as it was known in the United States was derived from the original French variant of this style in architecture and the applied arts. After 1925, however, a new and different sort of "modernism" made its presence felt in America: this embraced a version of Art Deco that had more in common with Functionalism, with the ideal of mass production, and with the use of new, emphatically contemporary materials.[10] The pioneers of this new trend in America were not French, but German and Austrian. For some time, German and Austrian émigrés had energetically promoted the virtues and relevance of this new ideology: these included Germans Bruno Paul and Lucien Bernhard, and Austrians Paul Frankl, Wolfgang and Pola Hoffmann, and Joseph Urban.[11]

Through the New York branch of the Wiener Werkstätte, Urban was one of the first in the United States to mount shows of modern European applied art. But the showroom proved to be ahead of its time: it soon ran into financial difficulty and was forced to close after less than two years.[12] Urban, who had bought the exhibited objects from his impoverished Viennese colleagues or their heirs/representatives (confident that he could easily sell them), faced the prospect of losing a great deal of money. He immediately sought to compensate for this eventuality by committing more energy to the movie industry and by seeking American patrons for architectural projects.

A generation older than most of the modernist German and Austrian designers who were to make their mark on the applied arts—and viewed by the majority as something of a father figure—Urban exerted an enormous influence on all aspects of interior design. In 1928, the American Designers' Gallery mounted its first exhibition. Although the show was advertised as presenting only the work of American designers, in fact, many of the contributors were émigrés, including Frankl, the Hoffmanns, and Urban. The show comprised ten completely furnished interiors, with additional displays of all types of objects. Thirty-six designers and artists participated, fifteen of whom (including Urban) were founders of the association.[13] Along with Ely Jacques Kahn, Urban devised the show's "architecture." He also designed a lady's bedroom and dressing room, entitled "Repose," in black mirror glass. Subsequent to this exhibition, Urban recycled elements of "Repose" for use in a private commission. Leo F. Wormser, Esq. approached Urban in 1929 to design a room for his teenage daughter Elaine. Photographs of the room taken after it was installed in the Drake Towers on Lake Shore Drive, Chicago, reveal Urban's changes to the original conception. For instance, while he appropriated the built-in desk, bookcases, and dressing table, he chose a floral carpet and bright draperies (in shades of blue, green, and yellow) to impart a more youthful atmosphere.[14]

The New York public was treated to another exhibition with an "all-American" cast in 1929, when The Architect and the Industrial Arts was mounted at the Metropolitan Museum of Art. The show was wildly popular, attracting more than 180,000 visitors. To demonstrate its thesis—that architects of twentieth-century buildings could and should design both exterior and interior—it featured sample rooms created by outstanding American architects and designers of the period: Armistead Fitzhugh, Raymond M. Hood, Ely Jacques Kahn, John Wellborn Root, Eliel Saarinen, Eugene Schoen, Leon V. Solon, Ralph T. Walker, and Joseph Urban. Participants were required to devise metal furniture and fittings based on a uniform scale, which would be combined to create a unified interior. Urban contributed a conservatory and a man's den.[15]

The stock market crash of 1929 signaled the beginning of a general slump in the building industry and ensured the representatives of Functionalism a more favorable hearing. Urban's work of this period faithfully reflects these developments, and it was precisely during this time of upheaval that he became most active as an architect in America. He had, in fact, received his first American architectural commission in 1925, rebuilding the extensive winter residence of Mar-a-Lago at Palm Beach, Florida. As the project involved a fair amount of sculptural work, Urban called on his former Hagenbund colleague, the sculptor Franz Barwig, inviting him and his son Walter to the States. Writing in 1975, Walter Barwig paints a vivid picture of Urban's multifaceted activities in the U.S. and his continuing connections with (and financial obligations to) artists in Vienna: "In 1925, Mama had written to the architect Urban in New York, insisting that, as he had done so well in the USA, he should now pay back the money that he still owed father. Urban replied that he would pay back no money, but that father could come and work for him in the USA. … So, at Christmas we set off, by ship, traveling first class. When we had arrived in New York, we were set to making clay models for [sculptures at] the Hutton residence at Palm Beach. The place where we went to do this work was one of the Goldwyn-Mayer film studios. Urban was then designing the sets for films and also for the Ziegfeld Follies. … He frequently devised curtains in a delightful Jugendstil manner: in combination with the finest girls that American society had to offer, the effect was splendid. Urban was an extremely talented décorateur. But our efforts were deemed to be insufficiently 'Jugendstil.' So he sent us down to Palm Beach: twenty-four hours on the Orange-Blossom Express."[16]

Mar-a-Lago, as reconstructed by Urban, evinced an idiosyncratic eclecticism, combining elements of a half-Romanesque, half-Gothic cloister, a Spanish South American hacienda, a Venetian palazzo, and an enchanted sandcastle. Urban employed a comparable stylistic allusiveness, albeit with more restraint, in designs for other buildings at Palm Beach: the Oasis Club, the Bath and Tennis Club, and the Paramount Theater. In 1929, however, in response to a commission to build the Atlantic Club on Long Island, he came up with a design of radical modernity.

Urban's intensive engagement with theater building was demonstrated in his book Theatres (1929), illustrating designs produced since 1926 for a Ziegfeld and a Max Reinhardt theater, and for a new Metropolitan Opera building. Of these, only the first was realized. Recent research on Urban has applied the explicitly ambiguous term "theatrical architecture" to these deeply imaginative and ornate designs.[17] As decoration for the auditorium of the Ziegfeld Theater, Urban created a mural titled The Joy of Life. This has recently been noted as including "the same selection of fanciful figures and kaleidoscopic color that had vitalized the Austrian capital a quarter century earlier."[18] A commentator writing in 1927 observed: "The painted scenes that decorate the auditorium do not tell a story or illustrate some particular activity. What we see here, beneath a roof formed of blossoms and foliage, in a landscape dotted with castles and hamlets, woods and meadows, are individuals in a blissful delirium, running, laughing, making music, singing, and falling in love with each other, and with no thought of the morrow, aware only of cheerfulness and happiness—a truly ecstatic frenzy of color."[19]

Urban's most significant work as an architect in America—and a project for which he was chosen over Frank Lloyd Wright—was the building for the New School for Social Research in New York (1929–31).

Widely regarded as one of the first significant examples of the International Style, it offers yet more proof of Urban's extraordinary stylistic versatility. In his first solo exhibition, hosted by the Architectural League of New York in February 1932, Urban was presented in his most pared down, functionalist mode. The show coincided with the Museum of Modern Art's landmark *Modern Architecture* exhibition, which defined the concept "International Style." At least two reviewers placed Urban's show in the same league,[20] and it is possible that the designs he exhibited were chosen partly in response to the Museum of Modern Art event. Exhibits included photographs of the New School and drawings for the Atlantic Club. But the focal point was Urban's recent proposal for the Palace of the Soviets.[21] Along with a small group of high-profile modernists and Expressionists, such as Le Corbusier, Gropius, Erich Mendelsohn, and Hans Poelzig, he had been invited to submit a design for this government complex planned for Moscow. Citing Urban's proposed design, one reviewer of the exhibition noted that it revealed the architect working "very much in the new International Style … [the project] shows a suppression of his fondness for elegance of design and ornamental finery."[22] But, as another critic remarked, Urban did not suppress his Viennese decorative background entirely. Alongside the sobriety of the recent architectural projects was "a reminiscent group of fairy tale illustrations done more than thirty years ago, in the days of Mr. Urban's youthful romanticism"[23]—probably the same illustrations he and Lefler had exhibited at the 1904 Saint Louis exposition.

Urban organized and installed the annual exhibition mounted in New York by the Architectural League in 1933, the last year of his life. In recognition of the quality of his highly praised scheme, the League awarded Urban its gold medal. His final project was the color scheme for the exhibition pavilions at the 1933 Century of Progress International Exposition in Chicago. By this time he was battling illness, and much of the work was done from a hospital bed. He died before the exhibition opened. In a tribute published in a Viennese journal, Hans Adolf Vetter said of this man once so celebrated in Austria: "When Vienna lost Joseph Urban to New York in 1911, the Viennese were only barely aware of any loss; but when New York in 1933 had to say farewell to him forever, the whole of America mourned at the grave of a great artist. That is typical—of Vienna."[24]

Decades would pass before Urban's career would receive scholarly or popular assessment. In 1958, his widow donated his artistic estate to the Dramatic Museum at Columbia University in New York. This donation consisted of some 300 stage-set models, hundreds of letters, 700 drawings and watercolors, numerous photograph albums, and other documents vividly reflecting the artist's life.[25] A 1987 exhibition at the Cooper-Hewitt National Design Museum in New York was devoted to his life and work in Austria and America. Finally, something of a renaissance in Urban studies was set in motion with the appearance in 1992 of the first Urban monograph. The exhibition *Visionäre & Vertriebene* (Visionaries and Exiles), presented in the spring of 1995 in Vienna, considered the work of Austrian architects who emigrated to America, with particular attention to Urban's achievement.[26]

In the fall of 2000, a second exhibition devoted entirely to Urban was held at the Miriam and Ira D. Wallach Art Gallery, Columbia University, focusing on his career as a set designer.[27]

During the course of his career, Joseph Urban emerged as a master of ephemeral architecture. He himself was aware—as were his clients—that this was his forte. Accordingly, the vast majority of his commissions were for temporary structures. Urban's exhibition installations, theater designs, and movie sets were explicitly provisional, and even many of the buildings that were intended to survive have a transitory quality, evoked by their decorative playfulness. It may be for this reason that so much of Urban's contribution to architecture and interior design was either destroyed or fundamentally altered within a few years of its creation. Often such work would have struck its owners as too "fashionable," too closely adapted to the taste of a particular moment. It is only today, with the perspective afforded by the passage of time, that a broader public is beginning to appreciate Urban's achievement.

Markus Kristan
Translated from the German by Elizabeth Clegg.

[1] On this term, see *Wiener Stilkunst um 1900: Zeichnungen und Aquarelle im Besitz des Historischen Museum der Stadt Wien*, ed. by Hans Bisanz, exhibition cat., Vienna, Historisches Museum der Stadt Wien, 1979, passim.

[2] See Ludwig Hevesi, "Neue Bilderkalender," in: *Kunst und Kunsthandwerk*, vol. 10 (1907), p. 674.

[3] *Austrian Works of Art, Arranged by the Royal Ministry of Education and Public Instruction, Louisiana Purchase Exposition*, St. Louis, 1904, p. 37.

[4] Adolf Schwarz, "Oesterreich auf der Weltausstellung in St. Louis," in: *Neue Freie Presse* (June 6, 1904), p. 2.

[5] Ibid.

[6] Initially, Urban's friend Josef Hoffmann was offered this commission, but he had declared himself unable to proceed when it became apparent that it would be the source of endless disagreement with the committee overseeing the planning of the procession.

[7] The room Urban designed for his daughters in their Vienna residence (1905) was illustrated by Mira Burr Edson, "The Child's Room: A Study of Environment," in: *Arts and Decoration*, vol. 1, no. 8 (June 1911), p. 336; the same illustration was printed in *Studio Year Book of Decorative Art* (1907), p. 215.

[8] Viennese architect and architectural historian Johannes Spalt has informed me

that Urban appears to have married his second wife before he was officially divorced from the first.

[9] A number of these sets remained in use until the mid 1960s.

[10] Crucial for this development was the 1925 *Exposition Internationale des Arts Décoratifs et Industriels Modernes* held in Paris. Charles Richards, director of the American Association of Museums, organized a touring exhibition presenting items from this Parisian "Expo 25" that visited eight cities in the United States.

[11] Alastair Duncan, *American Art Deco*, London: Abrams, 1986, p. 12.

[12] Matthias Boeckl, "Vom Märchenschloss zum Sowjetpalast. Joseph Urbans andere Moderne," in: *Visionäre & Vertriebene. Österreichische Spuren in der modernen amerikanischen Architektur*, ed. by Boeckl, exhibition cat., Kunsthalle Vienna, 1995, p. 73. For more on the Wiener Werkstätte of America, see Leslie Topp's essay in this volume.

[13] "Exhibit of American Designers' Gallery: An Ambitious Program in Art Moderne," in: *Good Furniture Magazine*, vol. 32 (January 1929), pp. 40–45; also Mary Fenton Roberts, "Beauty Combined with Convenience in Some Modernistic Rooms," in: *Arts and Decoration*, vol. 30 (February 1929), pp. 72–73, 112; and *American Designers' Gallery*, exhibition cat., New York, 1928.

14 Some of the room's contents were given to the Cincinnati Art Museum in 1973 by Elaine Wormser Reis.
15 *The Architect and the Industrial Arts,* exhibition cat., New York, Metropolitan Museum of Art, 1929; Shepard Vogelgesang, "Toward a Contemporary Art," in: *Good Furniture Magazine,* vol. 32 (March 1929), pp. 117–128; see also "American Industrial Art Exhibited at the Metropolitan Museum of Art," in: *The American Architect* (March 5, 1929), pp. 318, 321; Blanche Naylor, "Reversion to Primary Design Motifs Exemplified in Metropolitan Museum Contemporary Exhibit," in: *Design,* vol. 31 (November 1929), p. 115; "The Architect and the Industrial Arts" in: *American Magazine of Art,* vol. 20, no. 4 (April 1929), pp. 206–207, 209.
16 Walter Barwig, "Zum 125. Geburtstag Franz Barwig. 1868–1931," typescript, Altmünster, 1975, p. 22.
17 See *Architect of Dreams: The Theatrical Vision of Joseph Urban,* ed. by Arnold Aronson, exhibition cat., New York, Columbia University, Miriam & Ira D. Wallach Art Gallery, 2000, p. 11.
18 Duncan, *America Art Deco* (as note 11), p. 203.
19 *Architectural Forum* (May 1927), p. 416.
20 Edward Alden Jewell, "Designs by Joseph Urban for the Palace of the Soviets to Be Exhibited Today," in: *New York Times* (February 11, 1932), p. 19; "Modern Architecture Comes to Front in Three Simultaneous Events," in: *Art Digest,* vol. 6, no. 10 (February 15, 1932), p. 7.
21 "Urban 'Red Palace' Shown in Benefit," in: *New York Evening Post* (February 12, 1932).
22 "Joseph Urban, Architectural League," in: *Art News,* vol. 30 (February 20, 1932), p. 9.
23 "Urban 'Red Palace'" (as note 21).
24 Hans Adolf Vetter, "Joseph Urban," in: *Profil,* vol. 2, no. 1 (1934), p. 16.
25 When the Dramatic Museum closed in 1971, the Urban Collection was transferred to the university's Rare Book and Manuscript Library.
26 *Visionäre & Vertriebene* (as note 12).
27 *Architect of Dreams* (as note 17), passim.

DAGOBERT PECHE

*** APRIL 3, 1887, ST. MICHAEL IM LUNGAU**
† APRIL 16, 1923, MÖDLING BEI WIEN

JOSEPH·URBAN WISHES TO INTRODUCE IN AMERICA THE MASTER CRAFTWORKS OF THE ARTISTS OF VIENNA AND INVITES YOU TO THE OPENING OF THE WIENER WERKSTÆTTE 581·FIFTH·AVE NEW·YORK·CITY

Invitation to the opening of the Wiener Werkstätte of America, New York, June 1922. Joseph Urban Archive, Columbia University

The Wiener Werkstätte is generally associated with Josef Hoffmann, Koloman Moser, and a style that opposed the embellishment of Franco-Belgian Art Nouveau with the orderliness of geometry. Initially, the group's success was owed to its founders' ability to create utensils that were simple, yet of high quality. In this, the Wiener Werkstätte was inspired by the English Arts and Crafts movement and the high standards of the early nineteenth-century Austrian craft tradition, both of which successfully blended functionality and elegance. Hoffmann and Moser sought to achieve a similar high-quality result, through the deployment of a severe geometrical form. But the "supremacy of the square" did not last long. Nature insinuated itself into the orthogonal grid; flowers and leaves made their presence felt. The development of the Wiener Werkstätte style up to this point is familiar. Until recently, however, what and who determined the character of the group in its latter phase was little known. The answer is Dagobert Peche, whose ideas and designs may be said to have ushered in the first wave of postmodernism, as a counter to the modernism associated with Otto Wagner.

Those who knew him described Peche as slim and pale, a curiously ill-at-ease man, something of a loner, highly accident-prone, and a "grumbler." Peche's biographer, Max Eisler, wrote in his obituary for the artist: "It is curious how the work seemed to be at odds with the man. And yet what both had in common was a refined nervosity."[1] On the other hand, Eisler observed, there were moments when Peche "seemed to be a great, good-hearted, high-spirited lad," whose naiveté and heretical rashness found an outlet in craftsmanship. Anyone who seeks to understand the phenomenon of Dagobert Peche sooner or later will be forced to come to terms with the strong thread of ambivalence and contradiction that runs equally through his personality and his work. In response to the question posed by his fellow student and first reviewer, René Delhorbe—"Who is Peche?"[2]—there appears, in retrospect, to be only one possible answer.

Peche was an anarchist, albeit an unwitting one. The work he produced fit into none of the recognized categories: it defied the notions of stylistic development and functionality; it was made without heed to gender specificity, and discovered in sumptuousness a solace from war. Responding to a report that Peche, during his years in Zürich, had covered all of the fruit of an apple tree in gold leaf, Adolf Loos is said to have accused him, posthumously, of ruining an entire year's crop. Imbued as the modern mentality is with Loos's pragmatism, it is difficult now to see Peche as anything but a master of useless, extravagant bric-a-brac "for the reception rooms of ladies with time on their hands."[3] Nonetheless, objective examination of these curious objects should offer a new way of considering Peche's peculiarly idiosyncratic and bewildering approach to the materials with which he worked. If we join Eisler in accepting that Peche's "applied art" is not socially responsible,[4] then the conventional criteria by which we tend to judge him is rendered obsolete and we become aware of the relevance of other qualities. "We must look [at Peche] in a way that is more responsive to the facts," asserts his biographer, urging critics to take a closer look.

Born on Easter Sunday, 1887, in St. Michael im Lungau, Peche spent his childhood years in Upper Austria, attending the Benedictine high school at Kremsmünster, then a secular school in Salzburg, from which he graduated in 1906. Peche's origins were to persist as an influence in his work throughout his life: in his repertoire (so clearly derived from nature), in his recurring motifs (e.g., his column crafted in exaggerated Baroque), and in his extravagance founded in regional vernacular tradition (the prominent use of gold borders or sequins). Peche's contemporaries also found in his work a "truly Austrian spirit of champagne"[5] linking him with other celebrated sons of the region: "The lightness of Mozart and the joy in decoration of Makart—themselves children of the high-spirited Muse of Salzburg—were present at the birth of this exuberant talent."[6] Peche himself, after leaving Salzburg to study at the Technische Hochschule (Technical College) in Vienna, constantly dreamed of home, wondering: "Is it not possible to find a place in Salzburg where one can dream of Paradise without forgetting the world?"[7]

Although originally he had wanted to be a painter, Peche accepted his father's wish that he train as an architect. He transferred from the Technische Hochschule to the Akademie der bildenden Künste (Academy of Fine Arts), to study in the department of architecture, under Friedrich Ohmann. As the creator of the greenhouse in the Hofburg garden and the Stadtpark's monumental entryway (constructed over the River Wien), Ohmann represented a Romantic and painterly approach to architecture, in contrast to Otto Wagner, who also taught at the academy. Ohmann's style was much more in accord with Peche's gifts, and indeed his entire character, than the rationality of Wagnerian modernism. Peche, however, was not cut out to be an architect. Almost as a form of silent protest, it seems, he remained true, even after completing his architectural studies, to the two-dimensional realm that had so attracted him as a child.[8] Even the one architectural work that he completed was essentially a planar surface:

the courtyard facade for his own apartment, on Neubaugasse in Vienna.

Similarly, a trip to England in 1910 with the Architektenverein (Architects' Union) inspired him to create not architectural designs but a series of drawings that were clearly influenced by Aubrey Beardsley. Though not overly taken with the British artist's delight in shocking a society caught up in outdated ideas of morality, Peche was entranced by the details in many of Beardsley's compositions: the bouquet of flowers as a motif decorating the curtain around a bed; the striped pattern of a sofa covering; the rococo furniture in the illustration to a poem; and more generally, the effect of incisive chiaroscuro, which in his own work Peche softened through the use of a rich gold tone. Apart from its value as a source of motifs, Beardsley's work seems to have given Peche a general thematic impulse: a drawing by Beardsley illustrating one of Lucian's *True Stories* (which Peche presumably read) illustrates the transformation of human bodies into vines; the metamorphosis of women and men into trees and plants later became a central theme for Peche, particularly in his graphic work.

A visit to Paris in 1912 offered further signposts for his future. Ohmann had continuously urged his students not to neglect historical styles, and the applied arts collection in the Louvre gave Peche an opportunity to study them firsthand. Similarly, his exposure to interiors by French designers Louis Süe and Paul Iribe showed him how such styles could be used in a "contemporary" way. Soon after his Parisian experiences, Peche gave three-dimensional form to ideas he had previously expressed only on paper, and produced his first chair as an homage of sorts to the Rococo.

While the connection of Peche's approach to the adaptation of historical styles was invariably apparent, the results were always distinctive. This balance of old and new was achieved through a playful and unconventional, though never disrespectful, attitude toward his models. Central to Peche's work is the disturbance or disruption of established approaches to design, as well as of conventional ways of evaluating the outcome. This is what makes his works so inscrutable but also so exciting. A massive but elegant black cupboard resting on eight dainty feet has four doors opening on two sides, so that the piece can only be placed in the center of a room. Yet the sense of three-dimensionality is almost suppressed through the use of a gold surface pattern. This interplay of opposites pervades Peche's work.

Transformation, then, is a central theme of Peche's work: the transformation of two dimensions into three (and vice versa); of one material into another (wood made to look like cloth; ceramic or paper like sheet metal); of a decorative motif (used small-scale in a print or magnified in wallpaper, carved in wood on a piece of furniture, printed on silk for an evening coat). Daphne—transformed into a laurel tree—was the favorite mythological character of this architect who could not be an architect because architecture demands stability, and transformation signifies movement.

It was only logical, then, that Peche should excel in that most ephemeral of art forms: exhibition installation. After Josef Hoffmann invited him to join the Wiener Werkstätte in 1915, Peche was given

the chance to design the set for a fashion show at the Österreichisches Museum für Kunst und Industrie (predecessor of the Österreichisches Museum für angewandte Kunst). His solution was to transform the pillared central hall into a world of pink and white tulle, surrounded by secret, dark passages, which Eisler described as a "carefree and light-hearted paraphrase of the exhibition's theme: the elegant lady in the winter of 1915." That such extravagance was accepted in the midst of a war was proof, in Eisler's view, that no power on earth could restrain Peche's imagination. "The general state of hardship was felt by the man but not by the artist, who was, as ever, out of step with society. It would be a grave error, though, to mark down this aspect of his character as a defect in his art. For it was merely a manifestation of its independence."[9]

Peche was soon to enjoy independence in a material sense as well. Though he was drafted into the Austro-Hungarian army in 1916, the Wiener Werkstätte intervened on his behalf the next year, freeing Peche from military service so he could head the group's newly opened branch in Zürich. In Switzerland, Peche had dependable funding, a substantial staff, and a shop in the center of town with an interior of his own design. Between 1917 and 1919, he produced a number of elaborate pieces in silver, gold, precious stones, ivory, and mother-of-pearl, all in his own intricate yet seemingly "organic" style. Peche also experimented with inexpensive materials, expanding upon a formal, stereometric principle that had always characterized his work, but had been little noted: thus his sheet-metal vases, cubistic in form, are often wholly free of decoration, enlivened solely by their profile, their proportions, and their interplay of light and shadow. After his return to Vienna at the end of 1919, this stereometric principle was most evident in the furniture he designed for his upper-class clients, journalist Wolko Gartenberg and building contractor Eduard Ast. The formal simplicity of these designs should not, however, be mistaken for a loss of creative excitement, let alone a new concern for functionality. Peche remained true to his belief that everything humanity required for technical mastery of the problems of everyday life was in the province of the engineer. Once these problems had been solved, Peche wrote, "then everyone will have time to indulge their elemental feelings. Just as the lit match falls to the floor, or the dying leaf sinks to the ground," from this point on "every form of decorative art will flourish, too, for utility has been overcome."[10]

CRITICAL AND PUBLIC RESPONSE

Peche was ahead of his time, though; the era's material hardship called for objects that were useful. While the pieces Peche exhibited at the *Wiener Kunstschau 1920* brought him recognition, they also prompted the first negative reactions to his work. The critic at Vienna's *Neue Freie Presse* was outraged at two of his cabinets, which demonstrated, in his opinion, "the most unrestrained tastelessness." The *Wiener Mittag*'s critic felt alienated by the objects' cold intellectualism; to his mind it signaled the end of a still-worthy tradition. As for the infamous cabinets, he denounced them as "an imitation of the art of primitive peoples distilled for a metropolitan audience." Art histori-

an Hans Tietze, on the other hand, praised Peche's style as uniting the spirit of the vernacular with an acute refinement.[11] It was Peche's decorative instinct, lacking in so many other designers, that eventually won over most of his critics. In 1921, he designed a wallpaper collection for the Wiener Werkstätte. Manufactured by Flammersheim & Steinmann of Cologne, the collection sold especially well in Germany. Suddenly, home-decorating magazines were full of sample installations featuring Peche's wallpapers, now deemed appropriate for the "modern" interior. What is so striking about the patterns is their emphatic simplicity—perhaps a reaction to the "disaster" of the 1920 *Kunstschau*.

However, for Peche, simplicity and clarity were options as valid as complexity and extravagance. This attitude meant he was just as comfortable contributing to the exhibition *Einfacher Hausrat* (The Simply Equipped Household, 1920) as he was to *Vornehme Wohnungseinrichtungen* (The Distinguished Domestic Interior, 1921). Toward the end of his life, he sought to reorganize the Wiener Werkstätte along more commercial lines, so it could cater simultaneously to both ends of the market. Together with Philipp Häusler, the business manager of the Wiener Werkstätte, Peche had plans to establish not only a studio for gold- and silversmiths, who would work "in the spirit of the golden age of craftsmanship," but also workshops for the manufacture of cheap reproductions that would cater to simple tastes.

In 1922, Peche assembled a detailed proposal for the restructuring of the Wiener Werkstätte. The name he gave the text, which he never finished, was "Der brennende Dornbusch" (The Burning Bush).[12] Along with his suggestions for reorganization, it contains a number of statements revealing Peche's vision of art, as well as a highly critical appraisal of Hoffmann's work. What would save the Werkstätte, according to Peche, was a collaboration of "head and heart," balancing the coolly calculating mentality of the businessman with the artist's spontaneous joy in the design process. It was as if he were fighting his own tendency to let emotion predominate, a tendency he portrayed in symbolic terms early on, with his "signature": the crowned-heart motif.

Peche died in 1923, two weeks after his thirty-sixth birthday, but not before he was able to see the Wiener Werkstätte celebrate one last dazzling triumph: the opening of the Wiener Werkstätte of America showrooms on Fifth Avenue in Manhattan in the summer of 1922. The idea for this American branch came from architect Joseph Urban, who had emigrated to the United States in 1912 and had already made a name for himself as a set designer in New York. For the craftsmen of his now-sullied homeland, this "ambassador of Austrian art" designed a luxurious showroom and sales outlet, a consummate blend of the refined and occasionally naïve taste of the Wiener Werkstätte with the American "glamour style." Peche's work received a position of special prominence in the early Art Deco interior: his wallpapers were used throughout, his textiles covered every piece of seating, and his lamps, vases, bowls, and pots, his tea and coffee services, his lace and decorative objects, were all strikingly "staged" to produce a stunning effect.

Soon after the showroom's New York opening, the Metropolitan Museum of Art acquired a bird figurine in silver by Peche (of 1920; compare with cat. no. III.58), with further acquisitions soon to follow.[13] One observer, writing for *The International Studio*, saw the piece as an example of the distinctively Viennese ability to merge art and life to achieve a naturalistic effect, even when working in materials guaranteed to appear artificial; he noted too the rigorous way in which the material had been crafted, forced into the shape desired by the artist.[14] In Peche's bird, "dead" material seems transformed into "flesh and blood." Commenting on another silver piece by Peche—a piece of fruit with a branch attached—the same critic observed, "the leaves 'live,'" and "it looks as if the sap were running through their veins"—and he probably did not know of the above-mentioned apple-gilding, which gave Peche perfect study material. These examples demonstrate how Peche achieved a union of art and life on several levels; ultimately, this manifested itself in rather banal fashion, in the fact that his silver fruits were not merely decorative but could be opened and used as boxes.

Even after the closure of its New York branch in 1924, the Wiener Werkstätte maintained a presence, if sporadically, in the United States. In 1928, Macy's department store in New York mounted the *International Exposition of Art in Industry*, with Peche represented by works in wood, silver, and leather; eighteen months later, the *International Exhibition of Contemporary Glass and Rugs* displayed an extraordinarily wide range of Peche's glass designs to audiences not only in New York but in Boston, Philadelphia, Chicago, Saint Louis, Pittsburgh, Cincinnati, and Baltimore.[15] After 1930, however, the Wiener Werkstätte entered a long period of oblivion, and not only on the western side of the Atlantic. Changing attitudes about the function and appearance of utensils coincided with the failure of the workshop as a commercial concern in 1932; in an era of economic depression, the notion of infusing everyday life with art was no longer fashionable. It was not until the late 1970s, with the advent of postmodernism and the renewed search for fantasy in decoration, that the Wiener Werkstätte again began to draw attention, prompting museums and galleries to embark on a new campaign of acquisitions. Today Dagobert Peche is fairly well represented in U.S. collections: his work can be found at the Metropolitan Museum of Art, as well as at the Detroit Institute of Arts, the Art Institute of Chicago, and the Cooper-Hewitt National Design Museum in New York City.

Anne-Katrin Rossberg
Translated from the German by Elizabeth Clegg.

[1] Max Eisler, "Dagobert Peche †," in: *Dekorative Kunst,* vol. 31 (1923), p. 269.
[2] René Delhorbe, "Dagobert Peche," in: *Deutsche Kunst und Dekoration,* vol. 32 (1913), p. 363.
[3] Max Ermers, "Ein toter Künstler: Zur Dagobert-Peche-Gedächtnisausstellung im Österreichischen Museum," in: *Der Tag,* vol. 331 (October 29, 1923), p. 2.
[4] Max Eisler, *Dagobert Peche,* Vienna: Gerlach & Wiedling, 1925; reprint, Stuttgart: Arnoldsche Verlagsanstalt, 1992, p. 9.
[5] Ermers, "Ein toter Künstler" (as note 3), p. 2.
[6] Ibid.
[7] Peche, undated letter to a school friend (private collection).
[8] The Österreichisches Museum für angewandte Kunst owns a number of drawings

Peche made while still in school; these clearly reveal his preoccupation with the two-dimensional as well as his talent for it.
[9] Eisler, *Dagobert Peche* (as note 4), p. 23.
[10] Dagobert Peche, "Der brennende Dornbusch," in: *Die Überwindung der Utilität: Dagobert Peche und die Wiener Werkstätte,* ed. by Peter Noever, exhibition cat., Vienna, Österreichisches Museum für angewandte Kunst, 1998, p. 180.
[11] A.F.S., "Kunstschau 1920," in: *Neue Freie Presse* (July 1920), MAK-WWAN 83/555 (newspaper clipping); A.P., "Oesterreichische Kunstschau: Das Kunstgewerbe," in: *Wiener Mittag* (July 1, 1920), MAK-WWAN 83/379; Hans Tietze, review, in: *Wiener Mittagszeitung* (July 2, 1920), MAK-WWAN 83/376 (all at the Österreichisches Museum für ange-

wandte Kunst, Vienna). Note that here and below, MAK inventory numbers correspond to the "Wiener Werkstätte annals," a collection of press reports.
[12] See Peche, "Der brennende Dornbusch" (as note 10). The manuscript was transcribed by Philipp Häusler in 1961. Both the original and a copy of the transcription are in the collection of the Österreichisches Museum für angewandte Kunst.
[13] See, respectively, Bulletin of the Metropolitan Museum of Art, vol. 18, no. 2 (February 1923), pp. 33–35, and Janis Staggs-Flinchum, "Dagobert Peche," in: *The Magazine Antiques,* vol. 155, no. 1 (January 1999), pp. 188–195.
[14] F.E.W. Freund, "Vienna's Joy Seeks to Live," in: *The International Studio* (November 1922), MAK-WWAN 83/582, pp.

149–152. This was not the first account of Peche to appear in an English-language publication, as *The Studio Year Book of Decorative Art* featured his work on a regular basis from 1914 to 1932.
[15] *An International Exposition of Art in Industry: From May 14 to May 26, 1928, at Macy's,* exhibition cat., New York, Macy's, 1928, pp. 11, 14, 16; *International Exhibition of Contemporary Glass and Rugs,* exhibition cat., New York, Boston, Philadelphia, Chicago, Saint Louis, Pittsburgh, Dayton, Cincinnati, and Baltimore, American Federation of Arts, 1929–30, cat. no. 19; "An International Show," in: *Good Furniture and Decoration,* vol. 33, no. 6 (December 1929), pp. 333–334; and C. Adolph Glassgold, "International Exhibition of Glass and Rugs," in: *Creative Art,* vol. 6, no. 5 (May 1930), pp. 353–354.

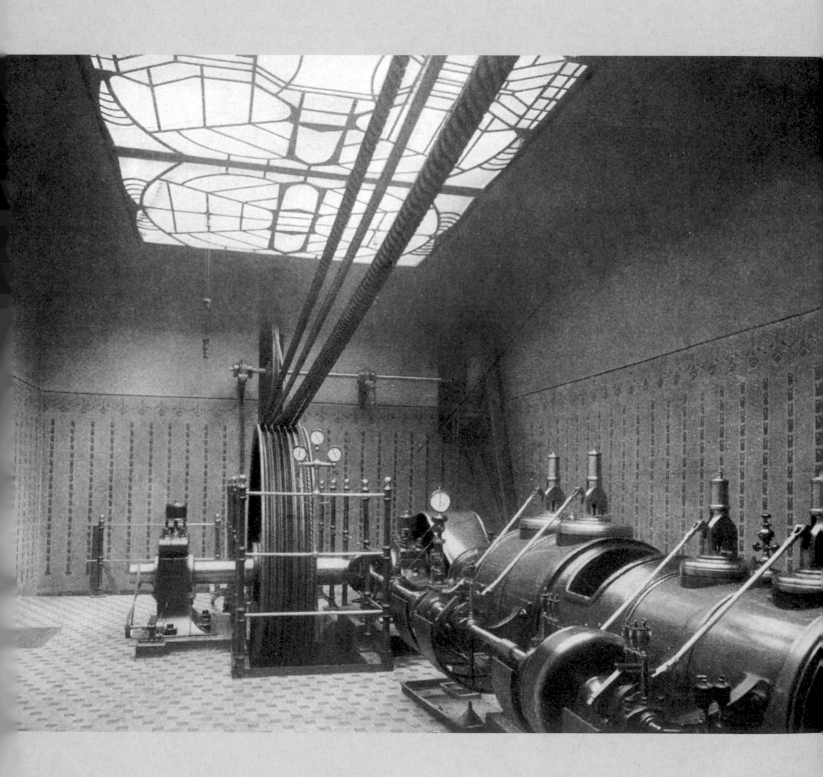

APPLIED ARTS AND ARCHITECTURE IN GERMANY, 1890s–1930s

- **PETER BEHRENS**
- **MARCEL BREUER**
- **LUDWIG MIES VAN DER ROHE**
- **MARIANNE BRANDT**
- **THEODOR BOGLER**
- **WILHELM WAGENFELD**
- **HANS PRZYREMBEL**

Henry van de Velde; Engine room of the Harkort company, Hagen, 1904

egorize, to analyze, and to shape a new pan-Germanic identity became a hallmark of the cultural discourse (Kulturkritik) about modern design and applied arts in the period.

In his "Unser Programm" article, Koch called for the unified German style to be "created by the people, directly tied to the current living situation."[10] Within a decade, this goal was the conscious aim of many German artists, architects, designers, and theorists. In 1907, the Deutscher Werkbund was founded: an organization dedicated to national and international advocacy of design, and to joint ventures between artistic, political, industrial, and economic interests. The Werkbund's founders—among them architect Fritz Schumacher—referred to this mission as "the reconquest of a harmonious culture" that could be expressed in tangible form as a "reformed" style.[11] And it is in this fundamental relationship of style to culture that one of the common bases of German design can be understood.[12] The will (Wollen) for stylistic unity among applied arts and architecture was always tied to the will for cultural unity.

In the late nineteenth century, Friedrich Nietzsche wrote, "Culture is above all unity of artistic style in all the manifestations of the life of a people."[13] By 1900, however, such a unity of artistic style seemed a distant ideal. Artistic forms and motifs from virtually any time or place could be reproduced, using the slew of new technological capabilities that accompanied nineteenth-century industrialization. With all of these influences now at hand, there evolved in Germany a rampant overabundance of new aesthetic expressions, which came to be known collectively under the term "Historicism" (comprising everything from neo-Gothic to neo-Rococo, with many unidentifiable style mixtures between). The panoply of aesthetic approaches was described by one Werkbund leader, the architect Hermann Muthesius, as akin to a "Tower of Babel."[14]

The diversity of styles was tied to a number of positive developments—among them, new technical virtuosity and the opening of borders through international commerce. At the same time, however, this Historicist eclecticism had at least two effects that many German artists and designers saw as profoundly negative: the division of artistic from technical powers in the creation of an object, and the loss of the unified soul and spirit (Geist) that had been an integral part of the preindustrial world of craft production. As Georg Simmel, a major sociologist of the era, put it, "The fact that the entire visual environment of our cultural life has disintegrated into a plurality of styles dissolves that original relationship of Style where subject and object are not yet separated."[15]

THE SOUL OF THE WORK AND INDIVIDUAL EXPRESSION

In the early 1900s, artists, designers, architects, writers, and even politicians in Germany banded together in an effort to rescue the soul and spirit from what they considered to be the destructive domination of materialistic and rationalist values of the nineteenth century. Muthesius described the situation as a degraded state of "mass production, price fixing, false use of the machine, and lack of knowledge by consumers."[16] Through the relocation of spirit and soul, and the redeployment of artistic powers (Kräfte) into technical production, German Reform movement leaders such as Behrens, van de Velde, and Muthesius envisaged the chance to regain the sense of integrated meaning and form that defined culture (in the Nietzschean sense). They hoped thereby to create a unified modern style based on Qualität (quality) of concept and execution.

Muthesius was scheduled to speak at the founding meeting of the Deutscher Werkbund in 1907, but his address was never made; it was decided that his presence at the meeting would engender controversy, following some radical proposals he had made earlier in the year for changes in education for artists and craftsmen. For this undelivered speech, Muthesius wrote: "The fragmentation and confusion that can, for the moment, still be observed in our economic life are only a reflection of the fragmentation of modern life in general. The freedom that the opening of the world has brought to the individual has also ended the tranquil development of mankind. ... To achieve once again this inner harmony of the soul is the most fervent quest of our age."[17]

At root, this was basically a conceptual quest—what Muthesius himself called "an intellectual movement. ... It is the Idea that gives cultures their stamp."[18]

In 1914, young architect Walter Gropius wrote an article titled "Der stilbildende Wert industrieller Bauformen" (The Style-Forming Value of Industrial Building Forms). As his text demonstrates, there was a sense of optimism about this mission to extract a "commonly accepted spiritual ideal" from the "chaos of individual approaches."[19] Focusing on advances in industrial architecture and social planning—including train stations, traffic systems, and commercial and factory buildings—Gropius explained: "The beginnings of a strong and unified will toward culture are unmistakable today. To the degree that the ideas of the time rise above material conditions, the longing for unified form, for a Style, has also been newly awakened in the arts. People recognize once again that the will to form [Wille zur

Richard Riemerschmid, view of Hellerau with ground plan, ca. 1910 (photograph by Gerhard Döring)

Form] is always the true value of the work of art. As long as the spiritual conception of the time hesitates and falters in the absence of a single, firm goal, art will not have the opportunity to develop Style, i.e. the unification of the creative will into a single conception."[20]

In Germany as in Austria, the power of individual expression *(individueller Ausdruck)* became a primary and unifying concern of the era.[21] Beginning at the turn of the century and to an increasing extent right up to the 1920s and '30s—in both the applied arts and architecture—individual expression became evident in the very conception of designs, and in the role of one work on dual levels of function. While a work might have been created for the specific context of an interior or exhibition installation, it was also presented as an autonomous object, usually mass produced, for the consumer market. These two levels of individual expression became a norm in the applied arts, along with a distinct, consistent, and dynamic drive toward "self-realization," shaping objects, interior designs, and architecture.

THE *GESAMTKUNSTWERK,* SELF-REALIZATION, AND AUTONOMY OF DESIGN

This movement toward object-autonomy and *Selbstverwirklichung*, a unity of content, execution, materials, and function, was a natural progression for German Reformist design. The first decades of the century presented a challenging environment in which artists, architects, and designers, as well as theoreticians were searching for forms of integrated expression, in both culture and style. They embraced the tenet of the *Gesamtkunstwerk*—the "integrated" work of art. This basic

notion had derived from earlier traditions—among them, applied-arts exhibitions in the second half of the nineteenth century, Wagnerian opera production, and the more recent developments of the British Arts and Crafts movement. This ready context for "integrated" expression helped to spur the manifestation of the *Gesamtkunstwerk*.[22] In the late 1890s, when Jugendstil emerged as the first major turn-of-the-century modern design genre in Germany, the definition of a *Gesamtkunstwerk* became rather broad. A *Gesamtkunstwerk* could be an entire "integrated" work of architecture—for example, Behrens's house at the artist's colony at Darmstadt (ca. 1901); or an exhibition installation, such as Richard Riemerschmid's design for a music room (1900) at the Exposition Universelle in Paris; or a single object, as in van de Velde's and George Lemmen's book design for Nietzsche's *Thus Spake Zarathustra* (1908).[23]

One of the core ideas that the *Gesamtkunstwerk* brought to the progressive movement was this: an "integrated" work of art could be instrumental in improving day-to-day life, by elevating the quality of objects and surroundings for people at all levels of society. Discussing plans for a garden suburb-development, Osthaus (founder of the Deutsches Museum für Kunst in Handel und Gewerbe and an active Werkbund leader, as well as an important patron of the arts) described his dream of a *Gesamtkunstwerk* on an urban scale. "In the modern Style movement," he wrote, "we seek to create art by producing connections [*Zusammenhänge*] and relationships. The curtain gains new meaning through its relationship to the carpet, the garden through its relationship to the house, the house through its relationship to the street and the city."[24] The most successful garden city *Gesamtkunstwerk* was the colony at Hellerau, near Dresden, initiated by craftsman-businessman Karl Schmidt (founder of the Deutsche Werkstätten für Handwerkskunst). Construction of this urban environment began in 1906–07; its underlying ideal was a complete integration of social, cultural, spiritual, and economic elements with factory and domestic architecture and furnishings.[25]

Despite the fact that many Jugendstil designs were conceived as parts of specific *Gesamtkunstwerke*, individual elements were often made available for production and sale beyond their original context. For example, from Behrens's own house in Darmstadt came the Behrens-designed porcelain (executed by Gebrüder Bauscher in 1900–01), and the ruby-footed glassware (made by Rheinische Glashütte, Cologne-Ehrenfeld, 1901). These designs came to be mass produced and sold in quantity

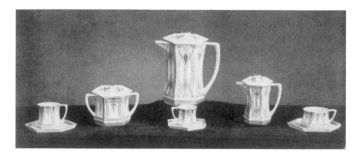

Peter Behrens, group of Darmstadt porcelain, in *Dekorative Kunst* (October 1901)

on the commercial market: functioning as fully independent objects outside the context of their original home interior.[26]

By about 1906, as the Jugendstil movement waned, and as debased, mass-produced variations of work in that style saturated the markets, more controlled collaboration among designers, industry, and commerce was urged by artists and critics as well as by progressive industrial producers and retailers. In 1907—through a plan initiated by Muthesius (not only an architect, but also an enthusiastic government bureaucrat) along with Schmidt and politician Friedrich Naumann—the Deutscher Werkbund was established to foster such collaboration. The organization was intended as a lobby group whose mission was to achieve higher-quality artist-designed products in direct cooperation with industry; to reform education in the arts-and-crafts professions; and to educate consumers in how to identify quality of works for themselves *(Geschmackserziehung)*.

There were several important models for the Werkbund's first goal of successful joint ventures between artist-designers and industry. Among them were Riemerschmid's work with Schmidt's Dresdener Werkstätten für Handwerkskunst (later

Richard Riemerschmid, Maschinenmöbel Einrichtung Nr. I, in Johann Vincent Ciassarz, *Dresdner Hausgerät Preisbuch 1*, Dresden, 1906. Collection Museum der Dinge, Werkbundarchiv, Berlin

the Deutsche Werkstätten) to design suites of modernist *Maschinenmöbel*—a range of high-quality, simply designed furniture intended for serial production and marketed in sales catalogues either as complete interiors or as single pieces.[27] Behrens played a vital role as the chief artistic advisor for the Allgemeine Elektricitäts Gesellschaft (AEG), responsible for industrial products—including clocks, barometers, turbine lamps, and electric kettles—as well as for the factory architecture, print graphics, and company logos.[28] In most cases, Riemerschmid's and Behrens's designs could function on two levels: as one part of a complete artistically devised *Gesamtkunstwerk* concept for factory or workshop, or as an autonomous consumer product. In essence, the process of *Selbstverwirklichung* allowed objects that were derived from individual expression to remain elements

Peter Behrens, AEG Electric Kettles, 1909. Collection Museum der Dinge, Werkbundarchiv, Berlin (photograph by Norbert Meise)

of a coordinated background—a "model environment"—while simultaneously being able to move out of that background to autonomous status. Acceptance, and even encouragement, of this dual role of objects and designs among were the most forward-looking contributions of the German progressive movement before World War I, and provided crucial raw material for design as it is understood today.

THE INTERDEPENDENCE OF FUNCTIONALITY AND AESTHETIC CONCEPT

The legacy of this will for autonomy and *Selbstverwirklichung* in objects, interiors, and architecture matured after World War I and throughout the Weimar period of the 1920s and early '30s to a remarkable and idiosyncratic new level of inventiveness. Individual works—and even complete architectural designs—became free, self-referential, unified entities. Marcel Breuer, in the conception of his *Lattenstuhl* (wood-slat chair; 1922), deconstructed the object down to the "idea" and "function" of a chair, then reconstructed it in simple materials as an abstracted sculptural profile, evoking at once the chair form and the act of sitting in it.[29]

With this new approach, the concept of a design could be fully realized only when that object was actually utilized. For example, in Ludwig Mies van der Rohe's Weissenhof chair (also known as the MR chair; 1927), the design concept is consummated only when the body of a sitter takes its place in the chair, filling out a spatial relationship that is incomplete in the chair's unused state. In Gerhard Marcks's and Wilhelm Wagenfeld's "Sintrax"

Ludwig Mies van der Rohe sitting in Weissenhof chair. Collection of the Chicago Historical Society (photograph by Ray Pearson)

coffee machine (1924 and 1931), the design is complete only when the coffee fills the transparent glass of the vessel. At Mies's Haus Tugendhat in Brno (1928–30), full realization of the unity of the environment occurs when the dwellers of the house become participants, looking out of the glass wall of windows that bring interior and garden into one environment. Ultimately in such works, complete autonomy is achieved only with the interaction between concept and function, and the penetration of user into the object.

THE BAUHAUS

In 1919, the Bauhaus school was founded in Weimar. Under the directorship of Gropius, the school evolved during the 1920s from an initial craft-oriented concept to a program encompassing ideals of rationalism and efficiency in design, and energetically embracing the machine in modern culture.[30] The Bauhaus also provided the name, or *Überbegriff*, that was to become a general defining term for the style of the period. While many of the important objects, interiors, and buildings of the Weimar era were made directly in the Bauhaus context, other classic designs that have come to be associated with the school were actually created independently of it. In a remarkable shift from the uncertainty of collectivizing the genres of the pre–World War I years, the Bauhaus name became and has remained a vital tool in critical analyses of the styles of the era.

During the Bauhaus's short existence in Germany—it lasted only fourteen years, from 1919 until it was dissolved after the National Socialists came to power in 1933—the school was led by three directors and was forced under political pressure to move to three different cities: Weimar, Dessau, and finally Berlin. An atmosphere of dislocation and transition marks the history of the Bauhaus—an environment more turbulent even than the Wilhelminian era, with its cultural and artistic confusion. World War I had brought many changes to Germany, economically, politically, and socially. After the war, the urgent priorities were to rebuild living spaces and to provide basic consumer goods. In response to these needs, Gropius revised his educational program in favor of workshops in which the production of experimental prototypes for industrial manufacture and commercial distribution had precedence.

Many of the most successful Bauhaus-style designs were executed in factory production and distributed internationally. The definition of *individueller Ausdruck* shifted with the changed circumstances of production, sale, and use in the era; the achievement of the universal or essential character in an object became an increasingly important element underlying the concept and the style. Wilhelm Wagenfeld—best known for his Bauhaus designs of the early 1920s, and subsequent independent works into the early 1940s—described this goal in 1931, in an article in the Werkbund publication *Die Form*. His aim, he explained, was to design form "completely divested of its individual, personally determined character … an expression of collective labor and collective achievement."[31] In this notion, the Weimar-era artist was actually following in the pre–World War I footsteps of Behrens, who had claimed in a 1913 lecture that "unified character, not the particular or the peculiar, is the decisive factor."[32]

Advertisement for the "Sintrax" coffee machine. Schott & Gen., Jena, 1932. Collection Stiftung Stadtmuseum Berlin (photograph by Christel Lehmann)

In the scope of German work from the turn of the century to the 1930s, it was always the *nature* and *intention* of the design, the *materials* employed, and the *forms* devised that generated autonomous and unified design concepts. In their reliance on appropriateness and fidelity to materials, and coordination of concept and function,[33] architects and designers of the era were drawing upon ideas that had already been espoused in the nineteenth century, by figures in Germany and Austria (such as Gottfried Semper and Jakob von Falke), by the British Arts and Crafts movement (particularly its leaders John Ruskin and William Morris), and by Americans (including Louis Sullivan,

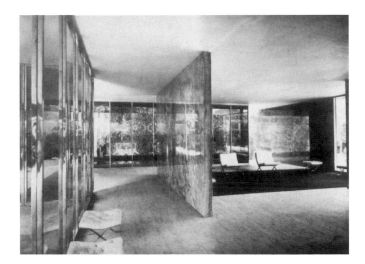

Ludwig Mies van der Rohe, interior view of the German Pavilion, International Exposition, Barcelona, 1929

Gustav Stickley, and Oscar Lovell Triggs).[34] In 1901, Wilhelm von Bode of Berlin, one of the great German museum directors and decorative-arts connoisseurs of the late nineteenth and early twentieth centuries, presciently summarized this central goal. He saw it as a call for works created with "true understanding of the needs of time and place, for the requirements of the materials, for the setting of the artistic forms from the condition of the individual artwork."[35]

Nearly half a century later, in the late 1940s, when former Bauhaus architect-designer Lilly Reich participated in the refounding of the Deutscher Werkbund after World War II, she reiterated a belief in these tenets as the basis of the best design solutions. At their core, she stated, all areas of creative works "are tied to materials, techniques, and use."[36] Thus, from 1900 to mid century, successful progressive design in Germany was continuously rooted in the interplay of these common core elements. The notion of high-quality design—the implication of

the words "Made in Germany"—began with the founding of the Deutscher Werkbund in 1907, and has continued to shape our understanding of the field to this day.

INTERNATIONAL STYLE

By the 1930s, though, the relationship of German design to a specific national culture had been effectively dissolved. Objects and architecture were no longer organically linked to any specific national environment—inevitably, the German style had become part of the "International Style."[37] This development was underscored in 1931 when, in an article in *Die Form*, a critic (identified only as "W.L.") juxtaposed the work of the American Frank Lloyd Wright with Bauhaus Style examples by Le Corbusier, Mies van der Rohe, and others. He said: "Before an artistic creation, whether it be a house by Mies, … a house by Le Corbusier, or a country house by Wright, the question of the [identity of] the architect is purely marginal. … But appearance is indeed not the most important [issue] … is it not false to judge the architecture by its forms or appearance? Is it not more important for the viewer and the critic to attempt to investigate the spiritual content and on that basis to understand the form?"[38]

The confrontation of German designers and architects with the context of their culture and style, and the emergence of autonomous design solutions, which had begun in the late nineteenth century, ultimately brought the German idiom beyond the national sphere. By 1929, Reich's and Mies van der Rohe's designs for the German Exhibition and Pavilion at the Barcelona World's Fair were received with critical acclaim by international circles. Subsequently, some of the same designs were shown at New York's Museum of Modern Art, as hallmarks of the International Style, at the *Modern Architecture: International Exhibition* in 1932.[39]

Within a few years, after the disbanding of the Bauhaus by the National Socialists in 1933, many of the Bauhaus members emigrated to America—Gropius and Breuer to Cambridge; Josef Albers to Black Mountain College in North Carolina; and László Moholy-Nagy and Mies van der Rohe to Chicago.[40] Through the diaspora of German design and design proponents, particularly to the United States, the evolutionary process of defining and shaping relationships between culture, style, and the autonomy of the object and architectural work achieved profound impact and continuing duration outside of Germany. Its legacy remained, intense and eloquent, but by the 1930s it was no longer encapsulated in a purely Germanic language.

1 Alexander Koch, "An die Deutschen Kunstler und Kunstfreunde!—Unser Programm," in: *Deutsche Kunst und Dekoration* (October 1897–March 1898), pp. i–ix.

2 Nikolaus Pevsner, *Pioneers of Modern Design: From William Morris to Walter Gropius,* 3d ed., Harmondsworth: Penguin, 1975 (originally titled *Pioneers of the Modern Movement,* and published by Faber & Faber, 1936).

3 See Julius Posener, *Anfänge des Funktionalismus: Von Arts and Crafts zum Deutschen Werkbund,* Berlin: Ullstein, 1964; or Winfried Nerdinger, ed., *Richard Riemerschmid: Vom Jugendstil zum Werkbund,* Werke und Dokumente, Munich: Prestel, 1982.

4 See Christian Witt-Dörring's essay in this volume for a fuller discussion of this theme.

5 See Karl Ernst Osthaus, "Der Hohenhof," in: *Die Folkwang-Idee des Karl Ernst Osthaus: Der westdeutsche Impuls 1900–1914, Kunst und Umweltgestaltung im Industriegebiet,* exhibition cat., Hagen, Karl Ernst Osthaus-Museum, 1984, pp. 93–102; Alan Windsor, *Peter Behrens: Architect and Designer 1868–1940,* New York: Whitney Library of Design, 1981, pp. 65–68; Alfred Ziffer, ed., *Bruno Paul: Deutsche Raumkunst und Architektur zwischen Jugendstil und Moderne,* exhibition cat., Munich: Klinkhardt & Biermann, 1992, pp. 188–189.

6 The idea of *Qualitätsarbeit* was commonly propagated by the Werkbund, from the founding treatise, "Bericht der Geschäftsstelle des Deutschen Werkbundes über die Gründungsversammlung am 5. und 6. Oktober 1907 zu München im Hotel Vier Jahreszeiten (Nach dem unkorigierten Stenogramme)," in the Document Collection of the Deutscher Werkbund, Werkbundarchiv, Museum der Dinge, Berlin. This is discussed in depth in Theodor Heuss, *Was ist Qualität? Zur Geschichte und Aufgabe des Deutschen Werkbundes,* Tübingen: N.p., 1951.

7 A multitude of studies on the Bauhaus could be cited. Several that provide a glimpse into the breadth that the concept of "Bauhaus style" has come to connote are: Elaine S. Hochman, *Bauhaus: Crucible of Modernism,* New York: Fromm International, 1997; Jeannine Fiedler and Peter Feierabend, eds., *Bauhaus,* Cologne: Könemann, 1999; and Torsten Bröhan and Thomas Berg, *Avantgarde Design 1880–1930,* Cologne: Taschen, 1994.

8 The notions of "style" and "name" here are taken out of today's jargon and refer to the then-contemporary idea of style as discussed below, and based on what has been called "social and programmatic concerns." See Bernard Tschumi, Preface, in: *The International Style: Exhibition 15 and The Museum of Modern Art,* exhibition cat., New York: Rizzoli and Columbia Books of Architecture, 1992, p. 7.

9 This is known as "cultural despair"; the standard reference on this subject is Fritz Stern, *The Politics of Cultural Despair: A Study in the Rise of the Germanic Ideology,* Berkeley: University of California Press, 1961.

10 See Koch, "An die Deutschen Kunstler" (as note 1), p. iv: "Was wir wollen, bringt der vorstehend abgedruckte 'Aufruf' zum Ausdruck: *die Förderung einer mitten im Leben stehenden, vom Volke getragenen, gesunden deutschen Kunst.*" For a more recent discussion of this topic and of the contribution of the efforts to achieve a framework in which to define and articulate a national design policy in Germany, see Laurie A. Stein, "German Design and National Identity, 1890–1914," in: *Designing Modernity: The Arts of Reform and Persuasion, 1885–1945,* exhibition cat., Miami, The Wolfsonian, 1995, pp. 49–77.

11 This phrase was used by Fritz Schumacher in his address at the founding meeting of the Deutscher Werkbund. He took the place of Hermann Muthesius as the keynote speaker. The notes for his speech can be found in copy form at the Document Collection of the Deutscher Werkbund, Werkbund-Archiv, Museum der Dinge, Berlin; or in Schumacher, "Die Wiedereroberung harmonischer Kultur," in: *Der Kunstwart,* vol. 21 (1908), pp. 135–138. For a wider discussion of the Werkbund and the notion of harmonious culture, see Joan Campbell, *The German Werkbund: The Politics of Reform in the Applied Arts,* Princeton: Princeton University Press, 1976, pp. 9–56.

12 Two excellent studies on this topic, and to which much of the information here is indebted, are Frederic J. Schwartz, *The Werkbund: Design Theory & Mass Culture Before the First World War,* New Haven: Yale University Press, 1996, and idem, "Cathedrals and Shoes: Concepts of Style in Wölfflin and Adorno," in: *New German Critique,* vol. 76 (Winter 1999), pp. 3–48.

13 Friedrich Nietzsche, "On the Uses and Disadvantages of History for Life," in: *Untimely Meditations,* transl. by R. J. Hollingdale, Cambridge: Cambridge University Press, 1983, quoted in: Schwartz, *The Werkbund* (as note 12), p. 23.

14 Hermann Muthesius, "Architektur und Publikum," in: *Die neue Rundschau,* vol. 18 (1907), p. 207.

15 Georg Simmel, *Philosophie des Geldes,* 2d ed., Leipzig: Duncker & Humblot, 1900, quoted in: Schwartz, *The Werkbund* (as note 12), p. 20.

16 Muthesius, "Unbenutzter Werkbundaufruf," Document Collection of the Deutscher Werkbund, Werkbund-Archiv, Museum der Dinge, Berlin, n.p.

17 Ibid., transl. in: Schwartz, *The Werkbund* (as note 12), p. 15.

18 Muthesius, "Die nationale Bedeutung der kunstgewerbliche Bewegung," in: *Kunstgewerbe und Architektur,* Jena: Diederichs, 1907, p. 125, transl. in: Schwartz, *The Werkbund* (as note 12), p. 21.

19 Walter Gropius, "Der stilbildende Wert industrieller Bauformen," in: *Deutscher Werkbund Jahrbuch,* vol. 3 (1914), p. 29.

20 Ibid., transl. in: Schwartz, *The Werkbund* (as note 12), pp. 23–24.

21 See Witt-Dörring's essay in this volume for further treatment of this issue.

22 See Stein, "German Design" (as note 10), p. 50, for additional discussion of the German idea of *Gesamtkunstwerk.*

23 On Behrens's house, see Tilmann Buddenseig, "Das Wohnhaus als Kultbau: Zum Darmstädter Haus von Behrens," in: *Peter Behrens und Nürnberg, Geschmackswandel in Deutschland, Historismus, Jugendstil und die Anfänge der Industriereform,* exhibition cat., Munich: Prestel, 1980, pp. 37–47; for Riemerschmid's music room, see Sonja Günther, *Interieurs um 1900: Bernhard Pankok, Bruno Paul und Richard Riemerschmid als Mitarbeiter der Vereinigten Werkstätten für Kunst im Handwerk,* Munich: Fink, 1971; see Stein, "German Design" (as note 10), pp. 54–58, for discussion of the Behrens house and the van de Velde–Lemmen book design as *Gesamtkunstwerke.*

24 Karl Ernst Osthaus, "Die Gartenvorstadt an der Donnerkuhle," in: *Deutscher Werkbund Jahrbuch,* vol. 1 (1912), p. 93, quoted in: Schwartz, *The Werkbund* (as note 12), pp. 24–25.

25 Stein, "German Design" (as note 10), pp. 67–68.

26 Museum Künstler-Kolonie, Darmstadt, 1990; also, Laurie A. Stein's essays on glass, metalwork, and ceramics during the Werkbund era, in: *Das Schöne und der Alltag: Die Anfänge modernen Designs 1900–1914,* ed. by Michael Fehr et al., exhibition cat., Krefeld, Kaiser Wilhelm Museum; and Hagen, Karl Ernst Osthaus-Museum, 1997, pp. 86–163.

27 See Klaus-Peter Arnold, *Vom Sofakissen zum Städtebau: Die Geschichte der Deutschen Werkstätten und der Gartenstadt Hellerau,* Dresden: Verlag der Kunst, 1993.

28 Tilmann Buddensieg in collaboration with Henning Rogge, *Industriekultur: Peter Behrens und die AEG, 1907–1914,* exhibition cat., Berlin: Mann, 1979; Schwartz, *The Werkbund* (as note 12), pp. 127–144.

29 On Breuer, see Magdalena Droste, Manfred Ludewig, and Bauhaus-Archiv, *Marcel Breuer Design,* exhibition cat., Berlin and Cologne: Bauhaus-Archiv and Benedikt Taschen, 1992; Christopher Wilk, *Marcel Breuer: Furniture and Designs,* exhibition cat., New York: Museum of Modern Art, 1981.

30 For a good overview of the Bauhaus, see Magdalena Droste and Bauhaus-Archiv, *Bauhaus 1919–1933,* Berlin and Cologne: Bauhaus-Archiv and Benedikt Taschen, 1998.

31 Wilhelm Wagenfeld, "Jenaer Glas," in: *Die Form,* vol. 6 (1931).

32 Peter Behrens, "Über den Zusammenhang des baukünstlerischen Schaffens mit der Technik," in: *Kongress für Äesthetik und allgemeine Kunstwissenschaft,* Berlin 1.–9. Oktober 1913, Stuttgart: Ferdinand Enke, 1914, p. 252, quoted in: Schwartz, "Cathedrals and Shoes" (as note 12), p. 13.

33 In 1910, Behrens had characterized this propensity as "a struggle with function, raw material, and technique." Behrens, "Kunst und Technik," a lecture given to the Verband Deutscher Elektrotechniker, May 26, 1910, quoted in: Schwartz, *The Werkbund* (as note 12), p. 21.

34 Among the vast literature available on the subject, see, for example Jakob von Falke, *Die Kunst im Hause: Geschichtliche und kritisch-ästhetische Studien über die Decoration und Ausstattung der Wohnung,* Vienna: Gerold, 1877; Gottfried Semper, *Kleine Schriften,* ed. by Hans and Manfred Semper, Berlin: Spemann, 1884; Barbara Mundt, *Historismus: Kunsthandwerk und Industrie im Zeitalter der Weltausstellungen,* Berlin: Staatliche Museen Preussischer Kulturbesitz, 1973; Linda Parry, ed., *William Morris,* exhibition cat., London, The Victoria and Albert Museum, 1996; Leslie Greene Bowman, *American Arts and Crafts: Virtue in Design,* exhibition cat., Los Angeles County Museum of Art, 1990; Oscar Lovell Triggs, *Chapters in the History of the Arts and Crafts Movement,* Chicago: The Bohemia Guild of the Industrial Art League, 1902.

35 Wilhelm von Bode, *Kunst und Kunstgewerbe am Ende des neunzehnten Jahrhunderts,* Berlin: Cassirer, 1901, quoted in an extremely interesting and informative essay by Susanne Netzer, "'Am Ende des Neunzehnten Jahrhunderts': Bode und das Kunstgewerbe," in: *Wilhelm von Bode als Zeitgenosse der Kunst: Zum 150. Geburtstag,* exhibition cat., Berlin, Nationalgalerie, Staatliche Museen, 1995–96, p. 103.

36 Lilly Reich, "On the Reconstruction of Schools," unpublished manuscript, April 2, 1946, quoted in: Matilda McQuaid, *Lilly Reich: Designer and Architect,* exhibition cat., New York: Museum of Modern Art, 1996, p. 43.

37 See, for example, Terence Riley, *The International Style* (as note 8).

38 W.L., "Unter der Lupe: Frank Lloyd Wright und die Kritik," in: *Die Form,* vol. 6, no. 7 (September 15, 1931), p. 358.

39 See Riley, *The International Style* (as note 37).

40 An insightful discussion of the relationship of the Bauhaus émigrés to American museums and institutions can be found in Vivian Endicott Barnett, "Banned German Art: Reception and Institutional Support of Modern German Art in the United States, 1933–45," in *Exiles and Émigrés: The Flight of European Artists from Hitler,* ed. by Stephanie Barron and Sabine Eckmann, exhibition cat., Los Angeles County Museum of Art; and Berlin, Neue Nationalgalerie, Staatliche Museen, 1997–98, pp. 273–284.

Alternating-current table fan, 1908 cat. IV.1

Electric wall clock with synchronous motor, ca. 1910 cat. IV.2

ti 114 Man's wardrobe, 1927 (closed) cat. IV.4

ti 114 Man's wardrobe, 1927 (opened) cat. IV.4

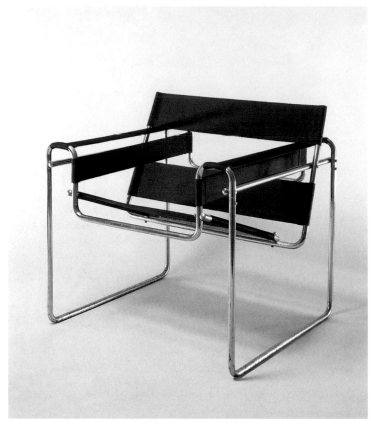

B3 ("Wassily") chair, 1925 cat. IV.3

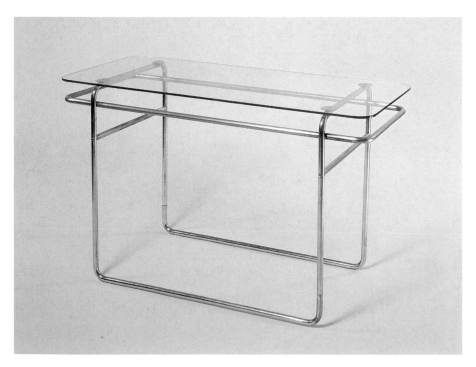

Table, predecessor of B19 cat. IV.5

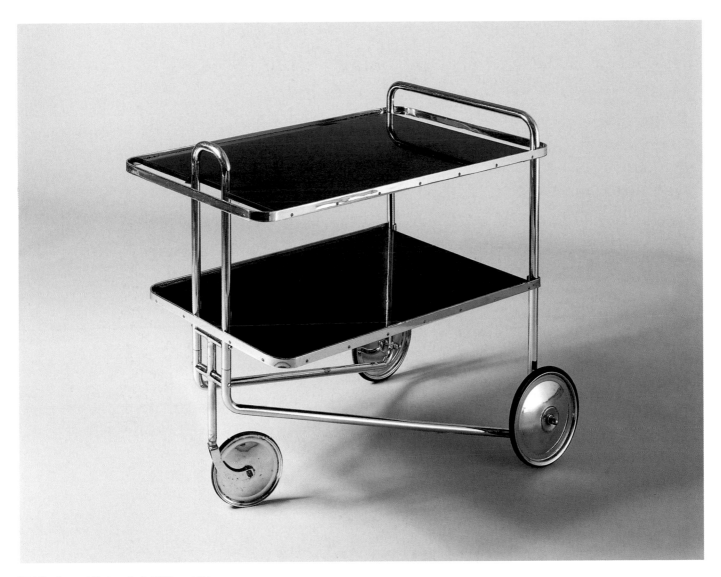

B54 Serving cart (first version), 1928 cat. IV.6

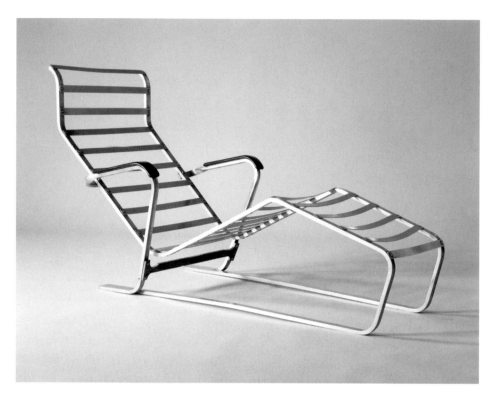

Chaise longue, 1932 cat. IV.8

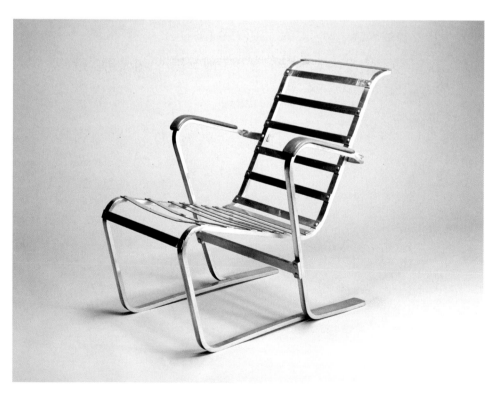

Armchair, 1932 cat. IV.9

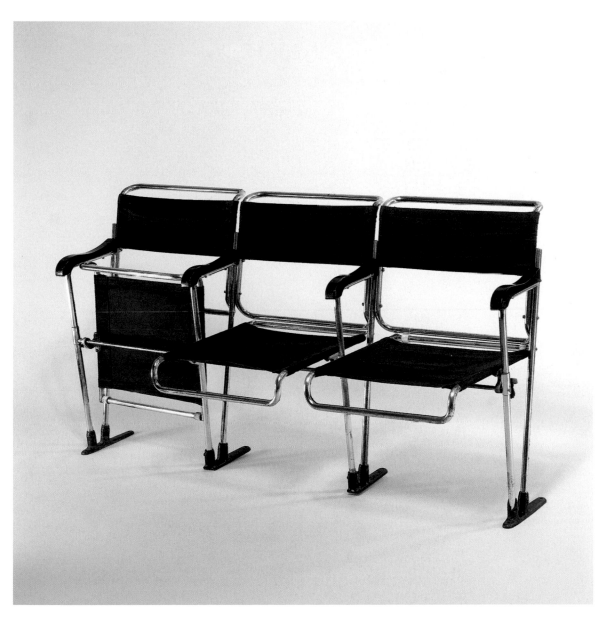

Row seating with fold-up seats, adaptation of B1 theater chair, 1930 cat. IV.7

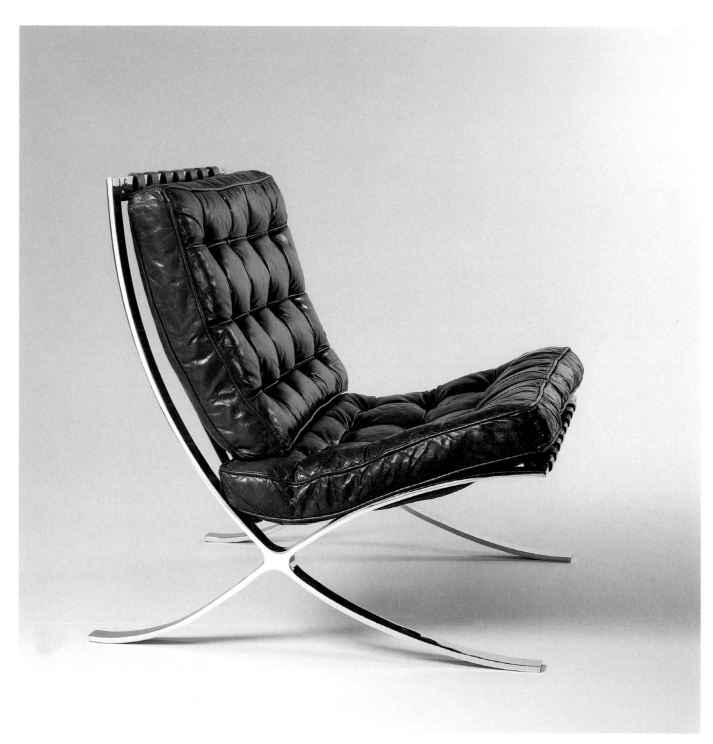

"Barcelona" chair, 1928 cat. IV.11

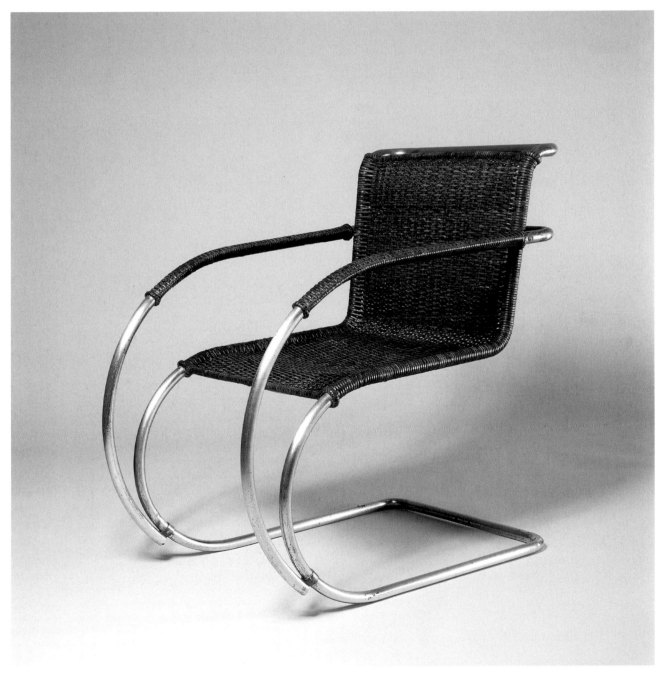

Armchair from the apartment of Philip Johnson in New York, 1927 cat. IV.10

Dining room table for the apartment of Philip Johnson in New York, 1930 cat. IV.12

Creamer (part of coffee and tea service), 1924 cat. IV.13

Ashtray, 1924 cat. IV.14

Lamp for bedside table or wall (type 39), 1926–30 cat. IV.16

Stand with burner for teapot, 1929–30 cat. IV.18

Table lamp, 1923–24 cat. IV.15

"Sintrax" coffee percolator, 1931 cat. IV.20

Pieces from tea service, 1931 cat. IV.19

Tea caddy, 1927–29 cat. IV.17

Tea caddy, 1926 cat. IV.21

Combination teapot from the estate of Theodor Bogler, 1923 cat. IV.22

Teapot, 1925–26 cat. IV.23

CHECKLIST: APPLIED ARTS AND ARCHITECTURE IN GERMANY

Laurie A. Stein

Please see Bibliography for cited literature.

PETER BEHRENS

IV.1
Alternating-current table fan
Design: Peter Behrens, 1908, Berlin
Execution: AEG, model no. P.L.Nr.
66311 WB1 (35-watt)
Cast iron, painted green with tombac
strip; sheet brass
H. 29 × Diam. 27 cm (11.6 × 10.8 in.)
Marks: 71552 u. 6 (stamped on base),
Marke: Nr. 739969 / VOLT 110/120 /
AMP 50~ (brass label)
Ill. p. 524

Private collection, New York

Literature:
Buddensieg, pp. D 156, P 42.

When architect-designer Peter
Behrens was named artistic director at
Allgemeine Elektricitäts Gesellschaft
(AEG) in 1907, it was heralded as a
model for the union of art and industry
promoted by the Deutscher Werkbund.
At this Werkbund-member firm,
Behrens was responsible for the design
of advertising graphic programs, factory
buildings, products such as electric ket-
tles, barometers, arc lamps, and the
synchronous wall clock (1910; cat. no.
IV.2) and table fan (1908). The ideal of
Gesamtkunstwerk and serial production
of artistic design was extended through
Behrens's activities to include even the
company's corporate identity. The uni-
fied form-language of Behrens's de-
signs made them easily identifiable as
AEG products, while their fusion of
functionalism and aesthetic quality
made them a commercial success—the
precursors of modern industrial design
as we know it today.
Behrens explained that the starting
point in his work for AEG was the idea
that "the same factors that determine
architecture also hold for the smaller
objects manufactured by industry."[1] In-
deed, by reducing the design to a set of
lucid formal relationships, with clear de-
lineation of planes and surfaces, he
conceived architectonic formulas for
objects suitable for machine execution
and mass production. Most of his de-
signs were offered in a range of closely
related variations. For example, table
fans were devised for pivoting stands or
wall mounts, direct, alternating, or
three-phase current, and in at least four
different motor types. In all variations,
the open metalwork housings and the
mechanical parts combined in a re-

markable layering of design elements
and functional necessities.

[1] *Berlin 1900–1933: Architecture and De-
sign,* ed. by Tilmann Buddensieg, exhibition
cat., New York, Cooper-Hewitt Museum,
1987, p. 152.

IV.2
**Electric wall clock with synchro-
nous motor**
Design: Peter Behrens, ca. 1910, Berlin
Execution: AEG ca. 1920, model no.
AFU Nr. 155662
Sheet metal and sheet brass, glass
H. 10.7 × Diam. 32.5 cm (4.3 × 13 in.)
Marks: AEG (on dial), Type:
AFU/181/250V, N°: 155662/A
50/290426 (on back)
Ill. p. 525

Private collection, New York

Literature:
Buddensieg, pp. D 182, P 105.

MARCEL BREUER

IV.3
B3 ("Wassily") chair
Design: Marcel Breuer, 1925, Dessau
Execution: Standard-Möbel Lengyel &
Co., 1927, Berlin
Nickel-plated tubular steel; black *Eisen-
garn* fabric (replaced)
H. 73.5 × W. 75.5 × D. 67.5 cm
(29.4 × 30.2 × 27 in.)
Ill. p. 528

Private collection, New York

Literature:
Droste and Ludewig, p. 62, fig. 12d.
Christopher Wilk, *Marcel Breuer:
Furniture and Interiors,* New York:
Museum of Modern Art, 1981, p. 83.

In 1924, Breuer described his approach
to chair design, writing: "A chair, for ex-
ample, should not be horizontal/vertical,
nor should it be expressionist, nor con-
structivist, nor designed purely for ex-
pediency, nor made to 'match' a table; it
should be a good chair, and as such it
will match a good table."[1] Within a year,
the designer had extended his theoreti-
cal approach in a radical new direction
with a chair design he called the "steel
club armchair," known today as the
"Wassily" or B3 chair. Combining indus-
trially manufactured nickel-plated tubu-
lar steel (light, durable, and readily

available) and *Eisengarn* upholstery (a
stiff, shiny cotton yarn treated with wax
and paraffin and used as the warp yarn
in twill-weave fabrics developed at the
Bauhaus around 1926), the design
grew out of Breuer's intensive experi-
mentation with the possibilities of metal
as a material for furniture, and from his
interest in devising products for indus-
trial execution and commercial sale. In
early examples of the chair, the tubular
steel parts were welded together, but
when production began at Standard-
Möbel Lengyel & Co., co-founded by
Breuer in 1926–27, welding was dis-
carded for bolt construction to allow for
easier packaging, distribution, and as-
sembly. After 1928, when Thonet took
over the firm, the same international
distribution network and commercial
export structures that had been devel-
oped for their bentwood production
were used to market the Breuer design
worldwide.
Yet it was less these pragmatic consid-
erations than the interplay of form, ma-
terial, and transparency of space—what
artist George Grosz derisively termed
the "technical romanticism"[2] of Breuer—
that made this chair an icon of Bauhaus
modernism. The design took shape
amid an atmosphere of tension and
changing attitudes toward art, craft, and
industrial production at the Bauhaus.
Exhibited first in 1926 in an exhibition
of Breuer's work at the Kunsthalle
Dessau, and later that same year at the
newly opened Gropius-designed school
building in that same city, in Bauhaus
publications the design was referred to
simply and tellingly as "the abstract
chair."[3]

[1] Marcel Breuer, "Form Funktion," in: *Junge
Menschen,* vol. 5, no. 8 (1924), p. 191. Cited
in: Magdalena Droste and Manfred Ludewig,
Marcel Breuer: Design, Cologne: Taschen,
1992, pp. 12–13.
[2] George Grosz and Wieland Herzfelde, *Die
Kunst ist in Gefahr,* Berlin: Malik, 1925, p. 12.
[3] List of Photographs for the *Leipziger Illustrier-
te Zeitung,* GN 3/107, Bauhaus-Archiv Berlin.

IV.4
ti 114 Man's wardrobe
Design: Marcel Breuer, 1927, Berlin
Execution: Möbelwerkstätte Bauhaus,
Dessau
Cherry veneer over wood-core plywood,
wood painted black
H. 175 × W. 180 × D. 60 cm
(70 × 72 × 24 in.)
Ill. p. 526/527

Private collection, New York

Literature:
Droste and Ludewig, pp. 82ff.

IV.5
Table, predecessor of B19
Design: Marcel Breuer, 1927, Berlin
Execution: Thonet, Frankenberg
Nickel-plated tubular steel; glass,
rubber
H. 73 × L. 120 × W. 50 cm
(29.2 × 48 × 20 in.)
Ill. p. 528

Private collection, New York

Literature:
Christopher Wilk, *Marcel Breuer:
Furniture and Interiors,* New York:
Museum of Modern Art, 1981, p. 78,
fig. 73.

IV.6
B54 Serving cart (first version)
Design: Marcel Breuer, 1928, Berlin
Execution: Thonet, Frankenberg
Nickel-plated tubular steel, wood-core
plywood painted black, rubber wheels
H. 77.5 × L. 88 × W. 46.5 cm (31 ×
35.2 × 18.6 in.)
Ill. p. 529

Collection of Neue Galerie New York

Literature:
Droste and Ludewig, pp. 100ff.
Christopher Wilk, *Marcel Breuer:
Furniture and Interiors,* New York:
Museum of Modern Art, 1981, p. 83.

The B54 Serving Cart embodies the
emergence of objects from the back-
ground of culture in the 1920s and
'30s, as furniture moved away from its
traditional role as static background to
a state of autonomous and active inter-
action with its surroundings. The tubu-
lar-steel design references ship prows
and old-fashioned three-wheeled bicy-
cles, with the aspect of mobility brought
into the visual plane through its shape
and its sleek mechanistic imagery.[1]
Multifunctional and suited to the effi-
ciency of modern lifestyles, the serving
cart could not only serve as a standing
buffet, but also traverse space (from
kitchen to dining room to living room)
and even be deconstructed by the user
so the tray could be used separately.
The first version of the serving cart, pic-
tured here, was made with spoked
wheels; later versions used solid rubber.

[1] Christopher Wilk, *Marcel Breuer: Furniture and Interiors*, New York: Museum of Modern Art, 1981, p. 83.

IV.7
Row seating with fold-up seats, adaptation of B1 theater chair
Design: Marcel Breuer, 1930, Berlin
Execution: Thonet, 1930–31, Frankenberg
Chrome-plated tubular steel, cast iron painted black, beechwood painted black, white rubber, *Eisengarn* fabric (replaced)
H. 89.2 × L. 174.5 × D. 60.4 cm (35.7 × 69.8 × 24.2 in.)
Ill. p. 531

Private collection, New York

Literature:
Droste and Ludewig, pp. 60ff.
Christopher Wilk, *Marcel Breuer: Furniture and Interiors*, New York: Museum of Modern Art, 1981, p. 42.

In these theater seats, Breuer's basic language of form, developed initially for a single chair, has been fused to a new conception for endless repetition as integrated rows of folding seats. In a visually expressive manner, the simplicity, functionalism, and formal rhythm of the design highlight the Bauhaus tendency toward the democratization of objects. With far-sighted pragmatism, this row seating fulfilled the Bauhaus principles of cooperation with industry and the creation of designs suited to serial mass production. It could be made to order for an infinite variety of public spaces and mass settings—inexpensive to produce and ship, easy to install, efficient in its use of space, modern in its aesthetics, and, quite simply, comfortable to sit in. Breuer's first design for this type of seating was used in the auditorium of the Bauhaus Dessau in 1926. The version at the Neue Galerie was shown at the 1931 *Bauausstellung* (Building Exhibition) in Berlin.

IV.8
Chaise longue
Design: Marcel Breuer, 1932, Zürich
Execution: Embru for Wohnbedarf, 1934, Switzerland
Aluminum, mahogany, original cushion with jacquard-weave cover
H. 75 × W. 60 × D. 136.5 cm (30 × 24 × 54.6 in.)
Ill. p. 530

Neue Galerie New York

Literature:
Droste and Ludewig, p. 119, fig. 50.
Christopher Wilk, *Marcel Breuer: Furniture and Interiors*, New York: Museum of Modern Art, 1981, p. 125.

IV.9
Armchair
Design: Marcel Breuer, 1932, Zürich
Execution: Embru for Wohnbedarf, 1934, Switzerland
Aluminum, birch
H. 72 × W. 58 × D. 85.3 cm (28.8 × 23.2 × 34.1 in.)
Ill. p. 530

Private collection, New York

Literature:
Droste and Ludewig, pp. 122–123.
Christopher Wilk, *Marcel Breuer: Furniture and Interiors*, New York: Museum of Modern Art, 1981, p. 122.

LUDWIG MIES VAN DER ROHE

IV.10
Armchair from the apartment of Philip Johnson in New York
Design: Ludwig Mies van der Rohe, 1927, Berlin
Execution: Berliner Metallgewerke Joseph Müller, 1930, Berlin
Nickel-plated tubular steel, caning (formerly stained black)
H. 82 × W. 55 × D. 84 cm (32.8 × 22 × 33.6 in.)
Ill. p. 533

Private collection, New York

Literature:
Ludwig Glaeser, *Ludwig Mies van der Rohe: Furniture and Furniture Drawings from the Design Collection and the Mies van der Rohe Archive*, New York: Museum of Modern Art, 1977, pp. 22ff. *Mies van der Rohe: Architecture and Design in Stuttgart, Barcelona, Brno*, exhibition cat., Weil am Rhein, Vitra Design Museum, 1998, pp. 80ff.

Many of the designs we associate with the Bauhaus were actually created apart from the school. This tubular-steel cantilevered, or *Freischwinger*, chair, for example, was conceived by Mies van der Rohe around 1927 before he was a member of the Bauhaus. Introduced in the exhibition *Die Wohnung* (The Home, organized by the Deutscher Werkbund in Stuttgart), this design was also known as the "Weissenhof Chair," after the housing development built for the exhibition. If we compare it to a number of other tubular-steel and cantilevered designs by Marcel Breuer, Mart Stam, and Josef Albers from the same period, we see they all share a focus on new modes of expression in function, form, and materials. Viewed as a group, it is also apparent that these designs make conscious (and perhaps competitive) reference to one another. But Mies's design, more expressively than any other of the period, evokes its purpose through its form: looking at it, one sees the lines of the chair's construction and, at the same time, the relationship of the sitter to the form; the arms follow the curve of the legs, as if a sitter were placing his hands on his knees. When a person is seated in it, the interrelationship between the human body and the chair's form bring completion to the concept, and the full autonomy of the design becomes evident. The armchair here was owned by Philip Johnson, and was used as part of Mies's interior design for his New York apartment in 1930.

IV.11
"Barcelona" chair
Design: Ludwig Mies van der Rohe, 1928, Berlin
Execution: Bamberg Metallwerkstätten, 1931, Berlin, model no. MR 90
Flat steel, chrome-plated; leather
H. 75.5 × W. 74.8 × D. 75.5 cm (30.2 × 29.9 × 30.2 in.)
Ill. p. 532

Private collection, New York

Literature:
Ludwig Glaeser, *Ludwig Mies van der Rohe: Furniture and Furniture Drawings from the Design Collection and the Mies van der Rohe Archive*, New York: Museum of Modern Art, 1977, pp. 46ff. *Mies van der Rohe: Architecture and Design in Stuttgart, Barcelona, Brno*, exhibition cat., Weil am Rhein, Vitra Design Museum, 1998, pp. 87ff.

This design, a radical and idiosyncratic reinterpretation of classic scissor-form chairs, was developed by Mies van der Rohe as part of a Deutscher Werkbund commission for the German Pavilion of the 1929 International Exposition in Barcelona. In keeping with the restrained modernist elegance of the pavilion, the design for this chair and its companion stool were conceived with expensive, luxurious materials and labor-intensive construction. The Barcelona chairs were apparently made by the Berlin firm Joseph Müller, but soon after, the Bamberg Metallwerkstätten took over production, introducing modifications to make the design more commercially viable. Manufactured continuously by a variety of firms since the 1930s, the Barcelona chair has become a metaphor for the high quality and innovative conception of late-Weimar German design, symbolizing the emergence of design from the constraints of national culture toward International Style.

IV.12
Dining room table for the apartment of Philip Johnson in New York
Design: Ludwig Mies van der Rohe and Lilly Reich, 1930, Berlin
Execution: Richard Fahnkow (?), Berlin
Rosewood veneer
H. 74 × L. 180 × W. 80 cm (29.6 × 72 × 32 in.)
Ill. p. 534

Private collection, New York

Literature:
Architectural Forum, vol. 79, no. 6 (1943), pp. 90ff.
Hillary Lewis and John O'Connor, *Philip Johnson: The Architect in His Own Words*, New York: Rizzoli, 1994, pp. 20ff.
George Nelson, *Living Spaces*, New York: Whitney Publications, 1952, p. 118.
Schulze, 1985, p. 178.

Mies van der Rohe's first commission in the U.S. was for the interior of architect Philip Johnson's apartment. At the time, Mies was director of the Bauhaus in Dessau, having earned international renown with his designs for the architecture and interiors of the German Pavilion at Barcelona in 1929 and the Villa Tugendhat in Brno in 1928–30. Johnson traveled extensively in Germany during this period and was knowledgeable about the work of the Bauhaus and other modern trends in European architecture and design. This table was conceived by Mies together with Lilly Reich. Working from Germany, they relied on floor plans and detailed elevations to devise a *Gesamtkunstwerk*, or complete interior, for Johnson's New York apartment, from the wall colors to the curtain rods to the tubular-steel and rosewood furniture. The elegance of rosewood as a material is emphasized by the smoothed flatness of the table's surfaces. Through the reduction of the overall design to a stark geometric profile, the piece itself embodies the formal longings of design at that time, serving as a framing device for the contrasts between negative and positive forms and interior and exterior volumes.

MARIANNE BRANDT

IV.13
Creamer (part of coffee and tea service)
Design: Marianne Brandt, 1924, Weimar
Execution: Metallwerkstätte Bauhaus Weimar, model no. MT 50-55
Silver, ebony
H. 13.5 cm (5.4 in.)
Ill. p. 535

Private collection, New York

Literature:
Die Metallwerkstatt am Bauhaus, exhibition cat., 1992, p. 142, cat. nos. 44, 41.

IV.14
Ashtray

Design: Marianne Brandt, 1924, Weimar
Execution: Metallwerkstätte Bauhaus Weimar, model no. MT 36
Brass, partially nickel-plated
H. 6 × Diam. 11 cm (2.4 × 4.4 in.)
Marks: "BAUHAUS"
Ill. p. 535

Private collection, New York

Literature:
Walter Gropius, *Neue Arbeiten der Bauhauswerkstätten* (Bauhausbücher no. 7), Munich: Langen, 1925, p. 51.
Die Metallwerkstatt am Bauhaus, exhibition cat., 1992, p. 144, cat. no. 46.

Objects coming out of the metal workshops of the Bauhaus typically displayed a mixture of concept, technical inventiveness, and spatial autonomy. Marianne Brandt's MT 36 ashtray, for instance, though small and starkly functional, is in itself a mature, self-sufficient *Gesamtkunstwerk.* The rounded metal form, cut with a geometric insert and placed on a raised foot, is tactile and eloquent; the design has volume far beyond its size, achieving a unity of expression through conscious manipulation of the relationships between surface texture, proportion, material, and form. From 1923 on, through the influence of László Moholy-Nagy and Christian Dell, the designs produced in the Bauhaus metal workshop by Brandt, Josef Albers, Carl Jakob Jucker, Wilhelm Wagenfeld, and other students were rooted in the idea of conceiving objects for industrial serial production. Experimental works, on the other hand, were often executed only as unique objects, or in limited serial production in silver, brass, or nickel-plated brass. These represent some of the most sensuous objects ever to come out of the Bauhaus.

WILHELM WAGENFELD

IV.15
Table lamp

Design: Carl Jakob Jucker and Wilhelm Wagenfeld, 1923–24, Weimar
Execution: Metallwerkstätte Bauhaus Weimar, model no. MT 9/ME 1
Nickel-plated brass, plate glass, opalescent glass
H. 38.7 cm (15.5 in.)
Ill. p. 538

Private collection, New York

Literature:
Walter Gropius, *Neue Arbeiten der Bauhauswerkstätten* (Bauhausbücher no. 7), Munich: Langen, 1925, p. 68.
Die Metallwerkstatt am Bauhaus, ed. by Klaus Weber, exhibition cat., Berlin, Bauhaus-Archiv, 1992, p. 298, cat. no. 325.
Täglich in der Hand, pp. 228ff., catalogue raisonné no. 2.

IV.16
Lamp for bedside table or wall (type 39)

Design: Wilhelm Wagenfeld, 1926–30, Weimar
Execution: Weimar Bau- und Wohnungskunst GmbH, Weimar
White metal, brass, plastic shade (originally opalescent glass)
H. 27 cm (10.8 in.)
Ill. p. 536

Neue Galerie New York

Literature:
Sales catalogue of Bau- und Wohnungskunst GmbH, Weimar, n.d.
Täglich in der Hand: Industrieformen von Wilhelm Wagenfeld aus sechs Jahrzehnten, 4th ed., ed. by Beate Manske and Gudrun Scholz, Bremen: Worpsweder, 1998, p. 304, catalogue raisonné no. 36.

IV.17
Tea caddy

Design: Wilhelm Wagenfeld, 1927–29, Weimar
Execution: Metallwarenfabrik Walter & Wagner, Thuringia
German silver
H. 14 × Diam. 7.2 cm (5.6 × 2.9 in.)
Ill. p. 540

Private collection, New York

Literature:
Die Form: Zeitschrift für gestaltende Arbeit, vol. 4 (1929), p. 40.
Die Metallwerkstatt am Bauhaus, ed. by Klaus Weber, exhibition cat., Berlin, Bauhaus-Archiv, 1992, p. 304, cat. no. 332.
Täglich in der Hand, p. 82, catalogue raisonné no. 16.

IV.18
Stand with burner for teapot

Design: Wilhelm Wagenfeld, 1929–30, Weimar
Execution: Metallwarenfabrik Walter & Wagner, Thuringia
Nickel-plated brass, opalescent glass
H. 10.5 × Diam. 16 cm (4.2 × 6.4 in.)
Ill. p. 537

Private collection, New York

Literature:
Die Metallwerkstatt am Bauhaus, ed. by Klaus Weber, exhibition cat., Berlin, Bauhaus-Archiv, 1992, p. 302, cat. no. 330.
Täglich in der Hand, pp. 78ff., catalogue raisonné no. 18.

IV.19
Pieces from tea service

Design: Wilhelm Wagenfeld, 1931, Berlin
Execution: Glaswerk Schott & Gen., Jena
Clear heat-resistant glass
Teapot: H. 10.5 cm (4.2 in.)
Sugar bowl: H. 4.6 cm (1.8 in.)
Creamer: H. 4.6 cm (1.8 in.)
Cup: H. 4.6 cm (1.8 in.)
Saucer: Diam. 14.5 cm (5.8 in.)
Cake plate: Diam. 19.8 cm (7.9 in.)
Marks: SCHOTT & GEN. JENA. (base of teapot)
Ill. p. 539

Private collection, New York

Literature:
Täglich in der Hand, p. 95, catalogue raisonné nos. 61a, b, c, e, f.

In 1931, Wilhelm Wagenfeld, who had been a member of the Bauhaus in Weimar but left the school when it moved to Dessau, worked on a freelance basis for Schott & Gen. glassworks in Jena, conceiving a wide range of innovative heat-resistant domestic glassware for the mass consumer market. His designs included a revised version of the Sintrax coffee machine (1931; cat. no. IV.20), originally created by Gerhard Marcks in 1924, and a tea service (1932–34). In the teapot, creamer, sugar bowl, cups, and saucers, the power of the design is concentrated in the austere shapes and profiles of the heat-resistant glass and in an inherent ambivalence between the individuality of the conception and the collective nature of the execution and distribution as industrial design. Wagenfeld's tea service has become a classic of the machine aesthetic in early heat-resistant glass design.
At the end of the era of modernist and Bauhaus design, Wagenfeld's work with Schott & Gen. in the early 1930s, and for the Vereinigte Lausitzer Glaswerke from 1935 to 1947, was a continuation of the Werkbund ideal of artists collaborating with industry to produce high-quality work. This illustrates the breadth of developments in Germany from the 1890s through the 1930s, as artist-craftsmen evolved into effective artist-industrial designers.

IV.20
"Sintrax" coffee percolator

Design: Gerhard Marcks, 1924; partial redesign Wilhelm Wagenfeld, 1931
Execution: Glaswerk Schott & Gen., Jena, and H. Behrend Elektrogeräte, Berlin, 1931
Clear heat-resistant glass, rubber gasket, ebonized beechwood, aluminum
H. 38 cm (15.2 in.)
Marks: Jenaer Glas/SCHOTT & GEN. JENA./Sintrax 1 Ltr. (exterior of upper glass container), H.Behrend Flektrogeräte/Berlin 89/6026 Buchholz (transfer label on underside of heating element), HB 550W 2201 (stamped on underside of heating element)
Ill. p. 539

Private collection, New York

Literature:
Täglich in der Hand, catalogue raisonné no. 68/1.

HANS PRZYREMBEL

IV.21
Tea caddy

Design: Hans Przyrembel, 1926, Dessau
Execution: Metallwerkstätte Bauhaus, Dessau
German silver
H. 20.7 × Diam. 6 cm (8.3 × 2.4 in.)
Marks: "BAUHAUS"
Ill. p. 541

Neue Galerie New York

Literature:
Die Metallwerkstatt am Bauhaus, 1992, p. 244, cat. nos. 225, 226.

THEODOR BOGLER

IV.22
Combination teapot from the estate of Theodor Bogler

Design: Theodor Bogler, 1923, Weimar
Execution: Steingutfabrik Velten Vordamm
Stoneware, matte black glaze, wicker-covered German-silver handle
H. 11.8 cm (4.7 in.)
Ill. p. 542

Neue Galerie New York

Literature:
Walter Gropius, *Neue Arbeiten der Bauhauswerkstätten* (Bauhausbücher no. 7), Munich: Langen, 1925, p. 102.
Keramik und Bauhaus, exhibition cat., 1989, ill. 44, cat. nos. 17, 18, 159.
Wolfgang Ketterer, Munich, sale no. 191: "*Jugendstil,*" November 13, 1993, lot no. 492.

IV.23
Teapot (lid missing)
Design: Theodor Bogler, 1925–26,
Weimar
Execution: Steingutfabrik Velten Vor-
damm
Stoneware, glazed semi-opaque white;
metal handle
H. 13 cm (5.2 in.)
Marks: incised TB, highlighted in blue
Ill. p. 543

Private collection, New York

Literature:
Keramik und Bauhaus, exhibition cat.,
1989.

Consistent with Walter Gropius's early
call for an emphasis on craft-based de-
sign at the Weimar Bauhaus, the pieces
created at the ceramic workshop in
Dornburg, some thirty kilometers away
from the school, were initially grounded
in traditional aesthetics of domestic
clayware, using the local Thuringian
techniques of turning, glazing, and fir-
ing. But as the Bauhaus approach shift-
ed toward collaboration with industry,
the leaders of the ceramics program,
sculptor Gerhard Marcks and potter
Max Krehan, and their students, includ-
ing Theodor Bogler, Otto Lindig, and
Marguerite Friedlaender-Wildenhain,
began to experiment more with modern,
functional adaptations of the craft tradi-
tion. Beginning in 1922, Bogler espe-
cially began to devise new models of
domestic ceramics for industrial serial
production.
The Bogler teapot, though it appears to
be a unique, handcrafted work, was ac-
tually part of an innovative series in
which the individually cast elements
could be combined in "mix and match"
fashion. Manufactured by Steingut-
fabrik Velten Vordamm, the expressive
earthenware form is composed of inter-
penetrating geometric elements and is
coated with a semi-opaque white glaze
common in many of the artist's early
works. Most Bauhaus ceramics, how-
ever, including this piece, are a variation
of the modern aesthetic typically asso-
ciated with the school. With the move
of the Bauhaus to Dessau, the ceram-
ics department was dissolved, but the
artists' accomplishments continued
through their later work at other work-
shops and factories.

PETER BEHRENS

*** APRIL 14, 1868, HAMBURG-BORGFELDE**
† FEBRUARY 27, 1940, BERLIN

Cover of *Peter Behrens und seine Wiener akademische Meisterschule/Peter Behrens and His Academic Master-School, Vienna*, Vienna, 1930. Collection Österreichische Nationalbibliothek

Of all the German architect-designers active in the Reform movement of the early twentieth century, Peter Behrens has achieved the most enduring international reputation. His work has become synonymous with the emergence of industrial design as a German idiom. His influence on the younger generation, particularly through assistants who worked in his practice during the first decades of the century (including Ludwig Mies van der Rohe, Le Corbusier, Walter Gropius, and Adolf Meyer), is seen as a catalyzing force for the development of modern architecture throughout the world.

Behrens's international legacy centers on his designs for industrial products and his profound influence on modernist architecture. But this focus is somewhat narrow. A closer look at his entire career reveals that Behrens's forward-looking designs and buildings constitute only part of the reason for his enduring significance. Another factor that made Behrens the ultimate "early modern German designer" before World War I—and has kept him "modern" since—was his relationship to the rapidly changing developments of his own era. Behrens's career mirrored the multifaceted and complex evolution of modern German design during his own lifetime. Through the artist's lifelong critical musings on theoretical modernism and its historical sources, as well as on the relationship between abstraction and functionalism, Behrens was both product and symbol of the reform efforts of his era. His unique legacy and the power of his influence emanate from his persuasive, almost literal translation of ideological developments into design objects and buildings.

Even among colleagues, Behrens was acclaimed as the embodiment of the early modern German designer. His work encompassed an extreme diversity of stylistic expressions, including the overlapping (and sometimes conflicting) tendencies among Jugendstil, Werkbund, Bauhaus, and Expressionist design in Germany from the turn of the century up to the 1930s. The range reflects the conscious and some-

times contradictory nature of evolutionary and experimental developments for designers in those decades. In Behrens's case, though, the stylistic diversity was a unique mixture of innovation and conservatism, functionalism and individualism.

But his work was viewed by colleagues in contradictory ways. The artist's role at the 1914 Deutscher Werkbund exhibition in Cologne, for example, illustrates how Behrens's symbolic authority could be shaped to fit varying positions. For this climactic presentation of German modernism, Behrens was accorded the honor of contributing the design for the show's official poster. Yet, his rendering of a torch-carrying man on a black horse became controversial. It was interpreted by some as an allusion to Nietzschean calls for artistic creativity, by others as an overtly pragmatic and traditional reference to the goal of the exhibition as a showcase for "the value of German work, German industriousness, and the activities of the German Werkbund."[1] Some colleagues, such as Munich artist Hermann Obrist, flatly rejected the appropriateness of the design, stating with bold simplicity, "It is reactionary."[2]

Behrens was born in Hamburg to a family of prosperous agricultural landowners from Holstein. After the early death of his parents, he was raised in Altona under the guardianship of powerful Hamburg figures in the legal profession. From 1885 to 1887, he studied painting at the Kunstschule in Karlsruhe, and thereafter undertook further fine arts studies in Munich and Düsseldorf. In the autumn of 1889, he finally settled in Munich, married Elisabeth (Lilli) Krämer, and began private lessons with the painter Hugo Kotschenreiter. By 1892, he was working independently in a naturalistic *plein air* style. He became active in the founding of the Münchner Sezession (Munich Secession) and the Freie Vereinigung Münchener Künstler (Free Union of Munich Artists). In the mid 1890s, however, Behrens's artistic direction began to change. In keeping with a similar shift among a group of young reform

artists in Munich, including Otto Eckmann, Richard Riemerschmid, and Hermann Obrist, Behrens was increasingly influenced by decorative elements and, by 1897, had decided to devote himself to the applied arts. He participated in the debut installations of Munich Jugendstil at the annual Glaspalast (Glass Palace) exhibitions. In 1898, he became a member of the Vereinigten Werkstätten für Kunst im Handwerk (United workshops for handcrafted art), the center of Munich Jugendstil design production. Behrens's early experiments with decorative arts included designs for glassware, carpets, textiles, porcelain, furniture, and even jewelry. He also focused on bookbinding and illustration, making colored woodcuts such as *Der Kuss (The Kiss,* 1898), a remarkable design of linear interplay and abstract patterning produced for the Berlin art journal *Pan.*

By the time the artist moved to Darmstadt in 1898, accepting an invitation to co-found the Künstlerkolonie (Artists' colony) at the Mathildenhöhe, the sinuous graphic quality of his first designs had begun to evolve toward a more geometric style. These changes were visible throughout the home he built for himself on the Mathildenhöhe as his contribution to the first exhibition of the Darmstadt group, *Ein Dokument deutscher Kunst* (A Document of German Art), in 1901. This was Behrens's initial foray into architecture—a *Gesamtkunstwerk* encompassing exterior and interior as well as furnishings, fittings, textiles, table-, silver-, and glassware. The entire design is a play of relationships between volume and surface, decoration and form, abstract and functional elements. This can be seen in complete rooms for the house such as the library, or in smaller objects such as the cutlery.

Behrens's interest in the philosophy of Friedrich Nietzsche, which had subtly informed his concept for the house, became more overt in his theater and exhibition design during his Darmstadt years. At the first *Esposizione Internazionale d'Arte Decorativa Moderna* (International Exhibition of Modern Decorative Arts) held in Turin in 1902, Behrens's contribution of an Anteroom was a potent homage to Nietzsche's ideas about artistic will and national identity. The installation, known as the *Hamburger Vorhalle* (Hamburg vestibule of the power and the beauty), was a rectangular room defined by massive sculptural arches set around an interior courtyard, which featured a sunken pool enclosed by monumental rounded cement figures. A blue glazed tile roof covered by a yellow opalescent glazed canopy created a mystical lighting effect. But the sacred icon of the space was a copy of Behrens's design for a binding to Nietzsche's *Thus Spake Zarathustra,* placed on a pedestal within the installation as an object of veneration, a symbol of the philosopher's ideas about power and beauty.

The artist also turned his attention to teaching. In 1901–02, he led the first master classes established by the Bayerisches Gewerbemuseum (Bavarian Crafts Museum) in Nuremberg. These progressive courses were part of an educational endeavor to enable master craftsmen to acquire new training under the guidance of reform movement artists. Soon thereafter, in 1903, Behrens became the director of the Kunstgewerbeschule (School of Applied Arts) in Düsseldorf. Through innovative pedagogy and astute hiring of progressive young staff such as F. H. Ehmcke and J. L. M. Lauweriks, the school was soon transformed into the leading German site for training in applied arts.

During this period, Behrens's fascination with geometry as the conceptual and formal basis for design intensified. Projects including the dining room for the Wertheim department store exhibition *Moderne Wohnräume* (Modern Living Spaces, 1902) in Berlin, the pavilion at the *Nordwestdeutsche Kunstausstellung* (Northwest German Art Exhibition, 1905) in Oldenburg, and the Eduard-Müller-Krematorium (1906) in Hagen reveal a deepening experimentation aimed at achieving a modernist design idiom that would encompass stereometric and geometric elements. In this quest, the artist drew on influences from Greco-Roman antiquity and early Renaissance architecture. At Oldenburg, Hellenic sources dominated. In Hagen, the Krematorium architecture evokes associations with Italianate Renaissance precedents.

In 1907, Behrens left Düsseldorf for Berlin, where he was named artistic advisor to the major industrial concern Allgemeine Elektricitäts Gesellschaft, or AEG. The appointment occurred in the same week that the Deutscher Werkbund was founded by a group of artists, architects, industrialists, government officials, and publishers as a lobby group to promote collaboration between art and industry. Behrens's role at the AEG—one of the first direct partnerships between an artist and a commercial firm—was hailed as a model for the Werkbund's program. Setting the precedent for industrial designers, Behrens created the company's logo, numerous posters, and advertising materials; a group of products such as turbine lamps, electric kettles, and barometers; and even factory architecture, such as the Brunnenstrasse factory in Berlin-Wedding, the entrance for the complex in Berlin-Humboldthain, and most notably, the Turbine Factory on Huttenstrasse in Berlin. Of all Behrens's accomplishments, the most famous are his wide-ranging products and architecture created for the AEG from 1907 to 1914.

Products designed by Behrens for the AEG, some of which were thoroughly new types and others revised from existing product lines, demonstrate a reductive process. In the six-sided tea kettles, for example, formal elements are interwoven in a simplified play of functional and decorative geometricism. But in all the AEG designs, Behrens retained a few decorative traces. In some of the kettles, for example, he employed beaded elements as framing devices, and in others he used hammered surfaces that hint at earlier handcraft traditions rather than mass-produced design. At the Turbine Factory, architectural ornament is expressed in reductive repetitions of building elements such as the sensuous hinging of three-pinned arches near the lower base of the long side walls.

At the same time, in contrast to the industrial character of the AEG designs, Behrens executed more luxurious architectural commissions. For example, from his studio in Neubabelsberg near Potsdam, around 1910–12, he created the single-family residence called Villa Wiegand in Berlin, and the official German embassy in St. Petersburg. The style of these works drew on what Behrens described in 1908 as "monumental Art."[3]

After World War I, the direction of Behrens's architecture diverged again into a phase of self-reflective experimentation, first with utopian Expressionist tendencies during 1918–25, and thereafter through a new modular aesthetic based on cubic forms. From 1922, he refocused his energies on teaching, working as the head of the architecture department at the Akademie der bildenden Künste (Academy of Fine Arts) in Vienna until 1936, and at the Preussischen Akademie der Künste (Prussian Academy of Arts) in Berlin from 1936. With the exception of a few projects such as a residence in the Werkbund's Weissenhofsiedlung (Housing estate, 1927) in Stuttgart and the Berolina and Alexander office structures at Alexanderplatz in Berlin (1931–32), Behrens's influence in these later years stemmed less from new work than from the inspiration his teachings and earlier architectural achievements provided for the work of apprentices and pupils, now active throughout the international community. And, in the final years of his life, when many protégés such as Gropius and Mies had emigrated from Germany, Behrens at first suffered denunciation as a cultural bolshevik by the National Socialists, but soon began to work with the Third Reich government on new AEG designs and continued to do so until his death in 1940.

BEHRENS'S RECEPTION IN THE UNITED STATES

Early twentieth-century American audiences were exposed to the different facets of Behrens's career and approach as early as 1901–04, when *The Studio* and *The International Studio* published four extensively illustrated articles on his work. Here Behrens is presented as an innovative and versatile artist-designer, shifting from painting to woodcuts to designing objects, interiors, gardens, and entire buildings.[4]

Behrens's work was exhibited to American audiences for the first time at the 1904 Louisiana Purchase International Exposition in Saint Louis. The exhibition reinforced the impression of Behrens as both innovative and exceptionally versatile, an artist of formal rigor exploiting the rhythmic quality of straight lines while others were still experimenting with Art Nouveau curves. Among the well-received interior installations of German decorative arts, Behrens contributed a salon—incorporating elements from the artist's *Hessisches Zimmer* (Hessian room), another of his entries at the Turin exhibition of 1902—and a new reading room designed for the Düsseldorf city library around 1904. While the salon was a small space featuring "heavy mahogany furniture with colored inlays"[5] in a dark red tone, the reading room was one of the larger installations among some forty German entries to the section of decorative arts housed in the fair's Palace of Varied Industries. In the official government report on the show written by Hermann Muthesius, the reading room is described as exemplifying the northern variation of the modern German aesthetic.[6] Muthesius noted Behrens's employment of luxurious materials, particularly in what he termed the "primary decoration," a monumental clock of red marble with enameled numerals and pendulum, flanked by sculptures of female forms modeled by Rudolf Bosselt.[7]

The room included tables and chairs made of cedar with pigskin surfaces and upholstery bearing discreet gold-tooled ornamentation.

The ensemble was unified by the repetition of geometric forms throughout—on furnishings, lighting fixtures, and wall and ceiling decoration. The interior was distinguished by rectilinearity, but the horizontality of lighting and table elements transformed the whole into an abstract study in controlled geometricism. Muthesius stated, "The entire room makes an impression of deep earnestness and monumental dignity in its strictly stylized, rather severe design conception."[8] One remarkable aspect of the design is the clear relationship it exposes between Behrens's work and that of contemporary international artists such as the Scotsman Charles Rennie Mackintosh, the Austrian Josef Hoffmann, and the American Frank Lloyd Wright.[9]

Behrens also designed the official catalogue for the German section of the exhibition. Published in a limited edition of 300, the striking design includes a cover printed in black and gold ink on morocco, and black abstract geometric banding. The volume testifies to the artist's profound engagement with bookmaking, advertising graphics, and typographic design.[10]

Significant examples of Behrens's typography and book design were shown to the American public in 1912–13, in the major touring exhibition *German Applied Arts*.[11] This large exhibition, the first major American showcase of modern German industrial design, architectural photography, and decorative arts, was organized by Karl Ernst Osthaus's Deutsches Museum für Kunst in Handel und Gewerbe. It included over 1,300 objects and traveled to six venues in America. Behrens's work was included in the sections on architecture, advertising and printed matter, book industries, wallpapers, linoleum, textiles, glass, and metalwork. Thanks to his creative versatility, Behrens appears to have dominated the exhibition. Among the architectural entries, photographs of his house in Darmstadt and his architecture for the AEG were showcased. Americans were thereby able to view the artist's accomplishments in both domestic *Gesamtkunstwerk* design and industrial architecture as well as AEG store interiors and display windows, with views of Behrens's kettles, fans, and other products. The advertising sections included major examples of the designer's print graphics for the AEG and other firms such as Anker Linoleum.

In assessing the exhibition, the American press responded most strongly to the work of industrial art and advertising design—the areas of Behrens's greatest strength. The journal *Handicraft* singled out for praise the Germans' approach to poster and advertising design.[12] *Art and Progress* was especially impressed by the AEG-Behrens collaboration: "A typical instance of intelligent and sympathetic co-operation on the part of some of the larger commercial firms is that of the Allgemeine Elektrizitätsgesellschaft, Berlin, in appointing Prof. Peter Behrens … to a position on its permanent staff, and in entrusting to him not only the building and equipment of its business premises and residences for officials but the designing of all its electric light fittings, and all its catalogues, advertisements and other literature."[13]

William French, director of the Art Institute of Chicago, also commended the partnerships between art and industry: "It would be well to emphasize the part German manufacturers have taken in the

progress of the art craft movement; American manufacturers should be urged to follow their examples. Intelligent and sympathetic co-operation between artists and manufacturers has proved a conspicuous success in Germany. New life has been instilled into many industries by procuring the services of able artists. Even commercial firms intrust [sic] to prominent artists the entire artistic equipment of their businesses, from the designing of the furniture and building fittings down to the catalogues, advertisements and other literature."[14] Without identifying Behrens by name, French is clearly referring to his work for the AEG.[15] At least one American designer was drawn to emulate Behrens's AEG designs: around 1915, Chicago designer Emery Todd produced a silver and wood teapot that pays obvious homage to Behrens's AEG electric kettles.[16]

After the Newark exhibition, critical reception of Behrens's work continued to focus on his various personae—the dominant one being the rigorous, rational architect and industrial designer, although there are glimpses of his ongoing work as a designer of domestic interiors, an Expressionist, and a historicist. His roles as theorist and teacher were also introduced. Beginning in 1913, Behrens occasionally published in American journals. His first article did not appear in an architecture or design venue, but in the *Scientific American Supplement*, a weekly whose purpose was "to publish the more important announcements of distinguished technologists." In an article titled "The Aesthetics of Industrial Buildings: Beauty in Perfect Adaptation to Useful Ends,"[17] Behrens focused on architecture but conveyed a message similar to that given at Newark about the benefits of a marriage between art and industry; again the Turbine Factory and other buildings for AEG were illustrated. The focus today on Behrens's industrial designs, and particularly his work for the AEG, reflects a recurring theme in the American reception; the Turbine Factory, which is still *the* canonical work by Behrens, seems to have defined his career in American minds from that time onward.

In 1925, *The American Architect* published a series of articles on tendencies in modern German architecture, including two by Behrens.[18] These must be understood in the context of a desire to demonstrate to U.S. audiences the viability of a union between art and industry, which, it was argued, would contribute to a unified overall culture. Both essays highlight industrial architecture, and are illustrated with photos and plans—all depicting industrial buildings, but encompassing a range of visual forms. These include several AEG projects as well as the Mannesmann-Röhrenwerke Hauptverwaltung (Mannesmann main office building) in Düsseldorf, 1910–12, with its combination of influences from the Renaissance palazzo and traditional German civic architecture, and the Höchst IG-Farben Administration Building in Frankfurt-am-Main, 1920–24, with its medievalizing Expressionism.

At the same time, Behrens continued to be presented in more popular venues as a designer of elegant domestic interiors. In 1911, *House and Garden*—which must have been scouring back issues of German art magazines—illustrated two 1902 interiors by Behrens as part of a feature entitled "Suggestions from German Country Homes."[19] In 1929, a dining room "exactly reproduced from a plan by Professor Behrens" and a table by the designer were included in the furnished rooms displayed at Marshall Field's department store in Chicago.[20] Based on a description of the dining room, it seems to have combined an austere structure with Chinese references and luxurious materials (for instance, a black lacquered dining table, taffeta draperies, and silk velvet upholstery). This recalled for American audiences the Behrens of the 1904 Saint Louis exposition, a designer of elegant and plush modern interiors (versus the rigorous architect for industry). During the same year, Behrens's drawing of a stairway in the College of Saint Benedict in Salzburg (1924–26) was published in the architectural journal *Pencil Points*, demonstrating his ability to execute more traditional commissions.[21]

An exhibition of Behrens's work and that of his students was held at the Brooklyn Museum of Art in 1930. Titled *Projects by Graduates from the Behrens Master School in Architecture at the Academy of Fine Arts in Vienna*, it featured designs by forty students, with a large amount of space devoted to Behrens's work. As one reviewer observed, "the occasion may be regarded as an affirmation of [Behrens's] architectural principles."[22] Once again demonstrating the complexity and variety of his approach to architecture, Behrens exhibited pre- and postwar projects (although no decorative arts objects), including photos of the Höchst IG-Farben building, the German embassy in St. Petersburg (an example of monumental simplified classicism), and the Turbine Factory.[23] The *Brooklyn Museum Quarterly* extolled the latter as "a building which is considered to have marked a peak in the history of contemporary architectural development,"[24] and two other critics emphasized its importance.[25] Reviews were generally positive, focusing on the rational modern approach to contemporary social and architectural challenges. The dissenting voice was conservative critic Royal Cortissoz, who identified in Behrens's work "a certain Teutonic heavy-handedness, an austerity that passes into grimness ... [A]ll through our examination of his buildings we have found ourselves thinking of some routine cosmos such as is beloved of Mr. H. G. Wells. Of the loveliness and enchantment in architecture there is no sign."[26]

A long article on Behrens by Shepard Vogelgesang appeared in *Architectural Forum* in conjunction with the Brooklyn show. Tracing Behrens's career from 1901 onward, the author delineated certain constants running through the various experiments and stylistic shifts: "Early he realized the power of the simple, geometric form and whether his work sometimes recalled the early Tuscan Romanesque or the German Empire of Schinkel, this quality dominated it."[27] Several industrial buildings—especially the AEG Turbine Factory—are praised as "possibly the greatest contributions which this painter has made to art."[28] And, in contrast to Cortissoz's emphasis on Behrens's stern rationality, Vogelgesang draws out the connections to Romanticism. He mentions as well the several Americans who had studied with Behrens in Vienna, including Muschenheim, the exhibition's organizer.[29]

If Behrens had a presence in the U.S. during the 1950s and '60s, it was largely through his former European assistants, Gropius and

Mies van der Rohe. His status was that of a "pioneer" of the modern movement. Later projects of the kind shown at the Brooklyn Museum were neglected, his long and complex career obscured by the fame of the AEG work. Gradually since the 1970s, German, British, and American scholarship has filled out our picture of Behrens's career, with two recent publications providing particularly excellent and innovative assessments.[30]

It is only in the last two decades that Peter Behrens's achievement in objects that bridge decorative arts and industrial design have found their place among permanent museum installations throughout America. Examples range from the furniture and porcelain of the 1902 Wertheim dining room, glassware such as the early Bismarck series or the Darmstadt ruby-footed stemware, woodcuts, bookbindings, advertising design, and AEG industrial products. The largest American holdings of Behrens's objects are at the Saint Louis Art Museum and the Museum of Modern Art in New York.

Laurie A. Stein

1 Hermann Muthesius and Friedrich Naumann, *Die Werkbund-Arbeit der Zukunft,* Jena: Diedrichs, 1914, p. 4, quoted in: Angelika Thiekötter & Laurie Stein, "Markenware—Werkbundmarke, Der Deutsche Werkbund," in: *Die Kunst zu Werben. Das Jahrhundert der Reklame,* Munich: Münchner Stadtmuseum and DuMont, 1996, p. 249.

2 Muthesius and Naumann, *Die Werkbund-Arbeit* (as note 1), p. 63.

3 Peter Behrens, "Was ist monumentale Kunst?" in: *Kunstgewerbeblatt,* vol. 20, no. 3 (December 1908), pp. 46, 48.

4 Franz Blei, "Peter Behrens: A German Artist," in: *The International Studio,* vol. 12 (February 1901), pp. 237–241; W. Fred, "The Artists' Colony at Darmstadt," in: The *International Studio,* vol. 15 (November 1901), pp. 21–30; "The International Exhibition of Modern Decorative Art at Turin: The German Section," in: *The Studio,* vol. 27 (December 1902), pp. 188–197; H.W.S., "Studio-Talk: Düsseldorf," in: *The International Studio,* vol. 23 (October 1904), pp. 356–358.

5 Hermann Muthesius, *Amtlicher Bericht über die Weltausstellung in St. Louis, 1904,* Teil II, Berlin: Reichsdruckerei, 1906, p. 288.

6 Ibid., p. 287.

7 Ibid. Muthesius sharply criticized the fact that the dimmed library lighting hindered appreciation of the installation.

8 Ibid.

9 I am grateful to Christopher Wilk for sharing his unpublished master's thesis with its examination of the Saint Louis installations. Furthermore, regarding the relationship of Behrens's work to his international contemporaries, it is interesting that, removed from the context of purely German developments, the lines of influence and similarity between artists of differing countries become more striking. Through Muthesius's introduction, Behrens had already traveled to Scotland and met with Mackintosh by this date, and he was probably aware of Hoffmann's work. When Frank Lloyd Wright sent his assistant down to Saint Louis to study the German exhibits, it is likely that the power of the reading room installation and the relationship to Wright's own style would have been communicated.

10 *International Exposition St. Louis 1904, Official Catalogue, Exhibition of the German Empire / Weltausstellung in St. Louis 1904. Amtlicher Katalog, Ausstellung des deutschen Reichs,* Berlin: Stilke, 1904. From 1902 to 1914, Behrens was a pioneer of experiments in new artistic print types, designing the Behrens-Schrift, Behrens-Kursive, Behrens-Antiqua, and Behrens-Medieval fonts. The St. Louis catalogue was produced in two versions: that described here, and a less deluxe version without gold ink or a morocco leather cover.

11 *Touring Exhibition of the Deutsches Museum für Kunst in Handel und Gewerbe, Hagen,* exhibition cat., Newark Museum and other venues, 1912–13; Laurie A. Stein, "'Der Neue Zweck verlangte eine neue Form'—Das Deutsches Museum für Kunst in Handel und Gewerbe im Kontext seiner Zeit," and Barry Shifman, "Design für die Industrie: Die Ausstellung 'German Applied Arts' in den Vereinigten Staaten, 1912–13," in: *Das Schöne und der Alltag: Die Anfänge modernen Designs 1900–1914,* ed. by Michael Fehr et al., exhibition cat., Krefeld, Kaiser Wilhelm Museum; and Hagen, Karl Ernst Osthaus-Museum, 1997, pp. 19–25, 377–389. Shifman's article appears in English as "Design for Industry: The 'German Applied Arts' Exhibition in the United States, 1912–13," in: *Journal of the Decorative Arts Society,* vol. 22 (1998), pp. 19–31. See also Leslie Topp's essay in this volume.

12 Louise Connolly, "The Traveling Exhibition of German Applied Arts," in: *Handicraft,* vol. 5, no. 3 (June 1912), p. 30.

13 "Modern German Applied Arts," in: *Art and Progress,* vol. 3, no. 7 (May 1912), pp. 586–587; in this passage, the *Art and Progress* article is quoting L. Deubner, "German Architecture and Decoration," in: *Studio Year Book of Decorative Art* (1912), p. 128.

14 William French, "Art and Artist," in: *Chicago Evening Post* (August 10, 1912), quoted in: Shifman, "Design for Industry" (as note 11), p. 25.

15 Although French wished to purchase the entire poster section of the show for Chicago, this did not occur.

16 W. Scott Braznell [catalogue entry], in: Wendy Kaplan with Eileen Boris et al., *"The Art That Is Life": The Arts and Crafts Movement in America, 1875–1920,* exhibition cat., Boston, Museum of Fine Arts, 1987, p. 163.

17 Behrens, "The Aesthetics of Industrial Buildings: Beauty in Perfect Adaptation to Useful Ends," in: *Scientific American Supplement,* vol. 76 (August 23, 1913), pp. 120–121.

18 Behrens, "Administration Buildings for Industrial Plants," in: *American Architect,* vol. 128, no. 2479 (August 26, 1925), pp. 167–174, plates 224–226, and "Seeking Aesthetic Worth in Industrial Buildings," in: *American Architect,* vol. 128, no. 2486 (December 5, 1925), pp. 475–479. According to Stanford Anderson (*Behrens and a New Architecture for the Twentieth Century,* Cambridge, Mass.: MIT Press, 2000, p. 382), the former is in part a translation of a 1912 speech by Behrens at the dedication of his Mannesmann building.

19 "Suggestions from German Country Homes," in: *House and Garden,* vol. 19, no. 1 (January 1911), p. 40. The rooms were not labeled but can be identified as a study (*Herrenarbeitszimmer*) for the publisher Alexander Koch, exhibited at the *Esposizione Internazionale d'Arte Decorativa Moderna* in Turin, and a dining room exhibited in 1902 at the Wertheim department store in Berlin.

20 Athena Robbins, "Distinctive Rooms at Marshall Field's," in: *Good Furniture Magazine,* vol. 32, no. 6 (June 1929), pp. 325–330.

21 *Pencil Points,* vol. 10, no. 1 (January 1929), p. 32.

22 Royal Cortissoz, "Peter Behrens at the Brooklyn Museum," in: *New York Herald Tribune* (April 27, 1930), sec. 7, p. 9. Shepard Vogelgesang refers to "a traveling exhibition shown throughout Germany," which Behrens had been hoping for two years to bring to the U.S., and implies that the Brooklyn show is a version of this; see Vogelgesang, "Peter Behrens, Architect and Teacher," in: *Architectural Forum,* vol. 52, no. 5 (May 1930), pp. 715–725, esp. pp. 720–721. The *Brooklyn Museum Quarterly* says the show was put together by William Muschenheim, an American former student of Behrens; see "An Exhibition of Architectural Projects," in: *Brooklyn Museum Quarterly,* vol. 17 (July 1930), pp. 102–109, esp. p. 102. A related publication, in both German and English, is Karl Maria Grimme, ed., *Peter Behrens und seine Wiener akademische Meisterschule/ Peter Behrens and His Academic Master-School, Vienna,* Vienna: Adolf Luser, 1930, with an introductory essay on Behrens at his school by Grimme, and an essay by Behrens on architectural education.

23 This information was supplied by the Brooklyn Museum of Art library and archive.

24 "An Exhibition" (as note 22), p. 102.

25 Helen Appleton Read, "Architectural Projects by Professor Behrens and His Pupils at Brooklyn Museum Are Cross Section of Contemporary European Ideals and Needs," in: *Brooklyn Daily Eagle* (April 20, 1930), p. E5; Elizabeth Luther Cary, "Viennese Experiments: Professor Behrens's Work, Pupils' Projects, at Brooklyn Museum," in: *New York Times* (April 20, 1930), sec. 8, p. 10.

26 Cortissoz, "Peter Behrens" (as note 22).

27 Vogelgesang, "Peter Behrens" (as note 22), p. 716.

28 Ibid., pp. 716–717.

29 Ibid., p. 719.

30 Anderson, *Behrens and a New Architecture* (as note 18), and Frederic J. Schwartz, *The Werkbund: Design Theory and Mass Culture Before the First World War,* New Haven: Yale University Press, 1996.

MARCEL BREUER

*** MAY 21, 1902, PÉCS (HUNGARY)**
† JULY 1, 1981, NEW YORK CITY

Cover of the catalogue *Exhibition by Marcel Breuer*, Graduate School of Design, Harvard University, Cambridge, Massachusetts, 1938. The Museum of Modern Art Library, New York

Marcel Breuer was born in Pécs, southwestern Hungary on May 21, 1902. With the help of a stipend, he began his artistic schooling at the Akademie der bildenden Künste (Academy of Fine Arts) in Vienna in 1920. Shortly thereafter, he learned of the newly founded Bauhaus school in Weimar, to which he immediately applied. Breuer remained at the Bauhaus for four years: after completing the preliminary course taught by Johannes Itten, he trained in the carpentry workshop, and graduated In 1924. In the following year he went to Paris, where he worked for a short time in an architectural practice. He returned to Germany in 1925, having been invited by Walter Gropius, founder of the Bauhaus, to take over the furniture workshop at the school, which had recently been forced to move to the city of Dessau. It was in this year that Breuer began to develop his first designs for tubular-steel furniture.

From the time he enrolled at the Bauhaus, it was apparent that Breuer would be one of the school's most outstanding students. The furniture and interiors that he went on to design not only realized ideas that were central to the Bauhaus ethic, but also set new standards and stimulated further development. His *Lattenstuhl* (a chair with wooden slats), which he originally conceived in 1922 and re-worked in 1923, is just one example of this level of innovation. It was also the first chair devised as a prototype specifically for mechanized mass production. In the words of Anni Albers, one of the Bauhaus's chief proponents: "There is only one route to the good object: the prototype." In their approach to everything from teapots to houses, the experimental Bauhaus workshops had as their goal the perfect prototype.[1]

Breuer's *Lattenstuhl* was the first of the Bauhaus prototype chairs to be produced and sold in large quantities. Ultimately, however, this design came to be understood not so much as a pragmatic object but as an icon of the early Bauhaus ideology. In marked contrast to the Red-Blue Chair by Dutch designer Gerrit Rietveld in 1917, Breuer's chair was insignificant as a piece of furniture to be sold and used. From

Rietveld's chair, Breuer borrowed the concept of the *open construction* of space, through the use of standardized planes: this gave the object the look of having been mechanically produced. Moving even further with this idea, Breuer created a method for producing prototypes: in 1925, he evolved a modular system utilizing both hollow and solid furniture forms.

At the same time, Breuer began to experiment with new materials and techniques in the production of furniture. It was also in 1926 that he first showed his B3 armchair (see cat. no. IV.3), in an exhibition at Dessau's Kunsthalle. This had a resilient frame of bent nickel-plated steel tubing, two parallel runners in place of the usual four legs, and stretched bands of fabric for the chair's seat and back. The B3 chair remains one of Breuer's most widely admired creations. Commercial production of the piece was taken up again in 1962, when the Italian company Gavina marketed the B3 as the "Wassily" chair. (Today, the chair is still being manufactured, by Knoll International.)

Because of its physical lightness, Breuer's tubular-steel furniture could easily be moved about, thus accommodating a new desire for easy mobility. From 1928, these pieces were also offered in a chrome finish, which further emphasized the cool elegance of the designs. Although tubular steel had been employed in the nineteenth century in the construction of garden furniture and hospital beds, its first application for chairs and tables intended for domestic use was an innovation that would prove to be extraordinarily influential. Breuer brought to the tubular-steel chair an aesthetic of lightness and transparency that was fully in tune with the mood of the 1920s, and that suited in particular the approach to space prevailing in the *Neues Bauen* (New architecture) of the era. His designs launched a pan-European fashion for tubular-steel furniture, and this soon spread to the United States.

The catalogue *Breuer Metallmöbel* (Breuer's Metal Furniture), which contained prototypes of chairs, stools, and tables, was published in 1927. Initially, these were manufactured by Standard-Möbel (a firm

established for this purpose by Breuer and a colleague), and from 1928 by Thonet (long renowned for its bentwood chairs), which took over Standard-Möbel in that year. In 1926, Breuer had already designed individual pieces of furniture for the main Bauhaus building in Dessau and for the new housing that had been provided for its staff. He was also one of the interior designers for all of these structures. In 1928, Breuer again succeeded in designing a chair that was soon to be established as a classic. His cantilevered B32 and B64 chairs retained the tubular-steel frame, but had a seat and back made of "Viennese" woven cane framed in wood—resulting in a look that was less severely modern than that of his first tubular-steel chairs. The new model, which has been marketed since the 1960s as the Cesca, is still being manufactured by Thonet and Knoll, although it is also available in numerous pirated versions. In the long term, this has proved to be the most successful cantilevered chair design ever devised. However, while all of Breuer's designs for tubular-steel furniture were conceived with mass production in mind, they were initially taken up only by a small, intellectual elite.

While still in Weimar, Breuer had begun to engage in architectural projects. In 1924, in collaboration with two Bauhaus colleagues, Georg Muche and fellow Hungarian Farkas Molnár, he showed designs for apartments at the *Bauausstellung* (Architectural Exhibition) in Stuttgart. In 1926, Breuer devised a scheme for a small house entirely constructed of prefabricated metal panels, and in the following year created his *Bambos* design for prefabricated row houses. With the support of Gropius, Breuer became a member of the Bund Deutscher Architekten (Union of German Architects) in 1928, even though he had not received a specifically architectural training (indeed, until that year such training was not part of the Bauhaus curriculum). When Gropius, Herbert Bayer, and László Moholy-Nagy left the Bauhaus in 1928, Breuer went with them. He then moved to Berlin, where he worked until 1931, mainly as an interior designer.

Breuer's interiors of the period 1928–35 often incorporated steel and aluminum furniture of his own invention. As in the case of the rooms designed by Le Corbusier for his Pavillon de l'Esprit Nouveau (1925), shelves, sideboards, and other wall units made of wood were utilized to structure the available space. Linear and graceful, these elements—with the tubular furniture—played an important part in achieving an effect of transparency and an illusory enlargement of the space.

In general, the furniture designed by Breuer is characterized by the sparing use of a few basic colors, which assert the formal unity of a given piece; another trademark was his frequent use of glass panes, including black opaque glass, for tabletops and sliding doors. Breuer invariably favored pale textile floor coverings of uniform tone: these too encouraged the impression of a more open space. It was, moreover, only on such floor surfaces that the tubular furniture could be moved around silently. Illumination for these spaces was generally uplighting provided by wall-mounted spotlights. Breuer's clean, bright rooms achieved a rationalization of the domestic interior that is still

seen as the epitome of the "new lifestyle" associated with the Weimar Republic.

The international economic crisis in the early 1930s resulted, inevitably, in a decline in commissions. Breuer traveled widely between 1931 and 1935, visiting Spain, North Africa, Greece, Switzerland, Italy, and the Balkan countries. His last significant commission in Germany was for the Harnischmacher House in Wiesbaden (destroyed during World War II).

During the Weimar years, Breuer participated in numerous important exhibitions. As early as 1924, his *Lattenstuhl* was included in the Stuttgart exhibition *Die Form*, presented by the Deutscher Werkbund. Three years later, at another Werkbund show, *Die Wohnung unserer Zeit* (The Dwelling in Our Time) of 1927, Breuer presented a number of designs for interiors. When Gropius was hired in 1930 to design the German section of a Paris exhibition being planned by the Société des Artistes Décorateurs (Society of Decorative Artists), he chose Breuer, along with Bayer and Moholy-Nagy, as his partners in this project. Breuer designed a Lady's Room and a Gentleman's Room, which were shown as examples of accommodation for an apartment hotel. This event has come to be recognized as a high point in the history of exhibition installation. At the *Berliner Bauausstellung* (Berlin Building Exposition) in 1931, Breuer presented his "House for a Sportsman" and a prototype apartment measuring seventy square meters. Breuer's contributions to these shows established his reputation, although by this time his work was also being promoted through publications (texts in architectural journals, books on architecture or design, and so on).

In 1932, Breuer moved to Switzerland, where he settled in Zürich. Here, in collaboration with the Embru firm in Rüti, he created designs for aluminum furniture, which were soon in production. These designs won first prize in an international competition for aluminum furniture organized in Paris by the French company Alliance Aluminium. In these aluminum pieces, Breuer once again achieved an outstanding synthesis of innovative form and unconventional material, as he had with tubular steel furniture. His reclining chair Embru No. 313 of 1932 was intended primarily for outdoor use (the series also included side- and armchairs). As outdoor furniture, these pieces had to be lightweight and easily transportable—a quality evoked in the pages of the catalogue (designed by Bayer) in which they first appeared: "Lightness: not only the elasticity of a feather, but light as a feather." The carefully contrived form of the aluminum frame added to their sculptural effect.

In this period, Breuer also accepted a commission to design new street facades and interiors for the Zürich and Basel branches of Wohnbedarf, a retailer specializing in modern household furniture and objects. In 1934, he designed two entire apartment blocks for the Doldertal district of Zürich; on these, he worked with Swiss architects Alfred and Emil Roth; the project was commissioned by the architectural historian Sigfried Giedion.

With the advent in 1933 of the National Socialist regime in Germany, there had come a marked change in the cultural climate, and Breuer

received no further German commissions. In 1934, Gropius left Germany for England, and the following year Breuer followed his example, moving to London, where (with Gropius's help) he was immediately able to start working with the architect F. R. S. Yorke, and with Jack Pritchard of the Isokon Corporation.

The first fruit of this new collaboration was the plywood furniture Breuer made for Isokon. These were basically reworkings of his 1932 aluminum pieces in plywood—a material that was then widely being "discovered" for use in domestic furniture. His work in plywood issued in genuinely "sculptural" pieces that signaled the end of the "industrial aesthetic" of his tubular-steel period and his adoption of a new formal language. Breuer's last important furniture designs were the pieces conceived in 1935–36 for Isokon; his new approach of this period would, however, be continued later in his architectural work. It is now recognized as one of the preconditions of his success as an architect in the United States.

BREUER IN AMERICA

It was not long before Breuer decided to move to America and, here again, the assistance of Gropius was crucial. In 1937, Breuer was appointed research associate at Harvard University, where Gropius had recently begun teaching.

Breuer's name had been known in the United States since the late 1920s, and from the beginning it was equated with the invention of tubular-steel furniture.[2] These pieces (in particular the tubular chair) entered the American mainstream early on—so that by 1938, the critic for the *New York Sun* was able to state that "tubular furniture … is widely accepted as synonymous with modern. In the Mid-West, when they want to bring a hotel foyer up to date, they send for a set of chromium plated chairs."[3] A. Everett (Chick) Austin, Jr., director of the Wadsworth Atheneum in Hartford, Connecticut (and friend of both Henry-Russell Hitchcock and Alfred H. Barr), acquired one of the early B3 chairs, and exhibited it in 1928 when he opened to the public a suite of rooms in his own home.[4] The "armchair of metal tubing and webbing," as it was described in the accompanying catalogue,[5] may have looked strangely out of place in a study filled with furniture by the French Art Deco designer Pierre Chareau. But a complete interior by Breuer (a dining room from the 1927 Deutscher Werkbund *Weissenhofsiedlung* exhibition) could be seen by readers of *Good Furniture Magazine* in 1928, in the context of an article by Wilhelm Lotz on German furniture. The "puritanically charmless" dining room was furnished, naturally, with tubular furniture. "These chairs of steel tubing," wrote Lotz, "must be the most logical furniture that has come out of extreme modernism!"[6] John Gloag, writing in *Creative Art* in 1929, was also unconvinced. In reference to the chairs of Breuer and Mies van der Rohe, he wrote: "The metal furniture of the Robot modernist school is as efficient and about as interesting as modern sanitary fittings."[7] On the other hand, in *The House Beautiful*, Dorothy Todd, writing in the same year, was an enthusiastic convert: "Beauty … results from the elimination of the unnecessary … the result of such selection, of the sloughing off of the unnecessary and

cumbersome, may be seen in the metal chairs in Figure 2 [a Breuer dining room]."[8]

In 1930s America there was a growing interest in and acceptance of modernist design; by the time Breuer arrived in the United States, he encountered a welcoming public. Harvard University, his future employer, was the first to host an exhibition devoted to the Bauhaus, in 1930–31—this included photographs of Breuer's Dessau interiors.[9] Edward Steichen photographed a model in a straw hat and summer dress, seated in the B3 chair, for *Vogue* in 1932.[10] The *Machine Art* exhibition, curated by Philip Johnson at New York's Museum of Modern Art in 1934, displayed a cantilevered tubular chair and nested tables by Breuer, alongside tubular furniture manufactured by the American firm Howell—available at "department and furniture stores."[11] By 1935, in an article titled "A Guide for Buying Modern" by American designer Russel Wright, readers were counseled on how to distinguish the real thing from the imitation; the B3 chair was already at this point "a famous chair … a high spot in furniture history."[12] Breuer's metal furniture was heavily featured in the exhibition on the early years of the Bauhaus that was held at the Museum of Modern Art in 1938.[13]

If "amateurs of the arts … know of Marcel Breuer, they usually identify him as the inventor of tubular metal furniture," wrote a *Time* magazine critic in the same year. His first designs "were promptly pirated and vulgarized, and being identified as a furniture designer has injured Architect Breuer ever since."[14] The occasion for this comment was the first American exhibition devoted exclusively to Breuer's work, again at Harvard. The show, probably organized by Hitchcock, can be seen as a concerted attempt to present "Architect Breuer"—now a professor at Harvard's School of Architecture, after all—to an American public. Breuer's furniture made up only a quarter of the exhibition (and much of it was of his later plywood designs); the rest consisted of architectural models, photographs, and plans.[15] These ranged from a 1925 study for a prefabricated house to 1936 plans, designed with F. R. S. Yorke in England, for a "Garden City of the Future." Also included was "recent work carried out by Mr. Breuer in association with Mr. Gropius in America."[16]

Breuer had already received a commission to design the furniture for a new dormitory at Bryn Mawr College in Pennsylvania in 1937; he also began to make his mark as an architect. He and Gropius collaborated in 1937–38 on a house for Gropius in Lincoln, Massachusetts, and in 1939 Breuer built a home for himself on a neighboring plot of land. In the houses they built in Cambridge, Massachusetts, Breuer and Gropius used materials and construction techniques in such a way as to achieve a synthesis between European modernism and the traditions of New England. They employed, for example, building materials typical of the region (such as natural stone and wood shingles), and integrated traditional American forms (such as the porch or veranda, and the fireplace); but they also incorporated elements characteristic of "Bauhaus modernism," such as continuous strip windows and an overall shape based on the cube. Breuer is now recognized as the dominant force in the planning of these ostensibly joint projects. His

popularity as an architect in the United States was, however, only assured through numerous publications on these first designs for America—designs that would have a marked influence on the architecture of the single-family house in New England.

Breuer and Gropius also formed an architectural partnership, executing the Frank House together in Pittsburgh in 1939, but their partnership survived only until 1941. In announcing its dissolution, Breuer effectively freed himself from a father figure.

In 1944, Breuer became an American citizen. He taught at Harvard until 1946, and in the same year moved his architectural practice to New York City. The first building Breuer designed after his partnership with Gropius had ended was the Geller House, of 1945. He divided the building into a quiet sleeping area and an expansive living area; the two were connected by a glazed corridor (in a so-called H-plan). Breuer frequently circumvented one element that was thought to be an indispensable component of the International Style: the flat roof. For his houses with an H-plan, he introduced the celebrated "butterfly" roof and, in the case of his "one-box houses," the "desk" roof. With these and other designs, Breuer grasped what has been described as "the importance of the single-family house to his new compatriots and the increasing desire of even affluent Americans for a newly informal, up-to-date domesticity."[17] The Geller House was referred to as "Tomorrow's House Today," and other houses designed by Breuer as models of "informal living."[18]

In the period from the 1940s to the 1960s, Breuer designed some seventy single-family houses, most of them in New England. He continued to receive many important commissions from Europe, as well as from across America. In 1956, he founded Marcel Breuer and Associates, Architects. In connection with a commission to design the headquarters for UNESCO in Paris, he opened an office in the French capital. Among his other executed architectural designs are Saint John's Abbey and the Abbey University complex at Collegeville, Michigan (1953–61), the University Heights campus of New York University (1956–61), and the Whitney Museum of American Art in New York (1963–66). In 1976, poor health constrained Breuer to retire.

Over the years, Breuer developed important links with New York's Museum of Modern Art. In 1948, he entered designs for chairs in the museum's International Competition for Low-Cost Furniture Design. And he was also present as an architect, participating in 1948 in its symposium devoted to the question "What Is Happening to Modern Architecture?" alongside Gropius, Eero Saarinen, Lewis Mumford, and others.[19] In the same year, the museum organized a traveling exhibition dedicated to Breuer, which appeared at the Busch-Reisinger Museum and other venues (although not at the Museum of Modern Art itself). In 1949, Philip Johnson commissioned Breuer "to design a small, suburban house for a commuter," which he described as a "low-cost house for someone who works in a big city but returns home each evening to a 'dormitory' suburb." The design was also intended to demonstrate "how much good design could be obtained at what cost."[20] The result—a furnished model house erected in the Museum of Modern Art's garden, and an accompanying monograph on Breuer written by Peter Blake—ensured a rapid increase in regard for Breuer as an architect. Some 70,000 visitors came to see the house, and it was given extensive press coverage.

Breuer's reputation as an architect reached its peak in the 1950s and '60s. His first significant large-scale commission was for the UNESCO headquarters in Paris, on which he collaborated in 1953–58 with the Italian Pier Luigi Nervi and the Frenchman Bernard Zehrfuss. This project opened the way for others of similar scale and importance and brought Breuer international recognition. Evidence of the high regard in which Breuer was by this time held in the United States was the solo show celebrating his work, presented in 1972 at the Metropolitan Museum of Art in New York. This was the first one-man exhibition that this institution had ever devoted to an architect. Breuer was now seen, alongside Gropius and Mies van der Rohe, as one of the significant trio of Bauhaus architects who had emigrated to the United States during the 1930s. While Breuer is still largely regarded as a furniture designer in Germany, in the United States he has become part of the history of American architecture.

Both as a practicing architect and in his teaching career at Harvard University, Breuer exerted enormous influence on students and younger colleagues; those most clearly indebted to his example and to his principles are I. M. Pei, Harry Seidler, Richard Meier, and Edward Larrabee Barnes. Unlike Gropius, Breuer did not propound a particular theory. It has recently been argued that "Breuer's resourcefulness reflects his freedom from the bondage of theory."[21] To the "visionary global blueprint"[22] of some great architects, Breuer opposed a pragmatism that was typical of many representatives of the second generation of modernism.

Examples of Breuer's furniture are today in every important museum devoted to, or embracing, the field of design. Particularly extensive collections are held by the Bauhaus-Archiv in Berlin; the Stiftung Bauhaus in Dessau; the Vitra Design Museum in Weil am Rhein; a private design collection in Berlin; the Centre Georges Pompidou in Paris; the Museum of Modern Art in New York; and the Busch-Reisinger Museum at Harvard University, in Cambridge, Massachusetts.

Manfred Ludewig and Magdalena Droste
Translated from the German by Elizabeth Clegg.

[1] Anneliese Fleischmann (Anni Albers), "Wohnökonomie," in: *Beilage der Neuen Frauenkleidung und Frauenkultur* (1915), pp. 7–8.

[2] Margret Kentgens-Craig traces mention of Breuer in American architectural journals in the late 1920s and '30s; see Kentgens-Craig, *The Bauhaus and America, First Contacts, 1919–1936,* Cambridge, Mass.: MIT Press, 1999, pp. 143–144.

[3] J.W.H., "Tubular Chairs 14 Years Old," in: *New York Sun* (January 28, 1939), Museum of Modern Art Archives, New York: Public Information Scrapbooks (9; 826).

[4] Helen Searing, "From the Fogg to the Bauhaus: A Museum for the Modern Age," in: *Avery Memorial, Wadsworth Atheneum: The First Modern Museum,* ed. by Eugene Gaddis, exhibition cat., Hartford, Conn., Wadsworth Atheneum, 1984, pp. 19–21.

[5] *Exhibition of Modern Decorative Art,* exhibition cat., Hartford, Conn., under the auspices of Wadsworth Atheneum, 1928, n.p.

[6] Wilhelm Lotz, "German Furniture of the Twentieth Century," in: *Good Furniture Magazine,* vol. 31 (November 1928), p. 239, ill. p. 237.

[7] John Gloag, "Wood or Metal?" in: *Creative Art,* vol. 4 (January 1929), pp. 49–50.

[8] Dorothy Todd, "Some Reflections on Modernism," in: *The House Beautiful,* vol. 66, no. 4 (October 1929), p. 474, ill. p. 416.

[9] See Leslie Topp's essay in this volume.

[10] *Vogue,* vol. 1799, no. 10 (May 15, 1932), p. 57.

[11] *Machine Art,* exhibition cat., New York, Museum of Modern Art, 1934, n.p.

[12] Russel Wright, "A Guide for Buying Modern," in: *Arts & Decoration,* vol. 42, no. 4 (February 1935), p. 27.

[13] See Leslie Topp's essay in this volume.

[14] "Architectural Odyssey," in: *Time* (August 1, 1938), p. 19.

[15] "Exhibition by Marcel Breuer," typescript catalogue, Department of Architecture, Graduate School of Design, Harvard University, Cambridge, Mass., 1938. Hitchcock wrote an introduction to the catalogue.

[16] Memorandum on the Breuer exhibition (appended to letter from Joseph Hudnut to A. Wild, June 18, 1938), in the Harvard University archives.

[17] Kathleen James, "Changing the Agenda: From German Bauhaus Modernism to U.S. Internationalism. Ludwig Mies van der Rohe, Walter Gropius, Marcel Breuer," in: *Exiles and Émigrés: The Flight of European Artists from Hitler,* ed. by Stephanie Barron and Sabine Eckmann, exhibition cat., Los Angeles County Museum of Art; Montreal Museum of Fine Arts; and Berlin, Neue Nationalgalerie, 1997–98, 252, p. 250.

[18] See Joachim Driller, *Marcel Breuer. Die Wohnhäuser 1923–1973,* Stuttgart: Deutsche Verlags-Anstalt, 1998, p. 14.

[19] "What Is Happening to Modern Architecture?" in: *Museum of Modern Art Bulletin,* special issue, vol. 15, no. 3 (Spring 1948), p. 15.

[20] Karen Köhler, "Walter Gropius und Marcel Breuer. Von Dessau nach Harvard," in: *Bauhaus: Dessau, Chicago, New York,* ed. by Georg W. Költzsch and Margarita Tupitsyn, exhibition cat., Essen, Museum Folkwang, 2000, p. 81.

[21] Franz Schulze, "The Bauhaus Architects and the Rise of Modernism in the United States," in: *Exiles and Émigrés* (as note 17), p. 232.

[22] A term used in Driller, *Marcel Breuer* (as note 18), p. 8.

LUDWIG MIES VAN DER ROHE

*** MARCH 27, 1886, AACHEN**
† AUGUST 17, 1969, CHICAGO

Installation view of *Exhibition of Architecture by Mies van der Rohe*, Art Institute of Chicago, December 15, 1938–January 15, 1939. Courtesy Franz Schulze

Although Mies van der Rohe is universally regarded as a pioneer of modernist architecture, he was already well into his thirties before his work took on the qualities customarily associated with that movement. Such deliberateness may have been typical of Mies's well-known resistance to haste, but his shift from a conservative idiom to a manner more stylistically advanced was negotiated abruptly and, excepting several modest commissions undertaken for profit rather than principle, with finality.

The change occurred in the early 1920s. By that time, he had been living and working in Berlin for well over a decade. Born in Aachen on March 27, 1886, to a middle-class family of stonemasons, he learned architecture not by attending any formal academy, but by laboring as a teenage apprentice on building sites around Aachen and as a novice draftsman in local architectural offices, where he developed a facility in drawing. That gift was sufficient to prompt him to seek further work in architecture by moving to the German capital in 1905.

Mies, long on ambition but prudent enough to recognize his drawbacks—chief among them his ignorance of the handling of wood—promptly signed on with Bruno Paul, an uncommonly versatile figure

in the German visual arts whose reputation rested on achievements in architecture, furniture design, and political cartooning. Mies worked for Paul for two years, gaining his first commission, a private residence in Potsdam, from Alois Riehl, whose expertise in the work of Friedrich Nietzsche connected with Mies's desire to learn more about philosophy. Riehl became as much a mentor as a client, greatly nourishing what developed into Mies's lifelong interest in philosophical issues.

That personal inclination is pertinent to any biographical account of Mies. While the exceptional quality of his work derived mostly from a natural form-giving ability, he did formulate an aesthetic point of view—affected largely by his understanding of Thomas Aquinas and Augustine—that set the direction of his thinking over the six decades of his professional life. In the most general terms, Mies matured into an artist of classical (as distinct from romantic) disposition, given to sobriety and simplicity of expression. Indeed, while his architectural style changed sharply in the 1920s, he remained forever true to an art of rational intent and clarity of form, eschewing any tendency toward idiosyncrasy, eccentricity, or fantasy.

What Mies absorbed about the use of wood as a design material is evident from the quality of the chairs and wall paneling he designed for the Riehl House (1907). Nonetheless, he persisted in believing he had more to learn, about architecture and the related decorative arts, and to this end in 1908 landed a position with the most famous architect in Germany at the time, Peter Behrens.

During his period of service with Behrens, he yielded willingly to the weight of the most important architectural influence of his life, the nineteenth-century romantic classicist Karl Friedrich Schinkel. Since Behrens was also an admirer of Schinkel, Mies's work took on a perceptible debt to the cool precision and sensitivity to proportion for which the earlier architect was especially notable. The effect was apparent in the most ambitious single project Mies designed prior to World War I, a huge villa meant for the Dutch industrialist and art collector A. G. Kröller and his German-born wife, Helene (née Müller). Mies's design, dating from 1912–13, was emphatically traditional in plan and classicist in ornamental vocabulary. Although he lost the commission, he submitted the design to a 1919 juried exhibition in Germany. One of the judges was Walter Gropius, who had worked in the Behrens atelier while Mies was there, and who was already a committed modernist. The Kröller-Müller project was turned down in favor of submissions clearly freer of historicist styles.

It is not certain how much that specific event affected Mies's turn from classicist to modernist form, but turn he did. Between 1921 and 1924 he designed five projects virtually without precedent in European architecture: two tall buildings sheathed in smooth, brilliantly reflective glass, an office building in concrete, and two country residences, one in concrete, one in brick. As a group they were startlingly advanced in their simplicity of form, their avoidance of ornament, and—in the case of the houses—their innovative treatment of the open plan. None of these seminal endeavors was ever realized, to some extent because of the depressed economy in postwar Germany. But several were shown as models or drawings in Berlin, or in exhibitions sponsored by progressive art groups, and they were central to the emergence of Mies as an important new figure on the German architectural scene. As if symbolically acknowledging his change in fortunes, during 1921 or 1922, he adopted a new professional identity: he gave up his birth name, Maria Ludwig Michael Mies, and thenceforth called himself Ludwig Mies van der Rohe, a combination of his father's surname (he originally added an umlaut, as "Miës," which was later dropped), his mother's maiden name (Rohe), and the invented "van der." More important to his new role, his first written statements were published, several appearing in the radical avant-garde journal G. The postwar years in Berlin encouraged vigorous ideological debate, and Mies responded accordingly, for the most part attacking what he called the formalist aesthetic: "Form is not the aim of our work, but only the result. . . . Form as an aim is formalism, and that we reject."[1] He expressed himself in writing rather as he did in designing, simply and directly, with the result often taking on an aphoristic quality: "Architecture is the will of the epoch, translated into space."[2]

Mies shifted his aesthetic position as the 1920s wore on. Having claimed in 1924 that "Ours is not an age of pathos; we do not respect flights of the spirit as much as we value reason and realism,"[3] he went on in 1930 to argue that "what is right and significant for any era—including the new era—is this: to give the spirit the opportunity for existence."[4] Nonetheless, while Mies became transfixed by the concept of the spirit in statements he made at the end of the 1920s, his efforts in architecture and planning remained palpably consistent in quality and direction. In 1925, he was selected by the Deutscher Werkbund to organize and supervise the creation of a colony of new houses in Stuttgart, the Weissenhofsiedlung (Housing estate). Mies's nomination was a clear sign of his growing importance in Germany.[5] Many of the leading European modernists—among them, Le Corbusier, Gropius, Behrens, J. J. P. Oud—accepted Mies's invitation to participate. Once completed, the settlement proved something of a triumph, persuading much of the international architectural community of the collective merits of the new modern movement.

But Mies did more at Stuttgart than organize an exhibition and design a building for it. He was occupied with furniture design as early as his days with Paul, and he continued to learn more about it from Behrens, whose own classicist furniture was echoed in the wooden chairs, tables, and upholstered sofas that Mies designed for the Werner House of 1913. But historicist classicism was hardly appropriate to the new modernism he had adopted in the early 1920s, which stood for an industrial technology expressed, in Mies's own words, in "the materials of our time." Chief among these was metal.[6]

He was, to be sure, hardly alone in this view. Marcel Breuer and Mart Stam had designed furniture made of tubular steel before Mies ever tried his hand at the medium. Indeed, it was Stam who in 1926 used steel, a substance lighter and stronger than wood, to make a chair with no rear legs—a cantilever chair that stood implicitly free of gravity. Such a concept was fully in keeping with the tendency of the modern arts toward abstraction and dematerialization. Mies himself seized

upon the idea, giving it actual form for the first time in what has come to be known as the MR chair, designed for his building at the Weissenhofsiedlung. Although not the first cantilever chair, it was clearly better proportioned and in fact more resilient than the one Stam produced, and it had the effect of leading Mies into a period of furniture design that lasted only about half a decade but that yielded some of the century's most beautiful chairs, chaises longues, tables, and sofas. Mies's special gift for deriving more than one solution from a single idea is apparent in the MR chair, which is handsomely impressive both with arms and without.

It is vital to observe that most of the furniture Mies designed, early and late, was done with a specific piece of architecture in mind. This applies especially to the work he did for the two most memorable buildings he realized while living in Berlin. For the German Pavilion at the 1929 Barcelona International Exposition he designed the so-called Barcelona chair, and a case can be made that both building and chair are the finest examples of their respective genres in his entire catalogue. The Tugendhat House, completed a year later in Brno, was a work comparable in quality to the German Pavilion, and one whose lavish budget was justified by several other classic pieces of modernist furniture that Mies produced for it. Among these, interestingly enough, were some examples of tables and chairs in wood. If Mies preferred working with metal frames, he did not turn away from wood, although he proceeded to apply to that ancient material the simplifications he had made his own by the end of the 1920s. The Parsons-type table was a standard form in his wood pieces, on which elegant veneers were often applied.

Fruitful though the years at the turn of the 1930s were, it seems likely that Mies could not have produced as much as he did at that time without the presence at his side of Lilly Reich, a gifted designer in her own right. The two were in close contact from the mid 1920s until his immigration to the United States in 1938. Reich did not design any of Mies's furniture, but her effect was apparent in the kind, quality, and color of materials used. The caning on the MR chair was her idea, and in the Tugendhat House several of the chairs were covered in lively colors associated more readily with her sensibilities than his. Reich also served on the faculty of the Bauhaus, which Mies directed in its final years 1930–33.[7] Subjected to pressure from right-wing political factions almost steadily from its founding in 1919, the Bauhaus finally lost state support in 1932. Mies managed to keep it open as a private school in Berlin for about a year, before the National Socialists forced its shutdown.

By that time, Adolf Hitler had assumed dictatorial powers as the chancellor of Germany. National Socialist doctrinal views were baleful enough and the party sufficiently powerful to convince many people of liberal sympathies to flee the country. Mies himself, for much of his adult life indifferent to politics, nursed the hope that he might stay on, but by 1937 it was apparent that the antimodernist views of the National Socialists left him with no promise of professional sustenance. Invitations for employment from abroad had begun to cross his desk, and in 1938 he elected to emigrate to Chicago, where the director-

ship of the architectural department of the Armour Institute of Technology (after 1940, Illinois Institute of Technology—IIT) awaited him. With this, a second full career began. Mies was one of a group of leading architects—including Gropius, Breuer, and Erich Mendelsohn—who left Germany to find a welcoming refuge in the United States, but he proved far and away the most successful of them. He saw no reason to alter his devotion to structural clarity, and Chicago, with its own tradition of first-rate architecture, embraced him eagerly. As a teacher he left his mark on several generations of students, among whom Jacques Brownson, James Ingo Freed, Myron Goldsmith, and Gene Summers became figures of consequence on their own, while Mies himself proceeded to exert an immense impact on the entire American profession.

The Bauhaus too was reestablished in Chicago under the direction of the Hungarian-born designer and photographer László Moholy-Nagy, who had served on the faculty in Germany. Mies was never part of the new Bauhaus (which was eventually called the Institute of Design), but his abiding renown and his earlier connection with the original school had the effect of forever linking his name with it.

One of Mies's first American architectural commissions was a totally new plan for the IIT campus. The result was the first modern college campus in the country. By the time that assignment was underway, he had been approached by Chicago developer Herbert Greenwald, who encouraged him to produce the apartment towers at 860–880 Lake Shore Drive. Completed in 1951 as a pair of lean steel cages with glass infill and no masonry, they deeply affected the design of the tall building everywhere in postwar America. Mies's own high-rise masterpiece, the bronze-clad Seagram Building (1958), was not only an exemplary curtain wall structure but, set back as it was from the edge of Park Avenue, an innovative exercise in urban planning as well. The American Mies also became fascinated by the low-rise building as a type, particularly in a form of his own invention, the unitary space free of interior columns. His exceptional ability to derive buildings of various function from a simple recipe yielded such distinguished structures as Crown Hall on the ITT campus (1956), the Nationalgalerie in Berlin (1968), and the celebrated one-room, glass-enclosed residence, Farnsworth House, in Plano, Illinois (1951).

Mies's reception in the United States was, if anything, more robust overall than the reputation he made for himself during his European years. Indeed, it can be traced as far back as the attention paid the first building he ever designed: the aforementioned Riehl House. In 1911, just four years after that building was finished, the magazine *Arts and Decoration* saluted it as "a typical example of the new movement in German domestic architecture. It exemplifies the scholarly and almost faultless styles of houses now being built."[8]

To all appearances, nothing more was heard about Mies in America for well over a decade. This hiatus is most likely traceable to several factors: the young architect's decision to join Behrens's atelier; his conservative manner of design prior to 1921; and the major interruption in communication brought on by World War I. In 1923, however, the German architecture critic Walter Curt Behrendt wrote an article

for the *Journal of the American Institute of Architects* titled "Skyscrapers in Germany," in which Mies's two boldly modernist high-rise proposals of 1921 and 1922 were hailed as works of importance. (In the same issue, two American commentators struck a decidedly contrary pose. George C. Nimmons called the Glass Skyscraper "fantastic and impractical," and William Stanley Parker suggested a caption for it: "A Nude Building falling down stairs.")[9] Two years later, in 1925, AIA president Irving Pond published an article that featured the same building, this time, however, only in the form of an illustration.[10]

By the end of the 1920s, American responses to Mies's accomplishments had perceptibly increased. Among the most notable was Henry-Russell Hitchcock's 1929 book *Modern Architecture*, an admirably thorough study covering European building from the eighteenth century to the then-present.[11] Hitchcock reviewed Mies's career up to the crucial year of 1929, when the newly completed Barcelona Pavilion attracted the attention of the well-known critics Helen Appleton Read and Sheldon Cheney.[12] The 1930s in turn witnessed even more concentrated American interest in Mies, as architect, organizer, and director of the Bauhaus. *The Architectural Review* referred to the Tugendhat House as "the consummate realization of the illusion of unclosed space: the envelope is so unobtrusive as almost to be unnoticeable."[13] Read, Hitchcock, and Philip Johnson were full of praise for the *Berliner Bauausstellung* (Berlin Building Exposition) of 1931, which was assembled by Mies and to which he contributed a full-scale house design.[14] In this instance, nonetheless, the more tradition-oriented American naysayers remained unconvinced, one of them finding European modernism guilty of "the degeneration of the calming effect of the simple line to dullness."[15]

Even so, Mies's reputation gathered adherents. His first recorded work in an American exhibition was a photograph of the Barcelona Pavilion, included in a 1930 display staged at the Harvard Society for Contemporary Art and consisting of work by figures associated with the Bauhaus. The catalogue featured an introductory note by Lincoln Kirstein, which lauded Mies both as a teacher and as an architect.[16]

While that show traveled to major venues in New York and Chicago, the event that did the most to bring Mies to the consciousness of American audiences was the historic *Modern Architecture: International Exhibition*, which opened at New York's Museum of Modern Art in February of 1932 and later circulated to Chicago and Los Angeles.[17] The organizers, Johnson (exhibition director), Hitchcock, and museum director Alfred H. Barr, Jr., gave pride of place to Mies, Le Corbusier, Gropius, Oud, and Frank Lloyd Wright. The catalogue featured essays on those five architects and related subjects. The article on Mies was written by Johnson, by far that architect's most enthusiastic American disciple. Coeval with the catalogue was a book, written by Johnson and Hitchcock, whose title, *The International Style*, has since become a catchword for most of the modernist architecture produced since the 1920s.[18]

The exhibition was presented to New York in quarters the museum occupied before it acquired its own building in 1939. About halfway through the decade, Barr, hoping for a new building, had conceived the idea of offering Mies the commission. More or less idle at the time in National Socialist Germany, Mies would have welcomed the prospect. The museum trustees, however, wanted an American architect, and Barr's proposal never came to pass. As matters turned out, Mies had to wait until he moved permanently to the United States before his first American building was realized. His immigration was both cause and consequence of his adopted country's steadily mounting awareness of him. Notice of his arrival in Chicago was widely observed by the nation's press,[19] and there was no better indication of the extent of his welcome than the ceremonial dinner staged in the fall of 1938 in the city's Palmer House hotel. The event was attended by 400 people, including the heads of some of the leading American architecture schools. As guest of honor, Mies was introduced to the gathering by Frank Lloyd Wright, who had already offered the architect hospitality at his Taliesin home and studio in Spring Green, Wisconsin.

Late in the same year, the Art Institute of Chicago put on the first American one-man exhibition of Mies's work. The show traveled in 1939 to the Albright Art Gallery in Buffalo, and included work by Mies's students at the Armour Institute.[20] In the meantime, an assignment of substantial proportions had arisen, the commission to redesign the entire Armour campus. Work on this project began in earnest in 1939, and while most of its completion would have to wait until World War II ended, by that time Mies had become a fixture in Chicago.

Nonetheless, the postwar American world was offered further displays of Mies's achievements. In 1947, the Renaissance Society at the University of Chicago staged a small exhibition[21] and the Museum of Modern Art a very large one. Philip Johnson, now in charge of the museum's architecture department, filled several galleries with the first full-scale retrospective of the work of Mies, who personally installed the exhibition.[22] At the same time, Johnson published the first monograph on Mies, a book that remains an important scholarly endeavor.[23] The architect's furniture also enjoyed a revival in the postwar U.S., largely through the efforts of its manufacturer, the Knoll Group of New York, and even today examples show up regularly in the offices of commercial firms and in new residences. In 1964, Knoll collaborated with Macy's department store in New York to stage an exhibition of Mies's furniture. Discussing one of the items on display, the Barcelona chair, the *New York Times* observed, "This elegant chair … has become almost a symbol for business, professional, cultural and governmental institutions that wish to express their progressiveness in their interiors."[24]

During the 1950s and first half of the '60s, Mies was probably the most influential architect in the world. A second large traveling retrospective was staged by the Art Institute of Chicago in 1968[25] and a third by the Museum of Modern Art in 1986,[26] on the occasion of the Mies centenary. Two landmark exhibitions opened concurrently in New York in June 2001: *Mies in Berlin* at the Museum of Modern Art, and *Mies in America*, organized by the Canadian Centre for Architecture and held at the Whitney Museum of American Art.[27] Meanwhile,

the literature on the architect has grown substantially. In 1963, he gave his personal papers to the Library of Congress in Washington, D.C., and his professional records to the Museum of Modern Art. In response, the latter set up the Mies van der Rohe Archive, the largest repository of Miesiana anywhere. Between 1986 and 1992, the archive published a twenty-volume catalogue raisonné of Mies's drawings, consisting of more than 20,000 entries.[28] The substantial cache of personal papers preserved at the Library of Congress is supplemented by archival material at the Art Institute of Chicago, the Illinois Institute of Technology, and the Bauhaus-Archiv in Berlin.

Franz Schulze
I would like to extend my thanks to Janis Staggs-Flinchum, Leslie Topp, and Christian Witt-Dörring for the assistance and advice they offered in the preparation of this essay.

[1] *G*, no. 2 (1923).

[2] *G*, no. 1 (1923).

[3] "Baukunst und Zeitwille," in: *Der Querschnitt*, vol. 4 (1924), pp. 31–32.

[4] "Die neue Zeit," in: *Die Form*, vol. 5, no. 15 (August 1, 1930), p. 406.

[5] Indications of attention to Mies by German writers on architecture can be found in the following sources: Paul Westheim, "Mies van der Rohe: Entwicklung eines Architekten," in: *Das Kunstblatt* (February 11, 1927), pp. 55–62; Walter Curt Behrendt, *Der Sieg des neuen Baustils*, Stuttgart: Wedekind, 1927; Walther Genzmer, "Der deutsche Reichspavillon auf der internationalen Ausstellung, Barcelona," in: *Die Baugilde*, vol. 11 (November 1929), pp. 1654–1657; Gustav Platz, *Die Baukunst der neuesten Zeit*, Berlin: Propyläen, 1927; Ludwig Hilberseimer, "Eine Würdigung des Projektes Mies van der Rohe für die Umbauung des Alexanderplatzes," in: *Das neue Berlin*, vol. 2 (November 1929), pp. 39–41; Curt Gravenkamp, "Mies van der Rohe: Glashaus in Berlin," in: *Das Kunstblatt*, vol. 14 (April 1930), pp. 111–113.

[6] For more information about Mies's furniture designs, see Ludwig Glaeser, *Ludwig Mies van der Rohe: Furniture and Furniture Drawings from the Design Collection and the Mies van der Rohe Archive*, exhibition cat., New York, Museum of Modern Art, 1977.

[7] For more information about the Bauhaus, see Hans Maria Wingler, *The Bauhaus: Weimar, Dessau, Berlin, Chicago*, Cambridge, Mass.: MIT Press, 1969. See also Margret Kentgens-Craig, *The Bauhaus and America: First Contacts 1919–36*, Cambridge, Mass.: MIT Press, 1999.

[8] "A Prototype of the New German Architecture," in: *Arts and Decoration*, vol. 1, no. 6. (April 1911), pp. 272, 274.

[9] Walter Curt Behrendt, "Skyscrapers in Germany"; George C. Nimmons, "Skyscrapers in America"; William Stanley Parker, "Skyscrapers Anywhere," in: *Journal of the American Institute of Architects*, vol. 11 (September 1923), pp. 365–372.

[10] Irving K. Pond, "From Foreign Shores," in: *Journal of the American Institute of Architects*, vol. 13 (November 1925), pp. 402–405.

[11] Henry-Russell Hitchcock, *Modern Architecture: Romanticism and Reintegration*, New York: Payson & Clarke, 1929.

[12] Helen Appleton Read, "Germany at the Barcelona World's Fair," in: *The Arts*, vol. 16 (October 1929), pp. 112–113; Sheldon Cheney, *The New World Architecture*, London: Longmans, Green, 1930.

[13] "House Plans, 1830–1930," in: *Architectural Review*, vol. 77 (March 1935), p. 104.

[14] Helen Appleton Read, "Exhibitions in Germany: The Berlin Architectural Show," in: *The Arts*, vol. 18 (October 1931), pp. 5–17; Henry-Russell Hitchcock, "Architectural Chronicle: Berlin, Paris, 1931," in: *Hound and Horn*, vol. 5 (October–December 1931), pp. 94–97; Philip C. Johnson, "The Berlin Building Exposition of 1931," in: *Shelter*, vol. 2, no. 1 (January 1932), pp. 17–19, 36–37.

[15] Mathilde C. Hader, "The Berlin Housing Exhibit," in: *Journal of Home Economics* (1931), p. 1135.

[16] Lincoln Kirstein, Introduction, *Arts Club of Chicago: Catalogue of an Exhibition from the Bauhaus, Dessau, Germany, 1931*, p. 3.

[17] Henry-Russell Hitchcock, Philip C. Johnson, and Lewis Mumford, *Modern Architecture: International Exhibition*, exhibition cat., New York, Museum of Modern Art, 1932.

[18] Hitchcock and Johnson, *The International Style: Architecture Since 1922*, New York: Norton, 1932.

[19] "Mies van der Rohe Joins Armour Faculty," in: *Pencil Points*, vol. 19, supp. 45 (October 1938); see also "Mies van der Rohe to Teach in Chicago," in: *Magazine of Art*, vol. 31, no. 10 (October 1938), p. 595, and "Armour's Architect," in: *Time*, vol. 32 (September 12, 1938), p. 50.

[20] Marion Rawls, "An Exhibition of Architecture by Mies van der Rohe," in: *Bulletin of the Art Institute of Chicago*, vol. 32, no. 7 (December 1938), p. 104; see also Walter Curt Behrendt, "Mies van der Rohe," in: *Magazine of Art*, vol. 32 (October 1939).

[21] *An Exhibition of Architecture by Mies van der Rohe*, exhibition cat., Chicago, The Renaissance Society, 1947.

[22] "Mies van der Rohe: Exhibition, Museum of Modern Art, New York," in: *Architectural Record*, vol. 102 (September 1947), pp. 81–88.

[23] Philip C. Johnson, *Mies van der Rohe*, New York: Museum of Modern Art, 1947.

[24] George O'Brien, "Furniture Classics Exhibited Like Works of Art: Macy's Offers Mies Designs for First Time," in: *New York Times* (October 16, 1964), p. 42.

[25] A. James Speyer, *Mies van der Rohe: A Retrospective Exhibition*, exhibition cat., Chicago, Art Institute and Graham Foundation for Advanced Studies in the Fine Arts, 1968. This exhibition traveled from Chicago to the Akademie der Künste, Berlin; the Walker Art Center, Minneapolis; The National Gallery of Canada, Ottawa; and the Amon Carter Museum of Western Art, Fort Worth.

[26] *Mies van der Rohe Centennial Exhibition* (no catalogue), 1986. This show traveled from New York to the Museum of Contemporary Art, Chicago and the Neue Nationalgalerie in Berlin.

[27] *Mies in Berlin*, exhibition cat., ed. by Terence Riley and Barry Bergdoll, New York, Museum of Modern Art, 2001; *Mies in America*, exhibition cat., ed. by Phyllis Lambert et al., New York, Whitney Museum of American Art, 2001.

[28] Arthur Drexler, ed., *The Mies van der Rohe Archive: An Illustrated Catalogue of the Mies van der Rohe Drawings in the Museum of Modern Art*, vols. 1–4, introductory notes by Arthur Drexler and Franz Schulze, New York: Garland, 1986. This publication was followed by two others: Schulze, ed., *The Mies van der Rohe Archive*, vols. 5–6, New York: Garland, 1990, and Schulze, ed., with George E. Danforth, consulting ed., *The Mies van der Rohe Archive, Part 2: 1938–67, The American Work* (vols. 7–20), New York: Garland, 1992.

MARIANNE BRANDT

*** OCTOBER 6, 1893, CHEMNITZ**
† JUNE 18, 1983, KIRCHBERG, SAXONY

Cover of the catalogue *International Exhibition of Metalwork and Cotton Textiles*, American Federation of Arts, 1930. Courtesy The Metropolitan Museum of Art

Marianne Brandt was born in Chemnitz on October 6, 1893, into a respectable, bourgeois family. She was the second of three daughters in the family of a counselor of justice by the name of Liebe. From 1911 to 1917, she studied painting and sculpture at the Grossherzogliche-Sächsische Hochschule für bildende Kunst (Ducal Saxon College of Fine Arts) in Weimar, and thereafter set up her own studio in the city and worked independently as an artist. She married the Norwegian painter Erik Brandt in 1919, and from that year until 1923 the couple traveled extensively in France and Norway. After their return to Germany, Brandt enrolled at the Bauhaus in Weimar in early 1924. There she took the preliminary course, which was taught by Josef Albers and László Moholy-Nagy. Moholy-Nagy suggested that Brandt join the school's metal workshop, which he directed.

Brandt followed this advice and studied in the metal studio from the summer semester of 1924 to the end of the winter semester of 1924–25, after which the school moved to Dessau. There, Brandt began an apprenticeship in metalwork, which she did not complete. During the summer semester of 1926, she designed lamps for Walter Gropius's new Dessau Bauhaus building. Later that summer, Brandt moved with her husband to Paris, where they stayed until April 1927. She then returned to the Bauhaus, and it was around this time that she made her first research into lighting techniques and established contacts with lighting manufacturers. After Moholy-Nagy left the Bauhaus, Brandt served, from April 1928 to the end of June 1929, as acting head of its metal workshop.

Brandt may be counted among the most successful students of the Bauhaus. Her 1924 teapot—one of her earliest creations—is now regarded as a design icon of the twentieth century. In fact, it was really *only* through her work at the Bauhaus between 1924 and 1929 that she exerted an influence on German design and achieved such high regard. When she initially joined the school as a student, Brandt destroyed almost all of her previous work as a painter. This decisive gesture signaled her passage from the fine arts to the applied arts—as required by the Bauhaus program—and was typical of the spirit of commitment and intensity that she brought to her work. While Brandt was at the Bauhaus—and in subsequent years—she made large-scale collages in which she addressed contemporary themes, combining her own photographs with scraps of text and illustrations from newspapers. She also worked as a photographer. However, these two areas of her artistic activity only came to light shortly before her death, as she had almost never included them in exhibitions.

When Brandt joined the Bauhaus, Moholy-Nagy immediately recognized her enormous sculptural talent, and his influence is clearly reflected in her work. In the Bauhaus metal workshop, which was initially oriented toward traditional craft skills, Moholy-Nagy introduced two innovative notions: design projects for the latest products (such as lighting fixtures), and a new emphasis on basic geometric forms—the sphere, the cylinder, the circle, and the square—and their interrelationships. Moholy-Nagy also had a distinct sensitivity to the use and juxtaposition of materials; this too made a decisive impact on Brandt. With all of this as her starting point in 1924, Brandt designed in swift succession a spherical and a hemispherical teapot, various ashtrays, and other objects. The theoretical basis for her work was the analysis of function. Each object devised was intended as a "prototype for mass production."[1] In the metal workshop, as in all the Bauhaus studios, basic general forms were considered especially suitable for mass production. Certain items—for example, the teapot—were made to order. At this point in her career, Brandt achieved an independent understanding of Bauhaus principles, which she applied at a consistently high level.

At the Dessau Bauhaus, Brandt played an important part in the reorganization of the metal workshop. The development of lamps of every possible type now became a specialty of the studio; and it was chiefly through these that the workshop became reoriented toward mass

production. During the second half of the 1920s, it produced an enormous variety of prototypes: desk lamps, bedside-table lamps, lighting fixtures for the wall or ceiling, including many designs with hinged, movable supports. Several prototypes, in particular the "Kandem lamps," were made with fellow student Hin Bredendieck.

Under Brandt's leadership, the metal workshop entered a new phase of collaboration with manufacturers, including the firms Körting & Mathiesen AG and Schwintzer & Gräff. Whereas at the Weimar Bauhaus, lamps had been developed at the school and only then offered to manufacturers, at Dessau, both producer and designer were involved in the design process. In 1929, however, Brandt was forced to resign from her position as head of the workshop, when Hannes Meyer (who succeeded Gropius as the school's director) merged the metal studio with the workshops for furniture and for murals, creating a multipurpose interior-design unit under the direction of Alfred Arndt. It is interesting to note that, during the 1920s, technical appliances—telephones, toasters, radios, vacuum cleaners, and so on—were basically ignored at the Bauhaus. Even with the greater degree of designer-manufacturer collaboration instituted after 1925, "industrial design" in the true sense was never really achieved at the school. This was first to emerge in Germany in the 1930s, and after the school's demise.

After leaving the Bauhaus, Brandt went to work at Gropius's architectural practice in Berlin, initially on designs for furniture and interiors for the Dammerstock estate in Karlsruhe. In 1929, she was among the artists represented in the exhibition *Film und Foto* (Film and Photography) mounted in Stuttgart. For three years beginning in 1930, Brandt worked for the Ruppelwerke metalware factory, in Gotha, Thuringia. She was responsible for the design and redesign of small objects and appliances made of enameled sheet metal: napkin holders, stamp boxes, pen rests, inkwells, clocks, wardrobes. After the high quality of her work at the Bauhaus, the banality of these objects is almost shocking. It is interesting to compare Brandt's career in this respect with that of Wilhelm Wagenfeld. When, in 1935, he was appointed artistic director of the glass factory Vereinigte Lausitzer Glaswerke, that company too had relatively low aesthetic standards. But he was able to establish an entirely new image for the firm through his extraordinary single-mindedness and tenacity. Clearly, it was in these qualities that Brandt was lacking, and not in artistic talent. It has not yet been established whether Brandt left the Ruppelwerke firm in 1933 of her own volition, or because she was dismissed for political reasons. She was subsequently unable to find a post of equal status and significance, despite her continuing support from Moholy-Nagy. Her oil paintings, textiles, and other work produced between 1933 and 1949, when she lived at her parents' house in Chemnitz, were undertaken purely to earn a living or for her own pleasure.

In 1949, Brandt was appointed by architect Mart Stam to teach at the Staatliche Hochschule für Werkkunst (State College for Applied Art) in Dresden. Here, she served as a lecturer on wood, metal, and ceramic design. It was at this point that a new phase began in Brandt's career, as a designer of earthenware objects. Although she created only a handful of these pieces—a lamp and some stackable canteen tableware—they are of note in that they presage the angular look of designs in the 1960s. But Brandt was unable to pursue this direction in Dresden—from 1949 a part of the German Democratic Republic, where modernism in design (as in the fine arts) would soon be rejected as formalist, and historical and decorative forms were again in demand. Over the following decade, none of the designs that Brandt produced were realized.

From 1951 to 1954, she lectured (again under Stam) at the Hochschule für angewandte Kunst (College for Applied Art) in the Weissensee district of East Berlin. The department she led there subsequently evolved into an institute for industrial design. The highlight of Brandt's life in East Germany was her role as chief organizer of the exhibition *Deutsche angewandte Kunst* (German Applied Art), which took her to Beijing and Shanghai in 1953–54.

Brandt retired in 1954, and returned home to Chemnitz (by this time known as Karl-Marx-Stadt), where she devoted herself over the next years to painting and small-scale sculpture. In 1976, ill health forced her to move into a nursing home, where she died in 1983.

Over the course of her career, Brandt remained faithful to the spirit of the Bauhaus in her approach to design; she nonetheless lacked the initiative, the stimulating environment, and the self-confidence to make her creative presence felt during her lifetime. She was, of course, also working in a field that was still overwhelmingly dominated by men, and during an era of enormous political pressures. Brandt never consciously focused on the pursuit of her own artistic career: there is no known evidence of an exhibiting strategy to draw attention to her work through publications.

While the Bauhaus eventually acquired a degree of acceptability in the German Democratic Republic, Brandt's reputation did not much profit from this; her contributions (unlike those of certain other Bauhaus members) could not easily be reconciled with the ideals of Communism. Those of her designs that remained in production in East Germany were sold through a state-run art dealership based in Leipzig. Beginning in the 1960s, Brandt managed to circumvent official channels, and to have examples of her designs placed in the Bauhaus-Archiv in West Berlin.

Through a number of group exhibitions in the United States since the 1930s (notably those devoted to the Bauhaus), Brandt's name has become familiar to an interested American public. A photograph of a lamp by Brandt was included in the very first American Bauhaus exhibition, organized by the Harvard Society for Contemporary Art in 1930–31—it was lent by Philip Johnson, one of the earliest American supporters of the Bauhaus.[2] Also in 1930–31, a traveling exhibition of metalwork and textiles organized by the American Federation of Arts appeared in Boston, New York, Chicago, and Cleveland; the show featured (alongside work by Wagenfeld) four examples of Brandt's metal designs from the Dessau Bauhaus.[3] The show *Bauhaus 1918–1928*, organized by Herbert Bayer and Walter and Ise Gropius for New York's Museum of Modern Art in 1938, also included Brandt's work. The catalogue that accompanied this exhibition thoroughly documented the school's metal workshop. In addition

to designs now readily associated with Brandt, also presented were lesser-known works, such as a fish casserole dish and an egg boiler.[4] Lewis Mumford, in his review of the show, singled out Brandt's lighting designs, which he describes as setting "new standards for machine design."[5] The exhibition *50 Years Bauhaus*, first shown in Stuttgart in 1968, toured internationally until 1974, including presentations in 1969–70 in Chicago, Toronto, and Pasadena. The catalogue for this major show illustrated many of Brandt's metalwork designs, including her 1924 teapot and various examples of lighting design.

The Museum of Modern Art acquired its first works by Brandt in 1938, the Busch-Reisinger Museum as early as 1948. Brandt designs are also in the collections of the Saint Louis Art Museum, the Metropolitan Museum of Art in New York, and the Wadsworth Atheneum in Hartford, Connecticut. The four public collections with the greatest concentrations of her work today are: the Bauhaus-Archiv in Berlin, the Bauhaus-Museum in Weimar, the Stiftung Bauhaus in Dessau, and the Busch-Reisinger Museum in Cambridge, Massachusetts.

Since the 1980s, the Italian company Alessi has marketed several of Brandt's ashtray designs, her silver tea and coffee service, and other objects. While Brandt's work has been featured in almost every exhibition devoted to the Bauhaus, no substantial biographical study has yet been published on her, nor has she been the subject of a solo exhibition in Europe or in the United States.

Manfred Ludewig and Magdalena Droste
Translated from the German by Elizabeth Clegg.

[1] Wilhelm Wagenfeld, "Zu den Arbeiten der Metallwerkstatt," in: *Bauhaus Weimar*, special issue of the journal *Junge Menschen* (1924); reprint, Munich: Kraus, 1980, p. 187.
[2] *Bauhaus, 1919–1923 Weimar, 1924 Dessau*, exhibition cat., Cambridge, Massachusetts, Harvard Society for Contemporary Art, 1930, n.p. For further information on this exhibition, see Leslie Topp's essay in this volume. Also available for study at this exhibition was Bauhaus publication no. 7: *Neue Arbeiten der Bauhauswerkstätten*, Passau: Passavia Druckerei, 1925; reprint, Mainz: Kupferberg, 1981. The section on the metal workshop opened with an illustration of Brandt's iconic teapot of 1924 (p. 46). Also included were illustrations of a full coffee/tea service and examples of her ashtray designs.
[3] *Third International Exhibition of Contemporary Industrial Art: Decorative Metalwork and Cotton Textiles*, exhibition cat., American Federation of Arts, 1930–31.
[4] *Bauhaus 1919–1928*, ed. by Herbert Bayer, Walter Gropius, and Ise Gropius, exhibition cat., New York, Museum of Modern Art, 1938, pp. 52–55.
[5] Lewis Mumford, in his column "The Sky Line," in: *The New Yorker* (December 31, 1938), p. 38. Museum of Modern Art Archives, New York: Public Information Scrapbooks [9; 826].

THEODOR BOGLER

*** APRIL 10, 1897, HOFGEISMAR**
† JUNE 13, 1968, MARIA LAACH

Cover of the invitation to the preview of *Bauhaus 1919–1928*, Museum of Modern Art, New York, December 6, 1938–January 30, 1939. The Museum of Modern Art Archives, New York: Archive Pamphlet File, no. 82. Photograph © 2001 The Museum of Modern Art, New York

Born on April 10, 1897, Theodor Bogler was raised in the town of Hofgeismar, near Kassel. He completed his high-school education in 1914, and then served as an officer for the duration of World War I. In 1919, he worked briefly at an architectural practice, and in October of that year enrolled at the Bauhaus in Weimar. He studied there for three semesters, completing the preliminary course taught by Johannes Itten and also attending classes given by Lyonel Feininger. Bogler spent one semester in 1920 studying architecture and art his-

tory at the Technische Hochschule (Technical College) in Munich, before deciding to return to the Bauhaus. In November of the same year, he began an apprenticeship in the Bauhaus ceramics workshop based in Dornburg, outside of Weimar. He completed this term in July 1922, shortly before his marriage. Bogler helped organize the *Erste Bauhaus-Ausstellung* (First Bauhaus Exhibition) in 1923, and produced his first designs for earthenware containers for the Velten workshop, at the earthenware manufacturer Velten-Vordamm, near Berlin. Bogler served from early 1925 until the end of 1926 as head of the Velten-Vordamm modeling and mold workshop. His wife's suicide in 1925 threw him into a period of personal crisis. He converted to Catholicism and, on July 4, 1927, entered the monastery at Maria Laach in Germany's Eifel region. From 1929, Ars Liturgica, a commercial concern attached to the monastery, sold religious ceramics designed by Bogler and fabricated at Velten. After the Velten factory went bankrupt, Bogler and Ars Liturgica collaborated with two other manufacturers, HB Werkstätten Hedwig Bollhagen in Marwitz, and the state majolica factory in Karlsruhe. A number of items designed by Bogler remained in production at the Karlsruhe factory until the 1960s. Bogler formally entered the monastic order at Maria Laach in 1931, and in the following year he became a priest. For a period, he led the monastery's restoration workshop. Beginning in 1939, Bogler served for nine years as prior of the Benedictine abbey at Maria Laach, and from 1948 he was in charge both of the monastery's artistic workshops and of Ars Liturgica. He continued to make designs for containers and other objects; these were manufactured by a variety of local firms and sold anonymously. Bogler died at Maria Laach on June 13, 1968.

WORK AND RECEPTION

Unlike the other Weimar Bauhaus workshops, the ceramics studios were not located in the city itself but some thirty kilometers away, in the small village of Dornburg. According to Bauhaus principles, students pursued an apprenticeship in a particular workshop, and were taught in every case by a "master of form" (concerned with matters of aesthetics) and by a "master of craft" (concerned with specific technical procedures). At the ceramics workshop, the sculptor Gerhard Marcks held the former post, and master craftsman Max Krehan the latter. Bogler joined the ceramics studio in late 1920, and by 1922 he had begun to make his mark as its most gifted student, a reputation he was repeatedly to confirm.

In 1923, for the kitchen of the school's model house, Haus am Horn, Bogler designed a set of storage jars that were especially suitable for mass production. Each container design was developed out of basic stereometric forms: hemispheres and cylinders. Bogler based his design on the intended function of these items. As he explained: "The pots are to be placed close to each other, and yet it will be easy to pick out one from the row, because their lower, hemispherical sections are shaped in such a way that they can readily be grasped."[1]

At the Velten-Vordamm earthenware factory, which produced the prototypes of these designs, Bogler found an important source of inspiration and ideas, which he integrated into his activities at the Bauhaus workshop. Here he was entrusted with the production of plaster models, and with overseeing the mass production of pieces constructed from molds. This last was a new concept for the Bauhaus: up to this point, the production of its ceramics had involved only objects turned on a potter's wheel. In 1923, Bogler designed a "combination" pot, which was, in effect, a coalescence of all the design principles he had so far established. Here Bogler began with a basic teapot, formed out of a few simple shapes in accordance with his principle of montage, and recombined these individual parts to create an entirely new form. The inspiration for this new design came from Walter Gropius, who had sought to rationalize the architectural building process through standardization—utilizing a system of large-scale building blocks—thereby exploiting the possibilities offered by industrial mass production. The several variations on Bogler's teapot were in fact cast in the Bauhaus workshop (but it was discovered that the piece's lower, hemispherical section frequently sagged during the firing process).

Bogler was concerned that the objects he designed for mass production should have a look that was distinct from that of ceramics made by hand. Just as the individual handmade piece should, he felt, bear the traces of its production process, so should the mass-produced item attest, at least in its design, to the manner of its making.[2] Construction according to the principle of montage, and shapes that were "optimally concise and rigorous,"[3] were among the characteristics that were to ensure Bogler's work a special place, even in the context of the high standards of ceramic production during the Weimar era.

It did not take long for Bogler to recognize that the traditional practices of the Dornburg ceramics workshop would offer him little room for further development, and he decided to leave the Bauhaus. Later, when that institution was relocated at Dessau—now far more strictly a "school of design"—no ceramics workshop was established: the crafting of the individual object was no longer part of the Bauhaus program. In 1925, Bogler took over the modeling and mold workshop at the earthenware factory at Velten-Vordamm. He was the first former Bauhaus master to be appointed to such a position by an industrial concern *because* of his Bauhaus background, and the first to realize the Bauhaus principle of the union of art and technology in such a context.

In the two years before he entered the monastery at Maria Laach in 1927, Bogler produced an enormous number of designs for household ceramics: pots, bowls, jars, and so on. These objects (to which scholars have paid insufficient attention) demonstrate Bogler's recognition of the need to reconcile the formal principles of the Bauhaus with prevailing market conditions. The notion of the "perfect prototype" was replaced by the creation of a variety of products, while a greater decorative element conceded to the tastes of potential buyers. Painted surfaces were introduced, the favored patterns—for example, concentric circles—often deriving from the form of the object itself. However, after leaving the Bauhaus, Bogler was never again to achieve the aesthetic quality of his early work.

Ironically, it was only after Bogler's term of association with the Bauhaus that audiences in the United States had their first occasion to discover his work. The exhibition *Bauhaus, 1919–1923 Weimar, 1924 Desssau* was organized by the Harvard Society for Contemporary Art, and was first presented in Cambridge, Massachusetts December 1930–January 1931. Included among the Bauhaus publications displayed for patrons to view was *Staatliches Bauhaus, Weimar 1919–1923* (which featured Bogler's mocha machine and combination teapot), the first record of the Bauhaus activities. Also available for study were the books *Ein Versuchshaus des Bauhauses in Weimar* (documenting the Haus am Horn exhibition), and *Neue Arbeiten der Bauhauswerkstätten*. The latter referenced Bogler's work extensively—his combination teapots, storage containers with lettering, mocha machine, plain storage containers, as well as an advertisement for Haus am Horn, illustrated with a view into the kitchen.

Bogler's commitment to the religious life of the brotherhood at Maria Laach was incompatible with any emphasis on his identity as an artist; he was nonetheless able to put his artistic abilities to the service of the monastic community.[4] It is in the context of the Bauhaus, however, that his name is best remembered. Bogler's pieces are outstanding examples of two central Bauhaus tenets: the search for prototypes suitable for mass production and the drive toward a reconciliation of ceramic works with basic forms.

Unfortunately, very little of Bogler's work has survived. The finest collection, without question, is that at the Bauhaus-Museum in Weimar, followed by that at the Bauhaus-Archiv in Berlin. A few items are at the Museum für Kunst und Gewerbe (Museum of Fine and Applied Arts) in Cologne, and at the Kunstgewerbemuseum (Museum of Applied Arts) in Berlin. In the United States, Bogler's work can be found in the collections of the Cooper-Hewitt National Design Museum and the Museum of Modern Art in New York; the Carnegie Museum of Art in Pittsburgh; the Detroit Institute of Arts; and the Virginia Museum of Fine Arts in Richmond. A one-man show devoted to Bogler has yet to be organized, either in Germany or in the United States—this is undoubtedly because of the scarcity of existing work. Nonetheless, Bogler's achievements have been featured in every substantial exhibition devoted to the Bauhaus. Of particular significance for Germany in this respect was the exhibition *Keramik und Bauhaus* (Ceramics and the Bauhaus), organized in 1989 by the Bauhaus-Archiv in West Berlin and subsequently shown at the Gerhard Marcks Haus in Bremen and the Hetjens Museum in Düsseldorf.

Bogler's early work has been shown only twice in America: in 1938, in the exhibition *Bauhaus 1919–1928*, organized by Herbert Bayer and Walter and Ise Gropius, and presented at the Museum of Modern Art, New York; and in the touring exhibition *50 Years Bauhaus*, sponsored by the Federal Republic of Germany, which appeared at the Illinois Institute of Technology in Chicago in 1969 before traveling to Toronto and Pasadena in 1969–70. In both the 1938 and 1969 Bauhaus exhibitions, Bogler was represented with his designs from 1923: the combination teapot, mocha machine, and storage containers—all conceived with the needs of mass production in mind. Bogler's designs did not attract the attention of critics who reviewed either of these exhibitions; they chose instead to focus on the Bauhaus' avant-garde furniture designs and metalwork. Nonetheless, Bogler's contribution to the manifestation of the Bauhaus ethic and ideals was pivotal: his distinctive work was not only among the principal achievements of the school's ceramics workshop, but of the Weimar Bauhaus in its entirety.

Manfred Ludewig and Magdalena Droste
Translated from the German by Elizabeth Clegg.

[1] Klaus Weber, "Theodor Bogler," in: *Keramik und Bauhaus*, ed. by Weber, Berlin: Bauhaus-Archiv, 1989, p. 61.
[2] Ibid., p. 63.
[3] Ibid., p. 65.
[4] Weber's biography of Bogler (as note 1) was based largely upon extensive research carried out at the monastery.

WILHELM WAGENFELD

*** APRIL 15, 1900, BREMEN**
† MAY 28, 1990, STUTTGART

Cover of exhibition catalogue *Contempora Exposition of Art and Industry*, Art Center, New York, June 18–September 15, 1929

Because of his long and successful involvement with industry, and the ethical and aesthetic integrity of his approach to design, Wilhelm Wagenfeld is today regarded as one of the founding fathers of industrial design as we now understand the field. In the context of design in Germany, Wagenfeld's achievement embodied—more compellingly, consistently, and effectively than that of any other exponent of the Bauhaus—a commitment to the integration of art and industry.

Wagenfeld was born April 15, 1900 in Bremen. From 1914 to 1918, he trained as a draftsman at Koch & Bergfeld, a silverware manufacturer in that city. For three years starting in 1916, he also attended the local Kunstgewerbeschule (School of Applied Arts), where he took courses in calligraphy and drawing. Subsequently, from 1919 to 1922, he studied design, modeling, silversmithing, and metal engraving at the Zeichenakademie (Drawing Academy) in Hanau; then, at the start of the academic year 1923–24, he joined the Bauhaus in Weimar. He took the preliminary course taught by László Moholy-Nagy and, because of his earlier training, was immediately allowed to join the metal workshop. Wagenfeld formally completed his apprenticeship as a silversmith on April 3, 1924.

With the encouragement of Moholy-Nagy, Wagenfeld focused on the design of lighting fixtures, and the development of the Bauhaus table lamp. His 1924 concept for the lamp was one of his first outstanding designs, made when he had been at the Bauhaus only a few months. Of this piece, Wagenfeld observed: "A circular base, a cylindrical stem, and a spherical shade are its most important elements."[1] Following the thinking of Moholy-Nagy, Wagenfeld's design combines glass and metal to establish a sense of contrast between two materials, and achieves a harmonious balance between weight and lightness, stability and transparency. While the Bauhaus table lamp looks like a mass-produced object, its appearance as such is deceptive: each lamp was made individually and demanded the skills of specialized craftsmen. (In fact, it was not until the early 1930s that Wagenfeld would establish his mastery of design for mass production.)

Over the following months of 1924, he also produced designs for a coffee and tea service, three "fat/lean" sauceboats (so named because they had two different spouts for pouring heavy or thin liquids), two tea caddies, and several variations on a spherical pitcher. After the closing of the Weimar Bauhaus in 1925, Wagenfeld did not relocate with the school to Dessau; instead, he stayed on at the Weimar metal workshop. When the Staatliche Bauhochschule (State Architectural School) opened in the city, he joined that institution's metal workshop, and from April 1926 served as assistant to its director, Richard Winkelmayer. Wagenfeld replaced Winkelmayer as head of the workshop in April 1928, and remained in this post until the school was closed in 1930.

At the Bauhochschule, Wagenfeld drew on his enormous knowledge of metalworking processes to concoct new combinations of material and form. He devoted himself primarily to the design of lamps, notably the adjustable bedside-table lamp and the wall light No. 39. These pieces, and his metal tableware of the same period, no longer evince a "constructive" process, but highlight Wagenfeld's emphasis on soft, flowing lines.

This fluid aesthetic was later to become the starting point of his designs for the Jena manufacturer Schott & Gen., producers of heat-resistant glass. In 1931 Wagenfeld designed for Schott & Gen. a collection of plates, bowls, and pots, in addition to his well-known glass tableware and accompanying teapot. According to Walter Scheiffele: "The body of the pot resembles an elastic glass bubble slightly de-

formed by its own weight. The lid, spout, and handle emerge … organically out of the body. … Like Wagenfeld's earlier Bauhaus table lamp, the tea service was to become a classic of avant-garde design. … Nothing could be better suited to the new tubular-steel tables … with their light glass tops."[2] Along with the Bauhaus table lamp, this glass tea service made Wagenfeld's name. These pieces embody some of the characteristics that were to dominate throughout Wagenfeld's career as a designer: contours that are taut yet delicate, and a use of line that is always sensitive and never severe, angular, or ornate.

In 1933, Wagenfeld, Walter Gropius, and Martin Wagner were the only three members of the Deutscher Werkbund to oppose the ruthless measures being taken by the new National Socialist regime. From 1931 to 1935, Wagenfeld taught at the art school in Berlin. He also took on independent work in this period: for example, creating new designs to improve the quality of the work produced by glassblowers based in the Thüringer Wald—this was Wagenfeld's introduction to working with glass; shortly thereafter, he made his first designs for Schott & Gen.

Wagenfeld's work soon proved to be commercially successful. In 1935, he became the artistic director of the glassware company Vereinigte Lausitzer Glaswerke (VLG) in Weisswasser, in the Upper Lausitz region. There, he established a combined design, modeling, and research workshop for glass production. For three years beginning in 1942, his career as a designer was interrupted by military service and eventual internment as a prisoner of war. After World War II, Wagenfeld received numerous requests from all over Germany for his services as teacher, advisor, or artistic director—but soon found that his own uncompromising standards for the quality of work were incompatible with the realities of the offers he accepted. With the formal division of Germany into two republics in 1949, Wagenfeld could not continue his collaboration with the VLG (which was based in East Germany)—although a number of his designs for drinking glasses remained in production there until the 1960s. Many of Wagenfeld's designs were rejected as insufficiently "decorative."

Wagenfeld served from 1947–49 as a professor of industrial design at the Hochschule für bildenden Künste (College of Fine Arts) in West Berlin. In 1949, he began to produce designs for the metalwork specialist Württembergische Metallwerkfabrik (WMF) in Geislingen, and in 1954 he established his own design office in Stuttgart, the Werkstatt Wagenfeld (this remained in existence until 1978). Here he designed models intended for mass production in porcelain, glass, metal, and a variety of plastics. A great deal of his work at this time was for manufacturers of lighting fixtures and for WMF. Toward the end of his life, Wagenfeld received numerous honors and tokens of esteem. He died in Stuttgart on May 28, 1990.

During an era in which the concept of "designer" as a distinct professional category had yet to be established, Wagenfeld played a pioneering role, both in practice and in theory—and he was aware of this responsibility. Of his own career, he observed: "No one was there to lead the way for me, but many were able to follow the path that I established."[3] A working relationship existed between the commission-ing manufacturer and Wagenfeld that was determined largely by him, the designer—this status quo was his innovation, and came to be an essential component of his approach to design. Wagenfeld conceived of design in its broader, social context; he believed that the designer should function as an organizer, and should carry out his work in a socially responsible way. He was concerned with the various technical processes involved in the realization of each design, experimented at length with materials, implemented the principle of teamwork, and repeatedly reconsidered the function of the object at hand. He also made a point of drawing on users' feedback for the improvement of individual objects.

At the same time, Wagenfeld maintained a commitment to objective advertising, with the aim of enlightening his potential market. This strategy became an integral part of his work—he would even write his own advertising copy (deploying such terse statements as: "Even the cheapest glass can be beautiful"). The sales representatives for Wagenfeld's designs were also trained in accordance with his principles. All of Wagenfeld's objects produced by the VLG bore the diamond-shaped trademark designed and repeatedly refined by Wagenfeld—this was, in effect, his "seal of quality."

In Wagenfeld's work with the VLG, he was able to realize his ideal of the harmonious and productive collaboration of "technician, artist, and businessman."[4] But even in his earlier position with Schott, Wagenfeld had begun to implement this notion: there, he had persuaded his former teacher Moholy-Nagy (who worked at Schott & Gen. until 1937) to design stands for the firm's presentations at industrial expositions, in addition to publicity posters and other printed material.[5]

Wagenfeld collaborated with Lily Reich on the design of the 1936 exhibition mounted by the VLG at Leipzig's Grassimuseum.[6] In his work for this company, Wagenfeld managed to alter the public's negative perception of cheap, mechanically produced, pressed glass. Through good design and careful production, he raised its profile as no other designer has done since. The most celebrated example of this is Wagenfeld's stackable, square glass tableware, with its innovative, space-saving shape that made it especially suited for use in the new refrigerators.

Many of Wagenfeld's designs made life easier for the middle-class German housewife, who in the 1920s was adjusting to two new aspects of life in the "modern home": a reduced kitchen size and the absence of servants. Both factors were closely related to a climate of reform in housekeeping in Germany during the Weimar era. The glass saucepan designed by Wagenfeld could be taken directly from stovetop to table, and transparent glass storage jars allowed one to see directly which items would soon need to be restocked. The forms designed by Wagenfeld were most often gently rounded in shape, and therefore easy to clean.

Wagenfeld's work after 1945 reveals a disdain for the mercantile aspect of design. The form of even the most commonplace objects, which would be sold at very low prices—a brush, a plastic sprinkler, an egg spoon—would be evolved painstakingly without any concern for the development costs. From the early 1930s on, there has been

hardly a household in Germany that has not contained at least one object by Wagenfeld. A great many of his designs remained in production and on sale for decades, and until the 1960s, Wagenfeld continued as the most highly regarded, but also most commercially successful, of German designers.

During his time at the Bauhaus, Wagenfeld was the adherent of a radical form of Functionalism; but he aimed, at the same time, at reducing form to its simplest elements. In 1938, however, he declared that functionality was to be the *starting point*, rather than the goal, of his work.[7] He went beyond the Bauhaus ideal of rationalization and sought a reasonable, realistic approach in terms of usage, low production costs, and simplicity. He rejected a purely economic way of thinking and saw his work as a contribution toward an "ordered existence for humanity." All practices, he argued, "must retain the capacity to be beautiful; in no other way do things achieve and express their purpose."[8]

RECEPTION

Since the 1930s, Wagenfeld's work has been known to a broad public in Germany through numerous individual and group exhibitions. These presentations have included shows focused on the Bauhaus as a whole, as well as thematic exhibitions devoted to glass or industrial design. Wagenfeld's first—and in all probability barely noted—one-man show opened May 11, 1930 at the Kunstgewerbemuseum für Edelmetall-Industrie (Applied Arts Museum for Work in Precious Metals) in Schwäbisch-Gmünd. From 1939, all the items that Wagenfeld designed for mass production were included in the publication *Deutsche Warenkunde*. Among the most important solo shows to take place since 1945 are *Wilhelm Wagenfeld, Zusammenarbeit mit Fabriken 1930–1962* (Wilhelm Wagenfeld: Collaboration with Manufacturers 1930–1962) at the Akademie der Künste (Academy of Arts) in West Berlin in 1962, and *Wilhelm Wagenfeld. 50 Jahre Mitarbeit in Fabriken* (Wilhelm Wagenfeld: Fifty Years of Collaboration with Manufacturers), initiated by the Kunstgewerbemuseum in Cologne in 1973. To coincide with this latter show, the first catalogue raisonné of Wagenfeld's designs was published. The publication accompanying the exhibition *Täglich in der Hand. Industrieformen von Wilhelm Wagenfeld aus 6 Jahrzehnten* (*Täglich in der Hand*: Six Decades of Wilhelm Wagenfeld's Forms for Industry), which opened in Bremen in 1987, contained a carefully revised catalogue raisonné. The Wagenfeld Stiftung, established in 1993, has itself presented two carefully researched and curated one-man shows, and there is now a Wilhelm Wagenfeld museum.

Wagenfeld never wanted to be defined as an artist or a designer but, rather, as a seeker and inventor of forms. Accordingly, although well aware of the high quality of his work and anxious to prevent its plagiarism, he allowed his designs to speak for him and retreated from the spotlight of personal publicity. In the United States, no one-man show has yet been devoted to Wagenfeld. For the interested American public, he is associated mainly with the Bauhaus table lamp and the Jena glass teapot.

Indeed, the table lamp was the first design by Wagenfeld to be included in an American exhibition, the *Contempora Exposition of Art and Industry*, which ran for three months at the Art Center in New York City in 1929.[9] The following year, a tea caddy, a kettle, and a hot-water pot by Wagenfeld were included in a similar show of designs for mass production: the *Third International Exhibition of Contemporary Industrial Art: Decorative Metalwork and Cotton Textiles*, which traveled to Boston, New York, Chicago, and Cleveland. Cambridge, Massachusetts hosted the first American exhibition devoted to the Bauhaus; it opened in December 1930—here one of the *Bauhausbücher* (Bauhaus Books) on display illustrated several Wagenfeld designs from 1923–24, including, again, the table lamp.[10] In 1931, the *American Magazine of Art* featured a photograph of a metal teapot and strainer by Wagenfeld, illustrating an article by Wilhelm Lotz that traced "a most interesting development" of the previous twenty years: "The German artist and the German architect gave up their ambition to invent new patterns and ornaments merely to improve the outward appearance of objects and began seriously to consider whether the forms of the objects themselves were as good as they might be, whether they really fulfilled the purpose for which they were intended, or whether they were hollow shams, formed solely for the sake of appearance. Furthermore, they examined the forms as to whether they had arisen from the natural requirements of the machine."[11]

New York's Museum of Modern Art, in 1933, mounted an exhibition curated by Philip Johnson entitled *Objects 1900 and Today*, in which contemporary objects were compared to objects with the same function made three decades before. In the "teapots" and (not surprisingly) "table lamp" categories, Wagenfeld designs represented "today." A Tiffany teapot was juxtaposed with Wagenfeld's glass teapot designed for Schott & Gen. The pairing was described as "curvilinear floral ornament vs. the clarity of glass and the color of tea."[12]

The Museum of Modern Art was also the venue, in 1938, for the most important American exhibition on the Bauhaus (which included objects designed by Wagenfeld), *Bauhaus 1919–1928*, organized by Herbert Bayer and Walter and Ise Gropius. The accompanying catalogue remained until well after 1945 the most authoritative publication on the Bauhaus available in America. In this volume, Wagenfeld was not only featured as the designer of the Bauhaus table lamp, but was also represented with his set of "Bremen" glasses, designed for VLG in 1935.

In the 1950s, Edgar Kaufmann, Jr. of the Museum of Modern Art organized a series of *Good Design* exhibitions in collaboration with the Chicago wholesale marketer Merchandise Mart—these were shown in Chicago and New York and were yet another effort to promote the importance of design for industry. Work by Wagenfeld was included in four of these exhibitions between 1952 and 1955.

Wagenfeld also had some succeess in the United States as a designer: his "Atlanta" cutlery, produced by WMF in 1954–55, sold well, as did his tableware made in Cromargan.[13] The flatware was featured in the traveling exhibition *Design in Germany Today*, sponsored by the Federal Republic of Germany and circulated in the U.S. by the Smith-

sonian Institution. A number of Wagenfeld designs were featured in *50 Years Bauhaus*, an exhibition documenting the successes of former Bauhaus members over four decades, presented in 1969–70 in Chicago, Toronto, and Pasadena.

Over the decade following Wagenfeld's death, numerous important museums with departments devoted to the applied arts, and in particular to design, have acquired examples of his work. Among those in America are the Saint Louis Art Museum, as well as the Metropolitan Museum of Art and the Museum of Modern Art in New York. A collection of work by Wagenfeld established at a much earlier date is to be found at Harvard's Busch-Reisinger Museum, in Cambridge, Massachusetts.

Manfred Ludewig and Magdalena Droste
Translated from the German by Elizabeth Clegg.

[1] Wilhelm Wagenfeld, "Zu den Arbeiten der Metallwerkstatt," in: *Bauhaus Weimar,* special issue of the journal *Junge Menschen* (1924); reprint, Munich: Kraus, 1980, p. 187.
[2] Walter Scheiffele, cited in: Wilhelm Wagenfeld, ed., *Gestern, heute, morgen. Lebenskultur im Alltag,* Bremen: Hauschild, 1995, p. 48.
[3] Wagenfeld, ed., *Gestern* (as note 2), p. 129.
[4] Beate Manske and Gudrun Scholz, eds., *Täglich in der Hand. Industrieformen von Wilhelm Wagenfeld aus 6 Jahrzehnten,* 2d ed., Bremen: Worpsweder, 1988, p. 43.
[5] Walter Scheiffele, "Typofoto und Jenaer Haushaltsglas. Laszlo Moholy-Nagys Reklame für Schott & Gen.," in: *Über Moholy-Nagy. Ergebnisse aus dem internationalen László Moholy-Nagy Symposium, Bielefeld 1995, zum 100. Geburtstag des Künstlers und Bauhauslehrers,* ed. by Gottfried Jäger and Gudrun Wessing, Bielefeld: Kerber, 1997, pp. 225–233.
[6] Olaf Thormann, "Die Leipziger Grassimessen," in: *Über Moholy-Nagy* (as note 5), pp. 104–125.
[7] *Über Moholy-Nagy* (as note 5), p. 18.
[8] Ibid., p. 38.
[9] Contempora was a short-lived organization, based in America, but with international membership. It was dedicated to promoting the interaction between art and industry. One aspect of this exhibition was a lighting display with designs produced by the Berlin firm Schwintzer & Gräff. No designers are credited in the accompanying catalogue, but an installation view indicates that Wagenfeld's table lamp (1924) was included in the display. (Schwintzer & Gräff serially produced this lamp between 1928 and 1930.)
[10] *Bauhaus, 1919–1923 Weimar, 1924 Dessau,* Harvard Society for Contemporary Art, December 1930–January 1931. For further information, see Leslie Topp's essay in this volume. The Bauhaus book was no. 7: *Neue Arbeiten der Bauhauswerkstätten,* Passau: Passavia Druckerei, 1925; reprint, Mainz: Kupferberg, 1981.
[11] Wilhelm Lotz, "Industrial Art in Germany," in: *American Magazine of Art,* vol. 22 (February 1931), p. 103, ill. p. 107 (top).
[12] Philip Johnson, "Objects 1900 and Today," typescript of exhibition cat., New York, Museum of Modern Art, 1933, n.p. See also Terence Riley, "Portrait of a Curator as a Young Man," in: *Philip Johnson and The Museum of Modern Art, Studies in Modern Art,* no. 6, New York: Museum of Modern Art, 1998, pp. 47–51.
[13] See Wagenfeld, *Gestern* (as note 2), p. 154; and "Wilhelm Wagenfeld Werbeblätter für die USA," in: *Wilhem Wagenfeld. 50 Jahre Mitarbeit in Fabriken,* ed. by B. Klesse, exhibition cat., Cologne, Kunstgewerbemuseum; and Munich, Die neue Sammlung, 1973–74, p. 130.

HANS PRZYREMBEL

*** OCTOBER 3, 1900, HALLE**
† 1945, IN CAPTIVITY (EXACT DATE AND PLACE UNKNOWN)

Cover of the exhibition catalogue *Bauhaus 1919–1928,* Museum of Modern Art, New York, December 6–January 30, 1939

A photograph taken about 1924 shows the students of the Weimar Bauhaus metal workshop grouped around their teacher László Moholy-Nagy. Hans Przyrembel is there, though standing on the edge of the group and barely recognizable in the darkness of the background.[1] The photograph can be seen as a symbol of the life and work of this artist: there is almost nothing known about his life, and his work has always existed in the shadow of his more talented colleagues Marianne Brandt, Wolfgang Tümpel, and Wilhelm Wagenfeld.

Przyrembel was only fifteen when, as a locksmith's apprentice, he first came in contact with metal as a material. After being drafted into military service in the last year of the war, he then went on to practice as a locksmith before beginning his studies at the Weimar Bauhaus in 1924. He completed the preliminary course under Moholy-Nagy, and then began to study with him in the metal workshop during the following winter semester. The workshop had already produced several design classics: Brandt's teapot; her ashtrays; the tea-ball holders by Otto Rittweger, Tümpel, and Wagenfeld; Wagenfeld's tea canister; and finally the famous table lamp by Wagenfeld and Karl Jakob Jucker. Przyrembel oriented himself toward these designs in his own work—as seen in a tea service from 1925–26 that was often attributed to Brandt,[2] or his cylindrical tea canister, a further development of the example by Wagenfeld.

In 1925, the Bauhaus relocated to Dessau, and in the fall of 1926 moved into the new school building designed by Walter Gropius. The metal workshop, outfitted with the latest technology, was supposed to develop models that could be industrially manufactured, thus generating commercial success. This had up until then not been the case, as Gropius had critically remarked earlier that year: "In the metal workshop, it remains imperative that we cut down on the production of containers and concentrate on those objects that sell. That is, above all, lamps."[3] Hand in hand with this criticism went the need for lighting fixtures for the new school building, and thus were created what are probably the most beautiful lamps of classic modernism. They are above all the work of Marianne Brandt, who also collaborated with Przyrembel in the design of a ceiling lamp. It had a pulley arrangement for adjusting its height, making it suitable for various workspaces in the Bauhaus; it was also used as the dining-room lamp in Gropius's own house in Dessau.

"We executed all these designs in a Junker firm on the edge of the city," Brandt reported later, referring to the collaboration with local industry.[4] As a result of these positive experiences, the Junker plant (which specialized in the manufacture of airplanes and heating appliances) contributed generously to the technical outfitting of the metal workshop and profited from the Bauhaus members' inventive talents. Przyrembel, who often worked in the Junker plant in his free time, designed a prototype for a gas-powered boiler in 1928, but nothing is known of what became of the design.

Also in 1928, Przyrembel turned his attentions back toward handcrafting. He created a teapot for his journeyman's examination in silversmithing, and then took over the Werkstatt für Gefässe, Schmuck und Beleuchtung (Workshop for containers, jewelry, and lighting) from his colleague Wolfgang Tümpel. After the workshop closed in 1929, he founded his own smith's shop in Leipzig, and passed the master's examination in 1932.

From 1935 on, there is evidence of Przyrembel's participation in the trade fair exhibitions at the Grassimuseum in Leipzig; his products appear here again in 1949. Their appearance had meanwhile changed markedly: from the late 1930s, he designed copper pots and brass lanterns as a concession to the volkisch taste of the times. These designs were awarded a bronze medal at the seventh Triennale in Milan in 1940.[5] But beyond fascist Europe, the "modern" Przyrembel continued to receive exposure. The adjustable ceiling lamp he designed with Brandt was exhibited as part of the 1938 Bauhaus exhibition at the Museum of Modern Art's temporary quarters at Rockefeller Center in New York. But no matter which tendency Przyrembel is identified with, he remained the type of artist whose creativity depended on the existence of favorable conditions.

Anne-Katrin Rossberg
Translated from the German by Leslie Topp.

[1] Die Metallwerkstatt am Bauhaus, ed. by Klaus Weber, exhibition cat., Berlin, Bauhaus-Archiv, Museum für Gestaltung, 1992, p. 20, fig. 14.
[2] Ibid., p. 241 (cat. no. 221).
[3] Walter Gropius, "Bericht über die Missstände in den Werkstätten" (January 21, 1926), quoted in: Klaus Weber, "'Vom Weinkrug zur Leuchte': Die Metallwerkstatt am Bauhaus," in: Metallwerkstatt am Bauhaus (as note 1), p. 25.
[4] Marianne Brandt, in an interview of 1973, quoted in: Helmuth Erfurth, "Symbiose von Kunst und Technik: Das Bauhaus und die Junkerswerke in Dessau," in: Metallwerkstatt am Bauhaus (as note 1), p. 92.
[5] J. H., "Leipziger Kunsthandwerk auf der Mailänder Triennale: Silberschmiedemeister Hans Przyrembel erhielt eine bronzene Medaille," in: Leipziger Neueste Nachrichten (July 21, 1940), Archive of the Grassimuseum, Museum für Kunsthandwerk, Leipzig; Grassimuseum: Leipziger Frühjahrsmesse 1941, Aussteller-Verzeichnis, ill. p. 64.

MOMENTS IN THE RECEPTION OF EARLY TWENTIETH-CENTURY GERMAN AND AUSTRIAN DECORATIVE ARTS IN THE UNITED STATES

LESLIE TOPP

Should Americans start producing things like these? Could they be taught to do so? Would these items sell well in our Chicago store? Would this look good in my living room? These are the sorts of questions that are encountered in an examination of the American reception of early twentieth-century German and Austrian decorative arts. The world of easel painting, sculpture, and fine graphic arts exists, for the most part, in galleries and museums, and in the pages of art journals. But when the subjects at hand are lamps, tables, and teapots—viewed as objects to be used and lived with, rather than as elements in the canon of design history—we find ourselves in a less rarified universe. Here, too, there are museums and art journals, but there are also world's fairs, trade shows, boutiques, department stores, and home-decorating magazines. The audience for these objects is made up of critics and connoisseurs, but also of store buyers, manufacturers, craftspeople, and owners of homes large and small. And when the museum world engages with the decorative arts, it tends to do so with the aim of redefining the way a museum can relate to the wider community.

If the audience for modern German and Austrian decorative arts was wider, and the atmosphere around them less exclusive than was the case with the fine arts, the decorative arts were nonetheless taken just as seriously. In fact, the applied arts were seen in the early twentieth century as *culturally central*, a position they seem no longer to have, on either side of the Atlantic. From the display of Jugendstil interiors at the Louisiana Purchase International Exposition at Saint Louis in 1904, to the controversial Bauhaus exhibition at the Museum of Modern Art in 1938, Americans were regularly challenged by the objects and ideals on view: their tastes, their domestic,

industrial, and educational cultures were all measured against models imported from Germany and Austria.

THE LOUISIANA PURCHASE INTERNATIONAL EXPOSITION, SAINT LOUIS, MISSOURI, 1904

World's fairs provide a unique context in which the commercial, the artistic, and the educational are combined; and it was in the mixed setting of the 1904 Louisiana Purchase International Exposition at Saint Louis that German and Austrian decorative arts received their first significant exposure to an American public. That public, according to Emil Fischer, an Austrian-American businessman who was commissioned by the Austrian Ministry of Trade to write a report on the exposition, had a particular interest in the decorative arts: "The western farmers, who appeared in St. Louis in their millions, who up to then had had no or almost no need for household decoration, and people, like immigrants, who had raised themselves up from nothing to become rich agriculturists and landowners, they came to St. Louis to study taste, and to decorate their homes with goods, which they would not have dreamed of in their earlier life."[1] The decorative arts were enormously important to both Germany's and Austria's presence at the fair, and appealed to a wider audience on a practical level in a way that the fine arts could not. The most significant representatives of the "new" German and Austrian fine arts were in fact absent, but in the decorative arts an innovative, cutting-edge approach dominated.[2]

Germany's contribution in the decorative arts was more elaborate than Austria's, which was for the most part contained in its small national pavilion. Germany's larger and more central pavilion was a replica of the Charlottenburg palace in Berlin and

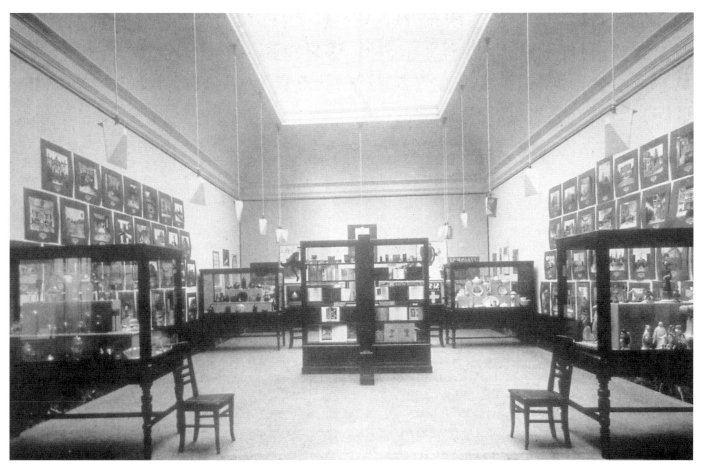

Installation view of *German Applied Arts* at the John Herron Art Institute (now the Indianapolis Museum of Art), 1912–13

contained Baroque-replica interiors. Modern German decorative arts were collected in the rather vaguely named Palace of Varied Industries, of which Germany had managed to secure some 80,000 square feet, about one-fifth of the total floor space.[3] In contrast to the historical re-creations in the German pavilion proper, the sixty-two interiors in the Palace of Varied Industries, each created by a different artist, were variations on the theme of simple, bold, modern design, and the collaboration of artist and craftsman in the name of truth to purpose, structure, and materials.[4] Peter Behrens's reading room for the Düsseldorf city library and his sales-office room shared this overall approach, although they were in the minority as public, non-domestic spaces. There were several dining rooms, living rooms, receiving rooms, music rooms, and boudoirs. Bruno Möhring designed the main entrance hall, and Joseph Maria

Olbrich (who, having moved from Vienna to Darmstadt in 1900, represented the Germans here rather than the Austrians) was responsible for a suite of six rooms and a courtyard with a fountain, identified as a "courtyard in a summer residence of a lover of art."[5] Among the other participants whose names are still remembered were Richard Riemerschmid, Bruno Paul, and Wilhelm Kreis.[6]

Austria's decorative arts contributions also included fully designed interiors, all located in a fourteen-room pavilion by the state architect Ludwig Baumann, a derivative pastiche of Secessionist design. The interiors did not stand on their own, but were instead either circulation areas or frameworks for the display of other decorative arts objects or paintings.[7] Several innovative architect-designers, many of them former students of Otto Wagner, were represented with interiors—these

View of Bruno Möhring's entrance hall to the North German Empire section, Louisiana Purchase International Exposition, Saint Louis, 1904, in *The Craftsman* (August 1904)

included Josef Hoffmann and Joseph Urban as well as Leopold Bauer, Jože Plečnik and Jan Kotěra.[8] (Wagner himself exhibited a model of his 1890s Nussdorf dam buildings, in a room devoted to Austria's waterways.[9]) Part of the Austrian pavilion was given over to the accomplishments of the empire's education system for arts and crafts.[10] This was the context for Hoffmann's interior for the Vienna Kunstgewerbeschule (School of Applied Arts), where he was a professor. The room contained stained glass, woodcuts, mosaics, bookbindings, metalwork, glass, and ceramics, as well as folders of studies and designs by Hoffmann's own pupils and those of Koloman Moser, including Jutta Sika and Therese Trethan.[11] The Vienna Secession, objecting to the government's attempts to influence its exhibit (which was to have been in a room designed by Hoffmann, and dominated by the large university paintings by Gustav Klimt), refused to participate.[12] However, the other preeminent forward-looking artists' association, the Hagenbund, was represented in a room designed by Urban, who came to Saint Louis to oversee the installation.[13]

Of the two countries, Germany received the bulk of the American press attention.[14] "Germans can teach others how to live," wrote one observer, and it was as eager students of interior design principles—rather than as connoisseurs of high-art objects—that critics approached the interiors in the Varied Industries building.[15] Moreover, the appropriate American audience was understood to be very broad, including professionals and laypersons, men and women. A reviewer for *The House Beautiful* wrote: "Not alone to decorators and furniture designers will the German section be of value, but to every house-builder and home-maker in the land."[16] One of the most progressive designers in the United States, Gustav Stickley, reviewed the German interiors in detail and saw their lesson as "one of simplicity and symmetry, which are complementary forces—so much more difficult to employ than a superfluity which has no reason for existence and quickly becomes wearisome."[17] For *The House Beautiful*'s writer, these interiors stood "for thoroughness, stability, love of detail, and abhorrence of sham. These are German characteristics…"[18]

Exterior view of the Austrian Pavilion, Louisiana Purchase International Exposition, Saint Louis, 1904, in *Dekorative Kunst* (September 1904)

The Austrian rooms, according to the same journal (in 1908, four years after the event), had also "contained much that was worth studying." Like the German rooms, the Austrian interiors were received here as innovative but still understandable and applicable to an American context: "Decorative schemes were unique without being bizarre and furniture was refreshingly out of the ordinary."[19] The international jury at the fair itself awarded the whole exhibition of Austrian arts-and-crafts education a gold medal for "the best, most beautiful and most tasteful installation" among all the art exhibitions.[20] Fischer's report also tells

us that a large number of the student-designed objects in Hoffmann's Kunstgewerbeschule rooms were purchased during the exhibition.[21]

NEWARK MUSEUM, NEW JERSEY, 1912

The impact of the Saint Louis World's Fair on the taste and purchasing patterns of Americans was perhaps not as immediate as the organizers of the German and Austrian sections would have wished. When, eight years later, a large touring exhibition of German and Austrian applied arts was organized by the Newark Museum—featuring, again, work by Behrens, Hoffmann, and Moser, as well as by Riemerschmid, Olbrich, Paul, and others—it was treated, by some at least, as a new discovery.

avid reader of art journals such as *Deutsche Kunst und Dekoration* and an admirer of the Deutscher Werkbund.[24] His goal was not much different from that of the critics who had encouraged American craftspeople and homeowners to pay attention to the German interiors in Saint Louis: he dreamed of raising the level of industrial design in his country by exposing American producers and consumers to the objects and interiors he was reading about. In Karl Ernst Osthaus, Dana found a perfect collaborator—Osthaus had recently founded the Deutsches Museum für Kunst in Handel und Gewerbe (German Museum for Art in Trade and Craft) in Hagen, Westphalia. For that museum, he had collected objects by leading decorative artists of the modern tendency, as well as compiling an archive of

WANDER-
AUSSTELLUNG
DES
DEUTSCHEN MUSEUMS
FÜR KUNST IN HANDEL
UND GEWERBE
HAGEN I.W.

UNTER MITWIRKUNG
DES
OESTERREICHISCHEN
MUSEUMS FÜR KUNST
UND INDUSTRIE
IN WIEN

❀

NEWARK
CHICAGO · INDIANAPOLIS
PITTSBURGH · CINCINNATI
ST. LOUIS

1912-1913

Title page of exhibition catalogue *Wanderausstellung des Deutschen Museums für Kunst in Handel und Gewerbe, Hagen,* in *Handicraft* (June 1912)

Installation view of *German Applied Arts,* Newark Museum, 1912. Collection of The Newark Museum

German and Austrian progress in the applied arts, wrote one reviewer, "is little known or appreciated in the United States, partly because it has been carelessly overlooked and partly because most of our foreign art news comes via Paris or England."[22] The same reviewer went on to claim that the exhibition would demonstrate to Americans that "if all German art were divided into two parts, that shown in oil paintings and that shown in all other fields, the latter would prove by far the more important."[23]

The instigator of this exhibition was John Cotton Dana, librarian and later museum director in Newark, New Jersey, who was an

architectural photos for the purpose of publicizing new applied art. The organization of touring exhibitions was a key aspect of the Hagen museum's directive; this educational, proselytizing mission seems to have interested Dana as much as the objects themselves.

Osthaus's goal for the American exhibition *German Applied Arts* was to achieve the most comprehensive representation possible of the "new artistic direction" in Germany and Austria; thus more than 1,300 exhibits by more than 200 different artists were displayed in sections devoted to architecture, graphic and advertising arts, book industries, wallpapers,

linoleum, textiles, ceramics, glass, metalwork, wood, and ivory, as well as photography. The progressive Austrian Museum für Kunst und Industrie (Museum of Art and Industry; now the Museum für angewandte Kunst, or MAK) cooperated with Osthaus in planning the exhibition, in addition to lending some forty-nine objects, twenty-two of which were examples of Wiener Werkstätte metalwork. Not only the objects, but the two institutions—the Austrian museum and especially Osthaus's new German museum—were, in a sense, on display. A full page in the catalogue was devoted to the German museum, announcing that it would undertake "the organization of ART and ART INDUSTRY EXHIBITIONS both at HOME and ABROAD."[25]

True to the new ideals in design, the exhibition was "not directed so much towards … single trade, or isolated commercial products as towards reforming the whole of our lives."[26] While the exhibits themselves lacked the careful overall design that was the standard at Saint Louis and at numerous European exhibitions of applied art, they did include a strong architectural component in the form of large-format photographs of important progressive buildings. Judging from press reports, visitors were struck by the artists' mission to apply innovative design to all objects of daily use. Though many of the objects were in fact for sale, the exhibition, in its series of prestigious museum settings (it traveled to art museums in Saint Louis, Chicago, Indianapolis, Cincinnati, and Pittsburgh before ending up at the National Arts Club in New York City[27]), was received less as a commercial presentation than as an educative example for American manufacturers.[28] The idea, controversial in the American context, of displaying contemporary industrial design in museums had proved successful; the objects here, with their strong "artistic" content, must have made this transition easier. The show can be seen as part of a drive on the part of the new Newark Museum to establish itself as a vital participant in both the cultural life of the region and in its economic activity, distancing itself from the image of the museum as a custodian of historical masterpieces for the enjoyment of the wealthy. The mixed Newark audience described by one reviewer must have been gratifying for Dana: "Out of the whole exhibit, artists are getting a respect for the courage of their transatlantic brethren, the public is getting a bewildering sense of the variety, richness, and vigor of German daily life, and manufacturers in a hundred lines are being stirred by something that will bear fruit in future years. … But most ostensibly the exhibit is inspiring to the handicraftsmen who are flocking to it from New York and neighboring cities and who judged by concentrated observation and pertinent comment seem to be its most appreciative visitors."[29]

Museum visitors flocking from New York to Newark! But New York would not be upstaged: after the show toured the Midwest, receiving glowing reviews and crowds of visitors, a final stop in March 1913 at the National Arts Club in Gramercy Park was arranged, for which "several especially interesting pieces of keramik [sic], silverware and textiles" were sent over specially from Germany.[30] During the planning stages, the Metropolitan Museum had been approached as a potential venue—but it rejected the show as too commercial.

THE WIENER WERKSTÄTTE OF AMERICA, NEW YORK, 1922

If the Newark exhibition brought a certain commercialism—or at least a popular, practical element—into the museum, the Wiener Werkstätte of America brought something of the art museum into the high-end shop.

The original Wiener Werkstätte had been founded in Vienna back in 1902 by Josef Hoffmann, Koloman Moser, and the businessman Fritz Waerndorfer, as a cooperative venture to produce modern, handcrafted objects and interiors. The Wiener Werkstätte of America, which opened in early summer of 1922 on Fifth Avenue between 47th and 48th Streets in Manhattan, was the initiative of the Austrian expatriate Joseph Urban.[31] The Austrian Wiener Werkstätte had never been on secure financial footing, and Urban had never himself been a member of it; however, he had a cordial relationship with Hoffmann, and when Urban visited him and his colleagues in Vienna in 1921, he was affected by their struggle to survive in the depressed postwar economy. The Fifth Avenue showroom was conceived as a way of buoying their fortunes and gaining new commissions from wealthy Americans.

Upon its opening in June 1922, the Wiener Werkstätte of America was presented and received more as a serious exhibition than as a commercial venture, and was the subject of extensive reviews in newspapers and magazines both in and beyond New York.[32] In the luxurious black, cream, silver, and green "interiors" designed by Urban, the objects that dominated were by Hoffmann and Dagobert Peche (who by this time had replaced Moser as Hoffmann's main collaborator in the Wiener Werkstätte). They were displayed in a manner that was much truer to Vienna's exhibition design ideals than the haphazard arrangements of the Newark Museum show had been a decade earlier.[33] A tension seems to have existed between the notion

of these pieces as objects of use, displayed as they were in Urban's pseudo-domestic sitting and dining rooms, and what one reviewer called their "art value," so carefully placed in these artificial environments alongside purely decorative ceramic and metalwork by Peche and Susi Singer, and paintings by Gustav Klimt (*Die Tänzerin [The Dancer;* 1916–18], cat. no. I.15) and Egon Schiele (*Madonna;* 1911).[34] The emphasis in the reviews was on the vivacity, originality, and energy of the objects on display, on their compelling combination of simplicity and dramatic extravagance.[35] One reviewer hoped that the influence of "all this" would be that Americans would open their minds to the possibility of hybrid objects that were at once artistic and frivolous: "Something of ... the Puritan strain persists in the United States and even American artists are inclined to look with suspicion on gayety [*sic*] in art. But here in the Viennese exhibit are lots of things done just almost in the spirit of fun and yet no less beautiful."[36]

The transition from a Fifth Avenue shop to major national museum happened easily: once the first displays in the New York shop were dismantled, Urban set them up again in September and October 1922 at the Art Institute of Chicago. Again, the displays had the effect of subverting spatial and institutional assumptions. According to the report in the Art Institute's *Bulletin*, "The atmosphere of coldness and formality which the large galleries of a museum tend to possess was overcome by the gay colors and contrasting blacks of hangings and wall papers, and by the arrangement of the *objets d'art* in specially-designed shrine-like cases and on tables, which have the informality and intimacy of a home."[37]

But none of this produced the sales that could have made the venture sustainable—some reviewers commented that no matter how charming and interesting they found the Wiener Werkstätte work, they could not see American homeowners embracing it.[38] By the end of 1923, the shop's closing was announced. The tone adopted by reviewers had changed since the Newark exhibition of 1912; Americans were now in the position of philanthropic superiority toward the needy artists of postwar Europe—a position they would adopt again in the late 1930s.

THE BAUHAUS AT HARVARD AND THE MUSEUM OF MODERN ART, 1930–31 AND 1938

The Wiener Werkstätte of America offered Americans something that, in its genre if not in the particulars of its form, had also been offered by Germany and Austria at Saint Louis in 1904—namely, elegant, modern, handcrafted interiors for

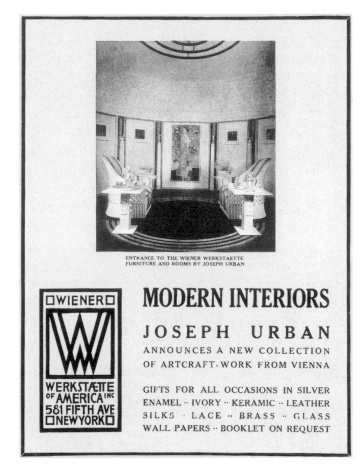

Advertisement showing the entrance rotunda to the Wiener Werkstätte of America, from *The News Picture of Society*, 1922. Courtesy Historical Design, Inc., New York

wealthy people with progressive tastes. During the 1920s, another, quite different version of the German approach to design slowly emerged on the American scene: the Bauhaus.[39] Apparently, Bauhaus furniture designs—most prominently Marcel Breuer's tubular-metal chairs—were being pirated by American designers already, and not so much for rarified domestic settings as for theaters and other public places.[40] But there was little that was populist or commercial about the first exhibition devoted to the Bauhaus in the U.S. in 1930–31; on the contrary, it seems to have been very much a highbrow affair.

The host of *Bauhaus, 1919–1923 Weimar, 1924 Dessau* was the Harvard Society for Contemporary Art. This society had been founded two years earlier by a group of Harvard undergraduates, to expose Harvard and Radcliffe students and the people of greater Boston to challenging contemporary painting, sculpture, architecture, and decorative arts.[41] Various media were represented in the show in an effort to reflect the Bauhaus's wide range of activities: paintings, drawings, and

prints by Lyonel Feininger, Paul Klee, Vasily Kandinsky, Johannes Itten, and others were there alongside examples of typography by Herbert Bayer, the *Bauhausbücher* (Bauhaus Books), photographs of the Bauhaus buildings and interiors (with Breuer chairs) at Dessau, of a lamp by Marianne Brandt, and of the Barcelona Pavilion by Ludwig Mies van der Rohe. Four decorative-arts objects with no named designer (chromium steel plates, a lamp, an ashtray, and a scarf of rayon silk) were lent by Philip Johnson.[42] (After leaving Harvard, the show traveled to New York and Chicago.)

The Bauhaus was still operating in 1931, but as the show's title implied, the school's history was emphasized. In his introduction to the catalogue, one of the Harvard Society's founders, Lincoln Kirstein, adopted a dispassionate, scholarly stance, tracing the pedigree of the Bauhaus back to William Morris, the Wiener Werkstätte, Henry van de Velde, and De Stijl. He outlined the development of the Bauhaus through the founding years under

Installation view of *Modern Austrian Art Exhibited by the Wiener Werkstaette of America,* Art Institute of Chicago, September 19–October 22, 1922, in *Bulletin of the Art Institute of Chicago* (November 1922)

Walter Gropius, the move from Weimar to Dessau, and the directorship of Hannes Meyer up to the arrival of Mies van der Rohe in 1930. With a connoisseur's powers of discrimination, Kirstein distinguished between the years of "wild experimentation" and the later "work of real achievement." There was a political or, better, *antipolitical* undertone here as well; Kirstein favored Mies's focus on "the development of architecture as such" to the political engagement of Meyer, who wanted "to stop the school as an art school and turn the Bauhaus into a communist hospital." But it would be wrong to see Kirstein as a formalist. To exhibit the Bauhaus, he wrote, was to focus not on any particular stylistic category but on an "experiment in education," which "however intermittent and unstable, must rank as

the most important original movement in the instruction of Fine Arts in the first part of the twentieth century."[43]

Five of the show's photographs of the Dessau colony were reproduced in the *Boston Herald*'s Rotogravure Section, including an interior view of Moholy-Nagy's house, designed by Gropius with furniture by Breuer; the caption read: "In a German communist artist's dining room, home furnishings of the future …"[44] The paper's reviewer was bemused by the photos, "which tell the American world how different the modern European world of art has become from anything ever conceived in the American mind."[45] Bauhaus design was seen in Boston in 1930 as too exotic, too formally and politically alien, to be relevant to an American public in the way earlier German and Austrian design was. Modernist mass production and "design for the masses" were perceived, at this stage, as the province of the intellectual elite.

A much larger exhibition was devoted to the Bauhaus in 1938, at the Museum of Modern Art in its temporary quarters in the basement of Rockefeller Center. The whole situation around the Bauhaus and its relationship to the United States had of course changed by then. Gropius himself had left Germany and was director of the School of Architecture at Harvard. Breuer had joined him there. Mies would accept the directorship of the Armour Institute of Technology in the same year. Josef and Anni Albers had been at Black Mountain College in North Carolina since 1933, the same year the Bauhaus was closed by the

Cover of the exhibition brochure *Bauhaus, 1919–1923 Weimar, 1924 Dessau,* Harvard Society for Contemporary Art, Cambridge, Massachusetts, December 1930–January 1931, designed by Lincoln Kirstein. The Museum of Modern Art Archives, New York

National Socialists. The Museum of Modern Art show was organized by Gropius himself, along with his wife, former Bauhaus student Ise Gropius, and former Bauhaus master Herbert Bayer, under the sympathetic gaze of Alfred H. Barr. This exhibition focused on the years from the Bauhaus's founding in 1919 to 1928, and managed not only to be more historical in its parameters than the 1930 Harvard exhibition, but also to raise issues that were vitally relevant to an American context.

The show unleashed a debate about whether the Bauhaus was dead or alive. That is: had it been killed by the National Socialists (or, according to some, done in by its own internal problems), or had it merely been displaced to America in the form of Moholy-Nagy's New Bauhaus, Gropius and Breuer's classes at Harvard, the Albers' Black Mountain College, Mies's Illinois (Armour) Institute of Technology, the Design Laboratory in New York, and any number of other progressive Bauhaus-influenced initiatives in art and design education? Was the exhibition an epitaph to the Bauhaus, or evidence of its continuing vitality and relevance? Barr, in his preface to the book published to accompany the exhibition, was emphatic: "The Bauhaus is not dead; it lives and grows through the men who made it, both teachers and students, through their designs, their books, their methods, their principles, their philosophies of art and education."[46]

Certainly the aversion of the American art world to the repressive cultural tactics of the National Socialists added power to these kinds of statements about the Bauhaus's survival and essentially positive influence. According to one admiring exhibition review, the National Socialists closed the Bauhaus because "the Bauhaus principle, that human achievement depends on the free co-operation of people regardless of race, creed, or nation, strikes at the foundation of Nazi doctrine."[47] Several reviewers invoked the powerful image of the National Socialists' desecration of Gropius's Dessau Bauhaus building with a pitched "Nuremberg" roof, the architectural equivalent of the *Entartete Kunst* exhibition.[48] In some cases, anti–National Socialist sentiment actually served to draw people to the exhibition who would otherwise have been repelled by the Bauhaus's modernism. A *New York Times* columnist overheard one "daunted but determined woman" say, "I don't expect to *enjoy* it, exactly, but if Hitler has banned it I think we *ought* to look at it."[49] We know that censorship under the National Socialists granted Expressionist art increased exposure and a largely sympathetic reception in the United States in the late 1930s.[50] This was true despite the fact that Barr (who was hugely influential) had lost much of his early enthusiasm for

"Germany Sends Experimental Art and Architecture to Cambridge, Massachusetts," in the *Boston Herald* (December 28, 1930). The Museum of Modern Art Archives, New York

Expressionism by this time, as he developed his arguments for the importance of abstraction. It may be that, for those like Barr, the Bauhaus provided an alternative German avant-garde—equally persecuted and exiled—but one that *was* actually becoming a strong force in the United States.

That said, many of the reviews of the museum's Bauhaus exhibition were pointedly negative. Most complained of the fragmentation and confusion of Bayer's exhibition design. But there was also a concerted effort to attack Bauhaus principles and products. The underlying message was this: the fact that so many ex-Bauhaus affiliates were now in the U.S. did not require American design and art education to follow the Bauhaus route. Henry McBride of the *New York Sun* argued that simply because the Bauhaus was closed by the National Socialists did not necessarily mean it was worth emulating: "At a time like this when international entanglements are difficult to unravel, there is the temptation to be extra kind to any group of artists that wishes to make itself effective in our comparative[ly] safe country, but with all the best wishes in the world, it is impossible to suppress the feeling that there is something essentially forced and repellent in most of the Bauhaus work. They are under the suspicion of being modern for the sake of being modern and not because of any necessities of their system of living. They

Cover of the *Bulletin of the Museum of Modern Art* (December 1938), showing an installation view of "The Bauhaus Synthesis," from *Bauhaus 1919–1928*, Museum of Modern Art, New York

want to astound even when they have nothing with which to astound."[51]

Another reviewer, Jerome Klein of the *New York Post*, went further, implying that the Bauhaus actually shared responsibility for the rise of the National Socialists, because the tendency toward "utopian abstraction" in its social theory meant it was weak in the face of "the facts of life."[52] Others did see the exhibition as an epitaph for the Bauhaus, and denied that a set of principles and methods developed in a past time and another culture could be transplanted to the American context. In the words of Nathalie Swan, a designer and former Bauhaus student: "In America we have our own tradition, and, we hope, our own future. In the field of design we must be continually watchful for valid ideas based on our own ecological and social needs and we must always beware of dated ideologies. The Bauhaus, having moved from Weimar to Dessau to Berlin to Chicago, and having failed through its own weakness to acclimatize itself, has shown its ghostlike nature. This exhibition in the caverns of Radio City is a final danse macabre."[53]

It is of particular interest to note how the Museum of Modern Art exhibition, which was after all a display of objects produced in Central Europe more than ten years earlier, so easily triggered a passionate debate about the future of American design. This can be partly explained by the important positions in architecture, art, and design education that ex-Bauhaus émigrés assumed just around this time. But further, the way German design had been received in America since the 1904 Louisiana Purchase International Exposition in Saint Louis—the recurring sense that it was there not to be admired or evaluated from a scholarly or aesthetic distance, but to be taken seriously as a model for American practice—had a great deal to do with both how the show was presented and how it was received.

In today's museums and art history departments, there is an ongoing concern about whether the decorative arts are taken seriously enough; they tend to be marginalized by the art historical models with which we operate. The "moments" in the American reception of early twentieth-century German and Austrian decorative arts traced here—the 1904 exposition in Saint Louis, the 1912 Newark exhibition, the opening of the Wiener Werkstätte of America in 1922, and the two Bauhaus exhibitions of 1930 and 1938—show how seriously they could be taken when viewed through a different kind of filter. Americans were in search of models, not only for specific objects but also for the development of modern "taste" in the design of their surroundings. Ideas about the role of the museum in the economic and cultural life of the wider community were in formation, as were efforts to reform art and design education—Osthaus's Deutsches Museum and the Bauhaus provided innovative and challenging examples to follow, as the Vienna Kunstgewerbeschule had in Saint Louis in 1904.

Do we still look to these objects as models? Certainly, what have now become classic modern designs—Hoffmann's chairs, Brandt's lamps—continue to inspire contemporary designers, and are themselves reproduced and used to furnish twenty-first-century interiors. What has fallen away is the sense that these objects are interesting because of what they have to say about a new way of doing things: educating, manufacturing, and even living. The traces of those ideas and utopias—those *new worlds*—remain, though absorbed now into American life and taken for granted.

I would like to thank Anne-Katrin Rossberg and Janis Staggs-Flinchum for their kind help with this essay. I also thank Laurie Stein for her original research in the field.

1 Emil S. Fischer, *Rückblick auf die Beteiligung der österreichischen Regierung an der Louisiana Purchase Exposition World's Fair St Louis 1904*, Vienna: Niederösterreichischer Gewerbeverein, 1906, p. 21.

2 For an account of the exclusion of progressive art from the German fine art section at Saint Louis, see Peter Paret, "German Impressionism and the Conflict Over Art at St. Louis," chapter 4 in: *The Berlin Secession: Modernism and Its Enemies in Imperial Germany*, Cambridge, Mass.: Belknap, 1980. On the absence of Klimt and the Vienna Secession, see "Die Wiener Secession und die Ausstellung in St Louis," in: *Ver Sacrum* (February 1904), reprinted in: Marian Bisanz-Prakken, *Heiliger Frühling: Gustav Klimt und die Anfänge der Wiener Secession, 1895–1905*, Vienna: Brandstätter, 1999, p. 216.

3 "Germany at the St. Louis Exposition," in: *Scientific American Supplement*, no. 1507 (November 19, 1904), p. 24148.

4 See the catalogue produced by the German mission to the exhibition (and designed by Peter Behrens): *Official Catalogue for the Exhibition of the German Empire, International Exposition Saint Louis 1904*, Berlin: Stilke, 1904, pp. 428–430; published in German as: *Weltausstellung in St. Louis 1904. Amtlicher Katalog, Ausstellung des deutschen Reichs*, Berlin: Stilke, 1904, pp. 438–440.

5 Jean Hamilton, "German Interiors as Seen at the St. Louis Fair," in: *The House Beautiful*, vol. 16, no. 6 (November 1904), p. 29.

6 In his review of the German section of the Palace of Varied Industries, the American designer Gustav Stickley listed the contributors Leo Nachtlicht, Arno Körnig, the Rank brothers, G. Bertsch, Hermann Billing, Max Läuger, and Fritz Dreschler, as well as Möhring, Riemerschmid, Paul, Kreis, and Olbrich (but not Behrens) as "leader[s] in the new art in Germany" (Gustav Stickley, "The German Exhibit at the Louisiana Purchase Exposition," in: *The Craftsman*, vol. 6 [August 1904], p. 501).

7 For a complete contemporary description of the Austrian pavilion, see Adolf Schwarz, "Oesterreich auf der Weltausstellung in St. Louis," in: *Neue Freie Presse* (June 6, 1904), pp. 1–3; and Max Creutz, "Die Weltausstellung in St. Louis 1904, Der österreichische Pavillon," in: *Dekorative Kunst*, vol. 13 (December 1904), pp. 125–128.

8 Ibid.

9 Ibid., p. 2. See also the photograph in *Wiener Bauindustrie-Zeitung*, vol. 22, no. 1 (1904–05), p. 35.

10 English and German catalogues for this section of the pavilion were published, containing extensive essays on arts and crafts education in Austria (*Weltausstellung Saint Louis 1904*, Österreich, k.k. Ministerium für Kultus und Unterricht; *Ausstellung k.k. kunstgewerblicher Lehranstalten* [Vienna, 1904]; *Universal Exposition Saint Louis 1904; Austria, Imperial Royal Ministry for Public Instruction Exhibition of Professional Schools for Arts and Crafts* [Vienna, 1904]).

11 Of the fifty-six exhibitors in the Vienna Kunstgewerbeschule display, twenty were women, and all except Hoffmann himself were students. Moser's class was well represented, but none of his own designs were included (*Official Catalogue of Exhibitors, Universal Exposition, St. Louis, USA* [1904], pp. 102–105).

12 See "Die Wiener Secession und die Ausstellung in St. Louis" (as note 2), p. 216.

13 There were four rooms in the pavilion devoted to painting: the Hagenbund room, a room for the Genossenschaft der bildenden Künstler Wien (often referred to as the Künstlerhaus, the conservative group from which the Secession had split off in 1898), a room devoted to Polish art, and one, designed by Jan Kotěra, devoted to the art of Bohemia (Schwarz, "Oesterreich" [as note 7], pp. 2–3).

14 This is not surprising, considering that, in the words of *The Nation*'s correspondent, Germany's contribution was "considered by all to be the fullest, the most generously equipped, and the most intelligently designed and constructed exhibit" in the entire exposition ("The Exhibits of the German Empire at St. Louis," in: *The Nation* [July 28, 1904], p. 72).

15 James Glen, "A Measure of German Progress," in: *The World's Work*, vol. 8 (August 1904), p. 5153.

16 Hamilton, "German Interiors" (as note 5), p. 30.

17 Stickley, "The German Exhibit" (as note 6), p. 506.

18 Hamilton, "German Interiors" (as note 5), p. 30.

19 "An Austrian Dining Room," in: *The House Beautiful*, vol. 20, no. 3 (August 1908), p. 26.

20 Fischer, *Rückblick* (as note 1), p. 27.

21 Ibid., p. 12. All the German interiors in the Palace of Varied Industries—including those specially designed for public and private buildings in Germany—were also offered for sale. The decision to offer them (in addition to the historical re-creations in the main pavilion) for sale was only made once the fair was underway, and in response to the fact that "this exhibition has created such an impression upon the visiting public" (Preface, *Descriptive Catalogue of the German Arts and Crafts at the Universal Exposition, Saint Louis, 1904*, Berlin: Imperial German Commission, 1904, n.p.).

22 "Modern German Applied Arts," in: *Art and Progress*, vol. 3, no. 6 (April 1912), p. 569.

23 Ibid.

24 Dean Freiday, "Modern Design at the Newark Museum: A Survey," in: *The Museum* (Newark), vol. 4 (Winter–Spring 1952), pp. 10–11.

25 *Touring Exhibition of the Deutsches Museum für Kunst in Handel und Gewerbe, Hagen I.W. with the co-operation of the Oesterreichisches Museum für Kunst und Industrie in Wien*, exhibition cat., Newark, Chicago, Indianapolis, Pittsburgh, Cincinnati, Saint Louis, 1912–13, p. 106.

26 Karl Ernst Osthaus, Introduction, in: ibid., p. 4.

27 A full account of this exhibition and its reception is given in Barry Shifman, "Design für die Industrie: Die Ausstellung 'German Applied Arts' in den Vereinigten Staaten, 1912–13," in: *Deutsches Museum für Kunst in Handel und Gewerbe 1909–1919*, exhibition cat., Krefeld, Kaiser Wilhelm Museum; and Hagen, Karl Ernst Osthaus Museum, 1997, pp. 377–389; published in English as: "Design for Industry: The 'German Applied Arts' Exhibition in the United States, 1912–13," in: *Journal of the Decorative Arts Society*, vol. 22 (1998), pp. 19–31. The show was hosted by major museums in each of the cities (the Newark Museum, Saint Louis City Art Museum, Art Institute of Chicago, John Herron Art Institute [today the Indianapolis Museum of Art], Cincinnati Art Museum, and the Carnegie Institute in Pittsburgh), with the exception of New York, where it was shown at the private National Arts Club. A catalogue in German and English, with an introduction by Karl Ernst Osthaus and a series of critical essays, was produced in Germany (*Wanderausstellung des Deutschen Museums für Kunst in Handel und Gewerbe: Newark-Chicago-Indianapolis-Pittsburgh-Cincinnati-Saint Louis*, Hagen, Deutsches Museum für Kunst in Handel und Gewerbe, 1912). Shifman mentions that Dana began reading German art journals such as *Dekorative Kunst* and *Deutsche Kunst und Dekoration* in the 1890s (Shifman, p. 378, n. 6). Lillian Langseth-Christensen, who would study under Hoffmann in the 1920s, writes that she first became aware of Hoffmann through *Deutsche Kunst und Dekoration* during her (precocious) childhood in New York in the 1910s (Langseth-Christensen, *A Design for Living*, New York: Viking, 1987).

28 Shifman, "Design für die Industrie" (as note 27), pp. 384–386. For an account of the pioneering roles played by Dana and this exhibition in the introduction of industrial design into American museums, see Freiday, "Modern Design" (as note 24), pp. 1–19. Rudolph Rosenthal and Helena L. Ratzka, writing in 1948, see Dana's work at the Newark Museum as having been central to the difficult task of persuading American industry that design was important, and that training in modern design should be supported (Rosenthal and Ratzka, *The Story of Modern Applied Art*, New York: Harper, 1948, pp. 163–164). By 1913, at least one firm in New York, Joseph P. McHugh & Son, was carrying a range of Wiener Werkstätte textiles (see advertisement in *House and Garden*, vol. 24 [November 1913], p. 329). We also know that Rosenthal, who acted as a Wiener Werkstätte representative in the U.S., convinced the department store Wanamaker's to carry Wiener Werkstätte textiles before 1916, although he was forced to buy the collection back when Wanamaker's could not sell them (Dagobert Frey, "Arbeiten eines österreichischen Architekten in Amerika: Paul Theodor Frankl," in: *Die bildenen Künste*, vol. 1 [1916–18], p. 142).

29 Louise Connolly, "The Traveling Exhibition of German Applied Art," in: *Handicraft*, vol. 5, no. 3 (June 1912), p. 31. I would like to thank Laurie Stein for drawing my attention to this article.

30 "German Art Exhibit Here," in: *New York Times* (March 7, 1913), p. 11.

31 Janis Staggs-Flinchum has written the first account of the Wiener Werkstätte of America based on a thorough investigation of sources ("A Glimpse into the Showroom of the Wiener Werkstaette of America, 1922–23," in: *The International 20th Century Arts Fair*, catalogue, New York, Haughton's, 1999, pp. 26–35). I am grateful to her for sharing contemporary newspaper and magazine reviews with me.

32 G.S.L., "A Millionaire of Imagination and a Refreshing Stream of Art and Craft," in: *Christian Science Monitor* (July 24, 1922); Mary Fanton Roberts, "Curious and Brilliant New Arts and Crafts from Vienna," in: *Vogue* (October 15, 1922), pp. 81, 104; David Lloyd, "A Workshop Background by Urban, With Reflections on the Viennese Revolt," in: *New York Evening Post* (June 17, 1922); "Exhibition Brings Viennese Art Here," in: *New York Times* (June 25, 1922); Leon V. Solon, "The Viennese Method of Artistic Display: New York Galleries of the Wiener Werkstatte of America," in: *Architectural Record*, vol. 53 (1923), pp. 266–271.

33 It seems that no inventory lists have survived for the Wiener Werkstätte of America, but from the photographs of the original displays and from the reviews, it is clear that Hoffmann and Peche were well represented. All the furniture was of Urban's own design; apparently, only relatively portable objects were imported from Vienna. Other designers represented included Susi Singer, Hilda Jesser, Fritzi Löw, and Julius Zimple.

34 "Exhibition," in: *New York Times* (June 25, 1922). It was not only the design of the galleries that encouraged the reception of the objects as art; only a fraction of the holdings were put on display at one time, and a sold item was handed over to its new owner only after the display of which it was part was dismantled (Staggs-Flinchum, "A Glimpse" [as note 31], pp. 26–28).

35 David Lloyd described the Wiener Werkstätte style as "ostentatiously simple" *(New York Evening Post,* [June 17, 1922]); Mary Fanton Roberts, writing retrospectively in the 1930s, described it as "young, gay, simple and extravagant" ("Timeless Modernism," in: *Arts and Decoration,* vol. 44 [1936] p. 11, quoted in: Staggs-Flinchum, "A Glimpse" [as note 31], p. 34).

36 C.S.L., "A Millionaire" (as note 32).

37 "The Austrian Exhibition," in: *Bulletin of the Art Institute of Chicago,* vol. 16, no. 6 (November 1922), pp. 84–85.

38 See Staggs-Flinchum, "A Glimpse" (as note 31), pp. 31–32.

39 For a comprehensive account of the reception of the Bauhaus in the United States up to 1936, see Margret Kentgens-Craig, *The Bauhaus and America: First Contacts 1919–1936,* Cambridge, Mass.: MIT Press, 1999.

40 See two reviews of the Bauhaus exhibitions at the Museum of Modern Art in 1938: Jerome Klein, "Modern Museum Surveys 10 Years of the Bauhaus," in: *New York Post* (December 10, 1938), p. 5; and Ruth Willard Robinson, "Designed for 1939," in: *Hatboro* [Penn.] *Public Spirit* (January 5, 1939). Museum of Modern Art

Archives, New York: Public Information Scrapbooks [referred to hereafter as PI] (9; 826).

41 *Second Annual Report,* The Harvard Society for Contemporary Art, 1930–1931, n.p. The Society had already mounted shows dedicated to *The School of Paris, The School of New York, Contemporary Mexican Art, Contemporary German Art, International Photography,* Maurice Prendergast, and Alexander Calder, as well as exhibiting Buckminster Fuller's Dymaxion House, and *Japanese and English Handicrafts.*

42 See *Bauhaus, 1919–1923 Weimar, 1924 Dessau,* exhibition cat., Cambridge, Mass., Harvard Society for Contemporary Art, 1930, n.p. Other lenders included Wilhelm R. Valentiner and Alfred H. Barr.

43 This catalogue text received considerable exposure. Large excerpts from it were reproduced in articles in the *Boston Herald* (F. W. Coburn, "Radical European Art Is Revealed in Harvard Society's German Display" [December 14, 1930], sec. 1, p. 2), and, when a smaller version of the show traveled to the John Becker Gallery in New York, in *Art News* ("The Bauhaus Exhibit, Becker Gallery," vol. 29, no. 16 [January 17, 1931], p. 12) and *Art Digest*

("The Bauhaus," vol. 5 [January 15, 1931], p. 27). The John Becker Gallery also produced a catalogue using Kirstein's cover—inspired by Bauhaus graphics—and his introduction. Yet another catalogue was produced for the show's final venue, the Arts Club of Chicago, again with Kirstein's introduction (reproduced in Kentgens-Craig, *Bauhaus* [as note 39], pp. 233–237).

44 "Germany Sends Experimental Art and Architecture to Cambridge, Massachusetts," in: *Boston Herald,* Rotogravure Section (December 28, 1930), n.p. The same view is reproduced and identified in Hans M. Wingler, *The Bauhaus: Weimar, Dessau, Berlin, Chicago,* Cambridge, Mass.: MIT Press, 1969, p. 412.

45 Coburn, "Radical European Art" (as note 43), p. 2.

46 Alfred H. Barr, Jr., Preface, in: *Bauhaus 1919–1928,* ed. by Herbert Bayer, Walter Gropius, and Ise Gropius, exhibition cat., New York, Museum of Modern Art, 1938, p. 5. The fact that the exhibition did not deal with the most recent phase of the Bauhaus but stopped at 1928 (when Gropius resigned as director) is put down to "reasons beyond the control of any individual involved."

47 Robinson, "Designed for 1939" (as note 40).

48 For example, Robert Coates, "The Art Galleries," in: *The New Yorker* (December 24, 1938), p. 30; and "Modern Museum Illustrates the Bauhaus Idea," in: *Art Digest,* vol. 13, no. 6 (December 15, 1938), p. 6.

49 "Bauhaus 1919–1928," in: *New York Times* (December 25, 1938). Museum of Modern Art Archives, New York: PI (9; 826).

50 For further discussion of American sympathy for art banned by the National Socialists, see Pamela Kort's essay in this volume.

51 Henry McBride, "Attractions in the Galleries," in: *New York Sun* (December 10, 1938), p. 38.

52 Klein, "Modern Museum" (as note 40), p. 5.

53 Nathalie Swan, Letter to the Editor, in: *New York Times* (December 18, 1938). Museum of Modern Art Archives, New York: PI (9; 826). For similar views on the death of the Bauhaus and the impossibility of transplanting it to America, see "Bauhaus Post Mortem," in: *Magazine of Art* (January 1939). Museum of Modern Art Archives, New York: PI (9; 826).

BIBLIOGRAPHY

INDEX

AUSTRIAN AND GERMAN EXPRESSIONISM

Der Blaue Reiter, ed. by Christine Hopfengart, exhibition cat., Kunsthalle Bremen, 2000.

Die Blaue Vier: Feininger, Jawlensky, Kandinsky, Klee in der Neuen Welt, ed. by Vivian Endicott Barnett and Josef Helfenstein, exhibition cat., Kunstmuseum Bern; and Düsseldorf, Kunstsammlung Nordrhein-Westfalen, 1997–98.

Expressionisten: Die Avantgarde in Deutschland, ed. by Roland März and Anita Kühnel, exhibition cat., West Berlin, Nationalgalerie and Kupferstichkabinett, 1986.

Gordon, Donald, *Expressionism: Art and Idea*, New Haven: Yale University Press, 1987.

Lloyd, Jill, *German Expressionism: Primitivism and Modernity*, New Haven: Yale University Press, 1991.

Myers, Bernard Samuel, *The German Expressionists: A Generation in Revolt*, New York: Praeger, 1957.

Schorske, Carl E., *Fin-de-siècle Vienna: Politics and Culture*, New York: Knopf, 1979.

Sehnsucht nach Glück: Wiens Aufbruch in die Moderne: Klimt, Kokoschka, Schiele, ed. by Sabine Schulze et al., exhibition cat., Frankfurt am Main, Kunsthalle Schirn, 1995.

Selz, Peter, *German Expressionist Painting*, Berkeley: University of California Press, 1957.

Skulptur des Expressionismus, ed. by Stephanie Barron, exhibition cat., Cologne: Josef-Haubrich-Kunsthalle, 1984.

Traum und Wirklichkeit: Wien 1870–1930, exhibition cat., Vienna, Historisches Museum der Stadt Wien, 1985.

Vergo, Peter, *Art in Vienna: 1898–1918*, London: Phaidon, 1975.

Vienne 1880–1938: L'apocalypse joyeuse, ed. by Jean Clair, exhibition cat., Paris, Centre Georges Pompidou, 1986.

Vienna 1900: Art, Architecture & Design, ed. by Kirk Varnedoe, exhibition cat., New York, Museum of Modern Art, 1986.

Werenskiold, Marit, *The Concept of Expressionism: Origin and Metamorphoses*, Oslo: Universitetsforlagert, 1984.

Werkner, Patrick, *Austrian Expressionism: The Formative Years*, Palo Alto, Calif.: Society for the Promotion of Science and Scholarship, 1993.

Neue Sachlichkeit

Buderer, Hans-Jürgen, and Manfred Fath, *Neue Sachlichkeit: Bilder auf der Suche nach der Wirklichkeit*, Munich: Kunsthalle Mannheim and Prestel, 1995.

Crockett, Dennis, *German Post-Expressionism: The Art of the Great Disorder, 1918–1924*, University Park: Pennsylvania State University Press, 1999.

Hülseweg-Johnen, Jutta, *Neue Sachlichkeit, magischer Realismus*, exhibition cat., Kunsthalle Bielefeld, 1990.

Der kühle Blick: Realismus der Zwanzigerjahre in Europa und Amerika, exhibition cat., Munich, Kunsthalle der Hypo-Kulturstiftung, 2001.

Schmied, Wieland, *Neue Sachlichkeit und Magischer Realismus in Deutschland 1918–1933*, Hannover: Fackelträger, 1969.

Dada

Bergius, Hanne, *Das Lachen Dadas: Die Berliner Dadisten und ihre Aktionen*, Giessen: Anabas, 1989.

Bergius, Hanne, *Montage und Metamechanik: Dada Berlin—Artistik von Polaritäten*, Berlin: Gebr. Mann, 2000.

Janco, Marcel, and Hans Bolliger, eds., *Dada: Monograph of a Movement*, New York: Wittenborn, 1957.

Richter, Hans, *Dada: Kunst und Antikunst*, Cologne: DuMont Schauberg, 1964.

Rubin, William, *Dada and Surrealist Art*, New York: Abrams, 1968.

Waldman, Diane, *Collage, assemblage, and found object*, New York: H. N. Abrams, 1992.

Bauhaus

Fiedler, Jeannine, and Peter Feierabend, eds., *Bauhaus*, Cologne: Könemann, 1999.

Kentgens-Craig, Margret, *The Bauhaus and America: First Contacts, 1919–1936*, Cambridge, Mass.: MIT Press, 1999.

Whitford, Frank, *Bauhaus*, London: Thames & Hudson, 1984.

Wingler, Hans Maria, *The Bauhaus: Weimar, Dessau, Berlin, Chicago*, Cambridge, Mass.: MIT Press, 1969.

LITERATURE ON THE ARTISTS

Max Beckmann

Belting, Hans, "Malerei als Konfession," in: *Malerei des deutschen Expressionismus*, ed. by Serge Sabarsky, Stuttgart: Edition Cantz, 1987.

Belting, Hans, *Max Beckmann: Tradition as a Problem in Modern Art*, New York: Timken, 1989.

Buenger, Barbara C., ed., *Max Beckmann: Self-Portrait in Words. Collected Writings and Statements, 1903–1950*, Chicago: University of Chicago Press, 1997.

Gallwitz, Klaus, et al., eds., *Max Beckmann Briefe*, 3 vols., Munich: Piper, 1993–96.

Glaser, Curt, *Max Beckmann*, Munich: Piper, 1924.

Göpel, Erhard, and Barbara Göpel, *Max Beckmann. Katalog der Gemälde*, 2 vols., Bern: Kornfeld, 1976.

Hofmaier, James, *Max Beckmann: Catalogue Raisonné of His Prints*, 2 vols., Bern: Galerie Kornfeld, 1990.

Max Beckmann, ed. by Perry T. Rathbone, exhibition cat., City Museum of Saint Louis and other venues, 1948–49.

Max Beckmann, ed. by Peter Selz, exhibition cat., New York, Museum of Modern Art, 1964–65.

Max Beckmann Retrospektive/Retrospective, ed. by Carla Schulz-Hoffmann and Judith C. Weiss, Munich, Haus der Kunst; Berlin, Neue Nationalgalerie; Saint Louis Art Museum; and Los Angeles County Museum of Art, 1984–85.

Max Beckmann, Gemälde 1905–1950, ed. by Klaus Gallwitz, exhibition cat., Leipzig, Museum den bildenden Künste; and Frankfurt am Main, Städelsches Kunstinstitut, 1990–91.

Max Beckmann in Exile, exhibition cat., New York, Guggenheim SoHo, 1996–97.

Spieler, Reinhard, *Max Beckmann: Bilderwelt und Weltbild in den Triptychen*, Cologne: DuMont, 1998.

Wiese, Stephan von, *Max Beckmanns zeichnerisches Werk: 1903–1925*, Düsseldorf: Droste, 1978.

Lovis Corinth

Berend-Corinth, Charlotte, *Die Gemälde von Lovis Corinth: Werkkatalog*, Munich: Bruckmann, 1958.

Laux, Walter Stephan, *Der Fall Corinth und die Zeitzeugen Wellner*, Munich: Prestel, 1998.

Lovis Corinth, ed. by Peter-Klaus Schuster et al., exhibition cat., Munich, Haus der Kunst; Berlin, Nationalgalerie; and Saint Louis Art Museum, 1996–97.

Uhr, Horst, *Lovis Corinth*, Berkeley: University of California Press, 1990.

Otto Dix

Otto Dix zum 100. Geburtstag 1891–1991, ed. by Wulf Herzogenrath and Johann-Karl Schmidt, exhibition cat., Galerie der Stadt Stuttgart; Berlin, Nationalgalerie; and London, Tate Gallery, 1991–92.

Pfäffle, Suse, *Otto Dix: Werkverzeichnis der Aquarelle und Gouachen*, Stuttgart: Hatje, 1991.

Strobl, Andreas, *Otto Dix: Eine Malerkarriere der zwanziger Jahre*, Berlin: Reimer, 1996.

Lyonel Feininger

Hess, Hans, *Lyonel Feininger*, Stuttgart: Kohlhammer, 1959.

Luckhardt, Ulrich, *Lyonel Feininger*, Munich: Prestel, 1989.

Lyonel Feininger. Von Gelmeroda nach Manhattan: Retrospektive der Gemälde, ed. by Roland März, exhibition cat., Berlin, Neue Nationalgalerie Staatliche Museen, 1998.

Ness, June, ed., *Lyonel Feininger*, New York: Praeger, 1974.

Scheyer, Ernst, *Lyonel Feininger: Caricature and Fantasy*, Detroit: Wayne State University Press, 1964.

Richard Gerstl

Kallir, Jane, *Richard Gerstl–Oskar Kokoschka*, New York: Galerie St. Etienne, 1992.

Kallir, Otto, "Richard Gerstl–Beiträge zur Dokumentation seines Lebens und Werkes," in: *Mitteilungen der Österreichischen Galerie*, vol. 17, no. 64 (1974).

Schröder, Klaus Albrecht, *Richard Gerstl, 1883–1908*, exhibition cat., Vienna, Kunstforum der Bank Austria; and Kunsthaus Zürich, 1993–94.

George Grosz

Envisioning America: Prints, Drawings, and Photographs by George Grosz and His Contemporaries, ed. by Beeke Sell Tower, exhibition cat., Cambridge, Mass., Busch Reisinger Museum, Harvard University, 1990.

George Grosz: Berlin–New York, ed. by Peter-Klaus Schuster, exhibition cat., Berlin, Neue Nationalgalerie; and Düsseldorf, Kunstsammlung Nordrhein-Westfalen, 1994–95.

Grosz, George, *An Autobiography* (1955), transl. by Nora Hodges, Berkeley: University of California Press, 1998.

Grosz, George, *Briefe 1913–1959*, ed. by Herbert Knust, Reinbek bei Hamburg: Rowohlt, 1979.

Grosz, George, *Der Spiesserspiegel*, Berlin: Arani, 1955.

McCloskey, Barbara, *George Grosz and the Communist Party: Art and Radicalism in Crisis, 1918 to 1936*, Princeton: Princeton University Press, 1997.

Möckel, Birgit, *George Grosz in Amerika, 1932–1959*, Frankfurt am Main: Lang, 1997.

Neugebauer, Rosamunde, *George Grosz, Macht und Ohnmacht satirischer Kunst: Die Graphikfolgen "Gott mit Uns," Ecce homo, und Hintergrund*, Berlin: Gebr. Mann, 1993.

Erich Heckel

Dube, Annemarie, and Wolf-Dieter Dube, *Erich Heckel, das graphische Werk*, 3 vols., New York: Rathenau, 1964–74.

Erich Heckel 1883–1970, Gemälde, Aquarelle, Zeichnungen und Graphik, ed. by Felix Zdenek, exhibition cat., Essen, Museum Folkwang; and Munich, Haus der Kunst, 1983–84.

Moeller, Magdalena M., ed., *Erich Heckel. Meisterwerke des Expressionismus. Aquarelle und Zeichnungen aus der Sammlung des Brücke-Museums Berlin*, Munich: Hirmer, 1999.

Vogt, Paul, *Erich Heckel*, Recklinghausen: Bongers, 1965.

Vasily Kandinsky

Barnett, Vivian Endicott, *Kandinsky Watercolors: Catalogue Raisonné*, 2 vols., Ithaca, N.Y.: Cornell University Press, 1992–94.

Barnett, Vivian Endicott, *Vasily Kandinsky: A Colorful Life. The Collection of the Lenbachhaus, Munich*, ed. by Helmut Friedel, Cologne: DuMont, 1995.

Derouet, Christian, and Jessica Boissel, *Kandinsky: Oeuvres de Vassily Kandinsky (1866–1944)*, Paris: Collections du Musée National d'Art Moderne, 1984.

Grohmann, Will, *Wassily Kandinsky: Life and Work*, New York: Abrams, 1958.

Hoberg, Annegret, *Wassily Kandinsky and Gabriele Münter: Letters and Reminiscences, 1902–1914*, Munich and New York: Prestel, 1994.

Illetschko, Georgia, *Kandinsky und Paris*, Munich: Prestel, 1998.
Lindsay, Kenneth C., and Peter Vergo, eds., *Kandinsky: Complete Writings on Art*, 2 vols., Boston: G.K. Hall, 1982.

Röthel, Hans K., *Kandinsky, das graphische Werk*, Cologne: DuMont Schauberg, 1970.

Röthel, Hans K., and Jean K. Benjamin, *Kandinsky: Catalogue Raisonné of the Oil-Paintings*, 2 vols., Ithaca, N.Y.: Cornell University Press, 1982–84.

Ernst Ludwig Kirchner

Dube-Heynig, Annemarie, and Wolf-Dieter Dube, *E. L. Kirchner, das graphische Werk*, Munich: Prestel, 1967; rev. ed., 1980.

Ernst Ludwig Kirchner, Gemälde, Aquarelle, Zeichnungen und Druckgraphik. Eine Ausstellung zum 60. Todestag, ed. by Magdalena M. Moeller and Roland Scotti, exhibition cat., Vienna, Kunstforum; and Munich, Kunsthalle der Hypo-Kulturstiftung, 1998–99.

Farben sind die Freude des Lebens: Ernst Ludwig Kirchner, das innere Bild, ed. by Mario-Andreas von Lüttichau and Roland Scotti, exhibition cat., Davos, Kirchner Museum; and Essen, Folkwang Museum, 1999–2000.

Gordon, Donald E., *Ernst Ludwig Kirchner*, Cambridge, Mass., and Munich: Harvard University Press and Prestel, 1968.

Grisebach, Lothar, ed., *E. L. Kirchners Davoser Tagebuch: Eine Darstellung des Malers und eine Sammlung seiner Schriften*, new ed., Stuttgart: Hatje, 1997.

Paul Klee

Franciscono, Marcel, *Paul Klee: His Work and Thought*, Chicago: University of Chicago Press, 1991.

Glaesemer, Jürgen, *Paul Klee: The Colored Works in the Kunstmuseum Bern: Paintings, Colored Sheets, Pictures on Glass, and Sculptures*, Bern: Kornfeld, 1979.

Haxthausen, Charles, *Paul Klee: The Formative Years*, New York: Garland, 1981.

Klee, Paul, *Handzeichnungen*, 3 vols., Bern: Kunstmuseum, 1973–84.

Klee, Paul, *Tagebücher, 1898–1918*, ed. by Wolfgang Kersten and Paul Klee-Stiftung, Stuttgart: Hatje, 1988.

Die Ordnung der Farbe: Paul Klee, August Macke und ihre Malerfreunde, exhibition cat., Kunstmuseum Bonn; and Kunstmuseum Bern, 2000–2001.

Osterwold, Tilman, *Paul Klee: Spätwerk, Arbeiten auf Papier, 1937–1939*, exhi-bition cat., Stuttgart, Württembergischer Kunstverein, 1990–91.

Paul Klee at the Guggenheim Museum, exhibition cat., New York, Solomon R. Guggenheim Museum, 1993.

Paul Klee: In der Maske des Mythos, ed. by Pamela Kort, exhibition cat., Munich, Haus der Kunst; and Rotterdam, Museum Boijmans Van Beuningen, 1999–2000.

Paul-Klee-Stiftung, ed., *Paul Klee: Catalogue Raisonné*, 5 vols. to date, Bern: Die Stiftung, 1998–.

Gustav Klimt

Eisler, Max, *Gustav Klimt*, Vienna: Druck und Verlag der österreichisches Staatsdruckerei, 1920.

Eisler, Max, ed., *Gustav Klimt, eine Nachlese*, Vienna: Druck und Verlag der österreichisches Staatsdruckerei, 1931.

Fischer, Wolfgang Georg, with the assistance of Dorothea McEwan, *Gustav Klimt und Emilie Flöge, Genie und Talent, Freundschaft und Besessenheit*, Vienna: Brandstätter, 1987.

Hofstätter, Hans H., *Gustav Klimt, erotische Zeichnungen*, Cologne: DuMont, 1979.

Novotny, Fritz, and Johannes Dobai, *Gustav Klimt*, ed. by Friedrich Welz, Salzburg: Verlag Galerie Welz, 1967; 2d ed., 1975.

Pauli, Tatjana, *Gustav Klimt*, New York: Rizzoli, 2001.

Pirchan, Emil, *Gustav Klimt, ein Künstler aus Wien*, Vienna: Wallishauser, 1942.

Pirchan, Emil, *Gustav Klimt, mit 12 Vierfarbendrucken und über 150 einfarbigen Bildbeigaben*, Vienna: Bergland, 1956.

Strobl, Alice, *Gustav Klimt, die Zeichnungen 1878–1918*, 4 vols., Salzburg: Verlag Galerie Welz, 1980–89.

Oskar Kokoschka

Kokoschka, Oskar, *Oskar Kokoschka Briefe*, 4 vols., ed. by Olda Kokoschka and Heinz Spielmann, Düsseldorf: Claassen, 1984–87.

Oskar Kokoschka, ed. by Klaus A. Schröder and Johann Winkler, exhibition cat., Vienna, Kunstforum Länderbank, 1991.

Oskar Kokoschka: Works on Paper. The Early Years, 1897–1917, exhibition cat., New York, Solomon R. Guggenheim Museum, 1994.

Rathenau, Ernest, *Kokoschka: Handzeichnungen*, vol. 1, Berlin: Rathenau, 1935.

Spielmann, Heinz, ed., *Oskar Kokoschka. Das schriftliche Werk*, 4 vols., Hamburg: Christians, 1975.

Strobl, Alice, and Alfred Weidinger, *Oskar Kokoschka, das Frühwerk (1897/98–1917): Zeichnungen und Aquarelle*, exhibition cat., Vienna, Graphische Sammlung Albertina, 1994.

Westheim, Paul, *Oskar Kokoschka*, Potsdam: Kiepenheuer, 1918.

Whitford, Frank, *Oskar Kokoschka: A Life*, New York: Atheneum, 1986.

Wingler, Hans Maria, *Oskar Kokoschka: The Work of the Painter*, Salzburg: Galerie Welz, 1958.

Winkler, Johann, and Katharina Erling, eds., *Oskar Kokoschka: Die Gemälde, 1906–1929*, vol. 1, Salzburg: Galerie Welz, 1995.

Alfred Kubin

Hoberg, Annegret, ed., *Alfred Kubin 1877–1959*, Munich: Spangenberg, 1990.

Hoberg, Annegret, ed., *Alfred Kubin, das lithographische Werk*, Munich: Hirmer, 1999.

Kubin, Alfred, *Mein Werk. Dämonen und Nachtgerichte*, Dresden: Reissner, 1931.

Kubin, Alfred, *The Other Side*, transl. by Denver Lindley, New York: Crown, 1967.

Kubin, Alfred, "Wie ich illustriere," in: *Zeitschrift für Bücherfreunde*, vol. 37 (1933).

Wilhelm Lehmbruck

Lahnsen, Margarita C., *Wilhelm Lehmbruck. Gemälde und grossformatige Zeichnungen*, Munich: Hirmer, 1997.

Schubert, Dietrich, *Die Kunst Lehmbrucks*, 2d ed., Worms and Dresden:

Wernersche Verlagsgesellschaft and Verlag der Kunst, 1990.

Schubert, Dietrich, *Wilhelm Lehmbruck: Catalogue Raisonné der Skulpturen 1898–1919*, Worms: Wernersche Verlagsgesellschaft, 2001.

Wilhelm Lehmbruck (1891–1919). Plastik, Malerei, Graphik aus den Sammlungen des Wilhelm-Lehmbruck-Museums der Stadt Duisburg, ed. by Peter Betthausen et al., exhibition cat., Duisberg, Museen der Stadt Gotha im Museum der Natur; Berlin, Alte Nationalgalerie; and Leipzig, Museum der bildenden Künste, 1987–88.

August Macke

August Macke. Gemälde, Aquarelle, Zeichnungen, ed. by Ernst-Gerhard Güse, exhibition cat., Münster, Westfälisches Landesmuseum für Kunst und Kulturegeschichte; Bonn, Städtisches Kunstmuseum; and Munich, Städtische Galerie im Lenbachhaus, 1986–87.

Erdmann-Macke, Elisabeth, *Erinnerungen an August Macke*, Stuttgart: Kohlhammer, 1962.

Friesen, Astrid von, *August Macke. Ein Maler-Leben*, Hamburg: Ellert & Richter, 1989.

Heiderich, Ursula, *August Macke. Aquarelle. Werkverzeichnis*, Stuttgart: Hatje, 1997.

Meseure, Anna, *August Macke 1887–1914*, Cologne: Benedikt Taschen, 1999.

Moeller, Magdalena M., *August Macke: Die Tunisreise*, Munich: Prestel, 1989; 4th ed., 1998.

Vriesen, Gustav, *August Macke*, 2d ed., Stuttgart: Kohlhammer, 1957.

Franz Marc

Franz Marc 1880–1916, ed. by Rosel Gollek, exhibition cat., Munich, Städtische Galerie im Lenbachhaus, 1980.

Franz Marc. Kräfte der Natur, ed. by Erich Franz, exhibition cat., Münster, Westfälisches Landesmuseum für Kunst und Kulturgeschichte, 1994. *Franz Marc: Pferde/Horses*, ed. by Christian von Holst, exhibition cat., Stuttgart, Staatsgalerie, 2000.

Lankheit, Klaus, *Franz Marc. Katalog der Werke*, Cologne: DuMont Schauberg, 1970.

Lankheit, Klaus, *Franz Marc. Sein Leben und seine Kunst*, Cologne: DuMont, 1976.

Lankheit, Klaus, ed., *Franz Marc: Schriften*, Cologne: DuMont, 1978.

Levine, Frederick S., *The Apocalyptic Vision: The Art of Franz Marc as German Expressionism*, New York: Harper & Row, 1979.

Rosenthal, Mark, *Franz Marc*, 2d ed., Munich: Prestel, 1992.

George Minne

Constantin Meunier, George Minne: Dessins et sculptures, exhibition cat., Brussels, Musées Royaux des Beaux-Arts de Belgique, 1969.

George Minne. Plastiken und Zeichnungen, exhibition cat., Hagen, Karl Ernst Osthaus-Museum, 1962.

George Minne en de kunst rond 1900, exhibition cat., Ghent, Museum voor Schone Kunsten, 1982.

Guenther, Peter W., "George Minne," in: *German Expressionist Sculpture*, ed. by Stephanie Barron, exhibition cat., Los Angeles County Museum of Art; and Cologne, Joseph-Haubrich-Kunsthalle, 1983–84, pp. 145–147.

László Moholy-Nagy

Kostelanetz, Richard, ed., *Moholy-Nagy*, New York: Praeger, 1970.

László Moholy-Nagy. Fotogramme 1922–1943, exhibition cat., Essen, Museum Folkwang, 1996.

Margolin, Victor, "László Moholy-Nagys Odyssee. Von Ungarn nach Chicago," in: *Bauhaus: Dessau, Chicago, New York*, ed. by Georg W. Költzsch and Margarita Tupitsyn, exhibition cat., Essen, Museum Folkwang, 2000, pp. 198–207.

Gabriele Münter

Eichner, Johannes, *Kandinsky und Gabriele Münter: Von Ursprüngen moderner Kunst*, Munich: Bruckmann, 1957.

Gabriele Münter: Fifty Years of Her Art, exhibition cat., New York, Leonard Hutton Galleries, 1966.

Gabriele Münter: Between Munich and Murnau, ed. by Anne Mochon, exhibition cat., Cambridge, Mass., Busch-

Reisinger Museum, Harvard University, 1980.

Gabriele Münter 1877–1962, Retrospektive, ed. by Annegret Hoberg and Helmut Friedel, exhibition cat., Munich, Städtische Galerie im Lenbachhaus, 1992.

Gabriele Münter: The Years of Expressionism, 1903–1920, ed. by Reinhold Heller, exhibition cat., Milwaukee Art Museum, 1997.

Hoberg, Annegret, ed., *Wassily Kandinsky and Gabriele Münter: Letters and Reminiscences, 1902–1914*, Munich and New York: Prestel, 1994.

Kleine, Gisela, *Gabriele Münter und Wassily Kandinsky: Biographie eines Paares*, rev. ed., Frankfurt am Main: Insel, 1994.

Emil Nolde

Emil Nolde, ed. by Ingrid Brugger and Manfred Reuther, exhibition cat., Vienna, Kunstforum Bank Austria, 1994–95.

Haftmann, Werner, *Emil Nolde*, 8th ed. Cologne: DuMont, 1988.

Nolde, Emil, *Das eigene Leben* (1931), 7th ed., Cologne: DuMont, 1994.

Nolde, Emil, *Jahre der Kämpfe* (1934), 6th ed., Cologne: DuMont, 1991.

Nolde, Emil, *Reisen, Ächtung, Befreiung 1919–1946*, 5th ed., Cologne: DuMont, 1994.

Nolde, Emil, *Welt und Heimat. Die Südseereise 1913–1918* (1936), 3d ed., Cologne: DuMont, 1990.

Osterwold, Tilman, and Thomas Knubben, eds., *Emil Nolde. Ungemalte Bilder. Aquarelle 1938 bis 1945 aus der Sammlung der Nolde-Stiftung Seebüll*, Stuttgart: Hatje Cantz, 1999.

Reuther, Manfred, *Das Frühwerk Emil Noldes. Vom Kunstgewerbler zum Künstler*, Cologne: DuMont, 1985.

Sprotte, Martina, *Bunt oder Kunst? Die Farbe im Werk Emil Noldes*, Berlin: Gebr. Mann, 1999.

Urban, Martin, *Emil Nolde: Catalogue Raisonné of the Oil-Paintings*, 2 vols., London and New York: Sotheby's Publications and Harper & Row, 1987.

Max Pechstein

Fechter, Paul, *Das graphische Werk Max Pechsteins*, Berlin: Gurlitt, 1921.

Heymann, Walther, *Max Pechstein*, Munich: Piper, 1916.

Der junge Pechstein. Gemälde, Aquarelle und Zeichnungen, exhibition cat., Berlin, Staatliche Museen, Nationalgalerie, and Hochschule für Bildende Künste, 1959.

Max Pechstein, ed. by Jürgen Schilling, exhibition cat., Kunstverein Braunschweig, 1982.

Max Pechstein. Das ferne Paradies. Gemälde, Zeichnungen, Druckgraphik, exhibition cat., Städtisches Kunstmuseum Spendhaus Reutlingen; and Städtisches Museum Zwickau, 1995.

Max Pechstein: Sein malerisches Werk, ed. by Magdalena M. Moeller, exhibition cat., Berlin, Brücke-Museum, 1996–97.

Pechstein, Max, *Erinnerungen*, ed. by Leopold Reidemeister, Wiesbaden: Limes, 1960.

Christian Schad

Christian Schad, exhibition cat., Milan, Galleria del Levante, 1970.

Christian Schad, ed. by Matthias Eberle and Hanne Bergius, exhibition cat., Berlin, Staatliche Kunsthalle, 1980.

Christian Schad. Dokumentation: Druckgraphiken und Schadographien in Einzelblättern und Mappenwerken 1913–1981, ed. by Günter A. Richter, Rottach-Egern: Edition G.A. Richter, 1997.

Christian Schad 1894–1982, exhibition cat., Kunsthaus Zürich; Munich, Städtische Galerie im Lenbachhaus; and Kunsthalle in Emden (Collection Henri and Eske Nannen), 1997–98.

Heesemann-Wilson, Andrea, *Christian Schad. Expressionist, Dadaist und Maler der Neuen Sachlichkeit. Leben und Werk bis 1945*, Ph.D. dissertation, Universität Göttingen, 1978.

Egon Schiele

Comini, Alessandra, *Egon Schiele's Portraits*, Berkeley: University of California Press, 1974.

Kallir, Jane, *Egon Schiele: The Complete Works*, rev. ed., New York: Abrams, 1998.

Kallir(-Nirenstein), Otto, *Egon Schiele: The Graphic Work*, New York and Vienna: Crown and Zsolnay, 1970.

Kallir(-Nirenstein), Otto, *Egon Schiele: Oeuvre Catalogue of the Paintings*, New York and Vienna: Crown and Zsolnay, 1966.

Leopold, Rudolf, *Egon Schiele: Gemälde, Aquarelle, Zeichnungen*, Salzburg: Residenz, 1972.

Leopold, Rudolf, *Egon Schiele: Die Sammlung Leopold, Wien*, exhibition cat., Kunsthalle Tübingen; Düsseldorf, Kunstsammlung Nordrhein-Westfalen; and Hamburger Kunsthalle, 1995–96.

Nebehay, Christian M., *Egon Schiele—Leben, Briefe, Gedichte*, Salzburg: Residenz, 1979.

Nebehay, Christian M., *Egon Schiele. Leben und Werk*, Salzburg: Residenz, 1980.

Nirenstein(-Kallir), Otto, *Egon Schiele: Persönlichkeit und Werk*, Vienna: Zsolnay, 1930.

Oskar Schlemmer

Grohmann, Will, ed., *Oskar Schlemmer, Zeichnungen und Graphik: Œuvrekatalog*, Stuttgart: Hatje, 1965.

Herzogenrath, Wulf, *Oskar Schlemmer: Die Waldgestaltungen der neuen Architektur*, Munich: Prestel, 1973.

Hildebrandt, Hans, ed., *Oskar Schlemmer, catalogue raisonné*, Munich: Prestel, 1951.

Maur, Karin von, *Oskar Schlemmer: Monographie und Oeuvrekatalog der Gemälde, Aquarelle, Pastelle und Plastiken*, 2 vols., Munich: Prestel, 1979.

Oskar Schlemmer, ed. by Arnold L. Lehmann and Brenda Richardson, The Baltimore Museum of Art; New York, IBM Gallery of Science and Art; San Francisco Museum of Modern Art; Minneapolis, Walker Art Center; and Amsterdam, Stedelijk Museum, 1986–87.

Oskar Schlemmer: Der Folkwang-Zyklus, Malerei um 1930, ed. by Karin von Maur, exhibition cat., Stuttgart, Staatsgalerie; and Essen, Museum Folkwang, 1993.

Scheper, Dirk, *Oskar Schlemmer: Das triadische Ballett und die Bauhausbühne*, Berlin: Akademie der Künste, 1988.

Schlemmer, Tut, *Oskar Schlemmer. Briefe und Tagebücher*, Munich: Langen, 1958.

Karl Schmidt-Rottluff

Grohmann, Will, *Karl Schmidt-Rottluff*, Stuttgart: Kohlhammer, 1956.

Karl Schmidt-Rottluff: Retrospektive, ed. by Gunther Thiem and Armin Zweite, exhibition cat., Kunsthalle Bremen; and Munich, Städtische Galerie im Lenbachhaus, 1989.

Moeller, Magdalena M., ed., *Karl Schmidt-Rottluff. Aquarelle*, Stuttgart: Hatje, 1991.

Moeller, Magdalena M., *Karl Schmidt-Rottluff. Tuschpinselzeichnungen*, Munich: Hirmer, 1995.

Moeller, Magdalena M., *Karl Schmidt-Rottluff: Werke aus der Sammlung des Brücke-Museums*, Munich: Hirmer, 1997.

Rathenau, Ernest, *Karl Schmidt-Rottluff. Das graphische Werk seit 1923*, Weinheim: Beltz, 1964.

Schapire, Rosa, *Karl Schmidt-Rottluffs Graphisches Werk*, Berlin: Euphorion, 1924.

Valentiner, Wilhelm R., *Schmidt-Rottluff*, Leipzig: Junge Kunst, 1920.

Wietek, Gerhard, *Schmidt-Rottluff: Oldenburger Jahre 1907–1912*, Mainz: von Zabern, 1994.

Kurt Schwitters

Aller Anfang ist Merz. Von Kurt Schwitters bis heute, ed. by Susanne Meyer-Büser and Karin Orchard, exhibition cat., Hannover, Sprengel Museum; Düsseldorf, Kunstsammlung Nordrhein-Westfalen; and Munich, Haus der Kunst, 2000–2001; English trans. by Fiona Elliott: *In the Beginning Was Merz: From Kurt Schwitters to the Present Day*, Ostfildern: Hatje Cantz, 2000.

Dietrich, Dorothea, *The Collages of Kurt Schwitters: Tradition and Innovation*, 2d ed., Cambridge: Cambridge University Press, 1995.

Elderfield, John, *Kurt Schwitters*, London: Thames & Hudson, 1985.

Elger, Dietmar, *Der Merzbau von Kurt Schwitters. Eine Werkmonographie*, 2d ed., Cologne: König, 1999.

Lach, Friedhelm, *Der Merzkünstler Kurt Schwitters*, Cologne: DuMont Schauberg, 1971.

Orchard, Karin, and Isabel Schulz, eds., *Kurt Schwitters, Werke und Dokumente: Verzeichnis der Bestände im Sprengel Museum Hannover / Kurt Schwitters: Catalogue of the Works and Documents in the Sprengel Museum Hannover*, Hannover: Sprengel Museum, 1998.

Schmalenbach, Werner, *Kurt Schwitters*, New York: Abrams, 1967.

Webster, Gwendolen, *Kurt Merz Schwitters: A Biographical Study*, Cardiff: University of Wales Press, 1997.

DECORATIVE ARTS IN AUSTRIA

Eisler, Max, *Österreichische Werkkultur*, Vienna: Schroll, 1916.

Fliedl, Gottfried, *Kunst und Lehre am Beginn der Moderne. Die Wiener Kunstgewerbeschule 1867–1918*, Salzburg: Residenz, 1986.

Forsthuber, Sabine, *Moderne Raumkunst: Wiener Ausstellungsbauten von 1898 bis 1914*, Vienna: Picus, 1991.

Gmeiner, Astrid, and Gottfried Pirhofer, *Der Österreichische Werkbund*, Salzburg: Residenz, 1985.

Kallir, Jane, *Viennese Design and the Wiener Werkstätte*, New York: Galerie St. Etienne and Braziller, 1986.

Koller, Gabriele, *Die Radikalisierung der Phantasie. Design aus Österreich*, Salzburg: Residenz, 1987.

Kunst: Anspruch und Gegenstand. Von der Kunstgewerbeschule zur Hochschule für angewandte Kunst in Wien 1918–1991, ed. by Hochschule für angewandte Kunst in Wien, Salzburg: Residenz, 1991.

Neuwirth, Waltraud, *Österreichische Keramik des Jugendstil*, Munich: Prestel, 1974.

Vienna 1900: Art, Architecture & Design, ed. by Kirk Varnedoe, exhibition cat., New York, Museum of Modern Art, 1986.

Visionäre & Vertriebene. Österreichische Spuren in der modernen amerikanischen Architektur, ed. by Matthias Boeckl, exhibition cat., Vienna, Kunsthalle Wien, 1995.

DECORATIVE ARTS IN GERMANY

Arnold, Klaus-Peter, *Vom Sofakissen zum Städtebau. Die Geschichte der Deutschen Werkstätten und der Gartenstadt Hellerau*, Dresden: Verlag der Kunst, 1993.

Bauhaus: Dessau, Chicago, New York, ed. by Georg W. Költzsch and Margarita Tupitsyn, exhibition cat., Essen, Museum Folkwang, 2000.

Berlin 1900–1933: Architecture and Design/Architektur und Design, ed. by Tilmann Buddensieg, exhibition cat., New York, Cooper-Hewitt Museum, 1987.

Droste, Magdalena, *Bauhaus 1919–1933*, Cologne: Taschen, 1991.

1910 Halbzeit der Moderne. Van de Velde, Behrens, Hoffmann und die anderen, ed. by Klaus Bussmann, exhibition cat., Münster, Westfälisches Landesmuseum für Kunst und Kulturgeschichte, 1992.

Das Schöne und der Alltag: Deutsches Museum für Kunst in Handel und Gewerbe 1909–1919, exhibition cat., Krefeld, Kaiser Wilhelm Museum; and Hagen, Karl Ernst Osthaus-Museum, 1997.

Schwartz, Frederic J., *The Werkbund: Design Theory and Mass Culture Before the First World War*, New Haven: Yale University Press, 1996.

Selle, Gert, *Design-Geschichte in Deutschland. Produktkultur als Entwurf und Erfahrung*, Cologne: DuMont, 1990.

Wanderausstellung des Deutschen Museums für Kunst in Handel und Gewerbe: Newark-Chicago-Indianapolis-Pittsburgh-Cincinnati-St. Louis, exhibition cat., Hagen, Deutsches Museum für Kunst in Handel und Gewerbe, 1912–13.

Der Westdeutsche Impuls 1900–1914. Kunst und Umweltgestaltung im Industriegebiet. Die Deutsche Werkbund-Ausstellung Cöln 1914, ed. by Felix Zdenek, exhibition cat., Cologne, Kölnischer Kunstverein, 1984.

Der Westdeutsche Impuls 1900–1914. Kunst und Umweltgestaltung im Industriegebiet. Die Margarethenhöhe. Das Schöne und die Ware, ed. by Felix Zdenek, exhibition cat., Essen, Museum Folkwang, 1984.

Der Westdeutsche Impuls 1900–1914. Kunst und Umweltgestaltung im Industriegebiet. Die Folkwang-Idee des Karl Ernst Osthaus, ed. by Felix Zdenek, exhibition cat., Hagen, Ernst Osthaus-Museum, 1984.

Wingler, Hans M., *The Bauhaus: Weimar, Dessau, Berlin, Chicago*, Cambridge, Mass.: MIT Press, 1969.

LITERATURE ON THE ARTISTS

Peter Behrens

Anderson, Stanford, *Peter Behrens and a New Architecture for the Twentieth Century*, Cambridge, Mass.: MIT Press, 2000.

Buddensieg, Tilmann, with Henning Rogge et al., *Industriekultur: Peter Behrens and the AEG, 1907–1914*, transl. by Iain Boyd Whyte, Cambridge, Mass.: MIT Press, 1984.

Krawietz, Georg, *Peter Behrens im Dritten Reich*, Weimar: Verlag und Datenbank für Geisteswissenschaften, 1995.

Moeller, Gisela, *Peter Behrens in Düsseldorf: Die Jahre 1903 bis 1907*, Weinheim: VCH, 1991.

Schuster, Peter-Klaus, ed., *Peter Behrens und Nürnberg, Geschmackswandel in Deutschland: Historismus, Jugendstil und die Anfänge der Industrieform*, Nuremberg and Munich: Germanisches Nationalmuseum and Prestel, 1980.

Theodor Bogler

50 Jahre Bauhaus, ed. by Wulf Herzogenrath, exhibition cat., Stuttgart, Württembergischer Kunstverein, 1968.

Keramik und Bauhaus, ed. by Klaus Weber, exhibition cat., Berlin, Bauhaus-Archiv, 1989.

Marianne Brandt

Brockhage, Hans, and Reinhold Lindner, *Marianne Brandt, "Hab ich je an Kunst gedacht,"* Chemnitz: Chemnitzer Verlag, 2001.

50 Jahre Bauhaus, ed. by Wulf Herzogenrath, exhibition cat., Stuttgart, Württembergischer Kunstverein, 1968.

Die Metallwerkstatt am Bauhaus, ed. by Klaus Weber, exhibition cat., Berlin, Bauhaus-Archiv, 1992.

Scheidig, Walter, *Bauhaus Weimar, 1919–1924*, Leipzig: Edition Leipzig, 1966.

Wingler, Hans M., *The Bauhaus: Weimar, Dessau, Berlin, Chicago*, Cambridge, Mass.: MIT Press, 1969.

Marcel Breuer

Blake, Peter, *Marcel Breuer: Architect and Designer*, New York: Museum of Modern Art, 1949.

Blake, Peter, ed., *Marcel Breuer: Sun and Shadow: The Philosophy of an Architect*, New York: Dodd, Mead, 1955.

Droste, Magdalena, and Manfred Ludewig, *Marcel Breuer, Design*, Cologne: Taschen, 1992.

Jones, Cranston, ed., *Marcel Breuer: Buildings and Projects, 1921–1961*, New York: Praeger, 1962.

Papachristou, Tician, *Marcel Breuer: New Buildings and Projects*, New York: Praeger, 1970.

Josef Hoffmann

Josef Hoffmann Designs, ed. by Peter Noever, exhibition cat., Vienna, Museum für angewandte Kunst, 1992.

Schweiger, Werner J., *Wiener Werkstätte: Design in Vienna, 1903–1932*, New York: Abbeville, 1984.

Sekler, Eduard F., *Josef Hoffmann: The Architectural Work*, Princeton: Princeton University Press, 1985.

Adolf Loos

Adolf Loos 1870–1933, ed. by Burkhardt Rukschcio, exhibition cat., Vienna, Graphische Sammlung Albertina, 1989.

Loos, Adolf, *Ins Leere Gesprochen* (1921), English ed.: *Spoken into the Void: Collected Essays, 1897–1900*, transl. by J. O. Newman and J. H. Smith, Cambridge, Mass.: MIT Press, 1982.

Loos, Adolf, *Sämtliche Schriften*, 2 vols., ed. by Franz Glück, Vienna: Herold, 1962.

Loos, Adolf, *Trotzdem, Gesammelte Schriften 1900–1930* (1931), reprint, Vienna: Prachner, 1982.

Münz, Ludwig, and Gustav Künstler, *Adolf Loos: Pioneer of Modern Archi-*

tecture, transl. by H. Meek, New York: Praeger, 1966.

Rukschcio, Burkhardt, and Roland Schachel, *Adolf Loos, Leben und Werk*, Salzburg: Residenz, 1982; 2d ed., 1987.

Tournikiotis, Panayotis, *Adolf Loos*, Princeton: Princeton Architectural Press, 1994.

Ludwig Mies van der Rohe

Cohen, Jean-Louis, *Mies van der Rohe*, London: E and FN Spon, 1996.

Mies van der Rohe: Architect as Educator, ed. by Rolf Achilles, Kevin Harrington, and Charlotte Myhrum, exhibition cat., Chicago, Illinois Institute of Technology, 1986.

Mies in America, ed. by Phyllis Lambert et al., exhibition cat., New York, Whitney Museum of American Art, 2001.

Mies in Berlin, ed. by Terence Riley and Barry Bergdoll, exhibition cat., New York, Museum of Modern Art, 2001.

Neumeyer, Fritz, *The Artless Word: Mies van der Rohe on the Building Art*, Cambridge, Mass.: MIT Press, 1991.

Schulze, Franz, *Mies van der Rohe: A Critical Biography*, Chicago: University of Chicago Press, 1985.

Schulze, Franz, ed., *Mies van der Rohe: Critical Essays*, with contributions by James Ingo Freed, Fritz Neumeyer, Richard Pommer, Franz Schulze, and Wolf Tegethoff, Cambridge, Mass.: MIT Press, 1989.

Spaeth, David A., *Mies van der Rohe*, preface by Kenneth Frampton, New York: Rizzoli, 1985.

Koloman Moser

Fenz, Werner, *Koloman Moser: Graphik—Kunstgewerbe—Malerei*, Salzburg: Residenz, 1984.

Fenz, Werner, *Kolo Moser: Internationaler Jugendstil und Wiener Secession*, Salzburg: Residenz, 1976.

Koloman Moser 1868–1918, ed. by Oswald Oberhuber and Julius Hummel, exhibition cat., Vienna, Museum für angewandt Kunst and Hochschule für angewandte Kunst, 1979.

Telkamp, Maike, *Japonismus im Werk Koloman Mosers*, Master's thesis, University of Vienna, 2001.

Dagobert Peche

Eisler, Max, *Dagobert Peche*, Vienna: Gerlach & Wiedling, 1925; reprint, Stuttgart: Arnoldsche Verlagsanstalt, 1992.

Die Überwindung der Utilität: Dagobert Peche und die Wiener Werkstätte, ed. by Peter Noever, exhibition cat., Vienna, Museum für angewandte Kunst, 1998 (includes full bibliography).

Hans Prutscher

Hajós, Géza, "Hans Prutscher und einige Probleme der Wiener Architektur vor dem Ersten Weltkrieg," in: *Mitteilungen der Gesellschaft für vergleichende Kunstforschung*, vol. 30, no. 1 (1978), p. 5.

Levetus, A. S., "Architekt Hans Prutscher in Wien," in: *Moderne Bauformen*, vol. 11 (1912), pp. 570–572.

Prutscher, Hans, *Auslese meiner Arbeiten 1898–1928*, Vienna: Selbstverlag, 1928.

Prutscher, Hans, "Behauptungen," in: *Das Interieur*, vol. 12 (1911), p. 66.

Schestag, August, "Arbeiten von Hans Prutscher und Hubert von Zwickle," in: *Kunst und Kunsthandwerk*, vol. 9 (1906), pp. 439–440.

Otto Prutscher

De Giorgi, Gabriele, et al., eds., *Otto Prutscher, 1880–1949*, Metamorfosi vols. 22–23, Rome: Uniénone Stampa Periodical Italiana, 1994.

Eisler, Max, *Otto Prutscher*, Vienna: Hubsch, 1925.

Otto Prutscher 1880–1949. Architektur, Interieur, Design, ed. by Matthias Boeckl et al., exhibition cat., Vienna, Hochschule für angewandte Kunst, 1997.

Hans Przyrembel

Bauhaus 1919–1928, ed. by Herbert Bayer, Walter Gropius, and Ise Gropius, exhibition cat., New York, Museum of Modern Art, 1938.

Bauhaus-Profile, exhibition cat., Zehntscheuer, Stadt Balingen; and Leipzig, Museum für Kunsthandwerk / Grassimuseum, 1996–97.

Burchard, Carl, *Gutes und Böses in der Wohnung in Bild und Gegenbild:*

Grundlagen für neues Wohnen, Leipzig: Beyer, 1933, ill. 433.

Kentgens-Craig, Margret, *The Bauhaus and America: First Contacts, 1919–1936*, Cambridge, Mass.: MIT Press, 1999.

Die Metallwerkstatt am Bauhaus, ed. by Klaus Weber, exhibition cat., Berlin, Bauhaus-Archiv, 1992.

Jutta Sika

Frauen im Design: Berufsbilder und Lebenswege seit 1900 / Women in Design: Careers and Life Histories Since 1900, ed. by Design Center Stuttgart, exhibition cat., Design Center Stuttgart, 1989.

Levetus, A. S., "Modern Decorative Art in Austria," in: *The Art-Revival in Austria* (The Studio Special Issue), ed. by Charles Holme, London, 1906, p. D X, pls. D 8, 9, 10, 51, 53.

Plakolm-Forsthuber, Sabine, *Künstlerinnen in Österreich 1897–1938. Malerei, Plastik, Architektur*, Vienna: Picus, 1994.

Ricke, Helmut, et al., *Lötz. Böhmisches Glas 1880–1940*, vol. 1: *Werkmonographie*, Munich: Prestel, 1989.

Zuckerkandl, Berta, "Wiener Kunst im Hause," in: *Dekorative Kunst*, vol. 12 (1904), pp. 169–174.

Therese Trethan

Anscombe, Isabelle, *A Woman's Touch: Women in Design from 1860 to the Present Day*, London: Virago, 1984.

Eisler, Max, *Österreichische Werkkultur*, Vienna: Scholl, 1916, p. 260, no. 574. *Frauen im Design: Berufsbilder und Lebenswege seit 1900 / Women in Design: Careers and Life Histories Since 1900*, ed. by Design Center Stuttgart, exhibition cat., Design Center Stuttgart, 1989.

Plakolm-Forsthuber, Sabine, *Künstlerinnen in Österreich 1897–1938. Malerei, Plastik, Architektur*, Vienna: Picus, 1994.

Zuckerkandl, Berta, "Wiener Kunst im Hause," in: *Dekorative Kunst*, vol. 12 (1904), pp. 169–174.

Joseph Urban

Architect of Dreams: The Theatrical Vision of Joseph Urban, ed. by Arnold

Aronson, exhibition cat., New York, Columbia University, Miriam and Ira D. Wallach Art Gallery, 2000.

Carter, Randolph, and Robert Reed Cole, *Joseph Urban: Architecture, Theater, Opera, Film*, New York: Abbeville, 1992.

Kristan, Markus, *Joseph Urban: Die Wiener Jahre des Jugendstilarchitekten und Illustrators, 1872–1911*, Cologne: Böhlau, 2000.

Urban, Joseph, *The New School for Social Research*, New York, 1930.

Urban, Joseph, *Theatres*, New York: New York Theatre Arts, Inc., 1929.

Wilhelm Wagenfeld

Manske, Beate, ed., *Wilhelm Wagenfeld (1900–1990)*, Ostfildern-Ruit: Hatje Cantz, 2000.

Schöne Form, gute Ware: Wilhelm Wagenfeld zum 80. Geburtstag, ed. by Andrea Berger-Fix and Herbert Meurer, exhibition cat., Stuttgart, Württembergisches Landesmuseum, 1980.

Täglich in der Hand: Industrieformen von Wilhelm Wagenfeld aus sechs Jahrzehnten (Manske-Scholz 1988), 2d ed., ed. by Beate Manske and Gudrun Scholz, Bremen: Worpsweder, 1988.

Wilhelm Wagenfeld: 50 Jahre Mitarbeit in Fabriken, ed. by Carl-Wolfgang Schümann, exhibition cat., Cologne, Kunstgewerbemuseum; and Munich, Die Neue Sammlung, 1973–74.

Otto Wagner

Asenbaum, Paul, et al., *Otto Wagner: Möbel und Innenräume*, Salzburg: Residenz, 1984.

Graf, Otto Antonia, *Otto Wagner*, vol. 1: *Das Werk des Architekten 1860–1902*; vol. 2: *Das Werk des Architekten 1903–1918*; vol. 3: *Die Einheit der Kunst: Weltgeschichte der Kunstformen*; vol. 4: *Siccardsburg und Van der Null: Zu den Anfängen der Moderne*; vol. 5: *Baukunst des Eros 1863–1888*; vol. 6: *Baukunst des Eros 1889–1899*; vol. 7: *Baukunst des Eros 1900–1918*, Vienna: Böhlau, 1985–2000.

Lux, Joseph August, *Otto Wagner*, Munich: Delphin, 1914.

Wagner, Otto, *Einige Skizzen, Projekte und ausgeführte Bauwerke. Vollständi-*

ger Nachdruck der vier Originalbände von *1889, 1897, 1906, 1922*, intro. by Peter Haiko, Tübingen: Wasmuth, 1987.

Wagner, Otto, *Moderne Architecture: A Guide for His Students to This Field of Art*, intro. by Harry Francis Mallgrave, Santa Monica, Calif.: The Getty Center, 1988.

Eduard Josef Wimmer-Wisgrill

Eduard Josef Wimmer-Wisgrill. Modeentwürfe 1912–1927, exhibition cat.,Vienna, Hochschule für angewandte Kunst, 1983.

Hansen, Traude, *Wiener Werkstätte Mode: Stoffe, Schmuck, Accessories*, Vienna: Brandstätter, 1984.

Ligthart, Jeanne, *Eduard Josef Wimmer-Wisgrill, seine Bedeutung für die Modeabteilung der Wiener Werkstätte 1910–1922*, Master's thesis, Universität für angewandte Kunst, 1997.

Völker, Angela, *Textiles of the Wiener Werkstätte, 1910–1932*, New York: Rizzoli, 1994.

Völker, Angela, *Wiener Mode + Modefotografie: Die Modeabteilung der Wiener Werkstätte, 1911–1932*, Munich: Schneider-Henn, 1984.

INDEX

PHOTOGRAPH CREDITS

COPYRIGHT CREDITS